Sculpture Index

by

Jane Clapp

Volume 1 — Sculpture of Europe
and the
Contemporary Middle East

The Scarecrow Press, Inc.

Metuchen, N.J. 1970

Copyright 1970, by Jane Clapp

SBN 8108-0249-x

Contents

Symbols for Books Indexed

ACA Art in California. A survey of American art with special reference to California painting, sculpture and architecture--past and present, particularly as those arts were represented at the Panama-Pacific International Exposition. San Francisco, R. L. Bernier Publisher, 1916

ADA Adams, Adeline Valentine. Spirit of American sculpture; written for the National Sculpture Society. New York, 1929

ADAM Adams, J. T., and others. Album of American history. 6 v. New York, Scribner, 1944-61. Volumes 1, 3, 5 indexed.

ADD Addison Gallery of American Art. Phillips Academy, Andover, Massachusetts. Handbook. 1939

ADL Adam, Leonard. Primitive art. 3rd ed. London, Cassells Co. Ltd., 1954

AGARC Agard, Walter Raymond. Classical myths in sculpture. Madison, University of Wisconsin Press, 1951.

AGARN Agard, Walter Raymond. The New architectural sculpture. New York, Oxford University Press, 1935

ALB Albright-Knox Art Gallery. Catalogue of painting and sculpture in the permanent collection. Edited by Andrew C. Ritchie. Buffalo, N. Y., Buffalo Fine Arts Academy, 1949

ALBA Albright-Knox Art Gallery. The Gallery. Samuel C. Miller, editor. Buffalo, New York

ALBB Albright-Knox Art Gallery. Contemporary British painting and sculpture, from the collection of the Albright-Knox Art Gallery and special loans. Buffalo, N. Y., Albright-Knox Art Gallery, 1964

ALBC Albright-Knox Art Gallery. Catalogue of contemporary paintings and sculpture. The Room of Contemporary Art Collection. Edited by Andrew C. Ritchie, Buffalo, N. Y., Buffalo Fine Arts Academy, 1949.

i

ALBC--1-4 Albright-Knox Art Gallery. Contemporary Art: Acquisitions Buffalo, N. Y.
 --1 1954-1957 --3 1959-1961
 --2 1957-1958 --4 1962-1965

ALBG Albright-Knox Art Gallery. Gifts to the Albright-Knox Art Gallery from A. Conger Goodyear, December 14-January 6, 1963

ALBK Buffalo Fine Arts Academy. Albright-Knox Art Gallery. Kinetic and optic art today, catalog of an exhibit February 27-March 28, 1965. Buffalo, N. Y., Buffalo Fine Arts Academy, 1965

AM Brussels. Exposition Universelle et Internationale, 1958. American art: four exhibitions. 17 April to October 18, 1958. New York, American Federation of Arts, 1958

AMA Amaya, Mario. Pop as art, a survey of the New Super Realism. London, Studio Vista, 1965 Published in U. S. under title: Pop Art...and after. New York, Viking Press, 1966

AMAB American Abstract Artists. World of abstract art. New York, George Wittenborn, 1957

AMF American Federation of Arts. Art in our country, handbook. Washington, D. C., American Federation of Arts, 1923

AMHI American Heritage. Book of Indians. American Heritage; distributed by Simon and Schuster, 1961

AMHP American Heritage. American Heritage book of the pioneer spirit. American Heritage; distributed by Simon and Schuster, 1959

AMON Amon Carter Museum of Western Art, Fort Worth, Texas. The artist's environment: West Coast, an exhibition presented by the Amon Carter Museum of Western Art, Fort Worth, Texas, in collaboration with the University of California at Los Angeles Art Galleries and the Oakland Art Museum, 1962-1963. 1962

AP American Philosophical society. A catalogue of portraits and other works of art in the possession of the American Philosophical Society. Philadelphia, The Society, 1961 "Every president until very recent years is represented, with the addition also of many other officers and distinguished members." (p. v)

ARN	Arnheim, Rudolf. Art and visual perception: Psychology of the creative eye. Berkeley, University of California, 1957
ART	Artist in America, Editors. The artist in America. New York, W. W. Norton, 1967
ARTA	Art of Australia, 1788-1941; an exhibition of Australian art... under the auspices of the Carnegie Corporation. Published for the Carnegie Corporation by the Museum of Modern Art, New York, 1941.
ARTJ	Art treasures from Japan. Catalog of an exhibition held jointly by the National Commission for Protection of Cultural Properties and the participating museums in the United States of America and the Dominion of Canada. Tokyo, Kodansha International, 1965
ARTS	Arts Council of Great Britain. Welsh Committee. Sculpture 1961. London, Arts Council, 1961
ARTSA	Arts Council of Great Britain. Background, the artist and his environment: Alan Davie, Merlyn Evans, Ivon Hitchens, Victor Pasmore. London, Arts Council, 1965
ARTSB	Arts Council of Great Britain. Contemporary British sculpture

--58	1958	--64	1964
--61	1961	--65	1965
--62	1962	--66	1966

ARTSBR	Arts Council of Great Britain. Welsh Committee. British art and the modern movement, 1930-1940. London, Arts Council, 1962
ARTSC	Arts Council of Great Britain. Construction England. London, Arts Council, 1963
ARTSCH	Arts Council of Great Britain. Chromatic sculpture (folder). London, Arts Council, 1966
ARTSI	Arts Council of Great Britain. Twenty Italian sculptors. London, Arts Council, 1966
ARTSM	Arts Council of Great Britain. In motion, an Arts council evolution of kinetic art. London, Arts Council, 1966
ARTSN	Arts Council of Great Britain. Art Nouveau in Britain. London, Arts Council, 1965
ARTSP	Arts Council of Great Britain. Painters of the Brucke. London, Arts Council, 1964
ARTSR	Arts Council of Great Britain. Edinburgh Festival Society. Rumanian art treasures: Fifteenth to eighteenth century. London, Arts Council, 1965

ARTSS	Arts Council of Great Britain. Sculpture from the Arts Council collection. London, Arts Council, 1965
ARTST	Arts Council of Great Britain. Towards Art II, sculptors from the Royal College of Art. London, Arts Council, 1965
ARTSW	Arts Council of Great Britain. Welsh Committee. Art in Wales. London, Arts Council, 1962
ARTSY	Arts Council of Graet Britain. Contemporary Yugoslav painting and sculpture. London, Arts Council, 1961
ARTV	Art treasures from the Vienna collections, lent by the Austrian government, 1949-1950
AS	Asia Society. Masterpieces of Asian art in American collections, as shown in Asia House, New York City, January-February, 1960. New York, Asia Society, 1960
ASH	Ashton, Leigh, and Basil Gray. Chinese Art. 6th impression. London, Faber and Faber, 1953
ASHS	Ashton, Leigh, ed. Style in sculpture. London, Oxford University Press, 1947 Account of changes in style during last 1,000 years. Basedon an exhibition held at Victoria and Albert Museum, London, in 1946
AUB	Auboyer, Jeannine, and Robert Goepper. The Oriental world, New York, McGraw-Hill Book Co., 1967
AUBA	Aubert, Marcel. Art of the High Gothic Era (original French title: Le Triomphe de l'Art Gothique). New York, Crown Publishers, 1965
AUES	Auerbach, Arnold. Sculpture, a history in brief. London, Elek Books, 1952
AUM	Aumonier, William, ed. Modern architectural sculpture. New York, Scribner, 1930
BAA	Baal-Teshuva, Jacob. Art treasures of the United Nations. New York, Thomas Yoseloff, 1964
BALD	Baldinger, Wallace S., and Harry B. Green. The visual arts. New York, Holt, Rinehart, and Winston, 1960
BALTW	Baltimore Museum of Art. Alan Wurtzburger Collection of African sculpture. Baltimore, Baltimore Museum of Art, 1958
BAN	Bandi, Hans-Georg. Art of the Stone Age. London, Methuen; New York, Crown Publishers, 1961
BAR	Barbanson, Adrienne. Fables in ivory; Japanese netsuke and their legends. Rutland, Vt., Charles E. Tuttle, 1961

BARD Bardi, P. M. Colorslide tour of the museum of
 Sao Paulo, Brazil. New York, Harry N.
 Abrams
 (Panorama Colorslide Art Program, v. 7)

BARD--2 Bardi, P. M. The arts in Brazil; a new museum
 at Sao Paulo. Milan, Edizione del Milione,
 1956

BARG Palace of the Bargello, and the National Museum.
 Handbook and itinerary. Florence. Arnaud
 Publisher, 1963
 (Mirabilia Series)

BARSTOW Barstow, Charles L. Famous Sculpture. New
 York, The Century Company, 1921

BAS Baschet, Jacques. Sculpteurs de ce temps. Paris,
 Nouvelles editions francaises, 1946

BATT Batten, Mark. Stone sculpture by direct carving.
 London, Studio Publications, 1957

BAUR Baur, John I. H. Revolution and tradition in
 modern American art. Cambridge, Harvard
 University Press, 1951

BAZINB Bazin, Germain. Baroque and Rococo art.
 London, Thames and Hudson; New York,
 Frederick A. Praeger, Publishers, 1964

BAZINH Bazin, Germain. A history of art from prehistoric
 times to the present. New York, Houghton
 Mifflin, 1959

BAZINL Bazin, Germain. The loom of art. New York,
 Simon and Schuster, 1962

BAZINW Bazin, Germain. World history of sculpture.
 Greenwich, Ct., New York Graphic Society,
 1968

BEAZ Beazley, John Davidson, and Bernard Ashmole.
 Greek sculpture and painting to the end of
 the Hellenistic Period. Cambridge, Cambridge
 University Press; New York, Macmillan, 1932
 Reprint of chapters on Greek art in Cambridge
 Ancient History--text revised and new pictures
 added

BECK Beckwith, John. Art of Constantinople. New York,
 Phaidon Publishers; distributed by New York
 Graphic Society, 1961

BECKC Beckwith, John. Coptic sculptures, 300-1300.
 London, Alec Tiranti, 1963

BECKM Beckwith, John. Early Medieval art. London,
 Thames & Hudson; New York, Frederick A.
 Praeger, Publishers, 1964

BED Beddington, Jack. Young artists of promise.
 London, New York, Studio Publications, 1951

BEN Benesch, Otto. Art of the Renaissance in Northern
 Europe. New York, Phaidon Publishers;
 distributed by New York Graphic Society, 1965

BER Berlin. Akadamie der Kunste. Tscheckoslowakische
 Kunst der Gegenwart. Berlin, Akademie der
 Kunste, 1966

BERCK Berckelaers, Ferdinand Louis. The sculpture of
 this century, by Michel Seuphor (pseud). New
 York, George Braziller, 1960

BEREP Berenson, Bernard. The passionate sightseer;
 from the diaries, 1947 to 1956. New York,
 Simon and Schuster, 1960

BERL Berlin. Staatliche Museen. Art treasures from
 the Berlin State Museums. Introduction by
 John Russell. Leipsig, Edition Leipsig, 1962;
 New York, Harry N. Abrams, 1964

BERLE Berlin. Staatliche Museen zu Berlin. Deutche
 Bildwerke aus seiben Jahrhunderten. Berlin,
 Museen, Skulpturen-Sammlung, 1958

BERLEI Berlin. Staatliche Museen zu Berlin. Italien-
 ische Plastik des 15-17 Jahrhunderts.
 Museen, Skulpturen-Sammlung, 1963

BERLEK Berlin. Staatliche Museen zu Berlin. Kunstwerke
 der Skulpturen-Sammlung in Bode-Museen.
 Berlin, 1962

BERLER Berlin. Staatliche Museen zu Berlin. Romische
 Skulpteren, Antiken-Sammlung. Berlin,
 Museen zu Berlin, 1965

BERLES Berlin. Staatliche Museen zu Berlin. Staatliche
 Museen zu Berlin. Leipzig, Veb Edition, 1963
 "...a selection from the most beautiful and
 precious objects...of every department."
 Text in German, English, French

BIB The Bible in art; miniatures, paintings, draw-
 ings and sculptures inspired by the Old
 Testament. London, Phaidon Press, 1956

BIH Bihalji-Merin, Oto. Yugoslav sculpture in the
 twentieth century. Beograd, Mihajlova, 1955

BISH Bishop, Minor L. Fountains in contemporary
 architecture. New York, October House, 1965

BL Lothrop, S. K. Pre-Columbian art: Robert
 Woods Bliss Collection. Text and critical
 analyses by S. K. Lothrop. London, Phaidon
 Press, 1957

BLUA Blunt, Anthony. Art and architecture in France,
 1500-1700. London, Penguin Books, 1953

BLUC Blunt, Cyril George Edward. A history of
 Russian art, from Scyths to Soviets. London,
 New York, Studio Publications, 1946

BMA	Baltimore Museum of Art. 200 objects in the Baltimore Museum of Art, compiled by Gertrude Rosenthal. Baltimore, The Museum, 1955
BMAF	Baltimore Museum of Art. 1914--Fiftieth Anniversary exhibition. Baltimore, The Museum, 1964
BO	Boardman, John. Greek art. London, Thames & Hudson; New York, Frederick A. Praeger, Publishers, 1964
BOA	Boas, Franz. Primitive art. Paper reprint. New York, Dover, 1955 Unabridged reprint of first edition of 1927
BOAS	Boase, T. S. R. English art, 1100-1216. Oxford, Clarendon Press, 1953
BOASE	Boase, T. S. R. English art, 1800-1870. Oxford, Clarendon Press, 1959
BODE	Bode, Wilhelm von. Florentine sculptors of the Renaissance. 2nd ed. , rev. London, Methuen; New York, Scribner, 1928
BOE	Boeck, Urs. Sculpture on buildings. London, A. Zemmer; New York Universe Books, 1961 Plastik am Bau; beispiele europaischer bauplastic vom altertum bus zur neuzeit
BOES	Boesen, Gudmund. Danish museums. Copenhagen, Committee for Danish Cultural Activities Abroad, 1966
BON	Bonython, Kim. Modern Australian painting and sculpture, a survey of Australian art from 1950-1960. Adelaide, Griffin Press, 1960
BOSMA	Boston Museum of Fine Arts. Arts of the Near East. Boston, Museum of Fine Arts; distributed by October House, 1962
BOSME	Boston Museum of Fine Arts. European masters of our time, catalog of an exhibition at the museum October 10 through November 17, 1957. Boston, The Museum, 1957
BOSMEG	Boston Museum of Fine Arts. Ancient Egypt as represented in the Museum of Fine Arts, Boston. Text by William S. Smith. 4th ed. New York, Beacon Press, 1960
BOSMG	Boston Museum of Fine Arts. Greek Gods and Heroes. 5th ed. Boston, The Museum, 1962
BOSMGR	Boston Museum of Fine Arts. Greek and Roman portraits, 470 B. C. - A. D. 500, by Cornelius Vermeule. Boston, The Museum, 1959

BOSMI	Boston Museum of Fine Arts. Illustrated handbook. Boston, The Museum, 1964
BOSMP	Boston Museum of Fine arts. Masterpieces of primitive art, catalog of an exhibition held at the Museum, October 16 through November 23, 1958. Boston, The Museum; distributed by October House, 1958
BOSMT	Boston Museum of Fine Arts. The Trojan War in Greek art, a picture book. Boston, The Museum, 1965
BOSTA	Boston. Institute of Contemporary Art. American art since 1950. Loan exhibition sponsored by the Poser Institute of Fine Arts, Brandeis University, and Institute of Contemporary Art, Boston, November 21-December 23, 1962. Boston, The Institute, 1962
BOW	Bowness, Alan. Modern sculpture. London, Studio Vista Limited; New York, E. P. Dutton, 1965
BOWR	Bowra, C. M. Classical Greece. New York, Time, Inc. 1965
BOY	Boyd, E. Popular arts of Colonial New Mexico. Santa Fe, Museum of International Folk Art, 1959
BOZ	Bozhkov, Atanas. Bulgarian art. Sofia, Foreign Language Press; distributed by Vanous, 1964
BR	Encylopaedia Britannica. Chicago, Encyclopaedia Britannica, Inc., 1966 Index of illustrations in Sculpture article, v. 20
BRIE	Brieger, Peter. English art, 1216-1307. Oxford, Clarendon Press, 1957
BRIO	Brion, Marcel. Art of the Romantic Era. London, Thames & Hudson; New York, Frederick A. Praeger, Publishers, 1966
BRION	Brion, Marcel, ed. Art since 1945. New York, Harry N. Abrams, 1958
BRIONA	Brion, Marcel. Animals in art. New York, Franklin Watts, 1959
BRIONR	Brion, Marcel. Romantic art. New York, McGraw-Hill, 1960
BRIT	Great Britain. British Council. British Pavilion: Five young British artists, XXXIII Venice Biennale, 1966
BRITM	British Museum. General Introductory Guide to the Egyptian collection in the British Museum, by I. E. S. Edwards. London, British Museum, 1964
BRO	Broadbent, Arthur Tee. Sculpture today in Great Britain, 1940-1943. London, John Tiranti, Ltd., 1944

BROO Brookgreen Gardens, Brookgreen, South
 Carolina. Brookgreen Gardens, sculpture, by
 Beatrice Gilman Proske. Brookgreen, S. C.,
 printed by order of the Trustees, 1943
BROWF Brown, Frank P. English Art Series--3 vols in
 1. London, Isaac Pitman & Sons, 1933
 V. 1 London Buildings; v. 2 London Paintings;
 V. 3 London Sculpture
BROWMS Brown, Milton Wolf. The story of the Armory
 Show. New York, Joseph H. Hirshhorn
 Foundation, 1963
BRUM Brumme, Carl Ludwig. Contemporary American
 sculpture. New York, Crown Publishers, 1948
BRY Bryson, Lyman, ed. An outline of man's knowl-
 edge of the modern world. New York, McGraw-
 Hill Book Co., 1960
BSC Berlin. Staatliche Museen (Berlin-Dahlem). Bild-
 werke des christlichen Epochen von der
 Spatantike bis zum Klassizismus, aus den
 Bestanden der Skulpturenabteilung. Berlin-
 Dahlem, Preussischer Kulturbesitz; Munchen,
 Prestel-Verlag, 1966
BUH Buhler, Alfred, et al. The art of the South Sea
 Islands. New York, Crown Publishers, 1962
BUL Bullard, Frederic Lauristen. Lincoln in marble
 and bronze. New Brunswick, Rutgers Uni-
 versity Press, 1952
 Published for the Abraham Lincoln Associa-
 tion, Springfield, Illinois
BULL Bulliet, Clarence Joseph. Art masterpieces in a
 Century of Progress fine arts exhibition at
 the Art Institute of Chicago. Chicago, North-
 Mariano Press, 1933
 V. 1 indexed
BURC Burckhardt, Jacob Christoph. Civilization of the
 Renaissance in Italy. 3rd rev ed. London, New
 York, Oxford University Press, 1960 reprint
BURL Burling, Judith, and Arthur Hart Burling.
 Chinese art. London, Studio Publications,
 1953
BURN Burnham, Jack. Beyond modern sculpture: The
 effects of science and technology upon the
 sculpture of this century. New York, George
 Braziller, 1968
BUSB Busch, Harald, and Berud Lohse, eds. Baroque
 sculpture. Frankfurt, U. M. Schau Verlag;
 London, B. T. Batsford; New York, Macmillan
 Co., 1964

BUSG	Busch, Harald, ed. Gothic Europe. London, B. T. Batsford; New York, Macmillan Co., 1959
BUSGS	Busch, Harald, and Bernd Lohse, eds. Gothic sculpture. New York, Macmillan Co., 1963
BUSH	Bushnell, G. H. S. Ancient arts of the Americas. New York, Frederick A. Praeger, Publishers, 1965
BUSR	Busch, Harald, and Bernd Lohse, eds. Renaissance sculpture. London, B. T. Batsford, 1962; New York, Macmillan Co., 1964
BUSRO	Busch, Harald, and Bernd Lohse, eds. Romanesque sculpture. London, B. T. Batsford, 1962; New York, Macmillan Co., 1963
BUT	Butterfield, Roger. The American past. New York, Simon and Schuster, 1947
CAB	Cabanne, Pierre. Great collectors. New York, Farrar Straus, 1963
CAF	Caffin, Charles H. American masters of sculpture. New York, Doubleday, Page & Co., 1903
CAH	Cahill, Holger, and Alfred H. Barr, eds. Art in America; a complete survey. New York, Reynal & Hitchcock, 1935
CAHA	Cahill, Holger, and Alfred H. Barr, eds. Art in America in modern times. New York, Reynal & Hitchcock, 1934
CAL	Calvesi, Maurizio. Treasures of the Vatican. Geneva, Editions d'Art Skira; distributed by World Publishing Co., 1962
CALA	Calas, Nicolas, and Elena Calas. The Peggy Guggenheim Collection of Modern art. New York, Henry N. Abrams, 1966
CALF	California State Fair & Exposition, Sacramento. Catalog of Art Exhibit. Sacramento 17 catalogs indexed: --48 1948 to --65 1965. 1964, catalog not available locally
CAM	Montreal. Museum of Fine Arts. Handbook of the Collections--painting, sculpture, decorative arts. Montreal, The Museum, 1960
CAMI	Montreal. Museum of Fine Arts. Images of the Saints (L'Art et Les Saints), exhibition catalog, March 5-April 4, 1965. Montreal, The Museum, 1965
CAN	Ottawa. National Gallery of Canada. Catalogue of paintings and sculpture, edited by R. H. Hubbard. v. 1. Older Schools. Toronto, University of Toronto Press, 1957

CAN--2 _____. v. 2 Modern European schools. 1959
CAN--3 _____. v. 3. Canadian schools
CAN--4 Ottawa. National Gallery of Canada. 300 years of
 Canadian art. Ottawa, National Gallery, 1967
CANK Canaday, John. Keys to art. New York, Tudor
 Publishing Co. , 1962
CANM Canaday, John. Mainstreams of modern art. New
 York, Simon and Schuster, 1959
CARL Carli, Enzo. Musei Senesi. Novara, Instituto
 Geografico de Agostini, 1961
 Musei e Monumenti series
CARNI Carnegie Institute. Department of Fine Arts.
 Pittsburgh International Exhibition of Con-
 temporary Painting and Sculpture. The
 Institute
 4 catalogs indexed since 1952, when exhibition
 became triennial:
 --58 1958
 --61 1961
 --64 1964
 --67 1967
CARP Carpenter, Edward. A House of Kings; the
 history of Westminster Abbey. London, John
 Baker, 1966
CARPE Carpenter, Rhys. The esthetic basis of Greek
 Art. New York, Longmans, Green, 1921;
 reprint Bloomington, Indiana University Press,
 1959
CARPG Carpenter, Rhys. Greek sculpture: A critical
 review. Chicago, University of Chicago Press,
 1960
CARR Carrieri, Raffaele. Pittura, scultura d'avanguardia
 (1890-1950) in Italia. Milan, Edizione della
 Conchiglia, 1950
CART Carter, Dagny Olsen. Four thousand years of
 China's art. rev ptg. New York, Ronald
 Press, 1951
CARTW Cartwright, W. Aubrey. Guide to art museums
 in the United States. East Coast--Washington
 to Miami. New York, Duell, Sloane &
 Pearce, 1958
CAS Cassou, Jean, et al. Gateway to the twentieth
 century, New York, McGraw-Hill Book Co. ,
 1962
 French title: Les Sources du XXe siecle, les
 arts en Europe de 1884 a 1914. Exhibit
 Nov 4, 1960 - Jan 23, 1961, Paris, Musee
 d'art moderne. London, Thames & Hudson, 1962

CASL Casson, Lionel. Ancient Egypt. New York,
 Time, Inc., 1965
CASS Casson, Stanley. Sculpture of today. London,
 Studio Publications, 1939
CASSM Casson, Stanley. Some modern sculptors.
 London, Oxford University Press, 1928
CASSTW Casson, Stanley. XXth century sculptors.
 London, Oxford University Press, 1930
CHAM Chamot, Mary. Russian painting and sculpture.
 Oxford, Pergamon Press; New York,
 Macmillan Co., 1963
CHAN Chanin, Abraham L. Art guide to New York.
 New York, Horizon Press, 1965
CHAR--1 Charbonneaux, Jean. Treasures of the Louvre
 --2 (Les Merveilles du Louvre). 2 v. Paris,
 Librairie Hachette et Societe d'Etude et de
 Publications Economiques, 1959; New York,
 G. P. Putnam's Sons, 1966
 v. 1. From the fourth millenium B. C. to the
 dawn of the Renaissance
 v. 2. From the Renaissance to Impressionism
CHAS Chastel, Andre. Flowering of the Italian Renais-
 sance. New York, The Odyssey Press, 1965
CHASE Chase, George Henry. Greek and Roman sculp-
 ture in American collections. Cambridge, Har-
 vard University Press, 1924
CHASEH Chase, George Henry, and Chandler Rathfon Post.
 A history of sculpture. New York, Harper,
 1925
CHENSA Cheney, Sheldon. Art-lover's guide to the Ex-
 position, explanations of the architecture,
 sculpture and mural paintings... Berkeley,
 At the sign of the Berkeley oak, 1915
CHENSE Cheney, Sheldon. Expressionism in art rev ed.
 New York, Tudor Publishing Co., 1948
CHENSN Cheney, Sheldon. A new world history of art.
 rev ed. New York, Viking Press, 1956
CHENSP Cheney, Sheldon. Primer of modern art. 14th
 ed. New York, Liveright Publishing Corp.,
 1966
CHENSS Cheney, Sheldon. The story of modern art. rev
 and enl ed. New York, Viking Press, 1958
CHENSW Cheney, Sheldon. Sculpture of the world: a
 history. New York, Viking Press, 1968.

CHICA	Chicago. Art Institute. Annual American exhibition of paintings and sculpture. Chicago, The Institute

CHICA Chicago. Art Institute. Annual American exhibition of paintings and sculpture. Chicago, The Institute
31 catalogs listed: 24th (1911) through 60th (1951)--broken listings:

--24	1911	--35	1922	--45	1932
--25	1912	--36	1923	--46	1935
--26	1913	--37	1924	--47	1936
--27	1914	--38	1925	--48	1937
--28	1915	--39	1926	--49	1938
--29	1916	--40	1927	--51	1940
--30	1917	--41	1928	--52	1941
--31	1918	--42	1929	--53	1942
--32	1919	--43	1930	--54	1943
--33	1920	--44	1931	--60	1951
--34	1921				

CHICB Chicago. Art Institute. Brief illustrated guide to the collections. Chicago. The Institute, 1941

CHICC Chicago. Art Institute. Chicago collects, September 20-October 27, 1963. Chicago, The Institute, 1963

CHICH Chciago. Art Institute. Half a century of American art, November 16, 1939-January 7, 1940. Chicago, The Institute, 1939

CHICP--1 Chicago. Art Institute. Catalogue of a Century of Progress exhibition of paintings and sculpture, lent from American collections, edited by D. C. Rich. 2nd ed. Chicago, The Institute, 1933

CHICP--2 Chicago. Art Institute. Catalogue of a century of Progress exhibition of paintings and sculpture. Chicago, The Institute, 1934

CHICS Chicago. Art Institute. Modern sculpture in the collections of the Art institute of Chicago. Chicago, The Institute, 1940

CHICSG Chicago. Art Institute. Sculpture: A generation of innovation, catalog for exhibit, June 23-August 27, 1967. Chicago, The Institute, 1967

CHICT Chicago. Art Institute. Treasures of Versailles, a loan exhibition from the French Government..., 1962-1963. Chicago, The Institute, 1962

CHR Christensen, Erwin O. The index of American design. New York, Macmillan Co., 1950

CHRH Christensen, Erwin O. History of western art. New York, New American Library (Mentor), 3rd ptg 1961

CHRP	Christensen, Erwin O. Pictorial history of western art. New York, New American Library, 1964
CIN	Cincinnati. Art Museum. Contemporary American sculpture, works by artists resident in Ohio, Indiana, Illinois, Michigan, Wisconsin, Minnesota, Kentucky, and Missouri. Cincinnati, Art Museum, 1961
CIR	Cirici-Pellicer, Alexander. Treasures of Spain, from Charles V to Goya. Geneva, Editions d'Art Skira, 1965
CLAK	Clark, Kenneth. The nude: a study in ideal form. New York, Pantheon Books, 1956
CLE	Cleveland Museum of Art. Handbook. Cleveland, The Museum, 1966
CLEA	Cleveland Museum of Art. Paths of abstract art, by Edward B. Henning. Cleveland, The Museum; distributed by Harry N. Abrams, 1960
COL	Collier's Encyclopedia. New York, Crowell-Collier, and Macmillan, 1966 Index of illustrations in Sculpture article
COLG	Colgate, William G. Canadian art, its origin and development. Toronto, Ryerson Press, 1943
COLW	Colonial Williamsburg, Inc. The Abby Aldrich Rockefeller folk art collection, a descriptive catalog by Nina Fletcher Little. Boston, Little, Brown, 1957
CON	The Connoisseur Period Guides, ed by Ralph Edwards and L. G. G. Ramsey. 6 vol. New York, Reynal and Co. 1957
	--1 The Tudor Period, 1500-1603
	--2 The Stuart Period, 1603-1714
	--3 The Early Georgian Period, 1714-1760
	--4 The Late Georgian Period, 1760-1810
	--5 The Regency Period, 1810-1830
	--6 The Early Victorian Period, 1830-1860
COOMA	Coomaraswamy, Ananda K. Arts and crafts of India and Ceylon. New York, Farrar, Straus, 1964
COOMH	Coomaraswamy, Ananda K. History of Indian and Indonesian art. New York, E. Weyhe, 1927; reprint, New York, Dover Publications, 1965
COOP	Cooper, Douglas. Great private collections. New York, Macmillan Co., 1963

COOPC	Cooper, Douglas. Courtauld Collection. University of London, Athlone Press, 1954
COOPF	Cooper, Douglas. Great family collections. London, Weidenfeld and Nicolson; New York, Macmillan Co., 1965
COPGE	Copenhagen. Ny Carlsberg Glyptothek. Egyptian sculpture in the Ny Carlsberg Glyptothek, by Otto Koefoed Petersen. Copenhagen, 1962
COPGG	Copenhagen. Ny Carlsberg Glyptothek. Guide to the collections, by Vagn Poulsen. 11th ed. Copenhagen, 1966
COPGM	Copenhagen. Ny Carlsberg Glyptothek. Moderne skulptur dans og udenlandsk, by Haarvard Rostrup. Copenhagen, 1964
COR	Corcoran Gallery of Art, Washington, D. C. Illustrated handbook of paintings, sculpture, and other art objects (exclusive of the W. A. Clark Collection). Washington, D. C., The Gallery, 1939
CPL	California Palace of the Legion of Honor, San Francisco, California. Handbook of the collections. 4th ed. San Francisco, The Palace, 1960
CRAVR	Craven, Thomas A. The rainbow book of art. Cleveland, World Publishing Co., 1956
CRAVS	Craven, Wayne. Sculpture in America. New York, Thomas Y Crowell, 1968
CRU	Crump, Charles George, ed. Legacy of the middle ages. Oxford, Oxford University Press, 1926; 1962 reprint
CUM	Cummings, Paul. A dictionary of contemporary American artists. New York, St. Martin's Press, 1966
DA--1 --2	Davidson, Marshall B. Life in America. Boston, Houghton Mifflin, 1951 2 v
DAIN	Daingerfield, Marjorie Jay. The fun and fundamentals of sculpture. New York, Scribner, 1963
DAM	Damaz, Paul. Art in European architecture. New York, Reinhold Publishing Corp., 1956
DAN	Daniel, Howard. Adventures in art, a guide to gallery-going. London, New York, Abelard-Schumann, 1960
DECR	Decker, H. Romanesque art in Italy. London, Thames & Hudson; New York, Harry N. Abrams, 1960
DENV	Denver. Art Museum. Guide to the collection. Denver, The Museum, 1965

DENVK Denver. Art Museum. Samuel H. Kress Col-
lection of paintings and sculpture. Denver,
The Museum, 1954

DESA Desroches-Noblecourt, Christiane. Ancient
Egypt; the New Kingdom and the Amarna
Period. London, Oldbourne Press; Greenwich
Ct., New York Graphic Society, 1960

DETC Detroit Institute of Arts. Collection in progress:
selections from the Lawrence and Barbara
Fleischman collection of American art.
Detroit, The Institute, 1955

DETD Detroit Institute of Arts. Decorative arts of the
Italian Renaissance, 1400-1600, exhibition in
memoriam--William R. Valentiner, Nov 18,
1958-Jan 4, 1959. Detroit, The Institute, 1958

DETF Detroit Institute of Arts. Flanders in the fif-
teenth century, exhibit Oct-Dec 1960.
Detroit, The Institute, 1960

DETI Detroit Institute of Arts. Art in Italy, 1600-1700,
organized by Frederick Cummings. Detroit,
The Institute; distributed by Harry N. Abrams,
New York, 1965

DETS Detroit Institute of Arts. Sculpture in our time:
Italy, France, Germany, Russia, Spain,
Great Britain, the United States; collected by
Joseph H. Hirshhorn, exhibit May 5-August
23, 1959. Detroit, The Institute, 1959

DETT Detroit Institute of Arts. Treasures from the
Detroit Institute of Arts. Detroit, The
Institute, 1960

DEVA Devambez, Pierre. Greek sculpture. New York,
Tudor Publishing Co., 1960

DEVI--2 Devigne, Marguerite. Art treasures of Belgium,
1951-1954. 2 v. New York, Belgian Govern-
ment Information Center, 1954
v 2, with subtitle: Sculpture, indexed

DEW Dewey, John. Art as experience. New York,
Minton, Balch & Co., 1934

DEY De Young Memorial Museum, San Francisco.
Illustrations of selected works. San
Francisco, The Museum, 1950

DEYE De Young Memorial Museum. European works
of art in the De Young Museum. Berkeley,
Diablo Press, for the de Young Museum
Society, 1967

DEYF De Young Memorial Museum. Frontiers of
American art. San Francisco, 1939

DIS	Disselhoff, Hans Dietrich, and Sigvald Linne. Art of ancient America. London, Methuen; New York, Crown Publishers, 1960
DIV	De Valentin, Maria M., and Louis de Valentin. Everyday pleasures of sculpture. New York, James H. Heineman, 1966
DOCA	Dockstader, Frederick J. Indian art in America: The arts and crafts of the North American Indian. Greenwich, Ct., New York Graphic Society, 1961
DOCM	Dockstader, Frederick J. Indian art in Middle America: Precolumbian and contemporary arts and crafts of Mexico, Central America, and the Caribbean. Greenwich, Ct., New York Graphic Society, 1964
DOCS	Dockstader, Frederick J. Indian art in South America: Pre-Columbian and contemporary arts and crafts. Greenwich, Ct., New York Graphic Society, 1967
DODD	Dodd, Loring Holmes. The golden age of American sculpture, an anthology. Boston, Chapman & Grimes, 1936
DOU	Douglas, Frederick H., and Rene d'Harnoncourt. Indian art of the United States. New York, Museum of Modern Art; distributed by Simon and Schuster, New York, 1941
DOV	Dover, Cedric. American Negro art. 2nd ed. Greenwich, Ct., New York Graphic Society, 1960
DOWN	Downer, Marion. The story of design. New York, Lothrop, Lee and Shepard Co., 1963
DR	Drioten, Etienne. Egyptian art. New York, Golden Griffin Books, 1950
DREP	Drepperd, Carl W. Pioneer America, its first three centuries. Springfield, Mass, Pond-Ekberg Co. Reprint of 1949 ed published by Doubleday
DUNC	Duncan, David Douglas. The Kremlin. Greenwich, Ct., New York Graphic Society, 1960
DUR	Durant, Will J. Story of Civilization. v 4. Age of Faith. New York, Simon and Schuster, 1950
DURS	Durst, Alan, Wood carving. rev ed. London, New York, Studio Publications, 1959
EA	Encyclopedia Americana, International Edition. New York, Americana Corp., 1967 Index of illustrations in Sculpture article, v. 24

ELIS Eliscu, Frank. Sculpture: Techniques in clay,
 wax, slate. Philadelphia, Chilton Co., 1959
ENC Encyclopaedia of the arts, consulting editor
 Herbert Read. London, Thames & Hudson;
 New York, Meredith Press, 1966
ESC Monastery San Lorenzo de El Escorial. Tourist
 guide, text and notes by Matilde Lopez
 Serrano. 2nd ed. Madrid, Editorial
 "Patrimonio Nacional", 1966
ESD Esdaile, K. E. English church monuments,
 1510-1840. London, B. T. Batsford, 1946;
 New York, Oxford University Press, 1947
EVJE Evans, Joan. English art, 1307-1461. Oxford,
 Clarendon Press, 1949
EVJF Evans, Joan. Art in Medieval France, 987-
 1498. London, New York, Oxford University
 Press, 1948
EVJL Evans, Joan. Life in Medieval France. London,
 Phaidon Press, 1957
EX Expo 67. Official guide. Toronto, Maclean-
 Hunter Publishing Co., 1967
EXM Expo 67. Man and his world: International Fine
 Arts Exhibition, 28 April-27 October, 1967.
 Montreal, Expo 67, 1967
EXS Expo 67. International exhibition of contemporary
 sculpture, introduction by Guy Robert.
 Montreal, Expo 67, 1967
FAA Fagg, William Butler, and Margaret Plass.
 African sculpture, an anthology. London,
 Studio Vista, Ltd.; New York, E. P. Dutton
 & Co., 1964
FAAN Fagg, William Butler. Nigerian images; the
 splendor of African sculpture. London, Lund
 Humphries; New York, Frederick A. Praeger,
 Publishers, 1963
FAIN Faison, Samson Lane. A guide to the art museums
 of New England. New York, Harcourt Brace &
 Co., 1958
FAIR Fairman, Charles E. Art and artists of the
 Capitol of the United States of America.
 Washington, D. C., U. S. Government Printing
 Office, 1927
 69th Congress, 1st Session. Senate Document
 No. 95
FAIY Faison, Samson Lane. Art Tours and detours in
 New York State. New York, Random House,
 1964

FAL Faldi, Italo. Galleria Borghese, le sculture dal
 secolo XVI al XIX. Rome, Istituto
 Poligrafico dello Stato, 1954
FAUL Faulkner, Ray Nelson, et al. Art today, an
 introduction to the fine and industrial arts.
 4th ed. New York, Holt, 1963
FEIN Feininger, Andreas. Maids, madonnas and
 witches. New York edition, Harry N. Abrams,
 1961
FIN Finlay, Ian. Art in Scotland. London, Oxford
 University Press, 1948
FISH Fisher, Ernest Arthur. An introduction to Anglo-
 Saxon architecture and sculpture. London,
 Faber & Faber, 1959
FLEM Fleming, William. Arts and ideas. rev ed. New
 York, Holt, 1963
FOC--1 Focillon, Henri. Art of the west in the Middle
 --2 Ages. 2 v. London, Phaidon Press; Green-
 wich, Ct., New York Graphic Society, 1963
 v 1. Romanesque art
 v 2. Gothic art
FOU Fourcade, Francois. Art treasures of the Peking
 Museum. New York, Harry N. Abrams, 1965
FPDEC Musee des Arts Decoratifs, Palais de Louvre,
 Pavillon de Marsan. Catalogue jeune peinture,
 jeune sculpture, biennale 57. Paris, 1957
FPMO Musee d'art Moderne de la Ville de Paris. Onze
 sculpteurs americains de l'Universite de
 California, Berkeley. Exhibit 28 Sept-3-Nov,
 1963
FRA Frankfurt, Henri. Art and architecture of the
 ancient orient. 3rd revd impression. Ham-
 mondsworth, Baltimore, Penguin Books, 1963
FREED Freeden, Max Hermann von. Gothic sculpture,
 the intimate carvings. Greenwich, Ct., New
 York Graphic Society, 1962
FREEMR Freeman, Lucy Jane. Italian sculpture of the
 Renaissance. New York, Macmillan Co.,
 1901, reprinted 1927
FREM Fremantle, Anne. Age of faith. New York,
 Time, Inc., 1965
FRIED Friedman, B. H., ed. School of New York:
 Some younger artists. London, Evergreen
 Books; New York, Grove Press, 1959
FRY Fry, Roger, Vision and design. New York,
 Brentano's, 1920; reprint 1947, Meridian
FRYC Fry, Roger. Chinese art. 5th impression.
 London, B. T. Batsford, 1952

FUR Furtwangler, Adolf. Masterpieces of Greek Sculp-
ture. new and enl ed. Chicago, Argonaut, 1964
Reissue of 1895 ed. with revisions

GABO Gabo, Naum. Of divers arts. New York, Bollingen
Foundation; distributed by Pantheon Books,
New York, 1962

GAD Gador, E., and G. O. Pogany. Ungarische
Bildhauerkunst. Budapest, Corvina Verglag.
1955

GAF Guide to the art treasures of Paris (Guide
Artistique de France). Paris, Editions Pierre
Tisne, 1964; New York, E. P. Dutton, 1966

GAM Gamzu, Haim. Paintings and sculpture in Israel;
half a century of the plastic arts in Eretz,
Israel. new, enl and rev ed. Tel-Aviv, Dvir
Publishers, 1955

GARB Garbini, Giovanni. The ancient world. New
York, McGraw-Hill Book Co., 1966

GARDAY Gardner, Albert Ten Eyck. Yankee stone-cutters:
The first American school of sculpture, 1800-
1850. New York, published for the Metro-
politan Museum of Art by Columbia University
Press, 1945

GARDE Gardner, Ernest Arthur. Six Greek sculptors.
London, Duckworth and Co., 1910; reprinted
New York, Scribner, 1915

GARDH Gardner, Helen. Art through the ages. 4th ed,
New York, Harcourt, Brace & World, 1959

GARDHU Gardner, Helen. Understanding the arts. New
York, Harcourt, Brace 1932

GARL Garlick, Kenneth. British and North American
art to 1900. New York, Franklin Watts, 1965

GAU Gauthier, Maximilien, ed. Louvre: Sculpture,
ceramics, and objects d'art. London, Old-
bourne Press, 1961; New York, Appleton
(Meredith), 1964

GAUN Gaunt, William. Observer's book of sculpture.
New York, Frederick Warne, 1966

GEL Gelder, Van Hendrik Enno. Guide to Dutch art.
The Hague, Government Printing and Publish-
ing Office, 1952

GER Gerson, Horst, and Engelbert Hendrik ter Kuile.
Art and architecture in Belgium--1600 to 1800.
Harmondsworth, Baltimore, Penguin Books,
1960

GERN Gernsheim, Helmut. Focus on architecture and
sculpture, an original approach to the photo-
graphs of architecture and sculpture. London,
Fountain Press, 1949

GERT	Gertz, Ulrich. Plastik der Gegenwart. 2. erweiterte Aufl. Berlin, Rembrandt-Verlag, 1953
GIE	Giedion-Welcker, Carola. Contemporary sculpture: an evolution in volume and space. 3rd rev ed. London, Faber & Faber; New York, Wittenborn, 1960
GIT	Giteau, Madeleine. Khmer sculpture and the Angkor civilization. New York, Harry N. Abrams, 1966
GLA	Glass, Frederick James. Modelling and sculpture. London, B. T. Batsford, 1929
GLE	Gleichen, Lord Edward. London's open-air statuary. London, New York, Longmans, Green, 1928
GOE	Goetz, Hermann. India: Five thousand years of Indian art. London, Methuen; New York, McGraw-Hill Book Co., 1959
GOLDE	Goldscheider, Ludwig. Etruscan sculpture. Phaidon ed. London, Allen; New York, Oxford University Press, 1941
GOLDF	Goldscheider, Ludwig. Five hundred self portraits from antique times to the present day in sculpture, painting, drawing, and engraving. London, Oxford University Press, 1937
GOLDR	Goldscheider, Ludwig. Roman portraits. London, Allen; New York, Oxford University Press, 1940
GOLDWA	Goldwater, Robert, and Marco Treves. Artists on art. 3rd ed. New York, Pantheon Books, 1958
GOMB	Gombrich, Ernst Hans Josef. The story of art. 11th ed. London, Phaidon Press, 1966
GOME	Gomez Moreno, Manuel. The golden age of Spanish sculpture. Greenwich, Ct., New York Graphic Society, 1964
GOODA	Goodrich, Lloyd, and John Ireland Howe Baur. American art of our century. New York, published for the Whitney Museum of American Art by Frederick A. Praeger, Publishers, 1961
GOODF	Goodrich, Lloyd, and E. Bryant. Forty artists under forty, from the collection of the Whitney Museum of American Art. New York, Frederick A. Praeger, Publishers, 1962.
GOODT	Goodrich, Lloyd. Three centuries of American art. New York, Frederick A. Praeger, Publishers, 1966 Pictorial survey of American art from Colonial times to present based on historical exhibition, "Art of the United States: 1670-1966", marking

opening of new building of the Whitney
Museum of American Art, New York City

GOOS Goossen, E. C., et al. Ferber--Hare--Lassaw,
trois sculpteurs americains. Paris, Le Musee
de Poche, 1959
English language edition: Three American
sculptors. New York, Grove Press, 1959

GOR Goris, Jan-Albert. Modern sculpture in Belgium.
3rd rev ed. New York, Belgian Government
Information Center, 1957

GRAB Grabar, Andre. Art of the Byzantine Empire.
Baden-Baden, Holle Verlag; London, Methuen;
New York, Crown Publishers, 1966

GRANT Grant, Michael. Myths of the Greeks and Romans.
Cleveland, World Publishing Co., 1962

GRAT Grate, Pontus, ed. Treasures of Swedish art.
Malmo, Allhem Publishers, 1963
Originally published on the occasion of the
exhibition, "Tresors d'art suedois", opened
May 30, 1963, at the Louvre, Paris

GRAYR Gray, Camilla. Russian art: The great experi-
ment. 1863-1922. London, Thames & Hudson,
New York, Harry N. Abrams, 1962

GRID Gridley, Marion E., comp. America's Indian
Statues. Chicago, The Amerind, 1966

GRIG Grigson, Geoffrey. Art treasures of the British
Museum. London, Thames & Hudson; New
York, Harry N. Abrams, 1957

GRIS Griswold, Alexander B., et al. Art of Burma,
Korea, and Tibet. New York, Crown
Publishers, 1964

GROS Groslier, Bernard Philippe. Art of Indochina,
including Thailand, Vietnam, Laos and
Cambodia. London, Methuen; New York,
Crown Publishers, 1962

GROSS Gross, Chaim. The technique of wood sculpture.
New York, Vista House Publishers, 1957

GRU Grube, Ernest J. World of Islam. New York,
McGraw-Hill Book Co., 1966

GUG The Solomon R. Guggenheim Museum, New
York. A handbook of the collection. New
York, The Museum, 1959

GUGE The Solomon R. Guggenheim Museum, New
York. Guggenheim International Exhibition,
1967--Sculpture from twenty nations. New
York, The Museum, 1967

GUGH	Solomon R. Guggenheim Museum, New York. Modern sculpture from the Joseph H. Hirshhorn collection. New York, The Solomon R. Guggenheim Foundation, 1962
GUGP	Arts Council of Great Britain. Peggy Guggenheim collection--exhibition at Tate Gallery, 31 Dec 1964-7 March 1965. 2nd ed. London, Arts Council, 1965
GUID	Guidol, Jose. Arts of Spain, Garden City, N. Y., Doubleday, 1964
GUIT	Guitton, Jean. The Madonna. Paris, Editions Sun; New York, Tudor Publishing Co., 1963
GUN	Gunnis, R. Dictionary of British sculptors, 1660-1851. London, Odhams Press, 1953; Cambridge, Harvard University Press, 1954
HAD	Hadas, Moses. Imperial Rome. New York, Time, Inc., 1965
HALE	Hale, John. Renaissance. New York, Time, Inc., 1965
HAM	Hammacher, A. M. Colorslide tour of the Kroller-Muller Museum, Otterlo, Holland. New York, Harry N. Abrams, 1961 (Panorama Colorslide Art Program, v. 12)
HAMF	Hammacher, A. M., and R. Hammacher Vandenbrande. Flemish and Dutch art. New York, Franklin Watts, 1965
HAMM	Hammacher, A. M. Modern English sculpture. New York, Harry N. Abrams, 1967
HAMP	Hamilton, George Heard. Painting and sculpture in Europe, 1880 to 1940. Harmondsworth, Baltimore, Penguin Books, 1967
HAMR	Hamilton, George Heard. Art and architecture of Russia. London, Baltimore, Penguin Books, 1954
HAN	Hanfmann, George M. A. Classical sculpture. Greenwich, Ct., New York Graphic Society, 1967
HAR	Hare, Richard Gilbert. The art and artists of Russia. London, Methuen; Greenwich, Ct., New York Graphic Society, 1965
HARO--1 --2 --3	Harold, Margaret, comp. Prize-winning sculpture. Fort Lauderdale, Florida, Allied Publications, 1964-1966 Bk 1. 1964 Bk 2. 1965 Bk 3. 1966
HART--1 --2	Hartmann, Sadakichi. A history of American art. 2 v. Boston, L. C. Page, 1932

HARTS Hartmann, Sadakichi, ed. Modern American
sculpture; a representative collection of the
principal statues, relics, busts, statuettes
and specimens of decorative and municipal
work, executed by the foremost sculptors in
America in the last twenty years. New York,
Paul Wenzel and M. Krakow, 1918

HARVGW Harvey, John. The Gothic world, 1100-1600, a
survey of architecture and art. London, B. T.
Batsford, 1950

HAUS Hauser, Arnold. Mannerism. London, Routledge
& Kegan Paul, 1965
v 2: 322 plates

HAUSA Hauser, Arnold. The social history of art.
London, Routledge & Paul; New York, Knopf,
1951; Vintage 4 v paperback ed, 1957

HAY Hayes, Bartlett H. Naked truth and personal
vision. Andover, Mass., Addison Gallery of
American Art, 1955

HEMP Hempel, Eberhard. Baroque art and architecture
in central Europe. Harmondsworth, Baltimore,
Penguin Books, 1965

HENNI Henning, Edward B. Fifty years of modern art,
1916-1966. Cleveland, Cleveland Museum of
Art; distributed by Western Reserve University
Press, Cleveland, 1966

HENT Hentzen, Alfred. Deutsche Bildhauer der
Gegenwart. Berlin, Rembrandt Verlag, 1934

HERB Herbert, Eugenia W. The artist and social
reform; France and Belgium, 1885-1898.
New Haven, Yale University Press, 1961

HERM Leningrad. Ermitazh. The Hermitage Museum;
a short guide. Moscow, Foreign Languages
Publishing House, 1955

HERMA Leningrad. Ermitazh. Art treasures in the
USSR, v. 2. The Hermitage State Museum;
painting and sculpture; 20 reproductions.
Moscow and Leningrad, State Art Publishers,
1939

HF Hall of Fame for Great Americans, at New York
University. Official handbook, edited by
Theodore Morello. New York, New York
University Press, 1967

HOB Hobson, R. L. Chinese art; 100 plates in color.
2nd rev ed. London, Ernest Benn, 1954

HOF Hoffman, Malvina. Sculpture inside and out. New
York, W. W. Norton, 1936

HOO	Hooper, J. T. and C. A. Burland. The art of primitive peoples. London, The Fountain Press, 1953
HOR	Horizon Magazine. Horizon book of ancient Greece. New York, American Heritage Publishing Co., 1965
HORS	Horizon Magazine. Shakespeare's England. New York, American Heritage Publishing Co., 1964
HOW	Howe, Thomas C. Colorslide tour of the California Palace of the Legion of Honor. New York, Harry N. Abrams, 1961 (Panorama Colorslide Art Program, v. 11)
HUB	Hubbard, Robert H., ed. Anthology of Canadian art. Toronto, Oxford University Press, 1960
HUBE	Hubert, Gerard. Les Sculpteurs Italiens en France sous la Revolution, L'Empire, et la Restauration, 1790-1830. Paris, Editions E. De Boccard, 1964
HUN	Hunter, Samuel. Modern painting and sculpture. New York, Dell Publishing Co., 1959 4th ptg 1963
HUNT	Henry E. Huntington Library and Art Gallery, San Marino, California. Sculpture in the Huntington Collection, by R. R. Wark. San Marino, 1959, 2nd ptg 1960
HUNTA	Henry E. Huntington Library and Art Gallery, San Marino, California. The Huntington Art Collection, a handbook. 8th ed. San Marino, 1964
HUNTV	Henry E. Huntington Library and Art Gallery, San Marino, California. Visitor's guide to the exhibitions and gardens. San Marino, 1964
HUX	Huxley-Jones, T. B. Modelled portrait heads. London, Studio Publications, 1955
HUYA	Huyghe, Rene. Art treasures of the Louvre. New York, Harry N. Abrams, 1960
HUYAR	Huyghe, Rene. Art treasures of the Louvre. New York, Harry N. Abrams, 1951
IBM	International Business Machines Corporation. Sculpture of the Western Hemisphere, permanent collection IBM Corporation. New York, 1942
IND	India (Republic). Ministry of Information and Broadcasting. Museums and art galleries. Delhi, Indian Ministry of Information and Broadcasting, 1956
INTA--1 --2	International art sales, edited by George Savage. London, Studio Books; New York, Crown

```
        Publishers
        --1    1961
        --2    1962
```

IRW Irwin, David. English neoclassical art. London,
 Faber & Faber, 1966

JAG Jagger, Sergeant. Modelling and sculpture in the
 making. London, New York, Studio Publications,
 1933; 1947 reprint

JAL--1-5 Jalabert, Denise. La sculpture francaise. 5 v. Paris,
 Musee National des Monuments Francaise, 1958

 1--v. 1. Sculpture pre-romane et romane IIIe-
 XIIe siecle)

 2--v. 2 Sculpture gothique aux XIIe et XIIIe
 siecles

 3--v. 3. Sculpture gothique aux XIVe et XVe
 siecles

 4--v. 4. Sculpture de la Renaissance. XVIe siecle

 5--v. 5. Sculpture des Temps Modernes, XIIe,
 XIIIe, et XIXe siecles

JAM James, Juliet Helena (Lumbard). Palaces and courts
 of the Exposition; a handbook of the architecture,
 sculpture and mural paintings, with special
 reference to the symbolism. San Francisco,
 California Book Co. , 1915

JAMS James, Juliet Helena. Sculpture of the Exposition
 palaces and courts, descriptive notes on the art
 of statuary at the Panama-Pacific International
 Exposition. San Francisco, H. S. Crocker Co. ,
 1915

JAN Janis, Sidney. Abstract and surrealist art in Amer-
 ica. New York, Reynal & Hitchcock, 1944

JANSH Janson, Horst W., and Dora Jane Janson. History
 of art, a survey of the major visual arts from the
 dawn of history to the present day. New York,
 Harry N. Abrams, 1962

JANSK Janson, Horst W. , ed. Key monuments of the his-
 tory of art: A visual survey. Englewood Cliffs,
 N. J. , Prentice-Hall, 1959; Harry N. Abrams,
 New York, 1964 ptg

JAR Jarnuszkiewicz, Jadwiga. Modern sculpture in
 Poland. Warsaw, Polonia Publishing House, 1958

JLAT Junior League of Albuquerque. Twentieth century
 sculpture, exhibit at the University Art Museum,
 University of New Mexico, March 25-May 1,
 1966. Albuquerque, University of New Mexico,
 1966

JOH Johnson, Lillian (Bass). Sculpture, the basic meth-
 ods and materials. New York, David McKay Co. ,
 1960

JOHT	Johnstone, William. Creative arts in Britain from the earliest times to the present. London, Macmillan, 1950
JOO	Joosten, Ellen. The Kroller-Muller Museum, Otterlo, Holland. New York, Shorewood Publishers, 1965
JOR--1 --2	Joray, Marcel. La sculpture modern en Suisse. Neuchatel, Editions du Griffon, 1955-1959 L'Art Suisse Contemporain, v 12, v14
KAH	Kahler, Heinz. The art of Rome and her empire. London, Methuen, 1963; New York, Crown publishers, 1962
KAM	Kampf, Avram. Contemporary synagogue art, developments in the United States, 1945-1965. New York, Union of American Hebrew Congregations, 1966
KAP	Kaprow, Allan. Assemblages, environments and happenings. New York, Harry N. Abrams, 1966
KEPS	Kepes, Gyorgy, ed. Structure in art and in science. New York, George Braziller, 1965
KEPV	Kepes, Gyorgy, ed. Visual arts today. Middleton, Ct., Wesleyan University Press, 1960
KIA	Kidder, Alfred, and Carlos Samoya Chinchilla. Art of the ancient Maya. New York, Thomas Y. Crowell Co., 1959
KIDM	Kidder, J. Edward, ed. Masterpieces of Japanese sculpture. Tokyo, Bijutsu Shuppansha; Rutland, Vt., Charles E. Tuttle, 1961
KIDS	Kidson, Peter. The medieval world. New York, McGraw-Hill Book Co., 1967
KITS	Kitson, Michael. The age of the Baroque. New York, McGraw-Hill Book Co., 1966
KN	Nelson Gallery-Atkins Museum, Kansas City, Mo. Sound...Light...Silence: Art that performs, catalog, text by Ralph T. Coe. Kansas City, The Museum, 1966
KO	Koepf, Hans. Masterpieces of sculpture from the Greeks to modern time. New York, G. P. Putnam's Sons, 1966
KRA	Samuel H. Kress Foundation. Art treasures for America; an anthology of paintings and sculpture in the Samuel H. Kress collection, commentary by Charles Seymour. New York, Phaidon Press, 1961
KRAM	Kramrisch, Stella. The art of India: Traditions of Indian sculpture, painting and architecture. 3rd ed. London, Phaidon; distributed by New York Graphic Society, 1965

KUBA Kubler, George. Art and architecture of ancient America. Harmondsworth, Baltimore, Penguin Books, 1962

KUBS Kubler, George, and Martin Soria. Art and architecture in Spain and Portugal and their American Dominions, 1500-1800. Harmondsworth, Baltimore, Penguin Books, 1959

KUH Kuh, Katherine W. Art has many faces. New York, Harper, 1951

KUHA Kuh, Katherine W. Artist's voice. New York Harper, 1962

KUHB Kuh, Katherine W. Break-up. London, Adams & Mackay; Greenwich, Ct., New York Graphic Society, 1965

KUHN Kuhn, Charles Louis. German and Netherlandish sculpture, 1280-1800: The Harvard collections. Cambridge, Harvard University Press, 1965

KUHNG Kuhn, Charles Louis. German Expressionism and abstract art: The Harvard collections. Cambridge, Harvard University Press, 1957

KUL Kultermann, Udo. Junge Deutsche Bildhauer. Mainz, Berlin, Florian Kupferberg, 1963

KULN Kultermann, Udo. The new sculpture: Environments and assemblages. New York, Frederick A. Praeger, 1968

KUN Kung, David. Contemporary artist in Japan. Honolulu, East-West Center Press, 1966

LAC Laclotte, Michel. French art from 1350 to 1850. New York, Franklin Watts, 1965

LAF LaFollette, Suzanne. Art in America. New York, Harper, 1929

LAH Los Angeles County Museum of Art. Illustrated handbook. Los Angeles, The Museum, 1965

LAHF Los Angeles County Museum of Art. Five younger Los Angeles artists. Los Angeles, The Museum, 1965

LAJ La Jolla, California. Museum. New Modes in California painting and sculpture, May 20-June 26, 1966. La Jolla, Museum of Art, 1966

LANG Lange, Kurt, and Max Hirmer. Egypt: Architecture, sculpture, painting in 3000 years. 3rd ed rev. London, Phaidon Press; Greenwich, Ct., New York Graphic Society, 1961

LARA Larousse encyclopedia of prehistoric and ancient art. London, Paul Hamlyn; New York, Prometheus Press, 1962

LARB	Larousse encyclopedia of Byzantine and medieval art. London, Paul Hamlyn; New York, Prometheus Press, 1963
LARK	Larkin, Oliver W. Art and life in America. rev ed. New York, Holt, 1960
LARM	Larousse encyclopedia of modern art, from 1800 to the present day. London, Paul Hamlyn; New York, Prometheus Press, 1965
LARR	Larousse encyclopedia of Renaissance and Baroque art. London, Paul Hamlyn; New York, Prometheus Press, 1964
LAS	Lassus, Jean. Early Christian and Byzantine World. New York, McGraw-Hill Book Co., 1967
LAWC	Lawrence, Arnold Walter. Classical sculpture. London, Cape, 1929
LAWL	Lawrence, Arnold Walter. Later Greek sculpture and its influence on East and West. London, Cape; New York, Harcourt & Brace, 1927 "The illustrations have been drawn largely from American museums and have in general been selected to include as many unpublished and unfamiliar objects as possible." (p. xv)
LEE	Lee, Sherman E. Colorslide tour of the Cleveland Museum of Art, Cleveland, Ohio. New York, Harry N. Abrams, 1960 (Panorama Colorslide Art Program, v. 8)
LEEF	Lee, Sherman E. History of Far Eastern art. New York, Harry N. Abrams, 1964
LEU	Leuzinger, Elsy. Africa: The art of the Negro peoples. London, Methuen; New York, McGraw-Hill Book Co., 1960; reprint 1962
LIC	Licht, Fred S. Sculpture--The 19th and 20th centuries. Greenwich, Ct., New York Graphic Society, 1967
LIL	Lill, Georg. Deutsche Plastik. Berlin, Volksverband der Bluchefreunde, 1925
LIP	Lippard, Lucy R. Pop art. London, Thames & Hudson; New York, Frederick A. Praeger, 1966
LIPA	Lipman, Jean Herzberg. American folk art in wood, metal and stone. New York, Pantheon Books, 1948
LIPW	Lipman, Jean Herzberg, ed. What is American in American art? New York, McGraw-Hill Book Co., 1963

(handwritten: NB197 .L5)

LLO	Lloyd, Seton. The art of the ancient Near East. London, Thames & Hudson; New York, Frederick A. Praeger, Publishers, 1961
LOH	Lohse, Bernd, and Harald Busch. Art treasures of Germany. London, B. T. Batsford, 1958
LOM	Lommel, Andreas. Prehistoric and primitive man. New York, McGraw-Hill Book Co., 1967
LOND	London County Council. Sculpture in the open air, catalog. London, The Council --5 1960 --6 1963 --7 1966 Triennial exhibit. 1966 exhibit author: Greater London Council
LONDC	London. County Council. Sculpture 1850-1950, exhibition at Holland Park, London, May to September, 1957. London, The Council, 1957
LONG	Long, Edward John. America's national monuments and historic sites; a guide... Garden City, N. Y., Doubleday, 1960
LOT	Lothrop, Samuel K. Treasures of ancient America. Geneva, Editions d'Art Skira; distributed in U. S. A. by World Publishing Co., Cleveland, 1964
LOUM	Musee National du Louvre. Les sculptures Moyen Age, Renaissance, temps modernes au Musee du Louvre, by Michele Beaulieu, Marguerite Charageat, and Gerard Hubert. Paris, Editions des Musees Nationaux, 1957
LOWR	Lowry, Bates. The visual experience. Englewood Cliffs, N. J., Prentice-Hall; New York, Harry N. Abrams, 1961
LULL	Lullies, Reinhard, and Max Hirmer. Greek sculpture. rev ed. New York, Harry N. Abrams, 1960
LUN	Luna Arroyo, Antonio. Panorama de la escultura mexicana contemporanea. Mexico, Ediciones del Instituto Nacional de Bellas Artes
LYN	Lynton, Norbert. The modern world. New York, McGraw-Hill Book Co., 1965
LYNC	Lynch, John. How to make mobiles. London, Studio Publications; New York, Thomas Y. Crowell Co., 1953
LYNCM	Lynch, John. Metal sculpture--new forms, new techniques. New York, Studio-Crowell, 1957
LYNCMO	Lynch, John. Mobile design. New York, Studio-Crowell, 1955

LYT	Lytton Center of the Visual Arts. Contemporary California Art from the Lytton Collection. Los Angeles, The Center, 1966
MACL	Maclagen, Eric Robert Dalrymple. Italian sculpture of the Renaissance. Cambridge, Harvard University Press, 1935
MAE	Marlborough-Gerson Gallery, New York. The English eye, November-December, 1965. New York, The Gallery, 1965
MAG	Magazine of Art. Painters and sculptors of modern America; introduction by Monroe Wheeler. New York, Thomas Y. Crowell Co., 1942
MAI	Maillard, Robert, ed. A dictionary of modern sculpture. London, Methuen, 1962; New York, Tudor Publishing Co., 1960
MAIU	Maiuri, Bianca. National Museum, Naples (Le Musee National) Novara, Instituto Geografico de Agostini, 1959 French and English text
MAL	Male, Emile. Religious art: From the 12th to the 18th century. Pantheon Books, 1949
MALL	Mallowan, M. E. L. Early Mesopotomia and Iran. London, Thames & Hudson; New York, McGraw-Hill Book Co., 1965
MALV	Malraux, Andre. Voices of silence. New York, Doubleday, 1953
MAN	Mansuelli, G. A. The art of Etruria and early Rome. New York, Crown Publishers, 1965
MARC	Marchiori, Giuseppe. Modern French sculpture. New York, Harry N. Abrams, 1963
MARI	Maritain, Jacques. Creative intuition in art and poetry. New York, Pantheon Books, 1953
MARQ	Marquand, Allan. A text-book of the history of sculpture. rev ed. New York, Longmans, Green, 1911; 1925 reprint
MARTE	Martel, Jan and Joel Martel. Sculpture. Paris, Moreau, 1928
MARY	Maryon, Herbert. Modern sculpture, its methods and ideals. London, I. Pitman, 1933
MAS	Masterworks of Mexican Art from Pre-Columbian times to the present. Catalog Los Angeles County Museum of Art Exhibition, October 1963-January 1964, text by Fernando Gamboa. Los Angeles, The Museum, 1963
MATT	Matt, Leonard von. Art in the Vatican. New York, Universe Books, 1962

MATTB	Matt, Leonard von. Baroque art in Rome. 1st American ed. New York, Universe Books, 1961
MATZ	Matz, Friedrich. Art of Crete and early Greece, the prelude to Greek art. London, Methuen; New York, Crown Publishers, 1962
MCCA	McCarthy, Mary. The stones of Florence. New York, Harcourt, Brace & Co., 1959
MCCL	McClinton, Katherine Morrison. Christian church art through the ages. New York, Macmillan 1962
MCCUR	McCurdy, Charles, ed. Modern art; a pictorial anthology. New York, Macmillan, 1958
MCSPAD	McSpadden, Joseph Walker. Famous sculptors of America. New York, Dodd Mead, 1927
MEILC	Meilach, Dona, and Elvie Ten Hoor. Collage and found art. New York, Reinhold, 1964
MEILD	Meilach, Dona, and Don Seiden. Direct metal sculpture. New York, Crown Publishers, 1966
MEN	Mendelowitz, Daniel Marcus. History of American art. New York, Holt, 1960
MERC	Mercer, Eric. English art: 1553-1625. Oxford, Clarendon Press, 1962
MERT	Mertz, Barbara. Temples, tombs and hiero-glyphs: The story of Egyptology. New York, Coward-McCann, 1964
MID	Antwerp. Open Air Museum of Sculpture, Middelheim Park. Middelheim das plastik, museum im freien. Berlin, Rembrandt Verlag, 1959
MILLE	Miller, Alec. Stone and marble carving. Berkeley, University of California Press, 1948
MILLER	Miller, Alec. Tradition in sculpture. New York, London, Studio Publications, 1949
MILLS	Mills, John W. Technique of sculpture. New York, Reinhold, 1965
MINB	Ministero della Publica Istruzone. Direzione Generale delle Antichita e Belle Arti. Villa Borghese, by Paolo della Pergola. Rome, Istituto Poligrafico della Stato, 1954
MINC	Minneapolis. Institute of Arts. Four centuries of American art. Minneapolis, The Institute, 1964
MINE	Minneapolis. Institute of Arts. European art today; 35 painters and sculptors. Loan exhibition--Sept 23-Oct 25, 1959. Minneapolis, The Institute, 1959
MINF	Minneapolis. Institute of Arts. Fiftieth anniversary exhibition catalog, November 4, 1965-January 2, 1966. Minneapolis. The Institute, 1965

MINP	Minneapolis. Institute of Arts. Paintings and sculpture from the Minneapolis Institute of Arts, a loan exhibition. Minneapolis, The Institute, 1957
MIUH	Michigan. University Museum of Art. Handbook of the collection. Ann Arbor, The University, 1962
MOD	Musee National d'Art Moderne, Paris. Catalogue-guide, by Jean Cassou, Bernard Dorival, and Genevieve Homolle. Paris, Musee National d'Art Moderne, 1954
MOHN	Mohaly-Nagy, Laszlo. The new vision. 4th rev ed. New York, George Wittenborn, 1947
MOHV	Moholy-Nagy, Laszlo. Vision in motion. Chicago, Paul Theobald, 1956
MOLE	Molesworth, H. D. European sculpture from Romanesque to Neoclassic. London, Thames & Hudson; New York, Frederick A. Praeger, Publishers, 1965
MOLS--1 --2	Molesworth, H. D. Sculpture in England. 2 v. London, New York, published for the British Council by Longmans, Green, 1951 v. 1. Medieval v. 2. Renaissance and early nineteenth century
MONT	Monteverdi, Mario, ed. Italian art to 1850. New York, Franklin Watts, 1965
MOO--1 --2	Moore, William. The story of Australian art from the earliest known art of the continent to the art today. Sidney, Angus & Robertson, 1934
MOREYC	Morey, Charles Rufus. Christian art. New York, Longmans, Green, 1935; reprint Norton, 1958
MOREYM	Morey, Charles Rufus. Medieval art. New York, Norton, 1942
MOT	Motherwell, Robert, ed. Modern artists in America. 1st series. New York, Wittenborn, Schultz, 1952
MU	Munro, Eleanor C. Golden encyclopedia of art. New York, Golden Press, 1961
MUE	Muensterberger, Warner. Sculpture of primitive man. London, Thames & Hudson; New York, Harry N. Abrams, 1955
MUL	Muller, Theodor. Deutsche Plastik der Renaissance bis zum dreissig jahrigen Krieg. Konigstein am Taunus, K. R. Langewiesche, 1963
MULS	Muller, Theodor. Sculpture in the Netherlands, Germany, France, and Spain: 1400-1500. Harmondsworth, Baltimore, Penguin Books, 1966

MUNC	Munsterberg, Hugo. Art of the Chinese sculptor. Rutland, Vt., Charles E. Tuttle, 1960
MUNJ	Munsterberg, Hugo. Arts of Japan: An illustrated history. Tokyo, Rutland, Vt., Charles E. Tuttle, 1957
MUNSN	Munson-Williams-Proctor Institute. 1913 Armory Show, 50th Anniversary exhibition, 1963. Utica, N. Y., The Institute, 1963
MUR	Murdock, Myrtle Cheney. National Statuary Hall in the nation's capitol. Washington, D. C., Monumental Press, 1955 Illustrates 78 statues presented by states, and 8 statues received by gift, purchase or commission
MURA	Muraro, Michelangelo, and Andre Grabar. Treasures of Venice. Geneva, Albert Skira; distributed in U. S. A. by World Publishing Co., 1963
MURRA	Murray, Peter, and Linda Murray. Art of the Renaissance. New York, Frederick A. Praeger, Publishers, 1963
MYBA	Myers, Bernard S. Art and civilization, New York, McGraw-Hill Book Co., 1957
MYBG	Myers, Bernard S. German expressionists, a generation in revolt. concise ed. New York, McGraw-Hill Book Co., 1963
MYBM	Myers, Bernard S. Modern art in the making. 2nd ed. New York, McGraw-Hill Book Co., 1959
MYBS	Myers, Bernard S. Sculpture: Form and Method. London, Studio Vista; New York, Reinhold, 1965
MYBU	Myers, Bernard S. Understanding the arts. New York, Holt, 1958
NAD	Nadeau, Maurice. History of surrealism. New York, Macmillan, 1965
NATP	National Portrait Gallery, London. Catalogue of seventeenth century portraits in the National Portrait Gallery, 1625-1714, compiled by David Piper. Cambridge, Cambridge University Press, 1963
NATS	National Sculpture Society, New York. Contemporary American sculpture, The California Palace of the Legion of Honor, Lincoln Park, San Francisco, April to October 1929. New York, Press of the Kalkhoff Co., 1929
NATSA	National Sculpture Society, New York. Exhibition of American sculpture, catalogue--156th Street

West of Broadway, New York, April 14 to
August 1, 1923. New York, 1923
"...best works from all parts of the country,
as well as that of Americans now abroad."

NATSS National Sculpture Society, New York. New York,
The Society, 1967 -67: 34th 1967

NCM North Carolina. Museum of Art, Raleigh.
Masterpieces of art; in memory of William R.
Valentiner, 1880-1958. Exhibition North
Carolina Museum of Art, April 6-May 17,
1959. Raleigh, The Museum, 1959

NEL Nelken, Margarita. Escultura mexicana con-
temporanea. Mexico, Ediciones Mexicanas,
1951

NEUW Neuhaus, Eugen. World of art. New York,
Harcourt, Brace, 1936

NEW New Art around the world: Painting and sculp-
ture. New York, Harry N. Abrams, 1966

NEWA Newark Museum. Fifty years, a survey.
Newark, The Museum, 1959

NEWAS Newark Museum. A survey of American sculp-
ture, late 18th century to 1962. Newark, The
Museum, 1962

NEWAW Newark Museum Association, Newark, N. J.
Women artists of America, 1707-1964,
exhibition catalog. Newark, 1965

NEWM Newmeyer, Sarah. Enjoying modern art. New
York, Reinhold, 1955

NEWTEA Newton, Eric. The arts of man; an anthology
and interpretation of great works of art.
London, Thames & Hudson; Greenwich, Ct.,
New York Graphic Society, 1960

NEWTEB Newton, Eric. British sculpture, 1944-1946.
London, J. Tiranti; New York, Transatlantic
Arts, 1947

NEWTEE Newton, Eric. European painting and sculpture.
4th ed. Harmondsworth, Baltimore, Penguin
Books, 1956; reprinted 1958

NEWTEM Newton, Eric. Masterpieces of European sculp-
ture. New York, Harry N. Abrams, 1959

NEWTER Newton, Eric. Romantic rebellion. London,
Longmans, Green, 1962; New York, St.
Martins, 1963

NEWTET Newton, Eric, and William Neil. 2000 years of
Christian art. London, Thames & Hudson;
New York, Harper, 1966

NM--1 -8 Metropolitan Museum of Art. Guide to the
collections. New York, The Museum

--1 American Wing. 1961
--2 Ancient Near East art, by Vaughn
Emerson Crawford, et al. 1966
--3 European arms and armor. 1962
--4 Egyptian art. 1961
--5 Greek and Roman art, by Dietrich von
Bothmer. 1964
--6 Islamic art, by Marie G. Lukens. 1965
--7 Medieval art. 1962
--8 Western European arts, by Edith A.
Standen. 1963

NM--10 Metropolitan Museum of Art. Guide to the col-
lections, Part I: Ancient and Oriental art--
Egyptian, Mesopotamian, and Classical, Far
Eastern, Near Eastern, Oriental armor. New
York, The Museum, 1934

NM--11 Metropolitan Museum of Art. Guide to the col-
lections, Part II: European and American
art--Medieval art, Renaissance and Modern
art, American Wing, arms and armor,
painting, prints. New York, The Museum,
1934

NM--12 Metropolitan Museum of Art. The Cloisters:
The building and the collection of medieval art
in Fort Tryon Park, by James J. Rorimer.
rev ed. New York, The Museum; distributed
by New York Graphic Society, Greenwich,
Ct., 1962

NM--13 Metropolitan Museum of Art. American sculpture,
1951; a national competitive exhibition,
December 7, 1951 to February 24, 1952. New
York, The Museum, 1951

NM--14 Metropolitan Museum of Art. Chinese sculpture
in the Metropolitan Museum of Art, by Alan
Priest. New York, 1944

NM--15 Metropolitan Museum of Art. The Lewisohn Col-
lection, foreword by Henry Francis Taylor,
and introduction by Theodore Rousseau. New
York, The Museum, 1951

NMA Metropolitan Museum of Art. Art treasures of
the Metropolitan. New York, Harry N.
Abrams, 1952

NMAB Museum of Modern Art. Abstract painting and
sculpture in America, by Andrew Carnduff
Ritchie. New York, The Museum, 1951

NMAC Museum of Modern Art. Cubism and abstract
art, by Alfred H. Barr. New York, The
Museum, 1936

NMAD	Museum of Modern Art. The new decade; 22 European painters and sculptors, edited by Andrew Carnduff Ritchie. New York, The Museum, 1955
NMAF	Museum of Modern Art. American folk art; the art of the common man in America, 1750-1900. New York, The Museum, 1932
NMAJ	Museum of Modern Art. New Japanese painting and sculpture, by Dorothy Miller and William Lieberman. Catalog of the work of 46 artists. New York, The Museum; distributed by Doubleday, 1964
NMAM	Museum of Modern Art. Americans 1942; 18 artists from 9 states, edited by Dorothy Miller. New York, The Museum, 1942
NMAN	Museum of Modern Art. African Negro art, edited by James Johnson Sweeney. New York, The Museum, 1935
NMANA	Museum of Modern Art. Ancient arts of the Andes, by Wendell C. Bennett, and Rene d'Harnocourt. New York, The Museum, 1954
NMANA--1	Museum of Modern Art. 32 masterworks of Andean art, from an exhibition: Ancient arts of the Andes. Supplement to Ancient arts of the Andes, catalog. New York, The Museum, 1955
NMAP	Museum of Modern Art. American painting and sculpture, 1862-1932. Eighteenth loan exhibit catalog, October 31, 1932-January 31, 1933. New York, The Museum, 1932
NMAR	Museum of Modern Art. Recent American sculpture, catalog with text by James Thrall Soby. New York, The Museum, 1959
NMAS	Museum of Modern Art. American sources of modern art. New York, Norton, 1933
NMASO	Museum of Modern Art. James Thrall Soby collection of works of art pledged or given to the museum. New York, The Museum, 1961
NMAT	Museum of Modern Art. Twenty centuries of Mexican art. New York, The Museum, 1940
NMFA	Museum of Modern Art. Fantastic art, Dada, Surrealism, edited by Alfred H. Barr. 3rd ed. New York, The Museum, 1948
NMG	Museum of Modern Art. German art of the twentieth century, by Andrew Carnduff Ritchie. New York, The Museum; distributed by Doubleday, 1958

NMI	Museum of Modern Art. Italian masters, lent by the Royal Italian government, exhibition January to March 1940. New York, The Museum, 1940
NML	Museum of Modern Art. Latin-American collection of the Museum of Modern Art, by Lincoln Kirstein. New York, The Museum, 1943
NMN	Museum of Modern Art. New horizons in American Art, with an introduction by Holger Cahill. New York, The Museum, 1936
NMPS	Museum of Modern Art. Painting and sculpture from sixteen American cities. New York, The Museum, 1933
NMS	Museum of Modern Art. New Spanish painting and sculpture, text by Frank O'Hara. New York, The Museum; distributed by Doubleday, 1966
NMSS	Museum of Modern Art. Arts of the South Seas, by Ralph Linton. New York, Simon and Schuster, 1946
NNMMA	Museum of Modern Art. Americans 1963, edited by Dorothy Miller. New York, The Museum, 1963
NNMMAG	Museum of Modern Art. German painting and sculpture, introduction and notes by Alfred H. Barr. New York, The Museum, 1931
NNMMAP	Museum of Modern Art. Art in progress, survey prepared for the fifteenth anniversary of the Museum. New York, The Museum, 1944
NNMMARO	Museum of Modern Art. Art in our time; an exhibition to celebrate the tenth anniversary. New York, The Museum, 1939
NNMME	Museum of Modern Art. Modern masters from European and American collections. New York, The Museum, 1940
NNMMF	Museum of Modern Art. Fifteen Americans, edited by Dorothy Miller. New York, The Museum, 1952
NNMMFO	Museum of Modern Art. Fourteen Americans, edited by Dorothy Miller. New York, The Museum, 1946
NNMML	Museum of Modern Art. Living Americans; paintings and sculpture by living Americans. Ninth loan exhibition. New York, The Museum, 1931
NNMMM	Museum of Modern Art. Masters of modern art, edited by Alfred H. Barr. 3rd rev ed. New York, The Museum; distributed by Doubleday, 1959

NNMMS	Museum of Modern Art. Sixteen Americans, edited by Dorothy Miller. New York, The Museum, 1959
NNMMT	Museum of Modern Art. Twelve Americans, edited by Dorothy Miller. New York, The Museum, 1956
NNWB	Whitney Museum of American Art. Between the Fairs: Twenty-five years of American art, 1939-1964, by John I. H. Baur. New York, published for Whitney Museum of American Art by Frederick A. Praeger, Publishers, 1964
NOG	Nogara, Bartolomeo. Art treasures of the Vatican. Bergamo, Istituto Italiano d'Arti Grafiche; New York, Tudor Publishing Co., 1950
NORM	Norman, Percival Edward. Sculpture in wood. London, Studio Publishers; New York, Transatlantic Arts, 1954
NOV	Novotny, Fritz. Painting and sculpture in Europe, 1780-1880. Harmondsworth, Baltimore, Penguin Books, 1960
NPPM	Museum of Primitive Art, New York. Masterpieces in the Museum of Primitive Art. New York, The Museum; distributed by New York Graphic Society, Greenwich, Ct., 1965
NYW	New York World's Fair, 1939-1940. American art today. New York, National Art Society, 1939
NYWC	New York World's Fair, 1939-1940. Complete catalogue of the paintings and sculpture. Masterpieces of art. rev and enl ed. New York, Art News, 1940 (?)
NYWL	World's Fair, New York, 1965. American Express Pavilion. Art '65: Lesser known and unknown painters; young American sculpture--East to West. Catalog, text by Wayne V. Anderson. New York, American Express Co., 1965
OAK	Oakland Art Museum, Oakland, Calif. Pop art USA, catalog text by John Coplans. Oakland, The Museum, 1963
OST	Osten, Gert von der. Plastik des 20. Jahrhunderts in Deutschland, Osterreich und der Schweiz. Konigstein im Taunus, K. R. Langewiesche, 1962
OZ	Ozenfant, Amedee. Foundations of modern art. rev ed. New York, Dover, 1952

PAA	Pennsylvania Academy of Fine Arts, Philadelphia. Annual exhibition of painting and sculpture. Philadelphia, The Academy

--25	1925	--46	1946
--28	1928	--47	1947
--40	1940	--48	1948
--41	1941	--49	1949
--42	1942	--52	1952
--44	1944	--53	1953
--45	1945		

PACH Pach, Walter. Classical tradition in modern art. New York, Thomas Yoseloff, Publishers, 1959

PACHA Pach, Walter. Art museum in America. New York, Pantheon Books, 1948

PAG--1-15 Pageant of America; a pictorial history of the United States, edited by Ralph Henry Gabriel and others. Washington Edition. New Haven, Yale University Press, 1925-1929 15 v

PAI Paine, Robert Treat, and Alexander Soper. Art and architecture of Japan. reprint with corrections. Harmondsworth, Baltimore, Penguin Books, 1960

PAL Pallottino, Massimo. Art of the Etruscans. London, Thames & Hudson; New York, Vanguard, 1955

PANA--1
--2 Pan American Union. Guia de las colecciones publicas de Arte in Los Estados Unides. 2 v. Washington, D. C. Union Panamericana, 1951, 1954
v. 1. Costa Oriental: Florida a New York
v. 2. Nueva Inglaterra

PANB Panofsky, Dora, and Erwin Panofsky. Pandora's box. rev ed. New York, Pantheon Books, 1962

PANM Panofsky, Erwin. Meaning in the visual arts. Garden City, N. Y., Doubleday, 1955

PANR Panofsky, Erwin. Renaissance and renaissances in western art. Stockholm, Almquist and Wiksell, 1960

PANS Panofsky, Erwin. Studies in iconology. New York, Oxford University Press, 1939; paper ed. New York, Harper, 1962

PAR--1
--2 Parkes, Kineton. Art of carved sculpture. 2 v. London, Chapman, 1931
v. 1. Western Europe, America and Japan
v. 2. Central and Northern Europe

PARS--1
--2 Parkes, Kineton, Sculpture of today. 2 v. London, Chapman; New York, Scribner, 1921
v. 1. America, Great Britain, Japan
v. 2. Continent of Europe

PAS	Pasadena Art Museum. New American sculpture, exhibit catalog, February 11 through March 7, 1964. Pasadena, The Museum, 1964
PAU	Paulme, Denise. African sculpture. London, Elek Books; New York, Viking, 1962
PEAR	Pearson, Ralph M. Modern renaissance in American art, presenting the work and philosophy of 54 distinguished artists. New York, Harper, 1954
PEL	Pelligrini, Aldo. New tendencies in art. New York, Crown Publishers, 1966
PEN	Pendergast, W. W., and W. Porter Ware. Cigar store figures in American folk art. Chicago, Lightner Publishing Co., 1953
PEP	Pepper, Stephen Coburn. Principles of art appreciation. New York, Harcourt, Brace, 1949
PER	Perry, Hubert Montagu. New materials in sculpture--glass fibre, polyester resins, cold casting in metal, vinamould hot melt compounds, vinagel. 2nd rev and enl ed. London, A. Tiranti, 1965
PERL	Perlman, Bennard B. The immortal Eight. New York, Exposition Press, 1962
PERR	Perry, Stella George (Stern). The sculpture and mural decoration of the Exposition; a pictorial survey of the art of the Panama-Pacific International Exposition. San Francisco, P. Elder, 1915
PEVE	Pevsner, Nikolaus. Englishness of English art. London, Architectural Press, 1956
PEVP	Pevsner, Nikolaus. Pioneers of modern design. New York, Museum of Modern Art, 1949 Revision of: Pioneers of the modern movement, 1936
PH	Phillips Collection, Washington, D. C. The Phillips Collection, a museum of modern art and its sources. Catalogue. Washington, D. C., The Collection, 1952
PIE	Pierson, William Harvey, and Martha Davidson, eds. Arts of the United States: A pictorial survey. New York, McGraw-Hill Book Co., 1960
PM	Paris. Musee National d'Art Moderne. Catalogue-guide, by Jean Cassou, et al. Paris, The Museum, 1950
POM	Pope, Arthur Upton. Masterpieces of Persian Art. New York, Dryden, 1945

POPG	Pope-Hennessy, John. Introduction to Italian sculpture. v 1. Italian Gothic sculpture. London, Phaidon Publishers; Greenwich, Ct., New York Graphic Society, 1955
POPR	Pope-Hennessy, John. Introduction to Italian sculpture. v. 2. Italian Renaissance sculpture. London, Phaidon Publishers; Greenwich, Ct., New York Graphic Society, 1958
POPRB	Pope-Hennessy, John. Introduction to Italian sculpture. v. 3. Italian High Renaissance and Baroque sculpture. London, Phaidon Publishers; Greenwich, Ct., New York Graphic Society, 1963
POR	Porada, Edith, and R. H. Dyson. Art of ancient Iran: Pre-Islamic cultures. London, Methuen; New York, Crown Publishers, 1965
POST--1 --2	Post, Chandler Rathfon. History of European and American sculpture from the early Christian period to present day. 2 v. Cambridge, Harvard University Press, 1921
PPA	Philadelphia Museum of Art. The Louise and Walter Arensberg Collection. v. 1. 20th century painting and sculpture. Philadelphia, The Museum, 1954
PRAD--1 --2	Museo del Prado. Catalogo de la Escultura. v 1. Escultura Clasicas; v. 2. Esculturas, copias e imitaciones de las antiguas (Siglos XVI-XVII), by A. Blanco. Madrid, Museo, 1957
PRAEG	Praeger picture encyclopedia of art. New York, Frederick A. Praeger, Publishers, 1958
PRIV	A private view, by Bryan Robertson, and others. London, Thomas Nelson, 1965
PUL--1 --2	Pulitzer, Louise, and Joseph Pulitzer. Modern painting, drawing and sculpture collected by Louise and Joseph Pulitzer. 2 v. Cambridge, Fogg Art Museum, 1958
PUT	Putnam, Brenda. The sculptor's way. 1st rev ed. New York, Watson-Guptill Publications, 1948
RAD	Radcliffe, A. G. Schools and masters of sculpture. New York, D. Appleton, 1894; reprint 1908
RAMS	Ramsden, E. H. Sculpture: Theme and variations, towards a contemporary aesthetic. London, Lund Humphries, 1953 "Review of sculptural achievements of the first half of the twentieth century."

RAMT Ramsden, E. H. Twentieth-century sculpture. London, Pleiades Books, 1949
RAY Rayner, Edwin. Famous Statues and their stories. New York, Grosset & Dunlap, 1936
RDAB Rice, David Talbot. Art of the Byzantine era. New York, Frederick A. Praeger, Publishers, 1963
RDB Rice, David Talbot. Art of Byzantium. London, Thames & Hudson: New York, Harry N. Abrams, 1959
RDE Rice, David Talbot. English art: 871-1100. Oxford, Clarendon Press, 1952
RDI Rice, David Talbot. Islamic art. London, Thames & Hudson; New York, Frederick A. Praeger, Publishers, 1965
READA Read, Herbert, Art and society. 3rd ed. London, Faber & Faber, 1956
READAN Read, Herbert. Art now, an introduction to the theory of modern painting and sculpture. 2nd ed. London, Pitman, 1960
READAS Read, Herbert. Art of sculpture. 2nd ed. London, Faber & Faber; New York, Pantheon Books, 1961
READCO Read, Herbert. Contemporary British art. rev ed. Harmondsworth, Baltimore, Penguin Books 1964
READCON Read, Herbert. Concise history of modern sculpture. New York, Frederick A. Praeger, Publishers, 1964
READG Read, Herbert. Grass roots of art. New York, Wittenborn, 1955; 1961 reprint, Meridian
READI Read, Herbert. Icon and idea. Cambridge, Harvard University Press, 1955
READM Read, Herbert. Meaning of art. London, Penguin Books, 1949
READO Read, Herbert. Origins of form in art. New York, Horizon Press, 1965
READP Read, Herbert. Philosophy of modern art. New York, Horizon Press, 1953; 1955 reprint, Meridian
READS Read, Herbert. Surrealism. New York, Harcourt, Brace, 1936
REAU Reau, Louis, L'art religieux du moyen-age (la sculpture). Paris, Fernand Nathan, 1946
REED Reed, Merrilla. Historic statues and monuments in California. San Francisco, Author, 1956
RHC Rhode Island School of Design, Providence. Contemporary boxes and wall sculpture. Catalog,

	text by Daniel Robbins. Providence, The School, 1965
RHS	Rhode Island School of Design, Providence. Sculpture in the collection of the artist. Exhibit catalog, January 30-February 24, 1963. Providence, The School, 1963
RICH	Richardson, Edgar Preston. Way of western art, 1776-1914. Cambridge, Harvard University Press, 1939
RICHT	Richter, Hans. Dada: Art and anti-art. New York, McGraw-Hill Book Co., 1965
RICHTH	Richter, Gisela M. Handbook of Greek art. 4th ed. London, Phaidon Press; Greenwich, Ct., New York Graphic Society, 1965
RICJ	Rich, Jack C. Materials and methods of sculpture. New York, Oxford University Press, 1947
RIJ	Amsterdam. Rijksmuseum. Het Rijksmuseum, kreuze van de afbeeldingen entekst, van E. R. Meijer. Amsterdam, Van Ditmar, 1965
RIJA	Amsterdam. Rijksmuseum. Art treasures of the Rijksmuseum, texts by Arthur F. E. Schendel, and B. Haak. New York, Harry N. Abrams, 1966
RIT	Ritchie, Andrew Carnduff. Sculpture of the twentieth century. New York, Museum of Modern Art, 1952
ROBB	Robb, David M. Art in the western world. 4th ed. New York, Harper, 1963
ROODT	Rood, John. Sculpture with a torch. Minneapolis, University of Minnesota Press, 1963
ROODW	Rood, John. Sculpture in wood. Minneapolis, University of Minnesota Press, 1950
ROOS	Roos, Frank J. Illustrated handbook of art history. rev ed. New York, Macmillan, 1954
ROOSE	Rooses, Max. Art in Flanders. New York, Scribner, 1931
ROS	Rosenberg, Jakob, et al. Dutch art and architecture: 1600-1800. Harmondsworth, Baltimore, Penguin Books, 1966
ROSE	Rosenbaum, Robert. Cubism and twentieth century art. New York, Harry N. Abrams, 1961
ROSS	Ross, Malcolm Mackenzie, ed. Arts in Canada; a stock-taking at mid-century. Toronto, Macmillan, 1958
ROSSI	Rossi, Filippo. Colorslide tour of the Pitti Palace, Florence. New York, Harry N. Abrams, 1960 (Panorama Colorslide Art Program, v. 10)

ROTH	Roth, Cecil, ed. Jewish art; an illustrated history. New York, McGraw-Hill Book Co., 1961
ROTHS	Rothschild, Lincoln. Sculpture through the ages. London, Whittlesley House; New York, McGraw-Hill Book Co., 1942
ROTHST	Rothschild, Lincoln. Style in art. New York, Thomas Yoseloff, 1960
ROTJB	Rothenstein, John. British art since 1900. London, Phaidon Publishers; distributed by New York Graphic Society, Greenwich, Ct., 1962
ROTJG	Rothenstein, John. The Tate Gallery. London, Thames & Hudson; New York, Harry N. Abrams, 1958
ROTJT	Rothenstein, John. A brief history of the Tate Gallery. London, Pitkin Pictorials, 1963
ROUT	Rousseau, Theodore. Colorslide tour of the Metropolitan Museum of Art, New York City. New York, Harry N. Abrams, 1961 (Panorama Colorslide Art Program, v. 5)
ROW	Rowland, Benjamin. Art and architecture of India: Buddhist, Hindu, Jain. 3rd rev ed. Harmondsworth, Baltimore, Penguin Books, 1967
ROWE	Rowland, Benjamin. Art in East and West: An introduction through comparisons. Cambridge, Harvard University Press, 1954
ROY	Roy, Claude. Art of the savages. New York, Arts, 1958
RITC	Rice, Tamara Talbot. Ancient arts of Central Asia. London, Thames & Hudson; New York, Frederick A. Praeger, Publishers, 1965
RTCR	Rice, Tamara Talbot. Concise history of Russian art. London, Thames & Hudson; New York, Frederick A. Praeger, Publishers, 1963
RUBL	Rublowsky, John, and K. Heyman. Pop art. New York, Basic Books, 1965
RUS	Ruskin, Ariane. Pantheon story of art for young people. London, Heinemann; New York, Pantheon Books, 1964
SAID	Said, Hamed, ed. Contemporary art in Egypt. Belgrade, Jugoslavia Ministry of Culture and National Guidance, in cooperation with Publishing House "Jugoslavia," 1964 Missing plates: 47; 68-73

SAL	Salvini, Roberto. Modern Italian sculpture. London, Oldbourne; New York, Harry N. Abrams, 1962
SALT	Saltus, John Sanford, and Walter E. Tisne. Statues of New York. New York, G. P. Putnam's Sons, 1922
SAN	Santangelo, Maria. Etruscan museums and monuments. Novara, Istituto Geografico de Agostini, 1963 French and English text
SANT	Santos, Reynaldo dos. L'art portugais: Architecture, sculpture et peinture. Paris, Librairie Plon, 1953
SAO	Sao Paulo, Brazil. Meseu de Arte Moderna. Bienal. Catalogo

<table>
<tr><td>--1</td><td>1951</td><td>--5</td><td>1959</td></tr>
<tr><td>--2</td><td>1953</td><td>--6</td><td>1961</td></tr>
<tr><td>--3</td><td>1955</td><td>--7</td><td>1963</td></tr>
<tr><td>--4</td><td>1957</td><td>--9</td><td>1965</td></tr>
</table>

SBT	Santa Barbara. Museum of Art. Three young collections; selections from the collections of Donald and Lynn Factor, Dennis and Brooke Hopper, Andre and Dory Previn. Santa Barbara, The Museum, 1967
SCHAEF	Schaefer-Simmern, Henry. Sculpture in Europe today. Berkeley, University of California Press, 1955
SCHEF	Schefold, Karl. Myth and legend in early Greek art. Munich, Hirmer Verlag. 1964; London, Thames & Hudson, New York, Harry N. Abrams, 1966
SCHERM	Scherer, Margaret R. Marvels of ancient Rome. New York, Phaidon, 1956
SCHMI	Schmitz, Carl A. Oceanic sculpture, the sculpture of Melanesia, Greenwich, Ct., New York Graphic Society, 1962
SCHMU	Schmutzler, Robert. Art Nouveau. Stuttgart, Verlag Gerd Hatje; New York, Harry N. Abrams, 1964
SCHN	Schneir, Jacques F. Sculpture in modern America. Berkeley, University of California Press, 1948
SCHO	Schoder, Raymond B. Masterpieces of Greek art. 2nd rev ed. Greenwich, Ct., New York Graphic Society, 1965
SCHW	Schwarz, Karl. Jewish sculptors. Tel-Aviv, Jerusalem Art Publishers; distributed by M. Neuman, 1954

SCOM	Scottish National Gallery of Modern Art, Edinburgh. Catalog, The Gallery. Edinburgh, HMSO, 1963
SCON	National Gallery of Scotland. Illustrations. Edinburgh, HMSO, 1965
SCUL	Scultura Italiana del XX° secolo, prefazione de Palma Bucarelli. Rome, Editalia, 1957
SDF	San Diego. Fine Arts Gallery. Catalog, a selective listing of all the collections of the Fine Arts Society, San Diego. San Diego, Fine Arts Society, 1960
SDP	San Diego. Palace of Fine Arts. Balboa Park. California Pacific International Exposition, 1935. Illustrated catalog of the official art Exhibition. San Diego, Frye & Smith, 1935
SEAA	Seattle World's Fair. Art since 1950, American and International. Seattle, 1962
SEAM	Seattle World's Fair. Catalogue: Masterpieces of Art, Fine Arts Pavilion, April 21 to September 4, 1962.
SEATL	Seattle Art Museum. Ten from Los Angeles. Catalog, text by John Coplans. Seattle, The Museum, 1966
SECK	Seckel, Dietrich. Art of Buddhism. London, Methuen; New York, Crown Publishers, 1964
SEG	Segy, Ladislas. African sculpture speaks. 3rd ptg. New York, Hill & Wang, 1961
SEIT	Seitz, William C. Art Israel: 26 painters and sculptors. New York, Museum of Modern Art; distributed by Doubleday, 1964
SEITA	Seitz, William C. Art of Assemblage. New York, Museum of Modern Art, 1961
SEITC	Seitz, William C. Contemporary sculpture. New York, Art Digest, 1965
SEITR	Seitz, William C. The responsive eye, catalogue. New York, Museum of Modern Art, 1965
SELZJ	Selz, Jean. Modern Sculpture: Origins and evolution. New York, Braziller, 1963
SELZN	Selz, Peter H. New images of man. New York, Museum of Modern Art, 1959
SELZP	Selz, Peter H. Directions in kinetic sculpture, with an introduction by George Rickey and statements by the artists. Berkeley, University of California, University Art Museum and Committee for Arts and Lectures, 1966
SELZPN	Selz, Peter H., and Mildred Constantine, eds. Art Nouveau. New York, Museum of Modern Art; distributed by Doubleday, 1959

SELZS Selz, Peter H. Seven decades: 1895-1965, cross currents in Modern Art. Greenwich, Ct., New York Graphic Society, 1966

SET Seton, Julia M. American Indian arts. New York, Ronald Press, 1962

SEW Sewall, John Ives. History of western art. rev ed. New York, Holt, 1961

SEY Seymour, Charles. Sculpture in Italy: 1400-1500. Harmondsworth, Baltimore, Penguin Books, 1966

SEYM Seymour, Charles. Masterpieces of sculpture from the National Gallery of Art, Washington, D. C. New York, Coward McCann, 1949

SEYT Seymour, Charles. Tradition and experiment in modern sculpture. Washington, D. C. American University Press, 1949

SEZ Seznec, Jean. Survival of the pagan gods. New York, Pantheon Books, 1935

SFAA San Francisco. Museum of Art. Art in the 20th century. Exhibition commemorating the tenth anniversary of the signing of the United Nations charter, June 17-July 10, 1955. San Francisco. The Museum, 1955

SFAF San Francisco. Museum of Art. Fifty California artists. Catalog. 1962

SFAP San Francisco Art Association. Painting and Sculpture. Berkeley, University of California Press, 1952

SFGC San Francisco. Golden Gate International Exposition, 1939-1940. Department of Fine Arts. Contemporary art; official catalog, Division of Contemporary Painting and Sculpture. San Francisco, 1939

SFGM San Francisco. Golden Gate International Exposition, 1939-1940. Masterwords of five centuries. San Francisco, San Francisco Bay Exposition Co., 1939

SFGP San Francisco. Golden Gate International Exposition 1939-1940. Pacific cultures. San Francisco, Exposition, 1939

SFMB San Francisco. Museum of Art. British art today. Catalog, Nov 13-Dec 16, 1962. San Francisco, The Museum, 1962

SFPP San Francisco. Panama-Pacific International Exposition, 1915. Sculpture and mural paintings in the beautiful courts, colonnades and avenues of the Panama-Pacific Exposition, text by Jessie Niles Barnes. San Francisco, R. A. Reid, 1915

SG--2-7	Sculptors Guild, New York. Sculpture, catalog of annual exhibition at Lever House, New York
	--2 1960 --5 1963
	--3 1961 --6 1964
	--4 1962 --7 1965
SGO	Sculptors Guild, New York. Outdoor sculpture exhibition. New York, The Guild, 1938-
	--1 1938 --10 1948
	--2 1939 --17 1955
	--4 1942
SGT	Sculptors Guild, New York. Sculptors Guild Traveling Exhibition, 1940-1941. New York, The Guild, 1940
SHAP	Shapley, Fern Rusk, and John Shapley. Comparisons in art; a companion to the National Gallery of Art, Washington, D. C. Greenwich, Ct., New York Graphic Society, 1957
SICK	Sickman, Laurence, and Alexander Soper. Art and architecture of China. 2nd ed. Harmondsworth, Baltimore, Penguin Books, 1960
SIN	Singleton, Esther, ed. Famous sculpture as seen and described by great writers. New York, Dodd, Mead, 1910
SLOB	Slobodkin, Louis. Sculpture, principles and practice. Cleveland, World Publishing Co., 1949
SMI	Smithsonian Institution. Authentic reproductions of the originals in the Smithsonian Institution. v 1. Sculpture reproductions by Alva Museum Replicas, Inc., New York, and Ram Studios, Arlington, Va.
SMIBJ	Smith, Bradley. Japan: A history in art. New York, Simon and Schuster, 1964
SMIBS	Smith, Bradley. Spain: A history in art. New York, Simon and Schuster, 1966
SMITP	Smithsonian Institution. National Portrait Gallery. Nucleus for a national collection, entries compiled by Robert G. Stewart. Washington, D. C., Smithsonian Institution, 1966
SMITR	Smithsonian Institution. National Portrait Gallery. Recent acquisitions. Washington, D. C., Smithsonian Institution, 1966
SMIW	Smith, William Stevenson. Art and architecture of ancient Egypt. Harmondsworth, Baltimore, Penguin Books, 1958
SOBYA	Soby, James Thrall. After Picasso. New York, Dodd, Mead, 1935

SOBYT	Soby, James Thrall, and Alfred H. Barr. Twentieth century Italian art. New York, Museum of Modern Art, 1949
SOT	Sotriffer, Kristian. Modern Austrian art. New York, Frederick A. Praeger, Publishers, 1963
SOTH	Sotheby, firm, Auctioneers, London. Ivory Hammer, Sotheby sales. New York, Holt --1 Year at Sotheby's, 1962-1963. 1964 --2 _____ 1963-1964. 1964 --3 _____ 1964-1965. 1965 --4 Art at auction, 1965-1966. 1966
SP	Sprengel, Bernhard. Sammlung Sprengel. Exhibit of the Sprengel Collection: Kunstverein Hannover, Kestner-Gesellschaft, Hanover Niedersachsisches Landesmuseum, Oct 10-Nov 28, 1965. Hanover, 1965
SPA	Spaeth, Eloise. American art museums and galleries. New York, Harper, 1960
SPE	Speiser, Werner. Art of China. New York, Crown Publishers, 1960
SPI	Spinden, Herbert Joseph. Maya art and civilization, rev and enl with added illustrations. Indian Hills, Colo, Falcon's Wing Press, 1957 Plates indexed
ST	Styles of European art, introduction by Herbert Read. London, Thames & Hudson, 1965; New York, Harry N. Abrams, 1967
STA	Stadler, Wolfgang. European art; a travellers' guide. New York, Herder & Herder, 1960
STE	Stewart, Virginia. 45 contemporary Mexican artists. Stanford, Stanford University Press, 1951
STECH	Stech, Vaclav Vilem. Baroque sculpture. London, Spring Books, 1959
STI	Stiles, Raymond S. The arts and man. New York, McGraw-Hill Book Co., 1940
STM	Stad Antwerpen Kunst Historishe Musea. Openlucht Museum voor Beeldhouwkunst, Middelheim. Antwerp, The Museum
STON	Stone, Lawrence. Sculpture in Britain: The Middle Ages. Harmondsworth, Baltimore, Penguin Books, 1955
STRONGC	Strong, Donald E. The classical world, New York, McGraw-Hill Book Co., 1965
STRONGD	Strong, D. E. Roman imperial sculpture; an introduction to the commemorative and

1

	decorative sculpture of the Roman empire down to the death of Constantine. London, A. Tiranti, 1961
SULI	Sullivan, Michael. Introduction to Chinese art. London, Faber & Faber; Berkeley, University of California, 1960
SULT	Sullivan, Michael. Chinese art in the twentieth century. London, Faber & Faber; Berkeley, University of California Press, 1959
SUNA	Sunset Publishing Company. Art treasures in the West. Menlo Park, Calif, Lane Magazine and Book Co., 1966
SWA	Swarzensi, Hans. Monuments of Romanesque art. London, Faber & Faber; Chicago, University of Chicago Press, 1954
SWANJ	Swann, Peter C. Introduction to the arts of Japan. Oxford, Bruno Cassirer; New York, Frederick A. Praeger, Publishers, 1958
SWANJA	Swann, Peter C. Art of Japan. Baden-Baden, Holle Verlag; New York, Crown Publishers, 1966
SWANNC	Swann, Peter C. Art of China, Korea and Japan. New York, Frederick A. Praeger, Publishers, 1963
TAFT	Taft, Lorado. History of American sculpture. new ed. New York, Macmillan, 1930
TAFTM	Taft, Lorado. Modern tendencies in sculpture. Chicago, published for the Art Institute of Chicago by University of Chicago Press, 1921
TAT	Tatlock, Robert Rattray, ed. Spanish art; an introductory review of...sculpture. New York, Weyhe, 1927
TATEB	Tate Gallery. Modern British paintings, drawings, and sculpture, by Mary Chamot, and others. London, Oldbourne Press, 1964 v. 1. Artists A-L v. 2. Artists M-z This catalog, one "of a new series of detailed catalogs to be printed by the Tate Gallery," lists and pictures the work of British artists born in or after 1850
TATEF	Tate Gallery. Foreign paintings, drawings and sculpture, by Ronald Alley. London, Tate Gallery, 1959
TATES	Tate Gallery. British sculpture since 1945, by Dennis Farr. London, Tate Gallery, 1965
TAYFF	Taylor, Francis Henry. Fifty centuries of art. rev ed. New York, Harper, 1960

li

TAYFT	Taylor, Francis Henry. Taste of angels; a history of art collecting from Rameses to Napoleon. New York, Little, Brown, 1948
TAYJ	Taylor, Joshua C. Learning to look: A handbook for the visual arts. Chicago, University of Chicago Press, 1957
THOR	Thorp, Margaret (Farrand). The Literary sculptors. Durham, N. C., Duke University Press, 1965
THU	Thurston, Carl. Structure of art. Chicago, University of Chicago Press, 1940
TOK	Tokyo National Museum. Pageant of Japanese art. v. 3. Sculpture. popular ed. Tokyo, Toto Shuppan Co.; distributed by Charles E. Tuttle, Rutland, Vt., 1952
TOKC	Tokyo. National Museum of Western Art. Catalog. Tokyo, The Museum, 1960 Text in Japanese and French, also English titles of works
TOLC	Toledo Museum of Art. Chilean contemporary art, and exhibition sponsored by the Ministry of Education of the Republic of Chile, and the Faculty of Fine Art of the University of Chile. Toledo, The Museum, 1946
TOR	Toronto. Royal Ontario Museum. Art treasures in the Royal Ontario Museum, by Theodore Allen Heinrich. Toronto, McClelland & Stewart, 1963; Greenwich, Ct., New York Graphic Society, 1964
TORA	Toronto, Art Gallery of Toronto. Painting and sculpture, illustrations of selected paintings and sculpture from the collection. Toronto, The Gallery, 1959
TOW	Townsend, James Benjamin. 100; The Buffalo Fine Arts Academy, 1862-1962. Buffalo, N. Y., Albright-Knox Art Gallery, 1962
TREW	Trewell, Margaret. Classical African sculpture. rev ed. London, Faber & Faber; New York, Frederick A. Praeger, Publishers, 1964
TRI	Trier, Eduard. Form and space; sculpture of the Twentieth century. London, Thames & Hudson; New York, Frederick A. Praeger, Publisher, 1962
TUC	Tuchman, Maurice, ed. American sculpture of the sixties. Los Angeles, Los Angeles County Museum of Art, 1967

UCIF University of California. Irvine. Five Los
Angeles sculptors. Catalog for an exhibit, Jan
7 to Feb 6, 1966. Irvine, University of
California, 1966

UCIT University of California. Irvine. Twentieth century
sculpture, 1900-1950, selected from California
collections. Catalog for an exhibit, October 2-
24, 1965. Irvine, University of California,
1965.

UCLD University of California, Los Angeles. Virginia
Dwan Collection. Catalog, October 3-24, 1965.
The University, 1965

UIA--6-13 Illinois University. College of Applied Arts. Bi-
ennial exhibition of contemporary American
painting and sculpture. Urbana, The University

--6	1953	--10	1961
--7	1955	--11	1963
--8	1957	--12	1965
--9	1959	--13	1967

UMCF Harvard University. William Hayes Fogg Art
Museum. Survey of the Fogg Collection. 1964

UNA United American Sculptors. First annual exhibi-
tion, catalog. New York, 1939

UND Underwood, Eric Gordon. Short history of English
sculpture. London, Faber & Faber, 1933

UNNMMAM Museum of Modern Art. Modern works of art;
fifth anniversary exhibition, November 20,
1934-January 20, 1935. 2nd ed New York, The
Museum, 1936

UNNMMAS Metropolitan Museum of Art. American sculpture,
a catalogue of the collection of the Metropolitan
Museum of Art, by Albert Ten Eyck Gardner.
Metropolitan Museum of Art; distributed by
New York Graphic Society, 1965
160 photographs representing "all major
sculptures and schools from the early 19th
century to the present."

UPJ Upjohn, Everard Miller, et al. History of world
art. 2nd rev ed. New York, Oxford University
Press, 1958

UPJH Upjohn, Everard, Miller, and J. P. Sedgwick.
Highlights: An illustrated handbook of art
history. New York, Holt, 1963

USC United States Congress. 88th Congress, 2nd Ses-
sion. Compilation of works of art and other
objects in the United States Capitol, prepared
by the Architect of the Capitol, under the
direction of the Joint Committee on the Library.

	Washington, D. C. , U. S. Government Printing Office, 1965 House Document No. 362
USNC	United States National Gallery of Art. Preliminary catalogue of paintings and sculpture. Washington, D. C. , The Gallery, 1941
USNI	United States National Gallery of Art. Book of illustrations. 2nd ed. Washington, D. C. , The Gallery, 1942
USNK	United States National Gallery of Art. Paintings and sculpture from the Kress Collection. Washington, D. C. , The Gallery, 1945
USNKP	United States National Gallery of Art. Paintings and sculpture from the Kress Collection, acquired by the Samuel H. Kress Foundation, 1945-1951. 2nd ed. Washington, D. C. , The Gallery, 1959
USNKS	United States National Gallery of Art. Supplement to the Kress Collection in the National Gallery, by Felix Frankfurter. New York, The Art Foundation, 1946
USNM	United States National Gallery of Art. Makers of history in Washington, 1800-1950. Catalog of an exhibition celebrating the sesquicentennial of the establishment of the Federal Government in Washington, June 29-November 19, 1950. Washington, D. C. , The Gallery, 1950
USNP	United States National Gallery of Art. Paintings and sculpture from the Mellon Collection. Washington, D. C. , The Gallery, 1949
VA	Vaillant, George Clapp. Artists and craftsmen in ancient Central America. New York, American Museum of Natural History, 1949
VAL	Valcanover, Francesco. Colorslide tour of the Accademia Gallery, Venice. New York, Harry N. Abrams, 1961 (Panorama Colorslide Art Program, v. 9)
VALE	Valentiner, Wilhelm Reinhold. Origins of modern sculpture. New York, Wittenborn, 1946
VEN	Venice. Biennale di Venezia, Esposizione internazionale d'Arte. Catalog. Venice, The Biennale

--97	1897, v. 2	--34	1934
--99	1899	--36	1936
--1	1901	--38	1938
--3	1903	--40	1940
--5	1905	--42	1942
--7	1907		

--10	1910	--48	1948
--12	1912	--50	1950
--14	1914	--52	1952
--20	1920	--54	1954
--22	1922	--56	1956
--24	1924	--58	1958
--26	1926	--60	1960
--28	1928	--62	1962
--30	1930	--64	1964
--32	1932	--66	1966, v. 33

31 catalogs indexed. 1895, v. 1, and 1909, v. 8, contain no illustrations of sculpture

VER Vermeule, Cornelius. European art and the classical past. Cambridge, Harvard University Press, 1964

VEY Vey, Horst, and Xavier de Salas. German and Spanish art to 1900. New York, Franklin Watts, 1965

VICF Victoria and Albert Museum. Fifty masterpieces of sculpture. London, HMSO, 1951

VICG Victoria and Albert Museum. The Great Exhibition of 1851: A commemorative album. Compiled by C. H. Gibbs-Smith. A description of the Hyde Park Crystal Palace, with over 200 illustrations. London, HMSO, 1950

VICK Victoria and Albert Museum. Kings and queens of England, 1500-1900. London, HMSO, 1937

VICO Victoria and Albert Museum. One hundred masterpieces, Renaissance and modern. London, HMSO, 1931

VICOR Victoria and Albert Museum. The Orange and the Rose--Holland and Britain in the age of observation, 1600-1750. An exhibition...October 22 to December 13, 1964. London, The Museum, 1964

VOL Volbach, W. F., and M. Hirmer. Early Christian art. London, Thames & Hudson; New York, Harry N. Abrams, 1961

WADE Wadsworth Atheneum, Hartford, Ct. Eleven New England sculptors: Loan exhibition, July 18 through September 15, 1963. Hartford, Ct., Atheneum, 1963

WAG Wagner, Frits A. Art of Indonesia. Baden-Baden, Holle Verlag; New York, McGraw-Hill Book Co., 1959

WALD Waldberg, Patrick. Surrealism. Geneva, Skira, 1962

WALK Walker, John. Colorslide tour of the National
Gallery of Art, Washington, D. C. New York,
Harry N. Abrams, 1960
(Panorama Colorslide Art Program, v. 2)

WALKA Walker Art Center, Minneapolis. New art of
Argentina. Minneapolis, The Center, 1964

WALKB Walker Art Center, Minneapolis. New art of
Brazil. Minneapolis, The Center, 1962

WALKC Walker Art Center, Minneapolis. Classic tradition
in contemporary art. Exhibit catalog, April 24
through June 28, 1953. Minneapolis, University
of Minnesota, 1953

WALKE Walker Art Center, Minneapolis. Expressionism
1900-1955: Walker Art Center... Minneapolis,
The Center, 1956

WALKR Walker Art Center, Minneapolis. Reality and
fantasy, 1900-1954. Exhibit catalog, May 23,
through July 2, 1954. Minneapolis, The Center,
1954

WALKS Walker Art Center, Minneapolis. Eight sculptors.
Minneapolis, The Center, 1966

WALKT Walker Art Center, Minneapolis. Ten American
Sculptors; an exhibition organized by Walker
Art Center and shown in the American section
of the VII Bienal de Sao Paulo in Brazil,
September 28 through December 31, 1963.
Minneapolis, The Center, 1963
Text in Portuguese and French

WALTA Walters Art Gallery, Baltimore. Catalogue of the
American works of art including French medals
made for America, by E. S. King and M. C.
Ross. Baltimore, Trustees of the Gallery,
1956

WARN Warner, Langdon. Enduring art of Japan. 2nd
ptg. Cambridge, Harvard University Press,
1958

WATT Watt, Alexander. Art centers of the world--
Paris. Cleveland, World Publishing Co., 1967

WB World Book Encyclopedia. Chicago, Field
Enterprises, 1967
Index of illustrations in Sculpture article

WCO--1-3 World Confederation of Organizations of the
Teaching Professions. Man through his art.
Greenwich, Ct., New York Graphic Society
--1 v. 1. War and peace. 1964
--2 v. 2. Music. 1964
--3 v. 3. Man and animals. 1965

WDCM	Washington, D. C. Gallery of Modern Art. Permanent collection, catalog. Washington, D. C., The Gallery, 1966
WEB	Webster, T. B. L. Art of Greece: The age of Hellenism. New York, Crown Publishers, 1966
WEG	Wegner, Max. Greek masterworks of art. New York, George Braziller, 1961
WES	West, Robert. Spanish sculpture from the 15th to the 18th century. Munich, Hyperion, 1923
WHEE	Wheeler, (Robert E.) Mortimer. Roman art and architecture. New York, Frederick A. Praeger, Publishers, 1964
WHIN	Whinney, Margaret, and Oliver Millar. English art, 1625-1714. Oxford, Clarendon Press, 1957
WHINN	Whinney, Margaret. Sculpture in Britain, 1530-1830. Harmondsworth, Baltimore, Penguin Books, 1964
WHITEH	White House Historical Association. The White House, an historic guide. Washington, D. C., The Association, 1962
WHITJ	White, John. Art and architecture in Italy, 1250-1400. Harmondsworth, Baltimore, Penguin Books, 1966
WHITN	Whitney Museum of American Art, New York. Between the Fairs: 25 years of American art, 1939-1964, by John I. H. Baur. New York, Frederick A. Praeger, Publishers, 1964
WHITNA	Whitney Museum of American Art. Nature in abstraction; the relation of abstract painting and sculpture to nature in twentieth-century American art. Text by John I. H. Baur. New York, Macmillan, 1958
WHITNA-- 1-19	Whitney Museum of American Art. Annual exhibition of contemporary American sculpture, water colors and drawings. New York, The Museum

--1	1946	--10	1955	--19	1968
--2	1947	--11	1956		
--3	1948	--12	1956/57		
--4	1949	--13	1957		
--5	1950	--14	1958		
--6	1951	--15	1960		
--7	1952	--16	1962		
--8	1953	--17	1964		
--9	1954	--18	1966		

19 catalogs indexed, 1946 through 1968.
Sculpture exhibit biennial beginning in 1958

WHITNB Whitney Museum of American Art. Business buys American art... exhibition by the Friends of the Whitney Museum, March 17-April 24, 1960 New York, The Museum, 1960

WHITNC Whitney Museum of American Art. Catalogue of the collection. New York, published for The Museum by Rudge, 1931

WHITNF Whitney Museum of American Art. The Museum and its Friends--Twentieth-century American art from the collections of the Friends of the Whitney Museum, a loan exhibition, April 30-June 15, 1958. New York, The Museum, 1958

WHITNF-- Whitney Museum of American Art. The Museum
2 and its Friends--Eighteen living American artists selected by the Friends of the Whitney Museum, a loan exhibition, March 5-April 12, 1959. New York, The Museum, 1959

WHITNF-- Whitney Museum of American Art. The theatre
4 collects--fourth loan exhibition by the Friends of the Whitney Museum, April 10-May 16, 1961. New York, The Museum, 1961

WHITNF-- Whitney Museum of American Art. The Friends
7 collect--Recent acquisitions by members of the Friends of the Whitney Museum, a loan exhibition, May 8-June 16, 1964. New York, The Museum, 1964

WHITNFA Whitney Museum of American Art. Juliana Force and American art, a memorial exhibition, September 24-October 30, 1949. New York, The Museum, 1949

WHITNFY Whitney Museum of American Art. The first five years--Acquisitions by the Friends of the Whitney Museum, 1957-1962, exhibition May 16-June 17, 1962. New York, The Museum, 1962

WHITNM Whitney Museum of American Art. Modern American painting and sculpture, Roy and Marie Neuberger Collection, exhibition, November 17-December 19, 1954. New York, The Museum, 1955

WHITNN Whitney Museum of American Art. New Decade: 35 American painters and sculptors, exhibition, May 11-August 7, 1955. New York, The Museum, 1955

WHITNP Whitney Museum of American Art. Pioneers of modern art in America, exhibition, April 9-May 19, 1946. New York, The Museum, 1946

WHITNR Whitney Museum of American Art. The collection
of the Sara Roby Foundation, exhibition,
April 29-June 14, 1959. New York, The
Museum, 1959

WHITNS Whitney Museum of American Art. Howard and
Jean Lipman Foundation, New York. Con-
temporary American sculpture, selection 1.
New York, The Museum, 1966

WHITNT Whitney Museum of American Art. 20th century
artists; a selection of paintings, sculpture and
graphic arts from the Museum's permanent
collection. New York, The Museum, 1939

WHITNY Whitney Museum of American Art. Young Ameri-
 --1 can art--Young America. New York, The
 --3 Museum
 --1 Thirty American painters and sculptors
 under thirty-five. 1957
 --3 ---------. 1965
 The second Young American art exhibition
in 1960 included 30 painters, no sculptors

WHITT Whittet, G. S. Art centers of the world--London.
Cleveland, World Publishing Co. , 1967

WHY Whyte, Bertha K. Seven treasure cities of Latin
America. New York, October House, 1964

WILL Willetts, William. Chinese art. New York,
George Braziller, 1958

WILM Wilenski, Reginald Howard. Meaning of modern
sculpture. London, Faber & Faber, 1932;
New York, Frederick A. Stokes, 1933

WILMO Wilenski, Reginald Howard. Modern movement in
art. 1st American ed. New York, Thomas
Yoseloff, 1957

WIN Wingert, Paul Stover. Sculpture of Negro Africa.
New York, Columbia University Press, 1950
"Examples illustrated by plates are all in
American collections. " (p. vi)

WINGP Wingert, Paul S. Primitive art, its traditions
and styles. New York, Oxford University
Press, 1962

WIT Wittkower, Rudolf. Art and architecture in Italy,
1600-1750. 2nd rev ed. Harmondsworth,
Baltimore, Penguin Books, 1965

WOLD Woldering, Irmgard. Art of Egypt. New York,
Crown Publishers, 1963

WOLFFA Wolfflin, Heinrich. Art of the Italian Renaissance.
New York, Putnam, 1913; 1963 reprint, New
York, Schocken Books

WOLFFC	Wolfflin, Heinrich. Classic art: An introduction to the Italian Renaissance. 2nd ed. New York, Phaidon, 1953; 1959 reprint
WOLFFP	Wolfflin, Heinrich. Principles of art history. 6th ed. London, G. Bell, 1932; 1950 reprint, New York, Dover
WOOLM	Woolley, Leonard. Art of the Middle East, including Persia, Mesopotamia, and Palestine. New York, Crown Publishers, 1961
WOR	Chicago. World's Columbian Exposition. Official illustrations, edited by Charles M. Kurtz. Chicago, 1893
WORC	Worcester Art Museum, Massachusetts. Art through fifty centuries, from the collections of the Worcester Art Museum. Worcester, Mass., The Museum, 1948
WORR	Worringer, Wilhelm. Form in Gothic. London, A. Tiranti, 1957; New York, Schocken Books, 1964
WPN	Warsaw. Museum Narodowe. National Museum in Warsaw, handbook of the collection. Warsaw, 1963
WW	Who's who among Japanese artists. Prepared by Japanese National Committee for the International Association of Plastic Arts, under the auspices of Japanese National Commission for UNESCO. Tokyo, Printing House, Japanese Government, 1961
YAH	Yale University. School of Fine Arts. Handbook of the gallery. New Haven, Associates in Fine Arts, 1931
YAP	Yale University. Gallery of Fine Arts. Paintings, drawings and sculpture collected by Yale alumni, an exhibition, May 19-June 26, 1960. New Haven, 1960
YAPO	Yale University. Portrait index, 1701-1951. New Haven, Yale University Press, 1951
YAS	Yashiro, Yukio. 2000 years of Japanese art. New York, Harry N. Abrams, 1958
ZOR	Zorach, William. Zorach explains sculpture-- what it means and how it is made. New York, Tudor, 1960

Sculpture Location Symbols

(Locations given are from publications indexed
and may not be current.)

Collections not Identified by
Geographic Location

-A	Coll. Ackerman-Pope
-Ac	Art of This Century
-Ad	Coll. Larry Adler
-Bak	Coll. Dr. Ruth Morris Bakwin
-Be	Coll. Alan Bennett
-Br	Coll. Joseph Brummer
-Bu	Coll. Mrs. Cora Timkin Burnett
-Bur	Coll. G. Burt
-But	Coll. John Butler
-Cal	Coll. Mrs. Meric Callery
-Cha	Coll. Mme Annick du Charme
-Chal	Galerie Chalette (UNNCh)
-Co	Coll. O. Le Corneur
-Coi	Coll. J. Coifford
-Col	Coll. Colonel Norman Colville
-Cos	Coll. Maurice Coskin
-Cr	Coll. Templeton Crocker
-Cu	Coll. Curtis
-D	Coll. P. J. Dearden
-Da	Coll. Mr. David M. Daniels
-Dan	Coll. Baron Ino Dan
-Dav	Coll. B. A. Davies
-De	Coll. Demotte
-Dot	Former Coll. Dottari
-Dug	Coll. Dugald-Malcolm
-E	Coll. G. W. Elliott
-El	Coll. Samuel Ellenburg
-Ep	Coll. Epstein
-Eu	Former George Eumorfopoulos Coll.
-Ev	Coll. Walker C. Everett
-F	Coll. A. Flowers
-Fab	Coll. Fabius
-Fe	Coll. Mme. Feron-Stoclet

-Fej	Coll. Paul Fejos
-Fig	Coll. Figdor
-Fo	Coll. Mrs. David McHattie Forbes
-For	Forum Gallery
-Foy	Folye Art Gallery
-Fr	Coll. Harry G. Friedman
-Fu	Fujita & Company
-Gaf	Coll. Rene Gaffe
-Gal	Coll. Signora P. Varzi Galliate
-Gar	Coll. Margaret Gardiner
-Ge	Coll. Gernsheim
-Gir	Coll. Dr. Maurice Girardin
-Go	Coll. Maurice Goldmann
-God	Coll. Y. and A. Godard
-Gol	Coll. Bertrand Goldberg
-Goldschmidt	Coll. Robert Goldschmidt
-Gr	Coll. Chaim Gross
-Gri	Coll. Marcel Griaule
-Gu	Coll. Late Franklin Mott Gunther
-Gue	Coll. Leonce-Pierre Guerre
-Guen	Coll. Guennol
-H	Coll. Late Mrs. Christian R. Holmes
-Ha	Coll. Tatsujiro Hashimoto
-Ham	Coll. Hamlin
-Han	Coll. Dr. James Hanson
-He	Coll. Baron Eduard von der Heydt
-Hea	Coll. G. E. Hearn
-Heb	Coll. Mrs. Jean Hebbeln
-Hee	Coll. N. Heeramaneck
-Her	Coll. Mr. and Mrs. Arnold L. Herstand
-Ho	Coll. Mr. and Mrs. Edward Jackson Holmes
-Hof	Coll. Hoffmann
-Hol	Coll. Mrs. Margot Holmes
-Hou	Coll. Mrs. Frank Lewis Hough
-Hs	Coll. Blair Hughes-Stanton
-I	Coll. R. Sturgis Ingersoll
-Ii	Coll. Shoichi Iijima
-J	Coll. Ralph Jonas
-Ja	Coll. Jameson
-K	Coll. Kramer
-Ka	Coll. Mrs. Otto K. Kahn
-Kam	Former Coll. Kamor
-Kau	Coll. Edgar Kaufmann, Jr.
-Kay	Coll. Harold Kaye
-Ke	Coll. D. G. Kelekian
-Kei	Coll. Mrs. Alex Keiller (EKink)
-Kev	Coll. H. Kevorkian
-Kj	Coll. Carl Kjersmeier

-Ko	Coll.	Fahim Kouchakji
-La	Coll.	A. Lancaster
-Le	Coll.	Leconsfield
-LeG	Coll.	Le Guillou
-Leff	Coll.	Leff
-Lem	Coll.	Samuel and Lucille Lemberg
-Leo	Il Leone Gallery	
-Lint	Coll.	Ralph Linton
-Lo	Coll.	Mr. and Mrs. Milton Lowenthal (UNNLow)
-Loc	Coll.	Dr. Alain Locke
-Lov	Coll.	C. Buxton Love, Jr.
-Mac	Coll.	MacGregor
-Mag	Coll.	Alex Maguy
-Mar	Coll.	Mr. and Mrs. Arnold Maremont
-Marc	Coll.	Stanley Marcus
-Mart	Coll.	Bradley Martin
-Mas	Coll.	Baron Taro Masuda
-Masl	Coll.	Mr. and Mrs. Samuel H. Maslon
-May	Coll.	Albert Mayeux
-Maye	Coll.	William Mayer
-Me	Coll.	Gustav Metzger
-Met	Coll.	Mr. and Mrs. John Metzenberg
-Mo	Coll.	Mrs. William H. Moore
-Mon	Coll.	R. de Montagne
-Moo	Coll.	Mrs. Irina Moore (EMoo)
-Mu	Coll.	Andrew Muir
-Mug	Coll.	M. Mugica Gallo
-Mul	Coll.	Dr. O. Muller-Widmann
-Mur	Coll.	K. C. Murray
-Nez	Coll.	Kaichiro Nezu
-No	Coll.	Kichibei Noda
-Nol	Coll.	Mr. and Mrs. Kenneth Noland
-O	Coll.	W. O. Oldman
-Od	Coll.	R. H. M. Ody
-Og	Coll.	Yasuyuki Ogura
-Ol	Coll.	Jules Olitski
-Op	Coll.	H. J. Oppenheim
-P	Coll.	P. Peissi
-Pas	Coll.	Jack Passer
-Pe	Coll.	M. Peltzer
-Pem	Coll.	Mr. and Mrs. Murdock Pemberton
-Pi	Coll.	Pitcairn
-Pl	Coll.	Margaret Plass
-Pla	Coll.	Webster Plass
-Ple	Coll.	Rene Pleven
-Pr	Coll.	Vincent Price
-Pry	Coll.	Dr. M. G. M. Pryor
-Q	Coll.	John Quinn

-Ra	Coll. Oscar Raphael
-Raf	Coll. Alexander Rafaeli
-Ras	Coll. Rene Rasmussen
-Rath	Coll. Mr. and Mrs. Gustave Rath
-Re	Coll. Bernard Reis
-Ril	Coll. Mr. and Mrs. Chapin Riley
-Ro	Coll. Mr. and Mrs. Paul Robeson
-Rob	Coll. Mrs. J. Rosenbaum
-Rog	Coll. Mrs. M. A. Rogers
-Roth	Coll. Elie de Rothschild
-Ru	Coll. Rutherston
-Rub	Coll. William Rubin
-Rus	Coll. John Russell
-Rome	Coll. Harold Rome
-Sai	Saidenberg Gallery
-Sal	Coll. Canon Quirk Salisbury
-Sch	Coll. Schnell
-Scha	Coll. Dr. Rosa Schapire
-Sh	Coll. Mr. and Mrs. Joseph R. Shapiro
-Si	Coll. Professor Roy Sieber
-Sip	Coll. Walter Siple
-Sm	Coll. Rebecca and Candida Smith
-So	Coll. Mr. and Mrs. Edward Sonnenschein
-St	Coll. R. Stora
-Sti	Coll. E. Clark Stillman
-Sto	Coll. Storno
-Stu	Peter Stuyvesant Foundation
-Sug	Coll. Suco Sugiyama
-Sw	Swiss Confederation
-T	Coll. Mr. and Mrs. Yves Tanguy
-Ta	Coll. M. A. Tachmindji
-Til	Coll. Paul Tilles
-Tm	Turan Museum
-Tr	Coll. Margaret Trowell
-V	Vasarely Collection
-Va	Coll. Dr. Vanbremeersch
-Van	Formerly Coll. Mrs. van den Berg
-Ve	Coll. Verite
-Vet	Coll. P. S. Verity
-Vog	Coll. Dr. Felicitas Vogler
-Wa	Coll. Edward M. M. Warburg
-Wal	Coll. Furst Ottingen Wallerstein
-War	Coll. John W. Warinner
-We	Coll. Captain Welch
-Wh	Coll. M. D. Whyte
-Wi	Coll. Wielgus
-Wil	Coll. William Wilder (UWi)
-Win	Coll. Mr. and Mrs. David J. Winton

-Wo	Coll. Dr. Nathaniel S. Wolf
-Y	Coll. Howard Young (UNNYo)
-Z	Coll. Ed. Zern

Austria

-AE	Emperor of Austria
AA	Altenburg
AAdB	Admont. Benedictine Abbey
AF	Friesach, Carinthia
AFrP	Frauenstein. Parish Church
AGJ	Graz. Landesmuseum Johanneum
AGLG	----- Landesmuseum Joanneum. Alte Galerie
AGM	----- (near). St. Martin Church
AGuC	Gurk. Cathedral
AI	Innsbruck
AIA	----- Schloss Ambras
AIFr	----- Franciscan Church
AIH	----- Hofkirche
AIHe	Innsbruck. Helbinghaus
AIT	----- Tiroler Landesmuseum Ferdinandeum
AK	Klosterneuberg Convent Church
AKe	Kefermarkt
AKrS	Kremsmunster. Stifliskirche
AL	Lochen
AM	Mils bei Hall, Tyrol
AMa	Mauer bei Melk
AMeA	Melk. Abbey Church (Benediktinerabtei Melk)
AMon	Mondsee Abbey Church
APA	Pressburg. Palace of Administration (Now: Bratislavia, Czechoslovakia)
APC	Pressburg. Cathedral
ASF	Salzburg. Festival Theatre
ASFr	----- Francescan Convent
ASM	----- Mirabell Palace
ASS	----- Salzburger Museum Carolino Augusteum
ASSt	----- Achiepiscopal Stables
ASc	Schleedorf
ASch	Schongrabern
AStGF	St. Georgen a. d. Mattig. Filialkirche
AStPS	St. Polten. Schweighof
AStW	St. Wolfgang Parish Church
ASta	Stams
AVA	Vienna. Albrechts-Platz
AVAB	----- Akademie der Bildenden Kunste
AVAg	----- Church of the Augustinians (Augustinerkirche)
AVAr	----- Archaeological Museum
AVAs	----- Aspern

AVB	----- Coll. Gustav Benda
AVBa	Vienna. Austrian Baroque Museum (Osterreichische Galerie. Barokmuseum) (AVO)
AVBe	----- Belvedere Palace
AVC	----- Capuchin Church (See also AVKa)
AVD	----- Daun-Kinsky Palace
AVE	----- Coll. Este
AVEu	----- Prinz Eugen Stadtpalais
AVEv	----- Evangelical Church
AVG	----- Graben
AVH	----- Hofmuseum
AVHa	----- Coll. Counts Harrach
AVHof	----- Hofburg
AVI	----- Austrian Ministry of the Interior
AVJ	----- Josefplatz
AVK	----- Kunsthistorishes Museum
AVKa	----- Kapuzinerkirche (See also AVC)
AVL	----- Furstlich Lichtensteinsche Gemaldegalerie
AVM	----- Museum of Fine Arts
AVMH	----- Municipal Hall
AVMa	----- Karl Marx Hof
AVMe	----- Mehlmarkt
AVN	----- New Market
AVNM	----- Naturhistorisches Museum
AVNeP	----- Neustadt Parish Church
AVO	----- Osterreichische Galerie (AVBa)
AVOA	----- Osterreichisches Museum fur angewandte Kunst
AVOG	----- Osterreichisches Gesellschafts- und Wirtschafts-Museum
AVOI	----- Austrian Museum for Art and Industry
AVS	----- St. Stephen's Cathedral (See also AVSt)
AVSc	Vienna. Schwarzenberg Garden
AVSch	----- Schatzkammer
AVSt	----- Stephansdom (See also AVS)
AVT	----- Museum of the Twentieth Century (Museum des 20. Jahrhunderts)
AVU	----- Upper Belvedere
AVV	----- Museum fur Volkerkunde
AVVC	----- Vienna County-Council Tenements
AVW	----- Woodworkers' School
AVWi	----- Residence, corner of Wildbretmarkt and Brandstatte
AWG	Wiener Neustadt. St. George

Afghanistan

AfB	Bamian. Bamian Museum
AfKM	Kabul. Kabul Museum
AfT	Tashkurghan

Algeria

AlAL	Algiers. Coll. R. Lopez
AlAMB	----- Musee National des Beaux-Arts
AlCA	Cherchel. Musee Archeologique
AlDM	Djemila. Musee Archeologique
AlG	El Greiribat (site)
AlOM	Oran. Oran Museum (Musee Municipal DeMaeght)
AlTW	Tassili. Wadi Djerat
AlTi	Timgad. Musee Archeologique

Argentina

ArBNB	Buenos Aires. Museo Nacional de Bellas Artes
ArBT	----- Museo Instituto Torcuata di Tella
ArJ	Jujuy

Australia

AuAH	Adelaide. Coll. Mr. and Mrs. E. W. Hayward
AuANG	----- National Gallery of South Australia
AuBA	Brisbane. Queensland Art Gallery (Brisbane Gallery)
AuBJ	----- Coll. Mr. and Mrs. Brian Johnstone
AuBT	----- Town Hall
AuMA	Melbourne. Coll. D. L. Adam
AuMB	----- B'nai Israel Temple
AuMC	----- Coll. Dr. P. H. Cook
AuMCu	----- Coll. Peter Cullin
AuMGV	----- National Gallery of Victoria
AuMMV	----- National Museum of Victoria
AuMU	----- University of Melbourne
AuMV	----- Victoria Gallery of Art
AuMMo	----- Museum of Modern Art of Australia
AuPW	Perth. Art Gallery of Western Australia
AuSAu	Sidney. Australian Museum
AuSC	----- Commonwealth Bank of Australia
AuSF	----- New South Wales Forest Commission
AuSH	----- Morning Herald Office
AuSM	----- St. Mary's Basilica
AuSN	----- Art Gallery of New South Wales
AuSS	----- Coll. Ronald Steuart
AuST	----- Coll. Tony and Margaret Tuckson

Belgium

-BQE	Coll. Queen Elizabeth of Belgium
BA	Antwerp. Koninklijk Museum voor Schone Kunsten--Musee Royal des Beaux-Arts (See also BAR
BAA	----- St. Andrew's Church
BAB	----- Museum Mayer van den Bergh
BAC	----- Cathedral
BAG	----- Grand Palace
BAH	----- Hessenhuis
BAHe	----- Coll. Jan van Herck
BAJ	----- Coll. J. Janssen
BAKE	----- Kunsthistorische Musea der Stad Antwerpen--Musee d'Histoire del'Art de la Ville d'Anvers. Etnografisch Museum-- Musee d'Ethnographie
BAKO	----- Openluchtmuseum voor Beeldhouwkunst Middelheim--Musee de Sculpture en plain air Middelheim (BAM)
BAM	----- Middelheim (BAKO)
BAMu	----- Museum
BAO	----- Oplinter
BAP	----- St. Pauluskerk
BAR	----- Musee Royal des Beaux-Arts (See also BA)
BARo	----- Coll. Max Rooses
BAT	----- Hotel de Ville
BAndCh	Anderlecht. Church
BBA	Brussels. Musees des Arts Decoratifs
BBAr	----- Coll. Maurice d'Arquian
BBB	----- Banque Nationale
BBBo	----- Botanical Garden
BBC	----- Cathedral St. Gudule (See also BBGu)
BBCi	----- Musee et Parc de Cinquantenaire (See also BBRA)
BBCo	----- Galerie Cogeime
BBD	----- Coll. Philippe Dotremont
BBG	----- Coll. B. Goldschmidt
BBGr	----- Coll. E. Graeffe
BBGu	----- Ste Gudule (See also BBC)
BBH	----- Musee de la Porte de Hal
BBHV	----- Town Hall
BBHo	----- Coll. Baron Horta
BBJ	----- Palais de Justice
BBL	----- Coll. Baroness Lambert
BBLa	----- Banque Lambert
BBLo	----- Lombeek Notre Dame

BBLou	----- Avenue Louise
BBM	----- Musee Constantin Meunier
BBMG	----- Convent Church of St. Michael and St. Gudula
BBMa	----- Maison du Peuple
BBMu	----- Museum
BBN	----- Notre Dame de la Chapelle
BBNi	----- Coll. Peers and Nieuberg
BBP	----- House of Parliament
BBR	----- Musees Royaux des Beaux-Arts de Belguique
BBRA	----- Musees Royaux d'Art et d'Histoire (See also BBCi)
BBRP	----- Royal Palace
BBS	----- Coll. Jacques Stoclet; Coll. Adolphe Stoclet
BBTa	----- Tassel House, 12, rue de Turin
BBU	----- Coll. M. T. Ullens de Schooten
BBV	----- Musee Communal de Bruxelles
BBVe	----- Coll. Vernanneman
BBW	----- Coll. Withof
BBWit	----- L. Wittamer-De Camps Residence
BBa	Bastogne
BBo	Boom
BBrB	Bruges. Belfry
BBrC	----- Musee d'Eglise Notre Dame--Museum van de O. L. Vrouwkerk (See also BBrN)
BBrG	----- Gruuthusemuseum--Musee Communal Archeologique et d'Art Applique
BBrJ	----- Musee du Palais de Justice--Museum van het Gerechtshof
BBrJe	----- Musee de l'Hospital St. Jean
BBrJer	----- Church of Jerusalem
BBrN	----- Church of Our Lady (See also BBrC)
BBrO	----- Musea van de Commissie van Openbare Ondestand--Musees de l'Assistance Publique
BBrS	----- St. Salvator Church
BBrSa	----- Saint-Sauveur Cathedral
BBrSt	----- Stadhuis--Hotel de Ville
BBra	Brabant (Gaasbeek)
BCouH	Courtrai. Coll. T. Herbert
BCouN	----- Notre Dame
BDA	Dilbeek. St. Ambrose Church
BDiN	Diksmuiden. St. Nicolas
BDieS	Diest. St. Sulpitius Church
BES	Essen, near Dismuiden. Soldiers' Graveyard
BEtG	Etterbeek. St. Gertrude Church

BF	Friedhof in Essen
BFuSt	Furnes/Veurne. Museum of the City Hall
BGA	Ghent. Museum of Antiquities
BGB	----- Belfry
BGBa	----- St. Bavon Cathedral (See also BGC)
BGC	----- Abbaye de St.-Bavon (See also BGBa)
BGM	----- Coll. Baron Minne
BGMO	----- Museum voor Oudheden der Bijloke
BGMS	----- Museum voor Schone Kunsten
BGeD	Geel. St. Dimphna Church
BGo	Goesen
BHN	Huy (Liege). Notre Dame
BHaM	Hal. St. Martin
BHaN	----- Notre Dame
BHakS	Hakendover. St. Sauveur Church
BHasC	Hasselt. Church of the Recollects
BHasN	----- Notre Dame
BI	Ixelles
BKH	Kontich. Coll. Rev. Josse van Herck
BL B	Liege. St. Barthelemy Church
BLC	----- St. Paul Cathedral
BLCr	----- St. Croix
BLCu	----- Musee Curtius
BLG	----- Coll. Fernand C. Graindorge
BLJ	----- St. Jacques
BLL	----- Musee d'Archeologie et des Arts Decoratifs de la Ville de Liege
BLMB	----- Musee des Beaux-Arts
BLMD	----- Musee Diocesan
BLN	----- Notre Dame de St. Servais
BLeL	Leau. St. Leonard
BLiG	Lierre. St. Gommarius
BLo	Lombeek
BLouC	Louvain. Musee d'Art Chretien de l'Universite Catholique
BLouJ	----- St. Jacques Church
BLouN	----- Notre Dame Hors la Ville
BLouP	----- Collegiate Church of St. Pierre
BMC	Mechelen (Malines). Cathedral
BMJ	----- St. Jean
BMO	----- Onze Lieve Vrouwe van Hanswijk
BMP	----- Church of St. Peter and St. Paul
BMR	----- St. Rombout
BMoB	Mons. Boussu-lez-Mons
BMoW	----- Ste. Waudru
BMoWa	----- St. Waltrudis
BNG	Nivelles. Shrine of St. Gertrude
BNN	----- St. Nivelles

BNaM	Namur. Museum
BNaP	----- Pont des Ardennes
BOW	Overijse. Coll. Mme. de Carniere-Wouters
BOsN	Ostende. Coll. Pierre Nolvic
BRoC	Le Roeulx. Coll. S. A. S. le Prince de Croy-Roeuls
BSV	Soignes. St. Vincent
BTC	Tervueren. Koninklijk Museum voor Midden-Afrika--Musee Royal de l'Afrique centrale (formerly: Musee Royal du Congo Belge)
BTiG	Tirlemont. St. Germain
BToN	Tongren. Collegiate Church of Notre Dame
BTouC	Tournai. Tournai Cathedral of Notre Dame; Treasury
BTouM	----- Museum
BTouMad	----- St. Marie Madeleine
BVCh	Vise. Church
BWi	Wildern
BZ	Zuerbempde

<div align="center">Bolivia</div>

BoLA	La Paz. Museo al Aire Libre
BoLB	----- Coll. Fritz Buck
BoP	Pakotia, Lake Titicaca Basin
BoPoL	Potosi. San Lorenzo Church
BoT	Tiahuanaco

<div align="center">Brazil</div>

BrBA	Brasilia. Alvariadi Palace
BrBP	----- President's Palace
BrBaD	Bahia. Desterro Convent
BrCJ	Congonhas de Campo. Church of the Good Jesus (Shrine of Bom Jesus de Matozinhos) (See also BrMJ)
BrMI	Minas Gerais (Ouru Preto). Museu de Inconfidencia
BrMJ	----- Bom Jesus (See also BrCJ)
BrNL	Niteroi. Sao Lorenzo de los Indios
BrOF	Ouro Preto. Sao Francisco
BrObM	Obidos. Santa Maria
BrREd	Rio de Janeiro. Ministry of Education Building
BrRF	----- Convent of St. Francis
BrRI	----- Itamarati Palace, Foreign Ministry
BrRMo	----- Museu do Arte Moderna do Rio de Janeiro
BrRN	----- Museu Nacional des Bellas Artes
BrRS	----- Coll. Don C. da Silva-Negra

BrSan	Santos
BrSpA	Sao Paulo. Museu de Arte
BrSpC	----- Museu de Curia Metropolitiana
BrSpE	----- Emboi Church
BrSpL	----- Biblioteca Municipal
BrSpM	----- Museu de Arte Moderna de Sao Paulo
BrSpMo	----- Coll. Renoldo Motta
BrSpP	----- Prado House

Burma
BuMn	Myinpagan. Nanpaya Temple
BuPA	Pagan. Ananda Temple
BuPM	----- Archaeological Museum
BuW	Wet-Kyi-in Ku-Byauk-Kyi

Bulgaria
BulPW	Plowdim (Plovdiv). Archaeological Museum
BulSA	Sofia. Archaeological Museum
BulSJ	----- Court of Justice
BulSN	----- National Gallery of Art

Canada
-CL	Laing Galleries
-CN	Coll. C. S. Noxon
-CZ	Coll. Mr. and Mrs. Sam Zacks
CBG	British Columbia Government
CBlS	Blackburn Corners. Public School
CCT	Caughnawaga, Quebec. Tekakwitha Indian School
CHBN	Halifax. Bank of Nova Scotia
CLA	Lorette (Jeune-Lorette). Fabrique de Saint-Ambrose
CLH	----- Chapelle Huronne
CMB	Montreal. Coll. Mr. and Mrs. Peter Bonfman
CMBi	----- Coll. Henry Birks
CMC	----- Museum of Contemporary Art
CMD	----- Dominion Gallery
CMFA	----- Museum of Fine Arts
CMH	----- Hotel-Dieu
CML	----- Coll. Suzie and Nandor Loewenheim
CMN	----- National Bank of Canada
COB	Ottawa. Coll. Dr. Marius Barbeau
COD	----- Dominion Archives
COK	----- Coll. Yousuf Karsh
CON	----- National Gallery of Canada
CONM	----- National Museum of Canada
COP	----- Parliament Building
COR	Royal Ontario Museum of Art (See also CTRO)

COrF	Ile d'Orleans. La Fabrique de la Paroisse de Sainte-Famille
CQA	Quebec. Archeveche de Quebec
CQAr	----- Archives of Quebec
CQH	----- Hotel Dieu
CQL	----- Legislative Building (See also CQPa)
CQMA	----- Musee de l'Institut des Arts Appliques du Quebec
CQN	----- Fabrique de la Paroisse Notre Dame
CQP	----- Musee de la Province de Quebec
CQPa	----- Parliament House (See also CQL)
CQU	----- Ursuline Convent
CTA	Toronto. Art Gallery of Toronto
CTC	----- Coll. Mr. and Mrs. Walter Carsen
CTD	----- Coll. Mrs. Florence Dorsey
CTH	----- Hirschhorn Coll.
CTI	----- Isaacs Gallery
CTO	----- Art Gallery of Ontario
CTQ	----- Queen's Park
CTQE	----- Queen Elizabeth Way
CTR	----- Roberts Gallery
CTRO	----- Royal Ontario Museum
CTROA	----- Royal Ontario Museum of Archaeology
CTS	----- Coll. Mr. and Mrs. Peter A. Silverman
CTW	----- Coll. Mr. and Mrs. Percy Waxer
CVP	Victoria. Provincial Museum of Natural History and Anthropology
CVT	----- Thunderbird Park
CVaA	Vancouver. Vancouver Art Gallery
CVaR	----- Coll. Mr. and Mrs. Francis Reif
CVauM	Vaudreuil. St. Michel
CWH	Winnipeg. Hudson's Bay Company
CWM	----- Coll. J. A. MacAulay
CWP	----- House of Parliament

Cambodia

CaA	Temple of Angkor Wat
CaAB	Angkor. Bakong
CaABS	Angkor Wat. Banteay Srei
CaABaT	Angkor. Baphouon. Angkor Thom
CaABayT	----- Bayon. Angkor Thom
CaAC	Angkor Wat. Dept Archeologique de la Conservation d'Angkor (See also CaSA)
CaAP	----- Prasat Kravanh
CaAT	Angkor. Angkor Thom
CaBan	Banteay Srei
CaBatV	Battambang. Museum of Vat Po Veal

CaK	Koulen
CaPN	Phnom Penh. Musee National Vithei Ang Eng
CaPR	----- Royal Palace
CaPS	----- Musee Albert Sarraut
CaSA	Seimreap. Conservation des Monuments d'Angkor (See also CaAc)

Cameroon

CamAd	Coll. Albert G. Adams, Presbyterian Mission

Ceylon

CeA	Anuradhapura
CeAI	----- Isurumuniya Vihara
CeCNM	Colombo. Colombo National Museum
CeDM	Dedigama. Museum
CeKC	Kandy. Coll. A. R. Casse
CeKD	----- Coll. Dambevinne Family
CeKNM	----- Coll. National Museum
CeN	Nikawewa
CeP	Polonnaruva
CePG	----- Gal Vihara

China

-ChA	Formerly Academia Sinica, Nanking. Now -ChG
-ChG	Coll. The Chinese Government
ChAW	Anyang. Great Tomb at Wu-Kuan-ts'un
ChCC	Chufou, Shantung. Temple of Confucius
ChCha	Chang-ping-chou (ChPekT)
ChH	Hopei
ChHa	Hangchou
ChKM	Kansu. Mai-Chi-Shan Cave Shrine
ChKP	----- P'ing-ling Ssu Caves
ChKa	Kara-Shahr
ChL	Lung-men (Dragon Gate), Pin-yang Cave Temple
ChLL	Liu Li Ko
ChM	Mai-chi-shan Cave Temple
ChN	Nanking
ChPC	Peiping (Peking). Temple of Confucius
ChPekI	Peking. Imperial Palace
ChPek P	----- Peking Museum
ChPekT	----- Ming Tombs
ChSheH	Shensi Province. Tomb of General Ho Chu'u-p'ing
ChShK	----- Tomb of Emperor Kao-tsung
ChShaT	Shansi. T'ien-lung Shan Caves
ChShaY	----- Yun Kang (Cloud Hill) Cave Temples

ChShanT	Shantung. Tomb of Wu Liang Tzu
ChSzC	Szechwan. Ch'u-hsien
ChSzY	----- Ya-chou
ChT	Tun-huang (Caves of the Thousand Buddhas), Chinese Turkestan
ChTaA	Taihoku (formerly: Taipeh). Academia Sinica. Now: Ch-RTAS
ChTaP	Taipei, Taiwan. National Palace Museum and National Central Museum
ChTi	T'ien-Lung-Shan (Heavenly Dragon Mountain)
ChYK	Yun-Kang Caves
ChYM	Yn Men Shan, Shantung
Ch-RTAS	Taipei, Taiwan. Academia Sinica

Chile

ChiE	Easter Island
ChiGC	Graneros. Capilla de la Compania
ChiSC	Santiago
ChiSM	----- Coll. Norbert Mayrock
ChiSMH	----- Museo Nacional de Historia Natural
ChiSMN	----- Museo Nacional de Bellas Artes

Costa Rica

CoSB	San Jose. Banco Central de Costa Rica
CoSBal	----- Coll. Charles Balser
CoSN	----- Museo Nacional de Costa Rica

Colombia

ColBF	Bogota. San Francisco
ColBM	----- Museo Nacional
ColBO	----- Museo del Oro, Banco de la Republica
ColBR	----- Coll. Ruiz-Randall
ColCC	Cartagena. Cathedral
ColCD	----- Santo Domingo Church
ColCI	----- House of the Inquisition
ColCP	----- San Pedro Claver
ColCT	----- Santo Toribio de Mogrovejo
ColPF	Popayan. San Francisco
ColS	San Agustin, Upper River Magdalena
ColSM	----- Museo del Parque Arqueologico
ColTC	Tunja. Cathedral Nuestra Senora de Guadalupe
ColTD	----- Santo Domingo
ColTV	----- Casa Vargas

Congo

ConLM	Leopoldville. Musee de la Vie Indigene

<center>Cyprus</center>

CyNA	Nicosia. Museum of Antiquities
CyNC	----- Cypress Museum

<center>Czechoslovakia</center>

CzBM	Brno. Brno Museum
CzBMM	----- Moravske Museum
CzBV	----- Vegetable Market
CzBeC	Benesov. Collegiate Church
CzBeK	Benesov. Konopiste Castle
CzBes	Bestvinna
CzBiO	Bila Hora, near Prague. Church of Our Lady
CzBrCE	Bratislava (Formerly--1939-1945--GPr). Cathedral Chapel of St. Elemosynarius
CzBrN	----- Slovenske Narodne Muzeum
CzBro	Broumov
CzBu	Bucovice
CzC	Cerveny Hradek
CzCeZ	Ceske Budejovice. Zizka Square
CzCh	Chrudin
CzChl	Chloumek
CzCit	Citoliby
CzD	Decin
CzDo	Dolni Brezany
CzDoU	Dolni Ujezd
CzDu	Duchov
CzGC	Grussau. Cloister Church
CzH	Hradec Kralove (Koniggratz)
CzHl	Hlavenec
CzHo	Horin
CzJ	Jaromer
CzKB	Kuks (Kukus). Bethlehem Wood
CzKH	----- Hospital Church
CzKa	Karlovy Vary
CzKoL	Kosmonosy. Loretto Church
CzKon	Konopiste
CzKosE	Kosice. St. Elizabeth
CzKu	Kutna Hora
CzLi	Libechov
CzLn	Lnare. Castle
CzLoN	Louny. St. Nicholas Church
CzLyE	Lysa nad Labem. Eremitage
CzM	Manetin
CzMo	Moravska Trebova
CzN	Novy Bydsor (Novy Bydzov)
CzNa	Na Cihadle, near Lysa nad Labem
CzNoK	Nove Mesto nad Metuji. Kuks Castle

CzO	Omomouc
CzOp	Opocno
CzOsC	Osek. Cloister Church
CzPA	Prague. Arts and Crafts Museum
CzPAA	----- Archaeological Institute, Czechoslovak Academy of Sciences
CzPB	----- Brevnov
CzPC	----- Clam-Gallas Palace
CzPCS	----- Commercial School
CzPCa	----- St. Catherine Church
CzPCh	----- Charles Bridge
CzPChC	----- St. Charles Church
CzPCl	----- St. Clement's Church
CzPG	----- "The Golden Well"
CzPGa	----- St. Gallus Church
CzPH	----- Hradjin Palace
CzPHC	----- Hradcany Castle
CzPHS	----- Hradcany Square
CzPHo	----- Hopfenstoku
CzPJ	----- St. James Church
CzPJo	----- St. Joseph Church
CzPK	----- Kolovrat Palace
CzPKn	----- Knights of the Cross Church
CzPKr	----- Kreuzherrenkirche
CzPL	----- Little Quarter Square
CzPLo	----- Loretto Church
CzPM	----- Modern Gallery
CzPMo	----- Morzin Palace
CzPMol	----- Moldau Bridge
CzPN	----- National Gallery (Narodni Galerie)
CzPNM	----- National Museum (Narodni Muzeum)
CzPNML	----- National Museum Lapidarium (Lapidarium Narodniho Muzea)
CzPNe	----- New Town
CzPNi	----- St. Nicholas Church
CzPO	----- Olsany
CzPOu	----- Church of Our Lady
CzPOuN	----- Our Lady's Church Na Karlove
CzPP	----- Prague National Museum (Muzeum Hlavniho Mesta Prahy)
CzPS	----- St. Salvator's Church
CzPT	----- Palais Thun-Hohenstein
CzPTh	----- St. Thomas Church in the Little Quarter
CzPTo	----- Town Hall
CzPTr	----- Troja Chateau
CzPTy	----- Tyn Church
CzPV	----- St. Vitus Cathedral

CzPVr	Prague. Vrtba Palace
CzPVy	----- Vysehade Cemetery
CzPW	----- Wallenstein (Waldstein) Palace
CzPa	Pardubice
CzPi	Pisek
CzPlA	Plzen. Arts and Crafts Museum
CzPlB	----- Church of St. Bartholomew
CzPla	Plasy Church
CzPo	Pocatky
CzPolC	Policka. Collegiate Church
CzPrH	Pribram (near). Holy Mountain
CzR	Radic (near Sedlcany)
CzSC	Sloup. Sloup Castle
CzSm	Smirice
CzStC	Stara Boleslav. Chapter House
CzT	Teplice-Sanov
CzUh	Uherski Hradiste
CzV	(Vales
CzVa	(Valec
CzZ	Zirec
CzZd	Zdar
CzZe	Zelena hora
CzZi	Zirovec
CzZir	Zirec
CzZnB	Znojmo. Black Friar's Church

Denmark

DAA	Aarhus. Aarhus Kunstmuseum
DAF	----- Prehistoric Museum (Forhistorisk Museum)
DAK	----- Old Town Museum (Kobstadtmuseet)
DAR	----- Railway Station
DAlH	Aalborg. Aalborg Historiske Museum
DCA	Copenhagen. Amalienborg Square
DCB	----- Galerie Birch
DCBl	----- Coll. Alice Bloch
DCCF	----- Carlsberg Foundation
DCF	----- Frederiksberg Court House
DCH	----- Hirschsprung Coll.
DCJ	----- Coll. Jacobsen
DCJo	----- Coll. Elise Johanson
DCJu	----- Coll. Finn Juhl
DCK	----- Danske Kunstindustrimuseum
DCKA	----- Royal Academy of Fine Arts (Kunstakademiet)
DCN	----- Ny-Carlsberg Glyptotek
DCNM	----- National Museum

DCO	-----	Naval Museum (Orlogsmuseet)
DCOL	-----	Church of Our Lady
DCR	-----	Royal Copenhagen Porcelain Factory
DCRo	-----	Rosenborg Palace Royal Collection
DCSt	-----	Statens Museum for Kunst (Musee Royal des Beaux-Arts)
DCT	-----	Thorvaldsens Museum
DCTo	-----	Tojhusmuseet (Royal Arsenal Museum)
DFW		Frederikssund. J. F. Willumsens Museum
DFaM		Faaborg. Faaborg Museum
DFr		Fredericksberg
DHeK		Helsingor (Elsinore). Kronborg Slot
DHer		Herfursholm Abbey
DHiNF		Hillerod. National historike Museum pa Frederiksborg
DHjoV		Hjorring. Vendsyssels historiske Museum
DHuL		Humleback. Louisiana Museum
DJJ		Jutland. Jelling Church
DML		Maribo. Lolland-Falsters Stiftsmuseum
DOK		Odense. St. Knud Church
DOr		Ordrup
DRM		Ring Kobing. Ringkobing Museum
DRosC		Roskilde. Roskilde Cathedral
DRosM	-----	Roskilde Museum
DRuH		Rudkobing. Rudkobing historiske Museum
DS		Sondermark
DVJ		Vejen. Kunstmuseum (Hansen Jakobsen-Museet)
DVoL		Vordingborg. South Zealand Museum

England

-EB	Coll. Sir Alfred Bossom
-EBa	Coll. T. J. Barnes
-EBar	Coll. Sir Alan and Lady Barlow
-EBl	Coll. Mrs. Blundell-Ince
-EBo	Coll. Muirhead Bone (ELBo)
-EC	Coll. Mrs. M. Copner
-ECo	Coll. Colonel Norman Colville
-ECoo	Coll. M. E. Cooke
-ECr	Coll. Earl of Craven
-ED	Coll. Douglas Duncan
-EDa	Coll. Alex Davidson
-EEd	Coll. E. S. Ede
-EEp	Coll. Sir Jacob Epstein
-EEv	Coll. W. A. Evill
-EF	Coll. Elizabeth Onslow Ford (See also -EO)
-EGr	Coll. E. C. Gregory (ELGre)
-EH	Coll. Ashley Havinden

-EHe	Coll. John Heaton
-EHea	Coll. Adrian Heath
-EHo	Coll. L. Hore Belisha
-EHu	Coll. Blair Hughes-Stanton
-EI	Coll. Sir Giles Isham (ENorI)
-EJ	Coll. Patrick Johnston
-EK	Coll. Mrs. S. Kaye
-EKe	Coll. C. S. Kearley
-EKel	Coll. Kelvingrove
-ELa	Coll. Sir J. Lavery
-ELi	Coll. Viscount de L'Isle
-EM	Coll. Henry Moore
-EMa	Coll. Gavin Maxwell
-EMac	Coll. Lord Mackintosh of Halifax
-EMacd	Coll. Duncan Macdonald
-EMo	Coll. Mrs. Henry Moore
-EMoo	Coll. Mrs. Irina Moore
-EMor	Coll. Canon Mortlock
-EMu	Coll. Earl of Munster
-EN	Coll. Duke of Norfolk
-EO	Coll. Miss Elizabeth Onslow-Ford (See also -EF)
-EPe	Coll. Petworth
-EPol	Coll. Sir Montagu Pollock
-EPri	Coll. R. C. Pritchard
-ER	Coll. Earl of Roseberry
-ERed	Coll. C. S. Reddihough, and Margaret Gardiner (EIlkR)
-ERh	Coll. Richard Rhys
-ERi	Coll. Howard Ricketts
-ERu	Coll. Charles L. Rutherston
-ESa	Coll. Mrs. Philip Samuel
-ESan	Coll. Earl of Sandwich
-ESy	Coll. Mrs. H. Synge-Hutchinson
-ET	Coll. D. Talbot-Rice
-EW	Coll. Hon. Lady Ward
-EWa	Coll. Hugh Walpole
-EWe	Coll. Rebecca West
-EWed	Coll. Tom Wedgwood
-EWi	Coll. Mr. F. M. S. Winand
-EWy	Coll. John Wyndham (EPetL)
-EY	Coll. F. R. S. Yorke
EA	Coll. Arts Council of Great Britain (See also ELBrC)
EAb	Abergavenny
EAbb	Abbots Langley, Herts
EAbbot	Abbotsford House. Melrose. Coll. Mrs. Maxwell-Scott (EPL)

EAbe	Aberlady
EAbiH	Abingdon, Berks. St. Helen's
EAc	Acton Church, Suffolk
EAl	Aldworth Church (near Oxford)
EAlp	Alpington, Devon
EAs	Ashbourne Church, Derbys
EAsh	Ashburnham, Sussex
EAshd	Ashdown Forest, Sussex. Children's Settlement
EAth	Atherington, Devon
EAy	Ayston Hall, Rutland. Coll. G. S. Finch
EB	Birmingham. City Museum and Art Gallery
EBB	----- Barber Institute of Fine Arts, University of Birmingham
EBS	Coll. Mrs. Gisela Berthold-Sames
EBad	Badminton House, Glos
EBal	Balderton. St. Giles
EBan	Banwell, Som
EBar	Barfreston, Kent
EBarl	Barlaston. Wedgwood Museum
EBarn	Barnsely Park, Glos
EBarna	Barnack Church
EBarns	Barnstaple, Devon
EBas	Baskingstoke, Hants. The Hyne
EBathA	Bath Abbey
EBe	Bewcastle
EBed	Coll. Duke of Bedford
EBelM	Belgravia. Midland Bank
EBelt	Belton, Lincs
EBer	Berry Pomeroy
EBerkB	Berkshire, Burghfield
EBev	Beverley Minster
EBex	Bexhill
EBi	Bisham, Berks
EBib	Bibury
EBisG	Bishopsgate. Great St. Helen's
EBish	Bishopsteignton
EBishop	Bishopstone
EBl	Bletchingly, Surrey (See also ESurB)
EBle	Blenheim Palace
EBlox	Bloxham, Oxon
EBly	Blyth, Notts
EBo	Bottesford (ELeiB)
EBod	Bodmin, Cornwall
EBosB	Boston. St. Botolphs Church
EBou	Boughton-under-Blean, Kent (EKenB)
EBow	Bowden
EBox	Boxgrove, Sussex

EBrCh	Brent Knoll. Parish Church
EBraL	Bradford on Avon. St. Lawrence
EBradC	Bradford, Yorks. City Art Gallery and Museums
EBraug	Braughing, Herts
EBreE	Brent Eleigh, Suffolk
EBrea	Breamore
EBree	Breedon-on-the-Hill, Leics. St. Mary's
EBriA	Bristol. St. Augustine's
EBriBA	----- City Art Gallery
EBriC	----- Cathedral
EBriL	----- Lord Mayor's Chapel
EBriM	----- St. Mark's Church
EBriMu	----- City Museum
EBriQ	----- Queen Square
EBriS	----- St. Stephen's
EBrid	Bridlington Priory
EBrigA	Brighton. Art Gallery and Museum
EBright	Brightlinsea, Essex
EBrin	Brinsop
EBro	Brocklesby Park, Lincs
EBrom	Brompton-in-Allerton
EBrook	Brookland, Kent
EBru	Bruera, Cheshire
EBu	Bushey Park, Middlesex
EBuC	Buckland Newton, Dorset
EBuckA	Buckinghamshire. Amersham Church
EBuckAy	----- Aylesbury
EBuckC	----- Claydon House
EBuckG	----- Great Hampden
EBuckH	----- Hambledon
EBuckW	----- West
EBul	Bulkington, Warwicks
ECC	Chichester. Cathedral
ECaC	Canterbury. Canterbury Cathedral
ECaK	----- King's School
ECamC	Cambridge. Christ's College
ECamCo	----- Conington
ECamF	----- Fitzwilliam Museum
ECamJ	----- Jesus College
ECamK	----- King's College
ECamKC	----- King's College Chapel
ECamT	----- Trinity College
ECamUA	----- Cambridge University. Museum of Archaeology and Ethnology
ECar	Cardington, Beds
ECas	Castor
EChA	Cheltenham. Cheltenham Art Gallery

EChW	Cheltenham. Coll. Hugo van Wadenoyen
ECha	Chatsworth, Derby. Coll. Dukes of Devonshire
EChar	Chartham, Kent
ECharn	Charney Bassett
EChe	Chenies, Bucks
EChec	Checkendon, Oxon
EChesC	Chester. Cathedral
EChesCh	----- Chapter House
EChev	Chevening, Kent
EChi	Chillington Hall, Staff. Coll. Mrs. T. Gifford
EChic	Chichester Cathedral
EChr	Christchurch Prior, Hants (See also EHaC)
EChri	Christhall, Essex
ECiI	Circencester. Coll. Ingram
ECiM	----- Museum
ECl	Clandon Park, Surrey
ECla	Clacton-on-Sea
ECleN	Clerkenwell. New River Office
EClif	Cliffe Pypard, Wilts
ECo	Corhampton. Corhampton Church
ECod	Codford. St. Peter
ECol	Colerne
EColl	Collingham
ECom	Compton Place, Eastbourne, Sussex
ECon	Conington (ECamCo)
ECorL	Cornwall. Landrake
ECovC	Coventry. Cathedral
ECovG	----- Guildhall
ECr	Croft Castle, Herts
ECra	Cranford, Middlesex
ECro	Crofts, York
ECroom	Croome D'Abitot, Worcs
ECu	Cuckfield, Sussex
EDF	Dorset. Forde Abbey
EDH	----- Coll. John Hubbard
EDM	----- Coll. Melbury Samford
EDMap	----- Mapperton
EDS	----- Sherborne Abbey (ESh)
EDW	----- Whitchurch Canonicorum
EDWe	----- West Chelborough
EDag	Daglingworth Church
EDar	Darley Dale
EDeD	South Devonshire. Dartington Hall
EDee	Deerhurst
EDeer	----- Deerhurst Church
EDen	Denton, Lincs

EDerH	Derbyshire. Hardwick New Hall
EDerN	----- Norbury Church
EDi	Dinton
EDoA	Dorchester. Dorchester Abbey
EDoM	----- Dorset County Museum
EDown	Downside Abbey
EDr	Drayton Beauchamp, Bucks
EDuUO	Durham. University of Durham. Oriental Museum
EDurO	----- Cathedral
EDurCL	----- Cathedral Library
EDurCaC	----- Castle Chapel
EEC	Ely. Cathedral
EEQ	Coll. Her Majesty the Queen
EEa	Easton Neston, Norths (ENorthE)
EEar	Eardisley, Herts (See also EHereE)
EEas	East Barsham, Norfolk
EEd	Edenham, Lincs
EEl	Eltham
EElm	Elmley Castle, Worcs (ENorfE)
EEls	Elsing, Norfolk
EElstA	Elstree. A. T. V. House
EEsA	Essex. Audley End
EEsC	----- Clavering
EEsG	----- Great Maplestead
EEsL	----- Little Easton
EEsLM	----- Layer Marney
EEsN	----- North Ockendon
EEsRE	----- Romford. St. Edward the Confessor
EEsS	----- Stanstead Mountfitchet
EEw	Ewelme, Oxon (EOxfE)
EExC	Exeter. Cathedral
EExP	----- St. Petrock's Church
EExt	Exton, Rutland (ERutE)
EEy	Eyam
EF	Fyfield, Berks
EFaP	Farnham. Pitt-River Museum
EFai	Fairford
EFaw	Fawsley, Northants
EFl	Fletton Church
EFo	Fownhope
EFr	Framlingham, Suffolk
EFro	Castle Frome (See also EHereF)
EFuA	Fulham. All Saints
EGC	Gloucester. Gloucester Cathedral
EGGM	----- City Museum
EGM	----- St. Mary-le-Crypt
EGlI	Gloucestershire. Iron Acton

E GlNS	Gloucestershire. Northwick Park. Coll. E. G. (George) Spencer-Churchill
E GlNe	----- Newland
E GlSa	----- Sandhurst
E GlSc	----- South Cerney
E GlSo	----- Southrop
E GlT	----- Twyning
E GoP	Godalming. Phillips Memorial Cloister
E Good	Goodwood, Sussex
E Gos	Gosforth, Cumberland
E Gosf	Gosfield, Essex
E Gr	Great Warley, Essex
E Gro	Groombridge, Kent
E GrtB	Great Bookham, Surrey
E GuU	Gullane. United Free Church
E GuiT	Guildford. Holy Trinity
EHC	Hereford. Hereford Cathedral
EHG	Hertfordshire. Gorhambury
EHR	----- Ross-on-Wye
EHS	Herefordshire. Shobden Church
EHaC	Hants. Christchurch Priory (See also E Chr)
EHaf	Hafod Church, South Wales (Destroyed by fire, 1932)
EHalA	Halifax. All Souls
EHall	Halland, Sussex
EHam	Hampton Court Palace, Middlesex
EHampSW	Hampshire. Stratfield Saye House. Coll. Duke of Wellington
EHan	Handsworth
EHareM	Harewood, Yorks. St. Mary's
EHas	Haselmere, Surrey
EHatCh	Hatfield, Hertfordshire. Parish Church (EHeH; EMiddH)
EHatT	Hatfield Technical College
EHeH	Hertfordshire. Hatfield House (EHatch)
EHeO	----- Great Offley Church (EOf)
EHeT	----- Tring
EHea	Headbourne Worthy
EHem	Hempstead (ELAn)
EHerC	Hereford. (See also EHC)
EHer F	----- Castle Frome (See also E Fro; EHere F)
EHereC	Hertfordshire. City Council (EHatT)
EHereCl	Herefordshire. Clifford
EHereE	----- Eardisley (See also ELeo)
EHere F	----- Castle Frome (See also E Fro; EHer F)
EHereH	----- Hadam
EHereK	----- Kilpeck
EHereL	----- Leominster (See also ELeo)

EHereLu	----- Ledbury Church
EHereM	----- Much Marcle
EHereS	----- Stretton Sugwas
EHerr	Herringston, Dorset
EHex	Hexham
EHey	Heysham
EHi	High Wycombe, Bucks
EHo	Holkham Hall, Norfolk. Coll. Earl of Leicester
EHoll	Hollingbourne, Kent
EHow	Castle Howard. Coll. George Howard
EHuM	Hull. Market Place
EHyC	Hythe, Kent. Saltwood Castle. Coll. Kenneth Clark
EHydA	Hyde Abbey
EI	Isleworth, Middlesex
EIl	Ilam, Staffs
EIlkR	Ilkley. Coll. C. S. Reddibough, and Mrs. M. Gardiner Bernal
EIn	Ingelsham
EIpM	Ipswich. The Museum
EJ	Jedburgh, Roxburghshire
EJell	Jellinge
EJev	Jevington
EK	Kilpeck Church
EKeM	Kelham, Notts. Society of the Sacred Mission
EKenB	Kent. Boughton-under-Blean
EKenBe	----- Bexley Heath, Red House
EKenBo	----- Borden
EKenC	----- Cobham
EKenCh	----- Chilham
EKenG	----- Goudhurst
EKenK	----- Knole
EKenL	----- Lynsted
EKiF	Kingston-upon-Hull. Ferens Art Gallery
EKilA	Kilburn. St. Augustine Church
EKinK	Kingston Hall. Coll. Mrs. Keller
EKing	Kingswinford
ELA	London, Coll. Miss Marion G. Anderson
ELAl	----- Albert Memorial
ELAll	----- All Saints Church (ELF)
ELAn	----- Church of St. Andrew Undershaft (EHem)
ELAnd	----- Coll. Colin Anderson
ELAs	----- Asylum Road, Old Kent Road
ELAst	----- Coll. David Astor
ELAth	----- The Athenaeum

ELB	London. Coll. Sidney Bernstein
ELBH	----- Broadcasting House
ELBM	----- British Medical Council Building
ELBP	----- Buckingham Palace
ELBR	----- British Rayon Centre
ELBa	----- Old Bailey
ELBag	----- Coll. Mr. and Mrs. Leon Bagrit
ELBan	----- Bank of England
ELBar	----- Coll. Mrs. C. Barclay
ELBarc	----- Coll. David Barclay Ltd
ELBat	----- Battersea Park
ELBe	----- Coll. Alexander Bernstein
ELBed	----- Coll. Richard Bedford
ELBetA	----- Bethnal Green Borough Council
ELBl	----- Bloomsbury Gallery
ELBo	----- Coll. Muriel Bone
ELBou	----- Bourdon House
ELBr	----- British Museum
ELBrC	----- Collection British Council (Arts Council of Great Britain) (See also EA)
ELBrH	----- Brittanic House
ELBrN	----- British Museum--Natural History Museum
ELBra	----- Coll. Erica Brausen
ELBri	----- Brixton Day College
ELBro	----- Brook Street Art Gallery
ELBru	----- Coll. R. Bruce
ELBu	----- Coll. Sidney Burney
ELBur	----- Burlington House
ELC	----- Coll. London County Council
ELCS	----- Cavendish Square (ELCon)
ELCa	----- Paul Cassirer Ltd
ELCh	----- Charterhouse
ELChar	----- Charing Cross
ELCheH	----- Chelsea Hospital
ELCiM	----- Mansion House, London City
ELCiS	----- School, London City (ELLoS)
ELCl	----- Coll. Kenneth Clark
ELCo	----- Coll. Samuel Courtauld
ELCoh	----- Coll. Dennis Cohen
ELCom	----- Commonwealth Relations Office
ELCon	----- Convent of the Holy Child, Cavendish Square (ELCS)
ELCont	----- Contemporary Art Society
ELCop	----- W. T. Copeland & Sons
ELCou	----- County Hall
ELCr	----- Coll. Honorable Lady Cripps
ELD	----- Drian Galleries

ELDH	London. Dorchester House
ELDL	----- Drury Lane Theatre
ELDT	----- Duchess Theatre
ELDa	----- Coll. Sir Percival and Lady David
ELE	----- Embankment Gardens
ELEp	----- Lady Epstein Collection
ELF	----- Fulham Parish Church (ELAll)
ELFH	----- Fishmongers' Hall
ELFa	----- Coll. William Fagg
ELFe	----- Festival of Britain
ELFr	----- Robert Fraser Gallery
ELFu	----- Coll. Capt. A. W. F. Fuller
ELG	----- Gimpel Fils; Coll. Peter Gimpel
ELGH	----- Guild Hall Art Gallery (ELIH)
ELGM	----- Guildhall Museum
ELGa	----- Gas, Light & Coke Co. Building, Kensington
ELGo	----- Coll. E. Goldfinger
ELGol	----- Coll. M. Goldman
ELGom	----- Coll. D. Gomme
ELGr	----- Grocers' Hall
ELGre	----- Coll. E. C. Gregory
ELGro	----- Grosvenor Gallery
ELGroS	----- Grosvenor Square
ELGu	----- Guy's Hospital
ELH	----- Hanover Gallery
ELHC	----- Hampton Court
ELHG	----- Highbury Fields
ELHM	----- Horniman Museum and Library
ELHS	----- Hanover Square
ELHW	----- Hays Wharf
ELHa	----- Harlow Art Trust
ELHe	----- St. Helen's Bishopsgate
ELHi	----- Highgate Cemetery
ELHo	----- Horniman Museum
ELHow	----- Formerly Howitt Collection
ELHu	----- Coll. Dr. Alastair Hunter
ELHul	----- Coll. Lady Hulton
ELHy	----- Hyde Park
ELHyB	----- ----- Bird Sanctuary
ELI	----- Coll. Ionides
ELIA	----- Imperial War Museum
ELIC	----- Institute of Contemporary Arts
ELIH	----- Ironmongers' Hall
ELIHT	----- Institute of Hygiene and Tropical Medicine
ELIM	----- Indian Museum, South Kensington
ELJ	----- Convent of the Holy Child Jesus, Cavendish Square (See also ELCon)

ELJa	London. St. James Churchyard, Piccadilly
ELJe	----- Jewish Museum
ELK	----- Coll. Kasmin Ltd
ELKe	----- Kensington Gardens
ELKeL	----- New Kensington Library
ELKeP	----- Kensington Place
ELL	----- Lord's Gallery
ELLa	----- Lambeth Chapel
ELLan	----- Coll. Allen Lane
ELLe	----- Leicester Galleries
ELLea	----- Leathersellers' Company
ELLew	----- Lewisham
ELLewi	----- John Lewis Partnership Ltd
ELLi	----- Lincoln's Inn Fields
ELLo	----- London Museum
ELLoS	----- City of London School
ELM	----- Coll. J. Pierpont Morgan
ELMa	----- Marlborough Fine Arts Ltd
ELMac	----- Coll. Anne Maclaren
ELMan	----- Coll. D. M. and P. Manheim
ELMar	----- St. Martin-in-the-Fields
ELMarg	----- St. Margaret's Church, Westminster
ELMc	----- Coll. Miss McCaw
ELMcR	----- Coll. McRoberts & Tunnard, Inc.
ELMe	----- Methodist Missionary Offices
ELMi	----- Midland Bank, Prince's Street
ELMil	----- Library of Eric Millar, Lectionary of St. Trond
ELMo	----- Coll. Mount
ELMu	----- Mullard House
ELN	----- National Gallery
ELNH	----- Neville House
ELNL	----- New London-Marlborough Gallery
ELNP	----- National Portrait Gallery
ELNo	----- Coll. Messrs. Novello
ELO	----- Owen School, Islington
ELOl	----- Old Bailey
ELOld	----- Former Coll. W. O. Oldman
ELOldPY	----- Old Palace Yard
ELP	----- Coll. Roland Penrose
ELPC	----- The Painters' Company
ELPO	----- Peninsular and Oriental Steam Navigation Company
ELPS	----- Parliament Square
ELPa	----- St. Paul's Cathedral (See also ELStPG)
ELPad	----- Paddington Street
ELPar	----- Cinema de Paris
ELPaul	----- St. Paul's Church, Clapham

ELPe	-----	Pearl Assurance Company, 252 High Holborn
ELPi	-----	Piccadilly Circus
ELPim	-----	Pimlico Gardens
ELPl	-----	Plaza Theatre, Regent Street
ELPo	-----	Coll. E. J. Power
ELPow	-----	Coll. Alan Power
ELPr	-----	Printers-Stationers' Company
ELQ	-----	Queen Square, Bloomsbury
ELR	-----	Redfern Gallery
ELRA	-----	Royal Academy of Arts
ELRC	-----	Royal College of Physicians
ELRCA	-----	Royal College of Arts
ELRCS	-----	Royal College of Surgeons
ELRE	-----	Royal Exchange
ELRG	-----	Royal Geographical Society
ELRH	-----	Rhodesia House
ELRIA	-----	Royal Institute of British Architects
ELRN	-----	Royal Naval College, Greenwich
ELRS	-----	Royal Society
ELRSA	-----	Royal Society of Arts
ELRe	-----	Regent's Park
ELRed	-----	Red Lion Square
ELRo	-----	Rowan Gallery
ELRog	-----	Coll. Alan Roger
ELRow	-----	Rowley Gallery
ELRr	-----	Metropolitan Railway Building
ELRu	-----	Russell Square
ELRub	-----	Coll. Lawrence Rubin
ELS	-----	Coll. Robert J. Saintsbury
ELSa	-----	Coll. George Salting
ELSad	-----	Coll. Late Michael Sadleir
ELSav	-----	Saville Theatre
ELSc	-----	Coll. Mrs. Violet Schiff
ELSch	-----	School of Hygiene and Tropical Medicine
ELSci	-----	Science Museum
ELSe	-----	Selfridge Building
ELSed	-----	Coll. Mrs. Walter Sedgwick
ELSo	-----	Sir John Soane's Museum
ELSom	-----	Somerset House
ELSoth	-----	Sotheby & Company
ELSp	-----	Spink & Son
ELStA	-----	St. Andrew Undershaft (ELAn)
ELStG	-----	St. Giles, Cripplegate
ELStH	-----	State House
ELStJ	-----	St. James, Piccadilly
ELStJP	-----	St. James, Park Station (ELUR)

ELStL	London. St. Leonard's
ELStM	----- St. Margaret's, Westminster (ELMarg)
ELStP	----- St. Paul's School, West Kensington
ELStPC	----- St. Paul's Cathedral (See also ELPa)
ELStS	----- St. Stephen's, Ipswich
ELStT	----- St. Thomas Hospital
ELSto	----- Stone House
ELSton	----- Coll. Francis Stoner
ELStr	----- Coll. Mrs. G. R. Strauss
ELStu	----- Coll. Peter Stuyvesant Foundation
ELT	----- Tate Gallery
ELTC	----- Temple Church
ELTH	----- Trinity House (ELTr)
ELTL	----- Time-Life Building
ELTLC	----- Time-Life Building. Ville de Cologne
ELTS	----- Trafalgar Square
ELTh	----- Coll. James Thyne
ELTha	----- Tower Hamlets Secondary School for Girls, Biglands Estate
ELTo	----- Arthur Tooth & Sons
ELTow	----- Tower of London Armouries
ELTr	----- Trinity Almshouses, Mile End Road (ELTH)
ELTrS	----- Trinity Square
ELU	----- University College
ELUH	----- Unilever House
ELULC	----- University of London. Colonial Department. Institute of Education
ELULD	----- ----- Percival David Foundation
ELULJ	----- ----- Jewish Historical Society of England, Tuck Collection
ELUR	----- London Underground Railway Office
ELUn	----- Coll. Leon Underwood
ELUs	----- University College. Slade School of Fine Arts
ELV	----- Victoria and Albert Museum
ELVT	----- Victoria Tower Gardens
ELVa	----- Vauxhall Park, S. W.
ELVe	----- Coll. Michael Ventris
ELVg	----- Victoria Gardens Embankment
ELW	----- Waddington Galleries
ELWa	----- Walden House
ELWal	----- Wallace Collection
ELWar	----- Imperial War Museum
ELWat	----- Waterloo Palace
ELWe	----- Westminster Abbey
ELWeB	----- Westminster Bank
ELWeBr	----- Westminster Bridge

ELWeC	London. Westminster Cathedral
ELWeH	----- Westminster Hall
ELWeP	----- Westminster Palace
ELWel	----- Wellington Museum
ELWesP	----- Palace of Westminster, Prince's Chamber
ELWh	----- Whitehall
ELWhi	----- Coll. Hon. and Mrs. Jock Hay Whitney
ELWi	----- Windmill Press, Kingswood
ELWid	----- Coll. Dr. H. P. Widdup
ELWil	----- Coll. Peter Wilson
ELZ	----- Coll. A. Zwemmer
ELanI	Lancashire. Ince Blundell Hall
ELang	Langford, Norfolk
ELap	Lapford, Devon
ELeC	Leeds. City Art Gallery and Temple Newsam House
ELeCh	----- Parish Church
ELeT	----- Temple Newsam House (See also ELeC)
ELeU	----- Leeds University
ELeW	----- Whitkirk
ELec	Leckhamstead, Bucks
ELeiA	Leicestershire. Asby-de-la-Zouch
ELeiB	----- Bottesford
ELeiQ	----- Quorn
ELeiT	----- Theddingworth
ELeicM	Leicester. Leicester Museums and Art Gallery
ELenT	Lenton. Church of the Holy Trinity
ELeo	Leominster (See also EHereL)
ELetS	Letchworth. Coll. Jean Stewart
ELev	Levisham, Yorks
ELewCh	Lewisham. Church
ELiC	Lichfield. Cathedral
ELinC	Lincoln. Lincoln Cathedral of St. Mary
ELinM	----- Lincoln Minster
ELinU	----- Usher Art Gallery
ELincI	Lincolnshire. Irnham
ELincS	----- Spilsby
ELincT	Lincolnshire. Tattershall Castle
ELint	Linton, Kent
ELitB	Little Billing
ELitG	Little Gaddesden, Herts
ELitH	Little Horkesley, Essex
ELitS	Little Saxham, Suffolk
ELivC	Liverpool. Liverpool Cathedral
ELivG	----- St. George's Hall

E LivJ	Liverpool. St. James Chapel
E LivL	----- Liverpool City Museum
E LivLib	----- Liverpool Libraries, Museums, and Arts Committee
E LivW	----- Walker Art Gallery
E Lo	Longleat, Wilts. Coll. Marquess of Bath
E LongB	Long Buckby, Hants
E LouC	Loughborough. Loughborough College
E Low	Lowick
E Lu	Ludlow. Parish Show
E LutW	Luton Hoo. Wernher College
E Ly	Lynsted, Kent (EKenL)
EM	Coll. Mrs. Irina Moore
EMM	Much Hadham. Coll. Miss Mary Moore
EMMo	Much Hadham. Coll. Mrs. Irina Moore (-EM)
E MaA	Manchester. City of Manchester Art Gallery
E MaC	----- Cooperative Insurance Building
E MaCa	----- Manchester Cathedral
E MaM	----- Manchester Museum
E MaR	----- Rylands Library
E MalA	Malmesbury Abbey (See also EWiM)
E Malt	Government of Malta
E Malv	Malvern Priory
E Man	Mansion House
E Map	Mapperton, Dorset
E Mar	Layer Marney, Essex
E Me	Melbourne Hall, Derbys
E Mel	Melsonby
E Melb	Melbury Bubb, Dorset
E MelbS	Melbury Stampford, Dorset
E Meth	Methley, Yorks
E Mi	Mitton, Yorks
E Mid	Middleton
E MiddH	Middlesex. Harefield (EMiddH)
E MiddHe	----- Hendon
E MiddS	----- Stanwell
E MoM	Morcambe. Midland Hotel
E Mor	Moreton Valence, Glos
E Mu	Coll. Earl of Munster
ENI	National Trust. Ickworth, Suffolk
ENP	----- Petworth House, Sussex (EPetL)
ENW	----- Waddesdon Manor, Bucks
E NeB	Newcastle upon Tyne. Blackgate Museum
E Nee	Needham Market, Suffolk
E New	Newent
E NewpG	Newport. Grammar School
E NewpM	----- Museum and Art Gallery
E NoC	Nottinghamshire. City Art Gallery and Museum (The Castle Museum)

ENoH	Nottingham (shire). Hawton Church
ENoK	----- Kingston-on-Soar
ENoL	----- Langar
ENoM	----- Nottingham Museum
ENorG	Northamptonshire. Great Brington
ENorGe	----- Geddington
ENorH	----- Hardingstone
ENorI	----- Coll. Gyles Isham
ENorM	----- St. Matthew Church
ENorP	----- St. Peter's
ENorb	Norbury
ENorfB	Norfolk. Blicking Hall
ENorfD	----- Dersingham
ENorfE	----- Elsing
ENorfH	----- Houghton Hall. Coll. Marquess of Cholmondeley
ENorfI	----- Ingham
ENorfN	----- Norwich Cathedral
ENorfR	----- Reepham Church
ENorthC	Northamptonshire. Castor Church
ENorthCh	----- Charwelton
ENorthE	----- Easton Neston (EEa)
ENorthG	----- Great Brighton
ENorthH	----- Hardingstone
ENorthL	North Leigh
ENorthN	Northamptonshire. Norton
ENorthR	----- Rushton
ENorthS	----- Staverton
ENorthT	----- Tichmarsh
ENorthW	----- Woodford
ENorthWa	----- Warkton
ENorthWh	----- Whiston
ENorthuC	Northumberland. Chipchase Castle
ENorthwH	Northwood. Holy Trinity
ENortoA	Norton. St. Andrew's Church
ENorwC	Norwich. Cathedral
ENu	Nunnykirk, Northumberland
EO	Coll. Gordon Onslow-Ford
EOA	Oxford. Oxford University--Ashmolean Museum
EOAll	----- All Soul's Church
EOAllC	----- All Soul's College
EOB	----- Oxford University--Bodleian Library
EOC	----- Cathedral
EOCa	----- St. Catherine's College
EOCh	----- Christ Church
EOD	----- Divinity School
EOE	----- St. Ebbe's

EOJ	Oxford. St. John's College
EOM	----- Magdalen College
EOMC	----- Merton College Chapel
EON	----- New College
EOO	----- Old Palace
EOP	----- Pitt Rivers Museum
EOPC	----- Pembroke College
EOR	----- Roth Collection
EOS	----- Coll. Prof. C. G. Seligman
EOSc	----- Schools Quadrangle
EOT	----- Trinity College
EOU	----- University College
EOW	----- Wadford College
EOd	Oddington, Oxon
EOf	Offley, Herts
EOldW	Old Warden, Beds
EOsP	Oswestry. Park Hall
EOt	Otley
EOxD	Oxfordshire. Ditchley
EOxH	----- Hanwell
EOxI	----- Iffley
EOxS	----- Stanton Harcourt
EOxT	----- Great Tew
EOxfD	----- Dorchester Abbey
EOxfE	----- Ewelme Church
EOxfS	----- Somerton
EOxfSt	----- Stanton Harcourt
EPL	Port Sunlight. Lady Lever Art Gallery
EPaiK	Paignton. Kirkham Chantry
EParhP	Parkham Park, Sussex
EPeC	Peterborough. Cathedral
EPetL	Petworth. Coll. Lord Leconfield; Coll. John Wyndham
EPo	Powick, Worcester (EWorPo)
EPorL	Port Sunlight. Lady Lever Art Gallery (EAbbot)
EPot	Potterne
EPrH	Preston. Harris Museum and Art Gallery
ER	Coll. Herbert Read
ERad	Radlett. Coll. Pierre Jeannerat
ERam	Ramsbury
EReaM	Reading. Reading Museum
ERec	Reculver
ERed	Redgrave, Suffolk
ERei	Reigate, Surrey
ERet	Rettendon, Essex
ERiE	Ringwood, Hants. Coll. Brian Egerton
ERicP	Richmond. Coll. Alan Power

ERipC	Ripon. Coll. Mayor Edward Compton
ERoC	Rochester. Cathedral
ERock	Rockingham
ERomA	Romsey Abbey
ERos	Rostherne, Cheshire
ERou	Rous Lench
ERu	Ruthwell, Dumfries
ERutB	Rutland. Burley-on-the-Hill (EExt)
ERutE	----- Exton
ESA	Southampton. Southampton University. Faculty of Arts
ESaC	Salisbury. Cathedral
ESaCh	----- Chapter House
ESaCl	----- Clarendon Palace
ESaS	----- Salisbury Plain
ESalM	Salop. Much Wenlock
ESan	Sandon Hall, Staffs
ESeA	Selby Abbey
'ESh	Sherborne Abbey, Dorset (EDS)
EShaK	Shawhead. Coll. W. J. Keswick
EShef	Sheffield
ESher	Shelford, Notts
ESho	Shobdon
EShroQ	Shropshire. Quat
EShroW	----- Wroxeter
ESn	Snarford, Lincs
ESoM	Southwell. Southwell Minster
ESoc	Sockburn, Durnham
ESomB	Somerset (shire). Brent Knoll
ESomG	----- Glastonbury
ESomH	----- High Ham Church
ESomM	----- Montacute
ESomHi	----- Hinton St. George
ESomR	----- Rodney Stoke
ESomp	Sompting
ESon	Sonning, Berks
ESou	Southhill, Beds
ESoutU	Southampton. University. Faculty of Arts (ESA)
ESouthC	Southwark. Southwark Cathedral
ESouthS	----- St. Savior's
ESow	Sowerby, Yorks
ESp	Speen, Berks
EStA	St. Andrew-Auckland, Durham
EStal	St. Alkmund
EStB	St. Bartholomew Hyde, Winchester
EStC	St. Cuthbert
EStDS	St. Dunstan, Steepney

EStH	Strawberry Hill
EStM	St. Mary, Warwick
EStMa	St. Maurice Abbey
EStaC	Stafford. St. Chad's
EStafE	Staffordshire. Etruria Museum
EStam	Stamford. Lincs. St. Martin
EStanH	Stanton Harcourt, Oxon
EStap	Stapleford
EStapl	Staplehurst
ESteep	Steeple Aston, Oxon
EStevG	Stevenage, Herts. Barclay School
EStil	Stillingfleet
EStin	Stinsford
ESton	Stonleigh
EStou	National Trust. Stourhead, Wilts
EStowG	Stowlangtoft, Suffolk. St. George's Church
EStowe	Stowe-Nine-Churches. Northants
EStrad	Stradsett, Norfolk
EStratS	Stratford-upon-Avon. Shakespeare Memorial Theatre
EStren	Strensham
ESuAH	Sussex. Arundel. Coll. James Hooper
ESuB	----- Broadwater
ESuC	----- Culford Church
ESuH	----- Holmhurst. St. Leonards
ESuM	----- Midlavant
ESufB	----- Boxted
ESufBe	----- Benhall Lodge, Saxmundham
ESufBu	----- Butley Priory
ESufC	----- Culford
ESufE	----- Elmsett
ESufF	----- Framlingham
ESufG	----- Great Saxham
ESufH	----- Hengrave
ESufW	----- Woodbridge
ESurB	Surrey. Bletchingley. Coll. Earl of Munster (See also EB1)
ESurC	----- Cheam
ESurD	----- Deepdene
ESurE	----- Old Esher
ESurG	----- Godstone
ESurL	----- Loseley
ESurS	Surrey. Stoke d'Abernon. Coll. Lady d'Abernon
ESw	Swine, Yorks
ESwin	Swinbrook, Oxon
ETP	Twyford, Berks. Coll. Mr. and Mrs. R. Palmer

ETar	Tardebigge
ETaw	Tawstock, Devon
ETe	Tewkesbury Abbey, Glos (See also EWT)
EThor	Thorpe. Achurch
ETi	Titchfield
ETiv	Tiverton
ETo	Tottenham, Middlesex
ETof	Toftrees, Norfolk
ETop	Topsham
ETot	Totnes
ETr	Trentham
ETro	Trotten
ETw	Twickenham. All Hallows
EU	Ulcombe
EUp	Upwell
EWC	Worcester. Cathedral
EWT	Tewkesbury Abbey (See also ETe)
EWa	Coll. Peter Watson
EWak	Wakerley
EWakeA	Wakefield. City Art Gallery and Museum
EWal	Waltham Abbey
EWarMB	Warwick. St. Mary's Beauchamp Chapel
EWarS	Warwickshire. Shuckburgh
EWarSC	----- Sutton Coldfield
EWark	Warkton (ENorthWa)
EWarwA	Warwickshire. Aston Hall
EWarwN	----- Newbold-on-Avon
EWat	Watford
EWater	Waterperry
EWeC	Wells. Cathedral
EWeV	----- Corporation of Vicors Choral
EWedA	Wedern Abbey
EWel	Welbeck
EWemE	Wembley. Wembley Exhibition
EWen	Wentworth. Woodhouse
EWes	Westbury
EWestD	West Dereham
EWestGT	West Grinstead. Coll. W. G. Tillman
EWestMB	West Mercea. Coll. Bedford
EWestl	Westley Waterless
EWestmL	Westmoreland. Little Strickland Hall
EWhal	Whalley
EWhi	Whitchurch
EWiG	Wiltshire. Great Durnford
EWiL	----- Lydiard Tregoze
EWiLa	----- Langford
EWiM	----- Malmesbury Abbey
EWil	Wilton House. Coll. Earl of Pembroke

E Wim	Wimpole
E WinC	Winchester. Winchester Cathedral
E WinCol	----- College Chapel
E WinF	----- Feretory
E WinM	----- Winchester City Museum
E WindC	Windsor. Windsor Castle
E WindG	----- St. George's Chapel
E WindR	----- Royal Collections
E WindRL	----- Royal Library
E Wint	Winterbourne, Steepleton
E Winw	Winwick
E Wir	Wirksworth
E With	Withyham. Parish Church
E WoC	Worcester. Worcester Cathedral
E Wob	Woburn Abbey, Beds. Coll. Duke of Bedford
E WolA	Wolverhampton. Municipal Art Gallery and Museum
E WooC	Woodchurch. Church
E WorB	Worcestershire. Badsey
E WorP	----- Pershore
E WorPo	----- Powick (E Po)
E WorS	----- Salwarpe
E WorW	----- Westwood Park
E WorWi	----- Wickhamford
E Worm	Wormington
E Wr	Writtle
EY	Coll. Earl of Yarborough
EYoA	York (shire). Alne
EYoB	----- Burton Agnes
EYoBS	----- Barton-le-Street
EYoBe	----- Bedale
EYoBr	----- Brayton
EYoC	----- St. Mary's Cathedral (Museum)
EYoD	----- Dewsbury
EYoE	----- Easby Abbey
EYoG	----- Goldsborough
EYoH	----- Healaugh
EYoJC	----- St. John's College. Chapel
EYoM	----- St. Mary's Museum
EYoN	----- Newby Hall
EYoP	----- Museum of the Philosophical Society
EYoS	----- Silkstone
EYoY	----- Yorkshire Museum

Ecuador

EcQC	Quito. Santa Clara
EcQF	----- San Francisco Church
EcQCom	----- La Compania

EcQM	Quito. La Merced
EcQMe	----- Coll. Alberto Mena
EcQMen	----- Coll. Victor Mena

Egypt

EgAS	Abu-Simel
EgAb	Abydos
EgAbu	Abusir
EgAlB	Alexandria. Coll. Benaki
EgAlC	----- College des Ecoles Chretiennes
EgAlG	----- Greco-Roman Museum
EgAlM	----- Museum
EgAs	Aswan
EgCA	Cairo. Arabic Museum
EgCAl	----- al-Akmar Mosque
EgCC	----- Coptic Museum
EgCG	----- Mirrit Boutros Ghali Coll.
EgCH	----- Habib Gorgui's School, Wekalet El Ghouri
EgCHa	----- Mosque of al-Hakin
EgCI	----- Museum of Islamic Art
EgCM	----- Egyptian Museum (Museum of Antiquities)
EgCMA	----- Museum of Modern Art
EgCMo	----- Church of al-Mo'allaqa
EgCMu	----- Mukhtar Museum
EgCS	----- Permanent Exhibition of Traditional Arts, Sinnari
EgCT	----- Mosque of Ibn Tulun
EgD	Denderah
EgDa	Dashur
EgDe	Deir el-Bahari
EgEd	Edfu
EgG	Giza
EgK	Karnak--northern section site of ancient Thebes
EgKo	Kom Ombo Temple
EgKu	Kurna
EgL	Luxor--southern section site of ancient Thebes
EgMH	Medinet Habu. Temple
EgMe	Memphis
EgPh	Philae
EgS	Saqqara (Sakkara)
EgSi	Sinai
EgT	Thebes
EgTg	Tuneh el Gebel

El Salvador
E1SN San Salvador. Museo Nacional "David J. Guzman"

Ethiopia
EtA Aksum

France
FMa	Coll. Mme. Helene de Mandrot
FN	Coll. Vicomte de Noailles
FAgM	Agen. Musee Municipal
FAiF	Aisne. Chateau de la Feste-Milon
FAirN	Airaines. Notre Dame
FAire	Aire sur L'Adour
FAixA	Aix. Musee Archeologique
FAixC	----- Aix St. Sauveur Cathedral
FAixM	----- Museum
FAixV	----- Hotel de Ville
FAjN	Ajaccio. Musee Napoleonien, Hotel de Ville
FAlP	Allier. Benedictine Priory Perrecy-les-Forges
FAlbC	Albi. St. Cecile Cathedral
FAlbT	----- Toulouse Lautrec Museum
FAls	Alsace
FAm	Amiens. Cathedral Notre Dame
FAmM	----- Musee de Picardie
FAmbP	Ambierle. Priory Church
FAmbo	Chateau of Amboise, Touraine
FAnD	Angers. Musee David d'Angers
FAnM	----- Musee des Beaux-Arts
FAnd	Andlau Church
FAngC	Angouleme. St. Pierre Cathedral
FAngM	----- St. Michael d'Etraignes
FAnzCh	Anzy le Duc. Church
FArcG	Arcueil. Coll. Mme. Roberta Gonzalez
FArce	Arc-et-Senans
FArcen	Arcenant
FArlA	Arles. Musee Archeologique
FArlL	Arles. Musee Lapidaire d'Art Chretien
FArlLP	----- Musee Lapidaire d'Art Paien
FArlT	----- St. Trophime
FArrC	Arras. Cathedral
FArrM	----- Musee Municipal, Palais St. Vaast
FArt	Arthies. Village Church
FAsN	Assy. Eglise Notre Dame de Toute Grace
FAsnCh	Asnieres-en Montagne. Church
FAuE	Auxerre. St. Etienne Cathedral
FAuG	----- St. Germain Church

FAubB	Aube. Priory of Belleroc
FAubC	----- Chaource Church
FAubM	----- Sainte-Madeleine de Troyes
FAuba	Cistercian Abbey of Aubazine
FAuchA	Auch. St. Marie Cathedral
FAulCh	Aulnay. St. Peter Church
FAutL	Autun. St. Lazare Cathedral; Treasury
FAutLa	----- Musee Lapidaire
FAutR	----- Musee Rolin
FAuxN	Auxonne. Notre Dame
FAvL	Avalon. St. Lazare
FAveV	Aveyron. Charterhouse of Ville franche-de-Rouergue
FAven	Avenas. St. Vincent Church
FAviC	Avignon. Musee Calvet
FAviL	----- Musee Lapidaire
FAzCh	Azay le Rideau. Church
FBCh	Beaulieu. Abbey Church
FBaP	Bar-le-Duc. St. Pierre
FBarM	Bar-sur-Aube. St. Maclou
FBay	Bayel
FBayeC	Bayeux. Cathedral
FBe	St. Benoit sur Loire (See also FStBF)
FBeaE	Beauvais. St. Etienne
FBeaM	----- Musee Departmental del'Oise (Musee de Beaunais)
FBeau	Beaune
FBeauF	Beaufort sur Duron
FBel	Belz
FBelfC	Belfort. Chateau
FBerN	Berven. Notre Dame de Berven
FBesC	Besancon. Cathedral
FBesM	----- Musee des Beaux-Arts
FBess	Bessen Chandesse
FBi	Les Billanges Haute-Vienne
FBioL	Biot. Musee Fernand Leger
FBir	Biron
FBlB	Blois. Basilica of Our Lady of the Trinity
FBlaM	Blasimon. St. Maurice
FBlaz	Blazemont
FBod	Bodilis
FBorA	Bordeaux. Musee des Beaux-Arts
FBorAq	----- Musee d'Aquitaine
FBorAr	----- Archives Deparmentales de la Girone
FBorC	----- Cathedral
FBorCr	----- St. Croix Church
FBorL	----- Musee Lapidaire
FBouC	Bourges. Hotel Jacques Coeur

FBouCa	Bourges. St. Etienne Cathedral
FBouM	----- Museum
FBouc	Bouches-de-Rhone (FPlan)
FBour	Le Bourget-du-Lac
FBourg	Bourg-Dun Church
FBrK	(Brou, near Bourge-en-Bresse. Klosterkirche
FBrN	(----- St.-Nicholas-de-Tolentin
FBra	Brasparts
FBran	Brantome
FBre	Bredons
FBriM	Brive. Musee Ernest-Rupin
FBu	Bury. Village Church
FC	Carnac
FCC	Chartreuse de Champmol
FCa	Calais
FCahC	Cahors. St. Etienne Cathedral
FCahE	----- Jardin de l'Eveche
FCamM	Cambrai. Musee de Cambrai
FCamb	Cambronne-les-Clermont. Church
FCap	Cap Blanc
FCar	Carennac
FCarcN	Carcassonne. St. Nazaire
FCarp	Carpentras
FCe	Cellefrouin
FCh	Chartres. Notre Dame Cathedral
FChE	----- Jardins de l'Eveche
FChM	----- Musee des Beaux-Arts
FChaM	Champeaux. St. Martin Collegiate Church
FChaa	Chateau de Chaalis, Oise
FChad	Chadenac Church
FChai	Palais de Chaillot
FChalD	Chalon-sur-Saone. Musee Denon
FCham	Benedictine Abbey of Chamalieres
FChambM	Chambery. Museum
FChambS	----- Musee Savoisien
FChambo	Chambon du Lac
FChamp	Champigny-sur-Veude
FChanC	Chantilly. Musee Conde; Coll. Princess de Conde and Duc d'Aumale (FValle)
FChaoJ	Chaource. St. Jean Baptiste
FChar	Charlieu. Abbey
FCharF	----- Church of St. Fortunat
FChareD	Charente-Maritime. Abbaye-aux-Dames
FChareP	----- Parish Church St. Pierre d'Aulnay
FChari	Benedictine (Cluniac) Priory la Charite-sur-Loire
FCharr	Charroux
FChat	Chateau-Thierry

FChatA	Chatillon-sur-Seine. Musee Archeologique
FChatF	Chateau de la Ferte-Milon
FChatL	Chateau Larcher
FChatM	Chateau de Mainneville en Vexin
FChatMo	Chateau de Montal
FChate	Chateaudun. Castle
FChateC	----- St. Chapelle
FChatea	Chateaulin
FChateauP	Chateauneuf. St. Pierre Church
FChatel	Chatel-Montagne
FChatiM	Chatillon-sur-Seine. Musee Archeologique
FChau	Chauvigny. Eglise St. Pierre
FChauN	----- Notre Dame Church
FChaur	Chauriat
FChauvH	Chauvirey, Le Chatel. St. Hubert Chapel
FCheM	Cher. Marognes Church (FMonoCh)
FCiN	Civray. St. Nicolas
FCiv	Civaux. St. Gervais. St. Protais Church
FCl	Cluny. Abbey
FClF	----- Musee Lapidaire du Farinier
FClO	----- Musee Ochier
FCleC	Clermont-Ferrand. Maison du Centaure
FCleN	----- Notre Dame du Port
FCler	Clery. St. Andre
FClo	Clohars-Foursnant
FCoA	(Conques. St. Foi Abbey
FCoF	(----- St. Foy Treasure
FCoi	Coizard
FColU	Colmar. Musee d'Unterlinden
FComB	Comminges. St. Bertrand
FCorF	Correze. St. Fortunade
FCorbS	Corbeil. St. Spire
FCotA	Cote-d'Or. Benedictine Abbey St. Andoche de Saulieu
FCotB	----- Bussey-le-Grand Village Church
FCotT	----- Benedictine Priory Thil-Chatel
FCr	Cruas
FCreB	Crery-en-Valois. Bouillant
FCun	Cunault
FDA	Dijon. Commission des Antiquites du department de la Cote-d'Or
FDAr	----- Musee Archeologique de Dijon
FDB	----- St. Benigne
FDC	----- Carthusian Monastery (former Charterhouse of Champmol)
FDJ	----- Palais de Justice
FDL	----- Musee Lapidaire
FDM	Dijon. Musee des Beaux-Arts

FDMil	Dijon. Maison Milsand
FDN	----- Notre Dame de Dijon
FDa	Damvillers
FDam	Dammartin-en-Goele. Collegiate Church Notre Dame
FDampN	Dampierre. St. Nicholas
FDie	Die
FDin	Dinan
FDo	Dol, near Brittany
FDon	Donzy le Pre
FDouM	Douais. Musee de Douais
FDrH	Drome. Hauterives
FDreM	Dreux. Musee d'Art et d'Histoire
FEC	Ecos. Church
FEc	Ecouis. Notre Dame Church
FEoC	----- Collegiate Church
FEcCh	Ecouen. Chateau
FEch	Echillais
FElC	Elne. Cathedral
FEnM	Enserune. Musee National
FEnnV	Ennezat. St. Victor
FEntM	Entraigues. St. Michael Church
FEpM	Epinal. Musee Departmental des Vosges
FEuC	Eu. Convent Church
FEuL	----- St. Laurent
FEurC	Eure-et-Loire. Chateaudun. Castle Chapel
FEvT	Evreux. St. Taurin Church
FEvr	Evron
FFP	Fontainebleau. Musee National du Chateau de Fontainebleau
FFPF	Fontainebleau. Musee National du Chateau de Fontainebleau Galerie Francois I
FFa	Falaise
FFen	Fenioux
FFla	Flavigny sur Ozerain
FFo	Folleville
FFonCh	Fontaine-les-Dijon. Church
FFou	Foussais
FFrB	Franche-Comte. Brou Abbey (FBrK)
FGA	Grenoble. Place St. Andre
FGM	----- Musee de Grenoble
FGaG	Gard. Benedictine (Clunaic) Abbey St. Gilles
FGapM	Gap. Musee des Hautes-Alpes
FGarB	Garches. Coll. Adrienne Barbanson
FGeM	Gensac-la-Pallue. St. Martin Church
FGiG	Gisors. St. Gervais--St. Protais
FGrM	Gres des Vosges. Eglise de Munster
FGreL	Grenoble. St. Laurent Crypt

FGreM	Grenoble. Musee de Peinture et de Sculpture
FGu	Gumiliau
FGue	Guehenno
FH	Hattonchatel
FHa	Hauterives (FDrH)
FHu	Huelgoat. St. Yves Church
FHuN	----- Chapel Notre Dame ces Cieux
FHyN	Hyeres. Coll. Comte de Noailles
FHyO	----- Our Lady of Consolation
FIA	Issoire. St. Austremoine Monastery Church
FIP	Issoire. St. Paul
FInI	Indre-le-Loire. Benedictine Priory l'Ile-Bouchard
FJJ	Jonzy. St. Julien de Jonzy
FJa	Jailhac
FJo	Jouarre. Abbey
FJoiJ	Joigny. St. Jean de Joigny Church(FStJ)
FJos	Chateau Jossigny
FJuM	Jura. Montbenoit Convent Church
FK	Kerlons
FKe	Kermaria an Isquit. House of the Health-Giving Virgin
FLC	Lyon. Cathedral; Cathedral Treasury
FLM	----- Musee des Beaux-Arts
FLaB	Languedoc. St. Bertrand de Comminges
FLaBa	La Bastie D'Urfe
FLaC	La Charite sur Loire
FLaG	Languedoc. St. Genis des Fontaines
FLaF	La Ferte-Milon
FLaL	La Lande de Fronsac. Church
FLaS	La Sauvemajeure. Abbey
FLabA	La Bussiere-sur-Ouche. Assumption Church
FLaf	La Ferte-Milon Chateau
FLamN	Lamballe. Notre Dame Church
FLaMa	La Martyre
FLamp	Lampaul-Guimiliau
FLan	La Lande de Fronsac, near Bordeaux
FLaoC	Laon. Cathedral
FLar	La Rochefoucauld
FLasCh	Lascelle. Church
FLau	Lauris-sur-Durance
FLavA	Lavaur. St. Alain Cathedral
FLaz	Laz Church
FLeB	Le Bourget du Lac
FLeFB	Le Faouet. St. Barble Church
FLeFo	Le Folgoet. Notre Dame
FLeHG	Le Havre. Musee de sculpture Medievale et d'Archeologie de l'Abbaye de Graville

FLeHM	----- Musee du Havre
FLeHaM	Le Haye. Musee de la Haye
FLeMC	Le Mans. Cathedral St. Julien
FLeMN	----- Notre Dame de la Couture
FLeMa	Le Mas-D'Azil
FLeMeCh	Le Mesnil-Aubry. Church
FLePM	Le Puy. Musee
FLePN	----- Notre Dame
FLePrM	Le Pradot. Coll. Mme de Mandrot
FLecL	Lectoure. Musee Lapidaire
FLesE	Les Eyzles. Les Eyzles Museum
FLesM	Lespugue. Musee de Lespugue
FLevN	Levis-saint-Nom. Notre Dame de la Roche
FLh	L'Hospital St. Blaise
FLiP	Lille. Musee Palais des Beaux-Arts
FLiV	----- Boulevards Vauban et Liberte
FLiW	----- Musee Wicar
FLich	Licheres. Parish Church
FLimM	Limoges. Musee Municipal
FLisC	Lisieux. Cathedral
FLoB	Loiret. Abbey Church St. Benoit-sur-Loire
FLoc	Locmariaquer
FLocr	Lacronan
FLoiA	Loir-et-Cher. Benedictine Abbey St. Aignan
FLonC	Longpont-sur-Orge. Coll. William Copley
FLong	Longpoint-sous-Monthiery
FLotL	Lot-et-Garonne. Benedictine (Clunaic) Priory
FLouP	Louveciennes. Park
FLouvM	Louviers. Musee Municipal
FLouvN	----- Eglise Notre Dame
FMP	Moissac. Abbey Church St. Pierre (Eglise Abbatiale)
FMaB	Marseilles. Musee Borely
FMaG	----- Coll. Leonce Pierre Guerre
FMaL	----- La Major
FMaLo	----- Musee de Longchamps
FMaM	----- Musee des Beaux-Arts
FMagCh	Magny. Parish Church
FMai	Chateau de Maisons-Laffitte
FMain	Mainneville
FMalCh	Malicorne. Church
FManN	Mantes. Depot Lapidaire de la Collegiale Notre Dame
FMarCh	Martel. Parish Church
FMarcC	Marcorssis. Celestins Church
FMarm	Marmoutier. Abbey Church
FMars	Marsat
FMarv	Marvejois

FMarviM	Marville. Chevalier Michel House
FMas	Masevaux
FMau	Maurs
FMaur	Mauriac. Notre Dames des Miracles
FMeA	Meudon. Coll. Arp-Hagenbach
FMeD	----- Coll. Nelly van Doesburg
FMeR	----- Rodin Museum
FMea	Meaux
FMea B	----- Musee Boussuet
FMeal	Meallet
FMelH	Melle. St. Hilaire
FMelr	Melrand
FMen	Menec
FMetM	Metz. Musee Centrale
FMo	Montierender
FMoe	Moeze
FMolM	Molsheim. Metzig
FMolo	Molompize
FMonP	Montlucon. St. Pierre Church
FMone	Monesties-sur-Ceron. Hospital Chapel
FMont	Mont San Michel
FMonta	Chateau de Montal
FMontauI	Montauban. Musee Ingres
FMontb	Montbenoit (FJuB)
FMontc	Benedictine (Cluniac) Priory Montceau-l'Etoile
FMontco	Montcontour. Chapel Notre-Dame-du-Haut
FMonte	Montespan
FMontf	Montferrand
FMontmO	Montmorillon. Octogone
FMonto	Montoire
FMontpF	Montpellier. Musee Fabre
FMontpeM	Montpezat-de-Quercy. St. Martin Church
FMontrV	Montrouge. Coll. Mrs. S. Vitullo
FMontre	Montreal en Auxois
FMontroM	Schloss Montrottier. Musee Leon Mares
FMontsO	Montsoult. Maison des Peres de l'Oratoire
FMorF	Morlaas. St. Foy
FMorlM	Morlaix. St. Mathieu
FMoroCh	Morogues. Church (FChem)
FMouD	Moulins. Musee Departmental et Municipal
FMouL	----- Chapel Lycee Banville
FMouzN	Mouzon. Abbey Church Notre Dame
FMoz	Mozac
FMu	Mussy-sur-Seine
FMur	Murbach. Abbey Church
FND	Neuilly-en-Donjon
FNaB	Nantes. Musees des Beaux-Arts de Nantes

FNaC	Nantes. Cathedral
FNaCha	----- Chateau
FNaD	----- Musee Departementaux de Loire-Atlantique (Musee Archeologique Thomas Dobree)
FNaS	----- Musee des Salorges (Musee de la Marine et des Industries Nantaises)
FNanB	Nancy. Church Notre Dame de Bonsecours
FNanC	----- Cathedral
FNanCo	----- Cordeliers Church
FNanE	----- Musee de l'Ecole de Nancy
FNanF	----- Franciscan Church
FNanG	----- Grayfriars Monastery Chapel
FNanH	----- Musee Historique Lorrain
FNanM	----- Musee de l'Ecole de Nancy
FNeC	Nevers. Nevers Cathedral
FNeuN	Neuville-sous-Corbie. Notre Dame de l'Assumption
FNeui	Neuilly en Donjon
FNeuwP	Neuwiller. Church St. Pierre-St. Paul
FNiMM	Nice. Musee Massena
FNia	Niaux
FNieM	Nievre. Benedictine (Cluniac) Priory St. Marie de Donzy-le-Pre
FNimC	Nimes. Cathedral
FNimL	----- Musee Lapidaire
FNoA	Normandy. American Cemetery
FNog	Nogent. Le Rotrou
FNorCh	Nordpeene. Church
FNot	Notre Dame de Tronoen
FOA	Orleans. Benedictine Abbey St. Aignan
FOM	----- Musee des Beaux-Arts
FOlM	Oloron. St. Marie
FOr	Orange
FOu	Ourscamp. Abbey
FPA	Paris. Arc de Triomphe
FPAf	----- Musee des Arts Africains et Oceaniens (Formerly: Colonial Museum)
FPAl	----- Place de l'Alma
FPAm	----- Hotel Amelot de Bisseuil
FPAn	----- Coll. Anguera
FPAp	----- Galerie Apollinaire
FPAr	----- Archives Nationales
FPArm	----- Musee de l'Armee
FPArt	----- Art Market
FPAu	----- Hotel Aubert de Fontenay
FPB	----- Galerie Claude Bernard
FPBA	----- Bibliotheque de l'Arsenal

FPBN	Paris. Bibliotheque Nationale
FPBe	----- Galerie Berggruen
FPBea	----- Hotel de Beauvais
FPBeau	----- Coll. Countess Jean de Beaumont
FPBer	----- Castel Beranger
FPBeu	----- Coll. Michel Beurdeley
FPBi	----- Coll. Henry Bing
FPBig	----- Coll. Etienne Bignon
FPBo	----- Musee Bourdelle
FPBog	----- Coll. Zhenia Bogoslavskaya
FPBr	----- Galerie Breteau
FPBre	----- Coll. Andre Breton
FPBu	----- Galerie Jean Bucher (Galerie Bucher-Myrbor)
FPC	----- Cathedral
FPCF	----- Comedie Franciase
FPCa	----- Galerie Louis Carre
FPCal	----- Coll. Meric Callery
FPCar	----- Place du Carrousel
FPCarn	----- Musee Carnavalet
FPCas	----- Coll. Jeanne Castel
FPCe	----- Musee Cernuschi
FPCh	----- Champs Elysees
FPChT	----- Theatre Champs-Elysees
FPCha	----- Galerie Chardin
FPChad	----- Coll. Dr. Paul Chadourne
FPChal	----- Hotel de Chalons-Luxembourg
FPChap	----- Sainte Chapelle
FPChapE	----- Chapelle Expiatoire
FPChi	----- Coll. Compagnie de la Chine et des Indes
FPCl	----- Musee de Cluny
FPCle	----- Galerie Iris Clert
FPCo	----- Galerie Daniel Cordier
FPCol	----- Palais des Colonies
FPCom	----- Hotel Comans d'Astry
FPCon	----- Conservatory of Arts and Crafts
FPConc	----- Place de la Concorde
FPCr	----- Galerie Creuzevault
FPD	----- Coll. Gustave Dreyfus
FPDB	----- Coll. D. B. C.
FPDa	----- Coll. Alfred Dabor
FPDav	----- Coll. David-Weill
FPDavr	----- Coll. Jean Davray
FPDe	----- St. Denis
FPDec	----- Musee des Arts Decoratifs
FPDel	----- Coll. Mr. and Mrs. Deltcheff
FPDen	----- Place Denfert-Rochereau

FPDer	Paris. Coll. Andre Derain
FPDou	----- Coll. M. Douchet
FPDr	----- Galerie du Dragon
FPDro	----- Galerie Rene Drouin
FPDrou	----- Galerie Drouant-David
FPDru	----- Galerie E. Druet
FPDu	----- Coll. Jacques Dubourg
FPE	----- Ecole des Beaux Arts
FPEn	----- Musee d'Ennery
FPEth	----- Musee Ethnographique
FPEu	----- St. Eustache
FPF	----- Coll. M. Edmond Foule
FPFa	----- Galerie Paul Facchetti
FPFe	----- Coll. Felix Feneon
FPFl	----- Galerie Karl Flinker
FPFo	----- Castel Beranger, No. 16, rue La Fontaine
FPFr	----- Galerie de France
FPFra	----- Theatre Francaise
FPFre	----- Coll. Madame Freundlich
FPFri	----- Coll. Jean Fribourg
FPFu	----- Coll. Jean Furstenberg
FPG	----- Musee Guimet
FPGH	----- Coll. Mme Roberta Gonzalez-Hartung
FPGM	----- Galerie Mai
FPGP	----- Eglise St. Gervais-et-St. Protais
FPGe	----- Benedictine Abbey St. Germain des Pres (FPStGe)
FPGeo	----- Coll. Geoffrey-Dechaume
FPGi	----- Coll. Giacometti
FPGie	----- Coll. Gieseler
FPGiv	----- Galerie Claude Givaudan
FPGo	----- Coll. Mme Roberta Gonzalez-Hartung
FPGod	----- Coll. A. Godard
FPGr	----- Coll. Pierre Granville
FPGre	----- Rue de Grenelle, Faubourt, Saint-Germain
FPGu	----- Coll. Paul Guillaume
FPH	----- Musee de l'Homme
FPHI	----- Hotel des Invalides (Les Invalides)
FPHa	----- Coll. Hans Hartung
FPHai	----- Coll. Claude Bernard Haim
FPHaj	----- Coll. Mme. Etienne Hajdn
FPHe	----- Coll. Mme Bela Hein
FPHu	----- Editions La Hune
FPHug	----- Coll. Georges Hugnet
FPI	----- Cemetery (later Square or Place) of the Innocents

FPIF	-----	Institut de France
FPInst	-----	Institute Francaise d'Afrique Noir
FPInt	-----	Galerie Internationale d'Art Contemporain
FPIo	-----	Galerie Alexandre Iolas
FPJ	-----	Coll. Edward Jonas
FPJC	-----	Jardin des Carmes
FPJu	-----	Palais de Justice
FPJur	-----	Coll. Jurtzky
FPK	-----	Coll. Daniel-Henry Kahnweiler
FPKe	-----	Coll. Georges Keller
FPKn	-----	Galerie Knoedler
FPKo	-----	Coll. Mme. Jeanne Dosnickloss-Freundlich
FPL	-----	Louvre
FPLa	-----	Cimitiere du Pere Lachaise
FPLan	-----	Coll. Landau
FPLar	-----	Galerie Jean Larcade
FPLau	-----	Coll. Mme. H. Laurens
FPLe	-----	Galerie Louis Leiris
FPLeb	-----	Coll. Robert Lebel
FPLec	-----	Coll. Olivier Le Corneur
FPLef	-----	Coll. Andre Lefebvre
FPLev	-----	Parc de Levallois
FPLeve	-----	Coll. Andre Level
FPLo	-----	Coll. Eduard Loeb
FPLoe	-----	Coll. Pierre Loeb
FPLop	-----	Coll. Arturo Lopez-Willshaw
FPLou	-----	St. Paul-St. Louis Church
FPLu	-----	Luxembourg Gallery and Gardens (Musee de Luxembourg now: Musee National d'Art Moderne)
FPM	-----	Musee National d'Art Moderne (Formerly: FPLu)
FPMM	-----	Musee National des Monuments Francais
FPMP	-----	Musee d'Art Moderne de la Ville de Paris
FPMV	-----	Coll. Mouradian and Vallotton
FPMa	-----	Galerie Maeght; Coll. Aime Maeght
FPMai	-----	Coll. Maillard
FPMal	-----	Coll. Andre Malraux
FPMar	-----	Coll. Louis Marcoussis
FPMarm	-----	Musee Marmottan
FPMaz	-----	Bibliotheque Mazarine
FPMe	-----	Cabinet des Medailles, Bibliotheque Nationale
FPMet	-----	Metro Station
FPMeti	-----	Conservatoire National des Arts et Metiers

FPMeu	Paris. Coll. Leon Meyer
FPMi	----- Late Coll. Mire
FPMic	----- Place Saint-Michel
FPMo	----- Montmartre Cemetery (FPMont)
FPMon	----- Hotel des Monnaies
FPMone	----- Musee Monetaire
FPMont	----- Cimitiere de Montparnasse; Boulevard Montparnasse
FPMontb	----- Musee de Montbrison
FPMor	----- Musee National Gustave Moreau
FPMori	----- Coll. Antony Moris
FPN	----- Notre Dame de Paris
FPNa	----- Place de la Nation
FPNo	----- Coll. Vicomtesse de Noailles
FPO	----- Place de l'Observatoire
FPOp	----- Place Le Opera; Musee de l'Opera
FPOr	----- Musee Missionnaire des Orphelins d'Anteuil
FPOrt	----- Coll. George Ortiz
FPOu	----- Musee de la France d'Outremer
FPP	----- Place de Pyramides
FPPL	----- Pere Lachaise, end of avenue
FPPM	----- Parc Monceau
FPPP	----- Musee du Petit Palais
FPPT	----- Ministry of Posts and Telecommunications
FPPa	----- Musee du Jeu de Paume
FPPal	----- Musee de Paleontologie
FPPav	----- Pavillon de Flore
FPPe	----- Coll. M. P. Peissi
FPPol	----- Coll. J. P. Polaillon
FPPr	----- Coll. Miriam Prevot
FPR	----- Musee Rodin
FPRa	----- Coll. M. and Mme. Maurice Raynal
FPRan	----- Galerie Jacqueline Ranson
FPRas	----- Coll. Rene Rasmussen
FPRasp	----- Boulevards Raspail and Montparnasse
FPRat	----- Coll. Charles Ratton
FPRay	----- Coll. Man Ray
FPRe	----- Galerie Denise Rene
FPRen	----- Renoir et Colle
FPReno	----- Coll. Renou
FPRev	----- Coll. Emery Reves
FPRi	----- Galerie Rive Droite
FPRid	----- Ridgeway Collection
FPRo	----- Coll. Henri Pierre Roche
FPRoc	----- St. Roch (FPStR)
FPRoh	----- Hotel de Rohan

FPRos	Paris. Coll. Paul Rosenberg
FPRot	----- Coll. R. de Rothschild
FPRoth	----- Coll. A. de Rothschild
FPRoths	----- Coll. Elie de Rothschild
FPRou	----- Coll. Madeleine Rousseau
FPRoyG	----- Palais Royal Gardens
FPRu	----- Coll. Lawrence Rubin
FPRud	----- Coll. E. Rudier
FPS	----- Coll. Michel Seuphor
FPSC	----- Societe Centrale Immobiliere de la Caisse des Depots
FPSa	----- Coll. George Salles
FPSc	----- Schoffer
FPSe	----- Senat
FPSi	----- Galerie Simon
FPSo	----- Church of the Sorbonne
FPSon	----- Coll. Mrs. Ileana Sonnabend
FPSor	----- The Sorbonne
FPSp	----- Coll. Darthea Speyer
FPSt	----- Galerie Stadler
FPStE	----- Sainte-Chapelle
FpStE	----- St.-Etienne-du-Mont
FPStG	----- Bibliotheque St. Genevieve
FPStGe	----- St. Germain des Pres Church (FPGe)
FPStL	----- St. Paul-St. Louis (FPLou)
FPStR	----- St. Roch (FPRou)
FPStS	----- St. Sulpice
FPStSe	----- St. Severin
FPSu	----- Hotel du Sully
FPT	----- Coll. Tristan Tzara
FPTa	----- Coll. Taillemas
FPTo	----- Palais de Tokio
FPTou	----- Pont de la Tournelle
FPTr	----- Trocadero
FPTu	----- Jardins des Tuileries
FPU	----- UNESCO Building
FPV	----- Coll. Dina Vierny
FPVG	----- Galerie Villand et Galanis
FPVa	----- Coll. de Vasselot
FPVe	----- Coll. Pierre Verite
FPVi	----- Galerie Lara Viniy
FPVic	----- Place des Victoires
FPVr	----- Hotel de la Vrilliere (Banque de France)
FPY	----- Galerie "Y"
FPZ	----- Coll. Christian Zervos
FPaM	Paray le Monial. Musee du Hieron
FPai	Paimpont. Abbey Chapel

FPar	Parthenay le Vieux
FPauM	Pauillac. Chateau Mouton-Rothschild
FPeC	Perpignan. St. Jean-le-Vieux Church
FPeCA	----- Cathedral Annex
FPeJ	----- St. Jean Cathedral
FPenM	Penne (Tarn). La Magdeleine Cave
FPenc	Pencran. Church
FPenmN	Penmarch. St. Nonna Church
FPer	Perrecy Les Forges
FPl	Pleyben
FPla	Plaimpied. Church
FPlan	Plan d'Orgon. Bouche-du-Rhone (FBouc)
FPle	Pleumeur-Bodou
FPlo	Plougastel-Daoulas
FPloeA	Ploermel. St. Armel Church
FPloub	Ploubezre
FPloug	Plougonven
FPoA	Poitiers. Musee des Antiquaires de l'Ouest
FPoB	----- Musee des Beaux-Arts
FPoC	----- St. Pierre Cathedral
FPoM	----- Mellebaude Crypt
FPoMo	----- Benedictine (Clunaic) Priory Montierneuf
FPoN	----- Collegiate Church Notre-Dame-la-Grande
FPoP	----- Palace of Jean, Duc de Berry
FPoR	----- St. Radegonde
FPolH	Poligny. St. Hippolyte Collegiate Church
FPon	Pontoise
FPontL	Pont. L'Abbe D'Arnoult
FPontT	Pont-Aven. Tremalo Chapel
FPor	Port-Royal
FPrM	Pradet. Coll. Mme. Helene de Mandrot
FPra	Prayssas
FPro	Provence
FProvH	Provins. Hopital General
FPutM	Puteaux. Mairie de Puteaux
FPutV	----- Coll. Jacques Villon
FPuyM	Puy de Dome. Benedictine (Cluniac) Abbey Mozac
FPuyN	----- Notre Dame de Puy
FPuyV	----- Benedictine (Cluniac) Priory Volvic
FRB	Rouen. Hotel du Bourgtheroulde
FRC	----- Cathedral Notre Dame
FRS	----- Musee le Secq des Tournelles
FRaC	Rampillon. Templars' Church of St. Eliphe
FRamL	Rambouillet. Laiterie de la Reine
FReB	Rennes. Musee de Bretagne

FReM	Rennes. Musee de Rennes
FRet	Retaud
FRey	Reygades
FRhA	Rheims. Musee Archeologique
FRhC	----- Notre Dame Cathedral; Musee de Cathedral
FRhL	----- Musee Lapidaire
FRhM	----- Maison des Musiciens
FRhMu	----- Musee des Beaux-Arts
FRhPl	----- Place Royale
FRhR	----- Musee Saint Remy
FRiG	Rionm. Hotel Guimoneau
FRiM	----- Museum
FRiN	----- Eglise Notre Dame du Marthuret
FRie	Rieux-Minervois
FRiq	Riquewihr
FRoC	Rodez. Notre Dame Cathedral
FRoF	----- Musee Fenaille
FRoM	----- Museum
FRon	Ronchamp
FRosN	Roscoff. Notre Dame de Croaz Baz
FRouM	Roubaix. Coll. Jean Masurel
FRousG	Rousillon. St. Genis-des-Fontaines
FRouvC	Rouvres-en-Plaine. Church
FRuB	Rueil-Malmaison. Parc de Bois-Preau
FRuM	----- Musee National de Chateau de Malmaison
FSaM	Sanguesa. St. Maria La Real
FSai	Saintes
FSal	Salers
FSali	Salignac
FSan	Chateau de Sansac
FSau	Saulieu
FSeC	Senlis. Notre Dame Cathedral
FSeM	----- Musee de Haubergier
FSeN	----- Cathedral
FSel	Selles-sur-Cher
FSemM	Semur-en-Auxois. Museum
FSemN	----- Notre Dame
FSemu	Semur en Brionnais
FSenC	Sens. Tresor de la Cathedrale
FSenM	----- Musee Principal
FSep	Sept-Saints
FSer	Chateau Serrant
FSerr	Serrabone
FSevM	Sevres. Musee National de Ceramique
FSevR	----- Coll. H. P. Roche
FSi	Sizun

FSim	Simorre
FSoM	Souillac. St. Marie
FSoN	----- Notre Dame Abbey Church
FSoi	Soissons
FSol	Solesmes. Benedictine Abbey St. Pierre
FSom	Sommery
FSor	Sorde L'Abbaye
FSouP	Souvigny. St. Pierre
FStA	St.-Germain-en-Laye. Musee des Antiquities Nationales
FStAi	St. Aignan sur Cher
FStAm	St. Amand-le-Pas
FStAn	St. Andre de Sorede
FStAv	Staint Ave. Notre Dame de Loc Chapel
FStAve	St. Aventin Church
FStBF	Saint-Benoit-sur-Loire. Benedictine Abbey Fleury
FStBe	Saint-Bertrand-de-Comminges
FStBen	St.-Benoit-sur-Loire
FStC	St. Catherine de Fierbois
FStCl	St. Claude
FStD	St. Die
FStEM	St. Etienne. Musee Municipal d'Art et d'Industrie
FStFCH	St. Fortunade Church (FCorF)
FStFl	St. Flour
FStFo	St. Fort sur Gironde
FStG	St. Germain. Musee des Antiquites Nationales au Chateau de Saint Germain en Laye
FStGB	----- Le Vesinct. Garden Eugene Rudier
FStGe	St. Genis des Fontaines
FStGen	St. Genou
FStGi	St. Gilles du Gard. Abbey Church
FStGu	St. Guilhem-le-Desert. Benedictine Abbey
FStH	St. Hermine (FHu)
FStHe	St. Herbot Church
FStJ	St. Jean de Joigny (F Joi J)
FStJA	St. Jean d'Angely
FStJLCas	St. Jean-de-Luz. Casino
FStJo	St. Jouin de Marnes
FStJu	St. Julien de Jonzy
FStJun	St. Junien
FStLC	St. Laurent. Collegiate Church
FStLo	St. Loup-de-Naud
FStME	St. Mihiel. St. Etienne
FStMM	----- St. Mihiel Church
FStMS	----- St. Sepulcre Church

FStMa	St.-Martin-de-Boscherville. Abbey Church St. Georges
FStMal	St. Malo
FStMar	St. Marie de Menez Hom
FStMi	St. Michel de Cuxa
FStMic	St. Michel d'Entroygues
FStNC	St. Nectaire. St. Nectaire Church
FStOB	St. Omer. Musee des Beaux-Arts
FStPM	St. Paul. Foundation Maeght
FStPa	St. Paul de Varax
FStPau	St. Paul de Vence
FStPaul	St. Paul Les Dax
FStPol	St. Pol de Leon
FStQL	St. Quentin. Musee Antoine Lecuyer
FStRJ	St. Remy. Julii Monument
FStRe	St. Reverien
FStRiC	St. Riquier. Abbey Church
FStS	St. Saturnin
FStSe	St. Sever
FStTh	St. Thegonnec
FStRu	St. Tugen
FStYCh	St. Yrieix. Church
FStrC	Strasbourg St. Thomas Cathedral (FStr F)
FStrCN	----- Notre Dame Cathedral
FStr F	----- Frauenhaus Museum (FStrC)
FStrM	----- Musee des Beaux-Arts
FStrMu	----- Munster
FTB	Toulouse. Hotel de Bagis
FTL	----- Musee Lapidaire
FTM	----- Museum
FTMA	----- Musee des Augustins
FTMD	----- Benedictine (Clunaic) Abbey St. Marie-la-Daurade
FTR	----- Musee Saint-Raymond
FTS	----- Saint-Sernin Church
FThM	Thouars. St. Medard Church
FThu	Thuret
FToH	Tonnerre. Hotel Dieu
FTouP	Tournus. St. Philibert Abbey
FToulV	Toulon. Hotel de Ville
FTourC	Tours. Cathedral
FTourMA	----- Musee des Antiquites
FTrA	Troyes. Musee des Beaux-Arts
FTrC	----- St. Jean Cathedral
FTrH	----- Hotel de Dieu
FTrM	Troyes. Le Madeleine
FTrN	----- St. Nizier
FTrP	----- St. Pantaleon

FTrU	Troyes. St. Urban Church
FTre	Tregunc
FTreg	Treguier
FTro	Tronoen
FTuc	Le Tuc d'Audoubert (Ariege)
FV	Versailles. Musee de Versailles
FVa	Vaux-le-Vicomte
FVal	Vallauris
FValc	Valcabrere
FValeM	Valenciennes. Musee des Beaux-Arts
FVall	Valloiros. Cistercian Abbey
FValle	Vallery (F Chan C)
FVarM	Varzy. Musee Municipal
FVareB	Varennes. Brignoles Church
FVeM	Vezelay. Abbey Church St. Madeleine
FVeMu	----- Museum
FVenT	Vendome. La Trinite
FVencR	Vence. Chapel of the Rosary
FVes	Vesin
FVia	Vienne. St. Andre-le-Bas Church
FViC	----- St. Maurice Cathedral
FViL	----- Musee Lapidaire Chretien
FViP	----- Benedictine Abbey St. Pierre deChauvigny
FVil	Villemagne
FVillC	Villeneuve-les-Avignon. Eglise Collegiale
FVillaCh	Villandry. Church
FVille	Villefranche de Rouergue
FVo	Vouvant. Notre Dame
FYG	Ydes. St. Georges Church

<div align="center">Finland</div>

FiHA	Helsinki. Atheneum Art Museum (Ateneumin Taidemuseo)
FiHK	----- National Museum of Finland (Kansallismuseo)
FiHR	----- Railroad Station
FiHV	----- Coll. Veikko Vionoja
FiKA	Kajaani. Coll. Rosa Arola
FiOP	Orivesi. Parish Church

<div align="center">Germany</div>

-GB	Coll. Rudolf Buhler
-GH	Coll. Dr. Werner Haftmann
-GS	Estate of Dr. Rosa Schapire
-GW	Coll. Dr. Clemens Weiler
GAaC	Aachen. Aachen Cathedral Treasury
GAaM	----- Minster

GAcCh	Accum, near Wilhelmshaven. Parish Church
GAl	Alpirsbach. Abbey Church
GAltT	Altoetting. Treasury of Altoetting
GAlte	Altenerding
GAm	Amorbach. Abbey Church
GAnL	Andernach. Liebfrauenkirche
GArN	Arnsberg. Musee Napoleon
GAsP	Aschaffenburg. St. Peter's
GAsS	----- Schloss Kapelle
GAuA	Augsburg. Annakirche
GAuAF	----- ----- Fugger Chapel
GAuAr	----- Former Arsenal (Armory) (GAuZ)
GAuC	----- Cathedral
GAuM	Augsburg. St. Moritz
GAuMAx	----- Maximilianstrasse; Maximiliens Museum (Staatsgalerie)
GAuR	----- Rathaus
GAuSt	----- Stadtisches Museum
GAuU	----- Church St. Ulrich and St. Afra
GAuZ	----- Zeughauses von Elias Holl (GAuAR)
GBA	Berlin. Altes Museum
GBAF	----- Academy of Fine Art
GBAnt	----- Antiquarium
GBAr	----- Arsenal (GBZ)
GBB	----- Karl Buchholz Gallery
GBBe	----- Coll. City of Berlin
GBBu	----- Buntes Theatre
GBC	----- Paul Cassirer
GBCa	----- Cathedral
GBCh	----- Charlottenburg Palace
GBCha	----- Chancellery
GBCo	----- Berlin Conservatory
GBD	----- Deutsches Museum
GBDo	----- Dortheenstadtische Kirche
GBE	----- Ethnographical Museum
GBF	----- Coll. Max Frohlich
GBFB	----- Fruhchristlich-Byzantinische Sammlung, part of GBSBe
GBFl	----- Flechtheim Gallery
GBFle	----- Coll. Alfred Flechtheim
GBFr	----- Friedrichstrasse
GBG	----- Coll. Prof. Gonda
GBH	----- Coll. Frau Hannah Hoch
GBI	----- Islamisches Museum
GBK	Berlin. Kaiser Friedrich Museum. Now: Bodemuseum, part of GBSBe
GBKam	----- Kamecke House
GBKath	----- Katholischekirche, Wansee

GBKl	Berlin. Coll. Dr. von Klemperer
GBKo	----- Georg Kolbe Museum
GBKol	----- Coll. Dr. Hans Kollwitz
GBKr	----- Coll. Hanns Krenz
GBKu	----- Kunstgewerbemuseum. Now: Bode-museum, part of GBSBe
GBL	----- Lustgarten
GBLa	----- Laurentiuskirche, Moabit
GBM	----- Berlin Museum; State Museum
GBMK	----- East Berlin Museum fur Deutsche Geschichte
GBMu	----- Berlin Munzkabinett. Now: Bode-museum, part of GBSBe
GBN	----- National Gallery
GBNa	----- Former National Museum
GBNe	----- New Museum
GBNea	----- East Berlin Nationalgaleries
GBNew	----- New People's Theatre
GBNi	----- St. Nicholas
GBO	----- Old Museum
GBOs	----- Ostasiatische-Sammlung
GBP	----- Pergamon Museum Now: Part of GBSBe
GBPO	----- Post Office
GBR	----- Royal Palace
GBRat	----- Rathaus
GBRau	----- Rauch Museum. Now: Part of GBSBe
GBRe	----- Rheingold Restaurant
GBReu	----- Coll. Kurt Reutti
GBS	----- Staatliche Museum (Ehemals Staatliche Museen, Dahlem Museum, West Berlin
GBSB	----- Staatsbibliothek
GBSBe	----- East Berlin Staatliche Museen zu Berlin
GBSBeA	----- ----- Agiptisches Museum
GBSBeM	----- ----- Munzkabinett
GBSBeV	----- ----- Vorderasiatisches Museum
GBSBeVo	----- ----- Museum fur Vokskunde
GBSM	----- Staatliche Munzsammlung
GBSS	----- Schlossmuseum (Staatliche Schlosser und Garten)
GBSc	----- Skulpturen-Sammlung. Now: Part of GBSBe
GBSch	----- Galerie Schuler
GBSe	----- Coll. Ernst Seeger
GBSp	----- Galerie Springer
GBV	----- Vorderasiatisches Museum

GBVo	Berlin. Museum fur Volkerkunde
GBW	----- Emporium Wertheim
GBWan	----- Wannsee Bathing Beach
GBWe	----- Coll. Louis Werner
GBWis	----- Coll. Dr. Wissinger
GBZ	----- Zeughaus (GBAr)
GBaB	Bamberg. Staatliche Bibliothek
GBaC	----- Cathedral
GBaE	----- Alter Ebracher Hof
GBaH	----- Historisches Museum, in Alten Hofhaltung
GBadL	Bad Salzuflen. LVA Clinic
GBadeCe	Baden-Baden. Old Cemetery
GBadeS	----- Spitalskirche
GBauS	Bautzen. Staatmuseum
GBavR	Bavaria. Pilgrimmage Church of Rohr
GBavW	----- Die Wies (GDich; GWP)
GBerS	Berchtesgaden. Schlossmuseum
GBes	Besigheim
GBiH	Biberachender Riss. Coll. Dr. Hugo Haring
GBir	Birnau. Pilgrimmage Church
GBl	Blaubeuren. Benedictine Monastery
GBoM	Bonn. Munsterkirche
GBoRL	----- Reinisches Landesmuseum
GBorCh	Borghorst. Church
GBrA	Braunschweig. Alstadt Town Hall
GBrB	----- Burgplatz
GBrC	----- Cathedral
GBrD	----- Burg Dankwarderode
GBrR	----- Rathaus
GBrSM	----- Stadtisches Museum
GBrU	----- Staatliches Herzog Anton Ulrich Museum
GBranC	Brandenburg. St. Catherine Church
GBreC	Breisach. Cathedral
GBremC	Bremen. Cathedral
GBremF	----- Focke-Museum
GBremK	----- Kunsthalle
GBremR	----- Roseliushaus
GBremU	----- Ubersee-Museum
GBruR	Brunn. Rathaus
GBuCa	Buckeburg. Castle Chapel
GBucCh	Buchau/Federsee. Former Ladies' Convent Church
GBucH	----- Hospital Chapel
GBuck	Bucken on the Weser
GCM	Cassel. Museum
GCS	----- Staatliche Kunstsammlungen

GCeS	Celle. Schloss Celle
GChS	Chemnitz. Schlosskirche
GChaS	Charlottenberg Schloss
GCiCo	Cismar. Former Convent Church
GCoA	Cologne. Antoniterkirche
GCoAA	----- Galerie Aenne Abels
GCoC	----- Cathedral
GCoCh	----- Deutz Parish Church
GCoE	----- Erzbischofliches Diozesan-Museum
GCoG	----- St. Gereon Church
GCoH	----- Hildegardis Gymnasium
GCoHa	----- Coll. Lucy Haubrick-Millowitsch
GCoJ	----- Coll. Carl Jatho
GCoK	----- St. Kunibert's
GCoKK	----- Kunstgewerbmuseum der Stadt Koln
GCoKo	----- Coll. H. Konig
GCoKu	----- Kolnischer Kunstverein
GCoM	----- St. Maria im Kapitol Church
GCoO	----- Museum fur Ostasiatische Kunst der Stadt Koln
GCoP	----- Coll. Prof. Helmut Petri
GCoPa	----- Pantaleon
GCoR	----- Rautenstrauch-Joest Museum fur Volkerkunde der Stadt Koln
GCoRat	----- Rathaus
GCoRh	----- Rheinpark
GCoRom	----- Romisch-Germanisches Museum
GCoS	----- Schnutgen-Museum, Cacilienkloster
GCoSt	----- Coll. Stein
GCoU	----- University
GCoW	----- Wallraf-Richartz Museum
GCobD	Coburg. Ducal Foundation
GCobV	----- Veste Coburg Coll. (GVeC)
GConC	Constance. Constance Cathedral
GConM	Constance. Munster
GConR	----- Rosegartenmuseum Konstanz
GCrL	Creglingen. Herrgottkirche
GDA	Dresden. Albertinum (Staatliche Kunstsamm-lungen)
GDG	----- Grunes Gewolbe
GDH	----- Hofkirche
GDM	----- Museum
GDP	----- Porzellansammlung. Part of GDA
GDS	----- Stadtische Sammlungen
GDSc	----- Schilling Museum
GDZ	----- Zwinger Palace
GDaD	Darmstadt. Deutschen Vereinsbank
GDaH	----- Hessisches Landesmuseum Darmstadt

GDaI	Darmstadt. Coll. Dr. H. J. Imela
GDaM	----- Museum Darmstadt
GDaMat	----- Mathildenhohe
GDaP	----- Porzellanschlosschen
GDaR	----- Russian Chapel
GDalP	Dalhem. Pfarrkirche
GDeH	Dentz. Heribert Church
GDetP	Detmold, Prison
GDiCh	Die Wies. Church (GBavW; GWP)
GDiesS	Diessen. Stifliskirche
GDo	Doberan
GDonF	Donaueshingen & Heilisenberg. Coll. Princes Furstenberg
GDorR	Dortmund. Reinoldkirche
GDuK	Duisberg. Wilhelm-Lehmbruck-Museum der Stadt Duisberg
GDur	Durnstein
GDusB	Dusseldorf. Coll. Bagel
GDusC	----- Coll. Clausmeyer
GDusH	Dusseldorf. Hetjensmus
GDusHa	----- Coll. Ursala Haese
GDusK	----- Kunstmuseum
GDusM	----- Museum Dusseldorf
GDusMa	----- Mannesmann-Gebaude
GDusMe	----- Herrensitz Merrerbusch
GDusMey	----- Coll. Klaus Meyer
GDusR	----- Rolandschule
GDusRG	----- Rheinische Girozentrale
GDusS	----- Bankhaus Simons
GDuSc	----- Galerie Schmel
GDusV	----- Coll. Alex Vomel
GDusmS	Dusseldorf-Mettmann. Coll. F. Schniewind
GE	Eckernforde Church
GEA	Essen--Werden. Abbey Church
GEAr	Essen. Arenberische, A. G.
GEC	----- Cathedral Treasury
GEF	----- Museum Folkwang
GEK	----- Krupp von Bohlen Residence
GEV	----- Verwaltungsgabaude, Gute-Hoffung-shutte
GEiC	Eichstatt. Cathedral
GEn	Enger
GErB	Erfurt. Bartusserkirche
GErC	----- Cathedral
GErM	----- Marienkirche
GErS	----- St. Severus Church
GErU	----- Ursuline Convent
GEssF	Esslingen. Frauenkirche

GF	Frankfurt. Stadlische Galerie
GFB	----- Bethmann's Museum
GFC	----- Galerie Daniel Cordier
GFF	----- Frankfurt Gallery
GFFarb	----- Farbenindustrie
GFFo	----- Forshungsinstitut
GFFr	----- Friedhofskapelle
GFG	----- Coll. Helmutt Goldeckemeyer
GFH	----- Museum fur Kunsthandwerk
GFK	----- Liebfrauenkirche
GFKu	----- Museum fur Kunsthandwerk
GFL	----- Liebieghaus (Stadtische Skulpturen-Sammlung)
GFM	----- Museum fur Vor-und Fruhgeschichte
GFS	----- Sindlingen
GFSt	----- Stadelsches Kunstinstitut
GFStb	----- Stadtbibliothek
GFSts	----- All Saints Church
GFV	----- Museum fur Volkerkunde
GFiCh	Fischbach. Parish Church
GFlK	Flensburg. Kunstgewerbe-Museum
GFrec	Freckenhorst
GFreiA	Freiburg im Breisgau. Augustiner Museum
GFreiC	----- Cathedral
GFreiM	----- Marienkirche
GFreiUK	----- University. Kunstgeschichtliches Institut
GFreiUL	----- ----- University Library
GFreiUP	----- ----- Physics Institute
GFreuC	Freuenstadt. Stadtkirche
GFriC	Fritzlar. Collegiate Church
GFu	Furstenfeldbruck
GFulF	Fulda. Fasanerie Palace
GFusM	Fussen. Former St. Mang Convent Church
GGL	Gotha. Library
GGLM	----- Landesmuseum
GGM	----- Gotha Museum
GGeK	Gelnhausen. Kaiserpfalz
GGeL	----- Marienkirche
GGelH	Gelsenkirchen. Haus Tollmann
GGelS	----- Schalker Gymnasium
GGelT	----- Stadttheater
GGerC	Gernrode. Collegiate Church
GGmS	Gmund. Sommer, Schwabusch
GGnC	Gnesen. Cathedral
GGoJ	Goslar. Jakobikirche
GGoK	----- Kaiserhaus
GGoM	----- Marketplace

GGoMu	Goslar. Goslarer Museum
GGoN	----- Neuwerkskirche
GGosCh	Gossweinstein. Pilgrimage Church
GGotV	Gottingen. Sammlung des Instituts fur Volkerkunde
GGrC	Gross-Camburg. Collegiate Church
GGuC	Gustrow. Cathedral
GGunM	Gunzberg. Heimatmuseum Gunzberg.
GGutP	Gutersloh. Prison
GH	Hamburg. Kunsthalle
GHB	----- Estate Hermann Blumenthal
GHBar	----- Ernst Barlach Haus
GHG	----- Coll. Dr. Guhr
GHH	----- Galerie Rudolf Hoffmann
GHK	----- Kunsthalle
GHKG	----- Museum fur Kunst und Gewerbe
GHM	----- Museum
GHP	----- Primary School Hamburg-Niendorf
GHPe	----- Church of St. Peter
GHPl	----- Planten und Blomen
GHR	----- Coll. Hermann F. Reemstma
GHS	----- Coll. Samson
GHV	----- Hamburgisches Museum fur Volker- kunde und Vorgeschichte
GHVa	----- Coll. Jan Bontjes van Beek
GHVo	----- Volkspark
GHaA	Hannover. Aegidientor Platz; Ruins of St. Aegidienkirche
GHaB	----- Galerie Dieter Brusberg
GHaBo	----- Boeckler-Allee
GHaG	----- Grupenstrasse
GHaK	----- Kestner-Museum
GHaKL	----- Museum fur Kunst und Landesgeschichte
GHaL	----- Nidersachsiche Landesgalerie
GHaM	----- Merz Building
GHaMu	----- Museum
GHaMK	----- Marketkirche
GHaN	----- Neues Haus
GHaS	----- Coll. Dr. Bernhard Sprengel
GHaSt	----- Stadtpark
GHaU	----- Union Boden
GHaW	----- Welfen-Museum
GHaWa	----- Residence, Waldhausenstrasse 5, Teil auf Nahme
GHagF	Hagen. Folkwang Museum (Now: Karl-Ernst- Osthaus Museum)
GHagO	----- Stadtiches Karl-Ernst-Osthaus Museum
GHageM	Hagenau. Museum

GHalC	Halberstadt. Cathedral (Museum)
GHalL	----- Liebfrauenkirche
GHallL	Halle. Landesmuseum fur Vorgeschichte
GHallM	----- Moritzkirche
GHallSt	----- Stadt. Museum
GHallStG	Halle. Staatliche Galerie Moritzburg
GHallgP	Hallgarten. Parish Church
GHamT	Hamborn. Coll. August Thyssen-Hutte
GHeN	Hennef. Coll. Dr. Walter Neuerburg
GHef	Heffenthal bei Axchaffenberg
GHeiA	Heidelberg. Deutsches Apotheken-Museum
GHeiC	----- Heidelberg Castle
GHeilK	Heilbronn. St. Kilian's
GHiC	Hildesheim. Cathedral
GHiG	----- St. Godehard
GHiM	----- St. Michael Church
GHiMa	----- Magdalen's Church
GHiMu	----- Museum
GHiRP	----- Roemer-Pelizaeus-Museum
GHilV	Hilden. Volksschule
GHirZ	Hirsau. St. Aurelius Kirche
GHo	Hoven. Former Convent Church
GHofCa	Hofhegnenberg. Castle Chapel
GHomS	Homburg. Schloss Homburg
GJS	Jever. Stadtkirche
GKU	Kiel. University
GKaS	Kappenberg. Schlosskirche
GKalN	Kalkar. Nikolaikirche
GKapCh	Kappenberg. Church
GKarB	Karlsruhe. Badische Landesmuseum
GKarBu	----- Bundesgartenschau
GKarH	----- Coll. Dr. Hans Himmelheber
GKoS	Konigsberg. Now: Kalingrad, USSR, since 1945. Stadtische Kunstsammlungen
GKoSc	----- Schloss
GKonC	Konigslutter. Collegiate Church
GKot	Kotzschenbroda. Church
GKrA	Krensmunster. Abbey
GKrefW	Krefeld. Kaiser Wilhelm Museum
GLB	Leipsig. Museum der Bildenden Kunste
GLBi	----- State Library
GLK	----- Kunstgewerbe Museum
GLV	----- Museum fur Volkerkunde
GLS	----- Stadtgeschichtliches Museum
GLVo	----- Volkerschlactdenkmal
GLaM	Landshut. St. Martin
GLaR	----- Residenz

GLangW	Langen. Schloss Wolfsgarten. Coll. Prince Ludwig von Hessen und bei Rhein
GLeA	Leverkusen. Alkenrath
GLeM	----- Stadtisches Museum Leverkusen, Schloss Morsbroich
GLeMa	----- Mathildenhor
GLeiM	Leisnig. Matthauskirche
GLiC	Limburg. Cathedral Treasurey
GLiD	----- Diozesan-Museum
GLichCh	Lich. Convent Church
GLoM	Lorch. Marienkirche
GLuA	Lubeck. Annenmuseum
GLuB	----- Behnhaus
GLuC	----- Katherinenkirche
GLuCa	----- Cathedral
GLuH	----- Museen der Hanestadt Lubeck
GLuM	----- Marienkirche
GLuT	----- Town Hall
GLunT	Luneberg. Town Hall
GMA	Munich. Museum Antiker Kleinkunst
GMAl	----- Albertinum
GMAlt	----- Alte Pinakothek
GMAr	----- Archaeological Seminar
GMAs	----- Asam Church (Church St. Johann Nepomuk) (GMJ)
GMB	----- Bayerische Staatsgemalesammlungen
GMBN	----- Bayerisches Nationalmuseum
GMBo	----- Coll. Bohler
GMBu	-----Bugersaal, Carmelite Church (GMH; GMM)
GMD	----- Deutsches Museum von Meisterwerken der Naturwissenschaft und Technik
GME	----- Elvira Photographic Studio
GMEt	----- Museum of Ethnography
GMF	----- Fruenkirche
GMG	----- Gliptothek (GMSA)
GMH	----- Stadt-under Kulturgeschichte Munchens, Munchener Stadtmuseum (GMStM)
GMHo	----- Hofgarten
GMJ	----- St. John Nepomuk Church (GMAs)
GMK	----- Reiche Kapelle
GML	----- Galerie van de Loo
GMLa	----- Landesversorgungsamt
GMM	----- Munich Museum (Stadtmuseum) (GMH)
GMMS	----- Staatliche Munzsammlung (GMSA)
GMMa	----- Maximilian Platz
GMMi	----- St. Michael's Church
GMN	----- Nymphenburg

GMOp	Munich. Opera House
GMP	----- St. Peter
GMR	----- Residenzmuseum
GMRC	----- Reiche Kapelle
GMRat	----- Alter Rathaussaal (GMH)
GMS	----- Staatsbibliothek
GMSA	----- Staatliche Antikensammlungen (GMG)
GMSG	----- Staatsgalerie; Neue Staatsgalerie
GMSGal	----- Stadtische Galerie im Lenbachhaus
GMSH	----- Student's Hostel
GMSM	----- Staatliche Munzsammlung
GMSch	----- Hermann Schwartz Coll.
GMSt	----- Students' House
GMStm	----- Stadtmuseum (GMH)
GMT	----- Galerie Thomas
GMU	----- University
GMV	----- Staatliches Museum fur Volkerkunde
GMVan	----- Galerie van de Loo
GMT	----- German Transport Exhibition, 1953
GMaM	Mannheim. Kunsthalle
GMaSS	----- Sammlungen des Ehemaligen Schloss- museums und Stadtgeschichtliche Sammlun- gen
GMaV	----- Volkerkundliche Sammlungen der Stadt Mannheim
GMaW	----- Wohnhaus
GMagC	Magdeburg. Cathedral
GMagK	----- Kulturhistorisches Museum
GMagM	----- Market Place
GMaiA	Mainz. Altertumsmuseum
GMaiC	----- Cathedral
GMaiH	----- Historic Museum
GMaiMu	----- Museum
GMaidP	Maidbronn. Pfarrkirche
GMarE	Marburg. Elizabethkirche
GMarU	----- Marburger Universitatsmuseum fur Kunst and Kulturgeschichte
GMari	Mariental, near Helmstedt. Convent Church
GMariaCo	Maria Laach. Convent Church
GMarl	Marl
GMau	Maulbronn. Cistercian Monastery
GMeC	Merseberg. Cathedral
GMeiC	Meissen. Cathedral
GMetB	Metten. Benedictine Convent Church
GMiC	Minden. Cathedral
GMuC	Munster. Cathedral
GMuL	----- Landesmuseum fur Kunst und Kulturgeschichte

GMur	Murrhardt
GNA	Nuremberg. All Saints Chapel, House of the Twelve Brothers
GNG	----- Germanisches Nationalmuseum
GNH	----- Holzschuler Kapelle
GNL	----- St. Lorenz
GNM	----- Moritzkapelle
GNP	----- Pellerhaus
GNR	----- Rathaus
GNS	----- Sebalduskirche
GNaC	Naumberg. Cathedral
GNeC	Nenningen. Friedhofs Kapelle
GNeuU	Neu-Ulm (GH)
GNeubM	Neubirnau. St. Mary Parish Church
GNeumH	Neumunter. Coll. Aris. Hain
GNeusM	Neuss. Marienkirche
GNevS	Neviges. Coll. Willy Schniewind
GNi	Niederrottweil
GNoG	Norlingen. Parish Church St. George
GNonC	Nonnberg. Collegiate Church
GOL	Oberwesel. Liebfrauenkirche
GObP	Obermenzing. Church of the Passion
GOlL	Oldenburg. Landesmuseum fur Kunst und Kulturgeschichte
GOlR	----- Rodenkirchen
GOlV	----- Varel Church
GOsC	Osnabruck. Cathedral
GOsR	----- Rat Haus
GOtA	Ottobeuren. Abbey Church
GPA	Paderborn. Albinghof Monastery
GPC	----- Cathedral
GPD	----- Erzbischofliches Diozosanmuseum
GPF	----- St. Francis
GPaS	Passau. St. Severin
GPoN	Potsdam. Neues Palais
GPoS	Schloss Sanssouci
GPolM	Polling. Heimatmuseum
GPrC	Pressburg (German protected state 1939-1945; Now: CzBr). Cathedral
GPreCh	Preetz. Former Convent Church
GQS	Quedlinburg. Servatius Church
GRR	Rohr. Stifelskirche
GRaJ	Ratisbon. St. Jakob
GRavC	Ravensberg. Church
GReM	Reutlingen. Marienkirche
GRecI	Recklinghausen. Ikonenmuseum
GRecS	----- Stadtische Kunsthalle
GRegC	Regensburg. St. Jacob's Cathedral

GRegE	Regensburg. St. Emmeram's
GRegN	----- Niedermunsterkirche
GRegP	----- Prufening bei Regensburg
GRegS	----- Schloss Sunching Chapel
GRei	Reichenberg
GRemR	Remscheid. Deutches Rontgen-museum
GRoJ	Rothenberg. St. James
GRoJa	----- St. Jakob
GRonR	Ronsdorf. Rathaus
GRosC	Rosheim. Parish Church
GRotL	Rottweil. Kunstsammlung Lorenzkapelle
GRott	Rott-am-Inn
GRotte	Rottenbuch
GSaW	St. Wolfgang
GSaaS	Saarbrucken. Saarlandmuseum
GSaaU	----- Universitat
GSalA	Salem. Abbey
GScC	Schleswig. Cathedral
GSch	Schoneiche. Ev. Kirche
GSchl	Schleissheim
GSieg	Siegburg. Abbey
GSigK	Sigmaringen. Kaserne
GSoP	Soest. St. Patroklus
GSonMo	Sonnenberg. Monastery
GSpC	Speyer. Cathedral
GSpP	----- Historisches Museum der Pfalz
GStA	Stuttgart. Antikensammlung
GStCh	----- Convent Church
GStF	-----Familienbesitz
GStL	----- Lindesmuseum
GStLa	----- Landtagsgebaude
GStLan	----- Landesgewerbemuseum
GStLe	----- Coll. Lehmbruck
GStLu	----- Galerie Lutz & Meyer
GStM	----- Museum
GStMu	----- Galerie Muller
GStP	----- Coll. K. G. Pfahler
GStR	----- Raichberg-Mittelschule
GStS	----- Coll. Frau Schlemmer
GStSt	----- Staatsgalerie Stuttgart
GStT	----- Coll. Dr. Thiem
GStWL	----- Wurttembergisches Landesmuseum
GStaH	Starnberg. Stadliche Heimatmuseum
GStaW	Starnberg. Wurmgau Museum
GStad	Stadthagen
GSteH	Stettin. Stadtisches Museum
GStei	Steinhausen. Church
GSteinCh	Steingaden. Pilgrimage Church

GSterR	Sterzing. Rathaus
GSti	Stift Neuberg
GStrM	Stralsund. Kulturhistorisches Museum
GStrN	----- Nicolaikirche
GStraJ	Straubing. St. Jakob
GStraU	----- Ursulinenkirche
GStre	Strehla
GTB	Trier. Bischofliches Museum
GTC	----- Domschatz Cathedral (Cathedral Treasury)
GTD	----- Dreifaltigkeitskirche
GTL	----- Liebfrauenkirche
GTP	----- Landesmuseum
GTR	----- Rheinisches Landesmuseum
GTaH	Tallim. Church of the Holy Ghost
GTe	Teutoburg Forest
GTrP	Treves. Provincial Museum (See also GTP)
GTuIU	Tubingen. Vorgeschichtliche Sammlungen des Institutes fur Vor- und Fruhgeschichte
GTuL	----- Coll. Frau Anita Lehmbruck
GTuS	----- Stiftskirche
GTutG	Tuttlingen. Gewerbeschule
GUC	Ulm. Cathedral
GUH	----- Hochbrauamt
GUM	----- Munster
GUU	Ulm. Ulmer Museum
GUbM	Uberlingen. Museum
GUbN	----- St. Nicholas
GV	Vierzehnheiligen. Pilgrim's Church
GVeC	Veste Coburg (GCobV)
GViF	Villengen. Finunzamt (Revenue Office)
GWLM	Wiesbaden. Landesmuseum
GWP	Wies. Pilgrim Church (GBavW)
GWa	Waldessen, Bavarian Forest
GWeA	Werden-Essen. Abbey Church
GWecS	Wechselburg. Schlosskirche
GWeiG	Weimar. Goethehaus
GWeikS	Weikersheim. Schloss Weikersheim
GWeinCh	Weingarten. Convent Church
GWeisCh	Weissenregen. Pilgrimage Church
GWelC	Weltenburg. Convent Church
GWelM	----- Monastery Church
GWes	Westerwald
GWeyC	Weyarn. Ehemalige Klosterkirche (Church of the Augustinian Canons)
GWiM	Wismar. St. Mary's
GWic	Wickrath
GWieL	Wiesbaden. Landesmuseum

GWieSA	Wiesbaden. Stadtisches Museum Wiesbaden
GWienCo	Wienhausen. Convent Church
GWiesCh	Wies. Pilgrimage Church (GBavW)
GWoC	Worms. Cathedral
GWuB	Wurzburg. Bergerspital
GWuC	----- Cathedral
GWuE	----- Erbach Monastery
GWuH	Wurttemberg. Hohenzollern Burgkappele
GWUL	----- Luitpold Museum
GWuM	----- Marienkirche
GWuMai	----- Mainfranisches Museum (GWuR)
GWuN	----- Neumunster
GWuP	----- Residenz
GWuPG	----- Palace Gardens
GWuR	----- Otto-Richter-Halle der Freunde Main-frankisher Kunst and Geschichte
GWuV	----- Veitschochheim
GWuW	----- Martin von Wagner-Museum der Universitat Wurzburg
GWupJ	Wuppertal. Coll. R. Jahrling
GWupM	----- Von der Heydt-Museum der Stadt Wuppertal
GWupZ	----- Coll. Dr. Ferdinand Ziersch
GWurP	Wurzach. Residenz
GXC	Xanten. Collegiate Church
GZR	Zwenkau. Dr. Raabe House
GZer	Zerstort
GZuCh	Sweifalten. Convent Church

Ghana

GhA	Accra

Greece

GrAA	Athens. Acropolis; Acropolis Museum
GrAAG	----- Agora Museum
GrAAm	----- American School of Classical Studies
GrABy	----- Byzantine Museum
GrAC	----- Ceramics Museum (GrAK)
GrADip	----- Dipylon
GrAE	----- Erechtheum
GrAF	----- Ecole Francaise d'Athenes
GrAG	----- German Archaeological Institute
GrAK	----- Museum of Old Athens, and Museum of Keramaikos GrAK)
GrAM	----- Museum
GrAN	Athens. National Museum
GrANA	----- National Archaeological Museum
GrAP	----- Parthenon
GrAPa	----- Coll. E. Papastratos
GrAS	----- Stoa of Attalos Museum

GrAT	Athens. Theatre
GrCM	Corfu. Museum
GrCP	----- Royal Palace Museum
GrCAM	Candia. Candia Museum
GrChM	Chalcis. Chalcis Museum
GrCo	Cos. Museum
GrCorA	Corinth. Archaeological Museum
GrCyA	Cyrene. Museum of Antiquities
GrDM	Delphi. Delphi Museum
GrDeC	Delos. House of Cleopatra and Dioscourides
GrDeF	----- Temple of Good Fortune
GrDeM	----- Museum
GrDi	Didyma
GrElM	Eleusis. Eleusis Museum
GrEpM	Epidaurus. Epidaurus Museum
GrFH	Foce del Sele. Temple of Here
GrHA	Heraclion. Archaeological Museum
GrHM	----- Museum
GrKA	Korkyra. Temple of Artemis
GrKM	Korkyra. Museum
GrKavM	Kavalla. Kavalla Museum
GrKeA	Keos. Temple at Ayia Irini
GrKnM	Knossos. Palace of Minos
GrLyM	Lycosura. Lycosura Museum
GrMy	Mycenae
GrMycA	Mykonos. Archaeological Museum
GrNM	Nauplion. Archaeological Museum
GrOM	Olympia. Olympia Museum
GrOZ	----- Temple of Zeus
GrPM	Piraeus. Archaeological Museum
GrRA	Rhodes. Archaeological Museum
GrRM	----- Museum
GrSaA	Salonica. Archaeological Museum (See also GrTheA)
GrSaD	----- Hagios Dimitrios
GrSaG	----- Arch of Galerius
GrSamM	Samos. Samos Museum
GrSamT	----- Tigani Museum
GrSamV	----- Vathy Museum
GrSpM	Sparta. Archaeological Museum
GrTeM	Tegea. Tegea Museum
GrTenM	Tenos. Museum
GrThM	Thasos. Museum
GrTheA	Thessaloniki. Archaeological Museum (See also GrSaA)
GrTiM	Tigani. Museum
GrVM	Vathy. Museum

	Guatemala
Gu GN	Guatemala City. Museo Nacional de Arqueologia y Entologia
Gu La	La Amelia
Gu P	Piedras Negras
GuQ	Quirigua
GuTP	Tikal. University of Pennsylvania Museum
GuY	Yaxchilan

	Hungary
HBA	Budapest. Museum of Fine Arts
HBB	----- Burg
HBBP	----- Budapest City Park
HBBu	----- Budaorsi Street
HBD	----- Gyorgy Dozsa Street
HBG	----- Gellertberg
HBJ	----- Attila Jozsef Platz
HBK	----- Lajos Kossuth Platz
HBKf	----- Kerepsi Friedhof
HBM	----- Matthias Church
HBMA	----- Museum of Authors
HBMa	----- Margaret Island
HBNG	----- Magyar Nemzeti Galeria
HBNM	----- Magyar Nemzeti Museum
HBP	----- Petofi Platz
HBS	----- Stalin Platz
HBV	----- Varmuzeum
HBa	Baja
HC	Cluj
HDCa	Debrecen. Calvinist Church
HEC	Eztergom. Cathedral (Treasury)
HEg	Eger
HJC	Jak. Church
HJa	Jaszbereny
HNK	Nagatetny. Kastelymuzeum
HPD	Pecs. Dommuzeum
HSz	Szekesfahervar
HVi	Visegrad

	Haiti
HaP	Port-au-Prince

	Honduras
HoC	Copan

	Hong Kong
HonC	Hong Kong. Coll. J. D. Chen

-IF	Coll. Franchi
-IR	Coll. Marchese Rainieri Pao Lucci de Calboli
-IRe	Regina Madre
IAC	Agrigento. Agrigento Cathedral
IAM	----- Museo Civico Archeologico
IacL	Acqui. Coll. Otto Lenghi
IAeG	Aegadian Islands. Grotta di Levanzo
IAlM	Altomonte Calabro. Chiesa Madre
IAnM	Anagni. Cathedral Santa Maria
IAncL	Ancona. Loggia della Mercanzia
IAncM	----- Santa Maria della Piazza
IAoO	Aosta. Collegiate Church Sant'Orso
IApA	Apulia. Acerenza Cathedral
IApL	----- Lucera Cathedral (Treasure)
IAqB	Aquila. St. Bernardino
IAqM	----- Museo
IArC	Arezzo. Cathedral
IArM	----- Parish Church St. Maria Assunta e San Donato
IArP	----- Pinacoteca e Museo Medioevale e Moderno
IArPi	----- Pieve
IAsF	Assisi. St. Francesco
IAsM	----- St. Maria degli Angeli
IAscS	Ascanio Senese. Museo d'Arte Sacra
IAtB	Atrani. San Salvatore di Bireto Church
IAvT	Avezzano. Villa Torlonia
IB	Barzio. Museo di Barzio
IBR	Barzia. Museo Rosso
IBSC	Borgo San Dalmazzo. Cemetery
IBaM	Bari. Museo Communale
IBaN	----- Basilica Sannicola
IBaP	----- Cathedral San Nicola Pellegrino
IBaS	----- Cathedral San Sabino
IBagP	Bagheria. Villa Palagonia
IBai	Baiae
IBarA	Barletta. San Andrea Church
IBarCo	----- Museo e Pinacoteca Communale
IBarM	----- St. Maria Maggiore
IBarMN	----- National Museum
IBardM	Bardo. Musee National
IBargC	Barga. Cathedral San Cristofano
IBarzR	Barzio. Medardo Rosso Museo
IBe	Benevento
IBeB	Bergamo. Baptistry
IBeC	Benevento. Cathedral

IBerBi	Bergamo. Biblioteco Civica
IBerC	----- Colleoni Chapel
IBerM	----- S. Maria Maggiori
IBiV	Bitonto. Cathedral San Valentino
IBoA	Bologna. Archiginnasio
IBoC	----- Museo Civico
IBoCas	----- Coll. Countess Avia Castelli
IBoD	----- San Domenico Maggiore
IBoF	----- San Francesco
IBoM	----- S. Maria della Vita
IBoMS	----- S. Maria dei Servi
IBoN	----- Piazza del Nettuno
IBoP	----- Basilica di San Petronio
IBoPa	----- San Paolo
IBobC	Bobbio. San Colombano
IBolM	Bolzano. San Martino
IBolS	----- Staalliche Museen
IBolbG	Bolbec. Gardens
IBolsC	Bolsena. Antiquarium della Chiesa di Santa Cristina
IBomM	Bominaco. Parrochiale Santa Maria
IBomaO	Bomarzo, near Viterbo. Orisisin Palace
IBorC	Borgo. San Donnino Cathedral (IFidC)
IBrM	Brescia. Brescia Museum
IBrMC	----- Civico Museo dell'Eta Cristiana
IBrMV	----- Santa Maria de Vincoli
IBrMa	----- Coll. Luigi Marzoli
IBrS	----- Benedictine Abbey San Salvatore
IBriB	Brindisi. Benedictine Church San Benedetto
IBriL	----- Basilian Church Santa Lucia
IBuF	Buscate. Coll. Egone Fischi
ICC	Casentino. Chiesa Maggiore
ICaM	Capua. Museo Provinciale Compano
ICadC	Cadenabbio. Villa Carlotta
ICadu	Caduti
ICae	Caere
ICagC	Cagliari. Cathedral
ICagM	----- Museo Archeologico Nazionale
ICanP	Canosa di Puglia. Cathedral San Sabino
ICao	Caorle
ICasC	Castelvetrano. Museo Selinuntino
ICaseC	(Caserta. Great Cascade
ICaseP	(----- Palazzo Reale
ICasoC	Casole d'Elsa. Cathedral
ICeM	Cesena. Biblioteca Malatestiana e Raccolte Communali
IChT	Chieti. Cathedral Santi Tomaso e Giustino
IChiE	Chiusi. Museo Etrusco

ICi	Cividale del Friuli. Tempietto longobardo di Santa Maria in Valle
ICiB	----- Baptistry
ICiD	----- Cathedral San Donato
ICiM	----- S. Maria della Valle
ICiMa	----- S. Martino
ICivCM	Civitale, Castellana. Cathedral S. Maria
ICoC	Cosenza. Cosenza Cathedral
IComC	Como. Cathedral
IComP	----- Coll. Parizzi
IComVC	----- Villa Carlotta
ICorC	Cortona. Museo Civico
ICorE	----- Museo dell'Accademia Etrusca
ICorF	----- St. Francis Church
ICrC	Cremona. Cathedral
IEC	Empoli. Collegiate
IFA	Florence. Galleria dell'Accademia
IFAnn	----- SS. and Piazza Annunziata
IFAr	----- Museo Archeologico di Firenze
IFArg	----- Museo degli Argenti
IFB	----- Galleria Buonarroti
IFBL	----- Biblioteca Laurenziana
IFBN	----- Biblioteca Nazionale Centrale
IMBad	----- Badia
IFBap	----- San Giovanni Baptistry
IFBar	----- Bargello (See also IFMN)
IFBard	----- Museo Bardini
IFBe	----- Coll. Bernard Berenson
IFBo	----- Boboli Gardens
IFBon	----- Coll. Count Contini Bonacossi
IFBu	----- Coll. Marchese Bufalini
IFC	----- S. Maria del Fiore Campanile
IFCO	----- Museo dell'Opera del Duomo (See also IFOp)
IFCas	----- Villa Castello
IFCh	----- Chiesa del Carmine
IFCl	----- Clercq Coll.
IFCol	----- Societa Columbaria
IFCr	----- Santa Croce
IFD	----- Officina Pietre Dure
IFDa	----- Palazzo Davanzati
IFE	----- English Cemetery
IFEg	----- S. Egidio
IFF	----- Cathedral S. Maria del Fiore
IFFP	----- San Francesco da Paolo
IFFr	----- Palazzo della Fraternita
IFG	----- Giotto's Tower
IFGa	----- S. Gaetano

IFGh	Florence. Palazzo Gherardesca
IFGo	----- Palazzo Gondi
IFGu	----- Palazzo Guicciardini
IFH	----- Coll. Mrs. Elisabeth Brewster-Hildebrand
IFI	----- Ospedale degli Innocenti
IFJ	----- Borgo San Jacopo
IFL	----- Loggia dei Lanzi
IFLo	----- San Lorenzo (IFMe)
IFLor	----- Piazza San Lorenzo
IFLu	----- Lungarno Serristori
IFMA	----- S. Maria degli Angioli
IFMF	----- Museo di S. Maria del Fiore
IFMN	----- Museo Nazionale (See also IFBar)
IFMNA	----- Museo Nazionale di Antropologia
IFMO	----- Museo dell'Opera
IFMa	----- San Marco
IFMar	----- S. Maria Novella
IFMe	----- Medici Chapel, San Lorenzo (IFLo)
IFMi	----- Basilica de San Miniato al Monte
IFMich	----- Or San Michele (IFO)
IFMis	----- Misericordia
IFMo	----- Church of the Madonna dell'Impruneta, Chapel of the Holy Cross
IFMod	----- Galleria d'Arte Moderna
IFMon	----- R. Di Montalvo Coll.
IFO	----- Orsanmichele (IFMich)
IFOp	----- Museo dell'Opera del Duomo (See also IFCO)
IFP	----- Palazzo Pitti
IFPC	----- Pazzi Chapel
IFPG	----- Porta S. Giorgio
IFPa	----- Palazzo Panciatichi
IFPal	----- Galleria Palatina
IFPao	----- Hospital of S. Paolo
IFPe	----- Villa della Petraia
IFPoT	----- Ponte Santa Trinita
IFR	----- Railway Station
IFS	----- Palazzo Strozzi
IFSi	----- Piazza della Signoria
IFSp	----- S. Spirito
IFT	----- Santa Trinita
IFTr	----- Coll. Leone Traverso
IFU	----- Galleria degli Uffizi
IFV	----- Palazzo Vecchio
IFVia	----- Via dell'Angelo
IFViaC	----- Via Cavour

IFaC	Faenza. Cathedral
IFeG	Ferrara. Cathedral San Giorgio
IFeMA	----- Museo Archeologico Nazionale
IFeMC	----- Museo della Cattedrale (IFeG)
IFeS	----- Palazzo Schifanoia
IFerP	Ferentillo. Abbey S. Pietro
IFiB	Fiesole. Museo Bandini
IFiC	----- Cathedral
IFiD	----- Villa Dupre
IFiM	----- S. Maria Primerana
IFidC	Fidenza. Cathedral (IBorC)
IFoF	Folgino. Cathedral S. Feliciano e Messalina
IFogL	Foggia (Near). Abbey Church San Leonardo di Siponto
IFogM	----- Cathedral S. Maria Icona Vetere
IFoglCh	Fogliano. Parish Church
IForB	Forli. S. Biagio
IForP	----- S. Pellegrino
IForPC	----- Pinacoteca Communale
IFosC	Fossombrone. Cathedral
IFr	Frasiarolo Lomellina
IGP	Gropina. Parish Church San Pietro
IGaM	Gaeta. Cathedral S. Maria Assunta
IGeA	Gela. Gela Antiquario
IGenC	Genoa. San Lorenzo Cathedral
IGenI	----- Via degli Indoratori
IGenM	----- S. Maria di Carignano
IGenU	----- University
IGrA	Grottaferrata. Abbey
IGuR	Guastalla. Piazza Roma
IGubD	Gubbio. Ducal Palace
IIO	Ivrea. Coll. Centro Olivetti
ILaC	Lake Como. Villa Carlotta
ILaOG	Lake Orta. San Giulio
ILaVM	La Verna. Chiesa Maggiori
ILaVaM	La Valletta. Museum
ILeC	Lecce. Santa Croce
ILeN	----- Santi Niccolo e Cataldo
ILegP	Legnano. Coll. Franco Pensotti
ILeghD	Leghorn. Piazza della Darsena
ILoB	Lodi. Cathedral San Bassiano
ILorC	Loreto. Basilica della Santa Casa
ILuC	Lucca. Duomo San Martino
ILuCiv	----- Museo Civico
ILuF	----- San Frediano Church
ILuP	----- Pinacoteca
ILuR	----- San Romano
ILuSG	----- SS. Simone e Giuda

ILucL	Lucina. San Lorenzo
ILugM	Lugnano in Teverina. Parish Church Santa Maria Assunta
ILugT	----- Coll. Baron H. H. Thyssen-Bornemisza
IMA	Milan. Basilica Sant'Ambrogio
IMAM	----- Civica Galleria d'Arte Moderna
IMAP	----- Arco della Pace
IMAr	----- Galleria dell'Ariete
IMB	----- Pinacoteca di Brera
IMBa	----- Banca Commerciale
IMBo	----- Boschi Coll.
IMBro	----- Galleria Borromini
IMC	----- Tesoro del Duomo (Opera del Duomo)
IMCa	----- Coll. Cardazzo
IMCe	----- Milan Cemetery
IMCi	----- Museo Civico
IMCiA	----- Museo Civico Archeologico
IMCin	----- Piazzale delle Cinque Giornate
IME	----- S. Eustorgio
IMF	----- French Institute
IMFi	----- E. Fischi Coll.
IMGa	----- Coll. J. Gabriolo
IMGal	----- Galleria dell'Ariete
IMGi	----- Coll. Giampiero Giani
IMGr	----- Galleria del Grattacielo
IMI	----- Industrial Fair
IMJ	----- Palace of Justice
IMJe	----- Coll. Emilio Jesi
IMJu	----- Coll. Jucker
IML	----- Coll. Mrs. Alice Lampugnani
IMLo	----- Galleria Lorenzelli
IMLor	----- Lorenzin Coll.
IMLu	----- Coll. Antonio Lucchetti
IMM	----- Coll. Gianni Mattioli
IMMG	----- Sta. Maria delle Grazie
IMMa	----- Coll. Paolo Marinotti
IMMar	----- S. Maria Presso S. Celso
IMMi	----- Galleria del Milione
IMN	----- San Nazaro Maggiore
IMNav	----- Galleria del Naviglio
IMO	----- Casa degli Omenon
IMP	----- Museo Poldi Pezzoli
IMPa	----- Coll. Adriano Pallini
IMPan	----- Coll. Conte Giuseppe Panza di Biumo
IMPe	----- Coll. Carlo Peroni
IMR	----- Coll. R. M.
IMRC	----- Coll. R. C.
IMRa	Milan. Coll. Aldo Ravelli

IMRo	Milan. Coll. Rocca
IMS	----- Museo del Castello Sforzesco
IMSa	----- Sacristy S. Satiro
IMSc	----- Galleria Schwarz
IMT	----- 9th Triennale of Milan
IMTon	----- Toninelli Arte Moderna
IMW	----- Coll. Francesco Wildt
IMagM	Magliano de'Marsi (near). Abbey Church S. Maria in Valle Porclaneta
IManA	Mantua. Sant'Andrea
IManB	----- Broletta
IManD	----- Galleria e Museo di Palazzo Ducale (Palazzo de Te)
IMarA	Marzobotto. Antiquarium
IMasC	Massa Marittima. Cathedral
IMatB	Matera. S. Giovanni Battista Church
IMazC	Mazzaro del Vallo. Cathedral
IMeC	Messina. Messina Cathedral
IMeD	----- Piazza del Duomo
IMeDo	----- Coll. Donato
IMeMN	----- Museo Nazionale
IMedM	Medina de Rioseco. S. Maria
IMo	Modena. Cathedral San Geminiano; Museo del Duomo
IMoE	----- Galleria, Museo e Medagliere Estense
IMoG	----- Gallery
IMoGi	----- San Giovanni Battista
IMoM	----- Museum
IMonC	Monza. Monza Cathedral Treasury
IMonoP	Monopoli. Cathedral San Pietro
IMonrB	Monreale. Benedictine Cloister
IMonrC	----- Cathedral S. Maria la Nuova
IMons	Monselice
IMontC	Montepulciano. Cathedral
IMtAL	Mt. Athos. Monastery of Lavra
IMu	Murano
IMugM	Mugnano. S. Michele
INA	Naples. S. Angelo a Nilo Church
INAn	----- S. Anna dei Lombardi
INAr	----- Arche of Alphonso of Aragon
INC	----- S. Chiara
INCa	----- Castelnuovo
IND	----- S. Domenico Maggiore
ING	----- S. Giacomo degli Spagnuoli
INGal	----- Galleria Nazionale
INGio	----- S. Giovanni a Carbonara
INL	----- S. Lorenzo Maggiore
INM	----- S. Maria Donna Regina

INMA	Naples. Museo Archeologico Nazionale
INMC	----- Museo e Gallerie Nazionali di Capodimonte
INMCap	----- S. Maria a Capella Vecchia
INMG	----- S. Maria delle Grazia Coponapoli
INMM	----- S. Maria Materdomini
INMO	----- Monte Oliveto
INMP	----- S. Maria del Parto
INMar	----- S. Martino
INN	----- Museo Nazionale
INNM	----- Naples Museum
INO	----- Monte Oliveto
INP	----- Monte di Pieta
INS	----- Capella Sansevero de'Sangri
INSe	----- S. Severo
INaM	Nardo. Cathedral S. Maria
INeA	Nuttuno. American Cemetery
INoG	Novara. Basilica S. Giulio
IOM	Olympia. Museum of Olympia
IOrC	Orvieto. Cathedral
IOrD	----- S. Domenico
IOrF	----- S. Francesco
IOrM	----- Museo dell'Opera del Duomo
IOsM	Ostia. Museum
IOsO	----- Museo Ostiense
IOsS	----- Museo degli Scavi
IPA	Padua. Arena Chapel
IPAn	----- St. Anthony Church
IPC	----- Museo Civico di Padova
IPE	----- Eremitani (See also IPadE)
IPS	----- Piazza del Santo (IPSA)
IPSa	----- Santo
IPSA	----- Basilica Sant'Antonio (IPS)
IPaB	Parma. Baptistry
IPaM	----- Cathedral S. Maria Assunta
IPaMA	----- Museo Nazionale di Antichita
IPadC	----- Duomo
IPadE	----- Eremitani (See also IPE)
IPadS	----- Santo
IPadU	----- Universita degli Studi
IPaeM	Paestum. Museo Archeologico Nazionale
IPalA	Palermo. Cave of Addaura, Monte Pelligrino
IPalAg	----- S. Agostino
IPalC	----- Museo Civico
IPalD	----- D. Domenico
IPalF	----- S. Francesco
IPalG	----- Convento della Gancia

IPalL	Palermo. Oratory San Lorenzo
IPalM	----- Museo Nazionale
IPalO	----- Oratorio del Rosario
IPalP	----- Piazza Pretorio
IPalR	----- Palazzo Reale. Cappella Palatino
IPalT	----- Ente Provinciale per il Turismo
IPaleR	Palestrina. S. Rosalie Church
IParB	Parma. Baptistry San Giovanni (IPaB)
IParC	----- Cathedral (IPaC)
IPavCe	Pavia. Museo della Certosa
IPavL	----- S. Lanfranco
IPavM	----- S. Michele
IPavP	----- S. Petro in Ciel d'Oro Church
IPeA	Perugia. Museo Archeologico Nazionale dell' Umbria
IPeB	----- San Bernardino Oratory
IPeCiv	----- Museo Civico
IPeG	----- Galleria Nazionale dell'Umbria
IPePf	----- Piazza IV Novembre
IPeU	----- University
IPeV	----- Volumnii Tomb
IPerCh	Peretola. Parish Church
IPesD	Pesaro. S. Domenico
IPetG	Petrella, Tifernina. S. Giorgio
IPiA	Pistoia. S. Andrea
IPiB	----- S. Bartolomeo in Pantano
IPiC	----- Cathedral
IPiF	Pistoia. S. Giovanni Fuorcivitas
IPiO	----- Ospedale del Ceppo
IPiaM	Pianella. S. Maria Maggiore
IPiacC	Piacenza. Piazza Cavalli
IPiacM	----- Cathedral S. Maria Assunta
IPietC	Pietrasanta. Cathedral
IPisaB	Pisa. Baptistry (IPisaC)
IPisaC	----- Cathedral S. Maria (IPisaCam)
IPisaCa	----- S. Caterina
IPisaCam	----- Camposanto (IPisaC)
IPisaCar	----- Coll. Carozzi
IPisaMC	----- Museo Civico
IPisaMN	----- Museo Nacional
IPisaMS	----- S. Maria della Spina
IPoM	Pomposa. Abbey Church S. Maria di Pomposa
IPogM	Poggio. Medici Villa
IPolA	Pola. Augustus Temple
IPomA	Pompeii. Antiquario
IPosC	Possagno. Museo Canoviano
IPrC	Prato. Cathedral

IPrD	Prato. Duomo
IPrDe	----- Villa Demidoff
IPrM	----- Museo Communale
IPrMC	----- S. Maria in Carceri
IPraM	Pratolini. Villa Medici
IRA	Rome. S. Agostino
IRAM	----- Augustus Mausoleum
IRAP	----- Ara Pacis Augustae
IRAf	----- Museo Africano
IRAg	----- S. Agnese in Piazza Navona
IRAgr	----- Agricultural Fair, 1953
IRAj	----- Coll. Marquis d'Ajeta
IRAl	----- Villa Albani
IRAle	----- S. Alessio on Aventine
IRAn	----- Antiquarium Communale
IRAnd	----- S. Andrea al Quirinale Church
IRAndr	----- S. Andrea delle Fratte
IRAndrV	----- S. Andrea delle Valle
IRAp	----- SS. Apolstoli
IRAr	----- Argentarii Arch, Forum Boarium
IRArd	----- Cave Ardeatine
IRArt	----- Galleria Nazionale d'Arte Moderna
IRArtC	----- Galleria Nazionale d'Arte Contemporanea
IRAt	----- Galleria l'Attico
IRAte	----- Aterii Mausoleum, Via Labicana
IRB	----- Galleria (Villa) Borghese
IRBa	----- Coll. Luce Balla
IrBal	----- S. Balbina
IRBar	----- Galeria Nazionale Palazzo Barberini
IRBara	----- Coll. Barracco
IRBarb	----- Piazza Barberini
IRBarbe	----- Coll. Prince Urbano Barberini
IRBarn	----- S. Bernardino alle Terme
IRBarr	----- Museo Barracco
IRBer	----- S. Bernardino alle Terme (IRBarn)
IRBi	----- S. Bibiana Church
IRBie	----- Coll. Baron Marschall von Beiberstein
IRBoc	----- Piazza Bocca della Verita
IRC	----- Museo Capitolino
IRCa	----- Piazza del Campidoglio
IRCae	----- Palazzo Caetani
IRCap	----- Capitoline Hill
IRCapit	----- Capitol
IRCar	----- S. Carlo alle Quattro Fontane
IRCat	----- Museum of Praetexta Catacomb
IRCath	----- S. Caterina da Siena
IRCe	----- Cardinal's Church S. Cesareo
IRCec	----- S. Cecelia Church

IRChi	Rome. Museo Chiaramonti
IRChia	----- Coll. Michelangelo Chiaserotti
IRCiR	----- Museo della Civilta Romana
IRCl	----- S. Clemente
IRCo	----- Palazzo dei Conservatori (IRC)
IRCoB	----- Conservatore Braccio Nuovo
IRCol	----- Coll. Princes Colonna
IRColo	----- Piazza Colonna
IRCon	----- Constantine Arch
IRCor	----- Galleria Corsini
IRCos	----- S. Costanza
IRD	----- Palazzo Doria
IRDi	----- Diocletian Bath
IRF	----- Museo del Foro
IRFAO	----- FAO (Food and Agriculture Organization) Headquarters
IRFa	----- Fascist Revolution Exhibition Hall
IRFo	----- Antiquario Forense
IRFr	----- S. Francesco a Ripa Church
IRFra	----- Coll. Franchetti
IRG	----- Coll. Riccardo Gualino
IRGe	----- Il Gesu Church
IRGeM	----- Gesu e Maria Church
IRGes	----- Museo dei Gessi
IRGi	----- Museo Nazionale di Villa Giulia
IRGio	----- S. Giovanni in Laterano
IRGiof	----- Coll. Avvi Candeloro Gioffre
IRGiu	----- Coll. Riccardo del Giudice
IRGr	----- S. Gregorio al Celio
IRH	----- Hadrian's Villa
IRI	----- S. Ignazio Church
IRJ	----- S. John Lateran (IRGio)
IRK	----- K. L. M. Ticket Office
IRL	----- Lateran Museum
IRLC	----- Museo Lateranense Cristiano
IRLP	----- Museo Profano Lateranense
IRLa	----- Lanceolotti Palace
IRLat	----- Galleria L'Attico
IRLo	----- S. Lorenzo Fuori le Mura
IRLor	----- S. Lorenzo in Lucina
IRLu	----- Coll. Luigi de Luca
IRLud	----- Villa Ludovisi
IRM	----- S. Maria in Aracoeli
IRMA	----- S. Maria Antiqua
IRMAn	----- S. Maria degli Angeli
IRMAni	----- S. Maria dell'Anima
IRME	----- Museo della Antichita Etrusco-Italiche
IRML	----- S. Maria di Loreto

IRMM	Rome. S. Maria Spora Minerva
IRMMag	----- S. Maria Maggiore
IRMN	----- Museo Nazionale
IRMP	----- S. Maria del Popolo (IRPo)
IRMPa	----- S. Maria della Pace
IRMV	----- S. Maria della Vittoria (IRVi)
IRMa	----- Palazzo Massimi
IRMar	----- Coll. Signora Germane Marucelli
IRMarc	----- S. Marcello Church
IRMari	----- Coll. Benedetta Marinetti
IRMarl	----- Marlborough Gallery
IRMart	----- Coll. Mrs. Brigida Martini
IRMat	----- Piazza Mattei
IRMaz	----- Coll. Nattale Mazzola
IRMe	----- La Medusa
IRMo	----- Galleria Nazionale d'Arte Moderna
IRMoP	----- Cappella Monte di Pieta
IRMos	----- Mostra Augustea
IRMu	----- Museo Mussolini
IRN	----- Galleria Nazionale d'Arte Moderna
IRNC	----- Museo Nuovo Capitolino
IRNa	----- Piazza Navona
IRO	----- Galleria Odyssia
IROS	----- Ospedale di S. Spirito
IROb	----- Obelisco Galleria d'Arte
IRP	----- St. Peter's
IRPA	----- Ponte S. Angelo
IRPM	----- Formerly Ponte Molle
IRPa	----- S. Paolo fuori la Mura
IRPam	----- Coll. Pamphili
IRPe	----- Museo Petriano
IRPi	----- S. Pietro in Vincoli
IRPiM	----- S. Pietro in Montorio
IRPig	----- Pigorini Museum
IRPo	----- S. Maria del Popolo (IRMP)
IRPog	----- Coll. Sergio Pogliani
IRPol	----- Palazzo Poli
IRPr	----- Museo Nazionale Preistorico ed Etnografico Luigi Pigorini
IRR	----- Palazzo Riccardi
IRRi	----- Via di Ripetta
IRRh	----- Knights of Rhodes Loggia
IRRo	----- Museo di Roma
IRRr	----- New Railroad Station
IRS	----- Galleri Schneider
IRSa	----- Santa Sabina
IRSac	----- Palazzo Sacchetti
IRSal	----- Galleria La Salita

IRuM	Ruvo di Puglia. S. Maria Cathedral
ISA	Siena. Museo Archeologico
ISB	----- Baptistry of St. John (ISG)
ISC	----- Opera del Duomo (Cathedral Museum)
ISCL	----- Cathedral Library
ISCa	----- Oratory S. Caterina
ISD	----- S. Domenico
ISF	----- Fonte Gaja
ISG	----- S. Giovanni (ISB)
ISL	----- Public Library
ISM	----- S. Maria della Scalla (ISoS)
ISMa	----- San Martino
ISO	----- Osservanza
ISOs	----- Chiesa dell'Ospedale (ISM)
ISP	----- Palazzo Publico
ISPC	----- Piazza del Campo
ISPN	----- Pinacoteca Nazionale di Siena
ISPa	----- Loggia di S. Paolo
ISPi	----- S. Pietro Ovile
ISaC	Salerno. Cathedral S. Maria degli Angeli
ISal	Salo. Commune
ISanFC	San Frediano. Parish Church S. Cassiano
ISanR	San Remo
ISang	San Giulio
ISarF	Sarzana. S. Francesco
IScP	Scarperia, near Florence. Prepositura
ISeP	Sessa Aurunga. Cathedral S. Pietro
ISeg	Segesta
ISo	Solferino
ISpC	Spoleto. Cathedral
ISpE	----- S. Eufemia Church
ISpM	----- Cathedral S. Maria Assunta
ISpMC	----- Museo Civico
ISpP	----- Monastery Church S. Pietro
ISpeM	Sperlonga. Museo Archeologico della Grotto di Tiberio
IStG	S. Gabrial
IStGi	S. Gimignano (Siena). Museo d'Arte Sacra, Basilica Collegiata di S. Maria
ISuC	Susa. Cathedral Treasury
ISyA	Syracuse. Palazzolo Acreide
ISyM	----- Museo Archeologico Nazionale
ISyAr	----- Museo Medioevale, Palazzo Bellomo
ISyMN	----- Museo Nazionale
ITA	Turin. Museo di Antichita
ITAA	----- Museo d'Arte Antico, Palazzo Madama
ITAR	----- Armeria Reale

ITC	Turin. Piazza San Carlo
ITE	----- Museo Egizeo
ITG	----- Formerly Gualino Coll.
ITM	----- Turin Museum
ITMC	----- Museo Civico di Torino
ITMo	----- Galleria d'Arte Moderna
ITP	----- Pinacoteca
ITS	----- Piazza dello Statuto
ITaN	Tarquinia. Museo Nazionale Tarquiniese
ITarN	Taranto. Museo Archeologico Nazionale
ITiC	Tivoli. Cathedral
ITiE	----- Villa d'Este
ITiH	----- Hadrian's Villa
IToC	Torre de' Passeri. Abbey Church S. Clemente a Casauria
ITolN	Tolentino. S. Nicola
ITorC	Torcello. Cathedral
ITosC	Toscanella. Palazzo Campaneri
ITrM	Trieste. Trieste Museum
ITrMC	----- Museo Civico
ITrMCR	Trieste. Museo Civico Revoltella
ITraA	Trapani. Santuario dell'Annunziana
ITranC	Trani. Cathedral
ITranO	----- Ognissanti Church
ITreC	Treviso. Cathedral
ITroC	Troia. Cathedral
ITuM	Tuscania. Basilica S. Maria Maggiore
IUM	Urbino. Museum
IUNM	----- Gallerie Nazionale della Marche, Palazzo Ducale
IVA	Venice. Museo Archeologico
IVAc	----- Gallerie dell'Accademia
IVAr	----- Arsenal
IVAt	----- Ateneo Veneto
IVC	----- S. Maria del Carmine
IVCO	----- Ca' d'Oro
IVCa	----- Campanile
IVCam	----- Campiello Angaran, House No. 3717
IVCar	----- Coll. Cardazzo
IVCas	----- Castiglione d'Olona
IVCi	----- Coll. Count Vittoro Cini
IVCl	----- S. Clemente all'Isola
IVCo	----- Museo Correr e Quadreria Correr
IVE	----- S. Elena
IVF	----- S. Maria Gloriosa dei Frari (IVMF)
IVFr	----- S. Francesco dela Vigna
IVG	----- Peggy Guggenheim Foundation
IVGC	----- S. Giovanni Cirstostomo

IVelA	Velletri. Antiquarium
IVenA	Venosa. Monastery Abbazia della Trinita
IVerC	Vercelli. Museo Camillo Leone
IVerE	----- Cathedral S. Eusebio
IVerMC	Verona. Museo Castelvecchio
IVerZ	----- Basilica di S. Zeno Maggiore
IViL	Vicenza. S. Lorenzo
IVipF	Vipiteno. Frauenkirche
IVitF	Viterbo. S. Francesco
IVoC	Volterra. Cathedral
IVoD	----- Duomo
IVoG	----- Museo Etrusco Guranacci
IVu	Vulci

Iceland
IcR	Rekjavik
IcRN	----- National Museum

India
InA	Amaravati. Archaeological Museum (site)
InAc	Achalgarth
InAhS	Ahmadabad. Sidi Sayyid Mosque
InAiH	Aihole. Haccappyagudi Temple
InAj	Ajanta
InAlM	Allahabad. Municipal Museum
InAlaM	Alampur. Museum
InAr	Archaeological Survey of India
InAu	Aurangabad
InBa	Badami
InBam	Bamiyan
InBan	Banaras. Bharat Kala Bhavan Museum of Indian Arts and Archaeology
InBangMy	Bangalore. Mysore Government Museum
InBarM	Baroda. Baroda Museum
InBaraL	Barabar. Lomas Rishi
InBel	Belur
InBenB	Benares. Bharata Kala Parisad
InBenH	----- Hindu University. Bharat Kala Bhavan
InBerC	Berhampore. Coll. Maharaja of Cossim-bazar
InBhL	Bhuvaneshvara Temples. Lingaraja Temple
InBhM	----- Muktesvara Temple
InBhR	----- Raja Rani
InBhS	----- State Museum of Art and Archaeology
InBhV	----- Vaital Deul
InBha	Bhaja
InBhe	Bheraghat
InBij	Bijapur

InBo	See IndJB
InBod	Bodh Gaya
InBomA	Bombay. United Asia
InBomW	----- Prince of Wales Museum of Western India
InCB	Calcutta. Bangiya Sahitya Parisad
InCI	----- Indian Museum
InCP	----- Coll. Ponten-Moller
InCS	----- School of Art
InCV	----- Victoria Memorial Hall
InCh	Chandigar
InDA	Delhi. Museum of Antiquities
InDCA	----- Central Asian Antiquities Museum
InDN	----- National Museum of India
InDQ	----- Qutb Mosque
InDab	Dabhoi
InDe	Deogarh
InDi	Dilwara
InE	Elephanta
InElK	Elura. Kailasanaha Temple
INF	Fatehpur Sikri
InGA	Gwalior. Central Archaeological Museum
InGM	----- Man Singh's Palace
InGS	----- Shastri
InGanB	Gangaikondasolapurum. Brihadisuma Temple
InHH	Halebid. Hoyshaleshvara Temple
InHoG	Hoti-Mardan. Former Guides' Mess
InHyM	Hyderabad. Hyderabad Museum
InJC	Jaipur. Central Museum
InK	Karle
InKaKa	Kanchipuram. Kailasanatha Temple
InKal	Kalugumalai
InKan	Kanheri
InKarM	Karachi. Karachi Museum
InKhA	Khajuraho. Archaeological Museum
InKhD	----- Kali Devi Temple
InKhK	----- Kandarya Mahedeva Temple
InKhP	----- Parshvanatha Temple
InKhT	----- Laksmana Temple
InKhV	----- Visvanatha Temple
InKoS	Konarak. Surya Temple
InKu	Kumbhakonam
InKum	Kumbharia
InLM	Lucknow. Lucknow Museum
InLaM	Lahore. Lahore Museum
InM	Mamallapuram
InMP	----- Pallava Monument
InMaM	Mathura. Curzon Archaeological Museum

InMadM	Madras. Government Museum and National Art Gallery
InMadhB	Madhya Pradesh. Bhilsa Museum
InMeA	Melapaluvar. Agastyesvara Temple
InMod	Modhera
InMtAN	Mount Abu. Tejahpala's Temple to Neminatha
InN	Nayagarth
InNa	Nachna-Kuthara
InNad	Nadia (Sirohi)
InNag	Nagarjuna Konda. Archaeological Museum
InNagpM	Nagpur. Central Museum
InNalM	Nalanda Museum
InNo	Nokhas.
InOKat	Orissa. Katak District
InOR	----- Rani Gumpha
InOs	Osia
InP	Parasurameswar Temple
InPaM	Patna. Patna Museum
InPat	Pattadakal
InPer	Perur
InPitA	Pitalkhora. Archaeological Survey of India Coll.
InRa	Rajim
InRaiM	Raipur. Museum
InRajS	Rajasthan. Sikar Museum
InRajsM	Rajshaki. Museum
InRanN	Ranakpur. Neminatha Temple
InRat	Ratnagiri
InReV	Rewa. Venkata Vidya Sadan Museum of Art and Archaeology
InSM	Sanchi. Museum
InSaAM	Sarnath. Archaeological Museum
InSaM	----- Sarnath Museum
InShV	Shirangam. Temple of Vishnu
InSi	Sirpur
InSo	Sopara
InSrS	Srirangar. Sri Partap Singh Museum
InTP	Tirumala Tirupati. Srinivasa Perumal Temple
InTaB	Tanjore. Brihadeshavara (Great Temple)
InTaM	----- Tanjore Museum
InTaR	----- Rajrajesvara
InTadR	Tadpatri. Ramasvami Temple
InTe	Tewar
InTirSv	Tirumala. Srinivasa-Perumal
InTr	Trichinopoly
InU	Udayagiri, Madhya Bharat; Madhya Pradesh
InV	Vijayanagar

Indonesia

IndA	Angkor Wat
IndAB	----- Bakong Pyramid
IndBB	Bali. Bedulu
IndBBa	----- Bangli
IndBK	----- Kubu Tambahan
IndBaM	Java. Batavia Museum
IndJB	----- Borobudur (Stupa of Barabadur)
IndJC	----- Chandi Panataran
IndJCa	----- Candi Mendut
IndJCh	----- Chandi Djago
IndJD	----- Dieng
IndJL	----- Loro Jongrang. Siva Temple
IndJM	----- Madjakarta Museum
IndJMa	----- Mantingan
IndJP	----- Prambanam
IndJPa	----- Panatram
IndJS	----- Surawana
IndJT	----- Trawulan Site Museum

Iraq

IRQ	Babylon
IrBagI	Baghdad. Iraq Museum
IrN	Nimrud

Iran

IranB	Bishapur
IranBe	Behistan
IranF	Firuzabad
IranHG	Hamadan. Gumbat-i-Alaviyan
IranI	Isfahan
IranK	Kuh-i-Khwaja
IranKo	Khorsabad
IranL	Linjan
IranM	Masjid-i-jami (Mosque)
IranN	Naksh-i-Rustam
IranNaM	Nayin. Masjid-i-Jami
IranP	Persepolis
IranPa	Pasargadae
IranTA	Teheran. Archaological Museum
IranTB	Taq-i-Bustan
IranTF	Teheran. Coll. Foroughi
IranTM	----- Museum
IranTN	----- National Museum
IranTS	Tang-i-Sarwak

Ireland

IreA	Ahenny
IreB	Belfast
IreCP	Clare Picture Guild
IreDC	Durham. Cathedral
IreDNB	Dublin. National Museum of Ireland
IreLA	Londonderry. Altnagelvin Hospital
IreLN	----- N. W. Hospital
IreM	Momasterboice
IreN	New Orange

Israel

-IsAp	Coll. Aplit
-IsL	Coll. Mrs. J. List
IsCh	Chorazin. Synagogue
IsEA	Ein-Harod. Art Center
IsHM	Haifa. Museum of Modern Art
IsJA	Jerusalem. Museum of Antiquities
IsJB	----- Bezalel National Art Museum, Israel Museum
IsJJ	----- Jerusalem Museum
IsJK	----- Knesset Garden
IsJP	----- Museum of the Patriarchs
IsJR	----- Billy Rose Art Garden
IsJRe	----- Coll. A. Reifenberg
IsN	Nazareth. Franciscan Convent
IsNG	----- Greek Patriarch Museum
IsTI	Tel Aviv. Galerie Israel Ltd
IsTS	----- Coll. Schwimmer
IsTT	----- Tel Aviv Museum
IsTel	Tel Hai

Japan

-JN	Coll. T. Nakazawa
-JS	Coll. Sumitomo
-JSe	Coll. Seigenji
-JY	Coll. Y. Yamasaki
-JYas	Coll. Y. Yasuda
JAk	Akishino. Monastery
JAoE	Aomori-ken. Coll. E. Chigoya
JAshS	Ashikaga. Seido
JAtH	Atami. Hannya-in
JChu	Chuson-ji
JE	Ennoji Temple (JKaE)
JFK	Fukuoka. Kanzeon-ji (Buddhist Temple)
JGY	Gumma. Coll. Yamazaki
JHK	Hyogo. Kakurin-ji
JHiP	Hiroshima. Peace Park; Peace Center

JHirC	Hraizumi. Chuson-ji
JHisC	Hisachi-yuno. Civic Collection
JHo	Hokkedo
JIC	Iwata. Chuson-ji
JIseA	Isenzaki. Coll. Aikawa
JIshT	Ishikawa. Coll. Saburo Toma
JIwH	Iwashiro. High School
JJi	Jingoji
JKB	Kyoto. Byodo-in
JKD	----- Daihoon-ji
JKDa	----- Daigo-ji
JKDai	----- Daigaku-ji
JKG	----- Gansen-ji
JKH	----- Hokai-ji
JKHa	----- Coll. Setsuya Hashimoto
JKHo	----- Hokongo-in
JKJ	----- Jingo-ji
JKJo	----- Joruri-ji
JKK	----- Kozan-ji
JKKa	----- Coll. S. Kawai
JKKo	----- Koryu-ji
JKKu	----- Kurama-dera
JKKy	----- Kyo-o-gokoku-ji
JKM	----- Matsuno-o
JKMu	----- Kyoto Museum; Kyoto Municipal Museum of Art
JKMy	----- Mycho-in
JKN	----- Nanzen-ji
JKNa	----- Natsuno-o Jinsha
JKNi	----- Nishi Hongan-ji
JKR	Kyoto. Rokuharamitsuji
JKS	----- Sanjusangendo Temple
JKSe	----- Seiryo Temple
JKSi	----- Galerie 16
JKSo	----- Sokujoin
JKY	----- Yamada Art Gallery
JKZ	----- Zushin-in
JKaE	Kanagawa. Enno-ji
JKaK	----- Kotuku-in
JKaM	----- Meigetsu-in
JKaMat	----- Coll. N. Matsudaira
JKamM	Kamakura. Meigetsuin
JKamT	----- Tokeiji
JKoS	Kochi. Sekkei-ji
JKoKU	Kokugakuin University
JKoyH	Mt. Koya. Hojoin Temple
JKur	Kuramadera
JNA	Nara. Akishino-dera

JNC	Nara. Chugu-ji (Nunnery)
JNCh	----- Chogaku-ji
JND	----- Daian-ji
JNE	----- Enjo-ji
JNG	----- Gango-ji
JNH	----- Horyu-ji
JNHa	----- Hase-dera
JNHo	----- Hokke-ji
JNHor	----- Horinji
JNJ	----- Joruru-ji
JNK	----- Kofuku-ji
JNKan	----- Kanaya Miroku-dani
JNKas	----- Kasufa Jinja
JNKo	Nara. Nara Kokuritsu Hakabutsukan (Nara National Museum)
JNM	----- Muro-ji
JNO	----- Ok-dera
JNOn	----- On Zuto (mound)
JNOni	----- Onio-ji
JNS	-----Shorin-ji
JNSa	----- Saidai-ji
JNSh	----- Shin Yakushi-ji
JNSho	----- Shoso-in
JNT	----- Todai-ji
JNTa	----- Taimi-ji
JNTac	----- Tachibani-dera
JNTe	----- Tierakusha
JNTo	----- Toshodai-ji
JNY	----- Yakushi-ji
JNa	Nagasaki
JNiR	Nikko-shi. Ronnoji Jokodo Homotsuden (Treasure House of the Jokodo, Ronnoji Temple)
JOY	Oita. Yusuhara Hachiman-gu
JOsKa	Osaka. Kanshin-ji
JOsS	----- Shitenno-ji
JOsY	----- Yachu-ji
JSD	Shiga. Daiho Jinja
JSK	----- Kogen-ji
JSO	----- Onjo-ji
JSanN	Saitama-ken. Coll. Yoshio Negishi
JSen	Senko-ji
JSh	Shojoji
JTA	Tokyo. Coll. Mitsutake Arisaka
JTB	----- Coll. Raymond Bushnell
JTH	----- Coll. Moritatsu Hosokawa
JTI	----- Coll. Imperial Household Office
JTK	----- Coll. Motomasa Kanze

JTKi	Tokyo. Kinokuniya
JTKo	----- Coll. I Kongo; Coll. Kongo Family
JTM	----- Coll. Gakunan Matsubara
JTMa	----- Coll. Seigyo Matsubara
JTMat	----- Matsubara Coll.
JTMi	----- Minami Gallery
JTMu	----- Coll. Munsterberg
JTN	----- Coll. Sumio Nakazawa
JTNM	----- National Museum
JTNMM	----- National Museum of Modern Art
JTNMW	----- National Museum of Western Art
JTNa	----- Nakamura Coll.
JTO	----- Okura Museum
JTOk	----- Coll. Okue
JTS	----- Coll. Kusuo Shimizu
JTSh	----- Shudo Museum
JTT	----- Tokyo Gallery
JTTan	----- Tokyo University--Coll. Anthropological Faculty
JTY	----- Coll. Yoichiro Nakamura
JTeU	Tenri. University Research Museum
JTo	Toji
JTohU	Tohoku. University
JTsH	Tsugaoka. Hachiman Shrine
JUB	Uji. Byodo-in
JUb	Ube
JWK	Wakayama. Kongobu-ji
JWKo	----- Kokoku-ji
JWS	----- Shochi-in
JYH	Yokahama. Coll. Hara

Jordan

JoAM	Aman. Museum
JoJA	Jerusalem. El Agsa Mosque
JoJF	----- Archaeological Museum of the Studium Biblicum Franciscanum
JoJJ	----- Jerusalem Museum
JoJP	----- Palestine Archaeological Museum

Korea

-KL	Former Li Royal Museum
-KCh	Coll. Chun Hyung-pil
KKN	Kyongju. National Museum, Branch
KKS	----- Sokkuram Rock Temple
KSD	Seoul. Ducksoo (Toksu) Palace Museum of Fine Arts
KSN	----- National Museum
KSo	Sosan
KSok	Sokkul-am

Kenya
KeN Nairobi

Lebanon
LA Anjar
LBB Beirut. Coll. Emile Bustani
LBN ----- Musee National
LBaB Baalbeck. Temple of "Bacchus"

Laos
LaVV Vientiane. Vat Phra Keo Museum

Libya
LiL Leptis Magna Museum (ruins)
LiTA Tripoli. Archaeological Museum
LiTC ----- Castello Natural History Museum

Malta
Ma Malta

Malaysia
MalSU Singapore. University of Malaya Art Museum
MalTP Taiping. Perak Museum

Mexico
-Mec Coll. A. Carrillo Gil
-MeF Coll. F. V. Field
-MeFe Coll. F. Feuchtwanger
-MeH Coll. S. Hale
-MeO Coll. Dolores Olmeda de Olvera
-MeP Coll. Guy Puerto
MeAA Acolman. San Agustin Monastery
MeAn Angagua
MeCM Campeche. Museo Regional de Campeche
MeCh Chichen Itza
MeChi Chiapas
MeCu Cuernavaca
MeDC Desierto de Leones. Convent
MeGA Guadalajara. Museo de Antropolgia de
 Guadalajara
MeGuH Gunajunto. Dolores Hidalgo
MeH Hochob
MeJUA Jalapa. University of Veracruz. Museo de
 Antropologia
MeK Kabah
MeL Labna
MeMA Mexico City. Coll. Sra. Machido Armila
MeMAR Mexico City. Museo de Arte Religioso

MeMB	Mexico City. Coll. Mr. and Mrs. Manuel Barbachano
MeMC	----- Coll. Miguel Covarrubias
MeMCa	----- Cathedral of Mexico City Treasure
MeMCap	----- Capitol
MeMCo	----- Coll. Gustavo Corona
MeME	----- Experimental Museum
MeMF	----- Nacional Financiera Building
MeMG	----- Coll. Mr. and Mrs. Jacques Gelman
MeMI	----- Instituto Nacional de Bellas Artes
MeMM	----- Galeria de Arte Mexicano
MeMMu	----- Conservetorio Nacional de Musica
MeMN	----- Museo Nacional de Antropologia e Historia
MeMO	----- Coll. Lola Olmeda de Olvera
MeMP	----- Coll. Barbachano Ponce
MeMR	----- Coll. van Rhijn
MeMRi	----- Museo Diega Rivera
MeMS	----- K Stavenhagen Coll.
MeMSa	----- Sagrario Metropolitano
MeMU	----- Universidad Nacional de Mexico
MeMadC	Villa Madero. Parish Church
MeMeY	Merida. Museo Arqueologico de Yucatan
MeMi	Mitla
MeMo	Monte Alban
MeMon	Monterey
MeMorM	Morelia. Museo Regional de Michoacan
MeOM	Oaxaca. Museo Regional
MeOY	----- Yanhuitlan
MeP	Palenque
MePi	Piedras Negras
MePuM	Puebla. S. Maria Tonantzintla
MeQC	Queretaro. S. Clara
MeSLM	San Luis Potosi. Museo Regional Potosini
MeSalA	Salamanco. San Agustin
MeTa	El Tajin
MeTam	Tamazalapan
MeTax	Taxco. Santa Prisca y San Sebastian Church
MeTeM	Teotihuacan. Museo Arqueologico de Teotihuacan
MeTep	Tepotzotlan
MeTlO	Tlaxcala. Nuestra Senora de Ocotlan
MeTla	Tlalmanalco
MeToM	Toluca. Museo
MeTr	Tres Zapotes
MeTu	Tula
MeU	Uxmal
MeVP	Villahermosa. Parque Olmec (La Venta Parque)

MeVa	Valsequilo
MeVeJ	Vera Cruz. Museo Regional de Jalapa
MeViM	Villahermosa. Museo Regional
MeX	Xochicalco
MeYBr	Yachilan. British Museum
MeZC	Zacatecas. Cathedral

Melanesia

MelNb	New Britain

Morocco

MorM	Marrakesh
MorRA	Rabat. Musee des Antiquites Pre-Islamique

Netherlands

NAA	Amsterdam. Museum van Aziatische Kunst
NAD	----- Dam Palace (Old Town Hall)
NAE	----- The Exchange
NAG	----- Gemeentamusea
NAH	----- Handelmaat-Schaprij
NAJ	----- Jewish Historical Museum
NAN	----- Nieuwe Kerk
NAR	----- Rijksmuseum
NAS	----- Stedelijk Museum
NASt	----- Stocker Coll.
NASu	----- Suikerrui
NAT	----- Koninklijk Institut voor de Tropen
NATJ	----- Koninklijk Paleis (Royal Palace; formerly: Hall of Justice)
NATe	----- Technical School
NAW	----- Coll. Dr. van der Wal
NAlL	Alkmaar. St. Lawrence Church
NArP	Arnhem. Provinciehuis
NAsT	Ascona. Coll. Baron von der Heydt
NBG	Breda. Groote Kerk
NBP	----- Protestant Museum
NBaS	Baarlo. Coll. Kasteel Scheres
NBeG	Bergen, Op Zoom. Grote Kerk
NBeT	----- Town Hall
NBoA	Bockhoven. St. Anthony Church
NDN	Delft. Nieuwe Kerk
NDoG	Dordrecht. Coll. Mrs. S. van Gijn
NDoO	----- Our Lady Church
NEA	Eindhoven. Stedelijk van Abbe-Museum
NEK	----- Kunst-Licht-Kunst Exhibition
NEnG	Enkhuizen. St. Gommarus Church
NGM	Groningen. Groninger Museum

NHB	The Hague. Bouwegelust Settlement
NHG	----- Gemeentemuseum
NHH	----- Haags Gemeentemuseum
NHM	----- Mauritshuis (Koninklijk Kabinet van Schilderijen)
NHP	----- Koninklijk Penning Kabinet
NHS	----- Scheurleer Museum
NHaGK	Haarlem. Grote Kerk
NHaW	----- Coll. Frits A. Wagner
NHeB	's-Hertogenbosch. Brotherhood of Our Lady
NHeJ	----- St. John's Church (NShJ)
NHoen	Hoenderloo
NKR	Katwijk. Reformed Church
NKaT	Kampen. Town Hall
NLP	Leiden. Pieter Kerk
NLR)	----- Rijksmuseum van Oudheden
NLRO)	
NLRV	----- Rijksmuseum voor Vokenkunde
NLS	----- Stedelijk Museum--"De Lakenthal"
NLW	----- City Weigh House
NLeF	Leeuwarden. Fries Museum
NMaC	Maastricht. Cathedral
NMaO	----- Our Lady Church
NMaS	----- St. Servatius
NOK	Otterlo. Rijksmuseum Kroller-Muller
NOuH	Oudenaarde. Hotel de Ville
NRB	Rotterdam. De Byenkorf Store
NRBo	----- Bouwcentrum
NRBoy	----- Museum Boymans-van Beuningen
NRC	----- Rotterdam City
NRH	----- Coll. van Hogen dorpplein
NRL	----- Museum voor Land- en Volkenkunde
NRP	----- Post Office
NRU	----- Unilever Building
NRhC	Rhenen. St. Cunera Church
NRiI	Rijswijk. In de Bogaard Shopping Center
NSM	Steyl. Museum van het Missiehuis
NScA	Scheveningen. St. Anthony
NSchL	Schiedam. Coll. C. S. Lechner
NShJ	's-Hertogenbosch. St. Jan (NHeJ)
NT	Tilburg. City Collection
NUA	Utrecht. Archepiscopal Museum
NUC	----- Centraal Museum
NWA	Wassenaar. Coll. Elisabeth Anderson
NWa	Waalwijk
NZH	Zandvoort. Coll. Baron Edward von der Heydt

NZoL	Zoutleeuw. St. Leonard
NZuW	Zutphen. St. Walburg

Nigeria

-NiO	Coll. Oni of Ife
NiB	Bussa
NiBeM	Benin City. Benin Museum
NiEHI	Esie. House of Images
NiEM	----- Esie Museum
NiEkA	Ekiti. Arinjale Palace
NiEwO	Ewohimi. Onogie Palace
NiG	Nigerian Government Coll.
NiIA	Ife. Museum of Ife Antiquities
NiIO	----- Coll. Oni of Ife
NiIk	Ikom
NiJA	Jos. Federal Department of Antiquities
NiJF	----- Coll. William Fagg
NiJM	----- Jos Museum
NiJe	Jebba
NiLN	Lagos. Nigerian Museum
NiOM	Oron. Oron Museum
NiOwO	Owo. Coll. Chief Oludasa
NiT	Tada

Nicaragua

NicMN	Managua. Museo Nacional

Norway

NoA	Al
NoBV	Bygdoy. Viking Ship House
NoDM	Drammen. Drammens Museum
NoK	Kristiansung
NoOB	Oslo. Oslo Byes Vel
NoOF	----- Frogner Park
NoOM	----- Oslomuseum
NoON	----- Norsk Hydro Administration Building
NoONas	----- Nasjonalgalleriet
NoOUO	----- Universitetets Oldsaksamling
NoR	Ramsunberg
NoTC	Trondheim. Cathedral Museum
NoTNK	----- Nordenfjelske Kunstindustrimuseum
NoTi	Tind
NoTin	Tingelstadt
NoU	Urnes

New Zealand

NzAM	Auckland. Auckland War Museum
NzChC	Christchurch. Canterbury Museum

NzDO	Dunedin. Otago Museum
NzWD	Wellington. Dominion Museum

Oceania

OM	Melanesia

Poland

PBE	Breslau (Wloclawek). St. Elizabeth
PBS	----- Silesian Museum
PByMa	Masadell' Alta Silesia
PCB	Cracow (Krakow). St. Barbara
PCC	----- Cathedral
PCL	----- Church of Our Lady
PCN	----- Muzeum Naradowe w Krakowie
PCO	----- "Old" Synagogue
PCW	----- Cathedral on the Wawel
PDM	Danzig. Marienkirche
PGC	Gniezno (Gniezo). Cathedral
PGd	Gydnia
PM	Malbork (Marienburg)
PO	Olstyn
PPN	Poznan. Muzeum Narodowe w Poznaniu
PSP	Szczecinek. Museo Pomerania Occidentale
PTJ	Torun (Thorn). St. John
PTrA	Tremessen. Abbey Church
PWC	Warsaw. Coll. Warsaw City
PWN	----- Muzeum Narodowe
PWP	----- Palace of Culture and Science
PWS	Warsaw. Coll. H. and S. Syrcus
PZ	Zakopane
PZaS	Zamosc. Synagogue

Pakistan

PaKM	Karachi. National Museum
PaLC	Lahore. Central Museum
PaMA	Mohenjo-Daro. Archaeological Museum
PaPA	Peshawar. Archaeological Museum
PaPM	----- Provincial Museum
PaTA	Taxila. Archaeological Museum

Panama

PanPN	Panama City. Museo Nacional

Paraguay

ParT	Trinidad. Mission

Peru

PeA	Arequipa

clxv

PeC	Chanchan
PeCh	Chavin de Huantar
PeChiH	Chiclin. Coll. Rafael Larco Hoyle
PeCuA	Cuzco. Museo Arqueologico Universitario
PeCuAl	----- Almudena Church
PeCuB	----- Belen Church
PeCuBl	----- San Blas
PeCuC	----- Cathedral
PeCuCo	----- Compania
PeCuM	----- Museum
PeCuMA	----- Museo de la Universidad
PeH	Huaca Dragon
PeLA	Lima. Coll. Alzamora
PeLB	----- Buena Muerte
PeLC	----- Cathedral
PeLF	----- San Francisco
PeLL	----- Coll. Rafael Larco Hoyle
PeLLar	----- Museo Rafael Larco Herrera
PeLM	----- Coll. Miguel Mujica Gallo
PeLMA	----- Museo Nacional de Antropologia y Arqueologia
PeLN	----- Museo Nacional
PeLNA	----- See PeLMA
PeLO	----- Coll. Pedro de Osma
PeLP	----- San Pedro Church
PeLQ	----- Quinta Presna
PeP	Punkuri

	Portugal
PoAC	Alcobaca. Cistercian Church
PoAlC	Almoster. Convent
PoAlhCh	Alhodas. Church
PoAr	Arouca. Monastery
PoAvJ	Aveiro. Convento de Jesus
PoAvM	----- Museum
PoBD)	Batalha. Dominican Monastery
PoBM)	
PoBo	Bobadela
PoBrI	Braga. Igreja dos Jesuitas
PoCC	Coimbra. Cathedral
PoCM	----- Museu "Machado de Castro"
PoEA	Elvas. Coll. Marquesa Alegrete
PoLA	Lisbon. Museu Nacional de Art Contemporanea
PoLB	----- Tower of Belem
PoLC	----- Conceicao Velha
PoLCa	----- Cathedral
POLCo	----- Meseu Nacional des Coches

RuLL	Leningrad. Lazarus Cemetery
RuLMAS	----- Museum of Academy of Sciences
RuLPP	----- SS. Peter and Paul Cathedral
RuLR	----- Russian Museum
RuLW	----- Winter Palace
RuLo	Lvov (Lwow)
RuMA	Moscow. Abramtsevo Museum
RuMCA	----- Church of the Annunciation
RuME	----- Director Art Exhibitions
RuMFA	----- Museum of Fine Art
RuMH	----- State Historical Museum
RuMK	----- Kremlin
RuMKA	----- Kremlin. State Armory Palace
RuMKP	----- ----- Grand Palace
RuMM	----- Ministry of Culture
RuMT	----- Tretyakov Gallery
RuMV	----- Monastery of the Virgin of the Don
RuNI	Nerl. Intercession Church
RuNoS	Novgorod. St. Sophia Cathedral
RuOp	Opiza. Church
RuP	Pavlovsk
RuPet	Peterhof
RuSM	Smolensk. Museum of Smolensk
RuTC	Tsebalda. Church
RuTiG	Tiflis. Georgian National Museum
RuTs	Tsarkoe Selo. Catherine Palace
RuVD	Vladimir. St. Dmitri Church
RuVoM	Vologda. Vologda Museum
RuYG	Yuriev-Polski. St. George Cathedral
RuYaE	Yaroslal. St. Elijah Church
RuYeM	Yerevan. Erivan Museum
RuZM	Zagorsk. Zagorsk Museum

San Salvador

San S	El Salvador

Scotland

ScAA	Aberdeen. Aberdeen Art Gallery
ScAM	----- Marischal College
ScD	Durisdeer
ScDuP	Dundee. Panmure Salon
ScEA	Edinburgh. National Museum of Antiquities of Scotland
ScECS	----- Edinburgh Castle--Scottish Naval and Military Museum
ScEG	----- St. Giles Cathedral
ScEK	----- Coll. Prof. J. R. King
ScEM	----- Scottish National Gallery of Modern Art

ScEN	Edinburgh. National Gallery of Scotland
ScENP	----- Scottish National Portrait Gallery
ScEP	----- Parliament House
ScER	----- Royal Scottish Museum
ScEW	----- Willow Tea Room
Sc GA	Glasgow. Art School
Sc GC	----- Corporation Coll.
Sc GG	----- Glasgow Art Gallery and Museum
Sc GU	----- Hunterian Museum, and University of Glasgow Art Collections
Sc GlK	Glenkiln. Coll. W. J. Keswick
ScI	Iona
ScLLM	Liverpool. Liverpool City Museum
Sc Pa	Paisley
ScSK	Shawhead. Coll. W. J. Keswick

Senegal

SeDI	Dakar. Musee de l'Institut d'Afrique

Sweden

-SnB	Coll. Bo Boustedt
SnB	Blackeberg
SnGG	Gothenberg (Gotesborg). Gotaplastern
SnGK	----- Goteborgs Konstmuseum
SnGoB	Gotland. Burs
SnGoBu	----- Bunge Museum
SnGoG	----- Gammelgarn
SnGoM	----- Martebo
SnHH	Helsinki. Coll. Mrs. Sara Hilden
SnHN	Helsingborg. Navigation Monument
SnHa	Hahnstad
SnHaek	Haelsingland. Enanger's Kyrokomuseum
SnKS	Kalmar. Kalmar Slott och Museum (Castle and Provincial Museum)
SnLM	Lidingo. Millesgarden
SnLi	Linkoping
SnMA	Medelpad. Alno Church
SnMoH	Molndal. Coll. A. Hellstrom
SnNM	Narke. Mosjo-Kyrka
SnR	Coll. H. M. King of Sweden
SnRo	Rolagsbro
SnSA	Stockholm. Art Gallery
SnSAc	----- Academy
SnSAr	----- Medelhavsmuseet
SnSB	----- Bank of Sweden
SnSC	----- Concert Hall
SnSCa	----- Cathedral
SnSE	----- Statens Etnografiska Museum

SnSEn	Stockholm. Enskilda Bank
SnSH	----- Statens Sjohistoriska Museum
SnSHM	----- Statens Historiska Museum
SnSJ	----- Coll. G. Jungmarker
SnSK	----- Royal Collection
SnSL	----- Coll. S. Linne
SnSLa	----- Coll. M. Lagrelius
SnSLi	----- Lidingo
SnSM	----- Hotel Malmen
SnSMi	----- Tillhor Millesgarden
SnSN	----- Nationalmuseum
SnSNH	----- National History Museum
SnSNM	----- Nationalmuseum Moderna Museet
SnSNi	----- St. Nicholas Church
SnSNo	----- Noriska Museet
SnSO	----- Ostasiatiska Museet
SnSS	----- International Sports' Fair, 1950
SnSSM	----- Swedish Match Company
SnSSt	----- Stadtmuseum
SnSSta	----- Stadium
SnSSto	----- Storkkyra
SnSSv	----- Coll. Carl P. Svensson
SnST	----- Thielski Galleriet
SnSW	----- Wasavarvet (Wasa Dockyard)
SnSkW	Skokloster. Coll. Counts Wrangel and Brahe
SnUU	Uppsala. University Museum
SnVB	Vadstena. Former St. Birgitta Convent Church
SnVa	Vange
SnVal	Vallingby
SnVas	Vasteras
SnVax	Vaxjo
SnViG	Visby. Gotlands Fornsal
SnW	Westeras

South Africa

-SoL	Coll. S. Love
SoCG	Capetown. Gallery of South African Art
SoCSoM	----- South African Museum
SoDA	Durban. Durban Museum and Art Gallery
SoJB	Johannesburg. Coll. Bidel
SoJR	----- Rozetenville School of Arts and Crafts
SoL	Leefontein
SoM	Maretjiesfontein
SoPH	Pretoria. Coll. Erik Holm
SoPT	----- Transvaal Museum

clxx

SpCuE	Cuellar. S. Esteban
SpD	Santo Domingo de Silos Monastery (SpSanta; SpSilD)
SpDC	Santo Domingo de la Calzada
SpE	El Escorial. Real Monasterio
SpElgCh	El Garrobo. Church
SpGA	Granada. The Alhambra
SpGAn	----- S. Ana Church
SpGAnt	----- S. Anton
SpGAr	----- Museo Arqueologico Provincial
SpGB	----- Museo Provincial de Bellas Artes (SpGP)
SpGC	----- Cathedral
SpGCa	----- Palacio de Carlos V
SpGCar	----- Carthusian Monastery
SpGG	----- S. Geronimo
SpGI	----- Coll. Conte de la Infantas
SpGJ	----- S. Jose
SpGJe	----- S. Jeronimo
SpGJu	----- S. Juan de Dios
SpGP	----- Museo Provincial de Bellas Artes (SpGB)
SpGR	----- Museo de la Capilla Real
SpGS	----- Sacristy of the Charterhouse
SpGZ	----- Convento de Zafra
SpGenCh	Genevilla. Church
SpGerC	Gerona. Church
SpGuS	Guadalajara. Siguenza Cathedral
SpGua	Guadalupe. Abbey
SpHC	Huesca. Cathedral
SpHP	----- S. Pedro
SpHuC	Huerta. Cathedral
SpJC	Jaca. Cathedral
SpLP	Lerma. S. Pedro
SpLeA	Leon. Astorga Cathedral
SpLeI	----- S. Isidoro
SpLeM	----- S. Marcoa
SpLebM	Lebrija. S. Maria
SpLer	Lerida
SpLuM	Lucena. S. Mateo Church
SpME	Murcia. Ermita de Jesus
SpMM	----- Convent Las Maravillas
SpMS	----- Museo Salzillo
SpMaA	Madrid. Museo Arqueologico Nacional
SpMaAA	----- ----- Museo de America
SpMaAl	----- Coll. Duke of Alba
SpMaAr	----- Real Armeria
SpMaB	----- Buen Retiro

SpMaC	Madrid. Casino de Madrid
SpMaCo	----- Cofradia de los Navarros
SpMaD	----- Monastery de Las Descalzas Reales
SpMaF	----- S. Fernando Academy
SpMaH	----- Coleccion de la Real Academia de la Historia
SpMaHF	----- Hospicio de S. Fernando
SpMaHu	----- Coll. J. Huarte
SpMaL	----- Museo de la Fundacion "Lazaro Galdiano"
SpMaM	----- Museo Nacional de Arte Moderno
SpMaMo	----- Galeria Juana Mordo
SpMaN	----- National Museum
SpMaOr	----- Plaza de Oriente
SpMaP	----- Museo Nacional del Prado
SpMaPal	----- Royal Palace
SpMaPlM	----- Plaza Mayor
SpMaR	----- Real Academia de S. Fernando
SpMaRA	----- Museo de la Real Armeria
SpMaU	----- University Chapel
SpMalC	Malaga. Cathedral
SpMalD	----- S. Domingo
SpMeA	Merida. Museo Arqueologico de Merida
SpMed	Medina de Rioseco
SpMuJ	Murcia. Ermita de Jesus
SpMuS	----- Museo Salzillo
SpOC	Orvieto. Cathedral
SpPa	Palos
SpPalV	Palencia. Villalcazar de Sirga
SpPalmC	Palma de Mallorca. Cathedral
SpPalmL	----- "La Lonja"
SpPamC	Pamplona. Cathedral
SpParC	El Pardo. Capuchin Monastery
SpPob	Poblet. Monastery
SpRS	Rio Seco. San Francisco
SpRipM	Ripoll. Monastery S. Maria
SpRoG	Roussillon. S. Genis-des-Fontaines
SpRod	Ciudad Roderigo
SpSC	Seville. Cathedral
SpSCar	----- Caridad
SpSG	----- S. Gregorio
SpSHC	----- Hospital de la Caridad (SpSCar)
SpSI	----- S. Isidoro del Campo
SpSJ	----- S. Juan de la Palma
SpSL	----- S. Lorenzo Church
SpSLu	----- S. Luis
SpSM	----- Museum
SpSMA	----- Museo Provincial de Bellas Artes

SpSP	Seville. S. Paula
SpSQ	----- Quinta Augustia
SpSS	----- S. Salvador
SpSUC	----- University Chapel
SpSaI	Santiponce. S. Isidoro del Campo
SpSalC	Salamanca. New Cathedral
SpSalE	----- S. Esteban
SpSalF	----- Cologio Fonseca. Irish College
SpSalO	----- Old Cathedral
SpSalU	----- Old University
SpSalaC	Sala. Collegiata
SpSanC	Santiago de Compostela. Cathedral
SpSanH	----- Hospital
SpSanM	----- S. Martin Pinario
SpSangM	Sanguesa. S. Maria la Real
SpSanta	Santa Domingo de Silos (SpD)
SpSarC	Sargossa. Cathedral
SpSarP	----- Pilar
SpSeC	Segovia. Cathedral
SpSeM	----- S. Maria de Nieva
SpSeP	----- El Parral Monastery Church
SpSiC	Siguenza. Cathedral
SpSilD	Silos. S. Domingo (SpD)
SpSoD	Soria. S. Domingo
SpSolC	Solsona. Cathedral
SpTC	Toledo. Cathedral
SpTCl	----- S. Clara
SpTHA	----- Hospital de Afuera
SpTHT	----- Hospital de Tavera
SpTJ	----- Juan de los Reyes Church
SpTL	----- Coll. Duchess of Lerma
SpTT	----- Synagogue El Transito
SpTTo	----- S. Tomas
SpTaC	Tarragona. Cathedral
SpTeC	Teruel. Cathedral
SpToM	Toro. Colegiata de S. Maria la Mayor
SpU	Ubeda
SpVA	Valladolid. Iglesia de las Augustias
SpVG	----- Colegio di S. Gregorio
SpVM)	----- Museo Nacional de Escultura
SpVME)	
SpVMP	----- Museo Provincial de Bellas Artes
SpVMad	----- Magdalen Church
SpVMar	----- S. Martin Church
SpVN	----- Nuestro Senora de las Angustias
SpVP	----- S. Pablo
SpVaA	Valencia. Palace of the Marques de Dos Aguas
SpVi	Vich

SpZM	Zamora. Magdalena Church
SpZP	----- S. Pedro de la Nave
SpZT	----- Museo de la Catedral
SpZarC	Zaragoza. Cathedral
SpZarS	----- La Seo

Sudan

SuJbA	Jebel (Gebel) Barkal. Amon Temple
SuKM	Khartoum. Museum
SuN	Naga

Switzerland

-SwA	Coll. Theodore Ahrenberg
SwAM	Agaune. Treasury of S. Maurice
SwAr	Arenenberg aum Untersee. Napoleonmuseum Arenberg
SwAvR	Avenches. Musee Romain
SwBA	Basel. Antikenmuseum
SwBB	----- Coll. Bernouilli
SwBBe	----- Galerie Beyeler
SwBC	----- Cathedral
SwBF	----- Feuerwache
SwBFe	----- Galerie Feigel
SwBH	----- Coll. Marguerite Hagenbach
SwBHa	----- Handels-schule
SwBHi	----- Coll. R. von Hirsch
SwBK	----- Offentliche Kunstsammlung
SwBKH	----- Kunsthistorisches Museum
SwBKM	----- Kunstmuseum
SwBKl	----- Klingenthal Museum
SwBKo	----- Am Kohlenberg
SwBM	----- Coll. O. Muller; Muller-Widman Coll.
SwBMi	----- Minster
SwBMo	----- Galerie d'Art Moderne
SwBN	----- Neubadschule
SwBR	----- Stadt Seite der Mittleren-Rheinbrucke
SwBS	----- Coll. Maja Sacher
SwBSt	----- Staatlicher Kunstkredit
SwBV	----- Museum fur Volkerkunde und Schwizerisches Museum fur Volkshunde Basel
SwBeB	Bern. Coll. Serge Brignoni
SwBeC	----- Cathedral
SwBeF	----- Federal Government Coll.
SwBeG	----- Stadtisches Gymnasium
SwBeH	----- Bernisches Historisches Museum
SwBeK	----- Kunsthalle
SwBeKM	----- Kunstmuseum

SwBeKo	Bern. Konservatorium
SwBeKor	----- Kornfeld & Klipstein
SwBeMe	----- Coll. F. Meyer-Chagall
SwBeMu	----- Munster
SwBeR	----- Rupf Foundation
SwBeRu	----- Coll. Hermann Rupf
SwBeT	----- Tiefeenauspital
SwBi	Bienne
SwBie	Biel
SwCha	Chaux-de-Fonds. Musee des Beaux-Arts
SwChuM	Chur. Minster
SwD	Dornach
SwFC	Fribourg. Cathedral
SwFM	----- Museum
SwGA	Geneva. Musee d'Art et d'Histoire
SwGAd	----- Coll. Adler
SwGAs	----- Salle des Assemblees de la S. D. N.
SwGDR	----- Coll. Della Ragione
SwGG	----- Coll. M. P. Geneux
SwGGi	----- Edizione Claude Givaudan
SwGK	----- Galerie Krugier
SwGL	----- Coll. Arch. Mario Labo
SwGU	----- University
SwGW	----- Foundation C. Waechter
SwGo	Goteburg
SwGrP	Grenchen. Park-Theatre
SwI	Interlaken
SwLG	Lucerne. Gletscherpark
SwLaC	Lausanne. Cathedral
SwLaJ	----- Coll. Mr. and Mrs. Samuel Josefowitz
SwLaL	----- Landesausstellung
SwLaM	----- Musees du Vieux-Lausanne
SwLigV	Ligornetto. Museo Vela
SwMG	Maloja. Alberto Giacometti. Residence
SwMon	Montreux
SwMus	Mustair Monastery, Cantons de Grisson
SwNJ	Neuchatel. Coll. Marcel Joray
SwNe	Neu Birnau. Church
SwPC	Payerne. Payerne Church
SwSGB	St. Gallen. Stiftsbibliothek
SwSGCh	----- Former Convent Church
SwSGH	----- Handelshochschule
SwSGHM	----- Heimatmuseum
SwSMT	St. Maurice. Tresor de l'Abbaye
SwSMo	San Moritz
SwSiV	Sion. Musee de Valere
SwSoM	Soleure. St. Mary's Church
SwStM	Staws. Historiches Museum

SwTC	Thayngen. Church
SwWh	Winterthur. Coll. Mme. Hahnloser
SwWK	----- Kunstmuseum Winterthur
SwWR	----- Coll. Dr. Oskar Reinhard (t)
SwZA	----- Agricultural and Trade Fair, 1947
SwZB	----- Coll. Dr. Rudolph Blum
SwZBe	----- Coll. Dr. Walter Bechtler
SwZBr	----- Coll. Erica Brausen
SwZBu	----- Coll. Buhrle
SwZBur	----- Coll. Curt Burgauer
SwZC	----- Coll. August Carl
SwZCon	----- Convention Building
SwZE	----- Ethnological Collection
SwZG	----- Grossmunster
SwZGi	----- Coll. S. and C. Giedion-Welcker
SwZGia	----- Giacometti Foundation
SwZGim	----- Gimpel and Hanover Galerie
SwZH	----- Coll. von der Heydt
SwZHo	----- Hospital Garden (SwZUH)
SwZHu	----- Galerie Huber
SwZK	----- Kunsthaus (SwZMN)
SwZKa	----- Kanton of Zurick
SwZKr	----- Coll. Krayenbuhl
SwZKu	----- Kunstgewerbemuseum der Stadt Zurich
SwZL	----- Galerie Charles Leinhard
SwZLe	----- Coll. Elsy Leuzinger
SwZMAp	----- Museum for Applied Arts (SwZKu)
SwZMN	----- Musee National Suisse (SwZK)
SwZMe	----- Coll. Michel E. Meyer
SwZP	----- Public Park
SwZR	----- Museum Reitberg
SwZS	----- Schwizerisches Landesmuseum
SwZUH	----- University Hospital (SwZHo)
SwZUV	----- Universitat-Zurich-Sammlung fur Volkerkunde
SwZZ	----- Galerie Renee Ziegler

Syria

SyAN	Aleppo. Musees National d'Alep
SyB	Boghaz-Keul
SyDN	Damascus. Musee National de Damas
SyN	Nemrud Dagh
SyS	Saktche-Gozu

Turkey

TAA	Ankara. Archaeological Museum
TAH	----- Hittite Museum
TAkK	Aksaray. Kebir Cami

TAnM	Antayla (formerly: Adalia). Archaeological Museum
TB	Bogazkoy
TC	Cachemish
TDU	Divrigi. Ulu Cami
THH	Hatay. Hatay Museum
TIAM	Istanbul. Archeological Museum
TIAt	----- At-Meidan
TIH	----- Hagia Sofia
TIHip	----- Hippodrome
TIJ	----- St. John Studion
TIM	----- National Museum (Constantinople Museum)
TIO	----- Ottoman Museum
TIS	----- Hagios Sergios and Hagios Bacchus
TITh	----- Obelisk of Theodosius
TITo	----- Topkapi Saray Museum
TIv	Ivriz
TIzA	Izmir (Formerly: Smyrna). Archeological Museum
TKE	Konya. Ethnographical Museum
TKM	----- Ince Minare Madrassa
TKa	Karatepe
TMA	Manisa. Archaological Museum
TSM	Sivas. Gok Madrassa
TVA	Lake Van. Aght'amar (Church)
TY	Yasidikaya

Thailand

ThBF	Bangkok. Monastery of the Fifth King
ThBNM	----- National Museum
ThBNe	----- Coll. Mr. and Mrs. E. L. Neville
ThBP	----- Wat Paa Keo
ThBY	----- Coll. H. R. H. Prince Chalermbol Yugala
ThSM	Savankhalok. Wat Mahathat
ThW	Wat Cetiya Luang

Tunisia

TuCM	Carthage. Carthage Museum
TuQM	Quirawan. Great Mosque
TuTA	Tunis. Musee Alaoui
TuTB	----- Musee National du Bardo

United States

-UA	Coll. John P. Anderson
-UAd	Coll. Elbridge Adams
-UAi	Coll. Dorothy Ainsworth

-UB	Coll. Col. Sam Berger
-IBa	Coll. Mr. and Mrs. Walter Bareiss (UCtGB)
-UBak	Coll. Mr. and Mrs. Louis C. Baker
-UBar	Coll. Monroe G. Barnard
-UBe	Coll. H. Benevy
-UBl	Coll. Lawrence H. Bloedel
-UBr	Coll. Mr. and Mrs. Austin Briggs
-UBru	Avery Brundage Foundation
-UBu	Coll. Mr. and Mrs. William A. Burden
-UBur	Coll. Lt. John Burke
-UC	Coll. Mr. and Mrs. Oscar Cox
-UCop	Coll. W. Copley
-UCr	Coll. Mr. and Mrs. Sumner McK. Crosby
-UCro	Coll. Mrs. W. W. Crocker
-UD	Coll. Mr. and Mrs. Bruce C. Dayton
-UDel	Coll. Mr. and Mrs. Kurt Delbanco
-UDr	Coll. Katherine S. Dreier
-UE	Coll. Armand G. Erpf
-UF	Coll. Roy S. Frieuman
-UFi	Coll. Mr. and Mrs. Sol Fishko
-UFis	Coll. Mrs. Henry Fischbach
-UFit	Coll. H. William Fitelson
-UFl	Coll. Mr. and Mrs. Malcolm K. Fleschner
-UFlo	Coll. Milton Flower
-UFo	Coll. Mr. and Mrs. James W. Fosburgh
-UFor	Coll. Mr. and Mrs. Walter B. Ford, II (UMiDFor)
-UForc	Coll. Juliana Force
-UG	Coll. Richard P. Gale
-UGa	Coll. Naum Gabo
-UGar	Coll. Mr. and Mrs. Lewis Garlick
-UGard	Coll. Mr. and Mrs. Robert Gardner
-UGe	Coll. Titus C. Geesey
-UH	Coll. Mr. and Mrs. J. W. Hambuechen
-UHa	Coll. Mrs. Ira Haupt
-UHam	Coll. Mr. and Mrs. George Heard Hamilton
-UHar	Coll. Mr. and Mrs. Averill Harriman
-UHe	Coll. Mr. and Mrs. Henry J. Heinz, II
-UHem	Coll. Mrs. Barklie McKee Henry
-UHo	Coll. Mrs. Frederick W. Hilles
-UHil	Coll. Susan Morse Hilles
-UHir	Coll. Al Hirschfeld
-UJ	Coll. Philip Johnson
-UK	Coll. Mr. and Mrs. Illi Kagan
-UKa	Coll. Edgar J. Kaufmann
-UKam	Coll. Dr. George Kamperman
-UKi	Coll. Mr. and Mrs. Sidney Kingsley
-UKn	Coll. Mr. and Mrs. Seymour H. Knox

-UKl	Coll. Dr. Nathan Kleine
-UL	Coll. Lloyd Family
-ULa	Coll. Robert M. LaFollette, Jr.
-ULan	Coll. J. Patrick Lannon
-ULaw	Coll. Jack Lawrence
-ULe	Coll. Reginald LeMay
-ULes	Coll. Mac Le Sueur
-ULev	Coll. Robert H. Levi
-ULi	Coll. Jean Lipman
-ULo	Coll. Alain Locke
-UM	Coll. Mrs. Eugene Mayer
-UMa	Coll. Mr. and Mrs. Robert Meyer
-UMan	Coll. Dr. and Mrs. Mandelbaum
-UMi	Coll. Mr. and Mrs. G. MacCulloch Miller
-UMo	Coll. Anne Morgan
-UN	Coll. Mrs. Elie Nadelman
-UNe	Coll. Babette Newburger
-UNel	Coll. Marion John Nelson
-UO	Coll. Mr. Robert Ossorio
-UPa	Coll. Mr. and Mrs. Charles S. Payson
-UPh	Coll. Margaret Phillips
-UPhi	Coll. Mr. and Mrs. William Phillips
-UPr	Coll. Stuart Preston
-URa	Coll. Oscar Raphael
-URe	Coll. Mr. and Mrs. Stanley R. Resor
-URic	Coll. Horace Richter
-URica	Coll. James H. Ricau
-URo	Coll. Mr. and Mrs. Saul Rosen
-URon	Coll. Dr. and Mrs. Bernard Ronis
-URos	Coll. George Rosborough
-URu	Coll. Prof. William Rubin
-US	Coll. Arthur M. Sachler
-USc	Coll. Mr. and Mrs. Robert C. Scull
-USch	Coll. Stephen Karl Scher
-USchw	Coll. Mr. and Mrs. Seymour Schweber
-USe	Coll. Mr. and Mrs. Charles Seymour, Jr.
-USim	Coll. Mrs. Robert E. Simon
-USm	Coll. Mr. and Mrs. Solomon Byron Smith (UICSm)
-USo	Coll. Dr. and Mrs. Eugene Solow
-USt	Coll. J. Starrels; Coll. Eugene von Stanley
-USta	Coll. Blair Stapp
-USte	Coll. Mrs. D. O. Stewart
-USto	Coll. M. and R. Stora
-UStor	Coll. Dr. Gilbert Stork
-UT	Coll. Mr. and Mrs. Burton Tremaine
-UTe	Coll. David A. Teichman
-UTh	Coll. Mr. and Mrs. John S. Thacher

-UTho	Coll. G. David Thompson
-UTo	Coll. Mr. and Mrs. Benjamin Townsend
-UTom	Coll. Jay B. Tomlinson
-UTow	Towle Silversmiths Coll.
-UW	Coll. Weiner
-UWa	Coll. Mrs. Eleanor Ward
-UWar	Coll. Edward M. M. Warburg
-UWe	Coll. Mr. and Mrs. Frederick R. Weisman
-UWeb	Coll. Mrs. J. Watson Webb
-UWei	Coll. Fred Weisman
-UWi	Coll. William Wilder
-UWic	Coll. Forsyth Wickes
-UWin	Coll. Lewis Winter
-UY	Coll. Hanford Yang

--Alaska

UAB	Baranof Island
UAK	Ketchikan
UAWW	Wrangel. Coll. Walter Waters

--Alabama

UAlBC	Birmingham. City Museum and Art Gallery
UAlMC	Mobile. Conti Street
UAlTC	Tuskegee Institute. George Washington Carver Museum

--Arkansas

UArC	Caddo Gap

--Arizona

UAzGT	Grand Canyon. El Tovar Hotel
UAzKP	Kitt Peak
UAzP	Prescott
UAzPhA	Phoenix. Phoenix Art Museum
UAzTUA	Tuscon. University of Arizona. Arizona State Museum
UAzTeUAm	Tempe. Arizona State University. Collection of American Art

--California

UCA	Anaheim
UCAn	Angels Camp
UCArP	Arcadia. Pony Express Museum
UCBC	Berkeley. University of California. University Art Museum
UCBCA	----- ----- Robert H. Lowie Museum of Anthropology
UCBa	Bakersfield

UCBeC	Beverly Hills. Coll. Mr. and Mrs. Donn Chappellet
UCBeE	----- Temple Emmanuel
UCBeF	----- Harry A. Franklin Gallery
UCBeFa	----- Coll. Mr. and Mrs. Donald Factor
UCBeG	----- Coll. Mr. and Mrs. Gersh
UCBeH	----- Coll. Mr. and Mrs. Melvin Hirsh
UCBeK	----- Kleiner Foundation; Coll. Mr. and Mrs. Burt Kleiner
UCBeP	----- Coll. Mr. and Mrs. Vincent Price
UCBeR	----- J. W. Robinson (Department Store)
UCBeS	----- Coll. Mr. and Mrs. Richard E. Sherwood
UCBeSc	----- Coll. Taft Schreiber
UCBeSh	----- Coll. Mr. and Mrs. Arthur Shapiro
UCBeW	----- Coll. Mr. and Mrs. Frederick H. Weisman
UCBuC	Burlingame. Coll. Mrs. William W. Crocker
UCCA	Carmel. Coll. Bruno Adriani
UCCo	Corona del Mar
UCD	Donner Lake
UCElC	Elsinore. El Colorado Geriatric Hospital
UCFCM	Fresno. Courthouse Mall
UCFCi	----- Civic Mall
UCFM	----- Mooney Park
UCFaS	Fairfield. Solano County Free Library
UCGF	Glendale. Forest Lawn Cemetery
UCHA	Hollywood. Coll. Louise and Walter Arensberg
UCHW	----- Coll. Billy Wilder
UCHi	Hillsborough
UCHu	Humboldt County
UCLA	Los Angeles. Coll. Dr. and Mrs. Nathan Alpers
UCLAd	----- Coll. Mr. and Mrs. Abe Adler
UCLAn	----- Ankrum Gallery
UCLAs	----- Coll. L. M. Asher Family
UCLB	----- Coll. Mr. and Mrs. Sidney F. Brody
UCLBl	----- Coll. Irving Blum
UCLBla	----- Coll. Mr. and Mrs. Michael Blankfort
UCLBr	----- Coll. David E. Bright
UCLC	----- Comara Gallery
UCLCM	----- Los Angeles County Museum of Art
UCLCa	----- Carthay Center
UCLCal	----- Federal Plaza Building, 5670 Wilshire Boulevard
UCLCo	----- Comara Gallery
UCLD	----- Dwan Gallery; Coll. Virginia Dwan Kondratief

UCLE	Los Angeles. Everett Ellin Gallery
UCLE1	----- Coll. Jim Eller
UCLF	----- Ferus-Pace Gallery
UCLFa	----- Coll. Donald and Lynn Factor
UCLFe	----- Feigen/Palmer Gallery
UCLFei	----- Feingarten Galleries
UCLFr	----- Coll. Mr. and Mrs. Harry A. Franklin
UCLG	----- Griffith Park
UCLGa	----- Coll. Mrs. Digby Gallas
UCLGe	----- Coll. J. Paul Getty, Malibu residence
UCLH	----- Coll. Dennis and Brooke Hopper
UCLJ	----- Coll. Edwin Janss
UCLJa	----- Coll. Joan Jacobs
UCLK	----- Kleiner Foundation
UCLL	----- Felix Landau Gallery
UCLLa	----- Lafayette Park
UCLLe	----- Coll. Mr. and Mrs. Robert Levyn
UCLLi	----- Lincoln Park
UCLLy	----- Lytton Savings and Loan Association Coll; Coll. Bart Lytton
UCLM	----- Coll. Mr. and Mrs. Louis McLane
UCLMP	----- MacArthur Park
UCLMc	----- Coll. Mrs. James McLane
UCLMcc	----- Coll. Mr. and Mrs. John McCracken
UCLMo	----- Coll. William Moore
UCLN	----- Coll. Rolf Nelson Gallery
UCLO	----- Olvera Street
UCLP	----- Coll. Mr. and Mrs. Ingo Preminger
UCLPL	----- Los Angeles City Public Library
UCLPa	----- Herbert Palmer Gallery
UCLPla	----- Plaza, North Main Street
UCLPr	----- Coll. Mr. and Mrs. Otto Preminger
UCLPs	----- Primus-Stuart Gallery
UCLR	----- Esther Robles Gallery
UCLRo	----- Coll. Robson
UCLRow	----- Coll. Robert A. Rowan
UCLS	----- Stendahl Galleries
UCLSo	----- Southwest Museum
UCLSt	----- Coll. Miss Laura Lee Stearns
UCLSte	----- Coll. Josef von Sternberg
UCLStu	----- David Stuart Galleries
UCLUC	----- University of California at Los Angeles Art Gallery
UCLUn	----- Union Park
UCLV	----- Coll. Dr. W. R. Valentiner
UCLW	----- Coll. Dr. and Mrs. George J. Wayne
UCLWi	----- Nicholas Wilder Gallery
UCLaH	Laguna Beach. Coll. Sterling Holloway

UCLjD	La Jolla. Dilexi Gallery
UCLjS	La Jolla. Scripps Institute of Oceonography
UCLo	Los Gatos
UCLonC	Long Beach. California State College
UCLonL	----- Lincoln Park
UCM	Monterey
UCOB	Oakland. Temple Beth Abraham
UCOL	----- Latham Square
UCOLo	----- Jack London Square
UCOT	----- Tiden Regional Park
UCOTe	----- Teamster's Union Building
UCPL	Point Loma
UCPaP	Pasadena. Ambassador College
UCPaH	----- Coll. Walter Hopps
UCPaL	----- Coll. Mrs. F. L. Loring
UCPaM	----- Pasadena Art Museum
UCPaR	----- Coll. Mr. and Mrs. Robert Rowan
UCPaT	----- Coll. Mr. and Mrs. Thomas Terbell
UCPalL	Palo Alto. Lanyon Gallery
UCRM	Rancho Santa Fe. Coll. Mrs. Charles Meyer
UCSBC	Santa Barbara. University of California
UCSBM	----- Santa Barbara Museum
UCSDB	San Diego. Balboa Park
UCSDC	----- San Diego State College
UCSDCi	----- Civic Center
UCSDF	----- Fine Arts Gallery of San Diego
UCSDL	----- Point Loma
UCSDP	----- Presidio Park
UCSDSCo	----- San Diego County Administration Building
UCSDUC	----- University of California
UCSFB	San Francisco. Bolles Gallery
UCSFBe	----- Berkeley Gallery
UCSFBo	----- Bohemian Club
UCSFC	----- David Cole Gallery
UCSFCP	----- California Palace of the Legion of Honor
UCSFCh	----- Coll. Thomas Church
UCSFCi	----- City Hall
UCSFD	----- Dilexi Gallery
UCSFDeY	----- M. H. de Young Memorial Museum
UCSFDi	----- Dilexi Gallery
UCSFDo	----- Mission Dolores
UCSFE	----- Temple Emanuel
UCSFF	----- St. Francis Church, Montgomery Avenue and Vallejo Street
UCSFFein	----- Charles Feingarten Gallery
UCSFG	----- Golden Gate Park

UCStbA	Santa Barbara. Coll. Mr. and Mrs. Richard McC. Ames
UCStbL	----- Coll. Wright Ludington
UCStbM	Santa Barbara. Museum of Art
UCStbMo	----- Coll. Sigmund Morgenroth
UCStbT	----- Coll. Mrs. Warren Tremaine
UCStiM	Santa Inez. Mission Santa Inez
UCU	Upland
UCWB	Whittier. Broadway-Whittier Department Store

--Colorado

UCoCT	Colorado Springs. Taylor Museum, Colorado Springs Fine Arts Center
UCoDA	Denver. Denver Art Museum
UCoDC	----- Civic Center
UCoDCap	----- State Capitol
UCoDK	----- Coll. Vance Kirkland
UCoLM	----- Coll. Phyllis Montrose
UCoDS	----- Coll. Mr. and Mrs. Caswell Silver

--Connecticut

UCtBL	Byram. Coll. Mrs. Albert A. List
UCtBlC	Bloomfield. Connecticut General Life Insurance Company
UCtBrB	Bridgeport. Temple B'nai Israel
UCtBrP	Bridgewater. Coll. George D. Pratt
UCtCL	Cannondale. Coll. Howard and Jean Lipman
UCtES	East Glastonbury. Cemetery
UCtFA	Fairfield. Coll. Mary Allis
UCtGB	Greenwich. Coll. Mr. and Mrs. Walter Bareiss
UCtGeR	Georgetown. Coll. Sally Ryan
UCtHB	Hartford. Bushnell Park
UCtHC	----- Constitution Plaza
UCtHCap	----- State Capitol
UCtHCi	----- City Hall
UCtHM	----- Mutual of Hartford Insurance Building
UCtHP	----- Public Park Department
UCtHW	----- Coll. Samuel J. Wagstaff, Jr.
UCtHWA	----- Wadsworth Atheneum
UCtLW	Litchfield. Coll. William L. Warren
UCtMG	Middlebury. Coll. Mrs. Miriam Gabo
UCtMeT	Meriden. Coll. Mr. and Mrs. Burton Tremaine
UCtMyM	Mystic Seaport. Mariners' Museum
UCtNcA	New Canaan. Coll. Lee A. Ault
UCtNcC	----- Coll. Charles Carpenter

UCtNcJ	New Canaan. Coll. Philip Johnson
UCtNcS	----- Coll. Mr. and Mrs. James Thrall Soby
UCtNhC	New Haven. Coll. Mr. and Mrs. George Heard Hamilton
UCtNhHi	----- Coll. Mr. and Mrs. F. W. Hilles
UCtNhL	----- Coll. Dr. Ralph Linton
UCtNhP	----- Yale University. Peabody Museum of Natural History
UCtNhR	----- ----- Beineche Rare Book and Manuscripts Library
UCtNhY	----- ----- Campus
UCtNlA	New London. Lyman Allyn Museum
UCtOPo	Oakville. Post Office
UCtPO	Pomfret Center. Coll. Mrs. Culver Orswell
UCtPS	----- Pomfret School
UCtSB	Stamford. Coll. Alfons Bach
UCtSS	----- Coll. Herman Shulman
UCtT	Tomkinsville
UCtWB	Wilton. Coll. Mr. and Mrs. Lester T. Beall
UCtWaI	Waterbury. Temple Israel
UCtWaM	----- Mattatuck Historical Society
UCtWeI	Westport. Temple Israel
UCtWesB	West Hartford. Temple Beth El
UCtWiD	Winsted. Coll. Mrs. Walter Davenport
UCtWoT	Woodbury. Coll. Mrs. Yves Tanguy
UCtWooJ	Woodbridge. Congregation B'nai Jacob
UCtY	----- Yale University Art Gallery, New Haven
	--Washington, D. C.
UDCA	Arlington Memorial Bridge
UDCArl	Arlington Cemetery
UDCB	----- Coll. Mrs. Edward Bruce
UDCBl	----- Coll. Mr. and Mrs. Robert Woods Bliss
UDCBlu	----- Coll. Allan Bluestein
UDCBu	----- Coll. Mr. and Mrs. William A. M. Burden
UDCC	----- Corcoran Art Gallery
UDCCap	----- United States Capitol
UDCCapS	----- ----- Statuary Hall
UDCD	----- Dumbarton Oaks
UDCDo	----- Coll. Owen Dowdson
UDCFo	----- Folger Library
UDCFr	----- Freer Gallery of Art
UDCG	----- Gallaudet College

UDCGr	Washington, D. C. Gres Gallery
UDCH	----- Howard University
UDCI	----- Interior Department Building
UDCIn	----- Coll. Indian Arts and Crafts Board
UDCJ	----- Jefferson Place Gallery
UDCJu	----- Judiciary Square
UDCK	----- Coll. Mr. and Mrs. Andrew S. Keck
UDCKr	----- Coll. Mr. and Mrs. David Lloyd Kreeger
UDCL	----- Library of Congress
UDCLP	----- Lincoln Park
UDCLa	----- Lafayette Park
UDCLi	----- Lincoln Memorial
UDCLl	----- Coll. Mrs. H. Gates Lloyd
UDCM	----- Coll. Mrs. Eugene Meyer
UDCMa	----- Coll. Mrs. May
UDCMo	----- Gallery of Modern Art
UDCN	----- National Gallery of Art
UDCNA	----- National Academy of Sciences
UDCNC	----- Episcopal National Cathedral
UDCNM	----- National Museum
UDCNMS	----- ----- Smithsonian Institution
UDCNMSC	----- ----- ----- National Collection of Fine Arts
UDCNMSP	----- ----- ----- National Portrait Gallery
UDCP	----- Phillips Gallery
UDCPa	----- Pan American Union (Organization of American States)
UDCPo	----- Washington Post Office
UDCR	----- Rock Creek Park
UDCRC	----- Rock Creek Park Cemetery
UDCS	----- Swiss Embassy
UDCSc	----- Scottish Rite Temple
UDCSin	----- Temple Sinai
UDCSw	----- Coll. Carleton Byron Swift
UDCT	----- Robert A. Taft Memorial
UDCTr	----- United States Treasury Building
UDCTy	----- Coll. W. R. Tyler
UDCW	----- White House
UDCWpa	----- W. P. A. Art Program

--Delaware

UDeWG	Wilmington. Coll. Titus G. Geesey
UDeWi	Winterthur. Winterthur Museum

--Florida

UFMP	Miami Beach. Arthur Godfrey Road and Pine Tree Drive

UFMiH	Miami. Hope Lutheran Church
UFOT	Ormond Beach (near). Tomoka State Park
UFPN	Palm Beach. Norton Gallery
UFSR	Sarasota. Ringling Museum of Art
UFSsS	Silver Springs. Silver River
UFWN	West Palm Beach. Norton Gallery

--Georgia

UGAA	Atlanta. Atlanta Art Association
UGAU	----- Atlanta University
UGCU	Calhoun (Near). U. S. Highway 42 and State Highway 225 Intersection
UGS	Savannah
UGSM	Stone Mountain

--Hawaii

UHE	Ewa
UHHA	Honolulu. Academy of Arts
UHHB	----- Bernice Pauahi Bishop Museum

--Illinois

UIBJ	Benton. Coll. Dr. and Mrs. Richard Johnson
UIBaF	Barrington. Coll. Mr. and Mrs. Owen Fairweather
UICA	Chicago. Art Institute
UICAC	----- Arts Club
UICAb	----- Abbott Laboratories
UICAd	----- Adler Planetarium
UICAl	----- Coll. Mr. and Mrs. James M. Alter
UICAll	----- Coll. Robert Allerton
UICAr	----- Coll. Albert L. Arenberg
UICB	----- Board of Trade Building
UICBa	----- Coll. Mr. and Mrs. Herbert Baker
UICBe	----- Coll. Mr. and Mrs. Edwin A. Bergman
UICBen	----- Coll. Richard M. Bennett
UICBl	----- Coll. Leigh B. Block
UICBla	----- Coll. Blair
UICBr	----- Coll. Avery Brundage
UICC	----- Century of Progress Electrical Building
UICCar	----- Carson, Pirie, Scott Department Store (Formerly: Schlesinger-Meyer Building)
UICCh	----- Chicago Historical Society
UICCo	----- Cook County Courthouse
UICCu	----- Coll. W. Cummings
UICE	----- Elks National Memorial Building

UICEm	Chicago. Temple Emanuel
UICEp	----- Coll. Mrs. Max Epstein
UICF	----- Allan Frumkin Gallery
UICFa	----- Coll. Dr. Edith B. Farnsworth
UICFai	----- Fairweather-Hardin Gallery
UICFe	----- Richard Feigen Gallery
UICFea	----- Fairweather-Hardin Gallery
UICFein	----- Charles Feingarten Galleries
UICFl	----- Coll. L. Florsheim
UICG	----- Grant Park
UICGa	----- Garfield Park
UICGi	----- Coll. Willard Gidwitz
UICGid	----- Coll. Mr. and Mrs. Gerald Gidwitz
UICGil	----- Gilman Galleries
UICGl	----- Glenview
UICGr	----- Coll. Mr. and Mrs. Everett D. Graff
UICH	----- Coll. Mr. and Mrs. Leonard Horwich
UICHa	----- Fairweather-Hardin Gallery
UICHaf	----- Coll. Charles C. Haffner III
UICHar	----- Coll. William Harris
UICHi	----- Coll. Mr. and Mrs. Milton Hirsch
UICHo	----- B. D. Holland Gallery
UICHod	----- Coll. Mr. and Mrs. Barnet Hodes
UICHok	----- Coll. Mr. and Mrs. Edwin E. Hokin
UICI	----- Institute of Design
UICIn	----- Inland Steel Company
UICJ	----- Jackson Park
UICJu	----- Coll. Stephen Junkunc III
UICJud	----- Coll. Mrs. Sylvia Shaw Judson
UICK	----- Coll. Mr. and Mrs. B. Kowalsky
UICL	----- Lincoln Park
UICM	----- Coll. Mr. and Mrs. Arnold H. Maremont
UICMa	----- Coll. Mr. and Mrs. Lewis Manilow
UICMain	----- Main Street Galleries
UICMar	----- Coll. Mr. and Mrs. Henry A. Markus
UICMarq	----- Marquette Building
UICMic	----- Coll. Mr. and Mrs. D. Daniel Michel
UICMid	----- Midway Plaisance
UICMo	----- Montgomery Ward Building
UICN	----- Coll. Arthur J. Neumann
UICNe	----- Coll. Mrs. Albert H. Newman
UICNet	----- Coll. Mr. and Mrs. Walter A. Netsch, Jr.
UICNeu	----- Coll. Mr. and Mrs. Morton G. Neumann
UICNh	----- Chicago Natural History Museum (Formerly: Field Museum)

UICO	Chicago. Ontario East Gallery
UICPa	----- Palmer College
UICS	----- Coll. Howard Shaw
UICSc	----- Museum of Science and Industry
UICSch	----- Coll. Mrs. Ida Schutze
UICSe	----- Coll. Dr. and Mrs. Herman Serota
UICSh	----- Devorah Sherman Gallery
UICSm	----- Coll. S. B. Smith
UICSt	----- Coll. Mr. and Mrs. Joel Starrels
UICSte	----- Steinberg Collection
UICT	----- St. Thomas the Apostle Church
UICU	----- University of Chicago
UICUO	----- ----- Oriental Institute
UICW	----- Coll. Mr. and Mrs. Edward H. Weiss
UICWa	----- Washington Park
UICWi	----- Coll. Mr. and Mrs. Raymond Wielgus
UICWo	----- Coll. Mr. and Mrs. Charles H. Worcester
UICZ	----- Coll. Mrs. Ernest Zeisler
UICZu	----- Coll. Mr. and Mrs. Suzette Morton Zurcher
UICa	Cairo
UIChUK	Champaign. University of Illinois. Krannert Art Museum
UID	Danville
UIDeM	Decatur. Macon County Building
UIDeMi	----- Milliken University
UIEB	Evanston. Coll. Prof. William R. Bascom
UIDi	Dixon
UIF	Freeport
UIGH	Glencoe. Coll. Mr. and Mrs. Howard G. Haas
UIGP	----- Coll. Mr. and Mrs. Jay Pritzker
UIGS	----- Coll. Herman Spertus
UIL	Lawrence County
UIOS	Oak Park. Coll. Mr. and Mrs. Joseph R. Shapiro
UIOa	Oak Brook
UIOrR	Oregon. Rock River--East Bank
UIPP	Peoria. St. Paul's Church
UIQI	Quincy. Coll. George M. Irwin
UIRB	Rock Island. Black Hawk State Park
UIRiH	River Forest. Temple Har Zion
UIRiT	River Front. West Suburban Temple
UIRoG	Rosamund. Rosamund Grove Cemetery
UISCap	Springfield. State Capitol
UISI	----- Illinois State Museum of Natural History and Art

UISO	Springfield. Oak Ridge Cemetery
UIUU	Urbana. University of Illinois
UIUUA	----- ----- College of Fine and Applied Art
UIWA	Winnetka. Coll. Mr. and Mrs. J. W. Alsdorf
UIWM	----- Coll. Mr. and Mrs. Arnould H. Maremont
UIWMa	----- Coll. Mr. and Mrs. Robert B. Mayer

--Iowa

UIaAI	Ames. Iowa State University
UIaDCap	Des Moines. State Capitol
UIaDaM	Davenport. Davenport Public Museum
UIaDeN	Decorah. Norwegian-American Historical Museum
UIaFtL	Fort Dodge. Public Library
UIaIU	Iowa City. University of Iowa
UIaKR	Keokuk. Rand Park
UIaLC	Lakeview. Crescent Park
UIaOC	Oskaloosa. City Park
UIaW	Webster City

--Idaho

UIdBA	Boise. Boise Art Association

--Indiana

UInBH	Bloomington. Coll. Mr. and Mrs. Henry R. Hope
UInBU	Bloomington. University of Indiana
UInF	Fort Wayne
UInGB	Gary. Temple Beth El
UInGL	----- Lake County Children's Home
UInIH	Indianapolis. John Herron Art Institute
UInII	----- Indianapolis Hebrew Congregation
UInIU	----- University Park
UInNU	Notre Dame. University of Notre Dame Art Gallery
UInNhW	New Harmony. Workingmen's Institute
UInO	Odon
UInPP	Plymouth (near). Highway between Pretty Lake and Twin Lakes
UInSB	South Bend. Temple Beth El
UInSBM	----- Coll. Mrs. Olga Mestrovic
UInTB	Terre Haute. Coll. Mr. C. H. Biel (Biel, Inc., Tobacco Company)
UInTL	----- Coll. Mrs. Leroy Lamis
UInTP	----- Coll. A. W. Pendergast
UInW	Wabash

UMBFH	Boston. Faneuil Hall
UMBG	----- Public Gardens
UMBGa	----- Isabella Stewart Gardner Museum
UMBGr	----- Granary Burying Grounds
UMBH)	----- Massachusetts Historical Society
UMGHS)	
UMBK	----- King's Chapel
UMBMc	----- Coll. Mrs. Q. A. Shaw McKean
UMBMi	----- Boris Mirski Gallery
UMBO	----- Coll. 180 Corporation
UMBOS	----- Old State House
UMBP	----- Coll. Stephen D. Paine
UMBPL	----- Boston Public Library
UMBPS	----- Phipps Street Burying Ground
UMBPa	----- Park Square
UMBPac	----- Pace Gallery
UMBR	----- Coll. Mr. and Mrs. Perry T. Rathbone
UMBS	----- Scollay Square
UMBSh	----- Shore Galleries
UMBSo	----- Boston Society
UMBSol	----- Coll. Mr. and Mrs. Richard Solomon
UMBSt	----- Old State House
UMBSw	----- Swetzoff Gallery
UMBSwa	----- Coll. Mrs. Georg Swarzenske
UMCA	Cambridge. Mt. Auburn Cemetery
UMCB	----- Busch-Reisinger Museum
UMCC	----- St. Catherine's Church
UMCCa	----- Coll. Harriet Hosmer Carr
UMCCo	----- First Church of Cambridge Congregational
UMCF	----- Fogg Art Museum
UMCH	----- Harvard University
UMCHG	----- Harvard University. Biological Laboratory
UMCHC	----- ----- College Library
UMCHG	----- ----- Graduate Center
UMCHL	----- ----- Law School
UMCHR	----- ----- Robinson Hall
UMCM	----- Massachusetts Institute of Technology
UMCMC	----- ----- Chapel
UMCMt	----- Mt. Auburn Cemetery
UMCP	----- Peabody Museum of Archaeology and Ethnology
UMCR	----- Coll. Mr. and Mrs. Perry T. Rathbone
UMCRo	----- Coll. B. Rowland
UMCS	----- Coll. Sachs

UMCSe	Cambridge. Semitic Museum
UMChO	Chatham. Col. Elliott Orr
UMCha	Charlemonte, West of Shunpike Bridge
UMCheW	Chestnut Hill. Coll. Mr. and Mrs. Max Wasserman
UMCoL	Concord. Concord Free Public Library
UMCoS	----- Sleepy Hollow Cemetery
UMCohL	Cohasset. Coll. Harry V. Long
UMF	Fitchburg
UMGG	Groton. Groton School
UMGlA	Gloucester. Cape Ann Scientific, Literary and Historical Association
UMHF	Harvard. Fruitlands Museum
UMHa	Haverhill
UMHoJ	Holyoke. St. Joseph Hospital Chapel
UMJ	Jamaica Pond
UML	Lowell
UMLaC	Lawrence. Chemical-Plastic Division, General Tire and Rubber Company
UMLexT	Lexington. Town Hall
UMMR	Medford. Isaac Royall Mansion
UMMaS	Manchester. Stark Park
UMMarH	Marblehead. Marblehead Historical Society
UMMe	Methuen
UMMi	Milton
UMNSA	Northampton. Smith College. Museum of Art
UMNaE	Nantucket. Coll. Mrs. Edward H. Evans
UMNeCSt	Newton Center. Coll. Mr. and Mrs. Stephen A. Stone
UMNeS	Newton. Temple Shalom
UMNeW	----- Coll. Mr. and Mrs. Max Wassermann
UMNewC	----- Centre Street Burying Ground
UMNewO	New Bedford. Old Dartmouth Historical Society and Whaling Station
UMNoP	Norwood. Coll. G. A. Plimpton
UMPC	Plymouth. Cole's Hill
UMPP	----- Pilgrim Hall
UMPiB	Pittsfield. Berkshire Museum
UMPrG	Princeton. Albart Garganigo, Museum of Antique Autos
UMProC	Provincetown. Chrysler Art Museum
UMQG	Quincy. Granite Railway Company
UMSaE	Salem. Essex Institute
UMSaP	----- Peabody Museum
UMSoD	South Hadley. Mt. Holyoke College. Dwight Art Memorial
UMSouD	Southbridge. Wells Historical Museum
UMSpA	Springfield. Museum of Fine Arts

UMSpB	Springfield. Coll. Dr. and Mrs. Malcolm W. Bick
UMSpBe	----- Temple Beth El
UMSpBi	----- Coll. Mr. Raymond A. Bidwell
UMSpBu	----- Coll. H. Wesson Bull, Jr.
UMSpTB	----- Temple Beth El
UMStO	Sturbridge. Old Sturbridge Village
UMStoC	Stockbridge. Chesterwood--Studio of Daniel Chester French
UMSwT	Swampscott. Temple Israel
UMWA	Worcester. Worcester Art Museum
UMWAS	----- American Antiquarian Society
UMWE	----- Elm Park
UMWH	----- John Woodman Higgins Armory
UMWHS	----- Worcester Historical Society
UMWaB	Waltham. Brandeis University
UMWe	Wellfleet
UMWelC	Wellesley. Wellesley College. Farnsworth Museum of Art; Jewett Art Center
UMWelCL	----- ----- Wellesley College Library
UMWesD	Westwood. Coll. Richard L. Davisson
UMWh	Whittinsville
UMWiB	Williamstown. Coll. Mr. and Mrs. Laurence Bloedel
UMWiC	----- Sterling and Francine Clark Art Institute
UMWiL	----- Williams College. Lawrence Art Museum

--Maryland

UMdAN	Annapolis. United States Naval Academy
UMdBC	Baltimore. Colonial Dames of America, Chapter 1
UMdBF	----- Friends of Art
UMdBG	----- Greenmount Cemetery
UMdBH	----- Hebrew Congregation
UMdBJ	----- Johns Hopkins University
UMdBM	----- Baltimore Museum of Art
UMdBMH	----- Baltimore Historical Society
UMdBMay	----- Coll. Saidie A. May
UMdBMo	----- Morgan State College
UMdBO	----- Temple Oheb Shalom
UMdBP	----- Peabody Institute
UMdBPM	----- Peale Museum
UMdBV	----- Mt. Vernon Square
UMdBW	----- Walters Art Gallery
UMdBWu	----- Coll. Mr. and Mrs. Alan Wurtzburger
UMdF	Fort Lincoln. Cemetery

UMdFr	Frederick
UMdHW	Hagerstown. Museum of Fine Arts of Washington County
UMdPW	Pikesville. Coll. Mr. and Mrs. Alan Wurtzburger

--Maine

UMeBS	Bath. Loyall Sewall
UMeBrB	Brunswick. Bowdoin College. Museum of Fine Arts
UMeES	East Sullivan. Coll. Mrs. John Spring
UMeKB	Kennebunkport. Boat House Museum
UMeNB	Nobleboro. Coll. Mr. and Mrs. Henry Beston
UMeOA	Ogunquit. Museum of Art
UMeOL)	----- Coll. Robert Laurent
UMeOR)	
UMeP	Portland
UMeRR	Rockland. Coll. David Rubenstein

--Michigan

UMiAUA	Ann Arbor. University of Michigan. Art Gallery
UMiBC	Bloomfield Hills. Cranbrook Academy Museum
UMiBiC	Birmingham. Coll. Dr. and Mrs. Meyer O. Cantor
UMiBiW	----- Coll. Mr. and Mrs. Harry Lewis Winston
UMiBloC	Bloomfield Hills. Cranbrook Academy of Art
UMiCC	Cranbrook. Christ Church
UMiCI	----- Cranbrook Institute of Science
UMiCad	Cadillac
UMiD	Detroit. Institute of Arts
UMiDAth	----- Detroit Athletic Club
UMiDE	----- Eastland Center
UMiDF	----- Coll. Dr. G. Frohlicher
UMiDFe	----- Feinberg Collection
UMiDFl	----- Coll. Mr. and Mrs. Lawrence A. Fleischman
UMiDFo	----- Coll. Mr. and Mrs. Edsel B. Ford
UMiDFor	----- Coll. Mr. and Mrs. Walter B. Ford II
UMiDFr	----- Coll. Mrs. Michael Freeman
UMiDG	----- General Motors Plant (UMiWaG)
UMiDH	----- J. L. Hudson Gallery
UMiDK	----- Coll. Dr. George Kamperman
UMiDW	----- Coll. Mr. and Mrs. Harry Lewis Winston

UMiDbE	Dearborn. Edison Institute
UMiDbFM	----- Henry Ford Museum and Greenfield Village
UMiFB	Flint. Coll. Mrs. Everett L. Bray
UMiGN	Grosse Point. Coll. John S. Newberry
UMiGT	Grosse Pointe Farms. Coll. Robert H. Tannahill
UMiH	Mississippi. Hall of Fame
UMiI	Ironwood
UMiK	Kalamazoo
UMiL	L'Anse (Near). Site of Old Baraga Mission
UMiMH	Muskegon. Hackley Park
UMiPD	Pleasant Ridge. Coll. Dr. and Mrs. Brewster Broder
UMiPP	----- Coll. Mr. and Mrs. Max J. Pincus
UMiPoC	Pontiac. City Hall
UMiWaG	Warren. General Motors Technical Center (UMiDG)
UMiWpa	W. P. A. Art Program
UMiY	Ypsilanti

--Minnesota

UMnCJ	Collegeville. St. John's Abbey Church
UMnD	Duluth
UMnMC	Minneapolis. Coll. Mr. and Mrs. Morris Chalfen
UMnMD	----- Coll. Mr. and Mrs. Bruce B. Dayton
UMnMF	----- Church of St. Francis Xavier Cabrini
UMnMI	----- Minneapolis Institute of Arts
UMnMM	----- Minnehaha Creek, approximately 100' above Minnehaha Falls
UMnMP	----- Coll. Alfred F. Pillsbury
UMnMPL	----- Minneapolis Public Library
UMnMR	----- Coll. Mr. and Mrs. John Rood
UMnMU	----- University of Minnesota
UMnMW	----- Walker Art Center
UMnRA	Red Wing. Coll. John P. Anderson
UMnR	Red Lake River, 8 miles west of Red Lake Falls, or 13-1/2 miles northeast of Crookston
UMnStPB	St. Paul. Temple B'nai Aaron
UMnStPC	----- City Hall
UMnStPCo	----- Cochran Park
UMnStPM	----- Temple Mount Zion
UMnStPR	----- Coll. E. R. Rieff
UMnWD	Wayzata. Coll. Mr. and Mrs. Richard S. Davis
UMnWi	Winona

UMoA	St. Louis. Art Palace
UMoC	George Washington Carver National Monument
UMoKB	Kansas City. Coll. James Baldwin
UMoKF	----- Findlay Galleries
UMoKNG	----- William Rockhill Nelson Gallery, Atkins Museum
UMoKP	----- Penn Valley Park
UMoKUP	----- University of Kansas City Park
UMoKY	----- Yellow Transit Freightlines
UMoSD	St. Louis. Coll. Lionberger Davis
UMoSF	----- Forest Park
UMoSFe	----- Federal Building
UMoSL	----- City Art Museum
UMoSLA	----- Aloe Plaza
UMoSLG	----- Coll. Vladimir Goischmann
UMoSLH	----- Missouri Historical Society
UMoSLM	----- Mercantile Library
UMoSLMa	----- Coll. Mr. and Mrs. Morton D. May
UMoSLMe	----- Memorial Building
UMoSLP	----- Coll. Joseph Pulitzer, Jr.
UMoSLPf	----- Coll. Mrs. Henry Pflager
UMoSLS	----- Coll. Mrs. Mark C. Steinberg
UMoSLSo	----- Coll. Dr. Conrad Sommer
UMoSLWa	----- Washington University
UMoSLWe	----- Coll. Mr. and Mrs. Richard K. Weil
UMoSLa	----- Lafayette Park
UMoSW	----- Washington University. Art Collection
UMoSpA	Springfield. Springfield Museum of Art
UMoT	Tupelo

UMsCPo	Carthage. Post Office

UMtB	Big Hole. Battlefield National Monument
UMtBuC	Butte. W. A. Clarke House

UNAS	Auriesville. Shrine of North American Martyrs
UNAlB	Albany. Temple Beth Emeth
UNAlE	----- New York State Museum, State Education Building
UNAlI	----- Albany Institute of History and Art
UNArG	Ardsley. Geigy Pharmaceuticals
UNAu	Auburn
UNBB	Brooklyn. Brooklyn Museum

UNBBa	Brooklyn. Coll. Dr. Avrom Barnett
UNBC	----- Courthouse
UNBE	----- Eastern Parkway at Bedford Avenue
UNBG	----- Grant Square
UNBGar	----- Garfield Restaurant
UNBHP	----- Borough Hall Park
UNBL	----- Coll. Mr. and Mrs. Menahem Lewin
UNBMA	----- Brooklyn Memorial Arch
UNBP	----- Prospect Park
UNBiR	Binghamton. Roberson Memorial Center
UNBoS	Bolton Landing. Coll. David Smith
UNBrB	Brewster. Chester Beach Memorial Studio
UNBroL	Brookhaven. Coll. Mr. and Mrs. Knute D. Lee
UNBuA	Buffalo. Albright-Knox Art Gallery
UNBuF	----- Forest Lawn Cemetery
UNBuG	----- Guaranty Building
UNBuGo	----- James Goodman Gallery
UNBuHS	----- Buffalo and Erie County Historical Society
UNBuMS	----- Museum of Science
UNBuT	----- Coll. Mr. and Mrs. David A. Thompson
UNCV	Centerport. Vanderbilt Museum
UNCooF	Cooperstown. Fenimore House and Farmers' Museum
UNCooHS	----- New York State Historical Society
UNCooJ	----- Coll. Louis C. Jones
UNCooL	----- Lakewood Cemetery
UNCooO	----- Otsego Hall Site
UNCorC	Corning. Corning Museum of Glass
UNEE	Elmira. Elmira College
UNFC	Forest Hills. Forest Hills Cemetery
UNFI	----- Temple Isaiah
UNGA	Great Neck. Coll. Lester Avnet
UNGB	----- Temple Beth El
UNGE	----- Congregation of Temple Emanuel
UNGK	----- Coll. Mr. and Mrs. Harold Kaye
UNGS	----- Coll. Mr. and Mrs. Robert C. Scull
UNGaA	Garden City. Adelphi University
UNGeH	Geneva. Hobart College
UNGlH	Glen Falls. Hyde Coll.
UNGloS	Gloversville. Coll. Mr. and Mrs. Jacob Schulman
UNHG	Harrison. Coll. Mr. and Mrs. Kurt H. Grunebaum
UNHaC	Hamilton. Colgate University
UNHasS	Hastings-on-Hudson. Coll. Irene and Jan Peter Stern

UNHi	Hicksville
UNHoM	Hoosick Falls. Coll. George S. McKearin
UNHuF	Hudson. American Museum of Fire Fighting
UNHyR	Hyde Park. Franklin D. Roosevelt National Historical Site
UNIC	Ithaca. Cornell University
UNICM	----- ----- Medical School
UNICW	----- ----- Andrew Dickson White Museum of Art
UNKJ	Kingston. Coll. Fred J. Johnston
UNKS	----- Senate House and Senate House Museum
UNKijR	Kifkuit. John D. Rockefeller Hudson River Estate
UNKinS	Kings Point. Coll. Mr. and Mrs. Rudolph B. Schulhof
UNLF	Lake George. Fort George Park
UNLL	----- Lake George Battleground
UNLaK	Lawrence. Coll. Leon Kraushar
UNMW	Manhasset. Payne Whitney Bird Garden
UNMi	Mineola
UNMilB	Millburn. B'nai Israel Synagogue
UNMoS	Mountainville. Storm King Art Center
UNNA	New York City. Coll. Lisa Arnhold
UNNAC	----- A. C. A. Gallery
UNNAb	----- Coll. Abrams Family
UNNAd	----- Coll. James S. Adams
UNNAdr	----- Adria Art Gallery
UNNAl	----- Alan Gallery; Landau-Alan Gallery
UNNAld	----- Coll. Larry Aldrich
UNNAmA	----- American Academy of Arts and Letters
UNNAmM	----- American Museum of Natural History
UNNAmN	----- American Numismatic Society
UNNAmT	----- American Tobacco Company
UNNAme	----- Amel Gallery
UNNAn	----- David Anderson Gallery
UNNAp	----- Appellate Court Building
UNNArn	----- Coll. Mrs. Lisa Arnhold
UNNAs	----- Astor Place
UNNAu	----- Coll. Mr. and Mrs. Lee A. Ault
UNNB	----- Grace Borgenicht Gallery
UNNBa	----- Coll. Bay
UNNBak	----- Coll. Walter C. Baker
UNNBake	----- Coll. Richard Brown Baker
UNNBaker	----- Baker Coll.
UNNBakerl	----- Coll. R. Lynn Baker
UNNBan	----- Banfer Gallery
UNNBar	----- St. Bartholomew's Church
UNNBarb	----- Coll. Joel Barber

UNNBaro	New York City. Barone Gallery
UNNBat	----- Battery Park
UNNBe	----- Coll. Martin Becker
UNNBec	----- Coll. Mr. and Mrs. Ian Beck
UNBBel	----- Coll. Richard Bellamy
UNNBen	----- Coll. Mr. and Mrs. Robert M. Benjamin
UNNBene	----- Coll. Mr. and Mrs. Charles B. Benenson
UNNBi	----- Coll. Alexander M. Bing
UNNBia	----- Bianchini Gallery
UNNBir	----- Coll. Dr. Junius B. Bird
UNNBiri	----- Coll. Ben Birillo
UNNBl	----- Coll. Dr. Henry L. Blank
UNNBla	----- Coll. Jacob Blaustein
UNNBli	----- Coll. Donald M. Blinken
UNNBlu	----- Blumenthal Coll.
UNNBlum	----- Coll. Ruth and Leopold Blumka
UNNBo	----- Coll. Alice Boney
UNNBon	----- Bonwit Teller Building
UNNBoni	----- Galeria Bonino
UNNBow	----- Bowling Green
UNNBoy	----- Boyer Galleries
UNNBr G	----- Bronx Grand Concourse
UNNBrH	----- Bronx Municipal Hospital Group
UNNBrR	----- Bronx River
UNNBro	----- Coll. Mr. and Mrs. Jerome Brody
UNNBroa	----- Broadway and 73rd Street Intersection
UNNBroad	----- Broadway and 63rd Street Intersection
UNNBru	----- Brummer Galleries
UNNBry	----- Bryant Park
UNNBu	----- Buchholz Gallery
UNNBur	----- Coll. Mr. and Mrs. William A. M. Burden
UNNBy	----- Byron Gallery
UNNByk	----- Bykert Gallery
UNNC	----- Leo Castelli Gallery; Coll. Mr. and Mrs. Leo Castelli
UNNCC	----- New York State Chamber of Commerce
UNNCR	----- Columbia Records
UNNCT	----- Collins Tuttle and Company
UNNCa	----- Carstairs Gallery
UNNCag	----- Coll. John Cage
UNNCah	----- Coll. Holger Cahill
UNNCal	----- Coll. Mrs. Mary Callery
UNNCar	----- Carlebach Gallery
UNNCarr	----- Coll. W. Frederick Carreras
UNNCart	----- Coll. Dagny Carter

UNNCas	New York City. Castellano Gallery
UNNCat	----- Coll. T. Catesby Jones
UNNCc	----- Columbia Circle
UNNCent	----- Central Park
UNNCent M	----- Central Park Mall
UNNCh	----- Galerie Chalette
UNNCha	----- Channin Building, 42nd Street and Lexington Avenue
UNNChan	----- Margit Chanin, Ltd.
UNNChas	----- Chase Manhattan Bank, 410 Park Avenue
UNNChasP	----- Chase Plaza
UNNChr	----- Coll. Walter P. Chrysler, Jr.
UNNChri	----- Coll. Lansdell K. Christie
UNNCi	----- Museum of the City of New York
UNNCit	----- City Hall Park
UNNCity	----- City College
UNNCl	----- Coll. Stephen C. Clark
UNNCla	----- Claremont Avenue and 122nd Street Intersection
UNNCo	----- Columbia University
UNNCoE	----- ----- Earl Hall
UNNCob	----- Cober Gallery
UNNCoh	----- Coll. Mr. and Mrs. Erich Cohn
UNNCohe	----- Coll. Mr. and Mrs. Wilfred P. Cohen
UNNCol	----- College of the City of New York
UNNColi	----- Coll. Mr. and Mrs. Ralph F. Colin
UNNCon	----- The Contemporaries
UNNCoo	----- Cooper Union Museum; Cooper Square
UNNCor	----- Cordier & Ekstrom
UNNCot	----- Cottier & Company
UNNCr	----- Coll. Louise Crane
UNNCro	----- Coll. Frank Crowninshield
UNNCu	----- New York Custom House
UNNCun	----- Coll. John J. Cunningham
UNND	----- Downtown Gallery
UNNDa	----- Daily News Building
UNNDar	----- D'Arcy Gallery
UNNDe	----- Coll. Mr. and Mrs. Pierre Delfausse
UNNDeN	----- Tibor de Nagy Gallery
UNNDel	----- Delexi Gallery
UNNDi	----- Terry Dintenfass Gallery
UNNDik	----- Coll. Mr. and Mrs. Charles M. Diker
UNNDo	----- Downtown Gallery
UNNDoc	----- Coll. Dr. and Mrs. Frederick J. Dockstader
UNNDor	----- Dorsky Gallery
UNNDr	----- Coll. Katherine Dreier
UNNDu	----- Coll. John A. Dunbar

UNNDuv	New York City. Coll. Albert Duveen
UNNDw	----- Dwan Gallery
UNNE	----- Egan Gallery
UNNEl	----- Robert Elkon Gallery
UNNEli	----- Coll. Eliot Elisofon
UNNElk	----- Coll. Mr. and Mrs. Herman Elkon
UNNEm	----- Andre Emmerich Gallery
UNNEmi	----- Coll. Mr. and Mrs. Allan D. Emil
UNNEn	----- American Enka Corporation
UNNEr	----- Coll. Hobe Erwin
UNNEri	----- Coll. Ernest Erickson
UNNErl	----- Coll. Mr. and Mrs. Arthur L. Erlanger
UNNF	----- Frick Collection
UNNFa	----- Coll. Mr. and Mrs. Myron S. Falk-Jun
UNNFar	----- Coll. Farragut Junior High School
UNNFe	----- Federal Hall Memorial
UNNFei	----- Richard Feigen Gallery
UNNFein	----- Charles Feingarten Galleries
UNNFer	----- Ferargil Galleries
UNNFerb	----- Coll. Mr. and Mrs. Herbert Ferber
UNNFi	----- Fine Arts Associates
UNNFie	----- Coll. Mr. and Mrs. Leonard S. Field
UNNFis	----- Fischback Gallery
UNNFl	----- Flushing Meadow Park
UNNFo	----- Fort Greene Park
UNNFor	----- Coll. Dr. James A. Ford
UNNForm	----- Forum Gallery
UNNFou	----- Four Seasons Restaurant
UNNFr	----- Coll. Dr. Maurice Fried
UNNFra	----- Allan Franklin Gallery
UNNFre	----- French and Company
UNNFri	----- Rose Fried Gallery
UNNFru	----- Allan Frumkin Gallery
UNNFur	----- Coll. Dr. and Mrs. Irving Furman
UNNFut	----- Coll. Futterman Corporation
UNNG	----- Solomon R. Guggenheim Museum
UNNGal	----- Coll. A. E. Gallatin
UNNGan	----- Coll. Mr. and Mrs. Victor W. Ganz
UNNGe	----- Otto Gerson Gallery
UNNGel	----- Coll. Henry Geldzahler
UNNGer	----- Coll. George Gershwin
UNNGl	----- Coll. Mr. and Mrs. Arnold B. Glimcher
UNNGo	----- Coll. A. Conger Goodyear
UNNGol	----- Coll. Noah Goldowsky and Richard Bellamy
UNNGoo	----- Coll. Philip L. Goodwin
UNNGood	----- Coll. Jerome Goodman

UNNGr	New York City. Grand Central Art Galleries
UNNGra	----- Gramercy Park
UNNGrah	----- Graham Gallery
UNNGran	----- Grant Boulevard and 161st Street Intersection
UNNGrand	----- Grand Central Moderns
UNNGre	----- Greely Square
UNNGree	----- Green Gallery
UNNGreen	----- Coll. Sarah Dora Greenberg
UNNGri	----- Grippi and Waddell Gallery
UNNGro	----- Coll. Chaim Gross
UNNGru	----- Coll. Mr. and Mrs. B. Sumner Gruzen
UNNGu	----- Coll. B. C. Guennol
UNNGua	----- Guaranty Trust Company
UNNGutm	----- Coll. Melvin Gutman
UNNH	----- Coll. Joseph H. Hirshhorn
UNNHF	----- Hall of Fame for Great Americans, New York University
UNNHS	----- New York Historical Society
UNNHa	----- Coll. Laura Harden
UNNHah	----- Stephen Hahn Gallery
UNNHal	----- Coll. Hiram J. Halle
UNNHan	----- Hansa Gallery
UNNHanc	----- Hancock ,Square
UNNHar	----- Coll. Mr. and Mrs. S. Hartman
UNNHard	----- Coll. Laura Harden
UNNHarl	----- Harlem River Houses
UNNHarm	----- Harmon Foundation
UNNHarn	----- Coll. Mr. and Mrs. Rene d'Harnoncourt
UNNHas	----- Coll. Haskell
UNNHau	----- Coll. Mrs. Ira Haupt
UNNHe	----- Coll. Mr. and Mrs. Maxime L. Hermanos
UNNHea	----- Coll. William Randolph Hearst
UNNHee	----- Coll. Mr. and Mrs. Nasli M. Heeramaneck; Heeramaneck Galleries
UNNHel	----- Coll. Dr. and Mrs. Julius S. Held
UNNHell	----- William Heller, Inc.
UNNHer	----- Herald Square
UNNHew	----- Coll. Robert Hewitt
UNNHis	----- Hispanic Society of America
UNNHo	----- Coll. Mrs. C. R. Holmes
UNNHous	----- New York City Housing Project
UNNHu	----- Coll. Rev. Robert C. Hunsicker
UNNHy	----- Coll. Mrs. Louis F. Hyde
UNNI	----- Alexander Iolas Gallery
UNNIb	----- Coll. International Business Machines
UNNIn	----- International Nickel Company

UNNInAI	New York City. New York International Airport. International Arrivals Building
UNNInB	----- Coll. International Business Machines
UNNIs	----- Coll. Mr. and Mrs. Joseph S. Iseman
UNNJ	----- Martha Jackson Gallery; Coll. Martha Jackson
UNNJa	----- Sidney Janis Gallery
UNNJac	----- Coll. Mr. and Mrs. Martin D. Jacobs
UNNJan	----- Coll. Sidney Janis
UNNJe	----- Jewish Museum
UNNJo	----- Galerie Alexander Jolas
UNNJoh	----- Coll. Philip C Johnson
UNNJohn	----- Cathedral of St. John the Divine
UNNJon	----- Coll. T. Catesby Jones
UNNJos	----- Coll. Mr. and Mrs. Samuel Josefowitz
UNNJu	----- Coll. Charles S. Jules
UNNK	----- M. Knoedler and Company
UNNKa	----- Coll. William Kaufman
UNNKag	----- Coll. Mr. and Mrs. Illi Kagan
UNNKau	----- Coll. Edgar Kaufmann
UNNKe	----- Coll. Kevorkian
UNNKen	----- Coll. Messrs. Kennedy-Garber
UNNKl	----- Kleemann Galleries
UNNKle	----- J. J. Klejman
UNNKley	----- Kleykamp Collection
UNNKlo	----- Coll. Mr. and Mrs. A. J. T. Kolman
UNNKo	----- Samuel M. Kootz Gallery; Coll. Mr. and Mrs. Samuel Kootz
UNNKor	----- Kornblee Gallery
UNNKou	----- Coll. Fahim Kouchakji
UNNKr	----- Kraushaar Galleries; Coll. Leon Kraushaar
UNNL	----- Coll. Fritz Low-Beer
UNNLI	----- Liberty Island
UNNLa	----- Isabel Lachaise Estate (Felix Landau Gallery, Los Angeles, and Robert Schoelkopf Gallery, New York City)
UNNLad	----- Coll. Mr. and Mrs. Harold Ladas
UNNLaf	----- Lafayette Park and Washington
UNNLam	----- Coll. Mr. B. Lambert
UNNLas	----- Coll. Mrs. Imbram Lassaw
UNNLe	----- Lejva Coll.
UNNLef	----- Lefebre Gallery
UNNLefe	----- Coll. Mr. and Mrs. John Lefebre
UNNLeh	----- Coll. Robert Lehman
UNNLei	----- Fred Leighton, Inc.
UNNLev	----- Mortimer Levitt Gallery
UNNLevi	----- Coll. Mr. and Mrs. Irving Levick

UNNLevy	New York City. Coll. Julien Levy; Julien Levy Gallery
UNNLew	----- Coll. Adolph Lewisohn
UNNLi	----- Coll. Mr. and Mrs. Albert List
UNNLie	----- Coll. Mrs. Charles J. Liebman
UNNLin	----- Coll. Mr. and Mrs. Jack Linsky
UNNLinc	----- Lincoln Center, New York State Theatre
UNNLip	----- Coll. Mr. and Mrs. Howard W. Lipman
UNNLipc	----- Coll. Jacques Lipchitz
UNNLiv	----- Museum of Living Art
UNNLo	----- Coll. R. Loewy
UNNLoe	----- Albert Loeb Gallery
UNNLoo	----- Formerly Coll. C. T. Loo
UNNLow	----- Coll. Mr. and Mrs. Milton Lowenthal
UNNLu	----- Edward R. Lubin, Inc.
UNNM	----- Pierpont Morgan Library
UNNMAI	----- Museum of the American Indian
UNNMB	----- Manhattan East River Bridge
UNNMC	----- Museum of the City of New York
UNNMEA	----- Museum of Early American Folk Arts
UNNMG	----- Midtown Galleries
UNNMM	----- Metropolitan Museum of Art
UNNMMA	----- Museum of Modern Art
UNNMMC	----- ----- The Cloisters
UNNMPA	----- Museum of Primitive Art
UNNMa	----- Marlborough-Gerson Gallery
UNNMac	----- Coll. Mrs. Clarence H. Mackay
UNNMad	----- Madison Square; Madison Square Garden
UNNMan	----- Manufacturers' (Hanover) Trust Company
UNNMar	----- Marine Museum
UNNMark	----- Royal S. Marks Gallery
UNNMart	----- Coll. Bradley Martin
UNNMas	----- Masonic Temple
UNNMat	----- Pierre Matisse Gallery
UNNMatC	----- Coll. Mr. and Mrs. Pierre Matisse
UNNMay	----- Mayer Gallery
UNNMi	----- James A. Michener (Foundation)
UNNMid	----- Midtown Gallery
UNNMil	----- Coll. Mrs. David M. Milton
UNNMo	----- Coll. Earl Morse
UNNMo	----- Former Coll. J. Pierpont Morgan
UNNMoh	----- Coll. Sybil Moholy-Nagy
UNNMor	----- Coll. Charles Lucien Morley
UNNMorn	----- Morningside Avenue and 116th Street Intersection

UNNMu	New York City. Coll. Warner Munsterberger
UNNMul	----- Coll. Mr. and Mrs. Aladar Mulhoffer
UNNN	----- National Academy of Design
UNNNS	----- National Sculpture Society
UNNNa	----- Coll. Dene Ulin Nathan
UNNNag	----- Tibor de Nagy Gallery
UNNNas	----- Lillian Nassau Antiques
UNNNe	----- Coll. Mr. and Mrs. Roy R. Neuberger
UNNNeg	----- Coll. T. S. and J. D. Negus
UNNNeu	----- Coll. J. B. Neuman
UNNNew	----- Coll. Arnold Newman
UNNNi	----- Nierendorf Gallery
UNNNo	----- Leo Nordness Galleries
UNNO	----- Olivetti Showroom
UNNOd	----- Galleria Odyssia
UNNP	----- Coll. I. M. Pei
UNNPL	----- New York City Public Library
UNNPa	----- Betty Parsons Gallery; Coll. Mrs. Betty Parsons
UNNPac	----- Pace Gallery
UNNPach	----- Coll. Mrs. Nikifora L. Pach
UNNPan	----- Pan-American Building
UNNPar	----- Parma Gallery
UNNPark	----- Coll. Mrs. Bliss Parkinson
UNNParkp	----- Park Place Gallery
UNNPas	----- Georgette Passedoit Gallery
UNNPau	----- Coll. Mr. and Mrs. David Paul
UNNPe	----- Peridot Gallery
UNNPear	----- Coll. Mr. and Mrs. Henry Pearlman
UNNPed	----- Coll. Mrs. William A. Pedlar
UNNPen	----- Coll. Helen Penrose
UNNPenr	----- Penrose & Edgette
UNNPer	----- Perls Gallery
UNNPerl	----- Coll. Katherine M. Perls
UNNPerr	----- Coll. Mr. and Mrs. Hart Perry
UNNPers	----- Perspectives Gallery
UNNPet	----- Coll. Eric N. Peters
UNNPl	----- Players' Club
UNNPly	----- United States Plywood Company
UNNPo	----- Poe Cottage and Park
UNNPoi	----- Poindexter Gallery
UNNPol	----- Coll. Mrs. Frances M. Pollack
UNNPr	----- Printing House Square
UNNPs	----- Public School No. 34
UNNR	----- Paul Rosenberg & Company
UNNRa	----- Stephen Radich Gallery
UNNRad	----- Radio City. Music Hall
UNNRadT	----- ----- Time & Life Building

UNNRan	New York City. Randall House
UNNRay	----- Coll. Mrs. Bernard E. Raymond
UNNRe	----- Coll. Mr. and Mrs. Bernard J. Reis
UNNReh	----- Frank K. M. Rehn Gallery
UNNRei	----- Coll. Mr. and Mrs. P. Reinhardt
UNNRes	----- Coll. Mrs. Resor
UNNReu	----- Reuben Gallery
UNNRey	----- Coll. Jeanne Reynal
UNNRi	----- Riverside Drive
UNNRie	----- Coll. Mr. and Mrs. Victor S. Riesenfeld
UNNRiv	----- Riverside Park
UNNRo	----- Coll. Nelson A. Rockefeller
UNNRoIII	----- Coll. Mrs. John D. Rockefeller, III
UNNRob	----- Sara Roby Foundation
UNNRoc	----- Rockefeller Center; Rockefeller Plaza
UNNRocIII	----- Coll. John D. Rockefeller, III
UNNRocA	----- Rockefeller Center. Associated Press Building
UNNRocIn	----- ----- International Building
UNNRocR	----- ----- RCA Building
UNNRocU	----- ----- United States Rubber Company Building
UNNRocl	----- Coll. Laurence Rockefeller
UNNRoj	----- Coll. John D. Rockefeller, Jr.
UNNRojm	----- Coll. Mrs. John D. Rockefeller, Jr.
UNNRok	----- Roko Gallery
UNNRos	----- Coll. Mrs. Blanche B. Rosett
UNNRose	----- Coll. Billy Rose
UNNRosen	----- Paul Rosenberg & Company
UNNRoss	----- Coll. Mr. and Mrs. Walter Ross
UNNRossa	----- Coll. Mr. and Mrs. Arthur Ross
UNNRu	----- Coll. Helena Rubenstein
UNNRub	----- Coll. William Rubin
UNNRum	----- Coll. Mrs. Charles Cary Rumsey
UNNRy	----- Coll. Sally Ryan
UNNS	----- Jacques Seligmann & Company
UNNSC	----- Sculpture Center (Clay Club)
UNNSa	----- Coll. Mark M. Salton
UNNSai	----- Saidenberg Gallery; Coll. Mr. and Mrs. Daniel Saidenberg
UNNSal	----- Coll. L. J. Salter
UNNSalp	----- Salpeter Gallery
UNNSar	----- Coll. Mr. and Mrs. Robert W. Sarnoff
UNNSc	----- Coll. Mr. and Mrs. John B. Schulte
UNNSch	----- Coll. Baron von Schoeler
UNNScha	----- Bertha Schaefer Gallery
UNNSchi	----- Coll. Norbert Schimmel

UNNSchin	New York City. Coll. Gustave Schindler
UNNScho	----- Robert Schoelkopf Gallery
UNNSchw	----- Coll. Mr. and Mrs. Seymour Schweber
UNNSchwa	----- Charles M. Schwab Residence
UNNSchwar	----- Coll. Mr. and Mrs. Eugene M. Schwartz
UNNScu	----- Coll. Robert C. Scull
UNNSe	----- Segy Gallery
UNNSeg	----- Coll. Ladislaw Segy
UNNSel	----- Coll. Mr. and Mrs. Wladimir Selinsky
UNNSele	----- Selected Artists Galleries
UNNSev	----- 70th Street and Fifth Avenue Intersection
UNNSh	----- Coll. Herman Schulman
UNNSha	----- Coll. Ben Shahn
UNNSi	----- Coll. Mrs. Kenneth Simpson
UNNSim	----- Coll. Mr. and Mrs. Robert E. Simon, Jr.
UNNSl	----- Charles E. Slatkin Galleries
UNNSli	----- Coll. Mr. and Mrs. Alan B. Slifka
UNNSo	----- Coll. Benjamin Sonnenberg
UNNSol	----- Coll. Dr. A. Solomon
UNNSolo	----- Coll. Mr. and Mrs. Sidney Solomon
UNNSon	----- Coll. Mr. and Mrs. Michael Sonnabend
UNNSp	----- Coll. Charles B. Spencer, Jr.
UNNSt	----- Staempfli Gallery. Coll. Mrs. Emily B. Staempfli
UNNStG	----- St. George, Staten Island
UNNStJ	----- St. John the Divine Cathedral
UNNStM	----- St. Mary-the-Virgin Church
UNNStMa	----- St. Mark's Church-In-the-Bowery
UNNStP	----- St. Paul's Chapel
UNNStT	----- St. Thomas Church
UNNSta	----- Stable Gallery
UNNStam	----- Coll. Theodoros Stamos
UNNStatL	----- Staten Island. Mt. Loretto
UNNSte	----- Coll. Mrs. Jack Stewart
UNNStei	----- Gallery Gertrude Stein
UNNSteic	----- Coll. Kate Rodina Steichen
UNNStep	----- Stephen Wise Towers, New York City Housing Authority
UNNSter	----- Marie Sterner Gallery
UNNSti	----- Coll. Chauncey Stillman
UNNSto	----- Allan Stone Gallery
UNNSton	----- Coll. Mrs. Maurice L. Stone
UNNStr	----- Coll. Mr. and Mrs. Percy S. Straus
UNNStra	----- Coll. Mrs. Herbert N. Straus
UNNStre	----- Coll. Jon Nicholas Streep
UNNSu	----- Coll. Mrs. Cornelius J. Sullivan

UNNSw	New York City. Coll. Mr. and Mrs. James Johnson Sweeney
UNNT	----- Trinity Churchyard
UNNTa	----- Tanager Gallery
UNNTel	----- New York Telephone Building
UNNTh	----- St. Thomas Church
UNNTha	----- E. V. Thaw and Company
UNNTho	----- J. Walter Thompson Company
UNNThor	----- Coll. Mrs. Landon K. Thorne
UNNTi	----- Tishman Realty and Construction Company, 666 Fifth Avenue
UNNTo	----- Pierre Tozzi Gallery
UNNTr	----- Sub-Treasury Building
UNNU	----- Union Square
UNNUL	----- Union League Club
UNNUN	----- United Nations
UNNUS	----- United States Steel Corporation
UNNUn	----- Coll. Irwin Untermeyer
UNNV	----- Curt Valentin Gallery; Estate Curt Valentin
UNNVa	----- Van Cortland Park
UNNVaS	----- ----- Shakespeare Garden
UNNVe	----- Coll. Carl van Vechten
UNNVi	----- Catherine Viviano Gallery
UNNVo	----- Coll. Vogelgesang
UNNW	----- Whitney Museum of American Art
UNNWa	----- Coll. Mrs. Benjamin P. Watson
UNNWad	----- Coll. Jane Wade, Ltd
UNNWadd	----- Waddell Gallery
UNNWag	----- Coll. Samuel Wagstaff, II
UNNWal	----- Wall Street
UNNWalk	----- Maynard Walker Gallery
UNNWar	----- Coll. Mrs. George Henry Warren
UNNWarb	----- Coll. Edward M. M. Warburg
UNNWarbu	----- Coll. Mrs. Felix M. Warburg
UNNWard	----- Coll. Mrs. Eleanor Ward
UNNWarh	----- Coll. Andrew Warhol
UNNWash	----- Washington Arch
UNNWashS	----- Washington Square
UNNWat	----- Coll. Peter Watson
UNNWats	----- Coll. Thomas J. Watson
UNNWe	----- Weyhe Gallery
UNNWei	----- Coll. J. Daniel Weitzman
UNNWein	----- Coll. William H. Weintraub; Weintraub Gallery
UNNWeis	----- Coll. L. Arnold Weissberger
UNNWer	----- Coll. Frederic Wertham
UNNWi	----- Willard Gallery

UNNWil	New York City. Wildenstein & Company
UNNWill	----- Coll. Marian Willard
UNNWin	----- Coll. Mr. and Mrs. Paul S. Wingert
UNNWis	----- Coll. Mr. and Mrs. Howard Wise
UNNWise	----- Howard Wise Gallery
UNNWisej	----- Coll. John Wise
UNNWo	----- World House Galleries
UNNY	----- Coll. Hanford Yang
UNNYam	----- Coll. Messrs. Yamanaka
UNNYo	----- Coll. Mrs. Howard Young
UNNZ	----- Coll. Mr. and Mrs. Charles Zadok
UNNZw	----- Zwemmer Gallery
UNNe	New Rochelle
UNNoF	Northampton. First Church
UNOR	Ogdensburg. Remington Art Memorial
UNOlP	Olcott. Coll. Charles R. Penney
UNOyB	Oyster Bay. Coll. Mr. and Mrs. Joseph L. Braun
UNPR	Pocantico Hills. Coll. John D. Rockefeller
UNPV	Poughkeepsie. Vassar College. Art Museum
UNPaM	Painted Post. Monument Square
UNPeGPo	Penn's Grove. Post Office
UNPoH	Pound Ridge. Coll. H. J. Halle
UNPorK	Port Chester. Congregation Kneses Tifereth Israel
UNQC	Queens. Queens College
UNRW	Roslyn. Coll. Mrs. H. P. Whitney
UNRoA	Rochester. Rochester Museum of Arts and Sciences
UNRoB	----- Chapel B'rith Kodesh
UNRoR	----- University of Rochester. Memorial Art Gallery
UNRocF	Rockville Center. Coll. Mr. and Mrs. Walter Fillin
UNS	Saratoga
UNSaS	Sag Harbor. Suffolk County Whaling Museum
UNSatP	Satterwhite. Coll. Dr. Preston Pope
UNScK	Scarsdale. Coll. Lee A. Kolker
UNSt	Stony Brook
UNSyU	Syracuse. Syracuse University. Lowe Art Center
UNSyo	Syosset, Long Island
UNTB	Tarrytown. Temple Beth Abraham
UNUtM	Utica. Munson-Williams-Proctor Institute
UNWM	Westbury. Coll. Edwin D. Morgan
UNWo	Woodstock
UNYG	Yonkers. Greystone, Samuel Untermeyer Residence

```
UNYH              Yonkers. Hudson River Museum
UNYM              ----- Memorial Park

                        --Nebraska
UNbL              Lincoln. Antelope Park
UNbLCap           ----- State Capitol
UNbLP             ----- Pioneer's Park
UNbLS             ----- Coll. Frederick Seacrest
UNbLU             ----- University of Nebraska. Art Gallery
UNbOJ             Omaha. Joslyn Art Museum
UNbOL             ----- Lincoln School
UNbOLe            ----- Coll. Mr. and Mrs. Robert E. Lee

                        --North Carolina
-UNcS             Coll. Xanti Schawinskj
UNcCC             Charlotte. Coll. Mrs. Martin Cannon, Jr.
UNcG              Guilford. Courthouse
UNcMtR            Mt. Gilead. Coll. Horace Richter
UncRA             Raleigh. North Carolina Museum of Art
UNcRV             ----- Estate Dr. W. R. Valentiner

                        --North Dakota
UNdBCap           Bismark. State Capitol
UNdBM             ----- Mandan Village Site, north of Bismark
UNdNF             New Town (near). Four Bears Bridge, east
                    side Missouri River

                        --New Hampshire
UNhCP             Concord. St. Paul's School
UNhCS             Cornish. Saint-Gaudens Memorial
UNhHD             Hanover. Dartmouth College
HNhMC             Manchester. Central High School

                        --New Jersey
UNjE              East Orange
UNjJL             Jersey City. Lincoln Park
UNjL              Lincoln
UNjLaS            Lakewood. Congregation Sons of Israel
UNjLeS            Leonia. Coll. Mr. and Mrs. Gilbert Stork
UNjM              Morristown
UNjMiI            Millburn. Congregation B'nai Israel
UNjMoM            Montclair. Montclair Art Museum
UNjMon            Monmouth
UNjNBL            New Brunswick. Coll. Dr. and Mrs. Seymour
                    Lifschutz
UNjNewC           Newark. Courthouse
UNjNewL           ----- Lincoln Park
UNjNewM           ----- Newark Museum
```

UNjNewP	Newark. Prudential Life Insurance Company
UNjNewPl	----- Newark Public Library
UNjPA	Princeton. Art Museum of the University
UnJPK	----- Coll. Mr. and Mrs. Patrick J. Kelleher
UNjTJ	Teaneck. Jewish Community Center

<div align="center">--New Mexico</div>

UNmAA	Albuquerque. Coll. Mr. and Mrs. Clinton Adams
UNmAAl	----- Temple Albert
UNmAUA	----- University of New Mexico. University Art Museum
UNmCS	Chimayo. El Santuario
UNmCoL	Coolidge. Austin Ladd Collection
UNmGK	Gallup. Kimballs Wholesale Company
UNmSC	Santa Fe. Cristo Rey Church
UNmSL	----- Laboratory of Anthropology
UNmSM	----- Museum of New Mexico
UNmSMF	----- Museum of International Folk Art
UNmSN	----- University of New Mexico
UNmSR	----- Radio Plaza
UNmTJ	Taos. Coll. Mr. and Mrs. William H. Jones

<div align="center">--Ohio</div>

UOA	Adams County
UOAG	Akron. General Tire and Rubber Company. Chemical-Plastics Division
UOAl	Alliance
UOBP	Barberton. Portage Park (Indian Park)
UOCiA	Cincinnati. Coll. Mrs. Philip R. Adams
UOCiE	----- Thomas J. Emery Memorial
UOCiH	----- Hebrew Union College Museum
UOCiL	----- Lytle Park
UOCiM	----- Art Museum
UOCiT	----- Taft Museum
UOClA	Cleveland. Cleveland Art Museum
UOClAn	----- Congregation Anshei Chesed
UOClF	----- Fairmont Temple
UOClK	----- Coll. Mrs. Ralph King
UOClP	----- Park Synagogue
UOClPr	----- Coll. Mrs. Francis F. Prentiss
UOClW	----- Western Reserve Historical Society
UOClWi	----- Coll. H. Wise
UOCoGA	Columbus. Columbus Gallery of Fine Arts
UOCoSM	----- Ohio State Museum
UODA	Dayton. Art Institute
UOGM	Gates Mills. Coll. Katherine W. Merkel
UOGW	----- Coll. Mrs. Walter White

UOGn	Gnadenhutten
UON	Niles
UOOC	Oberlin. Oberlin College
UOSW	Sylvania. Coll. Mr. and Mrs. Harry B. Walchuck
UOTA	Toledo. Toledo Museum of Art
UOTF	----- Fallen Timbers Battle Site, Route 577, Lucas County
UOTW	----- Coll. Mr. and Mrs. Otto Wittmann, Jr.
UOTiMF	Tiffin. Monument Square, Frost Parkway
UOUO	Urbana. Oakview Cemetery
UOUPl	----- Urbana Public Library
UOWW	Wilberforce. Wilberforce University

--Oklahoma

UOkAI	Anadarko. Indian Hall of Fame
UOkBW	Bartlesville. Woolaroc Museum
UOkCR	Claremore. Will Rogers Memorial
UOkF	Fairfax Cemetery
UOkNU	Norman. University of Oklahoma. Stovall Museum
UOkOO	Oklahoma City. O'Neil Park
UOkOR	----- Will Rogers Park
UOkTB	Tulsa. Boston Avenue Methodist Church
UOkTG	----- Thomas Gilcrease Institute of American History and Art
UOkTI	----- Temple Israel
UOkTP	----- Philbrook Art Center

--Oregon

UOrEA	Eugene. University of Oregon. Museum of Art
UOrEU	----- University of Oregon
UOrPA	Portland. Portland Art Museum
UOrPF	----- Fountain Gallery of Art
UOrPG	----- Coll. Mr. Jan De Graaff
UOrPL	----- Lloyd Center
UOrPW	----- Washington Park
UOrSCap	Salem. State Capitol

--Pennsylvania

UPAT	Altoona. Coll. Mr. and Mrs. Frank M. Titelman
UPBK	Bear Run. Coll. Edgar Kaufman
UPDB	Doylestown. Bucks County Historical Society
UPDoM	Downingtown. Coll. Mr. and Mrs. Earle Miller
UPE	Elizabethtown

UPEaC	Easton. Congregation Covenant of Peace
UPG	Germantown
UPGe	Gettysburg
UPGeP	----- National Military Park
UPHCap	Harrisburg. State Capitol
UPHP	----- City Park
UPLF	Lancaster. Pennsylvania Farm Museum of Landis Valley
UPLaF	Lancaster. First Reformed Church
UPMeB	Merion. Barnes Foundation
UPPA	Philadelphia. American Philosophical Society
UPPB	----- Coll. William Bullitt
UPPBal	----- Coll. Frederic L. Ballard
UPPCh	----- Coll. Phillip Chapman
UPPCi	----- City Hall Square
UPPCom	----- Philadelphia Commercial Museum
UPPCrt	----- Federal Courthouse
UPPE	----- Pennsylvania Academy
UPPEaS	----- East Park. Strawberry Hill
UPPF	----- Fairmont Park
UPPFW	----- West Fairmont Park
UPPFed	----- Federal Reserve Bank
UPPFi	----- Fidelity Mutual Life Insurance Company
UPPFr	----- Franklin Inn Club
UPPH	----- Coll. Earl Horter
UPPHS	----- Historical Society of Pennsylvania
UPPHo	----- Pennsylvania Hospital
UPPI	----- Independence Hall
UPPIN	----- Independence National Historical Park
UPPIT	----- Integrity Trust Company Building
UPPIn	----- Coll. R. Sturgis Ingersoll (UPPeI)
UPPIns	----- Insurance Company of North America
UPPJ	----- John G. Johnson Coll.
UPPL	----- Little Gallery of Contemporary Art
UPPM	----- Committee on Masonic Culture of the R. W. Grand Lodge F. and A. M. of Philadelphia
UPPMc	----- Coll. Henry P. McIlhenny
UPPO	----- Coll. Dr. Perry Ottenburg
UPPPA	----- Pennsylvania Academy of Fine Arts
UPPPM	----- Philadelphia Museum of Art
UPPR	----- Rodin Museum
UPPRo	----- Congregation Rodeph Shalom
UPPS	----- Shakespeare Memorial
UPPU	----- University Museum
UPPUL	----- Union League
UPPUn	----- University of Pennsylvania
UPPW	----- Witherspoon Building

UPPeI	Penllyn. Coll. Mr. and Mrs. R. Sturgis Ingersoll (UPPIn)
UPPiA	Pittsburgh. Alcoa Building
UPPiC	----- Carnegie Institute
UPPiS	----- Coll. Mrs. Alexander Crail Speyer
UPPiT	----- Coll. G. David Thompson
UPPiW	----- Coll. Gordon Bailey Washburn
UPRHS	Reading. Historical Society
UPScE	Scranton. Everhart Museum
UPT	Titusville
UPUF	Uniontown. Fayette County Courthouse
UPWI	Wissahickon. Indian Rock
UPWoW	Womelsdorf (near). Conrad Weiser Memorial Park

--Rhode Island

URBK	Bristol. King Philip Museum
URCN	Cranston. Narragansett Brewing Company.
URIND	Narragansett. Coll. Mr. F. LeB. B. Dailey
URLW	Little Compton. Coll. Mrs. Thomas F. Woodhouse
URNewB	Newport. Coll. Wesson Bull
URNewW	----- Coll. Forsyth Wickes
URNoS	North Kingston. South County Museum
URPB	Providence. Temple Beth El
URPD	----- Rhode Island School of Design. Museum of Art
URPHS	----- Rhode Island Historical Society
URPW	----- Roger Williams Park
URTI	Tiverton. Island Park Amusement Company, Island Park
URWP	Westerly. Coll. Harden de V. Pratt
URWaM	Watch Hill. Memorial Building, Ray Street

--South Carolina

UScCh	Charleston
UScCoM	Columbia. Columbia Museum of Art
UScF	Fort Mill
UScGB	Georgetown. Brookgreen Gardens

--South Dakota

USdCT	Custer (near). Thunder Mountain, Black Hills
USdM	Mt. Rushmore
USdSt	Standing Rock Reservation

--Tennessee

UTCH	Chattanooga. Hamilton County Courthouse
UTF	Fort Donelson Military Park

UTGCo	Greeneville. Courthouse
UTKU	Knoxville. University of Tennessee
UTL	Lookout Mountain
UTLe	Lewis County
UTNF	Nashville. Fisk University. Carl van Vechten Gallery of Fine Arts
UTNO	----- Temple Oheb Shalom
UTNV	----- Vine Street Temple
UTSN	Shiloh National Military Park

--Texas

UTxAM	Addison. Coll. Mr. and Mrs. John D. Murchison
UTxBUM	Baird. University of Texas. Texas Memorial Museum
UTxDC	Dallas. Coll. Mr. and Mrs. Clark
UTxDE	----- Temple Emanuel
UTxDG	----- Coll. Mr. and Mrs. S. Allen Guiberson
UTxDH	----- Hall of State
UTxDM	----- Dallas Museum of Fine Art
UTxDMe	----- Coll. Algur H. Meadows
UTxDMa	----- Coll. Mr. and Mrs. Stanley Marcus
UTxDS	----- Coll. Stanley Seeger, Jr.
UTxDSt	----- Statler-Hilton Hotel
UTxES	El Paso. Temple Sinai
UTxFF	Fort Worth. Coll. Andrew B. Fuller
UTxFJ	----- Coll. Karen Carter Johnson
UTxFW	----- Coll. Mr. and Mrs. Ted Weiner
UTxHA	Houston. Museum of Fine Arts
UTxHMe	----- Coll. Mr. and Mrs. Jean de Menil
UTxHO	----- Coll. Mrs. Kenneth Dale Owen
UTxHS	----- Coll. Mr. and Mrs. Robert D. Straus
UTxHSc	----- Coll. Kenneth Schnitzer
UTxLB	Longview. Longview National Bank
UTxSAJ	San Antonio. San Jose
UTxSAR	----- Coll. Mr. and Mrs. Frank Rosengren
UTxSJ	San Jose. Mission

--Utah

UUPB	Provo. Brigham Young University
UUSP	Salt Lake City. "This is the Place", Mormon Pioneer Trail Monument
UUST	----- South Temple and Main Streets Intersection

--Virginia

UVAG	Alexandria. Coll. Walter S. Goodhue
UVAr	Arlington

UVCU	Charlottesville. University of Virginia
UVH	Holden's Creek, Accomack Co.
UVJ	Jamestown National Historic Site. Colonial National Historic Park
UVJC	----- Churchyard
UVM	Monticello
UVMtV	Mt. Vernon
UVNH	Norfolk. Hermitage Foundation Museum
UVNM	----- Norfolk Museum of Arts and Sciences
UVNeM	Newport News. Mariners Museum
UVRCap	Richmond. State Capitol
UVRCapG	----- ----- Capitol Grounds
UVRHi	----- Virginia Historical Society
UVRJ	----- Hotel Jefferson
UVRMu	----- Virginia Museum of Fine Arts
UVRVU	----- Virginia Union University
UVUM	Upperville. Coll. Mr. and Mrs. Paul Mellon
UVW	Williamsburg (Colonial Williamsburg)
UVWC	----- Williamsburg College
UVWL	----- Ludwell-Paradise House
UVWM	----- College of William and Mary
UVWR	----- Abby Aldrich Rockefeller Folk Art Collection

--Vermont

UVtAK	Algiers-in-Guilford. Coll. Robert S. Kuhn
UVtBH	Bennington. Historical Museum
UVtBuF	Burlington. Robert Hull Fleming Museum
UVtMCap	Montpelier. State Capitol
UVtMHS	----- Vermont Historical Society
UVtNB	North Bennington. Bennington College
UVtOB	Old Bennington. Bennington Museum
UVtSM	Shelburne. Shelburne Museum

--Washington

UWaMM	Maryhill. Maryhill Museum of Fine Arts
UWaSA	Seattle. Seattle Art Museum
UWaSB	----- Coll. Mrs. Robert Block
UWaSC	----- Cedar, Denny, and 5th Streets Intersection
UWaSD	----- St. Dunstan's Hall
UWaSF	----- Coll. Mrs. Charles Frick
UWaSN	----- Northgate Shopping Center
UWaSPL	----- Seattle Public Library
UWaSPh	----- Seattle Center Playhouse
UWaSSU	----- Washington State Museum, University of Washington
UWaSSe	----- Seattle Center

UWaSU	Seattle. University of Washington
UWaSW	----- World's Fair, 1962
UWaSWr	----- Coll. Mr. and Mrs. Charles B. Wright

--Wisconsin

UWiAC	Ashland. Ashland County Courthouse
UWiB	Burlington
UWiCM	Cedarburg. Meta-Mold Building
UWiGC	Green Bay. Courthouse Square
UWiH	High Cliff State Park (near Sherwood)
UWiKC	Kenosha. Courthouse
UWiLR	Lacrosse. Riverside Park
UWiMA	Milwaukee. Milwaukee Art Institute; Milwaukee Art Center
UWiMC	----- Milwaukee Cemetery
UWiMCap	Madison. State Capitol
UWiMM	Milwaukee. Coll. Dr. Abraham Melamed
UWiMP	----- Milwaukee Public Museum
UWiMV	----- Coll. Mr. and Mrs. William D. Vogel
UWiMZ	----- Coll. Mr. and Mrs. Charles Zadok
UWiMaH	Madison. State Historical Society
UWiMaT	----- Coll. R. and Mrs. Michael J. Thurrell
UWiOM	Oshkosh. Menominee Park
UWiOP	----- Paine Art Center
UWiR	Racine
UWiRiC	Ripon. Ripon College
UWiWC	Waupun. City Hall
UWiWP	----- Shaler Park

--West Virginia

UWvCI	Charleston. Temple Israel
UWvHH	Huntington. Huntington Galleries
UWvWM	Wheeling. Memorial Boulevard and National Road Intersection

Uganda

UgKU	Kampala. Uganda Museum

Uraguay

UrMN	Montevideo. Museo Nacional de Bellas Artes

Venezuela

VCM	Caracas. Museo Nacional de Bellas Artes
VCMC	----- Maternidad Clinic
VCMN	----- Museo Nacional de Ciencias Naturales. Department of Anthropology
VCS	----- Student Residence Center

VCU	Caracas. Caracas University
VCUA	----- Ciudad Universitaria. Great Auditorium

Vietnam--North

Vn-nHM	Hanoi. Hanoi Museum of E. F. E. O. (Revolutionary and Armed Resistance Museum)
Vn-nTM	Tourane. Tourane Museum
Vn-nTP	----- Musee Henri Parmentier

Vietnam--South

Vn-sSN	Saigon. National Museum

Wales

WAM	Abergavenny. Priory Church of St. Mary the Virgin
WAO	----- Our Lady and St. Michael Church
WBCh	Brecon. Priory Church
WCaN	Cardiff. National Museum of Wales
WCarN	Caernarvon. Royal Borough Council
WGC	Glamorgan. Glamorgan County Hall
WHW	Harlech. Wernfawr
WWe	Welshpool. Borough Council

Yugoslavia

YBMG	Belgrade. Modern Gallery
YBN	----- Narodny Muzej
YBNC	----- New Cemetery
YBYT	----- Yugoslav Trade Union Council
YBa	Batina Skela
YBj	Bjelovar
YBrP	Brac Island. Petrinovic Mausoleum
YBrS	----- Supetar
YBra	Brazza
YBri	Brioni
YCM	Cetinje. Museum
YCaMa	Cavtat. Racic Mausoleum
YDG	Dubrovnik. Umjetnicka Galerija (Galerie d'Art)
YDjC	Djakovo. Cathedral
YKC	Korcula (Curzola) Cathedral
YKa	Katowice
YKam	Kamnik
YL	Ljubljana
YLM	----- Mestni Musiz Ljubljani (Ljubljana City Museum)
YLMo	----- Moderna Galerija

YLN	Ljubljana. Narodna Galerija
YLT	----- Tivoli Park
YMtA	Mount Avala
YOM	Otavice. Mestrovic Mausoleum
YPM	Pristina. Muzej Kosova e Metohije
YR	Radimlja
YRaM	Ragusa. Mortuary Chapel
YRiMG	Rijeka. Moderna Galerija
YSB	Split. Baptistry
YSC	----- Cathedral
YSiC	Sibenik. Cathedral
YSkMG	Skoplje (Skopje). Modern Gallery
YSkS	----- Holy Savior Church
YSpK	Split. Coll. A. Kotunaric
YSt	Studenica Monastery
YTC	Trogir. Cathedral
YU	Urh
YZE	Zagreb. Council for Education and Culture of Croatia
YZMG	----- Moderna Galerija
YZS	----- Stone Gate
YZSt	----- Student Center
YZZ	----- Galerije Grada Zagreba (Zagreb City Gallery)
YZZS	Zagreb. Galerije Grada Zagreba. Galerija Suvremene Umjetnosti (Contemporary Art Gallery)
YZaA	Zadar. Arheoloski Muzej

Preface

Sculpture Index is a guide to pictures of sculpture in a select-
ed number of about 950 publications that may be found in public, col-
lege, school, and special libraries. The two volumes of Sculpture
Index are:

Volume 1. Sculpture of Europe and the Contemporary
Middle East

Volume 2. Sculpture of Americas, Orient, Africa,
Pacific Area, and Classical World

In addition to providing a key to pictures of sculpture, Sculpture
Index should prove a valuable reference work through presenting an
extensive listing of sculptors (identified in most instances by nationali-
ty and dates of life or work), in showing locations of sculptured works,
in identifying titles of works by sculptor, and in providing an icono-
graphic aid through the extensive subject listings of figures and inci-
dents in Christian and other religions, of historical, literary, and
mythological characters and events, of zoological forms, and of sepul-
chral and other social representations.

Sculpture Listed: Indexed are pictures of three-dimensional
works (carved, cut, hewn, engraved, cast, modeled, welded, or other-
wise produced) in a variety of materials (including wood, metal, clay,
terracotta, ivory, ceramics, wax, mixed media, marble). The size of
the sculpture listed ranges from monuments and memorials, free-
standing figures, room reliefs, facades and screens to miniature ob-
jects, such as jewels, medals, and coins. Types of sculpture listed
in this index, including works of "minor" and "applied" arts, are:

Portraits -- Statues, busts, cameos, seals, medals,
effigies;

Architecture and Architectural Elements -- Arches,
columns, capitals, facades, wall decoration,
doors and gateways, tombs, monuments and
memorials;

5

Church Furniture and Accessories -- Shrines, pulpits, candelabra, altars, fonts, screens;

Decorative and Utilitarian Objects -- Masks, book covers, gems, coins, jewelry, netsuke, figureheads, play sculpture, garden figures, fountains, sundials, weathervanes, reliquaries, musical instruments.

The time range of listed sculptures is from prehistoric fertility and hunting figures to contemporary Time/Space Art--assemblages, boxes, wall sculpture, environments, happenings, kinetic and optic art.

Information Given in Index: Sculptures are listed:

(1) By name of artist (or by nationality, area or tribe);
(2) By title, when distinctive;
(3) By subject, selectively.

For each work listed, the information (as given in the publications indexed) may include:

Artist--Name, alternate names by which known, nationality, dates of life or work;

and under listing by artist:

Original Location--Geographic area, monument, temple, or other building;

Material of Work--with indication of method of working, as beaten, cast, engraved, mosaic;

Dimensions of Work--Measurements are given in inches, unless otherwise indicated. Single measurement refers to height; two measurements to height and width; three measurements to height, width, and depth. Dimensions may be rounded to the nearer (or greater) half inch above twenty-four inches;

Location of Work--Institution, public or private collection, or city in which work may be seen is indicated by Location Symbol, given in the section "Sculpture Location Symbols". As an example, the Location Symbol FPL indicates a sculpture is located in the Louvre, Paris, France.

Identification, inventory, catalog, acquisition, or accession number of work follows the Location Symbol, if that information is given in indexed publications;

Books in Which Picture of Sculpture Appears--The publica-

tion in which the listed work is pictured is indicated by the Books Indexed Symbol, given in the section "Books Indexed Symbols"

Books Indexed: The publications indexed were chosen to include generally significant, up-to-date, and readily obtainable books, handbooks and catalogs--primarily general art histories, ready reference art books, national and regional art histories in English. While emphasis is on the sculpture of the Americas and Europe since 1900, an effort was made to index publications picturing sculpture of other areas and times, including sculpture designated Ancient, Classical, Oriental, African, Pre-Columbian, Pacific Area, Byzantine and Early Christian, Medieval, Renaissance, and Baroque. Among publications indexed are a limited number of specialized art histories; museum catalogs and handbooks; "classic" out-of-print titles; foreign language publications--French, German, Spanish, Italian; and catalogs of single and recurring group exhibitions (as, Venice Biennale, Sao Paulo Bienal, Carnegie International, Pennsylvania Academy Annual, Illinois University Biennial, London County Council Exhibitions, Whitney Museum Annual). Monographs on individual artists are excluded.

Acknowledgments: The assistance of many libraries and publishers is gratefully acknowledged, with particular thanks to those organizations, individuals, and publishers who provided publications otherwise unavailable. Especially appreciated was the publishers' help in making available four books released late in 1968:

> Burnham, Jack. Beyond Modern Sculpture. George Braziller (BURN)
>
> Cheney, Sheldon. Sculpture of the World. Viking Press (CHENSW)
>
> Craven, Wayne, Sculpture in America. Thomas Y. Crowell (CRAVS)
>
> Kultermann, Udo. The New Sculpture: Environments and Assemblages. Frederick A. Praeger (KULN)

Abbreviations

*	Indicates "Descriptive Title"--used when exact title not known	H	height
#	Following Title, indicates more than one work with this title	ht	half title page
		il	illustration(s)
ad	additional	il p	Notes on Illustrations page
aft	after	incl	including
ant	antiquities	int	interior
ap	appendix	L	length
archt	architect	LS	life size
attrib	attributed work(s)	Lt	left
avg	average	m	meter(s)
b	born	mem	memorial
bef	before	mil	millenium
beg	beginning	miscell	miscellaneous
bk cov	book cover	ms(s)	manuscript(s)
c	century (following number); circa (preceding number)	N	North
		NW	Northwest
cat	catalog	orig	original
circ	circumference	(p)	extrapolated page number
cl	classical	per	period
cm	centimeter(s)	pl	plate (illustration or figure)
col	pictured in color	pr	preface page
coll	collection	pseud	pseudonym
cont	contents page	ptd	painted, polychromed
cov	cover, or jacket	Q	quarter
d	died	reconstr	reconstructed; reconstruction
D	depth	Rt	right
dec	decade	S	South; Saint
Demol	demolished	Sc	Sculpture
det	detail	SE	Southeast
Dm	diameter	Sq	Square
drg	drawing	SS	Saints
E	East	t	title page
ea	each	u	university
ep	end papers	W	West; Width
equest	equestrian figure		
excl	excluding		
exec	executed by		
ext	exterior		
fac	facade		
fig(s)	figure(s)		
fl	floruit (flourished)		
Foll	Follower(s) Following; and Attribution, as: After, Atelier, Circle of; Influence of, Manner of, School of, Shop of, Studio of, Style of, Workshop of		
fr cov	Front cover		
front	frontispiece		

Volume I
Sculpture of Europe and the Contemporary Middle East
Index to Pictures of Sculpture

Ryland. Abraham and Isaac
ABRAHAMS, Ivor (English 1935-)
 The Huntress 1963/66
 KULN 20
 Red Riding Hood 1963
 KULN 78
Abrantegas. Dubuffet
Abruzzi Chalice. Italian--15th c.
ABRUZZI MASTER (Italian fl 1425-90)
 (influenced by Niccolo di
 Guardiagrele)
 Adoration of the Magi, Castel
 del Sangro c 1425 stone SEY
 pl 7B IFCO
 Virgin and Child, Nativity
 Group c 1490 ptd terracotta
 SEY pl 100B IAqM
Absinthe glass. Picasso
Abstract. Norman, P. E.
Abstract figure# Schlemmer
Abstract form in serpentine. Schleeh
Abstract nude. Viani
Abstract voids and solids of a head.
 Boccioni
Abstrakte Rindplastik. Schlemmer
Abdu-Abdullah See Boabdil
Abundance
 Adsuara. Abundance
 Leopardi, A. Flagstaff pedes-
 tal; Personification of Abun-
 dance with Sea Horses
The Abyss. Canonica
Acanthus
 Byzantine. Acanthus leaf
 capital #
 Czech--18th c. Acanthus frame
 of altar
 Early Christian. Balusters
 with acanthus and ivy leaf
 scrolls
 English--12th c. Crypt capital:
 Acanthus with beading
 French--12th c. Acanthus, Vir-
 tues trampling on Vices,
 West door Voussoir detail
 --Capital, St. Trophimus,
 head; acanthus scroll
 Italian--13th c. Baptismal font:
 Lombard lion support;
 acanthus motif
 --Capital; Acanthus decoration
Acca Larentia
 Quercia. Fontegaia: Acca
 Larentia with Romulus and
 Remus
Acca's Cross. Anglo-Saxon
Acceleration optique, relief. Yvaral
L'Accident. Roger-Bloche
Accolita. Lucchesi, A. C.

Accordions. See Musicians and Musi-
 cal Instruments
L'Accueil. Dejean
L'Accueil. Landowski
Accumulation. Arman
Ace. Paolozzi
Achelous.
 Bosio. Hercules battling ser-
 pent-form Achelous
ACHIAM (Israeli 1916-)
 Fecondite
 FPDEC il 1
 Shepherd with a horn granite
 MAI 1
Achilles
 Banks. Thetis and her nymphs
 consoling Achilles
 Banks. Thetis dipping the infant
 Achilles in the River Styx
 English--13th c. Ciborium of St.
 Maurice: Chiron and Achil-
 les, finial
 Fraccaroli. Wounded Achilles
 Pedoni. Achilles, scenes from
 life, relief
 Thorvaldsen. Priam entreating
 Achilles to deliver the body
 of Hector, relief
 Traverse. Education of Achilles
 Westmacott. Achilles
Achilles Shield. Flaxman
Acland, Mrs. Henry
 Munro. Mrs. Henry Acland,
 relief head
Acrobats
 Cannilla. Acrobati
 Capello. Acrobat(s)#
 Coulentianos. The last of the
 acrobats
 Dore. Acrobats
 Fazzini. Acrobats
 Fazzini. Gymnast
 French--11th c. Acrobat, with
 snake, capital
 French--12th c. Romanesque
 roundels: Dog; Acrobat;
 Siren
 Italian--12th c. Capital: Acro-
 bats
 Manes. The acrobats
 Minguzzi. Acrobat No. 1
 Minguzzi. Acrobat on trapeze
 Minguzzi. Contortionist#
 Romanesque--Spanish. Capital:
 Street acrobats
 Rossi, R. Acrobat II
 Rossi, R. Acrobate tombe
 Spanish--12th c. St. Martin;
 Acrobats

Actaeon See also Artemis
 Andreotti. Actaeon
 Brokoff, J. Courtyard fountain,
 with Polyphemus and
 Actaeon
L'Action Enchainee See Maillol.
 Chained Action
Action in chains See Maillol.
 Chained Action
Actors
 Antunac. An actress
 Husarski. Actress, head
 Willems. Actor in Turkish
 costume, Chelsea porcelain
Adagio. Kolbe
Adagio--Two versions. Herzog
Adalbert, Saint
 Braun, A. St. Adalbert
 Brokoff, M.J.J. St. Adalbert
 German (?)--12th c. Birth and
 baptism of St. Adalbert,
 door detail
 Weiss, F.I. St. Adalbert
Adalbert I (Bishop of Freisung 1158-84)
 German--12th c. Seal of
 Bishop Adalbert I
ADAM, Henri Georges (French 1904-)
 Beacon of the Dead, monument
 for Auschwitz 1957/58
 MAI 2
 Concrete sculpture 1955
 MAI 2 FLeHM
 The Couple 1946 plaster for
 marble; 78-3/4 TRI 13
 Engraving of woman 1948/49
 H: 98 BERCK 226
 Large Nude 1948&49
 BERCK 120 FPM
 Marine mutation 1959 bronze
 MAI 3
 Monumental sculpture for Le
 Havre museum 1959 cement;
 22-1/2'x 72'1" GIE 241;
 MARC pl 54; TRI 267
 FLeHM
 O morto 1942 gesso
 SAO-2
 Reclining nude 1947/48 plaster
 MARC 51 FPM
 St. Matthew 1960 bronze
 SELZJ 11 FPHu
 Sleeping woman 1945 plaster,
 L: 9'6' GIE 241 IVaM
 Trois pointes 1959 bronze;
 17-3/4x13-3/4
 LARM 325; READCON
 262
 The wave 1959 gilt-bronze

 MARC pl 55 (col) FPM
ADAM, Lambert Sigisbert (French
 1700-59)
 Neptune and Amphitrite (cen-
 tral group), Bassin de Nep-
 tune
 ROTHS 201 FV
 Neptune calms the storm 1733-
 37 marble; 36-1/2 ENC 6;
 KO pl 97 FPL
 Prometheus 1767 BAZINW
 415 (col) FPL
ADAM, Nicholas Sebastien (French
 1705-78)
 Catherine Opalinska mausoleum
 1749 GAF 185 FNanB
 Promethuus 1782 BUSB 209 FPL
ADAM, Robert (Scottish 1728-92)
 Doors, 1 Portman Square,
 London 2nd half 18th c.
 DOWN 136 UNNMM
 Overmantel mirror 1774
 SOTH-3: 278
 Syon House, interior
 ENC 7
 Wedgwood pottery: Classic
 decoration LARR 412
Adam and Eve
 Adriano Fiorentino. Eve, or
 Venus
 Antelami--Foll. Font: Adam
 and Eve
 Bandinelli, B. Adam and Eve
 Belgian--12th c. Cathedral doors
 Belgian--16th c. St. Adrian
 Berruguete. Eve, choir stall
 Blumenthal. Adam
 Bonannus of Pisa. Doors:
 Adam and Eve with their
 children
 Bonannus of Pisa. Porta San
 Ranieri: The Fall
 Brancusi. Adam and Eve
 Breuer. Adam and Eve
 Bunting. Adam and Eve, cor-
 bels
 Buon, G. The Fall
 Byzantine. Adam, plaque
 --Adam and Eve doing black-
 smith's work, casket
 --Consular Diptych of Areo-
 bindus
 --Diptych: Adam in Garden of
 Eden; St. Paul, scenes
 from life
 Cano, A. Eve, bust
 Carpeaux. Eve after the Fall
 Castelli. La nascita di Eva

Master Nicholas and Guillel-
mus. West porch: Adam
and Eve
Master Radovan. Door: Adam
on a lion
Master Wilhelm. Adam and
Eve, relief
Meit. Adam and Eve
Merzer. Eve
Messina. Eva
Munstermann. Adam and Eve
Nielsen, K. Eve and the ap-
ple
Notke. Eve
Oppler. Eve
Paganin. Adam
Pisano, A. The Creation of
Adam, relief
Pisano, A. Creation of Eve,
relief
Quercia. Fonte Gaia
Quercia. San Petronia Door-
way
Radovan. Adam and Eve,
portal figures
Reinhart, H., the Elder
Medal: Fall and Re-
demption of Man
Riemenschneider. Adam and
Eve
Riemenschneider--Attrib. Eve
Rizzo. Adam
Rizzo. Eve
Rodin. Adam
Rodin. Eve
Sienese. Adam
Solari. Eve
Stursa. Eve
Swedish--13th c. Capital:
Adam's Legend
Traverse. Eve
Verbruggen. Pulpit: Adam
and Eve banished from
Paradise
Vischer, Peter, the Young-
er. Eve
Vischer, P., the Younger--
Foll. Adam and Eve
Weiditz, C. Adam and Eve
Wiligelmus. Genesis scenes:
Creation and Fall of Man
Williams. Adam and Eve
Wittig. Eve
Wydyz. Adam and Eve
Zamoyski. Eve, reclining
figure
Adam Portal. German--13th c.

ADAM-TESSIER, Maxime (French
1920-)
Portrait--synthesis of M.C.Z.
marble MAI 4
Adams, John Quincy (Sixth President
of the U.S. 1767-1848)
Cardelli, P. John Quincy
Adams, bust
ADAMS, Robert (English 1917-)
Apocalyptic figure Winter,
1950/51 Ash; 10'
RIT 209 EA
Architectural Screen, maquette
1956 bronze; 29 1/2x9
ENC 8: HAMM 124; MAI
4; READCON 208 (col) ELG
Balanced forms 1963 Steel;
8' 5"x8' 4" LOND-6:#1
Barrier No. 1. 1962 bronzed
steel; 6'4 1/2" SFMB #95
Brass insect 1949 brass; 16
RAMS pl 77b
Climbing forms No. 1 1961
bronzed steel; 14 1/2
HAMM 125 (col) ELG
Divided pillar 1952 READAN
#66
Figure laburnum; 12 1/2
NORM 89
Forms on a bar 1962 bronzed
steel; 67 ARTSB-62:pl 1
Iron sculpture 1956 H:16-1/8
TRI 167 GWupJ
Large screen form 1962 metal;
79 SEITC 53 ELG
Large screen form No. 2
1962 bronzed steel; 75-
3/4x36x9 TATES pl 18
ELT (T.555)
Rectangular form no. 3 1955
H:10-3/4 BERCK 227 --F
Rising movement 1962 bronzed
steel MEILD 110 ELG
Seated woman 1947 white
marble RAMT pl 11
Screen form 1962 bronzed
steel; 19 HAMM 127 (col)
Screen form (Maquette) 1962
bronzed steel; 21-1/4
READCO pl 5 ELStr
Screen with slats, maquette
1965/66 welded steel;
5' 5"x3' 2"x8" LOND-7:#1
ELG
Sculpture 1955 AMAB 12
Standing figure 1950 brass;
40-1/2 RAMS pl 77a

Tall spike form 1957 iron and
steel; 90 ALBB 9 UNBuA
Theatre, detail 1957/59 BOE
pl 203 GGelT
Triangulated column 1960
bronzed steel; 92 ALBC-
3:#59 UNBuA
Triangulated structure 1960
steel; 8'3"x6'x6' LOND-5:
#1
Two circular forms No. 1
1962 bronzed steel; 74
ARTSB-64:pl 1 ELG
Two circular forms No. 2
1962 bronzed steel VEN-
62:pl 151
Two women and a child 1947
mahogany; 61-1/2 RAMS
pl 81b
Vertical form 1962 welded
iron; 67 PRIV 99
Vertical form No. 1 1962
bronzed steel; 68" ARTSB-
65:pl 1 ELG
Vertical forms 1957 iron and
steel; 10-12x2' LONDC
pl 1
Adams, Samuel (American Revolu-
tionary Statesman 1722-1803)
Nollekens. Dr. Samuel Adams
Monument
ADAMS, William (English 1745-1805)
Jasperware vase, classical
design 19th c stoneware
ENC 7
Adar. Delahaye
Adda, Countess d'
Vela. Tomb of Contessa
d'Adda
Addison, Joseph
Westmacott. Joseph Addison
Monument
Adelais de Champagne
French--13th c. Adelais of
Champagne tomb; mourn-
ers
Adelphia
Early Christian. Sarcophagus
of Adelphia
L'Adieu. Laurens
ADLHART-HALLEIN, Jacob
Theatre entrance AUM 89
ASF
ADMONT MASTER (Austrian)
Virgin and Child c 1310
BUSGS 159 AGLG
Adolar, Saint

German--12th c. Christ en-
throned; St. Adolar; St.
Eoban
Adolescence. Hajdu
Adolescence. Kreitz
Adolescence. Ulderico
Adolescent. d'Antico
Adolescent boy. Ugo
Adolescent standing. Lehmbruck
Adolescente. Melli
Adolescents. Rousseau, V.
Adonis See also Aphrodite
Carew. Adonis and the boar
Coustou, N. Adonis resting
from the hunt
Mazzuola, G. Death of
Adonis
Rodin. Death of Adonis
Soldani. Venus and Adonis
Thorvaldsen. Adonis
Traverse. Venus and Adonis
Adoration of the Child See Jesus
Christ--Adoration
The adoration of youth. Garbe,
R. L.
Adosse
French--12th c. Prophet
Adosse
ADRIAEN VAN WESEL See WESEL,
ADRIAEN VAN
Adrian, Saint
French--15th c. St. Adrian
Netherlandish. St. Adrian
Adrian V (Pope)
Arnolfo di Cambio. Adrian
V monument
Adrian VI (Pope)
Peruzzi. Adrian VI monu-
ment
ADRIANO FIORENTINO (Italian fl
1480's-1499)
Eve, or Venus c1490
bronze SEY pl 147 UPPM
Adrift III. Toyofuku
ADSURA, Juan (Spanish)
Abundance marble CASS 89
Flora plaster CASS 89
The load (Il carico) VEN-
28:pl 163
Motherhood plaster CASS 89
The advance. Ferenczy, B.
Adventure. Henning, Gertrude
Advertisement sign. Volten
Ady, Endre (Hungarian patriot 1877-
1919)
Csorba. Endre Ady memorial
ADYE, Thomas

Charles Sergison monument
d 1732 WHINN pl 101B ECu
John Fane, 7th Earl of West-
moreland, bust c 1742
marble MOLS-2: pl 30 ELV
Aedicula
Italo-Byzantine. Raising of
Lazarus, carved and
pierced tablet
Aeneas
Bernini, G. L. Flight from
Troy
German--17th c. Aeneas and
Anchises in flight from
Troy
Aeole's Prison. Arman
Aeolus I. Cimiotti
AERT VAN MAASTRICHT, Jan
(Netherlandish fl 1492-1501)
Font 1492 bronze GEL pl 111;
MULS pl 160 NShJ
AESCHBACHER, Hans (Swiss 1906-)
Bull 1947 stone; half LS
SCHAEF pl 34
Explorer I 1964 Marmor
Crislallina; 213x39x39
NEW pl 327
Face abstraction 1945 stone;
32 cm LIC pl 277
Female figure 1943 stone;
40 SCHAEF pl 33
Figure I 1953 lava; 79
BERCK 173
Figure I 1954 lava; 210 cm
JOR-1: pl 79
Figure I 1955 lava; 185 cm
JOR-1: pl 80
Figure 1 1955 lava; 73 GIE
243 SwB1
Figure 1 1956 JOR-2: pl 170
Figure 1 1956 granite; 2.95
m OST 97 SwZKu
Figure 1 1957 JOR-2: pl 132
Figure 1 1957 stone; 87
BERCK 228
Figure 1 1958 lava MAI 5
Figure 1 (dedicated to Otto
Muller) 1958 red sand-
stone; 57-1/2 TRI 68
SwZBe
Figure 2 1955 JOR-2: pl 169
Figure 2 1956 JOR-2: pl 134
Figure 2 1956 granite; 112
BERCK 173
Figure 2 1957 JOR-2: pl 171
Figure 4 1957 JOR-2: pl 172
Figure 5 1957 JOR-2: pl 133

Figure 9 1960 brass; 9-7/8
ENC 11: READCON 206
The harp (Die Harfe), garden
sculpture 1942/53 granite;
210 cm DAM 95; JOR-1:
pl 76; LIC pl 276; OST 96
SwZUH
Sculpture EXS 45
Aesculapius See Asclepius
Aesop
Legros, P. Aesop
Aesop Fables
English--18th c. Chelsea
"Fable" scent bottles:
Aesop Fable--Fox and
Stork
AFONSO, Jaoa (Portuguese)
Oliveira do Conde, effigy
1439-1440 SANT pl 75
Africa
Brokoff, F. M. Allegory of
Africa
Janniot. French Equatorial
Africa, relief
Theed, W., the Younger.
Albert Memorial: Africa
African, head. Leslie
African Madonna. Underwood
"African Queen"
Marcks. Woman of the Herero
tribe
African Warrior. Armour, Hazel
After the Bath. Drahonovsky
After the Bath. Haapasalo
After the Bath. Kafka
After the Bath. Lorcher
After the Bath. Missfeldt
AGAM, Yaacov (Israeli-French 1928-)
Free standing 1964 ptd
aluminum; 32x47 NEW pl
62 UNNMa
Aganippe Fountain. Milles
AGAR, Eileen
Quadriga 1935 READS pl 2
Object 1936 READS pl 1
Agateware Stag. English--18th c.
Agatha, Saint
English--16th c. A philosoph-
er and St. Agatha
German--16th c. Folding al-
tar with St. Agatha
German--18th c. St. Agatha
Portuguese--14th c. St.
Agatha
Agathonikos, Saint
Byzantine. St. Agathonikos,
relief

L'Age d'Airain See Rodin. Age of
 Bronze
Age of Barter
 Milles. Age of Commercial
 Exchange; Age of Inter-
 national Exchange; Age of
 Barter
Age of Bronze (male nude). Rodin
Age of Innocence. Drury
Age of International Exchange
 Milles. Ages of Commercial
 Exchange
The Age of Steam. Paolozzi
Aged Hercules. Boyce
Ages of Commercial Exchange.
Aged Hercules. Boyce
Agilbert, Saint
 French--7th c. St. Agilbert
 sarcophagus
Agilulph
 Italian--7th c. King Agilulph
 and his retinue, Lombard
Agnes, Saint
 Briosco. St. Agnes
 Ferrata. St. Agnes on the
 Pyre
AGNOLO DI VENTURA (Italian fl
 1312-49) See AGOSTINO DI
 GIOVANNI
Agnus Dei. French--12th c.
Agnus Dei Box pendant. German--
 15th c.
Agony in the Garden. Zarcillo y
 Alcarez
AGOSTINI DEI FONDUTI
 Children playing and read-
 ing, frieze MACL 191
 IMSa
AGOSTINO DI DUCCIO (Italian 1418-
 81)
 Agriculture, relief LARR 91
 IRiP
 Angel drawing a curtain, re-
 lief 1450's marble; under
 LS BAZINW 338 (col);
 ENC 13: MOLE 141;
 POPR pl 100 IRiB
 Apollo, relief c1450 marble
 SEZ 133 IRiF
 Arca degli Antenati POPR
 fig 73 IRiP
 Facade; tympanum, west
 facade 1457/61 marble
 CHAS 159; 158 IPeB
 --Virtue, panel relief MAR
 65; POPR fig 102
 Isaiah (design only), relief,

Chapel of the Ancestors
 c1454 marble SEY pl 65A
 IRiP
Jupiter, relief c1450 marble
 SEZ 133 IRiF
Madonna, arched relief, grey
 marble; 22x18-7/8 MACL
 133; READM pl 33; VICF
 45 ELV
Madonna, relief 1465 terra-
 cotta and ptd stucco; 33x
 30 BARG; KO pl 80 (col)
 IFBar
Madonna and child c1465
 marble; 28-1/4x22-3/8
 SEYM 92; 91; 93-4; SHAP
 pl 11; USNI 223; USNP
 154; WALK UDCN (A-5)
Madonna with angels, relief
 c1460 BUSR 81 IFCO
Mars. zodiac sign, relief
 1454/57 marble AGARC
 69; CHAS 37; SEZ 192
 IRiP
Mercury, zodiac sign, relief,
 Chapel of the Planets
 c1456 marble SEY 66A
 IRiP
Miracle of St. Bernardino
 1457/61 marble POPR fig
 105; SEY pl 86A IPeB
Miracle of San Bernardino of
 Siena 1457/62 marble;
 half LS MOLE 141 IRiB
Music-making angels c1460
 marble BAZINH 209 IPeB
Music-making angels, relief
 panel c1452 marble MACL
 131; NEWTEA 107 IRiP
Neoplatonic world, relief,
 Chapel of the Planets
 c1456 marble SEY pl 65B
 IRiP
Patience, one of four Fran-
 ciscan virtues, relief
 CHASEH 314; POST-1:
 175 IPeB
Playing Children POPR fig
 110 IRiP
Return of Jesus, from Dispute
 with Doctors in the Temple
 marble; 16x24 NCM 272
 UNNMM (14.45)
St. Bernardino in Glory,
 facade detail c1460 stone
 CHENSW 380 IPeB
St. Gemignano life, scenes,

relief POPR fig 104 IMo
St. Giustina tomb MACL 129
ELV
Temperance; Sibyl POPR fig
106 IRiP
Virgin and Child with angels,
relief 15th c. marble; 81x
77 cm CHAR-1:320; CHAS
160; LARR 102; LOUM 127;
POPR pl 98 FPL (715)
AGOSTINO DI DUCCIO--FOLL
Musician, decorative relief,
Chapel of the Virgin,
c1452 marble SEY pl 64B
IRiP
AGOSTINO DI GIOVANNI (Italian ca
1269-1350)
Cino di Sinibaldi, head, tomb
detail VALE 54 IPiC
Madonna and Child with
angels, relief marble; 30x
31 NCM 269 UMiD (25.151)
AGOSTINO DI GIOVANNI and
AGNOLO DI VENTURA
Tarlati Monument 1329-32
Marble POPG fig 59;
WHITJ pl 133 IArC
--Funeral Procession POPG
pl 34 IArC
Agresete. Colla
Agression. Luginbuhl
Agression. Mooy
Agression "Ammann". Luginbuhl
Agricultural Themes See also
Months
Agostino di Duccio. Agricul-
ture, relief
Bottiau. Decorative panels:
Agriculture; Transporta-
tion
Franchina. Agriculture
French-12th c. Capital: Agri-
cultural theme
French--13th c. Capital:
Grape harvest
Gerhard. Goddess: Agricul-
ture, garden figure
Italian--12th c. Ploughman
driving oxen, relief
Meunier. The reaper
Meunier. The soil
Meunier. The sower
Pisano, Andrea. Arts
Robbia, L. della. Peasant
reaping corn, roundel
Agrippa, Marcus Vipsanius (Roman
General and Statesman

63-12 BC)
Italian--17th c. Agrippa, bust
Ahti, Hancock, W.
AICHELE, Paul (German)
Sleep TAFTM 70
L'Aile. Delahaye
Ainsi Font, Font... See Arman
Little Hands
Air. Maillol
Air form# Kastner
Aire, Jean d'
Rodin. Jean d'Aire, head
Aiton, Robert
Fanelli, F. Sir Robert
Aiton, monument
Ajax
Byzantine. Dish: Athena
deciding quarrel between
Ajax and Odysseus
Akua-ba. Skeaping
Alabaster fish. Mackay
ALALOU-JONQUIERES, Tatania
(Russian 1902-)
Composition 1959 stone MAI
5
ALAMANNO, Pietro (German fl
3rd Q 15th c)
Kneeling angel c 1450/60
polychromed walnut; 9
KUHN pl 11 UMCB (1963.3)
ALARI-BONALCOISI See ANTICO, L.
The alarm. Dolinar
ALAVA, Juan de (Spanish fl 1505-
37)
Plateresque facade 1524/
1610 CIR 16 SpSa1E
Alba, Duke of (Spanish General
1508?-83)
Spanish--16th c. Duke of
Alba, with heads of
Spain's enemies
Alba, Duke of
Spanish--17th c. Grand Duke
of Alba
ALBERDI, J. de
Miss Elizabeth Frick plastic
metal HUX 91
Mrs. N. B. Gibbons plastic
metal HUX 91
Albero, Bishop
German--12th c. Christ
between Peter and Bishop
Albero
Albero. Marotta
Albert (Consort of Victoria of
England 1819-1861)
Armstead, H. H. Albert

Memorial, frieze on
Podium
Earle. Prince Consort
Scott, G. G. Albert Memorial
Wyon, W. Council Medal of
Great Exhibition, obverse:
Victoria and Albert, pro-
file heads
Albert IV (Count of Hapsburg)
Godl. Count Albrecht IV of
Hapsburg
Albert Memorial
Armstead, H. H. Albert Me-
morial, frieze on Podium
Scott, G. G. Albert Memorial
ALBERT OF SOEST (Albert von
Soest)(German fl 1575)
Door frames of Council
Chamber 1566/84 LOH
210 GLunT
--Darius and Temperentia
BUSB 30
Albert Pie of Savoie
Rosso, G. B. Albert Pie of
Savoie
ALBERTI, Leone Battista (Italian
1404-72)
Self-portrait, medal ENC 16
Self-portrait, medallion
GOLDWA 32 FPL
Self-portrait, oval medallion,
with winged-eye device
c1435 bronze; 7-29/32x5-
11/32x5/8 CARTW 94:
KRA 46 (col); MAR 49
(col); SEW 549; SEYM
121; SHAP pl 56 UDCN
(A--278.1B)
Albertoni, Lodovica
Bernini, G. L. Blessed
Lodovica Albertoni
Albertus Magnus, Saint (German
Scholastic, philosopher and
scientist 1193/1206-1280)
Marcks. The Blessed Al-
bertus Magnus
ALBIKER, Karl (German 1878-1961)
Female torso VEN-30: pl 184
Gefallenmal in Greiz 1926
bronze; 2.40 m HENT 52
Grabmal eines jungen Mad-
chens 1932 muschelkalk;
1.67 m HENT 53
Halbakt 1923 English cement;
1.03 m OST 28 GLuB
Der heilige Sebastian 1920/
26 wood; 1.45 m HENT

50 GDA
Die Mutter des Kunstlers 1922
bronze; LS HENT 51
Youth (Jungling) 1911 bronze;
29 HENT 49; NNMAG 162
GEF
Alcester Tau. English--11th c.
Alcorta, M.
Drivier. M. Alcorta, bust
Drivier. Le Fils de M.
Alcorta, bust
ALDHART-HALLEIN
Crucifix wood MARY pl 171
Aldobrandini, Luisa deti
Porta, Guglielmo. Luisa
deti Aldobrandini tomb
Aldobrandini, Olimpia
Lazoni. Olimpia Aldobrandini
Aldonza de Mendoza, Dona d 1435
Spanish--15th c. Dona
Aldonza de Mondoza,
effigy
ALEMAN, Juan (Rhenish-Spanish)
Puerta de Los Leones after
1465 MULS pl 146A
SpTC
ALEMAN, Rodrigo (German fl 1489-
97)
St. Peter, choir stalls 1503
MULS pl 150C SpCrC
Alencon, Catherine d'
French--15th c. Catherine
d'Alencon, effigy
Alene, Saint
Flemish--16th c. St. Alene
Aleph. Marotta
Alexander III (King of Macedon 356-
323 BC) known as Alexander
the Great
Bambaia. Alexander and
Bucephalus, relief
Byzantine. Ascension of
Alexander the Great
Gemito. Alexander, bust
Ipousteguy. Alexander before
Ecbatana
Loth, M. Alexander
Puget. Alexander and Diogenes
Puget. Victorious Alexander,
equest
Thorvaldsen. Triumph of
Alexander
Verrocchio. Alexander the
Great, relief
Alexander I (Czar of Russia 1777-
1825)
Rauch, C. D. Alexander I
of Russia

Alexander II (Czar of Russia 1818-81)
Russian--19th c. Alexander II,
in uniform of General of
Cossack Bodyguard Regi-
ment, equest
Alexander I (Saint and Pope)
Godefroid de Claire. Pope
Alexander, head reliquary
Alexander V (Pope 1340?-1410)
Wolff, T. Pope Alexander V,
medal model
Alexander VI (Pope 1431?-1503)
Caravaggio. Alexander VI,
bust
Italian--15th c. Medal:
Alexander VI
Alexander VII (Pope 1599-1667)
Bernini, G. L. Alexander
VII, kneeling figure
Bernini, G. L. Alexander
VII tomb
Caffa. Alexander VII, bust
Alexander VIII (Pope)
Rossi, A. de Pope Alex-
ander VIII, bust
Alexander (Archbishop of Novgorod)
Avraam. Korsun Gate:
Avraam, self-portrait;
Alexander, Archbishop
of Novgorod
ALEXANDER, George (Scottish 1881-)
Doors oak PAR-1:76 WGC
ALEXANDER OF ABINGDON (English
fl 14th c.)
Prince John of Eltham tomb
c1340 alabaster
MILLER il 89, 90 ELWe
--Effigy BROWF-3:33; STON
pl 124
--A king BUSGS 196
--Weepers STON pl 123
Alexander the Great See Alexander
III (King of Macedon)
Alexandria, Egypt
Byzantine. St. Mark and his
followers
ALFARO, Andrew (Spanish 1929-)
Celui qui enferme un sourire,
celui qui emmure une
voix 1964 iron NEW pl
142 SpA1C
"Si em mort, que al cant
siga realitat" 1966 iron
VEN-66:#210
ALFIERI, Edoardo (Italian 1913-)
Donne Foggiane, relief 1954
bronze VEN-56:pl 24

Alfonso V (King of Aragon 1385-
1458), called Alfonso el
Magnanimo
Francesco di Giorgio Mar-
tini. Medal: Alfonso of
Aragon
Gagini, D.--Attrib. Alfonso
or Ferrante of Aragon
victorious after battle
Laurana F., and Pietro di
Martini. Alphonso of
Aragon, relief detail
Mino da Fiesole. Alfonso of
Aragon, relief bust
Pisanello. Medal: Alfonso V
d'aragona; Eagles
Alfonso X (King of Castile and
Leon 1226?- 84), called
Alfonso el Sabio
Spanish--13th c. Alfonso X
and Dona Violante
Alfonso XII (King of Castile and Leon
1857-85)
Querol. Alphonse XII, monu-
ment, study
Alfonso V (King of Naples 1448-95)
Bertoldo di Giovanni. Alfonso
of Aragon, medal
Alfonso de Madrigal ("El Tostado")
Zarza, V. de la. Tomb of
Cardinal Alonso de
Madrigal
Alfonso el Sabio See Alfonso X (King
of Castile and Leon)
Alfred (Aelfred) (Saxon King 848-
900), called Alfred the Great
English--9th c. Alfred, head,
penny
Alfred, Duke of Edinburgh
Thornycroft, M. F. Alfred
Alfred Jewel. English--9th c.
ALGARDI, Alessandro (Italian 1602-
54)
Abraham sacrificing Isaac,
plaque terracotta; 31-1/2
x 22-1/4 DETI 57 UWaSA
Camillo (?) Pamphili, bust
after 1644 WIT pl 96B IRD
Domenico Ginnasi, bust
c1630/40 marble; .68 m
FAL pl 2 KITS 77 IRB
(CCLXX)
Innocent X, bust bronze
CLE 115 UOC1A (57. 496)
--bronze; 30-3/4 DETI 56
UMiD
Innocent X, relief detail:
Meeting of Attila and Pope

Leo the Great bronze
POPRB pls 165, 167 IRC
Innocent **X.**, seated figure
1645 MONT 17 IRCo
Laudivio Zacchia, bust 1626
marble; 70 cm (excl mod-
ern base) BSC pl 117;
POPRB pl 164; WIT pl 96A
GBS (2765)
Leo XI monument 1634/44
marble ENC 20; POPRB
pl 166; WIT pl 97A IRP
Madonna 1650 bronze; 48.5
cm BSC pl 122 GBS (7124)
Mary Magdalen c1628 stucco
WIT pl 95A IRSil
Martyrdom of St. Paul (De-
capitation of St. Paul)
1641/47 marble; 286 cm
(with base) POPRB pl
168; WIT pl 99 IBoPa
Meeting of Attila and Leo I,
relief 1646/53 marble
CHASEH 379; ENC 20;
MACL 253; MOLE 182;
MONT 17; POPRB fig 165;
POST-2:12; VER pl 87;
WIT pl 98 IRP
Minerva, panel, Casino delle
Allegrezze, Villa del
Belrespiro stucco COOPF
52 IRPam
Olimpia Maidalchini Pamphili,
bust c1645 marble BUSB
78; COOPF 50; MONT
393 IRPam
Pamphili Coat of Arms, panel,
Sala di Ercole, Villa del
Belrespiro stucco COOPF
51 IRPam
Roberto Frangipane, bust 1644
MONT 17 IRMarc
Scipione Borghese, bust
c1632 marble; 3-1/4' NM-
8:16 UNNMM (53.201)
Il Sonno marble; .48x.90 m
FAL pl 1 IRB (CLX)
ALGARDI, Alessandro, and Silvio
CALCI DA VELLETRI
Amphora with serpent handles
marble; .90 m; Dm: .52 m
FAL pl 3 IRB (CCXIX)
Alhambra
Vigarny de Borgona. Royal
Chapel Altar: Abu Abdula
leaving the Alhambra
Alice. Rousseau, V.
Alice, Duchess of Suffolk d 1477

English--15th c. Alice,
Duchess of Suffolk, tomb:
Effigy
ALIPRANDI, Giovanni; Johann Ul-
rich MAYER, and Ferdinand
GEIGER
Column of the Holy Trinity
STECH 42 CzPL
Allamont, Bishop d'
Delcour. Bishop d'allamont
monument
Allegorical Themes
Batten. Allegorical head
Falconet. Allegory of the
Chase
Falconet. Allegory of the Hunt
Ford, K. C. Allegory of the
Church
Franceso di Giorgio Martini.
Discordia (Allegory of Dis-
cord)
Gerhard. Allegorical figure
German--16th c. Allegory of
Childhood
Houdon. Faith banishes Heresy
Italian--13th c. Allegory of
Salvation
Lemoyne, J. B. The ocean
Mochi. Ranuccio Farnese
(Allegory of Good Govern-
ment)
Pilon. Allegory of Victory
Primaticcio--Foll. Two
allegorical figures
Queirolo. Deception unmasked
Raggi, A. Allegorical figures
Sansovino, J. Allegory of
Autumn
Sansovino, J. Allegory of the
Redemption
Sansovino, J. Allegory of
Venice
Schonherr. Allegory of Faith
Theodon. Barbarity: Faith
adored by barbarians
Xavery. Allegory of Faith
ALLEY, Anthea (Malayan-English
1927-)
Rock 1964 steel; 12x20x20
ARTSS #3 ELBrC
Spatial form 1962/63 welded
brass; 13-1/4x11x11-3/4
TATES pl 29 ELT (T.655)
Allied sovereigns arrive at Leipsig.
Monti, G.
Alligators
Cole, W. V. Cavial
ALLOATI, Adriano (Italian 1909-)

Large naiad No. 17, study No.
13 SAL pl 39
Naiad No. 17 bronze SAL pl
40 (col)
Alluye, Jean d'
French--13th c. Jean d'Alluye,
effigy
ALMEIDA, Jose d' (Portuguese 1700-
69)
Carriage of John V SANT pl
99
Jose Manuel, equest 1770/
75 bronze SANT pl 54
PoLT
ALMQUIST, Ausgar (Swedish)
Alabaster Electrolier; stair-
case figure AUM 104 SnSC
Lion, column support AUM 104
SnSSM
Musician Triton and nymph,
balustrade figures bronze
AUM 107 SnSC
Perforated panel limestone
AUM 106 SnSC
Alms Dish
English--17th c. Alms dish
Aloe Memorial Fountain
Milles. Meeting of the Waters
Aloisi, Pompeo
Riccardi. Pompeo Aloisi
Alonso, Infante (Brothers of Isabella
the Catholic d 1468)
Siloe, G. de. Infante Don
Alonso of Castile monu-
ment
Alonso de Cartagena d 1456
Spanish--15th c. Bishop
Alonso de Cartagena monu-
ment
Alonso de Madrigal See Alfonso de
Madrigal
Alonso de Velasco
Cueman, E. Alonso de
Velasco tomb
Alou con gli Artigli. Arp
Alpar, Ignac
Beran. Ignac Alpar, medal
Alpheus
Lorenzi, B. Alpheus and
Arethusa
Alpirsbach Lectern
German--12th c. Four
Evangelists Lectern
Alsace
Bourdelle. Virgin of Alsace
Altalena gialla. Caro
Altar Gates. Russian--18th c.

Altar of the Holy Blood. Riemen-
schneider
Altar Screens See also Reredos
Byzantine. Pala d'Oro
Villalpando. Altar screen
Altars See also Chantries; Reredos;
Retables
Ancheta, J. de. Trinity Altar
Asam, E. Q. Assumption of
the Virgin
Asam, E. Q. High Altar,
with St. George
Austrian--15th c. High Altar
Balmaseda. High Altar
Becerra. High Altar
Belgian--12th c. Portable
Altar of Stavelot
Belgian--15th c. Altar
(piece)#
Benedetto da Maiano. Altar
of the Annunciation
Benedetto de Maiano. Mastro-
guidici Altar
Berg, K. High Altar
Bergondi. Altar of St. Alexis
Bernini, G. L. Cathedri
Petri
Bernini, G. L. High Altar
Berruguete. Altar of San
Benito
Bologna. Altar of Liberty
Borman, J. the Elder. Altar
of St. George
Braun, M. B. The Crowning
Altar
Braun, M. B. High Altar
Broeuck. Altar
Bruggemann. High Altar
Byzantine. Altar frontal
Casas y Novoa, and M.
Romay. Main Altar
Cattaneo. Fregosi Altar
Celtic Tetramorph, altar
frontal
Chantrene. Altar
Churriguera, J. de. Main
Altar
Coelho. High Altar
Colombe. Altarpiece of St.
George
Corte. Queen of Heaven ex-
pelling the plague
Dancart. High Altar
Danish--12th c. Lisbjerg
Altar
Degler. Altar
Desiderio da Settignano.

Altars of the Sacrament
Ditterich. High Altar
Donatello. Altarpiece
Donatello. High Altar
Donner, G. R.--Foll. House
 Altarpiece
Douvermann. Altar of Virgin
 of the Seven Sorrows
Duque. Altar
Dutch--16th c. Passion Altar
Early Christian. Diptych of
 Niomachi and Symacchi
Early Christian. Marriage
 diptych
Early Christian. Priestess of
 Bacchus
Egas, E., and P. Gomiel.
 Altar Mayor
Egell. Mannheim Altar
English--14th c. High Altar
--Travelling Altar
Erhart, M., and Gregor,
 Erhart. High Altar
Eugenio de la Cruz, and Juan
 de la Concepcion. Altar
Ferrucci. Altarpiece
Feuchtmayer. Altar
Feuchtmayer, and J. G. Ubel-
 herr. Mercy Altar
Flemish--14th c. Hakendover
 Altarpiece
Flemish--15th c. Altarpiece
--Folding altar
--Geel Altarpiece
Flemish--16th c. Crucifixion
 Altar
--Passion Altar
Forment. High Altar#
French--9th c. Portable Altar
 of King Arnulf
French--12th c. Altar: Christ
 with Apostles
French--14th c. Diptych
 portable altar
--Portable altar
French--17th c. Altar of
 Notre Dame de la Grace
French--18th c. Altar of
 Seven Saints
--Altarpiece: Last Judgment
German--11th c. Basle Ante-
 pendium
--Gertrudis Portable Altar
--Golden Altar of Aachen
German--12th c. Crodo Altar
--Portable altar#
German--13th c. Mindener
 Altar

--Predella
German--14th c. Altar#
German--15th c. Altarpiece#
--Folding altar
--High Altar
--Mindener Altar
German--16th c. Altar with
 saints
--Folding altar#
Gibbons. High Altar
Gothic. Retable and Altar
Hegewald. Altar
Heidelberger. Chapel Altar
Herlim. High Altar
Hernandez, J. R. B., and
 J. Pellicer. Main Altar
Hukan. An altar
Italian--13/14th c. Altar of
 St. Jacopo
Italian--14th c. Arca di S.
 Agostino
Jacobello dalle Masegne, and
 Pierpaolo dalle Masegne.
 High Altar
Jacque de Baerze. Altar
Jaeckel, M. W. Altar#
Johan. High Altar
Jordan, E. Main Altar
Juncker, J. Passion Altar
Juni. Antigua Altar
Juni. Corral. Benavente
 Chapel, with altar of Juan
 de Juni
Kohl, H., and F. Preiss.
 Left-hand altar; right-
 hand altar
Kosso. Altar
Kriechbaum. Winged High
 Altar
Leonardi di Ser Giovanni,
 and Betto di Geri. Baptistry
 Altar
Leoni, P. Charles V and his
 family at prayer
Loguin. Crucifix Altar
Lombardo, Antonio. Zen Altar
Lopez de Gamiz. High Altar
Martinez Montanes. Altar of
 San Isidoro del Campo
Martinez Montanes, and
 Ribas. Altar of St. John
 the Baptist
Master Dancart. High Altar
Master H. L. High Altar
Master of Altar of St. Anne.
 Altar
Master Volvinius. Altar ante-
 pendium

Mino da Fiesole. Altar#
Montorsoli. High Altar
Mosan. Portable altar
Munstermann. Altar
Netherlandish. Altar of the
 Passion
--Altarpiece
--High Altar
--St. Leonard Altarpiece
Nicholas of Verdun. Altar of
 Verdun
Notke. Altar
Otte. High Altar
Pacher. St. Wolfgang Altar
Porta, Giacomo. Altar of the
 Apostles
Petit Juan, Roderigo the
 German. Altars
Pineda, B. S. de., P. Roldan,
 and J. Valdes Leal. High
 Altar
Portuguese--18th c. Main
 Altar
Quercia. Trenta Altar
Reichenau Workshop. Gold
 Altar frontal
Riemenschneider. Altar of
 Our Lady
Riemenschneider. Altar of
 the Holy Blood
Robbia, A. della. Altarpiece#
Robbia, L. della, and Miche-
 lozzo. Altar of the Holy
 Cross
Roccatagliata. Altar frontal
Roger von Helmarshausen.
 Abinghof Altar
Roger von Helmarshausen.
 Portable altar
Roldan, P. High Altar of La
 Caridad
Rosselli, D. Madonna and
 Saints, altar
Rossellino, A. Nativity Altar-
 piece
Roxas. Altar of St. Joseph
Rusconi, G. A. Altar of the
 Sacrament
Sansovino, A. Corbinelli
 Altar
Siloe, G. de, and D. de la
 Cruz. High Altar
Spanish. Gothic Altarpiece
Spanish--16th c. Altar
--Portable altar of Charles V
Stocker. Sculptured altar
Stoss. Altar of Our Lady
Stoss. Marienaltar

Theny. High Altar
Tolsa. High Altar
Tome. Transparente Altar
Vigarny de Borgona. Royal
 Chapel Altar
Villacher Meister. Folding
 Altar
Vittoria. Altar
Vivarina, A., and G.
 D'Alemagne. Altarpiece
Vuolvinio. Golden Altar
Wallbaum. Altar
Wolff, Eckbert, the Younger.
 Altar
Wolvinus. High Altar
Weiss, F. I. High Altar
Zimmermann, D. Wieskirche:
 Choir and High Altar
Zurn, Martin, and Michael
 Zurn. Rose Garland Altar
ALTDORF, E. (German
 Le Gardien des Astres FPDEC
 --German il 1
Alter-Ego. Witkin
Altovito, Bindo
 Cellini. Bindo Altoviti, bust
ALTRI, Arnold d' (Swiss 1904-)
 Cheval apocalyptique 1955
 JOR-2: pl 174
 Le couple 1956 JOR-2: pl
 175
 Griff in den Weltraum 1957
 JOR-2: pl 176
 Le Guerrier 1957 JOR-2: pl
 122
 Morphologie 1958 JOR-2: pl
 121
 School play sculpture:
 Giraffes 1950 DAM 210 SwZ
 Trinite 1957 JOR-2: pl 177
ALVAREZ, F.
 Custodia (Processional Mon-
 strance) 1568 gold STA
 101 SpM
Alvaro de Cabrera, the Younger
 Spanish--13/14th c. Don
 Alvaro de Cabrera the
 Younger tomb
Alvaro de Luna
 Sebastian de Almonacid.
 Monuments of Condestable
 Alvaro de Luna, and his
 wife
Alvear, Marcelo Torcuato de 1858-
 1942
 Bourdelle. Alvear monument
ALVERMANN, H. P. (German 1931-)
 Aphrodite 65 1965 KULN 20

Hommage a Dusseldorf 1962
mixed media; 53 NEW pl
317 GWupJ
Hommage a Helena Rubinstein
1964 KULN 107
Portrait of an Electric Pater
1963 object; c 5' LIP 172
ALVES, Calmada
The Dance (Der Tanz) 1954
bronze GERT 221
ALVING, Tatiana Pomus
Lamp base, cold cast copper
and old silver; 3' PER 60
AMADEO, Giovanni Antonio (Italian
1447-1522)
Angel, or Faith marble; 37
NCM 41 UCLCM
Annunciation, medallion LARR
212 FPL
Bartolommeo Colleoni tomb
c1475 marble CHASEH
324; POST-1:191 IBerM
--Road to Calvary; Charity
SEY pl 131A
Cloister doorway POPR fig
121 IPavCe
Cloister spandrel decoration
POPR fig 117 IPavCe
Colleoni Chapel--facade;
Virtue POPR fig 119 IBerC
--interior 1470/75 CHAS
209
Facade, lower part detail
c1491-1501 SEY pl 130
IPavCe
Filippo Maria Visconti, bust
marble; 20x14 USNKP
418 UDCN (A-52)
Flight into Egypt, bas-relief
1484/85 marble; 1.23x
.73 m CHAS 147 IPaMA
Gian Galeazzo Sforza, tondo
relief marble; Dm: 24-3/8
USNI 223: USNP 161
UDCN (A-10)
Kneeling angels marble; 19
and 18 USNI 224; USNKP
416, 417 UDCN (A-25; A-
24)
--one figure USNK 195
Madonna and Child USNI 223
UDCN (A-26)
Medea Colleoni tomb c1475
marble MACL 186; MONT
387; POPR fig 122, pl
113 IBerC
Playing children Istrian stone
POPR fig 115 IBerC

Putti, high relief after 1498
marble; .568x.273 m CHAS
91 ELV
S. Imerio giving alms marble
POPR pl 116 ICrC
Virgin Annunciate POPR fig
117 IPavCe
AMADEO, Giovanni Antonio, and
Benedetto BRIOSCO
Lodovico Sforza, tondo relief
c1494 marble; Dm: 24; D: 2
SEY pl 135A; SEYM 120;
USNI 223; USNP 160
UDCN (A-9)
AMADEO, Giovanni Antonio, and
PUPILS OF THE MANTEGAZ-
ZI
Certosa of Pavia, details side
facade: Visitation begun
1473 ROOS 114B IF
--Facade BAZINW 341 (col)
AMADEO, Giovanni Antonio, and
Rinaldo de' STAURIS
Decorated arcade 1464-80
terracotta SEY pl 132A
IPavCe
AMADEO, Giovanni Antonio--FOLL
Arca di S. Lanfranco: Presen-
tation in the Temple 1498
marble SEY pl 134 IPavL
Window, detail c1490 CHAS
239 IPavCe
Amadeus of Savoy
Calandra. Amadeus of Savoy,
equest
Amalberga, Saint
German--15th c. St.
Catherine and St. Amal-
berga
Amalthea. Saint-Paulien
Gli Amanti. Castelli
Gli Amanti complicati. Signori
Le Amanti dei Piloti. Fontana, L.
Amazons
Burckhardt. Amazon
Hussman. Dying Amazon
Kiss, A. Amazon attacked by
tiger
Stuck. Amazon, equest
Tuaillon. Amazon
Amber
Viking. Bear; bird
Ambiente spaziale plastico+ luce.
Fontana, L.
Ambo, raised desk
Byzantine. Ambon of Salonica
Early Christian. Ambo
Early Christian. Chancel

fragments
German--11th c. Ambo of
Henry II
Amboise Cardinals
Le Roux, Rouland, and Pierre
d'Aubeaux. Amboise
Cardinals tomb
Ambrose, Saint
Austrian--18th c. St. Ambrose
Bernini, G. L. Cathedra
Petri: St. Ambrose
Braun, M. B. St. Ambrose
Italian--11th c. Ciborium of
Sant'Ambrogio, relief
Master Volvinius. Altar ante-
pendium, back: Life of St.
Ambrose
Robbia, L. della, and Miche-
lozzo. Altar of the Holy
Cross
Sturm, J. A. St. Ambrose
AMBROSI, Gustinus (Austrian 1893-)
Man with broken neck
marble PAR-2
AMEN, Woody van (Dutch 1936-)
Checkpoint Charley, assem-
blage 1965 31-1/2x63 NEW
pl 154 NRC
America. Apolloni
America, torchere. French--19th c.
America, America. Raysse
American solider, head. Epstein
Amianus
Lombardo, Tullio. St. Mark
baptising Amianus, relief
AMMANATI, Bartolomeo (Italian
1511-92) See also Montorsoli
Antonio del Monte tomb
1553/54 BUSB 7 IRPiM
Benavides monument POPRB
fig 74 IPE
Buoncompagni monument
POPRB fig 72 IPisaCam
Del Monte chapel; detail
marble POPRB fig 69, pl
75 IRPiM
Neptune Fountain 1563/76
bronze BUSB 21; ENC 25;
NEWTEM pl 133 IFSi
--Marine God POPRB fig 98,
pl 74
--Marine Goddess MOLE 166
--Neptune LARR 196
Ops POPRB fig 131 IFV
Sacro Bosco Colossal head
c1560 rock BUSB 27 IBomaO
Venus 16th c. CLAK 137
IFBar

Victory marble; 262 cm
POPRB pl 73 IFBar
AMMANATI, Bartolomeo (Italian)
1511/92); G. BOLOGNA; and
others
Piazza della Signoria Fountain,
detail: Neptune's horses
MCCA 23 IFSi
--Nymph BAZINW 362 (col)
Amor See Eros
Amor carnalis. French--13th c.
Amor nostro. Mayer, G.
Amore delle stelle No. 2. Ladera
L'Amour. Kudo
L'Amour et Psyche
Rodin. Cupid and Psyche
L'Amour menacant. Falconet
Les Amoureux. Chagall
Amphion
Laurens. Amphion
Laurens. Great Amphion
Amphitrite
Adam, L. S. Neptune and
Amphitrite
Anguier, M. Amphitrite
Lorenzi, S. Amphitrite
Schluter. Kamacke House
Amphorae
Algardi, and Calci da Velletri.
Amphora with serpent
handles
Byzantine. Concesti Amphora
Calci da Velletri. Amphora
Grandjacquet. Amphora
Santi. Basin and amphora
L'Amphore
Richier, G. The Water
Ampulla. Kempe
Amsterdamer plastik. Uhlmann
Amulets See Charms
Anabasis I. Tucker
Ananias
Early Christian. Santa Giulia
Casket
ANASTASIJEVIC, Boris (Yugoslav,
born in France 1926-)
Orpheus 1952 terracotta BIH
172 YZE
The Swan 1954 plaster BIH
173
Anastasius I (Eastern Roman
Emperor 430?-518)
Byzantine. Barberini Ivory
Byzantine. Consular diptych
of Anastasius
Anatolia
Modigliani, A. Head of a
woman (Anatolia)

Anatomical parable. Cannilla
Anatomical trotting horse. Italian--
 16th c.
Anatomy figure. Houdon
Ancaster, 3rd and 4th Duke of
 Harris. 3rd and 4th
 Duke of Ancaster
 Monument
Ancestors of Christ
 French--12th c. Royal Portal:
 Ancestors of Christ
Ancher, Anna
 Noak. Anna Ancher
ANCHETA, Juan de (Spanish c1530-
 88)
 Trinita Altar 1575/8 poly-
 chrome alabaster KUBS
 77 SpJC
ANCHETA, Miguel de (Spanish)
 Crucifix wood WES pl 22
 SpPamC
Anchises See also Aeneas
 Byzantine. Dish: Aphrodite
 in tent of Anchises
Ancient Diety No. 3
 Lardera. Antique Goddess
 No. 3
Ancient figure. Brancusi
Ancient motif. Mirko
ANDALUSION MASTER
 Entombment of Christ ptd
 wood WES pl 8 SpGG
ANDERS, Liljefurs (Swedish) See
 ERIKSON, Elis
Andersburg, Hugo von
 Mino da Fiesole. Count Hugo
 von Andersburg monument
An-Di-Andi
 Stahly. Mountain mothers
Andirons
 Caffieri. Andirons
 English--17th c. Firedog,
 with royal arms of the
 Stuarts
 English--18th c. Andirons
 Flemish--15th c. Andirons
 French--18th c. Firedog#
 --Louis XV lion chenet
 Gauthiere--Attrib. Andirons:
 Opposing goats
 Germain. Andiron
 Pitoin. Andiron, with winged
 sphinxes
 Stevens. Firedog
 Vittoria. Andiron
 Walton. Andiron
ANDRAS, Catherine
 Admiral Lord Nelson, effigy

 wax CARP 257 EIWe
Andre, John (English Soldier in
 American Revolution 1751-80)
 English--18th c. Major John
 Andre monument
Andrea, Saint See Corsini, Andrea
ANDREA DA FIESOLE (Andrea di
 Guido) (Italian fl 1400-15)
 Monument of King Ladislas:
 Virtues c1417-28 marble
 SEY pl 14A INGio
ANDREA DE PONTEDERA See PI-
 SANO, Andrea
ANDREA DEL CASTAGNO See
 CASTAGNO, Andrea del
ANDREA DI CIONE See ORCAGNA,
 Andrea
ANDREA DI GUIDO See ANDREA DA
 FIESOLE
ANDREA DI JACOPO D'OGNABENE
 (Italian)
 Silver altar: Annunciation and
 visitation after 1316 POPG
 fig 29 IPiC
ANDREA DI MICHELE CIONE See
 VERROCCHIO
ANDREA MAESTRO
 Madonna and Child, relief
 c1470 marble SEY pl 98B
 IROS
ANDREOTTI, Libero (Italian 1877-
 1933)
 Actaeon bronze PUT 329
 Aldo Carpi, head cast bronze
 VEN-22:117
 Brandano il pescatore VEN-
 30:pl 31
 Cristo risorto, study for Bol-
 zano monument bronze
 VEN-28:pl 91
 Donna Maria Chiapelli cast
 bronze VEN-32:pl 192
 Fiorenzo PUT 35
 Giovinetta, bust bronze VEN-
 26: pl 56
 Justice VEN-34: pl 22
 Madame Horosse cast bronze
 VEN-10: pl 127
 Madonna and Child pietraforte
 VEN-24: pl 130
 Monument to soldiers fallen
 in the war AUM 42: rear
 view PUT 268
 The pardon AUM 41
 Resurrection bronze PUT 337
 St. Francis and the birds
 PUT 73
 Seated woman stone PAR-2:24

Thoroughbred (Puro Sangue)
bronze VEN-7: pl 96
Young Sculptor, head PUT 233
ANDREOU, Constantin (Greek 1917-)
Icarus 1958 metal MAI 6
Occhio-visione 1965 Bassori-
lievo colorato in ottone
saldato VEN-66:#185
Sirene FPDEC il 2
Victory 1952/53 soldered
brass; L:90 BERCK 229
Andrew, Saint
Belgian--12th c. Portable
Altar of Stavelot: Martyr-
dom of SS Andrew and
Philip
Bernini, G. L. Interior S.
Andrea al Quirinale
Byzantine. St. John the Bap-
tist with Apostles
Duquesnoy, F. St. Andrew
Dutch--15th c. St. Andrew
Egbert of Treves--Foll. Reli-
quary Shrine: Foot of St.
Andrew
Ferrucci, A. St. Andrew
Flemish--15th c. Apostles:
St. Matthew, St. Andrew,
St. Bartholomew
French--10th C. Reliquary of
Sandal of St. Andrew
French--11th c. St. Andrew,
relief
French--12th c. Apostles Paul
and Andrew
German--10th c. Reliquary:
Foot of St. Andrew
Giovanni di Francesco da Im-
ola. St. Andrew
Gislebertus. St. Andrew
Paolo Romano--Foll. Pius II
tomb: Reception of the
relic of St. Andrew
Riemenschneider. St. Andrew
Stoss. St. Andrew
Andrews, Thomas d 1590
English--16th c. Thomas
Andrews monument
ANDREYEV, Nikolai (Russian)
Lenin the leader, half figure
plaster of Paris BLUC
254
ANDRI, Ferdinand (Austrian 1871-
1956)
Angel Michael, corner figure
1908 SOT pl 84 AVWi
ANDRIESSEN, Mari Silvester (Dutch
1897-)

Bomb victim (Victim of the
Air-raid) 1951 bronze; 71
DEVI--2; MID pl 79; STM
BAM
The docker 1953 bronze; 112
BERCK 180
ANDRIEU, J. B. (French 1763-1872)
Medal: Baptism of King of
Rome 1811 LARM 77
ANDRIOLO DE' SANTI (Candriolo de
Sanctis) (Italian)
Jacopo da Carrara tomb 1351
WHITJ pl 189A IPadE
Raniero degli Arsendi monu-
ment 1358 POPG fig 28
IPadS
Andromeda
Bell. Andromeda
Cellini. Perseus freeing
Andromeda from sea-
monster
Fehr. The rescue of Andro-
meda
Puget. Perseus rescuing
Andromeda
ANDROUSOV, Vadime
Two figures on donkey* ter-
racotta MARTE pl 6
Woman with horse* terra-
cotta MARTE pl 6
Anemone. Martin, E.
L'Ange Dechu
Rodin. The fallen angel
Angel choir. English--13th c.
Angel of Death. See Barlach.
Hovering Angel
Angel of the Apocalypse. Mirko
Angel of the Citadel. Marini
Angela, Head. Emilian, C.
Angela. Jaeckel, J
Angela. Tugwell
ANGELI-RADOVANI, Kosta (Yugo-
slav, born in London 1916-)
Dobrica Cesaric, head 1952
bronze BIH 159
Dreznica peasant 1949 bronze
BIH 156 YDr
Equilibrium II 1955 bronze
BIH 158
Hero Nada Dimic, head 1947
bronze BIH 155 YB
Ivo Lola Ribar, head 1948
bronze BIH 157
Portrait of a boy 1947 bronze
BIH 154
Torso 1 1959 bronze; 30-3/4
ARTSY #86
Angelico, Fra

Boucher, J. Fra Angelico
ANGELO, Nicolo d', and Petrus
VASSALLETTUS
Woman, with man-headed li-
ons, Easter candlestick
base detail c1180 BUSRO
pl 129; DECR pl 113 IRPa
Angels See also Cherubs; names of
angels; and Biblical subjects,
as Mary, Virgin
Agostino di Duccio Angel
drawing a curtain
Agostino di Duccio. Music-
making angels#
Alamanno. Kneeling angel
Amadeo. Angel
Amadeo. Kneeling angel
Anglo-Saxon. Angel, apse
relief
Anglo-Saxon. Flying angels
Arnolfo di Cambio. Angel
Arnolfo di Cambio. Cardinal
de Braye monument: Two
angels
Arnolfo di Cambio. Censing
angel
Asam, E. Q. Angel in adora-
tion
Austrian--15th c. Pair of
angels
Austrian--18th c. Angel#
Austrian--18th c. Flying angel
Barbet. Angel
Barlach. The Fighter of the
Spirit
Barlach. Hovering angel
Bavarian. Angel head
Bavarian--18th c. Pair of
hovering angels
Beccafumi. Angel
Benedetto da Maiano. Angel
bearing candelabrum
Bernini, G. L. Angel(s)#
Bernini, G. L. Angel with
the superscription
Bernini, G. L. Kneeling
Angel
Bernini, G. L. Prophet
Habakkuk and the angel
Biderle, Fountain with resur-
rection of Christ: Angels,
heads
Bologna. Salviati Chapel:
Angel
Braun, M. B. Angel
Braun, M. B. Pulpit: Angels
Brokoff, F. M. St. Francis
Borgia: Angel

Brokoff, F. M. St. John the
Baptist: Angel
Brokoff, J. Pieta: Angel
Brokoff, M. J. J. Angel
Bruggemann. Lute-playing
angel
Byzantine. Angel, leaf of
religious diptych
Byzantine. Confronting angels,
relief
Canova, A. Stuart monument:
Mourning angel
Carlone. Angel
Christian. Angel, head, pul-
pit
Civitali. Angel of the An-
nunciation
Cornacchini. Guardian angel
Czech--17th c. Angel
Czech--18th c. Pulpit: Angels
Dalmata, G. Cardinal Bar-
tolommeo Roverella monu-
ment: Angel
Delcour. Angel
Denhof. Angel concert
Desiderio da Settignano. Altar
of the Sacrament: Angel,
head
de Szczytt-Lednicka. Black
angel
Dierkes. Fallen angel
Donatello. Cantoria: Dancing
angels, relief
Donatello. High Altar: Angels
playing musical instruments
Donatello, and Michelozzo.
Cardinal Rinaldo Brancacci
tomb: Angel
Donner. Angel#
Early Christian. Plate: Cross
with angels
Egell. Adoring angel
English--10th c. Angel#
--Censering angels
--Two angels
English--11th c. Angel, relief
fragment
English--12th ca. Angel capital
English--13th c. Angel#
--Censing angels
English--14th c. Percy Tomb,
detail
English--15th c. Alice,
Duchess of Suffolk tomb:
Angel
--Angel, roof-beam detail
--Angel of the Expulsion in
feathered tights

--Beauchamp Chapel
English--16th c. Triforium
 Gallery: Angel
Erminold Master. Dancing
 angel
Fancelli, C. Angel with sudary
Feuchtmayer. Angel with lute
Flemish--15th c. Geel Altar-
 piece
--Kneeling angel#
--Two flying angels
Flemish--16th c. Angel of the
 Annunciation
Flemish (?)--17th c. Angel
Foggini. Angels
Francesco di Giorgio Martini.
 Angel
French--11th c. Angel, relief
--Last Judgment: Angel
--Un Seraphin, relief
French--12th c. Angel
--Capital: The angel at the
 Sepulchre
French--13th c. Angel#
--Virgin of the Annunciation
 and Visitation: Angel
--Judgment Pillar: SS Mat-
 thew and Luke
--Smiling angel
French--14th c. Angel of the
 Annunciation
--Pastoral staff handle:
 Virgin and Child with
 angels
--Trumpeting angel
French--15th c. Angel of the
 Annunciation#
--Angel carrying reliquary
--Praying angel, relief
--Wind-vane: Angel
French--17th c. Angels sup-
 porting coat of arms of
 Marie de Medicis
Fritsch. High Altar. Guardian
 angel
German--11th c. Luneberg
 Candlestick foot
German--12th c. Angel#
German--13th c. Keystone,
 Bishop's Gallery: Angel
German--15th c. Angel with
 infant Jesus
German--16th c. Angel#
German--17th c. Angel#
German--18th c. Angel's head
--Floating angel
--Mercy Altar: Seated saint
 with cross

Ghiberti. Angels
Gill, E. Flying angel
Giovanni da Firenze, and
 Pacio da Firenze. King
 Robert of Anjou monument
Giovanni da Firenze, and
 Pacio da Firenze--Attrib.
 Angels
Giovanni di Stefano. Candle-
 bearing angel
Giuliani. Angel
Gonzalez. Angel
Gothic-German. Smiling Angel
Guggenbichler. Angel
Gunther, F. I. Kneeling angel
Hungarian--12th c. Angel,
 relief
Hungarian--15th c. Angel,
 head
Italian. Angel
Italian--11th c. Christ in
 Majesty, supported by
 angels, Ambo detail
Italian--12th c. Angel
Italian--14th c. Angel of the
 Annunciation
Jacquemon de Nivelles. Angel
 with musical instrument
Jahn-Germann. Engel
Jehan Barbet de Lyon. Wind-
 vane: Angel
Joseph Master. The Angel of
 St. Nicasius
La Pautre, P. Angel carry-
 ing cornucopia
Lombardo, A.--Attrib.
 Candelabrum-bearing angel
Lombardo, P. Angel
Lombardo, P. A singing angel
Maitani. Angel of St. Matthew
Maitani. Creation of Eve:
 Angel
Maitani. Two angels
Maitani. Virgin and Child en-
 throned with angels
Marcks. Mourning angel
Master, H. L. High Altar:
 Angel
Master of San Trovaso. An-
 gels with instruments of
 the Passion
Mazzuoli. G. Angels carry-
 ing the ciborium
Meier-Denninghoff. Angel
Michelangelo. Angel bearing
 candelabrum
Michellozzo. Angel
Mochi. Angel of the Annuncia-
 tion

Mosto. Angel
Munstermann. Angel's head
Nanni di Banco--Attrib. Angel
 of the Annunciation
Niccolo dell'Arca. Angel with
 candlestick
Niccolo dell'Arca. Kneeling
 angel
Niccolo dell'Arco, and
 Michelangelo. Shrine of
 St. Dominic: Angel
Nicholas of Verdun. Altar of
 Verdun: Angels sounding
 trumpets of Last Judgment
Orcagna. Angel with hurdy-
 gurdy
Orcagna. Angel with tambour-
 ine
Parbury. Four angels
Pasti. Music-making angels
Pisano, G. Angel, pilaster
Pisano, Niccolo. Siena Pul-
 pit; Three angels
Pisano, Nino. Annunciatory
 angel
Portuguese--14th c. Angels
Portuguese--16th c. Baroque
 angel#
Pugin. Angel
Quellinus, Arnold. Angel
Quercia--Attrib. Angel of the
 Annunciation
Robbia, L. della. Kneeling
 angels with candelabra
Rosandic. Angel, tombstone
 detail
Rossellino, A. Cardinal
 Jacopo of Portugal tomb
Rossellino, B. Beata Villana
 monument: Angel drawing
 back curtain
Rossellino, B. Tabernacle:
 Adoring angels
Russian--12th c. Angel
Sagrera. Angel
Sagrera. Archangel
Saupique. Church of the
 Sacred Heart: Angel
Sluter and Werve. Well of
 Moses: Angel
Spanish--12th c. Trumpet
 angel of Last Judgment,
 porch archivolt
Spanish--15th c. Reliquary:
 Gothic Chapel with cande-
 labra angels
Spanish--17th c. Angels

Stahly. The Angel
Stoss. The Annunciation: Fly-
 ing angel
Swiss--13th c. Bishop with
 angels, choir stall details
Szczepkowski. Angel of the
 Adoration
Szczepkowski. Musical angels
Thomsen. Angel with scales
Thorvaldsen. Angel holding a
 font
Tino di Camaino. Angel,
 kneeling in prayer
The Visitation Master. Angel
 of the Annunciation
Voort. High Altar: Seraphim
 heads
Wain-Hobson. Angel
Wesel. Singing angels
Wesel. Three music-making
 angels with Joseph
Wijnants. Angel, relief
Wolvinus. Flying angel, re-
 lief altar
Zurn, M. Kneeling angel
Zurn, M., the Younger.
 Angel
Angel's choir-screen. German--12th c.
Angelus. Stoss
ANGERMAIR, Christoph (German d
 1632)
 Satyr mask 1625 ivory; 32 cm
 BUSB 28; MUL 100 GMBN
ANGERS, Jacques Louis David D'
 See DAVID D'ANGERS, J. L.
Anglian Beast
 Anglo-Saxon. Breedon-on-the-
 Hill: Anglian Beast
 Anglo-Saxon. Newent Cross
 Shaft: Anglian Beast
ANGLO-GALLIC
 Leopard d'Or of Edward III
 1360 gold CLE 64 UOC1A
 (64.373)
ANGLO-NORWEGIAN
 Candle-bearer 12th c. cast
 bronze; 220 m SWA pl
 148 NoOM
ANGLO-SAXON See also English--1
 through 11th c.
 Acca's Cross c mid-8th c
 FISH pl 26C EHex
 Angel, apse relief c 910 stone
 FISH pl 43B; RDE pl 8B
 EDeer
 Animal head FISH pl 21A
 EDeer

Bewcastle Cross 7th c. stone
CHASEH 183; FISH pl 26A-
B; JOHT pl 24; LAS 108;
POST-1:17;
--cross-shaft detail STON pl 4
4 EBe
Bexhill Grave Slab early 11th
c. L:c 33 FISH pl 37B
EBex
Bibury Grave Slab c1000 H:25
FISH pl 39 EBib
Breedon-on-the-Hill Slab:
Anglian Beast; Great Beast
late 8th c. late 9th c.
FISH pl 32A; 33A EBree
Casket: Christ in mandorla;
Ascension c1000 boxwood;
90x154x70 m CLE 45; SWA
pl 66 UOC1A (53.362)
Castor Tympanum FISH pl
40A ECas
Ceremonial Whetstone, Sutton
Hoo STON pl 1 ELBr
Christ in Majesty, Sandford
10th c. cast bronze; 71 m
SWA pl 65 EOA
Christ in Majesty, relief
c1000/1050 40x18 FISH pl
42A; RDA pl 19a EBarna
Christ in Mandorla 11th c.
morse ivory; 100 m SWA
pl 62 ELV
Christ on Cross c1000 walrus
ivory; 125 m SWA pl 63
ELV
Christ on Cross c1070 cast
bronze; 160 m SWA pl 65
Christ panel: Harrowing of
Hell early 11th c. H:c 7'
FISH pl 42B EBriC
Coin: Edward the Confessor
1042/66 BAZINL pl 134
ELBr
Colerne Cross fragment c
850/75 FISH pl 36B; STON
pl 17 ECol
Collingham Cross Shaft c875
H:55 FISH pl 30B EColl
Cross, fragments, Aycliffe;
Gainford JOHT pl 27, 28
Cruciform brooch, Sleaford
JOHT pl 15
Crucifixion Panel c1050 H:c
30 FISH pl 43A; RDE pl
14a EDag
Cruet 11th c. bronze; c 3-
3/4 RDE pl 90b; SWA pl
65 ELBr

Deerhurst Font, double spirals
and vine scrolls late 9th
c. FISH pl 48D EDeer
Dowgate Hill Brooch, filigree
c900 gold; Dm:.8 ENC
303; RDE pl 92d ELBr
Easby Cross, fragment--
stylized animals sandstone;
18-1/2x12-1/2 ASHS pl 1,
2; MOLS-1: pl 4-5;
READA pl 34: STON pl
12-13; UND 2 ELV
--Heads of Apostles JOHT pl
29-32
Eyam Cross Shaft 8/9th c.
FISH pl 25B EEy
Figural slab late 8th c.
FISH pl 46A EBree
Figural slab late 8th c. panel:
19x17-1/2 FISH pl 47B;
STONE pl 15 ECas
Figural slab early 9th c FISH
pl 46B EPeC
Figural slab c825/50 H:29
FISH pl 47A EF1
Flying angels 10th c. L ea:
c 5' FISH pl 44 EBraL
Franks Casket end 7th c.
whalebone; L:9 KIDS 14
E1Br
--Assault on house of Egil the
Archer MOLS-1:pl 3
--Legend of Egil the Archer
STON pl 5
Gosforth Cross 10th c stone;
c 14-1/2' FISH pl 31A;
RDE pl 24a; STON pl 19
EGos
Gospels of Judith of Flanders,
cover details: Christ in
Mandorla; Mary at the
Cross c1040 embossed gold,
jeweled and enameled;
300x191 m SWA pl 64
UNNM
Great Buckle, Sutton Hoo 7th
c. ST 3 E1Br
Hedda's Stone late 8th c.
28x41x14, tapering to 13
FISH pl 45 EPeC
Hogback Grave Slab FISH pl
36C EHey
Ikley Cross 800/850 H:100
FISH 29B EI1k
Jedburgh Slab: Animals in
vine scroll late 7th c.
stone; 217x30 FISH pl
28B; STON 4 EJ

(fragment, now destroyed)
LARR 347 FMontsO
Dukes of Longueville monu-
ment marble and bronze
LOUM 149 FPL (891-898)
Henri II of Montmorency
tomb 1648/52 BLUA pl
150B; GAF 43 FMouL
Jacques Auguste de Thou
Monument marble and
bronze LOUM 145 FPL
(886-890)
Jacques de Souvre tomb
CHASEH 383 FPL
ANGUIR, Michel (French 1612-86)
Amphitrite c1680 marble; 78
AGARC 97; LOUM 165
BAZINW 394 (col); FPL
(902)
Ceres mid 17th c. bronze;
22 MOLE 212 ELV
Nativity, Val-de-Grace 1665
BLUA pl 151B FPStR
Anguish. Luppi
"Aniketos". Byzantine
Animal Form. Cummings
Animal Form. Rowe
Animal Head. Moore, H.
Animal Tamer, with double body,
capital. Romanesque--French
Animale Organico. Cesar
Animals See also Adam and Eve;
and names of animals, as
Birds; Cats; Dogs; Lions
Anglo-Saxon. Animal head
Biduinus. Architrave reliefs:
Animal procession
Byzantine. Consular diptych
of Areobindus
Celtic. Scottish tomb animal
figures
Celtic, and Avaric. Animals
Cesar. Animal
Chadwick. Beast No. 1
Croissant. Animal
Danish--4th c. Ornamental
animal head
Early Christian. Ambo,
Chancel of Archbishop
Agnellus: Square-framed
symbolic animals
Ellis. Two animals
English--7th c. Panel: Animals
in vine scroll
English--12th c. Crypt capital:
Animal musicians
Faberge. Animal sculptures
Folk Art--Russian. Kvosh:
Animal form

Frankish. Fibula: Animal
form
French--12th c. Beast,
frieze detail
--Capital: Animals in roundels
French--18th c. Chantilly
porcelain animals
Italian--10/11th c. Palazzo
facade panel: animal
motif#
Italian--13th c. Beast--
capital
Koinig. Animal
Merovingian. Animal fibula
Mosan. Aquamanile: Winged
beast
Robbia, L. della. Orpheus
playing to the animals,
campanile relief
Spanish--12th c. Double
capitals: Glass blowing;
Animals
Swedish--7/8th c. Torslunda
Matrices
Tuotilo. Ivory book cover--
foliate scrolls, with wild
beasts pouncing on cattle
Venetian. Decorative panel:
Animal motif#
Viking. Animal head, ship's
prow
Viking. Animal ornament
clasp
Viking. Fibula, animal form
Viking. Osebert Funeral Ship
Viking Style. Animal--head-
post
Wederkinch. Hare, eagle and
lynx
Wederkinch. Lynx and two
owls
Animals, Imaginary See also
Basilisks; Centaurs; Cerberus;
Chimeras; Dragons; Griffins;
Hippocampus; Horses, Winged;
Hydra; Manticore; Minotaur;
Pegasus; Phoenix; Salamanders;
Sea Serpents; Sphinxes; Uni-
corns
Angelo and Vassaletus. Woman
with man-headed lions
English--12th c. Crypt
capital: Animal juggler
English--145h c. Bird with
human head
--Stylized triple head and
grotesque animals,
misericord

Folk Art--Russian. Lion with
horse's head, window sill
detail
French--11th c. Capital: Fan-
tastic beasts
French--12th c. Animals of
India: Griffon, Unicorn,
Siren, Manticor, Elephant
--Capital: Animals fighting
--Capital: Men devoured by
monsters
--Capital: Monstrous figures
--Centaur shooting woman-
headed bird, capital detail
--Mythical beasts, capital#
--Monsters, portal detail
German--16th c. Two drink-
ing vessels: fantastic
animals
Melioranzio. Facade: At-
lantean figure; winged lion
Mosan. Fabulous bird, ewer
Picasso. Sculpture (Fabulous
beast biting tail)
Romanesque--English. Tym-
panum: Beasts feeding on
Tree of Life
--Winged beast, fragment
Romanesque--French. Winged
monster, capital
Romanesque--Spanish. Capitals:
Monsters
Russian--13th c. Facade de-
tails: Human and animal
figures
Spanish--12/13th c. Mythical
beasts, capital
Swedish--8th c. Gotland
Stone: Eight-legged horse
Teutonic. Sigwald Relief
"The Animated Bust"
Taylor. William Ashby ("The
Animated Bust")
Anime sole. Luppi
Anita. Gelli
Anita, detail. Jacob
Anjou, Louis I (King of Naples and
Duke of Anjou fl 1339-84)
French--14th c. Seal of
Louis I
Anna
French--13th c. Presentation
in the Temple; Simeon and
Prophet Anna
Anna with a fan. Salimbeni
Annaselbdritt
Gerhaerts. St. Anne, with
Mary and Jesus

Anne, Saint See also Mary, Virgin--
Birth; --Education
Egell. St. Anne
English--15th c. St. Anne,
Virgin and Child
French--13th c. St. Anne
with Virgin
French--14th c. St. Anne
carrying infant Virgin
French--15th c. St. Anne and
the Virgin
French--16th c. St. Anne#
--Virgin and Child and St.
Anne
Gerhaerts. St. Anne, with
Mary and Jesus
German--15th c. Altar of St.
Anne
--St. Anne with Virgin
Child
Holzinger, St. Anne
Italian--13th c. St. Anne,
head detail
Juni. Meeting of Joachim and
Anne
Juni. Reliquary: St. Anne, bust
Juni. St. Anne
Lower Rhenish School. Virgin
and Child with St. Anne
Master of Joachim and Anne.
Joachim and Anne at the
Golden Gate
Master of the Malberg Virgin.
Anne with Virgin and Child
Pacak, F. St. Anne#
Pacak, J. Altar figures: St.
Zacharias and St. Anne
Portuguese--16th c. St. Anne
Rhenish. Virgin and Child with
St. Anne
Rhenish-Westphalian. Madonna
with Child and St. Anne
Sangallo, F. Virgin and Child
with St. Anne
Sansovino, A. Virgin and
Child with St. Anne
Snasovino, A.--Foll. Virgin
and Child with St. Anne
Swabian. Madonna and Child
and St. Anne
Thuringian. Triptych of St.
Anne
Anne, bust. Gibson, C. E.
Anne (Queen of Great Britain and
Ireland 1665-1714)
Bird. Queen Anne
Anne de Bourgogne See Anne of
Burgundy

Anne de Bretogne See Anne of
 Brittany
Anne de Ghistelle
 Floris. John III de Merode
 and Anne de Ghistelle tomb
Anne of Austria 1601-66
 Guillain. Anne of Austria
Anne of Bohemia (Consort of Richard
 II of England 1366-94)
 Broker, N., and G. Prest
 Richard II and Anne of
 Bohemia tomb
Anne of Brittany (Anne de Bretogne)
 (Consort of Charles VIII and
 Louis XII of France 1477-
 1514)
 Giusti. Louis XII and Anne
 of Brittany tomb
 Leclerc, N., Jean de Saint-
 Priest and Jean Lepere.
 Anne of Brittany, medal
 Regnault. Children of
 Charles VIII and Anne de
 Bretogne tomb
Anne of Burgundy (Anne de Bour-
 gogne)
 Gerines--Foll. Anne of
 Burgundy as Humility
 Jacques de Gerines, and
 Renier van Thienen. Isa-
 bella of Bourbon tomb
 Vluten. Anne de Bourgogne
Anne of Denmark (Consort of James
 I of England 1515-57)
 English--16th c. Queen Anne
 of Denmark, effigy head
Anne of Lorraine
 French--12th c. Count of
 Vaudemont and wife, Anne
 of Lorraine, effigies
ANNESLEY, David (English 1936-)
 Big Ring 1965 ptd steel; 70x
 110x12 LOND-7:#2
 Untitled 1965 KULN 136
Annette# Giacometti
Annette garde a vous. Giacometti
Annibaldi Monument. Arnolfo di
 Cambio
ANNIS, James (English c1709-1775)
 Sir George Fettiplace, bust
 1743 GUN pl 1; WHINN
 pl 102A ESwin
Anno Quattordicesimo. Martini, A.
Annunciation See Mary, Virgin--
 Annunciation
Annunciation of the Shepherds See
 Shepherds

Anonymus. Ligeti
Ansano, Saint
 Francesco di Valdambino. S.
 Ansano
 Federighi. St. Ansanus
Ansbach Porcelain Figure. German--
 18th c.
Anseele, Edward (Belgian labor leader)
 Cantre. Edward Anseele Monu-
 ment
ANSELMO DA CAMPIONE, Como (fl
 12th c.)
 Choirscreen; seated support-
 ing figure 1160-80 DECR
 pl 241, 242 IMo
Anspach, Margrave of d 1806
 Canova. Margrave of Anspach
 Monument
Ant-eater. Bedford
Antaeus See Hercules
ANTAL, Karoly (Hungarian 1909-)
 Sandor Korosi (Soma, riding
 buffalo) 1943 bronze; 55 cm
 GAG 77
ANTELAMI, Benedetto (Benedetto of
 Parma; Master Benedetto)
 (Italian fl 1177-1233)
 Adoration of the Kings, tym-
 panum early 13th c. BAZINL
 pl 206; ENC 31 IPaB
 Baptistry Portal CHASEH 213
 IPaB
 Deposition, lectern relief detail
 1178 CHRC fig 83: DECR pl
 237, 238; BAZINW 273
 (col); MACL 36; MOREYM
 pl 78; NEWTET 99; ST
 194 IPaM
 Holy Family Portal, relief
 scenes POST-1:49 IPaB
 King David, west facade c1200
 BUSRO pl 138; JANSH 222;
 JANSK 440; ST 194 IFidC
 Labors of the Months, relief:
 Spring after 1196 stone
 LARB 282 IPaB
 --June KO pl 71
 --July BAZINL pl 203; KO pl
 71
 --Vine pruner; girl offering
 fruit DECR pl 239, 240
 --October (Wine Harvest)
 BUSRO pl 139
 --December MOLE 37
 Last Judgment, tympanum, Bap-
 tistry c1196 BAZINW 273
 (col) IPaC

The Last Supper, portal de-
tail 12th c. LARB 237
Main porch c1210 BOE pl 37
IBorC
Romanesque relief marble
VALE 81 IPaC
Soldiers throwing dice for
Christ's robe, Descent
from Cross, pulpit re-
lief 1178 BUSRO pl 137
IPaM
Virgil, seated figure c1215
PANR fig 84 IManD
ANTELAMI, Benedetto--FOLL
Door of the Months: August
c1200 LARR 23 IFeG
--September LARR 23
--October (Vintage)DECR
pl 228
Font: Adam and Eve
(Weihwasserbecken mit
Sundenfall und Abendmahl)
1200 marble; 124.3 cm
BSC pl 26-27 GBS (11/
64)
Antelopes
Barye. Python killing an
antelope
Behn. Antelope
Tremont. Antelope
Wrampe. Liegende Antilope
Antependium
German--11th c. Basle Ante-
pendium
German--12th c. Antependi-
um
ANTES, Adam (German 1891-)
Bank entrance--portal fig-
ures AUM 17 GDaD
Turned head marble PAR-2:
49
ANTHONI, and Alexander COLLINS
Facade figure details,
Ottheinrich Building
1557/66 BOE pl 166
GHeiA
Anthony, Saint
Campagna. Raising of the
youth at Lisbon, relief
Donatello. Gattamelata
Donatello. High Altar
Flemish--16th c. Joint-
cover: St. Anthony Hermit
Jespers, O. Temptation of
St. Anthony
Lombardo, Tullio. Miracle
of the Miser's Heart
Lombardo, Tullio. Miracle
of the New Born Child

Anthony of Padua, Saint
Cano, J., and P. Mena. St.
Anthony of Padua, head
detail
Lombardo, A. Miracle of St.
Anthony of Padua
Mayer, J. U. St. Anthony of
Padua
Anthony, Mark See Marcus Antonius
ANTHOONS, Willy (Belgian-French
1911-)
Ascetic 1957 gilded wood
MAI 7
Being 1952/56 stone from
Poullenay; 17-3/4x35-3/8
x15-3/4 TRI 168
Catedral Humana, Madeira
SAO-2
Infinite form 1949-60 Euville
stone; 63 READCON 186
NOK
Mediterranean 1951 white
marble BERCK 125
Motherhood 1952 ebony; 39
MID pl 117 BAM
North Sea 1952 wood BERCK
125
Anthropophiliac tapeworm Baargeld
Anti-Graceful
Boccioni. Antigrazioso
ANTICO, L' (Alari-Bonacolsi; Pier
Giacomo Ilario Bonacolsi)
(Italian 1460?-1528)
Apollo, from the Antique
1497/98 bronze SEY pl 146
IVCO
Covered vase bronze; .305 m
DETD 98 IMoE
Cupid POPR fig 137 IFBar
Goddess of the Via Traiana
1500 bronze; 18.4x23 cm
BSC pl 92 GBS (2550)
Hercules and Antaeus POPR
fig 142 ELV
Hercules and the Erymanthian
Boar bronze; Dm: 12-7/8
DETD 122 ELV
Hercules and the Hydra, plaque
bronze; Dm:12-7/8 DETD
123 IFBar
Hercules and the Nemean Lion,
tondo relief bronze; Dm:12-
7/8 CIAK 193; DETD 123
IFBar
Hercules and the serpents,
plaque bronze; Dm:12-7/8
DETD 122 ELV
Hercules resting after the
fight with the lion bronze;

10x5-3/4 DETD 114
UTxHA
Meleager c1510 bronze,
parcel gilt; 12-1/8 MAR
59 (col); MOLE 133 ELV
Paris c1497/1528 bronze;
14-5/8, excl base NM-
8:7 UNNMM (55.93)
Venus, or Atropos late 15th
c. bronze; 11-3/4 VICF
57 ELV (A. 16-1931)
Venus Felix bronze, parcel
gilt; 32 cm, with base
POPR pl 127 AVK
Antigracieux
Boccioni. Antigrazioso
Antigrazioso. Boccioni
Antigua Altar. Juni
Antioch, personification. Early
Christian
Antique Goddess No. 3. Lardera
Antoine de Sourches d1485/87
French--15th c. Antoine (?)
de Sourches tomb
ANTOKOLSKI, Mark (Israeli-French
1842-1902)
Ivan the Terrible, seated
figure 1868/69 bronze
SCHW pl 1 RuLH
The Jewish Scholar SCHW
pl 2
Spinoza, seated figure 1882
marble ROTH 863 RuLH
Antonello. Torresini
Antoninus, Saint 1389-1459
Bologna. Miracle of St.
Antoninus, relief
ANTONIUCCI, Volti See VOLTI
Anatomy of Burgundy medal.
Spinelli
ANTUNAC, Grga (Yugoslav 1906-)
An actress, bust 1944 marble
BIH 101
The painter Racki, head
1943 bronze BIH 100
Antwerp Docker. Meunier
Anxious Friend. Ernst
Apafu, Gyorgy
Hungarian--17th c. Monu-
ment of Gyorgy Apafu
Apennine (Figure). Bologna
Apertura nel vuoto. Ramous
Apes See Monkeys and Apes
Aphrodite (Venus)
Alvermann. Aphrodite 65
Ammanati. Venus
Antico. Venus, or Atropos
Antico. Venus Felix

Aspetti. Venus
Besnard. Birth of Aphrodite
Bologna. Crouching Venus
Bologna. Venus#
Byzantine. Dish: Aphrodite in
tent of Anchises
Canova. Italian Venus
Canova. Venus#
Cattaneo. Venus#
Coysevox. Crouching Venus
Danti. Venus Anadyomene
Dobson. Charnaux Venus
Drivier. Venus
Durst. Venus and Cupid
Early Christian. Dish: Toilet
of Venus
Epstein. Venus
Falconet. Madame de Pompa-
dour as the Venus of the
Doves
Falconet. Venus instructing
Cupid
Falconet. Venus spanking
Cupid
Fleer. Small Aphrodite
Francheville. Venus attended
by nymph and satyr,
fountain figure
Franco-Flemish. Venus with
apple
Franco-Italian. Venus and
Cupid
French--16th c. Aphrodite of
the Belvedere
French--17/18th c. Venus and
Adonis
German--14th c. "Venus"
Gibson, J. "Tinted Venus"
Gonzalez. Venus
Greco, El--Attrib. Venus
and Vulcan
Hubacher. Aphrodite
Hubacher. Torso der Aphro-
dite
Italian--16th c. Black Venus
--Venus Prudentia (?)
Janniot. Venus, relief
Jean de Bologne. Venus
MacMillan. The Birth of
Venus
Maillol. Venus
Marchegiani. Venus#
Marini. Venus
Matisse. Venus in a shell
Nielsen, K. Venus and Cupid
Nielsen, K. Venus with the
apple
Nimptisch. Fountain: Birth of
Venus

Nollekens. Venus chiding
 Cupid
Nollekens. Venus tying her
 sandal
Nost. Car of Venus
Pasti. Venus, relief
Petel, G. Venus and Cupid
Renoir. Standing Venus
Renoir. Venus Victorious
Riccio. Venus chastising
 Cupid
Rodin. Toilet of Venus
Sansovino, J. Venus
 Anodyomene
Sergel. Mars and Venus
Signori. Reclining Venus
Signori. Venus#
Soldani. Venus and Adonis
Toyofuku. Venus
Traverse. Venus and Adonis
Turnbull. Aphrodite
Utzon Frank. Aphrodite
Verhulst, R. Venus
Weiss, M. Venus barbare
Wheeler, C. Aphrodite
Wolff, Eckbert, the Younger.
 Portal of God: Venus
Apocalypse, doorway detail. French
Apocalypse. Soudbinine
Apocalyptic figure. Adams, R.
Apocalyptic Vision
 French--12th c. Christ with
 Evangelists and 24 Elders
Apollinaire, Guillaume (French Wri-
 ter 1880-1918)
 Picasso. Hommage a
 Guillaume Apollinaire
Apollo
 Agnostino di Duccio. Apollo,
 relief
 Antico. Apollo from the
 Antique
 Bernini, G. L. Apollo and
 Daphne
 Bertaldo di Giovanni. Apollo
 Boizot. Apollon Musagete
 Bologna. Apollo
 Boulle. Louis XIV pendulum
 clock with Apollo's chariot
 Bourdelle. Apollo, head
 Bourdelle. Apollo and the
 Muses, relief
 Bourdelle. Theatre de
 Champs-Elysees Prosceni-
 um
 Canova. Apollo#
 Candido. Apollo of Lycia
 Chinard. Apollo crushing

 superstition underfoot
 Flaxman. Apollo and Marpessa
 Flotner. Apollo Fountain
 Gianotti. Apollo and the con-
 stellations, ceiling
 Girardon. Apollo attended by
 nymphs
 Italian--16th c. Apollo
 Italian--18th c. Apollo and
 Marsias, relief
 Janniot. Apollo, torso
 Michelangelo. Apollo
 Michelangelo. Apollo with
 violin
 Michelangelo--Attrib. Apollo
 and Marsyas, relief
 Milles. Apollo, orchestra plat-
 form pediment figure
 Munstermann. Apollo
 Piccinino. Target: Apollo on
 Mt. Parnassus
 Rodin. Apollo and Python
 Rodin. Sarmiento Monument:
 Apollo
 Sansovino, J. Apollo
 Schluter. Apollo, and Daphne
 Sicard. Archibald Fountain
 Vischer. Apollo Fountain
 Vittoria. Apollo
APOLLONI, Adolpho (Italian)
 America WOR 226
 Beatrice, medallion WOR 136
 La Scultura, allegorical fig-
 ure plaster VEN-10: pl 138
 Young Peoples' Fountain bronze
 VEN-3: pl 59
Apollonia, Saint
 Multscher. Altar: St. Ursula;
 Virgin and Child; St.
 Apollonia
 Spanish--16th c. St. Appollonia,
 half figure
Apostles See also Jesus Christ--
 Apostles; names of Apostles,
 as Andrew, Bartholomew;
 Symbols--Evangelists
 Anglo-Saxon. Easby Cross
 Austrian--13th c. Giant's Gate
 Austrian--15th c. Apostle
 Austrian--16th c. Four Apostles
 Beauneveu. Apostle, head
 Berruguete. Altar of San
 Benito
 Byzantine. Apostles, relief
 Byzantine. Ciborium Arch:
 Heads of Apostles
 Byzantine. An Evangelist, bust
 Byzantine. Paten: Commission

of the Apostles
Byzantine. Throne of Maximi-
an
Early Christian. Apostle,
panel
Early Christian. Evangelist,
medallion bust
Early Christian. Santa Giulia
Casket
English--12th c. Apostle(s)#
English--13th c. Apostles,
Prophets and Patriarchs
--Boss: Four Evangelists
English--15th c. An Apostle
--Evangelist, w end screen-
work figure
Flemish--14th c. Standing
Apostle
Flemish--15th c. Apostle in
hat
Flemish--16th c. Two
Apostles
French--Two Apostles
French--10th c. Gospels of
Gauzelin Cover
French--12th c. Apostle(s)#
--The Ascension; combined
with Mission to the
Apostles, tympanum
French--12th c. Royal Por-
tal; Apostles
--Shrine: Apostles
French--13th c. Apostle(s)#
--Apostle and Prophet
--Sleeping Apostle
--Two Apostles
French--14th c. Apostle,
head
German--11th c. Book Cover:
Gospels of Bishop Bern-
ward of Hildesheim
--Luneberg Candlestick foot
German--12th c. Angel's
choir-screen: Apostles
--Apostle#
--Apostles and Prophets,
choir screen
--Komberg Chandelier:
Apostle
--Lectern, Alpirsbach: Four
Evangelists and symbols
--The Twelve Apostles
German--13th c. Paradise
Portal: Apostles
--Princes Portal
German--14th c. Apostle,
Chapel Tower

German--15th c. Apostle,
seated figure
--Departure of the Apostles
Goujon. Four Evangelists
Goujon. Two Evangelists
Gunther, F. I. Apostles
Hodard. Apostles
Jean de Cambrai. Apostle,
head
Joli. Apostle, head
Masegne, J. and P. Apostles,
choir screen
Master Mateo. Portico de la
Gloria: Apostles
Munsterman. Apostle
Pacino di Bonaguida. Com-
munion of Apostles
Pisano, G. Apostle, relief
head
Porta, Giacomo. Altar of the
Apostles
Robbia, L. della. Apostles,
medallions
Roger of Helmarshausen.
Portable altar
Romanesque. Apostles: Bar-
tholomew, James, Simon,
and Judas, choir screen
Romanesque--French. Apostles,
portal relief
Romanesque--German. Gallus
Gate: Apostles
Rusconi, Camillo. Two Apostles
Saxon. Seated Apostle, relief
Spanish--11th c. Apostle,
casket panel
--Thomas before Christ and
the Apostles
Spanish--12th c. Apostles
Spanish--16th c. Apostle, High
Altar
Stoss. Altar of Our Lady:
Apostle, head
Teutonic. Sigwald Relief
The Apothecary, house corner post.
French--15th c.
Apotheosis
Bosio. Apotheosis of Louis XVI
Braun, M. B.--Foll. Apothe-
osis of Count Sporck
Cortot. Apotheosis of Napoleon
Feill. Apotheosis
Flaxman. Homeric Vase
Permoser. Apotheosis of Prince
Eugen
APPEL, Karel (Dutch-French 1921-)
Two torsos 1961 ptd wood; 48
SEAA 137 (col)

Apple and Pear. Kolar
April. Macken
APRILE, Francesco (Italian d 1865)
 Pietro and Francesco Bolog-
 netti tombs, model after
 1675 WIT p1 118B ELV
Asparas. Charlet
Apthorp, Charles
 Cheere, H. Charles Apthorp
 Monument
Aquablanca, Dean
 English. Dean Aquablanca
Aquamaniles
 Danish--13th c. Aquamanile:
 Centaur
 Dutch--12th c. Lion aquama-
 nile
 English (?)--13th c. Horse-
 man
 Flemish--14th c. Lion, aqua-
 manile
 Flemish--15th c. Horse,
 aquamanile
 French--12th c. Dragon aqua-
 manile
 --Griffin aquamanile
 --Lion
 French--13th c. Aquamanile:
 Lion
 --Dragon devouring man,
 aquamanile
 French--15th c. "Aristotle's
 Fable"
 German--12th c. Bacchus head
 --Lion aquamanile
 --Samson aquamanile
 German--12/13th c. Aquama-
 nile: Dragon swallowing
 a man
 German--13th c. Aquama-
 nile#
 German (?)--14th c. Aqua-
 manile: Horse and Rider
 German--15th c. Aquamani-
 le: Aristotle and Cam-
 paspe
 --Aquamanile: Lion
 Medieval. Aquamanile:
 Dragon
 Russian--13th c. Aquamani-
 le: Cheetah
Aquarel. Peeters
Aquarius, relief. Pasti
Aquatic. Arp
Aquatic. Lambrechts
Arabesque. English
Arabesque over the right leg.
 Degas

Arabian and Egyptian Water-Carriers.
 Barth
Arabs
 Barye. Mounted Arabs killing
 a lion
Aragazzi, Bartolommeo
 Michelozzo. Bartolommeo
 Aragazzi Monument
Araldica. Franchina
Aranguren, Jose Louis L.
 Serrano. Jose Luis L.
 Aranguren
Arany, Janos (Hungarian Poet 1817-
 82)
 Strobl. Poet Arany Memorial
Arbora della Virgine
 German--12th c. Tribulzio
 Candelabra
Arbours
 English--18th c. Whieldon
 Arbour Group
ARBUS, Andre (French 1903-)
 Head in slate MAI 7
Arbusti. Leoncillo
Arc de Triomphe
 Rude. Departure of the
 Volunteers of 1792 (La
 Marseillaise)
ARCA, Niccola d'Antonio dall' See
 NICOLLO DELL'ARCA
Arca degli Antenati. Agostino di
 Duccio
Arca di S. Lanfranco. Amadeo--
 Foll
Arca of St. Augustine. Balducci
Arca of St. Dominic. Pisano,
 Niccolo--Foll
Arca of St. Peter Martyr. Balducci
Arcades
 Amadeo and Stauris. Decorated
 arcade
 English--12th c. Arcade
Arcadian Family. Marin
Arcadius (Eastern Roman Emperor
 377-408)
 Byzantine. Arcadius, head
 Byzantine. Dish: Theodosius I;
 Valentinian II; Arcadius
Arce, Vasquez d'
 Forment. Marquess Vasquez
 d'Arce tomb
Arch. Brancusi
Archaic figure. Eade
Archangels
 English--10th c. Archangel
 Lardera. Archangel No. 1
 Marini. Archangel
 Mascherini. Archangel Warrior

ARFE, Antonio de (Spanish 1510-66)
 Monstrance 1539-45 CIR 53
 (col) SpSanC
ARFE Y VILLAFANE, Juan de
 ('Spanish Cellini")
 Monstrance 1580-87 silver;
 146 CIR 54 (col) SpSC
ARFE Y VILLAFANE, Juan de, and
 Lesmes FERNANDEZ DEL
 MORAL
 Christobal de Rojas y Sando-
 val, kneeling effigy bronze
 CHASEH 365; CIR 33 (col);
 POST-1:262; WES 24 SpLP
Arguing figure, panel relief
 Donatello. Old Sacristy Doors
Argyle Jug. English--19th c(?)
Argyll, John, 2nd Duke of 1678-1743
 Roubiliac. John Campbell,
 2nd Duke of Argyle, Monu-
 ment
Ariadne
 Biagini. Sleeping Ariadne
 Byzantine. Ariadne
 Danneker. Ariadne on a
 panther
 Early Christian. Ariadne (?),
 high relief
 Kolbe. Ariadne
 Lombardo, T. Bacchus and
 Ariadne, busts
 Millet. Ariadne
 Poussin. Sleeping Ariadne
Ariadne, Empress (Consort of Zeno
 and Anastasius d c 515)
 Byzantine. Empress Ariadne
Arianna
 Byzantine. Empress Arianna
Ariel
 Gill, E. Ariel between Wis-
 dom and Gaiety, exterior
 relief
 Gill, E. Ariel hearing
 celestial music
 Gill, E. Prospero and Ariel
Arion. Bertoldo di Giovanni
Arion. Riccio
ARISCOLA See SILVESTRO DELL'
 AQUILA
Aristaeur. Bosio
Aristotle
 French--12th c. Royal Portal;
 Adoration of the Shep-
 herds; Aristotle
 French--12/13th c. Aristotle
 with writing tools, relief
 French--16th c. Choir stall:
 Aristotle at the mercy of
 his wife

German--15th c. Aquamanile:
 Aristotle and Campaspe
"Aristotle's Fable". French--15th c.
Arithmetic
 Pollaiuolo, A. and P. Sixtus
 IV Monument
Ark of the Covenant
 Jewish--3rd c. Ark of the
 Covenant on wheels
 Italian--3rd c. Open Ark
 Polish. Ark of Covenant
"Armada" Medal
 English--16th c. The "Dangers
 Averted", or "Armada",
 medal
ARMAN (Augustin Fernandez) (French
 1929-)
 Accumulation PEL 254 -Leo
 Aeole's Prison 1963 KULN 110
 Arteriosclerosis 1961 Assem-
 blage: Forks and spoons in
 glass-covered box; 18-3/4
 x28-5/8x3 SEITA 84 IMSc
 Le Couleur de mon Amour 1966
 KULN 19
 Diffraction in Desire 1965
 plastic; 16x18x5-3/8
 SELZA 176
 Glug-Glug. accumulation of
 bottle caps 1961 c 9x13
 LIP 179 IMSc
 Le Jeune Fille Pauvre 1962
 KULN 21
 Little Hands (Ainsi font,
 font...) 1960 Assemblage:
 Dolls' heads glued in a
 wooden drawer; 14-5/8x
 17-7/8x2-7/8 SEITA 127
 UNGS
 Toccata et Fugue, sculpture of
 accumulations 1962 Split
 violins; 65x51-1/2x5-1/8
 ALBC-4:52 UNBuA
 Variable and Invariable 1963
 metal on wood; 25-1/2x
 33-1/2 CALA 220 IVG
ARMANDO (Dutch 1929-)
 Composition with 24 bolts
 1962 panel with bolts;
 28-3/4x21-1/4 NEW pl 158
Armatura Lunare I. Gabino
Armed Figures. Meadows
Armengol VIII, Count of Urgel
 Spanish--13/14th c. Armengol
 VII tomb
Armengol X
 Spanish--13/14th c. Armengol
 X and Dona Dulcia tomb

ARMENIAN
 Cathedral, eastern facade c
 915 stone LAS 79 TVA
 King Gagik, relief, west
 facade 915/21 RTC 237
 TVA
 Seven Capital: Confronted
 peacocks and ducks 9/10th
 c. wood RTC 232
 Stela: Confronted birds, ro-
 settes, Christian symbols,
 Gaiana 9/10th c. stone
 RTC 229
Armets a Rondel See Armor--
 Helmets
ARMITAGE, Kenneth (English 1916-)
 Balanced figure 1961 bronze;
 48 SFMB #99 ELMa
 The bed 1965 polyester resin,
 glass fiber reinforced;
 48-1/2x35-1/2x68-1/2
 GUGE 74
 Children by the sea 1953
 bronze; 17-1/2 HAMM
 120
 Diarchy 1957 bronze; 11-3/4
 BERCK 149
 --CALA 208; GUGP 91 IVG
 Diarchy 1957 bronze; 68-1/2
 TRI 81
 --1957 bronze; 68-1/2
 SELZN 25 UIWM
 --1957 bronze; 69x44x39
 LOND-5: #2 ELMa
 Family going for a walk 1951
 bronze; 74x84x34 cm LIC
 pl 298
 --SP 3 GHaS
 --1951 bronze; 29 GIE 211;
 MCCUR 276; NMAD 57
 SCHAEF pl 71 UNNMMA
 --1953 BR pl 18 ELG
 Figure 1946 bronze; 24 NEW
 TEB pl 2
 Figure lying on its side,
 version 4 1957 bronze; L:
 46 ARTS #5
 Figure lying on its side,
 version 5 1958/59 bronze;
 15x33 ARTSB-68: 6; ENC
 39; MYBS 84; READCON
 222 ELBrC
 Friends walking 1952 bronze;
 22 YAP 247 UICSm
 Girl without a face 1958/59
 bronze; 65-1/2x19 CARNI-
 61/62:#12; HAMM 123
 (col) ELBrC

Group 1946 plaster; 30 NEW
 TEB pl 1
Krefeld Monument, model 1956
 bronze; 13-1/4 SELZN 25
 UNNRoss
Life study 1953 bronze; 43
 ARTS #3
Model for a large work 1963
 L:32 SEITC 48 ELMa
Model for a large work, version
 A 1962 bronze; L:15-3/4
 MAE 19
Model for a large seated group
 1957 bronze; 10 SELZN 24
 UNNHe
Monitor 1961 bronze; 60x78
 LOND-6:#3 ELMa
--1961 bronze; 152.5x198 cm
 JOO 201 (col) NOK
Moon figure 1948 bronze; 34
 ARTS #1 ELMa
Mouton variation 1964 brass;
 99x72x40 LOND-7:#4
Mouton variation: Small model
 1963 brass; 13-1/2 PRIV
 94
Pandarus, version 4 1963
 brass; 22 MAE 18; PRIV 95
--version 5 1963 brass; 13x5x
 4 ARTSS #6 ELBrC
--version 8 1963 brass; 70x34
 x20 ARTSB-66: pl 1 ELMa
--version 10 1964 bronze; 33
 HAMM 122 ELMa
--version 11 1964 brass; 88x
 39x25 LOND-7:#3
Pandarus IV 1963 bronze
 LARM 369 ELMa
--V 1963 bronze; 26-1/2
 NEW pl 98
People in a wind 1950 bronze;
 25-1/2x15-3/4x13-1/2
 BAZINW 444 (col); TATEB--
 1:1: TATES pl 5; WILMO
 pl 52, 53 ELT (T.366)
--CALA 207 IVG
Roly-poly 1955 READAN #122
--1965 KULN 55
The Seasons 1956 bronze; 34
 SELZN 26 UNNZ
--1957 bronze; 29-1/2 SELZS
 171 UNNZ
Seated figure with raised arms
 1957 small version bronze
 VEN-58: pl 153
Seated group listening to music
 1952 bronze; L: 49 MAI 10;
 NMAD 59 UNNScha

Seated woman with arms ex-
tended 1953/57 bronze; 42
ALBB 11; ALBC-3:#60;
EXS 61; SELZN 26: TOW
71 UNBuA
Slab figure 1961 bronze;
28-1/2x38 READCON 223
ELMa
Small model with 5 flanges
1963 brass; 13 PRIV 94
Small model with 6 flanges
1963 brass; 13 PRIV 94
Square figure, relief 1954
bronze; 42x27-1/2 NMAD
58
Square seated figure 1957
bronze; 9 ARTS #4
Standing Group 2 (large
version) 1952/54 bronze;
41-1/4 GIE 210; NMAD 58
UNNScha
Standing man 1953 bronze;
17-1/2 HAMM 121
Standing man 1960 bronze;
66 ARTS #7 ELMa
Standing woman 1965/67
bronze; 48 ARTSB-61: pl
1 ELMa
Sybil III 1961 bronze; 40-1/2
x 24-1/2x12-1/4 READCO
pl 8; TATES pl 6 ELT
(T. 416)
Tiger-Tiger 1966 aluminum;
86x84x54 LOND-7:#5
ELMa
Triarchy, model 1957 bronze;
L:15 ARTS #6
Two linked figures 1949
bronze; 39 ARTS #2
Two seated figures 1957
bronze; 41x55x39 LONDC
pl 2; MAI 10
Two standing figures 1951
BERCK 149 ELG
Walking group 1951 bronze;
9 READCON 222;
WILMO pl 29
Armoire. Sambin--Foll
Armor See also Games and Sports--
Jousting; Soldiers
Alfonso. Olivera do Conde,
effigy
Austrian--14/15th c. Singer-
tor: Fall of St. Paul
Bacque. Pothon do
Xaintrailles
Bontemps. Charles de
Maigny, effigy

Bontemps. Francis I tomb,
relief
Coysevox. Fame
Danish--16th c. Armor of Duke
Adolphus
DeVries. Rudolph II
Donatello. Gattamelata
Donatello. St. George
Early Christian. David slay-
ing Goliath, plate
Early Christian. Missorium of
Emperor Theodosius I
English--13/14th c. Sir Robert
de Bures
English--14th c. Black Prince
tomb
--Edward, Lord Despencer,
chantry effigy
--John of Eltham tomb
--The Resurrection
--Robert Hilton and wife,
effigy
--Sir Hugh Hastings
--Sir John and Lady de la Pole
--Sir John Lyons, effigy
--Sir Robert de Septvans
--Thomas, Earl of Warwick,
and his wife
English--15th c. Armed figure
vanquished
--Lord and Lady Camoys
--Ralph and Anne St. Leger
--St. George and the Dragon
--St. George killing the Dragon
--Sir Robert and Sir Thomas
Swynborne
English Royal Armory. Armor
of George Clifford.
Evesham. Henry Lord
Norris tomb, effigy
Flemish--15th c. Geel Altar-
piece
Frampton. St. George
Frauenpreiss, M., the Elder.
Armor--reinforcing breast-
plate and burgonet
Fremiet. Jeanne d'Arc
French--12th c. Porch, south
transept: St. Theodore
--Psychomachia capital
French--13th c. Abraham and
Melchizedek
--Portal des Martyrs: St.
Theodore
French--15th c. Dunois, chapel
statue
--Entombment: Armored figure
--Louis II de Sanserre, effigy

Austrian--15th c. Breastplate
Campi, B. Breastplate
German--16th c. Parade Armor of Maximilian II: Cuirass
Negroli, P. de. Breastplate
Spanish--16th c. Breastplate of Archduke Albert
--Helmets
Burt. Helmet
European--Western. Bascinet
Flemish--14th c. Militiaman of Ghent, bust
Flemish--15th c. Salet with mesail
Frankish. Chieftan's helmet
Frankish. Clasped helmet
French--15th c. Great Bascinet
French--16th c. Close helmet
--Helmet of Charles IX
French--18th c. Parade helmet of Louis XIV
French, or Italian--16th c. Embossed parade helmet
--Parade helmet of Galiot de Genouilhac
German--16th c. Armet
--Armet-a-Rondelle
--(?) Burgonet, or helmet with vizor
Giovanni di Salimbeni (?). Armet-a-Rondelle
Hermann and Heinz. Louis I, head detail
Italian--14th c. Basinet
Italian--15th c. Armet
--Armet a Rondelle
--Barbute
--Lion-headed display barbute
--Milanese visored sallet
--Parade helmet, Florence
--Three barbuti, and 1 salet
Italian--15/16th c. Barbuta
Italian--16th c. Helmet#
--Milanese embossed parade helmet
Lombardo, T. Andrea Vendramin tomb: bust of warrior
Negrol. Carlos I, helmet
Negroli. Parade helmet
Norman. Conical helmet with nasal
Piccinino. Burgonet
Russian--13th c. Helmet of Yaroslav
Russian--16th c. Helmet of Khan Mohammed
Russian--17th c. Hat of Yerikhon
Spanish--16th c. Helmet of Charles IV
Swedish--7th c. Helmet
Voys. Jousting helmet
--Sabatons
Italian--15th c. Milanese Gothic sabatons
--Shields
Celtic. Battersea Buckler
Desiderio da Settignano. Carlo Marsuppini Monument: Putto with shield
Flaxman. Achilles Shield
Flemish--16th c. Skokloster Shield
French--16th c. Shield
German--16th c. Heraldic epitaph
Negroli. Charles V round shield
Piccinino. Target: Apollo on Mt. Parnassus
Russian--16/17th c. War shields
Armor, Horse
German--16th c. Man and horse armor
Italian--15th c. Horse and rider armor
--Italian reinforcing couter and vambrace, and chanfron
Lochner. Knight and horse armor of Johann Ernst
Negroli, F. 3 saddle steels and a chanfron
ARMOUR, Hazel (English)
African warrior, head brass HOF 58
Leslie Hurry, head 1945 plaster; over LS NEWTEB pl 7
ARMOUR, Helen
Mo Ting Yuem bronze CASS 45
Armourium: Sculpture Number 123. Kemeny
Arms
Byzantine. Reliquary for arm and hand
Eilbertus--Foll. Arm reliquary
German--11th c. Arm reliquary of St. Blase

German--12th c. Arm
 reliquary
Italian--15th c. Arm reliquary
Ottonian. Reliquary arm of
 St. Sigismund
 Picasso. The arm
ARMSTEAD, Henry Hugh (English
 1828-1905)
 Albert Memorial, detail
 marble BROWF--3:80
 ELKe
 --frieze on Podium: Painters,
 sculptors, architects, poets,
 and philosophers MILLER il 162
ARNATT, Raymond (English)
 Articulated opposites
 (Rational-Irrational) 1966
 bronze; 144x60 ARTSB-
 66:pl 2
Arnaud,. M.
 Despiau. M. Arnaud, head
ARNOLD, Walter (German 1909-)
 Barbara 1949 bronze; 26-
 3/4 BERL pl 260; BERLES
 260 GBSBe (BI 650)
ARNOLDI, Alberto (Italian fl 1351-
 64)
 The Eucharist, lozenge re-
 lief 1350's marble POPG
 pl 54; WHITJ pl 182B IFC
ARNOLFO DA FIRENZE
 Boniface VIII, bust NOG 60
 IRP
ARNOLFO DI CAMBLO (Italian
 1232(?)-1300(?))
 Adrian V Monument 1276
 POPG fig 13 IVitF
 Angel 13th c. NCM 268
 UMiD (27.210)
 Angel holding book symboliz-
 ing Faith marble LOUM
 119 FPL (569)
 Angel of the Annunciation
 marble; 48 FAIN 113
 UMCF
 Annibaldi Monument, Relief
 detail marble; overall:
 68x212 cm POPG fig 54
 IRGio
 --Two clerics POPG pl 21
 Arca de S. Domenico, detail
 1264/67 marble WHITJ pl
 21B IBoD
 --Raising of Napoleone
 Orsini POPG pl 20
 Baldacchino POST-1:142
 IRPa
 Boniface VIII, detail LARR 33
 ISC

Boniface VIII blessing MCCA
 21 IFOp
Boniface VIII Monument CAL
 33 (col); POPG fig 55 IRV
Cardinal de Braye Monument
 after 1282 marble KO pl 75;
 MACL 49; MONT 23; POPG
 fig 12; WHITG pl 23B, 24,
 25B IOrD
--Two angels POPG pl 22, 23
Censing angel marble; 45-1/2
 UMCF UMCF (1957.57)
Charles of Anjou c1277 marble;
 over LS KIDS 137 (col)
 IRCap
Charles of Anjou, seated fig-
 ure c1277 ENC 41; MONT
 23 IRCo
Ciborium 1285 WHITJ pl 26A
 IRPa
Ciborium 1293 WHITJ pl 26B
 IRCec
Dormition of the Virgin, facade
 figure marble; L:170 cm
 POPG pl 24B Formerly
 GBK
Mourning Acolytes, monument
 fragment, frieze, Cloister
 of San Giovanni marble, with
 "cosmati work" background;
 28 MOLE 103 IRL
St. Peter, seated figure, nave
 bronze CAL 30 IRP
St. Peter in pontifical vest-
 ments, seated figure CAL
 31 (col) IRP
S. Reparata 1302 BAZINW 308
 (col); WHITJ pl 27A IFOp
Thirsting woman c1280 WHITJ
 pl 25A IPeG
Virgin and Child 1302 WHITJ pl
 28A IFOp
--c1300 marble; 68-1/2 JANSK
 534; MONT 371; POPG pl
 25
Virgin and Child Blessing, and
 SS Reparata and Zenobius
 MCCA 67 IFOp
Virgin of the Nativity 1296/
 1302 marble; L:174 cm
 LOWR 199; POPG pl 24A
 IFOp
ARNOLFO DI CAMBIO--FOLL
 Annunciation MACL 50 ELV
ARNOULD, Jean (French)
 Reestablishment of military
 discipline, roundel, cast by
 Pierre Le Negre. Design by
 Mignard 17th c. bronze
 LOUM 169 FPL (1256)

ARNOULD, Jean, and PIERRE LA
NEGRE
 Capture of Valenciennes,
 tondo relief 1686 BUSB 91
 FPL
Arnulf
 Byzantine. Bishop Arnulf
 Sarcophagus
ARONDEAUX, Reiner (Fl 1678-1702)
 Medal: Coronation of William
 III and Mary II 1689
 silver; Dm: 2-7/16
 VICOR pl 33E NHP
ARONSON, Naoum (Russian 1872-)
 L'Aurore TAFTM 84
 Despair TAFTM 83
 Group TAFTM 63
 An Old man TAFTM 83
 Old Silesian woman TAFTM
 84
 Petite Bretonne TAFTM 84
 Portrait--Bearded head
 TAFTM 84
 Study of a head marble PAR-
 2:165
 Young girl TAFTM 83
Arouet, Francois Marie See Voltaire
Around the Void, No. 3 Chillada
ARP, Hans (Jean Arp) (French 1887-
 1966)
 Alou con gli Artigli 1942
 VEN-54:pl 66
 Aquatic 1953 marble; 13
 READI pl 86; WALKER 34
 UNNV
 Bird Tripod bronze; 30 BOW
 67 FPRe
 Birdman (Vogelmensch) 1920
 ptd wood GERT 130;
 PANA-2:15 UCtY
 Birds in an acquarium, re-
 lief c1920 ptd wood; 9-
 7/8x8 BAZINW 433 (col);
 LYN 133; NNMMM 140
 UNNMMA
 Cobra-Centaur 1952 marble
 MAI 12
 Column with interchangeable
 elements 1945-55, made
 from elements of 1938
 plaster; 75 BERCK 104
 Configuration 1933 MOHV 221
 --1935 MOHN 40
 --1936 READS pl 5
 Configurations 1932 three
 forms movable on one
 large form, plaster; 9x13
 GIE 111

Constellation, relief 1932 ptd
 wood; 27x33-1/2 PPA 2
 UPPPM
Constellation according to the
 Laws of Chance, relief
 c1932 ptd wood LARM 298
 ELT
Constellation in Five White
 Forms and Two Black,
 Variation III 1932 oil on
 wood; 23-5/8x29-5/8
 CLEA 79 UNBuA
--GUG 188 UNNG
Constellation of Leaves 1937
 CANK 178 SwBPr
Construction 1919 wood RICHT
 pl 22
Construction of White Flowers
 in memory of a Dead
 Woman 1943 ptd wood
 MARC pl 42
Coupe Chimerique 1947 bronze;
 31 GERT 131; RIT 196
 UNNWar
Crown of Buds 1936 BURN 92
 UNNKo
Cypriana 1938 marble; 17
 CAN-2:185 CON
Demeter 1960 marble CHICC
 20 UICMar
Earth Forms, called "Tears of
 Enak" (Enak's Tears; Ter-
 restrial Forms), relief
 1916/17 ptd wood ENC 41;
 SELZJ 236 FMeA
Egg Board (Bread-Boards with
 Eggs) 1922 ptd wood; 29-
 1/2x39 JANSK 1024; WALD
 49 (col) BLG
Evocation: Human Lunar Spec-
 tral 1950 pink limestone;
 36-5/8 HAMP pl 177
 BrRMo
Evocation of a Form--Human,
 Lunary, Spectral 1950 cast
 cement; 33-1/2 GIE 118
 SwZGi
--white marble; 33 SOTH-3:
 76
Evocation of a Human-Form
 1950 limestone; 33 SCHAEF
 pl 100
Extreme of an Outer Mythology
 1952 stone SELZJ 10 UICa
Extremity of a Mythical Wine-
 skin (Outrance d'une outre
 mythique) 1952 stone; 17
 READAS pl 202 UNNV

Fallen Leaf (Feuille se Reposant) 1959-65 marble; 41-1/2, incl marble base GUGE 22 UNNJa

Figure Classique 1964 white marble; 96x14x16 ALBC-4:75 UNBuA

Figure Without a Name 1951 bronze; 20 BERCK 107

Floral Column 1957 bronze; 37-1/4 SELZS 172 UNNZ

Forest 1916 ptd wood; 12-5/8x8-1/4 MYBS 78; READCON 136 (col); RICHT 24 (col) ELP

Forms arranged according to Laws of Chance 1930 oak; 19-3/4x19-1/4 SELZS 92 UNNCh

Fruit of a Pagan Stone (Fruit d'Une Pierre Paienne) 1942 black granite; 8x13-1/2 GIE 117 UNNCal

Fruit of a Stone (Fruit d'Une Pierre) 1959/60 marble; 23-1/2x43x19 GUGE 21; HENNI pl 139

Gargoyle 1949 limestone; 11-3/4 BERCK 105

Garland of Buds I 1936 limestone; 18-1/8 CALA 104; GUGP 40; LIC 271 IVG

Glass figures CALA 16 (col) IVG

Growth 1938 bronze MAI 12

--1938 bronze (3 casts); 32" BURN 93; CHENSW 12; KO pl 105 UPPPM

--1938 marble; 39-1/2 GUG 189; TRI 150 UNNG

Head 1924/25 ptd wood; 11 NMAC pl 207 UNNMMA

Head on Claws 1949 bronze; 18-1/2 BERCK 105; DETS 27 UNNH

Human Concretion (Concretion Humaine) 1933 bronze; 29-1/2x22x13-3/8 READCON 83

--1933 SOBYZ pl 43

--1934 marble; 20x14-3/4 BAZINW 437 (col) FPM

--1935 (1949 copy) cast stone (original plaster); 19-1/2 BURN 90; LYN 133; NMAC pl 209; NMFA 149; NNMAP 138; NNMMARO pl 319; NNMMM 140; READS pl 4;

RIT 123; UPJ 641; UPJH pl 243; VALE 23 UNNMMA

--1936 stone; 19-1/2 GIE 114-5 SwBP

Human--Lunary--Spectral (Human-Moon-Ghost) concrete PRAEG 463

--(Menschlich-Mondhaft--Geisterhaft) 1950 cast cement GERT 132

--Human Lunar Spectral ii 1958 bronze; 47-1/4 SEAA 132 UCtMeT

Hurlou 1931 limestone BERCK 108

Idol 1950 bronze MARC pl 45 (col)

--1950 plaster; 43-1/2 GIE 119 BrRMo

Individuals 1931 ROOS 281D

Initial of a Leaf 1960 bronze; 35 EXS 62 CTC

Landmark 1958 wood lathe, turned and sawn; 23-5/8x 9-7/8x14-18 READCON 53

Landscape 1962 green granite VEN-62: pl XVII

Leaves and Navels, relief 1930 ptd wood; 31-3/4x 39-3/4 NMFA 147 UNNMMA

The Lips, relief 1926 16x17 SELZS 86

Madame Torso with Wavy Hat 1916 wood; 15-7/8x10-3/8 READCON 135 SwBeK

Maimed and Stateless (Mutile et Apatride) 1936 newspaper construction; 14-1/2x12-5/8 CALA 103; GUGP 39; READS pl 6 IVG

Mask 1931 READAN #113

Mediterranean Group 1941/42 bronze; 10x15 GIE 151

Miller, relief 1916 ptd wood; 24-1/2x19-3/4 NMFA 145

Moon-like, Hollowed out, Ghostly 1950 white marble; 16-1/2 SP 5; TRI 169 GHaS

Moustache, Bottles, Leaf, Head 1931 READAN #112

The Moustache of Machines (La Moustache des Machines) 1965 bronze; 21-3/4 GUGE 25 FPRe

Neo-Geometric Relief 1928 MOHV 135

Objects arranged according to

the Laws of Chance
(Navels), relief 1930
varnished wood; 10-3/8x
11-1/8 MCCUR 266;
NMFA 146 UNNMMA
Overturned Blue Shoe with
Two Heels under a Black
Vault, relief 1925 ptd
wood; 31-1/8x41 CALA
102 IVG
Pagoda Fruit (Fruit Hybrid
dit La Pagoda; Hybrid
Fruit Called Pagoda)
bronze VEN-50: pl 107
--1934 bronze; 34-3/4 BOW
69; TATEF pl 18g ELT
(6025)
--1949 bronze ENC 41
Painted Relief 1924 BERCK
216
Painted Relief 1943 BERCK
216
Paola and Francesca OZ 126
-Hof
Periods and Commas, relief
1943 ptd wood; 100x140
cm LIC pl 267 SwBKM
Poussah, relief 1920 wood
RICHT pl 8
Pre-Adamic Fruit 1938
bronze; 11-1/4 MIUH 52,
52a UMiAUA
Pre-Adamite Sculpture 1938
limestone; 19 SCHAEF pl
99
Ptolemy 1953 bronze MAI 13
Ptolemy (Ptolemaeus) 1953
limestone; 40-1/2 ABAM
151; GIE 121; JANSK
1027; LIC pl 270; READAS
front UNNBur
Ptolemy I 1953 bronze; 40-
1/2x20-7/8x16-7/8
READCON 53
Ptolemy III (Ptolemee III)
1961 bronze; 79-1/2
GUGE 23 FPRe
Relief 1914/15 wood; 46-1/4
x22-1/2 BMAF 53 UNNJa
Relief 1930 ptd wood; 23-
1/2x17-3/4 MYBM 368;
MYBU 140; NMAC pl 208
UNNWar
--1930 ptd wood; 27-1/2x
33-1/2 UNNMMAM #155
UNNGal
--1932 MOT 44 UNNJa

--1938/39 wood; 19-3/4 sq
FLEM 747 UNNMMA
Rock formed by a Human Hand
1937/38 limestone; 16-3/8
SCHAEF pl 98
Sculpture Classique 1964 77x
13x11-1/2 CARNI-64:#53
Sculpture Mediterraneenne
1941 marble RAMS pl 21;
RAMT pl 33
Seuil aux Creneaux Vegetaux
1959 bronze; 28-5/8
JLAT 7 UTxFJ
Shadow Scene 1947 bronze-
stone; 15-1/4 BERCK 105
Shape in Repose 1948/52 lime-
stone; 18 SCHAEF pl 101
Shell 1938 marble; 11 BOSME
pl 112 UCtPO
Shell and Head 1933 bronze;
7-7/8x9-7/8x7-1/4 CALA
105; GUGP 39; LARM 324;
READCON 56 IVG
Shell-Crystal 1946 bronze
BERCK 104
Shepherd of the Clouds (Cloud
Herdsman) 1949/53 plaster;
128 GIE 112
--1953 bronze MARC pl 44
VCU
--1953 bronze; 63 BOW 64
--Berger des Nuages 1953
bronze; 63x24x29 LOND-
5:#3
--Cloud Herdsman 1953 bronze;
167 cm JOO 187 (col) NOK
Shirt-Front and Fork 1922 22x
27-1/2 HAMP pl 176B
Siamois 1960 laminated bronze;
15x29-7/8x41-3/8 READCON
153
Silence 1949 marble; 20 HENNI
pl 108 UCLPr
Silent 1942 marble; 34x14x11
cm LIC pl 269
Siren 1942 bronze; 45x34x23
cm LIC pl 268 UNNBur
Stack of Cups 1947 bronze; 39
MID pl 53 BAM
Star (L'Etoile) bronze; 25x13-
1/8 CLEA 78 UNNG
--1939 gilded bronze; 6-3/4x
4-5/8x1-3/4 GIE 120 BBL
--1939-60 marble; 22-1/2x
20-1/2x3-7/8 READCON
152 FPLo
--L'Etoile (Grand Edition)

1956 polished bronze; 25
ALBC-2:#55 UNBuA
Statue* KULN 154 VCU
Tete Floral 1960 bronze;
18-1/2x7-1/4x7 UCIT
25 UCBeG
Three Buds 1957 white
marble; 20-3/8x15-1/2x
10 CARNI-58: pl 126
UNNJa
Three Graces (Trois Graces)
1961 wood and duralumi-
num; 20-1/2 GUGE 24
FPRe
Torse Poupee 1960 H:34
SEITC 41 UNNJa
Torso 1931 marble BERCK
102; LARM 324; MAI 11;
RAMS pl 70 SwBM
--1934 READAN #120;
READS pl 2
--1953 marble CHRP 380
UMNSA
La Trousse du Voyageur
1920 wood construction;
7-5/8x13 SEITA 37 FPT
Two Heads 1929 ptd wood re-
lief; 47-1/4x39-1/4 CANM
527; NMFA 148; RIT 122
UNNMMA
Two Screens 1950 stained
plywood attached to wood
sidings; 8x36' KUHNG pl
126 UMCHG
Undulating Threshhold 1960
bronze; L: 25-5/8 BOW
66 EKinK
Venus of Meudon 1956 bronze;
19-1/4 DETS cov UNNH
Wall relief 1950 redwood TRI
255 UMCHG
Watch (Orologio), relief 1924
ptd wood VEN-54: pl 67
SwBH
White Form 1950 marble; 10-
1/2 BOSME pl 113
UMoSLWe
Winged Being 1961 H:50
SEITC 171 UNNLi
Woman, cut-out 1916 wood
WALD 48 (col) SwBeRu
Wreath of Breasts 1945
marble MARC pl 43 (col)
IVG
ARP, HANS, and Sophie TAEUBER-
ARP
Sculpture Conjugale 1937
wood RAMT pl 34

ARPESANI, Lina (Italian)
The Victor (Il Vincitore)
marble VEN-20:110
ARPHE, Enrique de
Monstrance 1524 gold and
silver gilt; c 10' VEY 296
SpTC
Arpino, Giovanni
Rosso, Mino. Giovanni Arpino,
bust
Arquebusiers Guild
Dutch--16th c. Drinking horn
of Arquebusiers Guild
ARRAS, Jean d' See CHELLES,
Pierre de
ARRUDA, Diego (Portuguese)
Atlas--rope and ship's rig-
ging 1510/14 BAZINW 329
(col) PoTo
Manueline Great Window 1510/
14 BAZINW 329 (col) PoTo
Window, Convent of Christ
1510/14 BOE pl 144; SANT
pl 40
Arschot, Philippe d'
Heiliger. Philippe d'Arschot,
head
Arsendi, Raniero degli
Andriolo de'Santi. Raniero
degli Arsendi Monument
Art
French--12th c. Porch of
Mary; Madonna and Child;
Seven Fine Arts
Pisano, A. Arts
ART NOUVEAU
Door frame moulding, Wlde-
grave Room, Strawberry
Hill before 1762 SCHMU pl
48 ETW
Artemis (Diana)
Bernini, G. L.--Foll. Diana
sleeping
Bologna--Foll. Diana
Bugatti. Diana
Cametti. Diana
Cellini. Nymph of Fontaine-
bleau
Coysevox. Duchess of Burgoyne
as Diana
Dinlinger. Bath of Diana,
Centerpiece
Early Christian. Plate: Artemis
riding stag
Falguiere. Diana
Graziosi. Diana
Houdon. Diana#
Italian--16th c. Diana, copy of

Roman statue
Kern, L. Diana
Krsinic. Diana
LeMoyne, J. L. Diana
Morice. Diana and Endymion
Persico, P, Angelo Brunel-
 li, and Pietro Solari.
 Diana and Actaeon, foun-
 tain group
Quellen, A. , the Elder.
 Diana
Thornycroft, H. Artemis
Vanvitelli. The Great Cas-
 cade: Diana and Actaeon
Vianen, P. Diana and
 Actaeon, dish
Wallbaum. Diana on the Stag
Yencesse. Diane au Rocher
Artemisia (Queen of Halicarnassus
 fl 480)
Cavino. Artemisia
ARTEMOFF
St. Peter Fish wood CASS
 122
Arteriosclerosis. Arman
Arthur (King of the Britons fl 6th c)
 French--12th c. King Arthur
 and his knights, portal
 archivolt
 French--14th c. Casket:
 Matiere de Bretagne
 (Arthurian Cycle)
 Vischer, Peter, the Elder.
 King Arthur
Arthur, Mme.
 Despiau. Mme Arthur, bust
Articulated Opposites (Rational-
 Irrational)
 Arnatt
Artificial Sun. Paolozzi
ARTIGAS, Joseph Llorens See
 MIRO, Joan
The Artillery Memorial. Jagger
Artois, Jean d', Comte d'Eu d 1402
 French--15th c. Jean d'Ar-
 tois, Comte d'Eu, head
Artophorion. Henning. Johannes
ASAM, Cosmas, and Egid Quirin
 ASAM
 High Altar 1718/25 JANSK
 862 GRegS
ASAM, Egid Quirin (German 1692-
 1750)
 Angel in adoration, High
 Altar LARR 353 GBavO
 Assumption of the Virgin,
 chancel c1717-1722 ptd
 stucco; LS BAZINH 324;

BAZINW 410 (col); BUSB
152; CHENSW 458; ENC
43; HEMP pl 114; KITS
44; KO pl 91; MYBS front
(col); NEWTEM pl 145;
PRAEG 331; STA 178;
VEY GRR
Assumption of the Virgin 1717-
 1725 marble BAZINB 239
 (col) GBavR
Church Portal 1733/46 HEMP
 pl 113 GMJ
Facade, detail, with Athena
 and Sun Dial c1735 BOE pl
 181 GM
High Altar, with St. George
 Killing the Dragon 1721 ptd
 wood and stucco, twisted
 marble columns; altar fig-
 ures in gold and silver gilt
 stucco KITS 16 GWelM
--St. George killing the Dragon
 BAZINL pl 327; ENC 43;
 KO pl 91; ST 332
Mercy Seat, above High Altar
 c1740 ptd stucco BUSB 153;
 KO pl 91 (col); LOH 235
 GMJ
St. Karl Borromaus LIL 204
 GStraU
The Trinity 1733 HEMP pl 115
 GMJ
ASAM FAMILY (German)
 Baroque interior MCCL pl
 336 GMJ
ASBJORNSEN, Sigvald (Norwegian)
 Edward Grieg, bust 1914
 bronze SALT 142 UNBP
Asc. 1962/7. Hiltmann
Ascanius See Aeneas
Ascending Form--Gloria. Hepworth
Ascending Girl. Kolbe
Ascending Woman. Kolbe
Ascension. Freundlich
Ascension of Alexander the Great.
 Byzantine
Ascent. Freundlich
Ascesa. Milani
The Ascete. Beothy
Ascetic. Anthoons
The Ascetic. Barlach
Asclepius
 Canina, L. Aesculapius
 Fountain
 Rodin. Aesclapius
ASHBEE, Charles Robert
 Pendant c1900 silver, gold,
 mother-of-pearl; 5-1/8
 SCHMU pl 181 ELetS

Ashburnham, Sir William, and Lady
 Bushnell. Sir William and
 Lady Ashburnham tomb
Ashburnham Gospels
 German--9th c. Lindau
 Gospels
Ashby, William
 Taylor. William Ashby
Ashby Monument. Bacon, J.
Ashot, Kuropolate
 Georgian. Kuropolate
 Ashote presenting church
 to Savior
ASHTON, Robert See William
 TYLER
Asia. Lunteren
Asleep. Lishansky
ASOREY, Francisco
 St. Francis colored wood
 MARY pl 177 SpMa
Asparagus
 English--18th c. Chelsea
 Asparagus Tureen and
 Cover
ASPETTI, Tiziano (Italian 1565-
 1607)
 Faith bronze; 100 cm POPRB
 pl 132 IPadAn
 Martyrdom of St. Daniel,
 relief POPRB fig 135 IP
 adC
 Neptune bronze; 27-1/2 NCM
 46
 Venus bronze; 9-3/4 MIUH
 pl 13 UMiAUA
Aspiration to Life. Krop
ASSANTI, Riccardo (Italian 1883)
 Prince Ludovico Chigi, bust
 plaster VEN-36: pl 5
Assassins. Frink
"Assemblage" con bambole. Brown,
 A.
Assia. Despiau
Assume, concede. Woodham
Assunta. Kolbe
ASTBURY, John (English 1688-1743)
 Soldier glazed clay ENC 43
Astericos. Russian--16th c.
Asteroide. Ramseyer
Aston, Roger
 Cure, W. II. Sir Roger
 Aston tomb
Astrid, bust. Folkard, E.
Astrid (Queen of the Belgians 1905-
 35)
 Minne, G. Mother and Child
 (Queen Astrid Monument)

The Astronomer. Copnall
Astronomy
 Bologna. Allegory of Astronomy
 Bologna. Astronomy
Astruve, Aristride
 Wiener, C. Aristride Astrue,
 medal
ASURIAN
 Coffer of the Relics, given by
 Alfonso III to Cathedral of
 Astorga 10th c. GUID 59
 SpLeA
ASTYLL, Richard (Richard Atsyll)
 (English)
 --ATTRIB.
 Henry VIII and his son, Prince
 Edward, cameo CON-1:
 pl 77
At the Crest of the Hill. Bayes
At the Edge. Chillada
At rest. Augustincic
Ate and Litai, plaque. Flotner
Atelier Elvira. Endell
Athamas.
 Flaxman. Fury of Athamas
Athena (Minerva)
 Algardi, A. Minerva, panel
 Asam, E. Q. Facade: Athena
 and Sun Dial
 Bourdelle. Pallas Athene ou
 La Sagesse Active
 Byzantine. Dish: Athena de-
 ciding quarrel between Ajax
 and Odysseus
 Cellini. Athena
 Cheere, J. Minerva
 French--19th c. Minerva
 Clock
 Italian--16th c. Minerva
 Pendant
 Italian--17th c. Ewer
 --Minerva, bust
 Koslovski. Minerva and the
 Genius
 Mascherini. Minerva
 Renaissance. Jewel of Minerva
Athletes See also Games and Sports
 Belmondo. Athlete
 Cara. Athlete
 Despiau. Athlete in repose
 Duchamp-Villon. The Athlete
 Epstein. Columnar figure:
 Athlete
 Gimond. Athlete Vainqueur
 Leighton. Athlete struggling
 with python
 Strynkiewicz. Athlete, head

Athys. Donatello
ATKIN, William (English, aged 6)
 Portrait, head JOHT pl 213
Atkins, Richard
 Stanton, William. Sir Richard
 and Lady Atkins tomb
Atlanta
 Blundstone. Atlanta
 Byzantine. Dish: Atlanta and
 Meleager
 Pradier. Atlanta at her toilet
Atlantic. Ramseyer
Atlantis
 Doyle-Jones. Atlantis
 Jonsson. King of Atlantis
Atlas and Atlantes
 Arruda. Atlas--rope and
 Ship's Rigging
 Braun, M. B. Atlas, support-
 ing figures
 Corte, J. Atlas
 French--12th c. Atlantes,
 archivolt
 French--13th c. Man carry-
 ing sack, nave atlas
 --Peasant, supporting figure
 German--13th c. Font
 Italian--12th c. Pillar sup-
 port: Infidel serving
 Church
 Kraft. Sebald Schreyer Tomb:
 Self-portrait, kneeling sup-
 port figure
 Melioranzio. Facade: Atlante-
 an figure
 Permoser. Mermaid, rampart
 pavillion
 Permoser. Zwinger Pavillion
 Atlantes
 Portuguese--18th c. Atlantes
 Puget. Town Hall Doorway:
 Atlas
 Quellinus, A., the Elder.
 Atlas
 Romanesque--French. Atlas
 figure
 Schluter. Great Staircase:
 Atlas
 Tinguely. Atlas
Atmosphere Chromoplastique Number
 109.
 Tomasello
Atom Piece. Moore, H.
Atomised Man. Fabbri
Aton. Carmassi
Atropos
 Antico. Venus, or Atropos
 Carstens. Atropos

ATSYLL, Richard See ASTYLL,
 Richard
Attacking Figure. Lehmbruck
Attacking Tiger. Hardt
Attala, Abbot of Bobbio Abbey
 Italian--8th c. Grave slab of
 Abbot Attala: Tree of Life
Attila
 Algardi. Meeting of Attila and
 Leo I
Attis
 Early Christian. Plate: Cybele
 and Attis
Attitude. Wouters
Attlee, Earl
 Gray. The Rt. Hon. Earl Att-
 lee, head
Atys-Amorino. Italian--15th c.
Au Printemps. Lefebvre
AUBE, J. P.
 Dante
 MARY pl 42 FPPP
L'Aube. Cornet
AUBEAUX, Pierre d' See Rouland
 LE ROUX
Auberjenois, Rene
 Zschokke. Rene Auberjenois
AUBERTIN, Bernard (French)
 Tableau-feu 1961 KULN 187
 --1965 KULN 187
AUDEBERT, Giroud (French)
 Main Portal: Siren 12th c.
 GAF 361 FFou
AUDELEY, Jean d' (French)
 Dance of Salome, relief
 c1240 BUSGS 44 FRC
AUERBACH, Arnold (English)
 Dark Maternity bronze AUES
 pl 67
 Theatre figures AUM 156 ELDT
 Torso 1945 bronze; 30
 NEWTEB pl 34A
Aufstehender Jungling. Kolbe
Augier, Emile (French Author 1820-
 89)
 Barrias. Augier Monument
AUGSBURG MASTER
 Anna Kasper Dornle, tondo
 1525 pear wood; Dm: 22 cm
 MUL 18 GBS
AUGUSTE, Henry (French 1759-1816)
 Candelabrum (one of a set of
 four) silver-gilt; 23-5/8
 CPL 102 UCSFCP (1944.
 20A-E)
AUGUSTINCIC, Antun (Yugoslav 1900-)
 At Rest bronze BIH 88
 Carrying the Wounded 1946
 BIH 84 YB

Dr. Lujo Novak, head bronze
BIH 86
Fallen Fighter, head detail
bronze BIH 78 YBN
Female Torso BIH 89 YZMG
Marshal Tito, head detail
1947 bronze BIH 85 YZMG
"Melody", panel AUM 33
Memorial to the Fallen of
Nis, details 1930 bronze
BIH 82, 83
Mosa Pijade, head bronze
BIH 87 YZMG
Partisan Girl bronze BIH 80
Peace (Mir), North Rose
Garden bronze; 16';
Pedestal; 26' BAA 34; pl
16 UNNUN
The Red Army Monument,
detail 1945 BIH 80 YBa
Silesian Rebellion Memorial,
details, including Mother
of Silesia 1935 BIH 76, 77,
79 YKa
Augustine, Saint
Austrian--18th c. St. Augus-
tine
Balducci. Arca of St.
Augustin
Balducci. St. Augustine tomb
Bernini, G. L. Cathedra
Petri: St. Augustine
Dietrich, Joachim. Augustine
and Gregory
German--16th c. St. Augus-
tine and St. Jerome
Gunther, F. I. St. Norbert
and St. Augustine
Kerric. St. Augustine
Kohl, H. St. Augustine
Kohl, J. F. St. Augustine
Niclaus von Hagenau. St.
Augustine
Permoser. St. Augustine
Quitainer. St. Augustine
Augustus (Emperor of Rome 63 BC-
14 AD)
German--10th c. Lothair
Crucifix, set with 1st c
cameo of Augustus
Italian--17th c. Augustus,
bust
Porta, G. B. della. Augustus,
bust
Augustus Fountain. Gerhard
Aulne, Baron D' See Turgot, A.R.J.
AUMONIER, Eric (English)

Comedy and Tragedy, entrance
relief AUM 130 ELPar
Office building keystones AUM
130 ELGa
Over-door panel burnished
gold AUM 131
Panels, East Sheen Cinema
AUM 159
South Wind, relief stone AUM
128; PAR-1:84 ELUR
AUMONIER, W. (English)
Bank decorative figures AUM
159 ELWeB
Bank entrance AUM 146
ELWeB
Bank facade carving AUM 150
EBelM
Leathersellers' Company, coat
of arms AUM 144 ELLea
Menin Gate, details AUM 136
Aurelia. Scheuernstuhl
AURICOSTE, Emmanuel (French 1908-)
Group hammered lead MAI 14
Henry IV GAF 401 FMarv
Auroch. Balandin
Aurora See Eos
Auschwitz
Adam, H. G. Beacon of the
Dead, Monument for
Auschwitz
Auseinanderstechen. Witschi
AUSTEN, William, of London
(English fl 15th c.)
Richard Beauchamp tomb
c1453 bronze gilt EVJE pl
83; MILLER il 91, 92;
MOLS-1: pl 48, 50 EWarMB
Austria. Hanak
AUSTRIAN
Leda and the Swan MALV 321
AVAr
Ostrich, jewel casket, Vienna
lapis lazuli and enamel;
25-1/2 SOTH-4:239
Rococo Garden Vase WOLFFP
225 AVSc
--10th c. Imperial Crown, for
Reichenau coronation of
Otto I jeweled gold STA 37
(col) AVHof
--12th c. Crucifix c1160
Linden wood; 119 EXM 358
AIT
Man fighting lion, apse relief
c1120 BUSRO pl 142, 143
ASch
--13th c.
Door, panel details: Biblical

Themes c1220 wood BUSR O pl 164 AGuC

Giant's Gate (Riesentor): Apostle c1240 BUSRO pl 163 AVSt

Mourning of St. John, crucifix figure, Lungau c1200 ptd wood CLE 51 UOClA (58.189)

Mourning Virgin, crucifix group, Lungau c1200 ptd wood CLE 51 UOClA (57.500)

Samson and the lion, tympanum c1200 BOE pl 51; BUSRO pl 162 AGuC

Sisyphus, Tantalus and Ixion, relief c1230 PANR fig 59 ASch

Virgin and Child, Vienna wood GROSS fig 37

--14th c.

Crucifix, forked cross BUSG S 163 AF

Madonna c1320 ST 243 AVSt

Madonna and Child, Mariapfarr in Lungau c1395 cast stone CLE 65 UOClA (65.236)

Madonna and Child, Passau c1370/80 ptd lindenwood CLE 65 UOClA (62.207)

Reliquary bust, South Tyrol c1390 copper MULS pl 46B AVK

Servants' Madonna (Dienstbotenmaddona) c1325 BUSGS 185 AVSt

Virgin and Child c1310 BUSGS 158 AK

--14/15th c.

Fair Virgin, main portal c1390/1400 cast stone MULS 40B GMari

Krumau Madonna c1400/20 H:43 JANSK 498; LIL 80; MULS pl 39; ST 251 AVK

Singertor: Fall of St. Paul c1370/1450 BUSG 180; BUSR 6 AVst

--15th c.

Apostle c1490 MULS pl 130 AWG

Breastplate c1490 H:20-1/2 NM-3:4 UNNMM (29.150. 80)

Gallery of North Tower, detail BOE pl 133 AVSt

High Altar: Two female saints with suppliant BUSRO 160 AMa

High Altar c1480 MULS pl 131 CsKos E

King or Emperor c1470 ptd wood; 51 DEY 107, 108; DEYE 72 UCSFDeY (48.10)

Pair of angels c1490 lindenwood; 8-3/4 KUHN pl 12 UMCB(1960.1; 1960.2)

Pieta c1428 ptd poplar; 36-1/4 KUHM pl 6-7 UMCB (1959.95)

Pieta (Vesperbild aus Braunau am Inn) 1440 lindenwood; 89.5x83 cm BSC#46 GBS (7669)

St. Diakon lindenwood; 122.5 cm BERLE pl 36 GRSBe (8688)

St. George, Grosslobming c1410 stone; 42 KO pl 58 AVO

St. Martha, patron st of housewives, Salzburg region c1400 limestone BUSR 31 AVO

Salzburg Madonna c1415 ptd artificial stone; 43 KO pl 57 ASFr

--16th c.

Four Apostles, from Death of the Virgin c1500 poplar; 87.5 cm BERLE pl 39 GBSBe (8171)

Johannes Cuspinian, gravestone 1529 marble MUL 56 AVS

Maximilian tomb: Bianca Sforza, Margaret of Austria, Zimburgis of Masovia 1502-80 bronze KO pl 70 (col) AIH

--Elizabeth, Mary of Burgundy, Elizabeth of Hungary 1502/80 KO pl 70

St. Florian 1520 lindenwood; 102.5 cm BERLE pl 68 GBSBe (5914)

St. George, equest, altar relief 1572 limestone MULS 57 GPrC

St. Philip with book (Heiliger mit BUch) lindenwood; 148.5 cm, with base BERLE pl 41 GBSBe (7693)

--17th c.

Augsburg Mirror c1699 silver,

silver, silver-gilt, mother-
of-pearl, engraved glass
BAZINL pl 340 (col)
Reaping peasant after 1696
BUSB 122 AStPS
--18th c.
Angel carved and gilt KITS
front ELV
Angel Annunciate c1700/25
ptd lindenwood; 51-3/4,
with console x 25-1/2x19
KUHN pl 74 UMCB (1962.
23)
Bird Nesting Group c1745
white porcelain; 11 COOPF
119 AVHa
Court Dietrichstein c1770
porcelain; 6-1/2 COOPF
120 AVHa
Crucifixion pear wood; 33,
with base; Christ H:9-
5/8; base: 20-1/2x9-3/4
KUHN Pl 66-67 UMCF
(1931.58)
Crucifixion, Monastic Church
c1730 CHENSW 458 ASta
Crucifixion with Virgin and
St. John the Evangelist
ptd lindenwood; 11-1/2ʹ
KUHN pl 63-5 UMCB (1959.
128-1959.130)
Emperor Leopold I, bust
marble; 33-7/8 EXM 50
AVK
Flying Angel golded limewood
NEWTEA 198 ELV
Madonna Immaculata c1730/
50 ptd wood; 8, includ
base KUHN pl 67 UMCB
(1962.12)
Madonna of the Immaculate
Conception marble; 49
SCON 5 ScEN (833)
Magdalen in the Desert,
Vienna c 1740/50 ptd
lindenwood; 8-7/8x14-
1/2x6 KUHN pl 69 UMCB
(1961.3)
Medal of Leopold I 1683 lead;
Dm: 5-7/8 KUHN pl 56
UMCF (1956.16)
Rococo Facade c1775 HELM
pl 183 AIHe
St. Ambrose(?) c1725/50 ptd
lindenwood; 87-1/2 KUHN
pl 72 UMCB (1959.127)
St. Augustine c1725/50 ptd
lindenwood; 91 KUHN pl
73 UMCB (1959.126)

Virgin Annunciate c1700/25 ptd
lindenwood; 54-1/2x23-3/4
x18-1/2 KUHN pl 75 UMCB
(1962.22)
--19th c.
Austrian Spirit Wagon, Vienna
1828 L: 12-1/4 SOTH-3:
213
--20th c.
Paperweight, Vienna School of
Arts and Crafts c1910
glazed green; 6x9.5x8.7 cm
SOT pl 85 AVOA
AUSTRIAN, or GERMAN--18th c.
St. Joachim, half-figure gilded
and ptd wood FAIN 181
UMWiL
AUSTRIAN, or SOUTHERN GERMAN
St. John Nepomuck confessing
the Queen of Bohemia
c1750 MEILC 57 UNNCoo
Automobiles
Lefevre. Levassor
Autumn
Garbe, R. L. Autumn
Laurens. Autumn
Sansovino, J. Allegory of
Autumn
Soriano Montagut. Autumn
Wagner, J. P. A. Autumn
Autumn Calf. Simmonds
Autumn Crocus. Schwitters
AUVERA, Johann Wolfgang von de
(German 1708-56)
St. John the Baptist, Bozzetto
1750 lindenwood; c 29 cm
BSC pl 136 GBS (M231)
St. John the Evangelist,
Bozzetto 1750 lindenwood;
c 29 cm BSC pl 137 GBS
(M231)
Auvergne Virgin and Child. French--
12th c.
Aux Champs. Guillaume, Emile
L'Avaleur. Muller, R.
AVARIC See CELTIC
Ave-Maria. Wain-Hobson
The Avenger. Barlach
AVERLINO, Antonio di Pietro See
FILARETE
Aviators and Aviation
Bouchard. Monument to Aero-
nauts
Emerson. Young Aviator
Martini, A. Aviator
Monard, L. de. Aux Aviateurs
Avicenna (Arab Physician and Philoso-
pher 980-1037)
Vigh. Avicenna, medal

AVRAAM (Russian)
 Korsun Gate: Avraam, self
 portrait; Alexander, Arch-
 bishop of Novgorod 12th c.
 BLUC 41 RuNS
AVRAMIDIS, Joannis (Russian-
 Austrian 1922-)
 Figure 1958 plaster MAI 15
 Four figures 1959/60 bronze;
 VEN-62: pl 117
 Group of figures 1959 bronze;
 33-7/8 TRI 71
 Head IV 1959 construction in
 aluminum; plaster; bronze
 VEN-62: pl 118
 Large figure 1958 bronze; 77-
 1/4 LARM 381; READCON
 202 NOK
 Large group of three figures
 1961 bronze; 222 cm SOT
 pl 132
Avuoltoio
 Costa, Joseph Mendes da.
 Vulture
Awakening. Kafka
The Awakening. Kolbe
The Awakening. Krsinic
Awakening. Ledward
Awakening. Rubino, E.
Awakening of Love. Sidlo
Awakening Spring. Macherini
Awakening Strength. Liipola
Away. Caro
Axel, Count von
 Licudis. Count von Axel,
 head
AYRES, A. J. J. (English)
 Power, panel brick NEWTEB
 pl 4
AYRTON, Michael (English 1921-)
 Daedalus bronze; LS HOR
 400
 Icarus bronze ENC 50
 Icarus III 1960 bronze; 56
 READCON 215
 Mother and Child Bathing
 1956/57 bronze; 38
 ROTJB pl 131
Azambuja, Diogo d'
 Pires-O-Moco. Diogo d'
 Azambuja
Azian Chillada
AZPIAZU, Jose Ramon (Spanish
 1927-)
 Wood 1957 BERCK 234

B., Frau
 Breker. Frau B., head

Baal. McWilliam
Baal-Migof. Schultze
BAARGELD, Johannes Theodor
 (German)
 Anthropophiliac Tapeworm
 (Anthropofiler Bandwurm),
 assemblage 1919 RICHT pl
 79
BABERTON, Ivan Mitford (South
 African)
 Klaas Blankenberg, Hottentot
 man, head teak CASS 38
 Lioness Brazilian wood CASS
 126 SoDA
 Tinderketch, Suk man, Kenya,
 head teak CASS 38
 Yussif Bin Abdulla, Swahili
 man of Mombasa, head
 Jarrah wood CASS 38
BABIN
 Maternite FPDEC il 3
Babington Tomb. English--16th c.
Baboons See Monkeys and Apes
Baby, head. Zweden
Baby's Head. Gray
Bacchanale
 Byzantine. Veroli Casket:
 Bacchanalia
 Duquesnoy, F. Bacchanale of
 Putti
 Lerche. Bacchanale, vase
Bacchante See also Satyrs
 Bernard. Bacchante
 Bernard. Boy Bacchant
 Bourdelle. Bacchante
 Broch y Llop. Bacchante
 Clodion. Bacchant
 Clodion. Bacchante#
 Gargallo. Bacchante
 Laurens. Femme a la grappe
 (Bacchante)
 Maratti. Maenad, relief
 Monnot, M. C. Bacchante
 Rodin. Interlacing Baccantes
 Rodin. Orpheus and Maenads
 Villareale. Bacchante
Bacchus See Dionysus
Bacco, Erma di
 Italian--18th c. Erma di Bacco,
 bust
BACHELET
 Wyandotte Cock CASS 122
BACHELIER, Nicolas (French fl 1550)
 Hotel de Bagis, door 1538
 BAZINW 383 (col); BLUA pl
 40B; BOE pl 162 FTB
The Back# Matisse
BACKERE, Pieter de (Pieter de

Beckere) See BORMAN, Jan,
 the Elder
BACKOFFEN, Hans (German c1470-
 1519)
 Crucifixion LIL 144 GHef
 Uriel von Gemmingen Tomb
 1515/17 stone KO pl 67
 GMaiC
Bacon, Francis
 Wedgwood and Bentley. Fran-
 cis Bacon, bust
Bacon, John (English 1740-99)
 Ann Whytell Monument 1791
 WHINN pl 130A ELWe
 Ashby Monument relief, with
 Justice and Charity 1761
 ESD pl 34 ELeiA
 Earl of Chatham Monument
 1779/83 ENC 54; WHINN
 pl 129B ELWe
 George III 1788 bronze; GLE
 152 ELSom
 George III, bust 1774/75
 CON-4: pl 32; GUN pl 1;
 WHINN pl 128B EWindC
 George Montagu Dunk, 2nd
 Earl of Halifax Monument
 c 1783 marble MOLS-2: pl
 42 ELWe
 John Howard Monument 1795
 IRW pl 156 ELPa
 Samuel Johnson, bust c1770
 marble; 30 GARL 203
 EOPC
 Samuel Johnson Monument
 1796 WHINN pl 164B ELPa
 Samuel Whitbread Monument
 1799 WHINN pl 127 ECar
 Sickness 1778 GARL 17
 ELRA
 Sir William Blackstone,
 seated figure 1784 marble
 MOLE 257; WHINN pl
 132 EOAllC
 Thomas Egerton 1792 WHINN
 pl 129A ERos
 Thomas Guy Monument 1779
 WHINN pl 126 ELGu
 William Mason Monument,
 relief detail marble MOLS
 2: pl 43 ELWe
 William Pitt, the Elder, Sar-
 cophagus: Prudence, For-
 titude, Britannia, Earth
 and Sea POST-2: 55
 ELWe
BACON, John, the Younger (English
 1777-1859)

 Capt. Bensley Monument 1809
 ESD pl 140 ESurB
 John Moore Monument 1810/
 15 BOASE pl 48B; IRW pl
 85; WHINN pl 162B ELPa
 Third Lady Newdigate Monu-
 ment ESD pl 138 EMiddH
 Tree of Life, monument to
 Charles Parker 1795 ESD
 pl 144 EMiddH
 William Markham, Archbishop
 of York, bust 1813 GUN pl
 1 EWindC
Bacon, Lady
 Stanton, T. Lady June Bacon
 Monument
Bacon, Nicholas (English Church Of-
 ficial 1509-79)
 English--16th c. Nicholas
 Bacon, bust
BACQUE, Daniel L. (French)
 Nude MARY pl 149 FPLu
 Pothon de Xaintrailles, equest
 plaster, for bronze MARY
 pl 139 FAgM
Badges
 English--16th c. Hat Badge
 Flemish--15th c. Badge of
 Confraternity of Young
 Gentlemen
BAENNINGER, Otto Charles (Swiss
 1897-)
 Study of a woman MAI 17
BAERDT, Claes (Dutch)
 Dish 1691 silver; 39.2 cm
 GEL pl 138 NLeF
BRAERZE, Jacques de
 Schnitzaltar, detail 1391 wood
 KIDS 162 FDM
Bagge, Grace d 1834
 Westmacott. Grace Bagge
 Monument
BAGLIONI, Umberto (Italian 1893-)
 Susanna stone VEN-42: pl 35
Bagpipes See Musicians and Musical
 Instruments
Baille, William Hunter
 Chantrey. William Hunter
 Baille, bust
BAILLOU, J. B.
 Louis Quinze mantel-clock,
 elephant support bronze and
 ormolu INTA-1:106
BAILY, Edward Hodges (English
 1788-1867) See also Theed,
 William, the Elder
 Vassall Fox Monument. Kneel-
 ing Negro marble MOLS-2:
 pl 51 ELWe

Viscount Brome, recumbent
effigy 1837 GUN pl 2
ELint
BAINBRIDGE COPNALL See COP-
NALL, Bainbridge
Baines, Thomas
Catterns. Sir Thomas Finch
and Sir Thomas Baines
Monument
Le Baiser
Brancusi. The Kiss
Le Baiser
Rodin. The Kiss
BAJ, Enrico (Italian 1924-)
Modello SR 319 1964 iron
mobile VEN-64:pl 66
Bajor, Gizi
Kisfaludi-Strobl. Mrs. Gizi
Bajor, bust
BAKER, Herbert (English)
Swag, W. G. Grace Memori-
al, Lord's Cricket Ground
AUM 121
Baker, Mr.
Bernini, G. L. Mr. Baker,
bust
BAKER, Robert P. (English 1886-)
Soul Struggle NATS 21
The Baker and His Wife. French--
13th c.
Baker's Boy, and pair of deer with
trees. Staffordshire
BAKIC, Vojin (Yugoslav 1915-)
The Bull 1955 bronze; 59x
98-1/2 MID pl 124 BAM
Deployed Form 1958 plaster
cast LARM 396 ELD
--1961 aluminum; 15-3/4
READCON 258 ELD
Developed Form 1958 plaster,
for bronze; 27-5/8 TRI
166 FPRe
Female Head 1945 bronze;
BIH 150
Forme Luminose 5 1953/63
KULN 162
Head 1956 marble; 14-1/4
GIE 281
Head of a Woman VEN-50:
pl 92
Jovan Jovanovic--Zmaj Monu-
ment, sketch 1953 plaster
BIH 152
Leaf Form No. 1 (Razlistana
Forma 1) 1958/59 plaster;
31-1/2 GIE 247
Marx-Engels Monument,
sketch 1951 plaster BIH
153

Memorial to the Uprising 1947
bronze; BIH 149 IBj
Poet Ivan Goran Kovacic, head
1947 marble BIH 148
Reflecting Forms 5 1963/64
NEW pl 266 YZZS
Relief 1 1960 bronze; 43-1/4
x33-1/2 ARTSY #88
Sculpture IV bronze MAI 18
FPRe
Self-portrait, head 1952
bronze BIH 151 YDG
Torso II 1955 marble VEN-
56: pl 129
Bakirkoy Relief. Byzantine
Balaam on his She-ass. French--
12th c.
Balaam, Queen of Sheba, King Solo-
mon. French--13th c.
Balalaika
Folk Art--Russian. Bass
Balalaika
Balanced Figure. Armitage
Balanced Forms. Adams, R.
Balanced Forms in Gun Metal on
Cornish Granite. Moss
Balanced Sculpture. Chadwick
BALANDIN, P.
Auroch H:54 cm CASS 124
Balbiani, Valentine (Wife of Cancellor
de Brague d 1572)
Pilon. Valentine Balbiani
Monument
Balbiani, Valerie
Pilon. Valerie Balbiani Monu-
ment
Balbina, Saint
Italian--14th c. St. Balbina
Balbo, Paolo
Ruggieri. Paolo Balbo, head
"Bald-Pate"
Donatello. Prophet Habakkuk
The Baldacchino
Bernini, G. L. and Borro-
mini. Cathedra Petri
BALDACCINI, Cesar See CESAR
BALDESSARI, Luciano (Italian
1896-)
Architectural construction for
entrance to the Breda
Works Exhibition 1952 con-
crete; 52'8' BOE pl 206;
GIE 239 IMI
BALDUCCI, Giovanni (Balducci da
Pisa; Giovanni di Balduccio)
(Italian fl 1317-49)
Arca of St. Augustine 1362
POPG fig 75, pl 58; WHITJ
pl 197 IPavP

Arca of St. Peter Martyr 1338
 marble; 102 cm POPG
 fig 74 IME
--Charity POPG pl 57
--Temperance WHITJ pl 150,
 148A
Charity, relief marble; 17-
 3/4x13-7/8 USNKP 387
 UDCN (K-309)
Madonna and Child marble;
 25-1/8 NCM 37 UPPJ
St. Augustine Tomb c1370
 BUSR 8 IPavP
Virgin Annunciate early
 1330's WHITJ pl 147B
 IFCr
BALDUCCI DA PISA See BALDUCCI,
 Giovanni
Ball, Hugo
 Visser. Hugo Ball
Ball Games See Games and Sports
Ball of Twine
 Duchamp. Ready Made: Ball
 of Twine
BALLA, Giacomo (Italian 1871-1958)
 Boccioni's Fist--Lines of
 Force 1915 metal on wood
 base; 80x85 cm LIC pl 225
 IRBa
--1915 wood and cardboard,
 ptd red; 33x31x12-1/2
 READCON 124 UMiDW
Ballerina. Broggini
Ballerina con velo. Cannilla
Ballet Dancer Dressed. Degas
Balloons
 Clodion. Invention of the Bal-
 loon
BALMASEDA, Juan de (Spanish
 c1487-c1550)
 High Altar, Becerril de
 Campos, Palencia 1565
 50-1/2x28-1/2 CIR 80
 (col) SpMalC
 St. Luke c1524/27 KUBS pl
 73B SpLeM
Balme, Edward
 Flaxman. Edward Balme
 Monument
Balsamo, Giuseppe See Cagliastro,
 Count Alessandro di
Balusters See Columns
Balustrade, detail. Hildebrandt
Balzac, Honore de (French novelist
 1799-1859)
 Dantan. Balzac
 Kerenyi. Balzac Medal
 Rodin. Balzac#

Balzac, Jeanne de
 French--16th c. Jeanne de
 Balzac, bust
BALZICO, Alfonso (Italian 1825-1901)
 Duke of Genoa Monument,
 equest 1860/70 bronze
 SELZJ 42 IT
BAMBAIA (real name: Agostino Busti)
 (Italian 1483-1548)
 Alexander and Bucephalus, re-
 lief 1515 marble; 14-1/4x
 16-1/4 VICF 54 ELV
 (7260-1860)
 Charity; Fortitude POPR fig
 126 ELV
 Gaston de Foix tomb--effigy
 marble; 216x84 cm POPR
 pl 119 IMCi
--Man with horse, relief
 detail MACL 189
 Pilaster POPR fig 125 ITMC
BAMBERG MASTER
 St. Maurice as a knight after
 1250 BUSGS 88 GMagK
Bamberg Rider. German--13th c.
Bamberger Reiter
 German--13th c. Bamberg
 Rider
"Bambino"
 Robbia, A. della. Christ in
 Swaddling Clothes
Bambino al Sole. Rosso, M.
Bambino all'Asilo de Poveri. Russo,
 M.
Bambino Ebreo. Rosso, M.
BANDINELLI, Baccio (also called:
 Bartolommeo) (Italian 1493-
 1560)
 Adam and Eve HAUS pl 277;
 MACL 229 IFBar
 Choir: Two Prophets H:96.5
 cm, inside moulding POPRB
 fig 87 IFCO
 Cleopatra boxwood INTA-1:99
 Dead Christ with Nicodemus
 marble POPRB pl 65
 IFAnn
 Female figure 16th c. marble
 GLA pl 37
 Giovanni Dalle Bande Nere
 POPRB fig 120 IFLor
 Hercules POPRB fig 129
 IFBar
 Hercules and Cacus marble
 BAZINW 361 (col); ENC 61;
 POPRB pl 64
 Leo X Monument POPRB fig
 65 IRMM

St. Peter POPRB fig 41 IFOp
Self Portrait, profile relief ter-
 racotta GOLDF pl 113 GBK
Udienza POPRB fig 86 IFV
BANDINELLI, Giovanni (known as:
 Giovanni dell'Opera) (Italian
 1540-99)
 Cosimo I de' Medici, bust
 marble; 91 cm POPRB pl
 68 IFMN
BANDINI, Giovanni (Italian 1540-99)
 Architecture, model c1564
 terracotta; 13
 ASHS pl 24; VICF 65 ELV
 (4121-1854)
 Juno POPRB fig 134 IFV
 Michelangelo Monument:
 Architecture POPRB fig 67
 IFCr
BANDINI, Giovanni, and Pietro TAC-
 CA
 Ferdinand I; details by Tacca:
 Slave; Ferdinand I de'
 Medici bronze POPRB fig
 60, pl 96, 97 ILeghD
BANDURA, Jerzy (Polish 1915-)
 Crawl 1948 patined plaster
 JAR pl 21
Banel, Pierre
 Bartolini. Banel, bust
BANG, Arne (Danish)
 A bowl AUM 95
 The "Tycho Brahe" Vase AUM
 95
 Vase, with rim figure AUM
 95
Banks, Joseph (English Naturalist
 1743-1820)
 Chantrey. Joseph Banks, bust
BANKS, Thomas (English 1735-1805)
 Capt. Richard Burgess Monu-
 ment 1802 marble BOASE
 pl 48A; GARL 206; IRW
 pl 83; WHINN pl 140, 142
 ELPa
 Capt. Westcott Monument
 1802/05 WHINN pl 160A
 ELPa
 Death of Germanicus 1774
 marble IRW pl 58; MOLS-
 2: pl 44; WHINN pl 136
 EHo
 Falling Titan 1786 marble; 33
 BUSB 208; CON-4: pl 32
 IRW pl 62; MOLS-2: pl 45
 ELRA
 Martha Hand Monument 1785
 (Destroyed) WHINN pl
 143A ELStG

Mrs. Petrie Monument, attend-
 ed by Faith, Hope, and
 Charity 1795 ESD pl 35;
 IRW pl 63; WHINN pl 141B
 ELewCh
Penelope Boothby Monument
 1793 ENC 62; IRW pl 157;
 WHINN pl 141A EAs
Sir Clifton Wintringham Memori-
 al 1794 GUN pl 3 ELWe
Thetis and her Nymphs Consol-
 ing Achilles, oval relief
 1778 marble; 36x46-3/4x
 3-3/8 BRIONR pl 33; IRW
 pl 59; WHINN pl 137 ELV
Thetis dipping the Infant
 Achilles in the River Styx
 c1788 WHINN pl 138 ELV
Warren Hastings, bust 1794
 GARL 18 ELNP
--1799 WHINN pl 139A ELCom
Banlieu des Anges. Kemeny
BANNINGER, Otto Charles (Swiss
 1897-)
 Dr. Oskar Reinhart, head
 1946 bronze JOR-1: pl 25
 SwWR
 Girl VEN-42: pl 107
 Kaurende mit Draperie 1950
 cristallina-marmor JOR-1:
 pl 24
Bannister. Majorelle
Banting, Frederick
 Loring. Sir Frederick Banting,
 head
Baptism See also Jesus Christ--
 Baptism
 Andrieu. Medal: Baptism of
 King of Rome
 Enseling. Baptism
 French--11th c. Baptismal
 Font: Sinners saved by Bap-
 tism
 Lombardo, T. Mocenigo Monu-
 ment: St. Mark Baptizing
 Mazza. St. Dominic Baptizing
 Pisano, A. Baptistry south
 door
 Reiner von Huy. Baptismal
 Font
 Vigarny de Borgona. Royal
 Chapel Altar: Baptism of
 the Moors
Baptismal Fonts See Fonts
Baptistries
 Italian--13th c. St. John Story
 Mohammed Ibn el-Zain. Bap-
 tistry of St. Louis

Bar-Tracery See Window Tracery
BARA, Hadi (Turkish 1906-)
 Escultura iron SAO-6
 Sculpture 1954 welded iron
 VEN-56: 87
Baracca, Francesco
 Rambelli Monument to Fran-
 cesco Baracca
Baratinsky, Princess
 Troubetzkoy. Princess Bara-
 tinsky
En Barbar. Bonneson
Barbara, Saint
 Brokoff, F. M. St. Barbara,
 St. Margaret, and St.
 Elizabeth
 Burgundian--15th c. St.
 Barbara
 Colombe. Francis II of Brit-
 tany Tomb
 English--15th c. St. Barbara
 English--16th c. Henry VII
 Chapel
 Franco-Portuguese. St.
 Barbara
 French--15th c. St. Barbara
 French--15th c. St. Barbara
 and the Tower
 French--16th c. St. Barbara#
 Gerhaert--Attrib. St. Barbara,
 bust
 German--15th c. St. Barbara
 German--16th c. Folding
 Altar with Virgin and
 Saints: St. Barbara
 Gerthner. "Memorienpforte":
 St. Barbara
 Riemenschneider. St. Barbara
Barbara. Arnold
Barbarigo, Agostino
 Giambello--Foll Medal:
 Agostino Barbarigo
Barbe au Menton. Dubuffet
Barbel von Ottenheim
 Gerhaerts. Barbel von Otten-
 heim
Barberini, Anna Colonna 1601-1658
 Italian--17th c. Princess
 Anna Colonna Barberini,
 bust
Barberini, Francesco
 Bernini, G. L. Francesco
 Barberini, bust
Barberini Diptych
 Byzantine. Barberini Ivory
Barberini Ivory. Byzantine
BARBET, Jean (Jehan Barbet) fl
 1475-1514

 Angel, Chateau de Lude 1475
 bronze CHAN 171; MULS
 pl 145C UNNF
Barbey d'Aurevilly, Jules)
 (French Writer 1808-89)
 Sicard. Barbey Monument
BARBIERE, Domenico del See FIOR-
 ENTINO, Domenico
Barbutes See Armor--Helmets
Barca. Pascoli
Barcelos, Count
 Portuguese--14th c. Count
 Barcelos Tomb
Barcsay, Akos
 Hungarian--17th c. Akos Barc-
 say, medal
The Bard. Theed, the Younger
BARDI, Donato di Nicolo di Betto
 Bardi See DONATELLO
BARDOU, Emanuel (German fl 1744-
 98)
 Immanuel Kant, bust 1798
 marble; 46 cm BSC pl 144
 GBS (8321)
Bardsley, Betty
 Miller, A. Betty Bardsley,
 bust
Barere de Vienzac, Bertrand (French
 Revolutionist 1755-1841)
 Ceracchi. Barere, bust
Bargello Tondo
 Michelangelo. Madonna and
 Child with Young St. John
 the Baptist
Bari Throne
 Italian--12th c. Throne of
 Archbishop Elias
Barilli, Bruno
 Ruggeri. Bruno Barilli, head
BARISANUS OF TRANI (Apulian)
 Door Panels: Nicholas Pere-
 grinus Descent from the
 Cross; Lion's Head Door
 Handle; St. Eustace,
 Archer; Tree of Life c 1180
 bronze on wood BUSRO pl
 126 ITranC
 Panteleone Cathedral Doors:
 Panel reliefs 1179 bronze
 IRavP
 Pellegrino Cathedral Doors
 1175/79 bronze DECR
 pl 189 IBaP
Barker, William and Olivia
 Westmacott. William and
 Olivia Barker Monument
Barkham, Sir Robert and Lady
 Marshall, E. Sir Robert and

Lady Barkham Monument
BARLACH, Ernst (German 1870-
1938)
The Ascetic 1925 wood; 70x
 32x32 cm LIC pl 208 GHR
The Avenger (Der Racher)
 PRAEG 457
--RICJ pl 27-UBe
--wood VALE 59 UCtSS
--1914 bronze; L: 22-3/4
 BMAF 47; TOW 109
 UNBuA
--1914 bronze; 44x22x58 cm
 OST 39 GCoW
--1922 wood; 24 NNMMAG
 151 UNNSh
--1923 bronze GERT 116
--LARM 269 GHBar
--1923 bronze; L 23-1/4
 DETS 29 UNNH
--1923 bronze; 17 BOSME pl
 82; YAP 238 UCtGB
--1923 bronze; 23-1/4x7-
 1/2 SELZS 79 UNHG
--1923 wood RAMT pl 40
 UNNBu
The Beggar (Der Bettler)
 1919 wood; c 32 MCCUR
 255
The Beggar (Der Bettler;
 Crippled Beggar) 1930
 wood OST 4; ENC 64;
 MYBG fig 66 GLuC
--cast of niche figure, Church
 of St. Catherine, Lubeck
 1930 vitreous clay; 82
 FAIN 108; KUHNG pl 106,
 107; MU 250 UMCB (1931.
 5)
Beggarwoman 1907 bronze;
 9 NNMMAG 147 GHR
Der Berserke 1910 wood; 68
 cm HENT 11
Cleopatra 1904 ceramic; 9
 SELZPN 82 GBReu
--1904 ceramic; 23x67x25 cm
 LIC pl 207 GHR
The Dancer (Der Tanzer),
 relief 1923 wood; 93 cm
 OST 43 GHaL
Death 1925 bronze MAI 18
The Deserted, relief 1913
 wood; 52x52-3/8 BERL
 pl 248; BERLES pl 248
 GBSBe (B 418)
The Ecstatic One 1916 wood;
 20-1/2 BAZINW 428 (col)
 SwZK

Ecstatic Woman MYBA 661
The Fighter of the Spirit (Der
 Geistkampier; Kiel Memori-
 al), memorial for fallen
 students of Kiel University
 1928 bronze; 18 HENT 4:
 NNMMAG 153; RICH 177
 GKU
Figur vom "Fries der Lauschen-
 den" 1931 H:1.10 m HENT
 16
Freezing Girl (Frierendes Mad-
 chen) 1917 wood; 74x21 cm
 MYBU 149; OST 40 GHR
Frozen Old Woman 1937 teak;
 24 KO pl 101 GGuC
Fugitive wood CASS 112
"Have Pity!" 1919 wood GOMB
 430 UNNA
The Hermit 1911 wood VEN-
 50: pl 86
Hovering Angel (Angel of
 Death; Gustrow Memorial;
 Schwebender Engel),
 memorial to World War II
 dead 1927 bronze; 68x96
 NNMMAG 155 GGuC
--replica GARDH 753; GERT
 115; KO pl 101; MCCUR
 255; NEWTEM pl 162;
 NNMMAG 151 GCoA
--head detail bronze; L: 2.10
 m OST 45, 44
--head detail 1927 bronze;
 13-1/2 JOH 27; NNMMM 58;
 VALE 159 UNNMMA
--head detail 1927 bronze;
 14-1/2 CHICP-1: pl 95;
 NMG #93; NNMMARO pl
 273; UNNMMAM #159
 UNNWarb
Justus Brinckmann, memorial
 plaque 1902 bronze; 6-3/8x
 9-1/2 SCHMU pl 326 GMKG
Lesender Mann in Wind 1936
 bronze; 45.5 cm OST 46
 GHaL
Liegender Bauer 1908 Stein-
 zeug; 19 cm OST 38 GHaL
Luise Dumont Monument
 (Grabmal für Luise Dumont)
 1932 stone; 1.44 m HENT 15
Man Alone 1911 wood 34-5/8
 TRI 55 GH
Man Drawing a Sword wood
 PUT 319
--1911 wood SFGC 9 UNNBu
--CANM 429; CHENSW 11;
--1911 wood; 29-1/2

JANSH 510; JANSK 1015;
LOWR 85, 136; NNMMAP
127; RIT 92; UPJH pl
241; ZOR 214 UMiBC
Man in Cloak (Man in the
 Mantle)
 wood PAR-2: 60
Man in the stocks 1918 wood;
 18-3/4 NNMMAG 149 GH
--1920 wood; 26-1/2 RIT
 93 UNNV
Monks reading bronze; 23-
 1/2 CHICS; ROOS 278B
 UICA
--Lesende Monche 1933
 wood; 84 cm HENT 18
 GBN
Moses 1919 wood; 74 MARY
 pl 179; RAMS pl 62A
Niche Figures 1930-32 stone;
 1 figure: 207x55x44 cm
 LIC pl 209 GLuC
Old Woman with a Stick
 wood CHENSP 62; CHENSW
 486 GBC
Panel CHENSP 307 GBN
Panic-stricken 1912 wood
 RAMT pl 39 ELCa
Peasant Girl oak ROODW 86
Peasant woman 1945 ENC
 64 GLuC
Prodigal (Der Verschwender),
 relief 1923 wood; 93 cm
 OST 42 GHaL
The Procuress (Kupplerin)
 1931 bronze GERT 117
Reclining nude I 1907
 bronze; 13-1/2 CANM
 405 UMdBM
The Reunion (Meeting Again;
 Das Wiedersehen) 1926
 wood; 40 HENT 13; OST
 41; SCHAEF pl 6 GHR
Revenge 1928 wood; 24-1/2
 GROSS fig 41; ROODW 82
Russian Beggar-woman with
 Cup 1906/07 ceramic; 6
 CAS pl 188; RAMS pl
 62b GHR
Seated Girl 1908 Schwarz-
 burg porcelain; 9-3/8
 KUHNG pl 105 UMCB
 (1960. 5)
Shivering Woman c1937
 bronze; 10 JLAT
 UAzTeUAm
Singende Klosterschuler,
 facade figure 1932 ceramic;
 2 m HENT 17; OST 4 GLuC

Singing Boy 1928 bronze FAIN
 43 UCtN1A
Singing Man (Singender Mann),
 cast #1 SEYT 41 UDCK
--1928 bronze NMG #94 GBF1
--1928 bronze; 19-1/4 NEWTEM
 pl 159 GCoW
--1928 bronze; 19-1/2
 NNMMARO pl 272 UNNBu
--1928 bronze; 19-1/2 JOH
 17; NNMMAG 152; ROOS
 277 C UNNMMA
--1928 bronze; 50x46x42 cm
 SP 9 GHaS
--1928/30 bronze; 19-1/2
 SOTH-4: 73
--1928/30 cast zinc (several
 casts); 20 KO pl 101 GHK
Sleeping Tramps wood MARY
 pl 176
The Solitary One 1911 oak,
 after plaster model; 23-
 1/4 HAMP pl 61B GHK
Sorrowing Woman (Sorgende
 Frau) 1909 wood; 26 HENT
 6; ROBB 403; NNMMAG 148
Striding Woman 1910 glazed
 porcelain; 9-1/2 NEWA
 66 UNjNewM
The Vandal 1910 bronze; 54.7
 m CAS pl 187 GHR
Veiled Beggar Woman 1919
 wood READCON 27 UNNA
Woman in the Wind (Die Frau
 im Wind), facade figure
 1932 glazed ceramic;
 78-3/4 NNMMAG 154; OST 4
Village Fiddler wood; 24-3/4
 BMAF 45 UNNArn
Woman with Folded Arms 1922
 wood; 39-1/2 BOSME pl
 81; JLAT 9 UNbLU
Young Woman Meditating 1934
 wood; 40 SCHAEF pl 7
Barlee, Haynes
 Marshall, E. and J. Monu-
 ments to Wives of Haynes
 Barlee
Barley Fork. Chadwick
Barlow, Joel 1754-1812
 Houdon. Joel Barlow
Barnebuste. Dalou
Barnehoved
 Dalou. Barnebuste
BARONCELLI, Niccolo (Italian
 c1395-1453), and DOMENICO
 DE PARIS
 St. George POPR fig 129 IF
 St. Maurelio c1450 bronze

SEY pl 61a IFeG
BARONI, Eugenio (Italian)
Monument to the Infantry,
Station 4: Bread plaster
VEN-28: pl 76
--Station 6: The Mutilated
VEN-26: pl 132
--Victory VEN-32: pl 27
National War Memorial for
Italy (projected but not
executed): A Mother's
Blessing AUM 37, 38-9
Oar (Il Remo) VEN-34: pl 91
BAROQUE
Church Portal 17th c. STI
783 PeA
Grotesque, fountain detail
c1600 STI 655 IFBo
Pulpit of Truth STI 657 BBC
Torch Holder: Two Putti
INTA-1:97
--Germany
Pulpit, Pilgrim Church of
Wies, Upper Bavaria
1745/54 BAZINH 324
GWP
Roll-moulding, architectural
decoration, staircase
PRAEG 375 ASM
--Portugal
"Solomon" Type Column,
detail, Main Reredos
c1705 BAZINH PoOB
BAROQUE-ROCOCO
Entrance of northwest wing,
Zwinger Palace SEW 804
GDZ
BAROVIER, Filli
Primavera Piccione di Petro
VEN-30: pl 191
BARRAL, Emiliano (Spanish)
Bust of a woman VEN-32: pl
123
Head terracotta CASS 44
Rosita Diaz, head bronze
CASS 44
BARRIAS, Luis Ernest (French
1841-1905)
Augier Monument, detail
TAFTM 34
Nature Unveiling Herself
white veined marble
MARY pl 171 FPLu
--1899 marble and onyx
SELZJ 79 FPCon
Victor Hugo Monument
TAFTM 31

The Barrier. Pomodoro, G.
Barrier No. 1. Adams, R.
BARROIS, Francois (French 1651-
1726)
Cleopatra LOUM 184 FPL
(905)
Barrow, Isaac d1677
English--17th c. Dr. Isaac
Barrow, bust
Barry, Sir Charles (English Archi-
tect 1795-1860)
Philip. Albert Memorial:
Pugin, Scott, Cockerell,
and Barry
BARTH, Georg (German)
Arabian and Egyptian Water-
Carriers TAFTM 52
BARTHOLDI, Frederic Auguste
(Italian-French 1834-1904)
Lafayette and Washington
1900 bronze SALT 104
UNNLaf
Lion of Belfort NATSE
FPDen
--1875/80 red sandstone;
11x22 m LIC pl 101 FBelfC
Marquis de LaFayette 1876
bronze SALT 32 UNNU
Statue of Liberty (Liberty En-
lightening the World) 1884
hammered copper sheets
and stone pedestal; 152.
Figure to top of torch:
46.43 m; pedestal: 25.7
m; base: 20.24 m
BARSTOW 195; LONG 133,
129 (col); LIC pl 102; SIN
350 UNNLI
--distant view, October 28,
1886 ADAM-3: 386; ADAM-
5: 290
--Statue of Liberty (Liberty En-
lightening the World) GAF
115 FP
BARTHOLME, Paul Albert (French
1848-1928)
Mme Bartholome Tomb 1887
LIC pl 158 FCreB
Monument to the Dead (Monu-
ment aux Morts) 1899 lime-
stone CHASEH 454; LIC pl
157; POST 2: 160; TAFTM
40 FPLa
Woman Combing her Hair* cast
bronze VEN-7: pl 35
Bartholomew, Saint
Flemish--15th c. Apostles:

St. Matthew, St. Andrew,
St. Bartholomew
German--12th c. St. Bartholo-
mew, and St. Peter
--Shrine of Anno, details
Lagneau. Martyrdom of St.
Bartholomew
Michelozzo. S. Bartholomew
Portuguese--14th c. St.
Bartholomew
BARTOLI (Italian)
Lincoln, seated figure 1926
BUL 179 UPrS
BARTOLI, Pietro Santi (Italian c
1635-1700)
A Roman Marriage, relief--
from Bellori's Admiranda
Romanorum Antiquitatum
1693 WHINN pl 58B IRSac
BARTOLINI, Lorenzo (Italian 1777-
1850)
Banel, bust plaster HUBE
pl 28 FV
Charity RAD 451 IFP
Charlotte Bonaparte, bust
1840 marble HUBE pl 31
FRuM
Demidov Monument, detail
marble HUBE pl 33 IFLu
Empress Marie-Louise, bust
--after Bosio 1899 HUBE
pl 43 FPCF
Fargues, bust marble HUBE
pl 27 FPSe
Ingres, medallion 1806
bronze HUBE pl 26 FPE
Napoleon, colossal head
bronze HUBE pl 32
FRuB
Nymphe au Scorpion 1845
plaster JUBE pl 37 IF
Pauline Borghese, bust
marble HUBE pl 30
Princess Czartoryski of War-
saw
Monument; effigy detail
1837/44 LIC pl 49, 48
IFCr
Trust in God (La Fiducia in
Dio) 1835 marble; 95x60
cm HUBE pl 35; LIC pl
45, 46 IMP
The Wine-presser c1842/44
marble; 135 cm LIC pl 47
IFBu
BARTOLOMMEO DA FOGGIA (Itali-
an) See also Nicolo da Foggia

Cornice Facade, detail 13th c.
DECR pl 198 IFogM
BARTOLOMMEO See BANDINELLI,
Baccio
BARTTADI LEOPOLDO
(Italian)
Sculptures and Ornament of
Pantheon of the Infantes
ESC 65 SpE
BARWIG, Franz (Austrian)
Peasants Dancing oak PAR-
2: 90
BARYE, Antoine Louis (French 1796-
1875)
Ape riding a gnu c1847 bronze
ROTHS 219 FPL
Bull Attacked by Tiger bronze;
19x22 cm LIC pl 72 FPL
Candelabra c1858 bronze
LARM 207 -Fab
La Force 1854 plaster LOUM
XXVII FPL
Fortitude Protecting Labour
1859 plaster; 25 cm LIC
pl 71 FPL
General Napoleon Bonaparte
1847 bronze; 36 cm COPGM
73 DCM (I.N.1581)
A Horse LAC 17
Hound and Turtle DAIN 87
Indian Mounted on an Elephant
Killing a Tiger BRIO 43;
ENC 68; LARM 45
Jaguar Devouring Hare 1850/51
bronze; 16-1/2x37-1/2
CHASEH 439; JAL-5: pl 19;
JANSH 488; JANSK 919;
LAC 210; LIC pl 73;
MCCUR 245; PACH pl 21;
POST-2: 132; UPJ 491 FPL
Jaguar Devouring a Crocodile
c1850/55 bronze; 3-1/4x
9-1/2 BRIO 42; LYN 38;
NOV pl 188e DCN
Kaempende bjorne (Kampmel-
lem nordamerikansk og
indisk bjorn) 1833 bronze;
22 cm COPGM 69 DCN
(I.N.1469)
Lapith and Centaur 1850
bronze CASSM 47; GAF 141;
LARM 19 FPL
Leopard with Prey bronze; L:
c 36 FAIN 236 UVtOB
Lion, seated stone CHENSW 465
FPCol
Lion and Serpent 1832/35

bronze GAUN pl 49;
MARQ 259; UPJH pl 201
FPTu
Lion Vanquishing an Ibex
bronze SELZJ 52 FMaM
Lobende Afrikansk Elefant
1855 bronze; 16x19 cm
COPGM 75 DCN (I.N.1544)
Mounted Arabs Killing a Lion
bronze ROTHS 219 UNNMM
Napoleon, equest as Roman
Emperor 1856 bronze; 135
cm LIC pl 74 FPL
Napoleon Monument, equest,
study 1863 bronze SELZJ
51 FPPP
Nude Woman plaster and wax;
8-1/2 CHAR-2:311 FPL
Panther Seizing Stag RAY 55
UNBB
--bronze; 15x22 COR 116
UDCC (732)
Python killing an Antelope
bronze FAIY 193 UNEE
Sengalese Elephant
WB-17:202 UNNMM
Theseus Fighting the Centaur
Bianor (Lapith and Cen-
taur; Theseus and Cen-
taur) bronze BR pl 13;
PACH pl 19; RAY 80
UNNMM
--1850 bronze SELZJ 52
FLePM
Theseus Slaying the Minotaur
AGARC 126 UMdBW
--CRAVR 192 UNBB
--1848 ROOS 201D UNNMM
--1848 bronze; 47 cm CASSM
46
--1849/52 bronze; 18-1/2 cm
BAZINW 421 (col); BR
pl 13; LIC pl 170 FPL
Three Graces PACH pl 20
UNNMM
Tiger, detail c1830 wax;
L: 12-1/2 CHAR-2:296
FPL
Tiger Devouring a Gavial
1831 bronze; 7-5/8x20
FLEM 665 UNNMM
Tigre devorant une Gazelle
bronze; 12-3/4x23 SCON
5 ScEN (No. 1626)
Walking Lion BARSTOW 189
--bronze; 8-3/4 CAN-2:186
CON

Walking Tiger (Tiger Walking)
ROOS 201E FPL
--1836 bronze; 8-1/2 CAN-2:
186 CON
Young Nude Woman 1846 plaster
and wax; 21 cm LIC pl 75
FPL
Bas Relief en Cruz
Pevsner. Bas-Relief in Depth
Bas-Relief Variation. Cesar
BASALDELLA, Dino (Italian 1909-)
Homage 1963 steel VEN-64: pl
31 ITrMCR
Number 3 1960 H:39.4 CARNI-
61:#22 UNNVi
Repetizione Nuziale 1963 steel
VEN-64: pl 30
Bascinet See Armor--Helmets
Bascule, No. 10. Tinguely
Bashkirtsheff, Marie
Saint-Marceaux. Marie
Bashkirtsheff, bust
Basic. Kosso
Basic Dynamic Organization. Preston,
P. A.
BASILE, Ernesto (Italian)
Door detail VEN-5: pl 96
The Basilewsky Situla. Italian--10th
c.
Basilicas
Nicholas of Verdun. Shrine of
the Three Kings, basilica-
form
Basilisks
Danish--14th c. Top Handle:
Basilisk
French--13th c. Le Beau
Dieu (Amiens)
Basilius (Roman Consul)
Early Christian. Consul
Basilius, Rome, diptych
panel
Basins
Cardelli, L. Basin on Base
Santi. Basin and Amphora
Basket Capital. Byzantine
Basle Antependium. German--11th c.
BASQUE
Funerary Stele: Cross and
Solar Symbols 1646 stone
BAZINW 234 (col) FPH
Basques
Swiecinski. Young Basque
Woman
Bassianus. Saint
Italian--9/10th c. St.
Bassianus

Bassin de Neptune, Versaille Gardens
Adam, L. S. Neptune and
Amphitrite
Lemoyne, J. B. The Ocean
Bassius, Junius (Roman Prefect
d 359)
Early Christian. Sarcopha-
gus of Junius Bassius
Basso della Rovere, Girolamo
Sansovino, A. Girolamo
Bassaldella Rovere Monu-
ment
BASTERRECHEA, Nestor (Spanish
1924-)
Escultura* iron SAO-6
Bastien-Lepage, Jules (French
Painter 1848-84)
Rodin. Bastien-Lepage
Bastille
French--18th c. Stove:
Bastille
Bat-Man. Richier, G.
BAT-YOSEF, Myriam (German-
French 1931-)
Le Telephone des Sourds
1964 ptd object; 6-1/4
x8-5/8 NEW pl 65
BATES, Harry (English 1850(?)-
99)
Classical relief GLA pl 14
Pandora BROWF-3:78
BATES, Trevor (English 1921-)
Bird bronze BED 112
Two Birds bronze BED 112
Bathers
Cantre. Bather
Clara. Woman Bathing
Crocetti. Bather
Dalou. Bather
Degas, E. 17 bronze casts
of waxes
Dinlinger. Bath of Diana
Drivier. Bather
Falconet. Baigneuse
Falconet. Bather#
Falconet. Bathing Girl
Falconet--Foll. Bather
Fiori. Bagnante
Flemish--16th c. Bathing
Girl
Folkard, R. C. H. Boy Bath-
ing
Gimond. Baigneuse
Greco, E. Bather
Greco, E. Bathing Woman
Grzetic. Bather
Gsell-Heer. Badende
Gunzbourg. Boy Bather

Hartwell. Bathers
Henry. Bathing Man
Houdon. Bather
Hubacher. Bather
Ipousteguy. Woman in Bath
Jerichau. Badende Piger
Jespers, O. Bather
Kisfaludi-Strobl. Bather
Klimsch. Bather
Laurens. Baigneuse, half-fig-
ure
Laurens. Bathing Girl
Lawlor. The Bather
Leeuw. Les Baigneurs de
Baden-Baden
Lehmbruck. Bather
Maillol. Bather with Drapery
Mariani. The Bather
Marini. Bather
Martinuzzi. Bather
Mikus. Bathing Woman
Orloff. Bather
Perez Mateo. Bather
Picasso. Baigneuse Jouant
Picasso. The Bathers
Picasso. Bathing Woman
Poisson. Bather
Puvrez. Bather
Rodin. The Bather
Scharff. Badende
Toft. The Bather
Traverse. Baigneuse#
BATHORY, Andras (Hungarian)
Madonna and Child, relief
1526 stone; 68x51 cm GAD
34 HBA
Bathory, Zsigmond (Prince of Tran-
sylvania 1572-1613)
Hungarian--16th c. Zsigmond
Bathory, medal
Bathsheba
Milicz. Religious medal:
David and Bathsheba
BATIC, Stojan (Yugoslav 1925-)
Composition 1953 bronze BIH
170 KLV
In the Elevator 1960 bronze;
18-1/8 ARTSY #92
Bats
Richier, G. Bat
Richier, G. The Great Bat
The Batsman. Rossi, H.
BATTEN, Mark (Scottish-English)
Allegorical Head BATT 89
Diogenist 1959 Hoptonwood
stone; 41x51x30 BATT
front, 65; LOND-5:#4
Founder, Trinity College BATT
15 EOT

Singing Negress 1938 BATT 55
Sir Douglas Veale, head BATT
57 EOB
Sir Edmund Craster, head BATT
53 EOB
Victor, bust Hoptonwood stone
BATT 96
Battersea Group. Clarke
"Battle of the Nations" Monument.
Metzner
Battles See War and Battles
Baudelaire, Charles (French Poet
1821-67)
Duchamp-Villon. Charles
Baudelaire, death mask
Duchamp-Villon. Charles
Baudelaire, head
Rodin. Baudelaire, head
Baudime, Saint
French--12th c. St. Baudime,
reliquary bust
BAUDRENGHIEN, Joseph (Belgian)
Mausoleum, detail bronzed
plaster VEN-20: 103
Baudry, Paul Jacques Aime (French
Painter 1828-86)
Mercie. Baudry Monument
Bauer, Hermann
Bistolfi. Resurrection, Her-
mann Bauer Monument
BAUERMEISTER, Mary (German 1934-)
No Faces, detail 1964 mixed
media with lenses; 28x28
ALBK UNNBoni
BAUGUT, Franz
Plague Column 1713/15
STECH 43 CzKu
BAUM, Otto (German 1900-)
Bull (Stier) 1951 iron; 8
GERT 250; SCHAEF pl 60
Dr. M. Breuninger, head
1947 bronze; 24 SCHAEF
pl 58
Elephant Monument 1949
cement; 76 SCHAEF pl 59
Metamorphosis 1948/49 lime-
stone; 39-3/8 NNMMAG
176
Salutation 1956 bronze MAI
19
BAUMBACH, Max (German)
Dancing Figures WOR 172
BAUMGARTEN, W. See
HOFBAUER, J.
BAUTISTA CREZENCI, Juan
(Spanish)
Pantheon of Kings (Panteon
de los Reos) 17th c.
SMIBS 194-5 (col) SpE

BAVARIAN
Angel Head ptd lindenwood;
8-1/2x8 KUHN pl 76 UMCB
(1934.138)
--15th c.
Burial of Mary ptd wood;
20-1/2x34-1/2 DEY 105;
DEYE 52 UCSFDeY (48.9)
--16th c.
St. George and the Dragon ptd
wood; 48 DENV 42 UCoDA
(E-887)
--18th c.
God the Father Enthroned on
a Cloud ptd wood; 66-1/2
BOSMI 136 UMB (60.1455)
Pair of Hovering Angels
c1750/60 ptd lindenwood;
25-1/2x24-1/2 KUHN pl
76 UMCB (1964.19; 1964.
20)
BAVEAU (French)
Jacques Cartier 1905 bronze
GAF 242 FStMal
Baviera, Eugenio di
Baviera-Savoia. Eugenie
di Baviera, head
BAVIERA-SAVOIA, Bona di (Italian)
Eugenio di Baviera, head
VEN-38: pl 94
Bavo, Saint
Netherlandish. St. Bavo
Bayard, Seigneur de (French Hero
1473?-1524)
Raggi, N. B. Bayard
BAYES, Gilbert (English 1872-)
At the Crest of the Hill
TAFTM 77
Decorative Panels: Concrete
Utilities Bureau, British
Empire Exhibition AUM
132
The Fountain of the Valkyries
bronze, marble mosaic
MARY pl 170 NzA
Frieze artificial stone AUM
144; BROWF-3: 91; MARY
pl 167 ELSav
The Frog Princess figure:
bronze; base: salt-glaze
ware MARY pl 102 UCStb
Great Pan stone MARY pl 148
UCtG
Italian Wine Cart wood AUM
132
A Knight on his Warhorse
colored plaster MARY pl
67; TAFTM 77
Lure of the Pipes of Pan,

relief stone AGARC 153;
CASS 80 EB
Panel cement MARY pl 165
EWemE
Selfridge Clock BROWF-3:
92
Sigurd, equest bronze,
enamel, marble MARY pl
107 ELN
Unfolding of Spring marble
MARY pl 149; PAR-1: 56
BAYRISCHER MEISTER
St. George 1520 lindenwood;
154. 5 cm BERLEK front
GBSBe (3066)
BAYSER-GRATRY, Mme de
Gazelle CASS 125
Be in Love and You Will be Happy.
Gauguin
Beacon of the Dead. Adam, L. H.
The Beak. Martin, E.
Beakers
Brechtel. Beaker
Dutch--17th c. Nautilus
Beaker
Beam. Chillada
Bears
Biduinus. Architrave Reliefs:
Animal Procession;
gryphons attacking bear
Durst. Bear Cub
Durst. Ursus Major
English--16th c. Boss:
Roof Boss
Folk Art--Russian. Bear
Driving Troika Sleigh
Folk Art--Swiss. Butter
Mold: Bear, with flowers
Fremiet. Pan and the Bears
Fremiet. Young Pan and Cub
German--2nd c. She-Bear of
Aachen
Lemar. Bear
Luck, P. Bear
Mantynen. Bear on an Ant-
hill
Moiturier. Philippe Pot Tomb
Pauschinger. Bear, garden
figure
Pompon. Brown Bear
Pompon. Polar Bear
Pompon. Two Bears#
Tuotilo. Ivory book cover,
showing... Legend of St.
Gall
Viking. Bear; Bird
Westmacott. A Dream of
Horace

Beast No. 1. Chadwick
Beatitudes
German--12th c. Beatitude(s)#
--Chalice: Beatitudes
Beatrice, medallion. Apolloni
Beatrice. Messina
Beatrice (2nd Daughter of
Ferdinand of Aragon)
Laurana. Beatrice of
Aragon, bust
Le Beau Dieu# French--13th c.
Le Beau Dieu
French--12th c. Royal Portal
Beau Dieu Noir. French--
12th c.
Beauchamp, Richard, Earl of
Warwick 1382-1439
Austen, William, of London.
Richard Beauchamp tomb
Beauchamp, Thomas, Earl of
Warwick
English--14th c. Thomas,
Earl of Warwick, and his
wife
BEAUDIN, Andre (French 1895-)
Paul Eluard, bust 1947
bronze; 17 BERCK 235
FPLe
Three Profiles 1931 bronze
MAI 20
Beaufort, 1st Duke of Beaufort d 1700
Gibbons. 1st Duke of Beaufort
Tomb
Beaufort Chantry. English--15th c.
BEAUGRAND, Guyot de (Flemish)
Fireplace, after design of Lance-
lot Blondeel, Council Room
1529 wood ROOSE 150 BBrSt
BEAUGRAND, Guyot de, and Herman
GLOSENKAMP
Fireplace, with statue of Charles
V, Council Chambers wood
POST-1:246 BBrJ
Beauharnais, Hortense de (Queen of
Holland 1783-1837)
Bosio. Queen Hortense,
bust#
Beauharnais, Josephine de (Empress
of the French 1763-1814)
Bosio. Empress Josephine,
bust#
BEAUNEVEU, Andre (Netherlandish
fl 1360-1403)
Apostle, head, Sainte
Chapelle after 1392 MULS
pl 23A FBouM
Presentation in the Temple
c1390/1400 alabaster MULS
pl 21B FPC1

BEAUNEVEU, Charles
Charles V tomb 14th c. BR
pl 1 FPDe
Beautiful Madonna
German--15th c. Beautiful
Madonna
German--16th c. Beautiful
Madonna
Master of the Beautiful Ma-
donnas--Foll. Beautiful
Madonna
The Beauty of Death
Bistolfi. Sebastiano Grandis
tomb
BEAUVALLET (French)
Susanna Bathing marble
HUBE pl 24 FPL
BECCAFUMI, Domenico (Sienese
c1486-1551)
Angel c1515 MONT 28 ISC
BECERRA, Gaspar (Spanish c
1520-70)
High Altar 1558/62 52x40'
CIR 81 (col); KUBS 76B
SpAsC
St. Jerome ptd wood; 1/3
LS CHASEH 368; TAT
sc pl 11; WES pl 19
SpBCo
BECHTELLER, Theo (German
1903-)
Night Plant 1957 bronze;
15-3/4x10-5/8x3-1/2
TRI 163
BECK, Andras (Hungarian 1911-)
Arladar Schofflin, medal
1942 bronze; Dm: 6.5
cm GAD 129
Attila Jozsef Memorial
1952 bronze; 270 cm
GAD 104 HBJ
BECK, Fulop O. (Hungarian 1873-
1945)
Budapest Music School
Medal 1925 bronze; Dm:
7.3 cm GAD 95 HBA
Istvan Csok Medal bronze;
DM: 7 cm GAD 94 HBA
Istvan Ferenczy Medal
bronze; Dm: 7 cm GAD
94 HBA
St. Francis, relief CASS
113
Woman with Drapery stone
PAR-2:109
Zsigmond Moricz, head
1926 bronze; 33 cm GAD
69 HBA

BECKERE, Pieter de See BACKERE,
Pieter de
Beckford, William
Moore, J. F. William Beck-
ford Monument
Beckington, Bishop d 1465
English--15th c. Bishop
Beckington tomb
BECLEMICHEFF, Cleo
Nocturne CASS 72 ELBro
Bedford, 2nd Duke of
Wilton. Duke of Bedford,
2nd, Monument
Bedford, Francis, 5th Duke of
1765-1805
Westmacott. Duke of Bedford
BEDFORD, Richard (English 1883-)
Ant-Eater WILM 145
Flower JOHT pl 174; WILM
144
Opening Bud 1940 Roman
stone RAMT pl 4
Pea marble CASS 135
BEDNORZ, Robert(German 1882-)
Mussolini, head 1924 bronze;
40 cm HENT 57
Beds
Armitage. The Bed
English--16th c. Ceilinged
Bed
--Elizabethan Style Bed
--Great Bed of Ware
English--18th c. Chippendale
Chinoiserie Bedstead
French--16th c. Tester Bed
Bedtime Song. Sucharda
Bee Fountain
Bernini, G. L. Triton
Fountain
Bee Master. Konenkov
Beehives
Emes. George III Beehive
Honey Pot
BEERGRANDT, Brother (French)
Chapelle du Grand Seminaire,
detail 1670 LARR 349
FCam
Bees
English--18th c. Chelsea
"Goat and Bee" Jug
Beethoven, Ludwig von (German
Composer 1770-1827)
Bourdelle. Beethoven, head
Bourdelle. Beethoven, tragic
mask
Bourdelle. Beethoven Monu-
ment on a Rock, study
Garbe, R. L. Sonate Pathet-
ique--Beethoven, head

Klinger. Beethoven, seated
figure
Kolbe. Genius of Beethoven
Michel, G. Beethoven Monu-
ment
BEGAS, Reinhold (German 1831-1911)
Fountain POST-2:166 GB
Wilhelm I Memorial, equest
bronze CHASEH 457; MARY
pl 73 GBR
Beggars See also Martin, St.
Barlach. The Beggar
Barlach. Beggar Woman
Barlach. Russian Beggar-
Woman with Cup
Flemish--15th c. Miseri-
cords
Kruger. Beggar
Picasso. Beggar, head
Romanesque--Italian. Christ
in Mandorla, with angels;
Beggar with Pack
Wagner, S. Beggar in
Jerusalem
The Beginning of the World
Brancusi. Sculpture for the
Blind
Beguinage. Prampolini
BEHAIM, Hans, the Elder
Hare Window, Cloister north
window 16th c. BOE pl
138 GPC
Suspended Keystone 1505/06
BOE pl 138 GNA
Behmer, Marcus
Reuter. Marcus Behmer
BEHN, Fritz (German)
Antelope TAFTM 68
Female Figure, high relief
AUM 17
BEHNES, William (German-English
1795-1864)
Beriah Botfield Mourns his
Mother ESD pl 146
ENorthN
Prince George of Cumber-
land, bust 1828 CON-6: pl
47 EWindC
Princess Victoria, bust 1829
GUN pl 3 EWindC
Samuel Woodburn, bust CON-
5: pl 40
Behold the Man See Jesus
Christ--Ecce Homo
BEHRENS, Peter
Door in artist's house 1901
wood, with wrought metal
SCHMU pl 197; SELZPN
44 GDaMat

Beichlingen, Bishop Adalbert von
German--14th c. Bishop Adal-
bert von Beichlingen, tomb
relief
Being. Anthoons
Beings, Imaginery See also Angels;
Medusa
French--12th c. Capital:
Winged Genie
BEJEMARK (Swedish)
Sculpture* EXS 47 SnS
Bel Ange
French--13th c. Smiling Angel
Belchier, John
Roubiliac. Dr. John Belchier,
bust
BELGIAN
The Virgin, south portal
HAMF 291 BHaM
--9th c.
The Chaste Susanna, Lorraine
(?) c865 engraved rock
crystal; 11 mm SWA pl 13
ELBr
--10th c.
Wedding at Cana, book cover,
Liege 178x145 mm SWA pl
14 UOClA
--10/11th c.
Christ in Majesty between the
Four Evangelists, adored
by Bishop Notker of Liege,
relief ivory; 7-1/2x4-5/8
BECKM 139 BLCu
--11th c.
Book Cover: Christ in Mandor-
la; Angels; Evangelists
268x200 mm SWA pl 101 EOB
Psalter Cover: Lothair I, Lor-
raine silver gilt SWA pl 100
ELBr
Shrine of St. Hadelin: Christ
Trampling Lion and Dragon,
Liege c1075 silver gilt;
540 mm SWA pl 98 BVCh
--12th c.
Box: Inhabited Scrolls, Liege
(?) ivory; 97; Dm: 115 mm
SWA pl 117 GMBN
Cathedral Doors: Christ Ap-
pearing to Adalbert; Fleeing
Companions; Inhabited
Scrolls; Adalbert's Tomb,
Liege c1127 bronze; 328 cm
SWA pl 116, 117 PGC
Christ, head Tongres wood
MCCL pl 13
The Deposition c1140 SWA pl
154 ELMil

Mary's at Tomb, Liege (?)
ivory; 118x112 mm SWA
pl 103 IFBar
Philactery: Cardinal
Virtues; Beasts Holding
Wheel of Universe, Liege
c1160 copper gilt: Dm:
175 mm SWA pl 188
BNaM
Portable Altar of Stavelot:
Martyrdom of SS Andrew
and Philip; Evangelists
c1150 SWA pl 169 BBR
Reliquary Triptych of the
Holy Cross, Liege c1160
silver gilt; 550 mm SWA
pl 170 BLCr
Shrine of Hadelin: Miracle
of the Spring; Hadelin
Healing Mute Woman;
Hadelin Receiving Pupils
at Celles Abbey, Liege
c1140 silver gilt; 54x150
cm SWA pl 158, 159
BVCH
The Transfiguration, Gospel
of Afflighem Cover c1170
ivory; 170 mm SWA pl
176 FPBA
--14th c.
Childhood of Christ; scenes,
tympanum FOC-2:pl 126
BHN
Spice and Herb Merchants'
Guild Sign FREM 173 (col)
BG
--15th c.
Altar, dedicated by Claudio
de Villa c1470 MULS pl
11A BBR
Altar of the Passion, Brus-
sels c1480/90 MULS pl
110B BGeD
Altarpiece wood MARQ 238
BBLo
--16th c.
Eagle, Lectern detail brass;
61 BOSMI 121 UMB
(48.256)
Marriage of the Virgin,
altar detail 1512/16 wood
BUSR 204 BLo
Reliquary: Bishop, bust
1520 oak; 72.5 cm BSC
pl 67, 66 GBS (2/61)
St. Adrian c1500 cast and
chased brass; 12-1/8
YAP 213 UNNLeh

St. Stephen c1500 cast and
chased brass; 12-7/8 YAP
213 UNNLeh
--16/17th c.
Mechlin Cabinet GOR 4
--17th c.
Wine Cistern with Dragon
Handles c1690 SOTH-3:202
Belgian War Memorial, Paris MARY
94 FP
Belgium at Work, pierced relief.
Jespers, O.
Belgium at Work. Jespers, O., and
Henri Purvez
BELJON, J. J. (Dutch)
Hiroshima mon Amour 1964
KULN 161
BELL, John (English 1811-95)
See also Walker, A.
Andromeda bronze VICG 128
Dorothea, from Don Quixote
VICG 130 ELV
The Bell. Kemeny
Bell-Push. Faberge
Bell Towers. Borromino
BELLANO, Bartolommeo (Italian
c1434/96)
Cain and Abel, choir screen
relief c1434-96) bronze
BIB pl 19 IPadAn
David POPR fig 145 UPPPM
Europa and the Bull 1469/96
bronze; 8-1/2 MOLE 132
IFBar
Jonah Thrown into the Sea
c1485 bronze SEY pl 145B
IPadS
Mountain of Hell, table in-
cense burner c1485 bronze
POPR fig 146; SEY pl 144
ELV
St. Jerome, kneeling figure
bronze; 6 CAMI pl 25;
TOR 123 CTRO (968.48.1)
Samson Destroying the Temple,
relief bronze POPR pl 122
IPadAn
Virgin and Child, relief
marble CLE 85 UOClA
(20.273)
BELLANO, Bartolommeo--ATTRIB
St. Christopher bronze; 10-
1/4 DETD 116 UNNUn
"La Belle Allemande"
Erhart, Gregor, Penitent
Mary Magdelene
La Belle Allemande
Ernst. Round Head

"La Belle Florentine". Italian--
 15th c.
La Belle Heaulmiere. Rodin
Bellerophon
 Bertoldo di Giovanni. Belle-
 rophon Mastering Pegasus
 Early Christian. Bellerophon,
 panel
BELLI, Luigi (Italian 1848-1919)
 See PANISSERA, M.
BELLI, Valerio (Venetian 1468-
 1546)
 Rock Crystal Coffret ROSSI
 IFP
Belliard, General
 Geefs. General Belliard
Belling, C. R.
 Folkard, E. C. R. Belling,
 Esq, bust
BELLING, Rudolf (German 1886-)
 Alfred Flechtheim bronze;
 7-1/2 KUHNG pl 123
 UMCB (1931.75)
 August Kershensteiner, head
 1932 silvered bronze; 45
 cm HENT 96
 Head copper MARTE pl 11
 Head 1923 bronze; 15 NMAC
 pl 161; ROOS 281E UNNWe
 Head in Brass (Kopf in
 Messing) 1925 brass; 38
 cm OST 49 GSaaS
 Josef von Sternberg, head
 1930 silvered bronze; 21
 NMG #100 UCLSte
 Max Schmeling 1929 bronze;
 55 cm HENT 97 UNNMMA
 Sculpture* EXS 35
 Sculpture 1933 bronze; 18-
 7/8 BERCK 29; LIC 254; ·
 MCCUR 267; NNMMAG
 174 UNNMMA
 Threefold Harmony 1919
 wood MAI 20
 Triad (Drei Klang; Triple
 Clang) bronze; 35-3/8x
 33-1/2 READCON 224
 GMB
 --1919 bronze; 90 cm OST
 84, 85 GSaaS
 --1919 mahogany; 36 NMG #
 95 GBFl
 --1919/24 mahogany; 35-
 7/8 BERL 242; BERLES
 242; MARY 16 GBSBe
 (B 449)
Bellona. Rodin

BELLOTTO, Eugenio (Italian)
 Artist's Wife (La Moglie dell'
 Artista) bronze VEN-24: pl
 51
 Caress marble VEN-20: 120
 The Fountain bronze VEN-26:
 pl 99
 Primo Frutto VEN-12: pl 28
 Woman, bust marble VEN-30:
 pl 132
BELLOTTO, Umberto (Italian)
 Coppa da Metter in pallio per
 Regate a Remi iron VEN-
 24: pl 157
 Cup beaten iron and glass
 VEN-20: 127
 Cups beaten iron VEN-22:
 112
 Gates, Sola dell'Orafo iron
 VEN-30: pl 192
Bells
 Kememy. The Bell
 Russian--18th c. King of the
 Bells
BELLVER, Ricardo (Spanish 1845-)
 Cardinal Siliceo tomb POST-
 2: 217 SpTC
BELMONDO, Paul (French 1898-)
 Athlete BAS 223
 Auto Route de l'Ouest Figures
 BAS 221
 Idylle BAS 215
 Jacqueline, head BAS 216
 Jeune Fille, buste BAS 218
 Mme. Belmondo, three-
 quarters figure BAS 220
 FPMP
 Mlle. Vandeville, detail
 BAS 222
 M. Legros, head BAS 218
 M. Montagne BAS 220
 M. Sourel, head BAS 216
 Noelle, head BAS 217
 Pieta BAS 219
BELSKY, Franta (Czech-English
 1921-)
 Epicentre cold cast aluminum
 PER 41
 Girl cold cast bronze; 72
 PER 53
 Lesson 1856/57 metallized
 concrete; 64 LONDC pl 3
 Shell Fountain bronze; 30'
 WHITT 145 EL
 Sir Arthur Thomson, bust
 1960 cold cast bronze
 PER 52

BELT, Richard (English c 1850-1925)
 See also Bird, Francis
 Byron, seated figure 1880
 bronze figure on Rosso
 Antico marble GLE 62
 ELHy
Beltrame See Commedia dell'Arte
Belvedere
 Czech--17th c. Belvedere
 with statues, castle garden
Bem, Josef (Polish General 1795-
 1850)
 Ferenczy, B. General Josef
 Bem, medal
 Istok. General Josef Bem
Bemalte Drahtplastik. Bodmer
Bembo, Pietro (Italian Humanist
 1470-1547)
 Cattaneo. Bembo Monument
 Cellini. Medal: Pietro Bembo
 Italian--16th c. Pietro Bembo
 Medallion
BEN-SCHMUEL, Dan (Irish-Israeli
 1927-)
 Iconogram, assemblage 1967
 copper on wood base;
 87x66-1/2x69-1/2 GUGE
 103
BEN-ZVI, Zeev (Polish-Israeli
 1904-52)
 Actor Messkin, head bronze
 GAM pl 91; ROTH 942
 IsJB
 Dr. Magnes, head bronze
 GAM pl 92
 In Memory of Our Children
 (Mishmar Haemek):
 Maternity 1952 stone
 GAM pl 93, 94
 Monument to Cilla 1939
 SCHW pl 73
 Schmarjahu Levin, head
 1934 grey Jerusalem
 stone GAM pl 90; SCHW
 pl 72 IsTT
 The Sower, Levant Fair,
 Tel Aviv (dismantled)
 1934 SCHW pl 74
Benavente Chapel. Corral
Benavides Monument. Ammanati
BENAZZI, Raffael (Swiss 1933-)
 Elmwood 1962 26x16-1/8
 READCON 190
Benches
 Bloc. Garden Bench
 Brancusi. Bench
 Moller-Nielsen. Subway
 Bench

Smith, H. Tyson. Garden
 Bench
BENDEL, Ehrgott Bernhard (German)
 St. John the Evangelist
 LIL 200 GNG
BENDL, Ignaz (Austrian)
 Mercury Fountain 1693
 STECH pl 28 CzB
BENDL, Johann Georg (Czech
 1620-80)
 Church Portal 1655/59
 STECH 26 CzPS
 Column, Old Town Square
 1650 STECH 26 CzP
 Flight of Frederick of the
 Palatinate from Prague in
 1620, relief c1630 Oak
 STECH 25, pl 5 CzPV
 Garden Fountain, with
 Hercules STECH 31
 CzPHC
 St. Wenceslas, equest 1678/
 80 STECH pl 7 CzP
 St. Wenceslas, Vintner's
 Column 1676 STECH pl 6
 CzP
BENEDETTO DA MAIANO (Italian
 1442-97), also called Bene-
 detto di Leonardo
 Altar of the Annunciation
 1489 marble and porphyry
 CHAS 95; KO pl 78; POPR
 fig 47; pl 72; ROOS 112H
 INO
 Angel Bearing Candelabrum
 WOLFFA 16; WOLFFC
 11 ISD
 Birth of St. John the Baptist
 15th c. terracotta GLA pl
 36
 Filippo Strozzi, bust 1490
 terracotta; 44.5 cm
 BSC pl 83 GBS (102)
 Filippo Strozzi, bust marble;
 52 cm CHAR-1:336;
 LOUM 177; POPR fig 81
 FPL (693)
 Florentine Statesman, bust
 terracotta; 22-3/8x25-
 1/8 SHAP 31; USNI 224;
 USNK 187; USNKP 405
 UDCN (A-50)
 Madonna and Child, relief
 c1485 marble; 22-7/8x
 15-1/4x3-7/8 KRA 37:
 USNKP 406 UDCN (K314;
 A-1661)
 Madonna and Child, roundel

terracotta ptd white
MACL 151 UMBGa
Madonna and Child, tondo
marble: Dm: 26-3/4
USNK 188 UDCN
Maestroguidici Altar 1489
colored marble SEY pl
107 INAn
Onofrio Vanni, bust LARR
108 IStGi
Pietro Mellini, bust 1474
marble 53 cm BAZINW
339 (col); BUSR 140:
HALE 177; POPR fig 80,
pl 71; ROOS 113A; ROTHS
103; WOLFFP 57 IFMN
Pulpit 1472-76 marble
FREEMR 103; MACL 149;
MARQ 194 IFCr
--Death of St. Francis
FREEMR 104
--Life of St. Francis BUSR
42
--Martyrdom of Franciscan
Missionaries SEY pl 106
--St. Francis Receiving the
Stigmata marble; 28 LARR
89; MOLE 122; POPR fig
51; pl 73
St. John the Baptist marble;
134 cm POPR fig 54, pl
74 IFV
St. Sebastian c1497 marble;
c LS MOLE 145; POPR
fig 55 IFMis
Virgin and Child terracotta;
127 cm BERLEI 10;
BUSR 148; WOLFFA 49;
WOLFFC 43 GBSBe (104)
BENEDETTO DA MAIANO--FOLL.
St. John the Baptist, bust
terracotta; 12 BMA 19
UMdBM
Strozzi Madonna version,
tondo 1490-95 marble
SEY pl 156A IScP
BENEDETTO DA ROVEZZANO
(Italian 1474-after 1552)
Fireplace frieze detail,
Palazzo Borgherini c
1495 Pietra Serena SEY
pl 153B IFBar
St. John the Evangelist
POPRB fig 43 IFOp
BENEDETTO DI LEONARDO See
BENEDETTO DA MAIANO
BENEDETTO OF PARMA See
ANTELAMI, Benedetto

Benedict, Saint
Christian, J. J., M. Hermann,
and K. J. Riepp. Organ;
St. Benedict
German--11th c. Basle Ante-
pendium: St. Benedict and
an Angel
Guggenbichler. St. Benedict
Pacher. St. Wolfgang Altar:
Coronation of the Virgin
Benedict XIII (Pope 1649-1730)
Bracci, and others. Benedict
XIII tomb
Benedict XV (Pope 1854-1922)
Rodin. Benedict XV, head
Benedicte. Saint-Phalle
BENET, Eugene
Marche Funebre d'un Heros
MARY pl 100
Racine MARY 184
BENEVELLI, Giacomo (Italian
1925-)
Organic Construction No. 3,
model 1 1963 bronze VEN-
64: pl 71
Bengough, Henry
Chantry. Henry Bengough
Monument
BENINTENDI, Orsino--Attrib
Lorenzo de'Medici, bust ptd
stucco BURC pl 55 GBM
Benjamin
Ghiberti. Baptistry Doors--
East: Benjamin
BENKERT, Johann Peter (German
1709-69)
Chinese Tea Drinker, Tea
House 1754/56 gilt sand-
stone BOE pl 184; BUSB
192 GPoS
High Altar, after design of
J. M. Kuchel: St. Paul,
head 1740 BUSB 201, 202
GGosCh
BENKERT, Johann Peter, Paul
STRUDEL, and Mattias
RAUCHMILLER
Plague Column, after design
of Fischer von Erlach,
Graben 1687 BUSB 120
AV
BENLLIURE, Mariano (Spanish 1862-
1947)
Joaquin Sorolla y Bastida,
bust marble VEN-24: pl
105
Two Victims of the Fiesta
LARM 218

The Victim bronze VEN-14:
133
Benn, Gottfried (German Poet 1886-
1956)
Wolff, G. Gottfried Benn,
head
BENNET, Judd
Birds DIV 44
BENNEY, Gerald
Reredos with cross and
candlesticks silver MCCL
pl 52
Bennington. Caro
Benoit, Saint
French--8th c. Capital: Dis-
covery of the Tomb of
St. Benoit
Benoit, Peter
Cantre. Peter Benoit, head
BENQUET, A. (French 1861-)
Oval Wheel 1878 8-5/8x11
NMFA 232 FPBre
Bensley, Captain
Bacon, J., the Younger.
Capt. Bensley Monument
Benson, Elizabeth d 1710
Bird. Mrs. Elizabeth Ben-
son Tablet
BENTHAM, P. G. (English)
Doorway Panel, Gresham
Street Building AUM 133
EL
Office Entrance AUM 146
ELSto
Steamship Office Panels:
Fiji; Babylon; Australia
AUM 158 ELPO
BENTI, Donati (Italian 1470-c1536)
Pulpit c1500/04 marble SEY
Pl 109B IPietC
Bentivoglio, Ercole
Spinelli. Ercole Bentivoglio
BENTLEY-CLAUGHTON, R.
Boy, head "Stonehard",
mixed with aluminum
filings HUX 83
BEOTHY, Etienne (Hungarian-
French 1897-1961)
The Ascete 1931 H:21
BERCK 236
Couple 1947 wood; 23-1/2
GIE 229 FPLan
Figure* EXP 33
Interlocking Rhythms 1937
wood MARC pl 41 (col)
FPM
Man 1927 stone MAI 21
Nocturno 1956 Avodive wood;

47-1/4 READCON 185; TRI
184
Nostalgia 1948 oak; 42 BERCK
122 -P
The Sea. Opus 67, mobile
1934 Brazillian rosewood
MAI 22 SwGAd
Three Variations 1937 king-
wood; 34-3/4 SCHAEF pl
114
Tonisation 1949 sycamore;
21-3/8 SCHAEF pl 115
Wasp. Opus 138 1957 wood
MAI 22
BERAN, Lajos (Hungarian 1882-1943)
Ignac Alpar, medal 1925
bronze; 8.1 cm GAD 96
HBA
Berard, Antoinette
Osouf. Mlle Antoinette Berard,
head
Berceau I. Witschi
Beresford-Hope Cross. Byzantine
BERG, Christian
Bas-relief# bronze MARTE
pl 48
Figurine bronze MARTE pl 48
BERG, Klaus
Apostle St. James the Less
after 1532 oak; 49 BUSR
163; LOH 184 GGuC
High Altar, center shrine
1517/22 BUSR 162 DOK
Bergamasque. Dow
BERGEN, A. L. van den (Belgian)
Lincoln 1924 BUL 177 UWiR
BERGER, G. (German)
Femme Debout FPDEC-
German il 2
BERGER, Jacob (Flemish)
Fontaine du Grand Sablon
ROOSE 203 BB
Le Berger des Landes
Richier, G. Shepherd of the
Landes
BERGONDI, Andrea (Italian)
Altar of St. Alexis LARR 353
IRAle
BERKE, Hubert (German 1908-)
Bright Symbiosis 1958 wood
and metal; 10-1/2x27-1/8
CARNI-58: pl 121
Malanggan I 1959 mixed media;
36x12.4 ALBC-3:#68;
CARNI-61:#30
Berkeley, Thomas, Lord d 1461
English--15th c. Thomas,
Lord Berkeley, tomb
Berlin Porcelain

German--18th c. Temple of
Bacchus, center piece
Berlinghieri, Vacca
Thorwaldsen. Prof. Vacca
Berlinghieri Monument
BERLINGHIERO (Italian)
Crucifix 1228 LARR 34 IL
Bernard, Saint
Agostino di Duccio. Miracle
of St. Bernardino, relief
French--15th c. St. Bernard
Goldwitzer. Vision of St.
Bernard
Jaekel, M. W. Madonna
with St. Bernard
Moiturier. St. Bernard
Tordesilas. St. Bernard
BERNARD, Joseph (French 1866-
1931)
Baccante bronze VEN-26:pl
43
Boy Bacchant bronze VEN-32:
pl 108
La Chanteuse 1910 stone
RAMS pl 51 FGreM
Dance Frieze marble
PAR-1:176
Dancing Woman and Child
(Femme et Enfant Dan-
sant) gilt-bronze CASSM
57 FPLu
--1925 bronze: 75 MID pl
22 BAM
Festival of the Grapes, re-
lief marble PAR-1: front
Girl carrying water stone
CHENSP 274; CHENSW
482
Girl with a jug 1910 bronze
SELZJ 159 FPM
Jeune Fille a la Creche
1912 bronze MUNSN 178
FLM
Mother and Child, lunette
panel AUM 56
Water Carrier bronze MARY
pl 118 FPLu
Woman with Jug cast bronze
VEN-22: 57
A Young Girl AUM 55
Bernard, Leon
Dejean. Leon Bernard, head
Bernard of Wurzburg, Saint
Riemenschneider. St. Ber-
nard of Wurzburg
Bernardino, Saint
Agostino di Duccio. St.
Bernardino in Glory

BERNARDO DE SAULET (Spanish)
Christ's Capture, retable, St.
Juan de las Abadesas 1341
BUSGS 192 SpVi
Bernardo Memorial. Frampton
BERNEKER, Franc (Yugoslav 1874-
1932)
Portrait of a woman 1909
stone BIH 27 YLN
Bernhard von Breidenbach d 1498
German--15th c. Dean Bern-
hard von Breidenbach,
effigy
Bernhardt, Sarah
Gerome. Sarah Bernhardt,
bust
BERNINI, Giovanni Lorenzo (Italian
1598-1680)
Alexander VII, kneeling fig-
ure, model c1669 terra-
cotta; 12 ASHS pl 27 ELV
Alexander VII tomb 1671-78
white and colored marble,
gilt bronze; 24'2'x19'4'
BAZINW 393 (col); BR pl
10; CHASEH 375; KITS 141
(col); MOLE 185; NEWTET
188; POPRB pl 147; ROTHS
181; ROTHST pl 15; UPJ
365; UPJH pl 152; WIT pl
52B; WOLFFP 107 IRP
--Death with Hourglass MATTB
pl 21
Angel PUT 267
Angel Arrodillado terracotta
PANA-2:94 UMCF
Angel with the Crown of
Thorns 1668/71 BAZINW
392 (col); WIT pl 49A
IRAndr
The Angel with the Super-
scription 1668 marble; over
LS KITS 26 (col); POPRB
pl 157; WIT pl 49B IRAndr
Angels, Ponte Sant'Angelo
1688 MATTB pl 32-33 IR
Apollo and Daphne (Metamor-
phosis of Daphne) 1622-24
marble; 96 AGARC 11;
BARSTOW 168; BAZINW 388-
9 (col); BR pl 10; BUSB 69;
CANM 473; DAN 276; FAL
pl 35b; FAL pl 35c-e; FLEM
496; LARR 345; LIC
28; MACL 257; MATT pl
6-8; MILLER il 131;
MOLE 175; MU; MYBA
469; MYBU 311; POPRB

pl 142; POST-2:6; RAY
48; READAS pl 116;
ROOS 116B-C; STI 658;
UPJ 362; VER pl 85 IRB
(CV)
The Assumption, relief 1607/
10 BAZINW 386 (col)
IRMMag
Blessed Ludovica Albertoni
(Beata Albertona), effigy,
Altieri Chapel 1674/76
marble BR pl 7 (col);
BUSB 72-3; HAUSA pl 39;
MATTB pl 24-5; POPRB
pl 158; WIT pl 59A;
WOLFFP 112 IRFr
A Cardinal, bust marble
MILLER il 140 UNNMM
Cathedra Petri (Chair of St.
Peter; Throne of St.
Peter) 1657-66 bronze,
marble, stucco BAZINB
15; CHRC fig 186; JANSH
409; JANSK 775; KITS
35; LARR 335; MOLE
177 (col): POPRB fig 166;
ROTHS 183; UPJH pl 1 152
IRP
--Altar of the Cathedra
Petri NOG 41-43
--Baldacchino bronze, part gilt;
93; BAZINW 391 (col);
BROWF-3:58; CAL 195 (col);
ENC 91; KITS 35; MONT 35;
WIT pl 56
--Baldacchino and Papal
Altar NOG 40
--St. Ambrose MATTB pl 22
--St. Augustine MATTB pl
23: POPRB pl 154-5
--Shrine for Cathedra Petri
CHASEH 377
Cathedra Petri, model terra-
cotta and tinted plaster;
23x11-1/2 DETI 43 UMiD
Constantine (Constantine Ex-
periences Vision of the
Cross), equest, Scala
Regia 1654-68 marble
BUSB 70; KO pl 87;
MATT pl 32; NOG 37;
WIT pl 59B IRP
Coronation Chapel, with Ec-
stacy of St. Theresa:
Angel with Lance; St.
Theresa, head POPRB fig
163; pl 150-1 IRVi
Costanza Bonarelli, bust

1636/39
marble; 28-3/8 BARG;
BAZINW 391 (col); CHASEH
376; GOMB 328; JANSH
408; JANSK 786; MACL
259; NEWTEM pl 139; NMI
58-9; POPRB fig 176;
ROBB 389; SFGM #59;
WIT pl 55A IFBar
Countess Matilda Monument
POPRB fig 164 IRP
Daniel, kneeling figure MARQ
217; MATTB pl 14-15 IRMP
David (David Slaying Goliath)
1623 marble; LS BAZINW
388 (col); BUSB 75; FAL
pl 34a-b; JANSK 787; KITS
33; MACL 255; MATTB pl
4; MOLE 175; MONT 34;
POPRB fig 157; pl 141;
VER pl 83; WIT pl 46B
IRB (LXXVII)
Dr. Fonseca, effigy detail
after 1663 marble KO pl 87
ILucL
Ecstacy of St. Theresa (Vision
of St. Theresa) 1644-52
marble; over LS, Cornaro
Chapel AUES pl 24; BAZINB
26; BAZINH 300; BAZINL
pl 321; BAZINW 390 (col);
BUSB front (col). 71, 74;
CHENSN 508; CHENSW 455;
CHRC fig 187; ENC 65;
FLEM 460; GARDH 402;
GAUM pl 50; GOMB 329-
30; JANSH 408; JANSK 790;
KITS 17 (col); KO pl 88;
LARR 344; MACL 265;
MAL pl 42; MCCL pl 36;
MILLER il 134-5; MOLE
174; MONT 394; MU 179;
MYBA 470; MYBU 153;
MYRS 52; NEWTEA 178;
NEWTEE pl 17; NEWTEM
pl 138; POST-2:9; PRAEG
332; RAMS pl 17b; RAY 49;
READAS pl 118; READO
148; ROBB 382, 388; ROOS
116E; SEW 698; UPJ 285;
WIT pl 51 WOLFFP 61
IRVi
--Cornaro Family, donors of
Ecstacy of St. Theresa SEW
698
Fiumi Fountain (Four Rivers
Fountain: Rhine, Ganges,
Nile, de la Plata) 1674-75

stone BAZINW 392 (col);
KITS 36 (G. B. Falla en-
graving); LARR 342; MATTB
pl 29; NEWTEM pl 141;
ROBB 390; WIT pl 53B
IRNa
--de la Plata KO pl 88;
MATTB pl 30
--Ganges, exec Claudio
Adam BUSB 77; MATTB
pl 28
--Nile, exec F. A. Fancelli
MATTB pl 31; MOLE 180;
(col); POPRB fig 174, pl
153
Flight from Troy: Aeneas,
Anchises, Ascanius leav-
ing Troy 1618-19 marble;
220 cm AGARC 87; FAL
pl 32b; POPRB pl 139;
WIT pl 46A; IRB
--Aeneas and Anchises MATTB
pl 5
--Putto FAL pl c
Fountain Figure MONT 34
IVCO
Fountain Group (Brunnen-
gruppe), Bozzetto 1652
terracotta; 37.5 cm BSC
pl 116 GBS (1795)
Francesco I d'Este, bust
c 1651 marble; 100 cm, excl
base AUES pl 25; BAZINW
391 (col); HAUSA pl 39;
MACL 267; MONT 395;
POPRB pl 149; POST-2:7;
UPJ 363 IMoE
Francesco Barbarini, bust
marble; 31-1/8x26x10-1/2
KRA 152, 153; POPRB pl
144; USNKP 438 UDCN
(K-278; A-1646)
Gabriele Fonseca, bust 1665-
68 BUSB 79; MATTB pl
16; WIT pl 117B IRLor
Goat Amalthea, with playing
baby and baby faun marble;
45 cm FAL pl 30 IRB
(CXVIII)
High Altar POPRB fig 162
IRBi
--St. Bibiana MATTB pl 12;
POPRB pl 143; WIT pl
47A
Innocent X (Giambattista Pam-
phili), bust marble COOPF
50 IRPam
--CHENSW 456 IRD

Kneeling Angel c1672-74 terra-
cotta model; 13-1/8 FAIN
116; UMCF UMCF (1937.63)
Leopoldo de'Medici, bust
marble KO pl 89 FPL
Louis XIV, bust PRAEG 334
--1665 marble; 33-1/8x39-
3/8x17 BAZINL pl 326;
ENC 91; FLEM 494;
ROTHS 185; ROTHST pl 11;
SEYT 245; WIT pl 55B FV
--replica of Versaille bust
CARTW 61 CHRC fig 188;
DAN 166; READAS pl 117;
RUS 108; SEYM 152-3;
SHAP pl 84; UPJH pl 152;
USNI 225; USNK 202;
USNKP 439 UDCN (A-62)
Louis XIV (Marcus Curtius),
equest LARR 281 FV
Louis XIV, Roi Soleil, equest
monument, sketch 1670
terracotta; 30 BAZINW 392
(col); CHENSW 453; FAL
pl 38; FLEM 495; JANSH
445; JANSK 769; MATTB
pl 17; MONT 34; RAY 49;
VALE 117 IRB
Mary Magdalen 1661/63 WIT
pl 48B ISC
Minerva Obelisk, Square of
St. Maria Sopra Minerva
1667 MATTB pl 27; SEW
701 IR
Mr. Baker, bust LARR 345;
MACL 261; READM pl 42
ELV
The Moor Fountain (Fontana
del Moro; Del Moro
Fountain), Piazza Navona
AGARC 88; MATTB pl 28;
POPRB fig 172 IRNa
Neptune and Glaucus marble
MILER il 132 EV
Neptune and Triton c1620 mar-
ble; 73 BUSB 68; POPRB
fig 160; VICF 77; WHITT
82 ELV (A.18-1950)
Pluto and Proserpine RAY 49
IRB
Pope Paul V, bust 1618
marble: 35 cm FAL pl 31;
POPRB fig 175; WIT pl
54A IRB
Porch, Scala Regia 1663/66
BOE pl 161
Triton Fountain (Bee Fountain)
1640 marble CHASEH 374;

KO pl 90: MATTB pl
26; POPRB fig 170; SEQ
700; ST 359; WIT pl 53A
IRBarb
Prophet Habakkuk and the
Angel 1655/61 MATTB pl
13: WIT pl 48 IRMP
Rape of Proserpine 1622/25
marble 96 CHRP 258 (line
drg); FAL pl 33a-b; MOLE
174; MONT 34; POPRB pl
140; STA 73; UPJH pl 152
IRB (CCLXVIII)
--Cerberus MATTB pl 9
St. Andrea al Quirinale,
interior 1658/70 KITS 66
IRAnd
St. Jerome bronze; 195 cm
POPRB pl 156 ISC
St. Longinus 1635/38 marble;
c 14-1/2' JANSK 788; KO
pl 89; MOLE 178; POPRB
fig 159; WIT pl 47B IRP
--bozzetto 1629/38 terra
cotta VER pl 86 UMCF
Satyr, bust MINB 79 IRB
Scala Regia MATT pl 33 IRV
Scipione Borghese, bust
marble; 78 cm POPRB
pl 148 IFB
--1632 second study marble;
30-3/4 BAZINB 27; FAL
pl 36 a, b; GARDH 403;
MATTB pl 18; MONT 35;
NEWTEM pl 140; POPRB
fig 178; ROTHS 179; WIT
pl 54b; WOLFFP 58 IRB
(CCLXV; CCLXVI)
Self-portrait, head c1675
terracotta HERM il 50
RuLH
Triton with Sea Serpent terra-
cotta; 11 DETI 45; DETT
96 UMiD (52.219)
Triton with Shell terracotta;
12-3/8 DETI 44; DETT
96 UMiD (52.218)
Truth (Truth Unveiled; La
Verita), detail marble;
2.8 m FAL pl 37a, b;
MAL pl 47; MATTB pl
10-11; POPRB pl 152 IRB
--(Verite) c1645 terracotta;
21-1/2 CHAR-2:171;
LOUM 189 FPL (1543)
Urban VIII, bust, detail
WIT pl 44 ISpC
--bronze LOUM 153 FPL
(1544)

--marble; L: 3 cm POPRB
fig 177; pl 145 IRBarbe
Urban VIII tomb 1628/47
bronze and marble JANSK
789; MACL 263; MATTB
pl 18; MOLE 185; MONT
35; NOG 49; POPRB pl
146; POST-2:8 IRP
--Charity MATTB pl 20
Virgin and Child GUIT 74 FPN
BERNINI, Giovanni Lorenzo--ATTRIB.
Neptune bronze; .52 m FAL
pl 39 IRB (738 Corsini)
BERNINI, Giovanni Lorenzo--FOLL.
Diana Sleeping 17th c. marble
LS BARD; BARD-2: pl
162, 164 BrSpA
Thetis marble; 80-1/4x36
USNKP 440 UDCN (A-1616)
BERNINI, Pietro (Italian 1562-1629)
Assumption of the Virgin
marble POPRB pl 138
IRMMag
Charity POPRB fig 154 INP
Clement VIII Coronation
POPRB fig 156 IRMMag
St. John the Baptist 1614/15
marble POPRB pl 137; WIT
pl 40B IRAndrV
Un Termine: Bearded head
bearing jar of fruit MINB
90 IRB
BERNKOPF-COLMAR, Ellen (German
Israeli 1904-)
Meditation plaster, for bronze
SCHW pl 78
BERNUTH, Fritz
Fighting Cock (Kampfender)
1953 maple GERT 250
BERNWARD OF HILDESHEIM
(German c960-1022)
Column: Marriage at Cana
c1020 bronze; Column
D:22-7/8; Relief H: 17-3/4
NEWTEM pl 54 GHiC
Door: Abel; "Noli Me Tangere"
c1015 bronze; relief area:
17-3/4 NEWTEM pl 51, 52
GHiC
PORTRAITS AND MEMORABILIA
German--11th c. Hildesheim
Cathedral Doors (St. Bernward's
Door)
German--11th c. Book Cover: Gospel
of Bishop Bernward of Hilde-
sheim
BERROCAL, Miguel (Spanish 1933-)
David 1966 11-1/2x6-3/4
CARNI-67:#185 UNNLoe

Femme Inclinee 1963 H: 14-1/4
SEITC 125
Odalisca 1963 H: 5 SEITC 124
Samson 1963 H: 11-1/2 SEITC
--1964 VEN-64: pl 183
Soul of a Tree 1961 H: 57-1/4
SEITC 124
Torso Ronda II 1964 H: 6
SEITC 124
BERRUGUETE, Alonso (Spanish
1480/90-1561)
Adoration of the Magi, re-
lief detail ptd and gilded
wood; c 1/2 LS GOME 9
(col)
Altar of San Benito: Prophet;
heads of Apostles; St.
Sebastian; Sacrifice of
Isaac 1528/33 ptd wood;
c 1/3 LS GOME pl 17-22
SpVME
--Abraham and Isaac (Sacri-
fice of Isaac) BAZINW
374-5 (col); CHASEH 367;
CIR 45 (col); ENC 92; KUBS
pl 72C; RAY 46; VEY 277;
WES pl 17
--Abraham BAZINH 281
--Isaac BAZINL pl 288
--St. Sebastian head, San
Benito BUSR 206; CHASEH
367; KUBS pl 72B; LARR
157
The Annunciation, retable
detail, La Mejorado,
Olmedo c1525 ptd wood
GUID 219 SpVME
Don Juan de Tavera Tomb
marble CHENSW 399;
WES pl 18 SpTHA
Eve, choir stall detail
1539/43 Wood BAZINW
375 (col); BUSB 5; CIR 49
(col); KUBS pl 73A; POST
-1: 263; VEY 277 SpTC
Figure details TATSC pl 11 SpVM
BERRUGUETE, Alonso--FOLL
Crossing of the Red Sea
c1543 ptd wood BAZINW
375 (col) SpTC
Moses, choir stall detail
1539/43 KUBS pl 73C
SpTC
The Resurrection c1517
KUBS pl 64B SpVaM
St. Christopher before 1523
lacquered wood BUSR 207;
STA 101 SpVME

St. John, altar of S. Benito
1527/32 BAZINL pl 290;
KUBS pl 72A SpVME
St. John the Baptist, choir
stall 1539/48 wood; 31-
1/2x19-1/4 CIR 48 (col);
JANSH 382; JANSK 743
SpTC
Toledo Cathedral Choir
Stalls: The Bronze Serpent;
The Last Judgment wood
Dm: 19-1/2, and 33
GOME pl 23-4 SpTC
Transfiguration 1543/48 KUBS
pl 67A; MAR 135: VEY
163 SpTC
Berry, Duc de
Morel. Duc de Berry tomb
Berry, Jean de France, Duc de
1340-1416
Jean de Rupy. Duc Jean de
Berry, kneeling figure
BERRY, John (English)
Untitled 1966 KULN 130
Der Berserker. Barlach
BERTAGNIN, Roberto (Italian 1914-)
Cloaked Woman 1959 bronze
SAL 52
The Cow 1947 red porphyry;
38-1/2x49 MID pl 70 BAM
Bertaux, Marie-Jeanne, Countess de
Dazzi. Countess Marie-Jeanne
de Bertaux
Berthe, head. Despiau
BERTHOLD, Joachim (German 1917-)
Stooping Woman 1960 bronze;
25-1/4 READCON 181 EBS
Berthout Family
Faid'herbe. Berthout Family
Monument
BERTI, Antonio (Italian 1904-)
Barbara Hutton, seated figure
bronze VEN-38: pl 113
Count Volpi di Misurata, half
figure bronze VEN-36: pl 2
Il Duce, half figure bronze
VEN-42: pl 2
Paolo Ojetti, bust bronze
CASS 40: VEN-36: pl 17
Princess Marina Ruspoli,
half figure CASS 40
Victor Emmanuel III, King of
Italy, half figure VEN-42:
pl 3
Bertie, Peregrine d 1612
English--17th c. Sir Peregrine
Bertie, Lord Willoughby,
detail of daughter's Monument

BERTOLDO DI GIOVANNI (Italian
c1420-91)
Alfonso of Aragon, medal
bronze BODE 178 GBK
Apollo bronze; 44 cm POPR
pl 91 IFMN
Arion c1470/90 bronze; 17-
1/2 MOLE 143 IFBar
Bacchus Procession bronze
BODE 154 IFMN
Battling Horsemen, based on
classic sarcophagus c1480
bronze; 17x39 BODE 168;
BUSR 144-45; CLAK 202;
MAR 72; POPR fig 139, pl
92-93; SEY pl 152A IFBar
Bellerophon Mastering
Pegasus bronze; 12-3/4
ARTV pl 37; BAZINW 340
(col); BODE 169; HAUSA
pl 28; POPR fig 140 AVK
Crucifixion, right portion
relief c1475 bronze BARG;
SEY pl 112B IFBar
The Entombment, Gospel
Ambo Relief detail c1470
bronze SEY pl 82 IFLo
Hercules bronze BODE 170
ELM
--bronze POPRB fig 1-2 ELV
Hercules on Horseback
bronze; 10-3/4x10 DETD
121 IMoE
Hercules Slaying the Lion
bronze BODE 172 ELSa
Jason Resting after Slaying
the Dragon bronze;
8-3/4 DETT 71 UMiD
(56.33)
Kneeling Vulcan bronze
GOLDE 33 UNNStr
Mohammed II, medallion
VER pl 44 UDCN
--bronze BODE 178
--1480/81 bronze; DM: .94
m CHAS 14 ELBr
Negro and Lion bronze BODE
173 FPF
Pazzi Conspiracy Commemora-
tive Medal bronze BODE
178 ElBr
The Suppliant (The Gladiator;
The Slave) bronze BODE
171 GBK
BERTOLDO DI GIOVANNI--FOLL.
Military Glory, Relief de-
tail, Casa Scala Court-
yard c1480/90 stucco ptd

to imitate bronze SEY pl
155B IFGh
BERTOLINO, Tommaso (Italian 1897-)
Mary Magdalene, medal VEN-
40: pl 76
Medal: Consiglio Provincale
dell'Economia di Roma
bronze VEN-32: pl 190
St. Christopher, medallion
bronze VEN-34: pl 80
V. E. Orlando, medal 1951
bronze VEN-52: pl 52
BERTONI, Wander (Italian-Austrian
1925-)
B. Maiuscola 1955 wood VEN-
56: pl 102
C (Imaginary Alphabet) 1054/
55 bronze; 25-5/8x17-3/4x
13-3/4 READCON 253 AVT
La Croce 1958/62 wood VEN-
66:#142
D (Imaginary Alphabet) 1955
marble; 25x80 cm SOT
pl 135
Figure with Guitar (Figur mit
Instrument) 1950 plaster
GERT 241
Icarus 1953 aluminum: 47-1/4x
39-7/8x19-3/4 GERT 240;
GIE 269; MID pl 121; TRI
100 BAM
Movement 1955/58 stainless
steel; 177x98x79 TRI 268
AVMH
Plaintiff V 1961 black synthetic
marble; 240 cm SOT pl 94
Plant Composition II 1958
sandstone MAI 23
Woman Combing her Hair
(Figure che si Pettina)
1946 bronze; 29-1/2 BER-
CK 166 VEN-54: pl 72
BERTOS, Francesco (Italian)
Cyllarus Attached by Lapithae
marble; 30-1/2 c1725
SOTH-4: 266
Bertram (Prior of Durham fl 1189-
1212)
English--12/13th c. Seal of
Bertram
Bertulf, Abbot of Bobbio
Italian--8th c. Abbot Bertulf
Grave Slab: Plaited Orna-
ment
Berulle, Pierre de (French Cardinal
1575-1629)
Anguir, F. Cardinal de
Berulle, bust

Sarrazin. Cardinal de Berulle,
 effigy
Beside the Sea. Rodin
BESLIC, Ana (Yugoslav 1912-)
 Seated Figure 1953 terra-
 cotta BIH 178
 Torso 1954 plaster BIH 179
 Torso 1 1954 BERCK 237
BESNARD, Philippe (French 1885-)
 Birth of Aphrodite plaster
 VEN-34: pl 148
Bessarion, Cardinal
 Byzantine. Reliquary of
 Cardinal Bessarion
Best Man. Szczepkowski
Betrothals
 Early Christian. Bridal
 Casket of Secundus and
 Proiecta
The Betrothed, bust. Carpeaux
BETTO DI GERI See LEONARDI DI
 SER GIOVANNI
Betula. Marcks
BETZENBROECK, DeMeester de
 Bison, Leather Pavillion,
 International Exhibition,
 Brussels 1935 CASS 121
Beuret, Rose
 Rodin. Rose Beuret, head
BEUYS, Joseph (German 1921-)
 Stuhl mit Fett 1963 KULN
 80
BEVIS, L. Cubitt (English)
 A Daughter of Pakistan
 plaster HUX 89
 Miss Margaret Hindmarsh,
 head bronze NEWTEB
 pl 6
Bewcastle Cross. Anglo-Saxon
Bexhill Grave Slab. Anglo-Saxon
BEYNON, Eric (Swiss-French
 1935-)
 Object-Painting Number 37
 1960 wood, iron, steel,
 chair caning, nylon,
 sand, plastic; 60x100
 SEITA 142 FPSt
Beze, Theodore de (French Reforma-
 tion Leader 1519-1605)
 Bouchard, and Landowski.
 Reformation Monument
Bhat Tribe, India
 Milward. Bhat Woman, head
Bhil Tribe, India
 Milward. Bhil Man, head
BIAGINI, Alfredo (Italian 1886-)
 Camilla terracotta VEN-34:
 pl 95

Cercopiteco Russo bronze
 VEN-26: pl 39
Sleeping Ariadne (Arianna
 Dormiente) bronze VEN-32:
 pl 42
Biago, San See Blaise, Saint
Bianca. Messina
BIANCHI, Paul (Swiss 1920-)
 Cat (Chat; Katze) 1953 bronze;
 58 cm JOR-1; pl 28
 Coq (Hahn) 1954 bronze; 40
 cm JOR-1 pl 27
 Femme Debout (Stehende)
 1954 bronze; 44 cm JOR-
 1: pl 29
Bianchini, Mlle.
 Despiau. Mademoiselle
 Bianchini, head
BIANCINI, Angelo (Italian 1911-)
 Donna alle Fonte stone VEN-
 40: pl 81
 Lightening (Fulmine) 1958
 VEN-58: pl 16
Bianconcini Nunziante di Mignano,
 Countess
 Romagnoli. Countess Bian-
 concini Nunziante di
 Mignano
BIASI, Alberto (Italian 1937-)
 See GROUP N
BIBERACH FAMILY--ATTRIB.
 Kneeling Madonna with Two
 Angels INTA-2: 116
Bibiana, Saint
 Bernini, G. L. High Altar:
 St. Bibiana
Biblical Themes See also Jesus
 Christ; Mary, Virgin, and
 names of Biblical Characters
 and scenes
 Austrian--13th c. Door, panel
 details: Biblical Themes
 Delvaux. Truth Showing Holy
 Writ to Awaken Human Race
 Early Christian. Book Cover:
 Christian Symbols and
 Biblical Scenes
 Early Christian. Five-part dip-
 tych panel: Biblical scenes
 Early Christian. Reliquary
 Casket
 Early Christian. Sarcophagus:
 Biblical Scenes
 Early Christian/Egyptian.
 Book Cover: Biblical
 Scenes
 English--12th c. Capital:
 Biblical Scenes

French--12th c. Arcades with
 Biblical Figures
French--13th c. Amiens
 Cathedral, relief, west
 front
French--17th c. Cabinet on
 Stand: Scenes from Old
 Testament
German--9th c. Lindau
 Gospels
Italian--5th c. New Testa-
 ment Scenes
Master Nicholas, and
 Guillelmus. West Porch
Sternschuss. Biblical figures
Bibury Grave Slab. Anglo-Saxon
Bicycle Wheel
 Duchamp. Ready Made: Bi-
 cycle Wheel
Bicycles
 Charpentier, F. The Bicycle
 Picasso. The Bull, handle-
 bars and seat of bicycle
BIDDER, M. Joyce (English)
 Venite Adoramus, relief
 1942 Spanish chestnut
 BRO pl 1
Biddle, Nicholas
 Persico, E. L. Nicholas
 Biddle, bust
BIDERLE, Jan Michael (Jan
 Michel Bruderle) (Czech
 d1740)
 All Souls Altar: Angel 1725
 STECH pl 48 CzPTh
 Fount with Resurrection of
 Christ; Angels, heads
 1740 STECH pl 182-184
 CZPLo
BIDISCHINI, Primo (Italian 1907-)
 Medal VEN-52: pl 48
BIDUINUS (Italian)
 Architrave reliefs: Animal
 procession
BIENERT, Josef (Czech)
 Facade Figures 1707-12
 Stucco STECH pl 194
 CzKoL
BIENNAIS, Martin Guillaume (French
 1764-1832)
 Cream Jug 1809-10 silver
 gilt; 9 CHAR-2: 268 FPL
BIENNAIS, Martin Guillaume, and
 Pierre Benoit LORILLON
 Jam Dish 19th c. silver
 gilt; 13 CHAR-2: 265
 (col) FPL

BIESBROECK, Jules van (Belgian)
 Flagstaff Base bronze MARY
 pl 55 BG
 Grief TAFTM 79
 The People Mourn (Le Peuple
 le Pleure) MARY pl 35;
 TAFTM 79 FPLu
 To Our Dead, relief detail
 plaster VEN-3: pl 50
Biform. Calo
Big Bird. Fabbri
Big Ring. Annesley
Big Stripper. Davidson
Big Wood. Stahly
BIGARNY, Felipe (Felipe de Borgona)
 See VIGARNY DE BORGONA,
 Felipe
Biggar, Helen
 Scholtz. Helen Biggar, head
BIGUERNY, Philippe See VIGARNY
 DE BORGONA, Felipe
BILEK, Frantisek (Czech 1872-)
 Blind (Blind People) wood
 MARY pl 75; PAR-2:115
 Preghiera sulla Tombo wood
 VEN-10: pl 65
 Spiritual Meeting (Incontro
 Spirituale) wood VEN-26:
 pl 147
BILGER, Maria (Maria Biljan-Bilger)
 (Austrian 1912-)
 Group of Women 1950 terra-
 cotta; 8 SCHAEF pl 69
 Play Fountain, housing develop-
 ment DAM 212
 Women Carrying Water 1949
 ceramic; 10 SCHAEF pl 68
BILINSKI, Dominic (Polish)
 St. George and the Dragon
 limewood NORM 95
BILJAN-BILGER, Maria See BILGER,
 Maria
BILL, Max (Swiss 1908-)
 Construction 1937 Baveno
 granite; D: 71 TRI 262
 SwGrP
 Construction from a Ring
 1942/63 granite; 55x48x48
 LABC-4: 74; EXS 63 UNBuA
 Construction of 30 Identical
 Elements 1938/39 gilt
 brass GIE 226
 Construction out of a Circular
 Ring 1944/64 black granite;
 15-1/2x15-3/4 CHICSG
 UICA (1965. 355)
 Construction with circle 1940

polished black wood; 16
RAMS pl 98a -Mul
Construction with Suspended
 Cube 1908 MAI 23
Continuity (Kontinuitat) 1947;
 300 cm JOR-1: pl 93
--1947 concrete
DAM 142, 143; RAMT pl 63
 SwZA; SwZP
--1947 gypsum concrete;
 c 108 MCCUR 266
--1947 stainless steel
 MAI 24
--1947 stucco on steel;
 120 SCHAEF pl 123
--1947 reinforced iron plas-
 ter; 3 m OST 99 GZer
Continuous Surface in Form
 of a Column 1953-54 pol-
 ished brass; 104 ALBC-
 3: #72; BURN 145 UNBuA
Double Surface avec 8
 Aretes Courtes et 8
 Aretes Longues 1957-58
 JOR-2: pl 129
Double Surface sur la Base
 d'un Plan Circulaire 1957
 JOR-2: pl 128
Endless Loop, No. 1 1947-
 49 gilded copper, crystal-
 line base; 9-3/4x28x8
 MYBS 72; READCON 252
 UNNH
Endless Loop from a Circu-
 lar Ring, No. 2 1947-49
 gilded brass; 10x14-1/4
 x3-3/4 SELZS 135 UNN-
 Sar
Endless Ribbon (Ruban sans
 Fini; Unendliche Schiefe)
 1935-37 MOHV 225
--1935-53
 BURN 145 BAM
--1935-53
 JOR-2: pl 179
--1935-53; 1960 granite;
 1.5x1x1.2 m OST 98 FPM
--4th state 1935-53
 JOR-1: pl 94
Endless Torsion 1935-53
 bronze; 49 MID pl 97
 BAM
Georg Buchner Monument
 at Darmstadt, project
 JOR 2: pl 181
Group of Six Cells 1951 H:
 14-1/2 SEITC 49 UNNSt

Hexagonal Curses in Space
 1951 gold-plated bronze
 LARM 386 ELMa
Infinite Surface in the Form of
 a Column 1953 H: 61 BERCK
 175
--1953/55 polished brass; 79
 LYN 163
Monoangulated Surface in Space
 1957 JOR-2: pl 130; MEILD
 104
--1959 BURN 145 UMiD
Planes Defined by a Line
 1948/49 copper; 5-1/4x
 11-1/4x7-1/4 SCHAEF pl
 125
Rhythm in Space (Ritmo nello
 spazio; Rythme dans l'
 espace; Rythmus in Raum;
 Spatial Rhythm) plaster;
 60x20x58 ENC 95; GERT
 168; GIE 227; JOR-1: pl
 92; JOR-2: pl 179; KEPS
 151; PRAEG 467; VEN-58:
 pl 181
--1962 granite; 150x145x50
 cm LIC pl 256 UTxDC
Transition 1958 JOR-2: pl 183
--1958 chromed brass; 40x60
 x6 cm LIC pl 255
--1958 chromed iron; 23-1/4
 BERCK 175
Triangular Form in Space
 (Forme Triangulaire dans
 l'espace) 1956 JOR-2: pl 180
Triangular Surface in Space
 1956 BERCK 237; JOR-2:
 pl 179
--1962 29-1/2x72-1/2 CARNI-
 64: #221 UNNSt
Tripartite Unity 1947/58
 chrome-nickel steel; 46
 BR pl 17; GERT 169; MAI
 24; RIT 204; SAO-1; STA
 65; TAYJ 11 BrSpM
--1948 plaster, for steel; 48
 RAMS pl 99
22 1953/57 marble; 58-1/4
 JOR-2: pl 182; TRI 201
 marble; 58-1/4 JOR-2: pl
 182; TRI 201
--1965 19-1/2 (excl 6-1/4 base)
 x19-1/2 CARNI-67: #202
 UNNSt
Unit in Three Equal Volumes
 1965 black granite; 31
 GUGE 62 UNMos

McWilliam. Princess Macha
Marcks. Bird
Meadows. Bird
Meadows. Large Flat Bird
Merovingian. Fibulae: Birds
Miro. Bird
Moore, H. Bird and Egg
Orloff. Bird
Orloff. Spandril-pieces:
 Bird; Fish
Peat. Bird
Poot. The Bird
Russian--7th c. Clasp: Birds
 and female figures
Russian--11/12th c. Pendants:
 Horseman with Bow; Bird
Stahly. Combat of Birds
Tjomsland. Birds of the
 Northland: Ptarmigan,
 Tern, Penguin
Viking. Bear; Bird
Birds Erect. Gaudier-Brzeska
Birdsman Aquarium. Arp
Birgitta, Saint
 German--15th c. St. Birgitta
Birth. Stahly
Birth (Geboorte). Jespers, O.
Birth of Structures. Kemeny
The Birth of Venus. MacMillan
Bisham Crucifix. Gill, E.
Bishop of Kuban. Paolozzi
Bishops
 Belgian--16th c. Reliquary:
 Bishop, bust
 English. Bishop, head
 English--13th c. Figures,
 west front: Knight, Lady,
 Bishop, King
 English--15th c. Bishop's
 head
 French--14th c. Burgundian
 Bishop
 French--15th c. Burgundian
 Bishop
 German--12th c. Bishop,
 head
 German--16th c. Bishop
 Saint
 Italian--14th c. Bishop
 Rhenish. Bishop-Saint
 Swiss--13th c. Bishop with
 angels
Bishop's Chair
 Byzantine. Throne of Maximi-
 an
Bishop's Throne. English--14th c.
Bismark, Otto von
 Lederer, H. Bismark#

Bison See Buffaloes and Bison
Bissen, Emilie Hedvig (Moller) 1808-
 50
 Bissen. Emilie Bissen
BISSEN, Hermann Wilhelm (Danish
 1798-1868)
 Ellen Oxholm, head 1851
 marble; 56 cm COPGM 11
 DCN (I.N.2584)
 Emilie Hedvig Bissen 1851
 plaster; 129.5 cm COPGG
 107; COPGM 15 DCN
 (I.N.1947)
 Ida Wilde, bust 1863 marble;
 58.7 cm COPGM 19 DCN
 (I.N.2748)
 N. A. Holten, head 1834
 marble; 54.2 cm COPGM 7
 DCN (I.N.2747)
 Siddende Mand i Toga 1839 H:
 12.8 cm COPGM 21 DCN
 (I.N.2631)
BISTOLFI, Leonardo (Italian 1859-
 1933)
 Brides of Death, relief,
 Vochieri Tomb CHASEH 478
 The Dream (Il Sogno) plaster
 VEN-1: pl 55
 Garibaldi Monument 1887
 TAFTM 87 ISanR
 The Memories Comforting Sor-
 row, relief MARY pl 45 IT
 The Offering TAFTM 88
 Resurrection, Hermann Bauer
 Monument 1904 TAFTM 86;
 VEN-5: pl 80 SwG
 Sebastiano Grandis Tomb: The
 Beauty of Death POST-2:
 204; TAFTM 87 IBSC
 Segantini Monument: Spirit of
 The Snowy Alps TAFTM 87
 SwSMo
 Senator Orsini Monument:
 1905 TAFTM 86 SwG
 --The Cross VEN-5: pl 30
 The Sphinx TAFTM 86
Bitterns
 Kandler. Bittern
BIZACCHERI, Carlo and Maratti
 BIZACCHERI
 Triton Fountain 1710 marble
 KO pl 90 IRBoc
BJERG, Johannes C. (Danish)
 Two Decorative Panels AUM
 94
Bjornson, Bjornstjerne (Norwegian
 writer and political leader 1832-
 1910)

Lerche. Bjornstjerne Bjornson,
 bust
Vigeland. Bjornstjerne Bjorn-
 son, bust
Black and White Sculpture. Malich
Black Angel. de Szcaytt-Lednicka
Black Angel. Pullinen
Black Beast. Chadwick
"Black Boy" ("Virginian"). Folk Art--
 English
Black Crab. Meadows
Black Cut. Leoncillo
Black Horses. Dierkes
Black Panther. Constant, J.
Black Panther. Cuairan
Black Portrait. Signori
Black Prince See Edward, Prince
 of Wales, 1330-76
Black Venus. Italian--16th c.
Black Virgin. French--12th c.
Black Virgin of Dijon. French--
 11th c.
Blackamoor. Venetian
Blacksmiths
 Bouchard. Blacksmith in
 Repose
 Byzantine. Adam and Eve
 Doing Blacksmith's Work
 French--15th c. Blacksmith
 at his Anvil
 German--16th c. St. Eligius
 Meunier. The Smith
Blackstone, William
 Bacon, J. Sir William Black-
 stone#
BLAESER, Gustav (German)
 Humboldt, bust 1869 bronze
 SALT 60 UNNCent
Blaise, Saint
 German--12th c. Portable
 Altar: Martyrdom of St.
 Blaise
 Italian--12th c. Horn of St.
 Blasius
 Italian--12th c. Legend of
 St. Blaise, relief detail
BLAKE, Vernon (English 1875-
 1936)
 Le Plan d'Orgon War
 Memorial AUM 152 FPlan
 --Liberty PAR-1:68
 War Memorial AUM 153 FLau
Blake, William
 Epstein. William Blake, bust
Blanc, Anita
 Fazzini. Anita Blanc, bust
Blanc, Francesca. Manzu.
 Francesca Blanc

Blankenberg, Klaas
 Baberton. Klaas Blankenberg,
 Hottentot Man, head
Blanqui, Louis Auguste (French
 Revolutionary 1805-81)
 Maillol. Chained Action
Blasius
 Lackner. Rupertus; Blasius
Blauw--Rood--Geel. Bonies
BLAY, Miguel (Spanish 1866-)
 Chavarri Monument:Laborers
 CHASEH 488 SpBil
BLECHER, Wilfried (German 1930-)
 Zeitspiele 1964 mixed media;
 27-1/8x20-1/8 NEW pl
 302
BLEEKER, Bernhard (German 1881-)
 Gefallenendenkmal 1925 L:
 3.5 m HENT 77 GM
 Olaf Gulbransson, head 1932
 bronze; LS HENT 75
BLEKER, Arno (German)
 The Leader, head bronze
 CASS 34
Blessed
 French--12th c. Procession
 of the Blessed
"Blessed are those who weep",
 Beatitudes figure. Braun, M. B.
Blind See also Jesus Christ--Miracles
 Bilek. Blind
 Cruz Solis. Head of a Blind
 Man
 Dubuffet. Blind Man
 French--13th c. Blind Death
 French--13th c. Blind Led by
 Day
 Frink. Blind Man and Dog
 Gatto. The Blind
 Lishansky. The Blind
 Robert-Jones. Blind Man
 Touret. Parable of the Blind
 Wrampe. Blinder mit Hund
 Zanetti. The Blind and Orphans
 of War
BLIND SCULPTOR--congenitally blind,
 age 17
 Youth Imploring 20th c.
 READAS pl 36b
BLIND SCULPTOR--congenitally blind,
 age 18
 Pain 20th c. clay READAS pl 37b
BLOC, Andre (Algerian-French 1896-)
 Brass Sculpture 1959 H:27-5/8
 MAI 25; TRI 211
 Combination in White and Black
 Marble 1953 H:20 BERCK
 121 -V
 Construction 1953 plaster;
 24x12 GIE 238

Double Interrogation 1958
 bronze; 27-5/8 LARM
 325; READCON 213
Flight 1959 bronze MARC 55
Garden Bench DAM 206
Sculpture 1956 BERCK 121
Signal, Place de Jena, Paris
 1950 concrete; 40'
 SCHAEF pl 126
Signal 1959 bronze; 117
 LOND-5:#5 IMGr
Stained Glass Chapel Wall
 DAM 76 FBio
Structure 1950 concrete; 120
 SCHAEF pl 127
Unhuman Form 1954/55 white
 synthetic stone; 51 MID
 pl 102 BAM
BLOMBERG, Stig (Swedish 1901-)
 Children Running bronze;
 31x55 MID pl 76 BAM
 The Dance 1945 Scotch rose
 stone; 16 MID pl 75
 BAM
 Flores e Blanzeflor bronze
 VEN-42: pl 89
 Prince William of Sweden,
 bust bronze CASS 46
BLOMMENDAEL, Jan (Dutch
 c1650-c1703)
 William III, in Royal robes
 with chain of Order of
 the Garter, bust 1699
 marble; 31-1/2 VICOR
 pl 28 NHM
Blond Negress
 Brancusi. The White Negress
BLONDEAU See Boucher, F.
 Bagpipe Player
BLONDEL, Francois (French 1618-
 86)
 Porte Daint-Denis 1671 GAF
 119 FP
Blood Horse, head. Skeaping
Blue Tit
 English--18/19th c. Derby
 Blue Tit
Bluebirds
 Milles. Aganippe Fountain:
 Poet carrying a bluebird
Bluemner, Rudolf
 Wauer, W. Rudolf Bluem-
 ner, head
BLUMENTAL, Hermann (German
 1905-42)
 Adam 1931/32 bronze; 31-
 7/8 BOSME pl 96
 GDusV

Campagna Shepherd (Campagna-
 hirts) 1937 bronze; 46 cm
 GERT 80; OST 70 GMaM
Grosser Schwemmereiter 1939
 bronze; 70x66 cm OST 71
 GFSt
Kleine Kniende mit Erhobenen
 Armen 1934 bronze; 19.5 cm
 SP 22 GHaS
Kneeling Youth (Grosser
 Kniender) 1929/30 bronze;
 40-1/2 NNMAG 179; OST
 69 GBN
Man Sitting on a Stump 1931/
 32 bronze; 40-1/2 RIT 97
 GHB
Meditating Youth 1929 bronze;
 68-1/2 TRI 82 GDuK
The Prodigal Son 1933 plaster;
 22 SCHAEF pl 30
Standing Figure 1936/37 bronze;
 75 NNMMAG 180; OST 68
 GHaL
Woman at the Fountain, relief
 1934 plaster; 24x16
 SCHAEF pl 31
Young Man Seated MAI 26
Zwei Reiter, relief 1938
 bronze; 38.5/39-41.3x45
 SP22 GHaS
BLUNDSTONE, F. V.
 Atlanta MARY pl 36
 War Memorial MARY pl 39
Boabdil (Ruled Granada as Mohammed
 XI d 1533/34)
 Abu-Abdullah, called El Chico
 Vigarny de Borgona. Royal
 Chapel Altar: Abu-
 Abdullah leaving the
 Alhambra
Boadicea. Thornycroft
Boardwalk. Ray
Boats See Ships
BOBERG, Ferdinand (Swedish)
 Chest VEN-5:pl 96 SnSSv
 Portraits
 Milles. Ferdinand Boberg,
 bust
"Boboli Captive"
 Michelangelo. Julius II Tomb:
 "Boboli Captive"
Bocche di Leone
 Italian--16th c. Mouths of
 Truth "Bocchi di Leone":
 Masks
BOCCIONI, Umberto (Italian 1881-
 1916)
 Abstract Voids and Solids of a

Head (Concave and Convex
Abstraction of a Head;
Vuoti e Pieni astratti di
una Testa) 1912 plaster
(work destroyed) CARR 43;
GIE 84; ROSE pl 196
Antigrazioso (Anti-graceful;
Antigracieux; The Artist's
Mother; The Mother;
Ritratto Antigrazioso;
Unflattering Portrait),
head bronze MARY pl 120
--1911 bronze; 28
GIE 85; RAMS pl 67b
IRMari
--1911 ptd plaster; 58 cm
SCUL pl 4 IRMo
--1912 bronze; 22-7/8x19-
5/8x15-3/4 MAI 27;
READCON 119; SELZJ
217 IRN
--1912 bronze; 24 BERCK
40; BOW 125; CAS pl
145; LIC pl 220 UMiBiW
--1913 bronze SAL pl 4 (col)
The Bottle 1911 MOHV 221
Development of a Bottle in
Space (Evolution of a Bot-
tle in Space; Sviluppo di
una Bottiglia nello Spazio)
1912 bronze VEN-66:#7
--bronze; 15 BURN 27;
CARR 40; GIE 89; HAMP
pl 106; LIC pl 222; LYN
96 (col); MCCUR 263;
MYBS 70; NMAC pl 47;
READCON 121; RIT 136;
SAL pl 2 (col); SELZJ
217; SELZS 44; SOBYT
pl 12; TRI 165 UNNMMA
--1912/13 bronze; 12 RAMS
pl 68; SCUL pl 5 IMAM
--1912/13 bronze; 15x24
BERCK 42; BOW 126;
CANM 501; COOP 295
UMiBiW
Dynamic Construction of a
Gallop--Horse--House
1912/13 metal, wood,
and cardboard; 28 GIE 65
IRMari
--1913 metal, wood, and
cardboard; 44x32 CALA
92 IVG
Empty and Full Abstracts of
a Head 1913 bronze SAL
pl 3

Expansione spira lica di Muscoli
in Movimento 1913 plaster
CARR 43 IRMari
Fusion of a Head and a Window
(Fusione di una Testa e di
una Finestra) 1911 mixed
media, including plaster and
wood (Destroyed) CARR 41;
SEITA 28
Horse (Cavallo) 1911 metal and
cardboard RICHT pl 91
Horse+Rider+House 1914 ptd
wood and cardboard; 31-1/2
x43-1/4 READCON 117 (col)
IVG
Lignes-Force d'une Bouteille
MARY pl 120
Marching Man 1913 MOHV 237
Motion in Space bronze PRAEG
458
Muscles in Action (Muscles in
Motion; Muscles in Rapid
Motion; Muscoli in Velocita)
1911 ROOS 280F IMAM
--1913 plaster CARR 43 IMAM
--1913 bronze GIE 87; SAL
pl 1
The Origin of Movement in
Space 1913 STA 215
Single Form of Continuity in
Space 1913 bronze; 45
RAMS pl 69a
Synthesis of Human Dynamism
(Sintesi del dinamismo
umano) 1912 plaster CARR
39; SAL pl 5; SELZJ 218
IMAM
Testa+Casa+Luce 1911 polima-
terico CARR 36
Unique Forms of Continuity in
Space (Continuity in Space;
Forme Uniche della Con-
tinuita nella Spazia; Formes
Unique de la Continuite dans
l'Espace; Urform der
Bewegung in Raum) 1913
bronze; 43-1/2 BAZINW
432 (col); EXS 64; LIC pl
221; VEN-60: pl 9 IMM
--1913 bronze; 43-1/2 BOSME
pl 26; BR pl 15; BURN 29;
CANM 473; CARR 42; CAS
pl 144; COOP 302; ENC
105; GARDH 758; GERT
129; HAMP pl 107; JANSH
533; JANSK 1017; KUHB 51;
LARM 255; LOWR 233;

LYN 89 (col); LYNCMO
8; MARY pl 121; MCCUR
263; MU 252; NEWTEA
244; NMAC pl 49; NNMMM
101; PUT 47; READCON
118; RIT 134-5; ROOS
280E; ROSE pl 195; SAL
pl 6 (col); SELZJ 207
(col); SOBY pl 13; STI
747; UCIT 5; UPJH pl
242 UNNMM
--1913 bronze; 48-1/2 (with
base)x34 BERCK 43; BOW
130; COOP 302 UMiBiW
Boccioni's Fist--Lines of Force.
Balla
Bode, Wilhelm von
Klimsch. Wilhelm von Bode,
head
BODINI, Floriano (Italian 1933-)
Mrs. E. C. Clarke, head
1960 bronze VEN-62: pl
77
Bodley, Thomas
Stone. Thomas Bodley
Monument
BODMER, Walter (Swiss 1903-)
Bemalte Drahtplastik 1951
JOR-1: pl 108
Eisenplastik 1958 iron; 85
cm OST 95 SwBFe
Floating Sculpture 1953 wire
and tin, ptd red; 11
GIE 217 SwBeF
Metal Relief 1959 33-1/2x
27-5/8 READCON 242
SwZL
Metal Sculpture 1955 MAI
28
Relief aus Draht und Blech
1954 JOR-1: pl 110
Relief Metalique Rouge 1958
JOR-2: pl 162
Relief Tri-etage en Metal
1957 JOR-2: pl 187
Rote Schebeplastik 1953 H:
30 cm JOR-1: pl 111
Schwebeplastik 1955 metal
JOR-1: pl 109
Sculpture* EXS 43
Sculpture 1956/57 iron; 54
MID pl 96 BAM
Sculpture 1957/58 iron; 23-
3/4x58-1/4 TRI 199
Sculpture in Iron (Sculpture
en Fer) 1955/57 JOR-2:
pl 164

--1955/57 H: 54 BERCK 176 BA
--1957/58 JOR-2: pl 188
--1958 JOR-2: pl 163
--1958 H: 33 BERCK 176
Sculpture in Metal 1956 JOR-2:
pl 185
--JOR-2: pl 186
Wire Composition 1936 7x11
GIE 216
Wire Painting 1951 BRION pl
110A SwBK
Wire Painting in the Round
1938 MOHV 232
BODNAROV, Stevan (Yugoslav 1903-)
Painter Ljubica Sokic, head
1946 bronze BIH 119
Painter Pjer Krizanic, head
1946 bronze BIH 118
BOEHM, Joseph Edgar (Hungarian-
English 1834-90)
Duke of Wellington Monument:
Grenadier of the First
Guards 1888 GLE 59 ELHy
Thomas Carlyle, bust detail
1861 BOASE pl 61D ScENP
Thomas Carlyle, seated figure
BROWF-3: 83 ELE
BOETTI, Alighiero (Italian)
Senza Titolo 1966 KULN 129,
146
BOGACZYK, Wincenty (Polish)
Madonna wood MARY pl 180
PW
BOGAERT, Martin van den See
DESJARDINS, Martin
Bogenschutze. Wackerle
BOGGILD, Mogens (Danish 1901-)
Leda and the Swan VEN-36: pl
39
BOGLIONI, Umberto
Ginnasta Boy VEN-34: pl 57
BOGOMIL
Monument to the Little Voivode
12th c. BAZINW 232 (col);
YR
BOGONI, GINO (Italian 1921-)
Sviluppo Tridimensionale 1966
bronze VEN-66: #103
Bohemia, Queen of
Austrian, or Southern German.
St. John Nepomuck Confess-
ing the Queen of Bohemia
BOHEMIAN
Krumlov Madonna, Cesky Krum-
lov c1400 ptd limestone;
44 MAR 36 CzPN
Boigne, Benoit Le Borgne, Count of

Spalla. General de Boigne, bust
BOILEAU, Martine (French 1923-)
Sculpture MAI 28
Boileau-Despreaux, Nicolas de
(French Critic and Poet 1636-1711)
Girardon. Nicholas de
Boileau-Despreaux, bust
Boimow Mausoleum. German--17th c.
Bois Polychrome
Folmer. Polychromed Wood
BOISECQ, Simone (Algerian 1922-)
The Tree 1953 cement MAI 29
Boite-en-Valise. Duchamp
BOIZOT, Louis Simon (French 1743-1809)
Apollon Musagete c1786
Sevres LIC pl 29 FSevM
Louis XVI, bust marble; 34
HUNT pl 36 UCSmH
The Toilette of Madame
Sevres SPA 53 UMdBW
BOKROS-BIRMAN, Dezso (Hungarian 1889-)
Self-Portrait, head bronze;
32 cm GAD 78 HBA
BOLDOGFAI-FARKAS, Sandor
(Hungarian 1907-)
Prof. Ferenc Czeyda-Pommersheim, medal 1953
bronze; Dm: 8 cm GAD 129 HBA
BOLDRIN, Paolo (Italian 1891-)
King of Italy (Victor
Emmanuel III) ptd plaster
VEN-38: pl 1
BOLDU, Giovanni Zuan (Italian fl c1454-75)
Self-portrait, medallion
1458 GOLDF pl 58 GBSbeM
Youthful Caracalla, medallion 1466 VER pl 42 UMB
BOLDUQUE, Roque (Spanish 16th c.),
or Guillen FERRANT
Two Prophets wood; 40;
and 39-3/4 DETT 176
UMiD (45.19; 45.20)
BOLGI, Andrea (Italian 1605-56)
St. Helena 1629/39 ENC
108; WIT pl 113A
Bolivar, Simon (Venezuelan Patriot 1783-1830)
Cora. Simon Bolivar, equest

Bollard for a Canal Barge. Kennington
BOLOGNA, Giovanni (Italian 1524-1608), also known as Giambologna; Jean de Bologne; Jean de Boulogne; Jehan de Boullogne.
See also Ammanati, B. ;
Primaticcio, Francesco
Allegory of Astronomy 1573 gilt
bronze; 34.9 cm (excl base)
BSC pl 93 GBS (M71)
Altar of Liberty; detail:
Christ POPRB fig 73; pl
84 ILuC
Apennine Figure POPRB fig
100 IPrDe
--1577/81 BAZINW 365 (col);
BUSB 26 IPraM
Apollo STA 179 IFMN
--1573/75 bronze; 34-1/2
MAR 94 (Col); POPRB pl
79 IFV
Architecture POPRB fig 130 AVK
Astronomy bronze gilt; 24-
1/2 CLAK 138; HAMF 266;
IO pl 81; LARR 196 AVK
Bacchus bronze; 228 cm POPRB
fig 52; pl 80 IFJ
Bather bronze CHENSW 395
IFBar
Bird Catcher (Birdman;
Uccelatore) bronze; 10-3/4
NCM 46; ROTHS 177
Charity bronze; 175 cm POPRB
pl 88 IGenU
Cosimo I, equest 1587/94
bronze; c450 cm BAZINW
364 (col); MACL 245;
POPRB pl 90 IFSi
--Marching Soldiers bronze;
c12 MOLE 170 (col)
Cosimo I Receiving Homage,
relief POPRB fig 89 IFSi
Crouching Ape (Hockender
Affe) 1569/70 bronze; 42 cm
BSC pl 94, 95 GBS (3/36)
Crouching Venus bronze; 9-
7/8 HUNT pl 5; HUNTA
pl 15; SUNA 83 UCSmH
Doors, panel: Visit of the
Magi FREEMR 154 IPisaC
Eagle BARG IFBar
Ecco Home, relief bronze;
37x31 cm POPRB pl 87
IGenU
Ferdinand I, equest 1601/08
POPRB fig 137 IFAnn

Florence Triumphant over
Pisa POPRB fig 51 IFMN
--gesso model POPRB fig 50
IFA
--wax model POPRB fig 49
ELV
Fountain Figure, study 16th
c. terracotta; L:19
READAS pl 132, 133 ELV
Grotto c1540 BAZINW 365
(col) IFCas
Hercules and Antaeus terra-
cotta; 40x12x15 NCM 276
UNNMM (13.149.7)
--late 16th c. bronze INTA-1:
100
Hercules and Nessus RAY 45
ELV
Hercules and the Boar BARG
IFBar
Hercules and the Centaur
1600 marble; 106 MOLE
167; POPRB pl 91 IFL
Hercules Subduing the
Cretan Bull bronze; 23x
23-3/4 TOR 129 CTRO
(939.4.1)
Kneeling Man c1579 bronze;
11-3/4 DETD 129 UOTL
Leaping Horse bronze; 11-1/2
BERL pl 203; BERLES
203 GBSBe (279)
Mars bronze CLE 100 UOClA
(64.421)
Mercury (Flying Mercury;
Mercury Taking Flight),
winged feet and helmet,
caduceus bronze HUYA
pl 50; HUYAR 19; LOUM
90; RAY 45 FPL (379)
Mercury bronze; 24-5/8
EXM 282 AVK
Mercury bronze; 69-5/8x
19-3/32x37-5/16 SEYM
142-3, 144-5; TAYJ 25;
USNI 229; USNP 167;
WALK UDCN (A-20)
Mercury 1567 bronze ROTHS
177
Mercury c1572 bronze; 69
ARARC 78; BARG;
BARSTOW 166; BAZINW 364
(col); BR pl 8; CHENSW
394; CIAK 214; FREEMR
148; GARDH 371; GOMB
269; JANSK 695; LYNCM
13; MACL 240; MONT 36;
MU 159; MYBA 445;

ROOS 116D; ROTHST pl 14;
SEW 673; SIN 308; UPJ
327; USNI 229 IFBar
Miracle of St. Antoninus, re-
lief POPRB fig 88 IFMa
Monkey H:17 DETD 128 UNNLin
Neptune Fountain 1563/67
bronze; 152 BAZINW 363
(col); BUSB 18, 20; HAUS
pl 280; LARR 196; MOLE
167; POPRB fig 94; pl 81;
ST 306 IBoN
Nessus and Deianira bronze;
16-3/8 HUNT pl 6-8, 10;
HUNTA 15 UCSmH
Putto BARG IFBar
Oceanus Fountain 1567/70
CHASEH 346; MAR 95 (col);
POPRB fig 95 IFBo
--Euphrates LARR 202; POPRB
pl 83
Rape of a Sabine Woman POPRB
fig 55 INMC
Rape of the Sabine Women
PRAEG 273
--bronze GAUN pl 52 ELV
--bronze; 24 RAMS pl 23a-b
AVK
--bronze; 24 FAIN 164
UMWelC
--bronze; 75x90 cm POPRB
pl 86 IFL
--1583 marble; 13-1/2 AUES
pl 23; BAZINW 364 (col);
BR pl 6; CHASEH 347;
CHRP 204; FREEMR 150;
JANSH 384; JANSK 696;
KO pl 81; MACL 243;
MOLE 167; POPRB pl 84;
POST-1:240; ROBB 384;
ST 307; UPJ 328; UPJH
pl 152 IFL
--(cast) 1524/1608 bronze; 23
CHAR-2:100 FPL
--wax model# POPRB fig 53,
fig 54 ELV
River God c 1570 MONT 36
IFBar
--model terracotta; 13x14-1/2
ASHS pl 25; HAMF 19;
POPRB fig 99 ELV
Salviata Chapel; detail: Angel
POPRB fig 75, pl 89 IFMa
Samson GAF 18 FDouM
Samson and the Philistine 1568
marble; 210 cm BUSB 22;
ENC 108; HAMF 19; HAUS
pl 279; POPRB pl 82 ELV

Strutting Turkey Cock c1567
bronze; 19-1/4 BARG;
MONT 392
Venus late 16th c. bronze; 12-
1/2 SOTH-1:212
Venus, Fontana di Donzella c
1580 bronze; 49 BAZINH
262; BAZINW 363 (col);
BUSB 23; CANK 42;
NCM 47 IFPe
Venus Fountain in Boboli Gar-
dens after 1583(?) bronze;
42 DETD 128; NCM 276
UCLCM (5141, 51, 20)
Venus Bathing BARG IFBar
Venus Fountain (Fontana di
Venere), detail HAUS pl 281
IFBo
Virtue Vanquishing Vice
HAUS pl 278 IFBar
BOLOGNA, Giovanni, and Pietro
TACCA
Philip III, equest LARR 296
SpMP1M
BOLOGNA, Giovanni--FOLL.
Diana, Doccio porcelain figure,
copied from bronze ENC
250
Falcon bronze; 13-1/2 UMCF
UMCF (1934.1160)
BOLOGNE, Jean de See BOLOGNA,
Giovanni
Bolognetti, Pietro and Francesco
Aprile. Pietro and Francesco
Bolognetti Tombs, model
Cavallini. Tomb of Pietro and
Francesco di Bolognetti
Bolted flat. Hoskin
Bolton, Matthew
Flaxman. Matthew Bolton
Monument
BOLUS, Michael (South African-
English 1934-)
Number One 1965 ptd steel
LOND-7:#6 ELRub
Untitled 1965 KULN 136
Bomb Victim. Andiessen
BON, Giovanni Bartolomeo (Italian
c1400-c1464)
Porta della Carta, main
entrance 1438/41 MURA
91 IVP
Le Bon Dieu. Ipousteguy
BONACAISI, Pier Giacomo Ilaria
See ANTICO, L'
BONALUMI, Agostino (Italian 1935-)
Senza Titolo 1967 KULN col
pl 10 (col)

BONANUS OF PISA (Italian fl 1160-86)
Doors, detail 1186 bronze
ROOS 65A IMonrC
--Adam and Eve with Their
children ENC 109
--Baptism of Christ STA 147
--Cain and Abel ENC 638
Porta San Ranieri: Life of the
Virgin CHENSW 323, 368;
DECR pl 57; ROOS 65C
IPisaC
--The Fall c1160 bronze
BUSRO pl 127
--The Magi BUSR pl 127;
DECR pl 58; LARR 28;
ROOS 65C
--Nativity BAZINW 283 (col)
Bonaparte, Charlotte
Bartolini. Charlotte Bonaparte,
bust
Bonaparte, Jerome (Brother of Napole-
on I of France 1784-1860)
Clesinger. Jerome Bonaparte,
head
Bonaparte, Maria Letizia (Mother of
Napoleon I of France 1750-1836)
Canova. Letizia Bonaparte,
seated figure
Bonaparte, Pauline See Borghese,
Maria Pauline Bonaparte
Bonarelli, Costanza
Bernini, G. L. Costanza
Bonarelli, bust
Bonbonnieres
Chelsea Porcelain. Bonbon-
nieres
German--18th c. Horse's Head
Bonbonniere
Bonds. Hajdu
BONES, Phyllis M. (Scottish)
Working Partners bronze; L:
33 NEWTEB pl 14 -Mu
Bones. Kunst, M.
BONIES (Dutch 1932-)
Blauw-Rood-Geel 1966/67
KULN 140
Untitled 1966 KULN 140
Boniface, Saint
Rhenish--16th c. St. Boniface
Riemenschneider. St. Boniface
Boniface VIII (Pope 1235-1303)
Arnolfo da Firenze. Boniface
VIII, bust
Arnolfo di Cambio. Boniface
VIII#
Arnolfo di Cambio. Boniface
VIII
Monument

BONINO DA CAMPIONE (Italian fl
　1357-88)
　　Bernabo Visconti Monument,
　　　equest before 1363 POPR
　　　fig 76, pl 60; VALE 96;
　　　WHITJ pl 190 IMS
　　Cansignorio della Scale Monu-
　　　ment begun before 1375
　　　marble POPG fig 77, pl
　　　59; WHITJ pl 191 IVeM
　　Justice marble; 25-1/2x7-
　　　3/4 USNKP 384 UDCN
　　　(K-310)
　　Prudence marble; 20-5/8x7-
　　　1/2 USNKP 385 UDCN
　　　(K-311)
BONNARD, Pierre (French 1867-
　1947)
　　Girl Bathing bronze; 10-
　　　1/2 READCON 28 UNNH
　　Sitting Nude bronze SELZJ
　　　187
　　Standing Nude bronze
　　　SELZJ 187
BONNESEN, Carl J.
　　En Barbar, equest bronze
　　　MARY pl 124 DC
　　The Captive bronze MARY
　　　pl 132 DCSt
　　Life and Death bronze
　　　MARY pl 132 DCH
BONOME, Santiago P. (Spanish)
　　Carrettiere wood VEN-26:
　　　pl 169
　　Child's Throne VEN-28: pl
　　　162
　　Priest and Worshiper wood
　　　MARY pl 174 SpMaN
BONTEMPS, Pierre (French 1505-
　68) See also DE l'ORME, P;
　MARCHAND, F.
　　Charles de Maigny, effigy
　　　1557 BUSR 212 FPL
　　Francis I, tomb relief before
　　　1555 BUSR 213; JAL-4:
　　　pl 15 FPDe
　　--Battle of Marignan GAF 96
　　Monument for the Heart of
　　　Francis I 1550 BLUA pl
　　　56B FPDe
　　Philip Chabot, Comte de
　　　Brion, Admiral of France,
　　　effigy 1570/72 marble
　　　LOUM 71 FPL (320-323)
　　Queen Claude, effigy 1548/51
　　　BAZINW 381 (col); JAL-
　　　4: pl 14 FPDe

Book Clasps
　Anglo-Saxon. Metal Ornaments
Book Covers
　Anglo-Saxon. Gospels of Judith
　　of Flanders
　Anglo-Saxon. Ms 708 Book
　　Cover
　Belgian--11th c. Book Cover
　--Psaltar Cover: Lothair I
　Byzantine. Archangel Michael,
　　Book Cover
　Byzantine. Book Cover
　Byzantine. Enthroned Christ,
　　affixed to Book Cover
　Byzantine. Gospel Cover#
　Carolingian. Christ in Glory,
　　Book Cover
　Carolingian. Christ the Con-
　　querer, Book Cover
　Carolingian. Cover of Psalter
　　of Charles the Bold
　Carolingian. The Crucifixion,
　　Book Cover
　Castellani. Gospel Book Cover
　Celtic. Book Cover(?),
　　Crucifixion
　Dutch--10/11th c. Evangeliare
　　de Maestricht Cover
　Early Christian. Book Cover#
　Early Christian. Dagulfe Psalter
　　Cover
　Early Christian. Gospel Cover
　　Gauzelin of Toul
　Egbert of Treves--Foll. Codex
　　Aureus of Echternach: The
　　Crucifixion
　French--9th c. Book Cover
　--Evangeliary of St. Gauzelin
　--Gospels Manuscript Cover
　French--9/10th c. Book Cover:
　　Mass; Sacraments
　French--10th c. Christ in
　　Majesty, Cover of Gospel
　　of Marchiannes
　--Gospel of Gauzelin Cover
　French--14th c. Gospels of
　　the Sainte Chapelle Cover
　German. Book Cover: Baptism
　　of Christ
　--Carolingian Book Cover:
　　High Mass
　German--9th c. Codex Aureus
　　Epternacensis
　--Codex Aureus of St. Emmeram
　--Codex Monacensis Cover
　--Lindau Gospels
　German--10th c. Gospel Cover:

Prophet, altar detail, Brussels 1520 oak: 27x36 cm
BERLEK pl 36 GBSBe
(8086/87)
Reredos wood ROOSE 34
BLouN
BORMAN, Jan, the Elder--ATTRIB
St. John Oak HAMF 291
BLouP
BORMAN, Jan, the Elder, and
Pieter de BACKERE
Mary of Burgundy, effigy
1491/98 BUSR 118; DEVI-
2; MULS pl 161A; ROOSE
151 BBrN
BORMAN, Jan, the Elder--FOLL
Crucifixion Group c1490 oak
SOTH-2:215
BORMAN, Jan, the Younger (Flemish fl 1500-20)--FOLL
Reredos of the Nativity oak;
88x72 TOR 117 CTRO
(937.8)
BORREMANS, Jan See BORMAN,
Jan
Borro, Luigi
Lorenzetti. Luigi Borro,
bust
Borromeo, St. Carlo (Italian Ecclesiastic 1538-84)
Asam, E. Q. St. Karl
Borromaus
Braun, M. B. Holy Trinity
Column: St. Charles
Borromeo
Borromeo, Orietta
Lednicka Szczytt. Countess
Orietta Borromeo, head
BORROMINI, Francesco (Italian
1599-1667) See also Bernini,
G. L.
Bell Towers 1645/65 BOE pl
159 IRAndr
Facade, detail 1667 BOE pl
160 IRCar
Facade window, next to Arcaded Centre c1630 WIT
pl 68A IRBar
BORSOS, Miklos (Hungarian 1906-)
"Canticum Canticorum" 1963
Carrara marble VEN-66:
#220
Herkules Segers 1951 bronze;
Dm: 10.5 cm GAD 130
HBA
Jozsef Egri, bust 1951
marble; 33 cm GAD 109
HBA

Rembrandt, medal 1951 bronze;
Dm: 13.5 cm GAD 130 HBA
Tihany Shepherd 1952 marble;
50 cm GAD 108 HBA
Vivaldi, medal 1953 bronze;
Dm: 10.6 cm GAD 132 HBA
BORTOLOTTI, Timo (Italian 1887-)
Fulcieri Paulucci de Calboli,
half figure wax VEN-40: pl
8
Vittoria Fra Iventi, relief
plaster VEN-42: pl 39
BOSIO, Francois Joseph (French
1769(?)-1845)
Apotheosis of Louis XVI
1825 marble; 225 cm
HUBE pl 50; LIC pl 51
FPChapE
Aristaeus 1812 marble HUBE
pl 51 FPL
Catherine of Westphalia 1812
marble HUBE pl 47 GArN
Charles X, bust 1824 marble
HUBE pl 58 FV
Empress Josephine bust
plaster HUBE pl 39 FRuM
Empress Josephine, bust
plaster HUBE pl 41 FDM
General Charette, bust 1819
marble HUBE pl 59 FV
Henry IV as a child silver
HUBE pl 53 FPL
Hercules Battling Serpent-
Form Achelous bronze
HUBE pl 49 FPTu
Hyacinth 1817 marble HUBE
pl 54 FPL
Jerome of Westphalia 1812
marble HUBE pl 48 FAjN
King of Rome as a Child 1812
marble HUBE pl 55 FV
Louis XIV, equest 1822 bronze
GAF 137; HUBE pl 64;
LARM 69; WATT 171 FPVic
Louis XVIII, bust marble
HUBE pl 72 FChalD
Malesherbes Monument: La
France; Fidelity 1826
marble HUBE pl 46 FPJu
Marquise de la Carte, bust
1836 marble HUBE pl 57
Marshal Davout, bust plaster
HUBE pl 61 FV
Marshal Lauriston, bust 1822
plaster HUBE pl 60 FV
Napoleon, bust 1810 marble
HUBE pl 45 FV
Queen Hortense, bust marble

HUBE pl 38
Queen Hortense, bust plaster
HUBE pl 40 FPMarm
Queen Hortense, bust 1810
marble HUBE pl 42 FRuM
Salmacis marble HUBE pl 52;
POST-2:95 FPL
Talleyrand, bust 1810 marble
HUBE pl 44
Virgin Mary, head 1843 marble HUBE pl 56 FPL
BOSNIAN
Figure, Bogomil Tombstone
(Stachak), relief medieval
BIH 11 YR
BOSS-GOSLAWSKI, Julian (Polish
1926-)
Head 1957 metal JAR pl 39
Bosses
English--12th c. Boss, high
vaulting crossing
English--13th c. Boss#
English--14th c. Boss#
English--16th c. Boss: Roof
Boss, choir
BOSSI, Antonio (Swiss fl 1744-64)
Kaisersaal Figures 1749-
51 BUSB 106 GWuP
White Salon plasterwork
decoration 1744 HEMP pl
95 GWuP
BOSSI, Aurelio (Italian)
Cross (La Croce) ebony
VEN-14: 138
.David ebony VEN-26: pl 36
Dream about Mother (Il
Sogno della Mamma)
marble VEN-30: pl 17
Botetourt, Lord
Hayward. Lord Botetourt
Botfield, Beriah
Behnes. Beriah Botfield
Mourns his Mother
BOTO, Martha (Argentine-
French 1925-)
Mouvement Helicoidal
Lumineux 1967 KULN 192
Structure Optique 1963
plexiglas; 21-1/4x12-1/2
x12-1/2 CALA 219 IVG
Bottai, Signora
Ruggeri. Signora Bottai,
bust
BOTTIAU, Alfred Alphonse (French
1889-)
Decorative Panels: Agriculture; Transporation
AUM 78 UPPIT

France and America, War
Memorial AGARN il 35
FChat
Industry AGARN il 14 UCtHCi
The Bottle. Boccioni
Bottle. Magritte
Bottle and Newspaper. Laurens
Bottle Dryer
Duchamp. Ready Made: Bottle Rack
Bottle Holder
Duchamp. Ready Made; Bottle Rack
Bottle Neck
Duchamp. Ready Made: Bottle Rack
The Bottle of Beaune. Laurens
Bottle Rack
Duchamp. Ready Made: Bottle Rack
Bottle Stand
Duchamp. Ready Made: Bottle Rack
Bottle II. Vail
BOTZARIS, Sava
Anna May Wong, head MARY
pl 72
Charles Laughton, head CASS
58
Haile Selassie, head CASS 58
James Joyce, head CASS 55
Jean, head MARY pl 162
Mr. E. Thesiger, head
MARY pl 58
Nigger, head bronze MARY
pl 72
BOUCHARD, Henri (Louis Henri
Bouchard) (French 1875-)
See also Landowski, Paul
Ambassador's Room Decorative
Panel, Exposition des Arts Decoratifs, Paris, 1928 AUM 55
Blacksmith in Repose TAFTM
46
Child's Head 1922 bronze; 10
MID pl 21 BAM
Claus Sluter TAFTM 47
Fishermen TAFTM 46
Fountain: Girl with Gazelle
TAFTM 48
Girl and Gazelle, cast bronze
ELIS 98 UNNMM
Girl's Head VEN-38: pl 51
The Master Workman TAFTM
46
Monument to Aeronauts TAFTM
46
Plowing in Burgundy TAFTM 45

BOUCHARDON, Edme (French 1698-
1762)
 Baron Philipp von Stosch,
 bust 1727 marble; bust:
 85 cm; base: 19.8 cm
 BSC pl 125 GBS (M204)
 Clement XII, bust terracotta;
 29-3/4 DEYE 162
 UCSFDeY (54899)
 Cupid marble; 29; base: Dm:
 13-1/2 USNKP 443 UDCN
 (A1617)
 Cupid Making a Bow from the
 Club of Hercules 1747/50
 marble BAZINB 194;
 MOLE 238; VER pl 99 FPL
 Fountain of the Four Seasons
 (Fontaine de Grenelle)
 1739/45 stone BUSB 167;
 ENC 116; GAF 135 FPGre
 --Summer LAC 204
 Louis XV, equest (model by
 Louis Vasse) 1748/58
 bronze; 27 BAZINW 416
 (col) FPL
 Putti 18th c. GLA pl 40 FPGre
 River Marne 18th c. terra-
 cotta; 12x18 CHAR-2:
 188 FPL
 Sleeping Faun, detail 1732
 LAC 19 FPL
BOUCHARDON, Jacques Philippe
(French 1711-53)
 Gustavus III as a Child
 1753 ptd terracotta;
 14-3/4 GRAT 111 SnSN
BOUCHER, Alfred (French 1850-
1934)
 Thought c1900 marble SELZJ
 78 FPra
BOUCHER, Francois (French 1703-
70)
 Bagpipe Player, Sevres
 Porcelain, executed by
 Blondeau 1752/53 CLE
 135 UOClA (61.11)
BOUCHER, Jean (French)
 Fra Angelico TAFTM 47
 UMiD
BOUGET, Jacques (French 1919-)
 Les Elans Physiques 1950
 forged iron; 30 RAMS
 pl 78b
 L'Elan Spirituel 1950 forged
 iron; 51 RAMS pl 78a
Boughton, William d 1716
 Hunt. Sir William Boughton
 Monument

Bougie See Candelabra and Candle-
 sticks
Boulevard Impressions, Paris at
 Night.
 Rosso, M.
BOULLE, Andre Charles (French
1642-1732)
 Bureau of Elector of Bavaria;
 detail: Seasons ebony,
 tortoise shell, and brass
 marquetry; L:79; W:63
 CHAR-2:158, 160 FPL
 Clock with Louis XIV symbol:
 Head of Apollo 1700/10
 tortoise shell veneer; 84
 NM-8:19 UNNMM (58.53a-c)
BOULLE, Andre Charles--ATTRIB
 Louis XIV Pendulum Clock,
 with Apollo's Chariot LARR
 307 FFP
BOULLIER, Jean (French)
 Staircase, Hotel Aubert de
 Fontenay 1656/61 BLUA pl
 107A FPAu
BOULOGNE, Jean de See BOLOGNA,
 Giovanni
Boulogne, Jeanne de See Bourbon,
 Jeanne de
Boulton, Mrs.
 Chantrey. Mrs. Boulton, head
 detail
Bound Slave. Michelangelo
Boundary Markers
 French--15th c. Boundary
 Cross
Bouquet. Picasso
BOURAINE, Marcel (French 1886-)
 Volupte (Torse Volupte) 1923
 stone PAR-1:189
Bourbon, Charles de
 Morel. Charles de Bourbon and
 Agnes de Bourgogne Tomb
Bourbon, Jean II of d 1488
 French--15th c. Jean II of
 Bourbon
Bourbon, Jeanne de (Jeanne de
 Boulogne) c 1385
 French--14th c. Jeanne de
 Bourbon, head detail
 Jean de Liege. Jeanne de
 Bourbon
Bourbon, Louis II de fl 1448
 Morel. Louis II de Bourbon
BOURDELLE, Emile Antoine (French
1861-1929)
 Adam Mickiewicz Monument
 bronze MARY pl 169 FP
 --Adam Mickiewicz

AGARN il 42
--The Captives 1928 MCCUR
 251
--study 1909 plaster SELZJ
 141 FPBo
Alvear Monument, equest
 bronze AGARN il 134 ArB
--sketch, plaster model,
 bronze HOF 124
--"La Force" 1913/17 CASS
 43
--Eloquence, study 1917
 bronze; 19 GIE 28; MAI 31;
 SELZJ 133 FPBo
--Liberty, study MAI 30
 IFBo
Anatole France, bust 1919
 CASS 55; CASSM 53;
 CHENSW 475 FPLu
--1919 bronze; .71x.46x.31
 m MOD FPM
--1919 bronze; .71x.47x.34 m
 TOKC S-54 JTNMW
Apollo, head (Tete d'Apollon)
 1900 bronze AGARC 17;
 SELZJ 137 FPBo
--1900 bronze; 17-3/8
 MUNSN 47 UMBCr
Apollo and the Muses, facade
 relief 1912 284x440 cm
 AGARN il 1; LIC pl 174;
 STI 746 FPChT
Auguste Perret 1902 bronze;
 55 cm COPGM 77 DCN
 (I. N. 2712)
Bacchante 1909 bronze; .83x
 .52x.22 m TOKC S-55
 JTNMW
Beethoven, head TAFTM 45
--bronze MARY pl 78 FPLu
--1902 plaster SELZJ 137
 FPBo
Beethoven, tragic mask 1901
 bronze VEN-52: pl 74
--1901 bronze; 28 FAIY 78;
 JLAT 11 UNSyU
--1901 bronze; 30-3/4
 HAMP pl 20A; SELZS 24
 UNNSl
Beethoven, tragic mask
 (Grand Masque Tragique)
 1901 bronze; 32-5/8
 READCON 21; SELZJ 136
 FPBo
--4 ieme etude 1901 bronze;
 30-3/4x17-3/4x19-3/4
 GIE 30; MARC 13
 FPBo

Beethoven Monument on a rock
 1903 plaster SELZJ 130
 (col) FPBo
Centaur ROOS 277E
--original model CASSM 50
The Cloud MAI 32 FPBo
Czechoslavakian Croix de
 Guerre AUM 48
The Dance (La Danse) stone
 MARY pl 107; TAFTM 44
 SPChT
Daumier, head 1929 plaster
 MARC pl 3 FPBo
Decorative Panel AUM 48
Dying Centaur (Le Centaure
 Mourant) AUM 43
--1914 bronze GAF 458
 FMontAuI
--1914 bronze; 113-1/2x39-
 3/4 GIE 101 FPBo
--1914 bronze; .72x.52x.22 m
 TOKC S-56 JTNMW
L'Epopee Polonaise AUM 47
La France HOF 39
The Fruit (Le Fruit) 1907
 AUM 54; BAZINW 425 (col)
 FPM
--1907 bronze BERCK 47 FPBo
--1911 bronze; 226x110x70 cm
 LIC pl 177 FPBo
Hand of Warrior 1909 bronze;
 56x46x23 cm LIC pl 176
 FPBo
Head of a Man 1910(?) bronze;
 over LS RIT 56 UCStbL
Hercules (Herakles) TAFTM
 44
--RICH 184 UNNMM
--bronze PUT 331
Hercules (Heracles), head
 MARY pl 164 FPLu
Hercules as Archer (Ercole
 Suettante; Heracles;
 Herakles Archer) SCHN 5
--plaster VEN-14: 50
--bronze; 24-1/2 CPL 78
 UCSFCP (1940.128)
--1901 GAF 158; LIC pl 172
 FPBo
--1908/09 bronze; 26 MUNSN
 47 UMWiL
--1909 gilt-bronze CASSM 49;
 MARY pl 82 FPLu
--1909 gilt bronze CHENSW
 475 UNNMM
--1909 gilt-bronze; 99x59x65-
 1/2 AUES pl 38; CAS pl 121;
 ENC 117; GIE 29; MAI 30;

PM FPM
--1909 bronze; .63x.60x.28
 m TOKC S-57 JTNMW
--1909/10 bronze; 98 MID pl
 11 BAM
Hercules Shooting the
 Stymphalian Birds AGARC
 149 IRMo
Hoo-Wei-Te, bust HUX 75
Ingres, bust 1908 bronze;
 67 cm LIC pl 173; TAFTM
 45; VEN-14:49 FPBo
Koeberle, bust 1914 bronze;
 27 HUX 74; MID pl 14
 BAM
The Large Penelope 1912
 bronze; 240 cm JOO 183
 (col) NOK
Little Sculptress Resting
 1905/06 32x26x18 cm
 LIC pl 178 FPBo
Love in Agony 1886 plaster
 SELZJ 132 FPBo
Madeleine Charnaux 1917
 bronze SELZJ 194 FPBo
Mother and Child TAFTM 45
Monument on Mount Montau-
 ban, study 1893/94 plaster
 SELZJ 132 FPBo
Les Muses, detail AUM 47
Music TAFTM 44
Noble Burdens 1912 LARM
 267 FPBo
Pallas Athene on La Sagesse
 Active, relief AUM 48
 FPChT
Pallas with Drapery c1889
 bronze SELZJ 133 FPBo
Panels stone MARY pl 105
 FPChT
The Pathetic Soul, relief
 for Champs-Elysees
 Theatre 1912 BERCK 46
 FPBo
Penelope bronze SLOB 245
--1908 bronze MARC pl 4
 (col) FPM
--1915 (1st version 1903)
 bronze; 120x45x35 cm
 CAS pl 183
Polish Monument: Winged
 Figure HOF 197 FPAl
Rodin, bust BERCK 323;
 TAFTM 45 FPBo
Rodin at work 1910 bronze;
 66 cm LIC pl 173 FPBo
Rodin Working on the "Gate
 of Hell" (Rodin Travaillant
 a sa Porte de l'Enfer)

AUM 43
--bronze CLE 180 UOC1A
 (43.291)
St. Sebastian 1888 bronze; 71
 cm LIC pl 171 FPBo
Sappho, seated figure bronze
 MAI 31
Selene 1917 bronze; 34 GIE 31
 FPBo
Selene with a Bow (Selene
 l'Arc) 1917 bronze gilded;
 .85x.75x.21 m TOKC S-58
 JTNMW
Self Portrait, full figure c1920
 plaster, cast in bronze post-
 humously; 22-3/4 RIT 57
 UMnWD
Self Portrait, head bronze
 BERCK 240 FPBo
Sir James Frazer, bust 1922
 plaster; 27-1/8 TATEF pl
 20C ELT (4115)
Small Herakles 1909 bronze;
 14-7/8 JLAT 11 UNNDan
Stubborn Ram (Restive Ram)
 1908/09 bronze; 21 MID pl
 12 BAM
Theatre de Champs-Elysees:
 Proscenium; details: Pegas-
 us; Apollo; Architecture and
 Sculpture; Tragedy AUM 44,
 45-6 FPChT
--Tragedy, relief AGARC 148
Tolstoi c1906 bronze SELZJ
 141 FPBo
Virgin of Alsace (La Vierge
 d'Alsace) JAG 73; MARY
 pl 113; NATSE
--bronze AUES pl 35
--1920/22 CASSM 51 FA
--1922 pierre doree; 19'9"
 RAMS pl 10C FMas
--after 1922 bronze; 99 TOW
 38 UNBuA
Virgin and Child (Vierge et
 l'Enfant) 1920 bronze; .65x
 .25x.16 m TOKC S-59
 JTNMW
Virgin of the Offering marble;
 24-1/2 CHICS UICA
Warrior of Montauban SEITC
 175 IsJR
BOURDIN, Michel (French 1609-78)
 Louis XI Tomb, detail 1622
 GAF 275 FCler
 Sully Tomb 1642 GAF 288
 FNog
Le Bourgeois de Calais
 Rodin. Burghers of Calais

Boy and Girl. Butler
Boy Bathing. Folkard, R. C. H.
Boy Drinking. Martini, A.
Boy on Donkey. Gaul
Boy Playing Bagpipes. Cibber
Boy Playing with Toe. Marcks
Boy Rider. Folkard, E.
Boy Saint. Mena
Boy Sitting on the Ground. Marcks
Boy with an Injured Foot. Roksandic
Boy with Dolphin. Verrocchio
Boy with Grapes. La Rue
BOYCE, Richard (English)
 Aged Hercules 1966 KULN
 18
Boyd-Orr, Lord
 Huxley-Jones. Lord Boyd-
 Orr, bust
Boys Wrestling. Vasconellos
BRABENDER, Heinrich (German)
 St. Paul 1536 stone; 220 cm
 MUL 67 GMuC
BRACCI, Pietro (Italian 1700-73)
 See also Nicola SALVI
 Carlo Leopoldo Calcagnini
 Tomb 1746 WIT pl 168A
 IRAndr
 Clement XII, bust marble;
 .76 m FAL pl 40 IRB
 (CCLXXIII)
 --terracotta; 29 DEY 95
 UCSFDeY
 Maria Clementina Sobieska
 Tomb 1770 BUSB 187 IRS
BRACCI, Pietro, and OTHERS
 Benedict XIII Tomb 1734
 WIT pl 167B IRMN
Bracciolini, Francesco (Italian Poet
 1566-1645)
 Algardi. Francesco Braccio-
 lini, bust
Bracelets
 Byzantine. Armlet and Brace-
 let
 Celtic. La Tene Torc
 Early Christian. Bracelet
 Viking. Arm-Ring
Bracteates. Swedish--5/7th c.
BRADFORD, A. T. (English)
 Doors teak AUM 142
 Memorial Headstone AUM 131
 Theatre panel: Musical
 Instruments AUM 121 EL
BRADFORD, E. J. (English), and
 A. T. BRADFORD
 Window Panel AUM 133 ELPl
Bradley, Cilena l'Anson
 Hunt. Cilena l'Anson Bradley,
 bust

BRAECKE, Pierre (Belgian 1859-
 1938)
 Forgiveness marble MARY
 pl 47; ROOSE 299 BBMu
 The Prodigal Son GOR 32
 BBR
Brahe, Tycho (Danish Astronomer
 1546-1601)
 Johnsson. Ticho Brahe
Brake. King, Phillip
Brancacci, Rinaldo (Cardinal d 1427)
 Donatello, and Michelozzo.
 Cardinal Rinaldo Brancacci
 Tomb
Branch-Breaker. Vischer, P., the
 Elder
BRANCUSI, Constantin (Rumanian-
 French 1876-1957)
 Adam and Eve wood PRAEG
 458
 --1921 chestnut and old oak;
 88-1/2; limestone base;
 5-1/4 AMAB viii; GUG
 194; HAMP pl 175B;
 MARC 17; READAS pl
 216-7; READCON 51; VEN-
 60: pl 48 UNNG
 --1925 wood; 96 RIT 114
 FPRo
 Ancient Figure 1906/08
 stone BERCK 10
 Arch 1917 old oak; 113x96-
 3/4x108 PPA 12 UPPPM
 Bench 1917 old oak; 27-1/2
 x124-1/2x10 PPA 13
 UPPPM
 Bird 1912 marble; 24-3/8;
 marble base; 6 PPA 5;
 READCON 50 UPPPM
 --1925 OZ 110
 --c1925 ROOS 279F UPPPM
 --1940 polished bronze CANK
 181
 Bird (L'Oiseau) 1940 polished
 bronze; 59 GIE 141 IVG
 Bird at Rest 1920 grained, pale
 yellow marble; 54 BALD
 155 -UDr
 Bird in Space (Bird in Flight;
 L'Oiseau dans l'Espace)
 CHENSE 394
 --1919 polished bronze; 54
 BARD 155; BOW 61; BR
 pl 15; BURN 31; CHENSN
 646; CHENSS 706; FAUL
 482; GARDH 759; GAUN
 pl 60; JANSH 533; JANSK
 1016; MCCUR 260; NEWM
 pl 1; NMAC pl 107;

NNMMARO pl 315; NNMME
33; NNMMM 125 (col);
PANA-1:134; RAMS pl
22b; READCON 132;
RICJ pl 28; RIT 110-11;
RUS 146; UNNMMAM # 59;
VALE 155; WB-17:204;
ZOR 186 UNNMMA
--1925 polished bronze; 49-
3/4x7x5-1/4; black marble
and oak base; 48-1/8 BOSME
pl 60; CANM 496;
CHENSW 487; ELEM 740;
HENNI pl 34; KUH 88;
KUHB 107; LARM 255;
MU 260; PPA 19; SEW
918; TRI 142 UPPPM
--1926 polished bronze; lime-
stone and wood base
BERCK 10
--1927 polished bronze; 72-
1/2 SOTH-4:68 (col)
--1940 bronze MAI 36
--1940 polished bronze KO
pl 107 FPM
--1940 polished bronze; 51-
1/4 CALA 101 (col);
GUGP 37; LIC pl 191;
MARC pl 18 (col);
READAS pl 197 IVG
Boy, bust 1907 bronze; 20
cm LIC pl 186 UNNMa
--1907 bronze; 8 RIT 60
UNNV
Buddha c1917 VEN-60: pl
47
The Chief (Le Chef) 1922
wood; 20 (excl base)
GIE 284 UNNLam
--1923 wood GROSS fig 43
--1925 walnut ROTHS 251
--1925 wood
KULN 42 READS pl 11
Chimera (Chimaera) 1918
READS pl 10 FPRo
--1918 oak; 36-1/2x9-
3/4x8-1/4; oak base;
23-3/4 GIE 142; HENNI
pl 8 UPPPM
The Cock 1924 polished
bronze; 41x8-1/2x4-1/4
GIE 143; KO pl 107;
MOD; PM FPM
Cock Saluting the Sun (The
Rooster) 1941 bronze; 43
BERCK 61; EXS 65; LIC
pl 188; MAI 36 FPM
The Embrace (Abstract)
marble MILLER il 185
UNNRes

Endless Column (Column with-
out End) gilt steel; 100
BOY 63; GIE 139, 318;
HOF 252; RTG
--1918 KULN 113
Figure (Little French Girl)
before 1921 oak; 40 GUG
193 UNNG
The Fish marble on round
mirror SEYT 55 UCHA
--1918/28 marble VALE 155
--1922 marble; 5-1/4x16-
7/8; base--mirror: Dm:
17, and oak; 24 PPA 16
UPPPM
--1924 polished brass; 30 cm;
Dm: 50 cm BURN 33;
LIC pl 192 UMB
--c1925 polished brass; 4-
1/2; Dm: 19-5/8
BOSME pl 59 UNNMMA
--1926 polished bronze
MOHN 43
--1926 bronze; 31-1/2 BOW
58 ELPo
--1926 bronze and stainless
steel; 6x19-1/2 HENNI
pl 35 UNNJa
--1930 grey marble; 21x71;
stone base; 28-1/2 BURN
33; EXS 17; GIE 133; LARM
322; LIC col-5 (col);
LOWR 136; LYN 96 (col);
MCCUR 260; NNMMM 125
(col); RIT 113; SCHAEF
pl 97 UNNMMA
Flying Turtle after 1943 mar-
ble 17-7/8; stone base;
11 GUG 197 UNNG
The Gate of the Kiss 1935/38
stone GIE 137 RT
George (Portrait of George)
1911(?) marble; 9-1/4
GUG 191 UNNG
The Golden Fish (Poisson d'Or)
c1924 polished brass; 19-
3/4 BOSMI 165 UMB
(57.739)
--1929 polished bronze RAMS
pl 97 -EEd
Head (Kopf) TAFTM 30
--stone; 22-1/4 RIT 115
UNNMMA
--1907/08 stone; 11-3/4
GIE 40
--1919 stone GERT 137
King of Kings (The Spirit of
Buddha) 1937 wood; 118-
1/8 BERCK 61; BOW 111;
GUG 195; LIC pl 194;

LYN 135; MAI 35;
MCCUR 260; SPA 68
UNNG
The Kiss (Le Baiser; Tomb
of Tanosa Gassevskaia)
TAFTM 30
--HOF 69 RTG
--1908 plaster (Later version
than that exhibited at
Armory Show pictured)
BROWMS cat 616
--1908 granite; 125 cm
ENC 122; GIE 136; LIC
pl 187; MARC pl 16 (col)
FPMont
--1908 limestone; 23x13x10
CANM 497; EXM 150;
GERT 136; JANSH 532;
JANSK 1016; KUH 89;
LARM 262; MAI 34;
MCCUR 259; MUNSN 40;
PPA 3; RIT 106; SCHAEF
pl 94; SELZJ 242; TRI
56 UPPPM
Leda polished bronze HOF
70
--1920 marble; 24 NMAC
pl 108; UPJ 637 UNNDr
--1922/24 burnished bronze;
26-3/4 GIE 131
--1923 marble; 26x19; base:
25-1/8 BURN 33; GIE
130 UICA
Mlle Pogany TAFTM 30;
POST-2:267; ROOS 279E
--marble MARY 120
--marble; LS PUT 236;
STI 765
--1912 MUNSN 86
--1912 plaster BROWMS
cat 619
--1913 ROBB 405
--1913 bronze; 10-5/8x7x8
READCON 81 FPM
--1913 bronze; 17-1/4
NNMMM 125 (col); READAS
pl 195 UNNMMA
--1919 marble ROTHS 249
--1919 marble; 17 UNNMMAM
#160 UNNPol
--1919 marble; 27-1/2x8-3/4
x11 GIE 127 UCtNcA
--1919 marble; 67 SELZS
73 UNNAu
--1920 polished brass; 17
ALBA; ALBC 189;
BOSME pl 58; FAIY 10;
GERT 138; MCCUR 259;

READAS pl 196; RIT 109;
TOW 55 UNBuA
--c1920 bronze; 11-1/8 BOW
55 ELT
--1931 marble; 27-1/2 (with
stone base) AUES pl 46;
BR pl 15; CHENSW 487;
CHRP 379; HAMP pl 175A;
LARM 322; PPA 21;
READAS pl 194; RIT 108;
ROOS 279E UPPPM
Maiastra (Bird; Yellow Bird)
c1910 polished bronze;
35-5/8 (with limestone
base) SELZS 61 UNNSteic
--1912 marble; 22; limestone
base; 70 NNMMM 125
(col) UNNMMA
--1912 polished bronze; 37-
3/4 BMAF 80; MINP
UMnMI
1915 polished bronze; 24-
3/8 BOW 60; CALA 100;
GIE 140; GUGP 37;
MARC pl 17 (col); ST
427 IVG
Male Torso 1922 bronze;
18-3/8 MCCUR 259;
ROTHS 249
Miracle (Le Miracle; White
Seal) marble CASS 129
--1936 marble; 43x44x14-
1/2; limestone base, 2
sections; 21-5/8 GIE 135;
GUG197 UNNG
--1938 marble; L: 60
NNMMARO pl 316
Muse 1912 marble; 17-1/2
GUG 191; MUNSN 41 UNNG
Muse, bust CHENSP 290
The New Born (Le Nouveau Ne)
BERCK 242 FPRo
--1915 brass; 8-1/4 NMAC
pl 106 UNNLevy
--1915 marble; 6x8-1/2;
limestone base; 6-1/4
BOW 52; HAMP pl 176a;
PPA 9; TRI 11 UPPPM
--1920 bronze, after marble
of 1915; 5-3/4x8-1/4 LIC
pl 193; NNMMM 125 (col);
NNMMAP 136; RAMS pl
96; RAMT pl 52; RIT 112;
SELZJ 230 (col); SLOB
241; VALE 161 UNNMMA
Nude CLAK 361 UOClA
Penguins (Three Penguins)
1914 marble; 26x21x12-1/2

GIE 68; KULN 551; SCHAEF
pl 95 UPPPM
--1914 marble; 24x21 PPA
6 UPPPM
Portrait marble MARTE pl
10
The Princess polished
bronze, stone base SEYT
53 UCHA
--The Princess (The
Portrait) 1916 polished
brass; 22; limestone
base; 7-1/4 KUH 139;
PPA 11 UPPPM
Princess X 1916 marble
VEN-60: pl 46
Prodigal Son 1914 oak;
17-1/2x8-1/2x8-1/4;
limestone base; 12-1/2
GIE 66; PPA 7; RIT 107;
UCIT 4 UPPPM
Prometheus marble SEYT
17 UCHA
--1911 marble; 5x7 PPA 4
UPPPM
Sculpture for the Blind (The
Beginning of the World;
Sculpture pour les
Aveugles) VALE 22 UCHA
--1924 marble; 6x12x7
GIE 129; MAI 34 FSevR
--1924 marble; 6x12x7;
polished base; 10 BOW
53; BURN 85; CANM
497; PPA 18 UPPPM
Sculptured Mobile polished
bronze CASS 129
The Seal (The Miracle; Sea
Lion; Seehund) 1943 grey
marble; 62 BERCK 63;
BOW 59; GERT 139
--1943 marble; 62x41x14
BAZINW 429 (col); KO
pl 107 (col); MARC pl
19 (col) FPM
Sleeping Muse (Musa Adorme-
cida; La Muse Endormie)
SAO-2
--1906 marble GIE 124
--1909/10 marble; 11x11-
3/4x 6-1/2 GIE 125 -Dav
--1909/10 bronze; 10-1/2x
11-3/4x6-1/2 BAZINW
429 (col); CAS pl 203;
READCON 78 FPM
--1909/10 marble; L: 11-
1/2 MUNSN 41; SEITC
184 UNNH

--c1910 bronze; 6-1/2x10-
1/2x7-1/2 UCIT 8
Sleeping Muse I 1906 marble;
10-7/8x15-3/4 BOW 49;
READCON 78; SELZJ 242
RBMN
Sleeping Muse II 1910 bronze;
L: 11 BOW 51; BURN
84 UICA
Socrates wood READAN # 84
UNNMMA
Sorceress 1916 wood; 39-
3/8; limestone base;
5-7/8 GUG 192 UNNG
Temple of the Kiss HOF 69
RTG
Torment (Supplice) 1906
bronze; 8 GIE 14 UPPiT
Torso 1917 brass; 18-3/8x
12x6-5/8 CLE 197; CLEA
5; HENNI pl 5 UOCIA
Torso of a young girl 1922
onyx on stone base RAMT
pl 51 UNNLiv
--1922 onyx on stone base;
13-3/4 BOW 56; LIC pl
190
Torso of a Young Man 1922
maple; 19; limestone base;
7 BOW 57; LIC pl 189;
MAI 34; PPA 15 UPPPM
--1922 wood; 33 (with base)
SCHAEF pl 96
--1925 polished brass VEN-60:
pl 49 UNNSt
--1925 polished bronze; 18;
original wood base; 58-1/2
LYN 135; READCON 51
UNNH
The White Negress (Blonde
Negress; La Negresse
Blanche) MARTE pl 10
--brass; 15 BARD-2: pl 433
BrSpA
--1924 marble; 19; marble
base; 6-3/8 PPA 17
UPPPM
--1926 bronze BERCK 60
UMiBiW
--1926 bronze; 18 NNMMAP
137; SEITC 65 UNNMMA
--c1930 black and white
marble; 30 SOTH-4: 70
(col)
Yellow Bird 1925 marble; 45
CHENSW t; GIE 132;
MYBA 658; PPA 20
UPPPM

--yellow marble FAIN 39
UCtY
Brancusi's Breakfast. Morland
Branda, Cardinal
 Italian--15th c. Madonna
 with Saints and Donor
 (Cardinal Branda)
Brandano il Pescatore. Andreotti
BRANDENBURG, Jacob (Polish-
 Israeli 1889-)
 Ecstacy wood GAM pl 96;
 SCHW pl 60
 Head of Girl terracotta
 GAM pl 95
Brandenburg Gate
 Schadow. Quadriga of Vic-
 tory
BRAQUE, Georges (French 1882-
 1963)
 The Bird, relief ceramic
 MAI 37
 Esperide 1939 bronze
 VEN-58: pl 116 FPMa
 Figure 1920 plaster; 7-
 3/4 RIT 146 UNNWa
 Figurine 1920 H:8 BERCK
 20 FPMa
 Fragments d'Hesiode 1930/
 57 bronze; 11x17-1/2
 x8-1/2 CARNI-58: pl
 3 UNNK
 --1955 bronze; 10-1/4x
 18-1/4x8-1/4 JLAT 13;
 UCIT 11 UCLL
 Horse (Cheval) bronze
 INTA-2:120
 Horse's Head (Tete de
 Cheval) 1943 bronze;
 36 BRIONA 125; EX 37;
 EXS 66; LARM 284;
 MAI 38; MARC pl 13
 (col); FPM
 --1943/46 bronze; 48-1/2
 GIE 295; MALV 527
 FPMa
 Hymen 1939 carved and
 ground stones BERCK
 243 FPMa
 Ibis 1940/45 bronze; 5 GIE
 294; MAI 37 FPMa
 The Nile 1942 bronze
 MARC pl 12 FPMa
 Petit Cheval--Gelinotte
 (Horse) 1957 bronze;
 7-1/2 DETS 5 UNNH
 --1937 bronze; 7-7/8
 READCON 49 FPMa
 The Pony 1939 bronze; 7-
 1/4 MCCUR 273 UCStbL

Woman 1920 plaster; 20 cm
 LIC pl 241 FPLe
BRASINI, Armando (Italian)
 Zoo Gate 1911 MINB 94 IRB
Brass Insect. Adams, R.
Brass Sculpture. Bloc
Brass Toy. Gaudier-Brzeska
Brasses
 English--15th c. Robert
 Greyndour Brass: Free
 Miner of Forest of Dean
 English--16th c. Shroud-
 Brass of Rev. Ralph Ham-
 sterly
 English--17th c. Edward
 Younge, and his family,
 Brass
BRAUN, Anton (Czech fl 1720-40)
 Calvary 1720 STECH 112 CzS
 Church Door: detail: Cary-
 atid c1735 STECH pl 154,
 153 CzPNi
 Hercules and Omphale 1720/
 30 stucco STECH pl 157
 CzSC
 St. Adalbert c1730 ptd wood
 STECH pl 156 CzBeC
 St. Procopius c1735 STECH
 pl 155 CzPNi
 St. Procopius c1740 ptd wood
 STECH col pl 6 CzPN
BRAUN, Anton--FOLL.
 Allegory of Night 1730
 STECH pl 151b CzPHC
 Count Fr. Sporck Memorial
 1933 STECH pl 152 CzV
BRAUN, Erasmus
 Court Residence Gate 1575
 BOE pl 167 GBaH
BRAUN, Matthias Bernard (Czech
 1684-1738)
 Adoration of the Shepherds,
 relief 1729 STECH pl 119-
 20 CzKB
 Allegory of Time STECH 101
 CzCit
 Angel, Chapel of former
 Hermitage c1718 STECH
 96 CzNa
 Atlas, supporting figures
 18th c. MOLE 13 CzPC
 "Blessed are those who weep",
 Beatitudes figure STECH
 91 CzKH
 Castle Gate c1725 STECH
 105 CzBeK
 Charles VI Monument 1724
 STECH pl 148-49 CzH1
 Chronos, head detail c1717

STECH pl 93 CzCit
The Crowning Altar 1715/21
 wood STECH pl 113 CzPCl
Crucifix c1720 wood STECH
 93 CzPla
Eagle wood STECH 98 CzPN
Facade Figures c1735
 STECH 111 CzPNi
Faith, model for Kuks fig-
 ure STECH pl 140a CzPN
Female figure, attic of
 Clam-Gallus Palace,
 Prague 1712-15 STECH
 pl 145 CzPA
Garden Figure STECH 107
 CzPN
Garden Figure c1721 STECH
 pl 150
 CzPV
Garden Figures c1720
 STECH col pl 5 CzPVr
Gate Figure c1725 STECH
 pl 147 CzKon
Hermit Garinus (Hermit
 Onofrius) 1729 BAZINW
 414 (col); BUSB 138;
 STECH pl 142 CzKB
High Altar; details: SS
 Ludmilla and Wenceslas
 1718 STECH pl 124-7
 CzSt
Holy Trinity Column 1718
 STECH 90 CzT
--St. Charles Borromeo
 STECH pl 143
--St. Sebastian STECH
King David, confessional
 figure wood 1715/21
 STECH 84; pl 112 CzPCl
Marian Column STECH pl
 161a CzJ
Mary Magdalene STECHS
 pl 138 CzKB
Mary Magdalene confessional
 figure 1715/21 BUSB
 137 CzPCl
Mercury c1730 STECH pl
 151a CzLi
Miner Adoring Tomb of St.
 John of Nepomuk 1720/25
 wood STECH pl 129 CzPV
Organ Figures, details STECH
 pl 114-15 CzPCl
Palace Portal c1713 HEMP
 pl 79; STECH 88 CzPC
Palace Portal c1720
 STECH 88 CzPK

Prodigal Son, confessional
 detail 1715/21 wood
 STECH pl 111 CzPCl
Pulpit: Angels 1715/21
 STECH pl 118 CzPCl
Residence Doorway: Eagles
 KITS 47 CzPT
St. Ambrose 1715/21 stuc-
 co STECH pl 117b CzPCl
St. Ivo 1714 STECH pl 103
 CzPNM
--Justice STECH pl 104
--(copy) STECH pl 105
 CzPCh
St. Jerome STECH 85
 CzLyE
St. Jerome stucco STECH
 pl 117a CzPCl
St. Jude Thaddaeus 1712
 wood STECH pl 107-110
 CzPN
St. Ludmilla with young St.
 Wenceslas STECH pl 103
 CzPCh
St. Luitgarde at Foot of the
 Cross 1710 STECH pl 102
 CzPCh
St. Luke stucco STECH pl
 116 CzPCl
St. Wenceslas, head detail
 1719 wood STECH pl
 128 CzDu
Triton, fountain detail 1712
 STECH pl 146 CzPC
Virgin Mary, Annunciation
 figure wood STECH pl
 130 CzPlA
Virtues and Vices: Despair;
 Light-heartedness; Charity
 c1719 HEMP pl 80-81
 CzKH
--: Religion, Angel of Life;
 Anger; Frivolity; Charity;
 Faith; Wisdom STECH
 pl 132-37, 139, 140b, 141
BRAUN, Matthias Bernard--FOLL.
Apotheosis of Count Sporck
 (cast) 1733 BUSB 142
 CzVa
Death of St. Wenceslas
 c1720 stone STECH pl
 131 CzStC
Jupiter, head STECH 108
 CzPN
Vulcan, head STECH 108
 CzPN
BRAUNER, Victor (Rumanian

1903-)
Signe 1962 gilded bronze;
11-3/4x7-1/8 READCON
141 (col) UNNI
Wolf-Table 1939 wood, with
parts of stuffed animals;
21-5/8x22-7/8x11 SEITA
64
Bray, Guillaume de (Cardinal d
1282)
Arnolfo di Cambio. Cardinal
de Braye Monument
BRAZDYS, Antanas (Lithuanian-
English 1939-)
Horizontal Welded Heel 1963
steel; 55x62x25 ARTST
inside back cover
Shadow Slav 1966 steel, ptd
black; 23x60x60 LOND-
7:#7
The Brazen Serpent
Berruguete. Toledo Cathe-
dral Choir Stalls
Early Christian. Doors of
West Portal: Bronze
Serpent
BRAZZA
Finding of Moses (reproduc-
tion) REED 74 UCGF
Bread and Wine. Speck
Bread-Boards with Eggs
Arp. Egg Board
The Bread Winner. Studin
Breastplates See Armor
Brecht, Bertolt
Seitz. Bertolt Brecht
BRECHTEL, H. C. (Dutch)
Beaker 1641 silver; 79
cm GEL pl 135 NLS
BREDER, Hans
Untitled 1966 BURN 163
-Rath
BREE, Alvaro de (Portuguese)
Juan Rodriguez Cabrillo,
Cabrillo National
Monument 1949 LONG
9 UCPL
BREESE, Alan (English 1922-)
Head of a Girl clay BED
119
Painter, head 1946 plaster;
LS NEWTEB pl 9B
BREGNO, Andrea (Italian 1421-
1506)
Cardinal Bartolomeo
Roverella Monument:
Putto 1476/80 marble
SEY pl 94a IRCl

Cardinal De Lebretto Tomb
POST-1:203 IRM
Cristoforo della Rovere
Tomb, with Madonna by
Mino da Fiesole
CHASEH 330 IRMP
BREGNO, Andrea, and Giovanni
DALMATA, MINO DA
FIESOLE
Cardinal Pietro Riario Tomb
c1475 marble POPR fig
112, pl 112, SEY pl 95
IRAp
BREGNO, Antonio (Italian fl 1425-
57)
Foscari Monument c1454
Istrian stone POPR fig
152 IVMF
--central portion SEY pl
138
--Fortitude and Temperance
POPR pl 128
BREKER, Arno (German 1900-)
Frau B., head 1933 plaster,
for bronze; LS HENT 64
Rontgedenkmal 1930
bronze; 2 m HENT 66
GRemR
Stehender Jungling 1928
plaster, for bronze; 1 m
HENT 65
Wager (Wagner?) plster
VEN-40: pl 92
BRENNINGER, Georg (German
1909-)
Lady with Hat (Dame mit
Hut) 1951 bronze GERT
103
Mae 1953 concrete SAO-2
Brenzoni
Nanni di Bartolo. Benzoni
Monument
BRESCIA, Antonio da (Venetian
fl 1485-1515)
Niccolo Michiel, medal
bronze: Dm 73 mm
DETD 138 UCStbMo
BRETON
Apostles, Calvaire detail
16/17th c stone
CHENSW 352 FGu
Calvary: Deposition 1610
stone BAZINW 234 (col)
FStTh
Pleyben Calvary: The Magi
16/17th c. MALV 507
FP1
--Christ of the Resurrection

CHENSW 351
BRETON, Andre (French 1896-)
　　Objet-poeme 1941 wood and
　　　miscell objects; 18-1/4
　　　x21-1/8x4-3/8 SEITA
　　　67 UCtWoT
　　Poeme-objet 1935 READS
　　　pl 13
　　Poeme-objet, wall object
　　　1941 JAN 130 -T
Breton Mourners. Quillivic
BREUER, Peter (German)
　　Adam and Eve TAFTM 54
Breuninger, M.
　　Baum. Dr. M. Beuninger,
　　　head
Breydel, Jan (Flemish Revolution-
　　ary fl 1302)
　　Vigne. Jan Breydel, bust
BREYER, Tadeusz (Polish 1874-
　　1952)
　　Self-portrait head 1952
　　　plaster JAR pl 36
Breze, Louis de
　　Goujon. Louis de Breze
　　　Monument
　　Landowski and Bouchard.
　　　Reformation Monument
Briarde. Niclausse
The Bricklayer. Minne, G.
The Bride. Butler
The Bride. Moore, H.
The Bride Stripped Bare by her
　　Batchelors, Even
　　Duchamp. The Large Glass
The Bride's Door. German--14th c.
Brides of Death. Bistolfi
Bridges
　　Czech--18th c. St. Charles
　　　Bridge
Bridget. Folkard, E.
Bridget, Saint
　　Swedish--15th c. St.
　　　Bridget, seated figure
Bridgewater, 7th Earl of d 1823
　　Westmacott. Earl of Bridge-
　　　water, 7th, Monument
Briganti, Giuliano
　　Ruggeri. Giuliano Briganti,
　　　relief
Bright Symbiosis. Berke
BRIGNONI, Serge (Swiss-French
　　1903-)
　　Carved Mural, Nurses Home
　　　1948 DAM 189 SwBeT
　　Figure JOR-2:pl 191

Figure anthropomorphe 1957
　　JOR-2:pl 189
--JOR-2:pl 190
Figure No. 7 1957 wrought
　　iron MAI 39
The Walkers (Les Promeneurs)
　　1956 JOR-2:pl 123
--1957 iron; 30 BERCK 168
Brinckmann, Justus
　　Barlach. Justus Brinckmann,
　　　memorial plaque
BRIOSCO, Andrea di Ambrogio See
　　RICCIO, Andrea
BRISCO, Benedetto (Italian 1483-
　　1506) See also Amadeo, G.A.
　　Door, detail 16th c. BOE
　　　pl 152 IPavCe
　　Life of St. Bruno, framed
　　　with scenes from Life of
　　　Christ and the Saints in
　　　plaited garlands 1501-07
　　　BUSR 143 IPavCe
　　Mythological Subjects, relief
　　　marble; 13x47 NCM 40
　　　UNcRA
　　St. Agnes 1491 marble SEY
　　　pl 133 IMC
BRIOT, Francois (French)--ATTRIB
　　Ewer, with allegorical re-
　　　lief c1580 CLE 101 UOClA
　　　(40.16)
Briseis
　　Canova, A. Briseis sur-
　　　rendered to the Heralds
　　　of Agamemnon
Bristol, 3rd Earl of
　　Nost. John Digby Monument
BRISTOL CARVERS(?) (English)
　　Sir Hugh Poulett Monument
　　　1649 ESD pl 18; MERC
　　　pl 84a ESomHi
Britannia. Wright, F. A.
Britannicus, originally Claudius
　　Tiberius Britannicus 41-55
　　Banks. Death of Germanicus,
　　　relief
　　French. Cameo of Sainte-
　　　Chapelle: Glorification of
　　　Germanicus
BROADBENT, Eric (English)
　　Overdoor panel marble AUM
　　　135 ELBrH
　　Panel frieze AUM 134 ELBrH
　　Queen's Doll House: Panel
　　　AUM 134
Brocas, Mary d 1654

Pieta; detail: Angel 1695/
 96 STECH pl 33-34
 CzPCh
Turk, bust, garden figure
 STECH 40 CzK
BROKOFF, Michael Johann Josef
 (Czech 1686-1721)
 Angel, pedestal detail
 1709 STECH pl 53
 CzPCh
 Baptism of Christ, Charles
 Bridge 1707 STECH pl
 57-58 CzPNM
 House Portal 1710 STECH
 45 CzPHo
 St. Adalbert 1709 STECH
 pl 42b CzPCh
 St. John of Nepomuk 1709
 STECH pl 54 CzPTo
 St. John of Nepomuk 1715
 STECH pl 32a CzPL
 St. Vitus STECH 48 CzR
 St. Vitus wood STECH pl
 56 CzPN
 St. Vitus 1714 STECH 49
 CzPCh
 St. Vitus; St. John of
 Nepomuk; St. Wences-
 las, bridge figures
 STECH 46 CzD
BROKOFF WORKSHOP
 St. John of Nepomuk 1735
 STECH pl 32b CzPNe
BROLIE MASTER
 Votive statuettes: Female,
 and male SAN 55 IFAr
BROM, Eloy (Norwegian)
 Font bronze CASS 138
 NScA
Brome, Viscount
 Baily. Viscount Brome,
 recumbent effigy
Bromley, Thomas
 English--16th c. Sir
 Thomas Bromley Tomb
Brongniart, Alexandre
 Houdon. Alexandre Brongni-
 art as a Child, bust
 Houdon. Alexandre Brongni-
 art, bust
Brongniart, Louise
 Houdon. Louise Brongni-
 art, bust
Bronze Age
 Rodin. Age of Bronze
Bronze Box. Lovell
Bronze Serpent See Brazen
 Serpent

Brooches See also Fibulae
 Anglo-Saxon. Cruciform
 Brooch
 Anglo-Saxon. Dowgate Hill
 Brooch
 Anglo-Saxon. Kingston
 Brooch
 Anglo-Saxon. "Long" Brooch
 Anglo-Saxon. Metal Orna-
 ments
 Burgundian(?)--15th c.
 Morse: The Trinity
 Celtic. Brooches and
 Fibulae
 Cranach. Brooch
 English--10/11th c. Town-
 ley Brooch
 English--11th c. Stylized
 Fighting Animal Brooch
 German--5th c. Animal-
 style Brooch
 German--6th c. Animal-
 style Brooch
 German--10th c. Gisela
 Jewels
 German--11th c. Cloak-
 clasp
 --Eagle Brooch
 Icelandic--10/11th c. Clasp
 Italian--7th c. Dress Brooch
 Lalique. Art Nouveau Brooch:
 Woman-Butterfly
 Lalique. Brooch#
 Lalique. Oval Brooch
 Masriera. Art Nouveau
 Brooch
 Ostrogothic. Eagle Brooch
 Transylvanian. Brooch
 Viking. Brooch: Animal
 fighting Snake
 Visigoth. Eagle Brooches
Brooke, George
 English--16th c. George
 Brooke Tomb
BROSSE, Salomon de (French c1562-
 1626)
 Medici Fountain 1624 GAF
 135; WATT 173 FPLu
Brother and Sister. Rodin
BROTHER JOHN OF WISBECH
 Lady Chapel Wall, detail
 1321/49 BOE pl 109
 EEC
BROU, Frederic (French 1862-
 1926)
 Reception of Franklin by
 Louis XVI in 1778,
 relief, Franklin statue

PAG-11:61 FP
BROUGHTON, Owen
 Porpoise Tasmanian black-
 wood; 13 NORM 39
Brouning, John
 English--15th c. John
 Brouning, effigy
BROWER, W. C. (Dutch)
 Cinema Wall Panel Brick
 and terracotta AUM 110
 NA
BROWERE, John H. I.
 Isaac van Wart, life mask
 VALE 34
 John Paulding, Life mask
 VALE 34
BROWN, Aika (Israeli 1937-1964)
 "Assemblage" con bambole
 1964 VEN-66:#189 IsTS
 Picture Relief with Puppets
 1964 NEW pl 232
BROWN, Cecil (English 1868-1926)
 Imperial Camel Corps
 1921 bronze; 96 (with
 pedestal) GLE 100 ELVg
BROWN, James (French 1918-)
 Man plaster MAI 40
BROWN, Ralph (English 1928-)
 Clochard 1955 concrete; L:
 66 ARTS #9
 --detail 1955 concrete; L:
 60 ROTJB pl 129
 Confluence, maquette 1966
 cast aluminum; 70x64
 LOND-7:#8
 Divers 1960 bronze; 18 ARTS
 #13
 Figures with a Carcase
 1958/59 concrete with
 fibre-glass; 7x4x3-1/2'
 LOND-5:#6
 Lovers, relief 1960 bronze;
 L:24 ARTS #14
 Man and Child, relief 1960
 bronze; 26 ARTS #15
 Mother and Child bronze;
 42 ARTSB-58:13 EA
 The Queen 1963 bronze;
 18 READCO pl 6
 Seated Queen 1962/63
 bronze; 19-1/2 HAMM
 138
 Seated Woman Undressing
 1961/63 bronze; 60
 HAMM 139
 Sleeping Woman 1962 bronze;
 36 READCON 215 ELLe
 Swimming 1959/60 bronze;

23-3/4x31x12-1/2 TATEB-
 1:14; TATES pl 27 ELT
 (T.374)
Swimming Movement 1960
 bronze; 24 ARTSB-61:pl 2;
 GBA pl 2
--1959/60 bronze; 36 ARTS
 #12
Tragic Group 1953 bronze;
 18 ARTS #8 ELeT
Turning Woman 1962 bronze;
 36 MYBS 87
--1962 bronze; 62 LOND-6:
 #7
Vernal Figure 1957 concrete;
 56 ARTS #10
Walking Man and Child 1959
 resin; 50 ARTS #11
Brownlow, Sir John and Lady
 Stanton, W. Sir John and
 Lady Brownlow, busts,
 monument
Broz, Josip, called Tito (Yugoslav
 Premier 1890(?)-)
 Augustincic. Marshall Tito,
 head detail
BROZZI, Renato
 Pecore, plate silver VEN-
 20:126
BRUANT, Jacques, the Elder
 Facade, Hall of the
 Marchands-Drapiers c1655/
 60 BLUA pl 108 FPCarn
Bruce, Mrs. Edward
 Despiau. Mrs. Edward Bruce
Bruges Madonna. Michelangelo
BRUGGEMANN, Hans (Hans Brugger-
 man) (German 1480-1540)
 High Altar, Bordesholm
 Monastery 1514/21 unptd
 oak BUSR 158; LOH 179
 GScC
 --Christ in Purgatory CHRC
 fig 119
 --The Judas Kiss
 BUSR 159
 Lute-playing Angel 1520 oak;
 40 cm BSC pl 63 GBS
 (503)
 St. George, equest, Husum
 c1520 HARVGW 118 DCN
BRULIMANN, J. (German)
 Martin Luther, seated figure
 AUM 19
 St. George and the Dragon,
 facade relief AUM 22 SwZ
BRUMMACK, Heinrich (German
 1936-)

Galgonkonig 1965 bronze;
c 19-1/2 NEW pl 296
GBSch
Brune, Guillaume Marie Anne
(Marshal of France 1763-
1815)
Ceracchi Brune, bust
BRUNELLI, Angello See PERSICO,
P.
Bruni, Leonardo
Rossellino, B. Bruni Monu-
ment
BRUNI, Lev (Russian)
Construction 1917 perspex,
aluminum, iron, glass
(presumed destroyed)
GRAYR pl 177
--c1918 wood READCON 91
BRUNELLESCHI, Filippo (Italian
1379-1446)
Abraham's Sacrifice (Sacri-
fice of Isaac), contest
panel for Baptistry East
Door 1401 gilt bronze;
18x16 BARG; BUSR 47;
FLEM 338; MACL 73;
MAR 18 (col); MOLE
110; MONT 41; MU
134; MURRA 31; POPR
fig 2, pl 1; ROOS 107A;
SEW 518; SEY pl 6B;
STI 579; UPJH pl 108
IFBar
Crucifix c1410/15 ptd wood
LS MACL 74; MONT
375; SEY pl 17 IFMar
Dome decoration, detail
1467 BOE pl 145 IFCO
Old Sacristy, detail POPR
fig 41 IFLo
St. Matthew, tondo POPR
fig 3 IFPC
Self-portrait, tondo
MONT 41 IFCO
Two Prophets, Altar of
St. James 1398/1400
SEY pl 1B IPiC
BRUNELLESCHI and BUGGIANO
Lavabo POPR fig 4 IFCO
Pulpit POPR fig 48 IFMar
Bruno, Saint
Briosco. Life of St. Bruno
Fernandez. St. Bruno
Houdon. St. Bruno
Martinez Montanes. St.
Bruno
Mora. St. Bruno
Pereyra. St. Bruno

Sintenis. Bruno
Slodtz. St. Bruno
Bruno, Presbyter d 1194
German--12th c. Priest
Bruno Tomb Slab
Brunswick Candlestick. English--
12th c.
Brunswick Casket. English--9th c.
The Brunswick Lion
German--12th c. Lion of
Henry the Lion
BRUSSE, Mark (Dutch-French
1937-)
Hommage a Piet Mondrian
1965 wood and iron;
43-1/4x47-1/4x47-7/8
NEW pl 166 NAS
Brussels
Flemish--15th c. Geel
Altarpiece: Brussels
City Mark (Mallet)
Il Bruto. Niccolini
BRUTT, Adolf (German)
Girl Bathing WOR 249
The Night TAFTM 70
Phryne WOR 77
Saved WOR 78
Brutus I (Opus 74). Meadows
Brutus, Marcus Junius (Roman
Politician 85?-42 B. C.)
Michelangelo. Brutus
Bryce, James
Dick. James Bryce, bust
BRYCHTOVA, Jaroslava (Czech
1924-) See LIBENSKY, S.
BRYEN, Camille (French 1907-)
Objet a fonctionnement:
"Morphologie due de'sir"
1934/37 mounted casts of
ears, wood, candle,
flashlight, plywood; 7-7/8
x14-1/2x11 SEITA 61
BSCHORER, Hans Georg (German
1692-1764)
Maria Immaculata c 1735
limewood BUSB 150 GBS
Buanarotti
Mills. Study of Buanarotti,
head
Bucephalus
Bambaia. Alexander and
Bucephalus, relief
BUCHER, Franz (Swiss-German
1928-)
Holzplastik 1959 wood; 150x
160 cm KUL pl 10 GTutG
Wandergestaltung 1962 Beton;
260x420 cm KUL pl 11
GSigK

Le Bucher. Muller, R.
Le Bucheron. Niclausse
BUCHHOLZ, Erich (German 1891-)
 Hope, relief 1954 plaster
 ABAM 28 UNNFri
 Sculptures 1921/22 BERCK
 160
Buchner, George
 Bill, M. George Buchner
 Monument
Buchon, Mme. Max
 Courbet. Madame Max
 Buchon, bust
BUCKE, John (English)
 Staircase figure c1612
 MERC pl 41 EHeH
Buckets
 Early Christian. Holy Water
 Bucket
Buckingham, Duke of See Sheffield,
 John
Buckles
 Anglo-Saxon. Great Buckle
 Burgundian--6th c. Belt-
 buckle: Figure with
 raised arms
 Early Christian. Daniel in
 the Lion's Den, belt
 buckle
 Early Christian. Ornamental
 Buckle
 Flemish. Morse, from a
 cope
 Frankish. Buckle, and
 Spear Mounting
 French--13th c. Buckle#
 French, or English--13th c.
 Buckle
 Merovingian. Buckle#
 Velde. Belt Buckle
Buda Madonna. Hungarian--17th c.
Budapest. Patzay
Buddha. Brancusi
Buen Retiro Plaque. Spanish--18th c.
Buffaloes and Bison
 Betzenbroeck. Bison
 Faberge. Bison
 Kunstgewerbschule. Buffalo
Buffon, Georges Louis Leclerc de
 (French Naturalist 1707-88)
 Houdon. Georges Louis
 Leqlerc, Comte de Buffon,
 bust
 Pajou. Buffon, seated figure
BUGATTI, Rembrandt (Italian
 1884-1916)
 Diana cast bronze VEN-10:
 pl 126

Panther Walking c1906
 bronze; 8-1/8 (excl
 wood base) TATEF pl
 20H ELT (4482)
BUGGIANO, IL (Real name: Andrea
 di Lazzaro Cavalcanti)
 (Italian 1412-62) See also
 Brunelleschi, F.
 Lavabo, detail, South
 Sacristy c1445 marble
 SEY pl 56A IFCO
 Pulpit, detail: Presentation
 of Christ in the Temple
 c1440-53 marble, part
 gilt SEY pl 56A IFMar
BUGLIONE, Benedetto
 Santa Cristina, effigy un-
 glazed terracotta MACL
 157 IBolsC
BUGLIONE, Santi di Michele
 (Italian 1494-1576)
 Visiting the Sick, frieze
 detail, Corporal Works of
 Mercy MACL 155 IPiO
Building Construction
 Jagger. Modern Building
 Construction
 Sani. Builders
BULGARIAN--7th c.
 Belt Ornament gold ST 126
 BulSA
 --9th c. Bowl, Nagy Miklos
 Treasure gold BOZ 12
 AVK
 Jug, Nagy St. Miklos
 Treasure gold BOZ 11 AVK
 Lion Rampant, plaque, Pres-
 lav BOZ 20 BulSA
 Lioness, head, building
 detail, Preslav BOZ 21
 BulSA
 Madara Horseman, rock
 sculpture BOZ 19
Bulic, Frane
 Krsinic. Frane Bulic
Bull-Dog. Luginbuhl
Bull Fighting See Games and Sports
BULLA, Giovanni B., and J. P.
 CECHPAUER
 St. Sebastian, fountain detail
 STECH pl 180 CzCh
BULLA, Giovanni B., and J. P.
 CECHPAUER, and J. ROHR-
 BACHER
 Column: Transfiguration of
 the Lord STECH 119
 CzCH
BULLET, Pierre (French 1639-1716)

Porte, Saint-Martin 1674
GAF 119 FP
BULLOCK, George (English), and
Garrett JENSEN
Shakespeare, bust REED
160 UCSFG
Bunch of Grapes. Laurens, H.
BUNTING, John (English)
Adam and Eve, corbels
oak NORM 93 EOO
BUON, Bartolommeo (Italian
c1374-1467?)
Doorway LARR 139 IVMi
Madonna of Mercy Protect-
ing Members of the
Guild of Misericordia,
relief 1580 Istrian stone;
252x209 cm POPG pl
108 ELV
Porta della Carta: Justice
c1440 Istrian stone
POPG pl 106; SEY pl
45A IVP
--Putti POPG pl 107
BUON, Bartolommeo--ATTRIB.
Charity c1450 Istrian
stone SEY pl 45B IVSM
BUON, Bartolommeo, and Giovanni
BUON
Porta della Carta 1438-40
Istrian stone ENC 138;
HARVGW pl 289; POPG
fig 101 IVP
--Doge Kneeling before
Lion of St. Mark 1438/
42 BOE pl 148
--The Drunken Noah, south-
east corner BUSR 62
BUON, Giovanni (Italian c1355-
after 1428)
The Fall 1400-10 Istrian
stone; LS BOE pl 146;
MOLE 135 (col) IVP
Buoncampagni Monument. Ammanti
Burchard, Saint
Riemenschneider. St.
Burchard of Wurzburg,
half-figure
BURCKHARDT, Carl (Swiss 1878-
1923)
Amazon 1923 bronze; 2.31
m MAI 41; OST 72 SwBR
Art Gallery facade reliefs
AUM 23 SwZ
Dancer (Der Tanzer) 1921
bronze; 140 cm JOR-1;
pl 3 SwBKM
In Memory of H. Dieterle

1919 bronze; 26-1/2 GIE
32 SwZK
Korbtragerin 1918 bronze;
90 cm JOR-1: pl 2
St. George (Ritter George),
equest (final state) 1923
bronze; 74 GIE 33; JOR-
1: pl 1 SwBKo
The Burden. Daumier
Bureau, Jean
French--14th c. St. John
the Baptist; Jean Bureau
Bureaus
Boulle. Bureau of Elector
of Bavaria
Dubois, Jacques. Lacquered
Bureau
Oeben, F., and J. Riesener.
Cylinder Bureau of Louis
XV
Bures, Robert de d1302
English--13/14th c. Sir
Robert de Bures
Burger Theatre Relief. Luksch-
Makowska
Burgess, Richard
Banks. Capt. Richard
Burgess Monument
BURGES, William
Mantelpiece Frieze, Mel-
bury Road c1875/80
SCHMU pl 52 EL
Burghead Bull
Celtic. Incised Bull
Burghers of Calais
Rodin. Burghers of Calais
Rodin. Jean d'Aire, head
Rodin. Pierre de Wiesant
Burgonet See Armor--Helmets
BURGUNDIAN
Christ with Apostle, Portal
of Narthex, tympanum
POST 1:37 FVeM
Prophet or Saint, headless
figure sandstone; 49-1/8'
KUHN pl 2 UMCF
(1949.47.65)
--6th c.
Belt buckle: Figure with
Raised Arms MALV 130
SwLaM
--12th c.
Capital: Sacrifices of Cain
and Abel, Moutier-St.
Jean 1135 limestone; 25
UMCF UMCF (1922.18)
Nativity, relief GUIT 48
FAveN

Pentecost, tympanum, Main
 Portal c1132 PRAEG 249
 FVeM
--14th c.
Medal of Constantine (Church
 and Paganism) bronze;
 3-3/4; Dm: 21/64 SEYM
 39 UDCN
Medal of Heraclitus bronze;
 3-27/32; Dm: 17/64
 SEYM 38 UDCN
Saint, head limestone; 9-
 3/4 DEYE 27 UCSFDeY
Table Fountain STI 445
 UOClA
--15th c.
Female Mourner (Une Pleur-
 euse) c1450 marble NYWC
 pl 11a UNSatP
Holy Sepulchre 1454 CHASEH
 283 FToH
Madonna and Child REED
 59 UCLCM
Morse: The Trinity enamelled
 gold; Dm: 5 CHRC fig
 32; SEYM 40-42; SHAP
 pl 8 UDCN
Mourning Virgin, Cruci-
 fixion figure 1430 walnut;
 125 cm BSC pl 50;
 MULS pl 104A GBS (8475)
Notre Dame de Grace
 c1450 stone; 42-1/2
 NEWTEM pl 100 FTMA
Prophet, rood screen c1475
 MULS Pl 145A FAlbC
Prophet or Saint, headless
 figure 1425/30 sandstone;
 47-5/8 KUHN pl 3
 UMCF (1949.47.69)
St. Barbara c1450 marble;
 14-1/2 DEY 99 UCFDeY
St. Catherine c1470/80
 MULS pl 141A FAutR
St. James, Semur-en-
 Auxois c1460 stone
 MULS pl 101A FPL
St. John the Baptist,
 Poligny c1420 MULS pl
 56A UNNMM
St. Paul, Poligny c1420
 MULS pl 56B UNNMM
Virgin and Child limestone;
 62 cm BSC pl 49 GBS
 (8641)
--16th c.
Benedictine Monk c1500
 limestone; 60 CPL 74

UCSFCP (1956.19)
Cabinet: Carved figures and
 decoration walnut, ptd and
 gilded; 97 PRAEG 319
 (col) UNNMM
Madonna, nursing Child c1500
 FEIN pl 56 UNNMM
Burial in the Carpathians. Stursa
BURMAN, Belthaser (English fl
 1678-88)
Rachel, Countess of Bath
 1680 GUN pl 3 ETaw
Burney, Charles
 Nollekens. Dr. Charles
 Burney, bust
Burning Bush
 Danziger. Burning Bush
 Farber. Burning Bush
Burnous. D'Haese
Burns, Robert (Scottish Poet 1759-
 96)
 Flaxman. Robert Burns
 Steell. Robert Burns, seated
 figure
Burr, Purbeck
 Watson. A Hero: Purbeck
 Burr
The Burse of St. Stephen.
 Carolingian
BURT, Lawrence (English 1925-)
 Helmet 1962 aluminum; 40
 READCO pl 14 ELD
 Helmet I 1962 Iron; 27-1/4
 x15-1/2x18-1/2 MEILD
 28; TATES pl 28 ELT
 (T.639)
BURTON, Esmond (English)
 Courtyard Fountain AUM
 124 ELWi
 Memorial Headstone AUM 131
 Music-room Panels: St.
 George; Harry Lauder
 AUM 142 WHW
BURY, Pol (Belgian 1922-)
 18 Superimposed Balls 1965
 BURN 273 -Ril
 80 Rectangles on 20 Inclined
 Planes 1964 wood; 43-3/8
 x19-3/4x9-1/2 SELZP 31
 CTS
 Erectile Punctuation 1961
 PEL 171 FPCle
 434 Extra Large Flat Heads
 1964 wood and nails; 39-
 3/8x29-1/2 SELZP 29
 UPAT
 Hammered Copper (Rame
 Punteggiatura), relief

1963 VEN-64: pl 129
Inclined Plane with Forty-
nine Spheres 1966 wood
ptd, motorized elements;
71x22-3/4x44-1/2 GUGE
87 (col) UNNLef
Nine Balls on an Inclined
Plane 1964 wood; 40x27x16
SELZS 174 UNNLefe
Nine Balls on Five Planes,
motorized construction
1964 wood and synthetics;
39-3/8x8x16-3/4 ALBC-
4: 56; ALBC-; SELZ p 31
UNBuA
Oak Pegs on a Background of
the Same 1964 wood; 39-
3/8x29-1/2x5-7/8 SELZP
28, 29 UMBO
107 Balls of Different
Volumes 1964 ARTSM NAS
182 Balls on Two Opposing
Planes 1967 94x47x24
CARNI-67: #74 UNNLef
Punctuation 1963 wood and
nylon; 160x80 cm LIC
pl 306 UNNLef
Rods on Round Background
1962 wood and aluminum;
D: 35-1/2; W: 4-1/2
SELZP 30 UNNBro
23 Bouls sur 5 Plans In-
clines 1964 34x27-5/8x
15-3/4 NEW pl 193 UNNG
Busby, Richard (English Clergyman
and Schoolmaster 1606-95)
Bird. Dr. Richard Busby,
Monument
Buschor, Ernest
Wimmer. Ernest Buchor
BUSHNELL, John (English c1630-
1701)
Alvise Mocenigo Monument
1663 WHINN pl 30 IVL
Charles I 1671 stone; c
6-1/2' GARL 196;
WHIN pl 70a; WHINN
pl 28 ELO1
Charles II, bust ptd terra-
cotta CON-2: pl 44;
MOLS-2: pl 13; WHINN
pl 31A ECamF
Lord Mordaunt, effigy
CON-2: pl 42; MOLS-2:
pl 12; WHINN pl 29
ELF
Sir Thomas Gresham 17th c.
stone MOLE 254 ELBa

Sir William and Lady Ashburn-
ham Tomb 1675 GUN pl
2; WHINN pl 31B EAsh
BUSSI, Santino (?)
Staircase Figures 1695/1700
BOE pl 177 AVEu
Bust of a Lady# Desiderio da
Settignano
Buste (Tete Tranchante). Giacometti
BUSTELLI, Franz Anton (Swiss-
German 1723-63)
Chinoiserie Figures c1760
Nymphenburg INTA-1: 35
Columbine c1760 Nymphen-
burg; 7-3/4 KITS 29
(col) ELV
A Hunt Picnic c1760
Nymphenburg; 10-3/4
MONT 416 ELV
Lady with Flask c1760
Nymphenburg; 7-3/4
READAS pl 35 GHKG
Lady's Maid and Valet
c1760 porcelain KO pl
95 (col)
Lucinda and Ottavio c1760
Nymphenburg; DEYE 175
UCSFDeY (L61.4.3, 4)
Pantalone 1755/63 Nymphen-
burg BUSB 197; IARR
412 GMBN
Pluto c1760 Nymphenburg CLE
151 UOCIA (47.283)
Porcelain Figure ENC 142
Rococo Cavalier Nymphen-
burg STA 181 (col) GMBN
Der Sturmische Salan LIL 224
GMB
Woman c1760 Nymphenburg
READM pl 43 GHKG
BUSTI, Agostino See BAMBAIA
BUTLER, Reg (English 1913-)
Boy and Girl 1950/51 forged
iron; 81 BERCK 147;
GIE 213 ELBrC
The Bride 1954/61 bronze;
93 EXS 67 FPMat
--1954/61 bronze; 85 COND-
6: #8 ELH
Figure in Space 1956 bronze;
c 19 NMASo 30
--1957/58 bronze; 35-3/4
SELZN 42 UNNMat
--1959 bronze; 13-7/8 TRI
105
Figure in Space Catapult
1959 bronze; 24; base;
30 LOND-5: #7; SFMB

#101 ELH
Girl 1953/54 shell bronze;
70x16x9-1/2 ROTJB pl
130; ROTJG pl 22;
TATEB-1:13; TATES pl 3
ELT (6223)
--1954/56 bronze; 89
SELZN 43 UNNMat
--1956 bronze; 20-1/2
DETS 31 UNNH
--1956/57 bronze LOWR
139 UNNMat
--1956/57 bronze; 58
BERCK 147; ENC 143
ELH
--1957/58 bronze; 70
SCOM pl 8 ScEM
--1958 H: 70 CARNI-61:
#52 UNNMat
Girl and Boy 1950/51 forged
and welded iron; 81
NMAD 66; RIT 123 EA
Girl 5456 1954/56 bronze;
90 LONDC pl 4
Girl Looking Down 1956/57
bronze; 58 HAMM 110;
MID pl 120 BAM
Girl on a Wheel 1959
bronze; 19-1/2 SELZS
181 UNNJac
Girl on Her Back, State I,
study Feb 1967 1967
39-1/2x33-1/2x32-1/2
CARNI-67:#211 ELH
Girl with Vest (Sich
Entkleidende) 1955 bronze
GERT 205
--1953/54 shell bronze;
67-1/2 NMAD 68 UNNRo
Great Tower Study 1963
bronze; 14-1/2x10x10
CARNI-64:#235; HAMM
111 (col); LARM 369;
READCON 200 (col) ELH
Head 1949 bronze; 27
RAMS pl 76a
Italian Girl II, study 1960
bronze; 5-1/2x19-1/8x
7-7/8 MIUH pl 55 UMiAUA
The Manipulator 1954
READAN 44
--1954 bronze; 67 SOTH-
4:89
--1954 bronze; 68 BRION
pl 125
--1954 shell bronze; 65-1/2
x22-1/2x16-1/2 ALB 15;
FAIY 7; HENNI pl 126;

TOW 58 UNBuA
--1954 shell bronze; 67
READG 96
--1954 shell bronze; 67
MCCUR 276; NMAD 69
UPPiT
Ophelia A (Alice) 1955/56
bronze; 21-3/4 HAMM
107 (col) UPPiC
Ophelia 2 1956 bronze; 21-
1/4x7-1/4x5-1/4 CARNI-
58: pl 15 ELH
The Oracle (Das Orakel)
1952 bronze GERT 204
--1952 forged and cast
bronze; 73 NMAD 67
UNNMMA
--1952 shell bronze on
forged armature; L:78
DAM 110, 112; GIE 212
EHatT
--in process of construction
MILLS pl 78
Personage 1950 iron MEILD
12 UMNSA
Seated Girl, detail 1959/61
bronze; 35 NEW pl 99
Seated Woman with Child
1948 iron; 14-1/2 HAMM
106 ELHul
Tcheekle: Boite de Fetiches
1960/61 H:37-1/2 SEITC
52 ELH
Tcheekle: The Macaw's
Head 1960/62 bronze;
Tower: 39; Man: 16
READCO pl 2
Torso 1950 iron; 56-1/2
ALBC-1:#43 UNBuA
Torso 1955 bronze; 39
ARTSS #9 ELBrC
Tower 1962 bronze; 8-3/4
HAMM 109 (col)
Unknown Political Prisoner,
monument project 1952
bronze wire, stone base;
17-1/4 BAZINL pl 411;
BR pl 17; CHENSW 500;
ENC 43; HAMM 108; KULN
155; LIC pl 164; PEAR
27; READG 96 ELT
--1952 bronze, stone base;
17-7/8 HENNI pl 126;
MCCUR 276; NNMMM 159;
SELZN 42; TRI 235
--1952 bronze wire, stone
base; three figures: 96
(projected H: 150')

READAS pl 212 UNNKlo
--original maquette 1951/52
wire and metal, stone
base; 17-1/4 SOTH-2:77
--final maquette 1952 bronze
wire on plaster base; 18
BOW 151 GBAF
Woman flexible iron PRAEG
458
--1948 iron; 14 RAMS pl
76b ELGre
--1949 forged iron; 87x25
x19 MEILD 17; SELZN
40; TATES pl 9 ELT
(5942)
Woman Resting, study 1950
bronze wire LARM 366
ELT
Woman Standing 1952 bronze
wire, sheet metal; 18-1/2
READAS pl 210
Woman Walking 1951 bronze;
19-1/4 CALA 204; GUGP
91 IVG
Young Girl 1952/53 bronze
MAI 42 ELBrC
--1953/54 shell bronze
FAUL 462 UNNMMA
--1954 bronze; 35-1/2 KO pl
102 EL
Young Girl Removing her
Shift WILMO pl 27
Butter
Verhulst, R. Purchase of
Butter
Butter Markers. Folk Art--French
Butter Molds
Swiss--Folk Art. Butter
Mold: Bear with Flowers
Butterflies. Ceroli
Butterfly Ancestor. Penalba
BUTTI, Enrico (Italian 1847-)
Il Lavoro, monument figure
plaster VEN-1: pl 79
Buttresses
Metzner. Buttress: Human
face, and figures
BUVINA, Andrija (Croat)
Door Panels: Holy Legend
13th c. wood BIH 7
YSC
Self-portrait, choir stall
detail 13th c. BIH 6 YSC
BUXTON, Alfred (English)
Decorative Panels for a
vestibule AUM 121
Memorial Head Stone AUM
121

BUZI, Barna (Hungarian 1910-)
Woman with Basket 1953 bronze;
39 cm GAD 111 HBA
BUZIO, Ippolito
Coronation of Pope Paul V
POPRB fig 155 IRMMag
B'Wana-Ke. Lachat
By the Nile. Mokhtar
BYLAER, Gerhard van (Dutch fl 16/17th
c.)
Medal: "Tandem fit Surculus Ar-
bor", reverse 1602 gold; Dm:
1-3/8 VICOR pl 33C NHP
BYNG, L. H. R. (English)
Capt. R. C. Gordon-Canning,
head 1946 clay, for bronze;
LS NEWTEB pl 8
Lady Sarah Stuart, head 1946 clay, for
bronze; LS NEWTEB pl 8
BYRD, William (English)
Philip Harcourt, and Wife,
Tomb ESD pl 97 EOxfSt
Byron, George Gordon (English
Poet 1788-1824)
Belt. Byron, seated figure
BYSTROM, Johan-Niklas (Swedish-
Italian 1783-1848)
Juno and the Infant Hercules
(Origin of the Milky Way)
c1828 marble; 202x86 cm
LIC pl 39 SnSN
BYZANTINE
Abacus Capital c547 PRAEG
43 IRaV
Acanthus Leaf Capital LAS
163 IRaSN
--6th c.
LAS 163 TIS
Acanthus Leaf Capital, with
Monogram of Justinian
6th c. marble BAZINW
202 (col); CHRC 127;
LAS 64 (col) TIH
Adam, plaque 12th c. ivory;
2-3/4x3-1/8 JANSH 501;
JANSK 243 UMdBW
Adam and Eve Doing Black-
smith's Work, casket
c1000 ivory PANS pl 25
UOClA
Adoration of the Magi,
Epiphany bas-relief c420
marble; 69 cm GUIT 54-
55; HAN pl 347 IRaV
Altar Frontal, S. Carolino,
Ravenna 6th c. marble CLE
37 UOClA (48.25)
Altar Sacrifice, diptych leaf

(Simmachi) 5th c. ivory
GAUN pl 33 ELV
Ambon of Salonica 6th c.
marble; 17.9x82 cm RDB
pl 46, 47 TIAM
Angel, leaf of a religious
diptych 4th c. ivory
POST-1:12 ELBr
"Aniketos" (The Invincible):
Virgin and Child En-
throned, relief Cappella
Zeno 13th c. 46-1/2x31
MURA 36 IVM
Antioch Capital 5th c. lime-
stone; 21-3/4 BMA 13
UMdBM
Apostles, relief, Church of
St. John of Studion lime-
stone; 13.2x60 cm RDB
pl 17 TIAM (2394)
Arcadius, head 395/400
Pentelic marble BECK 18
TIAM
Archangel Gabriel, plaque
9th c. ivory; 15x8 cm
RDB pl 83 UDCTy
Archangel Gabriel, relief
6th c. marble RDAB 60
TAnM
Archangel Gabriel, relief
12th c. steatite; 15.2x
10.9 cm RDB pl 162
IFiB
Archangel Michael, book
cover 10/11th c. Enamelled
silver gilt BAZINL pl 175
(col); BECK 93; GRAB
171 (col); RDB 35 (col);
ST 112 IVM
Archangel Michael, diptych
leaf 519/27 ivory; 16-
7/8x5-1/2 BECK 32;
JANSH 168; JANSK 239;
MYBS 31; NEWTEM pl
46; RDAB 50; RDB pl
48, 49; ROBB 669; SEW
221; STI 323 ELBr
Archangel Michael, half
length, icon, repousse
relief enamelled gold;
18-7/8x14-1/2 MURA
24 (col) IVM
Archangel Michael, head
marble; 30 cm RDB pl
122 TIAM (3930)
Archangel Michael, relief
12th c. green steatite,
gilt; 5-7/8x4 RDAB 130
IFiB

Archangel Michael, repousse
10/11th c. gold, enamel;
18-1/8x13-3/4 MURA 67
(col) IVM
Ariadne, seated figure early
6th c. ivory BECK 37 AVK
Armlet and Bracelet gold;
Dm: 13.8 cm; and 7.6 cm
RDB pl 64 TIAM (3534
and 3841)
The Ascension, casket top
ivory; 5.5x16.5x9 cm
BECK 114; RDB pl 147
GStWL
The Ascension, relief 11/12th
c. ivory; 15x12 cm BECK
114; RDB pl 114 IFMN
Ascension of Alexander the
Great, borne by 2 Griffins,
north facade relief 39-1/4
x59 BEREP 60; MURA 37
Bakirkoy Relief 4th c. marble;
74x150 cm RDB pl 8
TIAM (2462)
Baptistry, east porch archi-
volts c1200 BOE pl 40
IPisaB
Barberini Ivory (Barberini
Diptych) c500 ivory; 34.1x
26.6 cm; central panel;
20.1x13.4 cm CHAR-1:221
(col); RDB pl 19 FPL
--Anastasius I, equest ivory;
13-7/16x10-1/2 ENC col
pl 20; VOL pl 219
--Justinian, Defender of the
Faith, diptych panel ivory;
13.4x10.6 GAU 117
--Triumph of the Emperor
LARB 45
Basket Capital stone MYBA
226 TIH
Battling Animals, relief
9/10th c. stone CHENSW
302 FPL
Bearded Head late 4th c.
Aphrodisian marble BECK
18 BBCi
Bearded Head stone CHENSW
303 UDCD
Beresford-Hope Cross 9th c.
cloisonne enamel on gold;
3-3/8x2-1/4 LAS 143 (col);
RDB pl 90 ELV
Bishop Arnulf Sarcophagus
12th c. PANR fig 24
FLisC
Book Cover 9/10th c. ivory
ROOS 59d FClO

Book Cover, Ada (original in
Vatican) ivory MYBS 32
ELV
Book Cover 10th c. ivory
ROOS 59B FClO
Book Cover 10th c. metal
with pearls and enamel
NEWTET 53 IVMarc
Book Cover 12th c. gold
enamel RDB 33 (col)
IVMarc (Ms Lat Cl 3,
No. 111)
Book Cover 12th c. silver
gilt and enamel; 30x21.5
cm RDB pl 141 IVMarc
(Ms Lat Cl 1, No. 100)
Book Cover 12th c. silver gilt
and enamel; 35x25.5 cm RDB
pl 140 IVMarc (Ms Lat Cl 3,
No. 111)
Book Cover: Anastasis 13th c.
silver gilt repousse; 33x20
cm RDB pl 174 IVMarc (A.1,
No. 55)
Book Cover: Christ on Cross,
with Saints and Archangels
886/912 enamel BECK 86 IV
Book Cover: Crucifixion 4th
c. silver gilt GRAB 57 (col)
IVMarc
Book Cover: Crucifixion 10/11th
c. ivory CHENSW 307 GMS
Box at Hippodrome: Battle with
Stags, panel 5th c. ivory
CHENSW 301 ELivL
Bronze Doors, Constanti-
nople 11th c. LARB 154
ISaC
Capital early 4th c. LARB
15 IFMi
--4th c.
LARB 15 IRaB
--552/37
UPJ 148 TIH
--6th c.
LARB 15 IRaSN
--6th c.
BAZINH 20; LARB 15 IRaV
Capital: Bird 610/41 marble;
27 cm RDB pl 34 TIAM
(2801)
Capital: Bird and Foliage 526
ROOS 57B IRaV
Capital: Cornucopia 7th c.
marble; 52x75 cm RDB
pl 34 TIAM (942)
Capital: Floral Motif
GARDH 205 IRaV

--6/7th c.
CHENSW 299 IRaMN
Capital: Foliate-Oceanus
6th c. marble; 38x52 cm
RDB pl 32 TIAM (2253)
Capital: Foliate-Theodosian
5th c. marble; 4.8x63 cm
RDB pl 32 TIAM (2367)
Capital: Griffin CHENSW
299 IPavM
Capital: Open work Scrolls
and Acanthas Foliage
JANSK 172; UPJH pl 51
TIH
Capital: Peacock and Foli-
ate c540 marble; 55x107
cm RDB pl 33 TIAM
(2655)
Capital: Trapezoid with
Abascus c547 PRAEG 43
IRaV
Capital: Winged Horse 6th c.
marble; 52x76 cm RDB
pl 33 TIAM (2404)
Capital: Capital with Mono-
gram of Justinian 523/37
VOL pl 196, 203 TIH
Capitals 532/37 BOE pl 30
TIH
Capitals: Foliage and Inter-
linear 11th c. ROOS 56F
IVM
Casket c900 ivory ROBB 672
UNNMM
Casket 11th c. ivory; 3-7/8x
5-3/4 MU 64-65 (col)
UMoKNG
Casket; details 11th c. ivory;
11.5x41.5x17.5 cm RDB
pl 110, 111 FPC1
Casket 11/12th c. ivory;
5-1/8x7-3/4 CLE 41;
LAS 164 UOC1A (24.747)
Casket: Busts of Christ,
Virgin, and Saints 12th c.
ivory; 12x49x15.2 cm
RDB pl 160, 161 IFMN
Casket: Hunting Scenes;
Mounted Emperors,
Phoenix 11th c. ivory;
5-1/2x10-1/4x5-1/8
RDAB 108, 109; RDB pl
152; FTrC
--Phoenix BECK 100
Casket: Mythological Scenes
10th c. ivory MYBA 230
UNNMM
Casket: Putti with Animals

12th c. ivory; 8 NM-7:10
UNNMM (17.190.239)
Casket: St. John Chrysostom;
St. John the Baptist 11/
12th c. ivory BECK 119
IFMN
Chalice: Christ and Apostles
10th c. enamel, agate
stem with silver gilt
mountings; 8-3/4 BECK
88; MURA 61 (col); RDB
pl 139 IVM
Chancel Plate: Peacocks
10th c. marble LAS 162
IVM
Chrismon 6/7th c. gold with
garnets CLE 39 UOC1A
(65.551)
Christ, intaglio 10/11th c.
GRAB 43 (col) FPMe
Christ, relief detail mid 10th c.
ivory GRAB 167 (col) FPMe
Christ, sarcophagus fragment 4th
c. ivory MOREYM pl 17A;
ROWE 43 GBK
Christ and Saints in Medallions
11th c. ivory BAZINW 206
(col) ELV
Christ between two Apostles, re-
lief 4/5th c. marble; 55-7/8x
55-3/4 BECK 25 POST-1:6;
SEW 223; VOL pl 73 GBS
Christ between two Apostles, re-
lief fragment 4/5th c. marble
BECK 22 TIAM
Christ Blessing 886/912 Jasper
BAZINW 205 (col); BECK 81
ELV
Christ Crowning Romanus and
Eudocia, relief 945/49 ivory;
9-1/2x6 BAZINL pl 154;
BAZINW 205 (col); BECK 81;
CHENSN 244; CHENSW 305;
LARB 153; RDAB 81; RDB
pl 97; ROOS 60C; ST 110;
STA 27; UPJ 51
FPMe
Christ Enthroned; Woman of
Samaria; Raising of
Lazarus, diptych 6th c.
ivory LARB 35 FPBN
Christ Enthroned, framed by
symbols of Evangelists
11th c. ivory; 6-1/2
HUYA pl 26; HUYAR 23
FPL
--diptych leaf metal CHENSW
309 IApL

Christ Enthroned with Apostle
Bearing a Cross, relief
7th c. marble BECK 27
TIAM
Christ in Mandorla stone
CHENSW 325 FTS
Christ on Cross, between
Virgin and St. John,
reliquary cover 10th c.
enamelled gilt silver BECK
92 IVM
Christ Pantocrater, Aleppo
plaque BAZINW 205 (col);
RDB pl 92 ELV (A.4.1910)
Christ Teaching the Apostles,
plaque 5th c. ivory LARB
13 FDM
Ciborium Arch: Heads of
Apostles, St. Mary Pana-
chrantos Church, Istanbul
6th c. (?) marble RDAB
61; RDB pl 62, 63 TIAM
(4268)
Coffer wood NORM 67 ELV
Coffer: Biblical Scenes 10th
c. ROOS 59F FPL
Coin: Commemorating Con-
stantinople Dedication:
Constantine I; reverse:
Constantinople, personi-
fication silver BECK 6
IMS
--NEWTET 79 ELBr
Coin: Constantine VII;
reverse: Christ, King of
Kings 945 gold BECK 68
ELBr
Coin: Julian the Apostate;
reverse: A Bull 361/63
bronze BECK 13 ELBr
Coin: Justinian II; reverse:
Christ, King of Kings,
Constantinople 685/95
gold BECK 54 ELBr
Coin: Leo III; reverse: Con-
stantine V 720/41 gold
BECK 61 ELBr
Coin: Leo VI; reverse:
Virgin Orans 945 gold
BECK 68 ELBr
Coin: Valentinian I; reverse:
Emperor in Quadriga 364/
75 gold BECK 13 ELBr
Concesti Amphora 4th c.
silver and silver gilt;
42 cm BECK 11, 12;
RDB pl 7, 6
RuLH

Confronted Peacocks, relief
12th c. marble RDAB 184
IVM

Confronting Angels, relief,
over west door RDAB
148 RuDC

Constantinople Coin:
Empresses Zoe and Theo-
dora; reverse: Panagia
Blachernitissa 1042 gold
BECK 105 ELBr

Constantinius II and his
Empress c335 chalce-
dony BECK 9 FPL

Consular Diptych ivory
AUES pl 10 ELV

Consular Diptych of Anas-
tasius 517 ivory; each
leaf: 14x5 BAZINW 199
(col); JANSK 242; POST-
1:11; RDB pl 26;
ROOS 58B; SEW 223;
VOL pl 220 FPMe

Consular Diptych of
Areobindus 506 ivory;
36x13.2x11 cm BECK
33; RDB pl 22 SwZS

Consular Diptych of Are-
obindus: Medallion of
Areobindus; Adam and
Eve with Animals 6/9th
c. ivory; 36x11.6 cm
CHAR-1:219; RDB pl
20 FPL

Consular Diptych of Flavi-
us Anastasius, leaf,
Constantinople 517
marble BECK 32 ELV

Consular Diptych of Justin
540 ivory; each leaf
33.5xc 13 cm BECK
40; BSC pl 8 GBS (6367)

Consular Diptych of Justini-
an 521 ivory; 36.8x12.7
cm BECK 39; RDB pl
31 IMS (A 13 and 13 bis)

Consular Diptych of Rufus
Germodius Probus
Orestes 6th c. ivory; each
leaf: 13.875x4.6 MYBS
28 ELV

Consular Solidus: Theodosius
II; reverse: Victory Hold-
ing Cross, Constantinople
c420 gold BECK 14 ELBr

Corinthian Capital 4th c.
BAZINW 202 (col) IRCos

Cross 960/63 silver BECK
94 UDCD

Cross of Justin II 563/78
silver gilt; 40x31 cm
BECK 44; RDB pl 71
IRV

Crown of Constantine IX
Monomachus; Zoe 1042/
50 gold and enamel BECK
108, 107 HBNM

Crowning of Constantine VII,
Porphyrogemitus, relief
fragment c944 ivory;
18.6x9.5 cm RDB pl
96 RuMFA

Crucifixion ivory CHASEH
181 UNNMM

--10th c. ivory CLAK 233
UNNMM

--10th c. ivory; 10-3/4x
6-1/4 CHENSW 306;
RDAB 80 ELBr

--11th c. ivory CHENSW 306;
SEW 295 UNNMM

Crucifixion and Deposition,
plaque 10th c. ivory
CHENSW 307 SwZMN

Daniel in Lion's Den;
Susanna and the Elders;
Susanna Before Daniel,
reliefs c310/20 ivory
BIB pl 206-208 IBrMC

Death of the Virgin, panel
c1000 ivory in jeweled
gold Gospel Book of Otto
III, Constantinople
BECKM 105 (col) GMS

Death of the Virgin, plaque
c1000 ivory; 4-5/8x6-
1/2 LAS 164; WORC 32
UNWA

Deesis: Christ between
Virgin and St. John the
Baptist, relief south
aisle 47-1/2x76 MURA
35 (col) IVM

The Deesis and Saints,
reliquary 963/69 ivory
BECK 82 ICorF

Deesis and Saints, triptych
2nd Q 10th c. ivory BECK
78 IRVen

Delivery of the Law, relief
4/5th c. marble BECK
23 TIAM

Diptych: Adam in the Garden
of Eden; St. Paul, scenes
from life c400 ivory
BARG; JANSH 311 IFBar

Diptych: Christ with Peter
and Paul; Madonna and

Child 6th c. ivory; 29x13
x12. 7 cm BSC pl 9 GBS
(564/565)

Diptych: Hunting Scenes
c450 ivory; each leaf:
32.2x10.6 cm RDB pl
36 RuLH

Diptych of Clementinus 513
ivory; 39x13 cm BECK
34; RDB pl 23 ELivL
(M.100036)

Diptych of Magnus, leaf 518
ivory; 26.3x13 cm BECK
36; RDB pl 27; ROOS
58D FPMe

Diptych of Philoxenus 525
ivory; each leaf: 38x14.3
cm RDB pl 30 EPMe (45)

Dish: Aphrodite in Tent of
Anchises, Constantinople
527/65 silver BECK 44
RuLH

Dish: Athena Deciding Quar-
rel between Ajax and
Odysseus silver; Dm:
26.5 cm RDB pl 74
RuLH

Dish: Atlanta and Meleager,
Constantinople 610/29
silver; Dm: 11 BECK 51;
RDAB 67 RuLH

Dish: Constantius II, equest
mid 4th c. silver BECK
10 RuLH

Dish: David Annointed by
Samuel, Cyprus 7th c.
silver; Dm: c 10-1/2
BIB pl 159; LAS 164
UNNMM

Dish: David Slaying Lion,
Constantinople 610/29
silver; Dm: 5-1/2 BECK
52; LARB 19; MU 64;
NMA 46; VOL pl 250
UNNMM (17.190.394)

Dish: Goatherd, Constanti-
nople 527/65 silver
BECK 42 RuLH

Dish: Marriage of David,
Constantinople, 610/29
silver; Dm: 10-5/8
BECK 52; RDAB 66; RDB
pl 73 CyNA (454)

Dish: Shepherd silver; Dm:
24 cm RDB pl 42 RuLH

Dish: Silenus 610/29 silver;
Dm: 25.7 cm RDB pl
75 RuLH

Dish: Theodius I; Valentinian
II; Arcadius 388 silver
BECK 17, 18 SpMaH

Dish of Paternus 518 silver;
Dm: 61 cm RDB pl 28, 29
RuLH

Door, south entrance c840
bronze RDB pl 81 TIH

Dormition of the Virgin,
relief ivory; 14.5x11 cm
RDB pl 119 GBS (Cod Lat
4453)

Ear Rings gold and jewels
RDB pl 65 TIAM

Emperor, head detail porphyry
BEREP 61 IVM

Emperor, relief fragment
marble; 73 cm RDB pl 148
TIAM (4207)

An Emperor of the East,
facade medallion marble
MURA 17 IVCam

Emperor on Horseback, and
Scenes of Victory, consular
diptych leaf c500/20 ivory;
13-1/2x10-1/2 JANSK 240
FPL

Empress, enthroned under
canopy c800 ivory MU 62
(col) AVK

Empress, head 4/6th c.
marble BAZINW 198 (col)
IMS

Empress Ariadne, diptych
leaf c500 ivory; 36.5x13.6
cm BECK 37; RDB pl 21
IFMN

Empress Arianna 6th c. ivory
BARG IFBar

Empress Eudocia, tabernacle
6th c. ROOS 58 IFBar

Empress Zoe, medallion
1028/50 enamel silver
gilt BECK 107 IVM

Enamel Cross, reverse 12th
c. silver gilt; 26x21 cm
RDB pl 170 ICoC
--obverse RDB 49 (col)

Enthroned Christ, affixed to
metal book cover 10th c.
ivory; 15 cm RDB pl 107
EOB (Auct. T. Inf. 1.10)

Entry into Jerusalem, relief,
Church of St. John of
Sudion 5th c. limestone;
39-1/4x59 RDB pl 16;
VOL pl 81 TIAM (2395)

Entry into Jerusalem, trip-

tych panel 10th c. ivory;
18.4x14.7 cm BSC pl 11;
PANR fig 23; RDB pl
115 GBS (1590)
Epiphany of Emperor Con-
stantine VIII Porphyro-
genitus, relief c945 ivory
BECK 68 RuMFA
An Evangelist, bust 4/5th c.
marble; 69 cm BECK 26;
HAN pl 346 TIAM
Filigree Foliate Capitals
527/36 marble BAZINL
pl 171; RDB pl 51 TIS
Filigree Foliate Capitals
527/37 marble RDB pl
57 TIH
Fishing Scene, casserole,
Constantinople 610/29
silver BECK 50 RuLH
Foliate and Vine Motif,
pierced slab 6th c.
marble LARB 231 IRaV
Foliate Capital c525/47
BAZINW 203 (col) IRaV
Foliate Motif, Antioch
architectural fragment
5th c. marble; 25-3/4
BMA 12 UMdBM
Foliate Pilaster and Capital
BEREP 58 IVM
Forty Martyrs of Sebastia
(Die Vierzig Martyrer
von Sebaste), middle panel
of triptych 10th c. ivory;
17.6x12.8 cm BAZINW
206 (col); BECK 136;
BSC pl 10; NEWTET 69;
RDAB 125; RDB pl 116,
117 GBS (574)
Gazelle Drinking from a
River of Paradise, relief
fragment 6th c. marble;
16-1/8x16-3/4 BMA 13
UMdBM
Geometric Ornamental
Slabs 12th c. marble;
93x195 cm; and 71x73
cm RDB pl 156 TIAM
(2250; and 2922)
Gladiators and Lions, plaque
ivory CHENSW 308 RuLH
Goblet gold; 16 cm RDB pl
82 TIAM (1531)
The Good Shepherd, Corinth
HOR 375 GrABy
Gospel Cover 10th c. gold
repousse with enamels
RDAB 111 ISL

Gospel Cover 10th c. silver
gilt, jewelled and
enamelled GRAB 177 (col);
175 (col)
Gospel Cover: Christ and
Saints 10th c. enamel,
jewelled; 11-3/4x8-1/4
MURA 71 (col) IVMarc
(Cod Lat 1, 100)
Gospel Cover: Crucifixion
and Saints and Angels
9/10th c. enamel, glass
paste mosaic border;
10-1/4x6-7/8 MURA 70
(col); RDB pl 91 IVMarc
(Cod Lat 1, 101)
Gospel Cover, Emperor
Nicephorus Phocas c970
silver gilt and enamel
RDAB 111 IMtAL
"Grotto of the Virgin", vase,
on crown of Leo VI, rock
crystal, gilt bronze figure;
7-7/8 MURA 63 (col) IVM
Hagia Sophia Capitals c537
FLEM 159 TIH
Harbaville Triptych 10/11th c.
ivory; 9-1/2x11 GAUN pl
32; JANSH 183; JANSK 243;
MYBA 234; NEWTET 51;
POST-1:16; ROBB 671;
ROOS 59A FPL
--reverse LARB 152; RDB
102
--Christ Enthroned with
Apostles; side leaves;
Saints of Greek Church--4
in military dress ivory;
central panel; 6-1/2;
side leaves; 4-1/2 CHAR-
1:222-23; HUYA pl 25;
HUYAR 94
--Deesis: Christ Enthroned
between the Virgin and St.
John the Baptist; Saints,
central panel BECK 79;
CHRP 130; GAU 124;
LAS 143 (col); MOREYM
pl 45; RDAB 77
--wings closed; inside; re-
verse of central panel
RDB pl 100, 101
Heraclitus 610/29 bronze
BECK 28 IBar
Hercules, bucket detail,
Constantinople 610/29
silver BECK 50 AVK
Hercules and Nemean Lion,
plate 6th c. silver

BAZINW 198 (col) FPMe
Hercules with Cerynean Hind
c500 marble; 45x31-1/2
KO pl 35; LARB 19; VOL
pl 180 IRaMN
Holy Crown of Hungary:
Michael VII Dukas and
his son Constantine, and
Geza I, King of Hungary
1074/77 gold and enamel
BECK 109 HBNM
Holy Women at the Sepulchre,
diptych leaf c400 ivory;
12-1/8x5-1/4 JANSK 239;
LAS 142 (col); VOL pl 92
IMS
Holy Women at the Sepulchre,
repousse plaque 11th c.
silver gilt; 16.5x11.8
CHAR-1:241; GAR 136;
LARB 154; RDB pl 167;
SWA 30 FPL
Homus Vase: Medallions of
Christ and Apostles,
Emesea 6th c. silver re-
pousse; 17-3/8; Dm:
11-3/8 CHAR-1:242; RDB
pl 44, 45; VOL pl 246
FPL
Horses of St. Marks 4th c.
gilded bronze BRIONA 68
IV
Hunting Scenes, plaque
bronze, silver inlay;
L: 18.7; W: 15 cm
RDB pl 37 FPL (3348)
Imperial Box at Hippodrome:
Theodosius I, Valentinian
II, Arcadius, Honorius,
obelisk base c390 marble
BECK 15 TIAt
--Patricians and Dancers at
Hippodrome BECK 20
India, relief detail 8th c.
MALV 628 TIM
Jonah and the Whale, re-
lief c310/20 ivory BIB pl
204-205 IBrMC
Joseph Distributing Corn in
Egypt; Meeting of Jacob
and Joseph, reliefs mid
6th c. ivory BIB pl 73,
74 IRaC
Joseph Story Scenes, box
relief 12th c. ivory
BIB pl 84, 85 GBK
Joseph Story Scenes, box
relief 12th c. ivory BIB
pl 86 ELBr

Joshua Life, scenes, casket
panel 10th c. ivory; 7.5x
27 cm RDB pl 112 ELV
(265.1867)
Justinian, equest, diptych
leaf, Constantinople 527
ivory BECK 38 FPL
Lambs, frieze, church archi-
trave after 404 BECK 22
TIAM
Lamp, North Syria 6/7th c.
bronze; 12-1/4 (with
chains) MIUH pl 1 UMiAUA
Lampstand 4th c. silver CLE
37 UOClA (54.597)
Leo VI and Saints, chalice
detail 886/912 enamel and
silver gilt BECK 87 IVMarc
Leo VI Crowned by Virgin,
with Archangel Gabriel,
sceptre fragment 886/
912 ivory BECK 67 GBS
Life of Christ Scenes, 3
register panel 13th c. ivory;
9-7/8x4-3/4 RDAB 183;
RDB pl 175 ELV (295)
Lion Attacking Deer, relief
11th c. marble; 86x106 cm
RDB pl 80 TIAM (1652)
Little Metropolis (St. Eleuthera)
11/12th c. BAZINW 206
(col) GrA
Liturgical Fan 6th c. silver
gilt; Dm: 25 cm RDB pl
68 TIAM (3758)
Madonna and Child 11th c.
ivory SEW 294 NUA
Madonna and Child with
Saints ivory CHENSW 305
UDCD
Madonna of St. Luke, pendant
10th c. steatite CLE 40
UOClA (51.445)
Madonna Orans, relief 11th c.
stone ROBB 339 IRaM
Medallion: Christ, bust 9th c.
steatite CLE 39 UOClA
(47.37)
Medallion: Constantius II;
reverse: Constantine, Con-
stantius, Constans 333/35
gold BECK 8 AVK
Medallion: Epiphany; Baptism
of Christ late 6th c. gold
BECK 48 UDCD
Medallion: Maurice Tiberius,
Cyprus 582/602 gold BECK
48 UNNMM
Medallion of Justinian

(electrotype of gold
original) 534/38 gold;
Dm: 8.6 cm LAS 7;
RDB pl 60 formerly
FPMe
Melon Capital: Foliate
Surface CHRC 127 IRaV
Moses Receiving the Law,
stele relief 7th c. lime-
stone BIB pl 113 GBK
Moses Story, scenes, box
relief c310/20 ivory
BIB pl 87-89 IBrMC
Mounted Emperors Offered
City Crown, casket lid
mid 11th c. ivory BECK
101 FTrC
Multiple Solidus: Constantius
II; reverse: Constantinople,
Nicomedia c355 gold BECK
8 ELBr
--Constantius II; reverse:
Constantinople, Antioch
355 gold BECK 8 ELBr
Multiple Solidus: Justinian
I; reverse: Justinian I
Preceded by Victory,
Constantinople c534 gold
BECK 14 ELBr
Muse and Poet (Seneca?),
diptych c500 ivory; 13-
3/8x4-7/8 BECK 41;
KO pl 35; VOL pl 221
IMonC
Necklace, Cyprus 6th c.
gold NM-7:9 UNNMM
(17.190.715)
Nereid on Sea Monster,
ewer 610/29 silver;
9-15/16; Dm: 5-5/16
BECK 50; KO pl 35;
VOL pl 253 RuLH
Oliphant, detail: War and
Pastoral Scenes c1100
ivory; detail H; c 20 cm
(1/3 horn length) BOES
34 DCNM
Opposing Gryphons by Tree
of Life, screen detail,
Italy 8/9th c. marble
LARB 87 UNNMM
Orpheus charming Animals
350/400 marble; 1.1 m
HAN pl 342 GRABy
Pala D'Oro, Altar Screen,
main altar 10/14th c.
enamels in gold, silver
jeweled framework;
82x137 LAS 144 (col);

MURA 48-49 (col) IVM
--Archangel Michael MURA
53 (col)
--Baptism of Christ MURA
50 (col)
Panel: Europa on the Bull;
other mythological scenes
9/10th c. ivory CHENSW
304 FPV
Panel Reliquary, reverse;
obverse 963/69 ivory;
31x17.4 cm RDB pl 120,
121 ICorF
Passion of Christ, relief
fragment 11/12th c.
steatite CLE 41 UOC1A
(62.27)
Paten: Communion of the
Apostles 567/78 silver,
partly gild; Dm: 14-5/8
RDAB 63; RDB pl 69;
VOL pl 247 TIAM (3759)
Paten: Crucifixion, Halber-
stadt 11th c. silver; Dm:
38.8 cm RDB pl 136
GHalC
Paten, six-lobed 11th c.
alabaster; Dm: 13-3/8
MURA 60 (col); RDB pl
137 IVM
Peacocks, slabs 12th c.
marble; 78x119 cm RDB
pl 157 TIAM (3978, 3979)
Peacocks Drinking, building
stone, Venice 7th c.
CHENSW 294 GBM
Pedestal, statue base c500
marble; 1.52 cm RDB pl
35 TIAM (4202)
Pendant: Intaglio portrait
6th c. garnet, gold
filigree CLE 38 UOC1A
(47.33)
Pictorial Triptych 10/11th c.
ivory; 12.2 cm; central
leaf W: 10 cm RDB pl 118
FPL
Pillar of Acre; Four Tetrarchs
MURA 33 (col) IVM
--Four Tetrarchs (Four
Emperors): Diocletian,
Maximian, Galerius, Con-
stantius Chlorus c300
porphyry; 52 KO pl 34;
VOL pl 25
Plate: David and Goliath,
Treasure of Cyprus 6th c.
silver CHENSW 302
UNNMM

Plate: India, personification--
seated female figure, with
hornlike headdress 6th c.
silver; 17-3/4 RDAB 51;
RDB pl 43 TIAM
Plates: Life of David: David
Receives Samuel's Mes-
sage; David kills a Bear
610/29 silver RDB pl
72 CyNA (423, 453)
Procession Transporting
Relics 6/7th c. ivory;
13.1x26.1 cm RDB pl 70
GTC
Pyx 5th c. ivory CHENSW
298 IFMN
Pyx Details: Martyrdom of
St. Menas; Sancturay of
St. Menas, with camel
heads, Constantinople?
6th c. ivory; 3-1/8x
4-1/4 BECKC pl 35, 36;
VOL pl 236 ELBr
Pyxis 6th c. ivory CLE 37
UOClA (51.114)
Reliquaries of True Cross
964/65 enamelled silver
gilt; 48x35 cm BECK 89-
91; RDB pl 124-26 GLiC
Reliquary: Domed Edifice
12th c. silver gilt; 15
MURA 64 (col) IVM
Reliquary, reverse: Leafed
Cross 12th c. silver
gilt; 42x29.8 cm RDB
pl 166 FPL
Reliquary for Hand and Arm
15th c. gold; L: 49 cm
RDB pl 196 TITo
Reliquary for True Cross
fragment 6th c. enamel;
6x5.5 cm RDB pl 70
FPoR
Reliquary framing True
Cross fragment 963/69
ivory; 12-1/4x6-3/4
RDAB 85 ICorF
Reliquary of Cardinal
Besserion 14/15th c. VAL
IVAc
Reliquary of St. Simeon
Stylites: Saint on Column
chased silver LAS 165
FPL
Riha Paten: Communion of
the Apostles 565/78 silver
and silver gilt BECK 47;
LARB 45; MCCL pl 7

UDCD
Rothschild Cameo: Emperor
Constantius II and his con-
sort c335 dark brown and
white sardonyx: Dm: 6-1/2
COOP 171; LARB 41
FPRoths
Rufus Probianus, diptych
detail c400 LARB 15
GBSB
Ruler, bust 8th c. H:c 36
STI 357 EgCM
Sacred College, plaque 5th c.
ivory LARB 229 FDM
St. Agothonikos, relief 12th
c. stone RDAB 185 ICao
St. Eudoxia, plaque 11th c.
incrustation work; 67x28
cm RDB pl 149 TIAM
(4309)
St. George of Cappadocia,
jewel 10th c. quartz CLE
40 UOClA (59.41)
St. John the Baptist, relief
11th c. ivory; 24.2x10.1
cm RDB pl 144 ELivL
(M.8014)
St. John the Baptist, with
Apostles: St. Philip and
St. Stephen, St. Andrew
and St. Thomas, mss
cover 10th c. ivory; 9-
1/8x5-1/4 BECK 118;
MCCL pl 11; NEWTEM
pl 45; RDAB 124; RDB
pl 145; READAS pl 66
VICF 13 ELV (215.1866)
St. John the Evangelist and
St. Paul, plaque 10th c.
ivory; 24.5x13 cm BECK
81; RDB pl 103 IVA
St. Mark and his followers
in Alexandria ("Preaching
of St. Paul") 6th c. ivory;
5.9x4.7 GAU 120 FPL
St. Sergius or St. Bacchus,
bowl 610/29 silver;
repousse with niello; Dm:
9-7/16 BECK 53; VOL
pl 249 ELBr
Saints, capital reliefs 11/12th
c. marble BECK 119 FPCl
Saints, or Apostles, relief
6th c.(?) marble BECK
26 TIAM
San Vitale Capital c547
FLEM 159 IRaV
Sarcophagus: Biblical Themes

marble STA 21
Sarcophagus: Symbolic Cross-
es and Doves 677/88 marble
STA 27 IRaS
Sarcophagus fragment, Sidi-
mara c400 marble; 142x124
cm BERLES 177 GBSBe
(2430)
Sariguzel Sarcophagus 4/5th
c. marble; 155x150x63
cm BECK 21; RDB pl 9
TIAM (4508)
"Seat of St. Mark", reliquary
shrine 6th c. marble; 58
MURA 54 IVM
Seated Figure and Attendants
9/10th c. stone MOREYM
pl 64 YSB
Sheep and Lion, tomb GLA
pl 31 IRaS
Silenus, dish fragment,
Constantinople 527/65
silver BECK 43 UDCD
Silenus and Dancing Maenad
610/29 silver and silver
gilt BECK 49 RuLH
Spear Mount 350/400 gilded
silver; 4-7/8 NM-7:12
UNNMM (17.192.145)
A Stag, relief fragment
8th c. marble; 89x98.5
cm RDB pl 80 TIAM
(2156)
Statue base 5/6th c. marble
BECK 24 TIAM
Strogonoff Ivory: Madonna
and Child 11th c. ROOS
60A UOCIA
Stuma Paten, Constantinople
565/78 silver and silver
gilt BECK 46 TIAM
Theodora, head c530
marble; 27 cm RDB pl
61 IMS
"Theodosian" Capital c453
BAZINW 202 (col) TIJ
Theodosian Obelisk Base
c395 RDB pl 5 TIHip
Throne of Maximian (Bishop's
Chair; Cathedra of
Maximianus; Episcopal
Throne of Maximian;
Throne of Maximianus)
c546/56 ivory panels on
wood frame; 59x23-5/8
BAZINH 122; BAZINW
200-1 (col); CHASEH
179; CHENSN 245;

CHENSW 300; ENC 424;
FLEM 164; JANSK 241;
LAS 141 (col); MARQ 141;
NEWTET 49; ROBB 670;
ROOS 57F; 58A; UPJ
150; UPJH pl 56; VOL
pl 226 IRaA
--Four Apostles SEW 229;
VOL pl 228
--Joseph's Dream and Flight
into Egypt; Annunciation;
Baptism of Christ VOL
pl 228-233
--Life of Joseph, scenes,
side panels POST-1:13;
RDAB 20; VOL pl 235
--Miracle of the Loaves and
Fishes BAZINL pl 158;
VOL pl 234
--The Nativity, back RDAB
21
--St. John the Baptist between
four Evangelists, front
panel BECKC pl 22; CHRP
128; GARDH 205; LARB
35; MOREYM pl 20; STI
356; VOL pl 227
Transenna, with pierced
decoration 6th c. marble
BAZINW 203 (col); LARB
42 IRaMN
Triptych ivory ROOS 59C
IFBar
Triptych 10th c. ivory; 18.5
x11.5 (W of central leaf)
cm RDB pl 123 ELutW
Triptych 12th c. cast bronze;
15.4x20.1 cm RDB pl 158
ELV (1615.1855)
Triptych: Christ on the
Cross 10th c. ivory; 23.4
x26.5 cm BSC pl 12 GBS
(1578)
Triptych, reverse; inside
10th c. ivory; 24x14.5
(W of central leaf) cm
RDB pl 98, 99 IRVen
Triptych, reverse of wings;
interior c988 27.5x16.3
(W of central leaf) cm
RDB pl 104, 105 ELBr
(1923-12-5)
Two Chlamydati late 4th c.
Aphrodisian marble BECK
19 TIAM
Two Horizontal Plaques, dip-
tych c500 ivory; 10.7x
10.4x33.6 cm RDB pl 18

IMS (A 11, and A 12)
Two Medallions: Life of
 Christ 6th c. gold: Dm:
 8 cm RDB pl 66 TIAM
 (82)
Valentinian II 387/390
 Aphrodisian marble BECK
 16 TIAM
Vase 4/6th c. silver CLE
 37 UOClA (57.497)
Veroli Casket 10th (?) c.
 ivory and bone overlay on
 wood; 4-1/2x15-3/4x6
 CHENSW 304; RDB pl
 108, 109; STI 358; VICF
 9 ELV (216.1865)
--Bacchanalia AGARC 56
--Bellerophon with Pegasus;
 Sea Horse; Dionysus on
 Chariot BECK 76-77
--Europa and the Bull
 AGARC 56; BECK 76;
 PANS 69; RDAB 86;
 SEW 284
--Putti and Animals
 BAZINW 205 (col)
--Sacrifice of Iphigenia
 BECK 76-77; JANSH 183
--Stoning RDAB 86
A Victory, relief, Gate of
 Ayvansaray mid 5th c.
 marble BECK 23 TIAM
The Virgin, relief 14th c.
 marble LARB 153 UDCD
The Virgin, relief detail,
 Venice 11th c. marble
 CARTW 19 UDCD
Virgin, tondo relief 1078/81
 green porphyry; Dm:
 17.9 cm RDB pl 150 ELV
 (A. L. 1927)
Virgin and Archangel
 Gabriel, panels 1078/81
 Psamtia marble BECK 117
 GBS
Virgin and Child 10th c.
 ivory; 12-3/4 RDAB 85;
 RDB pl 106 ELV (702.
 1884)
Virgin and Child 10/11th c.
 ivory ROOS 59G UNNMM
Virgin and Child 11/12th c.
 ivory; 9-1/8 NM-7:10
 UNNMM (17.190.239)
Virgin and Child 11/12th c.
 ivory; 12-3/4 READAS
 pl 179 ELV
Virgin and Child (Virgin
 Hodighitria: "Guide")

11th c. ivory BAZINW
 206 (col) ELV
Virgin and Child, panels
 11th c. ivory; each
 wing: 27.9x11.3 cm
 RDB pl 154 GBaB
 (Cod.A.11.54 and 55)
Virgin and Child, plaque
 11th c. marble; 78x74
 cm RDB pl 151 TIAM
 (4730)
Virgin and Child, plaque
 12th c. copper gilt; 22
 .4x14 cm RDB pl 158
 ELV (818.1891)
Virgin and Child, relief
 11th c. ivory; 26x13.6
 cm RDB pl 143 NUA
Virgin and Child Enthroned,
 plaque 11th c. ivory
 CLE 41; MILLER il 60
 UOClA (25.1293)
Virgin and Child with St.
 John the Baptist and
 Bishop Saint 10/11th c.
 ivory; 6-3/8 CHRC fig
 62; GARDH 214; LARB
 153; PANA-1:33 UDCD
Virgin Orans, medallion
 1078/81 serpentine BECK
 117 ELV
Virgin Orans, panel, Manganes
 11/12th c. marble BECK
 117 TIAM
Virgin Orans, relief fragment
 11th c. marble; 20.1x99
 cm RDB pl 142 TIAM (3914)
Visitation: Magi before Herod
 11/12th c. ivory ROOS
 59E ISaC
Warriors, equest, casket
 panel 10/11th c. ivory;
 11.1x43.5x17.5 cm RDB
 pl 112 UNNMM (17.190.237)

C, Mlle.
 Cornet. Mlle. C, bust
C (Imaginary Alphabet). Bertoni
Cabbages under the Snow. Gilardi
Cabeza Llamada el Encapuchado.
 Gonzalez
Cabinets
 Burgundian--16th c. Cabinet
 Dutch--17th c. Carved Oak
 Cabinet
 Dutch--17th c. Polished
 Rosewood Cabinet
 French--16th c. Two-Storied
 Cupboard

French--17th c. Cabinet on
 Stand
Italian--16th c. Florentine
 Cabinet, used as strong
 box
Russian. Wooden Cabinet
Cabot, John (Italian Navigator and
 Explorer 1450-98)
 Cusici and Capellano. John
 Cabot, relief bust
Cabrillo, Juan Rodriguez (Portu-
 guese Explorer in America
 d 1543)
 Bree. Juan Rodriguez
 Cabrillo, Cabrillo
 National Monument
 Portuguese. Cabrillo
Cacciatore Negroes. Duquesnoy, F.
CACCINI, Giovanni (Italian 1556-
 1612/13) See PAGNI
Cachet, C. A. Lion
 Zijl. Dr. C. A. Lion Cabot,
 head
Cactus-Man. Gonzalez
Cacus
 Bandinelli. Hercules and
 Cacus
Le Cadeau
 Ray. The Gift
Caduceus
 Bologna. Mercury (Flying
 Mercury)
 Idrac. Mercury Inventing
 the Caduceus
Caelum II. Toyofuku
Caesar, Julius (Gaius Julius)
 (Roman General and States-
 man 100-44 B.C.)
 Desiderio da Settignano.
 Julius Caesar, relief
 Early Christian. Caesar,
 wreathed head
 Giuliano da Maiano. Caius
 Julius Caesar, head,
 roundel
 Porta, G. B. della
 Julius Caesar, bust
Caesar Fountain. Czech--18th c.
CAFFA, Melchiorre (Melchiorre
 Cafa) (Italian 1635-1667/68)
 Alexander VII, bust 1667
 bronze; 39-1/2 DETI
 70 UNNMM
 Baptism of Christ bronze;
 15x16-1/2 DETI 70
 UWaSA
 Ecstacy of St. Catherine
 1667 marble, white and
 colored; over LS MOLE

186; WIT pl 114 IRCath
St. Thomas of Villanova
 Distributing Alms, model
 1661 terracotta WIT pl
 113B ILaVaM
Caffarelli, Scipione See Borghese
 Scipione
CAFFIERI, Jean Jacques
 (French 1725-92)
 Andirons gilt bronze; 17-1/2
 COOP 156 URNewW
 Canon Pingre, bust 1788
 terracotta JAL-5: pl 11;
 LARR 387 FPL
 Luzi Darinville, bust 1776
 terracotta; LS COOP 151
 URNewW
 Mlle. de Camargo, bust
 terracotta; 27 (with base)
 CPL 75 UCSFCP (1927.11)
 Ormolu Fire Dogs c 1750
 gilt bronze; 17 YAP 222
 -UWic
 Ormolu Fire Dogs 1752 gilt
 bronze CLE 138; LOWR
 246 UOClA (42.799;
 42.800)
 Rotrou, bust POST-2: 36
 FPCF
 Sculptor Van Cleve, bust
 CHASEH 392 FPL
 Young Girl, bust 1751
 marble; 31 (with base)
 HUNT pl 35 UCSmH
CAFFIERI, Jean Jacques--FOLL.
 Benjamin Franklin, bust
 c1800 marble; 27-1/4
 AP 117 UPPA
The Cage. Paolozzi
Cagliastro, Count Alessandro di
 (real name: Giuseppe
 Balsoma) (Italian Imposter
 1743-95)
 Houdon. Count Cagliastro,
 bust
Caiaphas See Jesus Christ--Trial
CAILLE, Pierre (Belgian 1911-)
 Bird Figures 1930's ceramic
 GOR 19
 The Camel ceramic BERCK
 178
 Rider ceramic MAI 42 BBR
 Two Devils 1961 bronze
 VEN-62: pl 121
Cain and Abel
 Bellano. Cain and Abel
 Bernward of Hildesheim.
 Door: Abel
 Bonannus of Pisa. Cain and Abel

Burgundian--12th c. Capital:
Sacrifices of Cain and
Abel
Dupre. Abel
French--12th c. Capital:
Cain and Abel
French--13th c. Adam and
Eve; Story of Cain and
Abel, west portal panels
German--11th c. Hildesheim
Cathedral Doors, left
door: Cain and Abel
--Sacrifice of Cain and
Abel
Ghiberti. Baptistry Doors--
East: Cain and Abel
Italian--13th c. Cain and
Abel, capital detail
Maitani. Cain killing Abel
Quercia. San Petronio
Doorway: Sacrifices of
Cain and Abel
Romanesque--French. Cain
and Abel
Vigeland. Abel
Wiligelmus. Slaying of
Cain, relief
Wostan. Cain
Cairoli, Enrico and Giovanni
Cairoli
Rosa. Cairoli Brothers
Monument
Cajetan of Thiene, Saint (Italian
Religious Reformer 1480-
1547)
Brokoff, F. M. St. Cajetan
Cake Molds
Folk Art--Russian
Gingerbread Figures: Mother
and Child; Horse--from
wood molds
Calais
Rodin. Burghers of Calais
CALANDRA, David (Italian 1856-
1915)
Amadeus of Savoy, equest
bronze and stone MARY
pl 68 IT
Umberto I, equest MINB 84
IRB
Calboli, Paulucci de
Bortolotti. Bulcieri Paulucci
de Calboli, half figure
Calcagnini, Carlo Leopoldo
Bracci. Carlo Leopoldo
Calcagnini Tomb
CALCI DA VELLETRI, Silvio
(Roman fl 17th c.)

Amphora black marble;
42 cm; Dm: 32 cm FAL
pl 41 IRB (CXXX;
CXXXIII)
Urn gilded metal; .52x.60 m
FAL pl 42 IRB (CLXIII;
CLXVII)
Calciatore. Moschi
CALDELARI, Sebasian (Italian)
Narcissus 1812 marble
HUBE pl 66 FRiM
Caligula
Italian--17th c. Caligula,
bust
Porta, G. B. della.
Caligula, bust
Call to Arms. Rodin
Calliope. Majou
Callirrhoe
Campeny. Sacrifice of
Callirrhoe
CALO, Aldo (Italian 1910-)
Biform 1959 wood and iron
MAI 48
Biform 1960 bronze and
crystal SAL pl 85
Danzatrice Indiana 1949
plaster; 30 cm CARR
316 IMRC
Figura 1956 iron; 2.20 m
SCUL pl 53
Great Slab (Grand Piastra)
1964 bronze; 50x60
ARTSI #1
Nude 1943 wood SAL pl 86
(col)
Piastra 1962 bronze VEN-
62:pl 33
Piastra (Monument to the
Liberation of Cuneo) 1963
bronze; 59 Sq NEW pl
116
Sculpture 1962 wood VEN-62:
pl 32
Torso No. 1 1954 stone
ABAM 42
Torso No. 2 1953/54
marble; .80 m SCUL pl
52
Vertical Breakthrough 1966/
67 87-3/4 (with base)x
64-1/2 CARNI-67:#134
CALORI, Guido (Italian)
Italica gens bronze VEN-30:
pl 16
Calotte 4. Kowalski
Calthorpe, Mary
Christmas, J. and M.

Mary Calthorpe Monument
CALVANI, Bruno (Italian 1904-)
 Pulcinella 1955 bronze SAL
 29
Calvary See also Crosses; Jesus
 Christ
 French. Calvary
 French--15th c. Calvary
 French--17th c. Calvary#
 French--19th c. Calvary
 Tavernari. Calvary
Calvin, John (French Theologian
 and Reformer 1509-64)
 Landowski and Bouchard.
 Reformation Monument
Camargo, Mlle. de
 Caffieri. Mlle. de Camargo,
 bust
Camargue X. Koenig
CAMBRAI, Jean (Jean de Rupy)
 (French)
 Apostle's Head 1408/16
 LOUM 39 FPL (1598)
Cambronne, General
 De Bay. General Cambronne,
 bust
Camburg, Wilhelm von
 Master of the Rood Screen.
 Wilhelm von Camburg
Camden, William d 1623
 English--17th c. William
 Camden, bust
CAMELIO (Vittore Gambello)
 (Italian 1460-1539)
 Fight of Giants, plaque
 bronze; 15x22 DETD 115
 IVA
Camels
 Brown, C. Imperial Camel
 Corps
 Byzantine. Pyx details:
 Martyrdom of St. Menas;
 Sanctuary of St. Menas,
 with camel heads
 Caille. The Camel
 Filarete. Basilica Doors;
 Master-sculptor with
 assistants
 German--17th c. Tray
 (Lokhan): Reconciliation
 of Joseph and Jacob
 Harth. Camel
 Kandler. Meissen Camel
 Renne. Camel and Rider
 Staffordshire. Teapot in
 form of Camel
 Theed, William, the Younger.
 Albert Memorial: Africa

Cameos
 Byzantine. Rothschild Cameo:
 Emperor Constantius II
 and his consort
 Flaxman. Cameo
 French. Cameo of Sainte-
 Chapelle: Glorification
 of Germanicus
 French--13th c. Embarkation
 of Noah
 German--10th c. Lothar
 Crucifix, with 1st c cameo
 of Augustus
 Italian--13th c. Cameo, in
 French 15th c. Triptych
 --Madonna and Child
 Enthroned, cameo
 Italian--16th c. Cameo
 --Pendant, with Byzantine
 cameo
CAMERON, Charles (Scottish
 Architect c1740-1812)
 Green Dining Room, detail
 ENC 151 RuTs
 Interior Doors 1782/85
 HAMR 128 RuTs
CAMETTI, Bernardino (Italian
 1669/70-1736)
 Colomba Vicenti, bust 1725
 MATTB pl 34 IRMarc
 Diana, Orsini Palace 1720
 marble; 258 cm (with
 base) BSC pl 118, 119
 GBS (9/59)
 Giovan Andrea Muti Tomb
 1725 WIT pl 168B IRMarc
Camilla. Biagini
CAMILLIANI, Francesco
 Fountain POPRB fig 168
 IPalP
Camoys, Lord and Lady
 English--15th c. Lord and
 Lady Camoys
The Camp. Savinsek
CAMPAGNA, Girolamo (Italian
 1549-1626?)
 Annunciation, relief: Angel
 of the Annunciation bronze;
 angel: 213 cm POPRB
 fig 118, pl 122 formerly
 IVePC
 God the Father in Benediction
 with four Evangelists
 bronze POPRB pl 123
 IVGM
 Raising of the Youth at
 Lisbon, relief POPRB
 fig 115 IPadAn

Campagna Shepherd. Blumenthal
Campaspe
 German--15th c. Aquamanile:
 Aristotle and Campaspe
Campbell, Colin, Baron Clyde
 (British Military Com-
 mander 1792-1863)
 Marochetti. Lord Clyde
 Stanley, C. Colin Campbell,
 medallion
CAMPBELL, G. E. (English)
 Archangel Gabriel, head
 1945 wood NEWTEB pl
 9A
Campbell, John See Argyll, John,
 2nd Duke of
CAMPBELL, Thomas (English 1790-
 1858)
 Pauline Bonaparte, seated
 figure MARQ 268 ECha
Campden, Viscount, Children
 Gibbons. Viscount Campden
 Monument
CAMPEN, J. van (Dutch 1595-
 1657)
 Organ-Case 1641-43 GEL pl
 114 NAlL
CAMPENY, Damian (Spanish
 1771-1855)
 Dead Lucretia 1834 marble;
 59-3/4x25 VEY 288
 SpBaR
 Sacrifice of Callirrhoe,
 detail VEY 168 SpMaR
CAMPI, Bartolomeo (Italian 1525-
 73)
 Breastplate BARG IFBar
CAMPI, Neto (Italian)
 Ceramic sculpture 2nd floor
 hall DAM 141 IMT
CAMPIN, Robert See DELEMER,
 Jean
CAMPIONE, Bonino da (Italian fl
 14th c.)
 Can Grande della Scala
 1370/74 bronze KIDS
 158 (col); MARY pl
 130 IVeC
CAMPIONESI (Group of Sculptors
 from Campione, Lake
 Lugarno fl 14/15th c.)
 Scaliger Family Tomb
 CHASEH 290 IVeM
Camponeschi, Maria Pereira
 Silvestro dell'Aquila. Marie
 Pereira Camponeschi
 Monument

Camus, Albert
 Hoflehner. Sysiphus (Homage
 to Albert Camus)
CANDELA, Felix (Architect)
 Iglesia de la Virgen
 Milagrossa 1954 BOE pl
 205 MeM
Candelabra and Candlesticks See
 also Chandeliers; Menorah
 Anglo-Norwegian--12th c.
 Candle-Bearer
 Auguste. Candelabrum
 Barye. Candelabra
 Benedetto da Maiano. Angel
 Bearing Candelabrum
 Carolingian. Candlestick
 Clodion. Candelabrum#
 Clodion--Foll. Bacchante
 Candelabrum
 Dumee. Candelabra
 Dutch. Delft Silver Pattern
 Candlestick
 Elliott. George III Candle-
 stick in "Gothik" style:
 Brick Tower
 English--12th c. Brunswick
 Candlestick
 --Gloucester Candlestick
 English--17th c. Charles II
 Pewter Candlestick
 --Charles II Table Candle-
 stick
 English--18th c. Chelsea
 Candlestick with Birds
 --Egyptian Style Louis XVI
 candelabra
 --George I Table Candlestick
 --George III Candelabra
 --Queen Anne Octagonal
 Candlestick
 English(?)--19th c. Candle-
 stick
 English--19th c. Regence
 wall Light
 --Regency Table Candelabra
 Fanelli, V. Octagonal
 Candelabrum, with 24 arms
 Flemish--15th c. Bracket-
 sconce
 French--12/13th c. Candle-
 stick
 French--13th c. Candlestick:
 Figure Seated on Lion
 French--17/18th c. Louis
 XIV Torchiere
 French--18th c. Louis XV
 Bougie d'Accrocher, with

Meissen Child and Vin-
cennes Flowers
--Louis Quinze Candelabra
--Louis Quinze Floral
Candelabra
--Louis Quinze Three-Branch
Candelabra
--Louis Quinze Wall Lights
--Louis Seize Bouillotte
Lamp
--Louis Seize Gouthiere
Blue Vase Light
French--19th c. Candelabra,
2 supporting caryatids
--Empire Candelabra
German. Candelabra and
Centerpiece, with hunt-
ing scene
German. Candelabrum
German. Louis XV Wall
Candelabra
German--10th c. Candlestick
German--11/12th c. Candle-
holder: Man on Lion
German--12th c. Trivulzio
Candelabra
--"Wolfram", male figure
candle bearer
German--13th c. Hildesheim
Candlestick
--Samson Candlestick
German--16th c. Wild-man,
candle holder
German, or English--Reims
Candlestick
Gilbert, W. and W. G.
Riley. Decorative Table
Light
Giovanni di Stefano. Candle-
Bearing Angel
Heming. George III Table
Candlestick, with sup-
porting female figure
Hitzberger. Candlestick
Italian. Capodimonte Candle-
sticks: Blackamoors
Italian--13th c. Trivulzio
Candlestick
Italian--16th c. Paduan
Candlebrum
Kandler. Louis XV Cande-
labrum, with Meissen
Pagoda figure
Kandler. Louis XV Meissen
Swan Candlestick
Kandler. Louis XV Ormolu
Candelabra, with Meissen
Cockatoo

Kandler. Parrots, on French
Candelabra
Kocks. Delft Dore Candlestick
Lenhendrick. Louis XV Table
Candlestick
Lombardo--Attrib. Cande-
labrum-bearing Angel
Loscher. Lucretia, cande-
labra figure
McDonald-Mackintosh and
MacDonald. Candle-holder
Meissonier, J. A.--Foll.
Louis XV Candlestick,
with Putto
Michelangelo. Angel bearing
Candelabrum
Niccolo dell'Arca. Kneeling
Angel
Olbrich. Candlestick
Pilgram. Candleholder:
Kneeling figure
Renier van Thienen. Paschal
Candelabrum
Riccio. Paschal Candlestick
Robbia, L. della. Kneeling
Angels with Candelabra
Roig, and J. Matons. Monu-
mental Candelabrum
Russian--18th c. Candelabra
Saint-Germain, J. J. de--
Attrib. Candelabrum
Schnellenbuhel. Candelabrum
for 24 candles
Schofield. George III Cande-
labra
Schofield. George III Three-
Light Candelabra
Thomore. Candelabrum of
American Independence
Velde. Candelabrum
Verrocchio. Candlestick
Vischer, Peter, the Elder
Peter Vischer, the
Younger; H. Vischer,
the Younger. Candelabra:
Female Figure
Wolfram. Erfurt Candlestick
CANDIDO, Elia (Netherlandish-
Florentine fl 2nd half 16th c.)
Apollo of Lycia bronze;
55x19-1/2 USNKP 435
UDCN (A-1618)
Candidus, Saint
French--11th c. St. Candidus,
reliquary head
Canefora, Martinuzzi
Canes
Perchin. Serpent head,

Faberge cane handle
CANIARIS, Vlassis (Greek 1928-)
Dia III 1964 ptd wood panel,
applied relief SAO-8
CANINA, Luigi (Italian 1795-1856)
Aesculapius Fountain MINB
99, 100 IRB
Lion Fountain MINB 103
IRB
Portraits
Italian--19th c. Luigi Canina,
bust
CANINA, Luigi--FOLL.
Sphinx green basalt; .52x
1.02 m FAL pl 43 IRB
(CCXI)
CANNILLA, Franco (Italian 1911-)
Acrobati 1955 ptd plaster;
1.90x1.50 m SCUL pl 45
Anatomical Parable 1959
brass MAI 48
Ballerina con Velo 1954
bronze; 60 cm SCUL pl 44
Struttura 1965 aluminum and
plexiglas VEN-66:#61
Struttura 1966 VEN-66:#62
Canning, George (British Statesman
1770-1827)
Westmacott. George Canning
CANO, Alonso (Spanish 1601-67)
Child Jesus of the Passion
ptd wood; 27-5/8 VEY 284
SpMaCo
Eve, bust c1667 ptd wood
BAZINW 401 (col) SpGC
Immaculate Conception,
Sacristy 1655 ptd cedar;
20 BAZINB 55; GOME 21
(col); pl 64; LARR 307
SpGC
St. Diego of Alcala 1653-57
KUBS pl 83A SpGCa
St. John of God, head
1652/67 ptd wood CIR
106 (col); GOME 22 (col);
LARR 225 SpGP
St. John the Baptist, seated
with lamb 1624 ptd wood
GOME pl 62-63 SpBaG
St. Paul, bust ptd wood;
larger than LS GOME pl
65 SpGC
La Virgen, Sacristy 1636
BUSB 89 SpGC
Virgin and Child 1629-31
KUBS pl 84A SpLebM
CANO, Juan de, and Pedro de
MENA

St. Anthony of Padua, head
detail ptd wood GOME pl
68 SpGB
St. Joseph with the Infant
Christ ptd wood GOME
pl 66-7 SpGB
Canon, Thomas
English--14th c. Thomas
Canon
CANONICA, Pieiro (Italian 1869-
1959)
The Abyss (L'Abisso)
marble VEN-12:pl 14
Communion marble VEN-1:
pl 75
Countess von Lutzow, bust
marble VEN-12:pl 16
Duchessa di Genova Madre,
bust VEN-1:pl 73 -IRe
In Cordis Vigilia marble
VEN-1:pl 74
Margherita of Savoy, Queen
Mother, bust marble VEN-
3:pl 1 -IRe
Il Muletto e L'Alpino MINB
86 IRB
Princess Clotilde di Savoia
Bonaparte marble VEN-14:
76
Spring marble VEN-99
Torso marble VEN-12:pl 15
Canopies
Russian--16/17th c. Canopy,
palmate and onionate
motif
Vischer, Peter, the Elder;
P. Vischer, the Younger;
H. Vischer, the Younger
S. Sebaldus Tomb
Canottieri del Tevere. Lerche
CANOVA, Antonio (Italian 1757-
1822)
Anglo Emo Monument 1792-
95 marble LIC pl 6
IVNav
Apollo VAL IVAc
Apollo Crowning Himself,
headless figure VER pl
111 IPosC
Archduchess Maria Christina
Monument 1798-1805
marble; 19' JANSH 486;
JANSK 915; LIC pl 10;
MARY pl 62; NOV pl 176
AVAg
Briseis Surrendered to the
Heralds of Agamemnon
1790 plaster; 110x210 cm

LIC pl 3 IPosC
Clement **XIII** Monument 1787-
92 marble IRW pl 81; LIC
pl 9; NOG 50 IRP
--Clement **XIII** Praying
CAL 202 (col)
Clement **XIV** Monument
1784/87 marble BR pl
11; LIC pl 5 IRAp
Cupid and Psyche (L'Amour
et Psyche) AGARC 109;
SIN 332 IComVC
--marble HUBE pl 23 RuLH
--1793 marble POST-2:79;
ROTHS 207; SELZJ 37
FPL
--1793 plaster; 135x151x81
cm LIC pl 4; MU 226
UNNMM
Daedalus and Icarus 1779
marble; 170x95x92 cm
LIC pl 2 IVCo
Danae 1780 terracotta; 36.2
x44.5 cm BSC pl 143
GBS (2/62)
Endymion COOPF 168 ECha
George Washington, seated
figure as Roman Emperor
(Lafayette viewing
Canova's statue of Wash-
ington in Old State House,
Raleigh, No. Carolina)
GARDAY front
--(engraving of destroyed
original) CRAVS 80
Giovanni Volpato Monument
1807 VER pl 118 IRAp
Hebe COOPF 168 ECha
--1816 marble LIC pl 7;
VER pl 115 IForPC
--detail moulage HUBE pl
16 IPosC
Hercules and Lycas 1812/
15 marble; 3.5 m
LIC pl 8 IRMo
Italian Venus c1812 MONT
45 IFPal
Letizia Bonaparte, seated
figure VER pl 119
IPosC
Madame Recamier, head
1813 marble; 46x29x19
cm LIC pl 32 IPosC
Margrave of Anspach Monu-
ment d 1806 WHINN pl
171B ESp
Meekness (Mansuetudine)
1783 terracotta; 13x11x9

cm LIC col pl 1 (col)
IPosC
Napoleon Bonaparte, nude
figure 1811 Carrara
marble; 136 MYBS 53;
WHITT 138 ELWel
Napoleon Bonaparte as a
Roman Emperor, nude
figure 1808 bronze;
c138 BAZINW 419 (col);
FLEM 619; LIC pl 11;
MCCUR 245; MONT 45
IMB
Napoleon Bonaparte, head
HU 280 IFMod
Paris, head (city) HUBE
pl 18 GMG
Pauline Bonaparte, bust
after 1880 marble KO pl
98 SwAr
Pauline Bonaparte Borghese,
as Venus Victrix (Venus
Victorious) c1808 marble;
70x81 BAZINH 392;
BAZINL pl 375; BAZINW
419 (col); BR pl 12;
CHASEH 420; CHENSW
461; COL-20:543; ENC
154; FAL pl 44a-c;
FLEM 620; JANSH 486;
JANSK 914; LARM 32;
LIC pl 12; MILLER il
148; MONT 397; NOV
pl 175; RAMS pl 19a; RAY
79; ROBB 395; ROOS
200D-E; SEW 824; ST
408; STA 186; UPJH pl
201; WB-17:202 IRB
(LIV)
Perseus with Head of
Medusa 1799/1801 marble
BR pl 12; CLAK 68;
MARQ 243; MYBU 394;
PRAEG 411; RAY 52;
UPJ 480; VER pl 113
IRV
Pieta VAL IVAc
Self-portrait, head VEN-22:1
Sleeping Nymph marble MACL
272; MILIER il 149 ELV
Stuart Monument 1819 marble
LYN 37 IRP
--Mourning Angel NATSE
Terpsychore, model plaster
HUBE pl 17 ICadC
Theseus and the Minotaur
1782 marble 58-1/4
MOLE 260 ELV

Three Graces, maquette
 terracotta HUBE pl 19
 FLM
--plaster HUBE pl 20 IPosC
--(line drwg) CHRP 370 RuL
Venus ROSSI IFP
Venus Leaving the Bath
 1812 marble; 69 SOTH-
 1:213
CANOVA, Antonio--FOLL
Nymph and Satyr 18th c.
 bronze; 23-1/2 HUNT pl
 47 UCSmH
Canovas del Castillo
Querol. Canovas del
 Castillo Tomb
Cantate Domino. Hepworth
"Canticum Canticorum". Borsos
Cantilevered Squares. Hoskin
Cantoria
Donatello. Cantoria
Robbia, L. della. Cantoria
CANTRE, Jozef (Belgian 1890-1957)
Bather bronze GOR 69
 BGMS
Edward Anseele Monument
 GOR 70 BG
Karel van de Wolstijne,
 head bronze GOR 68
 NRBoy
Peter Benoit, head 1934
 green Syenite; 28 MID
 pl 84 BAM
Two People 1931 teak; 41
 MID pl 83 BAM
Cap of Kazan. Russian--16th c.
Cap of Mikhail. Russian--17th c.
Cap of Monomakh. Russian--
 13/14th c.
Cap of Peter the Great. Russian--
 17th c.
Cap of the Ruby Cross. Russian--
 17th c.
Capallino. Dazzi
Le Capelan. Gilioli
Capella See Chapels
CAPELLAÑO, Antonio (Italian)
See also Causici, F.
Fame and Peace Crowning
 George Washington,
 bust and relief original
 sandstone USC 171
 UDCCap
--(copy of original) USC
 298 UDCCap
Preservation of Capt. John
 Smith by Pocahontas,
 relief c1825 USC292

UDCCap
Capellen Monument. Ceracchi
Capello, Bishop
Quellinus II. Monument
 of Bishop Capello
Capitals
Armenian. Sevan Capital:
 Confronted Peacocks and
 Ducks
Burgundian--12th c. Capital:
 Sacrifice of Cain and
 Abel
Byzantine. Abacus Capital
Byzantine. Acanthus Leaf
 Capital#
Byzantine. Antioch Capital
Byzantine. Basket Capital
Byzantine. Capital#
Byzantine. Corinthian Capital
Byzantine. Filigree Foliate
 Capitals#
Byzantine. Foliate Pilaster
 and Capital
Byzantine. Hagia Sophia
 Capitals
Byzantine. Melon Capital;
 Foliate Surface
Byzantine. "Theodosian"
 Capital
Corinthian Capital
Dutch--12/13th c. Choir
 Capital
Early Christian. Capitals:
 Melon-Shaped and Impost
Early Christian. Capitals
 and Columns
Early Christian. Leaf
 Capitals with Wind-Blown
 Acanthus
English--11th c. Capitals
English--11/12th c. Capital:
 Griffin
English--12th c. Angel Capital
--Capital#
--Choir Aisle Capital
--Cloister Capital
--Crypt Capital
--Scallop Capitals
English--12/13th c. Capital
 and Wall Carving
English--13th c. Capital#
--Chapter-House Capital:
 Foliate Motif
--Choir Capital: Foliate
 Motif
--Foliate Capitals
--Vine-Leaf Capital, with
 bird

English--13/14th c. Capital
English--17th c. Corinthian
 Capital
French. Capital#
French--7th c. Merovingian
 Capital
French--8th c. Capital:
 Discovery of the Tomb
 of St. Benoit
French--10th c. Double
 Capital
French--10/11th c. Capital
French--11th c. Acrobat,
 with Snake
--Ambulatory Capitals:
 Plainsong--4 tones
--Capital#
--Choir Capital: The Four
 Rivers and the Four
 Trees
--Corinthian Capital
--Earthly Paradise
--Porch Capital: Lions
--Romanesque Chancel
 Capital
French--12th c. Apse Capital
--Burgundian Engaged
 Capital
--Capital#
--Choir Capital: Virtues
 and Vices
--Cordoba-style Capital
--Corinthian Capital
--Emperor Constantine,
 equest#
--Engaged Capital
--Glutton, figure capital
--Historiated Capitals
--Joseph Accused by
 Potiphar's Wife
--Languedoc Capital
--Langon Capital
--Mythical Beasts#
--Pontaut Capitals
--Porch Capital; Capitals:
 St. Martin
--Romanesque Capitals#
--Samson Killing the Lion
--Stylized floral pattern,
 capital
--Twin Capital
--Two-headed Capital
French--12/13th c. Grotesque
 Capitals
French--13th c. Capital(s)#
--Clustered Pier Capital:
 Bird and Beast Figures
 in Foliage

--Engaged Capital
--Nave Capital: Two
 Harpies; Centaurs
--Triforium Capital
French--13/14th c. Double
 Capitals
French--15th c. Capital:
 The Nativity
French--16th c. Capitals
Georgian. Altar Screen
 Capital
Georgian. Cathedral Column
 Capital
German--11th c. Figured
 Capital
German--12th c. Cushion
 Capital
--Romanesque Capitals
German--13th c. Capital
--Foliated Capital with
 naturalistic hawthorn
 leaf
--Vine-leaf Capital
--Wormwood Capital
Gothic-English. Vine Leaf
 Capital
Gothic-French. Leaves and
 Flowers
Gothic--German. Capital:
 Vine Leaves
Hartmanus. Capital: Heads
 of Demons; Dragons
Hungarian--12th c. Capital
Iardella. Tobacco Capitals
Italian. Annunciation, capital
Italian. William II Offering
 the Church to the
 Madonna
Italian--11th c. Foliate
 Capital
Italian--12th c. Capital#
--Cloister Capital
--Mithras Capital
--Monreale Capitals
--Parma Capital: Fable--
 Fox dressed as Priest
--San Miccola, Main Portal
--William I Offering Church
 to Virgin, cloister
 capital
Italian--13th c. Barletta
 Capital
--Beast-Capital
--Pulpit Capital
Italian--14th c. Capital: The
 Planets and Their Children
Italian--15th c. Capital#
Lombard. Capital

Monopoli Cathedral Atelier.
Capital
Norman. Capital
Pellegrino, or Taddeo.
Pulpit; details Capital
Portuguese--12th c. 2
capitals
Portuguese--14th c. Capital
Romanesque. Interlaced-
animals Capital
Romanesque--English.
Capital#
--Multiple Cushion Capital
Romanesque--French.
Capital#
--Death of the Miser
--Gallery Capital--Geo-
metric decoration
--Holy Women at the
Sepulchre, capital detail
--Massacre of the Innocents,
capital detail
--Stylized Floral Pattern
--Temptation of Christ,
capital
--Winged Monster
Romanesque--Spanish.
Capital(s)#
Scott, G. G. Capitals
Spanish--11th c. Crypt
Capital#
Spanish--11/12th c. Roman-
esque Capital
Spanish--12th c. Capital:
Demons Hanging Victim
--Cloister Capital: Birds
Eating Fruit
--Double Capitals: Glass
Blowing; Animals
--Majesty Capital
--Marys at the Sepulchre,
capital
--Romanesque Capitals
Spanish--12/13th c. Mythical
Beasts
Swedish--13th c. Capital:
Adam's Legend
Swiss. Figures, Capital,
Payerne
Visigoth. Capital
CAPIZZOLDI
General Wolfe Monument:
Crossing of St. Lawrence
ESD pl 135
CAPPELLO, Carmelo (Italian 1912-)
Acrobat (Akrobat) 1954
bronze GERT 244

Acrobats (Akrobaten) 1955
plaster, for bronze
GERT 245
Boat 1953 bronze; 6x10-3/4
SCHAEF pl 81
Colloquy 1958 bronze VEN-58:
pl 42
Cow 1951 bronze; 16x28
SCHAEF pl 79
La Danze Marina 1956 bronze;
2.90x1.70 m SCUL pl 55
Eclipse 1959 bronze; 88-5/8
MAI 49; TRI 27
Lunar Caprice 1959 iron
SAL pl 81
MARINAE 1955 bronze;
2x.80 m SCUL pl 54
Provincials 1953 bronze; 22
SCHAEF pl 80
Superficie-Espaco: Itinerario
Circular 1964/65 Liga de
cobre e de Latao; 127x
112 cm SAO-8
Wall Relief, Entrance Lobby
1951 DAM 138, 139 IMT
Water Skis 1957 bronze SAL
pl 82 (col)
Cappello, Vittore d 1467
Rizzo. General Vittore
Cappello Monument
Capponi, Giovanni
Leoni, L. Giovanni Capponi,
bust
Capponi, Neri
Rossellino, B. Neri Capponi
Tomb
CAPRALOS, Christos (Greek 1909-)
Bird (Uccello) 1956 stone
VEN-62:pl 152
Nike 1961 bronze VEN-62:
pl 153
Capricorn. Ernst
Captain Cook's Last Voyage.
Penrose
The Captive. Bonnesen
Captive. Michelangelo
Captive Movement. Domeia
The Captives
Bourdelle. Adam Mickiewicz
Monument
Capua, personification. Italian--
13th c.
CAPUZ, Jose (Spanish)
Pieta, relief VEN-34: pl
125
Car of Venus. Nost
CARA, Ugo (Italian 1908-)

Athlete VEN-40: pl 74
Caracalla (Roman Emperor 188-217)
 Boldu. Youthful Caracalla,
 medallion
CARADOSSO (Cristoforo Caradosso
 Foppa) (Italian 1445-1527)
 Giangiacomo Trivulzio,
 square medal bronze; 46x
 44 mm DETD 139 UNNSa
 Medal: Bramante's Design
 for St. Peter's, Rome
 1506 bronze; Dm: .057 m
 CHAS 23; JANSH 354;
 JANSK 574 ELBr
CARDOSSO--ATTRIB
 Medal: Lodovico Sforza,
 called "The Moor" c1488
 bronze; Dm: .041 m
 CHAS 301 ELBr
CARAGEO, Boris (Rumanian
 1906-)
 Woman Student, head 1961
 bronze VEN-64: pl 181
 RBC
Carapace II. Frink
CARAVAGGIO, Pasquale da--ATTRIB
 Alexander VI, bust c1492
 marble BURC pl 58 GBM
Caravan. Gilioli
CARCANI, Filippo (Italian fl 1678)
 Decorative Figures, semi-
 dome detail, Capella
 Lancellotti c1685 stucco;
 over LS MOLE 187; WIT
 pl 161A IRGio
Carcassone
 French--13th c. Stone of
 Siege of Carcassone
CARDELLI, Lorenzo (Roman fl
 18th c.) See also M. La
 Broureur; L. Nizza
 Apollo and Daphne, left side
 of base FAL pl 35a IRB
 Basin on Base red marble;
 1.05 m (with base);
 Dm: 44 m FAL pl 45
 IRB (CCXXI)
CARDELLI, Pietro (Italian fl 1806-
 18)
 General Cervoni, bust 1809
 plaster HUBE pl 63 FV
 John Quincy Adams, bust
 1818 plaster; 23-3/4
 AP 150 UPPA
 Napoleon, bust 1806 marble
 HUBE pl 62 IVAr
CARDENAS, Augustin (French
 1927-)

Sculpture* EXS 47
Cardenas, Juan de
 Leoni, P. Juan de Cardenas,
 Duke of Maqueda and
 Juana de Ludena, kneeling
 effigies
Cardinal of Portugal
 Rossellino, A. Cardinal
 Jacopo of Portugal Tomb
Cardinal Virtues
 Belgian--12th c. Phylactery
Cardinals
 Bernini, G. L. A Cardinal
 Manzu. Cardinal#
 Manzu. Seated Cardinal
 Manzu. Standing Cardinal(s)#
Cardiogram of an Angel. Mack
Caress. Bellotto, E.
Caress. Huygelen
CARESTIATO, Antonio (Italian)
 Contadina Sarda terracotta
 VEN-30: pl 143
CAREW, John Edward (English
 1785?-1868)
 Adonis and the Boar 1825/26
 BOASE pl 81A; CON-6:
 pl 48 EPetL
 Henry Wyndham 1831 CON-6:
 pl 47 EPetL
Carey, Elizabeth
 Stone. Lady Elizabeth Carey,
 effigy
Caribbean Woman (La Luxure).
 Gauguin
Caribou
 Martin, P. von. Caribou
Caricature
 Spanish--16th c. Duke of
 Alba
Caritas
 French--12th c. Chancel
 Capital: Caritas Fighting
 Avarita
 Gaudier-Brzeska. Caritas
Caritat, Marie Jean Antoine
 Nicolas, Marquis de Condorcet
 1743-79
 Houdon, J. A. Marquis de
 Condorcet, bust
CARLES, Antonin Jean (French)
 June TAFTM 38
CARLIN, and GOUTHIERE
 Louis XIV Regulator Clock
 LARR 393 FPL
CARLINI, Augostino (Italian-
 English d 1790)
 George III, bust 1773 GUN
 pl 5 ELBur

Joshua Wood c1760 WHINN
pl 114B ELRSA
CARLO, Lorenzetti (Italian)
Laggiu plaster VEN-10:pl
139
CARLONE, Diego F. (Italian
1674-1750)
Angel, side altar after 1720
BUSB 161 GWeinCh
St. Joachim, transept altar
BUSB 160 GWeinCh
CARLSTADT, Cornelius
Winter, Kelsterbach 1763
porcelain BUSB 200 GDaP
CARLUCCI, Cosimo (Italian 1919-)
Space Light la--Variation
on the Golden Triangle
1966 stainless steel, iron
support; 44x38 ARTSI #2
Carlyle, Thomas
Boehm. Thomas Carlyle#
CARMASSI, Arturo (Italian 1925-)
Aton 1961/62 VEN-62:pl 62
Carmela de Pampulha
Zamoyski. Carmela de Pampulha
CARMINATI, Antonio (Italian)
Signorini Moretti bronze
VEN-7:pl 110
CARMONA, Luis Salvador (Spanish)
Pieta ptd wood WES pl 30
SpSalC
Carnage
Preault. Massacre
CARO, Anthony (English 1924-)
Altalena gialla 1965 Acciaio
dipinto VEN-66:# 182 ELT
Away 1966 40-1/2x208x33
CARNI-67:#212
Bennington 1964 H:40 SEITC
108 Ol
Early One Morning 1962
steel and aluminum ptd
red: L:244 BRIT; GAUN
pl 57 (col); HAMM 148-
9; NEW pl 91
Homage to David Smith
1966 BURN 124
Lock 1962 steel ptd blue;
34-1/2x111x120 MYBS
89; READCON 239 ELK
Man Holding his Foot
bronze; 26-1/2 ARTSB-58:
8
Man Lighting a Cigarette
(Uomo che si accende la
sigaretta) 1957 bronze
VEN-58:pl 82

Midday 1960 ptd steel;
94x38x150 BAZINW 444
(col); GUGE 91 (col);
LOND-6:#9 -Nol
Month of May 1963 aluminum
and steel ptd; 110x141x
120 LOND-7:#9; LYN
158 (col); SEITC 109 ELK
Pompadour 1963 aluminum,
ptd pink LARM 305 ELK
Prime Luce 1966 steel, ptd;
80x139x47 LOND-7:#11
ELK
Prospect 1964 ptd steel;
107x99x144 TUC 76 UCLJ
Rouge Madras 1965 aluminum,
ptd; 128x161-1/2x121
LOND-7:#10 ELK
Sculpture Two 1962 steel,
ptd green; 82x142 BOW
155; PRIV 205; SEITC
107 ELK
Sculpture Four 1962 alumi-
num; 98-1/2x187x84
READCO pl 12b
Span 1966 ptd steel; 72-1/2
x184x132 TUC 77
Standing Woman 1957 plaster
MAI 51
Titan 1964 H:41 SEITC 108-Rub
Wide 1964 ptd aluminum and
steel; 147.5x152.5x406.5
cm BRIT
Woman Waking Up 1955
bronze; 10-1/2x26-3/4x
13-3/4 TATEB-1:17;
TATES pl 15 ELT (T.264)
Woman's Body 1959 plaster,
for bronze; 74x40x34
LOND-5:#8
Yellow Swing 1955 ptd steel;
188x188x406.5 cm BRIT
(col) ELT
Caroline of Anspach (Consort of
George II of Britain 1683-
1737)
Rysbrack. Queen Caroline,
bust
CAROLINGIAN
The Annunciation, diptych
leaf of Genoels Elderen
8th c. ivory LARB 254
BBRA
Book Cover: Crucifixion
ivory CHENSW 305 FClM
Burse of St. Stephen jeweled
gold STA 35 AVHof

Candlestick 8/9th c. bronze;
6-1/2 BMA 15 UMdBM
Christ in Glory, book cover
c900 ivory STA 35
SwSGB
Christ the Conqueror, book
cover, Ada group end
8th c. ivory STA 35 BBR
Cover of Psalter of Charles
the Bold ivory, jewel in-
lays CHASEH 186; CRU
128 FPBN
The Crucifixion, book covers
ivory PANR fig 20 GMS
Crucifixion, intaglio 9th c.
rock crystal BAZINW
218 (col) FPMe
Symbols of 4 Evangelists,
font canopy detail 762/776
LARB 257 ICiB
Virgin and Child Enthroned,
book cover panel detail
9th c. ivory; 15x11 ASHS
pl 3 ELV
Carp. Sandoz
CARPEAUX, Jean Baptiste (French
1827-75)
Antoine Watteau JAL-5: pl
21 FValeM
Antoine Watteau, sketch,
monument design figure
c1867 plaster; 125 cm
COPGM 83; NOV pl 188b
DCN (I.N. 2763)
Antoine Watteau, study
c1860/62 plaster
SELZJ 70 FPPP
Baroness Sipiere, bust
1872 plaster; 84 cm
COPGG 101 DCN (593)
(I.N. 1414)
The Betrothed, bust 1869
plaster SELZJ 74 FPL
Bruno Cherier, head 1875
plaster; 62 cm LIC pl
88 FPL
Charles Garnier, bust 1869
plaster; 68 cm COPGM
85 DCN (I.N. 1415)
--bust 1869 LARM 189 FPL
La Chine, bust, model for
figure of Asia in
Fountain of the Four
Continents, Observatory,
Paris plaster; 28
CHICS UICA
The Dance, facade 1868/69
stone; c 15x8-1/2'

BOE pl 191; CHENSW 465;
GAF 132; HOF 197; LIC
pl 92; MARY pl 39;
MCCUR 245; POST-2:133;
ROOS 201C; SELZJ 75;
ST 410; UPJ 515; UPJH
pl 200 FPOp
--model 1867/69 plaster;
91-7/8 AUES pl 30; BAZINW
422 (col); CLAK 303; ENC
160; HUYA pl 57; JANSH
488; JANSK 918; LARM
189; LOUM XXI; NOV pl
189; ROTHS 217 FPL
Dancer with Tambourine
bronze; c20 BRIO 44;
MOLE 265
Dansen, sketch c1865
braendtler; 52.5 cm
COPGM 79 DCN (I.N.2831)
Duchess de Mouchy, bust
1867 JAL-5:pl 22 DCN
Empress Eugenie with
Imperial Prince, study
terracotta; 10 CHAR-2:34
FPL
Eve After the Fall (Eva apres
la Faute) terracotta; 14-
3/8 TATEF pl 22a ELT
(4199)
Gerome, bust JAL-5:pl 23
Girl with a shell 1867
marble; 40-3/4x16-7/8x
20-5/16 SEYM 165; 167;
USNK 205; USNKP 459
UDCN (A-65)
Head of Woman Wreathed
with Vine Leaves, study
for "La Danse", Paris
Opera BR pl 13 UNNMM
Henry James Turner, bust
c1873 marble; 29-1/2
(with base) TATEF pl
21g ELT
Mme. Carpeaux, bust LOUM
XXII FPL
Mlle Fiocre, bust 1869
plaster; 32 BAZINH 375;
BAZINW 422 (col); LAC
24; LIC pl 89; SELZJ 74
FPL
Marquise de la Valette,
bust 1861/62 plaster;
24-7/8 TATEF pl 21f
ELT (4198)
Mrs. Henry James Turner,
bust 1871 marble; 32
(with base) TATEF pl 21h

ELT (5629)
Neopolitan Fisherboy 1863
marble; 36-1/4x16-1/2x
18-7/16 CHRP 373; LIC
col pl 2 (col); SEYM
166; USNK 204; USNKP
458 UDCN (A-64)
Neopolitan Shell Fisher 1858
plaster; 35-1/2 CHAR-2:
294; LARM 189; LOUM
XXI FPL
Observatory Fountain (Four
Continents fountain:
Luxembourg Garden
Fountain) bronze; 82
GLA pl 41; LAC 210; LIC
pl 91; WATT 173 FPLu
Temperance 1863 wax SELZJ
66 FNiMM
Three Graces (Les Trois
Graces) 1874 terracotta
SELZJ 71 FPPP
--1874 terracotta; 31-7/8
TORA 31 CTA (57/27)
Triumph of Flora (Flora),
Pavillon de Flore 1863/
68 terracotta; 290x360
cm CHASEH 441; GAF
127; LARM 189; LIC pl
90; ROBB 398 FPL
Triumph of Flora, relief
JAL-5:pl 20; RAY 54
FPTu
Ugolino and his Children
1857-61 bronze LAC 24;
LOUM XIX; ROTHS 215;
SELZJ 67 (originally
FPTu) FPL
--1860/62 marble; 200 cm
LIC pl 87 FValeM
The Violinist 1870 plaster
SELZJ 26 (col) FPPP
CARPENTER, Andrew See
CARPENTIERE, Andries
Carpenter. Chelsea Porcelain
CARPENTIERE, Andries (Andrew
Carpenter) (French-English
1670's-1737)
Earl of Warrington Monu-
ment 1734 WHINN pl
100A EBow
Sir John Thornycroft,
effigy 1725 GUN pl 4
EBlox
Carpentry See also Masons and
Carpenters
Dick. Decorative Panels:
Carpentry; Boxing

Carpi, Aldo
Andreotti. Aldo Carpi, head
CARPI, Girolamo da (Italian 1501-
50)
Courtyard Facade c1550
BAZINW 368 (col) IRSp
CARPIGIANI, Dante (Italian 1921-)
Incontro Alato 1960 bronze
VEN-62:pl 61
Carra, Carlo
Marini. Carlo Carra, head
Carrara, Jacopa da
Andriolo de' Santi. Jacopa
da Carrara Tomb
Carrettiere. Bonome
Carretto, Ilaria del
Quercia. Ilaria del Carretto
Tomb
Carriages
Almeida. Carriage of John V
English--18th c. Carriage,
Wheel detail: St. George
and the Dragon
French--16th c. Travellers,
choir screen detail
Portuguese--18th c. Coach
of King John V
CARRIER-BELLEUSE, Albert Ernst
(French 1824-87)
Sleeping Hebe 1869 marble
SELZJ 44 FPL
Triton Carrying a Nymph
c1860 terracotta; 64 cm
LIC pl 98 ELBarc
Carillo de Albornoz, Alonso
(Bishop d 1439)
Spanish--15th c. Bishop Alonso
Carillo de Albornoz,
effigy
CARRINO, Nicola (Italian 1932-)
Struttura 1966 Rilievo in
legno smaltato bianco
VEN-66:#115
Carrying the Wounded. Augustincic
CARSTENS, Asmus Jakob (Danish
1754-98)
Atropos 1794 plaster; 18-3/4
LIC pl 37; NOV pl 181a;
VEY 23 GFSt
The Cart. Giacometti
Carte, Marquise de la, Angelique
Felicite Bosio
Bosio. Marquise de la
Carte, bust
CARTER, A. C. (English)
Primavera 1945 marble
NEWTEB pl 10
CARTER, Thomas I (English d 1795)

Thomas Moore Monument
after 1746 GUN pl 6;
WHINN pl 103B EGrtB
CARTER, Thomas I, and ECK-
STEIN
Death of Colonel Townshend
at Ticonderoga in 1758
ESD pl 124 ELWe
CARTER, Thomas II
Chaloner Chute, effigy
1775 WHINN pl 106
EBas
Carteret, Philip
David, C. Philip Carteret,
bust, monument
Cartier, Jacques (French Sailor
and Explorer 1491-1557)
Baveau. Jacques Cartier
Folk Art--French. Jacques
Cartier, medallion, ship
marker
CARTON, Jean (French 1912-)
Seated Figure bronze MAI
52
Cartouches See also Tombs
Egell. Manheim Altar:
Cartouche
English--17th c. Cartouche
to William Jarrett
English--18th c. Samuel
Pierson Cartouche
Carts
Bayes. Italian Wine Cart
Netherlandish. Five
Triumphs
Carving. Moore, H.
Carving, Horizontal I. Davis
Carving in Marble. Hepworth
Carving in Three Positions.
Moore, H.
Carving in White Alabaster.
Hepworth
Caryatids
Braun, A. Church Door:
Caryatid
English--13th c. Caryatid:
Bearded Figure
Fiori. Female Caryatid
French--16th c. Caryatid
Goujon. Caryatid(s)#
Heermann, G. Caryatids
Kozlovski. Caryatids
Ledward. Caryatid Figures
Modigliani. Caryatid
Permoser. Caryatids
Pisano, Niccolo. Fontana
Maggiore: Caryatids
Puget. Caryatid(s)#

Quellinus, A., the Elder.
Caryatid(s)#
Quellinus, A., the Elder.
Two Caryatids
Rodin. Caryatids
Rodin. Fallen Caryatid#
Sarrazin. Henri de Bourbon
Monument: Caryatids
Serrazin, and Gille Guerin.
Caryatids
Shchedrin. Caryatids
Stevens. Caryatid(s)#
Stijovic. Caryatid
Viani. Caryatid
Wotruba. Caryatid
Casa Batllo. Gaudi
Casa Martelli David. Donatello
Casals, Pablo
Muranyi. Pablo Casals,
relief
CASANOVAS, Enric (Spanish)
Two Figures*, relief 1924
stone PAR-1:212
CASAS y NOVOA, Fernande de
(Spanish d c 1751), and
Miguel ROMAY
Main Altar 1730/33 CIR
179 (col); KUBS pl 87B
SpSanM
Casati, Luisa
Troubetzkoy. Marquesa
Luisa Casati
CASCALIS, Jaime
Miracle of Whitsun, retable
after 1350 alabaster
BUGS 193 SpCorCh
CASCELLA, Andrea (Italian 1920-)
Happy Play 1966 white
granite; 28-3/4x28-3/4x
56 ARTSI # 3
Narcissus 1967 black Belgian
marble; 36 GUGE 78 IMAr
Pensatore de Stelle 1966
KULN 122
Pietra Aperta 1963 VEN-64:
pl 18
Summer Solstice (Solstizio
d'estate) 1963 marble
VEN-64:pl 19
Un'ora del Passato 1964
marble NEW pl 114
CASCELLA, Andrea and Pietro
CASCELLA
Apartment House Entrance
Figures glazed colored
ceramic DAM 189 IR
CASCELLA, Pietro (Italian 1921-)
Ceramic Sculpture 1953 DAM

145 IRAgr
Giallo Carico 1964 VEN-66:
#99
Portale 1966 stone VEN-66:
#100
Pygmalion 1963 stone; 47-
1/4x23-5/8 READCON
186 FPDr
Casimir IV (King of Poland 1427-
92)
Stoss. Casimir Jagiello,
effigy detail
Caskets See Boxes
Caspar, Charles
Italian--17th c. 6-ducats:
Charles, Caspar of
Trier
Casque Fendu. Ipousteguy
Casques See Armor--Helmets
Cassa-sistina. Ceroli
Cassandra
Klinger. Cassandra
CASSANI, Nino (Italian 1930-)
Slancio Trattenuto 1962
bronze VEN-62: pl 84
Cassapanca
Italian--16th c. Florentine
Cassapanca, settee
Cassoni
Italian--15th c. Cassone#
--Nerli Cassone
Italian--15/16th c. Cassone
Italian--16th c. Cassone#
--Venetian Chest
Italian--17th c. Cassoni
CASTAGNO, Andrea del (Italian
1425-57)
Niccolo da Tolentino, fresco
imitating sculpture 1456
BAZINW 335 (col) IFOp
CASTAYLS, Jaime (Spanish fl
1375-77)
Portal Statues, detail
LARB 399 SpTzC
St. Charlemagne 14th c.
alabaster VEY 274,
171 SpGerC
CASTELLANI
Gospel Book Cover 19th c.
NOG 53 IRP
CASTELLANI, Enrico (Italian
1930-)
Convergent Structure 1966
BURN 260; KULN 169
UNNPa
CASTELLI, Alfio (Italian 1917-)
Gli Amanti 1934 bronze;
1.20 m SCUL pl 33 IRMo

Colloquy 1964 bronze VEN-
64: pl 44
Crucifixion, detail 1956
marble SAL 27
Figure 1958/59 bronze MAI
52
Insieme DIV 84
Invasion 1964 bronze VEN-64:
pl 43
La Nascita di Eva 1949 wood;
1 m SCUL pl 32
Personaggi (Characters)
1963 bronze; 100x40
ARTSI #4
Personaggio DIV 84
Castle of Rimini
Pasti. Medal: Malatesta;
Castle of Rimini
Castle of Tears. Stahly
Castlereagh, Viscount See Stewart,
Robert
Castor and Pollux
Nollekens. Castor and Pollux
Castor Tympanum. Anglo-Saxon
CASTRO, Antonio de
Ewer 1565 silver; 16-1/2
COOP 88 IVCi
Castro, Ines de (Spanish Noblewoman
1320?-1355)
Portuguese--14th c. Ines de
Castro Tomb
La Catalane. Maillol
Catalane. Osouf
CATALDI, Amleto (Italian)
Bust of Woman plaster
VEN-10: pl 137
Dancer bronze VEN-20:112
Dancer bronze VEN-28: pl 118
Donna che Corre bronze
VEN-24: pl 40
Foggia Monument, detail
AUM 40
Medusa bronze VEN-22: 56
Nude Woman bronze VEN-26:
pl 37
Woman Holding Mirror bronze
VEN-30: pl 133
CATALONIAN
Seated Woman 12/13th c.
ptd wood; 25-1/2 TAT
sc pl 6
Catedral Humana. Anthoons
The Caterpillar. Gilioli
Caterpillar. Kastner
Catesby, Thomas d 1694
English--17th c. Thomas
Catesby, and Wife,
Monument

Cathedra See Thrones
Cathedra of Maximiana
 Byzantine. Throne of
 Maximian
Cathedra Petri. Bernini, G. L.
Cathedral. Penalba
The Cathedral (Hands). Rodin
Cathedral of Pain V. Lardera
Cathedral III. Jones, Anne
La Cathedrale d'Hircan. Jacob-
 sen, R.
Cathedrale Engloutie. Richards
Catherine de Valois (Queen of Henry
 V of England 1401-37)
 English--15th c. Queen
 Catherine of Valois, ef-
 figy head
Catherine of Alexandria, Saint
 Burgundian--15th c. St.
 Catherine
 Caffa. Ecstacy of St.
 Catherine
 Dutch--15th c. St. Catherine
 English--15th c. Christ
 Visiting St. Catherine in
 Prison, relief
 --St. Catherine in Prison
 Flemish--15th c. Reliquary;
 St. Catherine of
 Alexandria
 Flemish--16th c. St. Cather-
 ine
 French--14th c. St. Catherine#
 German--14th c. St. Catherine
 German--15th c. Decapitation
 of St. Catherine
 --St. Catherine#
 German--16th c. Catherine
 of Alexandria
 Giovanni da Firenze, and
 Pacio da Firenze. St.
 Catherine of Alexandria,
 life, scene
 Giovanni di Agostino.
 Madonna and Child with
 SS Catherine and John
 the Baptist
 Mariani. St. Catherine of
 Alexandria
 Multscher. St. Catherine,
 bust
 Siloe, G. St. Catherine
 Stoss-Foll. St. Catherine
 Ulrich von Ensingen. St.
 Catherine
Catherine of Cleves
 French--17th c. Duke of
 Guise and Catherine of
 Cleves Tomb

Catherine of Siena, Saint
 Italian--15th c. St. Cather-
 ine of Siena, head
 Mino da Fiesole. St. Cather-
 ine of Siena, bust
 Neroccio dei Landi. St.
 Catherine of Siena
 Straub. St. Catherine of
 Siena
Catherine of Wurttemberg (Queen
 of Westphalia 1783-1835)
 Bosio. Catherine of West-
 phalia
Cats
 Bianchi. Chat
 Delahaye. The Cat
 English--18th c. Chelsea
 Scent Bottles
 English--19th c. Rocking-
 ham Ornaments: Dog
 with Puppies; Cat with
 Kittens in Baskets
 Fabbri. Wartime Cat
 Fazzini. Cat (Gatto)
 Fazzini. Scratching Cat
 Kirchner, Heinrich. Cat
 Kirchner, Heinrich. Re-
 cumbent Cat
 Koster. Cat
 Lehmann, K. Cat
 Lehmann, R. Cat
 Matare, Katze
 Matare. Lauernde Katze
 Minguzzi. Gato Persa
 Romanesque--Spanish.
 Capital: Fable of the
 Cat and Mice
 Rossi, R. Chat
 Rossi, R. Gatto Predone
 Schreiner. Standing Cat
 Schwarz, Heinz. Chat
 Scottish--19th c. Cat Clothed
 in Roses
 Skinner. Red Cat
CATTANEO, Danese (Italian 1501-
 73)
 Bembo Monument POPR fig
 108 IPadAn
 Doge Loredan Tomb 1521
 LARR 144 IVGP
 Fortuna mid 17th c. bronze;
 19-3/4 MOLE 169;
 POPRB pl 119 IFBar
 Fregosa Altar: Risen Christ
 marble; Christ: 190 cm
 POPRB fig 106; pl 121
 IVeA
 Old Man, bust bronze; 32-
 3/8 ARTV pl 35 AVK

Venus c1560 bronze CLE 93
UOClA (50.578)
Venus Cyprica, relief,
Loggetta POPRB fig
104 IVMa
CATTERALL, Mary
John F. Kennedy Memorial
maquettes figures: 14'
PER 110, 111
CATTERNS, Joseph (English)
Monument to Sir Thomas
Finch and Sir Thomas
Baines, chapel ESD pl 111
ECamC
Cattle See also Agricultural Themes
Europa; and artist: Matare
Aeschbacher. Bull
Bakic. The Bull
Barye. Bull Attacked by
Tiger
Baum. Bull
Bertagnin. The Cow
Byzantine. Cain: Julian the
Apostate; reverse: Bull
Cappello. Cow
Celtic. Incised Bull
Clatworthy. Bull#
Durst. Bull#
Ehrlich. Sleeping Calf
French--13th c. Oxen
Geibel. Bull
Georgian. Column Capital:
Bull's Head, relief
Greco, E. Bull
Hamdy. Calf's Head
Henderson. Calf
Italian--11th c. Portal:
Cattle as Symbols of the
Ungodly
Jacot-Guillarmod. Taureau
Johnston, Pastoral
McFall. Bull Calf
Mallo. Bull
Manolo. In the Stable
Marcks. Sich Niedertuende
Kuh
Marcks. Spanish Bull
Marini. Bull
Martin, P. von. Ox
Martini, A. Cow
Mirko. The Bull
Mirko. Toro Ferito
Paladino Orlandini. Bull,
medallion
Picasso. The Bull
Pisano, A. Agriculture,
panel

Robbia, L. della. St. Luke
with the Bull, tondo
pendentive
Rossi, R. Bull
Rossi, R. Toro
Simmonds. Autumn Calf
Simmonds. Calf
Sintenis. Young Ox
Skeaping. Cow
Starcke. Tyrehoved
Studin. The Breadwinner,
relief
Studin. Dark Days, relief
Tuotilo. Ivory Book Cover:
Foliate scrolls, with
wild beasts pouncing on
cattle
Weiss, M. Taureau
CAUCASUS
Equestrian, Mosque over-
window relief, Kubachi
11th c. RTC 260 RuLH
Fighting Horsemen, relief,
Kubachi 12/13th c. stone
RTC 261 RuLH
Hunting Scene, relief Dag-
hestan 12th c. stone RTC
261 RuLH
Cauliflower
English--19th c. Worcester
Cauliflower Tureen, and
cover
CAUSICI, Enrico (Italian)
Conflict of Daniel Boone and
the Indians, relief 1826/
27 USC 290 UDCCap
Landing of the Pilgrims,
relief 1825 USC 291
UDCCap
Liberty and the Eagle, with
serpent-entwinded column-
fulcrum altar CRAVS 81;
FAIR 51; USC 276
UDCCapS
CAUSICI, Enrico, and Antonio
CAPELLANO
Christopher Columbus,
relief bust 1824 USC 293
UDCCap
John Cabot, relief bust 1824
USC 293 UDCCap
La Salle, relief bust 1824
USC 294 UDCCap
Sir Walter Raleigh, relief
bust 1824 USC 294
UDCCap
Cavaignac, Godefroi de

Rude. Godefroi de Cavaignac
 Monument
Cavalcade. Mastroianni
CAVALCANTI, Andrea di Lazzaro
 See BUGGIANO
Cavalcanti Annunciation. Donatello
CAVALIER, Jean (?)
 Gothofridus Kneller, medal-
 lion bust c1690 ivory;
 Dm: 3-3/4 NATP pl 31L
 ELNP
Cavalier IV. Delahaye
Cavalier Victorieux. Delahaye
CAVALIERE, Alik (Italian 1926-)
 La Main et la Rose 1965
 KULN 48
 Nature 1963 4x29-3/4x18
 CARNI-64:#141 IMSc
 Tellus Herbas Virgultaque
 Sustulit (erbe e virgulti)
 1963 silver VEN-64: pl
 62
 Terras Frugiferentis Con-
 celebras 1963 bronze
 VEN-64:pl 61 UNNI
Cavaliere
 Marini. Horseman
IL CAVALIERE ARETINO See
 LEONI, Leone
CAVALLINI, Francesco (Italian
 d 1684/86)
 Tomb of Pietro and Fran-
 cesco di Bolognetti before
 1675 BUSB 80 IRGeM
Cavallino Scorticato
 Leonardo da Vinci. Trotting
 Horse
Cavallo See Horses; Equestrians
Cavallo e Cavaliere
 Marini. Horse and Rider
CAVELLI, Gian Marco
 Andrea Mantegna, bust
 c1500 bronze HALE 85
 (col) IManA
Caviglia, Maresciallo
 Fabbri. Maresciallo
 Caviglia, head
CAVINO, Giovanni (Italian 1499/
 1500-70)
 Artemisia; and Mausoleum
 of Halicarnassus,
 medallion VER pl 67 UMB
CAWTHRA, Hermon (English)
 Boy and Goat stone; 32
 NEWTEB pl 11
 The Leopard 1941 slate
 BRO pl 2
 Rt. Hon Chuter Ede, bust
 NEWTEB pl 12A

Cayla, Comtesse de
 Houdon. Comtesse de Cayla,
 bust
CAYLOT, Augustin (French 1667-
 1722)
 Death of Dido 1711 LOUM
 185 FPL (1083)
CECHPAUER, J. P. See BULLA,
 Giovanni B.
Ceci, Adriana
 Dazzi. Adriana Ceci
Cecil, Robert, 1st Earl of Salis-
 bury
 Colt. Tomb of Robert Cecil
Cecilia, Saint
 German--12th c. St. Cecilia,
 tympanum detail
 Maderno. St. Cecilia
 Raggi. Death of St. Cecilia
CECIONI, Adriano (Italian 1838-86)
 Cocotte 1875 terracotta;
 48 cm LIC pl 93 IMGa
Ceiling Rose Dm: 30 PER 90
Ceilings
 English. Modelled Ceiling
 Decoration
 English--16th c. Robert
 Dormer, Monument Canopy,
 detail
 English--17th c. Ceiling#
 --Melbury House Ceiling
 Fontana. Spatial Decoration
 for a Cinema Ceiling
 Frick. Ceiling Panels
 German--18th c. Rococo
 Ceiling Decoration
 Giovanni da Udine. Ceiling
 Decoration, Loggia
 Mansart. The Visitation,
 Dome
 Milani. Ceiling Sculpture
 Mirko. Ceiling Relief
 Mola, A. and P. Ceiling
 Robbia, L. della. Ceiling
 detail, Chapel of Cardinal
 of Portugal
 Stanley, C. Colen Campbell,
 Medallion portrait, ceiling
 detail
 Vaga. Stucco Ceiling
 Zimmermann, D. and J. B.
 Church Ceiling
Celle qui Fut la Belle Heaulmiere
 Rodin. La Belle Heaulmiere
CELLINI, Benvenuto (Italian 1500-71)
 Athena POPRB fig 48 IFL
 Bindo Altoviti, bust c1550
 bronze FAIN 76; MACL 239;
 PANA-2:56; POPRB fig

Belt-shrine, detail, Moylough
8th c. BAZINL pl 18
IreDNB
Berber Stele, detail, Ain-
Barchouch BAZINL pl
160
Book Cover (?): Crucifixion
8th c. bronze JANSH 197
IreDNB
Bronze Disc 2nd c. Dm:
10-3/4 JANSK 27 ELBr
Brooches, Ireland bronze
and silver, or bronze
CHENSN 275 ELV
Brooches and Fibulae,
Tessin, Switzerland;
Ireland; England; France
CHENSW 316 SwZMN;
ELBr; ELV; FLP
Burial Crosses c10th c.
stone CHENSW 318 Ire
Casteldermot Cross,
Kildare 9th c. BAZINW
210 (col)
Cernunnos, with stag's horns,
cauldron relief, detail
4/1st c. B C silver;
20 cm BOES 30 DCNM
Circular Plaque, leaves and
trumpet scrolls 2nd c.
B C bronze; Dm: 7-1/4
ARTSW 26 WCaN
Coin, Marseilles MALV
336, 337 FPMe
Coins, La Tene LARA 210
ElBr
Collar Fragment 1st c. BC
bronze; Dm: 6-1/4
ARTSW 27 EBriMu
Cross bronze STA 128
IreDNB
Cross, with interlace 8th c.
KIDS 9 IreA
Cross at Kilbride, Argyel-
shire 16th c. stone
MILLER il 64
Cross of Abraham, St.
David's 1078/80 stone;
27 ARTSW 55 WCaN
Crucifix, detail bronze;
L: 8-1/2 SOTH-2:219
Crucifix, plaque, Athlone
8th c. gilt bronze LARB
76 IreDNM
Desborough Mirror, La
Tene 1st c. BC bronze;
10-5/8 CHRC 139;
JOHT pl 22; LARA 171;

LOM 69; PEVE 135;
READA pl 35 ELBr
Disk, La Tene style 2nd c?
bronze; Dm: 10-3/4
GRIG pl 89 ELBr
Drumcliffe Cross, Ireland
CHENSN 274
Eglwysilan Warrior, incised
figure, Wales (cast) H:
27 ARTSW 6, 51 WCaN
Elusate coin, Eauze, France
silver BAZINH 126 FPBN
Emly (or Monsel of Tervos)
Shrine c800 silver inlay,
gold, cloisonne enamels
and gilt bronze on yew
wood; 3-1/2 BOSMI 109
UMB (52.1396)
Fire Dog, Wales iron;
30x42-1/2 ARTSW 29
WCaN
God with stag's feet, Bournay
c100 BC bronze; .45 m
HAN pl 273 FStG
Guisando Bulls (Avila) stone
GUID 22 SpAv
The Gundestrup Cauldron
1st c. BC? BAZINW 98-99;
JANSK 26; LARA 217, 214 DCN
Head CLEA 8
Head 1st c. stone; 8 MOLS-
1:pl 2 EGCM
Hirfynnydd Slab (cast) 9/10th
c. stone; 28 ARTSW 53
WCaN
Iffley Church, Oxon, west
doorway arch, relief c1160
MILLER il 66 EOx
Incised Bull (Burghead Bull),
Burghead, Scotland c5th c.
stone; c4 FIN 105; JOHT
pl 41; STON pl 1 ELBr
Lamp Fragment, coil and
strap design 8th c. cast
and gilded bronze LARB
74 FStG
La Tene Torc 5th c. BC
silver on iron core ENC 546
Lintel c2000 BC BAZINL pl
16 IreN
Llangan Cross-head (cast)
10/11th c. stone; 51 ARTSW
53 WCaN
Llanhamlach Slab (Cast)
10/11th c. stone; 44
ARTSW 54 WCaN
Maesmynis Pillar-Cross
(cast) 9/10th c. stone;

70 ARTSW 52 WCaN
Madonna and Child, relief
 10/11th c. MILLER
 il 65
Moone Cross: Apostles,
 Kildare granite BAZINW
 210 (col)
Mother Goddess, seated
 figure 2/3rd c. stone;
 10-1/2 ARTSW 47
 ENewpM
Muirdach's Cross, Monaster-
 boice c900 stone LARB
 77; MYBA 243; ROOS
 70H; STON pl 19: UPJH
 pl 73 IreM
Newborough Font (cast) 12th
 c. stone; 18-1/2 ARTSW
 55 WCaN
Owl Head, cauldron frag-
 ment bronze BOES 192
 DAF
Penmon Pillar-Cross (cast)
 10/11th c. stone; 78
 ARTSW 54 WCaN
St. Martin's Cross FIN 8
 ScI
Scabbard, detail, Lisna-
 croghera bronze LAS 106
Scottish Tomb Animal
 Figures, drawings JOHT
 pl 43
Seated God, La Tene sheet
 iron repousse LARA 211
Spoons, Wales 1st c. BC
 bronze; L: 4-3/4; and
 4-5/8 ARTSW 28 EOA
Stele of Fahan Mura, Done-
 gal LARB 76
Sword of Charlemagne 9-
 14th c. MU 109 FPL
Tankard, Wales 1st c. BC
 bronze-sheeted wooden
 staves, yew base; 5-1/2
 ARTSW 27 ELivL
Tankard Handle, detail 2nd
 c. BAZINL pl 245
 ELivLib
Tara Brooch c700 gilt bronze,
 silver, glass, filigree,
 amber, enamel JANSK
 391; KIDS 34; LARB 74;
 MYBA 244; ST 125
 IreDNB
Tectosage Volcae Coin
 (Gaul) silver BAZINH
 126 FPBN
Tetramorph, Altar frontal

of the Patriarch Sicuald
 8th c. stone BAZINH 129
 ICi
Triskele Plaque (copy) 2nd c.
 BC Embossed copper: Dm:
 6 ARTSW 26 WCaN
Wandworth's Shield 3/2nd c.
 BC bronze; W: 15 SCHMU
 pl 250 ELBr
Warrior GAF 513 FAviL
Wine Ewer, Basse-Yutz
 (Moselle), detail bronze;
 15-1/2 LOM 69 ELBr
Wine Jug, La Tene bronze,
 with coral and enamel
 LARA 161 (col) IRGi
Wine Vessel bronze, with
 coral and enamel LARA
 368 ELBr
Yoke Mounting, Brno 2nd c.
 bronze; 4 MU 109 (col)
 CzBMM
CELTIC, and AVARIC
 Animals, Switzerland,
 England, France, Albania
 9th c. BC-6th c. A.D.
 bronze CHENSW 314, 315
 UNNMM; ELBr; UNjPA;
 SwZMN
CELTIC-PICTISH
 Stele of Hilton, Rosshire,
 Scotland LARB 77
CELTIC-ROMAN
 Male Head, Gloucester 1st c.
 WHEE 218
Celui qui Enferme un Sourire,
 celui qui
 Emmure une Voix. Alfaro
Cenotaph. Ipousteguy
Cenotaph, Whitehall. Lutyens
Censers
 English--10/11th c. Pershore
 Censer
 English--14th c. Censer
 French--13th c. Censer
 Gozbert. Censer: Temple of
 Solomon
 Reinier von Huy. Censer:
 Angel, and Three Worthies
 in Fiery Furnace
 Rumanian--14th c. Transyl-
 vanian Censer, Church
Centaurs
 Barye. Lapith and Centaur
 Barye. Theseus Fighting the
 Centaur Bianor
 Bologna. Hercules and
 Nessus

pl 3 ELRA
Temperance stone HUBE
pl 5 ELSom
Ceramic. Miro
Cerberus
Milles. Cerberus
Sangallo, F. Hercules
and Cerberus
Cerbone, S.
Gero di Gregorio. Arca
di S. Cerbone
Ceres See Demeter
Cerchi Potenziali. Le Parc
CEROLI, Mario (Italian 1938-)
Butterflies 1967 KULN 61
Cassa Sistina 1966 wood
KULN 25; VEN-66:#109
Gabbia 1967 KULN 206
Il Mister 1964 70-7/8x
39-3/8 NEW pl 124
--1965 KULN 23
Les Moutons 1966 KULN 61
The Piper (Discotheque)
1966 80x78-3/8x38-3/8
CARNI-67:#136 UNNBoni
L'Uomo di Leonardo 1964
KULN 25
Venere 1965 KULN 22
CERROTI
Louis XVIII, bust (after
Bosio) c1818 marble
HUBE pl 71 FPL
Cervoni, General
Cardelli, P. General
Cervoni, bust
Cerynean Hind See Hercules
Cesaire, Saint
French--13th c. St. Cesaire
CESAR (Cesar Baldaccini) 1921-
Animal FPDEC il 4
Animale Organico 1955/56
iron; 36x48x26 CARNI-
58:pl 133 UPPiT
Bas-relief Variation 1958
welded-iron; 32 MINE
30 FPB
Composition 1960 iron and
colored sheet metal MARC
pl 65 (col) FPPT
Compressed Motor Car
c1960 BAZINW 441 (col)
FPNo
The Devil 1956 bronze; 137-
3/4 TRI 135 FPB
--1959 bronze MARC pl 64
FPM
Draguignan Man 1957/58
bronze; 41 EXS 69 FPB

Facade Nr. 1 1961 collage
with automobile parts;
98-3/8x118-1/8 NEW col
pl 32 (col)
Figure 1955 BERCK 137
Galactic Insect 1953/55
welded iron; 19-3/8x36-1/2
x14-1/2 MEILD 98; SEW
The Grand Duchess 1955 iron
and steel MAI 53
Grand Panneau, detail 1958
welded iron; 72-3/4 BOW
77; ROTJT 24 ELT
Homage 1958 iron; 51-1/4
GIE 308 FPMai
The House of Davotte 1960
MARC 61 UNNH
Insecte 1956 KULN 56
Man in a Spider's Web 1955
welded iron; 14x7-1/4x7-
1/4 CALA 205; GUGP
94 IVG
The Man of Saint-Denis (L'
Homme de Saint-Denis)
1958 welded iron; 20-1/8
x43-1/8 (with base)
READCON 230; TATEF pl
22d ELT (T.138)
The Man of Villetaneuse
1957 BERCK 137
Motor 4 1960 welded iron,
steel, copper, nickel
pipes; 16x21 SEITZ 145
UNNSai
Mural Sculpture 1955 BERCK
220
Nude 1957 bronze; 25 SELZS
180 UNNOd
Nude of Saint-Denis 1956
iron KUHB 127 UNNSto
Nude of Saint-Denis, I 1956
forged and welded steel;
36 SELZN 52 UNNE1
Nude of Saint-Denis, IV 1957
bronze; 24-1/2 SELZN 54
ELH
Panel 1962 iron; 79x87
SEAA 134 FPB
Petit Panneau 1958 KULN
100
Une Place au Soliel welded
iron and copper; 22 SG-3
Le Pouce de Cesar 1965
KULN 47
Relief 1961 READCON 271
(col)
La Soeur de l'Autre 1962
iron LARM 327; MEILD

28 ELH
Torso 1954 welded iron;
 30-1/2 SELZN 51
Victory of Villetaneuse
 1965 bronze; 94 CHICSG;
 KULN 10 ELH
 --1965 iron; 88-1/2 GUGE
 84 FPB
Villetaneuse Venus 1962
 41-1/2x7-1/2 CARNI-
 64:#55 FPB
Winged Figure c1957 cast
 iron; L: 56 SELZN 53
 UMoSLWe
Cesarec, August
 Kerdic. Medal, observe, to
 Memory of August Cesarec
Cesaric, Dobrica
 Angeli-Radovani. Dobrica
 Cesaric, head
Cesi, Paolo
 Porta, Guglielmo. Cardinal
 Paolo Cesi Tomb
Cezanne, Paul (French Painter
 1839-1906)
 Maillol. Cezanne Monument
 Maillol. Reclining Nude,
 Cezanne Monument study
Chabot, Philip
 Bontemps. Philip Chabot,
 effigy
CHADRE, Ivan (Russian 1887-1941)
 Stones are the Arms of the
 Proletariat 1927 bronze;
 50 EXS 70 RuMM
CHADWICK, Lynn (English 1914-)
 Balanced Sculpture LYNCMO
 78 UNNMMA
 Barley Fork 1952 welded iron;
 26-1/2 NMAD 71 UNNRo
 Beast No. 1 iron and com-
 position MEILD 106 UICA
 Beast IX 1956 iron and
 composition ARTSB-58:17
 Beast XII 1967 KULN 55
 Bird 1956 iron LARM 253
 Black Beast 1960 bronze;
 40x82x26 LOND-5:#10
 Dance 1955 iron and com-
 position READAN #191
 Dragonfly Mobile 1951 iron;
 L: 116 ENC 632; TATES
 pl 10 ELT (6035)
 Encounter IV 1957 bronze;
 60-1/2 ENC 173; HAMM
 112; SAO-4; SFMB #104
 ELBrC

Encounter X 1959 bronze
 VEN-64: pl VII NoONas
The Fisheater 1950/51 copper
 and brass; 8'; Dm: 16'
 RIT 216 EA
Garden Stabile, Regatta
 Restaurant 1951 DAM 146
 ELFe
Indicator III 1963 H: 34
 SEITC 50 UNNMa
The Inner Eye 1952 iron,
 glass, and wire; 90-1/2
 GIE 215; LIC pl 299;
 NMAD 72; ROTJB pl 144;
 VEN-56: pl 123 UNNMMA
Mobile 1949 wood and stretched
 rayon RAMS pl 79b ELBR
Monitor 1964 LARM 369
Moon of Alabama 1957 iron
 composition; 60 GIE 248;
 MAI 54; PRAEG 463
Moon of Habana 1957 H: 13
 BERCK 148 FPCo
Pyramids 1962 iron and
 composition; 27 READCO pl
 7A
Rad Lad 1961 bronze; 11;
 Dm: 3 ARTSS #11 ELBrC
The Season 1955 H: 18
 BERCK 148 ELBrC
--study for second version
 1957 welded iron, plaster,
 cement; 27-1/2x13x16
 NMASO 30
The Spectator 1960 iron
 VEN-62: pl XIX
Starter II 1963 welded iron;
 15 PRIV 92
The Stranger II 1956 iron
 and conglomerate; 43-3/8
 TRI 137
Stranger III (Proposed
 Memorial to R.34), work-
 ing model 1959 iron and
 composition; L: 90 HAMM
 114
Stranger VII 1959 bronze;
 c78x103x21 cm DP 27 GHaS
Teddy Boy and Girl 1956 iron
 and other metals KO pl
 107; MAI 55
--1957 skin bronze; 80
 LONDC pl 5
--maquette 1955 iron and
 composition; 15-3/4 CALA
 206 IVG
--2 1957 bronze; 82 ARTSB-

61:pl 3 ELMa
Tokyo II 1962 steel; 20-1/2
 HAMM 116
Trigon, working model 1961
 iron and composition;
 98 HAMM 115 (col)
Twister II 1962 sheet steel:
 43 BAZINW 444 (col);
 HAMM 113 (col)
Two Dancing Figures 1954
 iron and composition
 stone; 71 ALBB 14;
 ALBC-1:#44; FAIY 9
 UNBuA
--1954 iron and composition
 stone; 71 MCCUR 276;
 NMAD 73 EChW
--VI 1955 iron and compo-
 sition; 72 ROTJB pl 143
 UICAr
Two Watchers 1958 iron and
 plaster, with iron chips;
 19-5/8 TRI 66 GWupZ
Two Winged Figures,
 maquette 1955/56 iron;
 22-1/2 BRION pl 126;
 HAMM 14
VIGIA IV 1960 bronze; 73.5
 cm SAO-6
Watcher II 1959 bronze;
 51x19.5x13 cm SP 27
 GHaS
The Watchers 1960 bronze;
 92 EXS 71; NEW pl 100;
 READCON 198 ELC
Winged Figures 1955 bronze;
 22x17x14 LARM 243;
 TATEB-1:19; TATES pl 7
 ELT (T.416)
--1962 ptd iron; 10x18 HAMM
 117 (col); LOND-6:#10;
 READCON 198
CHAGALL, Marc (Russian-French
 1887-)
Les Amoureux white marble;
 22-1/2 SOTH-1:85
King David, relief 1952
 stone BERCK 21 FPMa
Moses, relief 1952 stone;
 21 BERCK 21; MAI 55
 FPMa
CHAIM, Trude (German-Israeli
 1892-)
Young Girl with flute
 bronze SCHW pl 47
Chained Action. Maillol
Chair of St. Peter. Bernini,
 G. L.

Chaire de Santa Cruze
 Chanterene Pulpit
Chairs
 Dutch--15th c. Gothic Arm
 Chair
 English--16th c. Bench, Box-
 Top seat
 --Linenfold Tudor Chair
 English--17th c. Jacobean
 Arm-chair
 English--18th c. Chippendale
 Chair
 French--19th c. Empire
 Style Armchair
 Manzu. Chair with Fruit
 Walter of Durham.
 Coronation Chair
CHALEVEAU, Guillaume (French
 fl prior to 16th c.) See
 REGNAULT, G.
Chalices
 Byzantine. Chalice: Christ
 and Apostles
 Early Christian. Chalice of
 Antioch
 English--16th c. Chalice of
 Thomas a Becket
 French--10th c. Chalice
 with Paten
 French--12th c. Abbot Suger's
 Chalice
 French--13th c. Chalice of
 Brother Bertinus
 German--8th c. Chalice of
 Tassilo
 German--12th c. Chalice#
 --Wilten Chalice and Paten
 German--13th c. Kaiserpokal
 Italian--15th c. Abruzzi
 Chalice
 --Chalice, Siennese
Chalons, Rene de
 Richier, L. Rene de Chalons
 Tomb
CHAMBELLAN, Rene
 Doors: Endurance; Effort
 bronze CASSTW pl 26
 UNNCha
 Relief Figure
 HOF 210
Chamberlen, Hugh d 1728
 Scheemakers, P., and
 Delvaux. Dr. Hugh
 Chamberlen Monument
CHAMBERS, William (Architect)
 Facade, Somerset House
 1780 Portland Stone RAMS
 pl 2C ELSom

CHAMPEIL, J. B. (French)
 Godard Monument TAFTM
 34
Champlain, Samuel de
 French--20th c. Champlain
 Tercentenary Medal
Chandeliers
 Domenech y Montaner.
 Auditorium Chandelier
 Elkan. Bible Chandelier
 Ender. Oriole, Meissen
 Chandelier
 English--18th c. Chandelier
 --George II Chandelier
 --George II Rococo Chande-
 lier
 English--19th c. Regency
 Chandelier
 Flemish--15th c. Chandelier
 French--17/18th c. Louis
 XIV Chandelier
 French--18th c. "Bird Cage"
 Chandelier
 --Chandeliers
 --Louis XVI Wall Light
 --Regency Chandelier
 Gaudi. Chandelier
 German, or Austrian--17th
 c. Chandelier: Mermaid
 German, or Swiss--16th c.
 Chandelier: Woman
 Playing Lute
 Horta. Chandelier
 Johnson, T. Girandole
CHANDLER, Samuel (English fl
 1721-58)
 Edmund Humfrey Monument
 1727 GUN pl 4 ERet
Chanfron See Armor, Horse
The Channel. Trsar
CHANNEL SCHOOL
 Ciborium Bowl 12th c.
 niello, with silver,
 parcel gilt NM-2:137
 UNNMMC
Channel with Spheres. Clarke
Chant du Depart
 Rude. Departure of the
 Volunteers of 1792
Chantal. Hajdu
CHANTERENE, Nicholas (French,
 or Flemish fl 1517-51)
 Altar 1529-32 KUBS 95A
 PoSP
 Joao de Noronha Tomb
 c1526/28 KUBS pl 94A
 BrObM

Pulpit c1521/22 wood CHAS
 285; SANT pl 88 PoCC
--Chaire de Santa Cruze
 SANT pl 89
Virgin of the Annunciation
 BAZINW 360 (col); SANT
 pl 91 PoCM
La Chanteuse. Bernard
La Chanteuse Triste. Gaudier-
 Brzeska
Chantilly Porcelain Animals.
 French--18th c.
CHANTREY, Francis Legatt
 (English 1781-1841)
 Anna Maria Graves Monu-
 ment d 1819 WHINN pl
 178A EWater
 Bishop Ryder, kneeling
 effigy marble BOASE pl
 50A; MILLER il 59
 ELiC
 Children of Rev. W. Robin-
 son Monument (The
 Sleeping Children) 1812/17
 marble BOASE pl 54A;
 GARL 207; WHINN pl
 178B ELiC
 David Pike Watts Monument,
 detail WHINN pl 187
 Duke of Wellington, equest
 1844 bronze GLE 117 EL
 Edmund and Martha Harvey
 Monument 1819 ESD pl
 148 EKenCh
 Edward Johnstone, bust 1819
 WHINN pl 190A EB
 First Duke of Sutherland
 Monument, figure detail
 1838 WHINN pl 181B ETr
 First Earl of Malmesbury
 Monument 1823 WHINN pl
 185 ESaC
 Francis Horner Monument,
 figure detail 1820 WHINN
 pl 181A ELWe
 General Bowes Monument
 c1811 WHINN pl 163A
 ELPa
 George IV, equest 1828
 WHINN pl 192 FLTS
 George Crabbe, head ENC 175
 George Washington CRAVS
 81; POST-2:108 UMBSt
 Henry Bengough Monument
 1823 WHINN pl 184A
 EBriL
 James Watt Monument 1824

WHINN pl 182, 183 EHan
John Raphael Smith, bust 1825
WHINN pl 187A ELV
Joseph Banks, bust 1818
WHINN pl 188 ELRS
Joseph Nollekens, bust 1817
WHINN pl 190B EWob
Lady Charlotte Finch
Memorial ESD pl 149
ERutB
Lady Frederica Stanhope,
recumbent effigy 1823
GUN pl 5; BROWF-3:76
EChev
Lord Hume 1832 WHINN pl
191B ScEP
Marianne Johnes Monument
(destroyed 1932) 1812
ESD pl 145 EHaf
Mrs. Boulton, head detail
1834 BOASE front EOxT
Mrs. Jordan, head detail
1834 marble; 72 BOASE
pl 61B; CON-5:pl 39;
WHINN pl 179 EMu
Mrs. Jordan as Charity
1831/34 LIC pl 23 ESurB
Mrs. Siddons as Roman
Vestal Virgin BAZINW
420 (col) ELWe
Reginald Heber Monument,
Bishop of Calcutta 1835
marble MOLS-2:pl 50;
WHINN pl 186 ELPa
Rev. J. Horne-Tooke, bust
1811 WHINN pl 186
ECamF
Robert Dundas of Arniston,
seated figure 1824
WHINN pl 190B ScEP
Seventh Earl of Plymouth
Monument 1835 WHINN pl
184B ETar
Sir Walter Scott, bust 1820
BOASE pl 61A; WHINN pl
189 EPL
Sleeping Children BROWF-
3:76 EChev
Viscount Castlereagh, bust
1821 WHINN pl 187B
-ERi
Viscount Melville 1818
WHINN pl 180A ScEP
William Hunter Baille,
bust 1823 WHINN pl
191A RLRCS
William Pitt 1831 WHINN
pl 165B ELHS

Chantries
English--15th c. Beaufort
Chantry
--Chantry Chapel of William
of Wykeham
--Warwick Chantry
English--16th c. Chantry of
9th Earl of Delaware
Chapels
Amadeo. Colleoni Chapel
Ammanati. Del Monte
Chapel
Bernini, G. L. Coronation
Chapel
Bologna. Salviati Chapel
Corradini and Queirolo.
Cappella Sansevero In-
terior
Domenico di Niccolo. Chapel
of Palazzo
Dosio. Niccolini Chapel
French--17th c. Angels
Supporting Coat of Arms
of Marie de Medicis,
Chapel of the Trinite
Laurana. Chapel of St.
Lazare
Le Corbusier. Chapel at
Ronchamp
Simon de Colonia. Chapel
of the Constable
Spanish--15th c. Capella del
Conestabile
Spanish--18th c. Sacramental
Chapel (Sagrario)
Tacca, P. Capella dei
Principi
Torrigiano, P. Chapel of
Henry II
Wolff, Eckbert, the Younger.
Interior Decoration
CHAPU, Henri (French 1833-91)
Joan of Arc CHASEH 447;
RAD 460 FPL
Joan of Arc ROOS 201F
FPLu
Regnault Tomb, Cour du
Murier POST-2:145 FPE
Steam, designed for
Machinery Hall, Paris
1889 LARM 174
"Character Head". Messerschmidt
CHARBONNRAUX, Pierre (French)
Grape-Gatherers in
Champagne TAFTM 43
Le Chardon. Gurtler
Charette, General
Bosio. General Charette, bust

The Chariot of Apollo.
Chariots
 Agostino di Duccio. Mars,
 zodiac sign relief
 Bertoldo di Giovanni--Foll.
 Military glory
 Braque. Fragments d'Hesiode
 Burgundian--14th c. Medal
 of Heraclitus
 Early Christian. Constantius
 II, in chariot
 Giacometti. Chariot
 Hussmann. Last Curve
 Koenig. The Chariot
 Laurana, F., and Pietro
 di Martini. Triumphal
 Arch of Alfonso of
 Aragon
 Pasti. Venus, relief
 Varin. Richelieu's Medal,
 reverse: France riding
 in Chariot
Charity
 Balducci. Arca of St.
 Peter Martyr: Charity
 Balducci. Charity, relief
 Bambaia. Charity: Fortitude
 Bartolini. Charity
 Bernini, G. L. Urban
 VIII Tomb: Charity
 Bernini, P. Charity
 Bologna. Charity
 Buon, B.--Attrib. Charity
 Dalou. Charity#
 Dubois, Jean. Charity
 Fiorentino, D. Charity
 Flaxman. Charity
 Flemish--15th c. Charity
 Scene
 Giorgio da Sebenico. Charity
 Giovanni da Campione.
 Charity, Baptistry ex-
 terior
 Mino da Fiesole. Charity
 Quellinus, A., the Elder.
 Charity
 Serpotta. Charity
 Tino de Camaino. Catherine
 of Austria Monument:
 Charity
Charlemagne, Saint (King of the
 Franks and Emperor of
 the West 742-814)
 Castayls. St. Charlemagne
 Celtic. Sword of Charle-
 magne
 French--9th c. Charlemagne,
 carrying orb, equest

French--17th c.
 Frankish. Denier: Charle-
 magne, head
 German--9th c. Charlemagne's
 Throne
 German--13th c. Shrine of
 Charlemagne
 German--14th c. Reliquary:
 Charlemagne, bust
 Swiss--8th c. Charlemagne
Charles I (King of England 1600-
 1649)
 Bushnell. Charles I
 Cure, W. II. Prince Charles
 English--17th c. Charles I,
 bust
 Le Sueur. Charles I#
Charles II (King of England 1630-
 85)
 Bushnell. Charles II, bust
 Cibber. Charles II Succour-
 ing the City of London
 English--17th c. Charles II,
 bust
 --Charles II, effigy
 Fanelli, F. Charles II as
 Prince of Wales, bust
 Gibbons. Charles II
 Pelle. Charles II, bust
 Quellinus, Arnold. Charles II
Charles V (King of France 1337-80)
 Beauneveu. Charles V Tomb
 French--14th c. Charles V#
 --Scepter of Charles V
 Jean de Liege. Charles V
 of France as St. Louis
Charles IX (King of France 1550-74)
 French--16th c. Charles IX,
 equest, medallion
Charles X (King of France 1757-
 1836)
 Bosio. Charles X, bust
Charles II (Holy Roman Emperor
 823-77), called: Charles the
 Bald
 Early Christian. Psalter of
 Charles the Bald, cover
 German--9th c. Psalm 26,
 Prayer Book of Charles
 the Bald
Charles IV (Holy Roman Emperor
 1316-78), known as: Charles
 of Luxemburg
 German--14th c. Doorknock-
 er: Charles IV and Seven
 Electors
 Parler. St. Vitus between
 Charles IV and Wenzel
 IV

Charles V (Holy Roman Emperor
1500-58), also known as:
Carlos I, King of Spain
Beaugrand, and Herman
Glosenkamp. Fireplace,
with statue of Charles V
Daucher, H. Charles V,
equest, relief
Daucher, H. Triumph of
Charles V, panel
Leoni, L. Charles V#
Leoni, P. Charles V and
his Family at Prayer
Meyt. Charles V, bust
Negroli. Carlos I, helmet
with curled hair and
beard
Negroli. Charles V round
shield
Romanesque. Charles V,
medallion
Spanish--16th c. Carlos I
in full armor in cavalry
battle, relief
Charles VI (Holy Roman Emperor
1685-1740)
Braun, M. B. Charles VI
Monument
Donner. Apotheosis of
Emperor Charles V
Charles I (King of Naples 1226-85),
also known as: Charles of
Anjou
Arnolfo di Cambio. Charles
of Anjou#
Charles IV (King of Spain 1748-
1819)
Tolsa. Charles IV, equest
Charles XIV (King of Sweden
1763-1844)
Swedish--19th c. Charles XIV
as Mars
Charles Borromeo, Saint 1538-84
Raggi, A. St. Charles
Borromeo
Charles d'Artois d 1471
French--15th c. Charles
d'Artois, effigy
Charles Louis (Elector Palatinate
1617-80)
Dieussart. The Elector
Palatinate, bust
Charles the Bold (Last Duke of
Burgundy 1433-77) called:
Charles le Temeraire
Loyet. Charles the Bold
Reliquary

Charles, Theodore (Elector
Palatinate 1724-99)
Ceracchi. Charles Theodore
of Bavaria, bust
CHARLET, Jose (French 1916-)
Apsara 1957 ebony MAI 56
CHARLIER, Guillaume (Belgian)
Mater Dolorosa plaster
VEN-3: pl 4
Charlotte, Princess (English)
Wyatt, M. C. Monument to
Princess Charlotte
The Charmed Circle of Youth.
Moore, E. M.
Charms (Amulets, Fetishes,
Talismans)
Jewish. Amulet
Russian--6th c. Amulet:
Horse
Tumarkin. Fetish
Uhlmann. Fetisch
Charnaux, Madeleine
Bourdelle. Madeleine
Charnaux
Charnaux Venus. Dobson
CHAROUX, Siegfried (Austrian-
English 1896-)
Man 1957 cemented iron;
78 LONDC pl 6
Violinist 1959/60 cement;
90 LOND-5:#11
CHARPENTIER, Alexander (French
1856-1909)
Revolving Music Stand c1900
hornbeam; 48 SELZPN
99 FPDec
CHARPENTIER, Felix (French)
The Bicycle TAFTM 38
Voluptuousness TAFTM 38
Chartres. Gentils
Chasse
French--12/13th c. Chasse
French--13th c. Chasse Front
Chatelaines
English(?)--18th c.
Chatelaine and Watch
Chatham, Earl of
Bacon, J. Earl of Chatham
Monument
Chatillon, Louis de See Orleans,
Louis I
CHAUDET, Antoine Denis (French
1763-1810)
Amor Catching a Butterfly
(Eros; Love), completed
posthumously from model of
1802 marble; 31 CHAR-2:

270; CHASET 423; LIC
pl 30 FPL
Chaulnes, Duc de
Coysevox. Duc de Chaulnes,
bust
CHAUVIN, Jean (French 1895-1958)
En un Soir Chaud d'Automne
1945 marble RAMS pl 94
BLG
Female Figure* ebony
MARTE pl 39
Flake (Fiocco) 1955 wood
VEN-62: pl 140 UNNH
In a Cold Autumn Wind (In
una Calda Sera di Autum-
no) 1945 Pietra di Lens
VEN-54: pl 88
Maternity ebony MARTE pl
39
Wind of Life (Le Vent de
la Vie) 1949 bronze;
7x26 RAMS pl 95; TRI
183 BLG
CHAUVIN, Louis (French 1889-)
Couple 1940 wood MARC
pl 39
Don Juan 1945 bronze MARC
pl 40 (col) FPM
Motherhood 1913 cypress
SELZJ 243 FPMag
On an Accordion Tune 1920
SELZJ 243 FPMag
Sculpture MAI 57
CHAVALLIAUD
Mrs. Siddons, seated figure,
1897 marble GLE 164 ELPad
CHAVANNES, PUVIS DE See
PUVIS DE CHAVANNES
Chavarri. Monument. Blay
CHAVIGNIER, Louis (French
1922-)
First Figure MAI 57
Le Souffle FPDEC il 5
Checkpoint Charley. Amen
CHEERE, Henry (English 1703-81)
Admiral Sir Thomas Hardy
Monument d 1732 WHINN
pl 70A ELWe
Bishop Wilcocks Monument:
Westminster Abbey
GERN pl 36A ELWe
Charles Apthorp Monument
1758 GUN pl 4 UMBK
Christopher Codrington 1732
WHINN pl 72 EOA11C
Lord Justice Raymond
Monument d 1732 WHINN
pl 73B EAbb

Monument Commemorating
Centenary of Death of
Hampden ESD pl 27 EBuckG
Philip de Sausmarez Monu-
ment d 1747 WHINN pl
97A ELWe
CHEERE, John (English 1709-87)
Minerva WHINN pl 107B
ESou
Cheetahs
Italian--16th c. Cheetah
Russian--13th c. Aquamanile:
Cheetah
Ruwoldt. Cheetah
Le Chef
Brancusi. The Chief
Chekhov, Anton
Martini, A. Chekhov, bust
CHELLES, Pierre de
Philip the Bold Tomb c1300
CHASEH 230; LARR 21;
REAU pl 100 FPDe
CHELLES, Pierre de, and Jean
d'ARRAS
Philippe le Bel, head
1298/1307 EVJF pl
211A FPDe
Chellini da San Miniato, Giovanni
d1462
Rossellino, A. Giovanni
Chellini da San Miniato,
bust
CHELSEA PORCELAIN See also
English--18th c.; Rysbrack;
Willems
Bonbonneries and Scent Bottles
c1755/65 CON-4: pl 47 ELV
Carpenter c1755 H: 7-3/4
CON-3: pl 51 ELV
Dovecote, pot-pourri(?)
c1755 H: 14-1/2 CON-3:
pl 52 ELV
Harvesters 1758/60 H: 10
CON-4: pl 46 -ESy
Rabbit Tureen c1755 L: c
14-1/4 CON-3: pl 53 ELV
Spring c1755 H: 5-1/4 CON-
3: pl 52 ELV
Chenchu Tribe, India
Milward. Chenchu Boy, head
Chenets See Andirons
Chenier, Andre
Puech. The Muse of Andre
Chenier
Chercheur d'Amitie. Kemeny
CHERCHI, Sandro (Italian 1911-)
Mendicant 1955 bronze VEN-
56: pl 26

Nude 1947 bronze CARR 301
Cheremetian Woman
 Russian--18/19th c.
 Mordovinian and Cher-
 metian Women
Cherier, Bruno
 Carpeaux. Bruno Cherier,
 head
Cherubs See also Putti
 Desiderio da Settignano.
 Cherub Heads
 French--11th c. Cherubim,
 head
 French--12th c. Cherubim
 Rossellino, A. Head of
 Cherub
 Rysbrack. Sir Isaac Newton
 Monument
 Steinbrenner, H. Cherubim
 Valle. Cherub Head
Chess See Games and Sports
Chesterfield, 4th Earl of (Philip
 Dormer Stanhope English
 Statesman and Man of Letters
 1694-1773)
 Wilton. Earl of Chesterfield,
 head
Chests See also Cassoni
 Boberg. Chest
 English--17th c. Inlaid Chest
 French. Normandy Chest
 French--15th c. Gothic Chest
 French--16th c. Normandy
 Chest
 German--12th c. Romanesque
 Chest
 German--13th c. Chest
 Sagar. Chest#
 Spanish--16th c. Barcelona
 Bridal Chest
CHEVAL, Ferdinand (Le Facteur)
 (French 1836-1924)
 Ideal Palace (Le Palais
 Ideal) 1878/1922 BAZINW
 235 (col); DAM 218-21;
 GAF 429 FDrH
 --"The Fairies of the East
 Come to Fraternize with
 the West" MOHV 321
Cheval Bayard. Strebelle
Cheval et Jockey. Degas
Chevauchee Nocturne. Zwobada
CHEVERTON, Benjamin (English
 1794-1876)
 Queen Victoria, bust after
 marble bust by Sir Fran-
 cis Chantrey 1842 ivory;
 11-3/4 VICK 45 ELV
 (A. 28-1931)

CHEWETT, Jocelyn (Canadian, liv-
 ing in Paris 1906-)
 Sculpture 1953 limestone;
 28 BERCK 122; MAI 58
Chiapelli, Maria
 Andreotti. Donna Maria
 Chiapelli
Chiaro di Luna. Martini, A.
Chiavennan Head. Giacometti
CHIAVERRI, Gaetano
 Saints, roof-top figures
 MOHV 118 GDH
Chichele, Henry 1364-1443
 English--15th c. Bishop
 Chichele's Tomb
Chickens
 Bachelet. Wyandotte Cock
 Bianchi. Coq
 Brancusi. The Cock
 Dutch. Delft Japanese Cock
 Firk. Janosik and the
 Mountain Cock
 Fontana, L. Gallo
 Gargallo. The Rooster
 Haechler. Hahn
 Hajdu. Cock
 Kandler. Meissen Mustard
 Pot and Oil Jar: Woman
 and Chicken
 Lombard. Hen and Chicks
 Marcks. Rooster#
 Mascherini. Cock
 Meadows. Cock
 Meadows. Cockerel
 Meadows. Crowing Cock
 Minguzzi. Gallo
 Minguzzi. Man with a
 Rooster
 Picasso. Cock
 Piffard. Orpington Cock
 Remund. Der Rote Hahn
 (Le Fleau)
 Salimbeni. Gallo Vittorioso
The Chief. Brancusi
Chief. Turnbull
Chigi, Ludovico
 Assanti. Prince Ludovico
 Chigi, bust
Child in the Sun. Rosso, M.
A Child of the Century. Rodin
Child on a Dolphin. Vischer, P.,
 the Younger
Child Playing II. Kalin, Z.
Child with a flower. Leger
Child with a skull and Hourglass.
 Italian--15th c.
Child with Balloon. Jojon
Child with Bird and Apple
 Pigalle.

No. 4 1960 H: 50
SEITC 142
Chilly Woman. Godecharle
Chimeras
Brancusi. Chimera
Gilioli. La Chimere
Mascherini. Chimera
Mirko. Chimera
Mirko. Composition with
Chimera
Chimney. Gaudi
Chimney Pieces See Fireplaces,
Chimney Pieces, and
Mantles
Chimpanzee with its young. Vatagin
CHINARD, Joseph (French 1756-
1813)
Apollo Crushing Superstition Underfoot 1791 terracotta; 51 cm LIC pl 33
FPCarn
Madame Chinard POST-2:98
Madame Recamier, bust
1802/05 marble; 79 cm
CANM 25; CHASEH 424;
LARM 68; LIC pl 31 FLM
--terracotta MILLER il 153
FLM
--c1795 terracotta; 22
NEWTEM pl 152 GBS
Man, portrait bust RAY 53
FPL
Chinard, Mme. Joseph
Chinard. Mme. Chinard
Chinese (Subject)
Benkert. Chinese Tea
Drinkers
Carpeaux. La Chine
Codreano. Chinese Girl,
head
Derby Porcelain. Chinaman
and Boy
English--18th c. Bow
Chinoiserie Busts
--Chelsea Chinese Family
--Chilsea Chinese Musicians
--Chinese, kneeling figure
--Seated Chinese with Pot,
Chantilly Porcelain
Fritzsche. Meissen Chinaman and Bird
Fritzsche. Meissen Chinaman Arbour Figure
German--18th c. Artist and
Scholar Presented to
Emperor of China
Chinese Dog 2. Paolozzi
The Chinese Emperor. German--
18th c.

The Chinese Nightengale. Ernst
Chinese Philosopher, head. Gordine
"Chinese Trifles". Folk Art--
Russian
Chinoise. Gisiger
CHIO (Ernesto Galeffi) (Italian
1917-)
Bird 1959 bronze SAL pl
68 (col)
Fish 1960 bronze SAL pl 67
CHIRINO, Martin (Spanish 1925-)
Homage to Julio Gonzalez
1960 forged iron; 13-3/4
NMS 17
Root, Number 2 1960 forged
iron; 13-3/4 NMS 18
Root, Number 3 1960 forged
iron; 23-5/8 NMS 18
The Wind 1960 forged iron;
7-7/8 NMS 19
--1964 VEN-64:pl 184
Chiron
English--13th c. Ciborium of
St. Maurice: Chiron and
Achilles, finial
Chitabai, Lamani Woman, head.
Milward
Chlamydati
Byzantine. Two Chlamydati
Chloe. Gill, E.
CHLUPAC, Miroslav (Czech
1920-)
Torso 1964 sandstone; 39x
137 cm BER 29
Chocolate Pot of Marie Leczinska.
Cousinet
Choir Screens
Anselmo da Campione. Choir
Screen
Borgona. Agony in the
Garden, choir screen
detail
Dutch--16th c. Choir Screen
English--13th c. Angel Choir
French--15th c. Choir Screen:
Christ's Baptism
--Rood Loft and Choir Screen
figures: Judas Thaddeus;
Adam and Eve
French--15/16th c. Choir
Screen
French--16th c. Choir Screen,
Chartre
Gailde. Choir Screen, detail
Gattinger. Choir Screen
German--12th c. Angel's
Choir Screen
--Apostles and Prophets,
choir screen

German--13th c. St. George's
　　Choir
Hajek. Choir Screen
Lutma. Choir Screen
Naumberg Master.
　　Founders' Choir Screen
Spanish--17th c. Wrought
　　Iron Choir Screen
Vriendt. Choir Screen
Choir Stalls
　　Berruguete. Toledo
　　　Cathedral Choir Stalls
　　Christian. Choir Stalls and
　　　Organ
　　Christian, or J. A. Feucht-
　　　mayer. Choir Stall
　　Durst. Clergy and Choir
　　　Stalls
　　English--15th c. Choir
　　　Stall: Geese Hanging
　　　the Fox
　　French--15th c. Choir Stalls
　　French--16th c. Choir
　　　Stalls#
　　German--14th c. Choir
　　　Stall(s)#
　　German--18th c. Choir Stall
　　Italian--14th c. Choir Stalls
　　Jan van Mecheln. Choir
　　　Stalls
　　Ratcliff. Choir Stalls
　　Syrlin, J., the Elder.
　　　Choir Stall Busts
　　Terwen. Choir Stalls
Choirs
　　Bandinelli, B. Choir
　　English--13th c. Choir, with
　　　Percy Tomb
Choiseul, La Duchesse de
　　Rodin. La Duchesse de
　　　Choiseul
Chopin, Frederic Francois (Polish
　　Composer and Pianist 1810-
　　49)
　　French(?)--19th c. Frederic
　　　Chopin, death mask
　　Horno-Poplawski. Chopin,
　　　head
Chor, plaque. Lorcher
The Chorister. Hartwell
Chorus. Consagra
Chousat, Jean d 1433
　　French--15th c. Jean
　　　Chousat
Chrismatory: Turret. Pauwels, J.,
　　the Younger
Chrismon. Byzantine
Christ See Jesus Christ

Christ and Doubting Thomas
　　Verrocchio. Christ and St.
　　　Thomas
Christ and the German Soldier.
　　Manzu
Christ Blessing
　　French--13th c. Le Beau
　　　Dieu
Christ Courajod. French--12th c.
Christ of Good Fortune--Buen
　　Suceso
　　Fernandez. Christ of the
　　　Filipini
Christ of the Filipini. Fernandez
Christ Teaching
　　French--13th c. Le Beau
　　　Dieu
CHRISTIAN, Johann Joseph
　　(German 1706-77)
　　Angel, head, pulpit c1760
　　　BUSB 180 GZwCh
　　Choir Stalls and Organ
　　　c1750/64 BUSB 202
　　　GOtA
　　Ezekiel, bust c1764 BAZINW
　　　412 (col) GOtA
　　St. Conrad c1762 HELM pl
　　　154 GOtA
　　St. Dominic, principal altar,
　　　west transept c1760 BUSB
　　　178 GOtA
　　St. Nicholas, confessional
　　　c1775 BUSB 179 GBucCh
CHRISTIAN, Johann Joseph, or
　　Joseph Anton FEUCHTMAYER
　　Choir Stall, relief detail
　　　1768/69 BUSB 203 SwSGCh
CHRISTIAN, Johann Joseph, and Johann
　　Michael FEUCHTMAYER
　　Putti 1767 BAZINL pl 351
　　　GOtA
CHRISTIAN, Johann Josef; Martin
　　HERMANN; and Karl Josef
　　RIEPP
　　Organ; St. Benedict 1754/
　　　56 gilt wood BAZINW
　　　412 (col) GOtA
Christian III (King of Denmark and
　　Norway 1503-59)
　　Floris. Christian III
　　　Monument
Christian IV (King of Denmark and
　　Norway 1577-1648)
　　Dieussart. King Christian
　　　IV in Roman Costume,
　　　bust
Christina, Saint
　　Buglione. Santa Christina,

effigy
Christina (Queen of Sweden 1626-89)
Faveau. Queen Christine of
Sweden Refusing to Spare
her Equerry Monaldeschi
CHRISTMAS, John, and Matthias
CHRISTMAS (English)
Archbishop Abbott, effigy
ESD pl 49 EGuiT
Mary Calthorpe Monument
1640 WHINN pl 23A
EEas
Sir Robert Leman Tomb,
Lord Mayor of London
ESD pl 63 ELStS
Christmas Relief. Jordan
Christmas Tree. Schwitters
CHRISTO (Chinto Javacheff)
(Bulgarian-French 1935-)
Packaged Life Magazine
1962 plastic and string;
c 23x20 LIP 181; PEL
257 IRSal
CHRISTOFLE, Charles (French
1805-63)
Table Centre made for
Napoleon III 1855 LARM
207 FPDec
CHRISTOPH, Robert (German)
Prophet LIL 188 GGunM
Christopher, Saint
Bellano--Attrib. St.
Christopher
Berruguete. St. Christopher
Bertolino, T. St.
Christopher, medallion
English--15th c. St.
Christopher and the
Christ Child
--St. Christopher Carrying
the Christ Child
Feuchtmayer. St. Christopher
Flemish--16th c. St.
Christopher
Francesco Di Giorgio Martini.
Christopher
French--15th c. St.
Christopher #
--SS Christopher and Hubert
German--15th c. St.
Christopher#
--Schusselfelder. St.
Christopher
German--16th c. St.
Christopher#
German, or French--14th c.
St. Christopher

Kriechbaum. Winged High
Altar: St. Christopher
Master of Passau. St.
Christopher
Nanni di Banco--Attrib. St.
Christopher
Rhenish. St. Christopher
Christ's Ancestors
English--14th c. Christ's
Ancestors
French--12th c. Ancestors
of Christ
CHRONANDER, Bror Ivar
Dancer wood MARY pl 150
SnGK
Chronos See Time
Chrysalid. Penalba
Churches
Byzantine. Reliquary: Domed
edifice
Durst. Church, and Synagogue
Flemish--13th c. Shrine of
St. Gertrude: Gothic
Church
French--11th c. Capital:
Offering a Church
French--13th c. Reliquary
of St. Taurin in form of
Church
German--12th c. Domed
Reliquary: Church
Gunther, F. I. Emperor
Henry, as founder of the
Church of Rott
Italian--8th c. Santa Maria
in Cosmedin, interior
Italian--12th c. Abbot
Leonatus
Offering Church to Pope
Clement III, tympanum
--Monreale Capitals: King
Presenting Cathedral to
Virgin
Le Corbusier. Chapel at
Ronchamp
Rumanian--14th c. Tran-
sylvanian Censer: Church
Rumanian--17th c. Kivotion:
Church
Spanish--15th c. Reliquary:
Gothic Chapel
Churchill, John d 1715
Churchill, Robert (?).
John Churchill Memorial
CHURCHILL, Robert (?) (English)
John Churchill Memorial

after 1715 GERN pl 47;
ELMarg
--cartouche ESD pl 30
CHURRIGUERA, Jose de (Spanish
1665-1725)
Main Altar 1693 gilded
wood; c 100' BAZINW 405
(col); LARR 307; VEY
291 SpSalE
Chute, Chaloner
Carter, T. I. II. Chaloner
Chute, effigy
CHZYSOCHOIDOU, Titsa
Portrait of a Young Man,
model clay CASS 35
CIAMPI, Almondo (Italian)
Primo Peccato bronze VEN-
22:12
Ciano, Costanzo (Italian Naval
Officer and Statesman 1876-
1939)
Righetti. Costanza Ciano,
head
Ciano, Edda Mussolini
Messina. Countess Edda
Ciano, head
CIBBER, Caius Gabriel (English
1630-1700)
Boy Playing Bagpipes UND
77 ELV
Charles II Succouring the
City of London,
Soho
Square 1674 MILLER il
144-45; WHINN pl 36A
EL
Garden Urn, base detail:
Fauns, Guildhall Library
print BROWF-3:46
Justice 1688/91 WHINN pl
37 ECha
Melancholy Madness c1675
WHINN pl 36B ELGH
Monument, relief detail
1674 c L8' Sq WHINN pl
69b EL
Raving Madness, Bethlehem
Hospital c1680 ENC 186;
GARL 23 ELGH
Sackville Tomb 1677 marble
BUSB 98; CON-2:pl 45;
ESD pl 16, 17; GARL
198; WHIN pl 69a; WHINN
pl 38 EWith
Cibber, Colley (English Actor and
Dramatist 1671-1757)
Roubiliac. Colley Cibber,
bust

Ciboria
Arnolfo di Cambio.
Ciborium#
English--12th c. Malmsbury
Ciborium
--Warwick Ciborium
French--13th c. Ciborium
d'Alpais
Italian--11th c. Ciborium of
Sant' Ambroglio, relief
Mazzuoli, G. Angels carry-
ing the Ciborium
Il Ciccaiuolo. Trentacoste
Cicero
Italian--17th c. Cicero, bust
Syrlin, J., the Elder.
Cicero
Ciclopico. Loucopoulos
El Cid III. Fischer, L.
Il Cieco. Marini
"La Cieguecita". Martinez
Montanes
CIFARIELLO, Filippo (Italian)
Ermete Novelli, bust bronze
VEN-24:pl 112
Lino Pesaro, head bronze
VEN-26:pl 48
Cigar Store Figures
Folk Art--English. "Black
Boy" ("Virginian")
Folk Art--English. Highland
Laddie
Folk Art--English. Snuff
Highlander
Cilla
Ben-Zvi. Monument to
Cilla
Cimburg's of Massonia. Sessel-
schreiber
Le Cimetiere. Ipousteguy
CIMIOTTI, Emil (German 1927-)
Aeolus I 1960 bronze; 20
SEITC 56 GStLu
Bronzeplastik 1958 bronze;
45x20x25 cm KUL pl 8
GNevS
Eremit 1960/61 bronze; 18
SEITC 56 GStT
Group of Figures (Figuren
Gruppe) 1958 bronze MAI
59
--1958 32 cm Sq KUL pl 6
GWupZ
--1958 bronze; 40x28x28 cm
KUL pl 7; SEITC 56
GMVan
--bronze; 15-3/8 TRI 114
GDuK

--1958 bronze; 74 cm OST
104 GHaL
Landscape I 1959 36x20x16
CARNI-61:#66 GML
Plastik 1962 bronze; 30x25x
18 cm KUL pl 9 GUH
Rocks and Clouds (Rupi e
Nuvole) 1959 bronze; 17-
3/4x19-5/8x11-3/4
TRI 216; VEN-60:pl 170
GCoSt
Schebende Landschaft 1962
bronze; 24 SEITC 56
GNeumH
Sculpture 1958 bronze; 8
MINE 14
Sculpture 6/58 1958 bronze;
12 MINE 43 UPPiC
Siren 1957 bronze VEN-58:
pl 90
Untitled 1964 bronze; 21-5/8
x21-5/8x17-3/4 NEW pl
324
CIONE, Andrea di. See ORCAGNA,
Andrea
CIONE, Andrea di Michele See
VERROCCHIO, Andrea del
The Circle of Mothers. Kollwitz
Circlerette. King, Phillip
Circus Animals and Circus Wagons
German--20th c. Circus
Wagon: The Lion and the
Serpent
Circuses
Byzantine. Imperial Box
at Hippodrome
Cithera See Musicians and
Musical Instruments
Citizens of Calais
Rodin. Burghers of Calais
The City in Space. Kiesler
The City of the Circle and the
Square. Paolozzi
City on the Sea. Sax
City Square. Giacometti
CIUFFAGNI, Bernardo (Italian)
St. Matthew, seated figure
1410/15 POPG fig 37;
SEY pl 14B IFOp
CIVILETTI, Pasquale (Italian)
Giuseppe Verdi Monument,
with principal characters
from "Aida", "Falstaff",
"Otello", and "Forza del
Destino" 1906 SALT 96
UNNBroa
CIVITALE, Matteo (Italian 1436-
1501)

Adoration of the Child terra-
cotta; 47-1/8x44-1/4
USNK 191 UDCN
Angel of the Annunciation ptd
terracotta; 51-1/2 BR pl
7 (col); NCM 273; NMA
pl 182 (col); UNNMM (11.97)
The Annunciation 2nd half 15th
c. BUSR 135 ILuP
Ecce Home BARG IFBar
Faith (unfinished) c1475
marble SEY pl 104 IFBar
Madonna Adoring the Child,
kneeling figures FAIN 74;
MACL 158 UMBGa
Piero da Noceto Monument
POPR fig 63 ILuC
Prophet Habbakuk, Cappella
di S. Giovanni c1495
marble SEY pl 110B IGenC
St. Sebastian ptd terracotta;
25-5/8x6-29/32x3-13/16
SEYM 110; USNI 226;
USNK 190; USNKP 415
UDCN (A-51)
San Romano Tomb ptd marble
POPR fig 42, pl 75 ILuR
Tomb Relief: Clasped Hands
and Profile Head, Lucca
Cathedral BUSR 135;
MACL 159 ELV
CIVITALE, Matteo--FOLL.
Virgin Annunciate c1485/90
ptd wood SEY pl 110A
IMugM
CLACK, E. J. (English)
Mother and Child yew; 72
DURS 63
Clad Woman. Csaky
Clair de Lune. Martini, A.
Claire, Saint
Portuguese--14th c. St.
Claire
Claire et Clarisse. Hajdu, E.
Clamour. Frith
CLARA, Jose (Spanish 1878-)
Development bronze VEN-42:
pl 105
Divinity CHASEH 489
Eve 1938 bronze RAMT pl
58
Female Torso bronze VEN-36:
pl 77
Hungarian Pavilion, Turin
Exposition TAFTM 91
Seated Nude Figure TAFTM
90
Twilight TAFTM 90

Woman Bathing stone VEN-
34:pl 129
CLARAZ, Antoine (Swiss 1909-)
Le Felin plaster; 110 cm
JOR-1:pl 35
Clarence, Duke of
Gilbert, A. Duke of Clarence
Tomb
CLARET, Joachim (Spanish)
Adam and Eve terracotta
VEN-22:85
Clarinet
Laurens. Man with Clarinet
CLARK, P. Lindsey (English)
Madonna and Child, Charter-
house 1946 Portland
stone NEWTEB pl 28A
CLARKE, Geoffrey (English 1924-)
Aluminum Sculpture* MILLS
pl 80
Battersea Group 1962 sand-
cast aluminum
I. 3-1/2x11-1/2x3';
II. 2-1/2x10-1/2x4-1/2'
III. 4x13x3-1/2'
LOND-6:#12; READCON
179
Channel with Spheres 1965
cast aluminum; 18 HAMM
141 ELR
Complexities of Man 1951
iron MAI 60
Two Slabs and Thin Bars
1965 cast aluminum;
22 HAMM 142 ELR
Clarke, Mrs. E. C.
Bodini. Mrs. E. C. Clarke,
head
Clarke, Stephen Slaughter
Hayward. Rev. Stephen
Slaughter Clarke and Wife,
Monument
Clasps See Pins and Clasps
Classical Memorial. Puech
Classical Plaque 12x16 PER 87
Classical Relief 21x3 PER 69
CLATWORTHY, Robert (English 1928-)
Bull 1956 bronze LARM 369 ELT
--1956/57 bronze; 63 (with
base) READCON 221 ELC
--1956/57 treated plaster; 54x
120 LONDC pl 7; MAI 60
Seated Figure 1959/60
plaster for bronze; 53x
22x18 LOND-5:#12
Seated Figure 1963 concrete;
75 LOND-6:#13

Claude. Poisson
CLAUDE, Camille (French)
Clotho TAFTM 39
The Gossips TAFTM 39
The Ripe Age TAFTM 39
The Waltz TAFTM 39
Portraits
Rodin. Camille Claudet#
Claude de France (Queen of Francis
I, King of France 1499-
1524)
Bontemps. Queen Claude,
effigy
Delorme. Francis I and
Claude of France Tomb
Marchand, F., and P.
Bontemps. Monument of
Francis I
Claudel, Paul
Roberts-Jones. Paul Claudel,
head
Claudio. Cuneo
Claudius
Italian--17th c. Claudius,
bust
Porta, G. B. della. Claudius,
bust
CLAUGHTON, R. B. (English
1917-)
Queen Matilda 1960 mulberry;
72x20 LOND-5:#13
Claus, Brother
Folk Art--Swiss The Peasant
St. Nicholas
CLAUS, Fritz (German 1885-)
Die Frau des Kunstlers
1928/29 cast copper; LS
HENT 76
CLAY, Phyllis (English)
Doorway Relief, Govan stone
PAR-1:123
Clayton, Robert d 1707
Crutcher. Robert Clayton
Tomb
Clemenceau, Georges (French
Statesman 1841-1929)
Cognie. Clemenceau
Rodin. Clemenceau, bust
Sicard. Clemenceau Monu-
ment; Georges Clemenceau
Clement III (Pope d 1191)
Italian--12th c. Abbot
Leonatus Offering Church
to Pope Clement III,
tympanum
Clement IV (Pope d 1268)
Oderisi. Tomb of Clement
IV

Clement VIII (Pope 1536-1605)
 Bernini, P. Clement VIII
 Coronation
 Ponzio. Clement VIII Tomb
Clement IX (Pope 1600-69)
 Lucenti. Pope Clement IX,
 bust
Clement XII (Pope)
 Bauchardon, E. Clement
 XII, bust
 Bracci. Clement XII, bust#
 Verschaffelt. Pope Clement
 XII, bust
Clement XIII (Pope 1693-1769)
 Canova. Clement XIII
 Monument
Clement XIV (Pope 1705-74)
 Canova. Clement XIV Monu-
 ment
 Hewetson. Clement XIV, bust
CLEMENTE DA URBINO
 Medal: Frederico da Monte-
 feltro 1468 bronze; Dm:
 .094 CHAS 301
Clementel, bust. Rodin
Clementinus.
 Byzantine. Diptych of
 Clementinus
Cleopatra VII (Queen of Egypt
 69-30 BC)
 Bandinelli, B. Cleopatra
 Barlach. Cleopatra
 Barrois. Cleopatra
 Master, P. E. Cleopatra,
 relief
 Padovano. Anthony and
 Cleopatra
CLESINGER, Jean Baptiste Auguste
 (French 1814-83)
 Prins Jerome Bonaparte,
 head 1853 marble; 65
 cm COPGM 87 DCN
 (I. N. 1792)
 Woman Bitten by a Serpent
 1847 marble; 58x178 cm
 LIC pl 77 FPL
CLEVE, Corneille van 1645-1732
 Polypheme LOUM 182 FPL
 (1517)
 Portraits
 Caffieri. Sculptor van Cleve, bust
Climbing Form. Martin, M.
Climbing Forms No. 1. Adams, R.
Cloaked Woman. Bertagnin
Clinton, George
 Ceracchi, G. George
 Clinton, bust
Clochard. Brown, R.

Cloaks and Watches
 Arp. Watch
 Baillou. Louis Quinze
 Mantel-clock
 Bayes. Selfridge Clock
 Boulle. Clock with Louis XIV
 Symbol
 Boulle. Louis XIV Pendulum
 Clock, with Apollo's
 Chariot
 Carlin and Gouthiere. Louis
 XIV Regulator Clock
 Embriago. Clock in a Pool
 Falconet. Clock of the Three
 Graces
 French--18th c. Clock#
 --Empire Clock
 --Table Clock
 --Wall Clock
 French--19th c. Clock:
 Classical Figure
 --Minerva Clock
 Furet. Clock
 German--16th c. Automaton
 Table Clock, with Lion
 figure
 --Clock with Mannequin-Strik-
 ers
 German--18th c. Clock with
 Wooden cogs and figure of
 Death
 Kulibin. Watch--egg-shaped
 Lepautre. Louis XVI Table Clock
 with supporting figures and
 surmounting Cherub
 Ramsay. Clock, with silver
 plaques.
 Schwilgue. Astronomical
 Clock
CLODION (Claude Michel) (French
 1738-1814)
 Bacchant marble; 67x22
 USNKP 454 UDCN (A-1619)
 Bacchante marble; 63-1/2
 x17-5/8 USNKP 456
 UDCN (A-1621)
 --marble; 68-1/4x23
 USNKP 455 UDCN (A-1620)
 Bacchante and Satyr LAC 30
 FPL
 Bacchante Seated Playing
 with a Child terracotta;
 11-5/8 LAC 209 FPL
 Candelabrum bronze, gilt
 bronze, and gray marble
 CLE 157 UOCIA (42.59)
 --bronze, gilt bronze, and
 marble base CLE 157

UOC1A (44.124)
Cupid and Psyche late 18th c.
 terracotta; 23-1/2 MOLE
 241 ELV
Cupid and Psyche c1775
 ROBB 392 UNNF
Egyptian Woman with Shrine
 terracotta; 19 CHAR-2:
 250 FPL
Girl with Cupid (Madchen
 mit Cupide) 1790/95
 terracotta; 40 cm BSC
 pl 128 GBS (M235)
Intoxication of Wine (Bacchus,
 Nymph, and Cupid; Nymph
 and Satyr) c1775 terracotta;
 23 AGARC 102; BR pl 12;
 CHASEH 394; CHENSW 461;
 CHRP 297; CLAK 152; FLEM
 581; JANSH 448; JANSK 874;
 POST-2:37; RAY 50; ROOS
 200 C; UPJ 426; UPJH pl
 186 UNNMM
Invention of the Balloon,
 monument project 1784
 terracotta; 43-1/2 NM-8:
 42 UNNMM (44.21)
Montesquieu, seated figure
 begun 1779 LAC 30
 FPIF
Monumental Urns marble;
 51-3/4x38-1/4x28-3/4
 SEYM 158, 159; USNI
 219; USNP 172-3
 UDCN (A-43; A-44)
Nymph and Satyr Sevres
 Porcelain VER pl 98
 UNNMM
--1778 terracotta; 14 DEYE
 196 UCSFDeY (57.17.1)
Poetry and Music marble;
 46-1/4x35 USNKP 452
 UDCN (A-1622)
A River God terracotta;
 13-3/4x15-1/4 ASHS pl
 32; VICF 90 ELV (1064-
 1884)
Satyr Crowning a Bacchante
 ENC 192
Satyr with Tambourine LAC
 30 FPL
Satyress and Child, tondo
 1803 terracotta CLE 157
 UOC1A (63.251)
A Vestal marble; 37-1/2x
 16-1/2 USNKP 451; RUS
 108 UDCN (A-1623)

Woman Playing with a Child
 terracotta; 18 HUNT pl
 34 UCSmH
Young Girl terracotta CLE
 156 UOC1A (42.50)
CLODION--FOLL.
 Bacchante Candelabrum bronze
 LARR 393 FPL
Cloister, decorative detail. Spanish
 --14th c.
Clotho. Claudel
The Cloud. Bourdelle
Cloud. Reymond de Broutelles
Cloud Canyons. Medalla
Cloud Herdsman
 Arp. Shepherd of the Clouds
Cloud Journey. Kolbe
Clowns
 Miklos. Clown
 Savensek. Clown Dancing
 Szekely. Clown
Clytie
 Watts. Clytie
 Watts. Dying Clytie, bust
Coaches See Carriages
Coal Damp
 Meunier. Fire-Damp
Coats of Arms See Heraldry
Cobblers
 French--15th c. Maker of
 Sabots: St. Crispin
 Russian--19th c. Gardner
 Porcelain Figures
Cobham, Viscount
 Scheemakers, P. Viscount
 Cobham
Cobra-Centaur. Arp
COCCIA, Francesco (Italian)
 Memorial Groups 1951
 marble DAM 179 IRArd
Cock Fighting See Games and Sports
Cock Saluting the Sun. Brancusi
Cockatoos
 Kandler. Cockatoo
 Kandler. Louis XV Ormolu
 Candelabra with Meissen
 Cockatoo
Cockerel See Chickens
COCKERELL, Charles Robert
 (English 1788-1863)
 Spandrel Figure BOASE
 pl 73C ELivG
 Portraits
 Philip. Albert Memorial
 frieze detail: Pugin, Scott,
 Cockerell, Barry
COCKERELL, S. Pepys (English)

A Hunt, wall relief brick
MARY pl 66 EHas
Cocks See Chickens
Coco. # Renoir
Coconut Goblet. Muller, H. , of
Breslau
Cocotte. Cecioni
COCTEAU, Jean
Head with Drawing-pins
(Tete aux Punaises), col-
lage 1920 RICHT pl 95
Codex Aureus Epternacensis.
German--10th c.
Codex Aureus of Lindau
German--9th c. Lindau
Gospels
Codex Aureus of St. Emmeran.
German--9th c.
Codex Monacensis. German--9th c.
Codexes See Book Covers
CODREAÑO, Irene
Chinese Girl, head marble
MARTE pl 19
Head marble MARTE pl 19
Codrington, Christopher (British
Soldier 1668-1710)
Cherre, H. Christopher
Codrington
COECKE, Pieter (Flemish 1507-55)
Fireplace, Burgomaster's
Room ROOS 153 BAT
COELHO, Gaspar (Portuguese), and
Domingos COELHO (Portu-
guese)
High Altar c1590 KUBS pl 98A
PoPC
Coeur, Jacques (French Merchant
1395?-1456)
French--15th c. Galley of
Jacques Coeur, tympanum
Co-existence. Pomodoro, G.
Cofanetto. Italian--14th c.
COGNIE (French)
Clemenceau 1932 GAF 137
FPLu
Coins
Anglo-Gallic. Leopard d'Or
of Edward III
Anglo-Saxon. Coin: Edward
the Confessor
Byzantine. Coin#
Byzantine. Constantinople
Coin
Byzantine. Consular Solidus:
Theodosius II
Byzantine. Multiple Solidus#
Celtic. Coin(s)#
Celtic. Elusate coin

Celtic. Tectosage Volcae
Coin (Gaul)
Dutch--17th c. Dutch
Rigsdaler
English--9th c. Alfred,
head, penny
English--10th c. Penny:
Eadgar
English--14th c. Edward III,
coins
English--18th c. Queen Anne
Shilling
Frankish. Denier: Charle-
magne, head
French. Aquitaine coin:
Horse
French. Carnutes (Estampes)
coin
French. Coriosolites coin
French. Gallic imitation of
Rhoda coin: Hermes,
Catalonia
French. Lemovices (Haute-
Vienne) coin: Horse
French. Parisii coin:
Profile face
French. Osismii of Armorica
Brittany
French. Veliocasses (Basse-
Seine) coin: Ideographic
signs
French. Somme District coin
French--14th c. Double d'Or
--Mouton d'Or of Jean le Bon
German--12th c. Stoning of
St. Stephen
German, and Russian. 9
Thalers
Italian--13th c. Augustales:
Friedrich II
--Mantuan Grosso
Italian--17th c. 6 Ducats
Merovingian. "Eye Coin"
Polish. Coins with Hebrew
Inscriptions
Priscus and Domnulus. Coin
Rumanian. Transylvanian
coin
Spanish--18/19th c. Milled
Eight Real pieces
Viking. Gotland Bracteate
Colbert, Jean Baptiste (French
Statesman 1619-83)
Coustou, N. Jean Baptiste
Colbert, bust
Coysevox. J. B. Colbert,
bust
Coysevox. J. B. Colbert

Tomb, kneeling effigy
Desjardins. Colbert de
Villacerf, bust
COLE, Ernest (English 1890-)
Figures, South Pavilion
stone PAR-1:72 ELCou
COLE, W. Vivian
Cavial CASS 123
Swallow ebony CASS 122
Colerne Cross. Anglo-Saxon
Colet, John (English Classical
Scholar 1467-1519)
Thornycroft, H. Dean John
Colet
Coligny, Gaspard II, de (Hugenots
Leader 1519-72)
Landowski and Bouchard.
Reformation Monument:
Coligny
COLIJIN DE NOLE (Colijin de Nole)
(Belgian fl 16/17th c.)
St. Philip c1630 marble GER
pl 12 BMC
COLIJIN DE NOLE FAMILY
Renaissance Chimney Piece
1543/45 GEL pl 94
NKaT
COLIN, Alexander (Alexander Colins;
Alexander Colyns) (Flemish
1529-62)
Maximilian I Tomb ROOSE
154 AI
COLLA, Ettore (Italian 1899-)
Agreste 1952 welded iron
and steel parts of imple-
ments; 88-3/8x31-1/2
SEITA 148
Continuity 1951 welded con-
struction of wheels; 95-
1/8x53 SEITA 149
Dioscuri 1961 iron; 23-5/8
NEW pl 112
Divinita Industriale 1966
KULN 1966
Factory 1952/53 iron; 63x
37-1/2 SEAA 137
Grande Spirale 1962 KULN
159
Ritual 1962 iron VEN-64:
pl 32
Saturn 1962 iron; 200x58
ARTSI #5
Solar Workshop (Officina
Solare) 1964 welded as-
semblage--scrap iron and
found objects; 84 GUGE
53; VEN-64: pl 33

Collars
English--2nd c. Bronze Collar
Colleoni, Bartolommeo 1400-75
Amadeo. Bartolommeo Colleoni
Tomb
Verrocchio. Condottiere
Bartolommeo Colleoni
Colleoni, Medea
Amadeo. Medea Colleoni Tomb
Colleoni Chapel. Amadeo
Collett, Camilla
Vigeland. Camilla Collett
COLLIN, Alberic (Belgian 1886-)
Eagle DEVI II BA
Monumental Elephant, Congo
Pavillion, Brussels Inter-
national Exhibition 1935 re-
inforced concrete CASS 120
Collingham Cross Shaft. Anglo-Saxon
Collingwood, Lord
Westmacott. Lord Colling-
wood Monument
COLLINS, Alexander See ANTHONI
Collmann Infant
Stevens. Infant son of L. W.
Collmann, bust
Colloquio Abulico. Consagra
Colloquio Alto. Consagra
Colloquio con la Moglie. Consagra
Colloquio em Publio. Consagra
Colloquio Libero. Consagra
Colloquium. Consagra
Colloquy. Cappello
Colloquy. Castelli
Colloquy. Milani
Colloquy. Ramous
Colloquy with the Moon. Consagra
Colloquy with Time. Consagra
Colman, Edward
Dunn, Edward Colman Monument
Cologne
Matare. View of Cologne
COLOMBE, Michel (French c1430/
35-c1512) See also Girolamo
da Fiesole
Altarpiece of St. George, Chapel,
Gaillon 1508/09 BAZINW
352 (col); LAC 32 FPL
--The Princess BUSR 198
Francis II of Brittany and
his consort Marguerite de
Foix Tomb 1502/07
marble; 153-1/8x91-3/4
x50 BAZINW 352 (col);
BR pl 11; BUST 211;
CHASEH 241; GAF 225;
GIA pl 39; JAL-4: pl 1;

COLOMBE, Michel

LAC 195; POST-1:80;
REAU pl 124; FNaC
--Fortitude, detail of
Cardinal Virtues, from
design by Jean Perreal
LARR 148
--Prudence BAZINW 352
(col)
St. Magdalene, kneeling
figure 1496 GAF 296
FSolB
COLOMBE, Michel and Jerome
PACHEROT
Altarpiece of St. George:
St. George and the
Dragon, equest, relief,
Gaillon 1508/09 marble;
1.75x2.72 m BLUA pl 16;
BUSR 199; CHAS 278;
GAF 141; JAL-4:pl 3;
LOUM 49; MARQ 220;
RAY 36 FPL
COLOMBE, Michel--FOLL.
Man and woman, heads
marble CLE 73 UOCl A
(21.1003; 21.1004)
Virgin and Child (Olivet
Virgin) early 16th c.
marble; 1.83x.60 m
BAZINW 353 (col); CHAS
289 FPL
La Colombe du Cap. Giorgi, G. de
COLOMBO, Gianni (Italian 1937-)
Eccentric Structuralization,
electro-mechanical con-
struction 1962 acrylic
plaster and motors; 51-
1/4x12-3/4x17-1/4
SELZP 33; VEN-64:pl
101
Fluid Structuralization 1960
ARTSM
Pulsating Structuralization
1962 plastic foam blocks
in wooden box with motor;
51-1/4x133-3/4x17-1/4
SELZP 33
Color Space Object 13. Pfahler
Color without Weight. Kemeny
Coloured. Wisniewski
The Colporteur. Wynants
COLT, Maximilian (French-English
fl 1607-45), original name:
Poultrain
Alice, Countess of Derby,
Hearse Monument:
Crest 1636 marble ESD
pl 3, 74; GARL 194
EHatCh

--Lady Bridgewater ESD pl
75
Chimneypiece, Van Dyck Room
c1610 WHINN pl 15 EHat
John Eldred, medallion ESD
pl 58 ESufG
Margaret Lady Legh Monu-
ment ESD pl 65; MERC
pl 87b EFuA
Princess Sophia Tomb c1607
stone; 52x51 ESD pl 72;
GARL 195 ELWe
7th Earl of Shrewsbury
Tomb (drwg in College
of Arms) 1618 ESD front
(col) ELWe
Sir Robert Gardiner Monu-
ment: Crest ESD pl 78
ESufE
Tomb of Robert Cecil, 1st
Earl of Salisbury 1612
CON-2:pl 43 EHatCh
COLTON, Robert (English)
The Crown of Love TAFTM
76
Columbine See Commedia dell'Arte
Columbus, Christopher
Causici and Capellano.
Christopher Columbus,
relief bust
Meliday Alinari. Tomb of
Christopher Columbus
Persico, E. L. Capital East
front, central portion:
Discovery Group
Probst. Columbus
Russo, G. Christopher
Columbus Monument
Sunol. Christopher Columbus
Zocchi, A. Columbus
Column of Peace. Pevsner
Column Symbolizing Peace. Pevsner
Column with Interchangeable Ele-
ments. Arp
Column without End
Brancusi. Endless Column
Columns
Aliprandi, G., J. U. Mayer,
and F. Geiger. Column
of the Holy Trinity
Baroque--Portugal. "Solomon"
Type Column
Baugut. Plague Column
Bendl, J. G. Column
Benkert, Strudel, and Rauch-
miller. Plague Column
Bernini, P. Un Termine
Braun, M. B. Holy Trinity
Column

Braun, M. G. Marian Column
Brokoff, F. M. Marian
 Column
Brokoff, J. Column
Bully, G. B. , J. P. Cech-
 pauer, and J. Rohrbacher.
 Column
Coulientianos. La Colonne
Early Christian. Balusters
 with Acanthus and Ivy
 Leaf Scrolls
Early Christian. Capitals and
 Columns
Early Christian. Ciborium
 Column
Early Christian. Column,
 Capitals and Facade Slabs:
 Foliate Motif
Early Christian. Vine and
 Figure Column Drum
English--12th c. Column
 Figure, fragment
English--19th c. Egyptian
 Avenue Entrance Columns
Epstein. Columnar Figure:
 Athlete
Fischer von Erlach. Trinity
 Column
French--11th c. Central
 Doorpost: Endorsed Lions
French--12th c. Abbey of
 Coulombs Columns
--Birds Interlaced, central
 doorpost
--Facade Columns
--Sculptured Column
French--13th c. Columnar
 Figure(s)#
--Romanesque Pilaster
French--19th c. Vendome
 Column
Georgian. Column, capital,
 detail: Bull's Head
 relief
German--11th c. Easter
 Column
Gothic--French. Decorated
 Column
Hildebrandt, L. von. Column
 Figures
Italian. Colonna Rostrata
Italian--9th c. Sacred
 Column: Floriate Relief
Knobelsdorff. Atlantes
Lombardo, P. Column Base
Pacak, J. and F. Marian
 Column

Percier, C. , and P. Fontaine.
 Vendome Column
Permoser. Columnar Figures
Pisano, G. Column
Riga. Marian Column
Vigeland. Monolith
Vogeli. Colonne
Widdemann. Column
Wotruba. Column
Colville, Sara d 1631
 English--17th c. Sara
 Colville Monument
COLYNS, Alexander See COLIN,
 Alexander
COMAZZI, Luigi (Italian 1914-)
 Plow (L'Aratro) 1961 bronze
 VEN-62: pl 43
Combat of Birds. Stahly
Combattimento. Uher
Combination in White and Black
 Marble. Bloc
Comborn. Veysset
Combs
 Duchamp. Ready Made:
 Comb
 French--10th c. Liturgical
 Comb
 Italian--15th c. Ivory Comb:
 Story of Susannah, scenes
 Italian--15/16th c. Combs
 Lalique. Decorative Comb
 Russian--5th c. BC. Comb:
 Warriors in Combat
 Russian--17th c. Comb:
 Griffin, Lion, Human
 Heads
Comedy and Tragedy See also
 Actors;
 Masks
 Aumonier. Comedy and
 Tragedy
 Bourdelle. Theatre de
 Champs-Elysees: Tragedy
 Drei. Comedy
 Gilbert, A. Tragedy and
 Comedy
 McKennal. Tragedy En-
 veloping Comedy
 Morozzi. Comedy
Commedia dell'Arte See also Kandler,
 J. J.
 Bustelli. Columbine
 Bustelli. Lucinda and
 Ottavio
 Bustelli. Pantalone
 Calvini. Pulcinella
 Gargallo. Harlequin with

Flute
Gargallo. Harlequin with
Mandolin
German--18th c. Greeting
Harlequin
--Strasbourg Faience Harle-
quin
Gonda. Harlequins
Gris. Harlequin
Italian--18th c. Commedia
dell'Arte Figures
Stanzani. Arlecchino in Attesta
Stanzani. Arlecchino in
Movimento
Stanzani. Mort de l'Arlequin
Vermare. Pierrot
Commerce. Gurrfreund
La Commerce Maritime, dining-
room wall decoration.
Poisson
Commodes
Cressent. Marquetry Commode
Leleu. Commode.
The Communicant. McWilliam
Communion See also The Mass
Byzantine. Paten: Communion
of the Apostles
Byzantine. Riha Paten
Canonica. Communion
French--13th c. Abraham and
Melchizedek (The Knight's
Communion)
Mino da Fiesole. Nuns at
Holy Communion, predella
Pacino di Bonaguida. Com-
munion of the Apostles
Communist Party
Tatlin. Monument to the
Third International
Compagni Bastardi. De Martino
Compassion. Foley, M.
Compassion Cross
German--14th c. Forked
Cross Crucifixion (Ebarmde
Kreuze--Compassion
Cross; Pestkreuz--Plague
Cross)
Competitions
Baptistry Florence, East
Door (1401). Abraham's
Sacrifice (Sacrifice of
Isaac), relief medallion.
See Brunelleschi, and
Ghiberti
Unknown Political Prisoner,
International Sculpture
Competition (1953),

sponsored by Institute
of Contemporary Art,
London. Grand Prize
Winner ($2,500): Butler.
See also Consagra; Dzamon-
ja; Gilioli; Leygue; Min-
guzzi; Pevsner; Reuter
Complaint. Kollwitz
Complete Fragment. McWilliam
Complex Corner Relief. Tatlin
Complexities of Man. Clarke
Composition au Chasseur. Stanzani
Composition in Iron. Hoflehner
Composition in Iron. Serrano
Composition in Space (Project of a
Fountain). Pevsner
Composition of Elements. Marini
Composition with Chimera. Mirko
Composition with Three Figures and
a Head (The Sand). Giacometti
Composition with Three Stones. Haber
Composizione Astratta in gesso 15.
Melotti
Compressed Motor Car. Cesar
Concave and Convex Abstraction of
a Head
Boccioni. Abstract Voids and
Solids of a Head
Concavo-Convesso. Munari
Concentration Camps
Cremer. Buchenwald Con-
centration Camp Monument
Grzimek. Sachsenhausen Con-
centration Camp Monument
Wolff, H. Auschwitz Monument,
model
Concerto. Leinfellner
Concerto. Mirko
Concerto para Flauta Epercussao.
Rubio Camin
Concesti Amphora. Byzantine
Concetto Spaziale
Fontana, L. Spatial Idea
Concierge. Rosso, M.
Concrete Sculpture. Adam, H. G.
CONDE (Andre Affolter Conde)
(Swiss 1920-)
Etoile 1957/58 JOR-2:pl 192
La Mer 1957 JOR-2:pl 193
Radar, open air sculpture
1960 brass MAI 62
Conde, The Great (Grande Conde)
See Louis II de Bourbon
Conde, Prince de (Henry II 1588-
1646)
Sarrazin. Henri de Bourbon
Monument
Conde, Oliveira do

Afonso. Oliveira do Conde,
effigy
Condition-Female. Hoflehner
Condizione Umana. Guerrini
Condorcet, Marquis de See
Caritat, M.J.A.N.
Condottieri
Donatello. Gattmelata
Verrocchio. Condottiere
Bartolommeo Colleoni
CONDOY (Honorio Garcia Condoy)
(Spanish 1900-53)
Sculpture 1950 wood MAI 62
Wood 1952 BERCK 252
Conference. Lorcher
Confession
Austrian, or Southern German
St. John Nepomuck Con-
fessing the Queen of
Bohemia
Confessional. Flemish--17th c.
"The Confessors". French--13th c.
La Confidante. Orgeix
Configuration. Arp
Confirmation. Pisano, A.
Confluence. Brown, R.
Confluent Reaction in Plane Circu-
lation Substance. Kudo
Confraternity of Young Gentlemen
Flemish--15th c. Badge of
Confraternity of Young
Gentlemen
Congo (Subject)
Rau. Monument to the
Pioneers of the Congo
Congress of Berlin. Zala
Congreve, William (English
Dramatist 1670-1724)
Bird. Congreve Monument,
with copy of Kneller's
Kit Cat Portrait
CONNE, Louis (Swiss 1905-)
Centaure Jouant de la Lyre
1956 JOR-2:pl 194
Orphee 1957 JOR-2:pl 117
Orphee aux Enfers 1958
JOR-2:pl 195
Conoid Sphere and Hollow. Hepworth
The Conquered.
Rodin. Age of Bronze
Conquest. Mastroianni
Conquista Impenetrabilita. Somaini
Conrad, Saint
Christian. St. Conrad
Conrad, Joseph (Novelist 1857-1924)
Epstein. Joseph Conrad, bust
Conrad von Busnang
Gerhaerts. Conrad von
Busnang Monument

CONRAD VON EINBECK (German fl
1382-1416)
Self-Portrait, bust after 1382
MULS pl 45B GHallM
CONSAGRA, Pietro (Italian 1920-)
Chorus 1958 wood; 56-1/4
MINE 59; SELZJ 15 FPFr
Colloquio Abulico 1960
bronze; 40 EXS 73 UNNSt
Colloquio Alto 1956 bronze
VEN-56:pl 31
Colloquio con la Moglie 1960
wood; 61-3/4x58-1/4
READCON 262
Colloquio em Publico 1955
bronze SAO-3
Colloquio Libero 1961 bronze;
49-5/8x50-3/8 NEW pl 113
Colloquium 1954 wood VEN-
54:pl 32
Colloquy with the Moon
(Colloquio con la Luna)
1960 travertine VEN-60:
pl 99
Coro Impetuoso 1958 bronze
VEN-64:pl IX YZZS
Deep Colloquy 1956 bronze;
37-1/2x27-3/4x11 CARNI-
58:pl 29 UNNWo
Devilish Colloquy (Coloquio
Diabolico) 1960 wood VEN-
60:pl 98
Dialogue at S. Angelo 1960
bronze SAL pl 76 (col)
Dialogue with Time 1957 iron;
30x31 BERCK 156; MAI 63
Diary 1961 bronze; 54x56-1/2
ARTSI # 6
Eroe Graco 1949 bronze;
1.25x.70 m SCUL pl 48
Figure 1955 bronze; 1.16x
.57 m SCUL pl 49
Human Colloquy 1958 scorched
wood; 45-3/16x52 MAI 63;
TRI 43
Oracle of the Chelsea Hotel
1960 bronze SAL pl 75
Small Gatherine 1956 bronze;
35-1/4 MINE 58 UNNWo
Specchio Alienato 1961 bronze
VEN-62:pl XXI
Turquoise Iron (Ferro Tur-
chese) 1966 ptd iron; 99
GUGE 79 IRMarl
The Unknown Political
Prisoner 1952 bronze;
19-5/8 (excl marble base)
TATEF pl 23h ELT (6166)
Consolation. David, F.

Consolation. Drivier
Consolation. Ramseyer
Consolation. Trsar
Consoles
 English(?)--18th c. Console
 Table
 French--18th c. Louis XV
 Console
 Netherlandish. Console:
 Angel Holding Shield
Constancy
 French--13th c. Virtue and
 Constancy
CONSTANT (Constant Nieuwenhuys)
 (Dutch 1920-)
 Metal Construction with
 Planes in Color, Rotterdam
 Exposition 1955 BERCK 253
 New Babylon, model, concrete
 building for electronic
 music 1960 metal, plexi-
 glas, wood; 25-5/8x35-
 3/8 NEW pl 162
 Projected Monument for
 Amsterdam 1955 iron wire;
 23-3/8 (scale of Model--
 1:25) TRI 234
 "Spatiovore" con Piedestallo
 (sala per concerti di
 musica elettronica) 1960
 Acciaio, plexiglas and
 wood VEN-66:# 200
CONSTANT Joseph (Joseph Constan-
 tinovsky (Israeli-French 1892-)
 The Ape wood SCHW pl 49
 Black Panther wood ROTH
 876 IsEA
Constantine, Saint
 German--13th c. Bamberg
 Rider
Constantine I (Roman Emperor 280?-
 337), called The Great
 Bernini, G. L. Constantine,
 equest
 Burgundian--14th c. Medal
 of Constantine
 Byzantine. Coin, Commem-
 orating Constantinople
 Dedication: Constantine I
 Byzantine. Medallion: Con-
 stantius II; reverse:
 Constantine and his Three
 Sons
 Godefroid de Claire. Life of
 Constantine: Invention
 of the True Cross
Constantine II (Roman Emperor
 317?-340)

Early Christian. Constantine
 II Enthroned Between his
 Two Brothers, medal
Constantine V (Eastern Roman
 Emperor 719-75)
 Byzantine. Coin: Leo III;
 reverse: Constantine V
Constantine VII (Eastern Roman
 Emperor 905-59)
 Byzantine. Coin: Constantine
 VII
 Byzantine. Crowning of
 Constantine VII
 Byzantine. Epiphany of
 Emperor Constantine VII
 Porphyogenitus
 Byzantine. Holy Crown of
 Hungary
Constantinople
 Byzantine. Coin, Commemorat-
 ing Constantinople Dedica-
 tion: Constantine I; reverse:
 Constantinople: Dedication
 Byzantine. Multiple Solidus:
 Constantius II#
CONSTANTINOVSKY, Joseph See
 CONSTANT, Joseph
Constantius II (Roman Emperor
 317-361)
 Byzantine. Constantius II
 and his Empress
 Byzantine. Dish: Constantius
 II, equest
 Byzantine. Medallion:
 Constantius II
 Byzantine. Multiple Solidus:
 Constantius II#
 Byzantine. Rothschild Cameo:
 Emperor Constantius II
 and his Consort
 Early Christian. Constantius
 II, in Chariot Crowned by
 Victories, medal
The Constellation Virgin. Lambert-
 Rucki
Constellations
 Arp. Constellation#
 Gianotti Apollo and the Con-
 stellations, ceiling
 Rodin. Constellation
 Uhlmann. Constellation
Construction: Proun 2. Lissitzky
Construction and Motion. Corbero
Construction based on an Equi-
 lateral Hyperbola, XY= K.
 Vantongerloo
Construction dans l'Oeuf
 Pevsner. Construction in the

COQUET (French)
Louis XV Railings 18th c.
wrought iron GAF 75
FDam
CORA, R. de La
Simon Bolivar, equest 1884
SALT 90 UNNCent
CORADINO, Lodovico (Mantuan)
Medal: Ercole d'Este 1472
bronze; Dm: .57 cm
CHAS 301
Coralie, head# Osouf
Corbeil, Haymon, Count
French--17th c. Haymon,
Comte de Corbeil, effigy
Corbel Table. English--12th c.
Corbels
Bunting. Adam and Eve,
corbels
English--12th c. Grotesque,
corbel
English--13th c. Chapter-
House Corbel
--Corbel#
English--14th c. Bird with
Human Head, corbel
from nave
--Percy Tomb: Corbels
French--12th c. Grotesque
Mask Corbels
CORBERO, Xavier (Spanish 1935-)
Construction and Motion 1965
stainless iron, glass,
bronze; 9-7/8 sq NEW
pl 145 UNNSt
Death of Mercury 1960
10.8x18.8 CARNI-61:
69
Corbinelli Altar. Sansovino, A.
La Cordata. Vignoli
CORDIER, C. (French)
Negress, head VICG 131
ELV
CORDIER, Nicolas (French 1565-
1612)
St. Peter, bust 1608 marble
BAZINW 386 (col) IRSeb
CORDIERI, Niccolo (Nicola Cordier)
(French-Italian c1567-1612)
David marble POPRB pl
136 IRMMag
Moor with Child and Dog
marble; .70 m FAL pl
46 IRB (LVII)
St. Gregory the Great,
seated figure POPRB
fig 153 IRGr
La "Zingarella" bronze and

marble; 1.4 m FAL pl
47 IRB (CCLXIII)
CORDONNIER, Alphonse A. (French)
Funeral TAFTM 46
The Song TAFTM 38
Sur le Pave marble MARY
pl 42 FPLu
Core. Hepworth
Corinthian Capital c 42x36 PER 89
Corinthian Capital. Byzantine
Corinthos. Hepworth
Cork Float Figure. Morland
CORNACCHINI, Agostini (Italian
1685-1754?)
Endymion marble CLE 116
UOC1A (42.51)
Guardian Angel 1729 WIT
pl 160B IOrC
Cornaro, Marco (Doge of Venice
1264-1367)
Pisano, Nino. Cornaro
Monument
Cornaro Family (Venetian Nobles)
Bernini, G. L. Ecstacy of
St. Theresa: Cornaro
Family
Corner
Tatlin. Counter-Relief Con-
struction
Corner Relief. Tatlin
CORNET, Paul (French 1892-)
L'Aube BAS 205 FPMP
La Femme qui Marche
BAS 209
Figure BAS 205 FChai
Figure Drapee BAS 207
Figures pour un Surtout
de Table BAS 208
Guerrier BAS 202
Mlle. C., bust BAS 203
Mon Portrait, head BAS 202
Nina, bust BAS 204
Pomone BAS 207
La Vienne BAS 206 FLimM
Cornices
Bartolomeo da Foggia.
Cornice Facade
Cornucopias
Byzantine. Capital: Cornu-
copia
Francesco di Giorgio Mar-
tini. Winged Figure with
Cornucopia
Le Pautre, P. Angel Carry-
ing Cornucopia
Cornwall, Earl of
English--13th c. Arms of
Earl of Cornwall

Coro Impetuoso. Consagra
Coronation Chair. Walter of Durham
Coronation of Napoleon. Cortot
Corot, Jean Baptiste Camille
(French 1796-1875)
Larche. Corot Monument
Corpo Sospeso. Meli
Corporate Entity. Couzijn
CORRADINI, Antonio (Italian 1668-
1752)
Allegorical Figure of Modesty
1749/52 marble; over LS
BAZINW 403 (col); MOLE
193 INS
Virginity 1721 WIT pl 171A
IVMar
CORRADINI, Antonio, and
QUEIROLO, Francesco
Cappella Sansevero Interior
1750's BAZINW 403 (col)
INS
CORRAL, Jeronimo (Spanish fl
1536-c1560)
Benavente Chapel 1544/46,
with Altar of Juan de
Juni begun 1557 KUBS pl
74B SpMed
Corral with Water Spout. Danziger
Corrida. Mascherini
Corrida. Salvatore
Corsair
French--16th c. Corsair
head, misericord
Corsini, Andrea (Bishop of
Fiesole 1302-73), called
St. Andrea
Foggini. Mass of S. Andrea
Corsini
Pisano, G. Pulpit: St.
Andrea
Corsini, Neri (Florentine Liberal
Party Leader 1805-59)
Maini. Monument to Cardinal
Neri Corsini
CORTE, Josse de (Giusto Cort;
Giusto Lecurt) (Flemish
1627-79)
Atlas, Morosini Monument
1676 WIT pl 170A IVCl
Queen of Heaven Expelling
the Plague, High Altar
1670 WIT pl 170B IVMS
Cortes, Hernando (Spanish Con-
queror of Mexico 1485-1547)
Turnbull, Cortez
CORTONA, Pietro da (Italian 1596-
1669)
Theatre Entrance WIT pl
81B IRBar

Stuccoes, Sala di Apollo;
Sala di Giove 1647; 1643/
45 WIT pl 91 IFP
--1643/45 stucco, partly
gilt MOLE 183
CORTOT, Jean Pierre (French
1787-1843)
Apotheosis of Napoleon
(Triumph of Napoleon),
left relief 1837/38 H: 42'
FLEM 640; MYBA 570;
STI 706 FPA
Coronation of Napoleon
(Crowning of Napoleon
1833) RICH 25 FPA
Marie-Antoinette Surrounded
by Religion c1827 marble;
225 cm LIC pl 50
FPChapE
Pandora PANB 106 FLM
Cosden Head. Hepworth
Cosmas, Saint
Montorsoli, St. Cosmas
COSTA, Giovanni Antonio (Italian
1935-) See GROUP N
COSTA, Joachim (French 1888-)
L'Imagier, column relief
1922 walnut PAR-1:188
COSTA, Joseph Mendes da (Dutch
1863-1939)
The Ape SCHW pl 3 NOK
Fish Vendors in Amsterdam
1893 terracotta; 8-3/4x
11-1/2 HAMF 277 NHH
General de Wet ROTH 870;
SCHW pl 4 NHoen
Spinoza 1909 bronze GEL pl
107 NAS
Tile with Figures 1900 HAMF
35 NAS
Vulture (Avvoltoio) copper
VEN-22:106
COSTA, Toni (Italian)
Visual Dynamics 1965
BURN 259 UNNWadd
Costacciario, Bonaventura (General
of the Order of Conventuals
1543-49)
Italian--16th c. Bonaventura
Costacciario, medal
Costantini, V.
Melli. Critic V. Constantini,
head
COTTARD, Pierre (French d 1701)
Porte-Cochere 1657/60
BLUA pl 107B FPAm
Cotte, Robert de (Architect 1656-
1735)
Coysevox. Robert de Cotte, bust

COTTON, Robert d 1697
　　Gibbons. Robert Cotton
　　　　Monument
　　Roubiliac. Sir Robert Cotton,
　　　　bust
COULENTIANOS, Costas (Greek-
　　French 1918-)
　　La Colonne 1960 iron and
　　　　bronze MEILD 157 FPFr
　　Folgore VI 1964 iron NEW
　　　　pl 226
　　The Last of the Acrobats
　　　　1960 iron and lead
　　　　MARC pl 69 FPFr
　　Le Mollard 1961 aluminum;
　　　　66-1/2x26-3/8x25-5/8
　　　　READCON 183 FPFr
　　Monumental Sculpture 1956/
　　　　57 H: 82 BERCK 253
　　Piccolo Folgore di Bronzo
　　　　1964 iron and bronze VEN-
　　　　64:pl 161
　　Sculpture 1958 bronze and
　　　　iron MAI 65
Le Couleur de mon Amour. Arman
Couleur-Douleur. Kemeny
Couleurs Sonores III. Vardanega
Council of Basle Seal. German--
　　15th c.
Counter-Relief. Tatlin
Counterthrust II. Leigh
Country Girl. Lisowski
Coupe Chimerique. Arp
Coupe Lumineuse. Rehmann
The Couple. Adam, H. G.
Le Chocale. Altri
Couple. Beothy
Couple. Chauvin, L.
Couple# Gisiger
The Couple
　　Hoflahner. Figure 101
The Couple. Koenig
The Couple. Kolbe
Couple. Martin, E.
The Couple. Nele
Couple. Presset
Le Couple. Ramseyer
Couple. Reidel
The Couple. Zwobada
Courage
　　Dubois, P. Military Courage
　　Serpotta. Courage
Courage Cockerell PER 104
Courbes Virtuelles. Le Parc
COURBET, Gustave (French
　　1819-77)
　　Madame Max Buchon, bust
　　　　c1864 plaster SELZJ 166
　　　　FPDa

Coureur Cycliste
　　Maillol. Racing Cyclist
COURROY
　　Presentation au Temple
　　　　FPDEC il 6
Courtai Chest
　　Flemish--14th c. Flemish
　　　　Infantry Battle, French
　　　　Cavalry at Courtai,
　　　　relief detail
Courtauld, Samuel
　　Elkan. Samuel Courtauld,
　　　　head
Courtenay, Archbishop
　　English--14th c. Archbishop
　　　　Courtenay, effigy
Courtenay, Catherine de (Wife of
　　Charles de Valois)
　　French--13th c. Catherine
　　　　de Courtenay, effigy
Courtenay, Philippe de
　　Ramo di Paganello. Monument
　　　　of Philippe de Courtenay
Courtneys, Jean (French)
　　Platter c 1570 Limoges
　　　　enameled copper; L:
　　　　20-1/2; W: 14-1/2
　　　　DEYE 105 UCSFDeY (48.2)
COUSIN, Jean (French c1501-89)
　　Philippe de Jabot Tomb:
　　　　Figure with Lowered
　　　　Torch c1550 BUSR 6
　　　　FPL
COUSINET, Henri Nicolas (French
　　fl 1731-56)
　　Chocolate Pot of Marie
　　　　Leczinska 1729/30
　　　　silvergilt; 6-1/2 CHAR-
　　　　2: 204 (col) FPL
COUSTOU, Guillaume (French 1677-
　　1746)
　　Hercules on the Pyre (Hercule
　　　　sur le Bucher) LOUM 182
　　　　FPL (1096)
　　Horses of Marly (Chevaux de
　　　　Marly) 1740/45 marble
　　　　CHASEH 386; ENC 213;
　　　　GAF 137; KO pl 97;
　　　　POST-2:24; RAY 80;
　　　　ROOS 200B; WATT 167
　　　　FPConc
　　--Horse of Marly BAZINW
　　　　416 (col); UPJH pl 185
　　--Horse Tamer BUSB 166
　　Nicholas Coustou, bust c1730
　　　　terracotta; 24 BUSB 157;
　　　　KO pl 96; LOUM 174
　　　　FPL (1092)

COUSTOU, Guillaume, and Nicolas
 COUSTOU
 France Triumphant (Louis
 XIV Crossing the Rhine),
 panel, chapel AGARC
 101; MYBA 498; POST-
 2:23 FV
COUSTOU, Nicolas (French 1658-
 1733)
 Adonis Resting from the
 Hunt 1910 marble LOUM
 166 FPL (1098)
 Duke de Villars CHASEH
 385 FAixV
 Jean Baptiste Colbert, bust
 c1716 marble; 28 CHICT
 #28 FV (M.V.225)
 Le Retablissement de la Sante
 du Roi, relief 1693 LOUM
 180 FPL (1097)
 Portraits
 Coustou, G. Nicolas Coustou,
 bust
COUTAN, J. F.
 Eros marble MARY pl 20
 FPLu
Couter and Vambrace See Armor,
 Horse
COUTURIER, Robert (Belgian-
 French 1905-)
 Female Figure bronze
 MAI 67
 Hollow Woman 1954 bronze
 SELZJ 7 IMF
 Joven SAO-1
 Pastor bronze SAO-3
 Woman in an Arm Chair
 bronze MAI 66
 Woman with Jug (Donna
 con la Brocca) bronze
 BERCK 254; VEN-60:
 pl 165
 Young Girl Skipping (Girl
 with Skipping-Rope;
 Meisje en Springtouw)
 1951 bronze; 43 MID pl
 101; STM BAM
COUZIJN, Wessel (Dutch 1912-)
 Corporate Entity 1962
 bronze; 23x46' NEW pl
 164 NRU
 Enchained Emotions 1955/61
 H: 61 CARNI-61: #72
 ELNL
 Flight 1955 bronze MAI 68
 Flying 1956 BERCK 179
 Flying Figure 1958 bronze;
 22-1/2x12-5/8x5-1/2
 TRI 144 NAS

Head VEN-48:pl 79
Monument to the Mercantile
 Fleet, Rotterdam, project
 1951 bronze VEN-54:pl
 104
Rising Africa 1961 bronze;
 122 SEAA 139
Seated Greek (Zittende Griek)
 1964/65 Bronze; 50 GUGE
 68
Volante 1955 bronze VEN-60:
 pl 185
Coventry, 1st Lord d 1699
 Stanton, W. 1st Lord of
 Coventry Tomb
Coventry, John, Lord
 Gibbons. John, Lord
 Coventry, Monument
Cowardice
 French--14th c. Vice of
 Cowardice
Cows See Cattle
COX, Elford
 Torso cedar NORM 53 -ED
Coypel, Noel Nicolas (French
 Painter 1690-1734)
 Lemoyne, J. B. Noel
 Nicholas Coypel, bust
COYSEVOX, Antoine (French 1640-
 1720) See also Tuby, J. B.
 Charles Le Brun, bust ENC
 214
 --1676 terracotta; 26 BLUA
 pl 171; JANSH 446;
 JANSK 841; MOLE 237
 ELWal
 --1679 H: 26 CHASEH 384;
 UPJ 407
 Crouching Venus (Venus
 Pudique) 1686 marble
 LOUM 176 FPL (1117)
 Deification of Louis XIV,
 medallion, Salon de la
 Guerre 1680 BUSB 90 FV
 Duc de Chaulnes, bust
 marble; 41-3/4x40-1/2
 CHRC fig 215; USNK 203
 UDCN
 Duc de Villars, bust marble;
 29-1/8 CHICT #131 FV
 (M.V.1897)
 Duchess of Bourgogne as
 Diana 1710 marble; 77
 BLUA pl 179B; CHAR-2:
 175; JAL-5:pl 7; LAC
 203; LOUM 177 FPL
 (1120)
 Fame (Renommee; Renown),
 equest 1700/02 marble

GAF 137; KITS 144 (col);
KO pl 96 FPTu
Faun Playing Flute Traversi-
ere 1709 marble LOUM
166 FPL (1119)
Grande Conde, bust c1650
terracotta, bronze-ptd;
23 COOPF 244 FChanC
--1688 bronze; 23-1/4 1688
BAZINB 130; BAZINH
350; BAZINW 396 (col);
CHAR-2:155; GAF 141;
HUYA pl 53; JAL-5:pl
5; LARR 286; LOUM 163
FPL (1106)
J. B. Colbert, bust marble
LOUM 163 FPL (1104)
J. B. Colbert Tomb:
Kneeling Effigy 1685/
87 BUSB 95 FPEu
Louis XIV, from Town Hall,
Paris 1689 bronze LARR
279 FPCarn
Louis XIV bust c1680 H:
29-1/2 BLUA pl 170
ELWal
Louis XIV, bust before 1715
ROOS 199G FV
Louis XIV Triumphing Over
his Enemies, equest panel,
Salon de la Guerre
begun 1678 plaster BLUA
pl 159; JANSH 444; LAC
37; ROTHS 199 FV
Louis of France, the Grande
Dauphin, son of Louis
XIV, bust bronze; 35-
1/8 NM-8:16 UNNMM
(41.100.243)
--marble STA 85 FV
--marble; 31 (excl base)
x29-1/2x13-3/8 KRA
179; USNKP 444 UDCN
(A-1649) (K-193)
Marechal de Vauban, bust
c1700 marble; 30
KO pl 96; LOUM 171 FPL
(1688)
Marechal de Vauban Tomb
17th c. GAF 296; LARR
302 FSer
Marie Adelaide de Savoie
as Diana 1710 marble;
c 78 BAZINW 396 (col)
FPL
Marie Serre, mother of the
painter Hyacinthe Rigaud,
bust marble LOUM 171
FPL (1108)

Mercury, equest marble
AGARC 100; MOLE 235
FPTu
Nymph with Shell 1683/85
marble LOUM 179 FPL
(1116)
Reception for Louis XIV by
the Siamese Ambassadors,
relief 1716 bronze JAL-
5:pl 6 FV
River God of the Rhone
Early 18th c. ROOD 200A
FV
Robert de Cotte, bust 1707
BLUA pl 180 FPStG
La Seine 1698/1708 LOUM
177 FPL
Self-Portrait, bust marble
LOUM 174; POST-2:21;
ROOS 199E FPL (1107)
Self-Portrait, bust terracotta;
27-1/2 DEY 102-3; DEYE
160 UCSFDeY (47.19)
Urn (Vase de la Guerre) 1684
marble LARR 280 FV
COYSEVOX, Antoine, and Charles
LE BRUN
Palace of Versaille, Salon de
La Guerre-- Wall Decora-
tion MU 194 FV
COYSEVOX, Antoine; J. B. TUBY;
LE HONGRE
Cardinal Mazarin Tomb 1693
marble and bronze; Figure:
63 BAZINW 396 (col);
BLUA 169B; KITS 79;
LAC 37; LOUM 151 FPL
(1110-1115)
--Effigy BUSB 96; CHAR-2:
146
--Mourning Figure MARQ 225
COZZARELLI, Giacomo (Italian
1453-1515)
Bewailing of Christ c1500
ptd terracotta SEY pl 129
ISO
St. John the Evangelist
CARL 103 ISC
Crabbe, George (English Poet 1754-
1832)
Chantrey. George Crabbe, head
Crabs
Ipousteguy. Crab and Bird
Meadows. Black Crab
Meadows. The Crab
Cradles
Flemish--15th c. Repos de
Jesus
French--15th c. Duc de

Bordeaux's Cradle
Craggs, James
Guelfi. James Craggs Monument
CRAMPTON, Sean (English)
Bronze Seated Woman* 1946
H: 12 NEWTEB pl 26
CRANACH, Wilhelm Lucas von
(German 1861-)
Brooch: Jellyfish Smothering Butterfly 1900
enamelled and jeweled
gold CAS pl 248
GBWe
Cranes
French--18th c. Pair of Cranes
Cranfield, Lionel, Earl of Middlesex
English--17th c. Lionel Cranford and his
Countess, effigies
Cranio. Mazzullo, G.
Crankshaft Figure II. McWilliam
Le Crapaud Amoureux. Jacobsen, R.
Craster, Edmund
Batten. Sir Edmund Craster, head
Cravat. Gibbons
Crawford, Thomas (American 1889-)
Portraits
Gagliardi. Thomas Crawford, bust
Crawl. Bandura
Crazy Vegetation. Hiltmann
Creation See also Adam and Eve
French--13th c. God Meditating Creation
Juvin. Le Creation
Maitani. The Creation, facade reliefs
Wilgemus. Genesis Scenes: The Creation, west facade
The Creation of Man
Rodin. Adam
Creche
French--17th c. Creche
Italian--18th c. Neopolitan Presepio
Credenza
Italian--16th c. Credenza
Creed, Theophilus d 1721
English--18th c. Theophilus Creed, panel monument

Creglingen Altar
Riemenschneider. Altar of Our Lady
Creke, Sir John and Lady
English--14th c. Sir John and Lady Creke
Crematorium. Tumarkin
CREMER, Fritz (German 1906-)
Buchenwald Concentration Camp Monument, project
1952 bronze; 23-5/8
BERL pl 253; BERLES
253 GBSBe (B694)
Cremer, Herbert William
Gray. Herbert William Cremer, head
Il Crepusculo
Michelangelo. Lorenzo de'Medici Tomb: Evening
CRESANT, Jacob Matheus
(Flemish-Dutch 1734-94)
Male Portrait bust GEL pl 104 NUC
Crescenzio, Saint
Valdambrino. St. Crescenzio, bust
CRESSENT, Charles (French 1685-1765)
Marquetry Commode c1735-40 tulipwood, kinwood, bronze; 34 CHAR-2: 195 FPL
CRIBB, L. (English)
Panel bathstone CASS 99
Cricket See Games and Sports
Le Crieur de Journaux Zeitungsverkaufer. Lauritzen, T.
Crimean Memorial Group. Walker, A.; J. Bell; and J. H. Foley
Crinoline Figure, saltglaze. English--18th c. (?)
Crinoline Groups
Kandler. Crinoline Group#
Kandler. Meissen "Crinoline" Group
CRIPPA, Roberto (Italian 1921-)
Sculpture in iron 1956 H: 86
BERCK 157 IMBo
Thirst 1958 brass and bronze MAI 69
Victory 1958 brass and bronze MAI 69
Crippled Beggar
Barlach. The Beggar
Crispi, Francesco (Italian Statesman 1819-1901)
Jerace, F. Francesco Crispi, bust

Crispin, Saint
 French--15th c. The Leather
 Worker: St. Crispin
 French--15th c. Maker of
 Sabots: St. Crispinian
Cristal d'Esprit. Kemeny
CRISTOBAL, Juan (Spanish)
 Head marble CASS 50
 Venere Madrilena marble
 VEN-40:pl 101
CROATION
 Horse, in strap frame,
 relief, Nin BIH 3
 Massacre of the Innocents;
 Flight into Egypt, relief
 11th c. BIH 4 YZaA
 Portal Detail: Faces in
 Foliate Motif 15th c.
 BIH 14 YSiC
La Croce. Bertoni
CROCETTI, Venanzo (Italian
 1913-)
 Bather terracotta VEN-38:
 pl 134
 Figure bronze VEN-48:pl
 55
Crocodiles
 Barye. Jaguar Devouring a
 Crocodile
 German--16th c. Crocodile
 Sand Container
Crodo Altar. German--12th c.
Croft Monument, detail. English--16th c.
Crofts, Lord and Lady
 Storey. Lord and Lady
 Crofts, reclining
 effigies
Croga. Kneale
CROISSANT, M. (German)
 Animal FPDEC--German il 3
CROISY, Aristide (French 1840-99)
 Le Nid 1882 marble; LS LIC
 pl 346 FPMontb
Crommelynck, Fernand (Belgian
 Playwright)
 Wansart, A. Fernand Crom-
 melynck, bust
Cromwell, Agnes
 Flaxman. Agnes Cromwell
 Monument
Cromwell, Oliver
 English--17th c. Oliver
 Cromwell, death mask
 (The Frankland Mask)
 Pierce. Oliver Cromwell,
 Bust
 Thornycroft, H. Oliver
 Cromwell

Wilton. Oliver Cromwell,
 bust
Cromwell, Ralph, Lord
 English--15th c. Chimney Piece
 detail: Arms and Devices of
 Ralph, Lord Cromwell
Cronos (Cronus; Kronus; Saturn)
 Colla. Saturn
CROOK, T. Mewburn
 Lilies marble MARY pl 175
 St. Therese of Lisieux
 MARY pl 96
CROS, Cesar (French 1840-1907)
 Incantation, relief 1892
 LIC pl 142 FPM
Crosby, John (Alderman, City of
 London)
 English--14th c. Sir John
 Crosby Tomb
Cross in the Form of an Anchor.
 Pevsner
Cross of Lothair
 German--10th c. Lothar
 Crucifix
Cross of St. Bertin. German--12th c.
Cross of St. George. Fullard
Cross of Westminster. English--
 20th c.
Crossbows
 German--16th c. Pendant:
 Crossbow
 German--17th c. Saxon Sport-
 ing Crossbow and Winder
 Worms. Crossbow
Crosses See also Jesus Christ--
 Crucifixion; Anglo-Saxon
 Bistoli. Senator Orsini
 Monument: The Cross
 Byzantine. Beresford-Hope
 Cross
 Byzantine. Cross
 Byzantine. Enamel Cross
 Byzantine. Reliquary, reverse:
 Leafed Cross
 Celtic. Cross at Kilbride
 Durst. Altar Cross
 Early Christian. Cross:
 Monogram of Christ, with
 pendant Alpha and Omega
 Early Christian. Cross of
 Desiderius
 Early Christian, Processional
 Cross
 Eisenhoit. Processional Cross
 English--7th c. Pectoral Cross
 of St. Cuthbert
 English--10th c. Darley Dale
 Cross

English--10/11th c. Reliquary
 Cross
English--11th c. Whalley Cross
English--13th c. Eleanor Cross
English--15th c. Cross
Franco-Flemish. Altar Cross
French--14th c. Double d'Or:
 Philip VI on Gothic Throne;
 Flower Cross and Crowns
 in Ornamented Quatrefoil
French--16th c. Calvary#
--Hosanna Cross
German--11th c. Cross of
 Bernward of Hildesheim
--Cross of Gisela of Hungary
--Cross of Theophanu of
 Essen
--Gertrudis Cross
--Reliquary Cross of Bern-
 ward of Hildesheim
--Reliquary Cross of Bertha
 of Borghorst
German--12th c. Processional
 Cross
Italian--6th c. Cross of the
 Emperor Justin
Italian--7th c. Animal-
 Decorated Cross
--Animal-Style Cross
Italian--15th c. Processional
 Cross
--Silver Cross
John of Battle and William of
 Ireland. Eleanor Cross
Moore, H. Glenkiln Cross
Mosan. Enamelled Cross
Noll. Cross
Rumanian--16th c. Moldavian
 Processional Cross
Russian--17th c. Cross,
 Mount Athos type
--Pectoral Cross of Peter
 the Great
Venetian. Cross of St.
 Theodore
Crouchback, Edmund, Earl of
 Lancaster d 1296
 English--13th c. Edmund
 Crouchback Monument,
 Earl of Lancaster
Crouching Boy. Michelangelo
Crouching Girl. Heckel
Crouching Girl. Kolbe
Crouching Man. Derain
Crouching Venus. Bologna
Crouching Venus. Coysevox
Crouching Woman. Dierkes
Crouching Woman. Duras

Crouching Woman. Elkan
Crouching Woman. Laurens
Crouching Woman. Maillol
Crouching Woman. Manolo
Crouching Woman. Picasso
Crouching Woman. Rodin
The Crowd, study. Pomodoro, G.
Crowing Cock. Meadows
Crown of Buds. Arp
The Crown of Love. Colton
Crowning of Napoleon.
 Cortot. Coronation of
 Napoleon
Crowns
 Austrian--10th c. Imperial
 Crown
 Byzantine. Crown of Con-
 stantine X Monomachus
 Byzantine. "Grotto of the
 Virgin", vase on crown
 of Leo VI
 Byzantine. Holy Crown of
 Hungary
 Byzantine. Mounted Emperors
 offered City Crown
 Danish--12th c. Jesus Christ,
 head, Crucifix of Tirstrup
 Duplos, A., C. D. Ronde, and
 L. Ronde. Coronation Crown
 of Louis XV
 English--14th c. Crown of
 Princess Blanca
 European. Crown of Holy Roman
 Empire
 French--13th c. Crown of St.
 Louis
 French--19th c. Coronation
 Crown of Napoleon I
 Fyring, and C. Sauer. Crown
 Christian IV
 German--10/11th c. Crown of
 Holy Roman Empire
 Italian--7th c. Theodelinda's
 Crown
 Russian--13/14th c. Cap of
 Monomakh
 Russian--16th c. Cap of Kazan
 Russian--17th c. Cap of Mikhail
 --Cap of Peter the Great
 --Cap of the Ruby Cross
 Russian--18th c. Crown of
 Catherine I
 --Diamond Crown of Empress
 Anna
 Stockton. Heraldic Details:
 Dragon; Crown and Rose
 Swedish--18th c.
 Coronation

Crown of Queen Louisa
Ulrica
Visigoth. Crown of Guarrazar
Visigoth. Crown of King
Suintila
Croziers
English--11/12th c. Crozier,
head
English--12th c. Crozier
head#
English--14th c. Crozier
handle: Madonna and
Child
French--8th c. Crozier:
Grotesque
French--13th c. Bishop's
Crozier
--Crozier#
--Limoges Champleve Enamel
Crozier
German--10th c. Crozier
--Crozier of Bernward of
Hildesheim
Italian--14th c. Crozier-
head
Italian--16th c. Crozier of
Pope Clement VII
Crucifix. Kneale
Crucifix of Lothar
German--10th c. Lothar
Crucifix
Crucifix of San Isidore.
European--Western
Crucifixion See Jesus Christ--
Crucifixion
Cruesen, Andreas (Bishop)
Bishop Andreas Cruesen
Tomb
Cruet. Anglo-Saxon
Crusaders
French--12th c. Crusader
and Wife
--Return of the Crusader
Wildt. The Crusader
CRUTCHER, Richard
Robert Clayton Tomb 1705
EDS pl 19, 116-7; WHIN
pl 73b; WHINN pl 50A
ESurB
CRUZ MARTIN, Miguel de la
Las Deportistas wood
MARY pl 175
CRUZ SOLIS, Fernando (Spanish
1923-)
Head of a Blind Man
1956 bronze VEN-56:
pl 138
The Cry. Martin, E.

Cry of the Animal. Kerim
Crying Girl. Haller
The Crying Girl. Rodin
Crystal of Lothar. German--9th c.
CSAKY, Joseph (Hungarian-French
1888-)
Clad Woman 1913 plaster
BERCK 29 FPM
Head marble MARTE pl 36
Head 1914 bronze SELZJ
215 FStEM
Polychromed Relief
1920 stone; 16 BERCK
255; MARC pl 37
NOK
Purity 1958 bronze MAI
70 -Va
Stag (Cerf) marble MARTE
pl 26
Standing Woman 1913 Gilt
bronze MARC pl 38 (col)
FPM
Stele 1929 Stone MAI 70
Three Figures
MARTE pl 4
CSIKASZ, Imre (Hungarian 1884-1914)
Seated Girl 1911
bronze; 110 cm GAD
61 HBMa
Young Girl 1912 bronze;
165 cm GAD 63 HBA
Csok, Istvan
Beck, F. O. Istvan Csok,
medal
Csokonai Vitez, Mihaly (Hungarian
Author 1773-1805)
Izso. Csokonai-Vitez
Memorial
Csoma, Sandor Korosi See Korosi
(Soma Sandor)
CSORBA, Geza (Hungarian 1892-)
Endre Ady Memorial 1929
stone GAD 86; PAR-2:112
HBKf
Girl, bust 1916 bronze; 39
cm GAD 84 HBA
CUAIRAN, Florencio
Black Panther stone CASS
120 -Foy
The Cube. Pomodoro, A.
Cube V. Kowalski
Cubical Variations within Rectangular
Column. Schnier
Cubist Head. Giacometti
Cuckoos
English--18th c. Chelsea
Cuckoos

CUEMAN, Egas (Netherlandish fl
 1454-67)
 Alonso de Velasco Tomb
 1467/80 MULS pl 150B
 SpGua
Culpeper, Lady
 Marshall, E. Elizabeth,
 Lady Culpeper, re-
 cumbent effigy
Culpepyr, Alexander d 1537
 English--16th c. Sir Alex-
 ander and Lady
 Culpepyr Tomb, effigies
Cumaean Sybil
 Syrlin, J., the Elder.
 Cumaean Sibyl, choir
 stall
Cumberland, Duke of
 English--18th c. Duke of
 Cumberland, Chelsea
 bust
CUMMINGS, D.
 Animal Form wood NORM
 40
CUNEO, Renata (Italian
 1904-)
 Claudio VEN-42:pl 31
Cunliffe, Robert
 Nollekens. Robert Cunliffe
 Monument, medallion
 portrait detail
Cunningham Graham, R. B.
 Epstein. R. B. Cunningham
 Graham, head
Cupboards
 Sambin. Cupboard with Carya-
 tids
 Sansovino, J.--Foll. Cup-
 board
Cupid See Eros
Cupids See Putti
Cups See also Chalices
 Bellotto, U. Cup(s)#
 Cellini. Rospigliosi Cup
 Early Christian. Cup, with
 city personifications
 English--14th c. Lynn Cup
 English--17th c. Steeple
 Cup
 Flaxman. National Cup
 Flaxman. Theocritus Cup
 Flotner, and L. Krug.
 Holzschuher Cup
 French--15th c. Sculptured
 Cup Lid
 French--16th c. Standing
 Covered Cup
 French--17th c. Neptune Cup

German--15th c. Furstenberg
 Fief Cup
 German--16th c. Two Drink-
 ing Vessels: Fantastic
 Animals
 Lamerie. Rococo Cup
 Russian--19th c. Covered
 Cup
CURE, William II (William Cure,
 the Younger) (English fl
 1607-15)
 Alderman Humble, and
 Family, Monument ESD
 pl 69 ESouthS
 Lord Surrey Tomb c1615
 ESD pl 4 ESufF
 Mary, Queen of Scots,
 effigy 1607/12
 WHINN pl 12A ELWe
 Prince Charles c1614/15
 MERC pl 91b ECamT
 Sir Roger Aston Tomb 1612
 colored alabaster CON-2:
 pl 41; WHINN 10A ECra
Curle, William
 Stone. Sir William Curle
 Tomb
Curlew
 Hepworth. Stringed Figure
Curry, Jabel Lamar Monroe
 (American Educator 1825-
 1903)
 Sodini. Jabez Lamar Monroe
 Curry
Cursed Poet. Dazzi
Curtius, Marcus (Legendary Roman
 Hero 4th c. BC)
 Bernini, G. L. Louis XIV
 (Marcus Curtius), equest
Curved. Sieklucki
Curved Form# Hepworth
Curved Form with Inner Form:
 Anima. Hepworth
Curved Forms with String.
 Hepworth
Curwen, Henry
 Marshall, E. Henry Curwen
 Monument
Cuspinian, Johannes
 Austrian--16th c. Johannes
 Cuspinian, gravestone
Cut State. Ubac
Cutler, John
 Quellinus, Arnold. Sir John
 Cutler
Cuto, Princess
 Ugo. Princess Cuto, bust
CUVIELLES, Jean Francois de

(French 1698-1768)
Balcony Grille LARR 417
Cybele
 Early Christian. Plate: Cybele
 and Attis
 Rodin. Cybele
 Spanish--16th c. Cybele
Cycling See Games and Sports
Cyclops
 Paolozzi. Cyclops
Cylarrus
 Bertos, F. Cyllarus Attacked
 by Lapithae
Cymbals See Musicians and Musical
 Instruments
Cypriana, Arp
Cyriacus
 German--16th c. Cyriacus,
 Talheim Altar
 Urach, C. von. Cyriacus,
 altar detail
Cysp# Schoffer
Czartoryski, Princess
 Bartolini. Princess Czar-
 toryski of Warsaw Monu-
 ment
CZECH
 --17th c.
 Angel ptd wood STECH col pl
 2 (col)
 Belvedere with statues, castle
 garden c1700 STECH 37
 Courtyard Fountain 1637
 STECH pl 10 CzBu
 Courtyard Fountain, with
 Neptune 1668/80 STECH
 30 CzLn
 Crucifix 1660/80 wood STECH
 pl 9 CzPV
 Madonna 1636/44 stone
 STECH pl 4 CzPOu
 Raduit de Souche Tomb c
 1700 imitation marble
 STECH pl 29 CzZnB
 St. Michael the Archangel
 1660/80 ptd wood STECH
 29 CzPV
 --18th c.
 Acanthus Frame of Altar
 STECH pl 11 CzChl
 Caesar Fountain 1724
 STECH pl 30a CzO
 The Deposition, St. Mary
 Magdalene
 Cloister, Skalka c1730
 STECH pl 101
 Fountain with Statue of St.
 John Nepomuk c1730
 STECH 129 CzPo

"Golden Stag" House, facade
 c1726 STECH pl 87 CzP
Man and Woman Dwarves,
 Arena 1711 STECH 54
 CzNoK
Pulpit detail: Angels 1730/
 40 STECH pl 123
 CzPKn
St. Charles Bridge BUSB
 118 CzPCh
Tritons Fountain 1709
 STECH pl 30b CzO
Czeyda-Pommersheim, Ferenc
 Boldogfai-Farkas, S. Prof.
 Ferenc Czeyda-
 Pommersheim, medal

D (Imaginary Alphabet). Bertoni
D., Mme
 Maillol, Mme. D.
D., Mme A.
 Despiau. Mme A. D., bust
D., Maria
 Elkan. Maria D., head
D., Signorina H.
 Dvorak. Signorina H. D.,
 bust
D'Abernon, Edgar Vincent (British
 Financier 1857-1941)
 O'Connor. Lord D'Abernon,
 head
DACKER, Herbert
 Yves 1960 cold cast copper
 and bronze PER 59
Dada Head. Tauber-Arp
Dada Objects and Constructions
 See name of artist, as
 Duchamp, M.; Arp; J.;
 Oppenheimer, M.
DADLER, Sebastian 1586-1657
 Arrival of Princess Mary in
 Holland 1642 silver gilt;
 Dm 2-7/8 VICOR pl 33D
 NHP
Daedalus
 Ayrton. Daedalus
 Canova. Daedalus and Icarus
 Martini, A. Daedalus and
 Icarus
 Pisano, Andrea. Daedalus Try-
 ing out his Wings, relief
Daggers
 French--14th c. Dagger Hilt
 Spanish--17th c. Left-Hand
 Dagger
Dagobert, Saint
 Pierre de Montreuil. Legend
 of St. Dagobert
Dagobert
 Merovingian. Throne of Dagobert

Dagobert I (King of the Franks fl
 628-39)
 French--13th c. Dagobert I
 Tomb
Dagulf's Psalter. German--8th c.
DALCHEV, Lybomir (Bulgarian
 1902-)
 Themis, relief detail
 bronze BOZ 99 BulSJ
DALI, Salvador
 Head of Dante 1965 KULN
 43
 Mannequin SEITA 58
 The Swan of Dali, jewelled
 pin 1959 alexandrite and
 emerald LYN 116 (col)
DALLEGRET, Francois (French)
 The Machine 1966 172
 lights; 2 aluminum ex-
 trusions; L: 30' BURN
 356
DALLE MASEGNE, Jacobello
 (Italian fl 1393-1409)
 Doge Antonio Venier,
 kneeling figure marble
 MURA 114 (col); POPG
 fig 42 IVCo
DALLE MASEGNE, Jacobello, and
 Pierpaolo DALLE MASEGNE
 Iconostasis; detail: St.
 Mark marble; figure:
 136 cm POPG fig 78;
 pl 65 IVM
DALLE MASEGNE, Pierpaolo
 (Italian d 1403(?)) See
 DALLE MASEGNE, Jacobello
DALMATA, Giovanni (Ivan Duk-
 novic; Giovanni de Trau)
 (Yugoslav-Italian 1440-1509)
 See also Bregno, Andrea;
 Mino da Fiesole
 Cardinal Bartolommeo
 Roverella Monument:
 Angel SEY pl 94B IRCl
 Pope Paul II Tomb: God the
 Father in Glory 1471-77
 marble SEY pl 96 IRV
DAIMATA, Giovanni--FOLL.
 Martyrdom of St. Peter,
 Sixtus IX Ciborium
 relief c1475/80 SEY pl
 97, 98A IRV
Dalmation Woman with a Wine Skin.
 Lorzica
DALMATINAC, Juraj (Croation)
 The Flagellation, high
 relief 1448 BUSR 77
 YSC

Heads, apse moulding detail
 1443 BIH 15 YSiC
DALOU, Aime Jules (French 1838-
 1902)
 Alphonse Legros, head c1878
 ptd plaster; 20-1/8 (with
 base) TATEF pl 24C ELT
 (3610)
 Barnebuste (Barnehoved)
 1875/78 bronze COPGM
 91 DCN (I.N.2846)
 Bather cast bronze VEN-10:
 pl 125
 Charity c1878 terracotta;
 30 VICF 101 ELV
 (A.36-1934)
 Charity c1887 marble; 35-
 3/4 TATEF pl 15 ELT
 (3052)
 Delacroix Monument TAFTM
 31
 Faculty of Medicine Monument,
 project (probably not carried
 out) c1881/88 BAZINW 423
 (col) FPPP
 Female Torso gilded bronze;
 19 CPL 78 UCSFCP
 (1940.113)
 Femme Nue Lisant dans un
 Fauteuil 1878 bronze;
 13-3/4 SOTH-4:73
 French Peasant Woman
 (Paysanne Francaise) 1873
 terracotta; 53-3/4 (excl
 base) ENC 225; TATEF
 pl 24d ELT (4002)
 Labour Monument, sketch
 1889/91 plaster; 10 cm
 LIC pl 106 ELBou
 Maternal Love RAY 54 UNN-
 MM
 Mirabeau Replying to Dreux-
 Breze, June 23, 1789
 relief Palais-Bourbon
 bronze; 2.36x6.54 m
 JAL-5:pl 24 FV
 Motherhood, drinking fountain
 1879 GLE 118 EL
 Paysan bronze MARY pl 74
 FP
 Seated Woman c1876 terra-
 cotta; 9 ASHS pl 36 ELV
 Silens and Attendants bronze
 ARARC 124; CHASEH 444
 FPLu
 Sleeping Baby, head 1878
 terracotta; 31x18x18 cm
 LIC pl 107 FPPP

Torso bronze, part gilt CLE
171 UOC1A (18. 571)
Triumph of the Republic
(Monument to the French
Republic; Triomphe de
la Republique), monument
1899 bronze; 12.13x22.8
m BROWF-3:82; LIC pl
104-5; POST-2:137 FPNa
Vase: Putti and Garlands,
high relief RAY 7
La Verite Meconnue (Den
Miskendte Sandhed) 1890
COPG 93 DCN (I.N.1385)
Woman Reading c1880 plaster
LARM 159; SELZJ 82
FPPP
--Sketch model c1875 terra-
cotta; 9 BRIO 45; MOLE
265; READAS pl 134 ELV
Woman Sewing c1870/80
terracotta SELZJ 82 FPPP
Woman Taking off her
Stockings c1870/80 plaster;
21 cm LIC pl 108; SELZJ
83 ELT
Portraits
Roche. Monument to Dalou
Rodin. Jules Dalou, bust
D'ALTRI, Arnold (Swiss 1904-)
Genii 1949 cement; 86-5/8
x110-1/4 TRI 104 GLeM
Homo Faber 1957 MAI 71
Portrait of a Girl, head
1946 bronze; 13 SCHAEF
pl 16
Portrait of the Singer M.M.
1949 bronze; 16 SCHAEF
pl 18
Trinity 1957 bronze; 98
BERCK 168
Woman with a Washcloth
1946 bronze; 20 SCHAEF
pl 17
DALWOOD, Hubert (English 1924-)
Egyptian Column 1962
bronze; 20x12 ARTSS
#14 ELBrC
High Judge 1962 bronze;
72 LOND-6:#14 ELG
--maquette 1962 bronze;
23-1/2 HAMM 137 (col)
ELG
Icon 1958 aluminum; 57x31
ALBD-3:#61; VEN-62:
pl 150 UNBuA
Large Object 1959 aluminum;
30x35x35 TATES pl 16
ELT (T. 323)

Large Object 1959 aluminum;
34x38 LOND-5:#15
Lucca 1958 aluminum; 25 sq
HAMM 135 (col) ELG
Minos 1962 aluminum; 81
NEW pl 90
Mirage 1966 plastic and
aluminum; 64x69x88
LOND-7:#12 ELG
Monument for a Poet 1963
ptd aluminum; 10-1/2x
33-1/2x22 ALBB; ALBC-
4:61 UNBuA
OAS Assassins 1962 alumin-
um; 30x23 SFMB #108
ELG
Open Square 1959 aluminum;
16-1/2x13-1/2 READCO
pl 15a ELG
Persian Explosion 1964
aluminum; 17x22 ARTSCH
#4 ELG
Queen 1960 aluminum; 41-1/2
HAMM 136 ELG
Relief 1958 aluminum MAI
71
Standing Draped Figure 1954
lead; 20-1/4x9-1/2x6-3/4
TATEB-1:26 ELT (T. 266)
Standing Woman 1957 skin
bronze; 48 LONDC pl 8
Una Grande Liberta 1963
aluminum, gilt and wood;
60x30x10-3/4 READCON
209 (col); SEITC 52 ELG
DAL ZOTTO, Antonio (Italian)
G. Tartini VEN-97
La Dama dalla Veletta. Rosso, M.
DAMER, Anne Seymour (English
1749-1828)
Dog c1784 WHINN pl 135B
EChi
Two Dogs GUN pl 7 EGood
Portraits
Ceracchi, G. Anne Seymour
Damer
DAMMAN, Hans (German)
Salome TAFTM 65
DAMMARTIN, Guy de (French)
Triple Fireplace 1384/86
KIDS 155 (col) FPoP
"Damnation". Permoser
Damned
Permoser. Head of one of
the Damned
D'AMORE, Benedetto (Italian)
Rustic Harmony (Agreste
Armonia), relief marble
VEN-30:pl 88

DAMPT, Jean
 Grandmother's Kiss 1892
 marble CAS pl 28; MARY
 pl 19 FPLu
Danae
 Canova. Danae
 Cellini. Perseus: Danae
 with Boy Perseus
Danaid
 Gili. Danaid
 Rodin. Danaide(s)
DANCART, Pieter (Flemish fl
 1468-89), and MARCO
 FLAMENCO
 High Altar begun 1482 MULS
 pl 154A SpSC
Dance of Death
 German--17th c. Death of
 the Nobleman
Dance Monument
 Rodin. Mouvement de Danse
Dance-Step. Manzu
Dancer Looking at the Sole of her
 Right Foot. Degas
Dancers See also Degas; names of
 dancers, as Salome
 Alves. The Dance
 Barlach. The Dancer
 Barwig. Peasants Dancing
 Baumbach. Dancing Figures
 Bernard. Dance Figure
 Bernard. Dancing Woman
 and Child
 Blomberg. The Dance
 Bourdelle. The Dance
 Broggini. Ballerina
 Burckhardt. Dancer
 Calo. Danzatrice Indiana
 Cannilla. Ballerina con
 Velo
 Cappello. La Danza Marina
 Carpeaux. Dance
 Carpeaux. Dancer with
 Tambourine
 Carpeaux. Dansen
 Cataldi. Dancer
 Chadwick. Dance
 Chadwick. Two Dancing
 Figures
 Chronander. Dancer
 Daudert. Dancer
 Davis. Dancer
 Del Bo. Dancers
 Dierkes. Dancer
 Donatello. Cantoria: Dancing
 Angels, relief
 Erminold Master. Dancing
 Angel

 Fabbri. La Danzatrice
 Falconet. Dancer with
 Castenets
 Falguiere. Dancer
 Fazzini. Dancer
 Ford, E. O. Dancing
 French. Legend of St. Thomas
 French--13th c. Tithe Vessel
 for Grain: Dancing
 Peasants
 French--19th c. Danse Cham-
 petre
 Gaudier-Brzeska. The Dancer#
 Gaudier-Brzeska. The Red
 Stone Dancer
 German--18th c. Ludwigsburg
 Ballet Dancers
 Gerrard. The Dance
 Gonzalez. Dancer
 Gonzalez. Danseuse, dite a
 la Marguerite
 Grasser. Morris Dancer
 Herzog. Adagio--two versions
 Innocenti, B. Dancer
 Italian--16th c. The Dance,
 Florentine chessboard
 detail
 --Dancers, Padua
 Izso. Dancing Peasant
 Jarema. Dance
 Kandler. Four Meissen
 Commedia dell'Arte Figures
 Kirchner, E. L. Dancer
 with Raised Leg
 Kolbe. Dancer
 Krsinic. Dancer
 Larche. Loie Fuller Dancing,
 table lamp
 Laurens. Dance
 Lehmbruck. Dancer
 Leplae. Dancer
 Lux. Dancer
 Manzu. Dance-step
 Manzu. Grande Passo di
 Danza
 Marcus. Almtanz
 Marini. Dancer
 Martinez, G. Dancer
 Mazzullo, G. Danzatrice
 Medgyessy. Dancer
 Metzner. The Dance
 Milles. Dancing Girls
 Milles. Girls Dancing
 Nicolas de Vergara, the
 Elder. David Dancing
 before the Arc of Covenant
 Norman, P. E. The Dancer
 Obsieger. Girl Dancer

Style c1000 LOH 33
--12th c.
Jesus Christ, head, Crucifix
of Tirstrup c1140 H:124
cm SWA pl 109
Lisbjerg Altar: Plait work
and portraiture c1150
gilded copper plate; de-
tail: 43 cm BOES 33;
BUSRO pl 42, 43 DCNM
Madonna, Randersfjord wood
BUSRO pl 30 DCN
Virgin Mary c1140 copper
gilt; 275 mm SWA pl 109
DCN
--13th c.
Adoration of the Magi c1250
jewelled ivory; 17 cm
BOES 35 DCNM
Aquamanile: Centaur 1200/
50 bronze; 24 cm BOES
147 DVoZ
Archbishop, detail c1250
wood; 94 cm; detail:
36 cm BOES 169 DHjoV
Christ, crucifix detail
c1240 walrus ivory
BUSGS 73 DCNM
Crucifix 1200/50 enamelled
copper; 24.5 cm BOES
189 DAK
Seated Madonna c1240
BUSGS 71 GFlK
--14th c.
Crucifix c 1325/50 wood;
208 cm BOES 150 DML
Tap Handle: Basilisk c1300
bronze; 11.5 cm BOES
146 DRosM
Travelling Altar of Christian
I: Royal Saint c1300
walrus ivory BUSGS 175
DCNM
--15th c.
Drinking Horn, with bird
feet and curling tail end-
ing in rosette copper gilt
rim and mounts; 6-1/2
GRIG pl 117 ELBr
--16th c.
Armor of Duke Adolphus
c1560 H:180 cm BOES
116 DCTo
--17th c.
Coronation Chair and three
Silver Lions c1670 ivory
chair; 252 cm BOES 20
DCRo

--20th c.
Tiger ceramic DOWN 205
DANNECKER, Johann Heinrich
(German 1758-1841)
Ariadne on a Panther
marble MARQ 249; POST-
2:99; RAY 53 GFB
--1803 terracotta; 29 cm
LIC pl 19 GStSt
Girl with Bird CHASEH
425 GStM
Schiller, bust ENC 805
Self-Portrait, bust 1794
marble CHENSW 462; KO
pl 99 GStSt
--1797 toned plaster GOLDF
pl 365 GStSt
DANTAN, Jean Pierre (French
1800-69)
Balzac 1835 LIC pl 79
FPCarn
Paganini 1832 plaster; 18
NOV pl 186a
Dante Alighieri (Italian Poet 1265-
1321)
Aube. Dante
Dali. Head of Dante
Italian--14th c. Dante,
detail
Italian--15th c. Dante, head
Radaus. Dante, seated figure
Rodin. Dante, mask
Ximenes. Dante
DANTI, Vicenzo (Perugian 1530-76)
Decollation of St. John the
Baptist ENC 228; POPRB
fig 30 IFBap
--Salome POPRB pl 76
Descent from the Cross
bronze; 12-1/2x18-1/2
SEYM 136, 137-8 UDCN
Honour Conquering Deceit
(Honour and Falsehood;
Honour Pulling Out Tongue
of Falsehood; Honour Tri-
umphant over Falsehood;
Honour Vanquishing Deceit)
marble POPRB pl 77
IFMN
--c1560 terracotta CLAK
214; HAUS pl 276; MACL
233
Moses and the Brazen Serpent,
relief c1560/61 bronze; 32
MOLE 162; POPRB fig 85
IFBar
Venus Anodyomene bronze;
38-1/2 BAZINW 362-3

(col); POPRB pl 78
IFV
D'ANTINO, Nicola (Italian)
Adolescent bronze VEN-12:
pl 126
Fanciulla con Anfora bronze
VEN-20:41
Marquesa Medici del Vas-
cello, bust marble VEN-
22:20
Riri bronze VEN-14:107
Spring Primavera silver
VEN-24:pl 64
DANUBE SCHOOL
St. Michael c1510/20 ptd
linden; 32-3/4 KUHN pl
26-27 UMCB (1949.162)
DANZIGER, Itzhak (Isaac,
Yitzchak, Yitzhak Dantziger)
(German-Israeli 1916-)
Burning Bush c1960 iron
NEW pl 227 IsH
Corral with Water Spout
1962 H:26 SEITC 57
IsTI
Head Stone SCHW pl 103
"The Lord is My Shepherd"
(Negev Sheep) 1964
bronze; left: 34-1/8x76-
3/4x53-3/4; right:
32-1/8x82-7/8x38 SEIT
32 UNNH
Nimrod; detail sandstone
GAM pl 99, 101; SCHW
pl 104
Sculpture 1959 welded iron;
63-1/8x33-5/8x50 SEIT
33; SEITS 57 IsTI
Shabazia sandstone GAM pl
100
Sheep 1956 ROTH 942
Shepherd King, model 1964
SEITC 57 IsTI
Song of Battle 1961 H:120
SEITC 57 IsHV
Daphne See also Apollo
Fohl. Daphne
Gonzalez. Daphne
Sintenis. Daphne
Sintenis. Small Daphne
Darboy, Georges
Guillaume, E. Monseigneur
Darboy, bust
Darboy, M.
Guillaume, E. M. Darboy
Darcy of Chiche, Thomas, Lord
English--17th c. Thomas, Lord
Darcy of Chiche, Tomb
DARDE, Paul de (French 1890-)
Christ, head (Tete de Christ)

stone; .47x.30x.35 m TOKC
S-60 JTNMW
Eternal Grief (Eternelle
Douleur) bronze; .50x.45x
.37 m TOKC S-61 JTNMW
Faun lead HOF 310
Faun, garden figure lead HOF
187 FStGV
Head with Grapes (Tete aux
Grapes) stone; .74x.52x.33
m TOKC S-62 JTNMW
Darinville, Luzi
Caffieri. Luzi Darinville,
bust
Darius
Soest. Darius and Temperentia
Dark Days. Studin
Dark Maternity. Auerbach
Darley Dale Cross. English--10th c.
DA SESSO, Salamone (Ercole dei
Fedeli) (Italian fl 1487-1517)
Ceremonial Sword of Gonzaga
Family ROTH 507 FPL
DA TREZZO, Giacomo Nizolla (Italian
1515/20-1587) See LEONI,
Leone
DAUCHER, Adolph (German c1460-
1523/24)
Christ with Mary and St.
John 16th c. stone MOLE
94 GAuAF
The Entombment, Fugger
Chapel 1510/12 BUSR
173 GAuA
St. John the Evangelist early
16th c. stone; 32 ASHS
pl 16; VICF 33 ELV
(49.1864)
DAUCHER, Adolph--ATTRIB
Christ in the Garden of
Gethsemane, plaque
Kelheim stone CLE 107
UOC1A (47.128)
DAUCHER, Hans (German c1485-
1538)
Charles V, equest relief,
Augsburg 1522 Solnhofener
stone; 21.2x15 cm MUL
26
Deposition (Erbarmdegruppe),
Fugger Kapelle 1509/18
marble; 148 cm MUL 25
GAuAF
Madonna Relief of Queen
Eleanor of Portugal 1520
BUSR 174 GAuST
Triumph of Charles V, panel
CHASEH 361 UNNMM

Virgin and Child, Augsburg
Solnhofener 1530/35 Soln-
hofener stone; 43.3x31.7
cm MUL 27 ELV
Virgin and Nursing Child
1515 ptd stucco; 20.7x
21 cm MUL 28 SwBKH
DAUDERT, Rudolf
Dancer (Tanzerin) 1946
terracotta GERT 85
Standing Woman (Stehende)
1946 terracotta GERT 85
Daudet, Alphonse
Saint-Marceaux. Daudet
Monument
The Daughter. Martini, A.
Daughter of God. Lameras
A Daughter of Pakistan. Bevis
DAUMIER, Honore (French 1808-79)
Benjamin Delessert, bust
c1830/32 bronze SELZJ
25 (col) UNNH
The Burden c1855 terracotta;
35 cm LIC pl 78 FPRos
The Burden c1885 terracotta;
c 13-1/2 MCCUR 246;
SELZJ 59 UMdBW
La Degout Personnfie, bust
of Senator Fruchard
1830/32 colored clay;
5-1/2 GIE 2 FPL
The Emigrants, first version,
relief plaster BAZINW
422 (col); SELZJ 62
FPL
Les Emigrants (Emigranterne),
relief c1860/70 plaster;
37.5x77 cm COPGM 3
DCN (I.N.2613)
Le Fourbe et Ruse H:7-3/4
SEITC 186 UNNH
The Fugitives, relief 1860
plaster of Paris; 14-1/2x
30 BARD-2:pl 355 BrSpA
The Fugitives, relief c1870
plaster; 13x28 NOV pl
187
The Fugitives 1871 bronze;
L: c 30 MCCUR 246
formerly UNNK
L'Homme a Tete Plate c
1830/32 bronze; 5-1/2
READCON 11 UNNH
Jacques Lefebre, "L'Esprit
Fin et Trenchant", bust
1830/32 colored clay;
8 LYN 39 FMaM

Jean Fulchiron, bust 1830/32
bronze SELZJ 58 FMaM
Jean Harle the Elder, bust
GAF 521 FMaM
Migrants, relief c1870
bronze; 28x16 cm LIC
pl 80 FPGe
The Orator: Andre Dupin at
French Parliament c1832
bronze; 15 cm LIC pl 81
FMaM
Prunelle c1830/32 bronze;
13 cm LIC pl 83 FMaM
Ratapoil EXS 16
--ALBA UNBuA
--bronze; 17-3/8 YAP 223
-UHar
--bronze; 17-1/2 INTA-1:100
--1850 bronze MAI 72
--c1850 bronze ROTHS 231
FPLu
--c1850 bronze; 44 cm
COPGM 97 DCN (I.N.2720)
--c1850 bronze; 17 DETS 11
UNNH
--1850 bronze ST 411
GCoW
--1850 bronze; 18-1/2
BERCK 18; GIE 3;
LARM 163; LIC pl 85;
MCCUR 246; NOV pl
186b; RAMS pl 24; UPJH
pl 201 FPL
--1850 plaster original GIE
3 FPBi
Self Portrait, head c1855
bronze; 72 cm LIC pl 84;
SELZJ 63 FPBN
Le Stupide bronze CHRP 374
UDCN
Toothless Laughter c1832
bronze; 16 cm LIC pl 82
FMaM
Unknown Man, bust 1830/32
bronze SELZJ 58 FMaM
Portraits
Bourdelle. Daumier, head
DAVERAZZO, Bartolomeo
Mortar 1420 H:4-3/4;
D: 6-3/4 DEDT 19 UOTW
David, head. Huxley-Jones, T. B.
David. Ipousteguy
David (King of Israel 1013?-973?BC)
Antelami. King David
Bellano. David
Bernini, G. L. David
Berrocal. David

Bossi, Aurelio. David
Braun, M. B. King David
Byzantine. Dish: David
 Anointed by Samuel
Byzantine. Dish: David
 Slaying the Lion, plate
Byzantine. Dish: Marriage
 of David
Byzantine. Plates: Life of
 David
Chagall. King David, relief
Cordieri. David
Donatello. Casa Martelli
 David
Donatello. David#
Douvermann. Altar of Virgin
 of the Seven Sorrows:
 King David at the Root
 of the Tree of Jesse
Early Christian. David
 Slaying Goliath
Early Christian. Door
 Fragments: Scenes from
 Life of David
English--11th c. Tympanum:
 David and Lion
English--12th c. Tympanum:
 David(?)
Foggini. David and Goliath
Francheville. David with
 Head of Goliath
French--12th c. Capital:
 Samuel Anointing David
--David, Rheims
--King David, head
German--8th c. Dagulf's
 Psalter: King David and
 St. Jerome
German--10th c. Diptych:
 King David, and Pope
 Gregory the Great
German--12th c. Chalice:
 Life of David, scenes
German--16th c. David
Ghiberti. Baptistry Doors--
 East: David
Gibbons. King David Playing
 the Harp, relief
Holt. David
Kallos. David
Marchiori. David
Michelangelo. David
Milicz. Religious Medal:
 David and Bathsheba
Nicolas de Vergara, the
 Elder. David Dancing
 Before the Ark of
 Covenant

Norwegian--11th c. Weather-
 vane: David Rescuing Lamb
 from Lion
Riccio. David Dancing Before
 the Ark of Covenant
Romanesque--Spanish. King
 David
Russian--12th c. King
 David, enthroned with
 birds and animals, facade
 relief
Slanzovsky. Organ Figures:
 St. Ludmilla and King
 David
Sluter and Werve. Well of
 Moses
Spanish--11th c. King David
Spanish--12th c. King David,
 facade figure
Sveinsson. David and Goliath
Szwarc. David
Verrocchio. David
DAVID, Claude (French-English
 fl 1706-22)
 Philip Carteret, bust,
 monument d 1710 GUN pl
 8 ELWe
DAVID, Fernand (French
 Consolation TAFTM 46
David, Jacques Louis
 Rude. David, bust
DAVID D'ANGERS, Pierre Jean
 (French 1788-1856)
 Alfred de Musset, medallion
 GAF 260 FAnD
 Battle of Fleuris: General
 Jourdan Refuses to Accept
 his Enemy's Sword, relief
 1835 plaster; 110x156 cm
 LIC pl 55 FAngeM
 Delacroix Medal 1828 bronze;
 Dm: 10 cm LIC pl 53
 FAngeM
 General Drouot CHASEH 438
 FNan
 General Lafayette, bust
 marble USC 195 UDCCap
 George Washington, bust
 bronze FAIR 379; USC
 170 UDCCap
 Le Grande Conde 1817 bronze;
 37 cm LIC pl 52 FPL
 James Fenimore Cooper,
 bust 1828 marble; 1-1/2
 LS FAIY 173 UNCooF
 Johann Wolfgang von Goethe,
 tondo relief profile 1831
 plaster; Dm:9 NOV pl

182b FAnM
Lamennais, bust 1839 marble
 SELZJ 50 FReM
Napoleon I, tondo relief
 1833 bronze SELZJ 51
 FAnM
Nicolo Paganini, head 1830
 bronze; 62x38x34 cm
 LIC pl 54; SELZJ 50
 FAnM
Nicolo Paganini, medallion
 LARM 45
Pantheon Pediment, relief
 1837 plaster; 290 cm
 LIC pl 56 FAngeM
Thomas Jefferson bronze
 FAIR 67; MUR 102;
 POST-2:125; USC 275
 UDCCap
DAVIDSON, Michael John (English
 1939-)
 Big Stripper 1967 KULN 21
 Viva Maria 1967 KULN 21
DAVIE, Alan (English)
 Doll ARTSA 26
Davies, Betty
 MacPherson. Betty Davies,
 head
DAVIOUD, Gabriel (French 1823-88)
 Fontaine de l'Observatoire,
 with Carpeaux: Four
 Continents 1875 GAF
 135 FP
 St. Michael Fountain 1860
 GAF 135 FP
DAVIS, John Warren (English
 1919-)
 Carving Horizontal I 1959/60
 wood; L:54 READCO pl
 7b
 Dancer 1958 ciment fondu
 READAN # 67
 Seated Figure 1958 stone;
 24x16x15 ARTSS # 17
 ELBrC
Davout, Louis Nicolas (French
 Soldier 1770-1823)
 Bosio. Marshal Davout, bust
Dawn. Del Bo
Dawn. Hartwell
Dawn. Howes
Dawn. Jonsson
Dawn
 Michelangelo. Lorenzo de'
 Medici Tomb: Morning
Dawn. Schmiedt
Dawn and Germination. Szabo, L.

DAY, G. H. J.
 Woman Resting Roman stone
 CASS 77
Day
 Brokoff, F. M. Palace
 Portal: Day; Night
Day. Epstein
Day
 French--13th c. Blind Led
 by Day, relief
Day. Lim
Day
 Michelangelo. Giuliano
 de'Medici Tomb: Night
 and Day
Daybreak. Franchina
DAYMOND, John (English)
 Lychgate AUM 120 ECla
DAZZI, Arturo (Italian 1881-)
 Adriana Ceci VEN-12: pl 106
 Capallino wax VEN-28:pl 80
 Countess Marie-Jeanne de
 Bertaux bronze VEN-14:69
 Cursed Poet (Il Poeta
 Maledetto), detail 1952
 wood VEN-52:pl 12
 Dreaming Child (Sogno di
 Bambina) marble CASS
 70; VEN-26: pl 76
 Modern Venus AUM 36
 Soldiers, Arch detail
 CASS 98 IGen
Deacon
 Pisano, G. Pistoia Pulpit:
 Deacon
Dead Boy on a Dolphin. Lorenzetto
Dead King. Frank
Dead Men's Lantern
 French--12th c. Dead Men's
 Lantern#
 French--13th c. Dead Men's
 Lantern
Dead Warrior. Moore, H.
Deane, Lady d 1633
 Wright, W. Resurrection
 Monument to Lady Deane
Dean's Canopy. Gibbons
DEARE, John (English 1759-98)
 Edward and Eleanor, relief
 1788 marble CON-4:pl 31
 "Venus" 1787 GUN pl 7
 EParhP
Death See also Skeletons; Skulls
 Barlach. Angel of Death
 Barlach. Death
 Bartholome. Monument to
 the Dead

Bernini, G. L. Alexander VII
Tomb
Bonneson. Life and Death
Dirr, G., and J. G.
Wieland. Death and the
Abbot
French--13th c. Blind Death
French--16th c. Death
--Death Triumphant
German--14/15th c. Death
on Horseback
German--17th c. Death of
the Nobleman
--Personification of Death#
German--18th c. Clock with
Wooden Cogs and Figure
of Death
Italian--12th c. Death of
Saint and Sinner, porch
relief
Leinberger, H. Death
Pigalle. Marechal de Saxe
Tomb
Riccio. Humanism Overcomes
Death, relief detail
Richier, L. Rene de Chalons
Tomb: Death
Roubillac. Lady Elizabeth
Nightengale Monument:
Death
Schluter. Death
Stammel. Death
Death and the Maiden. French--
15th c.
Death and the Maiden. Schwarz,
Hans
Death Barque
French--13th c. Dagobert
I Tomb: Death Barque
Death of a Warrior. Wedgwood
Death of Adonis. Mazzuola, G.
Death of della Torre. Riccio
Death of Germanicus, relief.
Banks
Death of Mercury. Corbero
Death of the Miser# Romanesque--
French
Death Walk. Rapoport
DE BAY, Jean Baptiste Joseph
(Belgian 1779-1863)
General Cambronne, bust
DEVI-2 BBR
DEBONNAIRES, Fernand (Belgian
1900-)
Head of the Ingenue GOR 80
Self Portrait, head GOR 81
DEBSCHITZ, Wilhelm (German

1871-1948)
Inkstand 1906 bronze; 2
SELZPN 114 GStLan
Debussy, Claude
Maillol. Kneeling Woman:
Debussy Monument
Martel, J. J. Debussy
Monument
Dec 65 (Amboise). Nicholson, B.
La Decapitazione delle Giraffe.
Pascali
Deception Unmasked. Queirolo
DECLERCQ
Figure, Textile Pavillion,
International Exhibition,
Brussels 1935 CASS 108
DE CONDENHOVE, E See
HENDERSON, Elsie
Decorated Tracery See Window
Tracery
Decorations of Honour See also
Heraldry; Medals and
Medallions
English--16th c. Collar of
the Order of the Garter,
with "Lesser George"
Medallion
Flemish--15th c. Order of
the Golden Fleece Collar
DE CROZALS, Jean Vincent de
Centaure FPDEC il 7
Dedette. Wlerick
DEDIEU, Pierre (French 1928-)
Wood 1957;18 BERCK 256
Deep Colloquy. Consagra
Deep Fissure. Pierluca
Deer See also Artemis; Hercules
Barye. Panther Seizing Stag
Brokoff, F. M. St. Hubert
Byzantine. Box at Hippodrome
Byzantine. Lion Attacking
Deer, relief
Byzantine. A Stag, relief
fragment
Csaky. Stag
English--10th c. Cross-
Shaft: Deer in Interlacing
English--14th c. Chancel
Column: Stag
English--18th c. (?) Agate-
ware Stag
French--12th c. Centaur
Hunting Stag, roundels
Gaudier-Brzeska. Fawn
Gaudier-Brzeska. Sleeping
Faun
Gaudier-Brzeska. Stags

German--13th c. Aquamanile:
 Stag
Goujon. Diana of Anet
Italian--11th c. Pulpit: San
 Giulio
Maier. Stag
Martin, P. von. Hind
Norman, P. E. Faun
Origo. Death of a Stag
Palliser. Stag, relief
Pompon. Stag
Reznik, Arieh. Does
Staffordshire. Baker's Boy,
 and pair of Deer with
 Trees
Thomas. Deer, garden figure
Verschaffelt. Group of Deer
Wackerle. Youth and Deer
Weiss, M. Hirsch
Deerhurst Font. Anglo-Saxon
Deesis See Jesus Christ--Deesis
 (Christ Between Mary and
 John in Last Judgment)
The Defense. Rodin
DE FONDUTIS See FONDULE, A.
DEGAS, Edgar (French 1834-1917)
 Arabesque Over the Right
 Leg (Arabesque sur la
 Jambe Droite, le Bas
 Gauche dans la Ligne)
 1890/95, cast 1919/20
 bronze; 11-3/8 COOPC
 pl 84 ELCo (#225)
 --c1890/95 bronze; 20 cm
 LIC pl 134 UNNMM
 Ballet Dancer Dressed
 bronze, cloth skirt
 FAIN 168 UMWiC
 Ballet Dancer, dressed 1880
 bronze ROOS 277A
 The Bow c1900 bronze; 33
 cm LIC pl 135 UNNMM
 Cheval et Jockey bronze;
 11-1/4 SOTH-4:72
 Cheval Gallopant sur son
 Pied Droit bronze; 12-1/4
 x18-1/2 SOTH-3:74
 Cheval se Cabrant (Stejlende
 hest) bronze; 30.5 cm
 COPGM 101 DCN (I.N.
 2646)
 Dancer LARM 185 AlAMB
 --bronze MAI 73
 --bronze FEIN pl 134;
 SEYT 45 UMdBM
 --bronze; 11-1/2 YAP 230
 -UWeb

--bronze; 18-1/4 NM-15:34
--bronze; 21-1/2 CHICS
 UICA
--cast after model bronze;
 16 NM-8:48 UNNMM
 (29.100.400)
--1880 bronze; 38 CHAR-2:
 318 FPL
Dancer, Arabesque over
 Right Leg bronze; 12
 DETS 19 UNNH
Dancer, Arabesque over
 Right Leg, Right Arm in
 Front 1882/95 bronze; 8
 READCON 30
Dancer, in Tutu bronze; 39
 YAP 231 -UWeb
Dancer at Rest, her Hands
 behind her Back, Right
 Leg Forward (Danseuse
 au Repos, les Mains sur
 les Reins, la Jambe Droit
 en Avant; The Little
 Dancer) c1890 bronze;
 17-7/8 ROJT 22; TATEF
 pl 25h ELT (5920)
Dancer Looking at the Sole
 of her Right Foot (Danser-
 inde, der ser paa sin
 hojre fodsaal; Danseuse
 Regardant la Plante do son
 Pied Droit) bronze CLE
 173 UOClA (2028.47)
--bronze WATT 71 FPPa
--cast by Hebrard 1919/21
 bronze; 18 BMA 55 UMdBM
--bronze; 45.5 cm COPGM
 105 DCN (I.N.2676)
--1887/95 bronze; 18 JANSK
 972; UPJH pl 201 UNNMM
--1895, cast 1919/20 bronze;
 18 COOPC pl 75 ELCo
 (#226)
--1896 bronze; 19-1/2
 MCCUR 247
--after 1896 bronze; 19-1/2
 HAMP pl 2A UNNMM
--c1896/1911 bronze SELZJ
 169 FPDu
--(Dancer Holding her Right
 Foot) c1900 bronze; c 18
 RAMS pl 47b ELMac
--1910/11? bronze; 18-5/8
 BOW 8; LYN 68; TATEF
 pl 25g ELT (5919)
Dancer Putting on her Stock-
 ing bronze; 17 SELZS 46

MeMG
--(Danseuse Mettant son Bas)
c1900 bronze; 18-3/8
TATEF pl 25f ELT (5918)
Dancing Girl c1882 BERCK
18 FPL
Dressed Ballet Dancer, nude
studies 1879/80 bronze;
28-1/4 BARD-2: pl 404,
409 BrSpA
L'Ecoliere (Skolepigen)
bronze; 27.5 cm COPGM
113, 148 DCN (I.N. 2799)
Fourth Position Front, on
Left Leg 1882/95 bronze;
22-1/2 BARD-2: pl 399
BrRI
Grande Arabesque c1885/90
bronze; 16-1/2 GAUN pl
53; TATEF pl 25c ELT
(5917)
--first time 1896 bronze;
19-1/2 SELZS 25
--second study 1882/91
bronze; 40 cm CAS pl
118 FPL
--second time c1882/95
bronze SELZJ 169 FPDu
--third time 1882/95 FAUL
383 UNNMM
--third position bronze;
25 LAH 107 UCLCM
Grande Danseuse 1880 bronze,
tulle skirt and silk hair
ribbon; 39 UMCF UMCF
(1943.1128)
Horse bronze; 10-1/2 YAP
234 -UWeb
--bronze; 12 YAP 235 -UWeb
--bronze; L: 17 CHAR-2:
320; MALV 125 FPL
Horse and Jockey bronze;
9-1/2 YAP 232 -UWeb
--bronze; 11 YAP 233
-UWeb
Horse Clearing an Obstacle
(Cheval "S" enlevant sur
L'obstacle) c1881 bronze;
12 READAS pl 55; TATEF
pl 25e ELT (6072)
Horse Walking c1896 bronze;
8-1/2 JLAT 17 ULaNA
Jockey on his Horse c1880
bronze; 11-1/4 NOV pl
190b UNNMM
Little Dancer of Fourteen
Years (Danserinde med

balletskort; Dressed Ballet
Dancer; Fourteen-Year Old
Ballerina; Girl Dancer of
Fourteen; Little Dancer Aged
Fourteen Years; Petite
Danseuse de Quatorze Ans;
Young Dancer) bronze ENC
235
--c1880 bronze MAI 74
--c1880 bronze; 39 RAMS
pl 15a ELS
--c1880 bronze; 39 NEWTEM
pl 158 SwZBu
-1880 bronze; 39 BARD-2:
pl 402, 405-7 BrRI
--1880 bronze, muslin skirt,
satin hairribbon; 99 cm
BURN 22; CHENSW 466;
LIC pl 136-7 UNNMM
--1880/81 bronze; 39 BOES
95; COPGM 103 DCN
(616, XX)
--1880/81 bronze with cloth
accessories; 39 CANM
207 UPPMc
--1880/81 bronze, muslin
skirt and satin hair-
ribbon, on wood base; 39
(excl base) BOW 11; LIC
col pl 4 (col); MYBS 55;
READAS pl 192; ROTJG
pl 8; TATEF pl 14; WHITT
47 ELT (6076)
--1880/81 bronze and fabric;
40 GIE 4-5; MCCUR 247
FPL
--1881 bronze; 39 NOV pl
190a NRBoy
--1880/81 ptd wax; 39
READCON 33 (col) UVUM
--wax and cloth; 38-1/2 GAF
153 FPL
The Masseuse c1896 bronze;
42x38x30 cm LIC pl 139
UNNMM
Nude Study, for "The Four-
teen Year Old Dancer
Dressed" 1879/80 bronze;
28-1/4 SCON 24 ScEN
(No. 1624)
Pregnant Woman c1896/1911
bronze; 16-3/4 READCON
28 UNNH
Rearing Horse 1865/81
bronze; 12-1/8 MCCUR
247 UNNMM
Seated Woman Wiping her

Left Side c1900 bronze;
35 cm LIC pl 133 UNNMM
Seventeen Bronze Casts of
Waxes: Female Figures;
Dancers; Horses; Bathers
ELIS 82-93 UNNMM
Spanish Dancer (Danse Espag-
nole; Spansk Dans) bronze;
43 cm COPGG 104; COPGM
109 DCN I. N. 2678)
--c1881 bronze; 17 JLAT
16 UNNDan
--1900? bronze; 17 BARD-
2:pl 403 BrSpA
Study of Nude Dancer (Etude
de Nu pour la Danseuse
Habillee) c1879, cast
1919/21 bronze; 28-3/4
ALB 143; ALBA; FAIY
4; RIT 62 UNBuA
Trotting Horse c1879/81
bronze SELZJ 167 FPDu
The Tub c1886 bronze; 47x
42 cm BURN 22; LIC pl
138 UNNMM
Variations on the Grand Ara-
besque 1882/95 bronze;
15-3/4 GIE 6-7 FPPa
Woman in an Armchair bronze;
12-1/2 INTA-1:101
Woman Rubbing her Back with
a Sponge c1900 bronze; 18
CANM 207 UPPPM
Woman Washing her Left
Leg bronze; 7-7/8 DETS
16 UNNH
DI GIORGI, Giorgio (Italian 1918-)
Bronze Sculpture 1959 CANK
175
Figura in Piedi 1955
bronze; 1.9 m SCUL pl
38
Relief-Composition 1960
bronze MAI 75
Sculpture 1956 bronze
MAI 75 IMR
Scultura 1957 bronze;
2.35 m SCUL pl 39
DEGIER, Hans (German d 1637)
Altar wood CHASEH 405
GAuU
Birth of Christ, High
Altar 1604 ptd linden-
wood; LS MUL 16 (col)
GAuU
Le Degout Personnifie.
Daumier

Deianira
Bologna. Nessus and
Deianira
Traverse. Nessus and
Deianira
DEI FEDELI, Ercole See
DA SESSO, Salamone
DEIGHTON, Thomas D. (English)
Battle of Trafalgar, docu-
mentary model 1862
SOTH-4:vii
DEJEAN
L'Accueil, study BAS 151
Etude de Femme BAS 152
FPM
Femme a Genoux BAS 149
FPM
Hope (L'Esperance) BAS 150
Leon Bernard, head BAS 153
Nymph# BAS 147, 148 FPTo
Orphee Mort BAS 153
De Kinder, Mrs.
Leplae. Mrs. de Kinder,
head
DEKKERS, Ad (Dutch 1938-)
Variatie op Cirkels 1965
KULN 123
DE LAAK (Dutch)
Wall Relief cast concrete
DAM 71 NATe
Delacroix, Eugene (French Painter
1798-1863)
Dalou. Delacroix Monument
David D'Angers. Delacroix
Medal
Milles. Aganippe Fountain:
The Painter, representing
Eugene Delacroix
DELAHAYE, Jacques (Charles
Jacques Delahaye) (French
1928-)
Adar 1958 bronze; 7 MINE
21 UNNJ
L'Aile 1957 bronze; 21-3/4
ALBC-2:#49 UNBuA
The Cat 1952 bronze; 19-
5/8x63x14-5/8 TRI 147
FPSt
The Cat 1956 bronze; 18-1/2
MINE 21 UNNC
Cavalier IV bronze; 16x63x
15 CARNI-58:pl 7 FPSt
Cavalier Victorieux 1962
bronze; c 75 cm SP 34
GHaS
Personnage II 1956 MAI 76
Samurai, second version 1961

bronze MARC pl 81 (col)
FPSt
Standard, second version 1961
bronze MARC pl 80 FPSt
DELAISTRE (French)
Cupid and Psyche (Amour and
Psyche) 1814 marble
HUBE pl 25 FPL
DE LALAING, Jacques (Belgian)
Fighting Horsemen ROOSE
298 BBLou
Wrestlers, equest
MARY pl 133 BB
DELAPLANCHE (French? 1836-91)
Madonna marble
MILIER il 181 FPLu
De la Plata
Bernini, G. L. Fiumi Fountain
De la Pole, Sir John and Lady
English--14th c. Sir John and
Lady de La Pole
DE LA SONNETTE, Georges (French)
See also DE LA SONNETTE,
Jean M.; MICHEL, Jean
Mourner, Entombment detail
mid 15th c. BUSR 82 FToH
DE LA SONNETTE, Jean Michel, and
Georges DE LA SONNETTE
(French fl 15th c.)
Holy Sepulchre; detail:
Saint, head 1452 REAU
pl 120, 121 FToH
Woman with Box of Ointment
1451/53 stone KO pl 45
FToH
De Laszlo, Philip A.
King, W. C. H. Philip A.
de Laszlo, bust
DELAUNAY, Robert (French 1885-
1941)
Rhythm-Relief 1933 32x40
BERCK 257
De l'autre Cote du Pont
Tanguy, Y. From the Other
Side of the Bridge
Delaware, 9th Earl of
English--16th c. Chantry of
9th Earl of Delaware
De la Warr Tomb. English--16th c.
DEL BO, Romolo (Italian)
Dancers marble
VEN-22: 84
Dawn (Aurora) Gandoglia mar-
ble VEN-24:pl 44
Eclogue (Egloga) marble
VEN-26:pl 42
DELCOUR, Jean (Belgian 1627-1707)
A. K. Lamboy Tomb: Abbess

of Herchenrode
STA 167 BHasN
Angel, study 1681 clay
BUSB 106 BLCu
Bishop d'Allamont Monument
begun 1667 GER pl 21 BGC
--Madonna and Child
BUSB 108 BGC
Dead Christ
ROOSE 203 BHaC
--1696 GER pl 28b BLC
Delcroix, Carlo
Santagata. Carlo Delcroix,
bust
DE LEDNICKA LZCZYTT, Maryia
Il Santo, kneeling figure wood
VEN-28:pl 90 IR
DELEMER, Jehan (Netherlandish),
and Robert CAMPIN
Annunciation: Angel and Virgin
MULS pl 69 BTouMad
Delessert, Benjamin (French Indus-
trialist 1773-1847)
Daumier. Benjamin Delessert,
bust
DELFINO
Flight*
EXS 37
Delilah See Samson
DE LISI, Benedetto (Italian 1898-)
Swimmer (Nuotatrice)
VEN-34:pl 33
DELL, Peter (German 1501-45?)
Plaque pearwood
CLE 111 UOClA (27.427)
della Torre Monument. Riccio
DELLI, Dello di Niccolo (Italian
c 1404-66/67)
Coronation of the Virgin,
detail c 1424 terracotta
ptd white SEY pl 18A IFEg
Del Monte Chapel. Ammanati
DELNEST, Robert
Bas Relief, Pavilion entrance
1935 CASS 96
DE L'ORME, Philibert (French
Architect 1515(?)-1570) See
also Marchand, Francois
Screen c 1545
BLUA pl 33 FPStE
DE L'ORME, Philibert, and Pierre
BONTEMPS
Francis I and Claude of
France Tomb begun 1547,
finished 1558
BAZINH 266; BLUA pl 34;
ST 330 FPDe
DE LOTTO, Annibale (Italian)

Laborer
VEN-10:pl 134
Delphi
Hepworth. Curved Form
Delphine. Hajdu
Le Deluge. Gigon
DELUOL, Andre (French 1909-)
Female figure stone
MAI 76
DELVAUX, Laurent (Flemish 1695-
1778) See also Plumier,
Denis; Scheemakers, Peter
Pulpit, detail 1745
ENC 239 BGC
Theological Virtues
DEVI-2; LARR 402 BBR
Truth Showing Holy Writ to
Awakening Human Race,
pulpit base 1745 BUSB
147 BGBa
Vertumnus and Pomona c 1725
marble MOLS-2:pl 24;
WHINN pl 69
DEMARCO, Hugo Rodolfo (Argentine-
French 1932-)
Relief de Placement Continuel
1966 KULN 192
DEMARTINI, Hugo (Czech 1931-)
Relief I 1965 tin and lacquer
ptd; 100x60 cm GER 59
Structure 1965
KULN 168
DE MARTINI, Giovanni (Italian)
Compagni Bastardi
VEN-24:pl 129
Holy Child (Sacro Fanciullo)
bronze VEN-28:pl 72
Pastorello Divino bronze
VEN-30:pl 144
Demeter (Ceres)
Angier, M. Ceres
Arp. Demeter
Early Christian. Diptych of
Niomachi and Symmachi,
left panel: Ceres--
Priestess before Altar of
Cybele
Italian--15/16th c. Cassone:
Demeter and Hecate
Searching for Persephone
Ledward. Ceres
Martin, E. Demeter No. 3
Rousseau, V. Demeter
DEMETRIADIS, Kostas (Greek)
Head of Young Girl marble
CASS 35
Demetrius, Saint
Italian--13th c. St. Demetrius,
relief

Demeure, No. 3. Martin, E.
Demidov Monument. Bartolini
Democritus, bust. Netherlandish
La Demoiselle de Venise V
Giacometti. Woman (Venice V)
Demons See Devils
Demonstrators# Trsar
Denby "Reform Spirit" Flasks.
English--19th c.
DENHOF, Anna (Austrian)
Angel Concert, relief lime-
wood PAR-2:94
Denis, Saint
French--13th c. Portal of
the Virgin: St. Denis
Between Two Angels
French--14th c. St. Denis
Le Depart. Schwarz, Heinz
Le Depart pour le Guerre
Rude. Departure of the
Volunteers of 1792
Departure of the Volunteers of 1792.
Rude
DEPERO
Steel Devil
MARY pl 121
Deployed Form. Bakic
Le Deporte. Osouf
Las Deportistas. Cruz Martin
Deposition See Jesus Christ--
Deposition
Deposition. Piche
DERAIN, Andre (French 1880-1954)
Crouching Man 1907 stone;
13 GIE 44-5 FPLe
Head of a Woman 1939/53
bronze MAI 77
Man, bas relief 1939/53
bronze MAI 77
Nude Woman Standing 1906
stone SELZJ 195 FPMV
Squatter 1907 stone; 13
TRI 57 FPK
Derain, Mme.
Despiau. Mme Derain, head
Derby, Alice, Countess of
Colt. Alice, Countess of
Derby, Hearse Monument
Derby I. Koenig
DERBY PORCELAIN See also
English--18th c.
Bouquets late 1820's porcelain
CON-5:pl 61
Chinaman and Boy c 1755
porcelain; 9-1/4
CON-3:pl 51 ELV
Royal Family, in three
grouped pieces (after ptg
by Zoffany) c 1771 unglazed

CON-4:pl 47
DERKERT, Siri (Swiss 1888-)
 Ada Nilsson c 1950 glazed
 terracotta VEN-62:pl 188
 Artefact I 1961 cement
 VEN-62:pl 189
DE RUDDER, Isidore (Belgian
 1855-)
 The Nest
 ROOSE 298 BAMu
DERUJINSKY, Gleb
 Angel Gabriel wood
 PUT 317
 Annunciation wood
 PUT 317
DERWENT-WOOD, Francis (English
 1872-1926)
 Torso of a Girl
 UND 126 ELV
DESBOIS, Jules (French)
 Winter
 TAFTM 47
Descendent l'Escalier. D'Haese
Descent from the Cross See Jesus
 Christ--Deposition
Descent into Hell. Stammel
Descent of the Holy Spirit
 French--12th c. Christ in
 Miracle of the Pentecost
DESCOMBIN, Maxime (French
 1909-)
 Bird-Harp 1948 oak; 34
 SCHAEF pl 116
 Mural Composition 1957
 BERCK 218
 Small Sculptured Steel Shell,
 with Dynomystical Relief
 on a Single Planet 1957,
 1958 MAI 78
The Deserted. Barlach
Le Desespoir
 Rodin. Despair
Deshabille. Schwerdtfeger
DESIDERIO DA SETTIGNANO
 (Italian 1429-64) See also
 Donatello
 Altar of the Sacrament;
 Angel Heads; Dead Christ
 with Virgin and St. John
 c 1450/51 marble;
 1/2 LS POPR fig 45, pl
 62-3 IFLo
 --Angel Head
 MAR 45; MOLE 115
 --Dead Christ Mourned by
 Virgin and St. John
 SEY pl 89B IFLo

Boy, bust
 ROOS 112C AVE
A Boy, bust marble
 BODE 145 FPD
The Boy Christ and St. John
 Baptist marble
 BODE 141 FPD
Bust of a Lady (Isotta da
 Rimini) marble; 20-7/8x
 19-3/16x7-13/16 KRA 43:
 SEYM 86, 88; USNI 227;
 USNK 180; USNKP 402
 UDCN (A-30)
--c 1440 marble; 46 cm
 CHENSN 345; CHENSW
 380; ENC 242; HALE
 175; MCCA 78; POPR
 pl 66; WOLFFC 29 IFBar
Carlo Marsuppini Monument
 c 1455/58 marble;
 L: c 91 BR pl 11;
 ENC 242; FREEMR 105;
 LARR 112; MCCA 27;
 POPR fig 161; ROOS
 111F; SEY pl 72; ST
 305; UPJH pl 109
 IFCr
--Child, head
 HALE 171
--Eros
 ROOS 111G
--Madonna and Child, tondo
 relief MURRA 209; POPR
 pl 67; SEY pl 74A IFCr
--Putto marble; 38
 JANSK 633
--Putto with Shield marble;
 96 cm POPR pl 68
Cherub Head, Tabernacle
 fragment marble; 11-1/2
 NCM 271 UCLCM
 (A.5141.50.8)
Cherub Heads marble; 16
 NCM 271 UCLCM
 (A.514.50.926)
Child, head
 PUT 26
Chimneypiece, detail
 MACL 142 ELV
Christ and St. John the
 Baptist as Children, tondo
 marble LOUM 123 FPL
 (701)
The Christ Child c 1460
 marble; 12x10-7/16x6-
 7/16 KRA 38; SEY pl
 76B; SEYM 74-7; SHAP

pl 93; USNI 227; USNK
178; USNKP 401: WALK
UDCN (A-148)
The Christ Child, right hand
raised in blessing 15/16th
c. stucco; 28 CAN-1:145
CON (3083)
Florentine Girl, bust
WOLFFA 35
Foulc Madonna, relief 1455/
60 marble; 59x45 cm
POPR pl 61; ROBB 371
UPPPM
Julius Caesar, relief marble;
.42x.29 m CHAS 29 FPL
Laughing Boy marble
BAZINW 339 (col); BODE
144; WB-17:201 AVB
Little Boy, bust 1455/60
marble; 10-11/32x9-3/4
x5-7/8 CHENSW 380;
POPR fig 83; SEYM 78-9;
UPJH pl 111; USNC pl 15;
USNP 152 UDCN (A-2)
Madonna and Child, relief
CHASEH 311 IFPa
--marble
BODE 113 FPD
--marble
POST-1:179; SEW 490;
UPJ 261 ITP
--marble; 27x27-1/4
USNI 226; USNP 150
UDCN (A-3)
--15th c.
GLA pl 34
--3rd Q 15th c. marble;
10-5/8x6-1/2 ASHS pl 19;
MACL 141 ELV
--c 1460 marble
HALE 174; ROOS 112G
IFBar
Madonna and Laughing Child
clay BODE 150 ELV
Marietta Strozzi, bust
MACL 139 UNNMM
--marble
PRAEG 296
--marble; 22-1/2x20-15/32x
9-5/8 CHRC fig 62;
SEYM 81-2, 84-5; SEYT
20 UDCN
--1460/64 Carrara marble;
52.51 m
BODE 124; BSC pl 79
GBS (77)
Princess of Urbino, bust
c 1460 limestone; 18-1/2

BERL pl 202; BERLES
202; BERLEI front; BODE
125; KO pl 76; SEW 472-3
GBSc (78)
Profile of a Woman, relief
grey stone NYWC pl 23
UMiDFo
Profile of a Young Woman,
relief stone (pietra sirena);
20-1/4x13 DETT 72 UMiD
(48.152)
St. Jerome in the Desert
(St. Jerome and the Lion),
relief c 1455 marble;
16-3/4x21-1/2
POPR pl 65; SEY pl 71;
SEYM 102-5; SHAP pl 19
UDCN
St. John the Baptist as a
Child, relief c 1450
BARG; BUSR 78; POPR
fig 52 IFBar
St. Mary Magdalen
POPR fig 98 IFT
Tabernacle marble; 126-
5/8x31-3/4 CHRP 234;
USNKP 403 UDCN (A-1624)
Tabernacle c 1461 marble
CHAS 68; ROOS 112D-E;
SEY pl 90 IFLo
Unknown Warrior, relief
bust HOF 208
Woman's Head, relief fire-
place detail mid 15th c.
sandstone; 8-1/2x12'
READAS pl 159 ELV
The Young Christ with St.
John the Baptist, relief
marble; 15-3/4 Sq
CHRP 201; READAS pl 70;
USNI 226; USNP 151
UDCN (A-4)
DESIDERIO DA SETTIGNANO-FOLL
Bust of Girl 2nd half 15th c.
ptd wood; 22 HAUSA pl
26; KOPE 76 (col) FPL
Desiderius
Early Christian. Cross of
Desiderius
Design for Construction in Iron
Wire.
Picasso
Design for a Monument for the City
of Leeuwarden. Doesburg
Desire. Maillol
DESJARDINS, Martin (real name:
Martin van der Bogaert)
(Dutch-French c 1640-94)

See also Le Pautre, A.
Colbert de Villacerf, bust
 marble; 29
 KO pl 96; LOUM 163 FPL
 (1249)
Crossing the Rhine, relief
 1680/86 BUSB 91 FPL
Louis XIV, in classical dress
 marble; 38-3/8x19-3/8
 USNKP 442 UDCN (K-334)
Louis XIV Effecting the Peace
 of Europe, or the Peace
 of Nimbeque 1686 bronze;
 43x66 LOUM 167 FPL
 (1253)
--detail
 CHAR-2:150
Pierre Mignard, bust marble
 LOUM 163 FPL (1248)
DESKOVIC, Branislav (Yugoslav
 1885-1939)
Dog on the Scent 1913 bronze
 BIH 39 YZMG
DE SOETE, Pierre Jean (Belgian
 1886-)
My Daughter bronze
 VEN-36:pl 48
Desolation. O'Connor
de Soto, M.
 Gargallo. Monsieur de Soto,
 bust
Despair. Aronson
Despair, south aisle capital.
 French--12th c.
Despair. Rodin
Despenser, Edward, Lord d 1375
 English--14th c. Edward,
 Lord Despencer
Desperation. Han
DESPIAU, Charles (French 1874-
 1946)
A. Dunoyer de Segonzac,
 bust HUX 78
Anne Morrow Lindbergh,
 head 1939 bronze
 VALE 50 UMNSA
Antoinette Schulte, bust
 1934 bronze; 19-3/4
 ENC 243; TATEF pl
 26e ELT (4932)
--1934 original plaster;
 21-1/2 ALBC 179; RIT
 64 UNBuA
--1937 bronze; 18-3/4
 NNMMARO pl 267
Assia
 BAS 35

--1937 bronze; 75
 MID pl 16 BAM
--1938 bronze; 72-3/4
 BAZINW 427 (col); BOSME
 pl 95; JOH 17; MCCUR
 251; NNMMAP 123;
 NNMMARO pl 266; NNMME
 36; NNMMM 45; RIT 65;
 UPJH pl 239 UNNMMA
Athlete in Repose 1923 bronze;
 13 PUL-2:pl 126
Berthe, head 1928 bronze
 VALE 50
Bust of a Woman bronze
 PANA-2:139 UNhHD
Child, head
 PUT 234
Contesse Gilbert de Voisins,
 head
 BAS 32
Eve 1925 bronze; 190x60x42
 cm BAZINH 480; LIC pl
 180; MARC pl 8 FPM
La Femme aux Yeux Baisses
 BAS 33
Head
 CASS 34
L'Homme que Vase Lever
 BAS 31
Jeanne (Mlle. Kamienska)
 1921 bronze; 15 DETS
 35 UNNH
Jeune Fille des Landes, head
 plaster cast; 11-1/2;
 block; 5-1/2 LAH 106
 UCLCM
Jeune Landaise, head
 AUES pl 40 FPM
Little Peasant Girl 1904
 original plaster; 15-3/4
 NNMMAP 122 UNNMMA
M. E. P., Head
 BAS 31
Mme. A. D., bust
 BAS 34
Mme. Agnes Meyer, head
 1929 gilded bronze;
 .62x.19x.19 m MOD
 FPM
Mme. Arthur, bust
 AUES pl 39
Mme. Derain, head 1922
 bronze; 13; base; 6x6
 READCON 20 UDCP
--1922 original plaster model;
 13; on base; 6x6
 CHENSW 474;

PH pl 153; SEYT front UDCP
Mme. Fontaine, bust
BAS 37
Mme. Janick, bust
BAS 36
Mme. L. Henraux, bust
bronze VEN-30: pl 176
Mme. Leopold Levy, head
bronze BAS 32; SFGC 21
Mme. P. L. W., bust
BAS 37
Mme. P. M., bust bronze
HUX 79
Mme. Stone, head 1926
bronze; LS RAMS pl 41
Mlle. Bianchini, head 1929
bronze; 15 DETT 215;
GERT 53; RICH 185
UMiD (35.7)
Mlle. Jeanes plaster
ZOR 106 UNNMMA
Maria Lani, head bronze;
14 UNNMMAM # 62
UNNMMA
Mask plaster; 9
NCM 203 UNcRV
Mrs. Edward Bruce bronze
SEYT 37 UDCB
Mrs. Eugene Meyer, head
plaster; 32 YAP 236 - UM
M. Arnaud, head 1918
bronze; 12 CAN-2: 186
CON
M. Jean Thys, head
BAS 30
M. Lievre, head
BAS 30
Nude of a Young Girl
Standing 1925
MAI 79 FPM
Paulette, bust
BAS 29
--TAFTM 49
--1907 bronze RAMT pl 29
--1907 marble SELZJ 155
FPM
--1907 plaster MARC pl 9
(col) FPM
--1910 bronze; 41x30x20 cm
LIC pl 179 FPM
--1939 LARM 289 AlAL
Petite Fille des Landes,
head 1904 bronze; c 16
RAMS pl 40; RAMT pl 30
Portrait de Jeune Fille
MILLER il 193 FPL
Portrait Head bronze
SLOB 245 UNNMMA

Portrait of a Woman, head
bronze MAI 78
Portrait of an American,
head bronze; 15 MID pl
15 BAM
Princesse Murat, head
BAS 32
Seated Youth
PEP pl 14
--1932(?) bronze 30
NNMMARO pl 265
UNNRojm
Standing Female Figure
c 1925 bronze; 31-1/2
DETS 36 UNNH
Standing Figure c 1925
bronze; 31-1/2 SELZS
98 UNNH
Standing Nude
ROOS 278C FPLu
--bronze; 36
YAP 239 UNNCl
Torso
HOF 40
Torso of a Young Woman;
bronze; 52 PUL-1: pl 56
Young Peasant Girl, head
pewter; 11-1/2 RICJ pl
37 UNNMMA
DESRUELLES, Felix (French 1865-
1943)
Monument to Four Hostages
1924, destroyed 1941, re-
constructed 1960
LIC pl 347-8 FLiV
DESSERPRIT, Roger (French 1923-)
Sculpture bronze
MAI 80
DE STROBL, Zsigmund Kisfaludi
(Hungarian 1884-)
Morning pink Hungarian
marble PAR-2: 108
DE SWIECINSKI, George Clement
(Polish-French)
Wise Virgin marble
PAR-2: 176
DE SZCZYTT-LEDNICKA, Marie
(Polish 1895-)
Black Angel wood
PAR-2: 177
Le Deux Douleurs. Riviere
Deux Negresses. Matisse
Deux Plans S'Interpenetrant.
Witschi
Deutsche Wehr. Hussmann
DEVAL, John, the Younger
(English 1728-94)
Thomas Spackman Monument

1786
GUN pl 8 EClif
DE VECCHI, Gabriele (Group T)
(Italian 1938-)
Triangle-Quadrato 1963
electro-mechanical mobile
construction VEN-64:pl 102
De Vecchi di Val Cismon, Count
C. M.
Guerrisi. Count C. M. De
Vecchi di Val Cismon,
bust
Developable Column. Pevsner
Developable Column of Victory.
Pevsner
Developable Surface# Pevsner
Developed Form. Bakic
Development D. Marchese
Development of a Bottle in Space.
Boccioni
Devilish Colloquy. Consagra
Devils See also Gargoyles;
Grotesques
Ammanati, B. Colossal Head
Bologna. Apennine Figure
Caille. Two Devils
Cesar. Devil
Duret. St. Michael Over-
coming the Devil
English--12th c. Capital:
Devil
Flaxman. Satan Overcome
by St. Michael
Folk Art--Austrian. Devil
Mask, Tyrol
French--12th c. Capital:
Angel Enchaining a Devil
--Capital: Christ and the
Tempter
--The Damned Seized by
Devils
--Devil
French--13th c. Last Judg-
ment: St. Michael Weigh-
ing Souls; Angel and
Devil
German--12th c. Apse De-
mon's Head
German--13th c. Capital:
Human-Bird Demons
German--14th c. Demon
Animal Head
Gofridus. Choir of S.
Pierre--Grotesque Capitals
Hartmanus. Capital: Heads
of Demons
Italian--13th c. Devils,
reliefs

Medieval. Mystery Play
Masks
Reichle. Archangel Michael
Victorious over Satan
Richier, G. The Devil
Romanesque--French.
Temptation of Christ,
capital
Le Devouement. Stappin
The Dew. Le Lorrain
De Wet, Christiaan Rudolph (Boer
Soldier and Politician 1854-
1922)
Costa, J. M. da. General
de Wet
Dewey, John
Epstein. John Dewey, bust
D'HAESE, Reinhoud (Reinhoud;
Reinhout D'Haese) (Belgian-
French 1928-)
Burnous 1963 cobre; 44x21
cm SAO-7 FPFr
Le Cuocio Sempre al Burro
1965 ottone VEN-66:#148
UNNBro
Descendent l'Escalier 1961
red copper MEILD 130
FPFr
From the Moment he Suffers
1961 brass; 39-1/2
SEAA 141 FPFr
Sculpture 1959 copper
MAI 248
Sculpture B 1958 brass;
75 MID pl 118 BAM
D'HAESE, Roel (Belgian 1921-)
"A Lamumba" 1961 bronze;
56 SEAA 140 FPB
Eric, Norseman 1957 bronze
VEN-58:pl 134
The Flagellant 1959 bronze;
27-1/2 MINE 70 FPB
Ghermoska 1959 H: 20
CARNI-61:#91 FPB
The Great Ghost 1958 bronze;
26 BERCK 178
The Indifferent Man 1959
bronze; 26-3/4 TRI 139
FPHai
The Happy Violin 1965
bronze; 55 GUGE 85
GMVan
--1965 wax; 55-1/8
NEW pl 190 GMVan
I Stand in the Rain 1957
bronze; 24 MINE 32
UNNStre
Legendary Personage

(Personnage Legendaire)
1956 bronze; 28-3/4x14
GIE 307 BBG
La Nuit de Saint Jean 1961
bronze; 53-1/8x51-1/8
MEILD 105; READCON
249
The Saracen 1958 bronze;
30 MID pl 115 BAM
Sculpture*
EXS 16
Sculpture 1958 bronze
MAI 80
Siren 1951 marble; 24x39
MID pl 116 BAM
Song of Evil 1964 110-1/4x
106-1/4x31-1/2
CARNI-64:#18 FPB
Dia III. Caniaris
Diablo. Richier, G.
The Diabolos Player. Richier, G.
Diagonal Construction. Pevsner
Diakon, Saint
Austrian--15th c. St. Diakon
Tirolean. St. Diakon
Dialect and Rhetoric
Pisano, G. Pisa Pulpit:
Dialect and Rhetoric
Dialektisches Objekt 10. Lenk
Dialogue. Uhlmann
Dialogue at S. Angelo. Consagra
Diana See Artemis
Diana. Jenkins, F. L.
Diana as an Engine. Paolozzi
Diana Fountain. Fanelli, F.
Diana Fountain. Gleichen
Diana Fountain. Italian--18th c.
Diana Fountain. Milles
Diana of Anet. Goujon
Diana of Anet. Primaticcio--Foll
Diane de Poitiers, Duchesse de Val-
lentinois (Mistress of Henry
II of France 1499-1566)
Goujon. Diana of Anet
Goujon--Attrib. Diane de
Poitiers
Diaper-work
English--13th c. Angel Choir:
Diaper Work
Diaplanetic Light. Sklavos
Diarchy. Armitage
Diary. Consagra
Diaz, Rosita
Barral. Rosita Diaz, head
Dice See Games and Sports
DICK, William Reid (English
1879-)

Decorative Panels: Carpentry;
Boxing AUM 138 ELSe
Force Controlled Portland
stone MARY pl 154 ELUH
James Bryce, bust bronze
FAIR 354; USC 194
UDCCap
King George V, bust
HUX 70
The Kiss bronze
MARY pl 53; VEN-34:
pl 155
Kitchener Memorial Chapel
--Altar Panel
AUM 137 ELPa
--Kitchener Coat of Arms
AUM 131
--Pieta marble
AUM 138; MARY pl 45
--Putti
MARY pl 167
Little Boy
VEN-28:pl 143
President Roosevelt 1948
bronze; over LS RAMS pl
10b ELGroS
Silence
MARY pl 46
Diderot, Denis (French Scholar
1713/84)
Houdon. Diderot, head
Dido
Cayot. Death of Dido
DIEGA DE LA CRUZ (Spanish fl
1486-99) See SILOE, Gil de
Diego of Alcala, Saint See James
of Alcala, Saint
Dienstboten Madonna
Austrian--14th c. Servants'
Madonna
DIERKES, Paul (German 1907-)
Bird 1946 stone; 24
SCHAEF pl 24
Black Horses (Die Schwarzen
Pferde) 1949 stone
GERT 227
Crouching Woman 1946 stone;
28 SCHEAF pl 25
Dancer (Tanzerin) 1950 bronze
GERT 226; KO pl 106
Fallen Angel stone KO pl 106
Sheep's Head 1952 sandstone;
11-3/4x26-3/4x4 TRI 146
DIESNIS
Un Samaritain le Vit et Fut
Touche de Compassion
(St. Luc) FPDEC il 8

:

Bacchus, diptych leaf
German--12th c. Bacchus
 head(?), aquamanile
Hildebrand. Dionysus,
 relief
Italian--16th c. Bacchus
Lombardo, T. Bacchus and
 Ariadne, busts
Michelangelo. Bacchus and
 Faun
Roccatagliata. Bacchus
Sansovino, J. Bacchus
Tacca, F. Infant Bacchus
Traverse. Bacchus Enfant
DIOS DE LA MADERA See MARTIN-
 EZ MONTANES, Juan
Dioscuri. Colla
Diptique "Plessis-les Tours".
 Kalinowski
Diptychs
 Byzantine. Consular Diptych#
 Byzantine. Diptych#
 Early Christian--10th c.
 Rambona Diptych
 French--9th c. Diptych of
 Areobindus
 French--13th c. The Soissons
 Diptych: The Passion
 Italian--10th c. Diptych:
 Crucifixion
DIPTYCHS OF THE PASSION
 ATELIER
 Diptych: The Nativity; The
 Crucifixion 14th c. ivory
 NCM 285 UNNMM
 (11.203)
DIRR, George (fl 1780), and J. G.
 WIELAND
 Death and the Abbot c1774/
 94 alabaster, Salem,
 near Lake Constance
 BUSB 213
Disagreeable Object. Giacometti
Disciples See also Apostles
 Riemenschneider. Altar of
 Our Lady: Disciple, head
Discordia. Francesco di Giorgio
 Martini
Discovery Group
 Persico, E. L. Capital,
 East Front
Discs in Echelon. Hepworth
Discus Thrower. Encke
Dishes
 Baerdt. Dish
 Biennais and Lorillon. Jam
 Dish

Byzantine. Dish#
Early Christian. Dish#
English--16/20th c. West-
 minster Abbey Plate
French--16th c. St. Por-
 chaire Pedestal Dish
German--17th c. Ceremonial
 Dish and Jug: Europa and
 The Bull
German--18th c. Child with
 Cornucopia, dish cover
Joubert. Dish
Lutma. Dish
Palissy--Foll. Footed Dish
Russian--2nd c. Dish:
 Nereid Riding Hippocampus
Vianen, P. Diana and Actaeon,
 dish
Disillusion
 Queriolo. Deception Unmasked
Il Disinganno
 Queirolo. Deception Unmasked
Disintegration. Teana
DISKA, Patricia (American-French
 1924-)
 Eve 1959 ptd marble
 MAI 81
"Dismal Hound"
 English--18th c. Bow Dismal
 Hound
Dismas, Saint
 German--17th c. St. Dismas
Disputa. Raphael
The Disputation
 German--13th c. St. George's
 Choir Screen: Prophets in
 Disputation
Disraeli, Benjamin
 European (?). Disraeli
Distant Murmur
 Chillada. Whispering of the
 Limits
DISTEL, Herbert (Swiss)
 Kegelplastik VII 1965/66
 KULN 123
The Distressed Mother, Monument
 to Mrs. Warren. Westma-
 cott
Disturbed Balance. Duchamp
DITTERICH, Franz
 High Altar 1605
 HEMP pl 23 GStre
Divers See Games and Sports--
 Swimming and Diving
Divided Head. Moore, H.
Divided Pillar. Adams, R.

Diving See Games and Sports--
 Swimming and Diving
Divinita Industriale. Colla
Divinity. Clara
Djalski, Ksaver Sandor
 Kerdic. Medal: Ksaver
 Sandor Djalski, profile
 head
Dmitri, Prince
 Russian--17th c. Prince
 Dmitri, sarcophagus lid
Dobbie, William G. S.
 Gilbert, D. Lt. Gen. Sir
 William G. S. Dobbie,
 bust
DOBES, Milan (Czech 1929-)
 Pulsating Rhythm II 1967
 KULN 189
 White Lighthouse 1967
 KULN 193
DOBSON, Frank (English 1888-1963)
 Admiral Sir William James,
 bust HUX 84
 Charnaux Venus
 UND front
 Facade Decorations 1930
 gilded faience RAMS pl
 6b ELHW
 Figure in Hoptonwood stone
 1930 CASSTW pl 31
 Girl, seated figure 1925
 bronze CASSTW pl 27 ELT
 Group Study 1946 terracotta;
 4 NEWTEB pl 16
 Head of a Girl 1925 bronze
 CASSTW pl 28 ELT
 Jacynthe Underwood, head
 bronze UND 148
 John Underwood, head
 bronze UND 144
 Lydia Lopokova, bust
 WILMO pl 23
 The Man-Child
 AUM 118
 Marble Woman 1924
 CASSTW pl 30 ELCo
 Marine Group 1946 terra-
 cotta; 14 NEWTEB pl 18
 Morning
 AUM 119
 Mother and Child 1946; white
 marble; 12 NEWTEB / pl
 17
 Pax Portland Stone
 CASS 76 ELLe
 Reclining Figure marble
 AUES pl 56 ELCo

Reclining Nude
 CASS 70
 Sir Osbert Sitwell, head
 1923 polished brass;
 12-1/2x7x9 CASS 46;
 MILLER il 193; RAMS
 pl 44b; RAMT pl 6;
 ROTJB pl 93; ROTJG
 pl 16; TATEB-1:18; VEN-
 28:pl 142 ELT (5938)
 Source
 AUES pl 55
 Susannah
 AUM 119
 Two Heads
 AUM 119
 Welsh National War Memorial,
 sketch (not selected by
 Award Committee) 1923
 plaster AUM 118; CASSTW
 pl 29
 Woman with Bowl 1955 cement;
 69 LONDC pl 9
Doccia Porcelain
 Bologna--Foll. Diana (figure
 copied from bronze)
Dock Hand
 Meunier. The Docker
The Docker. Andriessen
The Docker. Meunier
DODEIGNE, Eugene (Belgian-
 French 1923-)
 Sculpture 1926
 BERCK 259
 Sculpture 1957 sognies-
 stein; 160 cm SP 36
 GHaS
 Sculpture 1958 Bluestone;
 74-3/4 TRI 176
 Sculpture 1958 Soignies
 stone MAI 81
 Stone Sculptures: Group and
 three figures 1964, 1964,
 1957, 1960 ea figure of
 three figures: 51 SEITC
 54
 Torso in Soignies Stone 1961
 32-5/8x15-3/4 READCON
 180 FPLo
Dodeka. Jones, Arne
DODERHULTARN (real name: Axel
 Pettersen) (Swedish)
 Funeral wood; 10-12
 GRAT 154-5, 157
 SnST; SnSJ; SnSN
 (Sk 1481)
 Medical Inspection wood

MARY pl 76 SnGK
DOESBURG, Theo Van (Dutch 1883-
 1931)
 Design for a Monument for
 the City of Leeuwarden
 1916 GIE 162 FMeD
Dog Among Reeds
 Minguzzi. Dog Among the
 Canes
Dog Among the Canes# Minguzzi
Dogs
 Agostino di Duccio. Mars,
 zodiac sign, relief
 Andreotti. Thoroughbred
 Barye. Hound and Turtle
 Blundstone. Atlanta
 Bone. Working Partners
 Brokoff, F. M. St. John
 of Mathy, St. Felix of
 Valois, and St. Ivan
 Cellini. Greyhound, oval
 plaque
 Cellini. Nymph of Fountaine-
 bleau: Dogs
 Cibber. Boy Playing Bag-
 pipes
 Cordier, N. Moor with
 Child and Dog
 Damer. Dog
 Damer. Two Dogs
 Dazzi. Countess Marie-
 Jeanne de Bertaux
 Deskovic. Dog on the Scent
 Early Christian. Vine and
 Figure Column Drums
 English--12th c. Crypt Capi-
 tal: Fighting Animals--
 Dragon Battling Dog
 English--13th c. Queen with
 her Dogs
 English--16th c. Boss: Roof
 Boss
 English--18th c. Bow "Dismal
 Hound"
 --Chelsea Shepherd and Two
 Dogs
 English--19th c. Rockingham
 Ornaments: Dog with
 Puppies
 Fabbri. Rissa di Cani
 Fischer, F. Chien Courant
 Fischer, F. Chien Mourant
 Flemish--15th c. Misericords
 French--11th c. Capital:
 Dogs
 French--12th c. Romanesque
 Roundels: Dog

French--14th c. Knight and
 Lady Riding to the Hunt,
 mirror case
French--17/18th c. Venus
 and Adonis
French--18th c. Monkey on
 Dog
Freund. Odin
Frink. Blind Man and Dog
Frink. Dog
Gaudier-Brzeska. Dog
Gauguin. Woman with Dog
 and Foliage, panel
German--16th c. Sitting
 Dog Scratching Himself
German--17th c. Tray
 (Lokhan)#
Giacometti. Dog
Gibson. The Hunter and his
 Dog
Hartwell. Bathers
Italian--4th c. Rhyton:
 Dog's Head
Italian--12th c. Ploughman
 Driving Oxen, relief
Johnston. Boy and Dog
Kandler. Harlequin with Dog
Kandler. Harlequin with Pug
 Dog
Kern, L. Diana
Keyser, William the Silent
 Tomb
Lemoyne, J. L. Diana
Luginbuhl. Grosser Bulldog
McWilliam. Man and Dog
Marshall, E. Lady Culpeper,
 recumbent effigy
Pisano, Niccolo. Pisa Bap-
 tistry Pulpit: Fidelity
Robbia, A. della. Boy with
 Puppies
Schwarz, Heinz. Fille au
 Chien
Schwerdtfeger. Poodle
Spanish--13th c. Alfonso
 the Wise
Spanish--16th c. Dona Mencia
 de Mendoza effigy
Stadler. Dog
Stadler. Standing Dog
Steell. Walter Scott, seated
 figure
Thorvaldsen. Shepherd Boy
Traverse. Rhythm
Traverse. Venus and Adonis
Troubetzkoy. Little Girl and
 Dog

Troubetzkoy. Marquesa Luisa
 Casati
Vanvitelli. The Great Cas-
 cade: Diana and Actaeon
Wallbaum. Diana on the Stag
Weekes. Sleeping Child and
 Dog
Wrampe. Blinder mit Hund
Wyatt, R. J. Penelope
DOLINAR, Lojze (Yugoslav 1893-)
 The Alarm, detail 1947
 bronze BIH 125
 Monument to the Executed
 Patriots at Jajinci 1954
 bronze BIH 127, 128
 The Painter Rihard Jakopic
 1947 bronze BIH 124
 Reconstruction, sketch detail
 1946 plaster BIH 126
D'OLIVEIRA, Abraham Lopes
 (English)
 Sabbath Lamp 1730 silver
 ROTH 331 ELJe
Dollfuss, Engelbert (Austrian
 Statesman)
 Rottler, M. P. Chancellor
 Dr. E. Dollfuss, head
Dolls
 Davie. Doll
 Folk Art--Russian. Ekaterina
 Koshkina and
 Ekaterina Penkina ("The
 Foster Mother")
Dolores. Epstein
Dolphins
 Golkovitch. Dolphin
 Janniot. Fontaine de Nice
 Janniot. Venus
 Lorenzetto. Dead Boy on a
 Dolphin
 Verrocchio. Boy with
 Dolphin
 Vischer, P., the Younger.
 Child on a Dolphin
 Yefimov. Dolphin
Dom Rupert's Madonna
 Romanesque. Galaktotrophusa,
 so-called Dom Rupert's
 Madonna
Domador de Cavalos. Grate
The Domed Man. Serrano
DOMELA, Cesar (Cesar Domela-
 Nieuenhuis) (Dutch-French
 1900-)
 Captive Movement 1947
 ABAM 96
 Construction 1929 glass,
 metal, oil and wood;

35x29-1/2 WALKC 23
 UNNFri
 Construction 1932 metal,
 glass; 17-7/8x13-5/8
 NMAC pl 217
 Sculpture 1957 cement,
 steel, brass BERCK 259
 UNNLe
DOMENECH Y MONTANER, Lluis
 (Spanish)
 Auditorium Chandelier 1906/
 08 SCHMU pl 222 SpBaPM
DOMENICO DI NICCOLO (Italian
 c 1363-1453)
 Chapel of Palazzo, detail
 CARL 43 ISP
 Virgin and St. John the
 Evangelist 1414/16 ptd
 wood; 166 cm POPG pl
 93 ISPi
DOMENICO DI PARIS (Italian c
 1450-92) See also Baroncelli,
 N.
 Decoration of Antecamera
 POPR fig 130 IFeS
Domes See Ceilings
Domestic Worry. Wouters
DOMINGUEZ, Oscar (Spanish-French
 1905-)
 Peregrinations of Georges
 Hugnet (Obect: Ptd wood
 with manufactured toys)
 1935 15-5/8x12-1/2
 NMFA 161 FPHug
Dominic, Saint
 Arnolfo di Cambio. Arca of
 St. Dominic
 Christian. St. Dominic
 Martinez Montanes. St.
 Dominic
 Mazza. St. Dominic Bap-
 tizing
 Niccolo dell'Arca and
 Michelangelo. Shrine of
 St. Dominic
 Robbia, A. della. Meeting
 of St. Francis and St.
 Dominic
Domitian (Roman Emperor 51-96)
 Italian--17th c. Domitian,
 bust
 Porta, G. B. della. Domiti-
 an, bust
Domnulus See Priscus
DOMAGATSKY, Vladimir (Russian)
 A. S. Pushkin, bust
 BLUC 252
Domus. Koenig

DONADINA DI CIVIDALE (Italian
 S. Donato, reliquary bust
 c 1375 WHITJ pl 183B
 ICiD
DONATELLO (Donato di Nicolo di
 Betto Bardi) (Italian c 1386-
 1466)
Abraham and Isaac
 MACL 100; POPR fig 6
 IFC
Altarpiece, sketch detail
 MACL 123 ELV
Amerino in Breeches
 ROOS 109I IFBar
Ascension with Christ Giving
 the Keys to St. Peter,
 relief before 1430 marble;
 16x45 MACL 107; MURRA
 39: POPR fig 22, pl 7;
 VICF 42; WHITT 80 ELV
 (7629-1861)
Athys, or Amore
 POPR fig 136 IFBar
--Feet in Sandals of Mercury
 MCCA 98
Bishop Pecci, tomb-plate
 bronze BODE 14 ISC
Bust of a Young Man
 (Giovanni Antonio da Narni)
 c 1440 bronze; 16-1/2
 BARG; NMI 15, 16; PANR
 fig 143; SFGM # 60 IFBar
Cantoria (Singing Gallery)
 c 1440 marble, polychrome
 inlay; 137x224 BAZINW
 334 (col); BARSTOW 124;
 BEREP 182; BODE 20, 21;
 BUSR 74; CHENSW 377;
 CLAK 289; FREEMR 82;
 JANSK 627; MACL 110;
 MCCA 91, 92 (col), 93;
 MONT 64; POPB fig 20,
 pl 9; POPR fig 20; ROOS
 110B, F, E; SEY pl 36A;
 ST 302; UPJH pl 111 IFCO
--Dancing Angels
 ROTHS 157
--Dancing Children
 ENC 253; KO pl 73; MAR
 34
--Putti
 MURRA 41
Casa Martelli David 1434/38
 marble; 64x19-3/4x16-11/
 16 PANA-1:49; READAS
 pl 84-5; SEYM 66-71;
 SHAP pl 18; VALE 52;
 WALK UDCN

Calvacanti Annunciation, re-
 lief, Tabernacle c 1430/35
 limestone; 95x74-3/4
 BAZINH 206; BODE 19;
 BROWF-3:12; BUSR 69;
 CHASEH 304; CHRC fig
 161; FREEMR 78; MONT
 380; POPR fig 37, pl 11;
 ROBB 368; ROOS 109L;
 SEW 493; STA 166; VER
 pl 29 IFCr
Christ before Caiaphas and
 Pilate, relief, south
 pulpit bronze BODE 29
 IFLo
Coat of Arms of the Miner-
 betti Family stone
 (pieta sirena); 85x29-1/4
 DETT 66 UMiD (41.124)
Crucifixion, relief panel
 BARG IFBar
The Dance of Salome, relief
 marble BODE 19 FLiW
David
 MACL 98 UPPPM
David 1430/32 bronze; 62-
 1/2 AUES pl 19; BAZINW
 333 (col); BIB pl 164;
 BR pl 4; BUSR 70; CHASEH
 300; CHENSW 379;
 CHRP 198; CLAK 54: ENC
 252; FLEM 343; FREEMR
 80: GARDH 312; JANSH
 312; JANSK 629; KO pl
 74; LARR 99; MACL 97,
 109; MEILD 4; MOLE
 111; MONT 64; MOREYM
 pl 163; MU 136; MURRA
 42; MYBA 373; MYRS 48;
 NEWTEA 103; NEWTEM
 115, 116; POPR pl 2, 30;
 RAY 40; ROBB 368; ROOS
 109D, H, I; ROTHS 149,
 153; ST 302; UPJ 257;
 UPJH 110; WOLFFA 12;
 WOLFFC 8 IFBar
--detail
 BARG fr cov (col)
David with the Head of
 Goliath 1430 bronze; 37 cm
 BSC pl 76 GBS (2262)
The Deposition terracotta
 MU 33
Entombment of Christ,
 relief detail
 NEWTER 156 IRP
The Flagellation and Cruci-
 fixion, relief clay

BODE 30 ELV
Font: Feast of Herod, relief
1425/30 bronze gilt;
23-1/2x24 BUSR 68;
GARDH 296; GOMB 167;
JANSH 310; JANSK 623;
LARR 100; MAR 23 (col);
MURRA 38; POST-1:164;
SEW 493; SEY pl 28
--Hope
POST-1:164
--Presentation of Baptist's
Head to Herod, relief
gilt bronze; 60x61 cm
POPR pl 17 ISB
--Putto
POPR fig 134
Gattamelata ("Honey)
Cat"), Condottiere
Erasmo da Narni,
equest c 1446/47 bronze;
c 11x13' BAZINH 208;
BAZINW 334 (col); BODE
26 BRIONA 80; BUSR 1,
67; CHASEH 300; CHENSN
343; CHENSW 376; COL-
20:541; ENC 253; FLEM
344; FREEMR 84; GARDH
312; HUX 63; JANSH 313;
JANSK 628; KO pl 79;
LARR 116; MACL 115;
MARQ 185; MARY pl
126; MONT 381; MOREYM
pl 155; MURRA 43; MYBA
376; MYBU 346; MYRS
45; POPR fig 88, pl 28-9;
POST-1:163; RA 46;
ROBB 369; ROOS 110C;
SEW 494-5; SEY pl 62;
ST 304; UPJ 259; UPJH
pl 110 IPSA
High Altar; Miracle of the
Repentent Son; Miracle
of the Miser's Heart;
Miracle of the New-Born
Child; St. Daniel;
Virgin and Child; St.
Giustina c 1447 bronze
POPR fig 26-7, pl 21-6
IPAn
--Angels Playing Musical
Instruments, reliefs
BODE 51
--The Entombment stone; 54
MOLE 131
Lamentation over the Dead
Christ
MURRA 45

--Miracle of the Angry Son
(cast) LARR 123 (col);
SEY pl 63
--Miracle of the Miser's
Heart (Heart of the Miser;
St. Anthony finding the
Miser's Heart to be Miss-
ing) PANR fig 132; ROTHS
158
--Miracle of the Mule bronze;
22-1/2 BODE 27; MACL
119; MOLE 130; MURRA
44; POPR pl 27; ROTHS
159
--Miracle of the New Born
Child bronze; c 22x48
BAZINW 335 (col)
--Miracle of the Repentant
Son bronze; .57x1.23 m
CHAS 129; GARDH 313
--St. Anthony of Padua
POPR fig 15
--Virgin and Child Enthroned
bronze; 62 BODE 57;
MACL 117; MOLE 129;
VER pl 30
Jeremiah, west side 1427/
36 marble; c 6-1/2
BAZINW 333 (col); BOE
pl 150; CHASEH 299;
GARDH 295; MONT 64;
NEWTEM pl 114;
POPR fig 7, pl 14; POST
-1: 149 IFC
Jesus as infant, bust
HOF 139 IF
Judith and Holofernes c
1457/60 bronze; 92-7/8
(with base)
BODE 23; CHASEH 200;
HAUSA pl 23; NEWTEM
pl 118; POPR fig 9-11,
pl 31, 32; ROOS 110D;
SEY pl 78 IFSi
The Lamentation (Christ in
the Sepulchre; The En-
tombment; Mourning over
Dead Christ), relief c
1480 bronze; 13-1/2x16-
1/2 ASHS pl 18; AUES
pl 18; BROWF-3-12;
CLAK 240; MACL 120;
MOLE 138; READAS pl
102 ELV
Lodovico III Gonzaga, bust
1450 bronze; 34 cm
BSC pl 77 GBS (52)
Madonna and Angels, relief

plaster BODE 59 ELV
Madonna and Child clay,
bronze BODE 64; SEW
488 ELV
--terracotta; 47-9/16x
18-19/32x13-3/16
SEYM 59-63; USNI 228;
USNP 148 UDCN (A-1)
--clay, colored and gilded
BODE 63 GBK
--ptd stucco on wood; 27x
26 NCM 38 UNcRA
--relief, San Lorenzo a
Tignano mid-15th c. ptd
terracotta; 41x29-1/2
KO pl 80; LOUM 121;
POPR pl 19 FPL (704)
Madonna in the Clouds
stiacciato c 1435 marble;
13 BOSMI 129 UMB
(17.470)
Madonna with the Crouching
Infant marble
BODE 62 GBK
Mary Magdalene (Repentant
Magdalen) c 1455/57 ptd
wood; 74 BR pl 4;
GARDH 314; JANSH 313;
JANSK 629-30; LARR 99;
MCCA 10; MONT 65;
MURRA 13; POPR fig
13, pl 33; RAY 41; SEW
496; SEY pl 79 IFBap
The Marzocco
BARG 9 IFBar
Niccolo da Uzzano, bust
c 1432 ptd terracotta; 18
BARG; BR pl 4; CHENSN
342; CHENSW 376;
CRAVR 68; PUT 227;
READA pl 44; READAS
pl 158; ROOS 109K; UPJH
pl 111 IFBar
Old Sacristy Doors 1434/43
bronze; 92-1/2x43
MAR 33; MCCL pl 27;
POPR fig 33 IFLo
--Arguing Figures, panel
relief MURRA 41
Pazzi Chapel: Assumption
of St. John the
Evangelist, tondo pig-
mented stucco; Dm: c
215 cm POPR fig 40, pl
24 IFPC
--Matthew, tondo Dm: 134
cm POPR pl 46

Pazzi Madonna, relief 1420
Carrara marble; 29-1/4
x27-1/8
BODE 58; BSC pl 75;
MOLE 115; NEWTEM pl
113; POPR pl 18 GBS (51)
Prophet
POPR fig 8 IFOp
--marble; 190 cm
POPR pl 13, 15
--east facade, Campanile
1415/20 marble; 1.9 m
CHAS 128
Prophet Habakkuk ("Bald-
Pate"; Il Popolano;
"Pumpkin Head"; "Lo
Zuccone") c 1423/36
marble; 77
BUSR 66 CHASEH 299;
CHENSW 377; FLEM 342;
GARDH 295; JANSH 309;
JANSK 620; MACL 101;
MAR 16; MCCA 66; MOLE
111; POPR pl 12; PRAEG
293; ROBB 367; ROOS
109E; SEW 487; SEY 33B,
35B; UPJ 238 IFC
Pulpit c 1460/66 bronze
FREEMR 86; MONT 65;
POPR fig 34-5 IFLo
--Ascension
MACL 124
--Christ in Limbo
POPR pl 35
--Deposition from the Cross
READAS pl 103-6; ROTHS
161
--Harrowing of Hell
MACL 124; SEY pl 81
--Lamentation
POPR pl 34; VER pl 32
--Resurrection
MACL 124; MURRA 46;
POPR pl 37; SEY pl 81
--Three Marys at the
Sepulchre
CHAS 69; POPR pl 36
Pulpit, external, paneled,
Duoma c 1438 marble
BODE 39; HALE 66 (col)
--Dancing Children
MOLE 107 (col)
--Putto (cherub)
BARSTOW 127
Putto (Cherub)#
BARG IFBar
Putto with Tambourine

(Engelputto mit
Tambourin) 1426/28 bronze;
36 BSC pl 74 GBS (2653)
St. Francis
POPR fig 16 IPAn
St. George, niche figure,
Gild of the Armourers
1416 marble; 82
BARG front; BARSTOW
123; BAZINW 332 (col);
BODE front; BROWF-3:16;
CANK 71; CHENSW 377;
FREEMR 76; GARDH 294;
GAUM pl 42; GOLDWA 41;
GOMB 166; KO pl 74;
LARR 93; MCCA 26;
MILLER il 111; POPR fig
5, pl 5; ROOS 109B, C;
RUS 59; SIN 236; STI 58
IFBar
--reproduction
REED 73 UCGF
St. George and the Dragon,
relief MACL 100 ELV
St. George Tabernacle
(Tabernacle of Arte dei
Corazzi) c 1415/17
marble; figure: 72
BUSR 66; HALE 109 (col);
JANSH 308; JANSK 618;
MARQ 180; MURRA 36;
SEY pl 22; UPJH pl 110
IFO
--St. George and the
Dragon, base relief detail
marble; 15-3/4
JANSH 309; JANSK 617;
MOLE 113; MONT 65;
MURRA 37; POPR fig
21, pl 6; RAD 326;
SEY pl 21
St. John the Baptist, Casa
Martelli (Youthful St.
John the Baptist) c 1430
marble; 68
BARG; KO pl 74;
CHENSW 378; POST-1:162;
RAY 41; ROTHS 155;
ROWE 62; SLOB 237
IFBar
St. John the Baptist (Aged
St. John the Baptist)
1457 bronze
POPR fig 12; ROTHS
155; SEY pl 80A ISC
St. John the Baptist, left
foot forward c 1425
ROOS 109G IFBar

St. John the Baptist, staff
in right hand c 1425
ROOS 109F IFBar
St. John the Baptist (Boy-
Baptist), bust colored
clay BODE 143 GBK
St. John the Baptist, bust
c 1425 marble; .49 m
CHAR-1:340; GAF 140;
LOUM 123 FPL (705)
St. John the Baptist, bust
c 1430 ptd terracotta;
c 18 STI 582 GBM
St. John the Baptist, bust
c 1440 ptd terracotta;
19-1/4x20-1/2x10-1/4
SEYM 72, 73; USNI 227;
USNK 182; WALK; UDCN
(A-19)
St. John the Baptist as a
Youth, head marble BUSR
73
St. John the Baptist, relief
RAY 41 UNNMM
St. John the Evangelist,
seated figure 1412/15
marble; 210 cm
GARDH 18; MACL 99;
POPG fig 35; POPR pl
4; ROTHS 147; SEY pl
13 IFOp
St. John the Evangelist
Drawn up to Heaven,
pendentive tondo decora-
tion c 1435/40 ptd stucco
MACL 113; SEYpl 51 IFLo
St. Louis of Toulouse
POPR fig 17 IPAn
St. Louis of Toulouse,
niche figure c 1423 gilt
bronze; 104-3/4
BODE 42; MAR 15; MONT
65; NEWTEM pl 117;
POPR fig 56, pl 16; SEY
pl 25 IFOp
St. Mark, Niche of Linen
Weavers 1411/13 marble;
93 JANSH 308; JANSK
619; POPR pl 3; SEY
pl 16B IFO
St. Peter Receiving the Keys
from Christ, relief detail
c 1425/30 marble SEW
491; SEY pl 32B ELV
St. Prosdocimus 1446/50
bronze POPR fig 18; SEY
pl 61B IPSa
SS Stephen and Lawrence,

Sagrestia Vecchia ptd
stucco; c 215 cm POPR pl
20 IFLo
Virgin and Child, relief
GUIT 75 ITAA
Virgin and Child, relief
terracotta GLA pl 38
Virgin and Child with
Angels, relief POPR fig
28 GBK
DONATELLO, or DESIDERIO DA
SETTIGNANO
San Giovannino, head detail
MCCA 26 IFBar
DONATELLO--ATTRIB
Ninfa, bust, medallion
stone CHENSW 395
IMCiA
DONATELLO and MICHELOZZO
Cardinal Rinaldo Brancacci
Tomb
--Angel and Effigy 1426/30
marble SEY pl 34 INA
--Assumption of the Virgin
1427 bronze CHASEH 303;
POPR fig 59, pl 8; ROTHS
157
--Virtue
POPR pl 38
John XXIII Monument
(Baldassare Coscia), Bap-
tistry c 1424/27 marble
and bronze BODE 38;
POPR fig 58; SEY pl 26
IFBap
Pulpit 1434
ROOS 110A IPr
Tabernacle of the Sacrament,
Capella dei Beneficiati
1432/33 marble; 76x47
BODE 15; CAL 52; POPR
fig 38 IRP
--The Entombment
CAL 55 (col)
DONATELLO and NANNI DI BARTO-
LO (ROSSO)
Sacrifice of Isaac 1421
marble BIB pl 45; SEY
pl 23A IFOp
DONATELLO--FOLL
Madonna and Child clay
BODE 160 GBK
Madonna and Child, relief
terracotta; 48x30
NCM 269; POST-1:165;
SLOB 236 UNNMM (12.78)
Male Figure, choir screen
decoration c 1450 marble

SEY pl 64A IPSa
Putto with Fish (Cupid with
Fish) 15th c. bronze; 15
VICF 41 ELV (475-1864)
St. John the Baptist
ROOS 112F IFBar
Struggling Children clay
BODE 159 GBK
Tomb Figure, relief 15th c.
GLA pl 38
Virgin and Child, relief
POPR fig 29 IVeF
Virgin and Child, tondo
POPR fig 30 ISC
DONATELLO and FILARETE--FOLL
Martin V Monument c 1432/
40 LARR 102; POPR
fig 36; SEY pl 53 IRGio
Donato, Saint
Donadino di Cividale. St.
Donato, reliquary bust
Pietro Aretino, and Paolo
Aretino. St. Donato,
reliquary bust
DONEGA, Jetta (Italian)
Form No. 1 1954 bronze
MAI 82
Donkeys
Androusov. Two Figures on
Donkey*
Gaul, A. Boy on Donkey
German--15th c. Christ on
the Ass (Palmesel)#
Koenig. Palm Sunday
Pepe. Donkey
Donna Acopala. Giacometti
Donna alle Fonte. Biancini
Donna che Corre. Cataldi
Donna che Ride# Rosso, M.
Donna col Gatto. Fabbri
Donna Incinta. Rossi, R.
Donne, John
Stone. John Donne Monument
DONNER, Georg Raphael (Austrian
1693-1741)
Angel, altar figure c 1735
HEMP pl 62 CzBrCE
Angel, former high altar,
Bratislava Cathedral
1733/35 lead
BUSB 165 HBNM
Apotheosis of Charles VI
1734 VEY 27 AVO
Hagar in the Desert, relief
marble LARR 418 AVO
Hands, Lamentation detail
1740/41 lead BUSB 164
AGuC

Judgment of Paris, relief
c 1730 bronze; 23-5/8x
38-1/4 VEY 143 AVO
Providentia Fountain
(Fountain of Mehlmarkt)
1738 (formerly AVMe)
AVBa
--Fountain Figures
CHASEH 409
--Nymph lead
LIL 220; ST 366
--Providence lead
BAZINB 240; MOLE 252;
POST-2:70
--The River Enns
HEMP pl 63
--The River March
HEMP pl 63
--The River Traun
BAZINW 415 (col); BUSB
162
Putto with Fish 1740 linden-
wood; 38.5 cm BSC pl
142 GBS (M229)
Reclining Nymph c 1739 lead
on marble base; figure:
3-1/2x15-7/8; base:
7-1/2x15 KUHN pl 68
UMCB (1964.7)
St. Martin and the Beggar,
former high altar 1735
lead BUSB 163; HEMP pl
64; KO pl 94; PRAEG
356; STA 60 (formerly
APC; GPrC) CzBrCE
DONNER, Georg Raphael--FOLL
House Altarpiece gilded
wood CLE 149 UOC1A
(64.357)
The Doom
French--18th c. Last Judg-
ment
Door Handles
Barisanus of Trani. Door
Panels: Nicholas Pere-
grinus, Descent from the
Cross; Lion's Head Door
Handle
Horta. Door Handles
Door Knockers
English--12th c. Durham
Door Knocker
English--12th c. Lion-head
Door Knocker
French--15th c. Door Knock-
er: Elongated Figure
French--16th c. Door
Knocker

German--9th c. Hildesheim
Cathedral Door(s):
Knocker--Lion-head Door
Knocker
German--12th c. Door Knock-
er: Lion's head
German--14th c. Door
Knocker
Italian--12th c. Door Knock-
er: Animal Head
Master Oderisius of Bene-
vento. Door Knockers:
Dragons and Lions
Spanish--15/16th c. Door
Knocker
Doors See also Gates and Gateways
Adam, R. Doors, 1 Portman
Square, London
Adlhart-Hallein. Theatre
Entrance
Albert of Soest. Door Frames
of Council Chamber
Alexander, G. Doors
Amade. Cloister Doorway
Antelami. Baptistry Panel
Antelami. Holy Family,
portal relief
Antelami. Main Porch
Antelami--Foll. Door of
the Months
Antes. Bank Entrance,
portal figures
Asam, E. Q. Church Portal
Audebert. Main Portal
Aumonier, W. Bank Entrance
Austrian--13th c. Door,
panel details: Biblical
Themes
Bachelier. Hotel de Bagis
Door
Barisanus of Trani. Door
Panels
Barisanus of Trani. Pelle-
grino Cathedral Doors
Baroque. Church Portal
Behrens. Door in Artist's
House
Bendl, J. G. Church Portal
Bentham. Doorway Panel
Bentham. Office Entrance
Bernini, G. L. Porch, Scala
Regia
Bonannus of Pisa. Doors,
detail
Bonannus of Pisa. Porta
San Ranieri
Bradford, A. T. Doors
Braun, A. Church Door

Scandinavian--11th c. Stave
Church Door
Scharff. Portal, Marienthal
Cathedral
Schilling, A. Church Door
Schinkel. School of Archi-
tecture Porch
Sluter. Portal
Spanish--11/12th c. Puerta
de las Platerias
Spanish--12th c. God the
Father with the Christ
Child
--Portal: Christian Scene
Panels
--Portico de la Gloria,
Santiago de Compostela
Spanish--13th c. Last Judgment
--West Portal
Spanish--14th c."La Preciosa",
chapter house door
--Portada de la Chapineria,
Toledo Cathedral
Spanish--15th c. Main Door-
way, S. Pablo
Spanish--16th c. Entrance,
Coneicao Velha, Lisbon
--Plateresque Portal
Spanish--17th c. Door of
Staircase, King's Pantheon
Stursa. Garden Entrance
Swiss--12th c. St. Gallus'
Porch
Vangara. Palace Door
Witten, Hans, and Franz
Maidburg. Side Porch
Wolff, Evert, and Jonas
Wolff. Portal of God,
Golden Hall
Doppel Kugel, Calbasse
Hiltmann. Double Sphere
DORAZIO, Piero (Italian 1927-)
Pastorale 1954/58, relief
metal; 49x48-1/2
CARNI-58:pl 120
DORE, Paul Gustave (French 1832-
83)
Acrobats bronze; 127x25x26
cm LIC 19 UFSR
Monumental Vase H:10'
REED 147 UCSFDeY
Dorgelo, Otto von
Kribbe. Otto von Dorgelo
Epitaph
Doric Figure. Hoflehner
Doric Figure. Mascherini, L.
Dormer, Robert d 1552

English--16th c. Sir Robert
Dormer Monument
Dormiente. Mazzullo, G.
Dornle, Anna Kasper
Augsburg Master. Anna
Kasper Dornle, tondo
Dorothea, Saint
Polish. St. Dorothea, reliquary
head
Dorothea, from Don Quixote. Bell
Dorothy. Roberts-Jones
Dorset, Frederick, Duke of
Nollekens. Frederick, Duke
of Dorset, monument
D'ORSI, Achille See ORSI, Achille D'
Le Dos
Matisse. The Back
DOSIO, Giovanni Antonio
Niccolini Chapel; detail by
Francavilla: Moses with
Tablets
POPRB fig 76, pl 94 IFCr
DOS REIS, Soares (Portuguese)
The Exile
CASS 62 PoLA
Dostoyevsky, Fyodor (Russian
Novelist 1821-81)
Konenkov. Dostoyevsky, bust
Double-Bass Player. Manes
Double Form. Hartung
Double Interrogation. Bloc
Double Sided Wall of Fire. Klein, Y.
Double Signal, Purple and Amber.
Takis
Double Standing Figure. Moore,H.
Double Surface Avec 8 Aretes
Courtes et 8 Aretes Longues.
Bill
Double Surface sur la Base d'un
Plan Circulaire. Bill
Doubled Form. Jancic
Doubleself. Kosso
DOUGHTY, Dorothy (English 1892?-
1962)
American Redstarts 1955
Worcester porcelain
INTA-2:127
La Douleur
Rodin. Head of Grief
DOUVERMANN, Heinrich (German
1510-44)
Altar detail 16th c. wood
STI 451 GXC
Altar of Virgin of the Seven
Sorrows 1517/22
--King David at the Root of
the Tree of Jesse

BUSR 157; LOH 181 GKal
--Root of Tree of Jesse
 Sprouting from Sleeping
 Isaiah
 BUSR 157
--Tree of Jesse
 LARR 17
St. Mary Magdalen 1535 oak
 MUL 66 GKalN
Virgin and Nursing Child
 (Muttergottes, das Kind
 Nahrend; Maria Lactans)
 1510 oak; 105 cm (with
 crown) BSC pl 62 GBS
 (7963)
DOUVERMANN, Heinrich--FOLL
 Jesse Tree c 1520/30 ptd
 oak; 9-1/2x51
 KUHN pl 31 UMCB
 (1957.125)
Doux Cerveau. Pommereulle
Dovecotes
 Chelsea Porcelain. Dovecote
Doves
 English. Worcester "Billing
 Doves" Tureen
 Epstein. Doves#
 French--13th c. Eucharistic
 Dove#
 --Pyx: Dove
 Maillol. Woman with a Dove
 Pompon. Turtle Dove
DOW, Harold (English 1922-)
 Bergamasque 1958 stone and
 fondu cement; 30x46x16
 LOND-5:#16
Dowgate Hill Brooch. Anglo-Saxon
DOWN, Roger, and John HILL
 Wooden screen, cornice
 detail, Atherington c 1538/
 42 STON pl 183 EAth
DOYLE-JONES, F. W. (English)
 Atlantis carved concrete
 PAR-1:77
D'Oyley, Cope d 1636
 Hargrave. Sir Cope D'Oyley
 Monument
Dragon Fly. Chadwick
DRAGONET, Ernest (French)
 Eve
 TAFTM 39
Dragons See also George, St.;
 Michael, St.
 Belgian--17th c. Wine Cistern
 with Dragon Handles
 Cellini. Rospigliosi Cup
 English--12th c. Crypt
 Capital: Fighting Animals--

Dragon Battling Dog
--Mirror Case: Dragon
English--13th c. Boss: Centaur
 and Dragon
French--11th c. Capital:
 Dragons
French--12th c. Dragon Aqua-
 manile
French--13th c. Dragon De-
 vouring Man, aquamanile
--Eve and the Dragon
German--12th c. Dragon,
 detail,
--Shrine of Anne: Monkeys
 Attacked by Dragons
German--12/13th c. Aqua-
 manile: Dragon Swallowing
 Man
German--13th c. Aquamanile:
 Lion Sitting on Dragons
--Dragon Mount, ostrich egg
--Inhabited Scroll: Men and
 Dragons
Hartmanus. Capital: Heads of
 Demons; Dragons
Italian--12th c. Capital:
 Dragons and Sphinxes Fight-
 ing
--Lion Fighting Dragon,
 relief
Italian--16th c. Dragon-stem
 Goblet, Venice
Italian--17th c. Dragon-Form
 Goblet
--Ewer
Martin, E. Dragon
Martin, E. Great Dragon
Master Oderisius of Benevento,
 Door Knockers: Dragons
 and Lions
Medieval. Aquamanile: Dragon
Minguzzi. The Dragons
Mosan. Christ Trampling the
 Beasts
Nicholas of Verdun. Shrine of
 the Three Kings, inhabited
 scrolls
Rodolfo, and Binello. Emperor
 Frederick I; Fighting
 Dragons
Romanesque--English. Tympa-
 num
Romanesque--Italisn. Choir
 Screen: Gryphon; Dragon
Sarachi--Foll. Vase: Dragon
Stockton. Heraldic details:
 Dragon
Draguignan Man. Cesar

DRAHONOVSKY, Josef (Czech)
 After the Bath marble
 PAR-2:118
Drahtplastik. Kramer
Drake. Garbe, R. L.
Drama See also Actors; Comedy and
 Tragedy; Commedia dell'Arte;
 Mystery Plays
 Bayes. Frieze detail:
 Dramatic players
Dramatic Occasion# Lardera
Draped Female Figure. Lehmbruck
Draped Figure. Lehmbruck
Draped Figure. Maillol
Draped Figure Against a Wall. Moore
Draped Reclining Figure. Moore, H.
Draped Reclining Woman. Moore, H.
Draped Seated Figure Against a Wall.
 Moore, H.
Draped Woman. Laurens
Drausin, Saint
 Early Christian. Sarcophagus
 of St. Drausin
The Dream. Bistolfi
The Dream. Lacombe
The Dream. Martini, A.
The Dream. Rodin
Dream about Mother. Bossi, Aurelio
A Dream of Horace. Westmacott
Dream of Joy. Monti, R.
Dream of Pharoah
 French--13th c. Satyr; Dream
 of Pharoah
Dreaming Child. Dazzi
Dreams. Reynolds-Stephens
DREI, Ercole (Italian 1886-)
 Boy Undressing (Ragazzo che
 se spoglia) bronze
 VEN-20:16
 Comedy ptd plaster
 VEN-28:pl 32
 Il Duce, head wax
 VEN-40:pl 3
 The King, head wax
 VEN-40:pl 2
 Lia marble
 VEN-26:pl 20
Dreifaltigkeitssaule
 Rauchmiller and Fischer von
 Ehrlach. Pestsaule
Dreiklang
 Belling. Triad
Dressed Ballet Dancer
 Degas. Little Dancer of
 Fourteen Years
The Dressing Table. German--18th c.
Dressoir
 French--16th c. Burgundy

Dressoir
DREW, Joseph (English)
 Cast Lead Figure H: 8
 NEWTEB pl 19
DREYER, Benedikt
 St. Michael, rood loft figure
 c 1510 (destroyed World
 War II)
 BUSR 96 GLuM
Dreznica Peasant. Angeli-Radovani
Drifting. Toyofuku
Drinking Fountains
 Krogh. Drinking Fountain#
Drinking Horns See also Oliphants
 Danish--15th c. Drinking horn,
 with bird feet and curling
 tail ending in rosette
 Dutch--16th c. Horn of St.
 Joris
 French--15/16th c. Drinking
 Horn
 German--18th c. Oldenburg
 Horn
 Kempe. Ampulla: Horn
 Swedish--14th c. Drinking
 Horn
 Viking. Drinking Horn
Driver of Trotting Cart. Farpi
Drivier, Juliette
 Drivier. Juliette Drivier,
 half figure
DRIVIER, Leon (French 1878-1951)
 Bather
 BAS 53
 Consolation
 BAS 46
 Le Fils de M. Alcorta, bust
 BAS 45
 La France Coloniale, Porte
 Doree
 BAS 50
 La Joie de Vivre
 BAS 44, 45 FChai
 Juliette Drivier, half figure
 BAS 54 FPM
 Mme Geoffroy, head
 BAS 48
 Mlle. Jossonne, first study
 bust
 BAS 44
 Mlle. Jossonne, three-quarter
 figure
 BAS 49
 M. Alcorta, bust
 BAS 51
 M. Legrand, head
 BAS 48
 Nymph

BAS 47 FChai
La Pensee; rear view
BAS 52, 53 FPM
Tireur a l'Arc
BAS 55
Torso of a Woman 1928 bronze
BAS 54; MAI 83 FPM
Venus
BAS 52 FPMP
Woman, portrait
VEN-32:pl 109
Driving Away. Pasztor
Dronning Dagmar. Starcke
DROSTE, Karl Heinze (German 1931-)
Jagna I 1960 bronze; 60x36 cm
KUL pl 33 GLeM
Drouot, Antoine (French General
1774-1847)
David D'Angers. General
Drouot
Drum-Head. Turnbull
Drum Horse. Pilkington-Jackson
Drums See Musicians and Musical
Instruments
The Drunkard, panel. Giotto and
Pisanello
The Drunken Noah
Buon, B. and G. Porta della
Carta
Drunkenness of Noah, relief detail.
Italian--14th c.
DRURY, Alfred (English 1859-)
Age of Innocence marble
MARY pl 109; RAY 59;
TAFTM 75 UNNMM
Door, detail
TAFTM 75 ELV
The Kiss bronze
MARY pl 145
Richard Hooker, seated figure
TAFTM 75
Sir Henry Roscoe, bust
MARY pl 71 ELBur
Sir Joshua Reynolds bronze
MARY 168 ELBur
The Spirit of the Night marble
MARY pl 163
Dryads See also Nymphs
Garbe, R. L. Dryad
Jacobsen. Dryad
Laviada. Dryad, group detail
Dryden, John (English Poet 1631-
1700)
Scheemakers, P. John Dryden
Monument
DUARDO, F. See HODART, F.
Du Barry, Marie (1746?-1793)
Pajou. Madame du Barry, bust

DUBOIS, Ernest (French)
The Pardon marble
MARY pl 35; TAFTM 39
FPLu
DUBOIS, Jacques (French)
Lacquered Bureau 31x72
CHAR-2:193 FPL
DUBOIS, Jean (French 1636-94)
Charity
LOUM 189 FPL (954)
DUBOIS, Paul (French 1829-1905)
Florentine Singer
MARQ 261 FPLu
Florentine Street Singer
RAY 54 UNNMM
General Lamoriciere Tomb
1876/78
POST-2:152 FNaC
Jeanne d'Arc, equest
BR pl 14 FRhC
Military Courage
BARSTOW 192 FP
St. John the Baptist bronze
CHASEH 448 FPL
DUBROEUCQ, Jacques (Flemish
1505-54)
Strength, rood screen detail
LARR 237 BMoWa
"Three Women in the Sculp-
tor's Studio"--artist at
work left, chancel screen
c 1535
GOLDF pl 60 BMoWa
DUBUFFET, Jean (French 1901-)
Abrantegas 1960
READCON 255 (col)
Barbe au Menton 1959 papier-
mache
FAIY 222 UNMoS
Blind Man 1959 sheet tin
MARC pl 14
The Duke 1954 sponge; 24
SEITA 94 UNNHah
Figure 1954 clinker; 16-1/2
SEITA 94 UMiBiW
The Jovial One 1959 papier-
mache
KUHB 37 UNNSchw
Knight of Darkness 1954 slag
and cinders; 35-1/2
SELZN 66 UNNLi
Madame J'Ordonne 1954
lava; 36-1/4
TRI 133 FPCo
The Madcap 1954 slag; 16
BERCK 136 UMiBiW
Maestro 1954 sponge
MAI 83

Moss Gatherer (Ramasse
 Mousse) mountain stone;
 6-1/4 LIP 73
The Sorcerer 1954 lava slag
 and wood-roots; 43-1/4
 TRI 50 GFC
Young Woman 1954 charcoal;
 11 BERCK 136
DUCAJU, Joseph Jacques (Belgian
 1829-91)
 Fall of Babylon
 ROOSE 292 BBMu
Ducasse, Isidore
 Ray. Enigma of Isidore
 Ducasse
Il Duce See Mussolini, B.
DUCHAMP, Marcel (French 1887-
 1968)
 Boite-en-Valise 1941/42
 object; 16x15
 JAN 131 -Ac
 --construction 1938/42 mixed
 media; 16-1/2x14-3/4x19
 UCLD 16 UCLD
 Construction, Group N, Padua
 1963 RICHT pl 41
 Disturbed Balance 1918 glass
 and oil; 20
 UNNMMAM #164 UNNDr
 Fountain, ready made, replica
 1950 1917 urinal; 18x15-1/8
 x12
 MYBS 80; RICHT pl 36;
 SEITA 47
 Fresh Widow 1920 miniature
 French Window with leather-
 covered panes; 30-1/2x17-
 5/8
 LIP 188 IMSc
 --SEITA 44 UNNMMA
 In Advance of the Broken Arm,
 ready made, replica of the
 lost original of 1915 1915/
 45 a commercial snow
 shovel; L: 47-3/4
 HAMP pl 143; LARM 337;
 READCON 138 UCtY
 --(copy 1964) L: 39-3/8
 LIP 105 IMSc
 The Large Glass (The Bride
 Stripped Bare by Her
 Bachelors Even; The Great
 Glass) 1915/23 oil and
 lead foil on glass; 109-1/4
 x69-1/8
 HAMP pl 144; LIC pl 97
 (col); PPA 83 RICHT pl
 58 UPPPM

--"Nine Malic Molds," lower
 left center BURN 217
Object in Glass and Zinc 1914
 OZ 116
Objet Dard 4/8 1962 bronze;
 7x4-1/2x3-1/2
 SBT UCLFa
Ready Made: Ball of Twine.
 (With Hidden Noise--a bruit
 secret) 1916 ball of twine
 in brass frame; 5x5x5
 KUHA 91; PPA 77; SEITA
 47 UPPPM
Ready Made: Bicycle Wheel,
 replica of lost original of
 1913 third version 1951
 H: 51-3/8 BURN 227;
 RICHT pl 33; SEITA 46;
 SUNA 73 UNNJa
Ready Made: Bottle Rack
 (Bottle Dryer; Bottle Hold-
 er; Bottle Neck; Bottle
 Stand) 1914
 RICHT pl 35; SEITA 47;
 ST 440
--MEILC 66 UNNMMA
--galvanized iron; 23-1/4x
 14-1/2
 GIE 90; LIC pl 258; LYN
 103; MCCUR 267 FPRay
--NMFA 127 FPZ
--galvanized iron; 29
 JLAT 19 UCLF
--galvanized iron; 29x14
 UCIT 12 UCLB1
Ready Made: Comb 1916 steel
 comb; 6-1/2x1-1/4
 PPA 77; SEITA 47 UPPPM
Ready Made: 50 cc Air de
 Paris 1919 glass ampoule;
 5-1/4
 PPA 80 UPPPM
--replica of 1919 object 1949
 glass ampoule; 6
 PPA 80; SEITA 47 UPPPM
Ready Made: Why not Sneeze,
 Rose Selavy? 1921 bird cage
 with marble lumps of sugar
 and a thermometer; 8-1/2
 x6x4-1/2
 NMFA 127 FPRo
--1921 marble blocks in shape
 of lump sugar, thermometer,
 wood and cuttlebone in
 small bird cage; 4-1/2x8-
 5/8x6-3/8
 CANM 525; ENC 262;
 KUHA 91; LIC pl 259;

PPa 82; SEITA 47 UPPPM
Revolving Glass 1920
RICHT pl 34
--at rest, and in motion
LOWR 726 UCtY
Rotary Demi-Sphere 1925
BURN 229
Three Stoppages etalon 1913/14
three threads glued on 3 glass
panels; 49-1/2x7-1/4 ea; 3
flat wooden ships repeating
curves of the threads, aver-
age L: 44-1/4 KUHA 82;
NNMMM 137 UNNMMA
To Be Looked at with One Eye,
Close To, For Almost an
Hour 1918 framed double
glass panel with oil paint
and collage; 20-1/8x16-1/8
xl-3/8 NAD after 160;
NNMMM 137 UNNMMA
Traveller's Folding Iron, Ready
Made small copy, 1917 H: 9
LIP 16 IMSc
Portraits
Pevsner. Marcel Duchamp
DUCHAMP-VILLON, Raymond (real
name: Raymond Duchamp)
(French 1876-1918)
The Athlete 1910 bronze; 23-
3/4 BAZINW 431 (col) FPM
Charles Baudelaire, death mask
1911 ROOS 278G FPL
Charles Baudelaire, head
bronze; 15-1/2 PACH pl 48;
UNNMMAM #165; VALE 54
UNNBi
--READCON 74 UNNH
--MUNSN 47 UOCoGA
--1911 bronze; 15-1/2x8-1/2
x10 GIE 79; MAI 84; MARC
pl 25 (col); MOD FPM
--1911 bronze; 40 cm HAM;
JOO 189 (col) NOK
--LIC pl 212 UNNMMA
Charles Baudelaire, head 1911
terracotta; 15 BOSME pl 39;
FAIN 167 UMWelC
--1911 terracotta; 42.5 cm
COPGM 115 DCN (I. N. 2725)
The Great Horse 1914 bronze;
39-3/8 BAZINW 431 (col);
BURN 209; JANSH 534;
JANSK 1019 UICA BMAF 55;
FAIY 90 UNUtM
Head of a Horse bronze; 18-7/8
BMAF 54
--1914 bronze; 19
PPA 86 UPPPM

The Horse
ENC 262
--1914 bronze
GERT 128
--1914 bronze; 17
BERCK 30; CAS pl 142 FPCa
--CALA 93; GUGP 25; READCON
120 IVG
--RIT 137 NAS
--1914 bronze; 39x44x44 GIE
77; MAI 85; MARC pl 26
(col) FPM
The Horse bronze
VALE 120 UNNMMA
--1914 ROOS 280H UNNMMA
--1914 bronze
LARM 271; NEWTEA 245
UNNMMA
--1914 bronze; 30 HAMP pl
102A; PEP pl 14 UNNMMA
--1914 bronze; 40 LIC pl 226;
LYN 104; MCCUR 262; NMAC
pl 97; NNMMAP 135;
NNMMARO pl 306; NNMMM
79; ROSE pl 194; TRI 141; UCIT
4; UPJH pl 243 UNNMMA
Horse, head 1914 bronze
SELZJ 224 FPCa
Horse and Rider, first state 1914
bronze SELZJ 225 FPCa
Large Horse 1914 bronze; 39
MID pl 25 BAM
--1914 bronze; 44
BR pl 215; EXS 74 UNmNW
Little Horse bronze
PRAEG 478
--1914 lead; 17-1/3
GIE 76 FPCa
The Lovers, relief 1913 lead;
27x39 BERCK 261 FPCa
--1913 original plaster; 27-1/2
x46 MCCUR 262; NNMMARO
pl 305; PACHA 203; ROSE
pl 191 UNNMMA
--final version 1913 bronze;
13-1/2x20-1/4 NMAC pl 96
Maggy (Female Head; Tete de
Femme), 3rd version 1911
bronze; 29-1/8 GUG 200;
HAMP pl 102B UNNG
--1912 H: 23-1/2
SEITC 186 UNNH
--1912 bronze; 28
GIE 20; SELZJ 229 (col)
FPCa
--1912 bronze; 28-3/8
SELZS 59 UNNBene
Professor Gosset, head 1917
bronze; 4x2-7/8 GIE 81
FPutV

--1917 bronze; 11-3/8x8-1/2x
8-1/2 ALBC-4: 78 UNBuA
--1917 plaster; 4
PPA 87 UPPPM
Rider c 1913 bronze; 11
RIT 136 NAS
Seated Woman 1914
ENC 220
--1914 bronze LARM
320; SELZJ 225 FPCa
--MAI 84 FPM
--1914 bronze; 27x9x11
GIE 78; ROSE pl 193 UCtY
--1914 bronze; 27-1/8
READCON 74 UNNH
Torso of a Young Man (Torse)
PACH pl 46 UNNBi
--1910/11 bronze; 21-1/8
MUNSN 47 UNNPach
--1911 plaster
BROWMS cat 610 UNNH
Ducks
Folk Art--Russian. Ladle, with
ducks on handle
Garbe, R. L. Drake
Gaudier-Brzeska. Duck
Gaul. Duck
Heerup. Laying Duck
Holman. Boy and Duck
Lanz. Strasbourg Duck Tureen
Russian--2nd mil BC. Scoop:
Duck
DUDENEY, Wilfred (English)
Falcon 1946 elm; 18
NEWTEB pl 15B
Dudley, Duchess
Marshall, E. Duchess Dudley
Tomb
DUESBURY, William
Goats Chelsea ware; 6-1/2
INTA-1:135
du Guesclin, Bertrand (Constable of
France 1320?-80)
Prive, and Loisel. Bertrand de
Gueslin, head
The Duke. Dubuffet
DUNOVIC, Ivan See DALMATA,
Giovanni
Dumas, Alexandre, Fils
Saint-Marceaux. Dumas
Monument
Dumbreck, Major
Huxley-Jones. Major
Dumbreck, head
DUMEE, Nicholas
Candelabra 1776 H: 20
INTA-2: 133
Dumont, Luise
Barlach, Luise Dumont Monu-

ment (Grabmal fur Luise
Dumont)
Dunant, H.
Wyss. Monument to H. Dunant,
study
Duncan, George
Huxley-Jones. George Duncan,
bust
Duncan's Maddened Horses. Garrard
Dundas, Henry, 1st Viscount of Mel-
ville 1742-1811
Chantrey. Viscount Melville
Dundas, Robert of Arniston
Chantrey. Robert Dundas of
Arniston, seated figure
DUNIKOWSKI, Xaweri (Ksawery Duni-
kowski) (Polish 1875-)
Actor Solski, bust 1910
bronze VEN-54: pl 107
Head of an Old Woman bronze
VEN-20: 50
Liberation Monument 1953 stone
JAR pl 1 PO
Mickiewicz, head wood
VEN-32: pl 126
Pregnant Woman bronze; 172 cm
WPN pl 187 PWN (189118)
Professor Starzynski, head
JAR pl 2
Rudzka-Cibis 1949 plaster of
Paris JAR pl 2
Dunk, George Montagu, 2nd Earl of
Halifax d 1771
Bacon, J. George Montagu Dunk
Monument
DUNN, Thomas (English c 1676-1746)
Edward Colman Monument
1739 GUN pl 6 EBreE
Dunois, Jean 1403-68
French--15th c. Dunois, Chapel
Statue
Dunoyer de Segonzac, Andre (French
Painter 1884-)
Despiau, C. A. Dunoyer de
Segonzac, bust
Dunstan, Saint
English--16th c. St. Dunstan's
Porch
Duo II. Hall, D.
DUPAGNE, A. (Belgian)
Panels, relief
GOR 3 UVRVU
Dupin, Andre
Daumier. The Orator: Andre
Dupin at French Parliament
DUPLESSIS, Jean Claude (real name:
Jean Claude Chamberlan)
(French d 1783)
Inkstand, Sevres porcelain

c 1770 apple green and white,
gilded; L: 7 KITS 95 (col)
ELWal
DUPLOS, Augustin, Claude
Dominique RONDE, and Laurent
RONDE
Coronation Crown of Louis XV
1722 jewelled gold; 9-1/2;
Dm: 7-1/2 CHAR-2:200 FPL
DUPON, Arthur (Belgian 1890-)
Fountain: Boy Figure 1930
bronze; 35 MID pl 41 BAM
Torso 1925 bronze; 49 MID pl
42 BAM
DUPON, Josue (Belgian 1864-)
The Pearl ivory
ROOSE 299 BARo
Duprat, Antoine (French Prelate and
Statesman 1463-1535)
French--16th c. Chancelier
Duprat, bust
DUPRE, Giovanni (Italian 1817-82)
Abel 1842
LIC pl 94 IFMod
Giotto, portico figure
MARQ 245 IFU
Sappho, seated figure 1857
marble SELZJ 39 IRN
DUPREE, F. (French)
Medal: Henry IV, and Marie
de'Medici 1603 gilt bronze;
Dm: 2-5/8 TOR 135 CTRO
(L 960.9.58)
DUPREY, Jean Pierre (French
1930-59)
Marine Relief 1959 MAI 86
DUQUE CORNEJO, Pedro (Spanish
1678-1757)
Altar, Novitiate Chapel c 1730
KUBS pl 87A SpSLu
DUQUESNOY, Francois (Known as: Il
Fiammingo) (Flemish-Italian
1594-1643)
Bacchanale of Putti, relief
FAL pl 50A-B IRB
(CCLXXVI)
Cacciatore Negroes stone; .65
m FAL pl 51A-B IRB
(CCLXXIV; CCLXXV)
Cupid Carving a Bow
CHASEH 378 GBK
Ferdinand van den Eynde Tomb
1633/40 WIT pl 103 IRMAni
Putto after 1630 bronze
WIT pl 102B ELV
Putto, Andrien Vryburch Tomb
1629 WIT pl 102A IRMAni
Putto Frieze, model for SS
Apostoli, Naples 1640/42

terracotta WIT pl 102C GBD
St. Andrew 1633 marble; c 15'
ENC 266; GER pl 13; HAMF
270; MOLE 178; POPRB pl
160; ROOSE 202; WIT pl 101
IRP
St. Susanna 1629/33 marble;
LS BAZINB 28; BAZINW 388
(col); HAMF 39; KITS 77;
MACL 251; MOLE 182; VER pl
88; WIT pl 95B, 100 IRML
Portraits
Rysbrack, J. M. 'Il Fiammingo'
(Francois Duquesnoy), bust
DUQUESNOY, Francois, and Jerome
DUQUESNOY, the Younger
Bishop Anton Triest Monument
c 1640/54 GER pl 14A BGC
--effigy detail
BUSB 100
DUQUESNOY, Jerome, the Elder
Hope, column figure
PANB 33
DUQUESNOY, Jerome, the Younger
(Hieronymus II Duquesnoy)
(Flemish 1602-54) See
DUQUESNOY, Francois
Duquesnoy, Mme.
Houdon. Madame Duquesnoy, bust
Durandus, Abbot
French--11th c. Abbot Durandus
French--11th c. Abbot Durandus
Tombstone
DURAS, Mary (Czech)
Crouching Woman bronze
VEN-36: pl 55
DURASOVA, Mary
Woman Seated
CASS 89
DURER, Albrecht See GODL, S.
DURET, Francisque Joseph (French
1804/65)
St. Michael Overcoming the
Devil 1860/61 bronze; 5.5 m
LIC pl 86 FPMic
DURHAM, Joseph (English 1814-77)
Waiting for his Innings 1866/67
marble; 3x3' BOASE pl 54B;
CON-6: pl 48; LONDC ELLoS
Durham Door Knocker. English--12th c.
DURST, Alan L. (English 1883-)
Altar Cross ivory and ebony
AUM 130; PAR-1:45
Annunciation; Madonna, Angel
1943 oak; L:66 BRO pl 3-5
Bear Cup lignum vitae; 16
DURS 15 -EBa
Bull lignum vitae; L: c 18
DURS front

Bull 1945 Swedish (light green)
marble; 10 NEWTEB pl 23
Bull Calf lignum vitae; L: 14
DURS 18 ScG
Church, and Synagogue oak; 42
DURS 76, 77 EYoJC
Clergy and Choir Stalls; Prayer
oak DURS 78-9 ENorthwH
The Good Shepherd, tympanum
oak; 74 DURS 80 EMaCa
Gossip, garden ornament
AUM 134
Horse 1947 Hoptonwood stone;
15x18x6 LOND-5:#17
Horse 1953 Swedish green mar-
ble; 25x14x10 LONDC pl 10
Pieta
AUM 143
Rood Screen oak
CASS 136 EWooC
St. Mary 1944 oak
DURS 75 EWinC
The Sea Bird pear wood; 24
DURS 74 -ESa
Shoe-Bill Stork ebony; 24
DURS 74
Ursus Major Cumberland ala-
baster; L: 36 CASS 118
Venus and Cupid Clipsham
stone PAR-1: 44
Duranmal. Paolozzi
Duse, Eleanora
Rodin. Duse, a study, head
DUSEIGNEUR, Jean Bernard (known as:
Jehan) (French 1808-66)
Orlando Furioso 1867, cast by
Charnod from 1831 plaster
model bronze; 51-1/4x57-
1/2 BRIO 40; BRIONR pl 34;
LARM 19 FPL
DUSZENKO, Franciszek (Polish 1942-)
Woman Doctor, bust 1952
plaster JAR pl 40
DUTCH
Delft Japanese Cock
SOTH-2:154 (col)
Delft Silver Pattern Candlestick
SOTH-2:154 (col)
--10th c.
Christ on Cross, Maastricht(?)
ivory; 165 mm SWA pl 23
NMaC
--10/11th c.
Evangeliere de Maestricht Cover
jewelled gold and silver gilt;
.38x.32 m CHAR-1: 242;
GAU 145 (col) FPL
--12th c.
Justice with Scales, chalice

details, Maastricht(?) cham-
pleve enamel; 270 mm SWA
pl 170 UNNMart
Lion Aquamanile, Maastricht c
1150 SWA pl 203 NMaC
Shrine of St. Servatius: Last
Judgment copper, silver gilt;
174x175x49 cm SWA pl 173
NMaC
--Truth (Veritas) Holding Scales
SWA pl 171
--12/13th c.
Choir Capital
GEL pl 90 NMaO
Cloister Tympanum
GEL pl 89 NMaS
Relief Figure, Northwest
Porch GEL pl 88 NMaO
Relief Figures, Odilienberg
Church GEL pl 87 NAR
--13th c.
Portal, South c 1240
BUGS 115 NMaS
--15th c.
Apostle, St. Catherine, fragments
stone GEL pl 91-2 NUC
Bird-Seller, choir stall relief
STA 114 NBG
Birth of the Virgin 1450/60 oak;
46. 5x26 cm BSC pl 51 GBS
(8333)
Creation of Eve, relief oak;
7 NORM 76 ELV
Gothic Arm Chair, panelled
ornament ST 241
Male Figure oak
CHENSN 298 UNNMM
St. Andrew oak, traces of paint
CLE 70 UOC1A (38.169)
St. Catherine c 1485 ptd Noten-
hout; 91 cm RIJ 130 NRA
Seated Man (Thronender Greis)
1460 alabaster; 16x11. 8 cm
BSC pl 48
--16th c.
Burial of Christ (De Verrijzenis
van Christus) c 1510 oak; 60
cm RIJ 131 NRA
Chain of Dordrecht Militia c
1516 GEL pl 129 NDoG
Choir Screen 1542
GEL pl 112 NEnG
Christus Rustende voor de
Kruisging c 1535 ptd oak; 41
cm RIJ 132 NAR
Horn of St. Joris (Drinking Horn
of Amsterdam Militia; Drink-
ing Horn of Arquebusiers
Guild, Amsterdam) 1566

buffalo horn, silver mount;
14-3/4 GEL pl 130; RIJ 140;
RIJA pl 123 NAR
Military Life, relief, Old
Military Hospital 1587 LARR
253 NAR
Passion Altar, Utrecht 1520
oak; 84x92 cm (excl wings)
BERLEK pl 37 GBSBe (8091)
Pieta (Beweinung Christi) 1500
oak; 49.5x49.5 cm BERLEK
pl 35 GBSBe (2396)
Pulpit 1525
GEL pl 108 NLP
Rood Screen wood
GEL pl 97 NRhC
Sideboard of Alkmaar Militia
c 1530 oak GEL pl 118 NAR
--17th c.
Blue Delft Jug ceramic
LARR 319 NAR
Carved Oak Cabinet c 1650
GEL pl 116 NAR
Dutch Rigsdaler ("Lion" or
"Dog" Dollar) 1648 PAG-4:
287 UNNAmN
Nautilus Beaker, detail 1659
nautilus shell, silver mounts;
11 BOSMI 143 UMB (63.256)
Polished rosewood cabinet
c 1690 GEL pl 117 NAR
Virgin, from Crucifixion Group
Boxwood; 26.5 cm BSC pl
130 GBS (7818)
--18th c.
Decorative Woodwork: Acan-
thus tendrils, flower gar-
lands, Haarlem House c 1790
ptd wood RIJA pl 30 NAR
Gravestone of Samuel Senior
Texeira: God Appears to In-
fant Samuel 1717 ROTH 23
Medal: Anthonie van Leeuwen-
hoek, bust 1716 silver; Dm:
2-1/8 VICOR pl 33B NHP
Torah Scroll Finials silver
ROTH 322 NAJ
DUTCH, or FRENCH--10th c.
Beasts of Evangelists, book
cover details, Reims or
Maastricht cloissone
enamels; 67x60 mm ea SWA
pl 26 FPL
DUTCH-GERMAN--16th c.
Lucretia 1570 pearwood; 36 cm
MUL 71 IFMN
Dutton, James
Westmacott. James Dutton
Monument

Dutton, John
Rysbrack. Sir John Dutton
Monument
DVORAK, Karel (Czech 1893-)
Decorative Panel
AUM 26 CzH
Entrance Figure
AUM 26 CzPCS
Nude Boy bronze
VEN-34: pl 142
Signorina H. D., bust bronze
VEN-26: pl 21
Dwarfs
Czech--18th c. Man and Woman
Dwarves, Arena
DWIGHT, John (English 1637/40-1703)
Prince Rupert, bust, Fulham
c 1680 stoneware
ENC 853
Dyad. Hepworth
Dying Amazon. Hussmann
Dying Captive
Michelangelo. Bound Slave
Dying Centaur. Bourdelle
Dying Clytie, bust. Watts
Dying King. Frink
Dying Slave
Michelangelo. Bound Slave
Dying Tecumseh. Pettrich
The Dying Warrior
Lehmbruck. The Fallen
Dying Warrior
Schluter. Courtyard Keystones:
Dying Warrior
Dynamic Architecture. Malevich
Dynamic Conjunction of Two Pairs
of Line Segments.
Oteiza
Dynamic Construction. Pevsner
Dynamic Construction of a Gallop--
Horse--House. Boccioni
Dynamic Form. Rosso, Mino
Dynamic Optical Deformation of a
Cube in a Sphere. Mari
Dynamic Projection in the 30th
Degree. Pevsner
Dynamic Square. Reich
Dynamic Vision. Group N
Dynamik I. Haukeland
DZAMONJA, Dusan (Yugoslav 1928-)
Female Group 1954 terracotta
BIH 165
Head of an Unknown Political
Prisoner 1952 bronze
BIH 164
Metal Sculpture 1959
VEN-60: pl 184
Metal Sculpture 3 1959 iron
and wood; 63

READCON 227 SwZL
Metal Sculpture 14 steel rods,
brass, and bronze
MEILD 158; VEN-64: pl XIII
ELT
Metal Sculpture 15 1960 iron;
44-1/2 ARTSY #95
Metal Sculpture 38 iron; 45x
36 cm SAO-8
Metal Sculpture 42 1965 26
(with base)x12x13
CARNI-67: #326 UNNAdr
Sculpture 1960 metal and glass
MAI 86
Sculpture 1963 H: 33-7/8
NEW pl 265 YZSt
Torso 1955 plaster
BERCK 177

EADE, Edward (English)
Archaic Figure 1946 bronze;
24 NEWTEB pl 25
Eadgar, called the Aetheling
(English Prince 1050?-1130)
English--10th c. Penny: Eadgar
Eager Friend. Ernst
Eagles See also Zeus
Belgian--16th c. Eagle, lectern
detail
Bologna. Eagle
Braun, M. B. Eagle
Braun, M. B. Residence
Doorway: Eagles
Carrier-Belleuse. Sleeping
Hebe
Causici. Liberty and the
Eagle
Collin. Eagle
French--12th c. Eagle of
Cluny
--Eagle Vase of San Denis
Frink. Eagle
Gaul. Eagle
German--11th c. Eagle Brooch
German--14th c. Fountain,
detail: Eagle, symbol of
Free Imperial City of Gos-
lar
German--15th c. St. Servatius
Protected by an Eagle
Against King of the Huns
Haizmann. Eagle
Harth. Eagle
Hernandez, M. Eagle
Liisberg. Eagle
Ostrogothic, Eagle Brooch
Pigalle. Marechal de Saxe
Tomb

Pisanello. Medal: Alfonso V
d'Aragona; Eagles
Raedecker. Eagle, garden
piece
Reger. Eagle, decorative
facade figure
Romanesque--Italian. Pulpit:
Figure and Eagle
Russian--19th c. Wrought Iron
Inner Doors: Tsarist Eagle
Valaperta. Eagle, frieze
Vigeland. Frogner Park
Fountain Panels: Boys
Wrestling; Boy with Eagle
Visigoth. Eagle Brooches
EARLE, Thomas (English fl 1860)
Prince Consort 1864 marble;
96 GLE 203 ELAs
Earle, William
Gibson, J. William Earle,
seated profile figure
EARLY CHRISTIAN
Adam, with animals of
Garden of Eden, relief
panel 5th c. ivory CLAK
52 IFBar
Altar frontal c 740
BAZINL 103 ICiMa
Ambo, chancel of Archbishop
Agnellus: Square-framed
Symbolic Animals 556/69
marble; 118x166
VOL pl 183 IRaC
Ampoule: St. Peter c 6th c.
terracotta; .7x.55 cm
CHAR-1: 214 FPL
Antioch, personification (copy
of LS statue by Eutychides,
c 300 BC) c 380 silver;
5-1/8 VOL pl 119 ELBr
Apostle, panel 1st half 5th c.
ivory; 4-3/4x2-3/4
VOL pl 99 FPL
Arch of Gallerius, south
pillar, east side and north
side c 297/303
VOL pl 2, 3 GrSaG
Ariadne(?), high relief c 500
ivory; 16-1/2x5-3/8
VOL pl 218 FPC1
Ascension of Christ, and
Women at the Tomb, relief
c 400 ivory; 7-3/8x4-1/2
CHENSW 158; KIDS 12; KO
pl 34; STA 21; VOL pl 93
GMBN
Balasters with Acanthus and
Ivy Leaf scrolls mid 5th c.

13-3/8x5 VOL pl 97
IFMN
Consul Felix, Rome, diptych
 panel 428 ivory; 11-1/2
 x5-1/4
 VOL pl 96 FPMe
Consul Sividius--floral and
 foliate diptych panel 488
 ivory; 5-3/4x4-1/8
 VOL pl 97 FPMe
Cross: Monogram of Christ
 with Pendant Alpha and
 Omega 5th c. bronze
 NEWTET 33 IVK
Cross of Desiderius, pro-
 cessional cross with gilded
 glass portrait of mother and
 two children 7/8th c.;
 portrait--4th c. jewelled
 silver; inset miniature;
 43-1/4 KIDS 19; VOL pl
 60; 61 (col) IBrMC
Crucifixion, carved door
 panel c 430 cypress
 BAZINW 196 (col); LARB
 31; MCCL pl 5; SEW 231
 IRSa
Cup, with city personifications
 gold; 6-3/8 NM-7:7
 UNNMM (17.190.1710)
Dagulfe Psalter Cover: Story
 of the Psalms ivory; ea
 plaque 1.68x.81 cm
 CHAR-1:228 FPL
Daniel in the Lion's Den,
 belt buckle 7th c. bronze;
 L: 1/2 LAS 105 SwFM
David Slaying Goliath, plate
 6th c. silver
 MOREYM pl 19 UNNMM
Death of Judas; Crucifixion,
 plaque c 420 ivory; .75
 cm
 HAN pl 341 ELBr
Diocletian, head, statue
 fragment, Nicomedia
 284/305 marble; 15-3/8
 VOL pl 1 TIAM
Diptych: Lamb of God ivory
 ST 86 IMC
Diptych: Stilicho; Serena and
 Eucheris ivory; 12-5/8x
 6-3/8 ST 93; VOL pl 62
 IMonC
Diptych of the Niomachi and
 Symmachi, left panel:
 Ceres-Priestess Before
 Altar of Cybele end 4th c.

ivory; 11-3/4x4-7/8
 VOL pl 90 FPC1
--right panel: Bacchus-
 Priestess with Handmaid
 Before Altar of Jupiter
 VOL pl 91 ELV
Diptych Panel: The Adoration;
 Nativity 6th c. ivory;
 8-1/4x3-1/8 RDAB 38;
 VOL pl 222 ELBr
Disc: Whirl Motif bronze
 LARB 315 IreDNB
Disc, repousse and engraved
 388 silver LARB 22 SpMaH
Dish: Putti Marking a
 Nilometer c 500 dish; Dm:
 9-5/8 VOL pl 252 RuLH
Dish: Toilet of Venus c 380
 silver; L: 14-1/2
 VOL pl 118 FPPP
Door Fragments; Scenes from
 Life of David end 4th c.
 cedar; 33-1/2x49-1/4
 VOL pl 102 IMA
Doors of West Portal; Biblical
 details: Crossing of Red
 Sea; Bronze Serpent;
 Ascension of Elijah; Zach-
 arias Struck Dumb Before
 Temple c 432
 VOL pl 103-5 IRSa
Duke Hilderic Panel, altar
 relief 739/40
 BAZINL 101 IFerP
Empress, head mid 5th c.
 marble; 10-5/8
 VOL pl 68 IMS
Empress Helena Sarcophagus
 4th c. porphyry; 95x91-
 3/4x61 LAS 16 IRV
Eutropios, head, Ephesus c
 450 marble; 12-1/2
 BAZINW 194 (col); JANSH
 168 AVK
Evangelist, medallion bust,
 Constantinople c 420 marble;
 27-1/8 VOL pl 74 TIAM
Feast of the Gods, plate 4th c.
 silver, niello decoration;
 Dm: 24-3/4
 VOL pl 108 ICeM
Five-part Diptych: Life of
 Christ 5th c. ivory;
 14-3/4x11-1/8
 VOL pl 100, 101 IMC
Five-part Diptych Panel:
 Biblical Scenes 6th c.
 ivory

VOL pl 223 IRaMN
Flagon: Healing of the Blind
5th c. silver; 5
VOL pl 121 ELBr
Funeral Stele: Fish of Christ
and Anchor of Faith
NEWTET 31 IRT
The Good Shepherd c 350
marble; 39
CHASEH 178; CHENSW
157; CHRP 123; CRAVR
50; FLEM 161; MARQ
131; MCCL pl 3; MU 61;
ROOS 57D; SEW 212; STI
353; STRONGD pl 101 IRL
The Good Shepherd 4th c.
marble CLE 36 UOC1A
(65.241)
The Good Shepherd, with
sheep MALV 175 IRT
The Good Shepherd 3rd c.
marble PRAEG 175
Good Shepherd Sarcophagus,
relief c 250 marble; .81 m
HAN pl 331 FVareB
Good Shepherd Sarcophagus,
detail c 270 marble
LAS 19 (col) IRMA
Gospel Cover of Gauzelin of
Toul enameled and jeweled
gold; 12-1/4x8-3/4
KIDS 27 (col)
The Great Berlin Pyxis (Grosse
Berliner Pyxis): Christ
Teaching, Alexandria-Trier
4th c. ivory; 4-3/4x5-3/4
BSC pl 7; RDAB 39; VOL
pl 95 GBS (363)
Healing of Man Sick of Palsy,
panel detail 5th c. ivory;
W: 3-7/8
ASHS pl 4B ELV
Holy Water Bucket c 1000
ivory, gold and precious
stones; 7
KIDS 28 (col) GAaC
Jonah under the Gourd Vine
4th c. marble
CLE 36 UOC1A (65.238)
Jonah Sarcophagus 3rd c.
86x27x26 BIB 203;
CHASE 212; CHENSW
158; SEW 233 IRL
--Jonah and the Whale
UPJ 139
Jug with Medallions of Apostles
5th c. cast silver, gilding;
7-1/4; Dm: 2-1/4
VOL pl 121 IRV

Lamp 3rd c. red clay; L: 5-
1/8 YAH 17 UCtY
Lamp, Syria or Asia Minor
6th c. bronze; .16x.10 m
CHAR-1:213 FPL
Lamp: Griffin Head Handle
4th c. bronze; L: 6-3/4
VOL pl 13 UCtHWA
Leaf Capitals, with wind-
blown acanthus, west wall,
and north transept
VOL pl 214 GrSaD
Life of Christ: Three Scenes,
plaque 5th c. ivory; 20x
8.1 cm
BSC pl 6 GBS (2719)
Limoges Casket, sacristy 12th
c. BEREP 101
Lozenge-form Crucifixion,
Syria 6/7th c. bronze;
.6x.5 cm
CHAR-1:214 FPL
Madonna and Child, Syria or
Egypt ivory MYBA 221
UMdBW
Man and Woman, relief Ghirza
6th c. BEREP 139 LiTA
Marriage Diptych, Symmachor
um: Young Woman Offering
Incense (Symmachi Panel)
4th c. ivory; 11.6x4.75
CHRC fig 61; MYBS 30 ELV
Mary with Angels, diptych,
right panel 6th c. ivory;
11-3/8x5
VOL pl 225 GBS
Medallion: Christ 5/6th c.
silver and gold; Dm: .15 m
CHAR-1:213 (col) FPL
Medallion: Justinian I, from
cast of lost original 535
gold; Dm: 3-3/8
VOL pl 244 ELBr
Miracles of Christ, plaque
c 5th c. ivory CHENSW
298 ELV
Miracles of Christ, sar-
cophagus detail GAF 509
FArlL
Miracles of Christ, sar-
cophagus relief 4th c.
ROOS 57C IRL
Missorium of Consul Ardabur
Aspar 434 chased silver;
Dm: 16-1/2 VOL pl 109
IFAr
Missorium of Emperor Theo-
dosius I 388 cast silver;
Dm: 29-1/8 VOL pl 53 SpMaH

Moggio Pyxis: Daniel in the
Lion's Den, Egypt 6th c.
ivory; 3-1/2; Dm: 4
MCCL pl 5; VOL pl 236
--Moses Receiving Tables of
Laws
VOL pl 236
Nativity, gospel cover detail
ivory MCCL pl 11 ELV
Neckband with Medallion Show-
ing Annunciation gold,
with coins; Dm: 9-5/16
VOL pl 255 GBS
Necklaces and Medallion,
Cyprus 600/610 gold;
medallion Dm: 2-1/2
VOL pl 248 UDCD
Obelisk of Theodosius: SE
side: Watching Chariot
Race; NW side: Watching
Chariot Race, and Persians
and Dacians Bearing
Tribute c 390 Proconnesian
marble; upper base: 94x
110x124
VOL pl 54-55 TIHip
Oil Lamp: Christ and St.
Peter in Boat 4th c. bronze
VOL pl 12 IFAr
Oil Lamp: Moses Striking the
Rock 4th c.
VOL pl 12 IFAr
Oil Vial Showing Biblical
Scenes, Palestine c 600
silver repousse; 7-1/2;
Dm: 5-7/8
VOL pl 254 IMonC
Open Work Slabs, Presbyteri-
um of San Vitale 6th c.
marble VOL pl 182 IRaMN
Ornamental Buckle 4th c. gold;
2 VOL pl 119 ELBr
Philosophical Argument,
relief fragment 4th c.
BAZINL pl 159 IRT
Pilgrim Bottle 6th c. chased
silver LAS 38 IMonC
Plate: Artemis Riding Stag
4th c. silver; 3/4;
Dm: 7-1/8 VOL pl 106
GBS
Plate: Cross with Angels
6th c. embossed silver;
Dm: 7-1/8
VOL pl 245 RuLH
Plate: Cybele and Attis,
Parabiago 4th c. silver
VOL pl 107 IMS

Plate: Hercules Strangling
Nemean Lion 6th c.
embossed silver; Dm:
23-5/8 VOL pl 251 FPMe
Priestess of Bacchus, dip-
tych leaf c 390/400 ivory;
11-3/4x5-1/2
JANSH 167 ELV
Processional Cross, Syria
6th c. H: 58-1/2 NM-7:8
UNNMM (50.5.3)
Prophets, 2 figures between
windows 449/58 stucco
BOE pl 31; VOL pl 143
IRaB
Pyxis: Adoration of Magi;
Raising of Lazarus 5th c.
silver embossed, partly
gilt; 2-1/4x4-3/4x2-1/8
VOL pl 120 FPL
Pyxis: Orpheus 4th c. ivory;
6-1/4x5-1/8
VOL pl 84 IBobC
Rambona Diptych, Museo Sac-
ra ivory
CAL 22 (col) IRV
Ravenna Sarcophagus: Apostles
4th c. marble; 45x196 cm
WPN pl 25 PWN (199446)
Reliquary Casket; Christ and
Apostles, other Biblical
Scenes 4th c. silver
VOL pl 110-15 IMN
St. Paul, panel, Abbey of
Mettlach 6/7th c. ivory;
9x4-1/4
VOL pl 237 UNNMM
St. Peter, plaque, Syria 6th
c. silver; 10-5/8
NM-7:7 UNNMM (50.5.2)
Santa Giulia Casket: Christ
Among Apostles; Christ
as Good Shepherd; Healing
the Woman with an Issue
of Blood; Ananias and
Sapphira; Healing of Blind;
Raising of Lazarus; Jairus'
Daughter 4th c. ivory,
silver lock; 8-5/8x12-7/8x
9-1/2
MCCL pl 7; VOL pl 85-9
--Ananias and Wife Struck
Dead by St. Peter
LARB 42
--Raising of Lazarus
KO pl 33
Sarcophagus
MARQ 135 IRLo

Sarcophagus, detail
BEREP 94 ISyAr
Sarcophagus marble
MARQ 133; STRONGC 164
IRL
Sarcophagus 3/4th c. stone
CHENSW 300 IRV
--CHENSW 301 IRMA
Sarcophagus 4th c.
CHASEH IRaMN
Sarcophagus 385/89 marble;
1.14 m
HAN pl 337 IMA
Sarcophagus Biblical Scenes
3rd c. VOL pl 40 IRL
Sarcophagus: Christ among
Apostles; detail: Giving
Law to St. Paul, San
Severo c 400 29-1/2x
81-1/2
VOL pl 174-5 IRaF
Sarcophagus: Christ between
SS Peter and Paul c 420/30
VOL pl 177 IRaC
Sarcophagus: Creation and
Fall of Man; Miracles of
Christ
MOREYM 15 IRL
Sarcophagus: Giving the Law;
Tree 5th c. 40x83
VOL pl 176 IRaMN
Sarcophagus: Good Shepherd
and Allegorical Vintage
4th c. marble
CHENSW 157; LAS 15; VOL
pl 6 IRL
Sarcophagus: Life of Christ
RUS 41 FPL
Sarcophagus; Orans and
Philosopher; Jonah and
the Whale; Good Shepherd
and Baptism of Christ
c 270
VOL pl 4-5 IRMA
Sarcophagus: Scenes of the
Passion 4th c.
LARB 30 IRL
Sarcophagus: Three Magis
with Mary and Christ
Child c 400/410 27-1/2x
84-3/4x28-1/4
VOL pl 179 IRaV
Sarcophagus: Two Bands of
Figures and centered
portrait busts of deceased
couple
CHASEH 176 IRL

Sarcophagus, No. 178: Scenes
from Old Testament, includ-
ing miracles
POST-1:9 IRL
Sarcophagus, No. 183: Good
Shepherd and Amorini
Harvesting Grapes
CHASEH 173 IRL
Sarcophagus from Psamathia
(Constantinople):
Figures Between Twisted
Columns c 400 marble
BAZINW 194 (col) GBS
Sarcophagus from Sariguzel:
Two Angels Holding Mono-
gram of Christ 2nd H 4th
c. marble
BAZINW 195 (col) TIAM
Sarcophagus from Sidamara c
150 MOREYM pl 12; SEW
217-8 TIO
Sarcophagus from Sidamara,
fragment c 400 marble;
55-7/8x48-7/8
BERL pl 177; STI 353
GBFB (2430)
Sarcophagus of Adelphia c 340
marble, originally ptd
HAN pl 338; LAS 14 ISyAr
--Adoration of the Magi; Feed-
ing the Five Thousand,
Raising the Widow's Son;
Christ's Entry into
Jerusalem c 340
VOL pl 37-39
--Christ's Entry into Jerusa-
lem BAZINL pl 157;
BAZINW 194 (col)
--Valerius and Adelphia
Medallion KO pl 34
Sarcophagus of Constantia
c 330 porphyry; 2.25 m
HAN pl 336 IRV
Sarcophagus of Junius Bassius
c 359 marble; 46-1/2x96
CHASEH 174; CHENSW 156;
HAN pl 339; JANSH 166;
JANSK 237-8; MOREYM
pl 26; MYBA 216; POST-
1:8; ROOS 57E; ST 92
--Christ as Judge between SS
Peter and Paul; Adam and
Eve; Healing Woman with
Issue of Blood; Entry into
Jerusalem; Cursing the Fig
Tree; Christ Giving St.
Peter the Law 4th c.

VOL pl 41-43
--Adam and Eve
 HAN pl 340; KO pl 34
--Christ Entering Jerusalem;
 Christ, head detail
 BAZINW 194 (col)
--Jesus as Master of the
 Universe
 LARB 26
Sarcophagus of Rinaldus:
 Peter and Paul Paying
 Homage to Christ in Heaven
 420/30 ST 93 IRaC
Sarcophagus of St. Drausin
 7th c. marble; .51x2.13x
 .74 m
 CHAR-1:211 FPL
Sarcophagus of St. Theodorus
 6th c. marble; 39-1/2x81
 CHASEH 177; CHRC fig
 53; FLEM 163; GARDH
 204; MOREYM pl 22; POST-
 1:10; ROBB 338; SEW 230;
 UPJH pl 56 IRaS
--Peacocks in Foliage
 ROOS 58E
Sarcophagus of Stilicho:
 Ascension of Elijah; Christ
 Teaches Apostles; Sacrifice
 of Isaac; Christ Giving the
 Law (from plaster cast in
 Milan) 4th c. 45x90-1/4x59
 VOL pl 46-47 IMA
Sarcophagus of the Good Shep-
 herd (Sarcophage de Bon
 Pasteur), Rome c 380
 marble; 1.10x2.50x1.35 m
 CHAR-1:203 FPL
Shield of Theodosius, relief,
 dish detail 388 silver
 LARB 27; MALV 340
 SpMaH
Ship-Form Lamp 4/5th c.
 bronze STA 21 IFAr
Slabs: Cross, Geometric and
 Vine and Peacock motifs
 6th c. VOL pl 181 IRaS
Story of Joseph, plaque 5th c.
 ivory
 CHENSW 298 FSenC
Triptych: Crucifixion
 MARQ 137
Ulysses and the Sirens, sar-
 cophagus detail
 AGARC 53 IRL
Vine and Figure Column Drum:
 Pair with Sacrificial
 Animals; Baptism of

Christ; Shepherd with
 Dog 5th c. marble; 25-
 5/8; Dm: 23-5/8; and
 30; Dm: 24-5/8
 VOL pl 76, 77 TIAM
Wall Ornamentation and
 Ornaments stone
 VOL pl 198, 200, 202 TIH
Winged Victory, relief c 400
 marble; 105-1/2x57
 VOL pl 72 TIAM
Youthful Christ Teaching seat-
 ed figure c 350 marble;
 .72 m
 HAN pl 343 IRT
EARLY CHRISTIAN-EGYPTIAN
 Book Cover: Biblical Scenes,
 Murano
 MOREYM pl 21 IRaMN
Early in the Morning. Haese
Early one Morning. Caro
Earrings
 Byzantine. Ear Rings
Earth
 Metzner. Fountain detail:
 The Earth
 Rodin. Earth and the Moon
Earth and Fire, detail. Franchina
Earth Child. Kennington
Earth Forms, called "Tears of
 Enak". Arp
Earth Rests. Ledward
Earthly Paradise, capital. French--
 11th c.
Easby Cross. Anglo-Saxon
East, Alfred (English Painter and
 Etcher 1849-1913)
 Frampton. Alfred East, head
Easter Column. German--11th c.
Easter Eggs
 Faberge. Imperial Easter Egg
 Faberge. Jewelled Easter Egg
Easter Sepulchre. English--14th c.
EATON, Bertram (English 1912-)
 Figure of Movement 1949
 laburnum wood
 RAMS pl 78C
L'Eau
 Richier, G. The Water
EBERLEIN, Gustav (German 1874-
 1910)
 Goethe Monument 1902
 MINB 76 IRB
 The Secret
 TAFTM 54
EBERLEIN, Johann Friedrich
 (German 1696-1749)
 Sense of Sight 1745 Meissen

porcelain; bronze-gilt
mount; 11-5/8 CPL 107
UCSFCP (1927.174)
Sense of Touch 1745 Meissen
porcelain; bronze-gilt
mount; 12-1/4 CPL 107
UCSFCP (1927.172)
EBNETH, Lajos van (Hungarian-
Dutch 1902-)
Crucifix 1942 rosewood
RAMS pl 54b, 55 -Van
Head of a Man 1946 bronze
RAMT pl 43
Ecce Homo See Jesus Christ--
Mocked and Scourged
Ecce Puer. Rosso, M.
Eccentric Structuralization. Colombo
Ecclesia
 English--13th c. Judgment
 Porch: Ecclesia
 French--13th c. Church
 (Ecclesia)
 German--13th c. Christ with
 Ecclesia as Bride
 German--14th c. Ecclesia
 on Tetramorph, ornamental
 gable
 Pisano, G. Fontana Maggiore:
 Ecclesia
Echo. Holt
Echo. Moeller
Echo II. Minguzzi
Echternach Codex
 German--11th c. Gospel
 Cover
Echternach Gospel
 German--10th c. Codex
 Aureus Epternacensis
Eckhart II, Margrave d 1046
 Naumberg Master. Eckhart
 and Uta
ECKMANN, Otto (German 1865-
1902)
 Electric Table Lamp wrought
 iron LARM 212
ECKSTEIN See CARTER, T. I.
Eclipse. Capello
Eclogue. del Bo, R
Ecstatic One. Barlach
Ecstatic Woman. Barlach
Ecstacy. Brandenburg
Ecstacy of St. Catherine. Caffa
Ecstacy of St. Theresa. Bernini,
 G. L.
Edberg, Saint
 English--14th c. St. Edberg,
 shrine base
Eddy, Arthur Jerome
 Rodin. Arthur Jerome Eddy,
 bust

Ede, Chuter
 Cawthra. Rt. Hon. Chuter
 Ede, bust
EDER. Otto (Austrian 1924-)
 Reclining Woman 1953 bronze;
 L: 31 cm SOT pl 136
EDGCUMBE, Ursula
 War Memorial at Zennor:
 Shadrach, Meshach and
 Abednego
 AUM 154
Edmund, Saint
 English--15th c. Martyrdom
 of St. Edmund, stall
 relief
Edward, called The Confessor
 (Anglo-Saxon King of England
 1002?-1066)
 Anglo-Saxon. Coin: Edward
 the Confessor
 English--11th c. Great Seal
 of Edward the Confessor
 --Shrine of Edward the Con-
 fessor
 Walter of Durham. Coronation
 Chair
Edward I (King of England 1239-1307)
 Deare. Edward and Eleanor
 Thornycroft, H. King Edward
 I, equest
Edward II (King of England 1284-
 1327)
 English--14th c. Edward II
 Tomb
 English--15th c. Edward II,
 and Edward III, choir
 screen detail
Edward III (King of England 1312-
 77)
 English--14th c. Edward III,
 coins
 --Great Seal of Edward III
 --Sixth Seal of Edward III
 English--15th c. Edward II,
 and Edward III, choir
 screen detail
 Orchard, John. Edward III
 Tomb
Edward VI (King of England 1537-
 53)
 Scheemakers, P. Edward VI,
 boy-king
Edward VII (King of England 1841-
 1910)
 Thornycroft, T. and A.
 H.R.H. Prince of Wales
 as a Young Shepherd
Edward VIII (King of England, after
 abdication, Dec 11, 1936:
 Duke of Windsor 1894-)

Elkan. Prince Edward as a
Child, head
Edward, Prince of Wales, called
Edward IV, or Edward of
Woodstock, or The Black
Prince (Eldest son of Ed-
ward III of England 1330-76)
English--14th c. Black Prince
Tomb
EDWARDS, H. E. (English)
Elephants, relief boxwood
AUM 142
EDWIN, A.
Corridor Panel
AUM 96 DCF
EDZARD, Kurt (German 1890-)
Liegender Jungling 1925
bronze HENT 63
Woman with Folded Arms
(Frau mit verschrankten
Armen) 1950 bronze
GERT 100
Effort
Chambellan, R. Doors:
Endurance; Effort
EFIMOV, I. (Russian)
Falcon (Hawk
BLUC 251
Fish porcelain
BLUC 251
EFTHIMIADI, Frosso (Greek)
Greek Shepherds iron;
54 cm SAO-5
EGAS, Enrique de (Spanish), and
Pedro GAMIEL
Altar Mayor gilded wood
WES pl 2 SpTC
EGAS, Enrique de--ATTRIB
Plateresque Main Doorway
16th c. LARR 171 SpSalU
EGBERT OF TREVES (Egbert of
Trier)--FOLL
Codex Aureus of Echternach
Cover: The Crucifixion,
Treves c 990 SWA pl 22
GCobD
Reliquary: Nail of Holy
Cross Case, Treves 977/
93 jewelled and enamelled
gold; 68x153x42 mm
SWA pl 27
Reliquary Shrine: Foot of
St. Andrew 977/93 gold,
ivory, enamel, jewels;
12-3/4
KIDS 82 (col) GTC
EGELL, Paul (German 1691-1752)

Adoring Angel, high altar
figure, Unterpfarrkirche,
Mannheim c 1735 HEMP
pl 100 GBSBe
Judas Thaddaeus, Bozzetto
c 1735 HEMP pl 101
GMaiA
Mannheim Altar 1730/35
lindenwood
--back panel 450x126 cm
BERLEK pl 45 GBSBe
(8443-45)
--bust of saint H: 86 cm
BERLEK pl 44 (8444-45)
--cartouche 95x85 cm
BERLE pl 94 AE (529/30)
St. Anne, Altar of Immacu-
late Conception 1729/31
HEMP pl 100 GHiC
St. Francis Xavier c 1735
HEMP pl 101 GMaSS
EGELL, Paul--FOLL
Summer 18th c. gray sand-
stone FAIN 116 UMCF
Egerius, Saint
Vivarini, A., and Giovanni
D'Alemagna. Altarpiece:
St. Sabina between SS
Jerome and Egerius
Egerton, Thomas
Bacon, J. Thomas Egerton
Monument
Egg Board. Arp
EGGERS, B. (Dutch 1637-91)
Male portrait bust
GEL pl 103 NAR
Egil (Norse Hero)
Anglo-Saxon. Franks Casket,
panel: Legend of Egil the
Archer
Eglwysilan Warrior. Celtic
Egri. Jozsef (Hungarian Painter)
Borsos. Jozsef Egri, bust
Egyptian Black Pitcher. English--18th c.
Egyptian Column. Dalwood
EHEMANN, Peter See MASTER
P. E.
EHLERS, Karl (German 1904-)
Buttressing Wall 1957 con-
crete; L: 98-1/2' TRI
246 GBadL
Many-faced figure 1951 oak;
4 SCHAEF pl 108
Owl (Eule) 1950 oak
GERT 249
Wall (Betonmauer) 1960
KUL 15 GDetP

Window (Betonfenster) 1960
 KUL 17 GGutP
EHRLICH, Georg (Austrian-English
 1897-)
 Horse's Head 1955/56
 bronze; 17-1/4 TATES
 pl 23; VEN-58:pl 132
 ELT (T.369)
 Italian Boy 1935 bronze;
 11-1/2 (excl marble base)
 TATEF pl 27c ELT (5394)
 Prof. H. Thietze, bust
 bronze VEN-32:pl 149
 Sleeping Calf 1961/63 bronze;
 16-1/2x42x36-1/2
 LOND-6:#15
 Two Sisters 1945/46 bronze;
 31 ARTSB-62:pl 2
Ehrman, Jacqueline
 Schnier. Jacqueline Ehrman
EICHLER, Theodor
 Female figure porcelain
 TAFTM 63
EICKHOFF, Gottfried (Danish 1902-)
 De syv frie Kunster, relief
 1953 bronze; 122.5x392.5
 cm COPGM 23 DCN
 (I.N.2758)
 Sun-Bathing 1960 bronze;
 65 cm BOES 151 DML
 Two Peasant Girls 1938/39
 bronze; 93 MID pl 77
 BAM
 Woman bronze
 CASS 75 DCNM
Eidsvoll Commemorative Column.
 Rasmussen
8 Beams. Visser
18 Superimposed Balls. Bury
80 Rectangles on 20 Inclined
 Planes. Bury
81 Cubitenairs. Sanejouand
EILBERTUS--FOLL
 Arm Reliquary, Guelph
 Treasure, Hildesheim
 c 1175 silver gilt,
 champleve enamel
 CLE 50 UOC1A (2223.30)
EINBECK, Konrad von
 Self-portrait c 1416
 GOLDF pl 6 GHallM
 Weeping Madonna, head
 detail c 1400
 BUSR 14 GHall
Einhorn, Muller, E.
Einsame Figur. Hepworth
Einstein, Albert
 Epstein. Albert Einstein,
 Head

Einstein Tower. Mendelsohn
EISENHOIT, Anton (German 1553-
 1603)
 Processional cross, base
 detail c 1600
 BUSB 25 GSoP
Eko-Akai. Paolozzi
EL AGHATI, Hassan (Egyptian
 1923-)
 Plastic Expression 1955
 bronze VEN-56:pl 110
L'Elan Spirituel. Bouget
Les Elans Physiques. Bouget
The Elder Brother. Foley
Elders of the Apocalypse. French--
 12th c.
ELDH, Carl (Swedish)
 Karl Nordstrom
 TAFTM 82
 Monument to Swedish Poet
 Wonnerberg
 TAFTM 82
Eldred, John d 1632
 Colt. John Eldred, medallion
Eleanor (Queen of Portugal)
 Daucher, H. Madonna Relief
 of Eleanor of Portugal
Eleanor Cross. English--13th c.
Eleanor Cross. John of Battle,
 designer; William of Ireland,
 figures
Eleanor of Aragon
 Laurana. Eleanor of Aragon
Eleanor of Castile (Queen of
 Edward I of England d 1290)
 Deare. Edward and Eleanor
 Torel. Eleanor of Castile
 William of Ireland. Eleanor
 of Castile
Eleanor of Toledo (Wife of Cosimo
 I de'Medici)
 Rossi, G. A. de'. Cosimo
 I de'Medici and Eleanora
 of Toledo and their
 children, relief
Electra-lectron. Kemeny
Electric Lamps and Fixtures
 Almquist. Alabaster
 Electrolier
 Horta. Electric Light Fix-
 ture
 Mack. School Light
 Mackintosh. Wall-bracket
 Lighting Fixture
 Moore, H. Two Wall Lights
 Sutkowski. Electric Light
 Fitting
Electro Signal III. Takis
Electromagnetic Musical Pendulum

and Elizabeth of York
Tomb
Elizabeth I (Queen of England 1533-
1603)
English--16th c. The "Dangers
Averted", or "Armada",
medal
--Queen Elizabeth, cameo
English--17th c. Elizabeth
I Tomb
Reynolds-Stephens. A Royal
Game
Elizabeth of Hungary, Saint
Austrian--16th c. Maximilian
Tomb
Dieussart--Attrib. Elizabeth,
Queen of Bohemia, bust
Franco-Thuringian. St.
Elizabeth of Hungary
Sesselschreiber. Mary of
Burgundy; Elizabeth of
Hungary
Elk
Milles. Young Elk
Swedish--2/1st mil BC. Elk's
Head
ELKAN, Benno (German-English
1877-)
Arturo Toscanini, head 1953
plaster for bronze
SCHW pl 16
Bible Chandelier, center
detail bronze
SCHW pl 17 ELWe
Carl Valentin, head
CASS 56
Crouching Woman
TAFTM 66
For the Victims granite
SCHW pl 18 GF
Head mercury gilt bronze
CASS 34
Herman Schoendorff, head
CASS 56
Maria D., head
CASS 56
Menorah
ROTH 874 IsJK
Persephone
TAFTM 62
Portrait Head
TAFTM 66
Prince Edward as a Child,
head CASS 56
Samuel Courtauld, head
CAB 74/75
Stone of Lamentation
TAFTM 66 GWic

ELLIOTT, William
George III Candlestick in
"Gothik" Style: Brick Tower
1814 SOTH-3:213
ELLIS, Clifford
Two Animals
CASS 124
Elmwood. Benazzi
Elne. Hajdu
Eloi, Saint See Eligius, Saint
Elopement at the Castle of Love,
mirror back. French--14th c.
Eloquence
Bourdelle. Alvear Monument,
study: Eloquence
Eltenberg Reliquary. Romanesque--
English
Eluard, Paul
Beaudin. Paul Eluard, bust
Elusate Coin. Celtic
Elzear, Saint
French--14th c. St. Elzear
EMANOUILOVA, Vaska
Toilet
CASS 86
Emblems See Guilds; Heraldry;
Symbols
The Embrace. Maratka
The Embrace. Rodin
The Embrace (Abstract). Brancusi
EMBRIACH I, Baldassare degli
(Italian 1389-1427)
Triptych ivory
BARG IFBar
EMBRIAGO, Giovan Battista
(Italian)
Clock in a Pool 1867
MINB 104 IRB
Embryonic Construction. Pevsner
Emerenziani, Saint
Ferrata, and L. Retti.
Stoning of St. Emerezniana
EMERSON, Robert J. (English)
Golden Youth 1941 bronze;
LS BRO pl 7 BWolA
Motherhood stone
PAR-1:113
Young Aviator 1940 bronze;
LS BRO pl 6
EMES, John
George III Beehive Honey
Pot 1802 SOTH-2:179
Emigrante. Stanzani
Emigranterne
Daumier. Les Emigrants
The Emigrants. Daumier
EMILIAN, Celine (Rumanian 1902-)
Angela, head 1930 bronze;

12-3/8 TATEF pl 27d
ELT 5051)
Luigi Pirandello, head
bronze VEN-40:pl 99
EMILIAN SCULPTOR
Legend of S. Terenzio, Shrine
of S. Terenzio c 1485 mar-
ble SEY pl 108B IFaC
Emly Shrine. Celtic
Emmaus See Jesus Christ--Emmaus
Emo, Angelo
Canova. Angelo Emo Monu-
ment
An Emperor, Barletta. Italian--
5th c.
Empresses
Byzantine. Empress
Early Christian. Empress,
head
Kenny. The Empress
L'Emprise. Rodin
Empty and Full Abstracts of a
Head. Boccioni
Empty Suspension. Oteiza
En un Soir Chaud d'Automne.
Chauvin, J.
Enak's Tears
Arp. Earth Forms
Enceladus
Marsy, G. Giant Enceladus,
head
Enchained Emotions. Couzijn
The Enchanted Princess. Laszczka
Enchantment. Mastroianni
ENCKE, Eberhard (German)
Discus Thrower
CASS 88
Enclume de Reve# Chillada
Encounter. Ruzic
Encounter.
Wozna. From "The Sea"
Series: Encounter
Encounter VI. Chadwick
Encounter X. Chadwick
End of the Warrior No. 1.
Minguzzi
End of the Worlds. Sekal
ENDELL, August (German 1871-
1925)
Atelier Elvira 1896
destroyed GME
--Staircase
CAS pl 267, 268; LARM
212; SELZPN 139
--Stucco Facade
LARM 217; SCHNU pl
200; SELZPN 138; ST
421

Frieze 1897/98 ptd stucco
destroyed SCHMU pl 199
GME
Radiator Screen, Buntes
Theater 1901 SCHMU pl
198 GBBu
ENDER, J. E.
Oriole, Meissen Chandelier
c 1741 porcelain, orna-
mented gilded bronze
BAZINL pl 354 (col)
ENDERLIE, Andreas (Norwegian
1884-)
Temptation red marble
PAR-2:192
Endless Column. Brancusi
Endless Loop, No. 1. Bill
Endless Loop from a Circular
Ring II. Bill
Endless Ribbon. Bill
Endless Torsion. Bill
Endless Track. Kramer
ENDSTORFER (Austrian)
Tenement Facade
AUM 87 AV
Endurance
Chambellan. Doors:
Endurance
Endymion
Canova. Endymion
Cornacchini. Endymion
French--17/18th c. Selene
and Endymion
French--18th c. Selene and
Endymion
Morice. Diana and Endymion
Energy Enchained
Maillol. Chained Action
Enfant. Hepworth
L'Enfant. Roger-Bloche
L'Enfant Prodigue See The Prodigal Son
Enfants S'Embrassant
Rodin. Children Embracing
ENGELBRECHT, Maja (German 1939-)
Bewegtes Eisen 1963 iron; 85
x55 cm KUL pl 42
Urkonig 1963 iron; 43x34 cm
KUL pl 41
Engelbrecht of Nassau
Netherlandish. Engelbrecht of
Nassau and Johanna of
Polanen Monument
Engelbrecht II of Nassau
Tommaso Vincidor da Bologna.
Engelbrecht II of Nassau
Tomb
Engels, Friedrich
Bakic. Marx-Engels Monument
Enger Reliquary. German--10th c.(?)

Bone Clasp, The Thames,
 London Dm: c 2-1/2
 STON pl 18 ELBr
Censing Angels walrus ivory;
 75x50 mm SWA pl 56
 EWinC
Christ in Majesty c 960
 ivory RDE pl 32
Cross
 RDE pl 24b ELeCh
Cross, fragment stone
 RDE pl 9b ERec
--10th c.
Cross Shaft stone
 STON pl 18 ESoc
Crucifix, Rhenish background
 c 950 ivory
 RDE pl 31
Darley Dale Cross H: 64
 RDE pl 25b EDar
Grave Slab stone
 STON pl 18 ELev
Nativity, relief c 950 ivory
 RDE pl 37
Pectoral Cross
 RDE pl 36b
Penny: Eadgar, Newark (?)
 c 973/75 silver
 SOTH-4: 254
Two Angels c 970 ivory
 RDE pl 33
Virgin stone; 24
 RDE pl 5b EBree
--10/11th c.
"Hogback" Tombstone
 STON pl 20 EBrom
Pershore Censer, Thurible
 of Godric bronze
 INTA-1: 96
Reliquary Cross c 990/1030
 gold filigree, ivory; c 60
 STON pl 23 ELV
Townley Brooch Dm: 3.8
 RDE pl 92c ELBr
--11th c.
Alcester Tau ivory; L 5-5/8
 RDE pl 40 ELBr
Angel, relief fragment c 1000
 stone RDE pl 10b EStin
The Baptism ivory figures
 RDE pl 35a
Candlestick Foot: Men with
 Falcon and Dogs, "Spinario"
 bronze gilt; 100x200 mm
 SWA pl 91 SwBHi
Capitals
 RDE pl 26b ESomp
Casket boxwood
 RDE pl 38b

Christ c 1050 stone; 36
 RDE pl 10a EJev
Christ, relief c 1025 H: 84
 RDR pl 12 EBriC
Christ Blessing, seated figure,
 relief 1083/89 H: c30
 RDE pl 19b FPoR
Cross Shaft, fragment stone;
 c 36 STON pl 22 ESher
Crucifixion 1020/50
 RDE pl 11b EWorm
Crucifixion, relief c 1020
 stone; 36 RDE pl 9a EStDS
Crucifixion, relief fragment
 1020/50 RDE pl 11a ELang
Crucifixion, with symbols of
 Evangelists, panel morse
 ivory; 2-3/8x1-5/8
 SOTH-1: 209
Door Hinges
 RDE 91a EStil
Door Hinges
 RDE 91b EStapl
Draped Crucifixion, headless
 relief c 1000
 JOHT pl 36
Font c 910
 RDE pl 30a EDee
Godwin Seal c 1000
 RDE pl 36d
Gravestone, St. Paul's
 Churchyard c 1035 W: 24
 RDE pl 23a ELGM
Great Seal of Edward the
 Confessor
 BROWF-3: 35 ELWe
Griffons Seizing Human,
 tympanum stone STON pl
 31 ELec
Halton Moor Bowl c 1000
 silver; 3-3/4 RDE pl 90c
 ELBr
Madonna and Child, seated
 fragment, York c 1000
 JOHT
Panel: Incised Figure stone
 STON pl 22 EBuc
Pectoral Cross# c 1000
 RDE pl 36a, 36c
Plaque bone
 RDE pl 38a
The Rood c 1020
 RDE pl 17 ELang
The Rood, relief c 1030
 H: c 78 RDE pl 16b
 EHea
The Rood, relief c 1040
 RDE pl 16a EBrea

Saint, relief c 1000
 RDE pl 15b ESomp
St. Peter, with Key, relief
 c 1050 H: c 30
 RDE pl 14b EDag
Shrine of Edward the Con-
 fessor
 BROWF-3:32 ELWe
Slab
 STON pl 24 EBriC
Slab c 1020 W: c 24
 RDE pl 23b ERou
Stylized Fighting Animal
 Brooch, Pitney, Somerset
 gilt bronze; Dm: 1-1/2
 STON pl 28 ELB
Tympanum: Archangel
 Michael c 1030
 RDE pl 27b ESoM
Tympanum: David and Lion;
 St. Michael and Dragon
 stone
 STON pl 29
Tympanum, Irish-Viking
 style
 CHASEH 208 EDi
Virgin, relief fragment
 c 1000 H: c 48
 RDE pl 18a EDee
Virgin and Child, lozenge-
 shaped plaque c 1000
 ivory
 RDE pl 34a
Virgin and Child, plaque c
 1040 ivory
 RDE pl 35b
Virgin and Child, plaque
 c 1070 ivory
 RDE pl 34b
Virgin and Child, relief
 c 1060 H: 36
 RDE pl 15a EIn
Virgin and St. John c 1010
 ivory; 4-1/2
 RDE pl 39a FStO
Whalley Cross
 RDE pl 25a EWhal
--11/12th c.
Capital: Griffin
 JOHT pl 73 EWinC
Crozier Head: Life of
 Christ, scenes c 1060
 ivory; 4-5/8x4-1/4
 ASHA pl 6, 7; RDE pl
 41; STON pl 62; VICF
 15 ELV (218-1865)
Raising of Lazarus, relief
 detail BAZINW 280 (col)
 EChic

--12th c.
Adoration of the Magi, plaque
 detail: Three Kings whale-
 bone; 14-1/4x6-1/4
 ASHA pl 5, 6; BUSRO pl
 25; CHENSW 308; GAUN
 pl 33; JANSK 441; LARB
 301; MCCL pl 16; MOLE
 18; MOLS-1:pl 12, 13;
 NEWTEA 54; NEWTEM
 pl 56; READAS pl 67-9;
 RDE front; STON pl 41;
 SWA pl 84, 125; STON
 pl 41; UND 15 ELV
 (142.1866)
Angel Capital, Reading Ab-
 bey
 BOAS pl 21C EReaM
Apostles, spandrels, east
 and west sides of south
 porch c 1160 limestone;
 c 1/2 LS
 BECKM 202-3; BUSRO
 pl 76; FOC-1:pl 141;
 JOHT pl 55; MOLE 35;
 MOLS-1:pl 21 EMalA
--an apostle, relief
 BOAS pl 78b
Arcade, north transept
 BOAS pl 8b ECaC
Bearded man, head
 JOHT pl 63 ESaCh
Boss, high vaulting cross-
 ing c 1184 stone
 STON pl 74 ECaC
Brunswick Candlestick,
 details c 1170 cast bronze
 SWA pl 199 GBrC
Capital
 BOAS pl 14c ERomA
--BOAS pl 77b EYoP
--c 1124 STON pl 44 ECas
--c 1140 stone
 STON pl 49 ENorfN
--c 1145/50 stone
 STON pl 51 EWinC
Capital: Animal Figures
 stone CHENSW 335 ECaC
Capital: Biblical scene
 c 1109/14
 STON pl 30 ESoM
Capital: Bird Biting Breast,
 Reading Abbey c 1130/40
 stone
 STON pl 37 ELV
Capital: Cat Head in Foliage,
 Reading Abbey c 1130/40
 stone STON pl 37 EReaM
Capital: Centaur Fighting

transepts
BRIE pl 33 ELWe
The Annunciation, chapter
house c 1250 stone; LS
BRIE pl 40; JOHT pl 71;
MOLS-1:pl 28-9; UND 26
ELWe
Apostles, Prophets, and
Patriarchs c 1230/50
BOE pl 106-7 EWeC
Arch, detail, Lady Chapel,
north door c 1220/30 stone
STON pl 78 ESomG
Arms of Earl of Cornwall,
east end nave c 1280/90
stone
STON pl 101 ELWe
Bishop Giles Bridport Tomb
BRIE pl 32 ESaC
Bishop Levericus c 1200/
1210 stone
STON pl 79 EWeC
Bishop Peter of Aigueblanche
Tomb
BRIE pl 31 EHerC
Bishop William of Kilkenny,
effigy c 1255/60 marble;
LS
BRIE pl 29b; MOLS-1:
pl 32; STON pl 90 EEC
Boss c 1297/1300 wood
STON pl 107 ELinC
Boss: Centaur and Dragon,
Muniment Room
BRIE pl 39b; MOLE 57
ELWe
Boss: Four Evangelists
BRIE pl 39c EDurC
Boss: Virgin and Child
BRIE pl 39a EChesC
Capital
BRIE pl 16a ELinC
Capital, Passage c 1290/95
stone STON pl 106 ESoM
Capital: Thorn in foot
stone MOLE 39 EWeC
Capital: Toothache
BARD 384; MOLE 39
EWeC
Capitals, east end of nave
c 1200/1210 stone
STON pl 75 EWeC
Capitals, south transept
c 1200/10 stone
STON pl 75 EWeC
Caryatid: Bearded Figure
c 1270 oak; 55
BOSMI 115 UMB (62.669)

Cathedral Facade 1230/60
BUSGS 126 EWeC
Censing Angels, south
transept c 1255 stone;
c LS
BARD 384; BROWF-3:32;
MOLS-1:pl 30; RAMS pl
16b ELWe
Centaurs, box detail ivory;
box: 3x2-1/2 MOLS-1:
pl 18 ELV
Chapter House Capital:
Foliate motif, actual plant
forms
BRIE pl 16c ESoM
Chapter House Corbel c 1240
stone STON pl 88 EOC
Choir, with Percy Tomb
1225/45
BUSG pl 75 EBev
Choir Capital: Foliate motif
BRIE pl 16b EEC
Christ, chapter house door
(ex situ) c 1253 stone
STON pl 97 ELWe
Christ and the Doctors;
Resurrection of the Dead,
frieze BRIE pl 11 EWeC
Christ in Majesty; restored
figure JOHT pl 59-61
ELinC
Ciborium of St. Maurice,
finial: Chiron and Achilles
cast bronze; 43 mm; Dm:
49 mm SWA pl 217 EStMa
--Journey of the Magi
SWA pl 217 EStMa
Corbel c 1200/10 stone
STON pl 77 EWeC
Corbel c 1235/40 marble
STON pl 89 ESaC
Corbel, triforium of choir
c 1250/55 stone
STON pl 91 ELWe
Corbel, West front c 1225/35
stone STON pl 90 ELinC
Corbel and Relief, north
transept; c 1250/55 stone
STON pl 94 ELWe
Edmund Crouchback Monu-
ment, Earl of Lancaster
c 1295/1300 stone
EVJE pl 3 ELWe
--canopy detail: Knight,
equest; Trefoil c 1295/
1300 stone
STON pl 120
--Weepers

STON pl 111
Effigies c 1280/90 wood
STON pl 112 ENorthW
Eleanor Cross 1294
EVJE pl 1 ENorGe
Female Figure
BATT 84 ELinC
Female Figure, fragment
stone BRIE pl 41a;
READM pl 25 EWinC
Figure c 1230/35 stone; 19
STON pl 86 EWinC
Figures stone
JOHT pl 74
Figures, west front, details
c 1230/40 STON pl 81-85
EWeC
--Hermit; Lady
BRIE pl 10
--Knight; Lady; Bishop;
King
BRIE pl 9
Foliage Capitals stone
MOLE 56 ESoM
Gilbert Marshall, effigy
STA 124 ELTC
Head
BUSGS 68 ESaCl
Head, chapter house detail
c 1272 BOE pl 108 ESaC
Head, north transept c 1250
marble STON pl 91 ELWe
Head Stops
BRIE pl 38 ELWe
Holy Trinity alabaster
CHR fig 113 UDCN
Horseman, aquamanile bronze;
11-3/16x14x6
SEYM 32-33 UDCN
John Swinfield, effigy c 1290
BRIE pl 77b EHerC
Judgment Porch, detail
c 1260/65
STON pl 100 ELinC
--Ecclesia
STON pl 99
--Foolish Virgin
KO pl 46
--Tympanum Quatrefoil (cast)
STON pl 98
--Virtues BRIE pl 75b
King John, effigy--first
royal effigy in England
c 1225/30 ptd marble,
set with jewels
BRIE pl 29a; STON pl 87
EWoC

Knight, effigy oak; 72
ARTS 62 WAM
Knight, effigy c 1270 stone
STON pl 89 EWorP
Knight, effigy 1270/90
BRIE pl 30b EDo
Knights Templar, effigies
c 1250 marble
BROWF-3:37; BUSGS 148
ELTC
Knight's Tomb c 1230/50
JANSH 253; JANSK 483;
MOLE 16 EOxfD
Madonna and Child, vaulting
boss c 1260 KO pl 46
EChesCh
Man, head c 1250/70
NEWTEM pl 76 ESaC
Moses, St. Mary's Abbey
c 1200 stone; 69-1/2
BOAS pl 78a; MOLS-1:
pl 25; READAS pl 25;
STON pl 71
Plate-Tracery, gothic window
BROWF-1:38
Priest, effigy wood
BRIE pl 77a EHereCl
Prophet, or Evangelist c
1200 stone; 68-1/2
READAS pl 24 EYoC
Queen stone
MILLER il 87 ELinC
Queen, cathedral tower
figure
KO pl 46 EWeC
Queen Margaret, exterior
figure c 1299
UND 33 ELinC
Queen with her Dogs, south
aisle boss c 1260
BARD 384 ELinC
Relief, detail c 1272/80
stone STON pl 101 ESaCh
St. Frideswide, shrine base,
detail c 1288/89 marble
STON pl 110 EOC
St. John stone
MOLE 51 EYoM
St. John the Evangelist,
Heggen im Vestfold
c 1250/60 wood; c 48
BUSGS 111; STON pl 100
NoDM
Saints c 1240 stone; LS
MOLS-1: pl 26-27 EWeC
Spandrel Relief, Lady Chapel
c 1225/30 stone

STON pl 78 EWoC
Spandrel Relief, east, south
transept c 1254/58 stone
STON pl 96 ELWe
Spandrel Relief, west, south
transept c 1254/58 stone
STON pl 96 ELWe
Thomas de Cantiloupe Tomb:
Knight Weepers 1282/84
stone
STON pl 118 EHC
Tower, northwest front
BRIE pl 1 EWeC
--Buttress Figure(s)
CHASEH 268; MOREYM
pl 130; POST-1:116
Transfiguration; creation--
quatrefoil fragments
c 1220 JOHT 79, pl 60
EWeC
Vine-Leaf Capital, with
bird c 1240
BUSGS 109 ESoM
Virgin and Child, Langham
Hall, Essex c 1200 wood;
16-1/2
STON pl 78 ELV
William de Valence, effigy
(ex situ) c 1290/1300
chased and enamelled
copper BRIE pl 76b;
MILLER il 83; STON pl
105 ELWe
William Longespee, Earl of
Salisbury, effigy c 1230
40 stone BRIE pl 30a;
STON pl 88 ESaC
Window Soffit Relief, north
transept c 1254/58 stone
STON pl 95 ELWe
Workman c 1220
READA pl 51 EWeC
--13/14th c.
Ascension Boss
JOHT pl 75 ETe
Capital
JOHT pl 75 EWeC
Choir Screen: Head, arms
from ears
JOHT pl 75 ESoM
Corbel, presbytery c 1295/
1301 stone
STON pl 106 EExC
Head, architectural detail
JOHT pl 63 EWeC
Sir Robert de Bures,
"Westminster" attitude of
Prayer brass

STON 139 EAc
--14th c.
Adoration of the Magi,
reredos detail c 1350/60
stone; c LS
MOLS-1:pl 40: STON pl
132, 134 EChr
Angel, choir vault 1337/50
EVJE pl 37 EGC
Annunciation c 1350/60 ptd
oak; c 72
MOLS-1:pl 42; STON pl
140 EWeV
Annunciation, diptych panel
ivory; 9-1/2
MOLS-1:pl 37 ELBr
Archbishop Courtenay,
effigy c 1397/1400
alabaster STON pl 152
ECaC
Aymer de Valence Tomb c
1325 stone, ptd in imita-
tion of marble
MILLER il 88 ELWe
--canopy relief: Galloping
Knight
MOLE 68; MOLS-1:pl 35
--Knight, equestrian, trefoil
STON pl 120
--Weeper
STON pl 122
Bagpipes, label stop and
altar screen detail c
1320/35 stone
STON pl 130 EBev
Bird with Human Head, nave
corbel, south aisle
FOC-2:pl 155 EBe
Bishop's Throne 1312
EVJE pl 13 EExC
Black Prince Tomb c 1377/80
EVJE pl 74 ECaC
--effigy copper gilt
BUSR 12; EVJE pl 70;
LARB 385; STON pl 143
Boss: Head with Foliage
Growing from Mouth and
Ears, foliate boss c 1335
stone
STON pl 131 EBev
Boss: Roof Boss, foliate head
stone MOLS-1: fr cov
ENorwC
Boss, Lady Chapel
FOC-2:pl 154 EEC
Brian Fitzalan and Lady
Fitzalan, effigies
c 1300/1310 stone

STON pl 117 EYoBe
Capital c 1330/40 stone
STON pl 128 EOxH
Censer, Whittlesea Mere
c 1380 silver gilt; 9-1/2
EVJE pl 34a ELV
Chancel Column: Stag
BOE pl 110 EYoC
Chest, detail oak; 30
NM-7:36 UNNMM (30.69)
Choir Stalls, detail c 1380
wood KIDS 115 (col)
EChesC
Christ's Ancestors, west
facade BOE pl 111 EExC
Church Porch c 1370
EVJE pl 22 EBosB
Coffer: Two Knights Jousting
c 1350 oak
EVJE pl 36A
Corbel c 1320
EVJE pl 25a EDoA
Coronation of the Virgin,
Nottingham alabaster;
15-1/4 TOR 111 CTRO
(938.21)
Coronation of the Virgin,
panel fragment c 1370/80
alabaster; 9
STON pl 146 ELBr
Crown of Princess Blanca
before 1399 jeweled and
enamelled gold
BAZINL pl 233 GMR
Crozier Handle: Madonna
and child ivory
NEWTEA 77 ELV
Dance of Salome, roof boss
detail
BUSGS 145 ENorwC
Decorated Bar-Tracery,
gothic window BROWF-1:38
Descent from the Cross
ENC 14 ESeA
Descent from the Cross,
panel c 1380/85 alabaster;
21 STON pl 147 ELV
Doorway Figure, chapter
house c 1300/1308 stone
STON pl 116 EWiM
Easter Sepulchre c 1330
stone EVJE pl 78; STON
pl 125, 128 ENoH
Edward II Tomb c 1330/35
BUSG 173; EVJE pl 73;
MILLER il 93, 94 EGC
--effigy alabaster; c LS
AUBA pl 22; BUSGS 200;

EVJE pl 69; GERN pl 33;
KIDS 136 (col); STON pl
119
Edward III, coins
BROWF-3:35
Edward, Lord Despencer,
chantry effigy c 1370/75
stone
STON pl 137 ETe
Effigy c 1310 stone
STON pl 116 EHC
Effigy head c 1320/30 stone
STON pl 118 EYoG
English Knight, effigy
c 1300 BUSGS 149 EDoM
Facade: Niche Figures, west
front 1350/65
BUSGS 198 EExC
Figures over main door
c 1360 EVJE pl 30b
ELinM
Flawford Madonna and Child
c 1350/70 alabaster; 32
EVJE pl 53; MOLS-1: pl
47; STON pl 145; UND 42
ENoC
Gallery Front Figure; nave
corbel c 1330/40 stone
STON pl 128, 129 EExC
Gatehouse, detail: Armorial
panel c 1326
EVJE pl 35b ESufBu
Geoffrey Luttrell Tomb, and
Easter Sepulchre
EVJE pl 77b ELincI
Grandisson Ivory: Annuncia-
tion; John the Baptist
c 1335/45 ivory; c 10-1/2
EVJE pl 31; STON pl 135
ELBr
Great Seal of Edward III
BROWF-3:35 ELWe
Green Glazed Jug
INTA-2:129
Head, tomb of Bishop de la
Marche c 1305/10 Caen
stone; 18
STON pl 113 EWeC
Henry Fitzroy, Duke of
Richmond, Tomb
ESD pl 5 ESufF
High Altar with Heraldic
Ornament, eastern end,
Lady Chapel
EVJE pl 35a EBriA
Holy Trinity, Nottingham
School before 1380
alabaster; 33-19/32x14x

Wykeham c 1404 EVJE
pl 80 EWinC
Chimney Piece, detail: Arms
and Devices of Ralph,
Lord Cromwell stone
EVJE pl 66 ELincT
Choir Stall: Geese Hanging
the Fox BUSR 11 EBrCh
Choir Stall Volute: Vine and
Grapes wood
DOWN 135 UNNMM
Christ Bearing the Cross,
retable panel alabaster;
20-1/2
STON pl 159 FNaD
Christ Visiting St. Catherine
in Prison, relief, Notting-
ham alabaster; 15x10
CAMI pl 23 CMFA
Cornice: Fighting Animals
c 1443/47
STON pl 167 EWarMB
Cross before 1439
EVJE pl 95 EGlI
Dean Hussey Tomb: Mercy
Seat--God Father and
Christ; Annunciation
c 1430 alabaster
BUSR 52, 53 EWeC
Decorated Style Screen 1459
wood
EVJE pl 23 ETot
The Deposition, panel
alabaster; 21
EVJE pl 55 ELV
Double Hammer Roof Beam
DURS 57 ENee
Draped and Headless Figure
stone; c 42
STON pl 160 EWinC
Edward II and Edward III,
choir screen detail c 1400
EVJE pl 46 ECaC
English Kings, choir stall
detail c 1400 STA 155
ECaC
Evangelist, west and screen-
work figure 1481
STON pl 177 EOD
Female Figure, Visitation
Group fragment, Terring-
ton St. John Church,
Norfolk wood
NORM 77 ELV
Figures, west front
STON pl 175 EExC
Henry IV and Joan of Navarre
Tomb c 1410/20 alabaster

BUSR 55; STON pl 155 E
CaC
--Henry IV, effigy
EVJE pl 71
Henry V's Chantry, figure
details: St. John the Bap-
tist, King; Equestrian,
Virgin of the Annunciation
c 1441/50
STON pl 160-3 ELWe
Holy Trinity, Nottingham
polychromed alabaster;
38-1/2
BOSMI 117; EVJE pl 54;
VALE 157 UMB (27.852)
"Image of Pity": Risen Christ,
half figure, exterior of
Tower stone; c 48
STON pl 178 EFai
John Brouning, effigy 1467
alabaster
STON 173 EMolbS
John the Baptist, head
c 1430 alabaster; 6-1/2
FREED pl 16 GMBN
Lord and Lady Camoys c 1419
brass
STON 199 ETro
Martyrdom of St. Edmund,
stall detail wood
DURS 54 ENortoA
Misericord: Hawk on Hare
wood DURS 54 EStouG
Misericord, St. Nicholas
Chapel, King's Lynn c
1415 wood; 12 NORM 75
ELV
Niche Figures: King Henry
I, King Stephen, King
Henry II 1480/1500
BUSR 123 EYoC
Panel c 1490/1500 stone
STON pl 181 EPaiK
The Passion, retable panel
detail CHASEH UNNMM
Perpendicular Bar-Tracery,
gothic window
BROWF-1:38
Prior Leschman, effigy
c 1491 STON 178 EHex
Queen Catherine of Valois,
effigy head
CARP 256 ELWe
Ralph and Anne St. Leger
c 1470 brass
STON 219 EU
Richard III, misericord
ENC 631 EHaC

William Rudhall Tomb, detail
c 1530 MERC pl 75b EHR
--16/17th c.
Sir John St. John, and his
first and second Wives and
Children, Monument
MOLE 223 EWiL
--16-20th c.
Westminster Abbey Plate
silver gilt
CARP 448 (col) ELWe
--17th c.
Alms Dish; Flagon 1684
CARP front (col) ELWe
Anne Rodney Monument
ESD pl 107 ESomR
Arms of the Corporation of
Trinity House wood
BROWF-3: 53 ELV
Bishop Tompson of Exeter,
Dean of Bray, Monument
ESD pl 95 EWindG
Capt. Smith Monument,
merchant ship 1697
ESD pl 133 EWal
Cartouche Tablet to John
Pritchett, Bishop of
Gloucester
ESD pl 25 EMiddH
Cartouche to William Jarrett
ESD pl 28 EWorB
Cathedral Shell Window
GERN pl 6 ELPa
Ceiling
MERC pl 29 EHerr
--MERC pl 30a EWestmL
Ceiling central panel, taken
from Peacham's "Minerva
Britanna"
MERC pl 33a ENorfB
Ceiling, with figure of
Neptune (destroyed)
MERC pl 36a EOsP
Ceiling of Long Gallery
(destroyed) c 1600
MERC pl 35a EYoB
Chapel Screen
MERC pl 32a EOW
Charles I, bust c 1640 chalk
UND 70 EChi
Charles II, bust wood; 19x11
NORM 79 ELV
Charles II, effigy wax
CARP 257 ELWe
Charles II Pewter Candlestick
SOTH-3: 201
Charles II Table Candlestick
c 1675 silver gilt
SOTH-2: 175

Children of Rev. Martin
Blake, Vicar of Barn-
staple, Monument
ESD pl 89, 90 EBarns
Chimneypiece
MERC pl 35b ESurL
--MERC pl 37b ENorthwC
--MERC pl 38b EDerH
--1610
MERC pl 39a EHeH
Church Doors, St. Lawrence
Jewry, Cheapside
(destroyed 1940)
DURS 61 EL
Church Porch 1623
MERC pl 25b EGro
Common Seal of Dean and
Chapter of Westminster,
die silver
CARP 144 ELWe
Corinthian Capital, drum
gallery
GERN pl 7 ELPa
Courtyard Door and Screen
c 1626 MERC pl 93b
ENorthR
Dr. Gabriel Goodman, Dean
of Westminster Abbey,
kneeling effigy d 1601
CARP 113 ELWe
Dr. Isaac Barrow, bust
marble
MOLS-2: pl 14 ELWe
Edward Younge, and his
Family, brass
ESD pl 53 EWiG
Elizabeth I Tomb
BROWF-3: 40 ELWe
Firedog, with Royal Arms of
the Stuarts c 1670 cast
brass, enamelled
VICK 16 ELV (M. 416-1905)
Font Cover c 1630
WHIN pl 11a EDurC
Frieze, bedroom
MERC pl 36b EDorH
Fulham Figure salt-glazed
stoneware
ENC 321
Gallery Chimneypiece
MERC pl 38a EDerH
The Golden Boy
BROWF-1: 70
"The Great Salt", London
1629(?) silver; 3-1/4;
base Dm: 6-1/2
UMCF UMCF (881. 1927)
Hall Screen
MERC pl 31 EEsA

Hall Screen c 1600 MERC
pl 32b ESomM
Heraldic Ledger Stone
ESD pl 32 ENorfD
Inlaid Chest holly and box oak,
MERC pl 44b ELV
Jacobean Arm-Chair walnut
BROWF-1:68
James, Duke of York boxwood
DURS 58 ELV
John and Elizabeth Peables
Monument c 1684
WHIN pl 71a EYoD
John Bingham Monument
MERC pl 86a ESothC
John Somerset, and Wives,
Monument 1633 ESD pl 91
ESomB
John Stow Monument
BROWF-3:51; ESD pl 61 ELAn
Kymer Family Monument c
1625
MERC pl 92a EDWe
Lady May Monument, drwg by
John Bushnell
ESD pl 56 ESuM
Lady Wolryche, effigy
ESD pl 100 EShroQ
Ledger Stone to Elizabeth
Wiseman
ESD pl 33 ELPa
Ledger Stone to Jeremy
Whichcot
ESD pl 31 EMiddHe
Lionel Cranford, Earl of
Middlesex, and his
Countess, effigies 1645
marble
MOLS-2: pl 5 ELWe
Lord and Lady Scrope Monu-
ment c 1630
ESD pl 12, 13 ENoL
Martin Pringle Tomb
ESD pl 88 EBriS
Melbury House Ceiling c 1620
MERC pl 30b EDM
Monteith 1695 silver
ENC 639
Monument to a Divine c
1630
ESD pl 59 EBishop
Monument to a Doctor 1615
ESD pl 57 EWiLa
Oliver Cromwell, death
mask (The Frankland
Mask) late 17th c. plaster,
bronze glaze; 11-1/4
NATP pl 6G ELNP

Orlando Gibbons, Organist of
Westminster Abbey 1623-
25, bust (copy from bust in
Canterbury Cathedral)
d 1625
CARP 417 ELWe
Over mantel c 1550/60
MERC pl 33b EDMap
Pitman Memorial c 1627
ESD pl 64 ESufW
Portland Vase, Wedgewood:
Marriage of Peleus and
Thetis? 1642
ENC 937 ELBr
Poyntz Monument 1606
MERC pl 78 EEsN
Pulpit, St. Mildred, Bread
St. (destroyed 1940)
DURS 60 EL
"Royal Charles", Stern
Decoration: English Arms
1663 ptd and gilded wood;
109x148-3/4
RIJA pl 156 NAR
St. John Family Monument
ESD pl 84 EWiL
Samuel Butler Monument,
detail: Mask
GERN pl 61 ELWe
Sara Colville Monument
MERC pl 90a ELAll
Savage Tomb 1631
BUSB 63; ESD pl 10, 11
EElm
Shakespeare, bust before
1623 LS
ENC 821
Sir Francis Vere Monument
c 1609
BROWF-2: 43; MERC pl 92b
EDWe
Sir Giles Mompesson, and
Wife, Monument
ESD pl 15 EWiL
Sir Henry Savile Monument
MERC pl 88 EOMC
Sir James Hales, his Wife
and Stepson, Monument
ESD pl 62 ECaC
Sir John Jeffrey Monument
c 1611
CON-1:pl 31; MERC pl
85 EDW
Sir John Kyrle Tomb; detail:
Crest
ESD pl 71, 80 EHereM
Sir John Poley Monument c
1680 ESD pl 108 ESufB

H: 5-1/2
SOTH-1:159
Chelsea Woman 1725
 BAZINL pl 346 (col)
 UNNUn
Chippendale Chair
 BROWF-1:76 ELV
Chippendale Chinoiserie Bed-
 stead 1740/60
 LARR 413 ELV
Console Table c 1740 mahoga-
 ny, veined marble top
 ENC 203
Crinoline Figure, salt glaze
 SOTH-3:194
Derby Porcelain Group
 ENC 241
Derby Porcelain Neptune
 1760/70 H: 13
 TOR 149 (col) CTRO
 (939.12)
Duke of Cumberland, Chelsea
 bust
 INTA-2:127
Egyptian Black Pitcher
 unglazed stoneware
 ENC 273
Egyptian Style Louis XVI
 Candelabra
 ENC 273
Epergne c 1778 silver
 ENC 283
George I Table Candlestick
 silver gilt
 SOTH-3:209
George II Chandelier carved
 and gilt wood; 48
 INTA-2: front (col), 131
George II Rococo Chandelier
 SOTH-3:281
George III Candelabra 1794
 SOTH-2:181
George III Medal, reverse:
 Iroquois Hunter
 PAG-6:213
John Locke, ivory portrait
 bust H: 7-3/4
 SOTH-3:263
Lady Lynch, panel monument
 ESD pl 113 ESurE
Lt. Col. Patrick Ferguson,
 bust
 PAG-6:237
Longton Hall Shepherd,
 Staffordshire c 1755
 ENC 570
Longton Hall Tiger
 SOTH-3:198

Lowestoft Putti 1757/1802
 ENC 574
Major John Andre Monument
 CARP 400 ELWe
Mantel marble
 CLE 162 UOClA (44.471)
Mirror in Chinese Taste
 c 1740 wood
 KITS 129 ELV
Mother and Two Sons in
 Church Pew salt-glazed
 stoneware
 DOWN 134 UNNMM
The Music Lesson, Chelsea
 c 1763 porcelain; 6x11
 MONT 416 ELV
Pew-Group: Woman Seated
 Between Two Men c 1730
 Staffordshire Pottery;
 6-1/2
 GRIG pl 125 ELBr
Queen 1775 lead; 84, on 72
 pedestal
 GLE 178 ELQ
Queen Anne Octagonal Candle-
 stick 1707
 SOTH-3:209
Queen Anne Shilling--obverse
 and reverse 1709
 PAG-4:287 UNNAmN
Rachel, Lady Poley, Monu-
 ment alabaster
 ESD pl 108 ESufB
Residence Doorway 1707
 pinewood
 BROWF-1:76
Royal Society Medal given
 to Franklin
 PAG-8:136 UNNPL
Samuel Pierson, cartouche
 ESD pl 29 ESurC
Sight; Hearing c 1755/60
 Chelsea porcelain; 11-1/8
 NM-8:43; NM-11:57
 UNNMM (14.58.117, 118)
Sir Isaac Newton, portrait
 bust ivory; 7-1/2
 SOTH-3:263
Sir R. Jennes, effigy
 1722/25
 CON-3:pl 74 EAc
Staffordshire Diners salt-
 glaze
 INTA-2:125
Theophilus Creed, panel
 monument
 ESD pl 114 ENorthT
Voltaire black porcelain

figure
CON-4
Whieldon Arbour Group
SOTH-4: 195
William Pitt in Toga as
Roman Senator, headless
figure 1770 marble
SALT 162 UNNHS
--18/19th c.
Derby Blue Tit
SOTH-2: 162
Miniature Derby Owl
SOTH-2: 162
--19th c.
Argyle Jug
ENC 38
Bone Ship Model
SOTH-3: XXII
Candlestick brass
CHR 171
Cephalus and Procis marble
VICG 128
Denby "Reform Spirit" Flasks
stoneware
ENC 240
Dick Turpin, flat-back equest
figure c 1850 pottery;
11-1/2
CON-6: pl 59 ELV
Egyptian Avenue Entrance
Columns c 1838
GERN pl 8 ELHi
George IV as Prince
Regent, bust c 1814 wax;
10
VICK 37 ELV (A. 84-1936)
Lord William Gordon Tomb
ESD pl 147 ELeW
Noah's Ark ptd wood
SOTH-4: vii
Pearlware Figures: Mars;
Spring and Autumn; 2
Musicians before 1820
Leeds Pottery
CON-5: pl 61 ELeC
Regence Wall Light silver
ENC 753
Regency Chandelier
SOTH-2: 239
Regency Table Candelabra
cut glass and ormolu
SOTH-3: 280
Rockingham Ornaments: Dog
with Puppies; Cat with
Kittens early 1820
CON-5: pl 61 ELutW
Rockingham Toby Jug early
1820's
CON-5: pl 61

Worcester Cauliflower Tureen,
and cover
SOTH-4: 203
--20th c.
Cross of Westminster, head
1922 silver gilt, gold and
ivory, with sapphires and
diamonds
CARP front (col) ELWe
Ground-Floor Keystone
AUM 135 ELBrH
ENGLISH, or DANISH--13th c.
Christ from Cross ivory;
71 cm
SWA pl 231 DHer
ENGLISH, or SCANDINAVIAN--
12th c.
Chessman, Uig, Isle of
Lewis, Scotland walrus
ivory; King, H: 4
ENC 424; GRIG pl 115,
116 ELBr
ENGLISH ROYAL ARMORY, Green-
wich
Armor of George Clifford,
3rd Earl of Cumberland
1590/95 H: 69-1/2
NM-3: 13; NM-11: 99
UNNMM (32.130.6)
Englishe Gruss. Stoss
Engraving of Woman. Adams, H. G.
Enid the Fair, head. Frampton
Enigma IV--Bird's Nest. Vesely
Enigma of Isidore Ducasse. Ray
Enns
Donner. Providentia
Fountain: The River Enns
Enseigne au Carre. Luginbuhl
ENSELUNG, Josef (German 1886-)
Baptism 1932 stucco; 73
SCHAEF pl 39
Ensor, James
Wouters. James Ensor, head
Entelechie II. Werthmann
Die Entfuhrung
Muller, R. Le Rapt
Entry into Jerusalem See Jesus
Christ--Entry into Jerusalem
ENWONU, Ben
Fulani ebony
NORM 85 FPap
Eoban, Saint
German--12th c. Christ
Enthroned; St. Adolar;
St. Eoban
Eos (Aurora)
Aronson. L'Aurore
Flaxman. Cephalus and Aurora
Gisiger. Eos

Laurens. Aurora
Michelangelo. Lorenzo de'
 Medici Tomb: Morning
Tinguely. Eos
Epergnes
 English--18th c. Epergne
Epicentre. Belsky
L'Epinette. Laurens
Epiphany
 Byzantine. Medallion:
 Epiphany
 Ordonez. Epiphany
Episcopal Throne of Maximian
 Byzantine. Throne of
 Maximianus
L'Epopee Polonaise. Bourdelle
EPSTEIN, Jacob (American-English
 1880-1959)
 Adam 1938/39 alabaster;
 over LS
 ENC 284; SCHW pl 22
 Admiral of the Fleet, Lord
 Fisher of Kilverstone,
 bust 1915 bronze
 SELZJ 204 ELWar
 --bronze; 16-1/2
 CAN-2:193 CON
 --bronze; 18-1/2
 RIT 71; ROTJB pl 41 ELI
 Albert Einstein, head
 INTA-2:121
 --bronze
 HUX 80
 --1933
 WALKE UNNH
 --1933 bronze; 17-1/4
 MCCUR 257 UNNHal
 --1933 bronze; 20
 SOTH-2:78
 American Soldier, head
 bronze
 MILLER il 191; WB-17:
 204 UNNMM
 Anita, detail
 WILMO pl 25
 The Annunciation bronze
 ROTH 883 ELT
 Billie Gordon, mask bronze;
 11-1/2
 CAN-2:193 CON
 Bust
 CASS 54 UHHA
 Christ
 CHENSP 304
 Columnar Figure: Athlete
 MOLE 13 ELRH
 Day, over-entrance figure
 1929 Portland stone;

 c 96
 AUM 126; MARY pl 22;
 RAY 73 ELUR
 Dolores 1923 bronze
 LIC pl 213 ELEp
 Doves, first group 1914/15
 marble; 29
 HAMM front
 --second group 1914 marble;
 13-3/4
 SOTH-2:76
 --third group 1914/15
 marble; L: 29
 HAMM 6 UNNRose
 Duchess of Marlborough,
 sketch head 1923 bronze;
 LS
 HAMM 52
 Ecce Home (Behold the Man)
 MCCL pl 53
 --1934/35
 ENC 284
 --1935
 CASS 133 ELLe
 --1935 Subiaco stone;
 10x4x2-1/2'
 LOND-5:#18 -EMo
 Esther 1930 bronze; 21x24
 x11
 LONDC pl 11 ELT
 --1948 bronze; 21
 MID pl 28 BAM
 Euphemia Lamb (Bust of
 E. L.), bust 1908 bronze;
 14-3/4
 MUNSN 45 ELT
 Ferosa Rastourmji, head
 1930 cast bronze; 14
 DENV 68 UCoDA (E-166)
 Genesis 1931 marble
 LARM 364; MCCUR 257
 -EB
 George Bernard Shaw, bust
 bronze;
 VEN-38:pl 61
 --BRUM pl 39 UNNWalk
 --bronze; 18
 WHITT 106 ELNP
 --1934 bronze; 16-1/2
 CAN-2:194 CON
 --1934 bronze; 24
 NNMMAP 132 -URos
 Head of a Girl bronze; 14
 CHICH pl 70; KUH 65
 UNNYo
 Isabel Powys, bust
 WILM 28
 Ishmael bronze

SGO-4:pl 16
Isobel 1931 bronze; 27
 ROTJB pl 38 EKiF
Jacob and the Angel 1940
 alabaster; 84
 AUES pl 53; READCON
 166 ELB
Jacob Kramer, bust 1921
 bronze; 25x21x10
 HAMP pl 114; MARY pl
 101; PRAEG 479; ROTJG
 pl 15; TATEB-1:29 ELT
 (3849)
John Dewey, bust bronze
 FAIN 235 UVtNB
--1928
 ROOS 279H UNNCo
Joseph Conrad, bust 1924
 bronze
 MARY pl 18; ROTHS 245
 ELBo
--1924/25
 FAIY 201 UNIC
--1924/25 bronze; 17
 DETS 37 UNNH
Kathleen (Bust of a Woman)
 bronze; 19
 YAP 237 UNNCl
Kitty, head
 INTA-2:121
Kitty with Curlers bronze; 16
 JLAT 19 UAzPhA
Lazarus 1949 Hoptonwood
 stone; 91
 RIT 70 EON
Lydia, bust
 INTA-2:121
Madame Epstein, head
 bronze; 10
 ALBG 7 UNBuA
Madame Epstein, mask
 CHENSP 303
Mlle Gabrielle Soene, bust
 bronze; 22-1/2
 CHICS UICA
--1921
 RICH 189 UOTA
Madonna and Child
 AUES pl 52; CAH 113;
 COL-20: 544
-- MYBA 657 UNBB
--bronze
 ZOR 187
--1927 bronze; 64-1/2
 GARDH 754; MCCUR 257;
 ROTHS 241 UNNRy on
 loan to UNNMMA
--1927 bronze; 67
 NNMME 38 ELT

--PIE 385 UCtGeR
--1952 bronze; 13'
 GAUN pl 59; LARM 364;
 MAI 67; MYBS 59;
 ROTJG pl 40; WHITT 148
 ELCon
Madonna and Child, maquette
 lead and brass; 13-3/4
 INTA-2:122
--1951 lead; 14x6
 ARTSS #19 ELBrC
Madonna and Child, seated
 figure
 CAHA 55
--1927
 ROOS 279I
Maternity, building figure
 AUM 137 ELBM
Meum I c 1916 bronze;
 21-3/4
 CHICP-1:pl 94 UNBuA
Mother and Child
 LAF 342
--BULL-1:pl 56 UMoKF
--1911 bronze: LS
 LOND-5:#19 AuAH
--(Mutter und Kind) 1913
 white marble
 GERT 248
--busts 1913 marble; 17-1/4
 BRUM pl 40; PIE 385;
 SEITC 67 UNNMMA (5.38)
Nan (The Dreamer) 1911
 bronze; L: 11
 HAMM 50 ECamF
Nan, bust
 CASSM 118; HOF ELT
Night, over-entrance figure
 1929 Portland stone; c 96
 AGARN il 8; AUM 127;
 JOHT pl 180; MARY pl 22;
 PAR-1:80; RAMS pl 4b;
 RAY 73; RICJ pl 7; ROOS
 279B; ROTHS 243; SCHW
 pl 21; WILM 92 ELUR
Oriol Ross, bust 1931 bronze;
 25
 CRAVR 240; NNMMARO pl
 283; NNMMM 107; PEP
 pl 11; PIE 385; SLOB
 246; UNNMMAM #166
 UNNMMA (2.33)
Oscar Wilde Tomb 1912
 Hoptonwood stone
 LIC pl 214 FPLa
Paul Robeson, head
 AUES pl 51
--1928 bronze
 ROTHS 247 UNNVe

Pola Nerenska, head bronze;
12-3/4x6-1/2x5-1/2
SDF 19 UCSDF
Primavera God
ROOS 279D
R. B. Cunningham
Grahame, head bronze; 14
TORA 65 CTA (1277)
Rabindranath Tagore 1927
bronze; LS
RAMS pl 42; RAMT pl 5
Right Hon. J. Ramsay Mac-
Donald, bust bronze
CASS 52
Rima: W. H. Hudson
Memorial 1925 stone; 5x10
CASS 96; GLE 67; MARY
pl 57 MCCUR 257 ELHyB
Rock Drill 1912/13 bronze;
28
HAMP pl 113 UNNMMA
--1913/14 bronze; 28
CAN-2:195; EXS 75 CON
--1913/14 bronze; 27-3/4
HAMM 51 (col); MYBS
76; READCON 166; ROTJB
pl 39; SELZJ 204; TATEB-
1:28; WHITT 56 ELT
(T. 340)
Romilly bronze; 8-1/4
CAN-2:194 CON
St. Michael and the Devil
1955/57
ENC 284 ECovC
Selina, bust
RAY 72 UNBB
Senegalese Girl 1921 bronze
CHENSW 493 UNNWein
Senegalese Woman, bust
bronze NMAP #128 UNBuA
The Sick Child 1928 bronze
GOLDWA 465
Social Consciousness 1952/53
bronze; 16'
BR pl 18; FAUL 480;
LIC pl 215; PIE 385 UPPP
Venus 1914 marble; 48-1/2
BMAF 48; SELZS 58
UMdPW
The Visitation 1926 bronze;
65
CASSM 119; CHENSW
493; HAMM 53 (col);
MARY pl 98; RICJ pl 27;
ROTJG pl 14; ROTJT 23
ELT
--1926 bronze; 65
DETS 38 UNNH

Weeping Woman 1922 bronze;
23
CPL 79; HOW; SCHW pl
20 UCSFCP (1930. 7)
William Blake, bust
CARP pl 68 ELWe
Wynne Godley, head bronze;
19 UIA-8:pl 1
Young Communist 1937
bronze; LS
RAMS pl 43 ELCr
Equation in Chrome. Vantongerloo
Equestrians See also Battles; Games
and Sports--Jousting; Hunters
and Hunting, and Knights
Almeda. Jose Manel
Austrian--14/15th c. Singer-
tor: Fall of St. Paul
Austrian--16th c. St. George,
equest, altar relief
Barye. General Napoleon
Bonaparte
Barye. Napoleon
Bayes. At the Crest of the
Hill
Bayes. Sigurd
Bendl, J. G. St. Wenceslas,
equest
Bernini, G. L. Constantine,
equest
Bernini, G. L. Louis XIV#
Bertoldo di Giovanni. Bat-
tling Horsemen
Bertholo di Giovanni. Hercu-
les on Horseback
Bertoldo di Giovanni. Negro
and Lion
Blumenthal. Grosse Schwem-
mereiter
Blumenthal! Zwei Reiter,
relief
Bologna. Cosimo I
Bologna. Ferdinand I
Bologna, and P. Tacca.
Philip III
Bonino da Campione.
Bernabo Visconti Monument
Bonnesen. The Captive
Bonnesen. En Barbar
Bonnesen. Life and Death
Bosio. Louis XIV
Bouchardon. Louis XV,
equest
Brock. A Moment of Peril
Bulgarian--9th c. Madara
Horseman
Burgundian--14th c. Medal
of Constantine

Byzantine. Barberini Ivory:
 Triumph of the Emperor
Byzantine. Casket: Hunting
 Scenes, Mounted Warriors,
 Phoenix
Byzantine. Emperor on Horse-
 back
Caille. Rider
Calandra. Amadeus of Savoy
Calandra. Umberto I
Campione. Can Grande della
 Scala
Caucasus. Equestrian,
 mosque over-window relief
Caucasus. Fighting Horses
Chantrey. Duke of Welling-
 ton
Chantrey. George IV
Colombe, M., and J. Pacher-
 ot. Altarpiece of St.
 George
Cora. Simon Bolivar
Coysevox. Fame
Coysevox. Louis XIV Tri-
 umphing over his Enemies
Coysevox. Mercury
Coysevox, and Charles le
 Brun. Palace of Ver-
 sailles, Salon de la
 Guerre
Czech--18th c. Caesar
 Fountain
Danish--14th c. Travelling
 Altar of Christian I
Daucher, H. Charles V
Delahaye, J. C. Cavalier
 Victorieux
de Lalaing. Fighting Horse-
 men
de Lalaing. Wrestlers
Donatello. Gattamelata
Donner. St. Martin and the
 Beggar
Duchamp-Villon. Horse and
 Rider
Duchamp-Villon. Rider
English(?)--13th c. Horse-
 man, aquamanile
English--14/15th c.
 Pilgrim's Badge: Thomas
 a Becket Riding in Tri-
 umph
--St. George and the Dragon
English--15th c. Henry V's
 Chantry
English--19th c. Dick
 Turpin
Fadrusz. Memorial to King
 Matthias

Falconet. Peter the Great
Filarete. Gian Galeazzo
 Sforza Monument
Folkard, E. Boy Rider
Foyatier. Joan of Arc
French--9th c. Charlemagne,
 Carrying Orb
French--12th c. Emperor
 Constantine
French--13th c. Buckle:
 Equestrian and other fig-
 ures
French--14th c. Knight and
 Lady, mirror case top
--Seal of Louis I
French--15th c. Portal,
 Wing of Louis XII
--St. Martin and the Beggar
French--16th c. Charles IX,
 equest, medallion
--Entrevue du Camp du Drap
 d'Or
French--17th c. Louis XIII
 as a Child
Fremiet. Col. Howard, equest
Fremiet. Jeanne d'Arc
German--8th c. Horseman of
 Hornhausen, relief
German--13th c. Bamberg
 Rider
German(?)--14th c. Aqua-
 manile: Horse and Rider
German--14/15th c. Death
 on Horseback
German--15th c. Horsemen
 Below Cross at Golgotha,
 relief
German--16th c. St. Martin
 and the Beggar, relief#
German--17th c. Tray (Lok-
 han): Reconcilliation of
 Joseph and Jacob
Gerome. Napoleon Bonaparte
 Entering Cairo
Giotto, and A. Pisano. Horse-
 manship
Girardon. Louis XIV
Goujon. Louis de Breze
 Monument
Hahn. Moltke Memorial
Henning, John. Horsemen,
 arch frieze
Hosel. A Hun
Hussmann. Deutsche Wehr
Hussmann. Dying Amazon
Italian--11th c. Equestrian
 plaque, ivory
Italian--13th c. St. Martin
 Sharing his Mantle with

a Beggar
Italian--14th c. Can Grande
della Scala
--Mastino II della Scala
Italian--15th c. Robert Mala-
testa, relief
Italian--17th c. Equestrian
Janniot. Melpomene
Keller. Cavalier#
Kennington. Horseman
Kirchner, Heinrich. Reiter
Kiss, A. Amazon Attacked
by Tiger
Klodt. Equestrian
Koenig. Horseman
Koenig. The Night Riders
Lancere. Standard-Bearer
Lauger. Tondo Relief:
Equestrians
Lauritzen. Retour a la
Terre zur Erde Zuruck
Lemot. Henry IV
Leonardo da Vinci. Trivulzio
Monument
Leonardo da Vinci--Foll.
Mounted Warrior
Leonardo da Vinci--Foll.
Negro on Horseback
Fighting a Lion
Leonardo da Vinci--Attrib.
Horse and Rider
Le Sueur. Charles I
Lienhard. Hirt zu Pferd
Machado de Castro. Monu-
ment to Joseph I
Marini. Angel of the Citadel
Marini. Equestrian and
Figure#, relief
Marini. Equestrian Monument
Marini. Horse and Rider
Marini. Horseman#
Marini. Little Horseman
Marini. The Miracle
Marini. Small Horseman
Marini. Young Rider
Marochetti. Richard, Coeur
de Lion
Marochetti. Emanuele
Filiberto Monument
Mastroianni. The Rider
Matare. Man on Horseback
Medgyessy. Equestrian
Meller. Commercial Build-
ing Doorway
Milles. Folke Filbyter#
Mochi. Alessandro Farnese
Mochi. Ranuccio Farnese
Muellner. Horseman

Myslbec. St. Vaclave
Ognabene. Altar, relief
detail: Equestrians
Patzay. Equestrian Memorial
Petrascu. Equestrian*
Pilkington-Jackson. Drum
Horse
Puget. Victorious Alexander
Rauch, C. D. Frederick the
Great
Riccio(?). St. Martin and the
Beggar, plaque
Riccio. Warrior on Horse-
back
Rochet. King William I
Romanelli. George Washing-
ton
Romanesque--French. Eques-
trian Figure, facade detail
Romano, Giulio. Sala degli
Stucchi: Horsemen
Rona. Prince Eugen von
Savoyen Memorial
Russian--11/12th c. Pendants:
Horseman with Bow
Russian--19th c. Alexander
II
Rustici. Horse and Rider
Rysbrack. William III
Saly. Frederick V, King of
Denmark
Scheemakers, P. William III
Schluter. Friedrich Wilhelm,
Great Elector
Schwarz, Heinz. Le Depart
Sidlo. Hungarian Warrior,
tondo
Siemering. Washington Monu-
ment
Simonis. Godfrey de Bouillon
Sinding. The Valkyrie
Somogyi. Hunyadis Memorial
Sperandio. Giovanni Frances-
co de Gonzaga
Staffordshire. Woman Eques-
trian
Stammel. St. Martin and the
Beggar
Steinl. Joseph I
Stevens. Wellington Memori-
al
Strobelle. Cheval Bayard
Stuck. Amazon
Szabo, I. Girl Riding Horse
Tacca, P. Horse and Rider
(Philip IV)
Tacca, P. Philip IV#
Thornycroft, H. King
Edward I

Thornycroft, T. and M. Queen
 Victoria on her Favorite
 Charger, Hammon
Thorvaldsen. Triumph of
 Alexander
Tolsa. Charles IV
Troubetzkoy. Horseman
Troubetzkoy. Leo Tolstoy
Verrocchio. Condottiere
 Bartolommeo Colleoni
Vigarny de Borgona. Royal
 Chapel Altar
Vischer Family. St. Martin
Vuolvinio. Golden Altar,
 detail of equestrian panel
Watts. Physical Energy
Wilton. George III, as a
 Roman Emperor
Wlerick. Marshall Foch
Zauner. Emperor Joseph II
Equilibrium. Pan
Equilibrium. Vieira, M.
Equilibrium II. Angeli-Radovani
Equipoised Sculpture. Sorensen-
 Popitz
Erasmus, Desiderius (Dutch
 Scholar 1466?-1536)
 European. Erasmus, medal-
 lion
 Keyser. Erasmus
Erbarmdedreuze
 German--14th c. Forked
 Cross Crucifixion
Erect Faun. Rodin
Erectile Punctuation. Bury
Eremit. Cimiotti
ERHART, George--FOLL
 Heiligenberg Madonna c
 1500 H: 45
 COOPF 194 GDonF
ERHART, Gregor (German 1470-
 1540/41)
 Adam and Eve 1500/10 lin-
 denwood; 19 cm
 MUL 11 ELV
 Horse, model for equest
 monument of Emperor
 Maximilian bronze
 CLE 109 UOC1A (52.108)
 --after model for Maximilian
 equest monument in Augs-
 berg 1508/09 bronze;
 15.2 cm
 MUL 10 GBS
 Madonna and Child, High
 Altar c 1490 ptd wood
 KO pl 66 GBl
 Madonna of Mercy 1502
 VEY 32 GBS

Madonna with the Protecting
 Mantle (Madonna of Mercy;
 Schutzmantel Madonna),
 Frauenstein, Austria c
 1500/15 ptd wood; 74
 BUSR 149; KO pl 66;
 VEY 137 AVK
Penitent Mary Magdalene ("La
 Belle Allemande") c 1520/30
 ptd wood; 69-1/2
 BAZINW 321 (col); BUSR
 150; CANK 30; CHAR-1:
 296 (col); KO pl 66;
 LOUM 113 FPL (546)
Vanitas Group: Figures c
 1500
 BUSR 151; MULS pl 172A
 AVK
Virgin and Child wood; 64
 DETT 157 UMiD (223)
ERHART, Michel (German
Madonna with Cloak (Virgin
 of the Misericord), Ravens-
 burg c 1480
 LOH 171; MULS pl 126
 GBS
ERHART, Michel and Gregor
 ERHART
 High Altar 1493/94 ptd and
 gilded wood
 MULS pl 171 GBl
Eric, Norseman. D'Haese, Roel
ERICSON, Sten (Swedish)
 Ball Room Lounge Figure
 DAM 124 SnSM
ERIKSSON, Elis; Liljefurs ANDERS;
 Sven Erik FRYKLUND; Egon
 Moller NIELSEN
 Primary School Wall Mosaic
 1954
 DAM 106, 107 SnVal
ERISKIRCH MASTER
 Elizabeth
 BUSR 38 GRotL
Erlach, Fischer von
 Benkert, Strudel, and
 Rauchmiller. Plague
 Column
Ermesindis, Countess (Wife of
 Count Ramon Berenguer II)
 Morey. Countess Ermesindis,
 head detail
ERMINOLD MASTER (Swiss fl 1280)
 Dancing Angel, archivolt
 figure, west portal
 BUGS 122 SwBKM
 St. Erminold Tomb 1270/
 1370
 LIL 56 GRegP

The Virgin Annunciate, pier
 figure
 BUSGS 123 GRegC
ERMOLIN, Vasili (Russian d 1485)
 St. George, bust fragment,
 Kremlin's Frolov Gate
 c 1480
 RTCR 192 RuMT
ERNEST, John (American-English
 1922-)
 Modulated Plane Construction
 II 1962
 PEL 189
 Sculpture*
 ARTSC
ERNST, Max (German-French
 1891-)
 Anxious Friend, 5th of 8
 casts made 1957 from 1944
 plaster original--now
 destroyed 1944 bronze;
 26-3/8
 GUG 201 UNNG
 Bird-Head 1956 bronze
 MARC pl 53 (col) IMCa
 Capricorn 1948/64 H: 95
 KULN 8; SEITC 171 UNNLi
 The Chinese Nightingale 1920
 READS pl 29
 Eager Friend 1943 bronze;
 c 36-1/4
 TRI 134
 Fruit of Long Experience
 1919 wood and metal ptd;
 18x15
 BAZINW 434 (col); HENNI
 pl 16; MYBS 81;
 READCON 137 (col);
 SELZJ 201 ELP
 Girl in the Form of a Flow-
 er 1944 bronze; 9-1/2
 CALA 196 IVG
 Glass blue glass
 CALA 16 (col) IVG
 In the Streets of Athens
 1960 bronze; 29-1/2
 CALA 197; GUGP 52;
 LIC pl 286 IVG
 King Playing Chess with his
 Queen 1944 bronze
 MAI 88 UTxHMe
 King Playing with the Queen
 1944 bronze; 87 cm
 OST 78
 --1944 bronze; 36x33
 EXS 76; GIE 298; LIC
 pl 285 UNNMMA

--1944 bronze; 39
 SELZS 109 UNNSli
--1944 (cast 1954) bronze;
 34-1/4
 READCON 147
--1954 bronze
 MARC pl 52 FLonC
Lunar Asparagus (Les
 Aperges de la Lune; Monds-
 pargel) 1935 plaster;
 65-1/4
 GIE 228; HAMP pl 154A;
 LIC pl 284; MCCUR 267;
 NMFA 169 UNNMMA
Un Microbe Vu a travers un
 Temperament 1954 bronze;
 34
 CHICSG -Sh
Moon Mad 1914
 ENC 285
--1944 bronze; 38
 READCON 146 UNNH
Niniche
 BERCK 118
Objet Dad'Art (destroyed)
 1919/20 string, wood,
 fabric and wire; 31-1/2
 GIE 91
Oedipe c 1934 bronze;
 23-3/4x10-3/4x7-1/4
 UCIT 15 UCLL
Painting-Construction cork
 LARM 249
The Parisian Woman 1950
 BERCK 262
The Poet glass
 CALA 258 IVG
Round Head (La Belle Alle-
 mande) 1935 plaster with
 objects incorporated;
 24-1/2
 NMFA 170
Sculpture 1935 granite
 GIE 300 SwMG
The Table is Set 1944 bronze;
 21-5/8x21-5/8
 READCON 145
Tete Double 1936
 READP pl 33
Tete Double: Oedipus 1935
 plaster; 27-1/2
 READCON 140
Two Children are Menaced
 by a Nightingale 1924
 ROOS 281C UNNMMA
ERNST, Max, and Hans ARP
 Laokoon, collage-sculpture

(Fatagaga) 1919
 RICHT pl 81
Ernst von Sachsen
 Vischer, P. , the Elder.
 Archbishop Ernst von
 Sachsen, effigy
Eroe Greco. Consagra
Eros See also Aphrodite
 Antico. Cupid
 Bouchardon, E. Cupid
 Bouchardon, E. Cupid Mak-
 ing a Bow out of the
 Club of Hercules
 Canova. Cupid and Psyche
 Chaudet. Amor Catching a
 Butterfly
 Chaudet. Love
 Clodion. Cupid and Psyche
 Coutan. Eros
 Delaistre. Cupid and Psyche
 Donatello. Amorino in
 Breeches
 Duquesnoy, F. Cupid Carv-
 ing a Bow
 Falconet. L'Amour Menacant
 Falconet. Cupid
 Falconet. Seated Cupid
 French--14th c. Eros Shoot-
 ing Mortals, mirror back
 French--18th c. Temple of
 Love
 Gilbert, A. Eros
 Italian--18th c. Amore
 Vincitore, plaque
 Lambert, G. Eros
 Michelangelo. Cupid
 Rodin. Cupid and Psyche
 Sergel. Cupid and Psyche
 Thorvaldsen. Cupid and the
 Three Graces
 Thorvaldsen. Mars and Cupid
 Tuby. Eros
 Wiligelmus. Cupid, with In-
 verted Torch
Erotic. Loeffler-Zbrozyna
Das Erwachen. Garbe, H.
ERWIN OF STEINACH See MASTER
 ERWIN OF STEINACH
Erymanthian Boar See Hercules
Esau
 Ghiberti. Baptistry Doors--
 East: Esau
L'Escangot. Matisse
Escodo. Salvatore
L'Escolier. Degas
Escombros. Petrovic
Esculape
 Rodin. Aesclapius

Espace de Reve. Scheps
Espansione Spiralica di Muscoli in
 Movimento. Boccioni
Espace et Masse Liberis--Hommage
 a l'Architecture. Teana
Esperide. Braque
Espirito, Agna e Sangue. Gilioli
Esquerda. Subirachs
Essen Madonna. German--10th c.
ESSER, Vincent Pieter (Dutch
 1914-)
 Hercules and Anteaus Foun-
 tain, with frieze by H.
 Verhulst
 BERCK 214 NArP
Este, Alfonso I d' 1486-1534
 Spinelli. Alfonso d'Este
 Medal
Este, Beatrice d' 1475-97
 Romano. Beatrice d'Este,
 bust
 Solari. Lodovico Sforza (Il
 Moro) and Beatrice d'Este
Este, Ercole I d' 1431-1505
 Coradino. Medal: Ercole
 d'Este
Este, Francis I d'
 Bernini, G. L. Francesco
 I d'Este, bust
Este, Leonello d' (Lord of Ferrara)
 Pisanello. Nuptual Medal:
 Leonello d'Este; Lion
Esther. Epstein
Estouteville, Guillaume d' (Cardinal)
 Mino da Fiesole. Estoute-
 ville Ciborium, relief
 detail: Miracle of the
 Snow
L'Eta d'Ora. Rosso, M.
L'Ete de la Foret. Stahly, F.
L'Eterna Domanda. Guerrini
The Eternal Drama. Kafka
Eternal Gulf. Darde
The Eternal Idol. Rodin
Eternal Light
 Jewish--17th c. Eternal
 Light
Eternal Spring. Rodin
Eternal Springtime
 Rodin. Eternal Spring
L'Eternel Printemps
 Rodin. Eternal Spring
Eternity. Hanak
Ethilwald Eye
 Anglo-Saxon. Seal of
 Ethilwald Eye
Ethiopians
 French--12th c. Mission of

the Apostles; detail: Pig-
Snouted Ethiopians
Etienne, Saint See Stephen, Saint
ETIENNE-MARTIN See MARTIN,
Etienne
L'Etoile
Arp. Star
Etoile. Conde
Etoilles, Alexandrine d'
Saly. Alexandrine d'Etoilles,
bust
Ettore Fieramosca. Franchina
Eucalyptus. Pomodoro, G.
The Eucharist See The Mass
Eucheris See Serena
Eudocia, Saint (Eudoxia)
Byzantine. St. Eudocia,
plaque
Eudocia Macrembolitissa (Eudoxia)
(Eastern Roman Empress
1021?-96)
Byzantine. Christ Crowning
Romanus and Eudocia
Byzantine. Empress Eudocia,
tabernacle
Eudoxia See Eudocia, Saint
Eugene (Prince of Savoy 1663-1736)
Johnsson. Prince Eugene,
bust
Permoser. Apotheosis of
Prince Eugene
Rona. Prince Eugen von
Savoyen Memorial
Eugenie (Empress of France 1826-
1920)
Carpeaux. Empress Eugenie
with Imperial Prince,
study
Lequien. Empress Eugenie,
bust
EUGENIO DE LA CRUZ (Spanish),
and JUAN DE LA CONCEP-
CION
Altar, Pantheon of the Kings
green marble
FSC 50 (col) SpE
Eugenius IV
Filarete. Basilica Doors:
Eugenius IV Receiving
the Keys from St. Peter
Eulalia of Barcelona, Saint
Ordonez. St. Eulalia Before
the Roman Prefect, re-
lief
Vilar and Ordonez. Eulalia
Legend, relief
Eulenspiegel
Wansart, A. Ulenspiegl

Euphrates
Bologna. Oceanus Fountain:
Euphrates
Europa
Bellano. Europa and the Bull
Byzantine. Panel: Europa on
the Bull
Byzantine. Veroli Casket:
Europa and the Bull
German--17th c. Ceremonial
Dish and Jug: Europa and
the Bull
--Tray (Lokhan): Rape of
Europa
Hildebrand. Wittelsbach
Fountain
Janniot. Europa
Milles. Europa and the Bull
Schluter. Europa
Wolff, G. H. Frau auf
Liegenden Pferd (Europa
zu Pferd)
EUROPEAN
Crown of Holy Roman Empire
c 962 gold, jewels, and
enamels
MU 109 (col) AVK
Disraeli, Lord Beconsfield
MARQ 270 ELWe
Erasmus, Medallion
ENC 284
Iconostasis 1703
BUSB 130 RuLPP
Synagogue Spice Containers,
central and eastern
Europe 17/18th c.
ROTH 335 IsJB
EUROPEAN--SOUTHERN
Lord Reprimanding Adam
and Eve 14th c. alabaster;
20-1/4x25-5/8
DEYE 25 UCSFdeY (59.40)
EUROPEAN--WESTERN
Bascinet c 1380
SOTH-3: 245
Crucifix of San Isidoro
before 1063 ivory
MOLE 21 SpMaA
The Europeans. Kneulman
Eurydice See Orpheus
Eurythmy. Ramseyer
Eusice, Saint
French--11th c. Life of St.
Eusice, apse frieze detail
Eustace, Saint
Barisanus of Trani. Door
panels
Eustorgio, Saint

Pollaiuolo, A.--Attrib. St.
 Eustorgio, bust
Euthymius (Bulgarian Patriarch d c
 1393)
 Markov. Patriarch Euthymius
Eutropios
 Early Christian. Eutropios,
 head
 Italian--6th c. Eutropios,
 head
Eva
 Rodin. Eve
Evangeliere de Maestricht Cover.
 Dutch--10/11th c.
Evangelists See Apostles
Evangelium Longum
 Tuotilo. Ivory Book Cover
 for Evangelium Longum
EVANS, David (Welsh)
 Magog limewood; 114
 DURS 69 ELGH
 Nurses' Memorial
 AUM 121 ELivC
 Panel 1940 terracotta; 48
 BRO pl 8 ELMe
EVANS, Garth (English)
 Rosebud 1965
 KULN 142
EVANS, Merlyn (English)
 Screen, detail H (total): 60'
 ARTSA 9 ELTha
Evans, Thomas
 Pierce. Thomas Evans, bust
EVESHAM, Epiphius (English fl
 1587-1632)
 Henry, Lord Norris, Tomb,
 effigy GERN pl 41 ELWe
 --Two Sons of Henry, Lord
 Norris ESD pl 73
 Hester Salisbury Tomb, de-
 tail: Escutcheon with
 Emblems of the Passion
 ESD pl 52 EEsS
 Lord Teynham Tomb 1632
 ESD pl 85; WHINN pl 9B
 EKenL
 --Daughters of Lord Teynham
 CON-1:pl 32; ESD pl 82;
 MERC pl 87a
 --Sons of Lord Teynham
 ESD pl 81
 Robert Rich, Earl of Warwick,
 Monument c 1619 WHINN
 11a ESn
 Sir John Farnham Monument
 ESD pl 66 ELeiQ
 Sir Thomas Hawkins Monu-
 ment 1618 WHINN 11B
 EKenB

 --Daughters of Sir Thomas
 ESD pl 8; MERC pl 89b
 --Sons of Sir Thomas
 ESD pl 9
Evasion. Ramseyer
Eve. Despiau
Eve. Whalen
Eve See Adam and Eve
L'Eveil. Osouf
Evening
 Copnall. Evening
 Michelangelo. Lorenzo de'
 Medici Tomb
Eventide. Schreiter
Evocation. Prinner
Evocation d'une Forme Humaine,
 Lunaire, Spectrale
 Arp. Evocation of a Form
 Human, Lunary, Spectral
Evocation of a Form Human, Lunary
 Spectral. Arp
Evocation of a Human Form. Arp
Evolution. Obrist
Evolution of a Bottle in Space
 Boccioni. Development of a
 Bottle in Space
Evreux, Jeanne d'
 French--14th c. Virgin of
 Jeanne d'Evreux
 Jean de Liege. Jeanne
 d'Evreux
Evreux-Navarre, Pierre d'
 French--15th c. Pierre d'
 Evreux-Navarre, effigy
Ewer Stand. Raymond, P.
Ewers
 Briot, F.--Attrib. Ewer
 Byzantine. Nereid on Sea
 Monster, ewer
 Castro. Ewer
 Celtic. Wine Ewer
 Dutch--17th c. Blue Delft
 Jug
 Early Christian. Jug with
 Medallions of Apostles
 Flemish--16th c. Ewer of
 Charles V
 French--10th c. Ewer, St.
 Denis
 French--12th c. Eagle, Vase
 of Saint-Denis
 French--16th c. Ewer#
 --Faience Ewer
 --St. Porchaire Ewer
 French--17th c. Ewer, with
 Leopard Handle
 French--18th c. Celadon Ewer
 Italian--16th c. Bird-Shaped
 Ewer

Italian--17th c. Ewer
Jamnitzer. Ewer#
Jansz. Ewer
Lamerie. Sideboard Ewer
Mosan. Aquamanile: Winged
 Beast
Mosan. Fabulous Bird
Palissy, B.--Foll. Handled
 Ewer
Portuguese--17th c. Ewer
 and Basin
Snello and Haertwich. Ewer
 for Holy Water
Vianen, A. Ewer
Willaume. Huguenot Ewer
Ex Voto. Muller, R.
The Exact Time, Paalen
The Execution, relief. Manzu
Executioners
 English--14th c. St. Sebastian
 and Two Executioners
Exeter, 5th Earl of
 Monnot, P. 5th Earl of
 Exeter Monument
Exhaltation. Hanak
Exhumated. Szapocznikow
The Exile. Dos Reis
Exiles. Pagels
Exorcism See Possession
Explorer I. Aeschbacher
Exposition Zurich. Kampmann
The Expulsion See Adam and Eve
Extensible Surface# Pevsner
Extern Stones. German--12th c.
Extreme of an Outer Mythology. Arp
Extreme Unction. Pisano, Andrea
Extremity of a Mythical Wineskin.
 Arp
Eyam Cross Shaft. Anglo-Saxon
EYCKERMANS, Lode (Belgian 1919-)
 Standing Figure
 GOR 85
"Eye Coin." Merovingian
Eye-Glasses
 English--16th c. St. Matthew
 Wearing Spectacles
Eyes
 French--12th c. Eye, detail
 of head
 French--13th c. Eye, detail
Eymard, Pierre Julien
 Rodin. Pere Pierre Julien
 Eymard, bust
Eynde, Ferdinand van den
 Duquesnoy, F. Ferdinand
 van den Eynde Tomb
EYNDE, G. van den (Dutch)
 Font 1527
 GEL pl 110 NZuW

EYNDE, H. A. van den
 Netherland Memorial Flag-
 pole, pedestal 1926 granite;
 pedestal H: 19' GRID 52
 UNNBat
Ezekiel
 Christian, J. J. Ezekiel, bust
 Italian--12th c. Ezekiel,
 portal

F., Mme.
 Niclausse. MMe. F.
F 49. Fiebig
F 54. Fiebig
FABBRI, Agenore (Italian 1911-)
 Atomised Man, detail
 LARM 253
 Big Bird 1956 bronze
 SAL pl 63
 La Danzatrice (Passo di
 Dianza) 1952 ptd terracot-
 ta; 1.60 m SCUL pl 24
 Donna col Gatto 1947 cetto;
 80 cm CARR 314 IMGi
 Lunar Being (Personaggio
 Lunare) 1960
 VEN-60: pl 62
 Maresciallo Caviglia, head
 bronze VEN-40: pl 83
 Maternity 1951 terracotta;
 28 SCHAEFpl 23
 Mother and Son 1952 ptd
 terracotta; VEN-52: pl 13
 Night Bird bronze
 SAL pl 64 (col)
 Rissa di Cani 1952 ptd terra-
 cotta; 1.10x.90 m SCUL
 pl 25
 Spatial Being (Personaggio
 Spaziale) 1960
 VEN-60: pl 63
 Spatial Figure 1959 bronze
 MAI 91
 Wartime Cat 1950 terracotta;
 LS SCHAEF pl 22
Faber, Tom
 King, W. C. H. Tom Faber,
 bust
FABERGE, Karl Gustavovich (French
 1846-1920)
 Animal Sculptures
 COOP 247 UNNChri
 Bell-Push bowenite and rose
 enamel; L: 2-13/16
 COOP 249 UNNChri
 Bison obsidian, matt surface
 with polished muzzle,
 horns, hoofs; 3
 COOP 246 (col) UNNChri

Mayer, J. U. House Facade
Mettel. Entrance Facade
Moore, H. Time-Life Facade
 Screen
Niccolo d'Arezzo. Facade
 Sculpture
Opitz. Apartment House
 Facade
Piene. Facade
Rodavi. Cathedral Facade
Rodriguez. Facade
Romanesque--French. Facade
Romanesque--Spanish. Facade
Rossellino, B. Facade of
 Misericordia
Russian--12th c. West Facade
 Panel, relief
Russian--13th c. Facade de-
 tails: Human and Animal
 Figures
Sambin. Facade
Scamozzi. Library of St.
 Mark Addition
Schade. Figures, Commercial
 Building Facade
Silvano. Facade
Spanish--15th c. Facade
 --Portal Facade: Royal Coat
 of Arms
Sue et Mare. Facade
Tibaldi. Facade
Werthmann. Facade Relief
Face. Abstraction. Aeschbacher
FACHARD, Robert (French 1921-)
 Sculpture red limestone and
 wrought iron MAI 92
LE FACTEUR See CHEVAL,
 Ferdinand
Factory. Colla
FADRUSZ, Janos (Hungarian 1858-
 1903)
 Memorial to King Matthias,
 equest 1895/1902 bronze
 GAD 58 HC
FAID'HERBE, Luc (Flemish 1617-
 92)
 Berthout Family Monument
 17th c. marble MOLE 244
 BMR
"Fair Hebe" Jug. Voyez
Fair Virgin See Beautiful Madonna
Fairfax, Eve
 Rodin. Miss Eve Fairfax,
 bust
"The Fairies of the East Come to
 Fraternize with the West"
 Cheval. Ideal Palace

Fairy Tales
 Lombard. Chancel Frieze
 detail: Fairy Tale Motifs
Faith See also Virtues and Vices
 Aspetti. Faith
 Braun, M. B. Faith
 Civitale. Faith
 Early Christian. Funeral
 Stele: Fish of Christ, and
 Anchor of Faith
 Ferrata. Faith
 Houdon, G. A. Faith
 Banishes Heresy
 Michelozzo. Bartolommeo
 Aragazzi Monument: Faith
 Mino da Fiesole. Faith
 Pisano, A. Baptistry South
 Doors: Hope and Faith
 Pisano, Niccolo. Pisa Bap-
 tistry Pulpit: Faith
 Schonherr. Allegory of Faith
 Theny. Allegory of Faith
 Theodon. Barbarity, detail:
 Faith Adored by Barbari-
 ans
 Verrocchio. Forteguerri
 Monument: Faith
 Xavery. Allegory of Faith
FALAISE, Richard (French)
 Misericords, choir stalls
 1522 GAF 69 FChaM
FALCONET, Etienne Maurice
 (French 1716-91)
 Allegory of the Chase,
 Sevres Factory before
 1758 clay; 12
 KO pl 97 DC
 Allegory of the Hunt c 1788
 ST 363
 L'Amour Menacant 1757
 VER pl 100 FPL
 Baigneuse. c 1760/80 marble;
 15 KITS 162 ENW
 Bather marble; 12-1/4
 HUNT pl 30, 32; HUNTA
 95 UCSmH
 Bather marble; 32
 BR pl 12; UPJ 425 FPL
 Bather with Sponge (Die
 Badende mit dem Schwamm);
 back view 1762 marble; 85
 cm BSC pl 127, 126 GBS
 (6/59)
 Bathing Girl 18th c. marble
 CHENSW 460; MOLE 240;
 POST-2:33 FPL
 Clock of the Three Graces

c 1760 marble HUYA pl
 56 FPL
Cupid mid 18th c. marble
 RAMS pl 18a FPL
Dancer with Castenets marble
 NYWC pl 130 UOClPr
Leda and the Swan c 1765
 porcelain; 13x12 MONT
 416 ELV
Love Crowned by Fidelity
 marble; 22-3/4 ASHS pl
 33 ELV
Madame de Pompadour as the
 Venus of the Doves
 marble; 29-1/2x28
 CHRC fig 216; KRA 187;
 SHAP pl 48; USNKP 449
 UDCN (A-1625)
Milo of Crotona
 LAC 46 FPL
Music
 CHASEH 391 FPL
Nymph Entering the Bath
 1756 marble; 32
 CHAR-2:238 FPL
Peter the Great, equest 1776/
 78 bronze; 199
 BAZINB 250; BAZINW
 416 (col); ENC 293;
 JANSH 448; JANSK 871;
 LAC 208; LARR 387;
 VALE 117 RuL
Pygmalion and Galatea 1763
 Sevres biscuit
 LARR 391 FPDec
Seated Cupid 1757 marble;
 34-1/4 RIJA pl 122,
 122a NAR
Venus Instructing Cupid
 AGARC 20; RAY 51
 UNNMM
Venus Spanking Cupid marble;
 18-1/2 UPJH pl 186 UMB
FALCONET, Etienne Maurice--FOLL
Bather marble; 10 HUNT pl
 29, 31 UCSmH
Falconry See Games and Sports
Falcons
 Bologna--Foll. Falcon
 Dudeney. Falcon
 Efimov. Falcon
 Ipousteguy. Helmeted Head,
 and Falcon's Head
FALGUIERE, Alexander (Jean-
 Alexandre Faloviere 1831-
 1900)
 Dancer
 TAFTM 38

Diana
 TAFTM 38
Henry de la Rochejacquelin
 TAFTM 38
Hunting Nymph
 POST-2:144
Woman with Peacock 1890
 marble CHASEH 445;
 SELZJ 2: TAFTM 38
 FTM
 Portraits
 Rodin. Falguiere, head
Falkenstein, Kuno (d 1333), and
 Anna Falkenstein (d 1319)
 German--14th c. Kuno and
 Anna von Falkenstein,
 relief effigies
The Fall See Adam and Eve
Fall of Babylon. Ducaju
The Fallen. Lehmbruck
Fallen Angel. Dierkes
The Fallen Angel. Rodin
Fallen Carystid# Rodin
Fallen Fighter. Augustincic
Fallen Leaf. Arp
Fallen Man
 Lehmbruck. The Fallen
Fallen Warrior. Moore,H.
Falling Figure. Startup
Falling Titan. Banks
Falling Warrior. Moore, H.
Falling Woman. Stursa
Fame
 Coysevox. Fame
 Fuido. Fame, Reviving the
 History of Louis XIV
La Famille. Traverse
Family. Moore, H.
The Family. Nilsson
Family. Slesinska
Family. Underwood
The Family. Wildt
Family Going for a Walk. Armitage
Family Group. Gibbons
Family Group. Miller, A.
Family Group. Moore, H.
FANCELLI, Cosimo (Italian 1620?-
 88)
 Angel with Sudary 1669
 WIT pl 119 IRPA
FANCELLI, Domenico Alessandro
 (Italian 1469-1518)
 Ferdinand and Isabella Tomb,
 Royal Chapel
 POST-1:259 SpGC
 Infant Don Juan of Arragon
 Monument 1511 marble
 KUBS pl 64A; WES pl 11
 SpAvT

FANCELLI, F. A. See BERNINI,
G. L.
Fiumi Fountain
FANCELLI, Francesco (Italian fl
1608-65)
Charles II as Prince of
Wales, bust 1640 bronze;
11-1/2 WHIN pl 31a EWel
Diana Fountain before 1640
WHINN pl 26B EBu
Pair of Horses, table
decoration bronze
SOTH-1:226 (col)
Sir Robert Aiton Monument,
bust detail 1637/38 bronze
MOLS-2:pl 6 ELWe
Fancialia Specchiantesi Nell'Acqua.
Portanova
Fane, John, 7th Earl of Westmore-
land d 1742
Adye. John Fane, bust
FANELLI, Virgilio (Italian)
Octagonal Candelabrum with
24 Arms; detail gilded
bronze; 2 m ESC 50 (col),
66 SpE
FANGOR, Wojciech (Polish 1922-)
Painted Structures 1967
3 modules; ea: 96x160-3/8
CARNI-67:#181 UNNCh
Fantasy-Sleep. Orsi
Les Fantomes, Monument to the
Second Victory of the Marne.
Landowski
FANZAGO, Cosimo (Italian 1691-
1678)
Cloisters, detail c 1630
WIT pl 112B INMar
FARBER, H.
Burning Bush, facade figure
ROTH 790 AuMB
Farbobjekt 64/15. Kampmann
Farel, Guillaume (French Reforma-
tion Leader 1489-1565)
Landowski and Bouchard. Re-
formation Monument
The Farewell. Laurens
Farewell. Pasztor
Fargues, Henri (French Senator)
Bartolini. Fargues, bust
FARKAS, Aladar (Hungarian 1909-)
Smelter 1953 plaster; 70 cm
GAD 117
The Farm Team. Simmonds
Farnese, Alessandro (1545-92)
Mochi. Alessandro Farnese,
equest

Farnese, Ranuccio 1569-1622
Mochi. Ranuccio Farnese,
equest
Farnese Bull. Susini
Farnham, John d 1587
Evesham. Sir John Farnham
Monument
FARPI, Vignoli (Italian)
Driver of Trotting Cart
CASS 114
Fascinated. Ray
FASSOLD, Eugen See MEYER FAS-
SOLD, Eugen
Fatagaga
Ernst, M., and H. Arp.
Laokoon
Fate. Lederer, H.
The Father
Kollwitz. Memorial for the
Flanders Dead
Father and Daughter. McWilliam
Father and Son. Hovi
Father and Son. Shemi
Fauchards
Italian--15th c. Fauchard of
Guard of Cardinal Camillo
Borghese
Faun des Mers. Penalba
Fauna of the Ocean. Pevsner
Faunesse. Gargallo
Faunesse Debout
Rodin. Erect Faun
Fauns See also Bacchus
Bouchardon, E. Sleeping Faun
Cibber. Garden Urn, base
detail: Fauns
Coysevox. Faun Playing Flute
Traversiere
Darde. Faun#
Mascherini. Faun#
Mascherini. Faunetto
Milles. Aganippe Fountain: Faun
Nicolini. Faun and Nymph
Rodin. Erect Faun
Sansovino, J. Bacchus and
Young Faun
Sergel. Faun
Sergel. Resting Faun
FAUTRIER
Large Head in Copper 1942
MAI 93 FPCas
FAUVEAU, Felicie de (French 1799-
1886)
Louis Fauveau Monument,
tomb of sculptor's mother
1856/58 marble
LARM 43; LIC pl 66 IFCr

Queen Christine of Sweden Re-
fusing to Spare her Equerry
Monaldeschi, relief terra-
cotta and colored plaster;
13-3/8x21-1/4 BRIO 39;
BRIONR pl 41 FLouvM
FPL
Fauveau, Louise
Fauveau. Louise Fauveau
Monument
FAVRE, Maurice (French)
Emil Fabre, bust
TAFTM 49
Fawcett, Henry (English Economist
1833-84)
Tinworth. Henry Fawcett
Fawns See Deer
FAYDEHERBE, Lucas (Flemish
1617-97)
Bishop Andreas Cruesen
Tomb, with figure of
Father Time 1660/69
marble BAZINW 398 (col);
GER pl 17; LARR 248
BMC
The Nativity 1677 marble
GER pl 18A BMO
FAZZINI, Pericle (born: Ascoli
Piceno Grottammare)
(Italian 1913-)
The Acrobats 1947 bronze
BERCK 152
--1947 bronze; 25
KO pl 105 UNNJo
--1948 bronze
SAL pl 46 (col)
--1948 plaster
CARR 234
--1952 bronze
MAI 94 UNNJo
Anita Blanc, bust wood
VEN-38: pl 121
Cat (Gatto) 1947 bronze; L:
27 SCHAEF pl 21
--1947 bronze; 35 cm
CARR 235 IMTon
Colonel Parizzi, head 1943
wood MAI 94 IComP
Dancer 1958 bronze
VEN-62: pl XXII
Female Figure bronze
DIV 53
Figure 1948 bronze
BERCK 263
Gymnast 1948 bronze
CANK 146
Il Ragazzo dai gabbiani 1940
ptd wood; 1.50 m
SCUL pl 22 (col);

Scratching Cat 1953 bronze
VEN-54: pl 17
Seated Girl 1954 plaster
SAL pl 43
Seated Woman (Donna Seduta)
1947 bronze; 37-3/8
CARR 236, 237; RIT 184;
SOBYT pl 127
Shell (Conchiglia) 1960/65
bronzed brass; 100
ARTSI #7
The Sibyl (La Sibilla) 1947
bronze
SAL pl 44 (col)
--1947 bronze; 37-1/4
NNMMM 172 UNNMMA
--1947 bronze; .98x.67 m
SCUL pl 23 IMAM
--1948 bronze; 37
MID pl 60 BAM
--1949 bronze
BERCK 152
Squatting Woman
SAL pl 45
Ungaretti, bust 1936 wood;
23-1/4 SOBYT pl 126;
VEN-54; pl 16 IRMo
Woman Holding her Foot,
No. 1. 1943 bronze; 5-
15/16
SOBYT pl 128
Woman Sitting 1947 bronze;
40 SCHAEF pl 20
Fear. German--18th c.
Fear. Stammel
Fear. Venard
Feast at Simon's, low relief.
French--12th c.
Feast of Dives, relief. English--
12th c.
Feast of Herod.
Donatello. Font
Feast of the Gods. Early Christian
Feast of the Gods. Vittoria
February 1956 (Menhir). Nicholson
Fecondazione# Salvatore
Fecondite. Achiam
FEDDERSEN, Hans P.
Composition 1963 bronze;
98-3/8 READCON 225
GHilV
FEDERIGHI, Antonio (Antonio
Federighi dei Tolomei)
(Italian c 1400-90)
Adam and Eve, font relief
CLAK 110 ISC
Baptismal Font
PANS pl 138; POPR fig 95
ISC

Capella di Piazza 1460/68
BAZINW 344 (col) ISP
Madonna and Child, relief
 marble; 24-3/8x14-5/8
NCM 40 UNcRA
St. Ansanus
POPR fig 94 ISPa
S. Vittorio 1456 marble
SEY pl 85A ISPa
Federighi, Benozzo (Bishop of Fie-
 sole d 1450)
Robbia, L. della. Benozzo
 Federighi Monument
Federzoni, Luigi (Italian Fascist
 Leader 1878-)
Messina. Luigi Federzoni,
 head
FEHR, Henry C.
Morning bronze
 MARY pl 40
The Rescue of Andromeda
 bronze MARY pl 155 ELN
FEHRENBACH, Gerson (German
 1932-)
Gesaltung eines Innenhoffes,
 study, Dusseldorf 1963
 for marble; 140x140 cm
 KUL pl 13
Plastik 1958 cement; 20 cm
 KUL pl 14
Plastik 1959 cement; 60 cm
 KUL pl 12
FEHRLE, Wilhelm (German 1884-)
Madchen 1932 marble; 50
 cm HENT 95
FEICHTMAYR, Franz Zaver (German
 1705-64), and Johann Michael
 FEICHTMAYER, et al
Church Interior
 BAZINW 411 (col) GDiesS
FEICHTMAYR, Johann Michael
 (German 1709-72)
Church Interior; detail:
 Putti c 1760 stucco
 KITS 139 (col), 138 (col)
 GOtA
FEICHTMAYR, Josef Anton (German
 1696-1770)
Angel
 BAZINW 413 (col) GNeu-
 bM
Pieta, Station of the Cross
 ptd stucco BAZINW 413
 (col) GNeubM
FEIGIN, Dov (Russian-Israeli
 1907-)
Composition with Horizontal
 1962 VEN-62:pl 158

Head stone
 SCHW pl 88
Lyre Player concrete
 GAM pl 113
Rehovot War Memorial (In
 Memory of Our Warriors),
 relief stone GAM pl 115
Woman Sitting concrete
 GAM pl 114
FEILL, Joseph (German)
Apotheosis, former Episco-
 pal Castle 1767/72
 BOE pl 187 GMu
FEILNER, Simon (Simon Feylner)
 (German 1720/30-98)
Medicine Cellar, Hochst
 c 1753 porcelain; 3-1/2
 KO pl 95 ELBr
Felbrigg, Simon
English--15th c. Stall Plate
 of Sir Simon Felbrigg
Felici, Cristoforo
Urbano. Monument of
 Cristoforo Felici
Felicita di Essere. Somaini
Le Felin. Claraz
Felipe, Infante Don d 1274
Spanish--13th c. Infante Don
 Felipe Tomb
FELIPE DE BORGONA See BIGARNY,
 Felipe
Felix (Roman Consul)
Early Christian. Consul
 Felix, Rome, diptych panel
Felix of Valois, Saint (French Monk
 1127-1212)
Brokoff, F. M. St. John of
 Mathy, St. Felix of
 Valois, and St. Ivan
Feminine Rock. Wotruba
Femme a Genoux
Lehmbruck. Kneeling Woman
La Femme a la Corbeille
Gonzalez. Woman with a
 Basket
Femme a la Grappe. Laurens
Femme Accroupie
Rodin. Crouching Woman
La Femme au Bain. Ipousteguy
Femme au Collier
Maillol. Venus with Neck-
 lace
La Femme aux Yeux Baisses. Despiau
Femme Couchee. Laurens
Femme Nue Accroupie
Manolo. Kneeling Woman
Femme Nue Lisant dans un Fauteuil.
 Dalou

La Femme qui Marche. Cornet
La Femme qui Marche
 Giacometti. Woman Walking
Femme se Coiffant
 Gonzalez. Woman Combing
 her Hair
Fences
 Guimard. Fence
La Fenetre. Raveel
Fenice. Pevsner
FENOSA, Apel'les (Spanish-
 French 1899-)
 Hair 1960 bronze
 SELZJ 7
 Storm Driven Away by Fine
 Weather 1958
 MAI 94
Ferdinand I (Grand Duke of Tuscany)
 See Medici, Ferdinand I de'
Ferdinand I (King of Castile and
 Leon d 1065)
 Spanish--11th c. Christ on
 the Cross
Ferdinand III (King of Castile
 1199-1252)
 Spanish--17th c. El Santo:
 Ferdinand III of Castile
Ferdinand V (King of Castile and
 Leon 1452-1516)
 Fancelli, D. A. Ferdinand
 and Isabella Tomb
 Spanish--16th c. Plateresque
 Portal; Ferdinand and
 Isabella
 Vigarny de Borgona. Fer-
 nando, kneeling effigy
 Vigarny de Borgona. Royal
 Chapel Altar: Ferdinand
 and Isabella Riding to
 Receive Keys to Conquered
 Granada
Ferencsik, Janos
 Ferenczy, B. Janos Ferenc-
 sik
FERENCZY, Beni (Hungarian 1890-)
 The Advance (Schreitende)
 1939 bronze; 39 cm
 GAD 79 HBA
 General Josef Bem, medal
 1951 bronze; Dm: 11.5
 cm
 GAD 131 HBA
 Goya, medal 1954 bronze;
 Dm: 8.5 cm GAD 133
 HBA
 Janos Ferencik, head 1953
 bronze; 36 cm
 GAD 119 HBA

Leonardo da Vinci, medal
 1952 bronze; Dm: 12.2
 cm GAD 131 HBA
Woman Portrait Bust 1936
 bronze GAD 80
 Portraits
 Vigh. Beni Ferenczy, bust
FERENCZY, Istvan (Hungarian
 1792-1856)
 Ferenc Kazinczy, bust 1828
 marble; 59 cm
 GAD 43 HBA
 Shepherdess, kneeling figure
 1822 marble; 94 cm
 GAD 44 HBA
 Portraits
 Beck, F. O. Istvan Ferenczy,
 medal
Ferguson, Patrick (British General
 in American Revolutionary
 War 1744-80)
 English--18th c. Lt. Col.
 Patrick Ferguson, bust
Fermor, George (English Knight
 d 1612)
 Hollemans. Sir George and
 Lady Fermor Monument
Fermor, Thomas d 1580
 Royley. Thomas Fermor
 Tomb
Fern. Hajdu
FERNANDES DE SILVA, Fernando
 (Portuguese)
 A Logica eo Silogismo
 cement SAO-2
FERNANDEZ, Augustin See ARMAN
FERNANDEZ, Gregorio (Gregorio
 Hernandez) (Spanish c 1576-
 1636)
 Baptism of Christ, relief;
 details, Christ, St. John,
 Hand after 1624 ptd wood;
 LS GOME pl 40-44;
 TAT sc pl 13 SpVME
 Christ of the Filipini (Christ
 of Good Fortune--Buen
 Suceso) 1627 ptd wood,
 figure: 74-3/8 GOME pl
 38-39; NEWTEM pl 137
 SpVME
 Entombment detail: Head of
 Christ MOLE 15 SpV
 High Altar, detail
 VEY 291 SpSC
 Mater Dolorosa, head detail
 17th c. ptd wood
 GUID 247 SpVME
 Pardo Christ 1614 ptd wood

BAZINH 313; BAZINW
399 (col); GOME 13 (col)
SpParC
Pieta 1606/16 ptd wood
GOME pl 35 SpVMar
Pieta 1617 ptd wood; LS
BAZINB 53 (col); BAZINW
399 (col); BUSB 46, 47;
CHASEH 411; GOME pl 36-
37; KITS 99; KO pl 87;
KUBS pl 80; LARR 227;
NEWTEM 21 (col); VEY
282 SpVME
St. Bruno 1634
KUBS 78B SpVM
St. Francis Xavier, detail
VEY 176 SpVMi
St. Theresa after 1624 ptd
wood GOME pl 45 SpVME
The Veronica 1614 ptd wood
ENC 299; KUBS pl 78A;
ST 360 SpVMP
Fernandez de Morales, Juan
Spanish--15th c. Juan Fer-
nandez de Morales, effigy
detail
FERNANDEZ DEL MORAL, Lesmes
See ARFA Y VILLAFANE,
Juan de
FERNEX
La Grande Jardiniere, after
Boucher Sevres biscuit
SOTH-2:157
Fernhout, Annetje
Raedecker. Annetje Fernhout,
head
FERNKORN, Anton Dominik von
Lion of Aspern 1858 sand-
stone; 6-1/4 (excl pedestal)
x15-1/2 NOV pl 184b
AVAs
FERON, Louis
Crucifix silver
MCCL pl 59
FERRANT, Angel (Spanish 1890-)
Modifiable Sculpture 1953
BERCK 184 SpMaHu
"959 Jul" 1960
VEN-60: pl 199
FERRANT, Guillen (Spanish) See
BOLDUQUE, Roque
FERRATA, Ercole (Italian 1610-86)
Faith before 1674 terracotta;
14-3/4 DETI 60 UOTA
Madonna and Child c 1660
gilt bronze; 16
DETI 58 UKLaUM
St. Agnes on the Pyre 1660
WIT pl 119 IRAg

FERRATA, Ercole, and L. Retti
Stoning of St. Emerenziana,
right altar detail 1660/20
marble; over LS
BUSB 83; MOLE 186; WIT
pl 115 IRAg
FERRUCCI, Andrea (Italian 1465-1526)
Altarpiece
MACL 221 ELV
Beheading of St. John the
Baptist, font predella
1494/97 marble SEY pl
149B IPiC
St. Andrew
POPRB fig 42 IFOp
FERRUCCI, Francesco di Simone da
Fiesole (Italian 1437-93)
Barbara Manfredi Monument,
effigy SEY pl 89A IForB
Ferry, Jules
Michel, G. Jules Ferry
Monument
Festival of the Grapes, relief.
Bernard
La Fete. Pini
Fetishes See Charms
Fettered Action
Maillol. Chained Action
Fettered Prometheus. Marcks
Fettiplace, George d 1743
Annis. Sir George Fetti-
place, bust
FEUCHTMAYER, Joseph Anton
(Austrian 1696-1770)
Altar of St. John the Baptist
marble stucco
ST 365 GBir
Angel with Lute, Constance
Region c 1730 ptd limewood;
60 KO pl 92 (col) GKarB
Figure, decoration detail
1747/49 stucco
BAZINB 240 SwNe
High Altar, detail: Putti
1746/50 BUSB 182
GBir
Honey Thief (Honey Taster;
Honigschlecker; Sweet
Tooth),
St. Bernard Altar 1746/50
stucco
BUSB 176; HELM pl 155;
LARR 356; LARR ht (col);
LOH 244; NEWTEM 23
(col); STA 178 GBir
Immaculata c 1720 ptd wood;
63-3/4
KO pl 92; LOH 245;
NEWTEM pl 148 GBS

FINOTTI, Novello (Italian 1939-)
 Immagine Disseptolta 1966
 bronze VEN-66:#32
The Finsen Monument. Tegner
Fiocre, Eugenie
 Carpeaux. Mademoiselle
 Fiocre
Fiore. Marotta
FIORENTINO, Domenico (real name:
 Domenico del Barbiere)
 (Italian 1506-1565/75)
 Charity 16th c. ptd stone
 MOLE 201 (col) FTrP
 St. John the Baptist 16th c.
 ptd stone
 MOLE 201 (col) FTrP
FIORENTINO, Niccolo Spinelli
 (Italian 1430-1510)
 Girolamo Santucci, Bishop of
 Fossom Brone bronze; Dm:
 84/84.5 mm DETD 136
 UCStbMo
 Medal: Giovanna Albizi
 Tornabuoni; Three Graces
 BARG IFBar
 --Three Graces
 PANS 124
 Medal: Lorenzo de' Medici
 bronze; Dm: 83 cm
 DETD 136 UCStbMo
 --1490 bronze
 MU 143
 --1490 bronze; Dm: 86 cm
 BARG; CHAS 301; HALE
 85 (col) IFBar
FIORENTINO, Rosso (Italian 1495-
 1540)
 Ignudo 1533/40 stucco; c LS
 MOLE 159 FFPF
Fiorenzo. Andreotti
FIORI, Ernesto de (Italian-German
 1884-1945)
 Bagnante 1917 ptd terracotta;
 1 m SCUL pl 2 NRBoy
 Female Caryatid 1924 bronze
 VEN-50:pl 2 GDusK
 Female Figure 1911
 MAI 73
 Fleeing Woman 1927 bronze;
 28-3/8 NMG #104 GBFl
 Hindenberg, head 1928 bronze;
 LS HENT 56
 Kneeling Woman terracotta
 VALE 47 UMiD
 Liegender Mann 1926 bronze;
 40 cm HENT 55
 Marlene Dietrich, head 1931
 colored plaster; 15
 NMG #105

Il Pugile Max Schmeling 1928
 ptd plaster SCUL pl 3 IRGiu
The Soldier 1918 bronze; 50-3/8
 READCON 23, RIT 96 GH
--1918 artificial stone; 52 NMG
 #101 GBFle
Standing Youth (Stehende Jung-
 ling) c1925 terracotta; 37-1/2
 KUHNG pl 114 UMCB (1933.32)
--1926 bronze; 2.20 m
 HENT 54 GSteS
Youth 1911 bronze; 43-1/4
 NNMMAG 162 GMaM
Fire-Back. English--16th c.
Fire-Damp. Meunier
Fire-Dogs. See Andirons
Firebird. Frink
Fireplaces, Chimney Pieces and Mantels
 Beauregard. Fireplace
 Caffieri. Ormolu Firedogs#
 Coecke. Fireplace
 Colijins de Nole Family.
 Renaissance Chimney Piece
 Colt, M(?). Chimneypiece
 Dammartin. Triple Fireplace
 Desiderio da Settignano.
 Chimneypiece, detail
 Dietterlin. Fireplace
 English--15th c. Chimney Piece
 detail: Arms and Devices of
 Ralph, Lord Cromwell
 English--16th c. Chimneypiece
 from Raglan Castle
 --Overmantel
 English--17th c. Chimneypiece#
 --Gallery Chimneypiece
 English--18th c. Mantel
 Flemish. Last Supper,
 mantelpiece relief
 Flemish--16th c. Hotel de Ville
 Fireplace
 French--15th c. Chimney Piece,
 relief figures
 --Fireplace, Hotel Jacques
 Coeur, Bourges
 French--16th c. Mantelpiece
 French--19th c. Napoleon III
 Chimneypiece
 German--16th c. Chimneypiece,
 detail of panels: Mars and
 other Gods
 Gilioli. Garden Fireplace
 Goujon. Renown, fireplace
 Greco, Il. Fireplace Frieze
 Holbein, Hans. Fireplace for
 Henry VIII, design
 Italian--18th c. Chimney Piece
 Junker, M. Fireplace
 Keldermans, St. Christopher
 Chimney Piece

Meller. Chimney Piece in
 Private house
Nost. Car of Venus,
 Chimney piece detail
Primaticcio. Mantelpiece
Rovezzano. Mantelpiece
Rysbrack. Chimney Piece
Stevens. Caryatids, Dor-
 chester House Fireplace
Thorvaldsen. Villa Carlotta,
 Salon: Fireplace
Webb. Rustic Fireplace
FIRK, R.
 Janosik and the Mountain
 Cock wood MARY pl 59
 PW
Firmin, Saint
 French--13th c. St. Firmin
 Blessing
 French--15/16th c. Choir
 Screen, south: Life of
 St. Firmin, relief
First Fugue. Chavignier
The First Morning. Rombaux
The First Sand Machine. Medalla
The First Swallow. Mascherini
First Swallows. Mikenace
First Vibrating Electro-Signals.
 Takis
FISCHER, Adam (Danish 1888-)
 Girl from Crete 1942/52
 Euville-stone; 55
 MID pl 29 BAM
 Girl with a Pitcher stone
 MARY pl 58
 Head*
 MARTE pl 15
 Head limestone
 MARY pl 17
 Sculptor, bust bronze
 MARY pl 72
 Woman with Jar*
 MARTE pl 15
FISCHER, Franz (Swiss 1900-)
 Chien Courant 1956
 JOR-2: pl 116
 Chien Mourant 1956
 JOR-2: pl 197
 Haut Relief 1955 H: 295 cm
 JOR-1: pl 54
 Marshal Mannerheim Monu-
 ment 1955 granite; 700 cm
 JOR-1: pl 55 SwMon
 Der Redner 1954 bronze; 100
 cm JOR-1: pl 53 SwBie
 Le Reve 1957
 JOR-2: pl 196

FISCHER, Lothar (German 1933-)
 El Cid III 1965 mixed media;
 25-3/8x17-3/4
 NEW pl 319 GMVan
 Gaa 1962 terracotta; 80 cm
 KUL pl 24
 Surrealer Gegenstand 1959
 terracotta; 40 cm
 KUL pl 23
FISCHER VON ERLACH, Johann
 Bernhard (Austrian 1656-1723)
 See also Rauchmiller, M.
 Side Door
 BOE pl 175 AVL
 Staircase: Column Figures
 1694/98, 1708/11
 KITS 70 AVEu
FISCHER VON ERLACH, Johann
 Bernhard, and FOLL
 Trinity Column
 POST-2: 71 AVG
Fish Head. Frink
"Fish in a Net"
 English--18th c. Chelsea
 Scent Bottles
Fish Venders in Amsterdam. Costa,
 J. M. da
The Fisheater. Chadwick
FISHER, Alexander
 Relief bronze
 MARY pl 81 ENe
Fisher, John Arbuthnot, 1st Baron
 Fisher of Kilverstone (British
 Admiral 1841-1920)
 Epstein. Admiral of the
 Fleet Lord Fisher of
 Kilverstone
Fisher, Saint John (English Roman
 Catholic Prelate and Martyr
 1459-1535)
 Torrigiano, P. John Fisher,
 Bishop of Rochester, bust
Fisherman's Wife. Martini, M.
Fishermen and Fishing
 Bouchard. Fishermen
 Byzantine. Fishing Scene
 Carpeaux. Neapolitan Fisherboy
 Gemito. Fisherman
 Gemito. Young Fisherman
 Gricci. Fisherman and Girl,
 Capodimonte
 Hagner. Fisherman Pulpit
 Italian--13th c. Fishermen
 Krsinik. Fisherman, relief
 Mikenace. Fishermen
 Pavanati. Fishermen, medal-
 lion

Zijl. Fishermen*, facade
 figures
Fishes
 Artemoff. St. Peter Fish
 Brancusi. The Fish
 Chio. Fish
 Efimov. Fish
 Italian--18th c. Console Table
 Supported by Fish
 Mackay. Alabaster Fish
 Maude-Roxby. Fish
 Milles. Fountain: Man and
 Fish
 Norman, P. E. Swimming
 Fish
 Orloff. Spandril Pieces: Bird;
 Fish
 Peat. Paper Knife: Fish
 Venetian. Tunny-fish
Fishermongers' Guild Fountain.
 Grupello
Fitzalan, Brian
 English--14th c. Brian Fitz-
 alan and Lady Fitzalan,
 effigies
Fitzharris, Lady
 Flaxman. Lady Fitzharris
 and her Children
Fitzherbert, Nicholas d 1463
 English--15th c. Sir
 Nicholas Fitzherbert Tomb
Fitzroy, Henry d 1529
 English--14th c. Henry Fitz-
 roy Tomb
Fitzwalter, Robert
 English--12th c. Galloping
 Knight, seal of Robert
 Fitzwalter
Fiumi Fountain. Bernini, G. L.
Five-Day Insurrection of 1848
 Grandi. Commemorative
 Monument to Five-Days
 Insurrection of 1848
Five Triumphs. Netherlandish
Flabella
 Byzantine. Liturgical Fan
 Italian--12th c. Flabella
The Flagellant. D'Haese, Roel
The Flagellation See Jesus Christ--
 Mocked and Scourged
Flagons See also Vases
 English--17th c. Alms Dish;
 Flagon
Flagstaff Base. Biesbroeck
Flake. Chauvin, J.
Flamboyant Gothic Facade. French--
 14th c.

Flamingoes
 Ruwoldt. Flamingos
Flamme. Heiliger
Flammes. Stahly
FLAMMINGO, Pietro See VERSCH-
 AFFELT, Pierre Anton
Flasks
 English--19th c. Denby
 "Reform Spirit" Flasks
 French--16th c. Flask
Flavian, Saint
 Italian--10th c. Diptych:
 Crucifixion; Roman
 Wolf; Madonna; Sts.
 Gregory, Silvester,
 Flavian
Flawford Madonna and Child.
 English--14th c.
Flax Scutch-Blades. Folk Art--
 German
FLAXMAN, John (English 1755-1826)
 Achilles Shield 1821/22
 IRW pl 79 EEQ
 Admiral Lord Howe Monument
 1803/11 GUN pl 9; IRW
 pl 80; WHINN pl 160B
 ELPa
 Agnes Cromwell Monument
 1800 IRW pl 76; WHINN
 pl 150, 151 ECC; ELU
 Apollo and Marpessa c 1775/
 1800 marble
 IRW pl 77; ROTHS 207
 ELRA
 Barbara Lowther Monument,
 sketch c 1806 plaster;
 110x66 cm LIC pl 21
 ELV
 Benjamin Franklin, bust after
 Jean Antoine Houdon 1802,
 after bust of 1778 plaster;
 26-1/2 AP 118 UPPA
 Cameo
 BROWF-3: 72
 Cephalus and Aurora 1790/94
 WHINN pl 144B EPL
 Charity, model for monument
 to Countess Spencer 1819
 WHINN pl 157 ELU
 A Child, seated figure, model
 c 1772 wax; with frame:
 12-1/2x11-1/2
 MILLER il 156; VICF 98
 ELV (295-1864)
 Dancing Hours 1778
 IRW pl 64 EBarlW
 Dancing Hours, relief orna-
 ment 1775 jasper ware

RAMS pl 8b, 8c EStafE
Dr. John Sibthorp Monument
 1799/ 1802 WHINN pl 154B
 EBathA
Dr. Joseph Warton Monument,
 with his Winchester
 Scholars 1801/ 04 marble
 ESD pl 36; GARL 205;
 WHINN pl 152 EWinC
Edward Balme Monument
 c 1810 WHINN pl 153B
 EBrad
Fury of Athamas 1790/ 92
 IRW pl 75; WHINN pl
 144A ENI
Hercules and Hebe 1792
 IRW pl 74 ELUs
Homeric Vase: Apotheosis
 of Homer, after Greek
 vase Wedgwood jasper-
 ware NM-11: 59 UNNMM
--c1776 Wedgwood jasper-
 ware ENC 404, 660
 ELBr
--c 1785
 LARM 74
--1786 Wedgwood jasperware
 IRW front (col) EBarlW
--c 1789 blue and white
 jasperware; 13
 KITS 165 ENoC
Julia, Lady Shuckburgh,
 monument 1819 ESD pl 143
 EWarS
Lady Fitzharris and her
 Children, effigies
 (Maternal Tenderness)
 1815 plaster; 110x66 cm
 BOASE pl 50B; LIC pl
 22; WHINN pl 156 EHaC
--Maternal Tenderness,
 model BROWF-3: front ELSo
Lord Mansfield Monument
 1795/ 1801 plaster; 110x66
 cm
 BOASE pl 49B; ENC 307;
 LIC pl 20; MOLS-2: pl
 47; POST-2: 103; WHINN
 pl 146 ELWe
--model
 BROWF-3: 75 ELSo
Mary Lushington Monument
 1799 WHINN pl 145
 ELLew
Matthew Boulton Monument
 1809 WHINN pl 154A
 EHan

National Cup 1819/ 26
 IRW pl 113
Nelson Monument 1807/ 18
 marble
 CHASEH 427; IRW pl 82;
 MOLS-2: pl 46; WHINN
 pl 147, 148; ELPa
--Horatio, Lord Nelson,
 head GERN pl 64
Pandora Brought to Earth
 by Mercury, relief
 PANB 92
Robert Burns 1822
 WHINN pl 149A ScENP
Sarah Morley Monument
 c 1784 IRW pl 109;
 WHINN pl 143B EGC
Satan Overcome by St.
 Michael SIN 342 ELV
--1822
 UND 90; WHINN pl 155A
 -EPe
Self Portrait, medallion
 1778 terracotta
 BROWF-3: 72; GARL 35;
 MILLER il 155 ELV
Sir William Jones Monument
 1798 WHINN pl 153A
 EOU
Theocritus Cup 1812/ 13
 IRW pl 78 EEQ
Vase: Classical Figures
 1812 silver gilt; 9-1/2
 BOASE pl 36B
Wedgwood Chessmen,
 designs 1785 IRW pl 110
 EBarlW
William Pitt 1812 marble
 MILLER il 157; WHINN
 pl 149B ScGG
Flaying of Marsyas. Foggini
Le Fleau
 Remund. Der Rote Hahn
Flechtheim, Alfred
 Belling. Alfred Flechtheim
Fleeing Woman. Fiori
FLEER, Fritz
 Laura 1950 bronze
 GERT 63
 Small Aphrodite (Kleine
 Aphrodite) 1950 bronze
 GERT 63
FLEISCHMANN, Arthur (Czech-
 English)
 Lot's Wife 1956/ 57 72x16x
 14 LONDC pl 12
FLEMISH

cast brass; 16-7/8
DETF 273 BLouJ
Breast Plate iron; 18-1/2,
and 14-15/16 DETF 312
BBRA (5442)
Calvary; details: Virgin and
St. John, Brussels c 1490
oak; 70-7/8; and 70-1/8
DETF 245-46, 247 (col)
BLouP
Chandelier brass; 30-11/16
DETF 274 BBrJe
Charity Scene, Brabant(?)
c 1490/1500 oak; 13-9/16
x10-15/16x2-1/16 DETF
260 BBRA (3251)
Compassionate God (Dieu de
Pitie), Brabant oak; 15-
3/4x8-7/8x4-1/8 DETF
257 BLMD
Crucifix of Neville, Brabant
wood; Christ: 2.90 m
CHAR-1: 298-99 FPL
Crucifixion Group, detail
DIV 29 UNNMM
Fist, expiatory symbol of
condemned prisoner 1499
bronze; 5-7/8 DETF 285
BFuSt
Folding Altar, Brussels 1480
oak; 123x105.5 cm BERLEK
pl 31 GBSBe (8077)
Geel Altarpiece (Passion
Altar) c 1480/1500 oak
--Brussels City Mark (Mal-
let) DETF 239 BGeD
--Mary Magdalene
DEVI-2
--St. Veronica; Centurion
Longinus; Two Angels
DETF 240; 242, 243
Gothic Side Board
ST 241
Horse, aquamanile bronze
CHENSW 337 FPCl
Jug, Dinand c 1425 bronze;
9-1/2 DEYE 33 UCSFDeY
(44.25)
King, decorative detail wood;
23-1/2 NORM 75 ELV
King of Judas(?), Brabant
oak; 36-5/8 DETF 256
BLeL
Kneeling Angel, Bruges(?)
oak; 16-1/8x10-1/4 DETF
254 BBrG
Kneeling Angel, Bruges(?)
oak; 16-1/2x9-7/8 DETF

255 BAHe
Mary Magdalene, Brussels
Before 1491/93 oak;
22-1/16x5-1/2x3-15/16
DETF 247 BBRA (2992)
Messina Lectern; reading
desks details: Symbols
of Evangelists brass;
17-1/2x16x12-1/4 to
19-1/2x14z14-3/8 DETF
278, 277 UMdBW (53.70-
53.73)
Misericords: Man Pushing
Dog in Wheelbarrow;
Sleeping Man; Lame Beg-
gar on Crutches; Marine
Knight c 1491/93 oak;
11-13/16x24-13/16
DETF 248-50 DDieS
Mourning Woman
TAYFF 104 (col) UNNMM
Order of the Golden Fleece
Collar 1430 gold and
enamel; 46-7/16 DETF
293 BRoC
Passion of Christ, altarpiece
detail c 18-7/8x14-1/8
DETF 252-53 BBRA
(866-869)
Pelican Lectern brass; 73-1/4
x26-3/4 DETF 272; ROOSE
33 BTiG
Privilege Equestrian Seal of
Mary, Duchess of Burgundy
1477 DETF 364 BBrSta
(1154)
Privilege Seal of Maximilian,
Archduke of Austria 1487
DETF 365 BBrSta (1225)
Reliquary: Christ Blessing
silver; 14-1/16 DETF
288 BToN
Reliquary: St. Catherine of
Alexandria chased silver;
13-3/4 DETF 303 BLouP
Reliquary: The Resurrection
silver, embossed and
chased; 9-1/4x8-15/16
DETF 304 BBrJer
Repos de Jesus, Brabant oak;
12-1/2x11x7-3/16
DETF 344 UNNBlum
Saint, detail stone
MOLE 82 BHalM
St. Gertrude of Nivelles oak;
47-11/16 DETF 251
BEtG
St. John, head stone

DEVI-2 BNN
St. Leonard Altarpiece, 3
details, right wing:
Legend of St. Leonard c
1475/80 ptd and gilded oak;
avg fig H: 16-9/16
DETF 238 BLeL
St. Margaret of Antioch,
Brabant(?) c 1470/80
oak; 34-5/8 DETF 236
BBrG (Inv II 66)
St. Paul oak
CHENSN 299 UNNMM
St. Peter, beam bracket oak;
fig: 29-1/2
DETF 235 BGMO (855)
St. Ursula with the "Eleven
Thousand Maidens", Brus-
sels 1480 oak; 56 cm
BSC pl 64 GBS (8076)
Salet with Mesail iron; 9-
7/16 DETF 314 BBRA
(3990)
Seal of City of Bruges, for
Lawsuits c 1430 silver;
Dm: 3-1/16 DETF 359
BBrSta
Tower Monstrance, Brabant
silver gilt; 30-7/8x
7-11/16 DETF 297 BLeL
Two Flying Angels oak; 33-
1/2 DETF 258 BBrO
Two Holy Women ptd and
gilded wood; 19-1/2
NM-7:41; NMA 53
UNNMM (41.100.128, 129)
Virgin and Child, Brussels
1480/90 oak; 43x24 cm
BSC pl 65 GBS (8104)
Weeping Women at Christ's
Entombment DEVI-2
BSV
--16th c.
Angel of the Annunciation
DEVI-2 BTouMad
Annunciation, Brabant c 1500
oak, or walnut; 9-1/16x
11-3/16x6-1/8 DETF 262
BBRA (1006)
Annunciation, detail, Altar
of the Seven Joys of the
Virgin c 1520 BUSR 196
FFrB
Bad(?) Thief, Crucifixion
Group detail, Brabant
c 1500 walnut; 15-5/16x
x6-1/2 DETF 261 BKH

Bathing Girl boxwood
SOTH-2: 214
Brabant Reliquary Bust
NM-12:184 UNNMMC
Christ, head c 1500 wood
DEVI-2 BMoB
Circumcision of Christ
(Beschneidung Christi),
Antwerp oak; 41 cm
BERLE pl 76 GBSBe
(495)
Crucifixion Altar ptd oak
PANA-1: 70 UMdBW
Door, Wheelwrights Chapel
1517 oak; 78x35-5/16
DETF 347 BBrSa
Ewer of Charles V 1558/59
silver, gilded and enameled;
17 CHAR-2: 68 (col)
FPL
Hotel de Ville Fireplace
CHASEH 356 BAT
The Infant Christ, fragment
marble; 15-3/4 SCON 37
ScEN (No. 1665)
Jean de Merode Tomb d 1559
ROOSE 154 BGeD
Jehan de Melun, and two
Wives, Tomb, relief
effigies
ROOSE 36
Jesse, seated figure with
Tree 1520 oak; 42x30 cm
BERLE pl 70 GBSBe (8088)
Joint-Cover: St. Anthony
Hermit, Brabant c 1500
oak; 152x7-7/8x7-7/8
DETF 263 BLouC
Madonna Standing on Half-
Moon, Mechlin 1520/30
ptd walnut; 41 cm JOO
177 (col) NOK
Mask, expiatory symbol of
condemned prisoner
bronze; 9-7/8x5-1/8
DETF 286 BFuSt
Passion Altar, Antwerp oak;
middle section: 244x112 cm;
side sections: 113x94 cm;
predella: 38 cm BERLEK
pl 71-2 GBSBe (7700)
Reredos 1533 alabaster fac-
ing ROOSE 34 BHa
Reredos of Claude de Villa
ROOSE 35 BBMu
Retable de Coligny, Anvers
ptd and gilded wood; 2.10

FLORENTINO, Jacopo See JACOPO
 FLORENTINO
Flores e Blanze Flor. Blomberg
A Floresta. Richier, G.
Florien, Saint
 Austrian--16th c. St. Florian
 Hungarian--18th c. St. Flori-
 an
 Pacak, J. St. Florian
 Pacher. St. Florian
FLORIS, Cornelis (Flemish 1514-70)
 See also Vriendt, Cornelis de
 Christ Carrying the Cross,
 rood screen detail c 1570
 marble BAZINW 385 (col);
 MOLE 214 BTouC
 Christian III Monument 1574/
 75 marble
 BOES 220 DRosC
 Jean III de Merode and Anne
 de Ghistelle Tomb marble
 HAMF 265 BGeD
Flotenspieler. Fueter
FLOTNER, Peter (German c 1485-
 1546)
 Apollo Fountain, Nuremberg,
 1532 bronze; 100 cm
 MUL 43 GNP
 Ate und Litai, plaque lead;
 Dm; 15.4 cm MUL 18
 GMBN
 Mortar Plaquettes 16th c.
 bronze CLE 113 UOClA
 (51.444)
 Triumph of the Sea-Goddess,
 roundel c 1530 steatite;
 Dm: 6-7/8 FAIN 107;
 KUHN pl 34 UMCB
 (1951.213)
FLOTNER, Peter, and Ludwig
 KRUG
 Holzschuher Cup c 1540
 coconut and silver gilt;
 17-1/4
 VEY 150 GNG
Flower of Granada. Inurria
Flowers
 Bedford. Flower
 Derby Porcelain. Bouquets
 French--18th c. Meissen
 Verniere filled with Vin-
 cennes and Meissen Flow-
 ers
 --Vincennes Basket of Flow-
 ers
 Picasso. Bouquet
 Rosselli, D.--Attrib. Vase
 with Carnations

Schwitters. Autumn Crocus
Fluctuations. Kemeny
Flughorn. Hafelfinger
Fluid Structuralization. Colombo
Flute See Musicians and Musical
 Instruments
Flying. Cuzijn
Flying Figure. Couzijn
Flying Mercury
 Bologna. Mercury
Flying Torso. Oudot
Flying Turtle. Brancusi
The Foal. Kafka
Foch, Ferdinand
 Landowski. Marshal Foch
 Tomb
 Wlerick. Marshal Foch
 equest
FOGELBERG, Bengt Erland
 (Swedish 1786-1854)
 The God Thor, study c 1840
 plaster; 26-3/8
 BRIONR pl 37; ST 409
 SnSN
FOGGINI, Giovanni Battista (Italian
 1652-1737)
 Angels, dome spandrels
 1692 BUSB 109 IFAnn
 Cardinal Gian Carlo de'
 Medici, bust last Q 17th
 c. marble; 41-1/2 MOLE
 191 ELV
 Cardinal Leopoldo de'Medici,
 Bozzetto 1681 terracotta;
 38.4 cm
 BSC pl 121 GBS (2163)
 David and Goliath 1723 terra-
 cotta CLE 143 UOClA
 (66.126)
 Ferdinando de'Medici, bust
 c 1685 marble; 39 (with
 base) COOPF 172 GDonF
 Flaying of Marsyas 1716
 bronze; 24-1/2 MOLE 191
 Mass of S. Andrea Corsini
 1685/91 WIT pl 169A
 IFCh
FOHL, Helga (German 1935-)
 Daphne 1963 iron; 45x30 cm
 KUL pl 36
 Grosse Gestalt 1959 iron;
 300x150x120 cm
 KUL pl 35
Foix, Gaston de, called The
 Thunderbolt of Italy (Duc de
 Nemours 1489-1512)
 Bambaia. Gaston de Foix,
 effigy

Foix, Marguerite de
 Colombe. Francis II of
 Brittany and his consort
 Marguerite de Foix Tomb
FOLEY, John H. (Irish-English 1818-
 74) See also Walker, A.
 The Elder Brother 1860 mar-
 ble; 72 LONDC ELRA
 Innocence 1847 Copland
 parian porcelain; 16-3/8
 CON-6: pl 59 ELV
FOLEY, Michael
 Compassion
 CASS 95
 St. Joseph
 CASS 115
Folgore VI. Coulentianos
Foliage. French--13th c.
Folien-Bett. Hoke
FOLK ART-AUSTRIAN
 Devil Mask, Tyrol
 NEUW 146 ASS
 --DANISH
 Mangle Board, detail: Adam
 and Eve 1833 ptd wood;
 board L: 68 cm BOES
 37 DCNM
 --ENGLISH
 "Black Boy" ("Virginian"), with
 headdress; skirt of tobacco
 leaves; pipe in right hand,
 tobacco roll in left hand
 c 1770 ptd wood PEN xii
 Figurehead: Woman, British ship,
 Rhine 1886 FAIN 26 UCtMy
 Highland Laddie, tobacconist's
 figure 18th c. PEN xxi
 Snuff Highlander,
 tobacconist's figure
 18th c. PEN xii
 --FRENCH
 Butter Markers
 GAF 238 FReB
 Crucifix de Cancale wrought
 iron GAF 238 FReB
 Jacques Cartier, medallion,
 ship marker wood; Dm:
 20 PAG-1: 287
 La Negresse, figurehead
 wood; c 10' GAF 226
 FNaS
 --GERMAN
 Chest Front, medallions of
 fabulous animals c 1300
 oak; 37-3/4x65
 BERL pl 166 GBKu
 (84, 1688)

Christ Crowned with Thorns,
 Constance c 1320 ptd wood;
 34 COOPF 187 GDonF
Flax Scrutch-Blades mid 19th c.
 beechwood, inlaid red and
 green wax; 17-3/8x9-1/4;
 and 16-7/8x6-3/4 BERL pl
 264; BERLES 264 GBSBeVo
 (EK 1925, 10a; 15H I)
Votive Figures: Fettered Man;
 Horse iron; 13-3/8; and 3-
 3/8 BERL pl 268; BERLES
 268 GBSBeVo (51G 72;45/23)
--ITALIAN
Stele of St. Valentine 1662
 BAZINW 233 (col) IVerMC
--POLISH
Benedictine Monk 18th c. ptd
 limewood NORM 95
Gingerbread Mold: Lady and
 Child, Torun wood
 BAZINW 234 (col) FPH
--RUSSIAN
Arches, placed on horses' necks
 ptd wood HAR pl 148B
Arfa, peasant harp
 BLUC 179 ELV
Bass Balalaika
 BLUC 179
Bear Driving Troika Sleigh
 wood BLUC 178
Bird with Fanned Wing and
 Tail feathers, toy 19th c.
 BLUC 175
"Chinese Trifles", copies of
 Popov porcelain figures
 ptd wood; 1-3/4 BLUC
 176
Circular mold 18th c.
 BLUC 174 RuVoM
Ekaterina Koshkina and
 Ekaterina Penkina ("The
 Foster Mother"), Viatka
 toy ptd clay BLUC 177
Gingerbread Figures: Mother
 and Child; Horse--from
 carved wood molds,
 Archangel
 GRAYR pl 51, 52
Gingerbread mold 1850
 BLUC 174
Gingerbread stamp 18th c.
 HAR pl 139B
Gingerbread Stamp for Cere-
 monial Gingerbread:
 Interlacing of Two-headed
 Eagle, Vologda

RTCR 112 ELV
Kobza, Ukraine
BLUC 180
Kvosh: Animal Form 18th c.
 wood RTCR 81 ELV
Ladle, with ducks on handle,
 Vologodskaya 18th c. wood
 GABO pl 43 RuMH
Lion, relief, Tikhvin 17/18th
 c. RTCR 110 ELV
Lion with Horse's Head,
 window sill detail, Volga
 region 19th c. GABO 125
 RuZM
Loom, detail, incised and
 painted: Bird 18th c.
 RTCR 110 RuMH
Peasant Carving
 GRAYR pl 11 RuMH
The Peasant St. Nicholas
 von Flue (Brother Claus)
 15th c. wood CHENSW
 356 SwStM
Peasant Sledge wood
 BLUC 168 RuLR
Ruilya, Ukraine
 BLUC 180
St. Anthony of Padua,
 Lithuania ptd wood
 BAZINW 235 (col) FPH
Shuttle 19th c. ptd wood
 RTCR 109 RuMH
Sleigh, central Russia 19th c.
 ptd wood, iron runners
 GABO pl 44 (destroyed
 WW II) RuSM
Wheeled Animal wood
 BLUC 175
Window Frame, carved and
 painted, Smolensk 18th c.
 RTCR 111
--SCOTTISH
Figurehead of Benmore ptd
 wood 1870 PANA-1:21
 UVNeM
--SWISS
Butter mold: Bear, with
 flowers MALV 502
Mask, Kippel Lotschental
 19th c. wood; 18
 JANSH 28; JANSK 28;
 MALV 564 SwZR
FOLKARD, Edward (English 1911-)
 Astrid, bust ciment fondu;
 LS PER 135
 Boy Rider ciment fondu
 PER 144
 Bridget 1953 ciment fondu;
 1/2 LS PER 125

C. R. Belling, Esq. bust
 ciment fondu; LS
 PER 137
 Onlookers 1956 ciment fondu;
 63x37 LONDC pl 13
FOLKARD, R. C. H. (English)
 Boy Bathing 1946 terracotta;
 23 NEWTEB pl 24
Folke, Filbyter
 Milles. Folke Filbyter#
Folkes, Martin
 Roubiliac. Dr. Martin Folkes
 bust
 Tyler, W., and R. Ashton.
 Dr. Martin Folkes Monu-
 ment, effigy
La Folle Chanson. Lambeaux
La Folle Danseuse
 Wouters. Wild Dance
Followed By. Waldberg
FOLMER, Georges (French 1899-)
 Polychromed Wood (Bois
 Polychrome) 1949/50
 BERCK 134
FONDULO, Agostino, also called:
 de Fondutis (Italian fl c 1480)
 Decorative Frieze c 1485
 terracotta SEY pl 132B
 IMSa
Fonseca, Gabriele
 Bernini, G. L. Doctor
 Fonseca, effigy
 Bernini, G. L. Gabriele
 Fonseca
FONTAINE, Gustave (Belgian)
 Fierens-Gevaert, head
 GOR 87
Fontaine, Mme.
 Despiau. Mme. Fontaine,
 bust
FONTAINE, Pierre Francois Leonard
 (French 1762-1853) See
 PERCIER, C.
FONTANA, Annibale (Lombard
 1540-87)
 Adoration of the Shepherds,
 relief terracotta; 43x
 22-1/2
 SEYM 139-41; USNI 228;
 USNK 200; USNKP 429
 UDCN (A-23)
 Virgin of the Assumption
 marble POPRB pl 102 IMMar
FONTANA, Domenico (Italian 1543-
 1607)
 Nicholas IV Tomb
 POPRB fig 148 IRMMag
 Pius V Tomb
 POPRB fig 150 IRMMag

Sixtus V Tomb, effigy detail
marble POPRB fig 149, pl
135 IRMMag
FONTANA, Domenico--FOLL
Maiolica Wine Cooler 1565/
71 ENC col pl 57 (col)
IFBar
FONTANA, Lucio (Argentine-
Italian 1899-)
Le Amanti dei Piloti
(Scultura a gran fuoco
colorata) 1931 H: 35 cm
CARR 289 IVCar
Ambiente Spaziale, plastico
and luce 1948 CARR 286
(col) IMNav
Bar Glass Mosaic, 2nd class
swimming pool,
Andrea Doria
DAM 216
Christ 1947 ceramic; 22-7/8
SOBYT pl 131
Christ 1950 ceramic
VEN-50: pl 49
Conversation 1933/34 bronze
gilt; 27-5/8
TRI 173; VEN-58: pl 6
Crucifixion 1948 ceramic
SAL 43
Gallo 1948 mosaic sculpture;
40 cm
CARR 290 IRMo
Guerriero 1949 ceramica
smaltata; 1 m
SCUL pl 71 (col) IRMar
Luminous Sculpture, stair-
case and 2nd floor hall
DAM 141 IMT
Masker 1947 ceramic;
35-1/2 SOBYT pl 132
Natura (Nature) 1959
KULN 118, 119
--1965 bronze; Dm: 40
ARTSI # 8 ELMarl
--I 1961 bronze; 25-1/2x36-
1/2; Circ: 93
ALBC-4: 56 UNBuZ
Paulette, bust 1936 H: 63 cm
CARR 291 SwGDR
Scultura 1934 iron
VEN-66: # 11 IRMarl
Scultura Astratta 1929/30
plastic CARR 288 UNc-S
Sculture Astratte Colorate
1929/30 CARR 287
Spatial Decoration for a
Cinema Ceiling
MAI 97

Spatial Idea (Concetto
Spaziale; Spatial Concept)
1952
VEN-54: pl 22
--1952 ferro colorato; Dm:
3 m SCUL pl 70
--1957 bronze
MAI 96
--1961 4 spheres; Dm:
40 (ea); 1 sphere; Dm:
35
GUGE 54 UNNH
--1962 ceramic
READCON 268
Spatial Idea (Concetto
Spaziale; Spatial Concept):
Expectation 1959 colored
cloth SAL pl 70 (col)
--: La Fine di Dio 1963
70-1/8x43-3/8 NEW col
pl 51 (col) IRMarl
--: Nature 1960 sandstone
SAL pl 69
Victory, 6th Milan Triennial
CASS 127
FONTANA, Orazio (Urbino 16th c.)
Vase from Set of Guido-
baldo II della Rovere
BARG IFBar
Wine Cistern: Handles--
Lion Mask and Acanthus
Leaves c 1560/70
ceramic; 14; Dm: 22
DETD 42 UMiFB
FONTANA, Orazio--FOLL
Wine Cooler 1565/71
ceramic BAZINL pl 297
(col) IFMN
La Fonte Gaia. Quercia
Fonts See Also Baptism
Aert von Maastricht. Font
Anglo-Saxon. Deerhurst
Font
Anglo-Saxon. Little Billing
Font
Anglo-Saxon. Melbury Bubb
Font
Anglo-Saxon. Potterne Font
Antelami--Foll. Font: Adam
and Eve
Brom. Font
Celtic. Newborough Font
Donatello. Font
English. Cornish Font
English. Font: Lion Surround-
ed by Magic Plaitwork
English--12th c. Font#
--Tournai Font

English--17th c. Font Cover
Eynde, G. van der. Font
Federighi. Baptismal Font
Flemish--11th c. Baptismal
 Font
Flemish--12th c. Baptismal
 Font#
French--11/12th c. Baptis-
 mal Font: Sins Washed
 Away by Baptism
German--13th c. Font#
German--14th c. Font
German--15th c. Font,
 detail
Hayward. Font: Classical
 Figures
Italian--12th c. Baptismal
 Font
Italian--13th c. Baptismal
 Font
Italian--15th c. Baptismal
 Font
Klinghe. Baptismal Font
Mosan. Baptismal Font
Pisano, G. Fonte Maggiore
Quercia, J. della, L.
 Ghiberti, Donatello. Font
Reiner von Huy. Baptismal
 Font
Robertus. Font: Life of
 Moses
Romanesque--English. Font
Romanesque--English. Frome
 Font
Romanesque--Swedish. Font:
 Animal and Human
 Figures
Swedish--13th c. Baptismal
 Font
Thomas. Memorial Font
Thorvaldsen. Angel Holding
 a Font
Urach, M. von, and C. von
 Urach. Font
Vallette. Baptismal Font
Wenzinger. Font
Foolish Virgin See Wise and Foolish
 Virgins
Foot. Kramer
Football Player. Sintenis
FOPPA, Ambrogio (Italian 1445-
 1527)
 Matthias Corvinus, King of
 Hungary, medallion
 c 1490 bronze; Dm:
 3-3/8
 YAP 217 -USe

FOPPA, Cristoforo Caradosso See
 CARADOSSA
...For Cello. Scott, T.
For the Victims. Elkani
For Your Living-Room, for
 Nostalgic Purposes. Kudo
FORANI, Madeleine Christine
 (Belgian 1916-)
 The Path hammered iron
 MAI 98
Force
 Barye. La Force
 Bourdelle. Alvear Monument:
 "La Force"
 Ceracchi. Capellen Monument
 Ceracchi. Force
Force Controlled. Dick
FORD, Edward Onslow (English
 1852-1901)
 Dancing
 MARQ 272
 Huxley, seated figure marble
 MARY pl 41 ELBrN
 Peace
 RAY 59 UNNMM
 Shelley Monument bronzed
 marble
 MILLER il 174 EOU
FORD, G. H. (English)
 Little Brother 1940 Portland
 stone; 27
 BRO pl 9
FORD, K. C.
 Allegory of the Church
 holly wood; 48 NORM 91
Forest. Arp
The Forest. Giacometti
Foret Noir, No. 2. Penalba
Forgiveness. Braecke
Forjot, Nicolas (Abbot of St. Loup,
 Troyes)
 French--16th c. Virgin and
 Child with Abbot Nicolas
 Forjot, donor
Forked Cross Crucifixion. German--
 14th c.
Form Enclosed. Hepworth
Form in Tin# Meier-Denninghoff
Form No. 1. Donega
Form without Name. Poncet, A.
La Forma si Sfascia la Materia
 Rimane. Stenvert
Forma Sospesa. Meli
Formations. Kemeny
Formazione I. Fabris
Forme II. Schilling, A.
Forme Balancier sur Trois Pointes.

Bernini, G. L. Fiumi Fountain
Bernini, G. L. Fountain Group
Bernini, G. L. The Moor
Fountain
Bernini, G. L. Triton Foun-
tain
Biderle. Fountain with
Resurrection of Christ
Bilger. Play Fountain
Bizaccheri, C. , and Maratti.
Triton Fountain
Bologna. Fountain Figure,
study
Bologna. Neptune Fountain
Bologna. Oceanus Fountain
Bouchard. Fountain: Girl
with Gazelle
Bouchardon, E. Fountain of
the Four Seasons
Bracci. Trevi Fountain
Brokoff, J. Courtyard
Fountain, with Polyphemus
and Actaeon
Brosse. Medici Fountain
Burgundian--14th c. Table
Fountain
Burton. Courtyard Fountain
Camilliani. Fountain
Canina. Aesculapius Fountain
Canina. Lion Fountain
Carpeaux. Four Continents
Fountain
Carpeaux. Observatory
Fountain
Czech--17th c. Courtyard
Fountain#
Czech--18th c. Caesar
Fountain
--Fountain with Statue of St.
John Nepomuk
--Tritons Fountain
Davioud. Fontaine de
l'Observatoire
Davioud. St. Michel
Fountain
Dietrich, Josef. Samson
Fountain
Dietterlin. Fountain of the
Composite Order
Donner. Providentia Fountain
Duchamp. Fountain
Dupon, A. Fountain--child
figure
English--12th c. Washing
Fountain, detail
Esser. Hercules and Antaeus
Fountain
Fanelli, F. Diana Fountain

Flotner. Apollo Fountain
Francheville. Venus Attended
by Nymphs and Satyrs,
fountain figure
French--14th c. Table
Fountain
French--14/15th c. Renaissance
Fountain
French--15th c. Fountain
French--15/16th c. Fountain
of Drennec
--Sacred Fountain
French--16th c. Chateau
Fountain
--Fontaine d'Argent
--Fontaine de Beaune
--Fontaine des Quartre
Dauphins
--Fontaine du Pilori
French--17th c. "Sinnbrunnen"
Fountain
French--18th c. Fontaine
Sainte-Barbe
French--19th c. Fontaine de
Palmier
--Fountain
--Wallace Fountain
Garbe, R. L. Song of the
Sea, fountain figure
Gerhard. Augustus Fountain
German--13/14th c. Three-
Tiered Fountain
German--14th c. Fountain:
Eagle, symbol of Free
Imperial City of Goslar
Gilbert, A. Shaflesbury
Memorial Fountain
Gleichen. Diana Fountain
Godwin. Fountain
Grupello. Fishmonger's Guild
Fountain
Guibal. Neptune Fountain
Hardiman. Fountain Figure:
Boy on a Shell
Hardt. Pelican Fountain
Herter. Heinrich Heine
Memorial
Hildebrand. Hubertus
Fountain, detail
Hildebrand. Wittelsbach
Fountain
Huhnerwadel. Memorial
Fountain
Italian. Gallery Fountain
Italian. Tortoise Fountain
Italian--16th c. Fountain of
the Organ
--Venus Fountain

Strebelle. The Fountain
Svor. Fountain
Syrlin, J., the Elder.
 Gothic Pinnacle
 Fountain: "Fish-Box"
Szentgyorgui. Fountain
Tacca, P. Merman,
 fountain
Torre, F. de, and H. Kohl.
 Courtyard Fountain
Il Tribolo. Figure,
 Medici Villa at Castello
Il Tribolo. Fountain of
 Hercules and Antaeus
 (design)
Il Tribolo. Fountain of the
 Labyrinth
Tuby. Fountain of Apollo
Utzon, Frank. Fountain
Verrocchio. Boy with
 Dolphin, fountain figure
Vigeland. Frogner Park
Vigeland. Fountain for
 Christiana
Vigne, P. de. Mercury
 Fountain
Vischer, Hans, the Elder.
 Apollo Fountain
Voimer. Peace Fountain
Vries. Hercules Fountain
Wren. Fountain Court
Wurzelbauer. Justice
 Fountain
Wurzelbauer--Foll. Neptune
 Fountain
Zschokke. Brunnen,
 Inselschulhof
FOUQUAY, Nicolas (French)--
 ATTRIB
 Seasons: two busts 18th c.
 faience; 79
 CHAR-2:161 (col) FPL
Four Angels. Parbury
Four Continents Fountain. Carpeaux
Four Crowned Saints
 Nanni di Banco. Quattro
 Santi Coronati
Four Figures. Avramidis
434 Extra Large Flat Heads.
 Bury
Four Moors in Chains. Tacca, P.
Four Part Sculpture No. 1. Tucker
Four Reliefs. Meadows
The Four Rivers and the Four Trees
 French--11th c. Choir
 Capital: The Four Rivers
 and the Four Trees

Four Rivers Fountain
 Bernini, G. L. Fiumi
 Fountain (Four Rivers
 Fountain)
The Four Seasons See Seasons
Four Soldiers' Heads. Frink
Four-Square (Four Circles).
 Hepworth
The Four Winds See Winds
La Fourbe et Ruse. Daumier
Fourteen-year-old Ballerina
 Degas. Little Dancer Aged
 Fourteen Years
The Fourth of May. Starcke
Fourth Position Front, on Left
 Leg. Degas
Fox, Charles James (English
 Statesman 1749-1806)
 Nollekens. Charles James
 Fox, bust
 Westmacott. Charles James
 Fox Memorial
Fox, Henry Vassall
 Baily. Henry Vassall Fox
 Monument
Foxes
 English--12th c. Crypt
 Capital: Animal
 Musicians--Fox Piper
 English--15th c. Choir
 Stall: Geese Hanging the
 Fox
 English--18th c. Bow White
 Fox
 --Chelsea Scent Bottles
 Flemish, or Burgundian.
 Spoon: Fox in Monk's
 Dress Preaching to Geese
 Italian--12th c. Parma
 Capital: Fable--Fox
 Dressed as Priest
Foy, Saint
 French--10th c. Sainte Foy,
 reliquary#
FOYATIER, Denis (French 1793-1863)
 Joan of Arc, equest 1855
 LARM 69 FO
FRACCAROLI, I. (Austrian)
 Wounded Achilles
 Carrara marble
 VICG 132 ELV
FRAENKEL, Elsa (German-English)
 A Young Frenchman,
 head 1935 bronze;
 13-5/8 (excl base)
 TATEF pl 29a ELT
 (6088)

Fragments d'Hesiode. Braque
FRAIKIN, Charles Auguste (Belgian
1817-93)
 Queen Victoria, bust
 DEVI-2 BBR
Frames
 French--16th c. Renaissance
 Frame
 Macdonald, MacKintosh, and
 Macdonald. Mirror Frame:
 Honesty
FRAMPTON, George James (English
1860-1928)
 Alfred East, head bronze
 VEN-3:pl 47
 Bernardo Memorial
 TAFTM 77
 Dame Alice Owen bronze
 CHASEH 486; POST-2:216
 ELO
 Enid the Fair, head
 MARY pl 109
 Lamia ivory, bronze, marble,
 jewels MARY 194
 Maternity
 MARY pl 51
 Mother and Son
 VEN-97
 Music bronze
 MARY pl 100 ScGG
 Peter Pan 1912 bronze
 BROWF-3:90; GLE 69;
 RAY 58; TAFTM 77 ELKe
 St. George, war memorial
 bronze; c 7' GLE 145
 ELPe
 St. Mungo, seated figure
 bronze MARY pl 99 ScGG
 "Thus he Leads Them to the
 Desired Gate" ("Cosi egli li
 conduce al lorodesiderato
 porto"), panel bronze
 VEN-5:pl 10
FRANCAVILLA, Pietro See
 FRANCHEVILLE, Pierre de
France, Anatole
 Bourdelle. Anatole France,
 bust
France (subject)
 Bosio. Malesherbes Monu-
 ment: La France
 Bourdelle. La France
 Dalou. Triumph of the
 Republic
 Rodin. France
 Varin. Richelieu's Medal,
 reverse: France Riding in
 Chariot

 Yencesse. La Republique,
 bust
La France Coloniale, Porte Doree.
 Drivier
France and America, war memorial.
 Bottiau
France Triumphant (Louis XIV
 crossing the Rhine).
 Guillaume, G., and Nicolas
 Coustou
Francesca da Rimini
 Rodin. Paolo Malatesta and
 Francesca da Rimini in
 the Clouds
FRANCESCHI, Jules
 Fortune 1886 plaster
 SELZJ 3 FP
FRANCESCO DA SANT'AGATA
(Paduan fl c 1520/30)
 Hercules 1520 boxwood
 LOWR 93 ELWal
 Hercules and Antaeus, Padua
 · c 1520 bronze; 15-1/16x
 4-3/4x10-1/2 READAS pl
 120-21: SEYM 133-35 UDCN
FRANCESCO DI GIORGIO MARTINI
(Sienese 1439-1502)
 Angel bronze; 124 cm
 POPR fig 101, pl 97 ISC
 Assumption and Coronation of
 the Virgin, relief bronze; 18-
 3/4; W, at base: 13 BOSMI
 129; DETD 112 UMB (55.620)
 Deposition, relief bronze
 ENC 315; MONT 70 IVMar
 Discordia (Allegory of Discord)
 stucco; W: 26-1/2 MACL
 179; READAS pl 71 ELV
 Flagellation of Christ, relief
 1478 bronze; 22 MOLE 139;
 POPR pl 96 IPeG
 Judgment of Paris 1475/85
 bronze; 5-5/8x5-5/32x
 19/64 SEYM 107 UDCN
 Medal: Alfonso of Aragon
 1479 bronze; Dm: .062 m
 CHAS 301 EOA
 Oratorio di S. Croce, relief
 detail: Bewailing of
 Christ c 1475 bronze
 SEY pl 112A IVMar
 St. Christopher ptd and
 gilded wood LOUM 119
 FPL (814)
 St. Jerome, plaque bronze;
 21-5/8x14-11/16x1-7/16
 KRA 89 (col); SEYM 106
 UDCN (A-165.2C)

St. John the Baptist
POPR fig 99 ISPN
St. John the Baptist 1464 ptd
wood SEY pl 84A IFoglCh
St. Sebastian, roundel bronze;
Dm: 8; D: 1-15/16
SEYM 108 UDCN
Winged Figure with Cornucopia
bronze; 17-3/8x6-7/8
USNKP 423 UDCN (A-1653)
FRANCESCO DI SIMONE FERRUCCI
(Florentine 1437-93)
Madonna and Child
USNI 228 UDCN (A-28)
FRANCESCO DI VALDAMBRINO
(Francesco di Domenico Val-
dambrino) (Italian fl 1401-35
See also Quercia, J. della
The Annunciation wood
POPG fig 32 IAscS
Ilaria del Carretto Guinigi
Monument: Winged Funerary
Genius SEY pl 10 ILuC
S. Ansano 1406/07 ptd wood
SEY pl 11A ILuSG
FRANCESCONI, Anselmo (Italian
1921-)
Mother and Child 1957 bronze;
15x14x9-1/4
CARNI-58: pl 137 UNNVi
FRANCHEVILLE, Pierre de (Pierre
de Franqueville; Pietro
Francavilla) (French 1548-
1618)
David with Head of Goliath
1608 BUSB 43 FPL
Henri IV, statue pedestal
detail: Slaves (destroyed)
1618 LARR 170 FPL
Orpheus 1598
BUSB 43 FPL
Prisoner bronze; 155 cm
POPRB pl 95 FPL
St. John the Evangelist
bronze gilt
CAMI pl 64 UNNKle
Venus Attended by Nymph
and Satyr, fountain figure
17th c. H: 8' SPA 14
UCtHWA
Virgin Mary bronze gilt
CAMI pl 63 UNNKle
Winter 1590's marble; over
LS MOLE 166 IFPoT
FRANCHINA, Nino (Italian 1912-)
Agriculture 1953 bronze
VEN-54: pl 34

Araldica 1955 lamiera battuta;
1.62 m SCUL 57 IPalT
Daybreak ("Le Jour se Leve")
1962 iron; 98-3/4x15
CARNI-64:#148; VEN-66:
#74
Earth and Fire, detail 1956
BERCK 265
Ettore Fieramosca 1960
iron; 52x14
ARTSI #9; SAL pl 83
Icaro 1963 sheet metal;
57-1/8 NEW pl 111
Metallurgica 1953 ptd iron;
3x2 m SCUL pl 56 (col)
New Reality 1949 bronze
MAI 99
Nike 1958 iron and brass;
106-1/4 TRI 95; VEN-58:
pl 43
L'Oiseau de Feu 1960 iron
SAL pl 84 (col)
La Sammarcota, detail
1946/47 stone
CARR 313
Trinacria, Sicily 1955 bronze
MAI 98
L'Uccello di Fuoco 1960 iron
VEN-66: #73
FRANCIA, Francesco (Bolognese)
Scholar, bust c 1500 marble;
26 DEY 95 UCSFDeY
Francis, Saint
Andreotti. St. Francis and
the Birds
Asorey. St. Francis
Beck, F. O. St. Francis,
relief
Benedetto da Maiano. Pulpit:
Life of St. Francis
Scenes
Donatello. St. Francis
Italian--14th c. Virgin and
Child with SS Laurence
and Francis, lunette
Mascherini. St. Francis
Mena. St. Francis of
Assissi
Robbia, A. della. Meeting
of St. Francis and St.
Dominic
Rucki. Facade Figures;
detail: St. Francis of
Assissi
Sexton. St. Francis of
Assissi
Tino di Camaino. Madonna

and Child with Queen
Sancia
Francis II (Duke of Brittany
1459-88)
Girolamo da Fiesole, and
M. Colombe. Francis II
of Brittany Tomb
Francis I (King of France 1494-
1547)
Bontemps. Francis I Tomb,
relief
Bontemps. Monument for the
Heart of Francis I
Cellini. Salt of Francis I
de l'Orme, P., and P.
Bontemps. Francis I and
Claude of France Tomb
French--16th c. Francis I,
medallion
Marchand, F., and P. Bon-
temps. Monument of
Francis I
Francis II (King of France 1459-88)
Colombe. Francis II of
Brittany Tomb
Francis I (Holy Roman Emperor
1708-65)
Moll. Sarcophagus of Franz
I and Maria Theresa
Francis Borgia, Saint 1510-72
Brokoff, F. M. St. Francis
Borgia
Martinez Montanes. St.
Francis of Borja, head
detail
Francis of Paola, Saint (Calabrian
Franciscan 1416-1508)
Guerin. St. Francis of
Paola
Francis Seraphicus, Saint
Preiss. St. Francis
Seraphicus
Franciscans
Benedetto da Maiano.
Pulpit: Martyrdom of
Franciscan Missionaries
Franciulla con Anfora. d'Antino
FRANCE, Francisco
Dr. Salazar
CASS 60
FRANCO-BURGUNDIAN
The Trinity Morse
(Ecclesiastical Brooch)
c 1400 gold and enamel
LOWR 252 UDCN
FRANCO-FLEMISH
Altar Cross c 1350 silver
and copper gilded, enamel;

figure: 2-3/4; base:
4-1/4; cross: 8-1/4
KUHN pl 5 UMCB (1961.57)
Christ Seated on Calvary
(Ecce Homo) c 1460 oak;
52-1/4 DETF 259; DEY
101; DEYE 51 UCSFDeY
(6545)
Luxuria 1320/30 oak;
146x62x29 cm BSC pl
34-35 GBS (5/57)
Massacre of the Innocents;
Flight into Egypt, choir
stall detail wood
NM-12:131 UNNMMC
Venus with Apple bronze;
14-7/8 HUNT pl 23
UCSmH
FRANCO-ITALIAN
Venus and Cupid 2nd half 16th
c. marble; 81-7/8
BERL pl 204; BERLEI
fr cov; BERLES 204 GBSBe
(1964)
FRANCO-NETHERLANDISH
Kneeling Prophet c 1400
gilt bronze CLE 62
UOCIA (64.360)
FRANCO-PORTUGUESE
St. Barbara 16th c. marble;
14-1/2x18-1/8 USNKP
426 UDCN (A-1626)
FRANCO-THURINGIAN
St. Elisabeth of Hungary
c 1510 lindenwood;
58-1/2 CPL 74; HOW;
REED 60 UCSFCP
(1932.8)
Francois de Bonne, Duc de Lesdig-
uieres(Constable of France
1541-1626)
Richier, J. Francois de
Bonne Tomb
FRANCONIAN
Education of the Virgin
c 1510/20 ptd lindenwood;
33 KUHN pl 22-23 UMCB
(1941.35)
Frangipane, Roberto
Algardi. Roberto Frangipane,
bust
Frankenthal Porcelain
German--18th c. Frankenthal
Chinese Tea House
--Frankenthal Group
FRANKISH
Bow Fibula c 600 gilt bronze
SOTH-4:159

Buckle, and Spear Mounting
 NM-11:9
Casket Panel, with Anglo-Saxon
 Runes Inscription 8th c.
 whalebone LARB 101 IFBar
Chieftan's Helmet 6th c. H: 7-
 1/2 NM-3:2 UNNMM
 (142. 50. 1)
Clasped Helmet, Merovingian
 8th c. LOH 35 GMaiH
Denier: Charlemagne, head
 silver ENC 177
Fibula: Animal Form 6/7th c.
 gold, jeweled MU 109 (col);
 MYBA 239; NM-7:12; NM-
 11:9 UNNMM
Memorial Stele (Niederdollen-
 dorf Stone), Rhineland-West-
 phalia 7/8th c. BAZINW 210
 (col); LARB 101; GBoRL
--Mythical Armed Figure
 LOH 39
Memorial Stele: Mounted War-
 rior, Hornhausen 7/8th c.
 BAZINW 209 (col) GHallL
Sword Fitting of King Childeric
 c 460/70 pontic inlay
 ST 121 FPMe
FRANKISH-ALEMONNIC
 Christ on the Cross, relief 8/
 9th c. ivory WORR 24 EWedA
The Frankland Mask
 English--17th c. Oliver Crom-
 well, death mask
Franklin, Benjamin
 Brou. Reception of Franklin by
 Louis XVI in 1778
 Caffieri. Benjamin Franklin,
 bust
 Houdon. Benjamin Franklin,
 bust
 Monteverde. The Genius of
 Franklin
 Nini. Benjamin Franklin,
 medallion
Frank's Casket. Anglo-Saxon
FRANQUEVILLE, Pierre de See
 FRANCHVILLE, Pierre de
FRANZISCUS OF MILAN (Master
 Franziscus)
 Silver Shrine of St. Simeon,
 saint of the city gate
 c 1380 BUSR 9 YZa
FRASCA, Nato (Italian 1931-)
 Strutturale Variante I 1966
 aluminum and plastic
 VEN-66:#116
Fratze. Hungarian--14th c.
Frau auf Liegenden Pferd. Wolff, G.H.

Die Frau im Wind
 Barlach. Woman in the Wind
FRAUENPREISS, Matthaus, the Elder,
 of Augsburg (German)
 Armor-reinforcing Breastplate
 and Burgonet, etched by Jorg
 Sorg 1550 SOTH-3:249
Fraulein in Algier. Szymanski
Frazer, James (Anthropologist and
 Author 1854-1941)
 Bourdelle. Sir James Frazer,
 bust
Frederick William, called The Great
 Elector (Elector of Brandenburg
 1620-88)
 Schluter. Friedrich Wilhelm,
 Great Elector of Branden-
 berg, equest
Frederick II (King of Denmark and
 Norway 1534-88)
 Schardt. Frederick II, bust
Frederick V (King of Denmark 1723-66)
 Saly. Frederick V#
Frederick III (King of Germany)
 Lederer, H. Frederick III
 Tuaillon. Frederick III
Frederick I (Archbishop Magdeburg,
 Saxony)
 Romanesque--German. Arch-
 bishop Frederick I, effigy
 relief
Frederick I (Holy Roman Emperor
 1123?-90), called Frederick
 Barbarossa
 Geiger. Frederick Barbarossa
 German--12th c. Frederick I,
 reliquary head
 Rodolfo and Binello. Emperor
 Frederick I: Fighting
 Dragons, relief
 Schmitz, Hundreiser, and
 Geiger. Kyffhauser Plateau
 Monument
Frederick II (Holy Roman Emperor
 1194-1250)
 Italian--13th c. Augustales:
 Friederich II Hohenstaufen
 Italian--13th c. Frederick II of
 Hohenstaufen, bust
 Romanesque--French.
 Emperor, head fragment
 (Frederick II?)
 Romanesque--Italian. Fred-
 erick II, seated figure,
 headless fragment
Frederick III (Holy Roman Emperor
 1415-93)
 Gerhaerts. Frederick III Tomb
 German--15th c. Duke
 Frederick V of Styria

GAF 203, 204 (col)
FMontco
Last Judgment
REAU pl 67 FRaC
Legend of St. Thomas, danc-
 ing scene BUSGS 44 FSemN
Lemovices (Haute-Vienne)
 Coin: Horse, detail
 MALV 143
Normandy Chest wood; 39-1/2
 x53-1/2 NCM 162 UNcRA
Notre Dame de Vauclair ptd
 wood; 29 GAF 402 FMolo
Osismii of Armorica,
 Brittany coin gold
 MALV 135 FPMon
Parisii Coin: Profile Face
 MALV 136 FPMon
Portal Figures
 MARQ 154 FArlT
St. Louis Green Overlay
 Molded Salamander
 Weight INTA-1:139
St. Madeleine
 REAU pl 112 FMonP
St. Matthew
 UPJH pl 87 FLeMN
Sign of Locksmith "Filliol"
 GAF 160 FPCarn
Somme District Coin
 MALV 140 FPMe
Two Apostles
 REAU pl 63 FPChap
Veliocasses (Basse-Seine)
 Coin: Ideographic Signs
 MALV 144 FPMe
Virgin and Child, St. Denis
 marble; 40 DETT 182
 UMiD (40.1)
Voussure de St. Nicolas de
 Civray REAU pl 30-31
Wrought Iron Grille
 DUR fig 29 FOu
--5th c.
Plaque: Scenes of Life and
 Miracles of Christ ivory
 MOREYC 90 FPL
Pyx, Trier c 400 ivory
 ENC 740
--7th c.
Chancel Panel, St. Pierre
 stone JAL-1:pl 1 FMetM
Crypt of St. Paul
 LARB 244 FJo
Hypogeum of Mellebaude
 (Hypogeum of the Martyrs),
 detail GAF 366; LARB
 FPoM

Merovingian Capital
 GAF 426 FGreL
St. Agilbert Sarcophagus
 LARB 244 FJo
Sarcophagus: Classical
 Funeral Symbol Marble,
 Cemetery of St. Sernin,
 Toulouse LARB 243 FTM
Theodochilde Tomb: Scallop
 Shell Motif
 LARB 244; LAS 91 (col)
 FJo
--8th c.
Capital: Discovery of the
 Tomb of St. Benoit
 JAL-1:pl 3 FStBen
Crozier: Grotesque Limoges
 enamel
 ROOS 85E UNNMM
Reliquary gold, garnet and
 colored paste
 ENC 754
--9th c.
Book Cover: Christ
 Trampling the Beasts, and
 scenes of his life ivory
 MOREYM pl 62 EOB
Book Cover: Psalm 50,
 Reims c 860/70 4-3/8x
 3-7/16 BECKM 47 FPBN
Book Cover: Carolingian
 St. Denis, or Reims c
 870 gold, jeweled CHRC
 fig 78 UNNM
Book Cover Fragment:
 Biblical Battle ivory;
 5.9x3.1 GAU 126 FPL
Charlemagne, carrying orb,
 equest c 870 bronze;
 9.4
 CHAR-1:227; FREM 18;
 GAU 127; JANSK 394;
 LARB 239; ST 149 FPL
Crucifixion, Lorraine(?)
 c 870 engraved rock
 crystal; 153 mm SWA pl
 13 ELBr
Diptych of Areobindus: The
 Earthly Paradise, with
 Adam and Eve, reverse
 detail, Tours ivory;
 14.2x4.3 GAU 128 FPL
Evangeliary of St. Gauzelin,
 Cathedral Treasury GAF
 184 FNanH
Gospels Manuscript Cover
 CHENSN 282 UNNM
Key of St. Servatius,

Lorraine silver; 290 mm
SWA pl 92 NMaS
Mary and John Mourning, book
cover, Reims(?) gold; 80
mm SWA pl 12 FPBN
Meeting of Abner and Job, re-
lief ivory; .53x.082 m
CHAR-1:229 FPL
Pepin Reliquary enameled and
jeweled gold; c 7-1/4x7-1/4
x3-1/2 LAS 103 (col) FCoA
Portable Altar of King Arnulf:
Gospel Scenes, Reims (?)
bossed gold: 590x310x240
mm STA 35; SWA pl 8
GMRC
Throne of Dagobert: Arm-
rest, Saint Denis SWA pl
92 FPMe
XXVII Psalm, plaque ivory
CHENSW 307 SwZMN
Wedding at Cana, book cover,
Reims (?) c 870 ivory;
138x83 mm SWA pl 14
ELBr
--9/10th c.
Book Cover: Mass; Sacra-
ments, Treasure of Saint
Denis ivory; 6.3x4.3
GAU 122 FPL
Nativity, coffer panel, School
of Metz ivory; 8.6x9.4
GAU 129 FPL
St. Gregory and Scribes,
panel ivory ENC 424
GTC
--9/14th c.
Coronation Sword of the Kings
of France gold; L 1 m
CHAR-1:265 FPL
--10th c.
The Ascension, Lorraine(?)
ivory; 206x147 mm
SWA pl 15 AVM
Beasts of Evangelists,
Champagne(?) Dm: 50 mm
(ea) SWA pl 26 FTrC
Chalice with Paten, Lorraine
gold, jeweled and
enameled; 132x134 mm
SWA pl 24 FNanC
Christ in Majesty, cover
of Gospel of Marchiennes,
Lorraine SWA pl 54 UNNM
Double Capital, eastern
arcade, north vault, upper
narthex
BAZINW 262 (col) FTouP

Ewer, St. Denis rock
crystal and gold; .24 m
CHAR-1:225 FPL
Gospel Scenes, diptych
ivory; 294x121 mm
SWA pl 20 EMaR
Gospels of Gauzelin Cover:
The Evangelists; The
Virgin, Lorraine gold,
jeweled and enameled;
305x220 mm
LARB 272 (col); SWA pl
23 FNanC
Liturgical Comb, Metz
ivory; .195x.105 m
CHAR-1:230 FPL
Mary and Apostles Watching
Ascension, fragment,
Lorraine 140x93 mm
SWA pl 56 GDaM
Reliquary of Sandal of St.
Andrew ENC col pl 24
(col) GTC
St. Foy, reliquary c 960
jeweled and enameled
gold and silver gilt plates
over wood core; 33-1/2
BAZINW 222 (col); EVJF
pl 5; GAF 438 (col), 448;
KIDS 49 (col); LARB 257
(col); MAL pl 4; MU 108
(col); REAU pl 38; SWA 33
FCoF
--10/11th c.
Capital 989/1029
EVJP pl 23a FLoiA
--11th c.
Abbot Durandus, cloister
relief FOC-1:pl 147 FMP
Abbot Durandus Tombstone
c 1100 BUSRO pl 22 FMP
Acrobat, with snake, capital,
Burgundy LARB 278 FanzCh
Adoration of the Magi, tran-
sept south crossing
GAF 319 FLaC
Ambulatory Capitals:
Plainsong--4 tones: Lute,
Timbrels, Psaltery,
Chime Bells (Gregorian
Modes), Cluny III (Third
Abbey Church) c 1088/95
limestone
BECKM 173; FLEM 209
FCloO
--Second Tone: Timbrels
EVJF pl 47
--Third Tone: Psaltery

MOLE 38
--Music, relief
REAU pl 4
Angel, relief gold relief over
wooden core
BAZINL pl 199 (col)
FPCl
The Annunciation, apse frieze
detail FOC-1:pl 40 FSel
Apocalyptic Elder, Psalter
Cover, Saint Bertin c 1050
morse ivory; 111 mm
SWA pl 67 ELBr
Apostle, relief, High Altar
1096
BAZINW 263 (col); BUSRO
pl 23; JANSH 219 FTS
The Ascension, Lorraine(?)
c 1000 ivory; 206x147 mm
SWA pl 15 GCoS
Baptismal Font: Sinners Saved
by Baptism
GAF 13 FAirN
Black Virgin of Dijon
MALV 521 FDN
Capital
ENC 248 FDijB
--FOC-1:pl 33 FPCl
Capital: Abduction of Gany-
mede(?) c 1095
REAU pl 15 FVeM
Capital: Animal Motif 1072/85
EVJF pl 26a FLotL
Capital: Beasts Attacking
Birds REAU pl 33 FSai
Capital: Daniel in Lions' Den,
Church of Saints Genevieve,
Paris marble; 19.7
CHAR-1:246; GAU 134;
LOUM 4 FPL (1)
Capital: Dogs
EVJF pl 27B FStBF
Capital: Dragons, Burgundian
stone; 22.8
GAU 132 FPL
Capital: Fantastic Beasts,
Saintonge LARB 278 FAulCh
Capital: Geometric Motif
EVJF pl 255A FArt
Capital: Mermaid with Double
Tail AGARC 64 FStD
Capital: Offering a Church
REAU pl 11 FAutL
Capital: St. Martin and the
Miracle of the Sacred Tree
REAU pl 14 FVeM
Capital: Temptation of Christ
REAU pl 10 FAutL

Capital: Corner Stone, nave
arcade GAF 57 FStMa
Capital, crypt
FOC-1:pl 34 FDB
Capital, with Elephants
c 1085 EVJF pl 24b FPoMo
Capital of Flavigny stone;
.58 m CHAR-1:245 FPL
Capitals
GAF 292, 293 FStBen
Capitals
GAF 483 FCr
Capitals, Cloitre de la Daur-
ade GAF 499 FTMA
Central Doorpost: Endorsed
Lions MOLE 28 FMP
Cherubim, head
BAZINH 500 FTS
Choir Capital: The Four Rivers
and the Four Trees c 1096
EVJF pl 45 FClO
Christ and Angels, altar
frontal c 1095
BAZINW 263 (col) FTS
Christ Between Apostles,
lintel c 1020 ST 155 FSt-
Ge
Christ in Majesty, with
Apostles, bas relief,
Languedoc 1019/20 marble
LARB 263 FLaG
Christ in Majesty, with
Symbols of the Evangelists,
lozenge relief, choir ambu-
latory 1094/96 marble
BECKM 203; FOC-1:pl
144; GAF 497; JANSK
429; KIDS 15; LARB 283;
REAU pl 16; ST 190 FTS
Christ in Mandorla, Arras(?)
ivory; 280x96 mm
SWA pl 67 GBM
Church Door
BOE pl 141 FStRiC
Corinthian Capital, Benedic-
tine Abbey of Cluny c 1096
EVJP pl 23c FClO
Earthly Paradise, capital,
Loire Valley
LARB 278 FBe
Facade: Figures in Arcade,
bas relief LARB 262 FAzCh
Facade Figures
RAY 32 FAm
Face stone
GAF 341 FTouP
Gargoyle
RAY 32 FTrU

Golden Altar, Basle, detail
before 1019 jeweled gold;
47-1/2x69-1/4
KIDS 51 (col) FPCl
Inhabited Scroll, staff detail,
Lorraine (?) ivory; 117
cm; Dm: 47 to 35 mm
SWA pl 88 ELV
Intertwining Snakes, doorway
detail LARB 85 FAvL
Last Judgment, detail:
Angel ROTHST pl 13 FAutL
Last Supper, frieze detail
GAF 467 FStPaul
Life of St. Eusice, apse
frieze detail
FOC-1:pl 41 FSeI
Lintel, S. Genis des Fon-
tanes c 1020 marble
BAZINL pl 201; BAZINW
262 (col); GAF 492;
JAL-1:pl 2; KIDS 77
FRousG
Lintel, center detail
GAF 493 FStAn
Lust, arch molding
GAF 445 FBorCr
Massacre of the Innocents,
relief ivory; 450 mm
SWA pl 17 ELV
Medallion, Reliquary of Begon
CHENSW 324 FCoF
Notre Dame de Claviers,
Virgin in Majesty
GAF 398 FJa
Porch Capital: Lions
EVJF pl 26B FStBF
Prophet, columnar Figure,
main portal
GAF 312 FAvL
Prudence
EVJF pl 46 FClO
Punishment of the Usurer,
nave capital
GAF 395 FEnnV
Romanesque Chancel Capital
c 1095 ENC 193 FCl
Romanesque Tympanum
GAF 335 FStPa
Saddle-Back Lintel, south
porch GAF 414 FThu
St. Andrew, relief stone;
1/2 LS MOLE 26 FMP
St. Candidus, reliquary head
beaten silver, jeweled
BUSRO front (col) SwSMT
St. Sernin, slab relief stone
KIDS 62 (col); MOREYM
pl 83 FTS

Un Seraphin, relief
REAU pl 17 FTS
Tympanum: Christ of Second
Coming
MOREYM pl 82 FMP
The Visitation, 4 figures
stone MILLER il 76 FCh
--11/12th c.
Baptismal Font: Sins Washed
Away by Baptism blue
stone; W: 36
GAF 25 FNorCh
Capital stone
CHENSW 322 FAngC
Capital: Fall of Simon
Magus
BUSRO pl 67; HAMF 292
FAutC
Central Portal
CHENSW 326 FVeM
Facade
CHENSW 322 FPoN
Hand of Justice of French
Kings, St. Denis(?)
ivory; 178 mm
CHAR-1:266; SWA pl
153 FPL
Head, capital, detail,
Poitiers Church
MALV 237 FPoA
Horse, door mounting wrought
iron NM-12:128 UNNMMC
Knight in Armor, equest
bronze CHENSW 337 FPL
--12th c.
Abbot Suger's Chalice c 1140
sardonyx cup, jeweled
silver gilt setting; 7-1/2
CHRC fig 81; KIDS 89
(col); SHAP pl 1; TAYFT
fol 64; WALK UDCN
--Christ Pantocrater, medal-
lion repousse gold; 1-1/16
x1 SEYM 27
Abbey of Coulombs Columns:
Twisted Spirals, floral and
figure decoration,
Romanesque stone; 66.9;
and 76.8
GAU 134, 135 FPL
Acanthus; Virtues Trampling
on Vices, west door vous-
soir detail
BUSRO pl 58 FB1aM
Adam and an Angel stone
CHENSW 342 FPN
Adam in the Mind of God
GAF 73 FCh
Adoration of the Kings,

STI 401 FCh
Atlante, capital
GAF 392 FChatel
Atlantes, archivolt
GAF 380 FVo
Auvergne Virgin and Child
ptd oak; 31x12-3/4
BR pl 5 (col); MALV 51;
NM-7:29; NMA 48; READAS
pl 173; UPJH pl 75; WB-
17:199 UNNMM (16.32.194)
Balaam on his She-Ass; Hang-
ing of Judas; Owl of
Minerva GAF 337 FSau
Baptism of Christ, Limoges,
retable group champleve
enamel, gilded copper;
14-1/2 BOSMI 113 UMB
(50.858)
Barbarian Slaves in Chains,
center post plinth
GAF 461 FOlM
Beast, frieze detail stone
MOLE 36 (col) FStGi
Beasts, jamb figures, west
porch BOE pl 60 FSoN
Beau Dieu Noir, head detail
GAF 409 FStFl
Biblical Capitals: Judgment
Angel; Angel of Death
Killing Eldest Son of
Pharoah; Mystic Mill;
Moses and St. Paul
Grinding Corn; Demons
FLEM 200 FVeM
Biblical Scenes, porch detail
CHENSW 327 FMP
Birds and Foliage in Plait-
Work FOC-1:pl 124 FT
Birds Attacking Figures,
church pillar, detail
MALV 234 FSo
Birds Interlaced, central
doorpost MOLE 28 FSoN
Black Virgin (Vierge Noir)
blackened walnut
GAF 300 FMars
Burgundian Engaged Capital:
Caryatidal Figure flanked
by Lions limestone CLE
48 UOC1A (63.477)
Burgundian Virgin Enthroned
ptd walnut
NM-12:55 UNNMMC
Capital
JAL-2:pl 4 FStLo
--c 1187
JAL-1:pl 23 IsN

Capital, Abbey of Moutiers
St. Jean stone
LOUM 15 FPL (1559)
Capital: Abraham Sacrificing
Isaac--Restrained by
Angel c 1145
BUSRO pl 52 FStBF
Capital: Adam and Eve c
1100 stone READAS pl 14
FChauN
Capital: Adoration of the Magi
c 1100 EVJF pl 43B
FViP
Capital: Agricultural Theme
VOE pl 65 FCl
Capital: Biblical Scenes--
Angel Appearing to Magi,
Burgundy c 1120/30
LARB 309 FAutL
Capital: The Angel at the
Sepulchre c 1130
EVJF pl 42b FPuyM
Capital: Angel Enchaining a
Devil c 1140
BUSRO pl 71 FVeM
Capital: Animals Fighting,
Saintonge stone; .58 m
CHAR-1:245 FPL
Capital: Animals in Roundels
EVJF pl 255B FCotB
Capital: Arrest of Jesus
JAL-1:pl 4 FTMA
Capital Assumption of the
Virgin STA 147 FAutL
Capital: Bearded Man Playing
Six-Stringed Cithera
JAL-1:pl 9 FCl
Capital: Cain and Abel,
Moutier St. Jean c 1130
limestone; 26x25 to 16
(top to bottom) FAIN 112;
UPJ 178 UMCF
Capital: Christ and Doubting
Thomas limestone
FAIY 55 UNRoR
Capital: Christ and the
Tempter (cast in Louvre)
c 1150 BUSRO pl 63 FPla
Capital: Daniel in the Lion's
Den, Saint Aignan sur
Cher limestone CLE 46
UOC1A (62.247)
Capital: Despair, south Aisle
1104/20
FOC-1:pl 112 FVeM
Capital: Donor Gulielmus de
Bez, giving column to prior
EVJF pl 6B FPuyV

Capital: Elephants, south aisle BRIONA 75; GAF 351 FAulCh

Capital: Entry into Jerusalem, west front KIDS 78 FCh

Capital: Fall of Adam and Eve, Corbie Abbey JAL-1:pl 17 FAmM

Capital: Feast of Herod, St. Etienne BAZINW 266 (col); JAL-1:pl 7 FTMA

Capital: Flight into Egypt c 1140 BUSRO pl 66; GAF 311; LARB 309; REAU pl 9 FAutL

Capital: Foliate Design, north gallery cloister .c 1100 FOC-1:pl 125 FMP

Capital: Joseph Reassured; Annunciation to Zacharias MOREYM pl 86 FCleN

Capital: Men Devoured by Monsters H: 27 WORC 35 UMWA

Capital: Monsters BAZINW 271 (col) FArlA

Capital: Monstrous Figures c 1160 BAZINH 147 FLoB

Capital: Myrophores au Sepulcre REAU pl 37 FPuyM

Capital: Mystic Mill (Mill of God) c 1140 BUSRO pl 70; FOC-1:pl 118; LARB 279; ROTHS 103; ROTHST pl 35 FVeM

Capital: Noah's Ark on Mt. Ararat JAL-1:pl 12; ROTH 103 FAutL

Capital: Riding to the Hunt 1132/40 BOE pl 62; ROTHS 103; ROTHST pl 35 FVeM

Capital: St. Martin 1120/78 ROTHS 103 FAutL

Capital: St. Martin and Pagan Tree c 1130 BAZINL pl 188 FVeM

Capital: St. Trophimus, head; Acanthus Scroll; head detail BUSRO pl 84, 85 FArlT

Capital: Samson and the Lion stone MOLE 29 (col) FAnzCh

Capital: Samson and the

Lion c 1152 stone BECKM 218 FViA

Capital: Samson and the Lion, narthex 1104/20 FOC-1:pl 114 FVeM

Capital: Samuel Anointing David stone READAS pl 15b FMP

Capital: Sheep Playing Harp FOC-1:pl 113, 116-7 FStNC

Capital: Temptation of Christ c 1130 BAZINL pl 208; LARB 309; UPJ 177 FAutL

Capital: Temptation of Christ in the Desert JAL-1:pl 14 FPla

Capital: The Four Winds c 1125 PANS pl 26 FVeM

Capital: The Last Supper FOC-1:pl 119 FIP

Capital: Three Maries and the Angel at the Sepulchre c 1130 EVJJ pl 42a; FOC-1:pl 115 FMP

Capital: Weighing of Souls, Loire Valley limestone CLE 47 UOClA (61.407)

Capital: Winged Genie c 1125 EVJF pl 23d FPuyM

Capital: Collegiate Church of St. Melaine, Preuilly sur Claise stone CLE 46 UOClA (30.17) (30.18)

Capital, crypt: Interlacing Foliate c 1100 EVJF pl 29a FOA

Capital, nave: Foliate c1119 EVJF pl 29b FCotA

Capital, Tribune: pink marble GAF 495 FSerr

Capital, twin columns c middle 12th c. LARB 17; WORR 51 FTMA

Capital; Portal, details: Foolish Virgin GAF 353 FChad

Capitals GAF 274 FCun

--GAF 321 FCl

--GAF 333 FPaM

Capitals: Daniel in Lion's Den; Sirens; Column medallion GAF 466 FLaS

Capitals: Human and Animal Figures; Scrolls

EVJF pl 255c FBu
Capitals: Hunting Scene;
 Judgment of Solomon
 GAF 293 FStAi
Capitals: Moses; An Execu-
 tion, La Madeleine,
 Vezelay c 1110 ROBB 343
Capitals, nave tympanum de-
 tail GAF 342 FVeM
Capitals, Saint Michel de
 Cuxa NM-12:70, 71
 UNNMMC
Carved Panel, Shoemaker's
 House, Cluny EVJF pl
 222b FClO
Caryatid, center post, south
 portal GAF 387 FBCh
Centaur Hunting Stag, roundels
 stone MOLE 29 FStGi
Centaur Shooting Lion;
 Grotesque Animals; archi-
 volt, Church of St.
 Cosmos, Narbonne
 AGARC 63 UNNMM
Centaur Shooting Woman-
 Headed Bird, capital
 detail, Church of St.
 Sernin, Toulouse stone
 MOLE 30 FTMA
Chapter House Capital
 GAF 441 FAg
Cherubim, portal
 GAF 336 FStRe
Choir Capital
 GAF 347 (col) FChau
Choir Capital: Virtues and
 Vices--Largitas and
 Caritas pierce Vices
 beneath their feet; Ira
 kills herself because
 Patience will not give
 battle c 1140
 EVJF pl 114 FCleN
 --Caritas Fighting Avarita
 BOE pl 62
Christ, snake throne stone
 KO pl 38 FPla
Christ, Trumeau
 CHENSW 331 FStLo
Christ, west facade
 stone KO pl 38 FAngC
Christ at Last Judgment,
 tympanum c 1120
 BUSRO pl 61 FSoM
Christ Courajod ptd wood;
 1.55x1.68 m
 CHAR-1:252; GAU 140
 (col) FPL

Christ, head ptd and gilded
 wood LOUM 11 FPL (1573)
Christ, head stone
 KUHB 27
Christ, head, capital detail
 MOLE 14 FPla
Christ, head, tympanum
 detail, narthex door
 c 1130
 BAZINH 138; BAZINW 268
 (col) FVeM
Christ from Lavaudieu, head,
 School of Massif Central
 ptd wood; 16.1
 GAU 141; WATT 116 FPL
Christ in Majesty, tympanum,
 detail stone
 MOLE 24 FCoF
Christ in Majesty, tympanum
 and lintel, west portal
 1170/80 DAM 26; NEWTET
 92; POST-1:37; UPJH pl
 73 FArlt
Christ in Majesty, detail
 MU 115 FAutL
Christ in Majesty; Last Sup-
 per, tympanum stone
 BECKM 217; LARB 235
 FJJ
Christ in Majesty and Danc-
 ing Angel, tympanum de-
 tail c 1135 GAF 447 FCahC
Christ in Miracle of the
 Pentecost (Descent of the
 Holy Spirit; Miracle of
 Whitsun), tympanum, main
 portal 1120/30 central
 portion; 35-1/2'x31'4"
 BOE pl 70; BUSRO pl 68-
 9; CHENSN 289, 300;
 COL-20:540; FLEM 198;
 FOC-1: pl 97; GAF 343;
 JAL-1: pl 11: KO pl 37;
 LARB 233; MYBU 361;
 NEWTEM pl 60; PUT 263;
 ROOS 67E; ROTHST pl
 35; WORR 119 FVeM
 --Pentecost (Descent of the
 Holy Spirit), narthex
 portal stone
 LARB 281; MAL pl 8;
 MOREYM pl 85; READAS
 pl 16, 19; ROWE 53; ST
 191
 --Signs of the Zodiac and
 Labors of the Months
 LARB 281; SEW 346
 --Christ of Lavaudieu ptd

wood; .41 m CHAR-1:
248 (col) FPL
Christ of the Last Judgment,
 west door c 1140 BUSRO
 pl 72 FBCh
Christ on the Cross, head
 detail gilt bronze; .22x.21
 m CHAR-1:253 (col) FPL
Christ Portal begun 1192
 BUSG 114 FBouCa
Christ with Evangelists and
 24 Elders (Apocalyptic
 Vision), tympanum, south
 portal c 1110/20 stone;
 W: 18' 8'
 BAZINW 264 (col); BR pl
 1; CHASEH 198; EVJF
 pl 34; FOC-1:pl 101-2;
 GARDH 228; KIDS 77;
 KO pl 37; LARB 280;
 MAL pl 1; MOLE 41;
 NEWTEM pl 59; READAS
 pl 17; REAU pl 19; ROOS
 68A; ROTHS 87; SEW 345;
 ST 191; UPJ 174; UPJH
 pl 74 FMP
--Elders of the Apocalypse
 FOC-1:pl 104; MALV 230;
 ROTHS 89
Church Door
 EVJF pl 252 FLich
Church Door, center, west
 front c 1120 BUSRO pl 83
 FStGi
Church Facade
 REAU pl 29 FPoN
Church Side Door
 REAU pl 32 FAulCh
Church Portal, and Tympanum,
 detail: Adoration of the
 Magi; Supper in the House
 of Simon, Burgundy
 c 1130 LARB 276 FND
Church Tympanum
 GAF 331 FNeui
Cloister
 REAU pl 23 FM
Cloister Capital: Foliate and
 Animal REAU pl 24 FM
Cloister Gallery
 BAZINW 270 (col); REAU
 pl 45 FArlT
Column, with entwining birds
 and figures REAU pl 25
 FS
Columnar Figure
 GAF 98 FStLo
Columnar Figure (Statue-pier)
 c 1120

EVJF pl 53A FCham
--EVJF pl 53B FStGu
--c 1170/80
 LARB 319 FPDe
--middle and left side
 porches BOE pl 75-6 FCh
--side portal
 GAF 468 FValc
Cordoba-style Capital
 GAF 466 FStSe
Corinthian Capital, nave
 c 1100 EVJF pl 23b FCotT
Coronation of the Virgin,
 ornament GUIT 139 (col)
 FPL
Coronation of the Virgin,
 tympanum, west portal
 c 1170 BUSGS 3; FOC-2:pl
 25; JANSK 480 FSeN
Count of Vaudemont and wife,
 Anne of Lorraine, effigies
 c 1163 FREM 52 FNanG
Creation of Eve c 1350
 BUSGS 48 FAuE
Cross Pedestal c 1160/75
 copper and champleve
 enamel GAF 27; LARB
 311 FStOB
Crouching Figures, Languedoc
 capital LARB 237 FLaB
Crucifixion ptd and gilded
 wood LARB 286; SELZJ
 20 FPL
Crucifixion of St. Peter,
 facade detail
 GAF 351; LARB 308
 FAulCh
Crusader and Wife
 LARB 284 FNanF
The Damned Seized by Devils,
 central portal, right
 archivolt AUBA 65 (col)
 FCh
David
 MALV 240 FCh
Dead Men's Lantern, grave-
 yard turret GAF 360 FFen
--GAF 408 FStGen
--GAF 352 FCe
Decorative Portal Figure
 LARB 277 FBCh
Descent from the Cross ptd
 and gilded wood LOUM 9
 FPL (68)
Descent from the Cross;
 Holy Women at the Tomb,
 rood screen detail
 GUIT 114-5 FBour
Descent from the Cross,

tympanum, Pyrenees
marble LARB 281 FOlM
Devil stone
KO pl 38 FP1a
Door c 1120/32
EVJF pl 41; ROTHS 93
FVeM
Door: Christ in Judgment
JAL-1:pl 5 FMP
Door: Life of Christ, scenes--
Annunciation; Visitation;
Adoration of the Magi c
1120 BUSRO pl 60 FSoM
Door: Sculptured Arch
EVJF pl 245 FThM
Door, detail
GAF 170 FAnd
Door, detail: Apostles c 1150
c 46x40' UPJ 171-2 FArlT
Door, details: Two Men
Wrestling
FOC-1:pl 100, 105-6
FSoM
Door, left, west facade
JAL-1:pl 19 FPuyN
Door, north, decoration detail
FOL-1:pl 130 FCahC
Door, north, decoration,
facade detail
FOC-1:pl 132 FPa
Door, outer west c 1140
stone KO pl 37 FChar
Door, south
GARDHU pl 20 FCh
Door, south 1115/50
GARDH 237; JANSK 430-1;
STI 398 FMP
--Christ in Glory (Maiestas
Domini)
CHRC fig 84
Door, south, detail
MARQ 162 FAm
Door, south, archivolts and
draped figures c 1160
STA 147 FBouCa
Door, south transept, details:
Bestiary Molding; Atlantes
Intrados
CHENSW 329; GAF 351
FAulCh
Door, southern half c 1140
EVJF pl 21 FGaG
Door, west
FOC-1:pl 99 FCar
Door, west c 1150
ST 192 FStGi
Door, west, north transept
BUSGS 5 FCh

--Capricorn
GARDHU 83
Doors, west; detail
JANSK 437, 436 FStGi
Doorway Decoration,
detail 1119/35
FOC-1:pl 129 FAulCh
Doorway, Moutiers Saint
Jean NM-12:14 UNNMMC
Doorway, Reugny
NM-12:17 UNNMMC
Dormition of Mary,
tympanum, west portal
1180/90 BAZINW 287
(col) FSenC
Double Capital, cloister
KIDS 77 FTMA
Dragon Aquamanile, Lor-
raine c 1130 bronze gilt;
170 mm SWA pl 114 AVM
Eagle of Cluny stone; .61x
.50 m CHAR-1:258 FPL
Eagle Vase of Saint Denis
(Eagle of Suger), ewer
1122/51 purple Egyptian
porphyry, with silver
gilt head, wings, tail,
feet; 17 CHAR-1:241;
GAF 151; GAU 136; HUYA
pl 30; HUYAR 75; SWA
pl 152-3; WCO-3:43 (col)
FPL
Earth and Fire, Lorraine
c 1180 cast copper; 103x
65x57 mm SWA pl 177
GMBN
Emperor Constantine, equest,
facade detail
GAF 355 FChateauP
Emperor Constantine, equest,
north porch
BOE pl 67; GAF 363
FMelH
Engaged Capital c 1100
EVJF pl 29c FPGe
Entablature, detail c 1140
PANR fig 28 FStGi
Enthroned Virgin wood
VALE 157 UNNMM
Entombment ptd stone
GAF 294 FStrC
Eve Before the Serpent,
lintel fragment 1130/40
stone BAZINW 268 (col);
BUSRO pl 64-5; CLAK
314; FOC-1:109; GAF
311; JAL-1:pl 13; KO pl
36; LARB 283; MALV 22;

NEWTEM pl 66 FAutL
Eye, detail of head
 MALV 238 FPDe
Facade
 MOREYM pl 90 FSaM
 --c 1140
 EVJF pl 73; LARB 276
 FAngC
Facade c 1180 stone
 CHASEH 201; CHRP 141;
 FArlT
--figures, west porch
 MOLE 33
--Christ with Symbols of
 Evangelists GOMB 124
 --Last Judgment; Twelve
 Apostles MOREYM pl 89
 --details
 ROOS 67D-F-G
Facade begun 1116
 BAZINW 270 (col) FStGi
Facade; detail: St. George
 GAF 351, 350 FAngC
Facade, detail, built by
 Abbess Sibylle de Bour-
 gogne EVJF pl 20 FChar-
 eD
Facade, west
 FOC-1: pl 96 FCiN
Facade, west
 MOREYC 102 FRhC
Facade, west c 1140
 BAZINW 271 (col); BOE
 pl 66; EVJF pl 117; FOC-
 1: pl 95 FPoN
Facade, west, detail c 1140
 NEWTET 101 FAngC
Facade, west, details: Virgin
 Portal Tympanum; Shepherd
 Led by Angel 1145/70
 FLEM 267 FCh
Facade and Window, north
 transept FOC-1: pl 46
 FBeaE
Facade Columns, detail
 1137/44 EVJF pl 32 FPDe
Feast at Simon's, low relief
 BAZINH 136 FND
Figure stone
 MILLER il 71 FSo
Figure Capital, nave
 GAF 453
Figures, detail, tympanum
 of Cabestany, Roussillon
 MALV 411
Figures, north jamb, central
 portal JANSH 222 FStGi
Figures, St. Martin, Angers

c 1180 ptd limestone
 YAH 9 UCtY
Font, detail
 KIDS 71 FStGi
Four Rivers of Paradise,
 capital 1120/40
 BAZINW 268 (col) FC1F
Frieze detail, west porch
 BOE pl 68 FNimC
Gargoyle(s), roof figures
 c 1125 CHENSW 310;
 ENC 328; MARQ 157;
 RAY 33 FPN
Glutton, figure capital
 GAF 359 FEch
God in Majesty, tympanum
 c 1120 GAF 333 FPer
God Reproaching Adam and
 Eve after the Fall, relief
 REAU pl 2 FC1O
Grammar, relief
 REAU pl 4 FC1O
Griffin Aquamanile, Lorraine
 c 1130 SWA pl 115 AVM
Grotesque Capitals
 GAF 356 FCiv
Grotesque Figures, balustrade
 NEUW 137 FPN
Grotesque Mask Corbels
 GAF 360 FPontL; FRet
Hand of Consecration, wall
 base medallion, south
 transept GAF 352 FCe
Historiated Capitals
 GARDH 238-9 FPM
Historiated Column, Abbey
 de Coulombs stone
 LOUM 15 FPL (48-49)
Holy Women in the Tomb,
 capital of The Resurrection
 GAF 404 FMoz
Horseman with Falcon
 (Guillaume Larcheveque?)
 GAF 365 FPar
Horses' Heads, portal mold-
 ing GAF 373 FStFo
House tympanum: Learning;
 Strength and Love c 1186
 EVJF pl 223A FRh
Inhabited Scrolls, Lorraine
 c 1130 SWA 36 ELV
Iron Work, west gallery,
 Cloisters FOC-1: pl 126
 FLePN
Isaiah, door jamb relief,
 west portal c 1110 stone;
 c 1/2 LS
 BATT 86; BAZINH 407;

Madonna and Child ptd wood
LOUM 13 FPL (69)
Madonna and Child, Ile de
France ptd oak MCCL pl
18 UMB
Man Fighting a Lion
FOC-1: pl 107 FClF
Manticore, Voussoir, arch
detail NM-12: 73 UNNMMC
Marriage at Cana; Sacrifice
of the Ancient Law, tym-
panum stone BECKM 217
FCharF
Martyrdom of St. Etienne,
tympanum GAF 393
FChambo
Medallions, left portal
FOC-1: pl 123 FStMi
The Mission to the Apostles,
tympanum, central portal,
narthex 1120/ 32 stone;
31'4"
BECKM 216; JANSK 434;
MCCL pl 14; NEWTET 89;
REAU pl 12-3; UPJ 175;
UPJH pl 74 FVeM
--Pig-snouted Ethiopians
JANSH 221
Mosaic Inscription
PUT 66 FMP
Monk of Morlaas stone
KO pl 38 FMorF
Monsters, Pilier de Monstres,
Languedoc c 1130/ 40
GAF 413; LARB 283 FSo
Moses, head c 1190/ 95
stone; 17 EXM 22 FManN
Moses with Tablets of the
Law, Lorraine; Prophet
cast bronze; 234; and
219 mm SWA pl 226, 227,
228 EOA
Mythical Beasts, capital,
Languedoc LARB 231
FElC
Mythical Beasts, capital,
Languedoc, Abbey of La
Daurade, Toulouse
LARB 231 FTMA
North Portal Figures; Isaiah
and Jeremiah; St. John
the Baptist stone
CHENSW 338-39 FCh
Notre Dame de Claviers,
Chapelle de Jalhac c 1170
wood BUSRO pl 31 FMeal
Notre Dame du Mont Cornador
(Madonna and Child) ptd
wood JAL-1: pl 18 FStNC

Our Lady of Jaulhac wood
GUIT 87 FLas
Pan Pipes, figure detail
ENC 692 FCh
Panels: Animals; Saint
JAL-1: pl 20 FStM
Parabole du Pauvre Lazare
et du Mauvais Riche,
porch relief REAU pl 22
FM
The Passion, capital, choir
GAF 469 FSor
The Passion, scenes: Peter,
Malchus, and the Guards
of Gethsemane, archi-
trave detail c 1120
BUSRO pl 82 FStGi
Paul and James, main
portal stone KO pl 36
FStGi
Phylactery Reliquary of the
Tooth of St. Maclou
EVJF pl 6a FBarM
Pier: Crossed Lions and a
Prophet 1100/ 50 stone
READAS pl 22 FMP
Pilgrims, facade: capitals
GAF 374 FStJo
Pillar
ST 193 FArlT
Pontaut Capitals
NM-12: 63, 64 UNNMMC
Porch, north transept begun
1194 BUGS 4 FCh
--Contemplation of Life
FLEM 270
--Melchisedek, Abraham,
Moses GOMB 136
Porch, south transept: St.
Theodore MOREYM pl
113 FCh
Porch Capital; capitals--
St. Martin before 1108
FOC-1: pl 35-7 FStBF
Porch of Mary: Madonna and
Child; Seven Fine Arts
BOE pl 74 FCh
Porch of Mary, archivolts:
Pythagorus and Allegory of
Music; Donatus and Al-
legory of Grammar
BOE pl 78 FCh
Portal Column-Statues 1150/
55 LARB 319 FLeMC
Portal figures, left portal
MARQ 160 FRhC
Portal Figures: St. Peter;
St. John the Evangelist;
St. Trophime ROTHS 99
FArlT

figure REAU pl 21 FM
St. Peter, Autun c 1180
MALV 233 FPL
St. Peter, Porte de Miege-
ville c 1115/18 LARB 283
FTS
St. Peter, head, Tomb of
St. Lazare 1170/89 LOUM
11 FPL (67)
St. Peter, seated figure wood
GAF 390 FBre
St. Peter, south portal fig-
ure c 1100/50 stone; 59x
19-1/4 AUES pl 11;
BAZINW 265 (col); BOE
pl 61; CHENSN 290;
CHENSW 328; GAF 456;
HAUSA pl 17; JANSH 219;
LARB 283; MOREYC 94;
NEWTET 98; READAS pl
174; STA 84; UPJ 173;
WORR 102 FMP
St. Steven, trumeau figure
CHENSW 340; REAU pl 58
FSenC
St. Trophime Facade: Sts
James, Trophime, John c
1180 ROBB 344 FArlT
--St. Trophime
JAL-1: pl 22
St. Vincent Protected by Two
Eagles, capital detail,
south aisle GAF 311;
LARB 237 FAutL
Saints
NEWTEE pl 5c FCh
SS. John the Evangelist and
Peter c 1140
PANR fig 30 FStGi
Sts. Peter and Paul, St.
Etienne, Toulouse 1110/50
BAZINW 266 (col) FTMA
SS. Peter, John the
Evangelist and Trophime
ROTHST pl 36 FArlT
Samson Killing the Lion,
capital, Languedoc
FOC-1: pl 110; LARB 229
FMP
Sculptured Column c 1115
EVJF pl 33B FSoN
Seal of Ramon de Mondragon:
Vassal Swearing Fealty to
Lord, Provence bronze
FREM 17 FPMe
Shrine: Apostles--Andrew,
James Minor, John, Saint
Denis(?), Casket fragment
SWA pl 153 FPL

Slaughter of the Sow,
misericord GAF 300 FVenT
Solomon and Queen of Sheba,
columnar figures, west
door, Benedictine Priory
of Notre Dame de Cor-
beil c 1180/90 stone;
93.7x89.8
BUSRO pl 93; CHAR-1:
254-5; EVJF pl 50;
GAU 39 FPL
--Queen of Sheba
GAF 140
Stylized Floral Pattern,
capital, Languedoc c 1100
LARB 279 FMP
Three Devils Bearing Away
Soul, capital, St. Andre
GAF 389 FBess
Three Magi, detail
GAF 311 FAutR
Torso wood
ZOR 41 UNNMM
Transept Portal: Apocalyptic
Elders, and Grotesques
MOREYM pl 88 FAulCh
The Transfiguration, over-
portal c 1110
EVJF pl 44 FChari
Trumeau: Fantastic Beasts
1130/40
BAZINW 266 (col) FSoM
Twin Capital, cloister c 1115/
25 EVJF pl 30B FTMD
Two-headed Capital,
Basilica of Nazareth c
1187 LARB 367
Two Prophets, capital
MOLE 49 (col) FChar
Tympanum
GAF 461 FOlM
Tympanum c 1110
EVJF pl 37B FAlP
Tympanum: Christ as Judge
JAL-1: pl 6 FBeaE
Tympanum: Madonna and
Child; Angels c 1130
EVJF pl 43A FNieM
Tympanum, Benedictine
Abbey of Saint Benigne
c 1130 EVJF pl 39 FDL
Tympanum, Monastery Church
ENC 774 FIA
Tympanum, Portail de la
Vierge REAU pl 60 FPN
Tympanum, St. Marie
Madeleine
JAL-1: pl 10 ENeui
Tympanum, St. Pierre

GAF 391 FCar
Tympanum, portal, north side,
 narthex; tympanum, window
GAF 425 FChar
Tympanum, south portal
GAF 327 FDon
Tympanum, west entrance:
 Last Judgment
JAL-1: pl 8 FCoF
Tympanum: Triforium capital
GAF 449 FCoA
Tympanum, detail
UPJH pl 87 FBouCa
Tympanum, detail
CHENSN 271; ROOS 68C
 FAutL
Tympanum, detail 1119/35
EVJF pl 246 FChareP
Tympanum, posts; capitals
GAF 456-7 FM
Types of Christ
MOREYM pl 108 FRhC
The Virgin bronze gilt;
 6-1/8 BOSMI 111 UMB
 (49.466)
Virgin, Autun wood; 35-3/4
FAIN 187; WORC 36
 UMWA
Virgin, head, Burgundy wood
LARB 233 FTouP
Virgin, head, portal before
 1115 BAZINW 268 (col)
Virgin, relief limestone
FAIN 187; WORC 33
 UMWA
Virgin and Child wood
JOHT pl 68
Virgin and Child, north
 transept BAZINW 287
 (col) FRhC
Virgin and Child, reliquary
 figure, Auvergne ptd
 wood; 33 BAZINW 263
 (col); CHAR-1: 251; HUYA
 pl 28; HUYAR 80 FPL
Virgin and Child, reliquary
 figure silver
GAF 387 FBCh
Virgin and Child, St. Martin
 des Champs c 1130 gilded
 and ptd wood
EVJF pl 8; FOC-2: pl 22;
GAF 97; NEWTET 98
 FPDe
Virgin and Child, tympanum
GAF 465 FStAve
Virgin in Majesty, St. Anne
 Portal BAZINW 287 (col);
 JAL-2: pl 3 FPN

Virgin of St. Gervazy,
 seated figure LARB 286
 FPuy
Virgin Portal Tympanum,
 details: Grammar;
 Pythagorus; Music 1145/70
FLEM 268 FCh
Virgin with Child at the
 Breast, lintel detail,
 Priory of Anzy le Duc
GUIT 69 FPaM
A Virtue Trampling Vice,
 portal molding
GAF 443 FBlaM
The Visitation
JAL-2: pl 5 FStLo
The Visitation
MILLER il 72 FCh
The Visitation, Chartres
WB-17: 198 UICA
Voissoirs 1150/1200
BAZINW 271 (col)
 FAulCh
Wedding of Cana; Sacrifice
 of Animals, small portal
 c 1170/75
BAZINW 269 (col); PARN
 fig 83 FCharF
Women at the Tomb, choir
 capital KO pl 40
 FStNC
Women with Signs of Zodiac:
 Lion, Ram, South door of
 transept, St. Sernin,
 Toulouse c 1150 BAZINW
 267 (col) FTMA
--12/13th c.
Aristotle with Writing Tools,
 relief HOR 387 FCh
Candlestick gilt bronze and
 iron; 6-7/8
DEYE 12 UCSFDeY
 (53.18.1)
Chasse, Limoges champleve
 enamel on copper over
 wood core
CLE 46 UOClA (54.599)
Coronation of the Virgin;
 Dormition of the Virgin;
 Prophets and Kings,
 facade 1163/1235 H:
 23'3" UPJ 199 FPN
Grotesque Capitals
GAF 69 FCamb
Job, relief
MALV 250 FPM
--12/15th c.
Grotesque
ROOS 77G FPN

--12/19th c.
Coronation Spurs of the Kings
of France gold and silver
gilt; L: .17 m CHAR-1:
264 FPL
--13th c.
Abraham, north portal relief
STI 477 FCh
Abraham and Melchizedek
(The Knight's Communion)
--knight in armor standing
before a priest who offers
a chalice, interior of
western facade c 1240
BOE pl 86-7; BUSGS 95;
EVJL pl 80; HARVGW 58;
JANSH 252; JANSK 491;
LARB 335; REAU pl 85
FRhC
Adam and Eve; Story of Cain
and Abel, west portal
panels c 1285/1305 LARB
356 FAuE
--Creation of Adam and Eve
FOC-2:pl 80
Adam and Eve Expelled from
Paradise, base medallion,
north portal GAF 313
FAuE
Adelais of Champagne Tomb,
Countess of Joigny, detail;
Mourners c 1290
EVJF pl 209, 210 FStJ
--Youth Standing in a Tree
EVJL pl 79; FOC-2:pl 89
Adoration of the Magi, tym-
panum, left door
JAL-2:pl 8 FLaoC
Amiens Cathedral c 1225
stone RAMS 2a FAm
--Facade reliefs beneath
figures of Herod and the
Three Kings POST-1:66
--Porte Mere-Dieu
POST-1:63
--Relief, west front
FOC-2:pl 81
--Stall, detail oak
MILLER il 103
Amor Carnalis, west facade
c 1280 PANR fig 64 FAuE
Angel wood
LARB 357 FPL
Angel c 1260/70(?) ivory
WHITJ pl 93B -De
Angel, 2nd buttress, chancel
north side c 1220
BOE pl 83 FRhC

Angel, west front c 1240
FOC-2:pl 86 FRhC
--head detail, a buttress c
1240 BAZINH 405
Angel Gabriel, Annunciation
figure, center portal 1250/
60 BUSG pl 56 FRhC
Angel of Rheims wood; 27.2
CHAR-1:270, 271; GAU
146; LOUM 27 FPL (98)
Angel Pier, transept c 1230
GAF 195; ST 246 FStrMu
Angel Pillar
BOE pl 97; LARB 350, 351
FStrC
--St. John
LARB 351
Angel with Bucket of Holy
Water 1241 H: 2.5 m
JAL-2:pl 19 FRhC
Angels, School of Reims
NM-12:154 UNNMMC
Announcement to Shepherds
JAL-2:pl 12 FCh
Annunciation, north transept
c 1215 PANR fig 33 FCh
--Angel of the Annunciation
BAZINH 501
Annunciation, west front
c 1225 BAZINW 291 (col);
LARB 339 FAm
Annunciation and Visitation,
Virgin Portal, central bay
(central porch, west facade)
c 1225/45 H: 10'2" BAZINW
292 (col); CHRC fig
109; DUR fig 28; GAF 189;
GARDH 264; JANSH 251;
JANSK 486, 487; MOREY
pl 119; PANR fig 40; SEW
419; UPJ 202; UPJH pl
87 FRhC
--Annunciation
BUSGS 102; CHASEH 229;
STA 84
--Annunciation, detail: Angel
HARVGW 91; ROTHS 111
--The Visitation
BAZINH 159; BOE pl 80;
BUSGS pl 41; EVJF pl 97;
FOC-2:pl 85; GUIT 97;
KIDS 104; KO pl 41;
LARB 319; MALV 245-7;
MILLER il 73; MOLE 53;
MYBA 324; MYBS 36;
NEWTEM pl 74, 78; PRAEG
244; REAU pl 79, 80;
ROTHS 113, 115; ST 246

Creation of Man, north portal
 LARB 321 FCh
Crocket Capital, north portal,
 Chartres (cast) c 1230
 BAZINW 297 (col) FPMM
Crown of Saint-Louis jeweled
 silver gilt; Dm: .21 m
 CHAR-1:267 FPL
Crozier, Limoges copper gilt
 and enamel; 12-7/16
 DETT 181 UMiD (59.297)
Crozier Handle: Annunciation,
 Limoges gilded copper and
 enamel
 FREM 37 FLC
Crozier Head c 1220/30
 Limoges enamel
 SOTH-4:262
Crucified Christ, detail,
 Paris 1280 poplar wood;
 58x54 cm BSC pl 31
 GBS (2/57)
Crucifix, Limoges champleve
 enamel on copper; 7
 BMA 15 UMdBM
Crucifix Figure ivory
 MILLER il 77 ELV
Dagobert I Tomb
 GAF 97; KO pl 42 FPDe
Dead Man's Lantern
 GAF 354 FChatL
Death of St. Thomas a Becket
 chasse champleve enamel
 on copper; 6-5/8x11-3/16
 CAMI pl 4; CLE 46 UOClA
 (51.449)
Death of the Virgin, south
 portal, tympanum after
 1230 red sandstone
 AUBA pl 21; BAZINW 297
 (col); BOE pl 95, 96;
 BUSG pl 28; CHASEH 256;
 GOMB 138; JANSH 251;
 JANSK 480; KO pl 51;
 LARR 23; REAU pl 86
 FStrC
Decorated Staff
 boxwood; 4' NORM 69 ELV
Descent from the Cross ivory;
 .29 m CHAR-1:272; EVJF
 pl 195 ; FREED front; MILER
 il 84; ROBB 675 FPL
Door, central, west portal--
 exterior, interior 1255/90
 BUSG pl 38, 39 FRhC
Door, interior, tympanum,
 north tower JAL-2:pl 24
 FBayeC

Dormition and Coronation of
 the Virgin; arch interior;
 St. Michael Slaying
 Dragon; Month of August
 c 1210/20 BAZINW 288
 (col) FPN
Dragon Devouring Man,
 aquamanile, Lorraine cast
 bronze; L: 300 mm SWA
 pl 156 RuLH
Embarkation of Noah, cameo
 PANR fig 45 ELBr
Engaged Capital, Langon
 PACHA 43 UNNMMC
Enthroned Virgin and Child,
 Meuse Valley ivory
 CLE 53 UOClA (28.760)
Entrance Figures
 RUS 49 FRhC
Eucharistic Dove champleve
 enamel; .13 m CHAR-1:259
 FPL
Eucharistic Dove enamel
 NM-12:142 UNNMMC
Eve, exterior transept,
 north BAZINW 294 (col);
 READAS pl 23 FRhC
Eve and the Dragon
 REAU pl 83 FRhC
Evil Pressed into Service of
 the Church, corbel figure
 c 1230 BUSGS 12 FLaoC
Eye, detail from Presentation
 in the Temple
 MALV 239 FPN
Facade
 PANR fig 21 FArlT
Facade 1230/65
 BAZINW 295 (col)
 FBouCa
Facade, south portal:
 Annunciation; Visitation;
 Presentation in the Temple
 1220/30 ROBB 351 FAm
Facade, west front 1231/90
 EVJL pl 2; ROTHS 109
 FRhC
Female Head, Reims boss
 fragment c 1250 limestone
 HUYA pl 34 FPL
Figure, bronze tablet, low
 relief MILLER il 81
 FAm
Figure, cloister, St. John
 Lateran FRY 9
Figure, rood screen detail
 (destroyed 1682) c 1240
 BUSGS 168 FStrC

MAL pl 22; NEWTET 105;
STI 449 FBouCa
--Abraham Holding Saved
Souls AUBA 79 (col)
--The Blessed (The Righteous)
EVJF pl 94; KO pl 42;
REAU pl 66
--The Damned (Devils Driving
Damned to Hell)
BUSGS 112; REAU pl 65
--Dead Rising
BUSGS 112
--St. Michael Weighing Souls;
Angel and Devil
AUBA 81 (col); BAZINW
296 (col); REAU pl 64
Last Judgment Panel (Christ's
Porch), north transept
c 1220
JANSK 485; MALV 349;
MYBA 312, 314 FRhC
--Blessed in Heaven
KIDS 137
--Devils Leading Damned to
Hell
EVJL pl 82; FOC-2: pl 76
Life of Our Lady, south portal
tympanum, west facade
KO pl 44 FAm
Limoges Champleve Enamel
Crozier SOTH-3: 259
Louis of France Tomb: Re-
cumbent effigy; Mourners,
Abbey of Royaumont after
1260
EVJF pl 206; JAL-2: pl 22;
POST-1: 68 FPDe
Lust, bracket
GAF 313 FAuE
Madonna and Child ivory
MILLER il 96
--limestone; 55
DENV 24 UCoDA
--stone
MILLER il 95
Magi Warned by an Angel,
choir screen detail
MOREYM pl 109 FCh
A Magus (?) wood
LARB 357 FPL
Male Figure, Rieux Minervois
Church c 1330
LARB 357 FTMA
Man Carrying Sack, nave atlas
BOE pl 84 FRhC
Man's Head stone
LOUM 26 FPL

Massacre of the Innocents,
tympanum, north transept
c 1250 BUSGS 97; LARB
329 FPN
Mater Dolorosa c 1200 bronze
PANR fig 41 GFreiUK
Melchizedek, trumeau, central
door, north porch
SEW 418 FCh
--Melchizedek, Abraham,
Moses, Samuel, David
MAL pl 17
Mosan Clasp c 1200 gilt
bronze NM-12: 144 UNNMMC
Music, portal figure
STI 424 FCh
Musician c 1240
BUSGS 103; GAF 188; KO
pl 43 FRhM
The Nativity, rood screen
fragment c 1200
BAZINW 287 (col); BUSGS
24; MARI pl 11A; REAU
pl 56 FCh
Nave Capital: Two Harpies;
Centaur c 1225
BOE pl 85 FRhC
Notre Dame la Blanche
c 1330 ROBB 355 FPC
Oxen, northwest tower
BOE pl 82 FLaoC
The Passion of Our Lord, dip-
tych relief ivory ROBB 674
ELV
Peasant, supporting figure,
west facade MOLE 12 FAm
Philip Augustus, head,
transept 1228/33 figure: 11-
1/2' BAZINW 293 (col)
FRhC
Philip III, Le Hardi, Tomb;
Mourners
REAU pl 117-9 FDM
Philip III, head, effigy
BAZINW 296 (col); BAZINH
162; JAL-3: pl 5 FPDe
"Pierre de Siege", relief stone
fragment BUSGS 96
FCarcN
Plants Framing Archivolt
MAL pl 14 FPN
Porch, south
FLEM 259 FCh
Porch, west, figures: St.
Nicasius; Angel c 1250
STA 155 FRhC
Porch of the Virgin, west

Romanesque Pilaster, Abbey of
Saint Guilhem le Desert
before 1206 limestone; 63
NMA 50 UNNMMC
(25.120.97, 119, 120)
St. Anne with Virgin, trumeau,
central portion c 1250
FLEM 270 FCh
St. Cesaire, reliquary bust
copper plated wood
GAF 400 FMau
St. Elizabeth
MALV 249 FRhC
St. Etienne
CANK 26 FBouCa
St. Etienne, central door,
trumeau, west front
c 1215/20 BAZINW 289
(col) FSenC
St. Firmin Blessing, west
front ptd and gilded stone
CRU 102; MILLER il 102;
MOREYM pl 111; MYBA
322 FAm
St. Firmin Portal, west facade:
Quatrefoils--Labors of the
Months; Zodiac Signs c 1225
single quatrefoil: 30
LARB 339; UPJ 203 FAm
-- --Harvest
LARB 339
-- --June; July; August; and
Leo; Virgo; Libra
JANSH 253; JANSK 481
-- --Libra; Scorpio; and
Labors of the Months
MOLE 54
-- --March: Aries; Tilling
the Fields; April: Taurus;
Hawking ST 244
-- --September: La Balance;
La Cueillette des Fruits
REAU pl 73-4
-- --Signs of the Zodiac
MYBS 323
-- --Sternness; March;
Massacre of the Innocents
BUSGS 48
-- --Zodiac Twins; Month
of May BAZINW 292 (col);
MOREYM pl 114
St. Genevieve stone
LOUM 21 FPL (82)
St. Jacobus Major 1243/48
BOE pl 98 FPChap
St. James, altar frontal relief,
Grandmont Abbey 1250/1300
H: 11-1/2 NM-7:18 UNNMM
(17.190.123)

St. John the Baptist, detail,
central north porch c 1220
stone; 90-1/2 BUSG pl 45;
BUSGS 8; HAUSA pl 19;
LARB 333; NEWTEM pl 69
FCh
St. John the Baptist, south
door, west front c 1215
GAF 188; KIDS 136; LARB
335; MALV 219 FRhC
St. John the Evangelist c 1250
NEWTEM pl 75 FRhC
St. Matthew Limoges enamel;
11.8x5.5 GAU 152 (101) FPL
St. Matthew Writing his
Gospel, relief stone; 25-1/2
HUYA pl 32; HUYAR 10;
LOUM 23; ROOS 84G
FPL (87)
St. Modesta, head, north
porch c 1230
BAZINH 161; MALV 266;
REAU pl 51 FCh
St. Nicaise between Two
Angels DUR fig 27 FRhC
St. Osanna, effigy head,
crypt BAZINW 296 (col)
FJo
St. Peter c 1250 walnut;
61-1/2 DEYE 15 UCSFDeY
(59.17)
St. Peter, head detail, left
portal, north transept
1220/25 BAZINW 289 (col);
PANR fig 35 FRhC
St. Simon, and St. Matthew
FRAM 135 (col) FCh
St. Stephen, reliquary, Mosan
silver gilt
NM-12:139 UNNMMC
St. Stephen Legend, tympanum,
Portal Saint Etienne REAU
pl 62 FPN
St. Theodore, left south portal
c 1210 stone; 86-5/8
BAZINW 286 (col); BUSGS
10; LARB 332; MYBA 321;
NEWTEM pl 70 FCh
St. Theodore, head, west
door, south portal
FOC-2: pl 83 FRhC
St. Yrieux, head, Limousin
silver; 14-3/4
NM-7:24 UNNMM (17.90.352)
Saints and Apostles, central
west portal c 1230
BUSGS 50 FAm
SS Martin, Jerome and
Gregoire Le Grand,

Portail des Confesseurs
REAU pl 55 FCh
Satyr; Dream of Pharoah,
west facade c 1280 PANR
fig 62 FAuE
Scrollwork, Portal of St. John
LARB 17 FRC
Seal of University of Paris:
Madonna and Child; Pro-
fessors Teaching silver in
iron setting AUBA 17;
FREM 95 FPMe
Shepherd, head, rood screen
detail c 1200
BUSGS 53
Shepherds Led by Angel, detail
MYBA 304 FCh
Shrine of St. Etienne
EVJF pl 72 FAuba
Shrine of St. Gertrude, detail
(destroyed 1940) after 1272
70-3/4x21-1/4x31-1/2
KIDS 112 BNG
Shrine of St. Taurin 1240/54
silver and gilded copper,
enamel plaques; 28
KIDS 113 (col) FEvT
Simeon with Christ Child and
John the Baptist c 1230
BUSGS 13 FLaoC
Sleeping Apostle c 1240 cast
bronze gilt; 38 mm SWA pl
233 ELWil
Small Portal
CHENSW 343 FRhC
Smiling Angel (Bel Ange)
BAZINW 292 (col); CHENSW
343; CRU 104; GAUN pl 35;
JAL-2:pl 20; LARB 335;
MALV 160; REAU pl 81-2;
ROWE 45; UPJH pl 87
FRhC
The Soissons Diptych: The
Passion; detail: The Deposi-
tion ivory; 12-3/4x9-1/8
FREED pl 3, 4; MOLE 63;
VICF 20 ELV (211-1865)
Solomon, facade figure
RAY 35 FAm
Stone of the Siege of Car-
cassone
GAF 379 FCarcN
Student Life, scenes, relief
c 1250/60
BUSGS 49; EVJL pl 91;
FOC-2:pl 79; FREM 175
(col); JAL-2:pl 15 FPN

Suffering of Job, jamb figure,
Virgin Porch c 1220
KIDS 117 (col) PFN
Synagogue after 1250 H: 16'
BUSGS 132 FRhC
The Synagogue c 1230/50
BAZINW 298 (col) FStrCN
Three Prophets: Jeremiah,
Simeon, and St. John the
Baptist, north porch
BR pl 1 FCh
Tithe Vessel for Grain: Danc-
ing Peasants; Falcon Hunt
bronze FREM 17 FPCl
Tobias, archivolt, north
porch FOC-2:pl 34 FCh
Tombstone
GAF 483 FElC
Transept, south c 1210/50
GARDH 259 FCh
Triforium Capital c 1240
EVJF pl 90A FRhC
Two Apostles
JAL-2:pl 21 FPStC
Tympanum; and Figures:
Musicians of Apocalypse
RAY 32 FCh
Tympanum, main portal
GAF 261 FAnD
--GAF 25 FMouzN
--north portal GAF 73 FCh
Tympanum of St. Mary's
Portal BUSG pl 28 FSeN
Tympanum, south transept
portal KO pl 44 FAm
Tympanum, west door
EVJF pl 116 FTrU
La Vierge Doree (Gilded
Virgin; Golden Virgin;
Soubrette Picarde), south
portal, central pier 1255/
60 figure H: c 10'
AUBA 71 (col); BAZINW
295 (col); BR pl 1;
BUSGS 70; CHENSW 347;
EVJF pl 196; FOC-2:pl 94;
GAF 15; JANSK 481; KO
pl 44; LARB 339; MOREYM
pl 117; MU 121; MYBA
316; RAY 35; REAU
pl 75, 76; ROBB 354;
SEW 421; ST 243; UPJ
216 FAm
Virgin
GAF 222 FMorlM
--RAY 33 FCl
Virgin; St. John the

Evangelist, figure fragments,
Crucifixion, Eglise des
Cordilliers c 1200 marble
BUSGS 30 FTMA
Virgin and Child, cemetery
chapel BAZINW 299 (col)
FStAm
Virgin, cloister portal figure
LARB 328 FPN
Virgin, north transept
BAZINW 294 (col); CHENSW
340; CHRC 191 FPN
Virgin Portal, northwest portal;
archivolt figures
BUSG pl 34, 35 FPN
Virgin and Child, portal,
c 1220 BAZINW 289 (col)
FLong
Virgin, Porte du Cloitre 1250
JAL-2: pl 13 FPN
The Virgin, south transept
c 1280 EVJF pl 95 FAm
Virgin, choir screen, Stras-
bourg Cathedral 1247/52
NM-12: 85 UNNMMC
Virgin, trumeau, north
transept portal c 1250
SEW 421 FPC
Virgin and Angel
COL-20: 540 FRhC
Virgin and Child c 1350 ptd
stone LARB 353 (col) ELV
Virgin and Child ptd oak; 31
MOLE 54 FPL
Virgin and Child ptd wood;
15-7/8 NM-7: 31 UNNMM
(17.190.725)
Virgin and Child, Ile de
France ptd oak; 61
BOSMI 103 (col) UMB
(59.701)
Virgin and Child, Ile de France
1320/25 LARB 357 FPL
Virgin in Majesty, tympanum
GAF 275 FCun
Virgin of Notre Dame de l'
Epine, reliquary metal-
plated wood, enamel and
jewels; LS GAF 275 FEvr
Virtue of Constance; Vice of
Inconstancy, south porch
MOREYM pl 112 FCh
The Virtues, tympanum detail
c 1240 LARB 334 FRhC
Virtues Trampling Vices, left
west portal after 1277
BUSGS 129, 133; LARB
350-1 FStrC

--Virtue red sandstone; 76
KO pl 53
Visitation: Mary and
Elizabeth; Virgin, head,
west facade c 1220 BAZINW
290 (col); 291 (col)
FRhC
The Visitation: Mary and
Elizabeth, and the Prophet
Daniel, left north portal
c 1220 BUSGS 9; LARB
333 FCh
--Prophet Daniel
ST 246
"Winter": Peasant Taking off
his Shoes, right door,
north portal
FOC-2: pl 82 FCh
Wise and Foolish Virgins,
south portal, front after
1277 REAU pl 93, 94
FStrC
--Foolish Virgin(s)
BUSGS 128; KO pl 53;
LARB 350; MOREYM pl
126
--The Seducer and the Fool-
ish Virgins (Le Seducteur
et les Vierges folles)
BUSG pl 105; GAF 194;
UPJH pl 90
--The Seducer and the Fool-
ish Virgins: Prince of the
World REAU pl 92
--Wise Virgin
LARB 351
Wise Virgin, central door
JAL-2: pl 9 FSeC
Wise Virgin; Prophet
GAF 355 FCharr
--13/14th c.
Biblical Scenes, diptych
ivory CHENSW 350 URPD
The Deposition ivory; 11-1/2
MOLE 64 FPL
Double Capitals, Bonnefont en
Comminges NM-12: 110
UNNMMC
Virgin of Sainte Chapelle,
Paris ivory; 16.1 GAU 154
FPL
Virgin of Verneuil sur Avre
ptd wood LARA 359
Virtue stone
CHENSW 346 FStrCN
Voissoirs, north transept
portal c 1200/35
BAZINW 286 (col) FCh

Eros Shooting Mortals, mirror
 back ivory
 FREM 113 (col) FPCl
Facade 1300 CHENSW 345
 FStrCN
Female Figure ptd wood
 LOUM 27 FPL (1594)
Female Saint 1300/50 gilt
 bronze; under 12
 FAIN 224 URPO
Flamboyant Gothic Facade,
 detail CHENSW 348 FRC
Folding Shrine: Virgin and
 Child with Angels ivory;
 15-1/2 NM-7: 23 UNNMM
 (17. 190. 211)
Funerary Mask
 GAF 16 FArrM
Game of Chess, mirror lid
 c 1300 ivory; Dm: 11. 8
 EVJL pl 63; GAU 147 FPL
Gold Sceptre with Ivory Handle:
 Main de Justice
 HUYA pl 37; HUYAR 11 FPL
Gospels of the Sainte Chapelle
 Cover 1379 gilded copper
 LARB 377 FPMe
Gothic Casket ivory; W: 5
 SOTH-4: 261
Hand Reliquary of St. Louis of
 Toulouse rock crystal,
 enameled silver and gold;
 . 60 m CHAR-1: 302 FPL
Jeanne de Bourbon, head
 detail, chimney piece of
 Great Hall c 1385
 EVJF pl 151; EVJL pl 27
 FPoP
Jeanne de Flandres, wife of
 Enguerrand IV, Sire de
 Coucy, recumbent effigy
 c 1300 EVJF pl 207A
 FLaoC
Jousting at Tournament, cas-
 ket panel ivory
 FREM 108-9 (col) IRaMN
Jousting Scene, casket plaque
 ivory MU 127 UNNMM
Kneeling Girl wood
 ZOR 213
Knight and Lady, mirror case
 top ivory
 MYBU 149 UNNMM
Knight and Lady Riding to the
 Hunt, mirror case ivory;
 Dm: 4-7/8 FREED pl 11
 ELV

Life of Christ, scenes: Ap-
 pearing to Disciples; At
 Emmaus; With Thomas,
 on Sea of Galilee ptd
 stone REAU pl 95-7 FPN
Life of Christ, scenes,
 facade detail c 1300
 LARB 351 FStrC
Life of Christ, scenes,
 triptych ivory
 LARB 379 FPCl
Life of Christ and the Virgin,
 scenes, diptych ivory;
 9-13/16x10-3/8
 DETT 183 UMiD (40. 165)
Lovers Casket: Lovers in
 Forest; Playing Chess,
 Church of St. Ursala ivory
 BUSGS 174 GCo
Luxuria, corbel figure c 1300
 BUSGS 135 FAuE
Madonna ivory
 ROOS 83E UNNMM
Madonna and Child
 FEIN pl 55 UNNMM
Madonna and Child ivory;
 11-3/4 NCM 161 UNcRV
Madonna and Child limestone;
 29 DEY 100; DEYE 28;
 SUNA 226 UCSFDeY
 (44. 22)
Madonna and Child 1339 silver
 SEW 428 FPL
Madonna and Child c 1350 ptd
 stone; 65
 TOR 115 (col) CTRO
 (938. 16. 1)
Madonna and Child, Central
 Loire Valley c 1385/90
 ptd limestone CLE 64
 UOClA (62. 28)
Madonna and Child (Mutter-
 gottes), Champagne 1340
 limestone; 79. 5 cm BSC pl
 32 GBS (5/57)
Madonna and Child, Villeneuve
 les Avignon ptd ivory
 MOREYM pl 122 FPL
Madonna and Child, head
 detail ivory FEIN pl 38
 UNNMM
Madonna and Nursing Child
 ivory; 11 TOR 114 CTRO
 (953. 170)
Medieval Sports, relief from
 writing tablet ivory
 ROBB 676 FPL

Metz Madonna and Child; head
detail c 1340 limestone; 51
DEY 96, 97; DEYE 22
UCSFDeY (55360)
Mirror Back: Minne Scene
ivory; Dm: 4-3/8
AUBA 19 IFMN
Mouton d'Or of Jean le Bon
1350/64 gold
CLE 64 UOC1A (64.372)
Nativity, relief
JAL-3: pl 1 FPN
Notre Dame de Paris 1330
SEW 428 FPC
Passion Scenes, diptych ivory
MU 268 UNNMM
Pastoral Staff Handle: Virgin
and Child with Angels
ivory; 5
FREED pl 9 ELV
Pentecost, relief alabaster
GUIT 125 FPTa
Portable Altar c 1330 ivory;
9-3/4 BUSGS 186
Portal of St. John the Baptist,
detail GAF 52 FRC
Portal of the Booksellers
(Portail des Libraires)
GAF 52 FRC
Prophet, facade detail
LARB 350 FStrC
Prophet, head from statue,
Strasbourg Minster c 1300
reddish sandstone; 14-3/8
BOSMI 115 UMB (Nickerson
Fund No. 2 56.506)
Recumbent Effigy, Abbey of Pont
aux Dames, Seine et Marne
EVJF pl 17
Reliquary Casket c 1320
SWA 14
Saint, Chapelle de Rieux
GAF 499 FTMA
St. Anne Carrying Infant
Virgin GAF 43; JAL-3: pl 2
FEc
St. Catherine marble
LARB 388
St. Catherine 1330/40 sand-
stone; 97 cm
BERLEK pl 5 GBSBe (8406)
St. Catherine, seated figure
ivory WATT 143 FPCl
St. Denis, Ile de France
c 1380 marble; 13-3/4
CAMI pl 10 CML
St. Elzear, Apt c 1373 marble
MULS pl 20B UNNMM

St. Jacques, Chapelle de
Rieux REAU pl 104 FTMA
St. John the Baptist stone
REAU pl 105 FMu
St. John the Baptist, head
detail BUSGS 189 FTMA
St. John the Baptist; Jean
Bureau 1373/75
EVJF pl 261 FAm
Saint-Louis, chapel c 1307 ptd
stone
REAU pl 102 FChatM
St. Madeleine
JAL-3: pl 4 FBorC
St. Mary the Egyptian
GAF 43; REAU pl 108
FEcC
St. Michael, detail walnut;
110.5 BERLEK pl 8
GBSBe (8022)
St. Paul c 1330
BAZINW 299 (col); BUSGS
188; EVJF pl 125 FTMA
St. Peter, Chapelle de Rieux
REAU pl 103 FTMA
St. Philip, head detail stone
CHENSW 346 FStrCN
St. Stephen, head detail stone
CHENSW 346 FStrCN
St. Valerius, reliquary bust
enameled silver
MULS pl 13 SpZarC
St. Veronica
EVJF pl 122; REAU pl
107 FEcC
Saints, facade
ROOS 78F FRhC
Sceptre of Charles V last Q
14th c. gold and silver gilt;
.22 m CHAR-1: 303 FPL
Seal of Louis I, King of
Naples and Duke of Anjou
1339/84 LARB 376 FPAr
Seated Madonna and Child box-
wood; 9
DEY 98; DEYE 29
UCSFDeY (54676)
Seated Virgin and Child stone
LOUM 33 FPL (141)
Siege of Castle of Love,
mirror case c 1360 ivory;
Dm: 5-1/8 ASHS pl 12;
EVJF pl 174; EVJL pl 64;
MOLE 63 ELV
Springtime of Life, west
front LARR 19 FLC
Tabernacle, Tiers ivory; .29
x.23 m CHAR-1: 274 FPL

Tabernacle of the Virgin ivory
EVJF pl 193 ELV
Table Fountain silver gilt and
translucent enamel
CLE 63 UOClA (24.859)
Three Saints, south portal
detail BR pl 2 FCh
Toilet Box ivory; 4-3/4
NM-7:24 UNNMM
(17.190.180)
Tomb Slab: Monk
ELIS 148
Triptych ivory
EVJF pl 194 FPCl
Triptych: Madonna and Child
gilded ivory CLE 65 UOClA
(51.450)
Triptych, S. Sulpice ivory;
12-1/2x11-1/4 KIDS 163
FPCl
Trumpeting Angel, Ile de
France alabaster; 16
BOSMI 117 UMB (61.196)
Two Kneeling Carthusian Monks
marble CLE 61 UOClA
(66.112; 66.113)
Tympanum, detail
CHENSW 347 FSemN
Urban V, head c 1370
MULS pl 26A FAviC
Vice of Cowardice: Armed
Man Throwing away Sword
and Fleeing from Rabbit,
quatrefoil medallion c 1320
AUBA 69 (col) FAm
La Virgen de Marfil (Ivory
Virgin) WHY 19 PrSC
Virgin
CHASEH 231 FPC
Virgin stone
EVJF pl 250 FMagCh
Virgin and Angel, pastoral
staff head ivory
MCCL pl 24 ELV
Virgin and Child
BAZINH 502 FTrC
Virgin and Child
JAL-3:pl 3 FChatM
Virgin and Child
KIDS 122 (col) FPN
Virgin and Child
NM-12:86 UNNMMC
Virgin and Child
POST-1:69 UMB
Virgin and Child LS
PACHA 47 GBS
Virgin and Child alabaster
LARR 23 FPCl

Virgin and Child boxwood;
10-3/4 BMA 16 UMdBM
Virgin and Child ivory; 3/4
GRIG pl 119 ELBr
Virgin and Child ivory; 8-1/4
ASHS pl 11 ELV
Virgin and Child ivory; 14
MOLE 64; READAS pl 77
ELV
Virgin and Child ivory; 16
(with pedestal)
FREED pl 6; VICF 22 ELV
(4685-1858)
Virgin and Child limestone
MILLE 13 UNNMM
Virgin and Child ptd and
gilded stone
LOUM 31 FPL (139)
Virgin and Child ptd ivory
BAZINW 298 (col); GUIT
93 (col) FVillC
Virgin and Child sandstone
MILLER il 98 ELV
Virgin and Child wood
ZOR 212 UNNMM
Virgin and Child c 1300 sand-
stone; 65-5/8 NEWTEM pl
91 GMSch
Virgin and Child 1339 silver-
gilt; 27-1/4 KIDS 121 (col)
FPL
Virgin and Child (Muttergottes)
1340 walnut; 174 cm BSC
pl 33 GBS (8323)
Virgin and Child, Abbeville
wood LARB 357 FPL
Virgin and Child, Ile de France
ivory STI 423 UOCiT
Virgin and Child, Ile de France
ptd stone; 61.8
GAU 149 (col) FPL
Virgin and Child, Piccardy
wood LOUM 95 FPL (135)
Virgin and Child, Yonne
District limestone; 69-1/2
BMA 15 UMdBM
Virgin and Child, relief ivory;
8-3/8 FAIN 188; WORC 38
UMWA
Virgin and Child, trumeau
figures MULS pl 24A FRiN
Virgin and Child of Celle ptd
stone; 1.57 m CHAR-1:268
(col) FPL
Virgin and Infant Christ ivory,
with gold and jewels; 16-1/2
HUYA pl 35; HUYAR 81
FPL

--Knights Riding Donkeys in
Mock Tournament; Man and
Woman Playing Chess or
Checkers EVJL pl 20
Fountain
GAF 241 FStAv
Galley of Jacques Coeur,
tympanum 1443/51 EVJL pl
68; JAL-3:pl 23 FBouC
God the Father, relief
Bourges MULS pl 25A FPL
God the Father in Benediction,
half figure c 1400 MULS
pl 27B FAviC
Gothic Christ, tracery front
ST 241
Gothic Portrait Bust of Woman
ptd wood INTA-1:97
Gothic Reliquary gilt silver;
14 DEYE 30 UCSFDeY
(47.3.1)
Great Bascinet
SOTH-3:246 ELTow
Guillaume le Francois tomb,
St. Barthelemy at Bethune
1456 BAZINW 317 (col);
LARR 21 FArrM
Heads, Chalons sur Marne
c 1470 MULS pl 98 FPL
Holy Sepulchre (Sepulchre of
Semur) POST-1:77 FSemN
Holy Sepulchre 1454
ROBB 356 FToH
Holy Sepulchre; The Magdalen,
kneeling figure 1496 stone
LAC 194; REAU pl 122-3
FSolB
Holy Trinity (Mercy Seat) lime-
stone; 60-1/2 DEYE 45
UCSFDeY (53.11)
Jacques Germain Tomb c 1424
EVJF pl 258B FDM
Jean II of Bourbon, Bourbon-
l'Archambault c 1470
MULS pl 140A UMdBW
Jean Chousat
JAL-3:pl 24 FPolH
Jean d'Artois, Comte d'Eu,
head EVJF pl 211B FEuL
Jesus Crowned with Thorns,
bust fragment ptd lime-
stone; 13-1/4 WORC 39
UMWA
Jean the Fearless Tomb
c 1400 ptd alabaster
MOLE 69 FDM
--Mourners
MOREYM pl 162, 164

Judith
JAL-3:pl 16 FA1bC
Kneeling Prophet bronze
wood; .14 m CHAR-2:
292 FPL
Knights Jousting c 1470
EVJF pl 173B FPCl
A Lady, chimney piece(?)
EVJF pl 156 FLeHG
Lamentation at the Tomb
JAL-2:pl 22 FSolB
The Leather Worker: St.
Crispin wood
EVJL pl 52
Little Horse of Altotting
before 1404 gold, pearls
and enamel BAZINL pl
234 (col) GA1t
Louis II de Sanserre, effigy
detail c 1402 BUSR 45;
GAF 97 FPDe
Louis de Chatillon, Sainte
Chapelle, Bourges c 1405
EVJF pl 183B; EVJL pl
29; MULS pl 24B FCheM
Madonna, head detail, seated
figure before 1500 stone
BUSR 119 FTM
Madonna and Child after 1400
marble BUSR 42 ELV
Madonna and Child, seated
figure ptd stone; 1/2 LS
MOLE 78 FTMA
Madonna and Nursing Child
c 1420 ptd stone BUSR 31
FPL
Maker of Sabots: St. Crispini-
an wood EVJL pl 53 GBM
Man of Sorrows, half figure
MULS pl 25B FBouM
Marriage of the Virgin, altar-
piece detail terracotta
GUIT 25 FPCl
Martyrdom, caryatid, Ossuary
Chapel GAF 222 FLama
Mary Magdalen
BAZINW 319 (col); LARB
321; LARR 146; MAL pl
30 FMonP
Mary Magdalen stone
LOUM 53 FPL (1605)
Mary Magdalen before 1500
pearwood MULS pl 189B
GMBN
Mary Magdalen c 1464
MULS pl 101B FChate
Mary Magdalene, seated
figure, tomb detail c 1496

BAZINW 319 (col); CRU
120; FOC-2: pl 142, 146
FSolB
Miraculous Virgin stone
GAF 213 FLeFo
Monk, Troyes 1470/80 lime-
stone; 31-1/2 ALB 141
UNBuA
Mourner c 1453 marble; 15-1/8
NM-7:40 UNNMM (17.190.389)
Mourner from a Lamentation
c 1470 BUSR 86 FEuC
Mourning Angel
BAZINW 316 (col) FSemM
Mourning Women, from
Crucifixion c 1430
MULS pl 74 PBS
Mourning Women from Holy
Sepulchre c 1440
BUSR 56 BSV
The Nativity
LARB 321 FDM
The Nativity c 1450 ptd lime-
stone; 17-5/8
NM-7:44 UNNMM (16.32.158)
Nicodemus, entombment group
c 1470 MULS pl 102A
UNNMM
Our Lady of Grace (Notre Dame
de Grace)
EVJF pl 266; GUIT 92;
MULS pl 58A FTMA
Ox of St. Luke, Burgundian
stone CHENSW 362 FPL
Pendant: Coronation of the
Virgin ptd ivory under rock
crystal: 3-3/16
BOSMI 119 UMB (54.932)
Philippe de Morvillier, effigy
detail 1427/38
MULS pl 54 FPL
Pierre d'Evreux-Navarre,
Count of Mortain, effigy,
Chartreuse, Paris 1412/13
marble MULS pl 28 FPL
Pieta
GUIT 106-7 FMonP
Pieta
MAL pl 26 FBay
Pieta, bas relief
GUIT 112 FTMA
Portal, wing of Louis XII
GAF 266 FBl
Praying Angel, relief ptd stone;
.33x.50 m CHAR-1:301
FPL
Prophet, corbel c 1465/70
MULS pl 99 FCl

Prophet, St. Sernin c 1470/80
terracotta
MULS pl 145B FTMA
Prophet and Diacre wood
LOUM 101 FPL (1600-1601)
Reliquary of St. Ursula: Ship
with Figures
EVJF pl 176 FRhC
Renaissance House Window
GAF 470 FVille
Retable 1484 stone
GAF 318 FChauvH
Rood Loft and Choir Screen
Figures: Judas and
Thaddeus; Adam and Eve
c 1500 BUSR 152, 153
Rood Screen
POST-1:90 BDiN
Rowel Spur c 1400 L: 7-1/4
NM-3:7 UNNMM (14.25.1737)
Saint, Lamentation figure
c 1480 wood
MULS pl 144A UNNMM
St. Adrian, Moselle Region
cast and chased brass;
12-1/8 CAMI pl 31
UNNLeh
St. Anne and the Virgin c
1480 CHASEH 242 FBorC
--St. Anne, bust detail
EVJF pl 267
St. Barbara
JAL-3: pl 13; REAU pl 111
FChateC
St. Barbara and the Tower,
Lorraine c 1450 Caenstone
MULS pl 102B; NCM 285
UNNMM (08.35.2)
St. Bernard
NEWTET 116 FLabA
St. Christopher marble; 44
(with base) KRA 76 UOrPA
St. Christopher, fragment
detail c 1480
MULS pl 97A UMoSL
St. Fortunade, head, reliquary
c 1450/60 bronze
CHENSW 361; EVJF pl
265; MULS pl 103B; REAU
pl 113 FCorF
St. Jean de Reome, Rochefort
c 1460 stone MULS pl 59C
FAsnCh
St. John, from Crucifixion
Group, Loches wood
EVJL pl 30 FPL
St. John, head detail wood;
1.40 m CHAR-1:290-1 FPL

St. John, Beaugerais c 1450
walnut MULS pl 103A FPL
St. John, Tours wood; 55.1
GAU 155 FPL
St. John at Foot of Cross wood
LOUM 53 FPL (243)
St. John Supporting Mary
BUSR 83 FCharm
St. John the Baptist
JAL-3: pl 12; REAU pl 110
FChateC
St. John the Baptist wood
MULS pl 17A FPL
St. John the Baptist 1400/50
limestone; 59-1/4
NM-7:40 UNNMM (34.44)
St. John, bust detail wood
RAY 78 UNNMM
St. Judith, choir screen detail
GAF 477 FAlbC
St. Martha
GAF 199 FTrM
St. Martin
JAL-3: pl 19 FArcen
St. Martin and the Beggar,
equest sandstone; 38x39-3/4
x 15 DENVK 77 UCoDA
St. Michael c 1430/40 stone
MULS pl 58B FTMA
St. Paul wood
CHENSW 357 FTM
St. Paul (Apostle with Book)
oak MULS pl 17C GMBo
St. Peter
RAY 37 UNNMM
St. Radegonde, head detail
stone GIE 34 FEurC
St. Ronan Tomb: Angel
granite GAF 220 FLocr
St. Stephen ptd and gilded
wood; .46 m
CHAR-1:293 (col); LOUM
101 FPL (226)
St. Yrieux, reliquary head
LARB 377 FStYCh
SS Christopher and Hubert,
lintel GAF 258 FAmbo
Sculptured Cup Lid c 1470
EVJF pl 178 ELV
Sibyl of Samos, niche figure
AGARC 61 FAixC
Singing Angels
JAL-3: pl 17 FViC
Tonsured Head c 1460/70
MULS pl 97B UNNMM
Vierge Bulliot (Vierge au
Poupon; Virgin of Autun),

Hotel Rolin Chapel c 1460
GAF 310; JAL-3: pl 18;
MULS pl 59B FAutR
Virgin, Annunciation Group
oak MULS pl 17B SwZBu
Virgin, Crucifixion Group
wood EVJF pl 256B
FTourMA
Virgin, Plombieres-les-
Dijon c 1430 BAZINW 315
(col) FPL
Virgin, head
GUIT 22 FPL
Virgin Adoring Infant, relief
ptd and gilded wood LOUM
109 FPL (537)
Virgin and Child
JAL-3: pl 11 FRiN
Virgin and Child
JAL-3: pl 14 FDampN
Virgin and Child
MULS pl 61B UNPV
Virgin and Child
MILLER il 110 FCC
Virgin and Child (La Vierge
d'Auxonne) c 1430/40
JAL-3: pl 15; LARB 375;
MULS pl 57A FAuxN
Virgin and Child ptd stone
LARR 55 FPL
Virgin and Child limestone;
43-1/2 CAN-1: 144 CON
(6487)
Virgin and Child stone
LOUM 40 FPL (211)
Virgin and Child wood
LOUM 93 FPL (559)
Virgin and Child H: 16-1/2
UPJH pl 75 UNNMM
Virgin and Child c 1400 stone;
26 FAIY 227 UNPV
Virgin and Child c 1425
MULS pl 60A FChate
Virgin and Child c 1470/80
wood LOUM 93 FPL (1899)
Virgin and Child c 1480/1500
BAZINW 318 (col) FAutR
Virgin and Child c 1500 wood
LOUM 103 FPL (517)
Virgin and Child, Burgundian,
Poligny c 1450/75 ptd lime-
stone; 53-1/4 MULS pl 65;
NM-7:39; NMA pl 53 (col)
UNNMM (33.23)
Virgin and Child, north portal
c 1400 MULS pl 60B
FLeMeCh

Virgin and Child, Notre Dame de
 Grasse BAZINW 318 (col);
 UPJH pl 75 FTMA
Virgin and Child, Quaiant
 c 1490 MULS pl 144C FArrC
Virgin and Child, Rouvroy ptd
 stone; 62.2 GAU 142-3 FPL
Virgin and Child, seated figure,
 Paris ivory; 15.8 GAU 51
 FPL
Virgin and Child on Crescent
 Moon c 1490 wood
 MULS pl 144B FAm
Virgin and St. John gold;
 .16 m CHAR-1:294 FPL
Virgin Carrying Child ptd and
 gilded wood LOUM 103 FPL
 (1891)
Virgin Carrying Infant, Stand-
 ing on Crescent Moon c
 1420 ptd terracotta
 LOUM 113 FPL (538)
Virgin of Pity (Vierge de Pitie)
 EVJF pl 236 FAubB
Virgin of Pity (Vierge de Pitie)
 1476
 GAF 457 FM
Virgin of the Annunciation
 c 1450 limestone; 24-1/2
 BOSMI 123 UMB (45.774)
Virgin with a Bird
 BAZINW 317 (col) FPuyM
The Visitation, Troyes stone
 MILLER il 75 FTrC
Votive Group 1470
 MULS pl 141B FAixC
Votive Relief stone
 MULS pl 11B FEC
Wind Vane: Angel, Chateau
 du Lude, Sarthe 1475 bronze
 EVJF pl 160 UNNF
Window
 SELZPN 14 FPStSe
--15/16th c.
Choir Screen, south: Life of
 St. Firmin, relief begun
 1490 MULS pl 187, 186B
 FAm
Doorway: Opposing Centaurs
 GAF 403 FCleC
Drinking Horn
 WATT 147 FPCl
Female Saint H:46
 UPJ 218 UNjPA
Fountain of Drennec
 GAF 211 FClo
Sacred Fountain
 GAF 207 FBerN

St. Eloi, right aisle
 GAF 207 FBerN
St. Gorgon, Holding Falcon
 1480/1520 wood; 66
 ALB 139 UNBuA
Woodwork, Abbeville
 NM-12:127 UNNMMC
--16th c.
Abbot's Stall 1500/15 oak
 CLE 71 UOC1A (28.657)
Allegory of Architecture
 juniper; 29 cm BSC pl 115
 GBS (7816)
Altar of Annunciation, Chapel
 of St. Marguerite GAF 316
 FBr
Aphrodite of the Belvedere
 cast bronze CLAK 20 FPL
Armand de Constant, Pieta
 Donor, detail c 1500 wood;
 34-3/8 NM-7:46 UNNMM
 (16.31.1)
Birth of Eve, relief, porch
 detail GAF 215 FGu
Bishop's Throne; detail: St.
 Peter walnut; 106x36
 CHAR-2:66, 67 FPL
Burgundy Dressoir walnut
 CLE 100 UOC1A (42.606)
Calvary
 GAF 215 FGue
--1554
 GAF 233 FPloug
Calvary, detail: Christ Wash-
 ing Feet of Disciples
 1581/88 GAF 215 FGu
Calvary; details: Christ,
 Flight into Egypt, Nativity
 GAF 230 FPl
Capitals: Figures 1550
 GAF 91 FPon
Caryatid, church porch
 GAF 206 FBod
Cathedral Ambulatory wood
 GAF 43 FEvT
Chancelier Duprat, bust
 terracotta LOUM 61 FPL
Chapel Portal
 CHENSW 362 FAmbo
Charles IX, equest, medallion
 marble; Dm: 13
 CHAR-2:72 FPL
Chateau Fountain lava
 GAF 411 FStS
Choir Screen, Chartres:
 Christ's Passion begun
 1514 BUSR 189 FCh

Kings c 1540 enamel on
gold CLE 101 UOClA
(38.428)
Hat Jewel: Rape of Helen
enamel on gold
CLE 101 UOClA (49.377)
Helmet of Charles IX enameled
gold; 13-1/2x14-1/4
CHAR-2:73 (col) FPL
Henri II's Armor: Battle
Scene c 1560
CHAR-2:74 FPL
--Scenes of Pompey H:79-1/2
HUYA pl 44; HUYAR 18
Holy Sepulchre c 1500
BUSR 204 FRoC
Holy Women, Calvary detail
GAF 207 FBra
Hosanna Cross (Temple of
Moeze) 1563 GAF 363 FMoe
Inlaid Table, Burgundian
CLE 103 UOClA (42.601)
Jeanne de Balzac, bust
JAL-4:pl 8 FChatMo
Jeanne de Bourbon d'Auvergne,
effigy, Eglise des Cor-
deliers de Vic c 1521 BUSR
209 FPL
Judith, Jube c 1500
BAZINW 318 (col) FA1bC
Jug c 1550/75 onyx, jeweled
gold and enamel mounts;
10-5/8 ARTV pl 41 AVK
Lamentation at the Tomb
JAL-4:pl 6 FVillC
Madonna, Chateau d'Ecouen
Chapel BUSR 205 FPL
Mantelpiece, Chateau of
Madrid (drwgs by du
Cerceau) 1530/40 BLUA
pl 18 ELBr
Massacre of the Innocents,
choir relief polychrome
GRAF 217 FHuN
Medallion Bust terracotta
JAL-4:pl 5 FLM
Mirror Back "En Resille"
enamel CLE 102 UOClA
(26.246)
Mourners, Nevers Entombment
c 1500 walnut
MULS pl 188 GFL
Mourning over Dead Christ
MOLE 88
Nicolas du Monstier and his
wife, kneeling in prayer
1518 EVJF pl 214
FAubC

Normandy Chest oak
CLE 101 UOClA (42.604)
Original Sin, choir stall
GAF 329 FMontre
Ossuary Figures
GAF 215 FGue
Pendants: Triton, Dragon,
Lamb enameled gold,
pearls; 2-4-1/2 CHAR-2:
76 (col) FPL
Philibert Le Beau Tomb,
detail: Sibyls
GAF 317 FBr
Pieta
BAZINW 317 (col) FAubC
Pieta ptd wood
DIV 29 UNNMM
Pillar of the Merchants (Pilier
des Marchands)
GAF 81 FGiG
Pons de Gontaut Biron Tomb
1524 GAF 389 FBir
Porch, north, detail
GAF 231 FPloeA
Portal, and Retable, details:
Seasons; Last Judgment
GAF 92, 93 FRaC
Portal Leaf: Prophet
GAF 507 FAixC
Presentation of Mary in the
Temple, rood screen
GUIT 17 FCh
Processional Cross, Carmelite
Monastery c 1500
EVJF pl 131 FPCl
Queen Louise de Savoie, bust
terracotta LOUM 61 FPL
Reliquary: Female figure,
bust RAY 37 -May
Renaissance Dormer Window
GAF 412 FSali
Renaissance Font, detail
GAF 38 FBourg
Renaissance Frame c 1550
boxwood; 21x14-1/4 DEYE
119 UCSFDeY (45.27)
Renaissance Window
GAF 181 FMarvM
Retable: Infancy of Christ;
Passion ptd and gilded wood
LOUM 107 FPL (1890)
Retable: Resurrection Scenes
BUSR 127 FPL
Ronsard, bust
JAL-4:pl 18 FBl
Sacrifice of Isaac, relief,
Chateau d'Ecouen c 1545
marble; 42x50 COOPF 246
FChanC

--16/17th c.
Pleyben Christ, Calvary detail
CHENSW 321 FPl
--17th c.
Altar of Notre Dame de Grace
1694 gilded wood
GAF 247 FStTu
Angels Supporting Coat of Arms
of Marie de'Medici, Chapel
of The Trinite, Fontaine-
bleau c 1615/25 BLUA pl
73 FFP
Baptistry with Baldaquin wood
GAF 215 FGu
Basalt Urn red jasper; 4-1/2
CHAR-2: 162 FPL
Cabinet on Stand: Scenes from
Old Testament c 1650
ebony; 90x84-1/2x30
DEY; DEYE 143 UCSFDeY
(47. 20. 2)
Calvary 1610
GAF 245; LARR 302 FStTh
Calvary, details: Flight into
Egypt; Agony in the Garden;
Last Supper 1602/04 granite
BUSR 203; GAF 231-2;
HOF 35; UPJH pl 185 FPlo
The Chariot of Apollo, pool
group lead HOF 308 FV
Christ with Column red jasper
and rock crystal, gold
mounting: 8-1/2 CHAR-2:
173 (col) FPL
Christianized Menhir of Saint
Duzec 1674 GAF 228 FPle
College Chapel Doorway,
Louis XIII Style 1624
GAF 43 FEuL
Creche gilt wood
GAF 461 FOlM
Crucifix silvered iron
CHENSW 398 -Cu
Cupids (Enfants de l'Escalier)
1642/52 JAL-5: pl 1 FMai
Doors, Galerie d'Apollon,
Chateau de Maisons c 1650
wrought iron CHAR-2:148
FPL
Duke of Guise, Henri le Balafre,
and Duchess of Guise,
Catherine of Cleves, Tomb
GAF 43 FEuL
Duke of Villeroy Tomb
BUSB 62; GAF 82 FMagCh
Elements: Earth and Water,
inner courtyard relief
BOE pl 164 FPSu

Embossed and Chased Chest
c 1645 gold
LARR 306 FPL
Enfants du Parterre d'Eau
JAL-5: pl 4 FV
Ewer, with Leopard Handle
1697 silver gilt LARR 306
FPoC
Facade
JAL-1: pl 21 FStGi
Goblet of Anne of Austria
c 1645 gold; 3-3/4
CHAR-2:127 FPL
Heymon, Comte de Corbeil,
effigy MAL pl 36 FCorbS
Louis XIII as a Child, equest
faience; 10-1/2
CHAR-2:108 (col) FPL
Louis XIV, bust bronze; 58 cm
WPN pl 62 PWN (158128)
Louis XIV Doors
NM-11: 28 UNNMM
Louis XIV's Inkstand red
jasper; 4-1/2
CHAR-2:162 FPL
Neptune Cup, shark decoration
lapis lazuli; 16
CHAR-2:157 (col) FPL
Ogier the Dane, head
GAF 86 FMeaB
Orpheus bronze; 17-1/2
MINF -Da
Pascal, death mask
GAF 90 FPor
Passion, details: Mocking of
Christ; Christ Carrying
the Cross 1610 GAF 245
FStTh
Portrait Bust
NM-11: 30 UNNMM
Pulpit 1683 ptd and gilded
wood GAF 245 FStTh
Pyxis ptd wood
GAF 244 FStPol
Shepherdess lead; 58-1/2
INTA-2:122
"Sinbrunnen" Fountain 1622
GAF 191 FRiq
Well
GAF 223 FMelr
--17/18th c.
Adam Wall Mirror gilt wood
SOTH-2:251
Louis XIV Chandelier ormolu
SOTH-1: 227
Louis XIV Torchere giltwood
SOTH-2:231

Frick, Elizabeth
 Alberdi Miss Elizabeth Frick
FRICK, Julius (German)
 Ceiling Panels
 AUM 14
Frideswide, Saint
 English--13th c. St. Frides-
 wide Shrine, base detail
Friederick of Saarwerden
 Elgius of Liege. Archbishop
 Friedrich of Saarwerden
 Tomb
Friedrich of Wettin
 German--12th c. Archbishop
 Friedrich of Wettin, tomb
 plaque
Friedrich von Hohenlohe d 1351
 Wolfkehl Meister. Bishop
 Friedrich von Hohenlohe,
 effigy
The Friends. Roeder
Friends Walking. Armitage
Friezes
 Fondulo, A. Decorative
 Frieze
 Palestinian. Fruits and
 Flowers, frieze detail
 Romanesque--French. House
 Frieze: Bird and Floral
 Motif
The Frightened Man. Hubacher
Frightened Torso (Opus 53)
 Meadows
FRINK, Elisabeth (English 1930-)
 Assassins bronze
 MILLS pl 46-52
 Blind Man and Dog 1958
 bronze; 72; and 30 ROTJB
 pl 127 ELBetA
 Carapace II 1963 bronze; 12
 SEITC 55
 Dead King 1962/63 bronze;
 L: 78 LOND-6:#17
 Dog 1958 bronze; 38
 SFMB #109 UCBeW
 Dying King 1963
 PRIV 87 (col)
 Eagle, lectern for Coventry
 Cathedral 1962 bronze;
 L: 45 HAMM 147
 Firebird. 1962 bronze; 17
 SEITC 55
 Fish Head 1961 bronze; 9
 HAMM 146

 Four Soldiers' Heads 1965
 bronze; 14x15-1/2

 LOND-7:#13 ELW
 Group I 1963 bronze; 22
 SEITC 55
 Harbinger Bird III 1961
 bronze; 17 READCO pl
 9a; READCON 221 ELBe
 Harbinger Bird IV 1960
 bronze; 8x6-3/4x1-1/4
 TATES pl 30 ELT (T.580)
 Head 1959 bronze; 1x16x8
 ARTSS #20 ELBrC
 Sentinel 1961 bronze; 51
 SEITC 55
 Spinning Man 1960 bronze;
 W: 60 LOND-5:#20
 Warrior 1957 concrete; 70
 LONDC pl 14
 Warrior Bird 1958 bronze
 MAI 100
 Portraits
 McWilliam. Elisabeth Frink
FRITH, Edgar S. (English 1890-)
 Clamour slate
 PAR-1: 65
FRITSCH, Bohumir
 High Altar, detail: Guardian
 Angel 1739 STECH pl 195
FRITZ, Gyula (German 1930-)
 Plastik 1961 bronze; 26x18x
 7 cm KUL pl 34
FRITZSCHE, Georg
 Meissen Chinaman and Bird
 Ormolu mounted
 SOTH-3:182
 Meissen Chinaman Arbour
 Figure c 1728 SOTH-1:
 148 (col)
Froehlich, Joseph
 German--18th c. Joseph
 Froehlich, court jester
 of Augustus the Strong
 Meissen porcelain
The Frog Princess. Bayes
Frogner Park Column
 Vigeland. Monolith
Frogs
 Faberge. Crouching Frog
 Lehmann, R. Frog
 Liskova. Frog
 Paolozzi. Frog Eating a
 Lizard
 Paolozzi. Large Frog
Le Froid. Roger-Bloche
From the Horizon. Chillada
From the Moment he Suffers.
 D'Haise, Reinhout

From Them. Martin, E.
From Within. Chillada
Frozen Old Woman. Barlach
Fruchard, Senator
 Daumier. La Degout
 Peronnifie, bust of
 Senator Fruchard
FRUGIANUS, Claude Pollion
 Diomedes of Cumae, after
 5th c. Greek original;
 head detail 1st c. MAIU
 21; 22 INN
The Fruit. Bourdelle
Fruit Baskets
 French--19th c. Fruit Basket,
 with three caryatids
Fruit des Illes
 Gaugin. Noix Sculptee
Fruit Hybrid dit la Pagoda
 Arp. Pagoda Fruit
Fruit of a Long Experience. Ernst
Fruit of a Stone. Arp
Fruitful Earth. Hiltmann
Fruitfulness. Krikawa
FRYKLUND, Sven Erik (Swedish)
 See ERIKSSON, Elis
Fucilazione. Mazzullo, G.
FUETER, Max (Swiss 1898-)
 Flotenspieler
 JOR-1: pl 20 SwBeKo
Fugit Amor. Rodin
Fugitive. Barlach
Fugitive Woman. Johnsson
The Fugitives. Daumier
Fugue. Schiffers
Fulani. Enwonu
Fulchiron, Jean
 Daumier. Jean Fulchiron, bust
Fulda Figure. German--18th c.
Fulda Fruit Sellers
 SOTH-3:185
Fulham
 Dwight. Prince Rupert, bust
Fulham. English--17th c.
FULLARD, George (English 1924-)
 Cross of St. George 1964
 various media; 123x49x42
 LOND-7:#14; MYBS 90
 (col); PRIV 285
 Infant St. George, assemblage
 1962/63 MILLS pl 73-4
 The Patriot 1959/60 ptd wood;
 70 to 84-1/2 READCON
 254 (col)
 The Second War Dream 1964
 various media; 10-1/4x5-
 1/2x8-3/4 PRIV 285

War Games 1962 ciment
 fondu; 58-1/2x57-1/2
 HAMM 144; PRIV 284
War Ghost 1961 steel; 55x61
 LOND-6:#18
Woman with Flowers 1959
 wood; 98 HAMM 145
Fuller, Loie
 Larche. Loie Fuller#
 Roche. Loie Fuller
Fulton, Robert (American Inventor
 1765-1815)
 Houdon. Robert Fulton, bust
FUNEFF, Ivan (Russian)
 Mrs. L., half figure
 CASS 86
Funeral. Cordonnier
Funeral. Doderhultarn
Funeral Genius. Rodin
Funeral Group. Wragg
Fur-Covered Cup, Saucer and Spoon
 Oppenheim. Objet
FURET, Jean Baptiste Andre (French)
 Clock, with Negress Bust
 and Cupids c 1785 H: 29
 NM-8:44 UNNMM
 (58.75.127)
Furstenberg, Elisabeth
 Lucarda. Countess Elisabeth
 Furstenberg, head
Furtwangler, Wilhelm
 Wimmer. Wilhelm Furtwang-
 ler, bust
Fury of Athamas. Flaxman
Fusion of a Head and a Window.
 Boccioni
Fyfe, William Hamilton
 Huxley-Jones. William
 Hamilton Fyfe
FYRING, Dirk (Danish), and
 Corvinianus SAUER
 Crown of Christian IV c 1596
 gold, enameled and
 jeweled, with pearls and
 diamonds; 17.5 cm
 BOES 18

Gaa. Fischer, L.
Gabbia. Ceroli
GABEL, Matthes (German 1500-74)
 Son of Martin III of Geuder,
 medal model Kelheim
 stone CLE 111 UOClA
 (56.25)
GABINO, Amadeo (Spanish 1922-)
 Armatura Lunare I 1966
 anodized aluminum and

steel VEN-66:#210
Gables
 Key. Meat Market Gable
Gabon. Soto
Gabriel, Archangel See also Mary,
 Virgin--Annunciation
 Arnolfo di Cambio. Angel of
 the Annunciation
 Byzantine. Archangel Gabriel#
 Byzantine. Virgin and
 Archangel Gabriel
 Campbell, G. E. Archangel
 Gabriel, head
 Derujinsky. Angel Gabriel
 French--12th c. Archangel
 Gabriel
 French--13th c. Angel Gabriel
 French--15th c. Angel Gabriel
 German--11th c. Basle
 Antependium
 German--13th c. Shrine of
 Charlemagne
 German--15th c. Angel Gabriel
 Jean de Valenciennes.
 Zachariah and the Arch-
 angel Gabriel
 Pisano, Nino. Archangel
 Gabriel
Gabriel, Jacques Ange (Architect
 1698-1782)
 Lemoyne, J. B. Gabriel, bust
GADOR, Istvan (Hungarian 1891-)
 Stirachiamento 1961
 VEN-62:pl 197
Gagarina, Princess
 Martos. Princess Gargarina,
 sepulchral monument
GAGGINI See GAGINI
Gagik (Armenian King)
 Armenian. King Gagik, relief
GAGINI, Antonello (also Gaggini)
 (Italian 1473-1536)
 St. Margaret 1520/30 marble
 CLE 95 UOCIA (42.564)
GAGINI, Antonello--FOLL
 Madonna del Buon Riposo
 1528 marble BAZINW
 343 (col) IPa1M
 Virgin of the Annunciation
 c 1500 marble SEY pl
 137A IPalG
GAGINI, Domenico (also Gaggini)
 (Italian 1448-92) See also
 Isaia da Pisa
 Life of John the Baptist,
 panel detail 1448/65
 marble SEY pl 136A
 IGenC

The Nativity, relief marble;
 35-1/2x20-1/2 USNI 230;
 USNK 196; USNKP 419
 UDCN (A-32)
GAGINI, Domenico--ATTRIB
 Alfonso, or Ferrante, of
 Aragon Victorious after
 Battle, arch, left interior
 relief 1457 marble SEY
 pl 68A INCa
 Giovanni Montaperto Monu-
 ment 1485 marble SEY pl
 137B IMazC
GAGINI, Pace (also Gaggini)
 (Italian fl 1507) See PORTA,
 Antonio della
GAGINI, Pace--FOLL
 St. George and the Dragon,
 outdoor relief c 1495
 marble SEY pl 136B IGenI
GAGLIARDI, Tommaso (Italian
 1820-95)
 Thomas Crawford, bust
 FAIR 141; USC 194
 UDCCap
GAHAGAN, Sebastian
 General Sir Thomas Picton
 Monument 1816
 WHINN pl 161A ELPa
GAILDE, Jean
 Choir Screen, detail 1508/17
 EVJF pl 280 FAubM
Gainsborough, 4th Earl of
 Nollekens. 4th Earl of Gains-
 borough Monument
Galactic Insect. Cesar
Galaktotrophusa. Romanesque
GALAL, Khaled (Syrian 1933-)
 Woman 1964 terracotta
 VEN-64:pl 113
Galatea See also Pygmalion
 Hepworth. Torso III (Galatea)
 Le Lorrain. Galatea, seated
 figure
 Wright, F. A. Galatea
Galatro-Colonna, Princess
 Jerace, F. Princess
 Galatro-Colonna, bust
Galaxy. Kiesler
Galba
 Italian--17th c. Galba, bust
 Porta, G. B. della. Galba,
 bust
GALEFFI, Ernesto See CHIO
Galgano, Saint
 Italian--13/14th c. Reliquary
 of St. Galgano
Galgenkonig. Brummack

with Falcon
French--13th c. Tithe Vessel
for Grain: Dancing
Peasants; Falcon Hunt
French--15th c. The Falconer:
Philippe le Bon
French--15/16th c. St.
Gorgon Holding Falcon
Lyngwode. Falconer, stall
spandrel
Meit. Falconer
Pilgram. The Falconer
--Football
Sintenis. Football Player
--Gladiators
Bertoldo di Giovanni. The
Suppliant
Byzantine. Box at Hippodrome
Byzantine. Gladiators and
Lions
Fletcher. Gladitorial Table
Le Sueur. Gladiator
--Horse Racing
Degas. Cheval et Jockey
Degas. Jockey on his Horse
Hussmann. Finish
Stern. Racehorse
--Ice Hockey
Moschi. Ice Hockey Medal
--Jousting
English--14th c. Coffer: Two
Knights Jousting
French--14th c. Jousting at
Tournament, casket panel
--Jousting Scene, casket
plaque
French--15th c. Fireplace de-
tail: Knights Riding
Donkeys in Mock
Tournament
German--16th c. Jousting
Armor
--Jump Rope
Couturier. Young Girl
Skipping
Karny. Jumpers
--Jumping
Mazzulo, G. Woman Jumping
--Polo
Sintenis. Polo Player
--Running
Marcks. Pair of Runners
Perincioli. Starter
Underwood. Runner
Vries. Nude Runner
--Shot Put
Grandtner. Shot Putter

--Skating
Lienhard. Patineurs
Manzu. Skater
Manzu. Skating Girl
--Soccer
Moschi. Calciatore, medal
--Swimming and Diving
Bandura. Crawl
Brown, R. Divers
Brown, R. Swimming
De Lisi. Swimmer
Guerrisi. Swimmer
Kennington. Diver
Malfray. Torso of a Swimmer
Malfray. Two Swimmers
Martini, A. Donne che
Nuota Sott'Acqua
Messina. Swimmer
Mukhina. Diver
Stadler. Diver (Taucher)
--Wrestling
Abbal. Wrestlers
de Lalaing. Wrestlers, equest
English--13th c. Angel Choir:
Boss--Two Wrestlers
French--12th c. Door;
details: Two Men Wrest-
ling
Greco, E. Wrestler
Hoonaard. The Wrestler
Iche. The Wrestlers
Lambeaux. Wrestlers
Lederer, H. Wrestler
Maillol. Wrestlers
Vasconcellos. Boys Wrest-
ling
Zadikow. Wrestler
GAMSARAGEN, Daria
Female Figure*
MARTE pl 49
Ganga, J. H.
Heiliger. J. H. Ganga, head
Ganges
Bernini, G. L. Fiumi
Fountain
GANGL, Alojz (Yugoslav 1859-1923)
France Preseren, bust 1890
marble BIH 26 YL
GANO DA SIENA (Italian d 1318)
Ranieri del Porrina, effigy
WHITNJ pl 131C ICasoC
Gansemancher Fountain. Labenwolf
Ganymede
Cellini. Ganymede
French--11th c. Capital:
Abduction of Ganymede
Hubacher. Ganymede

Tadolini. Ganymede
Thorvaldsen. Ganymede with
 Jupiter as the Eagle
GARAMI, Laszlo (Hungarian 1921-)
 Grape Harvester (Weinlese)
 1952 wood; 105 cm GAD
 127
GARBE, Herbert (German 1888-1945)
 Christus and Maria 1934 ton
 fur kunststein; 1.65 m
 HENT 108
 Das Erwachen 1931 stone; L:
 1.10 m HENT 106 GBN
 Mother and Child (Mutter und
 Kind) 1931/32 kunststein;
 1.25 m HENT 107 GBN
 Reaping Machine artificial
 stone VEN-34:pl 161
 Schnitterin 1933 kunststein;
 1.40 m HENT 107 GBN
 Sleep (Schlaf) 1919 wood;
 45x93x28 cm OST 11 GHaL
GARBE, Richard L. (English 1876-)
 The Adoration of Youth
 AUM 125
 Autumn ivory
 MARY pl 173 ELN
 Drake Irish limestone
 MARY pl 176 ELN
 A Dryad ivory and bronze
 AUM 125; MARY pl 173
 Figure terracotta
 NEWTEB pl 29
 The Mumner Serravezza
 marble PAR-1:40
 Primavera ivory
 MARY pl 173; PAR-1:41
 The Red Shawl Japanese ash
 lacquered MARY pl 74;
 MILLER il 188
 Sea Lion Verdi di Prato
 MARY 4 ELN
 Sonate Pathetique--Beethoven,
 head MARY pl 164
 Song of the Sea, fountain
 figure bronze AUM 125;
 MARY pl 145
GARBUTT, A. S.
 Abstract oak; L: c 11
 NORM 56
 Torso wood; 24
 NORM 17
Garcia Osorio, Don
 Siloe, G. de--Foll. Don
 Garcia Osorio Monument
Garden Bench. Bloc
Garden Fireplace. Gilioli

Garden of Eden See also Adam and
 Eve
 French--9th c. Diptych of
 Areobindus
 Italian--4th c. Adam in the
 Garden of Eden, diptych
 detail
Garden Sculpture and Ornaments
 Austrian. Rococo Garden
 Vase
 Braun, M. B. Garden Figure(s)
 Coysevox. Fame
 Gies. Pan
 Hepworth. Garden Sculpture
 (Meridian)
 Kolbe. Garden Figure
 Nost. Garden Figures
 Pilkington-Jackson. Garden
 Ornament
Les Gardien des Astres. Altdorf
Gare Invernali. Martini, A.
GARELLI, Franco (Italian 1909-)
 Figure 1953 bronze; .60 m
 SCUL pl 68
 Figure 1959 iron
 MAI 104
 Figure (Versione 1) 1957
 bronze; 1.55 m SCUL pl
 69
 Figure Ema 1958 iron; 61
 TRI 191
 Figure Emi 1965 iron
 VEN-66:#63
 The Host 1960 bronze
 SAL 50
 In the Studio 1954
 BERCK 268
 No. 9--Figure--Arrivederci
 1961 40x50.75 CARNI-60:
 #120 UNNPar
 Non Lasciarmi 1962 iron
 READCON 249; VEN-62:pl
 19
 T. R. 2 1966 iron
 VEN-66:#64
GARGALLO, Pablo Maella (Pau
 Gargallo) (Spanish 1881-1934)
 Antinous 1932 iron
 MAI 105
 Bacchante copper
 MARTE pl 21
 Faunesse 1908 copper
 SELZJ 205 FPAn
 Harlequin with Flute 1932
 bronze; .98x.20x.41 m
 BAZINH 481; MARC pl 24
 (col); MOD FPM

Harlequin with Mandolin 1925
 iron RAMS pl 73b
Head 1903 terracotta
 SELZJ 205 FPAn
Monsier de Soto, bust 1920
 lead
 SELZJ 210 FPAn
Picador 1928 wrought iron; 9-
 3/4 HOF 56; LIC pl 240;
 LYNCM 101; NNMARO
 pl 309; READCON 92;
 UNNMMAM #168 UNNMMA
Picasso, head 1912 stone
 HOF 145; MAI 105; MARY
 206 SpBaM
The Prophet 1933 bronze; 94
 BAZINW 435 (col); EXS
 79; LARM 291; MAI 106;
 MARTE pl 21; MID pl 50;
 RAMS pl 74; TRI 18 FPM
Rooster (Le Coq) 1930 wrought
 iron
 SDP LIV; ZOR 50 UNNMM
St. Peter iron
 VEN-56: pl 136 SpMaM
Self-Portrait iron
 MARTE pl 21
Small Mask 1911 copper
 SELZJ 210 FPAn
Urano 1933 bronze
 RAMT pl 56 SpBa
The Violinist bronze
 MARY pl 146 SpBa
Gargoyles See also Grotesques
 Arp. Gargoyle
 French--11th c. Gargoyle
 French--12th c. Gargoyles,
 Notre Dame, Paris
 German--13th c. Gargoyle
 German--14th c. Gargoyle
 Raverti. Gargoyle and
 Gigante
Garibaldi, Giuseppe (Italian Patriot
 1807-82)
 Bistolfi. Garibaldi Monument
 Martegana. Giuseppe
 Garibaldi, bust
 Turini. Giuseppe Garibaldi
Garinus
 Braun, M. B. Hermit Garinus
Garland of Buds I. Arp
Garment of Light. Guino
GARNIER, Charles (French Architect
 1825-98)
 Grand Staircase 1861-75
 JANSH 464; SCHMU pl 23
 FPOp

Portraits
 Carpeaux. Charles Garnier,
 bust
Garnier, Francis (French Explorer
 1839-73)
 Puech. Admiral Garnier
 Monument
GARNISSON, Robert
 Relief Decoration for Bank
 MARTE pl 38
GARRARD, George
 Duncan's Maddened Horses,
 relief 1797 plaster
 WHINN pl 135A ESou
Garrard, Jacob
 Horsnaile, C., the Elder.
 Sir Jacob Garrard,
 recumbent effigy
Garrick, David (English Actor
 1717-79)
 Roubiliac. David Garrick,
 bust
 Webber. David Garrick
 Monument
Gas Attack. Nelson
Gasparo da Salo
 Zanelli. Gasparo da Salo,
 bust
Gassevskaia, Tanosa
 Brancusi. The Kiss (Tomb
 of Tanosa Gassevskaia)
GASTEIGER, Matthias (German
 1872-)
 Hercules and the Hydra
 AGARC 152 UMoSL
Gate of Hell, sarcophagus detail.
 Italian--12th c.
The Gate of Hell# Rodin
Gates and Gateways
 Austrian--13th c. Giant's
 Gate
 Avraam. Korsun Gate
 Baroque-Rococo. Entrance
 of Northwest Wing,
 Zwinger Palace, Dresden
 Basaldella. Mausoleum of the
 Fosse Ardeatine: Gates
 Bellotto, U. Gates, Sala
 dell' Orafo
 Binet. Paris Universal
 Exhibition Entrance Gate
 Blondel. Porte Saint-Denis
 Brancusi. The Gate of the
 Kiss
 Brasini. Zoo Gate
 Braun, E. Court Residence
 Gate

SELZJ 220 UNNMMA
Brass Toy
 HOF 311; WILM 112
Caritas
 TAFTM 27
La Chanteuse Triste (The
 Singer) stone
 JOHT pl 170; MARY pl 113;
 TAFTM 27 ELN
The Dancer bronze; 1/3 LS
 CASSM 107
 --1913 bronze; 28-7/8
 ROTJB pl 34 ELSc
 --1913 plaster, on plaster
 base supported by wood
 armature; 31x7-1/4x7-1/4
 TATEB-1:27 ELT (6092)
Dog 1912/13 bronze; 14
 HAMM 54A -EEd
Duck 1913/14 bronze; 4-3/4
 HAMM 54B FPM
Ezra Pound, head marble
 TAFTM 27; VALE 54
Fawn
 AUES pl 50 ELT
 --green bronze
 CASSM 109 ELLe
Horace Brodzky, head 1913
 bronze; 26-3/4
 CAN-2:205 CON
 --HAMM 57 (col); ROTJG
 pl 11 ELT
The Imp 1914 veined
 alabaster; 40.5x8x8.5 cm
 CAS pl 202; LIC pl 195;
 RAMT pl 31 ELT
Red Stone Dancer 1913 Mans-
 field sandstone; 17
 HAMP pl 110B; READCON
 76; SELZJ 220 ELT
Seated Figure stone formerly
 -Q CHENSP 278; CHENSW
 486; MARY pl 108;
 TAFTM 27
Seated Woman
 VALE 58 UMSpBu
 --1914 marble; 18-1/2
 BOSME pl 14 URNewB
 --1914 marble; 19
 HAMM 56 FPM
Sleeping Faun 1913 plaster;
 5-1/2x10 RAMS pl 58a
 ELV
Stags 1914 alabaster
 LARM 322; MAI 106 UICA
Torso
 AUES pl 54 ELT

Torso (Torso of a Girl)
 c 1913 marble; 10
 CASSM 108; RAMS pl 57;
 READAS pl 193 ELV
Gauguin, Mette-Sophie Gad
 Gauguin. Mme. Gauguin, head
GAUGUIN, Paul (French 1848-1903)
 Adam and Eve, relief 1891/
 93 wood SELZJ 177
Be in Love and You Will Be
 Happy (Soyez Amoureuses
 vous Serez Heureuses),
 relief with self portrait
 1889 polished and ptd
 lindenwood; 47-1/8
 BOSMI 163; HAMP pl
 26B; LIC pl 143; SCHMU
 pl 128 UMB (59.52)
Caribbean Woman (La Luxure)
 1890/91 wood; 21-1/2
 READCON 47 DFW
Cupboard Panel 1881 ptd
 wood CAS pl 232
Huia 1895/98 bronze; 14-1/8
 BOW 116 ELMa
Idol
 ENC 330
 --wood
 LARM 245
Idol with Pearl 1895/98
 bronze; 9-1/2 BOW 115
 ELMa
Idole (a la coquille) 1900
 terre-vernisse; 28x23
 cm LIC pl 144
Mme. Emile Schuffenecker,
 bust c 1889 plaster
 SELZJ 176 FPL
Mme. Emile Schuffenecker,
 portrait vase 1888/89
 ceramic; 9-1/2 SCHMU
 pl 122 FPRev
Mme. Gauguin, head 1877
 white marble; 13
 COOPC pl 85; SELZJ 176
 ELCo (#227)
Manao Tupapau--She is
 Thinking about the Spirit
 of the Dead Man, relief
 1891/93 wood; 20-5/8
 TRI 40 SwB
Noix Sculptre (Fruit des
 Illes) c 1901/02 Head
 (coconut shell); 11x12x
 5-1/2 ALBC-4:81 UNBuA
Pitcher 1886/87 ceramic
 CAS pl 234 FPDec

GAUGUIN, Paul 371

Self Portrait, profile relief
terracotta GOLDWA 368
Table Centerpiece, with
figure 1888 ceramic CAS
pl 233
"Te Fare Amu", relief c 1896
ptd wood; 10x59 SELZS
37 UNNPear
Tehura, head 1891/93 wood
/SELZJ 177 UNNGe
Woman with Dog and Foliage,
panel wood MAI 107
GAUL, August (German 1869-1921)
Boy on Donkey
TAFTM 68
Duck (Stehende Ente) 1911
bronze; 40 cm OST 20
GHaL
Eagle
TAFTM 68
Lion (Lowe)
TAFTM 68
--1904 bronze; 52
HENT front GBN
--NNMMAG 144 GH
Mercury 1913 bronze; 1.97
m OST 18 GHK
Ostrich (Strauss) bronze;
6x5x2.3 cm (with bronze
base) OST 21 GBN
GAUQUIE, Henri (French)
Watteau Monument
TAFTM 33
GAUTHIERE, Pierre--ATTRIB
Andirons: Opposing Goats
ormolu; 19-1/2 BOSMI
139 UMB (27.521)
Gavel. Johnson, J.
Gavial
Barye. Tiger Devouring a
Gavial
Gawain
French--14th c. Casket:
Matiere de Bretagne
(Arthurian Cycle):
Lancelot; Gawain
Gay, John (English Poet and Play-
wright 1685-1732)
Rysbrack. John Gay Monu-
ment
Gay Bandolero. Johnstone
Gaya Nuno, Juan Antonio
Serrano. Juan Antonio Gaya
Nuno, head
Gazelles
Barye. Tigre Devorant une
Gazelle
Bayser-Gratry. Gazelle

Bouchard. Fountain: Girl
with Gazelle
Bouchard. Girl and Gazelle
Byzantine. Gazelle Drinking from
a River of Paradise, relief
fragment
Reznik, Arie. Gazelles
Tofanari. Gazelle in Watchful
Repose
GEBEL, Matthes (German)
Duke Philip der Streitbare,
Nuremberg 1530 lindenwood;
49 cm MUL 45 GMBN
Gee, Orlando
Bird. Sir Orlando Gee Monument
GEEFS, Guillaume (Belgian 1805-83)
General Belliard
GOR 23 BB
"Love When Thou Holdest Us"
(The Lion in Love) c 1851
ROOSE 291; VICG 127
Theodore Schaepkens, bust
GOR 24 BBHV
GEEL, Jan Frans van (Belgian),
See also VOORT, Michel and
Jan van HOOL
Pulpit detail: Calling of Saints
Peter and Andrew wood
CHASEH 398 BAA
GEERTGEN TOT ST. JANS
Painting of Altar Group,
detail: Sacrifice of Abra-
ham c 1480 MULS pl 105A
NAR
Geese
English--15th c. Choir Stall,
detail: Geese Hanging the
Fox
Faberge. Goose
Labenwolf. Gansemanchen
Fountain
Pasti. Venus, relief
Tofanari. Geese
Geffroy, bust. Rodin
Der Geflugelte. Werthmann
Gehaltene Unsicherheit. Witschi
GEIBEL, Hermann (German 1889-)
Bull (Stier) 1951 clay; L: 20
GERT 91; SCHAEF pl 55
Female Head (Frauenkopf)
1951 clay GERT 90
Pantheresque 1951 bronze;
L: 14-1/2 SCHAEF pl 54
GEIGER, Ferdinand See ALIPRANDI,
Giovanni
GEIGER, Nicolaus (German 1849-97)
See SCHMITZ, Bruno
GEISER, Karl (Swiss 1898-1957)

Groupe I bronze
 JOR-1: pl 18 SwBeG
Groupe II bronze
 JOR-1: pl 19 SwBeG
Monument au Travail 1952/57
 JOR-2: pl 112
Vater des Kunstlers, head
 1930 bronze; 30 cm JOR-
 1: pl 16
Weibliche Figure 1930/32
 bronze; 155 cm JOR-1: pl
 15 SwBeKM
Der Geistkampfer
 Barlach. The Fighter of the
 Spirit
Gelenkraum. Rehmann
Gelinotte
 Braque. Horse
 Braque. Petit Cheval
GELLES, Carl (Austrian 1889-)
 Lilly marble
 PAR-2: 95
GELLI, Lelio
 Anita
 CASS 75
 Young Bather bronze
 CASS 82
GEMELICH, Hans Leonhard (German
 1574-)
 St. Sebastian c 1627 wood
 BUSB 65 GAuM
Gemignano, Saint
 Agostino di Duccio. St.
 Gemignano life, scenes,
 relief
GEMITO, Vincenzo (Italian 1852-1922)
 Alexander, bust bronze
 VEN-28: pl 119
 Fisherman (Il Pescatore)
 VEN-32: pl 4
 L'Inverno silver
 VEN-20: 77
 Water Carrier
 CHASEH 477 UMCHR
 Young Fisherman (Fisher Boy)
 c 1880 bronze
 MOLE 266; POST-2: 201
 IFBar
Gemmingen, Uriel von
 Backoffen. Uriel von Gem-
 mingen Tomb
Geneigter Frauentorso. Lehmbruck
Genesis
 Epstein. Genesis
 Lambrechts. Genesis
 Nicolaus and Wiligelmus.
 Genesis, left of portal
 reliefs

Wiligelmus. Genesis Scenes
GENEVIEVE (Genevieve Pezet)
 (American-French 1918-)
 Figure ceramic
 MAI 108
Genevieve, Saint
 French--13th c. St. Genevieve
 Landowski. St. Genevieve
Genghis Khan (Mongol Conqueror
 1162-1227)
 King, Phillip. Genghis Kahn
Genie Funeraire
 Rodin. Funeral Genius
Geniessen. Herzog
Genii. D'Altri
Genius Guarding the Secret of the
 Tomb
 Saint-Marceaux. Secret of the
 Tomb
Genius of America. Persico, E. L.
Genius of Beethoven. Kolbe
The Genius of Franklin Monteverde
Genius of Victory
 Michelangelo. Julius II Tomb:
 Victory
Genius of War. Rodin
Genoa, Duke of
 Balzico. Duke of Genoa Monu-
 ment, equest
Genoels, Elderen Diptych
 Flemish--10th c. Visitation
Genova, Duchess
 Canonica. Duchessa di Genova
 Madre, bust
GENTILI, Antonio da Faenza
 Knife, Fork, and Spoon
 c 1580 silver, cast and
 chased; knife L: 8-1/2
 DETD 135 UNNMM
GENTILS, Vic (Belgian 1919-)
 Anonymous Tomb 1963
 VEN-64: pl 128 BBD
 Chartres, assemblage 1964
 70-1/8x47-1/4 NEW pl
 194 BBVe
GENNUCCHI, Giovanni (Belgian 1904-)
 La Notte 1945 stone; 50 cm
 JOR-1: pl 52
 Orsola 1949 H: 30 cm
 JOR-1: pl 51
Geoffroy, Mme.
 Drivier. Mme. Geoffroy, head
Geometry
 Pollaiuolo, A. and P. Sixtus
 IV Monument: Geometry
Georg, Count Palatine (Bishop of
 Speyer)
 Schwarz, Hans. Count Palatine
 Georg, medal

George, Saint

Asam, E. Q. High Altar, with
St. George and the Dragon
Austrian--15th c. St. George
Austrian--16th c. St. George,
equest, altar relief
Baroncelli, N., and Domenico
di Paris. St. George
Bavarian--16th c. St. George
and the Dragon
Bayrischer Meister. St.
George
Bilinski. St. George and the
Dragon
Borman, J., the Elder. Altar
of St. George
Bruggemann. St. George,
equest
Brullmann. St. George and
the Dragon, facade relief
Burckhardt, St. George,
equest
Burton. Music Room Panels:
St. George
Colombe. Altarpiece of St.
George
Donatello. St. George
Donatello. St. George Taber-
nacle: St. George and the
Dragon
English--12th c. Tympanum:
St. George
English--14th c. St. George
and the Dragon, coffer
front
English--14/15th c. St.
George and the Dragon
English--15th c. St. George
and the Dragon
--St. George Killing the
Dragon, equest
English--16th c. St. Thomas
More's Pendant
English--18th c. Carriage,
wheel detail: St. George
and the Dragon
Ermolin. St. George, bust
Frampton. St. George
Fremiet. St. George
French--12th c. Facade;
detail: St. George
French--16th c. St. George
and the Dragon
French, or Flemish--16th c.
Legend of St. George
Fullard. Infant St. George,
assemblage
Gagini, P.--Foll. St. George
and the Dragon

German--15th c. Agnus Dei
Box Pendant
--St. George#
Gilbert, A. Duke of Clarence
Tomb, trial case: St. George
Gilbert, A. St. George and the
Dragon
Italian--13th c. St. George and
the Dragon
Johan de Vallfogona, Pere. St.
George, equest relief
Klausenberg, G. and M. von.
St. George and the Dragon
Kolozsvari. St. George and the
Dragon
Leinberger, H. St. George
Leonardo da Vinci. St. George
Fighting the Dragon
Loyet. Charles the Bold
Reliquary
Luck, P. St. George and the
Dragon, relief
Maraini. St. George
Master of the Mercy Gate.
Mercy Gate, tympanum
Multscher. St. George
Netherlandish. St. George
Notke. Reliquary of St. George
Notke. St. George#
Pacher. St. George
Pistrucci. St. George and the
Dragon, medallion
Rumanian--15th c. Wallachian
Doors; detail: St. George
Tirolean. St. George
George. Brancusi
George I and George II (Cardinals of
Amboise)
Roux. Cardinals George I and
George II of Amboise Tomb
George I (King of England 1660-1727)
Marchand. George I, bust
Rysbrack. George I, bust
George II (King of England 1683-1760)
Lucke. George II, bust
Rysbrack. George II, bust
Rysbrack. George II, bust,
Chelsea Porcelain after
Rysbrack(?) model
Rysbrack. George II as a
Roman Emperor
George III (King of England 1738-1820)
Bacon, J. George III#
Carlini. George III, bust
Derby Porcelain. Royal Family
English--18th c. George III
medal
Nollekens. George III, bust

Turnelli. George III, bust
Wilton. George III as a Roman
 Emperor, equest
George IV (King of England 1762-
 1830)
 Chantrey. George IV, equest
 English--19th c. George IV
 as Prince Regent, bust
George V (King of England 1865-
 1936)
 Dick. King George V, bust
 Thornycroft, H. King George
 V, bust
George Dux d 1589
 German--16th c. George Dux,
 effigy
George of Cappadocia, Saint
 Byzantine. St. George of
 Cappadocia, jewel
George of Cumberland, Prince
 Behnes. Prince George of
 Cumberland, bust
GEORGIAN
 Altar Screen, detail 6th c.
 stone RTC 244 RuTC
 Altar Screen Capital: Animal
 Motif 5th c. RTC 238
 Cathedral Column Capital,
 west porch early 12th c.
 RTC 245 RuKuB
 Column Capital, detail:
 Bull's Head, relief, Sion,
 Bolinsk 478/494 RTC 238
 Kuropolate Ashote Presenting
 Church to Savior, relief
 826 RTC 240 RuOp
 St. Mamas Riding Lion, tondo
 6/7th c. silver RTC 242
 Stephanus I, Patriarch of
 Kartli, relief, east front
 7th c. RTC 240 RuDC
 Two Saints, plaque c 8th c.
 silver RTC 243
GEORGII, Theodor (German 1883-)
 Entombment
 TAFTM 69
 Pieta marble
 PAR-2:32
Gerarchie. Mazzacurati
GERARD (German)
 Osnabruck Font: Baptism of
 Christ, Lower Saxony
 c 1226 cast bronze; 260
 mm SWA pl 234 GOsC
GERARDI, Alberto (Italian 1889-)
 L'Arcangelo Michele e il
 Dragone 1952 bronze; 1.30
 m SCUL pl 17

Sleeping Woman (Dormiente)
 1947 terracotta SCUL pl 16;
 VEN-56: pl 30 IRZu
St. Michael, study 1950
 VEN-50: pl 34
Gerburg, Wife of Dietrich III of
 Brehna
 Naumberg Master. Founder's
 Choir
GERDUR (Gerdur Helgadottier) 1928-
 Sculpture in Iron
 MAI 109
Gereon, Saint
 German--10th c. Christ in
 Majesty Blessing St. Victor
 and St. Gereon
Gergy, Languet de
 Slodtz. Languet de Gergy Tomb
GERHAERTS, Nicolaus (Dutch fl
 1462-73)
 Archbishop Jacob von Sierck,
 effigy 1462 MULS pl 91
 GTB
 Barbel von Ottenheim 1464
 sandstone; 18-1/4 KO pl 60;
 MULS pl 92; NEWTEM pl
 101 GFL
 Barbel von Ottenheim (The
 Sibyl), bust (now destroyed)
 c 1470 BUSR 87 FStrC
 Canon Conrad von Busnang
 Monument 1464 MULS pl
 90A FStrMu
 Count von Lichtenberg, head
 c 1465 sandstone; 11 KO
 pl 60 FStrF
 Crucifix 1467 H: 90-1/2
 JANSK 599; MULS pl 90B
 GBadeC
 Friedrich III Tomb begun
 1467 BUSR 89; MULS pl
 95A AVS
 Grotesque Head c 1465 H: 14
 JANSK 601 FStrM
 Madonna, Dossenheim c 1480
 limewood; 30 KO pl 61
 FStrF
 Male Figure, half length
 c 1465 sandstone; 28-1/8
 MAR 110
 Male Head 1465/70 limestone;
 8-1/2 KO pl 60 GMBN
 St. Anne, with Mary and Jesus
 (Anna Selbdritt) c 1467 light
 red sandstone; 25-5/8
 BERL pl 193; BERLEK pl
 17; BERLES 193; FREED
 pl 17; MOLE 85 GBSBe (5898)

Self Portrait, bust c 1467
sandstone; 17-3/8
BAZINW 320 (col); CHENSW
358; ENC 334; KO pl 60;
MULS pl 93; NEWTEM pl
102 FStrF
GERHAERTS, Nicolaus (Nicolaus
Gerhaert von Leyden)--
ATTRIB
St. Barbara, bust ptd and
gilded lindenwood; 14
NMA pl 54 (col) UNNMM
(17. 190. 1735)
GERHARD, Hubert (German c 1540/
50-1620)
Allegorical Figure 1595
ST 329 GSchl
Archangel Michael 1588
bronze; over LS MUL 74;
ST 329 GMMi
Augustus Fountain 1589/94
bronze CHASEH 363 GAuR
--Allegorical Figure
KO pl 86
--River God and River God-
dess MUL 76, 77
Bavaria Cupola 1623 bronze
BUSB 24 GMHo
Goddess: Agriculture, garden
figure 1594 BAZINW 370
(col) GMR
Patrona Bavariae, in front of
Town Hall 1613 HEMP pl
18 GM
St. Michael Slaying the
Devil, facade, bronze
BAZINW 370 (col) GMMi
Sextus Tarquinius Threaten-
ing Lucrece bronze
CLE 113 UOC1A (62. 245)
GERICAULT, Theodore (French 1791-
1824)
Nymph and Satyr 1817/20
terracotta; 16 cm LIC pl
69 UNBuA
Satyr and Nymph c 1818
bronze; 11-1/2 NOV pl
183
GERINES, Jacob de--FOLL (Flemish
1445/48-1476)
Anne of Burgundy as Humility
bronze BAZINW 315 (col)
NAR
Germ-Construction. Pevsner
Germain, Jacques
French--15th c. Jacques
Germain Tomb

GERMAIN, (Francois) Thomas (French
1673-1748)
Andiron 1757 gilt bronze;
22 CHAR-2: 197 FPL
Candelabra and Centrepiece
with Hunting Scene 1757
COOP 134 FPLop
Candelabrum 1758 silver
CLE 138 UOC1A (40. 14)
Covered Porringer 1733/34
silver gilt: 4x11-3/4
CHAR-2: 202 FPL
Louis XV Wall Candelabra
1756 ormolu SOTH-2: 224
GERMAN
Education of the Virgin ptd
wood PANA-2: 89 UMCB
Elizabeth and Mary
BUSG pl 40 GBaC
--2nd c.
She-Bear of Aachen bronze;
35 NEWTEM pl 39 GAaC
--2nd/3rd c.
Proserpina Sarcophagus: St.
Michael's Chapel
KIDS 10 GAaM
--5th c.
Animal Style Brooch, detail
Galsted silver gilt
ENC 30
Animal Style Brooch, Jutland
silver gilt ST 120 DCN
Warrior, plaque, Gresin
terracotta LARB 83 FStG
--6th c.
Animal Style Brooch, Seeland
silver gilt ST 120 DCN
--6/7th c.
Christ, pyx relief, late
Roman-Christian style
ivory LOH 38 GWeA
--7th c.
Bracteate: Lancer and Fallen
Enemy gold plate ST 129
GStWL
Christ in Glory, book cover
detail ivory NEWTET 2
GBS
Triangular Belt Clasp
ST 126 GStWL
--8th c.
Chalice of Tassilo, Krems-
munster c 780 copper, ap-
plied silver niello CHRC
161; ENC 173
Dagulf's Psalter: King David
and St. Jerome; David

Choosing Poets of the
Psalms, and Playing the
Harp, Palace School,
Aachen before 795 ivory;
6-5/8x3-3/16 BECKM 34
FPL
Horseman of Hornhausen,
relief c 700 stone; 30-
3/4 NEWTEM pl 48 GHallL
--8/9th c.
Christ Treading the Beasts;
Scenes from Life of Christ,
book cover, Palace School,
Aachen ivory; 8-5/16x
4-7/8 BECKM 35 EOB
--9th c.
The Ascension, triptych frag-
ment ivory; 5-1/2x3-1/2
LAS 104 (col) GDaH
Book Cover: Annunciation,
Adoration of the Magi,
Massacre of the Innocents,
Metz ivory; 10x6-1/2
BECKM 65 FPBN
--Massacre of the Innocents
c850 ivory; 58 mm SWA
pl 16
Book Cover: Christ Treading
the Beasts, between Angels;
below: Magi Before Herod,
Lorsch Gospels early 9th c.
15x10-1/2 BECKM 36 IRVB
Book Cover: Virgin and Child
Enthroned Between Zacharias
and St. John; below: The
Nativity, Annunciation to
the Shepherds, Lorsch Gos-
pels, Palace School, Aachen
ivory; 15x10-1/2 BECKM
37 ELV
Charlemagne's Throne marble
slabs LAS 92 (col) GAa
Christ, Lorsch, Ada School,
diptych detail ST 150 IRV
Christ, head, Lorsch
BAZINW 218 (col) GDaH
Codex Aureus of St. Emmeran:
Christ, The Evangelists,
Gospel Scenes c 870 gold
leaf, embossed and jeweled;
420x330 mm BECKM 51
(col); LOH 55; NEWTET 96
(col); ST 150, 151; STA
33 (col); SWA pl 9, 10
GMS (Cod Lat 14000)
Codex Monacensis Cover:
Doctrine and Salvation

c 870 ivory, jeweled LOH
47 GMS
Crucifixion, book cover detail,
Metz c 850 ivory; 64 mm
CLAK 403; SWA pl 18 FPBN
Dormition of the Virgin, relief
ivory GUIT 128 GDaH
Grille. detail c 800 bronze
BAZINW 217 (col) GAaC
Life of Christ: 3 scenes,
Metz, from a book cover
ivory; 22.2x11.6 cm BSC
pl 14
--Christ in Majesty (Christus
in der Herrlichkeit,
Majestas Domini), with
symbols of Four Evangelists
ivory; 19x13 cm BSC pl 14
GBS (598)
Lindau Gospels (Ashburnham
Gospels; Codex Aureus of
Lindau): Crucifixion, Sun
and Moon, Mary and John,
Angels, St. Denis c 870
gold, jeweled; 13-3/4x10-
1/2 BECKM 50 (col);
GARDH 20; JANSH 218 (col):
JANSK 395; MOREYM pl 67;
SWA pl 11, 12 UNNM
Lion's Head Medallion c 800
bronze; Dm: 11-5/8
NEWTEM pl 47 GAaC
Psalm 26, Prayer Book of
Charles the Bold (copy from
Utrecht Psalter), Reims
c 870 4-3/8x3-7/16 BECKM
49; SWA pl 4 SwZS
Resurrection of the Dead, with
Personification of Roma, Sea,
Earth, Crucifixion detail,
Reims c 860 ivory; 281x128
mm SWA pl 5 GM
St. Michael, relief ivory
WORR 30 GLB
Sola, Anglo-Saxon Monk, tondo,
Solnhofen 819/42 BAZINW
218 (col)
Story of Suzanna, carved for
Lothair II, Abbey of Waul-
sort on the Meuse 855/62
rock crystal; Dm: 4-1/2
BECKM 69 ELBr
--9/10th c.
The Annunciation, book cover
panel ivory STA 46 GBS
Book Cover: Adoration of the
Magi, Presentation in the

Temple, Metz, formerly
at Sens BECKM 67 ELV
Book Cover: Crucifixion,
Metz, originally on a
Gospel in Cathedral
Treasury, Verdun ivory;
8-1/4x4-3/4 BECKM 66
ELV
Box of the Infancy of Christ,
Metz ivory; .224x.240 m
CHAR-1:226 FPL
St. Gregory with Three
Scribes, book cover relief
ivory; 8x4-7/8 ARTV pl
28; CHRC fig 75; FREM
35; KO pl 33 AVK
--10th c.
The Annunciation, relief,
Reichenau 980/90 ivory
STA 39 GBaC
Baptism of Christ, Metz or
Saxony ivory; 150x220x
110 mm SWA pl 54 GBrSM
Beasts of Evangelists, Essen
cloissone enamels; c 60x
50 mm SWA pl 27 GEA
Candlestick, detail: Striving
from Darkness of Vice to
Light of Christ silver gilt;
460 mm SWA pl 50 GHiMa
Christ and Attendants, plaque
ivory TAYFF 34 (col)
UNNMM
Christ in Majesty between
Four Evangelists, relief,
Trier ivory; 8-1/4x4-7/8
BECKM 134 GBS
Christ in Majesty Blessing
St. Victor and St. Gereon,
relief c 1000 ivory BECKM
139 GCoG
Codex Aureus Epternacensis
(Echternach Gospel): Christ
on the Cross between
Longinus and Stephaton,
Trier 983/91 ivory, panel
with enamels, pearls, and
jewels on gold ground;
8x5 BECKM 137 (col); KO
pl 47; LAS 99 (col) GNG
Cross of Mathilda, Essen;
reverse; front detail
c 980 gold; 445 mm
BECKM 140; SWA pl 28,
29 GEA
Crozier, Saxony(?) 999 gold
filigree SWA pl 25 GQS

Crozier of Bernward of
Hildesheim, head detail
silver gilt; 110 mm SWA
pl 51 GHiC
Crucifix, Trier 977/93 ivory,
enamels and jewels on gold
BECKM 150 (col) NMaS
Crucifixion, book cover,
Lorraine(?) 205x147 mm
SWA pl 18
Crystal of Lothar rock
crystal: Dm: 7-3/10
MU 110 ELBr
Diptych: King David and
Pope Gregory the Great,
Alpine Monastery c 900
BECKM 35 IMonC
Essen Madonna (Golden
Madonna; Golden Virgin of
Essen), Cologne c 980
gold leaf, wood core; 29-
1/8 BECKM 141 (col);
FREM 30 (col); KIDS 32
(col) LOH 49; NEWTEM pl
49; ST 151; SWA pl 39,
40; VEY 56, 130 GEC
Gero Cross c 970 oak, traces
of color; 73-5/8
BAZINW 221 (col); BECKM
151; CLAK 235; JANSH
205; JANSK 398; KIDS
141; KO pl 47; LOH 50;
NEWTEM pl 50; ST 152;
VEY 129 GCoC
Gisela Jewels: Eagle Clasp;
Brooches; Tassel; Ring,
Mainz(?) gold, enameled
and jeweled BERL pl 172;
BERLES 172 GBSBe
(61, 46; 61,48/49; 61,52;
61,58)
Gospel Cover, Abbey of
Echternach: Crucifixion,
relief ivory, wide gold
border POST-1:19; ROOS
72E GGL
Incredulity of St. Thomas,
Book Cover, Echternach
Group c 990 ivory WORR
47 -Fig
Incredulity of St. Thomas
(Christ and the Doubting
Thomas), plaque, Treves,
Abbey of Kues c 990 ivory;
9-1/2x4 BECKM 134;
JANSK 399; MYBA 255;
SWA pl 21, 22 GBM

378

Lothar Crucifix (Cross of
Lothair), with 1st c. cameo
of Augustus, and rock
crystal seal of Lothair,
Cologne c 1000 gold
filigree, jeweled and
enameled, on wood; 19-5/8
x 15-1/4 BECKM 141; 142
(col); KIDS 31 (col); KO pl
33 (col); LOH 45; PRAEG
193 (col); STA 38; SWA pl
28, 29; VEY 145 GAaC
Moses Receiving the Law,
Trier, Abbey of Kues c
990 ivory; 9-1/2x4 BECKM
134; SWA pl 21 GBM
Reliquary: Foot of St. Andrew,
Treves 977/93 copper gilt;
20x385 mm SWA pl 27 GTC
Situla: Church Figures and
Guardians of Heavenly City
c 1000 ivory, jeweled gold
ground; 7 BECKM 135 GAa-
C
Virgin and Child Enthroned,
relief, Trier or Mainz
ivory; 8-5/8x3-15/16
BECKM 139; SWA pl 38
GMaiA
Virgin Enthroned ivory;
8-5/8 NM-7:13 UNNMM
(17.190.49)
--10/11th c.
Crown of Holy Roman Empire,
Lorraine and Mainz(?)
SWA pl 30, 31 AVSch
--11th c.
Ambo of Henry II 100/24
LOH 65 GAaC
Apostles
BAZINW 280 (col) SwBC
Arm Reliquary of St. Blase,
Braunschweig c 1038
jeweled gold; 510 mm SWA
pl 27 GBrSM
Basle Antependium (Golden
Altar of Basle): Christ
Adored by Emperor Henry
II and Empress Kunigunde,
between Archangels Michael,
Gabriel, and Raphael, and
St. Benedict, formerly in
Basle Cathedral, Mainz or
Fulda c 1019 chased gold
leaf on cedar; 39-3/8x
68-7/8 BECKM 144 (col);
GAF 160; KO pl 48 (col);
SWA pl 41; WATT 149
FPCl

--Christ between Archangels
and St. Benedict
ST 154
--St. Benedict and Angel
NEWTEM pl 53
--St. Michael; Kunigunde;
Benedict and Michael;
Scrolls SWA pl 42, 44-45
Book Cover: Book of
Periscopes, executed for
Henry II, and presented by
Cathedral of Bamberg,
1012(?) ivory panel, set in
enameled and jeweled gold;
13x9-3/8
BECKM 48; 109 (col) GMS
Book Cover: Christ on Cross,
Mainz silver; 148x113 mm
SWA pl 30 GMaiC
Book Cover: Codex of Abbess
Uota of Niedermunster:
Christ in Majesty between
symbols of Four Evangelists
gold, enamels, pearls,
jewels; 15x10-5/8
BECKM 143 GMS
Book Cover: Gospels of Bishop
Bernward of Hildesheim:
Christ with Virgin and St.
John gold filigree, jeweled
PRAEG 47 (col) GHiC
Book Cover: Gospel of Abbess
Theophanu c 1039/56 gold
relief, ivory, jewels; 14x10-
1/4 BUSRO pl 6; SWA pl
36; VEY 145 GEC
Cathedral Door c 1050 bronze
KO pl 48 GAuC
--Moses and the Serpent
LARB 298; LO 59; VALE
83
--Old Testament and Allegor-
ical Scenes
ST 154
--Tree of Knowledge
FOC-1: pl 42
Cathedral Doors bronze
MARQ 168 GGnC
Centaur, symbol of Heresy,
relief, St. Severin
BUSRO pl 41 GCoS
Christ, Crucifix head detail
c 1070 copper gilt; 1/2
LS BUSRO pl 10 GMiC
Christ, Crucifix head detail,
St. George c 1070 wood
BUSRO pl 12 GCoS
Christ, Crucifix head detail,
Helmstedt Monastery c 1070

bronze BUSRO pl 13 GEA
Christ, relief, detail of Last
Judgment, west front,
Adalbert's Church, Bremen
c 1050 BECKM 172 GTR
Christ in Majesty (Majestas
Domini), Trier, Gospel
cover ivory; 21x12.4 cm
BSC pl 16 GBS (2423)
Christ with Key and Book,
Last Judgment, west front,
Archbishop Adalbert's
Church c 1050 BUSRO pl 9
GBremC
Crucified Christ, Salzburg
ptd wood; 71
BOSMI 111 UMB (51.1405)
Clement II Tomb, details:
Virtues--Moderation;
Strength
BUSGS 62 GBaC
Cloak Clasp c 1000 gold
filigree, set with sapphires,
amethysts, pearls
LOH 54 GDaH
Cologne Doors; panel detail:
The Healing of the Blind,
Whitsun Miracle c 1050
wood; 16xc 7' LOH 62, 63
GCoM
--Adoration of the Magi
LARB 298
--Annunciation to the Shepherds
BUSRO pl 7
--Christ on the Mount of
Olives FOC-1:pl 44
Column, cast for Archbishop
Bernward c 1020 bronze
BAZINW 220 (col)
Cross of Bernward of Hilde-
sheim c 1000 silver; 310x
210 mm BECKM 150; SWA
pl 28 GHiC
Cross of Gisela of Hungary,
Regensburg 1006 gold, set
with enamels, pearls,
precious stones
BECKM 142 GMR
Cross of Heriman 1036/56
SWA 17 GCoE
Cross of Holy Roman Empire:
Beasts of Evangelists; Lamb
of God; Apostles, Mainz
c 1031 silver SWA pl 32, 33
AVSch
Cross of Theophanu of Essen,
reverse: Christ; The
Beasts c 1050 silver gilt;

450 mm SWA pl 33, 100
GEA
Crucifix c 1000
READA pl 37 GWuN
Descent from the Cross
(Kreuzabnahme Christi)
pearwood; 26.7x17.7 cm
BSC pl 18 GBS (3145)
Door, south portal, with Door-
knocker: Head c 1050/60
bronze BAZINW 220 (col)
GAuC
Eagle Brooch (Gisela's Brooch),
Mainz c 1025 gold cloissone,
enameled and jeweled; 100x
93 mm LOH 48 (col); SWA
pl 25 GMaiMu
Easter Column 1015/22 bronze
BECKM 147; WHEE 181
GHiC
--Christ Curing the Man Born
Blind
BAZINL pl 198
--Jesus and the Samaritan
UPJH pl 73
--Lazarus at the Table of
Dives
SWA pl 52, 53
--Parable of the Fig Tree
BECKM 148
--Salome's Dance
SWA pl 52
--Transfiguration
MOREYM pl 73
Enger Reliquary: Pilgrim's
Pouch, animal figures
gemmed filigree LOH 44
GWir
Essen Candlestick, base
details: Personification of
Winds cast bronze; c 100
mm SWA pl 51 GEA
Female Saint, relief, east
tower, St. Maurice Church
limestone BECKM 173 GMuL
Figured Capital
PRAEG 43 GHiM
Gertrudis Crosses (First and
Second), Guelph Treasure
c 1041 gold, cloissone
enamel CLE 45 UOC1A
(31.55; 344.31)
Gertrudis Portable Altar
c 1041 embossed gold,
jeweled and enameled; 207x
103 mm CLE 45; LEE;
ROOS 72F-G; SPA 226; SWA
pl 36 UOC1A (345.31)

Golden Altar of Aachen, detail
c 1000 gold; 230 mm SWA
pl 37 GAaM
Hildesheim Cathedral Door(s)
(St. Bernward's Door; St.
Michael's Door) 1008/15
bronze; 187-7/8
BECKM 147; CHASEH 187;
GARDH 226; MYBA 272;
POST-1:20; ST 153; VEY
131 GHiC
--Lower Half: Scenes from
Genesis and Life of Christ
--Expulsion from Eden,
Labor of Adam and Eve,
Offerings of Cain and Abel,
Murder of Abel SEW 269
--Lion head Door Knocker
ROOS 73C
--Left Door: Genesis Scenes
--Adam and Eve ST 153
--Adam and Eve After the
Fall Reproached by the
Lord bronze; 23x43
BAZINW 219 (col); BECKM
148; GOMB 116; JANSH
207; LOH 51; NEWTET 91;
ROBB 341; SWA pl 46
--Adam Working the Fields
STA 39
--Creation of Eve
LARB 255; ROTHS 85;
UPJH pl 73
--Eve Nursing Her Child
FOC-1:pl 43
--Expulsion from Paradise
BAZINH 132; CHRC fig 82;
CLAK 313; JANSK 396;
MU 115; MYBA 273; SWA
pl 46
--The Fall
CLAK 313
--Adam and Eve in the
Garden STI 397
--Cain and Abel bronze;
c 23x43 BIB pl 18;
JANSK 396; SWA pl 48
--Right Door: Life of Christ
Scenes
--Adoration of the Three
Kings LOH 52; ROOS 73C
--Christ Before Pilate
MOREYC 97
--Christ Led to Herod
SWA pl 45
--Noli Me Tangere
BECKM 149; KO pl 48;
ROTHS 85

--Three Marys at the Tomb
ROTHS 85
--St. Joseph, Nativity
BAZINW 219 (col)
The Imad Madonna 1051/76
limewood, originally gold-
leafed; 42-1/8
BAZINW 221 (col); BUSRO
pl 11; NEWTEM pl 55;
ST 195 GPD
Imperial Throne of Goslar,
detail SWA pl 93 GGoK
Last Supper, reliquary casket,
Hildesheim c 1000 silver;
150x260x200 mm SWA pl
30 GHiC
Luneberg Candlestick Foot,
details: Evangelist Astride
River of Paradise; Angels
Lifting Column of Christ
over Adam Rising from his
Tomb bronze gilt SWA pl
91 GHaMu
Paul Let Down by the City
Wall of Damascus, relief
details cast bronze; ea
relief: 450 mm
SWA pl 53 GHiC
Plaque, inhabited scrolls,
Fritzlar(?) SWA pl 93 GCM
Portable Altar Plaques ivory
CLE 48 UOClA (22.307-.309)
Reliquary Cross of Bernward
of Hildesheim c 1000
jeweled gold SWA pl 34
GHiMa
Reliquary Cross of Bertha of
Borghorst Saints; Henry II
Received by Angels, Essen
c 1024 gold filigree; 410x
280 mm SWA pl 35 GBorCh
Rudolf, King of Swabia, Tomb
Cover ("oldest extant tomb
figure in the west") c 1080
bronze; 77-1/2x27
BECKM 175; BUSRO pl 20;
JANSK 399; SWA pl 99;
VALE 84 GMeC
Sacrifice of Cain and Abel,
reliquary casket, Luneberg
(?) copper; 146x227 mm
SWA pl 48 GHaMu
Saint, east tower relief, St.
Mauritz c 1070 H: c 29
BUSRO pl 8 GMuL
St. Metronus, head fragment
c 1000 BAZINW 279 (col);
BUSRO pl 1; LOH 61 GGerC

Scrolls, Essen sword sheath,
detail c 1000 embossed
gold; 802 mm SWA pl 44
GEA
Seated Nuns, relief limestone
BECKM 170-71 GWeA
Thomas and Moses, diptych
panels, Trier ivory; ea:
24x10 cm BSC pl 17 GBS
(8505/06)
Werden Crucifix c 1070 bronze;
43 BECKM 176; CHRH fig
85; JANSK 397; MYBA 274;
NEWTET 19; SWA pl 94-5
GWeA
--Christ, head detail
GARDH 242
--11/12th c.
Candleholder: Man on Lion
bronze CHENSW 337 FPL
--12th c.
Angel, Mosan c 1170 bronze
gilt; 100 mm SWA pl 174
IFBar
Angel of the Resurrection,
detail, Cologne 1170 poplar
wood; 24-3/8 BSC pl 19;
NEWTEM pl 63 GBS (2969)
Angel Receiving Soul of
Reinheldis, tomb relief
detail BUSRO pl 25 GRei
Angel's Choir Screen, detail:
Apostles, beneath repre-
sentation of Jerusalem LOH
67 GHiM
The Annunciation, plaque
(Verkundigung an Maria)
ivory; 18.4x11.9 cm BSC
pl 20 GBS (2787)
Annunciation of the Shepherds;
Woman at the Holy
Sepulchre, Gustorf Choir
Screen fragments c 1140
BUSRO pl 115-6 GBoRL
--Angel limestone; 35-3/8
NEWTEM pl 64
Antependium before 1140 wood,
copper gilt sheath
BUSRO pl 107 GGrC
Apostle, choir screen detail
c 1190 BUSRO pl 147
GHalL
Apostle (Groninger Emperor),
seated figure, detail 1170
stucco; 127x660 cm
BERLEK pl 1; BERLES
191 GBSBe (2739)
Apostle Matthew, head, rood

loft, or pulpit, support
c 1170 BUSRO pl 125 SwChuM
Apostle Paul, altar rail relief
c 1190 stucco ST 198 GHalL
Apostles and Prophets, choir
screen, detail stone
POST-1: 92 GBaC
Apse Demons Heads; Hares
Ensnaring Hunter c 1140
BUSRO pl 49 GKonC
Archangel Michael; Adoration
of the Magi, relief c 1120
BUSRO pl 24 GWuHB
Archbishop Friedrich of
Wettin, tomb plaque c 1150
bronze BUSRO pl 108;
CHASEH 206; ST 196 GMagC
Arm Reliquary, Braunschweig
c 1175 silver gilt; 510 mm
SWA pl 212 UOClA
Bacchus, head, aquamanile,
Aachen(?) cast bronze;
183x135 mm SWA pl 163
GAaM
Beatitude, Aachen c 1165
copper gilt; 275x257 mm SWA
pl 188
Beatitudes, south aisle stucco
BOE pl 50 GHiM
Birth and Baptism of St.
Adalbert door detail bronze
BAZINW 283 (col); BUSRO
pl 50; PGC
Bishop, head c 1160 wood;
c 11 BUSRO pl 120 GCoS
Calvary, rood Screen
POST-1: 96 GHalC
Chalice: Life of David
Scenes, Arnstein (?) c 1160
silver gilt; 155 mm SWA
pl 190 PTrA
Chalice: Moses at Burning
Bush; The Beatitudes,
Lower Saxony c 1170 silver
gilt; 170 mm SWA pl 191
PTrA
Christ, head detail, Crucifixion
CHENSW 334 GWeA
Christ between Peter and
Bishop Albero c 1147 BUSRO
pl 73 GTrP
Christ Enthroned; St. Adolar;
St. Eoban, altar retable,
Groningen c 1160
BUSRO pl 118 GBS
Christ on Cross; head detail
poplar wood; 163.5 cm
BERLE pl 6, 5 GBSBe (3137)

Christ on Cross 1150 poplar
 wood; 109 cm BERLE pl 4
 GBSBe (7810)
Christ on Cross, Helmar-
 shausen(?) copper and silver;
 117 cm SWA pl 104 GMiC
Christus, Helmarshausen
 c 1100/20 bronze; 5-3/4
 TOR 111 CTRO (955.2)
Crodo Altar Support: River
 of Paradise BUSRO pl 28, 29
 GGoMu
Cross, above rood screen part
 16th c. LOY 131 GHalC
Cross Base: Adam Rising from
 Tomb; Evangelists, Lower
 Saxony c 1130 cast bronze;
 W: 120 mm SWA pl 105
 GWeiG
Cross of St. Bertin, foot;
 details c 1180 cast bronze,
 gilt SWA pl 177-9 FStOB
Crouching Lion, Mosan bronze;
 L: 125 mm SWA pl 205 NAR
Crucifix c 1100 ptd wood
 KO pl 47 GAsP
Crucifix, head detail wood
 CHENSW 335, 334 GNG
Crucifix, Bockhorst, West-
 phalia MALV 252 GMuL
Cushion Capital
 PRAEG 43 GAl
Daniel in the Lion's Den;
 Prophet Habakuk Bringing
 Food and Drink, relief
 c 1180 BUSRO pl 128;
 LOH 74 GWoC
Domed Reliquary: Church,
 Treasure of the Guelphs,
 Cologne c 1175 oak, with
 champleve enamel, silver,
 copper, bronze; morse
 ivory figures; 18x16-1/8
 BUSRO pl 105; KO pl 49
 (col); LOH 89; PRAEG 194
 (col) GBrD
Domed Reliquary, Cologne,
 detail: Journey of the Magi
 c 1180 copper gilt,
 champleve enamel; 455x410
 mm SWA pl 213, 214 GBM
Door Knocker: Lion's Head,
 symbol of bound evil,
 framed by Dragons in Plait
 Work bronze BUSRO pl 102
 GAl
Dragon, detail, crest of
 Shrine of St. Albinus,

Cologne cast copper, gilt;
 51 mm SWA pl 222 GCoPa
Extern Stones, outdoor relief:
 The Deposition c 1115 c 18x
 c 14' BUSRO pl 15; LOH 60
 GTe
Font, detail: Christ Ascending
 to Heaven 1129 BUSRO pl 26
 GFrec
Four Evangelists Lectern
 (Alpirsbach Lectern) c 1150
 ptd limewood; 48 BUSRO pl
 97; cov (col); CHRP 143;
 KO pl 47 (col); LOH 69;
 PRAEG 191 (col) GFreuC
--St. Luke, head
 BUSRO front cov (col)
Frederick Barbarosa, reliquary
 head, Aix 1155/71 bronze
 BUSRO pl 104; LOH 90;
 SWA pl 165 GKaS
Grotesques, arcading, west
 choir FOC-1: pl 78 GWoC
Head Reliquary, Lower Saxony
 c 1150 bronze gilt; 310 mm
 SWA pl 165 GHaK
Head: Demoniacal Power, font
 detail BUSRO pl 36 GCoS
Jeremiah, detail of Three Kings'
 Shrine FOC-1: pl 154 GCoC
Komberg Chandelier: Apostle
 c 1130 copper gilt SWA pl
 108 GGrC
--: St. Magdalen H: 250 mm
 SWA pl 108.
Lion, aquamanile, detail cast
 bronze; 320x360 mm SWA pl
 204, 205 GMiC
Lion of Henry the Lion (Bruns-
 wick Lion) c 1166 cast bronze;
 L: 73 BUSRO pl 103; CHENSW
 334; JANSH 223; JANSK 433;
 LOH 77; PRAEG 220; ST 198;
 SWA pl 204; VEY 146 GBrB
Lion Striking a Lamb, symboliz-
 ing persecution of goodness
 c 1140 BUSRO pl 35 GMari
Lion's Head, symbol of the
 Devil, font detail 1129
 BUSRO pl 37 GFrec
Lion's Head, holy water
 sprinkler top, Werden(?)
 c 1130 SWA pl 155 GBoRL
Ludolf of Wichmann Tombstone
 1192 BUSRO pl 108 GMagC
Luke and John, Mosan c 1170
 bronze gilt; 84 mm
 SWA pl 175 IFBar
Madonna
 ST 197 GCoM

Madonna, Crucifixion group,
Sonnenberg Monastery
ST 197 GCoS
Madonna, fragment from
abbot's chair, Siegburg c
1170 BUSRO pl 114 GCoS
Madonna and Child, Christ
Child's hand raised in
blessing c 1160
BUSRO pl 121 GHo
Mary and John; John, head
detail c 1150 wood; 6
BUSRO pl 94, 95 GCoS
Michael, cross base, Mosan
c 1170 gilt bronze; figure:
86 mm SWA pl 175 ELV
Mourning Virgin (Klagende
Maria) 1150 limestone; 21.
3 cm BSC pl 30 GBS (3/60)
The Nativity, plaque ivory
RUS 48 ELV
Pediment Figures, west front
c 1150 BOE pl 46 GRos
Plozk Doors, detail: Creation
of Eve; Caster Abraham,
Magdeburg 1152/54 Abra-
ham H: c 40 cm SWA pl
201 RuNS
Porch, north aisle, detail
BAZINW 280 (col); BOE pl
48 GRegC
Portable Altar: Martyrdom of
St. Blaise, Helmarshausen
c 1100 copper gilt; 118x310
x185 mm SWA pl 101 GPF
Portable Altar of Eilbertius,
Cologne 130x357x210 mm
SWA pl 106 GBM
Portable Altar Retable: Christ
above the Apostles c 1160
BUSRO pl 107 GFriC
Priest Bruno Tomb Slav
c 1194 PANS pl 134 GHiC
Processional Cross bronze,
partly gilded; 12
COOPF 175 GDonF
Prudence with Snake, Mosan
c 1160 bronze gilt; 66x38 mm
SWA pl 174 FPL
Recumbent Madonna, choir
screen fragment,
Michaelskirche c 1186
BUSRO pl 145 GHiMu
Reliquary of St. Henry
champleve enamel; .23 m
CHAR-1:261 FPL
Retable c 1160 stucco
BUSRO pl 118 GErC

River of Paradise, Mosan
c 1150 cast bronze; 130 mm
SWA pl 169 FBesM
Romanesque Capitals
LOH 73 GGeK
Romanesque Chest
ST 187 SwSiV
St. Bartholomew, and St.
Peter, altar frontal, detail,
Komberg, or Corvey c 1130
copper gilt; 780 mm SWA
pl 107 GGrC
St. Cecilia, tympanum detail
c 1150 BUSRO pl 109
GCoS
St. Peter, choir screen figure
c 1186 BUSRO pl 146 GHiM
St. Peter, head, rood loft or
pulpit support c 1170
BUSRO pl 124 SChuM
St. Peter, relief, Westphalia
c 1130 copper gilt; 155 mm
SWA pl 107 NGM
St. Plectrudis, tomb relief
detail c 1180 BUSRO pl 123
GCoM
Samson Aquamanile, Lower
Saxony cast bronze; 238 mm
SWA pl 203 GBM
Saxon Duke Widukind, tombstone
relief c 1100 stone
BUSRO pl 21 GEn
The Sea, Mosan c 1180 cast
bronze; 90x56x35 mm SWA
pl 177 ELV
Seal of Bishop Adalbert I,
Freising bronze; Dm: 3
BERL pl 161; BERLES 161
GBSBe
Seated Madonna, Rhenish(?)
silver sheets on wood; 17
TOR 109 CTRO (L960.9.5)
Sentinel, chandelier figure
c 1140 BUSRO pl 106 GGrC
Shrine of Anne, details: St.
Peter; St. Bartholomew;
Monkey Attacked by
Dragons, Cologne c 1183
cast copper, gilt and
champleve enamel; .78x.46
x1.77 m SWA pl 223 GSieg
Shrine of St. Elizabeth, detail:
Landgravine Distributing
Alms c 1240 BUSGS 41
GMarE
Shrine of Heribert: Gable End
copper gilt, silver gilt,
enamel, jeweled; 26-3/4

x16-1/2 KIDS 83 (col);
SWA pl 182-4 GDeH
--Mary and Infant Jesus
LOH 108
Stoning of St. Stephen,
Bishopric of Halberstadt
Bracteate silver
BERL pl 156; BERLES 156
GBSBe
The Three Continents, candle-
stick base, Mosan c 1170
bronze gilt; 180 mm SWA
pl 175 GHiC
Tivulzo Candelabra (Arbera
della Virgine), detail: A
River of Paradise before
1200 bronze BUSRO pl 171
IMC
The Twelve Apostles, plaque,
Frankfurt ivory; 18.8x12
cm BSC pl 21 GBS (613)
Virgin, framed in relief of
Symbolic Beasts c 1150
limestone BUSRO pl 51
GGerC
Virgin and Child
LARB 286 GCoM
Walsdorf Crucifix, head detail
after 1150
BUSRO pl 112 GWLM
Wilten Chalice and Paten
c 1160 silver gilt, niello;
6-1/2 ARTV pl 30, 31;
SWA pl 192 AVK
"Wolfram", male figure candle
bearer 1150/60 H: 60
BUSRO pl 98, 99 GErC
--12/13th c.
Aquamanile: Dragon Swallow-
ing Man bronze; 8-1/2
NM-12:143; NMA 54
UNNMMC (47.101.51)
--13th c.
Adam Portal, south portal,
east end: Adam c 1235/40
sandstone
BAZINW 300 (col); NEWTEM
pl 77 GBaC
--: Adam and Eve
BUSGS 66-7; CLAK 310;
FOC-2:pl 90; LARB 391;
MOREYM pl 123; LOH 94
--: St. Peter
MOREYM pl 123
--: St. Stephen
MOREYM pl 123; NEWTEM
pl 73
Aquamanile: Centaur bronze;
14-1/4 NM-7:25 UNNMM
(10.37.2)

Aquamanile: Knight on Horse-
back bronze; 12-7/8x14
MINP UMnMI
Aquamanile: Lion bronze;
8x8-1/2 GRIG pl 122 ELBr
Aquamanile: Lion, Hildesheim
bronze; 9-5/8 DEYE 13
UCSFDeY (54.22)
Aquamanile: Lion, seated,
Dinant, Flanders bronze
PRAEG 213
Aquamanile: Lion, sitting on
Dragons, Lower Saxony
cast bronze; 250 mm
SWA pl 238 GHM
Aquamanile: Samson and the
Lion, Lorraine or Upper
Rhine bronze, engraved; 12
BOSMI 113; SWA pl 236,
237 UMB (40.233)
Aquamanile: Stag, Hildesheim
bronze; L: 11-1/4 SOTH-
1:208
Archangel Michael, choir
relief STI 399 GBaC
Archivolt Figures, detail c
1300 BUSGS 114 GFrei
Bamberg Rider (Bamberg
Horseman; Bamberg Knight;
Bamberger Reiter; King
Stephen; Royal Knight; St.
Constantine) 1220/30 sand-
stone; 90-1/2 BAZINH 169;
BAZINW 300 (col); BUSGS
60, 61; CHASEH 253;
CHENSW 353; CHRC fig
118; HAUSA pl 18; JANSK
488; KIDS 117 (col); LARB
358; LIL 40; LOH 97;
MOLE 60; MOREYM pl 124;
NEWTEM pl 80; PRAEG
219; ST 248; UPJH pl 90;
VALE 94; VEY 146 GBaC
Blessed Virgin, Visitation
group c 1240/55 ST 246
GBa
Book Cover: Baptism of Christ,
Augsburg silver; 7-3/4x
4-7/8 COOP 115 FPFu
Breviary Cover, Hildesheim
(ms 309) c 1260 silver
COOPF 189 GDonF (ms 309)
Capital: Conventionalized Stiff-
leaf Foliage c 1225 PRAEG
43 GGeL
Capital: Human and Animal
Figures in Foliage, porch
after 1250 LOY 92 GPC
Capital: Human-Bird Demons
c 1220 BUSRO pl 161 GMariaCo

figure c 1208 cast bronze,
gilt; 130 mm SWA pl 225
GHalC
Kaiserpokal Chalice, cup and
cover; detail: Virtues and
Vices PANR fig 68-77 GOsR
Key of St. Elizabeth, Marburg
cast bronze; 210 mm
SWA pl 202 GMarE
Keystone, Bishop's Gallery:
Angel, symbol of Matthew
the Evangelist c 1230
BOE pl 90 GMagC
Madonna 1232/37 stone
BAZINW 301 (col); KO pl
50 GBaC
Madonna, Furststrasse c 1240
BUSGS 104 GMaiC
Madonna of the Shrine of the
Virgin 1230/37 silver gilt;
figure: 14-1/8 NEWTEM
pl 67 GAaC
Magdeburg Rider (Imperial
Horseman), monument to
Emperor Otto II c 1250
stone BUSGS 89; VEY 146
GMagC
Mary, Triumphal Cross figure,
St. Moritz, Naumberg
c 1230 BUSRO pl 158 GBS
Mask of Damned, below
transept cornice c 1250
BUSGS 99 FRhC
Mindener Altar: Predella,
Westphalia 1260 oak; 71x
276x48 cm BERLE pl 13;
BERLEK pl 10 GBSBe
(5863A 8417)
Mirror Case with Handle:
Tristan and Iseult, Rhine-
land cast bronze, gilt; 88
mm SWA pl 202 GFM
Mounted Knight, choir stall
detail, convent church of
Wassenberg c 1280
BUSGS 176 GCoS
Mourning Virgin (Klagende
Maria), Triumphkreuz,
Naumberg 1230 oak; 65
BSC pl 29; FREED pl 1
GBS (7090)
Naumberg Crucifixion 1230
oak; 262x166.5 cm BERLE
pl 11, 12; BERLEK pl 3
GBSBe (7089)
Otto II, detail mid 13th c.
stone KO pl 50 GMagM

Paradise Portal, detail:
Apostles c 1230 BUSGS 38
GPC
Pieta wood; 34-1/2
JANSH 259 GBoRL
Prince of this World (Satan),
right side portal; west
porch sandstone KO pl 53
FStrMu
Prince's Portal (Fursten
Portal; Royal Porch) c 1230
BUSGS 63, 65 GBaC
--Evangelists and Apostles on
Shoulders of Prophets, left
jamb BOE pl 89;
LOH 78; POST-1:93; WORR
99
--Last Judgment
BAZINW 300 (col); KIDS
138; LARB 358; KO pl 50
--Synagogue
KO pl 50; POST-1:93
Rudolf von Habsburg, effigy
c 1285 BUSGS 121; LOH 71
GSpC
St. George's Choir Screen
1220/30 stone
--: The Annunciation
BUSRO pl 150; UPJH pl 90
GBaC
--Prophets
BAZINW 280 (col); BUSRO
pl 151-3; LARB 391
--Prophets: Jonah
BAZINH 152; BAZINW 281
(col); SEW 415
--Prophets: Jonah and Hosea
KO pl 50; LOH 93; STA
146; VEY 34, 132
St. James the Less ptd wood;
77 NM-7:30; NM-11:4;
NMA 57 (col) UNNMM (28.
32)
St. Lawrence, head detail,
cathedral porch c 1240
BUSGS 74 GMuC
St. Maurice, high choir frag-
ment after 1240 LOH 91
GMagC
Samson Candlestick, Schaalsee
LOH 88 GWieSA
Seated Monk, headless figure,
Upper Rhenish c 1280/90
red sandstone; 32
KUHN pl 1 UMCF (1949.47.
96)
Servant Woman, symbol of

Magdeburg c 1250
BUSGS 87 GMagK
Shrine of Charlemagne (Shrine
 of Our Lady) 1215 silver
 gilt, copper gilt, enamel,
 jeweled; 80-1/4x37x22-1/2
 BUSRO pl 172-3; KIDS 112;
 KO pl 49; LOH 102-3, 104
 (col) GAaC
--Charlemagne Dedicates
 Aachen Minster to Virgin
 KIDS 85 (col)
--Charlemagne in his Tent;
 Mourning Knights Killed in
 Battle
 BUSRO pl 177; LOH 106-7
--Collapse of the Walls of
 Pamplona
 BUSGS 40
--Henri III
 STA 46
--Henry IV, bust detail
 LOH 109; NEWTEM pl 68
Shrine of St. Elizabeth 1235/49
 LOH 111 GMarE
Triumphal Cross; St. John the
 Evangelist, head c 1220
 wood BUSGS 27, 28; BUSRO
 pl 159 GHalC
Vestibule Tower, detail
 BOE pl 102 GFreiM
Vine Leaf Capital, rood screen
 detail c 1245
 BUSGS 109 GGel
Visitation, Georgenchor
 1220/30 sandstone
 BUSGS 58, 59; CHRC fig
 114; DUR fig 39, 40 GBaC
--St. Elizabeth (Sibyl) sand-
 stone; 70-5/8
 JANSK 488; KIDS 162;
 LARB 391; LOH 95; MALV
 248; MARQ 171; MOREYM
 pl 120; NEWTEM pl 79
Walderich Chapel Chancel
 Apse: Lion motif c 1230
 BOE pl 47 GMur
Wise and Foolish Virgins
 after 1250
 BUSGS 105-7; FOC-2:pl
 91-2 GMagC
Wormwood Capital, western
 rood screen detail 1240/48
 BUSGS 109 GNaC
--13/14th c.
Three Tiered Fountain
 LOH 154 GMau
Verkundigungs Madonna of
 Regensburg LIL 60 GMB

--13/15th c.
Head fragment, mouchettes
 decoration, Heidelberg stone
 BAZINL 132
--14th c.
Albert von Hohenlohe, effigy
 CHASEH 258; POST-1:101
 GWuC
Altar, former convent church
 c 1331 BUSGS 182 GOL
Altar and Tabernacle c 1330
 BUSGS 183 GDo
The Annunciation, altar relief
 BUSGS 184 GCiCo
Apostle, Chapel Tower c 1340
 LOH 139 GRotL
Aquamanile: Horse and Rider
 bronze; 12-1/2x10
 GRIG pl 123 ELBr
Archangel Michael, Schwabisch
 Hall c 1320 BOE pl 119
Battle Scenes, frieze
 BOE pl 121 FStrMu
Bishop Adalbert von Beich-
 lingen, tomb relief c 1370
 BUSR 5 GErB
Bishop von Truhendingen Tomb
 sandstone
 VALE 45 GWuC
Bishop Wolfhart von Rot, ef-
 figy head bronze
 BUSGS 147; LARB 358;
 VALE 57 GAuC
Bride and Bridegroom, chapel
 tower c 1340 sandstone
 KO pl 56 GRotL
Bride's Door: The Madonna;
 St. Sebald; The Wise and
 Foolish Virgins
 MOREYM pl 128 GNS
Choir Reliefs c 1370
 BOE pl 127 GNS
Choir Stall Detail: Mary and
 Child Adored by Knight
 c 1330 wood LOH 142 GWa
Choir Stalls of the Novgorod
 Traders: A Fur Hunt
 BUSR 10 GStrN
Christ, head, Crucifix detail
 wood BEN 31 GCoM
Christ and St. John
 ST 250 GFreiA
Christ and St. John wood
 LARB 321 GBD
Christ and St. John c 1320
 ptd and gilded wood; 35x
 17-3/4 VEY 146 GBS
--c 1340 limewood; 35
 NEWTEM 15 (col) GBS

--Sigmaringen c 1340 ptd oak;
 36
 BUSGS 167; KO pl 54 (col)
 GBS
--seated figures lindenwood;
 88.5 cm BERLEK pl 7
 GBSBe (7724)
Christ and St. John the Baptist,
 seated figures c 1320 oak,
 ptd and gilded; 35-1/4
 AUBA 147 (col); BSC pl 36;
 LOH 145 GBS (7950)
Christ and St. John the Evan-
 gelist, Swabia c 1320 oak;
 35 FREED pl 5 GBS
Christ and St. John the Evan-
 gelist, seated figure,
 Swabia ptd wood CLE 52
 UOC1A (28.753)
Christ and the Virgin, choir
 pier figures c 1322 BUSGS
 157 GCoC
Christ with Soul of Mary,
 Felixenhof ptd oak; 23-1/2
 KO pl 55 (col) GStLa
Cross with Mourning Virgin
 and St. John c 1330 copper
 gilt, champleve enamel CLE
 52 UOC1A (42.1091-42.1093)
Crucifix
 BAZINW 303 (col) GCoM
Death of Our Lady, southeast
 portal sandstone
 KO pl 55 GEssF
Demon Animal Head, choir
 stall c 1300
 BUSGS 178 GLoM
Door, west: Gothic Figures
 LOH 123 GNL
Door Knocker: Charles IV
 and Seven Electors, com-
 memorating issuance of
 Golden Bull, 1356
 BUSGS 180 GLuT
Duke Rudolf IV, Choristers'
 Gate c 1375 stone
 KO pl 56 AVSt
Ecclesia on Tetramorph,
 ornamental gable, south
 porch c 1300 BOE pl 118
 GWoC
Facade: Ornamental Tracery
 BUSG 130 GNL
Font cast bronze
 PRAEG 54 GWiM
Foolish Virgins, portal detail
 c 1360 BUSG 113; BUSGS
 144 GErC

Forked Cross Crucifixion
 (Erbarmdekreuze: Compas-
 sion Cross; Pestkreuz:
 Plague Cross) 1304 H: 59
 AUBA 149 (col); JANSK 494;
 KIDS 119 (col) GCoM
--Christ, head detail
 BUSGS 165
Fountain Detail: Eagle, symbol
 of Free Imperial City of
 Goslar LOH 137 GGoM
Friedrich von Hohenlohe Tomb
 after 1352 stone; LS figure
 CHENSW 355; JANSK 492;
 KO pl 54; LIL 72; LOH
 130; NEWTEM pl 95, 96
 GBaC
Gargoyle
 BUSG pl 110
Gerhard von Schwarzburg Tomb
 CHASEH 258; POST-1:101
 GWuC
God the Father, embossed
 relief, Rhenish c 1325/50
 gilded copper; 3-1/4x2-3/4
 KUHN pl 5 UMCB (1958.250)
Gottfried and Otto von Kappen-
 berg, effigies c 1320 BUSGS
 151 GKaS
Heinrich I, effigy detail
 BUSGS 150 GMarE
Holy Sepulchre, based on
 Strasbourg example c 1330
 BUSGS 152-3 GFreiC
Hungarian Cross
 LOH 147 GAnL
Island of Sirens, east wing
 corbel, cloister 1330/40
 BOE pl 121 GSti
Kiss of Judas; Ascent of
 Christ, relief after 1351
 ST 252 GGm
Konrad von Weinsberg Tomb
 CHASEH 258; POST-1:101
 GMaiC
Kuno and Anna von Falkenstein,
 relief effigies
 BUSGS 195 GLichCh
Lion Reviving Still-born Young
 by his Breath, symbol of
 Resurrection, choir stall
 BUSGS 181 GDo
Madonna, chapel chancel
 c 1340 BOE pl 122 PM
Madonna, head, Holy Sepulchre
 detail 1330/40 sandstone
 KO pl 55 GFrei
Madonna and Child c 1325/50

ptd lindenwood; 21-1/2
KUHN pl 20 UMCF (1955.
110)
Madonna and Child 1330 lime-
stone; 98 cm BERLEK pl 4
GBSBe (7689)
Madonna and Child, seated
figure 1330 walnut; 98 cm
(excl base) BERLEK pl 6
GBSBe (8582)
Madonna of the Rosebush,
Straubing ptd stone; 2/3
LS BUSGS 160; MOLE 65
(col) GMBM
Mason at Work, leaf corbel
BOE pl 120 GXC
Milan Madonna C 1320 ptd
wood; c 84 AUBA 143
(col) GCoC
Misericord, choir stall
c 1300 BAZINW 304 (col)
GCoKK
Misericordiae: Falling Knight;
Peasant Woman c 1322
BUSGS 179 GCoC
Mystic Cross c 1300 ptd wood
KO pl 54 GNonC
Nine Heroes, Hanseatic Hall,
south wall c 1360 (destroyed)
BOE pl 124; BUSGS 199
GCoRat
Pieta wood
ENC 713
Pieta; Virgin, head detail
c 1330 BUSGS 170, 171
GErU
Porch Sculpture: Biblical
Figures c 1310
LOH 120 GFreiC
Prince of this World, as
Seducer, and Voluptas
c 1320 sandstone
BUSG pl 111; BUSGS 134;
KO pl 53 GFreiC
Prophet in Ecstacy, head
detail, south portal, chapel
tower BUSGS 164 GRotL
Reliquary c 1330 chased
copper gilt, cabochons and
glass inlay CLE 52 UOClA
(32.422)
Reliquary: Charlemagne, bust
c 1350 silver, chased
LOH 105 GAaC
Reliquary: Saint, bust 1300
lindenwood; 42.5 cm
BSC pl 37 GBS (8449)

Rome, seal of Emperor Ludwig
of Bavaria 1328 gold
SCHERM pl 6 GDS
Rottgen Pieta; detail: Head of
Christ ptd wood; 34-1/2
c 1320
BUSGS front (col), 172;
FREED pl 7, 8; JANSK 493;
LOH 146; MOLE 83 GBoRL
St. Catherine c 1300 sandstone
VALE 45 GNS
St. Mary Portal, tympanum
1309 BUSGS 190 GNS
Scheuerfeld Pieta c 1330 H: 69
AUBA 151 (col); BUSGS 173;
LIL 64 GVeC
Schnitzaltar c 1330 wood
KIDS 161 GOL
Sleeping St. John, head, Last
Supper detail c 1320
BUSGS 169 GStWL
Three Towers Reliquary c 1370
silver gilt, enamel plaques;
37x29 KIDS 114 (col) GAaC
The Trinity as a Mercy Seat
1319 BUSGS 194 GWuB
Two Kings sandstone
VALE 38 GFreiC
Uta, or Hemma, effigy c 1300
BUSGS 120 GRegE
"Venus" c 1300 red sandstone
VALE 46 GFreiC
Virgin, detail of Annunciation
group c 1300 wood
PRAEG 17 GRR
Virgin and Child, Cologne
pearwood; 58.5 cm
BERLE pl 18 GBSBe (8043)
Virgin and Child, southwest
portal, Pilgrimmage Church
c 1390/1400
MULS pl 9B GHall
Virgin and Child, seated figure
walnut; 65.5 cm BERLE pl
19 GBSBe (8012)
Virgin and Child with Donor,
choir stall detail, Wessen-
berg wood GROSS fig 39
GCoS
West Portal c 1350
BUSGS 191 GNL
--14/15th c.
Death on Horseback bronze
TAYFF 115 (col) UNNMM
Weeping Woman, Lamentation
Figure
LIL 88 GRotL

--15th c.

Adam and Eve, Upper Rhenish
c 1490/1500 lindenwood(?);
6-1/2x6-1/4
KUHN pl 17 UMCF (1957.
219a-b)
Adoration of the Magi c 1420
MULS pl 35 GFK
Agnus Dei Box Pendant:
Adoration of Magi; St.
George Fighting the Dragon
silver gilt; Dm: 3-1/2
HUYA pl 41 FPL
Altar of St. Anne c 1495 wood
MULS pl 164B GKalN
Altar Tabernacle: Madonna
and Child; Horse and Knight,
given to Charles VI by his
wife, Isabel of Bavaria
c 1404 EVJF pl 198 GAltT
Altarpiece, Blaubeuren
POST-1:111 GBl
Altarpiece late 15th c. carved
and ptd
LARR 72 (col) ELV
Angel Gabriel c 1439 over LS
LOH 159 GCoK
Angel with Infant Jesus,
Bavaria-Swabia c 1480 lime-
wood; 27-3/4 FREED pl 18
GMBN
Annunciation 1439
MULS pl 77 GCoK
Annunciation, Schnegg begun
1438 MULS pl 89A GConC
Annunciation, relief, Venningen
Tomb c 1470 MULS pl 114B
GSpC
Apostle, seated figure c 1400
terracotta BUSRO 20;
MULS pl 37 GNG
Aquamanile: Aristotle and
Campaspe c 1400 brass;
13-1/4 COOP 85 UNNLeh
Aquamanile: Lion c 1420 bronze;
13-3/4 FREED pl 10
GMBN
Armor of a Renaissance Prince
1460 MU 143 UNNMM
Beautiful Madonna (Fair
Virgin; Schone Madonna),
St. Elizabeth, Wroclaw
(Breslau) c 1400 MULS pl
40A PWN
--Reinhold Chapel c 1410
MULS pl 43B PDM
--c 1420/30
MULS pl 47A HBNM

--, in Mandorla c 1425/30
MULS pl 38 GNS
--c 1430
STA 154 PoTJ
--head detail c 1450
LOH 170 GPaS
Bust, Hospital of St. Marx
c 1470 MULS pl 118B
FStrF
Cathedral Portal, inner west
c 400 BOE pl 129 GMeiC
Centurian Group, altar detail,
Middle Rhine c 1400
alabaster BUSR 19 GFL
Christ, bust, west porch
MOLE 14 GUC
Christ on the Ass (Palmesel)
1480 lindenwood; 157 cm
BERLE pl 23 GBSBe (8144)
--wood
CHENSW 356 SwBKH
Christ on Way to Calvary,
Lorch MULS pl 33A GBS
Council of Basle Seal
(Baslerkonzilsbulle) c 1431
NEWTET 166 AVK
Crucifix, Dumlose Chapel c1430
wood MULS pl 42B PBE
Crucifixion, figure details 1425
H: 54 cm BSC pl 42-43
GBS (8499)
Crucifixion, Rimini c 1430
alabaster MULS pl 73B GFL
Crucifixion Altar: Three Groups
of Figures 1480 lindenwood;
123; 132.5; 117.5 cm
BERLE pl 30, 31 GBSBe
(5875-77)
Crystal Barrel in Silver Gilt
Setting HAR pl 30
Dead Christ with Angel, relief
1420/30 lindenwood; 44 cm
BSC pl 45 GBS (8477)
Dean Bernhard von Breidenbach,
effigy d 1498
MULS pl 166A GMaiC
Death of the Virgin, detail
c 1440 stone
MULS pl 78 GWuC
Decapitation of St. Catherine
1340 lindenwood; 74x60 cm
BSC pl 56 GBS (423)
Departure of the Apostles
(Auszug der Apostel), relief
lindenwood; 76x77 cm
BERLE pl 42 GBSBe (8126)
Elisabeth of Straubing-Holland
Monument d 1451

MULS pl 116A GTD
"Epistolae" of Pope Pius II,
Nuremberg binding for
Cardinal Francesco Pic-
colimini 1481 CAL 65 (col)
IRVB
Female Figure, corbel, mid-
dle aisle BOE pl 130 GUM
Female Saint; head detail
lindenwood; 95.5 cm
BERLE pl 20, 21 GBSBe
(2018)
Folding Altar; detail:
Coronation of the Virgin
1425 oak; 179x276 cm
BERLE pl 14-16 GBSBe
(5863)
Folding Altar, Brixen, 1490
lindenwood and pine; 273x
255 cm BERLE pl 66;
BERLEK pl 30 GBSBe
(3112)
Font, detail c 1467
LOWR 247 GErS
Frederick V, Duke of Styria
before 1452 sandstone
MULS pl 89B AWG
Friedrich der Streitbare,
effigy detail, Furstenkapelle
c 1440/50 bronze
MULS pl 82A GMeiC
Furstenberg Fiefcup, Nurem-
berg c 1490 enameled,
partly gilded; 15
COOPF 177 GDonF
Goldenes Rossel 1403 gold
enamel MULS pl 14 GAlt
Griffin Tankard 1434/53 gilded
silver LOH 208 GLS
Guelf Princesses c 1450
BUSR 61 GBrA
Hans von Burghausen, effigy
detail MULS pl 53B GLaM
High Altar, detail c 1465
MULS pl 117A GNoG
Horsemen below Cross at
Golgotha, detail c 1400
alabaster BUSR 18 GHalC
Instruction of the Virgin
c 1500 ptd wood; 26-5/8
DENV 29 UCoDA
Joseph of Arimathea, head,
Entombment group c 1420
terracotta MULS pl 46A
GDaH
Joseph of Arimathea, head
detail, Dernbach c 1410
BUSR 41 GLiD

Joseph of Arimathea in Con-
temporary Dress 1487
BUST 130 GWoC
Kneeling Virgin, Wonnenthal
Nativity c 1480
MULS pl 119A GBS
Little Saint of Dangolsheim
(Kleine Dangolsheimer
Heilige; Small Saint of
Dangolsheim), Upper Rhine
c 1480 limewood; 22
BERL pl 194; BERLE pl
33, 34; BERLEK pl 18;
BERLES 194 GBSBe (2240)
Lorsch Crucifixion, detail:
Mourning Women, Middle
Rhine c 1400 terracotta
BUSR 34 GBS
Ludwig of Bavaria Monument
c 1480 red marble
MULS pl 128 GMF
Lusterweibchen c 1480/90
limewood; 27
KO pl 65 GMBN
Madonna, Leiselheim 1490/
1500 limewood
KO pl 61 GKarB
Madonna, Niedermorschweier
c 1480 H: 62
KO pl 61 FColU
Madonna and Child ptd wood;
19-3/4 DEY 104 UCSFDeY
Madonna and Child ptd and
gilded wood MOLE 80 (col)
GFu
Madonna and Child c 1480/90
lindenwood; 29-3/4 KUHN
pl 20 UMCB (1963.34)
Madonna and Child, Altar of
Last Judgment, St. Nicholas
wood LARR 56 GStrM
Madonna and Child from
Krumau, Bohemia c 1400
stone; 44-1/8
VEY 22, 134 AVK
Madonna and Child on Crescent
Moon, Swabia 1420/30
lindenwood; 95 cm BSC pl
44 GBS (8042)
Madonna and Child on
Crescent Moon, Upper
Rhenish c 1480 wood; 39-1/2
NCM 156 UCLCM
Madonna of Seeon, seated
figure BAZINW 303 (col)
GMBN
Madonna with Apples, seated
figure, Altdorf c 1420

BUSR 30 GNG
Man, Hafnerware portrait bust
c 1500 glazed terracotta;
23 BOSMI 127 UMB (64.1)
Man of Sorrow, double figure
(Christus als Schmerzens-
mann), profile lindenwood;
128 cm BERLE pl 46, 47
GBSBe (382)
Martyrdom of St. Lawrence
c 1480 lindenwood; 15-1/2x
27-7/8 DEYE 53 UCSFDeY
(57.18.3)
Mindener Altar: Middle Wing,
Westphalia 1425 oak; 179x
551 cm BERLEK pl 11
GBSBe (5463)
Monstrance, with relic of St.
Sebastian, Guelph Treasure
c 1475 silver gilt, crystal
CLE 70 UOClA (31.65)
Mourning Women c 1430
LOH 145 (col) GBucH
Our Lady of Compassion,
Ravensburg c 1480 lime-
wood; 53-1/8 FREED pl
20, 21 GBS
Pieta (Vesperbild) ptd and
gilded wood; 30
MOLE 79 GMBN
Pieta c 1340 wood; 66-7/8x
41-3/4x22-1/2
VEY 146 GErU
Pieta 1440 pearwood; 52.5 cm
BERLE pl 35; BERLEK
pl 15 GBSBe (7719)
Pieta, Salzberg c 1420/30
stone; 29-1/2 FREED pl
13, 14 GMBN
Pieta, Seeon c 1400
MULS pl 41 GMB
Pieta, Swabia c 1490 ptd
lindenwood; 35-3/8
EXM 374 GMBN
Pieta, Unna
MULS pl 32B GMuL
Portal, west
FOC-2: pl 149 GUC
Prince-Bishop Dieter von
Isenburg Monument stone
MOLE 17 GMaiC
Saddle Carved: Battles and
Ideal Love c 1400 staghorn
over wood, rawhide and
birchbark
MU 127 UNNMM
St. Anne with Virgin and
Child (Anna Selbdritt)

1490 oak; 95 cm BERLE pl
38 GBSBe (8097)
St. Barbara, memorienpforte
c 1424/25 MULS pl 34A
GMaiC
St. Birgitta, Lubeck c 1410
BUSR 36 SnV
St. Catherine c 1460/70 oak
MULS pl 104B
St. Catherine c 1490/1500 ptd
wood; 40-1/2 BMA 17
UMdBM
St. Catherine and St. Amal-
berga, north side chancel
BOE pl 123 GBranC
St. Christopher, Bavaria
c 1480 ptd limewood; 9-1/4
FREED pl 24 GBS
St. Christopher Carries the
Christ Child through the
River 1442 BUSR 63 GNG
St. George c 1400 ptd lime-
wood; 52 KO pl 58 (col)
GMBN
St. George, High Altar c 1465
MULS pl 121 GNoG
St. George on Horseback,
Swabia c 1420/30 firwood;
24-3/4 EXM 280 GNG
St. John the Baptist, head
c 1430 MULS pl 73A GMBN
St. John the Evangelist,
Rhenish c 1480 ptd wood;
17-1/2 CAMI pl 18
St. Lawrence, Upper Rhenish
lindenwood; 11-7/8
KUHN pl 13 UMCB (1962.110)
St. Martin, Zeitlart 1480
MALV 303 GMBN
St. Matthew c 1430
MULS pl 76B GAaC
St. Michael, relief 1467
MULS pl 116B GErS
St. Michael Standing on
Dragon, Passau c 1490
limewood; 48-1/2
FREED pl 22, 23 GMBN
St. Peter, west facade stone
MOLE 80 (col) GRegC
St. Peter, reclining figure,
from Christ and Three
Apostles pinewood
INTA-1: 98
St. Sebastian c 1470 ptd wal-
nut; 38
BOSMI 125 UMB (63.589)
St. Sebastian, Swabia c 1490
limewood; 39 FREED pl 27
GBS

St. Servatius Protected by
Eagle against King of the
Huns, fragment, Maas-
tricht Servatius Reliquary
c 1403 silver
BUSR 28 GHKG
Scholar Saint, half figure,
cloister tympanum c 1490
MULS pl 168B GWuC
Schusselfelder St. Christopher,
St. Sebald 1442
MULS pl 80 GNG
Schutzmantel Virgin of
Ravensberg 1480 lindenwood;
135 cm
BSC pl 57 GBS (421)
Seated Man c 1430/35 stone
MULS pl 81 FStrF
Seated Virgin (Thronende
Maria) 1430 lindenwood;
95 cm
BERLE pl 44 GBSBe (5874)
Seeon Madonna, Chiemsee
c 1450 KO pl 57; MULS pl
51 GMBN
Stalls, detail back-rests 1468
CHAS 122, 124 IVMG
The Three Kings, retable
figures c 1489 ptd wood
NM-12:199 UNNMMC
Three Mourning Women, from
Deposition, Mittelbiberach,
Swabia c 1410 lindenwood;
116x56 cm
BERLEK pl 13; BERLES
192; BUSR 37; FREED pl
12; KO pl 58 GBSBe (5556)
Ulrich Kastenmayr, effigy
detail before 1431 red
marble
MULS pl 53A GStraJ
Unicorn Hunt (Einhornjagd),
relief, Altmark lindenwood;
90 cm BERLE pl 72 GBSBe
(7014)
Vintner's Madonna, standing
on crescent moon, child
holding grapes c 1430 clay
LOH 158 GHallgP
The Virgin, detail c 1425 ptd
wood
FAIN 106 UMCB
Virgin c 1466 stone
MULS pl 113A GCoM
Virgin and Child silver;
4-1/4
BOSMI 121 UMB (50.3)

Virgin and Child c 1420/25
MULS pl 33B GWuA
Virgin and Child c 1430 ptd
limewood; 42-1/2x33-1/8
FREED pl 15 GMBN
Virgin and Child (Schone
Madonna) 1430 poplar wood;
171 cm BERLE pl 22;
BERLEK pl 14 GBSBe
(8032)
Virgin and Child c 1460
MULS pl 76A GLuCa
Virgin and Child c 1470/80
MULS pl 119B EDown
Virgin and Child, St. Moritz
c 1490 parcel gilt silver
MULS pl 173A GAuMax
Virgin and Child, Strassburg
c 1480/90 applewood; 9-7/8
EXM 372 GBS
Virgin and Child, seated figure
lindenwood; 40 cm BERLE
pl 62 GBSBe (M 138)
Virgin and Nursing Child
(Thronende Maria) linden-
wood; 39 cm
BERLE pl 34 GBSBe
(408)
Virgin and St. John, Cruci-
fixion figures 1469(?)
MULS pl 112 GKalN
Virgin in the Rose Bower,
relief c 1460/70 limestone
MULS pl 94B GBS
Virgin of Mercy, Upper Swabia
c 1480 ptd wood
ROTHS 127 GBD
Woman, half figure ptd wood;
68-1/2 HUYA pl 46;
HUYAR 88 FPL
--16th c.
Adam and Eve, Nuremberg(?)
ptd pearwood
MUL 5 (col) GMBN
Allegory of Childhood, automaton
figure, astronomical clock,
Strassburg Munster 1571/74
ptd wood; 61 cm MUL 70 FStrF
Altar with Saints 1507 lindenwood;
pine shrine; 212x241.5 cm
BERLE pl 43 GBSBe (1982)
Angel, head, Talheim Altar
c 1515 ptd wood
KO pl 67 (col) GStLa
Angel with Lute 1500 linden-
wood; 49.5 cm
BERLE pl 25 GBSBe (7647)
Angel with Viola 1500

1500 lindenwood; 51 cm
BERLE pl 24; BERLEK pl
19 GBSBe (7648)
Armet, Maximilian Style
Helmet steel CLE 109
UOClA (16.1855)
Armet-a-Rondelle c 1515
SOTH-3: 246 ELTow
Armor, Nuremburg c 1520
FAIN 183 UMWH
Armor, Maximilian Style
c 1520
ROOS 170D UOClA
--Augsburg 1540 H: 66
NEWA 75 UNjNewM
--Nuremburg c 1505 H: 69
NM-3: 8 UNNMM (49.163.1)
Assumption of the Virgin
(Himmelfahrt Maria) 1520
lindenwood; 183 cm
BERLE pl 40 GBSBe
(7043)
Automaton Table Clock, with
Lion figure
SOTH-3: 235
Beautiful Madonna (Fair
Virgin) 1509
MULS pl 165B GLuCa
Birth of the Virgin, relief
1520 lindenwood; 58.5x84
cm BERLE pl 58; BERLEK
pl 26 GBSBe (453)
Bishop Saint; head detail 1520
lindenwood; 117 cm
BERLE pl 56, 57 GBSBe
(7962)
Burgonet, or Helmet with
vizor: Grotesque Human
Face iron; 10-1/2
GRIG pl 124 ELBr
Catherine of Alexandria,
Franconian c 1520 ptd
limewood; 28
KO pl 62 (col) GMBo
Celestial and Terrestrial
Globe, Augsburg 1588
ENC col pl 55 (col) AVK
Chimney Piece, detail of
panels: Mars and other
Gods
SEZ 193 GLaR
Clock with Mannequin-strikers
GAF 314 FBesM
Crocodile Sand Container,
Nuremberg c 1575/1600
gilded silver; L: 12-3/4
KUHN pl 45 UMCF
(1956.206)

Cyriacus, Talheim Altar c 1515
ptd limewood; 55
KO pl 67 GStLa
David bronze; 10
BMA 21 UMdBM
Education of the Virgin,
Danube School ptd wood; 20
CAMI pl 32 CMFA
Elephant, Augsburg 1560/70
bronze; 47 cm
MUL 19 GBrU
Elephant Jewel c 1585 baroque
pearl
COOP 168 FPRoths
Eva von Renneberg, effigy
detail 1567 black marble
BUSB 17 GAcCh
Facade, with figures, Otto
Heinrich Wing 1556/63
BAZINW 369 (col); LOH
212 GHeCa
Folding Altar with St. Agatha,
Ulm 1512 lindenwood; pine
shrine; 109 (excl predella)x
242 cm BERLE pl 63
GBSBe (3135)
Folding Altar with Virgin and
Saints; detail: St. Barbara
1520 lindenwood; pine
shrine; 177x288 cm
BERLE pl 74, 75 GBSBe
(7036)
Fortune, Augsburg 1520/25
lindenwood; 55 cm
BSC pl 105 GBS (8504)
George Dux, effigy after 1589
marble; LS
MUL 73 GHofCa
Good King Rene, medallion
wood; Dm: 5 CHAR-2: 23
FPL
Gothic Coffer c 1500 iron;
7x10x6-1/2
DEYE 79 UCSFDeY (4998)
Hands of St. Paul, detail:
Agony in the Garden c 1500
BUSR 110 AM
Heinrich von Ottenstein and
Wife Tomb c 1520
BUSR 167 GOL
Heraldic Epitaph (Totenschild),
relief c 1500 circular ptd
lindenwood; 46-1/2
KUHN pl 21 UMCB (1955.452)
Jousting Armor (Tilting Armor)
c 1500
NM-3: 6 UNNMM
(04.3.291)

--1575 H: 71
NM-3:6 UNNMM (29.154.1)
--Saxony c 1590
DETT 159 UMiD (53.197)
Judgment of Paris, relief
1st Q 16th c. cedar; 9-1/4
x7 ASHS pl 15 ELV
The Lord's Supper (Abandmal)
1500 oak; 49 cm
BERLE pl 73 GBSBe (M140)
Lucretia boxwood; c 8-5/8
FEIN pl 130 UNNMM
Madonna and Child, Middle
Rhenish(?) c 1520 linden-
wood; 58 KUHN pl 29
UMCB (1963.100)
Madonna in Glory, triptych,
Lower Saxon 1524 ptd lin-
denwood; 93x93 (central
panel), and 56-1/2 (ea wing)
KUHN pl 30 UMCB (1949.
306)
Man, medallion profile box-
wood; Dm: 2-1/4
MOLE 94 ELV
Man and Horse Armor c 1550
DENV 34 UCoDA (E-905)
Mary and St. John the
Evangelist, head details
c 1500 lindenwood; 50
DEY 108, 109 UCSFDeY
Mary, Elizabeth and Zacharias
c 1515 limewood
INTA-1:97
Mary Magdelen; detail 1500
lindenwood; 88 cm
BERLE pl 48, 50 GBSBe
(8158)
Mary Magdelene c 1520 wood
FEIN pl 58 UNNMM
The Nativity, Upper Rhenish
c 1500 ptd lindenwood;
28-1/4x30-1/2
KUHN pl 19 UMCB (1963.1)
Norfolk Pomander c 1575 gold
and enamel
INTA-2:136
Owl 1540 faience
CLE 113 UOClA (50.370)
Parade Armor of Maximilian
II c 1560/65 embossed and
damascened
ARTV pl 34 AVK
--Cuirass
ARTV pl 33
Pendant: Crossbow c 1500
gilt silver; 8
DEYE 78 UCSFDeY (60.2.6)

Pendant: Mermaid H: 5-1/2
INTA-1:111
Pieta (Klage um den Leichnan
Christi: Beweinung Christi)
1500 oak; 92x74 cm
BERLE pl 28; BERLEK pl
34 GBSBe (475)
St. Augustine and St. Jerome
c 1510 oak
FAIY 169 UNBiR
St. Christopher boxwood
SOTH-2:214
St. Christopher 1500 oak;
46 cm
BERLE pl 71 GBSBe (8175)
St. Eligius lindenwood; 74 cm
BERLEK pl 27 GBSBe (2706)
St. John, head c 1500
PANM il 4 GHKG
St. Martin and the Beggar,
relief oak; 19-3/4x14-1/4
KUHN pl 39 UMCB (1959.29)
St. Martin and the Beggar,
relief c 1500 oak; 34
SOTH-4:266
St. Mary Aegyptiaca
GAF 140 FPL
St. Nicholas, seated figure,
Ingolstadt 1520/30 linden-
wood; 97 cm
BERLE pl 69 GBSBe (5885)
St. Peter; detail 1500 cembra
pine; 132 cm
BERLE pl 49, 51 GBSBe
(8327)
Sitting Dog Scratching Himself,
Nuremberg bronze
CLE 108 UOClA (60.74)
Skull, memento mori ivory;
L: 3-3/4
GRIG pl 126 ELBr
Spice Container for Havdalah
Ceremony c 1550, restored
1651 silver
ROTH 338 UNNJe
Stoveplate (Ofen Platte) iron;
138x96 cm
BERLEK pl 38 GBSBe (AE
174)
Tazza, Augsburg c 1580 silver
gilt
NM-8:13 UNNMM
Two Drinking Vessels: Fantastic
Animals c 1600 shell and
silver gilt
COOP 168 FPRoths
Virgin and Child, seated figure,
Augsburg 1521 lindenwood;

68 cm BERLE pl 67;
BERLEK pl 24 GBSBe (7974)
Virgin and Child, and Donor
1500 willow; 76 cm
BERLE pl 53 GBSBe (5544)
Virgin and Child on Crescent
Moon (Maria mit dem Kind
auf der Mondsichel) 1500
lindenwood; 104.5 cm
BERLE pl 59 GBSBe (5861)
Virgin in Glory, Regensberg
(?) c 1520 unglazed Hafner-
ware; 12-5/8 BOSMI 127
UMB (63.34)
Way to Calvary, relief c 1550/
75 gilded bronze; 3-3/4x
2-3/4 KUHN pl 39 UMCF
(1926.116)
Wild-Man Candle Holder
c 1525/50 bronze; 10-1/2
(with base); Figure: 8-1/2
KUHN pl 36 UMCB (1962.79)
Willmann House, carved half-
timbering 1586 LOH 219 GOs
Window Lattice, interlaced cal-
ligraphy with flower orna-
ments wrought iron; 18-7/8
x29-7/8 BERL pl 173;
BERLES 173 GBSBe (71.195)
--17th c.
Adoration of the Shepherds,
altarpiece detail 1612
LARR 347 GUb
Aeneas and Anchises in Flight
from Troy AGARC 91 UPPJ
Angel c 1600/20 ptd lindenwood;
44-1/2 KUHN pl 41 UMCB
(1964.34)
Angel, confessional
BUSB 88 BBMG
Boimow Mausoleum 1609/17
HEMP pl 18 RuLo
Carved Spoon 1676 boxwood
NORM 78 ELV
Ceremonial Dish and Jug:
Europa and the Bull c 1630
silver, partly gilded, Jug:
16; Dish: 29x24-1/2
COOPF 179 GDonF
Christ Crowned with Thorns
c 1600/20 ptd lindenwood;
22-1/2x30-1/4x9 KUHN pl
47 UMCB (1962.99)
Coronation of the Virgin
(Kronung Mariae), relief
boxwood; 18.7x13.5 cm
BSC pl 108 GBS (8617)

Death and the Nobleman, re-
lief stucco BUSB 64 PoTaJ
Eilhard Schacht Tomb 1670
BUSB 87 GScC
Elector Johann Sigismund of
Brandenburg, badge 1610
gold, enameled and jeweled;
5-1/8x3-1/32 BERL pl
160; BERLES 161 GBSBe
Griffin as Escutcheon Holder,
Augsburg 1600 bronze; 41
cm MUL 80 GStWL
Knife Sheath 1626 boxwood,
silver band; L: 7-3/4
KUHN pl 45 UMCB
(1963.5479)
Madonna lindenwood; 154 cm
BERLEK pl 39 GBSBe
(8573)
Meissen Figure: Turk with
Guitar 1744 LARM 142
GCoKK
Nautilus Goblet, model,
Nuremberg(?) 1650/75
gilded silver; 2-3/8
KUHN pl 44 UMCB (1962.29)
Pendant: Pelican c 1600
enameled gold with rubies
CLE 111 UOC1A (59.336)
Pendant: Ship c 1600 gold,
enamel, crystal, jewels
MU 173 (col)
Personification of Death, Up-
per Rhenish c 1600/50
lindenwood; 10-1/8 KUHN
pl 48-9 UMCB (1959.32)
--c 1600/50 lindenwood; 10-
5/8 KUHN pl 50-51 UMCB
(1959.33)
Prince-Bishop Franz von Ingel-
heim Monument marble
MOLE 17 GMaiC
Rape of Proserpine c 1625/50
bronze with gray-green
patina; 29-1/2 KUHN pl 53
UMCF (1949.66)
Roadside Christ
DIV 56
Sacrifice of Isaac ivory; 14
KUHN pl 57 UMCB (1964.21)
St. Dismas H: 151 cm
BERLE pl 80 GBSBe (8386)
St. Sebastian 1600 lindenwood;
163 cm BERLEK pl 42
GBSBe (8455)
Salome boxwood; 12-1/4
ASHS pl 29 ELV

Saxon Sporting Crossbow and
Winder stock L: 32-3/4
NM-3:16 UNNMM
(29.158.650a, b)
Scroll of Esther Case silver
ROTH 347 ELJe
Stoveplate (Ofen Platte) 1615
iron; 146x133 cm BERLE
pl 78 GBSBe (AE 310)
Tankard, Augsburg ivory and
silver; 13-1/2 COOPF 88
SnSkW
Tankards ivory with silver
gilt mounts; 10-1/2
INTA-2:134
Tray (Lokhan): Rape of
Europa silver DUNC 98
(col)
Tray (Lokhan): Reconcilliation
of Joseph and Jacob, Augs-
burg 1647 silver DUNC 99
(col) RuMK
Two Handed Sword 1610 L:
66-1/2 NM-3:15 UNNMM
(04.3.273)
Virgin and Child, seated fig-
ure on crescent moon 1640
lindenwood and pine; 136
cm BERLE pl 81 GBSBe
(8430)
Virgin in Glory, with sickle
moon and sun c 1600 gilded
silver, wooden base; 13-3/4;
Madonna H: 7-7/8 KUHN pl
42-43 UMCB (1964.31)
--17/18th c.
Selene and Endymion bronze
REED 162 UCSFCP
Venus and Adonis bronze
REED 161 UCSFCP
--18th c.
Angel's Head lindenwood; 28.5
cm BERLE pl 96 GBSBe
(8315)
Ansbach Porcelain Figure
c 1730/50 ENC 30
Artist and Scholar Presented
to Chinese Emperor c 1765
Hochst Porcelain; 15-7/8
NMA 183 UNNMM (50.211.
217)
Augsburg Centerpiece 1775
silver ENC 169
Baroque Staircase, with
figures after 1723
LOH 243 GWurP
Bottger Period Meissen Fig-
ure, Augsburg INTA-2:126

Child with Cornucopia, dish
cover 1767/68 porcelain;
25.5; Dm: 36 cm BERLES
174 GBSBe (H260)
The Chinese Emperor c 1770
Hochst Porcelain; 15-7/8
DETT 162 UMiD (51.59)
Chinese Pavilion, detail: Head
1754/57 gilded bronze
GERN pl 51 GPoS
Choir Stall, Charterhouse,
Mainz 1723/26 wood, with
ptd and gilded angels;
84-1/2 NM-8:22 UNNMM
(58.120)
Clock with Wooden Cogs and
Figure of Death, the Grim
Reaper SELZP 4 GMD
The Dressing Table Franken-
thal Porcelain; 8 DEY 134
UCSFDeY
Fear boxwood
BUSB 199 ELV
Female Figure, Nymphenberg
1754/55 ENC 672
Floating Angel
BUSB 216 ELV
Floating Angel, Baptismal
Chapel c 1760 BUSB 181
GDiesS
Frankenthal Chinese Tea
House, detail porcelain
ENC 316
Frankenthal Group porcelain
ENC 316
Fulda Figure porcelain
ENC 321
Greeting Harlequin Meissen
Porcelain; 6 BMA 36
UMdBM
Henry II, Bamberg lindenwood;
164 cm BERLEK pl 50
GBSBe (8692)
Hochst Arbour Group of
Spring, after J. E. Nilson
engraving SOTH-8:186
Horse's Head Bonbonniere
SOTH-3:219
Immaculata, Schlossborn
c 1735 BUSB 132 GFiCh
Intruder at the Fountain,
Ludwigsburg porcelain; 8
DEY 134 UCSFDeY
Isabella and her Admirer
Meissen KO pl 95
FPPP

Kunigunde, Bamberg linden-
wood; 163 cm BERLEK pl
51 GBSBe (8693)
Jay c 1750 Hochst Faience
SOTH-4:193 (col)
Joseph Froehlich, court jester
of Augustus the Strong,
Meissen c 1728/29 porce-
lain; 20 DETT 163 UMiD
(59.295)
Judith with Head of Holo-
fernes, Wurzburg(?) c
1740/50 alabaster; 14-1/2
(with base) KUHN pl 70-71
UMCB (1963.5531)
Love Among the Ruins c 1754
Nymphenburg Porcelain
ENC 672
Ludwigsburg Ballet Dancers
porcelain SOTH-4:194
Meissen Chess Set 2-1/2 to
3-1/4 SOTH-4:xi
Meissen Group: Negro and
White Child VALE 90 UMiD
Meissen Magpies c 1733
porcelain; 21-1/2 and 21
COOP 144 UNNUn
Meissen Monkey with Ormolu
Mount SOTH-1:144 (col)
Mercy Altar, detail: Seated
Saint with Cross 1743/71
MYBS 51 GV
Nodding Mandarin, Meissen
SOTH-2:154
Oldenburg Horn c 1470 gilded
silver; 33 cm BOES 19
DCRo
Parrot Hochst Porcelain,
ormolu mounted SOTH-4:
192 (col)
Patriarch ptd limewood; 30
KO pl 94 (col) GStLa
Pieta (Vesperbild) lindenwood
and pine (cross); 187 cm
BERLE pl 89 GBSBe (5560)
Postmaster "Baron" Schmiedel,
Meissen c 1737 porcelain;
18-3/4 DETT 164 UMiD
(59.296)
Pulcinella, Meissen
ENC 738
Rococo Ceiling Decoration,
detail LARR 356
St. Agatha ptd limewood; 32
KO pl 93 (col) GStLa
St. Joseph and the Christ
Child, Bavaria c 1740/50
ptd and gilded wood; 49x27
CAMI pl 85 CMFA

St. Michael c 1700/1710 gilded
bronze, stone base; 5-1/2
(excl base) KUHN pl 56
UMCF (1952.31)
St. Roch (Heiliger Rochus)
1770/80 lindenwood; 154 cm
BERLE pl 92 GBSBe
(5895B)
St. Sebastian pine; 32 cm
BERLE pl 83 GBSBe (8644)
St. Wenderlin 1770/80
lindenwood; 143 cm BERLEK
pl 52 GBSBe (5895A)
Strasbourg Faience Harlequin
INTA-2:126
Swan Meissen Porcelain
SOTH-1:152
Swan Service Covered Tureen
c 1738 Meissen Porcelain
INTA-2:124
Table Center Piece, Augsburg
1775 BAZINL pl 359
Temple of Bacchus, Berlin
Porcelain center piece
ENC 89
Time
SOTH-2:214
--18/19th c.
Ludwigsburg Porcelain Group
1756/1824 ENC 576
--20th c.
Circus Wagon: The Lion and
the Serpent 1910 ptd wood
PANA-1:9 UFSR
Wheeled Toy Ship 1928
OZ 210
GERMAN, or AUSTRIAN
Chandelier: Mermaid c 1675/
1700 ptd lindenwood; figure
H: 17 KUHN pl 37 UMCF
(1957.185)
GERMAN, or ENGLISH
Reims Candlestick, details
12th c. cast bronze SWA
pl 149, 150 FRhMu
GERMAN, or FRENCH
St. Christopher c 1390
lindenwood; 30-3/4 DEYE
32 UCSFDeY (59.32)
GERMAN, or ITALIAN
Bird c 1200 bronze
NM-12:145 UNNMMC
Otto I Presenting Church to
Christ, plaque ivory;
5-1/8 NMA 47 UNNMM
(41.100.157)
GERMAN, or NETHERLANDISH
Madonna and Child c 1675/
1700 boxwood; 5-1/8

(with base) KUHN pl 67
UMCB (1954.105)
GERMAN, or SWISS
Chandelier: Woman Playing
Lute (Leuchterweibchen)
c 1550/75 ptd lindenwood;
figure H: 10-3/8 KUHN pl
37 UMCB (1961.110)
Madonna, detail wood
CHENSW 355 SwBKH
Mary Kneeling wood
CHENSW 355 SwBKH
GERMAN, and RUSSIAN
9 Thalers
BERL pl 158 GBMu
German Yeoman. Multscher
Germania. Schilling, J.
Germanicus. See Britannicus
Germinazione 2, Pepe
Gero of Cologne (Archbishop fl 969-
76)
German--10th c. Gero Cross
The Gero Cross. German--10th c.
GEROME, Jean Leon (French 1824-
1904)
Ironworker bronze
PAG-5:211 UNNSchwa
Napoleon Bonaparte Entering
Cairo 1897 bronze gilt
ROTHS 213 FPLu
Sarah Bernhardt, bust
CAS pl 17
Tanagra 1890 marble
SELZJ 78 FPL
Portraits
Carpeaux. Gerome, bust
GERRARD, A. H. (English 1899-)
The Dance 1959/60 Portland
stone; 6x16x1'
LOND-5:#21
North Wind
AUM 128 ELUR
--stone
PAR-1:85 ELStJP
GESTNER, Karl (Swiss 1930-)
Lens Picture 1962/64 plastic
lens and transparency of
concentric circles; 28x28
SEITR 42 UNNSt
Lens Picture No. 15, con-
struction (Lensbild) 1964
concentric circles behind
plexiglas lens; 28-3/8x
28-13/16 ALBC-4:62;
NEW pl 303 UNBuA
GERTHNER, Madern
Archbishop Konrad III, Count
von Daun Tomb c 1439
BUSR 29 GMaiC

"Memorienpforte", detail:
St. Barbara BUSR 38
GMaiC
South Porch Tympanum c
1420 BOE pl 131; BUSR
26 GFK
Gertrude, Saint
Maitre Jacques. Shrine of St.
Gertrude
Netherlandish. St. Gertrude
Vieira, J. St. Gertrude
Gertrude of Nivelles, Saint
Flemish--15th c. St. Gertrude
of Nivelles
Gertrudis Crosses. German--11th c.
Gertrudis Portable Altar. German--
11th c.
Gervasius
Master H. L. High Altar:
Angel; St. Luke;
Gervasius
Gesenkter Frauenkopf. Lehmbruck
Der Gesturtze
Lehmbruck. The Fallen
Gethsemane See Jesus Christ--
Gethsemane
GETTINGER, Lilli
Self Portrait bricks
SEYT 81
Gew Form. Mitchell, D.
GEZA, Vida (Rumanian 1913-)
Horitoare 1957 wood
VEN-58:pl 171
Geza I (King of Hungary fl 1074-77)
Byzantine. Holy Crown of
Hungary
Gherardesca, Ugolino della, known
as Ugolina da Pisa (Ghibel-
line Leader 1220?-89)
Carpeaux. Ugolino and his
Children
Gherassimov, S.
Tomski. S. Gherassimov, bust
GHERMANDI, Quinto (Italian 1916-)
Figure 1960 bronze
VEN-60:pl 89
Momento del Volo 1960 bronze;
70-7/8x47-1/2x47-1/4
READCON 260
Nocturnal Leaf (Foglia Not-
turna) 1959 bronze
VEN-60:pl 88
Pepete a Piombo 1966 bronze
VEN-66:#41
Timoteo 1966 bronze
VEN-66:#40
Ghermoska. D'Haese, Roel
GHIBERTI, Lorenzo (Italian 1378-
1455)

Angels, Shrine of San Zenobio
 MACL 61 IFCO
Baptistry Doors--East (Gates
 of Paradise; Old Testament
 Doors; Porto Paradiso)
 1425/47 bronze; 18-1/2'
 AUES pl 16; BARSTOW
 118; BAZINW 331 (col);
 BODE 32; BR pl 3 (col);
 BROWF-3:15; CHENSW 374;
 CHRC fig 159; FLEM 340;
 FREEMR 64; LARR 102;
 MYBA 372; POPG fig 87-8;
 PRAEG 298; ROBB 363;
 ROOS 107G; SEY pl 48;
 SIN 228; ST 303; STI 580;
 UPJ 256 IFBap
--detail
 ENC col pl 41 (col); GLA
 pl 35; PRAEG 18
--Abraham Story
 CHENSW 375; MARQ 177;
 MU 135; POPG pl 74, 77;
 ROBB 364; ROOS 108A
--Abraham Story: Sacrifice of
 Isaac
 CHASEH 305; CRAVR 70;
 MONT 377; ROOS 108A;
 SEW 520; UPJ 257; UPJH
 pl 108
--Adam and Eve (Creation of
 Man) CHENSN 340, 341;
 FLEM 341; MACL 77;
 MOREYM pl 156, 157;
 MYBA 373; MYBU 138-9;
 POPG pl 69-71; POST-1:
 168; SEY pl 49A
--Adam and Eve: Creation of
 Adam MYBU 58
--Adam and Eve: Creation of
 Adam and Eve
 BAZINH 206; GAUM pl 46
--Adam and Eve: Creation
 of Eve CLAK 288; POPG
 fig 96; SEW 521; UPJH pl
 109
--Benjamin: Finding the Cup
 in Benjamin's Sack
 ROOS 108B
--Cain and Abel 21 Sq
 BIB pl 20; MOLE 122;
 POPG pl 75-6; RAY 38;
 SEY pl 52
--David and Goliath
 BIB pl 158; ROTH 145
--Esau: Isaac Jacob and Esau
 JANSH 310; JANSK 625

--Esau: Jacob and Esau
 BAZINW 330 (col); BUSR
 48-51; CHASE 213;
 GOLDWA 31; KO pl 73
 (col); MAR 23 (col);
 MONT 74; MCCA 64;
 POPG pl 72-3
--Joseph
 BIB pl 72, 76; MURRA
 35; SEY pl 50
--Joshua
 BIB pl 136
--Male Figure
 CHAS 64
--Moses Receiving the Law
 BIB pl 114; MCCL pl 26
--Noah Story
 FREEMR 67; SEY pl 49B
--Noah Story; Noah After the
 Flood
 BIB pl 29
--Samson
 POPR fig 133
--Self Portrait, tondo bust
 BAZINW 332 (col); ENC
 336; GOLDF pl 4;
 GOLDWA 27; HALE 96
 (col); UPJH pl 109
--Solomon and the Queen of
 Sheba
 BIB pl 182; CHASE 211;
 CHENSW 375; FREEMR
 67; GARDH 297; ROOS
 108C
--Vittorio Ghiberti, head
 SEY pl 47B
Baptistry Doors--North
 1403/24 bronze
 ROOS 107B
--Adoration of the Magi
 BAZINW 333 (col); SEY 7A
--Adoration of the Magi: Two
 Kings
 MOLE 121 (col)
--The Annunciation bronze;
 17-3/4x15-3/4
 GUIT 29; MACL 92; MONT
 376; MURRA 32; POPG pl
 66
--Baptism of Christ
 FREEMR 62
--Life of Christ Scenes, with
 4 Evangelists and 4 Fathers
 of the Latin Church
 MOLE 118
--Life of Christ: Christ
 Before the Money Changers;

Christ and Peter on the
Water ROOS 107F
--Life of Christ: Christ
Bound to Pillar; Christ
before Pilate ROOS 107E
--Life of Christ: Christ
Carrying the Cross
POPG pl 68
--Life of Christ: Expulsion
from the Temple; Tri-
umphal Entry into Jerusalem
MONT 73
--Life of Christ: Expulsion of
the Money Changers
JANSK 537
--Life of Christ: The Flagel-
lation MURRA 32
--The Nativity
MACL 92; NEWTEM pl 111
--Nativity and Annunciation to
the Shepherds
POPG pl 67
Madonna and Child ptd terra-
cotta; 27 DETT 61 UMiD
(40.19)
Madonna and Child ptd terra-
cotta; 40-3/8x24-1/2x
11-1/8 KRA 42 (col);
SEYM 57-8; USNK 176;
USNKP 376 UDCN (A-147)
Madonna and Child terracotta;
24-3/4 NCM 38 UNcRV
Madonna and Child with Angels
clay BODE 43 GBK
Sacrifice of Isaac (competitive
panel) 1401/02 gilt bronze;
21x17-1/2
BARG; CLAK 239; FLEM
339; JANSH 264; JANSK
536; MACL 73; MAR 18
(col); MOLE 110; MU 134;
MURRA 31; POPG fig 31;
POPR fig 1; RAY 38;
ROOS 107C-D; SEW 518;
SEY pl 6A; STI 79; VER
pl 27 IFBar
St. John the Baptist, facade
1412/16 bronze; figure:
96 LOWR 252; MAR 11;
MONT 74; MURRA 34;
POPG fig 79; pl 78 IFO
St. Matthew, facade 1419/21
bronze; figure: 102
MAR 11; MOLE 123;
MURR 34; NEWTEM pl
112; POPG pl 79; SEY pl
24 IFO

St. Stephen
MACL 75; POPG fig 80
IFO
GHIBERTI, Lorenzo, and Giuliano di
SER ANDREA
Font: Baptism of Christ
c 1425 gilt bronze; 23-1/2
Sq ENC 336; GOMB 181;
JANSK 624; MURRA 39
ISB
--St. John the Baptist
Preaching before Herod
POPG pl 80
GHIBERTI--FOLL
Madonna and Child
MACL 81 ELV
Madonna and Child, panel ptd
terracotta; 24-1/2x18
TOR 121 CTRO (909.18.3)
Virgin Annunciate terracotta;
32 ASHS pl 17 ELV
Virgin and Child
POPG fig 94 UNRoR
GHIBERTI, Vittorio
Ghiberti, L. Baptistry Doors
--East: Vittorio Ghiberti
Ghidebert, King
French--13th c. King Ghide-
bert
GIACOMETTI, Alberto (Swiss 1901-
1966)
Annette VIII 1962 bronze;
23-1/8 GUGE 32
Annette IX 1964 bronze; 17-1/2
GUGE 32
Annette Gard a Vous 1955
JOR-2: pl 201
Bust bronze
DIV 52
Buste (Tete Tranchante)
1953 bronze JOR-1: pl 75
The Cart 1951 ptd bronze;
65 KO pl 108 FPMa
Chariot 1950 bronze; 57
BAZINW 439 (col); CHRP
384; JANSK 1022; JOR-1:
pl 73; NNMMM 151; RIT
212; UPJH pl 242 UNNMMA
Chiavennan Head (Tete
Chiavennan) 1965 bronze;
16-1/4 GUGE 33
City Square 1948 bronze;
8-1/2x25 LOWR 220;
MCCUR 268; READAS pl
207; RIT 211 UNNMMA
--1949 bronze; c 9
RAMS pl 84b

Large Figure 1958 ptd plaster
 SELZJ 194 FPMa
Large Head 1960 bronze
 CHENSW 502 UDCP
Large Seated Woman 1958
 bronze VEN-62:pl 86
 FPMa
The Leg 1959 gilt bronze; 86-
 1/4 (with base)
 TRI 74 GDuK
Lion Woman 1946/47 bronze;
 62 CALA 192; GUGP 69
 IVG
Long Head 1950 bronze; 11
 RAMS pl 84a
Man 1929 bronze; 15-3/4
 DETS 7; READCON 143
 UNNH
Man Pointing (L'Homme au
 Doight; Homme Signalant;
 Pointing Man) WILMO pl 28
--bronze; 70-1/2
 BMA 74 UMdBM
--1947
 ENC 337
--1947 bronze; 70 (with base)
 BOW 45; GIE 105; LARM
 322; MYBS 77; RAMS pl
 85; READCON 149; ROTJG
 pl 23; ROTJT 24; TATEF
 pl 30f ELT (5939)
--1947 bronze; 70-1/2
 CHENSW 502; COL-20:544;
 GARDH 649; SELZN 69,
 72 UNNMMA
--RIT 210 UNNRoIII
Man Walking (Schreitender;
 Walking Man) 1947 bronze
 GERT 158
--1947 bronze; 67
 BOSME pl 127 UPPiT
--1950 bronze
 GAUN pl 63
--1960 bronze; 71-3/4
 ALBA; ALBC-3:#73; FAIY
 7; TOW 109 UNBuA
--1960 bronze; 72-1/2
 HENNI pl 140 UIWM
Man Walking Across a Square
 in Sunshine 1948 bronze;
 27-1/2 GIE 102 FPMa
Man Who Walks I (Homme que
 Marche I) 1960 bronze;
 71-3/4 GUGE 28, 29
 UNBuA
Model for a Garden 1932
 wood; 7-7/8x11-7/8x9
 CALA 189; GUGP 67 IVG

Model for a Square (Projet
 pour Une Place) 1930/31
 wood; 4x12x9 GIE 99
 FPGi
Monumental Head 1960 bronze;
 37-1/2 READCON 151
 UNNH
Nude 1932/34 bronze; 58-1/4
 CALA 191; GUGP 69
 IVG
On ne Joue Plus 1931/32
 SOBYA pl 51
The Palace at 4 A.M.
 1932/33 construction in
 wood, glass, wire, string;
 25x28-1/4x15-3/4
 BOW 89; BR pl 16; GIE
 97; HENNI pl 59; JANSH
 534; LYNC 82; MAI 112;
 MCCUR 268; NMFA 173;
 NNMMM 150; READCON
 144; RIT 160; ROOS 282D;
 NNMMAP 141; NNMMARO
 pl 317; SELZN 14; WALD
 85 (col) UNNMMA
The Palace at 4 A.M., III
 1934 ROOS 282A FP
People of the Piazza 1948/49
 bronze; 17x60x41 cm
 LIC pl 282 SwBKM
Personnage 1935
 READAN #61 -Wh
Project for a Monument to a
 Celebrated Person 1956
 plaster; 18 BOW 6
Project for a Passage 1932
 LIC pl 278 SwZGia
Reclining Woman 1929 ptd
 bronze; L: 16-5/8
 READCON 144 UNNH
Seated Woman (Femme
 Assise) 1950 JOR-2:pl 202
--1957 bronze; 20
 DETS 41 UNNH
Six Figures 1955/56 plaster
 MARC 43
Slim Bust 1955 bronze
 SELZJ 5 FPMa
The Square (Piazza) 1948/49
 bronze; 6-3/4x23-5/8x
 16-1/8 CALA 16 (col),
 193; GUGP 70; MARC pl
 50 (col) IVG
--1948/49 bronze; 8-1/4x
 24-3/4x17-1/4 LYN 161
 SwBK
Standing Figure 1957 bronze;
 27-1/2 MIUH pl 60 UMiAUA

--1963 H: 22
 SEITC 45 UNNMat
Standing Woman (Femme
 Cuiller) 1926/27 (3rd of
 7 casts made in 1954 from
 1926/27 original) bronze;
 57 GUG 204 UNNG
--1960 bronze; 109-1/2
 EXS 80 SwBBe
Standing Woman III (Femme
 Debout III) 1960 bronze;
 92-1/2 GUGE 30 UNNMa
Suspended Ball 1930/31 wood
 and metal; 23-5/8 SELZP
 7 FPBre
Tall Figure 1947 bronze; 79
 SELZN 73
--1949 ptd bronze; 65-5/8
 KUHB 115; NMASO 44;
 SELZN 73 UCtNcS
Tall Figure, study 1947
 plaster KUHB 115
Three Figures (Trois Figures)
 1948 bronze; 30
 SCHAEF pl 72
Three Figures (Trois Figures)
 II 1949 KULN 9
Three Men (Groupe de Trois
 Hommes I) 1948/49 bronze;
 65 cm JOR-1:pl 72
Three Men Walking 1949 H:
 28 SEITC 71 -UTho
Two Figures 1926 plaster
 MAI 111
Two Heads; in progress clay
 MILLS pl 28, 29
Witching Hour
 CANK 159
Woman (Frau) bronze
 GERT 158
Woman (Venice I) (Femme,
 Venise I) 1956
 JOR-2:pl 204
Woman (Venice II) (Femme,
 Venise II) 1956
 MID pl 94 BAM
Woman (Venice IV) (Femme,
 Venise IV) 1957 bronze;
 45-5/8 BOW FPMa
--MILLS pl 30 ELT
Woman (Venice V) (Le
 Demoiselle de Venise V)
 1956 bronze; 44
 SOTH-3:77
Woman (Venice VII) 1957
 bronze; 46-1/8 TRI 22
Woman Holding a Void 1935
 bronze; 60-5/8
 TOW 109

Woman--Spoon 1926/27
 bronze; 57 BERCK 116
 FPMa
Woman Walking (La Femme
 qui Marche) 1933/34
 bronze; 59 SOTH-2:72
Woman with her Throat Cut
 1932 bronze; L: 34-1/2
 ENC 337; JANSK 1021;
 LIC pl 281; RIT 159
 UNNMMA
--1932/33 bronze; 8-5/8x25
 x26 CALA 190; GUGP
 68; WALD 86 (col) IVG
Yanaihara, bust (Buste de
 Yanaihara) 1961 bronze;
 17 GUGE 31 UNNCohe
Young Girl (Jeune Femme)
 plaster; 58 NNMMARO
 pl 318 UNNMat
--1954 bronze; 57 cm
 JOR-1:pl 74
Giacometti, Diego
 Giacometti. Diego#
GIACOMO DA CAMPIONE (Italian
 fl 1390's)
 Relief over north door of
 Sacristy WHITJ pl 188B
 IMC
Gallo Carico. Cascella, P.
GIAMBELLO--FOLL (Venetian)
 Medal: Agostino Barbarigo
 1486/1501
 bronze; Dm: .032 m
 CHAS 301
GIAMBERTI, Giuliano See SANGAL-
 LO, Giuiliano da
GIAMBOLOGNA See BOLOGNA,
 Giovanni
GIANNOTTI, Silvestro (Italian)
 Apollo and the Constellations,
 ceiling, Astronomical
 Theater
 SEZ 69 IBoA
"The Giant"
 Michelangelo. David ("The
 Giant")
Giants See also Polyphemus
 Bologna, G. da. The Apenine
 Figure
 Camelo. Fight of Giants,
 plaque
 Heermann, G. and P. Giants
 in Combat
 Primaticcio. Grotte, Jardin
 des Pins: Giants
Giant's Gate. Austrian--13th c.
Giants' Staircase. Sansovino, J.
GIBBONS, Grinling (English 1648-

1721)
Admiral Sir Cloudesley Shovell
 Monument after 1707
 marble
 MOLS-2:pl 20; WHIN pl
 72b ELWe
--reclining effigy
 GERN pl 46b
--Wreck of Sir Cloudesley
 Shovell's Flagship on the
 Scillies ESD pl 136
Charles II, in Roman
 Costume 1676 bronze
 GLE 88 ELCheH
Cravat limewood
 MILLER il 142
Dean's Canopy, detail: Putti
 BROWF-3:53 ELPa
Duke of Somerset 1691 LS
 WHIN pl 70C ECamT
Family Group cedar
 NORM 90
1st Duke of Beaufort Tomb
 d 1700 WHINN pl 39A
 EBad
Floral Decoration, reredos
 detail CHASEH 402 ELStJ
High Altar, detail: Flowers,
 Fruit, Leaves, Open Pea
 Pods limewood GERN pl
 48 EOT
James II
 GLA pl 44
--1686 bronze
 GARL 199 ELTS
-- , in costume of Roman
 Emperor 1687 bronze
 UND 75 ELStJ
James II Monument 1686
 bronze MOLS-2:pl 18;
 WHINN pl 42A ELN
John, Lord Coventry Monu-
 ment, detail 1690 GUN pl
 10 ECroom
Judy mahogany
 NORM 91
King David Playing the Harp,
 relief c 1680 boxwood
 SOTH-2:217
Mirror Frame limewood
 BROWF-1:68
Robert Cotton, monument
 medallion 1697
 CON-2:pl 46; WHINN pl
 45 ECamCo
Staircase, Cassiobury Park,
 Hertfordshire 1677/80
 wood; 15-1/2' NM-8:21
 UNNMM (32.152)

Stoning of St. Stephen, relief
 c 1671/77 lime and lance-
 wood; 72-1/2x52-3/4
 MOLS-2:pl 21; VICF 81;
 WHINN pl 40 ELV (446-
 1898)
Two Cherubs' Heads wood
 CON-2:71 ECamT
Viscount Campdon Tomb 1686
 CON-2:pl 45; ESP pl 103-4;
 WHINN pl 39B, 41 ERutE
Wall Detail wood
 ENC 337 EPet
GIBBONS, Grinling--FOLL
 Tobias Rustat Monument
 CON-2:72 ECamJ
Gibbons, Mrs. N. B.
 Alberdi. Mrs. N. B. Gibbons
Gibbons, Orlando (English Organist
 and Composer 1583-1625)
 English--17th c. Orlando
 Gibbons, bust
GIBBS, James (English Architect
 1682-1754)
 Portraits
 Rysbrack. James Gibbs, bust
GIBBS, James, and Michael
 RYSBRACK
 Katherine Bovey Monument
 (from James Gibbs, Book
 of Architecture, 1728)
 WHINN pl 100B ELWe
GIBSON (Osborne), Charlotte E.
 (English)
 Anne, bust 1940 plaster; 18
 BRO pl 10
 Man, head 1942 LS
 BRO pl 11
GIBSON, John (Welsh-English 1790-
 1866)
 The Hunter and his Dog
 1847 BOASE pl 81B ELinU
 Hylas and the Water Nymphs
 1826 marble; 78
 AGARC 114; LIC pl 40;
 LONDC ELT
 Mars and Cupid
 COOPF 168 ECha
 The Mourning Husband,
 relief c 1860 plaster copy;
 48x51x48 LONDC ELRA
 Narcissus 1829 marble; 42
 GARL 208; LONDC ELRA
 --1838
 GUN pl 10 ELBur
 Pandora
 UND 95 ELV
 Queen Victoria, head 1848
 CON-6:pl 47 ELivL

Queen Victoria, between Justice
and Mercy 1850/55
BOASE pl 52A ELWesP
"Tinted Venus" c 1850 marble,
slight pigmentation; 68
ENC 338; MOLE 262 -D
William Earle, seated profile
figure 1830 BOASE pl 51A
ELivJ
William Huskisson 1836 marble;
96 GLE 93 ELPim
GIES, Ludwig (German 1887-)
Box Lid wood
AUM 12
The Cross (Kreuz) 1952 bronze
GERT 125
Decorative Fireplace Panel:
Sheep cast iron
AUM 13
The Holy Family wood
AUM 13
Mother and Child (Mutter mit
Kind) 1950 bronze
GERT 124
Pan, garden figure 1954 stone;
35 cm OST 50 GCoHa
GIESE, Tiedemann (German)
Male Bust, relief 1520 pear-
wood; 90x60 cm
MUL 55 GKoSc
The Gift. Ray
Gift of the Girdle
Italian--14th c. Porta della
Mandorla
Gift Wrap. Smith, R.
Gigante
Raverti. Gargoyle and Gigante
GIGON, Andre (Swiss 1924-)
Bas-Relief-Spirale 1957
JOR-2: pl 207
Construction 1954 white
terracotta; 30 cm
JOR-1: pl 88
Construction 1955 black
sandstone; 35 cm
JOR-1: pl 87
Le Deluge 1957
JOR-2: pl 206
Large Object (Grand Objet;
Great Object) 1958 concrete;
47 BERCK 169; JOR-2: pl
136; MAI 114
Sculpture 1956
JOR-2: pl 208
--1957
JOR-2: pl 209
Sculpture Verticale 1957
JOR-2: pl 135

GILABERTUS See GISLEBERTUS
GILARDI, Piero (Italian 1942-)
Cabbages Under the Snow
1966 KULN 72
Tappeto Natura 1967
KULN col pl 3 (col)
GILBERT, Alfred (English 1854-1934)
Duke of Clarence Tomb
Mexican onyx, bronze,
silver, ivory
CHASEH 485; MARY pl
111 EWindG
--Virgin; St. Michael
TAFTM 73
--Trial Cast: St. George 1894
aluminum; 17-1/2x12
ARTSN #36
--Working Model: St.
Elizabeth; The Virgin
MARY pl 112 AuMGV
Eliza MacLoughlin, bust
bronze; 15-1/2 CAN-2:195
CON
Eros, formerly in Piccadilly
Circus 1893 aluminum; 36';
base W: 17-1/2' GLE 106;
RICJ pl 25 ELVg
--base detail
CAS pl 240
Icarus bronze
MARY pl 143 -EHe
Mother and Child
UND 140 ELT
Perseus
AUES pl 48 ELT
Perseus Arming bronze
AGARC 137; MARY pl 30
UNNMM
Queen Victoria Monument
POST-2:211; TAFTM 73
EWin
St. George and the Dragon
TAFTM 73
Shaflesbury Memorial Fountain
1887/93 SCHMU pl 190,
269 ELPi
Table Centre Piece 1887
silver, mother of pearl
and jewels inlay; 87x65x
95 cm CAS pl 239 EEQ
Tragedy and Comedy bronze
MARY pl 144
GILBERT, Donald (English)
Lt. Gen. Sir William G. S.
Dobbie, bust clay, for
bronze
BRO pl 12 EMalt
GILBERT, Stephen (Scottish-French

1900-)
Structure*
ARTSC
Structure 1959 Duralumin and
ptd steel
MAI 114
Structure 14C 1961 polished
aluminum, perspex base;
30-1/2x48x32
TATEB-1:35; TATES pl 22
ELT (T.464)
Structure 15A 1961 polished
aluminum; 48x20
READCON 252
Structure 16C 1961 polished
aluminum; 43-1/4x19-1/2
READCO pl 16 ELD
GILBERT, Walter (English), and
W. G. Riley
Decorative Table Light glass,
bronze base
AUM 141
GILBERT, Walter, and L. WEINGART-
NER
Memorial to the 55th Division
AUM 123 ELivC
The Gilded Virgin
French--13th c. La Vierge
Doree
Giles of Bridport d 1262
English--13th c. Bishop of
Giles of Bridport Tomb
GILI, Marcel (French 1914-)
Danaid 1958
MAI 115
Jeune Fille au Soleil Couchant
FPDEC il 9
GILIOLI, Emile (French 1911-)
Le Capelan 1957 granite
BERCK 120 FPCa
Caravan 1955 Carraro marble;
18-1/8 TRI 12 FPCa
The Caterpillar 1957 Carrara
marble MAI 116 FPCa
La Chimere 1956 Mexican onyx
12-3/4 READCON 190
UMiDW
Espirito, Agua e Sangue 1953
bronze SAO-3
Garden Fireplace
DAM 211
Imprisoned Bird 1958 Baccarat
crystal MAI 116 FPCa
Isolina 1949/56 marble
MARC pl 57 (col) FPM
Kingdom of Heaven 1954/55
bronze; 81 MID pl 98 BAM
Paquier 1951 bronze; 26-1/2
GIE 240

Prayer and Force (Priere et
Force), Unknown Political
Prisoner Monument 1953
marble; 43-1/4 GIE 235;
LARM 325 ELT
St. Martin 1958 alpine granite
MARC pl 56
The Sleeper 1946/61 marble
SELZJ 6 EPisaCar
GILL, Eric (English 1882-1940)
Ariel Between Wisdom and
Gaiety, exterior relief
CASS 80 ELBH
Ariel Hearing Celestial Music
AGARN il 9 ELBH
Bisham Crucifix Portland
stone AUM 149
Chloe ptd stone
CASS 78; RICJ pl 48; UND
155
Crucifixion (Kreuzigung) 1910
Hoptonwood stone
GERT 121; RAMT pl 1 ELT
The Deposition 1925 black
Hoptonwood stone; 24
RAMS pl 52 ECaK
Eve
VEN-32: pl 140
Figure with Angels, grave
marker relief
GARDHU pl 52
Flying Angel c 1928 Portland
stone RAMT pl 2 ELV
Headstone of Johnnie Mann
1925 NATSE
Incised Alphabets stone
PUT 65 ELV
Mankind 1927/28 Hoptonwood
stone; 95
AUM 160; CASSM 105;
MILLER il 202; ROTJB pl
35 ELT
Mater Amabalis, relief 1923
ROOS 277F
Mother and Child, relief Beer
stone AUM 149
Mother and Child, relief
Corsham stone
AUM 149
Odysseus Welcomed by
Nasicaa, relief Portland
stone
AGARC 154, il 10 EMoM
Prospero and Ariel
JOHT pl 171
--BATT 88 ELT
--soft stone model
HOF 202
--1932 Portland stone; 120

CASS 72; RAMS pl 5b ELBH
St. Sebastian 1920 Portland
stone; 34-1/2 RAMS pl 53
ELV
South Wind; North Wind; East
Wind AUM 128 ELUR
South Wind, relief stone
PAR-1: 85 ELStJP
The Sower
HOF' 177
Splits
AUM 160
Stations of the Cross, No. 1,
relief 1913/18
AUM 148; ENC 339 ELWeC
Stele
AUES pl 58; AUM 148
--1928 Hoptonwood stone;
c 36 CASSM 103; RICJ pl
52
--stone
CHENSW 480 ELT
Susan, head 1928 Bath stone
CASSM 104
Tobias and Sara, relief 1926
stone CHENSW 485
Torso
CHENSP 285
Wall Relief for Palace of
Nations, Geneva HOF 57
War Memorial, relief
AUM 160 ELeU
The Wind, relief stone
MAI 117 -Go
GILL, Marie (English 1918-)
Girl with Pitcher 1954
concrete; 54 BED 118
Seated Figure 1955 LS
BED 118
Gilles, Saint
French--12th c. St. Gilles
GILLET, Nicholas Francois (French
1709-91)
Paris Holding the Apple 1757
marble; 33 CHAR-2:184
FPL
GIMOND, Marcel (French 1894-)
Athlete Vainqueur
BAS 229
Baigneuse
BAS 228 FPChai
Etude pour un Monument
aux Morts BAS 229
Head (Kopf) 1950 bronze;
11-1/4 SCHAEF pl 41
--1954 bronze
GERT 122

Head of a Woman in a Turban
1930 bronze; .40x.22x.15
m MOD FPM
Head of a Young Girl 1950
bronze; 14 SCHAEF pl 40
Head of a Young Woman
bronze LARM 319; MAI
117 AlOM
Jeune Athlete, head
BAS 233
Jeune Fille, head
BAS 232
--BAS 233
Jeune Fille d'Aix, bust
BAS 231
M. Ch. Forot, head
BAS 232
St. Thomas Aquinas
BAS 230
Tete d'Enfant
BAS 234
GINES, Jose (Spanish 1768-1823)
Massacre of the Innocents,
group colored terracotta
LARM 74 SpMaF
Gingerbread Stamp# Folk Art--Russian
Ginnasi, Domenico
Algardi. Domenico Ginnasi,
bust
GINSBOURG, David (Russian 1890-)
Nude wood
PAR-2:154
Giocoliere. Marini
GIORDANI, Giorgio (Italian 1905-)
The Veil bronze
VEN-38:pl 107
Giordano, Davide
Scarpa Bolla. Davide
Giordano, bust
GIORGETTI, Antonio (Italian fl 1660-
70)
Martyrdom of St. Sebastian
marble LARR 346; MATTB
pl 40-41 IRSeb
GIORGI, Bruno (Italian 1903-)
Two Warriors (Os Guerreiros)
EXS 31 BrB
GIORGI, Giorgio de (Italian 1918-)
La Colombe du Cap 1961
bronze, stone base; 26-1/2
x20 READCON 248 UMiDW
GIORGIO DA SEBENICO (Giorgio
Orsini da Sebenico) (Yugo-
slav-Italian fl c 1440-d 1475)
Charity 1455/60 stone
SEY 67A IAncL
GIORGIS, Giacomo (Italian)

Maternity plaster
VEN-30:pl 105
Il Giorno
Michelangelo. Giuliano de'
Medici Tomb: Night and
Day--Day (Il Giorno)
GIOTTO (Florentine 1276?-1337?)
Portraits
Dupre, G. Giotto
GIOTTO, and PISANELLO (Andre
PISANO)
The Drunkard, panel
BROWF-3:14 IFC
Horsemanship, panel
BROWF-3:14; CHENSW 371
IFC
Giovanetta che S'Incammina. Zimmer-
mann, E.
GIOVANNI DA CAMPIONE (Italian
fl 1340-60)
Charity, Baptistry exterior
c 1340 marble
POPG pl 56 IBeB
GIOVANNI DA FIRENZE, AND PACIO
DA FIRENZE (Italian fl 1343-
45)
King Robert of Anjou Monu-
ment; detail: Angel
POPG fig 62, pl 32 INC
St. Catherine of Alexandria
Life, scene c 1343/45
marble WHITJ pl 134A
INC
--Father of St. Catherine of
Alexandria Dictates his
Testament, relief
POPG pl 33
GIOVANNI DA FIRENZE, and PACIO
DA FIRENZE--ATTRIB
Angels c 1350 marble CLE
55 UOC1A (1621.25;
1622.25)
GIOVANNI D'ALEMAGNA (Italian
c 1400-50) See VIVARINI, A.
GIOVANNI D'AMBROGIO (Italian fl
1384-1418)
Prudence, after Agnolo Gaddi,
relief 1386 marble
POPG pl 55 IFL
GIOVANNI DA NOLA (Italian)
Don Pedro da Toledo Monu-
ment POPRB fig 64 ING
--Maria Osorio. Pimentel
Reading POPRB pl 152
--Temperance, nude female
figure HALE 173

GIOVANNI DA NOLA, or GIOVANNI
DA MIRIGLIANO
Lamentation Over the Dead
Christ, relief marble;
figurated area: 100x165 cm
POPRB pl 54 INMG
GIOVANNI DA TRAU See DALMATA,
Giovanni
GIOVANNI DA UDINE (Italian 1487-
1564)
Ceiling Decoration, Loggia
1525 stucco
BOE pl 155 IRVMad
Foliated Scroll, piaster,
Raphael's Loggias 1517/20
LARR 187 IV
Stucco Work, detail 1519/25
BAZINL pl 330 IRVMad
--Shell, Loggia apse
BAZINW 352 (col)
GIOVANNI DA VERONA
Cathedral Facade, detail
1488/1508
marble facing
CHAS 206 IBrMV
GIOVANNI DEI GRASSI (Italian fl
1389-98)
Christ and the Woman of
Samaria, relief 1391
marble
POPG pl 61 IMC
GIOVANNI DELL'OPERA See
BANDINELLI, Giovanni
GIOVANNI DI AGOSTINO (Italian
c 1310-70)
Angel Appearing to St. John,
font detail c 1332/33
WHITJ pl 132B IArPi
Madonna and Child with SS
Catherine and John the
Baptist, relief marble
CLE 54 UOC1A (42.1162)
St. John the Baptist Entering
the Wilderness, relief
1332/33 marble POPG
pl 35 IArM
GIOVANNI DI BALDUCCIO See
BALUDCCI, Giovanni
GIOVANNI DI COSMA (Italian)
Stefano de Surdis Monument
POPG fig 14 IRBal
GIOVANNI DI FRANCESCO DA
IMOLA (Italian)
St. Andrew c 1425 ptd and
gilded wood
SEY pl 33A ISMa

GIOVANNI DI MARTINO DA FIESOLE
See LAMBERTI, Niccolo di
Pietro
GIOVANNI DI SALIMBENI (Italian
(?))
Armet-a-Rondelle c 1490
SOTH-3: 247
GIOVANNI DI STEFANO (Italian c
1446-before 1506)
Candle Bearing Angel, High
Altar 1497 bronze
SEY pl 111 ISC
GIOVANNI DI TURINI (Italian c
1385-1455)
Justice 1429/31
POPG fig 84 ISB
Madonna and Child, relief
ptd terracotta; 26-1/4x18
USNKP 398 UDCN (K-292)
Wolf Suckling Romulus and
Remus, City Arms of Siena
GRANT pl 67 ISP
Giovanni II Bentivoglio
Sperandio. Medal: Giovanni
II Bentivoglio
Giovanni, San See John, Saint, the
Evangelist
Giovannino. Michelangelo
Giovinetta. Andreotti
Giraffes
Altri. School Playground
Sculpture: Giraffes
Luginbuhl. Little Giraffe
Girandoles See Chandeliers
GIRARDON, Francois (French 1628-
1715)
Apollo Attended by Nymphs
(Louis XIV as Apollo),
Bath of Apollo (Bosquet d'
Apollon), Grotto of Thetis
(3 of 6 Nymphs by Regnaudin)
1666/73 marble AGARC 13;
BAZINB 128; BAZINH 349;
BAZINW 395 (col); BLUA pl
167; BUSB 92;KITS 78;LARR
285; ST 362; VER pl 95 FV
Fountain of Diana: Bathing
Nymphs c 1675
CANM 218; CHASEH 384;
GAF 105 JAL-5: pl 3;
ROBB 391 FV
Louis XIV, equest
RAY 51 FV
--bronze; 42-1/2
DETT 189; VALE 116
UMiD (25.10)
Louis XIV, equest, model
1687? wax; 30-1/4
JANSH 445 UCtY

Louis XIV, equest, model for
statue in Place de Conquetes
(Place Louis Le Grand;
Place Vendome) c 1669
(original destroyed 1792)
bronze; BAZINB 129;
BAZINW 395 (col);
LAC 51; LARR 282; LOUM
161 FPL (1320)
Nicholas de Boileau-Despreaux,
bust c 1690 marble
BUSB 94; LOUM 173 FPL
(1319)
The Rape of Persephone
1677/99 marble; 106
AGARC 98; BLUA pl 169A;
LAC 202; MOREYC 115 FV
Richelieu Tomb 1675/77
marble BR pl 11; BLUA pl
168; BUSB 99; JANSK 840;
POST-2: 22 FPSo
GIRAUD, Pierre (French 1785-1836)
Tomb of Young Woman and her
Two Children, detail 1827
wax: L: 57 CHAR-2: 282;
LIC pl 25 FPL
GIRELLI, Egidio (Italian)
Nella Raffica plaster
VEN-10: pl 133
Girieud, Marthe
Laurens. Marthe Girieud, head
Girl. Krsinic
Girl and Boy. Butler
Girl Bathing. Bonnard
Girl Bathing. Brutt
Girl Carrying Water. Bernard
Girl Combing her Hair. Stursa
Girl Crouching. Schotz
Girl Dancer of Fourteen
Degas. Little Dancer of
Fourteen Years
Girl Fastening Sandal. Vedres
Girl 5456. Butler
Girl from Crete. Fischer, A.
Girl from KRK. Radaus, V.
"Girl in a Swing"
English--18th c. Chelsea
Scent Bottles
Girl in Chair. Manzu
Girl in the Form of a Flower. Ernst
Girl Looking Down. Butler
Girl Looking Up. Kolbe
Girl Meditating. Lehmbruck
Girl on a Blossoming Bough.
Wallenberg
Girl on a Chair. Manzu
Girl on a Wheel. Butler

Girl on Her Back. Butler
Girl Seated Against Square Wall.
　Moore, H.
Girl Standing. Wimmer
Girl with a Book. Krsinic
Girl with a Bowl. Palavicini
Girl with a Jug. Bernard
Girl with a Pitcher. Fischer, A.
Girl with a Rose. Kos
Girl with a Shell. Carpeaux
Girl with Apple. Marcks
Girl with Bird. Danneker
Girl with Braids. Marcks
Girl with Clasped Hands. Moore, H.
Girl with Doves. La Rue
Girl with Folded Arms. Loutchansky
Girl with Garment. Seitz
Girl with Lifted Hands. Marcks
Girl with Long Hair. Spurr
Girl with Pitcher. Gill, M.
Girl with Skipping-Rope
　Couturier. Young Girl
　Skipping
Girl with Vest. Butler
Girl without a Face. Armitage
The Girls of My Town. Hajdu
Girl's Torso. Krop
GIROLAMO DA FIESOLE (Italian
　fl 1500), and Michel
　COLOMBE
　Francis II of Brittany Tomb
　1499/1507 BLUA pl 12B
　FNaC
Girotondo. Salvatore
Le Gisant. Gisiger
Gisela (Roman Empress, Wife of
　Conrad II d 1043)
　German--11th c. Cross of
　Gisela of Hungary
　German--11th c. Eagle
　Brooch
Gisela's Jewels. German--10th c.
GISIGER, Jean Georges (Hans Jorg
　Gisiger) (Swiss 1919-　)
　Chinoise 1956/57
　　JOR-2: pl 214
　Couple I 1958
　　JOR-2: pl 151
　Couple IV 1959
　　JOR-2: pl 152
　Eos 1954 plaster
　　JOR-1: pl 82
　Le Gisant (Recumbent)
　　1956/57 steel; L: 71
　　BERCK 172; JOR-2: pl 153
　Homage to Paolo Paoli 1958
　　steel MAI 119

　Rhea 1959 steel; 14-3/4x27-
　　5/8 READCON 259
　Tombeau d'Ulysse 1954
　　Travertin des Alpes; 150
　　cm JOR-1: pl 81
　Totem 1956/57
　　JOR-2: pl 213
　--1956/58 steel; 75
　　GIE 305
　Touchka 1957 steel; 16 BERCK
　　172; JOR-2: pl 215 SwBH
　Yatagan 1956
　　JOR-2: pl 212
GISLEBERTUS (Gilabertus) (French
　fl 1115-35)
　Capital: Temptation of Christ
　　c 1130
　　NEWTET 93 FAutL
　Eve Plucking Apple (L'Eve
　　Rampant), relief, St.
　　Lazare portal
　　ENC 343; FREM 61, 62;
　　REAU pl 8 FAutR
　Flight into Egypt, capital
　　detail c 1125 stone; 30
　　EXM 356; FREM 64 (col);
　　KIDS t FAutL
　Noli Me Tangere, north ar-
　　cades of nave
　　BOE pl 64 FAutL
　Peter and Paul, chapter house
　　door detail after 1100
　　BUSRO pl 87 FTMA
　St. Andrew, St. Etienne c
　　1130 PANR fig 31 FTL
　St. Thomas, relief figure,
　　chapter house of St. Etienne,
　　Toulouse c 1120/30 stone
　　BECKM 213
　Tympanum, west portal before
　　1135 stone: Christ and
　　Disciples MALV 232 FAutL
　-- : Last Judgment
　　BECKM 215; BUSRO pl 62;
　　FREM 66 (col), 68; MYBS
　　279-80; NEWTER 158;
　　REAU pl 5-7; SEW 348
　-- : Last Judgment: Christ
　　BOE pl 71
　-- : Last Judgment: The
　　Damned
　　KIDS 76
　-- : Last Judgment: Resur-
　　rection of the Dead
　　GAF 311
　-- : Last Judgment: Weighing
　　of Souls HAMF 292; KIDS 7

Gisleni Monument marble
 MILLER il 137 IRPo
La Gitana. Martini, A.
GIULIANI, Giovanni (Italian 1663-
 1744)
 Angel, High Altar, Heiligen-
 kreuz, convent church 1699
 BUSB 133 AVAB
 St. Roch lindenwood; 167 cm
 BERLE pl 90 GBSBe (3191)
 St. Sebastian lindenwood;
 165.5 cm BERLE pl 91;
 BERLEK pl 43 GBSBe
 (3190)
GIULIANO DA MAIANO
 Caius Julius Caesar, head,
 roundel terracotta
 MOLS-2: pl 1 EHam
Giulio, Saint
 Italian--11th c. Pulpit: San
 Giulio and Symbols of
 Evangelists
Giunone
 Italian--18th c. Giunone, bust
GIUSTI, Antonio (Juste, Jean)
 (Italian 1479-1519), and
 Giovanni GIUSTI
 Louis XII and Anne of
 Brittany Tomb ("House of
 Death") 1515/31 marble
 BLUA pl 13, 14; BUSRO
 210; CHRC fig 182; GAF
 97; HAUS pl 205-207;
 MAR 129 FPDe
 --Anne de Bretagne, effigy
 detail GAF 97
 Maximilian I Tomb 1508/33
 bronze MAR 129 AIH
GIUSTI, Giovanni (Italian 1485-
 1549) See GIUSTI, Antonio
Giustina, Saint
 Agostino di Duccio. St.
 Giustina Tomb
 Donatello. High Altar
Gladiatorial Table. Fletcher
Gladiators See Games and Sports
Glass Sculpture. Megert
Glass Workers. Martinuzzi
Glaucus
 Bernini, G. L. Neptune and
 Glaucus
GLAZ, Josef (German)
 St. John Nepomuk, Bavaria
 c 1785/95 wood; 65
 CAMI pl 84 UNNLu
GLEICHEN, Feodora (English 1861-
 1922)

Diana Fountain
 GLE front ELHy
Glenkiln Cross. Moore, H.
GLESKER, Justus (Justus Gleskher)
 (German c 1610-78)
 John the Baptist
 LIL 196 GMB
 Mary at the Foot of the Cross,
 St. Peter's Choir 1648/52
 BUSB 66 GBaC
GLICENSTEIN, Henryk (Polish 1870-
 1942)
 Antonio Mancini, bust bronze
 VEN-26: pl 68
 Auto Portrait, head 1925
 marble SCHW pl 8
 Fountain Group marble
 VEN-10: pl 132
 The Lute Player 1938 wood
 SCHW pl 9 UNBB
 Soldiers 1940 wood
 SCHW pl 10
Globes
 German--16th c. Celestial and
 Terrestrial Globe
"La Glorification du Modulor"
 Le Corbusier. Unite
 d'Habitation
Glorification of Art. Vigne
GLOSENKAMP, Herman (Belgian)
 See BEAUGRAND, Guyot de
Glinka, Mikhail Ivanovich (Russian
 Composer 1803-57)
 Vlad. Composer Glinka, bust
Gloria (dancer). Haveloose
"La Gloria"
 Tome. Transparente Altar;
 detail: "La Gloria"
Glass of Absinthe
 Picasso. Absinthe Glass
Gloucester, Duke of
 Hewetson. Duke of Gloucester
Gloucester Candlestick. English--
 12th c.
Glug Glug. Arman
GLUME, Friedrich Christian
 Hermae, with Hanging Grapes
 1745/48 BOE pl 182-3
 GPoS
GLURER, Ulrich
 Choir Stall, detail: Judith with
 Holofernes 1495
 BUSR 187 GAuC
Gluttony
 French--12th c. Glotton,
 figure capital
Glycera. Wyatt, R. J.

"Golden Stag" House. Czech--18th c.
Golden Treasure of Hiddensee.
 Danish--11th c.
Golden Virgin
 French--13th c. La Vierge
 Doree
Golden Youth. Emerson
Goldene Pforte
 German--12th c. Golden Door
GOLDMAN, Gyorgy (Hungarian
 1908-45)
 Head of a Worker 1928 plaster;
 30 cm GAD 93 HBA
 Seated Worker 1934 bronze;
 25 cm GAD 91 HBA
Goldones Rossel. German--15th c.
Goldsmith, Oliver (English Play-
 wright, Poet, and Novelist
 1728-74)
 Nollekens. Oliver Goldsmith
 Monument
The Goldsmith's Gold. Kerdic
GOLDWITZER, Johann Everhard
 (1682-1746)
 Vision of St. Bernard
 1623/24 BUSB 121 GBaE
Golgotha. Tapper
Goliath See also David (King of
 Israel)
 Donatello. Casa Martelli
 David: Head of Goliath
Golitsin, L.
 Troubetzkoy. Prince
 Golitsin, bust
GOLKOVITCH, Ivan
 Dolphin wood
 CASS 118
Golosso! Nicolini
Goloubeff, Mme.
 Rodin. Madame Goloubeff
GOMIEL, Pedro (Spanish) See
 EGAS, E. de
Gond Tribe, India
 Milward. Gond Man, head
GONDA, Alexander
 Harlequins (Harlekine) 1955
 plaster cast, for bronze
 GERT 222
 Pandora 1953 synthetic stone
 GERT 223
Gondelherde. Konig
Gontaut, Armand de (Bishop of
 Sarlat)
 French--16th c. Armand de
 Gontaut
Gontaut-Biron, Pons de
 French--16th c. Pons de
 Gontaut-Biron Tomb

Gonzaga, Cecilia
 Pisanello. Medal: Cecilia
 Gonzaga
Gonzaga, Ferrante
 Leoni, L. Ferrante Gonzaga
 Triumphant over Envy
Gonzaga, Giovanni Francesco de, II
 (Duke of Mantua d 1519)
 Sperandio. Giovanni Francesco
 de Gonzaga, Marquis of
 Mantua, equest
 Romano. Duke Gianfrancesco
 Gonzaga II, bust
Gonzaga, Lodovico III (Duke of
 Mantua 1414-78)
 Donatello. Lodovico III
 Gonzaga, bust
GONZALEZ, Jose Victoriano See
 GRIS, Juan
GONZALEZ, Julio (Spanish 1876-1942)
 Angel 1933 wrought iron; 62
 BAZINW 435 (col); MARC
 pl 22 (col) FPM
 --1933 wrought iron; 63
 GIE 199 UNNMMA
 --RIT 164 FPM
 --1933 H: 74
 SEITC 72 FPM
 Cabeza Llamada el Encapuchado
 1934 bronze; 9-7/8
 READCON 63 FPFr
 Cactus Man (L'Homme Cactus;
 Man Cactus) 1939
 KULN 10
 --1939/40 bronze; 25
 EX 36; EXS 81 CMFA
 Cactus Man No. 1 1939/40
 bronze; 25-5/8
 CALA 188; GUGP 71 IVG
 --1939/40 iron; 27
 BERCK 79
 --1939/40 iron; 69 cm
 LIC pl 312 FPGo
 Cactus Man No. 2 1939/40
 bronze; 31-1/2 MAI 121;
 READCON 65 (col)
 Composition 1931
 READAN #54
 Dancer 1934 wrought iron; 25
 GIE 196 FPGo
 Dancer with Flowing Hair 1934
 iron; 24-5/8 TRI 23
 Danseuse, dite a la Margeurite
 1938 bronze; 47 cm
 SP 57 GHaS
 Daphne c 1932 bronze; 55
 HENNI pl 53; SELZS 103
 UNNCh

"Gothic Man", Standing 1937
 bronze; 22 BERCK 78
 FPHa
Head c 1935 wrought iron;
 17-3/4 JANSH 537; JANSK
 1021; MCCUR 270; NMFA
 214; NNMARO pl 308;
 NNMMM 90; RIT 166
 UNNMMA
Head (Das Haupt) 1936 wrought
 iron GERT 171
Head of a Girl 1936 bronze;
 12-1/2 DETS 45 UNNH
Head with Mirror 1934 bronze
 AMAB 22 FPHa
Inclined Antique Head 1910
 bronze SELZJ 214 FArcG
The Kiss 1930 iron; 10x16-1/2
 BERCK 274; BOW 148
 UMiBiW
Little Classic Head 1910/14
 bronze; 27x20x15 cm
 LIC pl 308 FPHa
Little Venus 1935 bronze; 8
 MID pl 26 BAM
Mask 1929/30 iron; 9-1/4
 CIE 195 FPGo
Mask c 1935 bronze; 6x3-3/4
 x1-1/4 UCIT 16 UCBeG
Mask, called Meditative
 c 1912/14 bronze
 SELZJ 211 FArcG
Mask of Montserrat Scream-
 ing (Mascara de Montserat
 Grittando) 1936 H: 12
 BERCK 77
--1963 bronze; 19-5/8
 READCON 65 (col)
Masque Couche dit "Le
 Religieux" 1941/42 bronze;
 20x13x5.5 cm
 SP 58 GHaS
Maternity 1933
 BURN 158 SnSNM
Maternity 1933 wrought iron;
 55 RIT 165 FPGH
Montserrat 1937 sheet iron;
 65 CHENSW 13; LIC pl
 313; MAI 120; MCCUR
 270; RIT 104-5 NAS
Montserrat, head c 1942
 bronze; .32x.20x.30 m
 MARC pl 23 (col); MOD
 FPM
Montserrat No. 2., head
 1941/42 bronze
 MAI 122
--1942 bronze; 13
 SOTH-3: 77

Nola brass and copper sheets
 MEILD 142
Person Standing 1931 iron
 CANK 180
Reclining Figure 1936 wrought
 iron; 12-1/2
 GIE 197 FPGo
Sculpture 1932 silver; 9
 RAMS pl 75 UNNGal
Seated Woman 1935 iron;
 46-3/4 BAZINW 436 (col);
 HAMP pl 174B FPGo
Seated Woman (Woman Seated)
 1953 iron; 63
 BERCK 76
Seated Woman 1 1935 iron
 VEN-64:pl 148
Standing Figure (Personnage
 Debout) 1937 iron; 22-1/2
 GIE 201 FPHa
Still Life c 1927/29 iron;
 20x21 cm LIC pl 311 FPGo
Tia Lola c 1912/14 bronze
 SELZJ 211 FArcG
Torso 1936 iron; 27
 BERCK 77
Upright Figure (Aufrechtstehender)
 1936 wrought iron
 GERT 170
Venus 1927 wrought iron
 GIE 196
Woman Combing her Hair
 (Femme se Coiffant;
 Haarkaummende Frau; Woman
 Arranging her Hair)
 wrought iron
 RAMT pl 57a
--1932 wrought iron
 MAI 122
--1934/36
 ENC 352
--1936 wrought iron; 52
 BERCK 96; FAUL 462;
 LIC pl 310; LYNCM 13;
 MCCUR 270; MU 285;
 NNMMM 91 UNNMMA
--GIE 198 FPM
--1937 wrought iron
 GERT 170
--1937 wrought iron; 82
 LARM 322; RIT 167 FPGH
Woman with a Basket (La
 Femme a la Corbeille)
 c 1931 iron; 71
 HENNI pl 52 FPGo
Woman with a Mirror 1936 iron
 KUHB 109 FArcG
--1936 iron; 82
 GIE 200 FPGo

The Good Shepherd
 Byzantine. The Good Shepherd
 Durst. The Good Shepherd,
 tympanum
 Early Christian. The Good
 Shepherd, sarcophagus
 Early Christian. Santa
 Giulia Casket
 Early Christian. Sarcophagus#
 Izso. Good Shepherd
 Verhaegen. Good Shepherd
 Pulpit
GOODECHARLE, Lambert See
 GODECHARLE, Gilles Lambert
Goodman, Gabriel (Dean of West-
 minster Abbey d 1601)
 English--17th c. Dr. Gabriel
 Goodman, kneeling effigy
Goorle, Abraham van
 Keyser. Abraham van Goorle,
 medallion
GORDEEV (Russian)
 Prometheus bronze
 BLUC 218 RuA
Gordian Knot. Werthmann
GORDINE, DORA (Russian-English
 1906-)
 Above Cloud bronze
 NEWTEB pl 31
 Chinese Philosopher, head
 1937 bronze; LS
 RAMS pl 38b; RAMT pl
 13 UNNWats
 Goddess of Health 1949
 bronze; 67
 LOND-5:#22
 Helen bronze
 HUX 82
 Houri bronze
 NEWTEB pl 30
 Laughing Buttocks 1938
 bronze; LS
 RAMS pl 35a
 Malayan Sultana, head 1932
 bronze; LS
 RAMS pl 38a ELT
 Pagan bronze
 CASS 71 ELLe
 Young Man, head bronze;
 12 BRO pl 13
Gordon, Billie
 Epstein. Billie Gordon, mask
Gordon, William
 English--19th c. Lord Wil-
 liam Gordon Tomb
Gordon-Canning, R. C.
 Byng. Capt. R. C.
 Gordon-Canning

Gore, Charles
 Hollemans. Sir George and
 Lady Fermor Monument:
 Charles Gore
Gore, William d 1707
 Nost. Sir William Gore Tomb
Gorgon, Saint
 French--15/16th c. St.
 Gorgon, holding falcon
Gorgons See Medusa
GORIN, Jean Albert (French 1899-)
 Polychrome Spatial Con-
 struction 1955 metal
 MAI 123 IR
 Spatial Construction 1954
 BERCK 133
 Steel Sculpture
 CANK 8
GORO DI GREGORIO (Italian)
 Arca di S. Cerbone 1324
 WHITJ pl 132A IMasC
Gosforth Cross. Anglo-Saxon
Gospels
 French--9th c. Portable Altar
 of King Arnulf, Gospel
 Scenes,
 French--10th c. Gospel
 Scenes, diptych
Gosset, Professor
 Duchamp-Villon. Professor
 Gosset, head
Gossip, garden ornament. Durst
The Gossips. Claudel
GOTHIC
 Crucifix bronze
 ZOR 185
 Dalmatian Portal 1438/65
 HARVGW pl 292 YKC
 Female Saint
 MOREYC 118 UNjPA
 Madonna c 1375
 HARVGW 49 CzPlB
 Madonna and Child 12/14th c.
 TAYFF 35 (col) UNNMM
 Madonna from Gotland 14th c.
 HARVGW 49 FiHK
 Peter Parker, bust c 1375
 HARVGW 41 CzPV
 Retable and Altar alabaster
 NM-11:15 UNNMM
 Virgin and Child late 14th c.
 stone; 54
 SOTH-4:266
 Virgin Enthroned, Autun wood
 KUH 17 UNNMMC
 --ENGLISH
 Screen, detail wood
 GLA pl 33 ESomH

Vine Leaf Capitals, detail
LARB 385 ESoM
--FRENCH
Coronation of the Virgin,
with Adoring Angels,
relief BUSRO pl 145 FSeC
Decorated Column, Abbey
Church of Coulombs
WORR 52 FPL
Facade Decoration: Lacy
Gothic CHENSN 309 FRC
Flight into Egypt
AUES pl 12 FPN
Leaves and Flowers, capital
MOREYC 101 FNeC
Madonna, choir figure
MOREYC 105 FPN
Portal Statues, Grand Portal,
detail
CHENSN 295 FRhC
St. Matthew Writing at Com-
mand of an Angel, sur-
mounted by Heavenly
Jerusalem, School of
Chartres mid 15th c. stone;
25.6x19.7 GAU 138 FPL
Tympanum Statues, relief
RAY 7 FAm
--GERMAN
Capital: Vine Leaves
BUSG pl 100 GMarE
Christ, head wood
ZOR 210
Figure, from Entombment
LARB 391 GWoC
Foliate Triumphal Arch,
over rood screen
BUSG pl 95
Holy Sepulchre
BUSG pl 96 GConC
Madonna and Child wood
INTA-2:116
Madonna and Child, Monastery
of the Antonites, Isenheim
wood; 68 HUYA pl 36;
HUYAR 24 FPL
Margrave Dietrich, head,
west choir 1260/73
BAZINH 169 GNa
Mourner, figure from
Lamentation WORR 123
GLiD
Nuremberg Madonnas
BROWF-3:30 GN
St. Lawrence, detail wood
WORR 146 GKarB
Smiling Angel
LARB 391 GFrei

West Portal: Foliate Decora-
tion BUSG pl 103 GMarC
--ITALIAN
Wall Decoration, floral motif
wood ROOS 95H IVF
"Gothic Man" Standing. Gonzalez
Gothic Pinnacle Fountain: "Fish Box".
Syrlin, J., the Elder
Gotland
Gothic. Madonna from Gotland
Gottesstreiter. Kolbe
Gouin, M. E.
Osouf. M. E. Gouin, head
GOUJON, Jean (French c 1510-68)
Apostles John and Matthew,
relief, screen 1544/45
stone
ROTHS 195 originally FAuG;
FPL
Caryatids 1550/51 stone; 138
BAZINW 383 (col); BLUA
pl 30A; CHAR-2:60; MAR
105; MOLE 13; ST 331
FPL
The Deposition, relief, screen
BR pl 9; ROTHS 195
originally FAuG; FPL
Diana of Anet (Diana Chas-
seresse; Diana and Stag;
Diana de Poitiers as Diana,
the Huntress) 16th c. mar-
ble; 61x98
AUES pl 27; BLUA pl 54;
BR pl 8; CHAR-2:55;
CLAK 337; FEIN pl 131;
GAF 66; LARR 206; LOUM
69; MU 173; MYBU 19;
RAD 383; RAY 46; ROOS
199F; SIN 314 FPL (392)
Fountain of the Innocents
(Fontaine des Innocents)
c 1548/89 stone
AGARC 82; BR pl 9; CHRC
fig 181; GARDH 387; LAC
197 FPI
--(17th c. engraving)
LARR 205
-- : Nymph(s) (Water
Nymphs(s)), relief stone;
76x30
AUES pl 28; BAZINW 382
(col); BLUA pl 53;
CHASEH 351; GOMB 283;
HAUS pl 208; LAC 52;
LARR 205; MYBA 453;
POST-1:241; ROBB 385;
ROTHS 197; UPJ 344;
UPJH pl 185

-- : Relief detail
JAL-4: pl 12
-- : Rivers of France
PACH pl 2
Fountain of the Innocents:
Nymph(s) (Water
Nymph(s)), reliefs
c 1546 marble, after
plaster casts; individual
reclining figures; 29-3/4
x76-3/4
BAZINH 266; BLUA pl
55B; BUSR 6; CHAR-2: 70;
CRAVR 197; ENC 355;
GAUN pl 53; JAL-4: pl 11;
JANSH 403; JANSK 740;
LOUM 73; MARQ 223;
MOLE 205; RAY 47, 79;
ROOS 199D FPL (389-391)
Four Evangelists, Autel
D'Ecouen c 1546
JAL-4: pl 10 FChan
Judith with Head of Holo-
fernes, chimney piece
limestone; 153 BOSMI 131
UMB (48. 371)
July, relief wood
JAL-4: pl 13 FPE
Lamentation, relief 1545
BUSB 4 FPL
Louis de Breze Monument,
equest (from a cast)
c 1540
BLUA pl 52; GAF 53;
MOLE 205 FRC
Louvre Courtyard: Left
Corner Projection, west
facade 1546/55
BOE pl 163 FPL
Pieta, relief 1544/45 31-1/8x
37-3/8 BLUA pl 55A;
LAC 52 FPL
Renown, fireplace, main re-
ception room GAF 77 FEcCh
Two Evangelists, relief
BR pl 8 FPL
Wall Decoration: Figures
(See also Primaticcio) mid
16th c. stucco
MOLE 207 FFP
GOUJON, Jean--ATTRIB
Diane de Poitiers c 1515/1564
ptd wood; 64-1/2
PACHA 151; WORC 55
UMWA
GOULDEN, Richard Reginald (English)
Margaret MacDonald (Mrs.
Ramsay MacDonald)

Memorial 1914 bronze
GLE 146; MARY pl 62 ELLi
Gounod, Charles Francois
Mercie. Gounod Monument
Gout
Kandel. Gout Sufferer
GOUTHIERE, Pierre Joseph (French
1740-1806)
Celadon Vase gilt bronze
mounting; 21; Dm: 11-3/4
CHAR-2: 252 FPL
Government
Mocchi. Ranuccio Farnese,
equest: Allegory of Good
Government, relief
GOWER, R. E.
Shell wood; 7
NORM 51
William Shakespeare Memorial
HORS 142 EStrat
Goya, Francisco de
Ferenczy, G. Goya, medal
GOZBERT
Censer: Temple of Solomon
c 100 cast bronze; 220 mm
SWA pl 155 GTC
Gnus
Barye. Ape Riding a Gnu
Grabe, John Ernest d 1711
Bird. Dr. John Ernest Grabe
Monument
Gracchus, Caius
Marin. Caius Gracchus Leav-
ing his Wife, Licinia
Graces See Three Graces
GRAEF, Hans
Woman with Mirror (Die Eitle)
1952 terracotta
GERT 104
GRAEVENITZ, Gerhard von (German
1934-)
Proposition for a New Archi-
tecture III 1963 wood and
aluminum foil; Dm: 80 cm
KUL pl 65
Round Kinetic Object: White
with Small Black Discs
ARTSM
Le Grain. Richier, G.
Grain Man. Martinuzzi
Grammer
French--12th c. Grammar
--Virgin Portal Tympanum:
Grammar; Pythagorus;
Music
Robbia, L. della. The Gram-
mar Lesson, panel

Granada
 Vigarny de Borgona. Royal
 Chapel Altar: Surrender
 of Granada
Grand Blesse No. 1. Somaini
Le Grand Coq
 Picasso. The Cock
Le Grand Couple
 Martin, E. Large Couple
Le Grand Cri
 Martin, E. The Cry
Grand Dauphin See Louis, called Le
 Grand Dauphin
The Grand Duchess. Cesar
Grand Duke. Wostan
Grand Main Crispee. Rodin
Le Grand Matin
 Laurens. Le Matin
Grand Nu. La Fresnaye, R. de
Grand Nu Assis
 Matisse. Large Seated Nude
Grand Panneau. Cesar
Le Grand Portique. Stahly
Le Grand Poseur. Laurens
Grand Torso. Tavernari
Grande Arabesque# Degas
Grande Cavallo. Marini
Grande Conde See Louis II de
 Bourbon
Le Grande Danseuse. Degas
Il Grande Disco. Pomodoro, A.
Grand Elector See Frederick
 William, called The Great
 Elector
Le Grande Jardiniere. Fernex
Grande Lacerazione. Pierluca
La Grande Madre. Viani
La Grande Nuit. Laurens
Grande Passo di Danza. Manzu
Grande Pattinatrice. Manzu
Il Grande Radak. Pomodoro, A.
Grande Spirale. Colla
GRANDI, Giuseppe (Italian 1843-97)
 Commemorative Monument to
 Five-Day Insurrection of
 1848 1894 bronze
 LIC pl 146 IMCin
Grandi Contatti. Pomodoro, G.
Grandis, Sebastiano
 Bistolfi. Sebastiano Grandis
 Tomb
Grandisson, Lord Peter
 English--14th c. Peter, Lord
 Grandisson Tomb, head-
 less fragments
Grandisson Ivory. English--14th c.
GRANDJACQUET, Antonio Guglielmo
 (Italian 1731-1801)

Amphora marble; .78; Dm:
 .40 m; and alabaster and
 tartaruga; .84; Dm: .42 m
 FAL pl 52, 53 IRB
 (CXXII; CLXXIII)
Grandmother's Kiss. Dampt
GRANDTNER, Jeno (Hungarian 1907-)
 Imre Thokoly 1954 bronze;
 280 cm GAD 103
 Shot Putter 1953 plaster; 285
 cm GAD 114
Granite Sculpture. Haber
GRANT, Nan
 Madonna and Child, panel wood
 CASS 141
 Madonna and Child, panel wood
 CASS 141 ELRow
Grape Gathering in Champagne.
 Charbonneaux
Grape Harvester# Garami
Grapes
 Laurens, H. Bunch of Grapes
GRAPIGLIA, Giovanni
 Loredano Monument, relief
 details by Danese Cattaneo,
 and Girolamo Campagna
 bronze, marble; 76x76 cm
 POPRB fig 112, pl 117,
 120 IVGP
GRARD, Georges (Belgian 1901-)
 Female Figure
 GOR 74, 76
 Naiad
 DEVI-2 BA
 Niobe 1947 bronze; 59
 MID pl 88 BAM
 Plenitude bronze
 MAI 124 BBR
 Sleeping Woman
 GOR 75
GRASSER, Erasmus (German 1450-
 1518)
 Figures from Crucifixion,
 Pipping c 1480/90
 MULS pl 127 GMB
 Morris Dancer 1480 wood;
 c 30
 BUSR 94; JANSK 601;
 KO pl 63 (col); LIL 112;
 MAR 110; MULS pl 129
 GMH
 St. Peter, High Altar 1492
 MULS pl 174B GMP
Grasshoppers
 Riccio. Boy with Grasshopper
 Richier, G. Grasshopper#
GRASSI, Antonio (Austrian 1755-1807)
 The Portrait Painter

Viennese Porcelain; 11-3/4
ENC 359; MU 9 (col);
PRAEG 322 (col) GFH
GRATE, Eric (Swiss 1896-)
 Domador de Cavalos bronze;
 87 cm SAO-8
GRAUBNER, Gotthard (German
 1930-)
 Grausilber Kissen 1963/64
 oil and canvas over foam
 rubber NEW pl 299
Graunson, William, Lord d 1335
 English--14th c. William,
 Lord Graunson, Tomb
Grausilber Kissen. Graubner
Grave Markers See also Brasses;
 Cartouches; Ledger Stones;
 Monuments and Memorials;
 Stelae; Tombs
 Albiker. Grabmal eines
 Junger Madchens
 Anglo-Saxon. Bexhill Grave
 Slab
 Anglo-Saxon. Bibury Grave
 Slab
 Anglo-Saxon. Hogback Grave
 Slab
 Anglo-Saxon. Levisham Grave
 Slab
 Anglo-Saxon. Wirksworth
 Grave Slab
 Austrian--16th c. Johannes
 Cuspinian Grave Stone
 Bartholome. Madame
 Bartholome Tomb
 Bogomil. Monument to the
 Little Voivode
 Bosnian. Figure, Bobomil
 Tombstone (Stachak),
 relief
 Bradford, A. T. Memorial
 Headstone
 Burton. Memorial Headstone
 Buxton. Memorial Headstone
 Canova. Giovanni Volpato
 Monument
 Dutch--18th c. Gravestone
 of Samuel Senior Texeira
 Early Christian. Funeral
 Stele: Fish of Christ;
 Anchor of Faith
 English--9th c. Animals in
 Interlacing, grave slab
 fragment
 --Interlaced Grave Slab,
 fragment
 English--10th c. Grave Slab
 English--10/11th c. "Hogback"
 Tombstone

English--11th c. Gravestone
 --Slab
French--11th c. Abbot Durandus
 Tombstone
French--13th c. Tombstone
French--16th c. St. Herbot
 Tombstone
German--12th c. Archbishop
 Friedrich of Wettin, tomb
 plaque
--Ludolf of Wichmann Tomb-
 stone
Gill, E. Figure with
 Angels, grave marker relief
Gill, E. Headstone of Johnnie
 Mann
Guttfreund. Grave Monument
Hungarian--15th c. Gravestone
 of Janos Hunyadi
--Des Koniglichen Oberkam-
 merers Stibor, gravestone
Italian--8th c. Abbot Bertulf
 Grave Slab: Plaited
 Ornament
--Grave Slab of Abbot Attala:
 Tree of Life
Kenar. Christ in Meditation,
 tombstone
Kribbe. Otto von Dorgelo
 Epitaph
Notke. Herman Hutterock
 Tombstone
Scandanavian--6th c. Engraved
 Tombstone: Whorl and
 Beasts
Spanish--11th c. Alfonso, son
 of Count Pedro Ansurez,
 Tombstone
Stemolak. Tombstone Figure
Thorak. Entwurf fur ein
 Grabmal
Thormaehlen. Gefallenmal im
 Kreuzgang bei Unser Lieben
 Frauen
Viking. Grave Slab: Combat of
 Great Beast and Serpent
Viking. Tombstone of Toki
Weyden. Epitaph of Robert de
 Quinghien
Graves, Anna Maria
 Chantrey. Anna Maria Graves
 Monument
Gravidanza. Kerim
Gravitations Sentimentales. Kemeny
GRAY, Anthony
 Baby's Head cold cast bronze
 PER 58
 Herbert William Cremer, head
 1964 cold cast bronze PER 54

Mervyn Levy, head cold cast
 bronze PER 55
The Rt. Hon. Earl Attlee,
 head cold cast bronze
 PER 61
Grazing Foal. Sintenis
GRAZIOSI, Giuseppe (Italian 1879-)
 Ardengo Soffici, head
 VEN-40: pl 30
 Diana plaster
 VEN-24: pl 65
 Nude Woman* bronze
 VEN-28: pl 77
 The Source (La Sorgente)
 bronze VEN-26: pl 57
Great Amphion. Laurens
The Great Bat. Richier, G.
Great Beast
 Anglo-Saxon. Breedon-on-the-
 Hill Anglian Beast; Great
 Beast
Great Bed of Ware. English--16th c.
Great Berlin Pyxis. Early
 Christian
The Great Cascade. Vanvitelli
Great Diabolo. Richier, G.
Great Dragon. Martin, E.
Great Elector See Frederick Wil-
 liam, called The Great
 Elector
Great Exhibition, South Kensington,
 1851
 Stevens. Great Exhibition
 Memorial Model (not
 carried out)
 Wyon, W. Council Medal of
 Great Exhibition
The Great Ghost. D'Haese, Roel
The Great Glass
 Duchamp. The Large Glass
Great Horned Owl. Wostan
The Great Horse. Duchamp-Villon
The Great Initiated. Mirko
The Great Musician. Laurens
Great Pan. Bayes
Great Queen. Perez
"The Great Salt". English--17th c.
Great Slab. Calo
Great Sparkle. Penalba
Great Tower, study. Butler
GRECO, EL (Domenic Theotocopuli)
 (Greek-Spanish c 1542-1614)
 Casting Lots for Christ's
 Garments, detail
 TAT sc pl 13 SpTC
 Christ Resurrected 1595/98
 KUBS pl 75B SpTL

The Risen Christ 1595/98 ptd
 wood; 17-3/4
 VEY 281 SpTHT
St. Ildefonso Receiving the
 Chasable from the Virgin,
 sacristy 1585
 CIR 71 (col) SpTC
GRECO, EL--ATTRIB
 Venus and Vulcan(?) ptd wood;
 16-1/2 BAZINW 379 (col)
 SpGI
GRECO, Emilio (Italian 1913-)
 Bather 1956 bronze
 VEN-56: pl 46
 Bather (Bagnante) 1956 bronze;
 84-1/2 TATEF pl 31f ELT
 (T.198)
 Bather No. 2 1956/57 bronze
 MAI 124
 Bathing Woman 1956 bronze; 87
 MID pl 71 BAM
 Bull 1959 stone; 36
 SCHAEF pl 12
 Crouching Figure 1956 terra-
 cotta SAL pl 36 (col)
 Figure 1950 terracotta
 VEN-50: pl 32
 Figure 1951 marble
 NEWTEM pl 165
 Figure Accocolata 1956 bronze;
 68 m
 SCUL pl 20
 Grande Figure Accocolata
 1961 artificial stone
 VEN-62: pl XXIII
 Head of a Man 1947 bronze;
 8-1/4 SOBYT pl 129
 Head of a Woman ptd wax;
 27-3/4 NCM 237 UNcRV
 Large Bather (Grande Bagnante)
 No. 1 1956 bronze
 SAL pl 35
 Large Bather (Grande Bagnante)
 No. 2 1956/57 bronze; 90
 BERCK 151; TRI 83
 Large Bather (Grande Bagnante)
 No. 3 1957 bronze; 1.7 m
 SCUL pl 21
 Malgari Onnis
 HUX 88
 Nude
 EXS 29
 Pinocchio Monument 1956
 bronze SAL pl 37
 --model for monument at
 Pescia, Italy bronze; 33-1/2
 NCM 237 UNcRV

Portrait of a Woman bronze
SAL pl 38 (col)
Seated Figure (Figura Seduta)
1951, cast 1955 bronze;
52-1/8
ENC 361; READCON 219;
TATEF pl 31b ELT (T.14)
Sibyl, head detail 1951 terra-
cotta; 23
SCHAEF pl 13
The Singer 1948 bronze;
22-1/2 SOBYT pl 130
Wrestler 1947 bronze; 39
MID pl 72 BAM
GRECO, IL (Michele di Giovanni da
Fiesole) (Italian fl c 1460)
Fireplace Frieze, detail, Sala
di Iole c 1460 stone
SEY pl 87A IUNM
Greek Shepherds. Efthimiadi
GREEN, Thomas
Lord Justice Holt Monument
1719 ESD pl 118-120;
WHINN pl 49A ERed
Richard Welby; canopy detail
marble ESD pl 121, 122;
MOLS-2: pl 23 EDen
Greene, Robert
Prentys, T., and Robert
Sutton. Tomb of Robert
Greene
Greenwich Style See English Royal
Armory
Greeting Harlequin. German--18th c.
Gregoire Le Grand, St. See
Gregory I, Saint
Gregorian. Kastner
Gregorian Modes
French--11th c. Ambulatory
Capitals: Plainsong--4
tones
Gregory I, Saint, called Gregory
the Great (Gregoire Le
Grand, St.) (Pope c 540-
604)
Brokoff, F. M. St. Gregory,
portal figure
Cordieri. St. Gregory the
Great, seated figure
Dietrich, Joachim. Augustine
and Gregory
French--9/10th c. St. Greg-
ory and Scribes
French--13th c. Sts. Martin,
Jerome, and Gregoire le
Grand
German--9/10th c. St.
Gregory with Three Scribes

German--10th c. Diptych:
King David, and Pope
Gregory the Great
Italian--10th c. Diptych:
Crucifixion; Roman Wolf;
Madonna; Sts. Gregory,
Silvester, and Flavian
Laurana. St. Jerome and St.
Gregory, relief
Seyfer, H., the Elder.
Gregory
Gregory XIII (Pope 1502-85)
Rusconi, Camillo. Gregory
XIII Tomb
GREGORY, Waylande
Head terracotta
CASS 33 UNNBoy
Grenelle Fountain
Bouchardon, E. Fountain of
the Four Seasons
Gresham, Thomas d 1579
Bushnell. Sir Thomas
Gresham
English--16th c. Sir Thomas
Gresham Tomb
Greta. Innocenti, B.
Greviously Wounded--The Farewell.
Somaini
Grey-Rose Picture. Schwitters
Grey Smoke. Jacquet, A.
Greyndour, Robert d 1443
English--15th c. Robert
Greyndour Brass: Free
Miner of Forest of Dean
GRICCI, Giuseppe (Italian)
Fisherman and Girl,
Capodimonte c 1750
SOTH-1: 155
Il Grido. Marini
Il Grido
Martin, E. The Cry
Griechin. Wolff, G. H.
Grief
Biesbroeck. Grief
Kolbe. Grief
Kollwitz. Grief
Rodin. Head of Grief
Grieg, Edward
Asbjornsen. Edward Grieg,
bust
GRIENAUER, Edwin (Austrian)
Girl and Flower (La Ragazza
a il Fiore) bronze
VEN-24: pl 41
Griff in den Weltraum. Altri
Griffins
Biduinus. Architrave reliefs:
Animal Procession;

Gryphons Attacking Bear
Byzantine. Ascension of
Alexander the Great, Borne
by Two Griffins
Byzantine. Opposing Gryphons
by Tree of Life, screen
detail
Early Christian. Lamp:
Griffin Head Handle
English--11th c. Griffons
Seizing Human, tympanum
English--11/12th c. Capital:
Griffin
French--12th c. Griffin
Aquamanile
German--15th c. Griffin
Tankard
German--17th c. Griffon, as
Escutcheon Holder
Gofridus. Choir of S. Pierre:
Grotesque Capitals
Italian--8/9th c. Griffins,
altar frontal
Italian--11th c. Griffin
Italian--13th c. Griffins
Flanking Tripod, pillar
base
Laurana, F., and Pietro di
Martini. Triumphal Arch
of Alfonso of Aragon:
Griffin
Pisanello. Medal: Niccolo
Piccinino of Perugia;
Griffin
Quellinus, A., the Elder. E.
van Immerzeele Tomb
Romanesque-Italian. Gryphons;
Choir Screen
Russian--17th c. Comb: Grif-
fin, Lion, Human Heads
Le Griffu. Richier, G.
Grilles and Railings See also Iron
Work
Coquet. Louis XV Railings
Cuveilles. Balcony Grille
French. Wrought Iron Grille
French--12th c. Romanesque
Railing
German--9th c. Grille, detail
Le Parc. Grille
Maso di Bartolommeo. Bronze
Grille, detail
Panzer. Baptistry Grille
Pasquino da Montepulciano--
Attrib. Grille Detail
Spanish--16th c. Staircase
Handrail

Grimaldi, Ottavio (Prokurator of St.
Marks, Venice 1516-76)
Vittoria. Ottavio Grimaldi,
bust
Le Grisou
Meunier. Fire-Damp
Gritti, Andrea 1523-39
Italian--16th c. Gold Bull
("Bollo d'Oro"): St. Mark
Handing a Banner to
Andrea Gritti
Grasse, Comte Francois
Landowski. Admiral de Grasse,
detail
GRIMALDEN, Anne (Norwegian)
Horse, head, monument
detail 1938
HOF 227
GRIS, Juan (Original name: Jose
Victoriano Gonzalez)(Spanish
1887-1927)
Harlequin (L'Arlequin) 1917
ENC 366
--1917 plaster
SELZJ 200 FPLe
Harlequin (Torero) 1917
colored plaster; 22
GIE 50; READCON 72;
ROSE pl 212 UPPPM
Toreador 1917 ptd plaster;
21-1/4 NMAC pl 103 UNNGal
GRISELLI, Italo (Italian 1880-)
Plinio Nomellini, bust marble
VEN-42: pl 48
Story Teller (Il Cantastorie)
terracotta
VEN-32: pl 21
Woman* bust
CASS 115
GROFF, Wilhelm de (German 1680-
1742)
Elector Maximilian Joseph of
Bavaria 1737 silver; 1/2 LS
BUSB 155; MOLE 243 GAlt
GRONINGER, Heinrich (German)
Last Judgment, Furstenberg
Epitaph c 1620
BUSB 36 GPC
GRONINGER, Johann Mauritz (German
1650-1707)
Dean Heinrich Ferdinand von
der Leyen Tomb 1714
BUSB 131 GMaiC
GROOT, Guillaume de (Belgian 1839-)
Labour
ROOSE 294 BBMu
Grosse Agression. Luginbuhl

Der Grosse Berliner Pyxis
 Early Christian. The Great
 Berlin Pyxis
Grosse Gestalt. Fohl
Grosse Skulptur. Wotruba
Grosse Tete. Matisse
Grosser Bulldog. Luginbuhl
GROSSO, Luigi (Italian 1913-)
 Spigolatrice 1962 bronze
 VEN-62: pl 74
GROSSONI, Orazio (Italian)
 Verdi Memorial
 REED 125
Grotesques See also Gargoyles
 Baroque. Grotesque, fountain
 detail
 English--12th c. Grotesque,
 corbel
 French--8th c. Crozier:
 Grotesque
 French--12th c. Centaur
 Shooting Lion; Grotesque
 Animals, archivolt
 --Grotesque Figures,
 ballustrade
 --Grotesque Mask Corbels
 French--12/13th c. Grotesque
 Capitals
 French--12/15th c. Grotesque
 French--13th c. Grotesque,
 roof sculptures
 Gerhaerts. Grotesque Head
 German--12th c. Grotesques
 Gofridus. Choir of S. Pierre:
 Grotesque Capitals
 Martin Brothers. Grotesque
 Pitcher
 Rasmussen. Grotesques
 Silvano. Grotesque Ornament,
 and Batwing
"Grotto of the Virgin". Byzantine
Grotto of Thetis
 Girardon. Apollo Attended by
 Nymphs
GROTTAMMARE, Ascoti Piceno See
 FAZZINI, P.
Group in Tulip Wood. Strauss, A.
GROUP N (Gruppo N: Alberto Biasi;
 G. A. Costa; E. Landi;
 M. Massironi), Italian
 Group Exhibiting
 anonymously. Location:
 Padua. Disbanded 1964
 Dynamic Vision 1964
 plastic and wood
 VEN-64: pl 100
 Unstable Perception 1963
 metal; 17-7/8x18x3-1/2
 SEITR 4 UNNMMA

Group of Horsemen
 Koenig. Horsemen
Group of Riders
 Koenig. Horsemen
Group of Six Cells. Bill
Group of Twelve Figures. Hepworth
Group of Women. Bilger
Groupe de Trois Hommes I
 Giacometti. Three Men
Growing. Pomodoro, G.
Growth. Arp
Growth. Uhlmann
Grunwald, Bela
 Ligeti. Bela Grunwald, seated
 figure
Grunwald Monument
 Wiwulski. Jagiello
GRUPELLO, Gabriel (Italian 1644-
 1730)
 Fishmongers' Guild Fountain
 1675 upper section: 34-1/4;
 lower section: 46-1/2
 GER pl 29; HAMF 275 BBR
 --Neptune and Thetis
 DEVI-2
 Johann Wilhelm van Neuberg
 Wittelsboel, Count Palatine,
 bust DEVI-2 BBR
 Samson and Delilah
 HAMF 61 GBS
GRUPPO N See GROUP N
GRUSON, Paul (German 1895-)
 Oberburgomeister Sahm, head
 1932 bronze; LS
 HENT 71 GBRat
Gryphons See Griffins
GRZETIC, Ante (Yugoslav 1920-)
 Bather 1954 plaster
 BIH 177
 Horse 1954 plaster
 BIH 176
GRZIMEK, Waldemar (German 1918-)
 Kneeling Woman (Kniende)
 1950 terracotta
 GERT 212
 Sachsenhausen Concentration
 Camp Monument, model
 1959 bronze; 57-1/8
 BERL pl 252; BERLES
 252 GBSBe (B II 29)
GSELL-HEER, Margrit (Swiss 1887-)
 Badende 1949 bronze
 JOR-1: pl 30
Guarda-Sol. Taeuber-Arp
GUARDI, Andrea (Italian fl 1450)
 Faith and Hope, altar ante-
 pendium detail 1462 marble
 SEY pl 86B IPisa MS
The Guardian. Stahly

Guardian Angel
 Gunther, F. I. Guardian
 Angel Group
The Guardians. Fievre
Guardians of Transportation.
 Wikstrom
Guards Memorial
 Walker, A. , J. Bell, and
 J. H. Foley Crimean
 Memorial Group
Guarino da Verona (Humanist)
 Pasti. Guarino da Verona,
 medal
GUASPARRO, Giovanni Battista di
 Jacopo di See ROSSO, G. B.
GUAZZALOTTI, Andrea (Italian 1435-
 1494/95)
 Medal: Sixtus IV c 1481
 bronze; Dm: .060 m
 CHAS 301
 Niccolo Palmieri, Bishop of
 Orte, medallion c 1467
 bronze; Dm: 2-1/2
 YAP 216 -USe
Gubec, Matija
 Kralj. Matija Gubec Cycle
Gucurbita-Galbasse I. Hiltmann
GUDBRANDSON, Gisli (Icelandic
 1584-1620)
 Figure, chair detail c 1600
 ptd wood BAZINW 233
 (col) IcRN
GUDEWERTH, Hand, the Younger
 (German c 1600-71)
 Memorial to Heinrich Ripenau
 c 1653 HEMP pl 40 GE
 Putto, high altar figure 1640
 HEMP pl 41 GE
 St. Mark, high altar figure
 1640 HEMP pl 39 GE
 Worshipper at the Crib, altar
 fragment, Danischhagen
 1656 BUSB 85 GPreCh
Gueldres, Philippe de, Duchess of
 Lorraine
 Richier, L. Philippe de
 Gueldres Tomb
Guelf Princesses. German--15th c.
GUELFI, Giovanni Baptista (also
 Guelphi) (Italian fl 1714-34)
 James Craggs Monument 1727
 GUN pl 10; WHINN pl 54A
 ELWe
GUELPHI, G. B. See GUELFI,
 G. B.
Gueridon. French--18th c.
GUERIN, Gilles (French 1606-78)
 See also Sarrazin, Jacques

Duke Charles de la Vieuville,
 kneeling effigy, former
 Eglise des Minimes
 BUSB 97 FPL
St. Francis of Padua
 LARR 348 FPJC
Watering the Horses of Helios,
 grotto figures after 1667
 BUSB 93 FV
Le Guerrier. Altri
Guerriero. Fontana, L.
GUERRINI, Lorenzo (Italian 1914-)
 Condizione Umana 1954 stone;
 1 m SCUL pl 60
 L'Eterna Domanda 1956/57
 stone; 1.90 m
 SCUL pl 61
 Horizontal Man Machine 1963
 basalt type stone; 44x64
 ARTSI #10
 Man Renews Himself 1957
 stone; 118 BERCK 158
 Metamorphosis 1957 stone
 MAI 124
 Mono Macchina Orizzontale
 1963 stone of bagnoregio;
 61x63
 READCON 187
 Open Figure (Figura Aperta)
 1961 stone
 VEN-62: pl 1
 Scultura Forte 1958 stone;
 25-5/8
 TRI 177
GUERRISI, Michele (Italian 1893-)
 Count C. M. De Vecci di Val
 Cismon, bust bronze
 VEN-36: pl 3
 Emilio Zanzi, head bronze
 VEN-30: pl 90
 Resurrection of Lazarus,
 detail bronze
 VEN-38: pl 109
 Swimmer (Nuotatrice) bronze
 VEN-34: pl 90
 Walking Woman (Ragazza che
 Cammina) bronze
 VEN-32: pl 20
Guest, Joshua d 1747
 Taylor. Lt. Gen Joshua
 Guest, bust detail,
 monument
GUGGENBICHLER, Meinrad (Austrian
 1649-1723)
 Angel ptd and gilded wood
 FAIN 164 UMWe1C
 Dying St. Stephen, head, High
 Altar (destroyed) 1701
 BUSB 114 ASc

Return of the Holy Family
from Egypt, altarpiece
figures c 1690 ptd linden-
wood; figure: 30-1/4 to
17-1/2 KUHN pl 62, 65
UMCB (1956.275)
St. Benedict, Holy Ghost
Altar figure 1682/84
HEMP pl 60 AMon
Virgin and Child, High Altar
1709/13 BUSB 113 AL
GUGLIELMO See WILIGELMUS
GUGLIELMO DA MODERNO See
WILIGELMUS
GUGLIELMO DA PISA See
WILIGELMUS
GUGLIELMO DI CASTELBARCO
d 1320
Italian--14th c. Guglielmo di
Castelbarco Monument
GUIBAL, Dieudonne Barthelemy
(French 1699-1757)
Neptune Fountain
GAF 185 FNan
GUIBERT, Nicolas--ATTRIB
St. John the Baptist, Chartres
Cathedral c 1450 BUSR 76
FPL
Guidarelli, Guidarello
Lombardo, T. Guidarello
Guidarelli Tomb
Guide
Byzantine. Virgin and Child
(Virgin Hodighitria)
GUIDO, Domenico (Italian(1625-1701)
Crucifix, Pantheon of the
Kings bronze; 1.40 m
ESC 50 (col) SpE
Fame Reviving the History of
Louis XIV, Neptune
Fountain detail
LARR 348 FV
Lamentation over the Body of
Christ 1686
WIT pl 118A IRMoP
GUIDO DA COMO (Italian fl 1250)
Pulpit 1250
POPG fig 4 IPiB
--Annunciation; Adoration of
the Magi
MOREYM pl 80
Guilbert, Yvette
Rosso, M. Yvette Guilbert
Guilds
Aumonier, W. Leathersellers'
Company Coat of Arms
Belgian--14th c(?). Spice and
Herb Merchants Guild Sign

Buon, B. Madonna of Mercy
Protecting Members of Guild
of Misericordia, relief
French--18th c. Ensign of the
Sailors of the Loire
Grupello. Fishmongers' Guild
Fountain
Robbia, L. della. Arms of the
Guilds of Silkweavers and of
Merchants
Robbia, L. della, and A. della
Robbia. Three Guild
Emblems, plaques
GUILLAIN, Simon (French c 1581-
1658)
Anne of Austria 1647
BLUA pl 149A FPL
Louis XIII, from monument
at entry of Pont au Change
1647 bronze
LARR 279 FPL
Louis XIV as a Child 1639/43
bronze; 79
CHAR-2:109 FPL
Louis XIV as a Child, between
Louis XIII and Anne of
Austria, Port au Change
Monument c 1643 BAZINW
394 (col); LOUM 141 FPL
(1331-34)
GUILLAUME, Emile (French)
Aux Champs
TAFTM 43
GUILLAUME, Eugene
Monseigneur Darboy, bust
marble MARY pl 27 FPLu
GUILLAUME D'AUNIERS
Burgundian Knight c 1410 white
stone; 34
COOP 106 ILugT
GUILLAUMET, Jean (Jean de Chartres)
(French fl prior to 16th c.)
St. Anne Instructing the
Virgin, Chantelle Chapel
1500/03 stone
LOUM 53; MULS pl 189A
FPL
GUILLAUMET, Jean (Jean de Chartres)
--FOLL
Education of the Virgin 16th c.
CLE 74 UOC1A (23.51)
GUILLELMUS See WILIGELMUS
GUIMARD, Hector (French 1867-1942)
Door 1897/98
BAZINL pl 397 FPBer
Fence c 1900 ptd cast iron
SCHMU pl 156, 164, 274
FPMet

Gate, Castel Beranger 1894/
98 PEVP 64 FPFo
Metro Station Entrance Gate
c 1900 wrought iron
ENC 43; SELZPN 135 FP
La Guimard. Merchi
GUMIEL, Pedro (Spanish fl 1516)
Chapter Room Vestibule
1504/12 CIR 9 (col) SpTC
Guinevere and the Nestling.
Reynolds-Stephens
GUINO, Michel (French 1928-)
Garment of Light 1958
bronze MAI 126
GUINO, Richard See RENOIR, Auguste
Guisando Bulls. Celtic.
Guise, Henry I de Lorraine, also
known as Le Balafre 1550-88
French--17th c. Duke of
Guise Tomb
Guitar See Musicians and Musical
Instruments
Gulbransson, Olaf
Bleeker. Olaf Gulbransson,
head
GULLESON, Haakon (Swedish)
Madonna wood
FEIN pl 54 SnHaeK
GUMPEL, Mordechai (German-
Israeli 1911/12)
Bird of Prey stone
GAM pl 97
Ram's Head stone
GAM pl 98; SCHW pl 94
Samson and the Lion, relief
SCHW pl 111
Gundestrup Cauldron. Celtic
Gundulic, Ivan Franov (Croatian Poet
1588-1638)
Rendic. Ivan Gundulic, bust
Gunner. Muller, R.
GUNTHER, Franz Ignaz (German
1725-75)
Annunciation 1764 limewood; 63
BAZINW 414 (col); BUSB
184-5; HEMP pl 147; LARR
356; PRAEG 332; READAS
pl 114-5 GWeyC
--Angel of the Annunciation
KO pl 93
--Virgin of the Annunciation
(Maria Verkundigung)
KITS 31 (col); LIL 228
Apostles, detail mid 18th c. ptd
wood MOLE 247 GRegS
Archangel Michael 1755/60
lindenwood; 95 cm\
BSC pl 139 GBS (8286)

Emperor Henry, as founder of
the Church of Rott 1760/62
HEMP pl 145 GRott
Female Saint 1755 ptd lime-
wood; 60 MU 209 GStaW
The Guardian Angel 1763 ptd
wood; 71
ENC col pl 65 (col); HEMP
pl 145; KO pl 93 GMBu
--Archangel Raphael Leading
Tobias
CHRC fig 192
John of Nepomuk 1755/60
lindenwood; 172.5 cm
BSC pl 138 GBS (7750)
Kneeling Angel c 1760 wood
CLE 150 UOClA (66.18)
Madonna of the Immaculate
Conception ptd and gilded
wood CLE 150 UOClA
(63.294)
Male Saint 1759/63 ptd wood;
over LS
MOLE 250 (col) GRott
Pieta 1774 limewood; 64
ENC 372; MYBA 562;
NEWTEM pl 147; READAS
pl 111-13 GNeC
Raphael c 1760
HEMP pl 144 GMBN
St. Mary Magdalen 1755
ST 365 GStaZ
St. Norbert and St. Augustine
1765 terracotta; 33.5x35 cm
BSC pl 141 GBS (1305/04)
The Trinity, High Altar
1760/62
HEMP pl 146 GRott
GUNTHER, Franz Ignaz--FOLL
Madonna c 1760 ptd plaster;
6-7/8 KUHN pl 64 UMCB
(1964.35)
Putto ptd and gilded wood
CLE 150 UOClA (61.413)
GUNTHER, Johann Joachim (German
fl 1754-65)
The Four Seasons c 1760/65
sandstone; figures: 93;
pedestal: 37
KUHN pl 78-83 UMCF
(1952.11a-d)
GUNZBOURG, Ilia (Russian)
Boy Bather bronze
VEN-14:77
GURTLER, Walter (Swiss 1931-)
Le Chardon 1958
JOR-2: pl 216
Gust of Wind. Meier-Denninghoff

Gustavus III (King of Sweden 1746-92)
 Bouchardon, J. P. Gustavus
 III as a Child
Gustrow Memorial
 Barlach. Hovering Angel
GUTTFREUND, Otto (Czech 1898-)
 Bank Building Entrance
 AUM 25 CzP
 Commerce colored wood
 MARY pl 69
 Grave Monument stone
 PAR-2:121
 Head*
 MARTE pl 39
 The Printer terracotta
 VEN-28:pl 176
 Return of the Legionaries,
 relief
 CASS 90-91
GUY, Thomas
 Bacon, J. Thomas Guy
 Monument
GUYSKI, Marceli (Polish)
 Andrzej Zamoyski, bust
 bronze; 75 cm
 WPN pl 132 PWN
 (212924)
Guzman, Alfonso Perez de
 Martinez Montanes. Don
 Alfonso Perez de Guzman
 Sepulchre
Gymnast. Fazzini
The Gypsy. Martini
Gysbrecht van Amstel
 Zijl. Gysbrecht van Amstel,
 corner figure

H. I. S. (Dutch)
 Samson the and Lion 2nd half
 16th c. boxwood; 24 cm
 BSC pl 114 GBS (M 154)
HAAPASALO, Johannes (Finnish
 1880-)
 After the Bath
 PAR-2:180
 Archer 1926 red granite
 RAMT pl 24 FiHA
Haarkaummende Frau
 Gonzalez. Woman Combing
 her Hair
HAASE, Volkmar (German 1930-)
 Stahl 1962 Vertikal II 1962
 steel; 250 cm
 KUL pl 45/46
 Stahl 1963 Konfrontiert 1963
 steel; 190x50x60 cm
 KUL pl 47/48

Habakkuk (Biblical Hebrew Prophet)
 Bernini, G. L. Prophet
 Habakkuk and the Angel
 Civitale. Prophet Habakkuk
 Donatello. Prophet Habakkuk
 German--12th c. Daniel in the
 Lion's Den; Prophet Habakkuk
 Bringing Food and Drink,
 relief
 Pisano, G. Habakkuk
HABER, Shamai (Polish-Israeli 1922-)
 Composition with Three Stones
 1957/58 Breton granite;
 35-3/8 TRI 175 -Co
 Granite Sculpture
 MAI 127
 Sculpture, Salon des
 Realites Nouvelles 1957
 BERCK 276
 Small Monument 1962 Brittany
 granite; 24-1/8x28x26-1/2
 SEIT 40
 Space Construction 1960/61
 granite; 55x63x55
 SEAA 143
 Untitled 1960/61 granite; L:
 72 SEITC 51 NAS
 Untitled 1960/61 Brittany
 granite; 40x47x37
 SEIT 41 UCtBL
HABICH, Ludwig (German)
 Portal Figure
 TAFTM 67 GDa
Hadelin, Saint
 Belgian--12th c. Shrine of
 Hadelin
Hades (Pluto)
 Bernini, G. L. Pluto and
 Proserpine
 Bustelli. Pluto
 Mattielli. Pluto and Proserpine
 Poggini. Pluto
Hadrian (Roman Emperor 76-138)
 Italian--17th c. Adrian, bust
 Muskat. Emperor Hadrian,
 bust
HAECHLER, Peter (Swiss 1922-)
 Hahn (Coq) 1954 bronze
 JOR-1:pl 26
Haekendover Retable
 Flemish--14th c. Hakendover
 Altarpiece
HAERTWICH (German) See SNELLO
HAESE, Gunter (German 1924-)
 Early in the Morning 1966
 8-1/2x14-1/2 CARNI-67:#98
 ELMa

Flirt 1965 Filo di ottono
 VEN-66:#172 GDusHa
Olymp 1967 brass, copper;
 36-5/8x29-3/4x23-1/8
 GUGE 93
Zephir 1965 brass wire;
 7-5/8x12-1/4x10
 NEW pl 298 IRMarl
HAESE, Reinhoud d' See D'HAESE,
 Reinhoud
HAESE, Roel d' See D'HAESE, Roel
HAFELFINGER, Eugen (Swiss 1898-)
 Flughorn 1958
 JOR-2:pl 218
 Jemand 1958
 JOR-2:pl 221
 Penate 1958
 JOR-2:pl 220
 Tatzel 1959
 JOR-2:pl 219
Hagar
 Donner. Hagar in the Desert,
 relief
 Ghiberti. Baptistry Doors--
 East: Abraham Story
 Sicard. Hagar and Ishmael
HAGENAU, Niclaus von See NICLAUS
 VON HAGENAU
HAGNAUER, Friedrich (German fl
 1527-46)
 Phillip von Freising, Bishop,
 profile relief 1525/27
 lindenwood; 58.4x41.3 cm
 BSC pl 101; MUL 23
 GBS (3119)
HAGENAUER, Friedrich--ATTRIB
 Portrait Medallion boxwood
 CLE 110 UOClA (27.421)
HAGENAUER, Johann Baptist (Austri-
 an 1732-1810)
 Christ on the Column 1756
 gilt bronze
 CLE 149 UOClA (53.286)
HAGER, Johannes Paulus
 Fisherman Pulpit 1785
 BUSB 170 GWeisCh
Haggai (Biblical Hebrew Prophet)
 French--13th c. Prophet
 Aggee
 Pisano, G. Haggai, bust
 fragment
HAHN, Hermann (German 1868-1945)
 Goethe
 TAFTM 67 UICL
 Hohenflug 1932 bronze;
 1.95 m HENT 73
 Judith plaster
 VEN-5:pl 22

Luis Trenker, head 1931 bronze;
 40 cm
 HENT 74
Moltke Memorial, equest
 TAFTM 67 GBrem
Hahnloser-Buhler, Hedy
 Marini. Mme. Hedy Hahnloser-
 Buhler
Haile Selassie (Emperor of Ethiopia
 1891-)
 Botzaris. Haile Selassie, head
Hair. Fenosa
Hairdresser
 Luck, K. G. Lady at Hair-
 dresser
HAIVAOJA, Heikki (Finnish 1929-)
 Mattina 1966
 VEN-66:#163
HAIZMANN, Richard (German 1895-)
 Eagle 1931 polished bronze;
 26-3/4
 NNMMAG 175 GHG
HAJDU, Etienne (Rumanian-French
 1907-)
 Adolescence 1957 marble;
 35-3/4
 DETS 46 UNNH
 Bird Lyre 1956 marble; 21x13-
 3/4
 GIE 271 BBL
 Bonds 1958 hammered
 aluminum MAI 129
 Chantal 1958 marble; 23x11-3/4
 x6-1/2 CARNI-58:pl 80
 Claire et Clarisse 1964 H: 60-
 1/4 SEITC 133
 Cock 1954 brass
 LARM 325; MAI 128 UNNG
 Delphine 1960 marble; 20-1/2
 READCON 258 UNNK
 Elne 1964: H: 27-1/2
 SEITC 133
 Fabulation 1963 L: 122
 SEITC 134-35
 Fern 1959/60 bronze
 CHENSW 489 UNNK
 Field of Forces (Champs de
 Force) 1956 copper; 74
 GUG 205; MEILD 148 UNNG
 The Girls of My Town 1961
 marble MARC pl 60
 Head 1946 marble; 19-1/4x
 19-3/4GIE 270
 --1952 marble; 18
 SCHAEF pl 110
 --1957 marble
 BERCK 140
 The Lady of Bagneux 1952

lead; 72 SCHAEF pl 111
Marbre Pentelique 1964 H:
14-1/4 SEITC 131
Ouranos II 1956 bronze; 38
EXS 82 FPKn
Penelope 1966 27-1/4 (with
base)x16-1/8
CARNI-67:#54 UNNK
Pentelican Marble 1957
MAI 129 FPGr
Plane Combat, study 1948
hammered aluminum; 40
BERCK 221
Portrait Head 1950 marble;
18-1/4 NMAD 23 FPHaj
Saona 1963 40-1/2x20
CARNI-64:#68
Sculpture A 1961 marble
MARC pl 61
Small Figure 1957 Pentelic
marble; 20-1/2x7-1/8
TRI 72
Soldiers in Armor 1953 sheet
copper; 38-3/4x77-1/4
MCCUR 277 UNNMMA
--NMAD 23 FPBu
Syntia 1956 marble
BERCK 140
Tete Bronze Poli 1963 H:
23-1/2 SEITC 132
Tete Onyx Vert 1964 H:
17-3/4 SEITC 132
The Wolves 1953 chased cop-
per; 66-7/8x82-5/8 TRI 48
Woman with Braids 1953
bronze; 33-1/2 NMAD 24
UWiMZ
The Young Girls 1954 sheet
aluminum; 38-1/2x66
NMAD 25 FPBu
HAJEK, Otto Herbert (Czech-German
1927-)
Auditorium Relief 1959
BOE pl 202 GFrei
Choir Screen: Christ and
Two Apostles 1955 red sand-
stone; 6.5x4.8 m OST 15
GHirA
Exterior Wall Relief (Raum-
liches Relief) 1959 beton;
450x1400x90 cm
KUL pl 1 GFreiU
Relief 1960 beton; 128x929
cm KUL pl 2 GMaW
Sculpture (Plastik) 1959 220
x540x90 cm
KUL pl 3 GViF

Sculpture (Plastik) 6-3/4 1963
bronze; 82x52x18 cm
KUL pl 5
Sculpture (Plastik) 65/32 1965
bronze; 8-1/2x6-7/8x4-3/4
NEW pl 295
Space 1957 bronze
MAI 130
Space Cluster (Raumknoten) 35
1956 bronze; 70x30 cm
OST 105 GHaL
Space Cluster (Raumknoten)
56/I 1957 bronze; c 51x43x
22 cm SP 62 GHaS
Space Cluster (Raumknoten) 59
1958 bronze; 17-3/4
MINE 42 GMVan
Space Cluster (Raumknoten) 64
bronze; 27-5/8x15x3-7/8
TRI 156 GRavC
Space Planes 130 1959 25.6x
39.4 CARNI-61:#140 GCoAA
Spatial Wall 1959 molded con-
crete; 82-5/8x215x35-3/8
TRI 247 GViR
Wandgestaltung 1963 stahlbeton
KUL pl 4 GFFr
Halbakt. Albiker
Halberd. Swiss--15th c.
HALD, Edward
Zodiac, celestial globe 1929/30
engraved crystal; 21; Circ:
51-1/4 GRAT 163 SnSN
(142.1930)
Hales, James
English--17th c. Sir James
Hales, his wife and stepson
Monument
Hales, Stephen
Wilton. Dr. Stephen Hales
Monument
Half Clothed Maja. Marcks
HALL, David (English 1937-)
Duo II 1966
KULN 145
Isomet 1966 welded steel ptd;
70x108x66
LOND-7:#15 UNNFei
Throw Away 1964 welded steel;
14x24x16
ARTST inside fr cov
HALL, Teresa van (Dutch)
The Housewife oak
AUM 111
HALLER, Hermann (Swiss 1880-1950)
Clotilde S.
VEN-34: pl 175

Crying Girl (Weinendes Mad-
chen) OST 29 GDusK
Girl bronze
VEN-26: pl 98
Kneeling Girl 1920 terracotta
STA 65 GCoW
Marie Laurencin, head 1920
English cement
JOR-1: pl 4; MAI 131
Park Figure
RICH 184
Standing Girl (Stehende Mad-
chen) TAFTM 69
--c 1926 bronze; 14
UNNMMAM #169 UNNMMA
--1934 bronze
JOR-1: pl 5
Standing Woman
TAFTM 65
HALONEN, Emil (Finnish 1875-)
Girl 1908 aspenwood
RAMT pl 23 FiHA
HAMDY, Abdel Hamid (Egyptian 1917-)
Calf's Head plaster
VEN-54: pl 83
Hamey, John
Pierce. Dr. John Hamey, bust
Hamilton, Alexander (American
Statesman)
Ceracchi. Alexander Hamilton,
bust
Lanelli, J. Alexander Hamilton,
bust
Hamilton, Gavin
Hewetson. Gavin Hamilton,
bust
HAMILTON, Richard (English)
Just What Is It That Makes
Today's Home So Different,
So Appealing? 1956 collage;
10-1/4x9-1/4 LIP 38
Hamlet in a Japanese Manner.
Paolozzi
HAMM, Henri (French 1871-)
Sculpture 1950
BERCK 276
Sculpture in Plaster 1956
MAI 131
Hammarskjold, Dag
Hepworth. Single Form:
Memorial to Dag
Hammarskjold
Hammerhead. Wright, A.
The Hammerman. Meunier
Hampden, John (English Statesman
1594-1643)
Cheere, H. Monument Com-
memorating Centenary of the
Death of Hampden

Hamsterley, Ralph
English--16th c. Shroud-brass
of Rev. Ralph Hamsterley
HAN, O. (Rumanian)
Desperation bronze
VEN-38: pl 77
HANAK, Anton (Austrian 1875-1934)
Austria
TAFTM 67
Child Figure
TAFTM 67
Eternity
TAFTM 66
Exhaltation marble
PAR-2: 96
Head
TAFTM 66
Lifting
TAFTM 67
Man Aflame, study c 1922
bronze; 30 cm
SOT pl 86 AVO
Morning Sun (Sole Mattutino)
marble VEN-32: pl 148
Parting
TAFTM 67
Sphinx marble
PAR-2: 97
Hanako# Rodin
HANCOCK, John (English fl 1703-18)
Joseph Mellish, recumbent
effigy 1703
GUN pl 13 EBly
HANCOCK, Walter
Ahti terracotta
HUX 95
Hancock, William d 1676
English--17th c. William
Hancock and sons Monument
Hand, Martha
Banks. Martha Hand Monument
The Hand of God. Rodin
Handel, George Frederick
Roubiliac. George Frederick
Handel#
Handles
Sant. Dish Handle
Hands
Arp. Rock Formed by a Human
Hand
Bourdelle. Hand of Warrior
Civitali. Tomb Relief:
Clasped Hands and Profile
Head
Donatello. Casa Martelli David:
Hand
Donner. Hands, Lamentation
detail
Fernandez. Baptism of Christ

Harford, Richard
 English--16th c. Richard Har-
 ford Tomb
HARGRAVE, John (English)
 Sir Cope d'Oyley Monument
 ESD pl 94 EBuckH
Hargrave, William
 Roubiliac. General William
 Hargrave Monument
Harle, Jean, the Elder
 Daumier. Jean Harle, the
 Elder, bust
Harlequin See Commedia dell'Arte
Herman of Exeter (Bishop)
 English--16th c. Bishop Har-
 man of Exeter, effigy
Harmonie. Maillol
Harmony
 Kandler. Harmony
 Volti. Harmony
Harness
 Anglo-Saxon. Metal Ornaments
 Celtic. Yoke Mounting
 Folk Art--Russian. Arches,
 placed on horses' necks
 Russian--17th c. Regal
 Bridle
 Swedish--7th c. Animal-style
 Bridle Fitting
 Swedish--7/8th c. Vendel
 Ship Burials
 Swedish--9th c. Broa Bridle
 Fittings
 Turkish. Regal Harness
HARNISCHTER, D.
 Ceremonial Sword 1652 silver
 and steel; 52-1/2
 COOPF 178 GDonF
Harp See Musicians and Musical
 Instruments
The Harp. Aeschbacher
Harpies
 French--13th c. Nave Capital:
 Two Harpies
Harpsichord See Musicians and
 Musical Instruments
Harrington, James
 Simon. Medal: Sir Thomas
 Harrington
HARRIS, Charles
 3rd and 4th Duke of Lan-
 caster Monument c 1779
 WHINN pl 116B EEd
Harris, Lady Freda
 Copnall. Lady Freda Harris
HARTAS, Philip (English 1930-)
 Clay Figure
 BED 120

HARTH, Philipp (German 1887-)
 Camel (Kamele) 1926 wood;
 45 cm HENT 100
 Eagle (Adler) 1930 bronze; 65
 cm HENT 102 GKS
 Jaguar 1928 wood; 29-1/2
 HENT 103; NNMMAG 172
 GBN
 Ornamental Relief
 HENT 5
 Storck Group 1956 bronze;
 1x1.65 m OST 75 GCoRh
 Tiger 1933 marble; 38 cm
 HENT 101
HARTMANUS
 Capital: Heads of Demons;
 Dragons c 1150
 BUSRO pl 48 GGo
HORTSHORNE, Robert (English fl
 1715-28)
 Sir Thomas Powys, recumbent
 effigy 1720
 GUN pl 13 EThor
HARTUNG, Karl (German 1908-)
 Bird (Vogel) 1948 bronze;
 c 18x32x11.5 cm
 SP 64 GHaS
 Bronze 1941
 READAN # 65
 Composition II 1949 bronze;
 30x50 cm
 MID pl 109 BAM
 Double Form (Doppelform)
 1930 bronze
 GERT 141
 --1950 bronze
 STA 215
 Facade Design, Salon Elvira
 (removed 1933) colored
 stucco BOE pl 194 GM
 Figure 1950 bronze; 55
 RIT 201
 Grosse Kugelform 1950, 1956
 stone; 1.89 m
 OST 102 GHaA
 Insect Form II 1948 wood; 13
 SCHAEF pl 105
 Large Standing Figure#
 (Grosse Stehende) 1950/52
 clay; plaster
 GERT 144. 145
 Kore 1953 bronze
 MAI 133
 Monument 1955 bronze
 BERCK 162
 --1956 bronze; 62 cm
 OST 101 GCoW
 Portrait "L" 1951 marble; 11
 SCHAEF pl 107

Primeval Branchings 1950
 plaster, for bronze; W:
 78-1/2 GIE 267
Reclining Figure (Liegender)
 1938 bronze
 GERT 140
Relief 1963 bronze; 5-7/8x
 7-1/8 NEW pl 323 GBG
Sculpture (Plastik) bronze
 PRAEG 463
--1946 marble; 15-3/4
 SCHAEF pl 104
--1947 mahogany; 14-5/8
 TRI 186
--1949 wood; 14-1/2
 SCHAEF pl 106
--1953 cement
 GERT 143
--1954 cement; 1.1 m
 OST 100
--1956 plaster
 MAI 133
--1958 stone
 BERCK 278
Situation 1946
 KO pl 105
Standing Figure 1956/58
 bronze; 2.3 m
 OST 103
Stehende 1956/57 bronze; 30
 cm SP 64 GHaS
Stone 1947
 BERCK 162
Striding 1950 bronze; 55
 MID pl 133 BAM
Thronoi 1958/59 plaster, for
 bronze; 94-1/2
 TRI 79 GDuK
Torso 1950 H: 55
 NNMMAG 181 UTxFF
"Walking" (Schreiten) 1950 clay
 GERT 142
Winged Column 1965 bronze;
 80 EXS 83
Zwei Stehende Frauen 1939
 gebrannter rotlicher-ton;
 35 cm SP 65 GHaS
HARTWELL, Charles L.
Bathers bronze
 MARY pl 104
The Chorister, head bronze
 MARY pl 159
Dawn marble
 MARY 26 ELN
The Goatherd's Daughter
 bronze MARY pl 37
Refugees bronze
 CASS 45

HARVARD-THOMAS, James (English
 1854-1921)
Thyrsis
 UND 116 ELT
Harvesters and Harvesting See also
 Agricultural Themes; Autumn;
 Months
Chelsea Porcelain. Harvesters
Early Christian. Sarcophagus:
 Good Shepherd and
 Allegorical Vintage
Martinuzzi. Grain Man
Meunier. Monument to Labor:
 Harvest
Harvey, Edmund and Martha
 Chantrey. Edmund and Martha
 Harvey
Harvey, William (English Physician
 and Anatomist 1578-1657)
 Marshall, E. Dr. William
 Harvey, bust
Harvey, William and Elizabeth
 Roubiliac. William and
 Elizabeth Harvey, medallion
 portraits
HASLIN, Micolas(?) (French)
The Visitation c 1520
 EVJF pl 268 FTrC
HASSAN, Mohamed (Egyptian 1893-
 1961)
Abdel Fattah Sabry bronze;
 44.5 cm
 SAID pl 103 EgCMA
Mohamed Mahmoud Khalil,
 detail from The Three
 Knights bronze
 SAID pl 102 EgCMA
Haste Brooch. Swedish--5/7th c.
HASTINGS, Donald (English)
The Risen Christ concrete; 10'
 AGARN il 27 EE1
Hastings, Hugh d 1347
 English--14th c. Sir Hugh
 Hastings
Hastings, Warren (English Statesman
 1732-1818)
 Banks. Warren Hastings, bust
Hat Badge. English--16th c.
Hat Jewel# French--16th c.
Hat of Yerikhon, helmet. Russian--
 17th c.
Hatpin. Stamp
Hats
 Early Christian. Child in
 Phrygian Bonnet
HATWELL, Anthony (English 1931-)
Deposition from the Cross 1962
 Portland stone; 50x18-1/4x
 13-1/2 LOND-6:#22

HAUKELAND, Arnold (Norwegian
 1920-)
 Dynamik I 1960 forged iron;
 61-3/8x19-5/8x11-3/4
 NEW pl 175 NoOb
Haus Tietze: Decorative Details.
 Metzner
HAUSER, Erich (German 1930-)
 Freiplastik 1964 Nirosta
 (stainless) steel; 236-1/4
 x118-1/8x78-3/4 NEW
 pl 292 GStR
 Stahl 2 1962 steel; 235x90x
 60 cm KUL pl 52
 Stahl 4 1963 steel; 147x135x
 138 cm KUL pl 49, 50
 GStMu
 Stahl 7 1962 steel; 48x53x
 21 cm KUL pl 51
HAUSMANN, Raoul (Austrian-French
 1886-)
 Mechanical Head (Holzkopf),
 assemblage 1918
 RICHT pl 48
 --1918 wood, metal, leather,
 cardboard; 12-3/4
 SEITA 36 GBH
 --1919/20 wood, and other
 materials; 10 GIE 91;
 MCCUR 267
"Have Pity!" Barlach
HAVELOOSE, Marnix d' (Belgian)
 Gloria (dancer) bronze
 VEN-14:68
Hawkins, Elizabeth
 Hickey, J. Elizabeth Hawkins
 Monument
Hawkins, Thomas d 1618
 Evesham. Sir Thomas Hawkins
 Monument
Hawks
 English--15th c. Misericord:
 Hawk on Hare
Hay, Malcolm V.
 Schotz. Major Malcolm V.
 Hay, head
HAYWARD, Richard (English 1728-
 1800)
 Barton Booth Monument 1780
 ESD pl 131 ELWe
 Font: Classical Figures; Dog
 WHINN pl 113 EBul
 Ladies Newdigate Monument
 ('Storied Urn') 1762, 1774
 ESD pl 138 EMiddH
 Lord Botetourt 1773
 CRAVS 77; GUN pl 11
 UVWM

Rev. Stephen Slaughter Clarke
 and Wife Monument
 ESD pl 125 ELeiT
Head (Elegy). Hepworth
Head and Shoulders. McWilliam
Head in Slate. Arbus
Head-Landscape. Giacometti
Head-Object. Turnbull
Head of a Fisherman. Messina
Head of a Girl-Dancer. Wimmer
Head of a Thinker with Hand.
 Lehmbruck
Head of a Woman (Anatolia).
 Modigliani
Head of Grief. Rodin
Head of Pain
 Rodin. Head of Grief
Head of Sorrow
 Rodin. Head of Grief
Head of Wounded Bird. Meadows
Head on Claws. Arp
Head with Extended Surface.
 McWilliam
Head with Grapes. Darde
Head with Keys. Jacobsen, R.
Head with Mirror. Gonzalez
Headless Woman. Giacometti
Health
 Italian--15th c. Healthful
 Nature and Madness
 Melioli. Personification of
 Health, medal
The Heart. Muller, R.
Hearth Figure. Kennington
Heathfield, Lord
 Rossi, J. C. F. Lord Heath-
 field, monument
Heaven
 Gislebertus. Tympanum: Last
 Judgment
Heavenly Jerusalem
 French--13th c. Portal, central
 west, Archivolts: The
 Heavenly Jerusalem
Hebe
 Canova. Hebe
 Carrier-Belleuse. Sleeping
 Hebe
 Flaxman. Hercules and Hebe
 Thorvaldsen. Hebe
 Voyez. "Fair Hebe" Jug
 Vries. Hebe
Heber, Reginald (English Prelate and
 Hymn Writer 1783-1826)
 Chantrey. Monument to
 Bishop Heber
Hebrews in the Furnace
 Early Christian. Book Cover:

Miracles of Jesus; Hebrews
in the Furnace
Hecate
Italian--15/16th c. Cassone:
Demeter and Hecate
Searching for Persephone
HECKEL, Erich (German 1883-)
Crouching Girl 1912 limewood,
ptd black; 11-13/16
ARTSP 35
Portraits
Zschokke. Erich Heckel, head
Hector
Mirko. Hector
Hedda's Stone. Anglo-Saxon
HEERMANN, Georg
Caryatids, balcony over
portal 1685/89 STECH
pl 20 CzPTr
HEERMANN, Georg, and Paul
HEERMANN
Giants in Combat 1685/1703
STECH pl 17b, 19 CzPTr
HEERUP, Henry (Danish 1907-)
Happy Baby 1941 steatite
VEN-62:pl 130 DCJo
Laying Duck 1965 21-1/8x
13-1/2x25
CARNI-67:#34
Owl Pillar c 1933 stone;
80 cm BOES 63 DCSt
Self Portrait, relief 1955
granite; 32-1/4x14x8
CARNI-58:pl 103
Stone Sculpture 1959 20x32
CARNI-61:#151
HEGEWALD, Zacharias (German)
Altar 1638
HEMP pl 22 GKot
HEIDE, Henning von der (German
fl 1500) See also Notke,
Bernt
John the Apostle, detail
c 1510 wood
KO pl 64 GLuM
HEIDELBERGER, Johann Ernst
Chapel Altar 1630
STECH pl 8 CzPW
Heiligenberg Madonna. Erhart,
George--Foll
HEILIGER, Bernhard (German 1915-)
Carl Hofer, head 1950
cement GERT 201
--1951 bronze; 42 cm
OST 80 GHaL
--1951/52 cement; LS
SCHAEF pl 78

Ernst Reuter, head 1954
bronze; 18
NNMMAG 182 UNHG
--1954 cement; 15-3/4
TRI 124
--1955 cemento fuso
VEN-64:pl XXV GMSG
Ernst Schroder, head 1955
cement
VEN-56:pl 117
Flamme 1962/63 bronze;
252x248 NEW pl 325 GBBe
J. H. Ganga, head 1952 ce-
ment GERT 198
Large Kneeling Figure (Grosse
Kniende Figur) 1952 cement;
74 GERT 200; SCHAEF
pl 77
Large Kneeling Woman (Grosse
Kniende) 1955 stucco
GERT 202
Large Vegetative Sculpture
1965 bronze; 92 EXS 84
UNNSt
Philippe d'Arschot, head 1955
bronze; 55 cm
MID pl 111 BAM
Primitive Bird (Urvogel)
1962/63 64x31-1/2x33-1/2
CARNI-64:#95
Seraph 1950 cement; 24-3/4
GERT 199; RIT 199
Three Figures 1957 bronze
MAI 134 UCLRo
Transformation 1957 cement;
40 BERCK 160
Two Figures in Relation (Zwei
Figuren in Beziehung) 1950
bronze GERT 203
--1954 eternit; 245 cm
MID pl 112 BAM
Vegetative Sculpture 1955
bronze; 78-3/4
TRI 151 GHagO
--1956 bronze; 78
READCON 152 UNNSt
Verwandlung II 1958 bronze;
62 cm OST 112 UNNSt
Woman's Head 1948 cement;
17 SCHAEF pl 76
HEIMSUCHUNGSMEISTER See
MASTER OF THE VISITATION,
BAMBERG
Heine, Heinrich
Herter. Heinrich Heine
Memorial
Kolbe. Heinrich Heine
Monument

Heinrich of Antwerp
 Upheus. Heinrich of Antwerp,
 bust
Heinrich von Sayn d 1247
 German--13th c. Heinrich
 von Sayn, effigy
Helen. Gordine
Helena, Saint
 Bolgi. St. Helena
 Early Christian. Empress
 Helena Sarcophagus
 Petel, G. St. Helena
HELGADOTTIR, Gerdur See GURDUR
Hell
 Bellano. Mountain of Hell,
 Table incense burner
 English--12th c. Durham
 Door Knocker
 Maitani. Last Judgment:
 Damned (Inferno)
 Pisano, Niccolo. Siena
 Pulpit
 Rodin. Gates of Hell
HELLMER, Edmund
 Starhemberg, with equest
 figure marble
 MARY pl 141 AV
Helmet Head. Moore, H.
Helmeted Head, and a Falcon's Head.
 Ipousteguy
HELMSCHMIED, Lorenz (Colman)
 (German)
 Suit of Armor c 1480
 DETT 158 UMiD (53.193)
HEMING, Thomas
 George III Table Candlestick,
 with supporting female
 figure 1770 SOTH-3:212
Hemma See Uta
HENDERIKSE, Jan (Dutch 1937-)
 Box with Puppet Parts 1965
 29-1/2x29-1/2x29-1/2
 NEW pl 155
HENDERSON (de Condenhove),
 Elsie (English)
 Calf Portland stone
 PAR-1:124
Hengesit. Jacobsen, R.
Henley, William Ernest (English
 Writer 1849-1903)
 Rodin. William E. Henley,
 head
HENNING, Gerhard (Danish 1880-)
 Figure sandstone
 MARY pl 148 DC
 Liggende Pige 1942/50
 Fransk Kalksten (Euville);
 110x127 cm COPGM 35
 DCN (I.N.2710)

Liggende Pige, der ser paa/sin
 mave 1943 bronze; 26.5x
 40 cm
 COPGM 31 DCN (I.N.2585)
 Seated Girl (Siddende Pige),
 detail 1936 Bremer sand-
 stone; 112x94.5 cm
 BOES 96; COPGG 109;
 COPGM 37 DCN (I.N.1959)
 Staaende Pige 1937 bronze;
 142 cm COPGM 39 DCN
 (I.N.2837)
 Vase porcelain
 NM-11:49 UNNMM
 Woman with Mirror (Ragazza
 che si specchia) porcelain
 VEN-20:97
HENNING, Gertrude
 Adventure porcelain
 VEN-20:96
HENNING, Johannes (Rumanian
 1666-1711)
 Artophorion, Transylvania
 1692 silver gilt repousse;
 Dm: 47 cm ARTSR pl 40
 RBMN
HENNING, John
 Horseman, arch frieze 1828
 WHINN pl 166B ELHy
HENNING, P. R.
 Youth (La Jeunesse) terracotta
 MARTE pl 3
 Zarathustra, frieze fragment
 white pottery
 MARTE pl 3
HENNING VON DER HEYDE (German
 fl 1487-1536)
 St. John the Evangelist c 1505
 MULS pl 165A GLuM
Henraux, Mme. L.
 Despiau. Mme. L. Henraux
"Henri". Leplae
HENRI, Samuel (Egyptian 1929-) See
 also Henry, S.
 Kneeling Girl 1960 limestone;
 100 cm SAID pl 94-95
HENRICI, H.
 $xyz = K^3 (x+y+2-1)^3$, visual
 representation of algebraic
 formula GIE 157 ELSci
Henrietta Maria (Queen Consort of
 Charles I of England 1609-69)
 Le Sueur. Henrietta Maria
Henry (Duke of Saxony 1129-95),
 called: Henry the Lion
 German--12th c. Lion of Henry
 the Lion
 German--13th c. Henry the
 Lion and Wife Mathilde Tomb

Henry, Lord Norris d 1601
 Evesham. Henry, Lord Nor-
 ris Tomb, effigy
Henry I (King of England 1068-1135)
 English--15th c. Niche
 Figures: King Henry I;
 King Stephen; King
 Henry II
Henry II (King of England 1133-89)
 English--12th c. Great Seal
 of Henry II
 English--15th c. Niche
 Figures: King Henry I;
 King Stephen; King Henry
 II
 --Screen Statues: King
 Stephen; Henry II
 Torrigiano, P. Chapel of
 Henry II
Henry III (King of England 1207-72)
 Torel. Henry III, effigy
Henry IV (King of England 1367-
 1413)
 English--15th c. Henry IV
 and Joan of Navarre Tomb
 Jacquet. Henry IV, head
Henry V (King of England 1387-1422)
 English--15th c. Henry V's
 Chantry
 --Shrine of Henry V
Henry VII (King of England 1457-
 1509)
 English--16th c. Henry VII,
 effigy head, from death
 mask
 Michelangelo. Henry VII Tomb
 Oucheman. King Henry VII
 Chapel: Stone Figure
 Torrigiano, P. Henry VII
 and Elizabeth of York
 Tomb
Henry VII Chapel. English--16th c.
Henry VIII (King of England 1509-
 47)
 Astyll--Attrib. Henry VIII
 and his son, Prince
 Edward, cameo
 English--16th c. Henry VIII,
 medal
Henry II (King of France 1519-59)
 French--16th c. Suit of
 Armor of Henry II
 Pilon. Henry II#
 Pilon. Three Graces, bear-
 ing Reliquary for Heart
 of Henry II
 Primaticcio, F., and G.
 Pilon. Henry II and
 Catherine de'Medici Tomb

Henry IV (King of France 1553-1610)
 Auricoste. Henry IV
 Bosio. Henry IV as a Child
 Dupree. Medal: Henry IV and
 Marie de'Medici
 Lemot. Henry IV, equest
 Tremblay. Henry IV in Armor
Henry (Emperor of Germany)
 Gunther, F. I. Emperor
 Henry, as Founder of the
 Church of Rott
Henry II (Emperor of Germany
 973-1024), called Henry the
 Saint
 German--11th c. Basle Ante-
 pendium: Christ Adored by
 Emperor Henry II and
 Empress Kunigunde
 --Book Cover: Book of
 Periscopes
 German--12th c. Reliquary of
 St. Henry
 German--13th c. Adam Portal
 German--18th c. Henry II
 Master of the Mercy Gate.
 Mercy Gate, tympanum
 Riemenschneider. Henri II
 and Kunigunde
Henry III (Holy Roman Emperor
 1017-50)
 German--13th c. Shrine of
 Charlemagne: Henry III
Henry IV (King of Germany and
 Holy Roman Emperor 1056-
 1106)
 German--13th c. Shrine of
 Charlemagne
Henry VII (Holy Roman Emperor
 1275?-1313)
 Tino di Camaino. Henry VII
 and Councillors
Henry I (Landgrave of Hesse 1244-1308)
 German--14th c. Heinrich I,
 effigy detail
Henry (Prince of Portugal 1394-1460),
 called Henry the Navigator
 Gameiro. Prince Henry the
 Navigator Monument
HENRY, Samuel (Egyptian) See also
 Henri, S.
 Bathing Man 1961 wood
 VEN-62:pl 174
Henry of Bourbon (Henry II, Prince
 de Conde 1588-1646)
 Sarrazin. Henri de Bourbon
 Monument
HENRY OF CONSTANCE
 Christ--St. John, Katharinent-
 al 14th c. ptd walnut; 53
 KO pl 54 BAB

Henry the Lion See Henry (Duke of
 Saxony)
Henry the Navigator See Henry
 (Prince of Portugal)
Henry the Saint See Henry II Holy
 Roman Emperor and King of
 Germany)
HENTSH, J. B. (Dutch)
 Head, monument detail
 AUM 112
Hephaestus (Vulcan)
 Bertoldo di Giovanni. Kneel-
 ing Vulcan
 Braun, M. B. Vulcan, head
 Greco, El--Attrib. Venus and
 Vulcan
 Italian--16th c. Vulcan
 Taca, P. Lamp: Vulcan
 Seated at a Forge
HEPWORTH, Barbara (English 1903-)
 Ascending Form--Gloria 1958
 bronze; 75
 ARTS #21
 Biolith 1949 blue Ancaster
 stone; 61
 GERT 238; RAMS pl 91
 Cantate Domino 1958 bronze;
 200 cm STM BAM
 Carving in Marble 1936 H: 12
 GIE 152
 Carving in White Alabaster
 UND 171
 Conoid Sphere and Hollow
 1937 marble; 18x16
 SELZS 108 UNNFie
 Core 1955/56 bronze; 30
 ARTS #17
 Corinthos 1954/55 Nigerian
 scented guarea wood,
 interior ptd white; 41x42
 x40 TATEB-1:36; TATES
 pl 2 ELT (T.531)
 The Cosden Head 1949 blue
 marble; 24
 GIE 154; RIT 197;
 SCHAEF pl 87 EB
 Curved Form (Delphi) 1955
 scented guarea with dark
 brown strings, interior
 white; 42x32 BERCK 97;
 BOE 72; BRION pl 124
 ELG
 Curved Form (Travalgan)
 1956 bronze; 36
 ALBB 19; ALBD-2:#47;
 TOW 70 UNBuA
 --1956 bronze; 35-1/2x23-
 1/2x26-1/2 LONDC pl 15;
 TATES pl 12 ELT (T.353)

Curved Form: Wave II 1959
 bronze with steel rods;
 16x18.3 CARNI-61:#158
 UNNCh
--1959 bronze with steel rods;
 L: 18
 HAMM 85 AuPW
Curved Form with Inner Form:
 Anima 1959 bronze; L:
 27-3/4 ARTS #23; HAMM
 87; JOO 195 (col) NOK
Curved Form with String
 sheet aluminum and string
 MEILD 165 UMiD
Discs in Echelon 1935 darkwood;
 L: 20-3/4 HAMM 82 UNNMMA
--1935/39 bronze; L: 20-3/4
 BOW 73
Dyad 1949 rosewood; 50
 GIE 155
Einsame Figure 1952 wood
 GERT 239
Elegy 1946 beechwood
 RAMT pl 10 -EK
Enfant 1929 Burmese wood; 19
 HAMM 27 ELWid
Figure 1956 pale wood ptd
 white, with blue strings; 47
 BERCK 99
Figure 1964 bronze; 71-1/4
 HAMM 92
Figure (Archaean) 1959 bronze;
 85
 ARTSB-62:pl 3; HAMM 88
 (col); PRIV 43 (col)
 EOCa; NOR; UWaSU
Figure (Nanjizal) 1958 yew
 98-1/4x18x13; base:
 35-3/4x23-3/4x4-1/4
 HAMM 91 (col); TATES pl
 4 ELT (T.352)
Figure (Nyanga) 1960 elmwood;
 36 BOW 123; HAMM 89
 (col); READCO pl 4
Figure (Requiem) walnut
 PRAEG 483
Figure: Spanish Mahogany
 1952 READAN #64
Figure for a Landscape 1960
 CHENSW 492 UNNMa
Figure in Landscape 1952
 alabaster; 10
 TRI 179 UMNSA
Figure of a Young Girl 1951/
 52 mahogany; 59-1/2
 SCHAEF pl 88
Form Enclosed 1951/52
 alabaster; 17
 GIE 154

Forms in Echelon 1938 tulip-
wood; 40 ARTSBR 33;
HAMP pl 141 ELT
Forms in Movement
KULN 115
Forms in Movement--Galliard
1956 copper; L: 30
ARTS #19
Four-Square (Four Circles)
1966 23-5/8x14x11
CARNI-67:#220 ELG
Garden Sculpture (Meridian)
1958 bronze; 66
ARTSB-61:bk cov
Group of Twelve Figures
1951 Senavezza marble;
L: 20
BERCK 96
Head 1952 mahogany and string;
17 DETS 48 UNNH
Head (Elegy) 1952 mahogany
and strings; 17 READAS
pl 213 UNbLU
Hollow Form (Penwith)
1955/56 BURN 151
UNNMMA
Hollow Form with White
Interior 1963 Guarea
wood; 39
HAMM 93 (col)
Icon 1957 mahogany; 8x14x12
ARTSS #26 ELBrC
Image 1951/52 Hoptonwood
stone; 58-1/2 ARTSB-58:4
Image II 1960 white marble;
30 HAMM 101 (col)
Involute 1946 white stone
NEWTEB pl 33 -Ta
Involute 2 1956 bronze; 18
ARTS #18
Landscape Sculpture 1945
wood and strings; L: 26
RAMS pl 92
Landscape Sculpture I, 1944
(1962) bronze; L: 26
SFMB #111 ELW
Large and Small Forms 1945
Cornish elm; 62 cm
LIC pl 297
Marble Form (Core) 1956
H: 29-1/2 BERCK 280;
MAE 48
Marble with Color (Crete)
1964 H: 54-1/4
HAMM 96
Meridian 1958/59 bronze;
15' HAMM 98 ELStH
--model bronze; 14'
ENC 392 ELStH

Mother and Child 1934 pink
Ancaster stone; 12
ARTSBR 22 EWakeA
Musician
WILM 84
Oval Form (Trezion) 1962/63
bronze; L: 59-1/2; W: 30
LOND-7:#16
Oval Sculpture 1943 beechwood,
ptd white; 13-1/2x18
RAMS pl 93; VEN-50:pl 89
EIlkR
Oval Sculpture (Delos) 1955
Guarea wood; concavities
ptd white; L: 48 MAE 49
Pastorale. 1953 white marble;
L: 45 HAMM 94 NOK
Pelagos 1946 wood, with blue
interior and colored strings;
16
HAMM 84; MYBS 73; NORM
57; READCON 196 -EMacd
Pendour 1947 wood, ptd white
and blue; L: 28
GIE 153; JOHT pl 184
Pierced Form 1931 pink
alabaster; 10
READCON 194 (destroyed
in WW II)
Pierced Form 1963 Pentelicon
marble; 50-1/2
BOW 121; NEW pl 102
Pierced Form (Amulet) 1962
bronze; 10-1/2
READCON 195 ER
Pierced Hemisphere 1937
white marble RAMT pl 9
EWakeA
Pierced Hemisphere (Telstar)
1963 Guarea wood; 36-1/2
HAMM 97 (col); MAE 46
UNNMa
Pierced Monolith with Colour
1965 Roman stone; 68-1/2
MAE 47
Pierced Vertical Form 1960/63
Nebrasina stone; 96
PRIV 43 (col)
Reclining Figure 1958 bronze;
6 YAP 250 -UTo
Rock Form (Porthcurno) 1964
bronze; L: 59-1/2; W: 30
LOND-7:#18
Sculpture: Wood with Colour
1944 READAN #63 -EHa
--READM pl 61 -EH
Sculpture with Colour and
Strings 1939, cast 1961
bronze; 9-7/8 HAMM 81
ELMa

Sea Form: Atlantic 1964
 bronze; 78x51
 EXS 85; LOND-7:#17
 ELMa
Sea Form: Porthmeor 1958
 bronze; L: 46
 HAMM 86 (col) -CL; -CZ;
 ELBrC; NHG; UCtY; UNNH
Single Form 1935 satinwood;
 12 READCON 194 (destroyed)
Single Form (Memorial)
 1961/62 bronze; 123x78x
 120 BOW front; LOND-6:
 #23; NEW pl 101;
 READCON 197 (col) ELBat
--1961/62 H: 126
 HAMM 99 (col) ELC;
 UNNBla
Single Form: Memorial to
 Dag Hammarskjold
 DIV 93; PRIV 45 UNNUN
Sphere and Hemisphere 1962
 L: 4 SEITC 40 UNNCh
Sphere with Inner Circle 1963
 bronze; 38 SOTH-4: 89
Squares with Two Circles
 1963 bronze; 102
 ARTSB-64:pl 2; LARM
 365 ELT
Stringed Figure (Curlew) 1956
 brass; L: 22
 ARTS #20
--1956 brass, with strings;
 L: 31
 HAMM 90 DCCF
Stringed Figure (Curlew II)
 copper; 9-3/4; base:
 7-1/2x9-1/8 NCM 235
 UNcRV
Stringed Figure (Orpheus)
 1956 brass; 47
 BERCK 99; MAI 135 ELMu
Three Forms in Echelon
 1964 slate; 19-1/4 BOW
 74 ELMa
Three Standing Forms 1965
 stone; 69
 GUGE 57 ELG
Torso (Ulysses) 1958 bronze;
 52 LOND-5:#23
Torso 2--Torcello 1958
 bronze; 34
 ARTS #22
Torso III (Galatea) 1958
 bronze; 21-3/4
 HAMM 102 ELHu; ELMc
Totem 1960/62 white marble;
 54 HAMM 95 (col) -Stu

Turning Forms 1950
 READP 224
Two Figures
 ENC 392
--1947/48 wood, ptd white; 48
 MCCUR 266; ROTJB pl 118
 UMnMR
Two Figures--Menhirs 1954/55
 teak; 54
 ARTS #16; BERCK 98;
 MAI 135; SAO-5 ELG
--1954/55 teak; 54
 BOW 71; HAMM 83 (col);
 LARM 365 UICSm
Two Figures with Folded Arms
 (drwg) 1947
 READP 225
Two Forms 1937 marble; 26
 RAMS pl 90; READCON 195
Two Forms with Sphere
 AUES pl 57
Vertical Forms, relief for
 Technical School, Hatfield
 1951 Hoptonwood stone;
 65-1/2 DAM 111; HAMM 19
 EHat
Wave 1945 wood with colour
 and strings
 NEWTEB pl 32 -EH
--wood with color and string;
 L: 18 NORM 56 -EHa
Winged Figure 1962 aluminum;
 19'3" HAMM 100 ELLewi
Woman's Torso marble
 PAR-1:129
Wood and Strings, figure 1956
 mahogany
 AMAB 13 ELHu
Hera (Juno)
 Bandini. Juno
 Bystrom. Juno and the Infant
 Hercules
 Carles. Juno
 Maillol. Juno
 Sansovino. Juno, bust
Heraclitus
 Burgundian--14th c. Medal of
 Heraclitus
 Byzantine. Heraclitus
 Netherlandish. Heraclitus, bust
Heraldry See also Guilds
 Algardi. Pamphili Coat of Arms
 Colt. Alice, Countess of
 Derby, Hearse Monument;
 detail: Crest
 Colt. Sir Robert Gardiner
 Monument:
 Crest

Dick. Kitchener Memorial
Chapel; Kitchener Coat of
Arms
Donatello. Coat of Arms of
the Minerbetti Family
English--13th c. Arms of
Earl of Cornwall
English--14th c. Gatehouse
detail: Armorial Panel
--High Altar with Heraldic
Ornament
--Percy Tomb: Royal Shield
--Steelyard Weight, with
Heraldic Shield of King
Edward II
English--15th c. Arms of
James I
--Chimney Piece detail:
Arms and Devices of
Ralph, Lord Cromwell
--Stall-plate of Sir Simon
Felbrigg
English--16th c. Lock, with
Royal Arms used by
Henry VII and Henry VIII
English--17th c. Arms of
the Corporation of Trinity
House
--Firedog, with Royal Arms
of the Stuarts
--Heraldic Ledger Stone
--"Royal Charles" Stern
Decoration: English Arms
--Sir John Kyrle Tomb
Flemish--15th c. Geel Altar-
piece: Brussels City
Mark (Mallet)
French--15th c. Arms of
Brittany
French--16th c. Unicorns,
Coat of Arms
French--17th c. Angels
Supporting Coats of Arms
of Maria de'Medici
German--14th c. Fountain:
Eagle, symbol of Free
Imperial City of Goslar
German--16th c. Heraldic
Epitaph (Totenschild)
Giovanni di Turini. Wolf Suck-
ling Romulus and Remus,
City Arms of Siena
Italian--10th c. Diptych: Cruci-
fixion; Roman Wolf; Madonna;
Sts. Gregory, Silvester, and
Flavian
Italian--16th c. Coat of Arms
Loscher. Lucretia, candelabra
figure, with crest of Sterzing

Mohler. Arms of Town of
Stuttgart: Rearing Horse
Pigalle. Marechal de Saxe
Tomb: Leopard of England;
Lion of Flanders
Rumanian--15th c. Moldavian
Circular Tile: Arms of
Moldavia
Russian--20th c. Lenin;
Emblem of USSR
Spanish--15th c. Capella del
Conestabile, Burgos
Cathedral; Coat of Arms
--Portal Facade: Royal Coat
of Arms
Stockton. Heraldic Details
Vischer, Hans, the Elder.
Escutcheon with Centaur
Battle
Heralds
Ponzano. Heralds
Herbert, Jocelyn
Kennington. Jocelyn Herbert,
head
Herbot, Saint
French--16th c. St. Herbot
Tombstone
Der Herbst See Autumn
Herchenrode, Abbess of
Delcour. A. K. Lamboy Tomb:
Abbess of Herchenrode
Hercule Gaulois. Puget
Hercules See also Name of Artist:
Antico
Bandinelli, B. Hercules#
Bendl, J. G. Garden Fountain
with Hercules
Bertoldo di Giovanni. Hercules
Bologna. Hercules and Antaeus
Bologna. Hercules and Nessus
Bologna. Hercules and the Boar
Bologna. Hercules and the
Centaur
Bologna. Hercules Subduing
Cretan Bull
Bosio. Hercules Battling
Serpent-form Achelous
Bourdelle. Hercules
Bourdelle. Hercules as Archer
Bourdelle. Hercules Shooting
the Stymphalian Birds
Bourdelle. Small Herakles
Boyce. Aged Hercules
Braun, A. Hercules and
Omphale
Byzantine. Hercules, bucket
detail
Byzantine. Hercules with Cery-
neian Hind

Canova. Hercules and Lycas
Coustou, G. Hercules on the
 Pyre
Early Christian. Plate:
 Hercules Strangling Nemean
 Lion
English--12th c. Hercules
 Wrestling with Lion
Esser. Hercules and Antaeus
 Fountain
Flaxman. Hercules and Hebe
Francesco de Sant'Agata.
 Hercules
Francesco de Sant'Agata.
 Hercules and Antaeus
French--13th c. Hercules#
Gasteiger. Hercules with
 Hydra
Italian--14th c. Hercules and
 the Lernaean Hydra, fa-
 cade relief
Italian--16th c. Hercules
Lamberti, Niccolo di Pietro
 --Attrib. Hercules--
 Fortitude, decoration
 detail
Maderno. Hercules and
 Cacus
Martini, A. Hercules and a
 Lion
Michelangelo. Hercules and
 Cacus
Moreau, G. Hercules
Munstermann. Hercules, head
Opstal. Infant Hercules and
 Serpent
Permoser. Hercules
Pollaiuolo, A. Hercules
Pollaiuolo, A. Hercules and
 Antaeus
Pollaiuolo, A.--Foll. Hercules
 and Caecus
Pisano, A. Hercules, relief
Pisano, G. Pulpit, detail:
 Hercules
Pisano, Niccolo. Pisa
 Baptistry Pulpit:
 Fortitude in the Guise
 of Hercules
Rossi, V. de'. Hercules and
 the Centaur
Rysbrack. Hercules
San Gallo, F. Hercules and
 Cerberus
San Gallo, G. Hercules,
 fireplace detail
Sicard. Archibald Fountain
Spinelli. Ercole Bentivoglia,
 medal, obverse: Hercules
 and Hydra

Tegner. Heracles and the
 Erymanthian Boar
Tegner. Heracles and the
 Hydra
Theed, W., the Elder.
 Hercules Taming the
 Thracian Horses
Tribolo. Fountain of
 Hercules and Antaeus (de-
 sign)
Vischer, P., the Elder;
 Peter Vischer, the
 Younger; Hermann
 Vischer, the Younger.
 Sebaldus Tomb: Hercules
Vries. Hercules
Hercules Fountain. Vries
Herd X. Koenig
Here Lies Jean Onnertz. Spoerri
Heribert, Saint
 German--12th c. Shrine of
 St. Heribert
HERING, Doman (German fl 1554)
 Judgment of Paris (Das
 Urteil des Paris), relief
 1529 Solnhofener stein;
 22x19.7 cm
 BSC pl 102 GBS (1959)
HERING, Loy (German)
 Casting out of Romulus and
 Remus (Aussetzung von
 Romulus und Remus),
 relief 1530 limestone; 22.3
 x17.7 cm
 MUL 34 ELV
 St. Willibald, tomb figure
 1514 limestone; 200 cm
 MUL 24 GEiC
 Virgin and St. John,
 Crucifixion, Mortuarium
 BAZINW 356 (col) GEiC
HERLIM, Friedrich (German)
 High Altar after1466
 MULS pl 117B GRoJa
Herm Figure. Puget
Hermann I d 1217
 German--13th c. Hermann and
 Reglindis
HERMANN and HEINZ
 Louis I, head detail 1471
 CHAS 287 GMarE
HERMANN, Georg
 Outside Staircase Sculpture
 1685/89 BOE pl 170
 CzPTr
 Portraits
 Kels. Medal: George Hermann
HERMANN, Martin See CHRISTIAN,
 J. J.

HERMANNS, Ernst (German 1914-)
 Multiform Sculpture 1959
 bronze MAI 136
 Relief 1956 artificial stone;
 31-7/8x42-1/2
 TRI 157
Hermaphrodites
 Italian. Satyr and
 Hermaphrodite
Hermaphroditic Idol, No. I.
 Paolozzi
Hermes (Mercury)
 Agostino di Duccio. Mercury
 Bendl, I. Mercury Fountain
 Bologna. Mercury
 Braun, M. B. Mercury
 Coysevox. Mercury, equest
 Donatello. Athus, or Amore,
 detail: Feet in Sandals of
 Mercury
 Flaxman. Pandora Brought to
 Earth by Mercury, relief
 Gaul. Mercury
 Idrac. Mercury Inventing the
 Caduceus
 Italian--16th c. Hermes
 Pigalle. Mercury#
 Rude. Mercury
 Rustici. Mercury
 Sansovino, J. Hermes
 Sansovino, J. Mercury
 Thorvaldsen. Mercury Putting
 Man to Sleep with his
 Pipes
 Tietz. Mercury
 Vigne. Mercury Fountain
 Vries. Mercury and Pandora
 Vries. Mercury and Psyche
HERMES, Gertrude (English)
 Lectern oak
 CASS 136 ENewpG
 Seagull mahogany
 AUM 140
 A Swallow bronze
 AUM 141
Hermetic Vision. Milani
Hermits
 Barlach. The Hermit
 Braun, N. B. Hermit Garinus
 English--13th c. Figures,
 west front: Hermit; Lady
 Italian--11th c. Pulpit:
 Hermit among Symbols
 of the Evangelists
 Muller, R. Hermit
HERNANDEZ, Gregorio See
 FERNANDEZ, Gregorio

HERNANDEZ, Jeronimo (Spanish c
 1540-86)
 Resurrected Christ
 BAZINW 378 (col) SpSQ
HERNANDEZ, Juan Rodriguez Blas,
 and Jeronimo PELLICER
 Main Altar begun in 1528
 BAZINW 360 (col) SpSeP
HERNANDEZ, Mateo (Spanish 1889-)
 Eagle, black marble
 HOF 224; MARTE pl 29
 Hippopotamus black granite
 AUES pl 44; CASS 119;
 MARTE pl 29
 Javanese Panther 1922/25
 black Belgian marble
 MYBU 126; PUT 211 UNNMM
 Kneeling Woman black granite
 PAR-1: 219
 Marabou 1922 black granite
 BRIONA 125 FPM
Hero. Perez
A Hero: Purbeck Burr. Watson
Herod See also Magi
 Donatello. Font: Feast of
 Herod
 French--12th c. Capital:
 Feast of Herod
 French--13th c. Herod#
 Romanesque--Swedish.
 Herod's Feast, font detail
Heroic Age. Ladera
Heroic Captive
 Michelangelo. Rebellious Slave
Heroic Group. Martini, A.
Heroic Rhythm. Lardera
Heroic Torso. Mascherini
Heroic Woman. Valsamis
Le Heros. Landowski
Herosse, Mme.
 Andreotti. Madame Herosse
HERSCHER, Josef
 Motherhood
 STECH pl 190 CzM
HERTER, Ernest (German)
 Heinrich Heine Memorial:
 Fountain with figure of
 "Die Lorelei" 1897 white
 marble SALT 148
 UNNGran
HERZOG, Oswald
 Adagio--Two Versions bronze
 CASSTW pl 24, 25
 Geniessen plaster
 CASSTW pl 22
 Klage plaster, for bronze
 CASSTW pl 23

HESEDING, H. (German)
 Building Reliefs
 AUM 6, 7 GDusS
HESS, Tisa
 Labour, relief
 CASS 91
HESSE, Hans
 Saxon Emperor and Dukes,
 north wing figures 1447/68
 BOE pl 132 GBrR
HETHERINGTON, Rene
 Child with Toy terracotta
 NEWTEB pl 36B
 Madonna and Child terracotta
 NEWTEB pl 37
Heuss, Professor
 Marcks. Professor Heuss
HEWETSON, Christopher (Irish
 1739-99)
 Clement XIV, bust marble
 MOLS-2: pl 39 ELV
 Duke of Gloucester, bust 1772
 marble; 23
 GARL 204 EWind
 Gavin Hamilton, bust 1784
 CON-4: pl 32; WHINN
 pl 139B ScGU
Hexogonal Curses in Space. Bill
HEYMAN, Shoshana (Israeli 1923-)
 Standing Woman wood
 GAM pl 102
HEYNDRIKX, Werner (Belgian 1909-)
 Male Head*
 GOR 86
HICKEY, John (English)
 Elizabeth Hawkins Monument
 1780 ESD pl 128; WHINN
 pl 117A EAbiH
Hiddensee Treasure
 Danish--11th c. Golden
 Treasure of Hiddensee
Hieratic Head
 McWilliam. Complete Frag-
 ment: Hieratic Head
HIERNLE, Karl Josef (Czech
 c 1693-1748)
 Cloister Gate 1740
 STECH pl 181 CzPB
High Judge. Dalwood
High Night. Orion
Highland Laddie, tobacconist's figure.
 Folk Art--English
"Highlander" Tobacconist's Figure
 Folk Art--English Highland
 Laddie
 Folk Art--Snuff Highlande
Hilaire, Saint
 French--12th c. Hilaire Con-
 demned at the Council of
 Selencie

Hilarion, Saint
 Wiligelmus. St. Hilarion
HILBERT, Georges (French)
 Peccary black granite
 ELIS 165 UNNMM
HILDEBRAND, Adolf von (German
 1847-1921)
 Archers, relief 1888 plaster
 SCHAEF pl 1
 Archery Lesson, relief 1888
 stone; 130x110 cm
 LIC pl 153 GCoW
 Bogen, Schutze, Hubertusbrun-
 nen, detail 1900/17 bronze;
 2.1 m OST 17 GMN
 Dionysus, relief 1890 marble;
 51-1/4x54-1/2
 NNMMAG 143 IFH
 Dionysus, relief 1890 stone;
 53-1/2x56-1/4 NEWTEM
 pl 151 IFFP
 Duke Karl Theodor of Bavaria,
 bust marble
 TAFTM 52
 Hubertus Fountain, detail
 bronze MAI 137 GM
 Male Nude 1884 marble; 69
 CHASEH 463; LYN 69;
 POST-2:176 GBSBe
 The Net Carrier 1874/75 stone
 SELZJ 86
 Wittelsbach Fountain 1844 stone
 LIC pl 154, 155 GMMa
 --Healing Powers of Water
 PRAEG 423 GM
 Young Man Standing 1884
 RICH 146 GBN
 A Youth 1884 marble; 5-3/4
 NOV pl 191b GBNea
HILDEBRANDT, Johann Lucas von
 (Austrian 1663-1745)
 Balustrade, detail 1713/16
 HEMP pl 53 AVD
 Cupid, staircase detail 1721/27
 BAZINL pl 334 ASM
 Column Figures, entrance Hall,
 Sala Tarena
 BAZINB 229; JANSK 859
 AVU
 Garden Facade 1721/24
 FLEM 574 AVBe
HILL, Anthony (English 1930-)
 Constructional Relief 1960
 RVL and aluminum; 25-1/2
 x25 PRIV 287
 Relief 1957 copper, aluminum,
 perspex; 18x18x2 ARTSC
 Relief Construction 1960
 PEL 189 ELT
 Relief Construction C3 1963

aluminum, perspex, and
vinyl; 24x24 PRIV 287
HILLER, Anton (German 1893-)
Male Figure 1950 bronze; 76
SCHAEF pl 46
--Male Figure (Mannliche
Figur) 1950/51 plaster
GERT 102
Stehender Junge wood; 1.7 m
HENT 87
HILTMANN, Jochen (German 1935-)
Asc. 1962/7 1962 steel,
Edelstahl; Dm: 17 cm
KUL pl 44
Crazy Vegetation 1959 refined
steel; D: 55-1/8
TRI 217 GDusmS
Double Sphere (Doppel Kugel,
Calbasse) 1961/66 steel,
Edelstahl Dm: 30 cm
KUL pl 43 IRLat
Fruitful Earth 1964 37-1/2x
37-1/2 CARNI-64:#97
UNNOd
Gucurbita-Calbasse I 1960
H: 16 CARNI-61:#159
Schwarzer Bovist 1963
bronze, steel; D: 12 cm
SP 70 GHaS
Hilton, Robert
English--14th c. Robert
Hilton and Wife, effigies
HILTUNEN, Eila (Finnish 1922-)
Hyena 1959 welded steel
MAI 138
Hindenburg
Fiore. Hindenburg, head
Hindmarsh, Margaret
Bevis. Miss Margaret
Hindmarsh, head
Hinge No. 4. Pan
Hinges
English--11th c. Door Hinges#
Hippocampus See Sea Horses
Hippodrome
Byzantine. Imperial Box at
Hippodrome: Patricians
and Dancers at Hippodrome
HIQUILY, Philippe (French 1925-)
Calvary 1962 forged iron;
29-1/2x19-5/8
LARM 326; READCON 269
ELIC
Figure*
EXP 33
L'Horloge 1962 wrought iron;
39-3/8 NEW pl 69 FPFl
Seated Woman 1958 iron
MAI 138

Hirfynnydd Slab. Celtic
Hiroshima mon Amour. Beljon
Hirsch See Deer
Hirt zu Pferd. Lienhard
HISPANO-FLEMISH
Lamentation 1480/1500
NM-12:121 UNNMMC
Pieta, altarpiece detail,
Burgos c 1490/1500
MULS pl 186A UNNMMC
HISPANO-MORESQUE
Arch, Aljaferia Palace 11th c.
GUID 38 SpSar
Box: Medallions amid
stylized human and animal
figures 14th c. ivory;
3.9; D: 4.3
GAU 125 FPL
Casket, Cordova 964 ivory
RDI 81 formerly SpZT
Casket: Animals in Foliage
11th c. ivory; 1-1/8x3-1/2
RDI 161 FPL
Cross, donated to San Isidore,
Leon, by Ferdinand I and
Sancha 1063 ivory GUID
102
Leye Coffer 1005 ivory
GUID 42 SpPamC
Panel: Birds and Beasts in
Foliage late 10th c. ivory
READM pl 8 ELV
Historiated Capitals
French--12th c. Capitals:
Moses; An Executioner
Hitler, Adolf
Bleker. The Leader, head
Thorak. Il Fuhrer, head
Hippopotamuses
Hernandez, M. Hippopotamus
Pompon. Hippopotamus
HITZBERGER, Otto (German 1878-)
Candlestick wood
AUM 12
Decorative Fireplace Panel
AUM 18
Descent from the Cross
(Kreuzabnahme) 1928 wood;
90 cm
GERT 120; HENT 23
GBKath
Fireplace Decorative Relief
AUM 12
Pieta, Gefallenmal 1927 wood;
1.8 m
HENT 22 GBLa
Stairpost: Man and Woman
wood AUM 20
HLADIK, Karel (Czech 1912-)
Actor Tham, as character

from F. L. Vey novel:
Alois Jirasek 1955 bronze
VEN-56: pl 107
Reclining Woman 1962 wood;
11x26-3/8 NEW pl 250
Hlava. Nepras
Hoby, Philip and Thomas Hoby
English--16th c. Sir Philip
and Sir Thomas Hoby Tomb
Hockendo. Karsch, Joachim
HODART, Felipe (F. Duardos;
F. Odarte) (French fl 1522-
34)
Apostle(s), Last Supper detail
1530/34 clay
BAZINW 380 (col); KUBS
97; SANT pl 84, 85 PoCM
HOELZINGER, Peter See GOEPFERT,
Hermann
HOERBST, Hans (Swiss 1859-)
Mark Hopkins, bust bronze
HF 39 UNNHF
HOETGER, Bernhard (German 1874-
1949)
Bust of a Maiden
TAFTM 62
Frau S., bust
TAFTM 62
Girl's Head marble
PAR-2: 72
Light
TAFTM 62
Weiblicher Torso 1910 bronze;
1.03 m
OST 19 GHK
HOEYDONCK, Paul van (Belgian
1925-)
Spaceboys 1963 50-3/8x37-
3/4x18-1/2
NEW pl 192 BBCo
Triptiek van de Ruimte 1964
KULN 69
Untitled
PEL 293
The Unwritten Spacebooks
1965 KULN 66
HOFBAUER, J., and W. BAUM-
GARTEN
Entrance to Workmen's
Dwellings AUM 83 AV
Hofer, Carl
Heiliger. Carl Hofer, head
HOFLEHNER, Rudolf (Austrian
1916-)
Archon 1956 iron; 79
ALBC-3: #87
UNBuA
Composition in Iron 1952
L: 16 BERCK 167

Condition-Female 1961/62
iron; 178 cm SOT pl 96
Construcao
SAO-2
Doric Figure 1958 solid
iron; 73-5/8
ENC 400; READCON 203;
TRI 93 SwZMN
Figure bronze; 60x10-1/4x13
WDCM UDCMo
--1956 steel; 14
BERCK 281
Figure II 1961 iron; 71
SEITC 42 ELH
Figure IV 1957 iron; 197 cm
MAI 139; SAO-5 AVI
Figure 14 K ('Achaa') 1959
solid iron; 94 cm
OST 109 UCLBr
Figure 86; Figure 85 1964
iron; 69-5/8; and 76
NEW pl 328 UNNOd
Figure 101: The Couple steel
(unicat); 43x79x36
GUGE 75
Figure in Repose II 1960/61
iron; 160 cm
SOT pl 95
Miniature Sculpture (Klein-
plastik) 1953 brass
GERT 246
Monofer 1961/62 iron; 192 cm
SOT pl 96
Sculpture* EXS 39
Stoic Figure 1959 iron
VEN-60: pl 149
Sysiphus (Homage to Albert
Camus) 1959 solid iron;
88-1/2 GIE 306
HOGADT, Heinrich (Belgian)
Frisian Chieftan Edo Wiemken
Tomb 1561/64
LOH 217 GJS
Hogarth, William (English Artist
1697-1764)
Roubiliac. William Hogarth,
bust
Hogback Grave Slab. Anglo-Saxon
'Hogback' Tombstone. English--
10/11th c.
Hohenflug. Hahn
Hohenlohe, Albert von
German--14th c. Albert von
Hohenlohe Tomb
Hohenlohe, Friedrich von (Bishop
of Bamberg d 1352)
German--14th c. Friedrich
von Hohenlohe
Tomb

HOKE, Bernhard (German 1939-)
 Folien-Bett 1965
 KULN 83
 36 Puppen 1962
 KULN 69
hole in home. Spindel
HOLBEIN, Hans, the Younger
 (German 1497-1543)
 Fireplace for Henry VIII, ink
 and wash design
 MOLS-2: pl 2 ELBr
HOLLEMANS, Joseph
 Sir George and Lady Fermor
 Monument 1612/1628
 ESD pl 6; WHINN pl 9A
 EEa
 --Charles Gore
 ESD pl 76
 Sir John Spencer and Wife,
 Katherine, Monument 1586
 ESD pl 7 ENorthG
Holles, Francis d 1622
 Stone. Francis Holles
 Monument
Holles, George
 Stone. Sir George Holles
 Monument
HOLLINS, Peter (English 1800-86)
 Mrs. Thompson, recumbent
 effigy 1838
 GUN pl 12 EMalv
HOLLO, Barnabas (Hungarian 1866-
 1917)
 Miklos Wesselenyi memorial
 plaque 1899 bronze; 210x350
 cm GAD 65 HBK
Hollow Woman. Couturier
HOLMAN, George A. (English)
 Boy and Duck
 NEWTEB pl 38
Holmes, Admiral
 Wilton. Admiral Holmes
 Monument, detail
HOLMGREN, Martin (Swedish 1921-)
 Forms Seeking a Common
 Center 1955/60 bronze;
 27-5/8x35-3/8
 NEW pl 179 SnSNM
 Landscape, study 1964
 VEN-64: pl 192
Holofernes See Judith
HOLT, Gwynneth (Scottish)
 David 1943 beechwood; 24
 BRO pl 15B
 Echo ivory; 8
 NEWTEB pl 28B -Sal
 Female Figure 1941 ivory;
 6 BRO pl 15A -EJ

Goat 1940 teak; 17x20
 BRO pl 14
Holt, John (English Jurist 1642-1709)
 Green. Lord Justice Holt
 Monument
Holten, N. A. (Director for Oresunds
 Toldkammer 1775-1850)
 Bissen. N. A. Holten, head
HOLWECK, Oskar (German 1924-)
 Mobile, Rechts- und
 Wirtschafts-wissenshaftliche
 Fakultat 1963/64
 KULN 163 GSaaU
Holy Child. De Martino
The Holy Child, jeweled figure.
 Italian
Holy Family
 Antelami. Holy Family, portal
 relief scenes
 Gies. The Holy Family
 Guggenbichler. Return of the
 Holy Family from Egypt
 Michelangelo. Virgin and
 Child with Infant St. John
 the Baptist
Holy Ghost
 Bernini. Cathedra Petri
 French--12th c. Christ in
 Miracle of the Pentecost
 French--16th c. Choir Stalls:
 Miracle of Whitsun--Holy
 Spirit Descends in Bundles
 of Flames
 German(?)--9/10th c. St.
 Gregory with Three Scribes
 Munstermann. Pulpit Sounding-
 board, canopy detail: Des-
 cent of the Holy Ghost
Holy House. Sansovino, Antonio
Holy Sepulchre
 French--13th c. Holy Sepulchre
 French--15th c. Holy Sepulchre
 German--13th c. Holy Sepulchre
 Gothic-German. Holy Sepulchre
Holy Trinity
 English--13th c. Holy Trinity
 English--15th c. Holy Trinity
 French--15th c. Holy Trinity
 Jaeckel, M. W. Altar: Holy
 Trinity
 Vorovec. Holy Trinity
 Wende. Holy Trinity
Holy Water Basin
 Federighi. Baptismal Font
 Matisse. Holy Water Fountain
Holy Women
 Flemish--15th c. Two Holy
 Women

HOLZINGER, Franz Josef Ignaz
 (Austrian 1691?-1775)
 Christ with Supporting Figures,
 High Altar detail stucco
 MOLE 251 (col) AAl
 John the Baptist, head
 1722/24 stucco
 BAZINW 410 (col) GMetB
 St. Anne, altar figure 1722/24
 white stucco; LS
 BUSB 151 GMetB
Holzkopf
 Hausmann. Mechanical Head
Holzschuher Cup. Flotner, and L.
 Krug
Homage. Basaldella
Homage. Cesar
Homage to David Smith. Caro
Homage to Julio Gonzalez. Chirino
Homage to Lovecraft. Martin, E.
Homage to Michelangelo. Pomodoro,
 G.
Homage to Michelangelo. Viani
Homage to New York. Tinguely
Homage to Paolo Paoli. Gisiger
Homage to Rimbaud. Stahly
Homage to Vallejo. Penalba
Homer
 Flaxman. Homeric Vase:
 Apotheosis of Homer
 Orsi. Homer, seated
 figure
Homeric Vase. Flaxman
Hommage a Christopher Polhem.
 Ultvedt
Hommage a Dusseldorf. Alvermann
Hommage a Guillaume Apollinaire.
 Picasso
Hommage a Helena Rubinstein.
 Alvermann
Hommage a Piet Mondrian. Brusse
L'Homme a Tete Plate. Daumier
L'Homme au Chandail. Giacometti
L'Homme au Nez Casse
 Rodin. Man with the Broken
 Nose
Homme aux Mains Jointes
 Picasso. The Bathers
Homme et Femme. Miro
L'Homme Fontaine
 Picasso. The Bathers
Homme Qui Marche
 Giacometti. Man Who Walks
L'Homme Qui Marche
 Rodin. Walking Man
L'Homme Que Va Se Lever. Despiau
Homme Signalant
 Gicaometti. Man Pointing

HOMMES, Reinhold (German 1934-)
 Tektonische Plastik I 1960
 bronze; 29x30 cm
 KUL pl 18
Homo. Schlemmer
Homo Faber. D'Altri
Hon. Saint-Phalle
HONEGGER, Gottfried (Swiss 1917-)
 Reciprocite I 1961
 KULN 119
HONEL, Michael fl 1630
 High Altar, detail 1626/32
 gilt wood
 BUSB 57 AGuC
Honey Pots
 Emes. George III Beehive
 Honey Pot
Honey Taster
 Feuchtmayer. Honey Thief
Honey Thief. Feuchtmayer
Honour Conquering Deceit. Danti
HONTANON, Juan Gil de
 Cathedral Middle Door 1513/26
 BOE pl 142 SpSalC
Hoo-Wei-Te
 Bourdelle. Hoo-Wei-Te, bust
Hooker, Richard
 Drury. Richard Hooker,
 seated figure
HOOL, Jan van See GEEL, Jan Frans
 van
HOONAARD, Siem van den (Dutch
 1900-38)
 The Wrestler c 1937 copper;
 45 BERCK 281 NOK
Hope
 Buchholz. Hope
 Dejean. Hope
 Donatello. Font: Hope
 DuQuesnoy, J., the Elder.
 Hope
 Persico, E. L. Genius of
 America: America with
 Justice Holding Scales, and
 Hope
 Pisano, A. Baptistry South
 Door: Hope
 Poisson. Hope (Esperance)
 Sansovino, A. Ascania Sforza
 Monument: Hope
 Theny. Allegory of Hope
 Tino di Camaino, and G.
 Primario. Mary of Hungary:
 Hope
Hopkins, Mark (American Educator
 and Theologian 1802-87)
 Hoerbst. Mark Hopkins,
 bust

Hoppe, Marianna
 Klimsch. Marianna Hoppe,
 bust
Hopscotch. Taher
Horitoare. Geza
Horizontal Development. Mannoni
Horizontal Man Machine. Guerrini
L'Horloge. Hiquily
HORN, David (English 1937-)
 Liz, head 1962 bronze; 32x
 20x26 ARTST
Horn See Musicians and Musical
 Instruments
Horn of St. Blasius. Italian--12th c.
Horne-Tooke, J.
 Chantrey. Rev. J. Horne-
 Tooke, bust
Horner, Francis
 Chantrey. Francis Hooker
 Monument
HORNO-POPLAWSKI, Stanislaw
 (Russian-Polish 1902-)
 Chopin, head 1960
 VEN-62: pl 170 PByMa
 Mother of Beloyannis 1952
 plaster JAR pl 12
 Sailor, head 1949 granite
 JAR pl 13
HOROLDT, Johann Gregorius
 (Dutch 1696-1775)
 Vase, Meissen porcelain
 c 1727 H: 18-1/2
 RIJA pl 138 NAR
Horse and Jockey# Degas
Horse and Rider See also Equestrians
 Marini. Horse and Rider
Horse+Rider+House. Boccioni
Horse Pond Monument. Mandl
Horse Racing See Games and Sports
Horseman See Equestrians
Horsemanship, panel. Giotto, and
 Pisanello
Horses See also Equestrians;
 Hercules
 Altri. Cheval Apocalyptique
 Ammanati; Bologna; and
 Others.
 Piazza della Signoria
 Fountain: Neptune's Horses
 Androusov. Woman with
 Horse*
 Barye. A Horse
 Benlliure. The Victim
 Boccioni. Horse
 Bologna. Leaping Horse
 Braque. Horse
 Braque. Horse's Head
 Braque. Petit Cheval--
 Gelinotte

Braque. The Pony
Broggini. Horse (Cavallo)
Croatian. Horse, in strap
 frame, relief
Dazzi. Capallino
Degas. Cheval Gallopant sur
 son Pied Droit
Degas. Cheval se Cabrant
Degas. Horse#
Degas. Horse Clearing an
 Obstacle
Degas. Horse Walking
Degas. Rearing Horse
Degas. 17 bronze casts of
 waxes
Degas. Trotting Horse
Dick. Force Controlled
Dierkes. Black Horses
Duchamp-Villon. The Great
 Horse
Duchamp-Villon. The Horse
Duchamp-Villon. Large Horse
Duchamp-Villon. Little Horse
Durst. Horse#
Ehrlich. Horse's Head
English--17th c. State Car-
 riage, panel detail
Erhart, Gregor. Horse
Fanelli, F. Pair of Horses,
 table decoration
Flemish--15th c. Horse,
 aquamanile
Folk Art--German. Votive
 Figures: Fettered Man;
 Horse
Folk Art--Russian. Bear
 Driving Troika Sleigh
Fontana, L. Victory
French. Aquitaine Coin:
 Horse
--Lemovices (Haute-Vienne)
 Coin: Horse
French--11/12th c. Horse,
 door mounting
French--12th c. Horses' Heads,
 portal moulding
French--15th c. Little Horse
 of Altotting
French--17th c. The Chariot
 of Apollo
Garrard. Duncan's Maddened
 Horses
German--18th c. Horse's Head
 Bonbonniere
Grimalden. Horse, head,
 monument detail
Grzetic. Horse
Guerin. Watering the Horses
 of Helios

Hussmann. Walter Dear
Italian--15th c. Horse and
 Rider Armor
Italian--16th c. Anatomical
 Trotting Horse
--Rearing Horse
Kafka. The Foal
Kandler. Meissen Horse with
 Native Groom
Krop. Bridge Column Figures
Krop. Horse
Lehmann, R. Horse
Le Lorrain. Sun Horses
Leonardo da Vinci. Trotting
 Horse
Linck, W. Cheval Triste
Lorcher. Horses, relief
Manley. Horse of the
 Morning
Marc. Pferde
Marc. Zwei Pferde
Marcks. Grazing Horse
Marini. Horse
Marini. Quadriga
Martini, A. Horse (Cavallo)
Matare, Horse
Mettel. Man with Horse
Milles. Running Horse
Mohler. Arms of Town of
 Stuttgart: Rearing Horse
Moore, H. Horse
Pisano, G. Horse, detail
Probst. Young Colt
Riccio(?). Relief with Three
 Horses
Richier, G. Horse
Rossi, R. Chevaux
Russian--6th c. Amulet:
 Horse
Ruwoldt. Horse at the Start
Sassu. Rearing Horse
Scandanavian. Plaque, with
 stylized horse's head
Simmonds. The Farm Team
Sintenis. Galloping Pony
Sintenis. Grazing Foal
Sintenis. Prancing Foal
Sintenis. Youth with Colt
Skeaping. Blood Horse, head
Susini--Foll. Prancing
 Horses
Tacca, P. Rearing Horse
Viking. Gokstadt Ship
 Figurehead: Horse
Viking. Memorial Picture
 Stone: Saga details, with
 8-legged Horse of Odin
Vries. Horse

Weiss, M. Cheval
Wimmer. Saddled Horse
Wolff, G. H. Frau auf
 Liegenden Pferd
Horses, Winged
Byzantine. Capital: Winged
 Horse
Horses of Marly. Coustou, G.
Horses of St. Marks. Byzantine
Horses of the Sun. Marsy, G. and B.
HORSNAILE, Christopher, the Elder
 (English fl 1700-42)
 Sir Jacob Garrard, recumbent
 effigy 1730 GUN pl 13
 ELang
HORST, Henryck ter (Dutch)
 Mortar 17th c. bronze; 4-3/4
 BMA 29 UMdBM
HORTA, Victor (Belgian 1861-1947)
 Chandelier, detail, Solvay
 Residence 1895/1900
 SCHMU pl 12 BEWit
 Door Handles, Solvay Resi-
 dence 1895/1900 bronze
 gilt SCHMU pl 129, 130
 BBWit
 Doorway, Maison du Peuple
 1897/99 SELZPN 44 BBMa
 Electric Light Fixture, fire-
 place, Hotel Solvay 1895/
 1900 gilded bronze SELZPN
 92 BBWit
 Inkstand, Hotel Solvay c 1900
 bronze gilt; 4-3/8x18-1/8
 SCHMU pl 3; SELZPN 93
 BBHo
 Staircase, Tassel House, 12
 Rue de Turin 1893 iron
 CAS pl 270; DAM 27; ENC
 43; GOMB 405; PEVP 61;
 SELZPN 129; ST 421;
 UPJH pl 233 BBTa
 Wall Lamp, Solvay Residence
 1895/1900 SCHMU pl 305
 BBWit
 Window 1895/1900
 CAS pl 271
Hortense, Empress See Beauharnais,
 Hortense de
HORTHY, Miklos (Hungarian Admiral
 and Statesman 1868-1957)
 Kisfaludi-Strobl. Miklos
 Horthy, bust
 Sidlo. Miklos Horthy, bust
 Szentgyorgyi. Miklos Horthy,
 bust
Horus. Meier-Denninghoff
Hosanna Cross. French--16th c.

George Washington, sword in
right hand, left hand on pillar
LARK 82; RAY 80 UNNMM
--1788/92 marble; 74 ADA 6;
CRAVS 78; ENC 407; JANSH
485; JANSK 876; PAG-8:166
UVRCap
--replica of original in Capitol,
Richmond, Virginia bronze
HF 129 UNNHF
--replica of original in Capitol,
Richmond, Virginia bronze
GLE 13 ELTS
George Washington, bust
CRAVR 194 UNNMM
--1785 clay; 32 ADA 18; NOV pl
174b; ROOS 200F UVMtV
Giuseppe Balsamo, Count
Cagliostro, bust 1786
marble; 24-3/4 (excl
base)x23x13-1/2
KRA 192, 193; USNKP
457 UDCN (A-1527)
Joel Barlow 1804 plaster
ROTHS 205 UNNN
John Paul Jones terracotta
POST-2:40 UPPPA
--1780 plaster
ROTHS 205 UNNN
John Paul Jones, bust bronze
USC 195 UDCCap
A Lady, bust 1777 marble;
39 HUNT pl 37-40; HUNTA
95; HUNTV 3; SPA 208;
SUNA 83 UCSmH
Lafayette, bust
WB-17:202 UPPPA
--bronze
FAIY 193 UNEE
--1790 marble; 29-3/8
CHICT #133 FV (M.V.
1573)
Louise Brongniart, bust
1777/78 terracotta; 14
CHASEH 395; CHENSW t;
GARDH 425; HOF 139;
HUYA pl 55; HUYAR 89
FPL
--1779 marble; 14-13/16x
9-15/16x7-11/16
SEYM 163-64 UDCN
Mme de Serilly, bust
AUES pl 26 ELWal
Madame Duquesnoy, bust
c 1800 marble; 26-3/4
DEYE 206 UCSFDeY (54.9)
Madame Houdon, bust 1786
plaster; 24

CHAR-2:257; HOF 38; LARR
339; LOUM IX; ROTHS 203
FPL
Madame Jaucourt, detail 1777
marble; 27-1/2 KO pl 98
--bust 1777 marble; 24-3/8
NEWTEM pl 149 FPL
Madame Marie Adelaide Clotilde
Xaviere de France, bust
1774 marble SOTH-3:265
Madame Victoire, bust 18th c.
MOLE 241 ELWal
Marie Antoinette, bust bronze
FAIY 192 UNEE
Marquis de Condorcet 1785
marble; 30-1/2 AP 125
UPPA
Mirabeau, bust 1800/1801
marble LARR 375 FV
Napoleon, bust 1806 terra-
cotta; 32 NOV pl 174a
FDM
Robert Fulton, bust (replica)
bronze HF 85 UNNHF
Rousseau, bust
RAY 80 UNNMM
Sabine Houdon, bust c 1790
original plaster; 21
CHAR-2:237 (col); LAC
209; LARR 373 FPL
--1791 marble; 17-3/4
HUNT pl 44-46; HUNTA 95
UCSmH
St. Bruno c 1766 marble; 3.5
m JAL-5:pl 13; LAC 55;
LIC pl 1 IRMAn
St. John the Baptist plaster;
1.74 m
FAL pl 54a-b IRB
(CCLXXI)
Thomas Jefferson, bust c 1787
plaster; 29
ADAM-3:378; AP 128 UPPA
--plaster; 21-1/2
CRAVS 79 UNNHS
Unknown Man terracotta;
17-1/8 HUNT pl 43 UCSmH
Voltaire, bust
ENC 926
--bronze; 43 cm
WPN pl 63 PWN (129149)
--1778
JAL-5:pl 14 FV
--1778
NEWTET 231; ST 363 GGM
--1778 bronze; 25
HUYA pl 54; HUYAR 14;
ROTHS 203; UPJH pl 184 FPL

--1781 marble; 20
 FLEM 586; GAUN pl 52;
 GOMB 354; VICF 94
 ELV (A. 24-1948)
--1781 marble; 20
 DEYE 207 UCSFDeY
 (61.31)
--1788
 ROBB 392; RUS 113 UDCN
Voltaire, head 1781
 MARQ 228; ROOS 201B
 FPL
Voltaire, head without wig
 1778 bronze; 18
 CAN-1:146 CON (4223)
Voltaire, seated figure
 marble
 PRAEG 333
--1781
 GARDH 425; LAC 55;
 MU 214; POST-2:41 FPCF
--1781
 CHASEH 396; GAF 162;
 MYBU 291; RAD 389;
 RAY 50; UPJ 428 FPFra
--1781 marble; 138 cm
 HERM il 91; HERMA 20
 RuLH
--1781 terracotta model, for
 marble; 47
 BAZINW 418 (col); JANSH
 485; JANSK 875
 FMontpF
Voltaire, seated figure in
 Toga CHRP 298
Houdon, Mme. Jean Antoine
 Houdon. Mme. Houdon, bust
Houdon, Sabine (Eldest Daughter of
 Jean Antoine Houdon)
 Houdon. Sabine Houdon, bust
Houffalize, Didier d'
 Flemish--13th c. Didier
 d'Houffalize, effigy
Hough, Bishop
 Roubiliac. Bishop Hough
 Monument
Houri. Gordine
Hourglasses
 Bernini, G. L. Alexander
 VII Tomb: Death with
 Hourglass
 Italian--15th c. Child with
 Skull and Hourglass
 Sansovino, A. Virgin and
 Child with St. Anne
Hours
 Flaxman. Dancing Hours
The Hours and the Days No. 1.
 Lardera

The House of Davotte. Cesar
"House of Death"
 French--16th c. Louis XII
 and Anne of Brittany Tomb
House with the Golden Roof. Turing
Household of the Grand Mogul of
 Delhi. Dinglinger
The Housewife. Hall, T. van
Hoved. Starcke
Hovering Angel. Barlach
HOVI, Mikko (Finnish 1897-)
 Father and Son 1960 granite
 VEN-60:pl 164
Howard, John Eager (American
 Revolutionary Leader 1752-
 1827)
 Bacon, J. John Howard
 Monument
 Fremiet. Col. Howard, equest
Howe, Lord d 1758
 Flaxman. Admiral Lord Howe
 Monument
HOWE, Allan (English 1888-)
 Adam and Eve bronze
 AUM 154
 Dawn 1942 bronze, oxidized
 silver; 33
 BRO pl 16
 The New Age bronze
 AUM 154
 School Main Entrance
 AUM 155 ELSch
 Torso Roman stone
 PAR-1:114
HRDLICKA, Alfred (Austrian 1928-)
 Oskar Kokoshka, head 1963
 marble
 VEN-64:pl 126
 Robber 1962 reddish marble;
 180 cm
 SOT pl 134
HUBACHER, Hermann (Swiss 1885-)
 Aphrodite bronze
 VEN-38:pl 89
 Bather 1937/38 bronze
 JOR-1:pl 6 SwWK
 The Frightened Man (L'Uomo
 Spaventato) 1928/30 bronze;
 13 MID pl 32; VEN-32;
 pl 157 BAM
 Ganymede 1946/52 bronze;
 300 cm
 JOR-1:pl 9 SwZ
 Italienschen Madchen, head
 1932 JOR-1:pl 7 AVO
 Jeune Fille se Coiffant 1955
 JOR-2:pl 222
 Torso der Aphrodite bronze;
 133 cm JOR-1:pl 8

Hubert, Saint (Bishop)
 Brokoff, F. M. St. Hubert
 French--15th c. Saints
 Christopher and Hubert
Hubertus Fountain. Hildebrand
Hudson, William Henry
 Epstein. Rima: W. H. Hudson
 Memorial
HUET, Christophe (French)
 Panel, Grande Singerie
 LARR 392 FChan
Hugo, Victor
 Barrias. Victor Hugo Memori-
 al
 Pallez. Victor Hugo Monument
 Rodin. Victor Hugo
 Rodin. Victor Hugo at
 Guernsey
 Rodin. Victor Hugo Monument
Hugo of Tuscany
 Mino da Fiesole. Monument
 of Count Hugo of Tuscany
HUGUE, Manuel Martinez See
 MANOLO
HUHNERWADEL, Arnold
 Memorial Fountain
 AUM 22 SwZ
Huia. Gauguin
HUKAN, Karol
 An Altar
 MARY pl 73 PC
 Woman, head
 MARY pl 161 PC
Human Colloquy. Consagra
Human Concretion. Arp
Human--Lunary--Spectral. Arp
Human--Moon--Ghost
 Arp. Human--Lunary--
 Spectral
Humanism Overcomes Death. Riccio
Humbert I (Umberto I) (King of
 Italy 1844-1900)
 Calandra. Umberto I, equest
Humble, Alderman
 Cure, W. , II. Alderman
 Humble and Family Monu-
 ment
Humboldt, Friedrich Heinrich
 Alexander von (German
 Scientist 1769-1859)
 Blaeser. Humboldt, bust
Hume, Lord
 Chantrey. Lord Hume
Humfrey, Edmund
 Chandler. Edmund Humfrey
 Monument
Humility and Putti. Serpotta
"THE HUNCHBACK" See SOLARI, C.

HUNDREISER, Emil (German 1846)
 See SCHMITZ, Bruno. Kyff-
 hauser Plateau Monument
HUNGARIAN--12th c.
 Angel, relief, Pecs Cathedral
 stone GAD 22 HPD
 Capital stone
 GAD 21 HEC
 Christus aus Taban, tondo
 relief stone; 39x37 cm
 GAD 19 HBV
 --13th c.
 Bearded Head,capital
 GAD 25 HEC
 King, head, Kalocsa red
 marble; 17 cm
 GAD 20 HBA
 Tympanum, detail stone
 GAD 23 HJC
 --14th c.
 Fratze stone; 35 cm
 GAD 24 HBV
 Medusa Head stone; 54x27 cm
 GAD 24 HBV
 --15th c.
 Angel, head red marble; 18 cm
 GAD 29 HVi
 Girl's Head, Buda c 1400
 stone; 18 cm
 GAD 28 HBV
 Gravestone of Janos Hunyadi
 stone GAD 31 RA
 King Ladislaus, reliquary bust
 silver; 64.5 cm
 GAD 26 HBNM
 Des Koniglichen Oberkammer-
 ers Stibor, gravestone c
 1439 red marble; 106x210
 cm GAD 30 HBV
 --16th c.
 King Stephan, Matejovce Church
 c 1500 wood; 114 cm
 GAD 33 HBA
 Ladislaus, Matejovce Church
 c 1500 wood; 106.5
 GAD 33 HBA
 Sitzender Einsiedler von
 Zalaszentgrot c 1500 wood;
 79.5 cm
 GAD 32 HBA
 Zsigmond Bathory, medal
 1593 Dm: 4.1 cm
 GAD 40 HBNM
 --17th c.
 Akos Barcsay, medal 1659 Dm:
 4.3 cm
 GAD 40 HBNM
 Buda Madonna marble
 GAD 35 HBM

Gyorgy Rakoczi II, medal 1659
Dm: 4.6 cm
GAD 40 HBNM
Monument of Gyorgy Apafu;
detail: effigy stone; 105 cm
GAD 37, 36 HBA
--18th c.
St. Florian stone; 190 cm
GAD 39 HNK
St. Sebastian, Egevar Church
wood; 119 cm
GAD 38 HBA
Hungarian Cross. German--14th c.
Hungarian Pavilion, Turin Exposition.
Clara
Hungarian Warrior. Sidlo
Huns
Hosel. A Hun, equest
Huns, King of
German--15th c. St. Servatius
Protected by Eagle against
King of Huns
HUNT, John (English fl 1710-44)
Cilena l'Anson Bradley, bust,
monument 1726
GUN pl 111 ELongB
Sir William Boughton Monu-
ment ESD pl 20 EWarwN
A Hunt Picnic, Nymphenburg
Porcelain.
Bustelli
Hunter, Mrs. Charles
Rodin. Mrs. Charles Hunter,
bust
Hunter-Crawford, Mr.
Woodford. Mr. Hunter-Craw-
ford, head
Hunters and Hunting
Barye. Mounted Arabs Killing
a Lion
Byzantine. Casket: Hunting
Scenes
Byzantine. Diptych: Hunting
Scenes
Byzantine. Hunting Scenes
Plaque
Caucasus. Hunting Scene,
relief
Cockerell, S. P. A Hunt,
wall relief
Falconet. Allegory of the
Chase
French--12th c. Capital:
Riding to the Hunt
--Centaur Hunting Stag,
roundels
--Centaur Shooting Woman-
headed Bird, capital
detail

French--13th c. Tithe Vessel
for Grain: Dancing
Peasants; Falcon Hunt
French--14th c. Knight and
Lady Riding to the Hunt,
mirror case
German--12th c. Apse Demon's
Heads; Hares Ensnaring
Hunter
German--14th c. Choir Stalls
of the Novgorod Traders:
A Fur Hunt
German--15th c. Unicorn Hunt
Gibson. The Hunter and his
Dog
Jacquermat. Hunter and Hounds
Medieval. Mirror Case:
Hunting Scene
Hunting Nymph. Falguiere
Huntingdon, Francis, 2nd Earl of
d 1561
English--16th c. Francis,
2nd Earl of Huntingdon Tomb
The Huntress. Abrahams
Hunyadi, Janos (National Hero of
Hungary c 1387-1456)
Hungarian--15th c. Gravestone
of Janos Hunyadi
Hurdy-Gurdy
Orcagna. Angel with Hurdy-
Gurdy
Hurlou. Arp
Hurricane. Meier-Denninghoff
Hurry, Leslie
Armour. Leslie Hurry, head
HURTRELLE, Simon (French 1648-
1724)
Lamentation 1690 bronze
LOUM 182 FPL (1379)
HUSARSKI, Helena (Polish 1922-),
and Roman HUSARSKI
Actress, head 1955 ceramics
JAR pl 33
HUSARSKI, Roman (Hungarian 1923-)
See HUSARSKI, Helena
Huskisson, William 1770-1830
Gibson, J. William Huskisson
Huss, John
Saloun. Jan Hus Memorial
Hussey, Dean
English--15th c. Dean Hussey
Tomb
HUSSMANN, Albert H.
Deutsche Wehr bronze MARY
pl 138
Dying Amazon MARY pl 129
Finish bronze
MARY pl 134

Last Curve bronze
 MARY pl 122
Walter Dear bronze
 MARY pl 134
HUSZAR, Adolf (Hungarian 1843-85)
 Poet Petofi Memorial 1882
 bronze; 380 cm
 GAD 48 HBP
HUTCHINSON, Louise
 Sandor Vegh bronze
 HUX 92
Hutterock, Hermen (Burgomaster of
 Lubeck)
 Notke. Hermen Hutterock
 Tombstone
Hutton, Barbara
 Berti. Barbara Hutton,
 seated figure
HUTTON, John (English)
 Engraved Screen glass; 70x
 45 DAM 176 ECovC
Huxley, Thomas Henry
 Ford, E. O. Huxley, seated
 figure
HUXLEY-JONES, T. B. (South
 African-English 1908-)
 Charles Archer, head
 HUX 11
 Charles Wheeler, bust
 HUX 17
 David, head
 HUX 17 -SoL
 Eve 1946 LS
 NEWTEB pl 40
 George Duncan, bust 1944
 LS NEWTEB pl 41
 Girl's Head
 HUX 52, 55
 James Macdougal, Esq,
 head 1943 bronze; LS
 BRO pl 18
 Lord Boyd-Orr, bust
 HUX front
 Major Dumbreck, head
 HUX 51
 Mother and Child 1951 con-
 crete; 42x27x36
 LONDC pl 17
 Sir William Hamilton Fyfe,
 bust HUX 47 ScAA
 Torso 1941 ivory; 7
 BRO pl 17 -EDa
HUY, Jean Pepin de (Flemish)
 Robert II of Artois, effigy
 1317/20 BUSGS 148;
 LARB 375 FPDe
HUYGELEN, Frans (Belgian)
 Caress
 VEN-24: pl 111

Hvilende havfrue med to Saelhunde.
 Jerichau
Hyacinth. Bosio
Hybrid Fruit Called Pagoda
 Arp. Pagoda Fruit
Hydra See also Hercules
 Antico. Hercules and the
 Hydra, plaque
 Gasteiger. Hercules with
 Hydra
 Richier, G. Hydra
 Spinelli. Ercole Bentivoglia,
 medal, obverse: Hercules
 and Hydra
 Vries. Hercules Fountain
Hyenas
 Hiltunen. Hyena
Hylas
 Gibson, J. Hylas and the
 Water Nymphs
HYLL, John See DOWN, Roger
Hymen. Braque
Hymn to the Dawn. Landowski
Hypercube. Boriani
Hypogeum of Mellbaude. French--
 7th c.
Hypogeum of the Martyrs
 French--7th c. Hypogeum of
 Mellbaude
Hyperboloid Sculpture. Schmidt,
 Joost
Hypsilantis, D.
 Papas. D. Hypsilantis, bust

I am Beautiful. Rodin
I Print. Seale
I Stand in the Rain. D'Haese, Roel
IANCHELEVICI, Idel (Belgian 1909-)
 August Vermeylen, bust
 1935 bronze; 13
 MID pl 20 BAM
IARDELIA, Francisco (Italian 1793-
 1831)
 Tobacco Capitols, small
 rotunda, Supreme Court
 Section 1816 FAIR 28
 UDCCap
Ibexes
 Barye. Lion Vanquishing an
 Ibex
Ibises
 Braque. Ibis
 Faberge. Ibis
 Wiligelmus. Cupid, with
 Inverted Torch (2 figures);
 Ibis
Ibsen, Henrik
 Sinding. Ibsen

Icarus See also Daedalus
 Andreou. Icarus
 Ayrton. Icarus#
 Bertoni. Icarus
 Franchina. Icaro
 Gilbert, A. Icarus
 Mascherini. Icarus
 Mooy. Icarus
 Paolozzi. Icarus, II
Ice Hockey Medal. Moschi
ICELANDIC--10/11th c.
 Clasp bronze
 CHENSW 319 IcRN
Icelandic Girl. Warthoe
ICHE, Rene (French 1897-1955)
 Monument to the Dead of
 Ouveillan, relief
 MARTE pl 30
 The Wrestlers stone
 MAI 141
Icon. Dalwood
Icon. Hepworth
Icon. McWilliam
Iconogram. Ben-Schmuel
Iconostasis. Dalle Masegne, J. and P.
Iconostasis. European
Iconostasis
 Russian--19th c. Iconostasis,
 Abramtsevo Church
Idea# Manucci
Ideal Love
 German--15th c. Saddle:
 Battles and Ideal Love
Ideal Palace. Cheval
Idols
 Arp. Idol
 Gauguin. Idol
 Gauguin. Idol with Pearl
 Gauguin. Idole (a la Coquille)
 Paolozzi. Hermaphroditic
 Idol No. 1
 Turnbull. Idol#
L'Idoletto di Casa. Prini
IDRAC, Antoine (French 1840-84)
 Mercury Inventing the
 Caduceus AGARC 123 FPL
Idylle. Belmondo
Iffley Church, west doorway arch
 relief. Celtic
Ignatius, Saint
 Brokoff, F. M. St. Ignatius
 Martinez Montanes. St.
 Ignatius
Ignudo. Fiorentino, R.
'Il Moro' See Sforza, Ludovico
Ilarik, sepulchral stele. Chillada
Ildefonso, Saint
 Greco, El. St. Ildefonso Re-
 ceiving the Chasuble from
 the Virgin

Ile de France. Maillol
Ilkley Cross. Anglo-Saxon
Im Viereck. Roesner-Drenhaus
Imad Madonna. German--11th c.
Image# Hepworth
"Image of Pity"; Risen Christ, half
 figure, English--15th c.
Image with Four Sides. Kemeny
L'Imagier. Costa, J.
Imago, No. 2. Warren Davis
Imerio, Saint
 Amadeo. S. Imerio Giving
 Alms
Imhoff, Willibald (Nuremberg
 Patrician 1519-80)
 Schardt. Willibald Imhoff,
 the Elder, half figure
Immaculate Conception See Mary
 Virgin--Immaculate Conception
Immagine Dissepolta. Finotti
Immagine Fecondante. Pomodoro, G.
Immerzeele, E. van
 Quellinus, A., the Elder.
 E. van Immerzeele Tomb
Immortality. Vigne
IMOLA, Giovanni da See GIOVANNI
 DI FRANCESCO DA IMOLA
The Imp. Gaudier-Brzeska
Imperial Camel Corps. Brown, C.
The Imperial Eagle Watching Over
 Napoleon. Rude
Impetuous. Koman
Impetuous Dare Devil No. 2. Ladera
Impressao de Distancia. Pomodoro,
 G.
Impressioni d'Omnibus. Rosso, M.
Imprisoned Bird. Gilioli
In Advance of the Broken Arm.
 Duchamp
In Cordis Vigilia. Canonica
In Memory of H. Dieterle. Burckhardt
In Praise of Wine. Seale
In the Elevator. Batic
In the Hands of the Trolls. Jonsson
In the Morning Wind. Ramous, Carlo
In the Stable. Manolo
In the Streets of Athens. Ernst
In the Studio. Garelli
In the Sun. Otto
In the Sun. Jespers, O.
Incantation. Cros
Incense Burners
 Bellano. Mountain of Hell,
 table incense burner
 French--18th c. Incense
 Burner
Inclined Antique Head. Gonzalez
Inclined Plane with Forty-nine
 Spheres. Bury
Incognita. Penalba

Inconstancy
 French--13th c. Virtue of
 Constancy
L'Incontro. Roccamonte
Incontro Alato. Carpigiani
Incredulity of St. Thomas
 Verrocchio. Christ and St.
 Thomas
L'Incubo. Mercante
INDENBAUM, Leon (Russian-French
 1890-)
 Portrait Synthetique black
 granite PAR-2:150
 Young Man c 1940 bronze
 SCHW pl 39
Indestructible Object. Ray
India
 Byzantine. India, relief detail
 Byzantine. Plate: India
Indian Dancer. Stijovic
Indians of North America (Subject)
 Capellano. Preservation of
• Capt. John Smith by
 Pocahontas
 Causici. Conflict of Daniel
 Boone and the Indians,
 relief
 Causici. Landing of the
 Pilgrims, relief
 Eynde, H. A. van den.
 Netherland Memorial Flag-
 pole
 Milles. Peace Memorial:
 Indian Chief Smoking Peace
 Pipe
 Milles. The Spirit of Trans-
 portation
Indicator III. Chadwick
The Indifferent Man. D'Haese, Roel
Individuals. Arp
Industry
 Bottiau. Industry
 Metzner. Industry
 Meunier. Monument to Labor:
 Industry
 Polet. Workman, representing
 "Industry"
Infant of St. George, assemblage.
 Fullard
Infante
 Spanish--13th c. Infante, head
Inferno See Hell
Infinite Form. Anthoons
Infinite Surface in the Form of a
 Column. Bill
Inge
 Manzu. Inge, bust

Ingelheim, Franz von
 German--17th c. Prince-Bishop
 Franz von Ingelheim Monu-
 ment
Ingham, Oliver
 English--14th c. Sir Oliver
 Ingham, effigy
INGHELBRECHT, Jan
 Seal of City of Bruges 15th c.
 silver; Dm: 3-5/8
 DETF 357 BBrSta
Ingres, Jean Auguste Dominique
 (French Painter 1780-1867)
 Bartolini. Ingres, medallion
 Bourdelle. Ingres, bust
Initial of a Leaf. Arp
Inkstands
 Debschitz. Inkstand
 Duplessis. Inkstand
 French--17th c. Louis XIV's
 Inkstand
 Horta. Inkstand
 Riccio. Boy with Grasshopper
 Riccio. Inkstand#
 Vischer, G. Inkstand, with
 Vanitas
Innen-Aussen. Witschi
Inner Eye. Chadwick
INNES, George B. (English)
 Woman*, head bronzed plaster
 CASS 43
Innocence. Foley
Innocent VII (Pope 1336?-1406)
 Pollaiuolo, A. and P. Pope
 Innocent VII Monument
Innocent VIII (Pope 1432-92)
 Spinelli. Pope Innocent VIII,
 medal
Innocent X (Pope 1574-1655)
 Algardi. Innocent X, bust
 Bernini, G. L. Innocent X,
 bust
Innocent XI (Pope 1611-89)
 Monnot, P. Innocent XI Tomb
Innocent XII (Pope 1615-1700)
 Valle. Tomb of Innocent XII
INNOCENTI, Bruno (Italian 1906-)
 Dancer bronze
 VEN-38:pl 116
 Greta
 CASS 115
 Woman, bust
 VEN-34:pl 71
INNOCENTI, Pierluca Degli See
 PIERLUCA
Insane and Insanity
 Cibber. Melancholy Madness

Cibber. Raving Madness
Italian--15th c. Healthful
 Nature and Madness
Lambertsz. Madwoman
Picasso. The Madman
Inscriptions See Writing
The Insect Bird. Uhlmann
Insect Form II. Hartung
Insects See also names of insects,
 as Bees; Grasshoppers
Beothy. Wasp, Opus 138
Cesar. Galactic Insect
Cesar. Insecte
Uhlmann. Winged Insect
Insieme. Castelli
Instable-Continuel Lumiere. Le Perc
Instrument a cordes. Koch, O.
Intercamera Plastica. Scheggi
Interior-Exterior Reclining Figure.
 Moore, H.
Interlacing Bacchantes. Rodin
Interlocking Rhythms. Beothy
Internal and External Forms.
 Moore, H.
Internal Movement. Popovic
International Red Cross Monument,
 Solferino. Manucci
Intoxication of Wine. Clodion
Intruder at the Fountain. German--
 18th c.
INURRIA, Mateo (Spanish 1867-1924)
 Flower of Granada marble
 RAMT pl 57b SpMaC
Invasion. Castelli
Invention of the Balloons. Clodion
Inversion. Paolozzi
Invisible Object. Giacometti
Involuntary Velocity. Kemeny
Involute# Hepworth
IOCUBONIS, Ghedeminas (Russian
 1927-)
 Mother, monument to victims
 of Facism, Pirciupus,
 model 1958
 VEN-64: pl 198
IPOUSTEGUY, Jean (French 1920-)
 Alexander Before Ecbatana;
 detail 1965 bronze; 68x47-1/4
 x158 GUGE 80, 81 FPB
 Le Bon Dieu 1959 H: 18-1/8
 SEITC 58 UNNLoe
 Casque Fendu 1958 H: 16-1/4
 SEITC 58 UNNLoe
 Crab and Bird 1958 bronze;
 62 EXS 86 FPB
 Cenotaph 1957 sheet iron;
 W: 84
 LOND-5: #24 FPB

Le Cimetiere 1959 H: 51
 SEITC 58 FPB
David 1959 H: 50
 CARNI-61: #173 FPB
David and Goliath 1959
 BURN 329 UNNMMA
La Femme au Bain 1966
 polished bronze; 59x43x79
 CHICSG; KULN 18 UNNFru
Helmeted Head, and a Falcon's
 Head MAI 141
Man (Homme) 1963 bronze
 VEN-64: pl 149
--1963 H: 79
 SEITC 58 ELH
--1963 bronze; 79-1/4
 SELZS 181 UNNMat
Remoulus 1962 H: 38
 SEITC 58 UNNLoe
Sculpture*
 EXS 19 I
La Terre 1962 bronze; 68-7/8
 READCON 181
Vauban 1960 H: 10
 SEITC 58 UNNLoe
Woman in Bath 1966 59x79
 CARNI-67: #56 UNNFru
Iris
 Rodin. Iris#
Irish Bog Table
 Fletcher. Gladitorial Table
Iron 5925. Somaini
Iron Pig. Kneale
Iron Sculpture. Adams, R.
Ironworker. Gerome
Ironworker. Meunier
Ironworkers. Marques
Iroquois
 English--18th c. George III
 Medal, reverse: Iroquois
 Hunter
Irula Tribe, India
 Milward. Irula Man, head
Isaac See also Abraham
 Berruguete. Altar of San
 Benito
 Brunelleschi. Abraham's
 Sacrifice
 Donatello. Abraham and Isaac
 Donatello and Nanni di Bartolo.
 Sacrifice of Isaac
 Early Christian. Sarcophagus of
 Stilicho
 French--16th c. Sacrifice of
 Isaac
 Ghiberti. Baptistry Doors--
 East: Abraham
 Story

Ghiberti. Sacrifice of Isaac
 (competitive panel)
ISAACO DA IMBONATE (Italian)
 Virgin Annunciate 1402
 marble POPG pl 62;
 WHITJ pl 188A IMC
Isabella, Saint (Queen of Portugal
 1271-1336), known as
 Isabella of Aragon
 Italian. Isabella of Aragon
 Tomb
 Laurana. Isabella of Aragon,
 bust
Isabella I (Queen of Ferdinand V,
 King of Castile and Leon
 1451-1504) See also
 Ferdinand V
 Francelli, D. A. Ferdinand
 and Isabella Tomb
 Vigarny de Borgona. Isabella,
 kneeling figure
Isabella and her Admirer. German--
 18th c.
Isabella Monument. Spanish--12/13th
 c.
Isabella of Bourbon
 Jacques de Gerines, and
 Renier van Thenen, the
 Elder. Isabella of Bourbon
 Tomb
Isabella of Portugal (Empress of
 Portugal 1503-36) See also
 John II (King of Castile)
 Leoni, L. Empress Isabella,
 medal
Isabelle (Queen of France)
 French--13th c. Isabelle,
 Queen of France,
 Mausoleum
ISAIA DA PISA
 Martinez de Chavez Monu-
 ment: Temperance c 1450/
 55 marble POPR fig 108;
 SEY 67B IRGio
 Virgin and Child with SS
 Peter and Paul and Two
 Donors: Eugene IV, and
 Cardinal Orsini, bas
 relief c 1447/50 marble
 CHAS 111; MAR 48; POP
 IRV
ISAIA DA PISA, PIETRO DA
 MILANO, PAOLO ROMANO,
 MINO DA FIESOLE;
 DOMENICO GAGGINI
 Triumph of Alfonso of Aragon
 Arch 1455/58 marble
 MAR 57 (col); SEY pl 69
 INCa

Isaiah
 Agostino di Duccio. Isaiah
 (design)
 Douvermann. Altar of the
 Virgin of the Seven Sorrows:
 Root of Tree of Jesse
 Sprouting from Sleeping
 Isaiah
 English--15th c. Tree of Jesse
 Springing Forth from Sleep-
 ing Isaiah
 French--12th c. Isaiah, door-
 way jamb relief
 --North Portal Figures
 French--13th c. Chartes
 Cathedral, north transept
 Italian--12th c. Isaiah, facade
 figure
 Nanni di Banco. Isaiah
 Pisano, G. Isaiah, head detail
 Sluter. Crucifix Base:
 Zachariah; Daniel; and
 Isaiah
 Sluter and Werve. Well of
 Moses
ISELIN, Heinrich (German fl 1466-78)
 Stall Ends, Weingarten c 1478
 MULS pl 124 GBerS
Isenburg, Dieter von d 1482
 German--15th c. Prince-
 Bishop Dieter von Isenburg
 Monument
ISENRATH, Paul (German 1936-)
 Plastik 1962 bent copper sheet;
 6-7/8x5x4-3/4
 NEW pl 333 GMT
ISENSTEIN, Kurt Harald (German-
 Danish 1898-)
 Memorial to 18,000 Danish
 Jews Saved by Swedes,
 relief SCHW pl 57 SnH
Isham, Justinian
 Scheemakers, P. Sir Justiniam
 Isham
Ishmael. Epstein
Ishmael. Youngman
Isidore, Saint
 Spanish. St. Isidore
Isle of Avalon. Martel, J. and J.
Islingtonians Monument. MacKenna, L.
Islip, John d 1532
 English--16th c. Abbot John
 Islip, head
Isobel. Epstein
Isolina. Gilioli
Isomet. Hall, D.
Isotta da Rimini
 Desiderio da Settignano. Bust
 of a Lady (Isotta da Rimini)

ISTOK, Janos (Hungarian 1873-)
 General Josef Bem bronze;
 65 cm GAD 72 HBA
ITALIAN See also Sienese
 Angel, Pisa
 MALV 257 FPL
 Annunciation, capital
 BEREP 117 IMonrB
 Bird, Laver fragment
 BEREP 92 ISyM
 Capodimonte Candlesticks:
 Blackamoors H: 6
 INTA-2: 126
 Casket of the Enamelled
 Cross of the Sancta Sanc-
 torum patterned silver
 NOG 232 IRV
 Colonna Rostrata
 MINB 108 IRB
 Facade, detail
 DUR fig 42 IOrC
 Figure and Foliage Decoration,
 central porch
 BEREP 69 IMeC
 Filippo Sangineto Tomb
 BEREP 157 IAlM
 Gallery Fountain, The
 Belvedere MATT pl 42
 IRV
 The Holy Child, jeweled
 figure BEREP 27 IRM
 Intarsia Panel--Classical
 Foliage (line drwg)
 CHRP 240 IFMar
 Isabella of Aragon Tomb;
 Madonna and Child
 BEREP 151, 152 ICoC
 Judgment of Solomon, relief
 BROWF-3: 28 IVP
 Madonna and Child, Florence
 clay BODE 48 ELV
 Madonna and Child on Cres-
 cent Moon ivory and amber
 COOPF 56 (col) IRPam
 Panel Figures
 MARQ 200 IPavCe
 Pincio Obelisk
 MINB 101 IRB
 Princess of the Odescalchi
 Chigi Family Tomb
 BEREP 29 IRPo
 Pulpit, San Miniato
 BEREP 187 IFMi
 Putto
 ENC 740 IUNM
 Regolini-Galassi Tomb
 Fibula gold
 NOG 288 IRV

 Renaissance Arabesque (line
 drwg) CHRP 240 IGubP
 St. Peter bronze
 NOG 39 IRP
 St. Peter, seated figure,
 grottoes marble
 NOG 55 IRP
 St. Sebastian silver, silver
 gilt, blue enamel, coral
 COOPF 56 (col) IRPam
 Satyr and Hermaphrodite
 (Satyr Pursuing Nymph)
 VER pl 97 IRNC
 Socle, lion-form, Tomb of
 Frederick II porphyry
 BEREP 121 IPalC
 Suit of Armor c 1480
 MYBU 224 UNNMM
 Tortoise Fountains
 NATT pl 44 IRV
 Virgin with Child at the Breast,
 relief
 GUIT 78 IBarA
 --3rd c.
 Open Ark, with Torah Scrolls
 and Menorah, catacombs,
 Verde, Italy marble slab
 KAM 8
 --4th c.
 Adam in the Garden of Eden,
 diptych detail ivory
 BAZINH 108 IFBar
 Jesus Christ, head, sarcopha-
 gus of Junius Bassus
 marble BAZINH 116 IRP
 Rhyton: Dog's Head terracotta;
 . 215 m
 CHAR-1: 147 FPL
 --5th c.
 Ascension of Elijah, church
 door relief c 430 cedar
 wood BIB pl 196 IRSa
 An Emperor, Barletta c 450
 bronze NEWTEM pl 44
 IBar
 Moses, life scenes, church
 door relief c 430 wood
 BIB pl 94 IRSa
 New Testament Scenes: 2-
 panel plaque ivory
 CHENSW 297 GBM; FPL
 --6th c.
 Cross of Emperor Justin
 (treasure)
 NOG 52 IRP
 Diptych of the Muses ivory;
 . 29x. 075 m
 CHAR-1: 218 FPL

Eutropius, head c 550 marble
 NEWTEM pl 43 AVK
Multiple Diptych: Biblical
 Scenes, as Christ En-
 throned; Jonah and the
 Whale, Murano ivory;
 14x12
 RDAB 17, 18 IRaMN
--7th c.
Animal-decorated Cross gold
 ST 122 IBerBi
Animal-style Cross, Lombard
 y Ticino ST 126 SwZS
Dress Brooch, Perugia silver
 gilt ST 123 IRMN
King Agilulph and his Retinue,
 Lombard, plaque gilt
 copper BARG IFBar
Theodolinda's Crown jeweled
 gold KIDS 19 IMonC
--8th c.
Abbot Attala Grave Slab: Tree
 of Life
 DECR pl 227 IBobC
Abbot Bertulf Grave Slab:
 Plaited Ornament
 DECR pl 226 IBobC
Adoration of the Magi, altar
 fragment
 BAZINW 216 (col); LARB
 ICi
Diptych: Crucifixion and
 Biblical Scenes; Wolf
 Suckling Romulus and
 Remus, Monastery of
 Rambona ivory
 NOG 231 IRV
Lombard-Panelled Pulpit
 marble
 BAZINW 217 (col) ITuM
Peacock Relief, San Salvatore,
 Benedictine Monastery
 c 760 DECR pl 19 EBrMC
Procession of Holy Women,
 Oratory stucco
 BAZINW 216; LARB 246 ICi
Saints, relief figures; Vine
 Foliage, detail c 750
 stucco
 DECR pl 251 ICi
Santa Maria in Cosmedin,
 interior
 READAS pl 10 IR
Sigvald Relief: Apostle
 Symbols 762/776 36x60
 BAZINW 216 (col); JANSK
 385 ICiD

Stucco Relief
 MACL 3 ICiM
Visitation, Pemmo Altar,
 detail 744/49
 DECR pl 253 ICiD
--8/9th c.
Griffins, altar frontal marble;
 29 NM-7:27 UNNMM (30.30)
Wellcurb, Venice stone
 CLE 44 UOClA (1678.16)
--9th c.
Capitals, S. Benedetto Oratory,
 Malles stucco
 BAZINW 216 (col) IBolS
Ivory Diptych: Passion and
 Resurrection of Christ;
 detail: Judas Receiving
 30 Pieces of Silver, Milan(?)
 BECKM 131 IMC
Sacred Column: Floriate Relief
 DECR pl 87 ISpE
--9/10th c.
St. Bassianus, head, relief
 red Veronese marble
 DECR pl 23 ILoB
--10th c.
Basilewsky Situla c 980 ivory;
 6-1/4x4-1/5x5
 BECKM 130 ELV
--Death of Judas
 ASHS pl 4A
--Judas Receiving 30 Pieces of
 Silver
 BECKM 131
Diptych: Crucifixion; Roman
 Wolf; Madonna; Sts.
 Gregory, Silvester, and
 Flavian c 900 ivory
 MOREYC IRVB
Ivory Panel Showing Christ in
 Majesty, between the Virgin
 and St. Maurice, Attended
 by Angels and Adored by
 Otto II, Empress Theophano,
 and the future Otto III,
 Milan c 980
 BECKM 129 IMS
St. Matthew, panel, Milan
 ivory; 7-1/4x4-1/4
 BECKM 133 ELBr
St. Matthew, situla given to
 Basilica of Sant'Ambrogio,
 Milan c 980 ivory; 7-1/4
 x4-7/8
 BECKM 130 IMC
Well Head: Floral Motif stone
 BATT 37 ELV

Facade: Staring Heads; Masks
 c 1200
 DECR pl 196 IBarM
Female Ideal Head, Capua
 VER pl 20 GHKG
Fisherman, central doorway
 detail marble
 MURA 109 IVM
Frederick II, bust
 LARR 29 GBS
Frederick II of Hohenstaufen,
 bust c 1225/50
 BAZINW 306 (col) IBaM
Griffins Flanking Tripod,
 pillar base c 1200 marble
 VER pl 16 UMB
Head Detail, staircase support
 DECR pl 232 IPiacM
Jonah and the Whale, relief
 c 1260 marble
 JANSK 439 ISeP
July, relief c 1200 stone
 KO pl 71 IFeG
Madonna and Child (Thronende
 Muttergottes) c 1200 ivory;
 4.8 cm BSC pl 22 GBS
 (10/63)
Madonna and Child Enthroned,
 Umbria c 1250 ptd wood;
 62-1/2
 DETT 55 UMiD (30.383)
Madonna and Child Enthroned,
 cameo c 1230 onyx; 1x3/4
 COOPF 180 GDonF
Main Portal, detail: Months--
 November (Bird Hunting);
 December--(Butchering a
 Pig) c 1275
 LARR 28 IVM
-- : Trades--Smithy; Fisher-
 men
 LARR 28
Mantuan Grosso c 1257
 PANR fig 86
Mask in Foliage, pillar base
 c 1200 marble
 VER pl 17 UMB
Medieval Inscription (Latin)
 BEREP 192 IScM
Nativity, relief c 1200 marble
 DECR pl 73 IArM
Pedestal c 1250/1300
 BAZINW 306 (col) IBoC
Pier delle Vigne, bust
 CHASEH 216 ICaM
Pulpit
 ROOS 65H IRavP

Pulpit: Lions; Biblical Scenes
 1233 stone
 DECR pl 53 IBargC
Pulpit, Lion Pillars
 ST 193 ISeP
Pulpit Capital c 1207
 MCCA 41 IFMi
Reliquary della Testa di S.
 Galgano
 CARL 67 ISC
Romulus and Remus Suckled
 by Wolf, pillar base c 1200
 marble
 VER pl 15 UMB
Ruler, torso fragment marble
 ST 195 IBarMN
St. Anne, head detail c 1260
 poplar wood
 DECR pl 207 IChT
St. Demetrius, relief
 PANS pl 157 IVM
St. George and the Dragon 1283
 BUSGS 90 IFPG
St. John Story, Pisa, Baptistry,
 architrave, main door
 FOC-2: pl 110 IPisaB
St. Martin Sharing his Mantle
 with a Beggar, west facade
 c 1240
 BOE pl 112; BUSGS 91 ILuC
Samson and the Lion, relief
 c 1220 marble
 DECR pl 52 ILuCiv
Sibylla, middle porch; Column
 BOE pl 112 ILuC
Signs of Zodiac, marble intarsia
 pavement 1207
 MCCA 42 IFMi
Trivulzio Candlestick, details:
 Rivers of Paradise c 1200
 cast bronze, rock crystal;
 Dm: 20 mm
 SWA pl 215 IMC
Vinea Bust, triumphal arch of
 Frederick II 1239 marble;
 36
 KO pl 71 ICaM
Virgil, seated figure c 1227
 PANR fig 85 IManB
Virgin and St. John ptd red
 pine
 NM-12: 27 UNNMMC
--13/14th c.
Altar of St. Jacopo 1287,
 1314/16
 WHITJ pl 186 IPiC
Reliquary of S. Galgano
 WHITJ pl 64A ISC

Angel of the Annunciation c
 1300 copper
 DECR pl 236 IPaM
Baptistry, exterior
 POPG fig 73 IBeB
Basinet c 1380 Dm: 17-1/2
 NM-3:4 UNNMM (04.3.235)
Beato Pacifico Monument
 1432/37 terracotta
 POPG fig 45 IVMF
Bishop ptd wood
 NM-12:89 UNNMMC
Campanile, exterior
 POPG fig 72 IFC
Can Grande delle Scala, equest
 tomb figure 1330 marble
 BAZINW 310 (col); BUSGS
 177; JANSH 263; KIDS 167;
 LARR 32; POPG fig 23;
 VALE 95, 96; WHITJ pl
 149B IVeM
Capital: The Planets and
 Their Children
 SEZ 72 IVP
Cardinal Guglielmo Longhi
 Monument
 POPG fig 20 IBerM
Choir Stalls, detail early
 1330's
 WHITJ pl 140A IOrC
Christ, head, Crucifix wood
 BAZINW 310 (col) IMeMN
Church Doorway
 POPG fig 38 IPesD
Cofanetto ptd and gilded wood
 CLE 55 UOC1A (54.600)
Crozier Head ivory
 BARG IFBar
Crucifix, Venice c 1330 ptd
 wood, partly gilded; 44x36
 DETT 54 UMiD (58.384)
Dante, detail bronze
 DUR front INN
Door, south frame: Human,
 Animal, Floral Ornament
 c 1308
 DECR pl 214 IAqM
Drunkenness of Noah, south-
 east tower relief Istrian
 limestone; 79
 MURA 116; NEWTEA 70;
 POPG pl 101 IVP
Enrico Scrovegni Monument
 POPG fig 27 IPadA
Enthroned Madonna and
 Child, Sienna c 1300 gilt
 wood; 35
 NCM 267 UCLCM
 (A.5832.47.45)

Facade Figures, old facade,
 Duomo
 MCCA 19 IFOp
The Fall, column figures
 c 1330/50 Istrian stone
 POPG pl 100; READAS pl
 12B IVP
Francesco Dandolo Monument
 1339
 POPG fig 24; WHITJ pl
 128A IVMF
Genesis Pier: Creation, other
 scenes
 CHENSW 369 IOrC
Genesis Pier, detail:
 Creation of Woman
 MOREYM pl 144 IOrC
Guglielmo di Castelbarco
 Monument
 c 1320
 POPG fig 21; WHITJ pl
 149A IVeA
Hercules and the Lernaean
 Hydra, facade relief
 SEZ 36 EBerC
Judgment of Solomon, north-
 west corner relief Istrian
 limestone; 79
 MURA 117 IVP
Last Judgment, detail:
 Resurrection of the Dead,
 right pier relief, west front
 after 1310
 AUBA 167 (col); BUSGS 140;
 CHENSW 359 IOrC
Madonna and Child, Florentine
 ptd wood; 69-1/2
 COOP 87 IVCi
Madonna and Child, seated
 figure
 BAZINW 310 (col) ICA
Madonna and Child Enthroned
 with Angels, Palazzo Laz-
 zaro, Padua 1321 marble;
 35-1/4
 USNKS 18 UDCN
Madonna dello Schippo, relief
 marble; 173x72 cm
 POPG pl 64 IVM
Mastino II della Scala, equest
 before 1351
 POPG fig 22; WHITJ pl
 192A IVeM
Meleager Sarcophagus, detail
 PANR fig 115 formerly
 IFMon
Milan Madonna c 1320
 ST 251
 GCoC

Mirror Case Carving ivory
 FOC-2:pl 125 IFMN
Porta della Mandorla 1391/96
 POPG fig 39 IFCO
--Gift of the Girdle
 BOE pl 149
--Prudence
 PANR fig 111
Prophet, head
 BAZINW 311 (col) IMC
Saint marble
 LOUM 119 FPL (579)
S. Balbina, Abruzzan
 WHITJ pl 181C IAqM
Virgin and Child with SS.
 Lawrence and Francis,
 lunette after 1344
 POPG fig 26 IViL
Visitation, 3rd pier c 1310/30
 WHITJ pl 139A IOrC
--14/15th c.
Palazzo Ducale, ext
 POPG fig 99 IVP
--15th c.
Abruzzi Chalice, Abbey of
 Martino al Cimino, San
 Vitterbo c 1340 gold
 CAL 45 (col) IRP
Adoration of the Christ
 Child, Lombardi marble,
 some gilding
 CLE 84 (UOClA (1874.28)
Aldus Manutius, profile bust,
 medal bronze
 HALE 85 (col) IVCo
The Annunciation, diptych
 ivory, silver, bronze;
 18 cm
 DETD 159 ELV
Arm Reliquary gilt copper;
 17-1/2
 DEYE 31 UCSFDeY
 (53.18.3)
Armet, Rhodes (?) c 1400
 COOP 52 IBrMa
Armet a Rondelle, Milan c
 1475 H: 9-5/8
 NM-3:4 UNNMM
 (29.158.51)
Armor, with red velvet
 breast plate cover steel;
 66-1/2
 NM-3:6; NM-11:97 UNNMM
 (29.154.1)
Atys-Amorino (Time as a
 Playful Child Throwing
 Dice); rear view c 1440
 PANR fig 131, 132 IFMN

Baptismal Font
 POPG fig 83 ISB
Barbute c 1470 H: 11-3/8
 NM-3:4 UNNMM (60.151)
Battista Sforza, death mask
 terracotta
 SEY pl 102B FPL
"La Belle Florentine", bust
 ptd and gilded stuccoed
 wood; .55 m
 BUSR 72; CHAR-1:337 (col);
 LOUM 125; MILLER il 115
 FPL (622)
Book Cover: Annunciation,
 Florence c 1467/69 niello;
 16-3/8x11-3/8
 DETD 162 UOClA
Book Cover: Biblical Scenes
 c 1467/69 niello; 16-3/8x
 11-1/2x5/8
 DETD 163 UMnMI
Bordered Window marble, iron
 grating and wood frame
 DOWN 113 UNNMM
Bust of a Lady, Florentine
 USNI 227 UDCN (A-18)
Bust of a Woman bust
 CHENSW 381 FPL
Bust of a Woman, Florentine
 c 1460/70 limestone; 18-1/2
 NEWTEM pl 121 formerly
 GBS
Capital: Seated Figure with
 Lion, Palace of Doges
 PANM il 83 IV
Capital of Court Column:
 Floral Motif
 ROOS 99H IFGo
Capitoline Wolf (Wolf Suckling
 Romulus and Remus) bronze;
 14-3/8x25-1/4
 USNK 192; USNKP 424;
 USNKS 31 UDCN (A-155)
Cassone (Marriage Chest)
 c 1440 gilded wood
 HALE 123 ELN
--c 1475 ptd and gilt wood
 NCM 277 UNNMM (14.39)
Cassone: Hunting Scene,
 Florence(?) ptd wood,
 gilded gesso; 7-1/8; Dm:
 10-7/8
 BOSMI 121 UMB (47.116)
Chalice, Siennese silver and
 gilt copper
 BARG IFBar
Child with Skull and Hourglass
 bronze; 4-7/8
 VICF 49 ELV (A.16-1936)

Christ, bust, Florence ptd
 terracotta
 CLE 81 UOC1A (21.956)
Crucifix, west coast c 1490
 marble
 SEY pl 109A ISarF
Crucifixion of St. Peter,
 relief detail c 1480
 POPR fig 111 IRV
Dante, head
 ENC 227
Death Mask
 MACL 160 ELV
Doorway of Stanga Palace,
 Cremona marble
 LOUM 83 FPL (642)
Ducal Palace, detail: Corner
 Figures
 BURC pl 9 IVP
Fauchard of Guard of Cardinal
 Camillo Borghese
 NM-11:96 UNNMM
Ficino, medal
 ENC 301
Footed Bowl with Dolphin
 Handles bronze
 BARG IFBar
Girl, bust, relief marble; 18
 VICF 46 ELV (923-1900)
Healthful Nature and Madness,
 Farrarese relief bronze
 PANB 23
Horse and Rider Armor
 FREM 151 UNNMM
Italian Reinforcing Couter and
 Vambrace, and Chanfron
 SOTH-3:248
Ivory Comb: Story of
 Susannah, scenes
 BARG IFBar
John of Calabria, son of Rene
 D'Anjou, medallion brass:
 Dm: 3-3/4
 YAP 216 -USe
John the Baptist, Siena(?)
 bronze; .31 m
 CHAR-1:341 (col) FPL
Knight's Sword L: 40-1/4
 NM-3:3 UNNMM (32.75.225)
Life of Christ Scenes, dip-
 tych leaf ivory
 CHENSW 349 UDCN
Lion-headed Display Barbute,
 Venice c 1460 embossed
 copper-gilt covering steel
 bowl; 10-3/4
 NM-3:5; NM-11:94
 UNNMM (23.141)

Lorenzo de'Medici, bust
 ENC 613
Lorenzeo de'Medici, death mask
 cast 1492 plaster
 BURC pl 54 IFCol
Lorenzo de'Medici in Antique
 Armor, medal 1495 bronze
 BUSR 91 FPMe
Madonna and Child ptd and
 gilded stucco
 DOWN 108 UNNMM
Madonna of Mercy (Madone de
 la Misericorde; Madonna
 della Misercordia), Umbrian
 wood
 BARG IFBar
Madonna with Saints and Donor
 (Cardinal Branda), col-
 legiata lunette 1428 stone
 SEY pl 43A IVCas
Man, bust c 1470 ptd stucco
 VALE 34 UMiD
Medal: Alexander VI c 1496
 lead and bronze; Dm:
 .056 m
 CHAS 301 IFBN
Medal: Cosimo Vecchio de'
 Medici, profile bust c 1464
 bronze MU 143
Milanese Gothic Sabatons
 SOTH-3:245 ELTow
Milanese Visored Sallet c 1450
 SOTH-3:247 ELTow
Miracle of St. Mark, facade
 detail c 1490
 MAR 146 (col) IVSM
Nature and Grace, with
 Fountain of Life, Medal of
 Constantine, reverse c 1400
 PANS 110 AVK
Natural Philosopher amidst the
 Elements, Farrarese relief
 bronze
 PANB 23
Nerli Cassone
 ENC 163
Nicodemus Bewailing the
 Christ, detail c 1485/90
 ptd terracotta
 SEY pl 128B IRegG
Old Man, bust, Florence 1450/
 1500 terracotta; 23-1/4
 READAS pl 160 UDCN
Parade Helmet, Florence
 BARG IFBar
Pax: Coronation of the Virgin
 niello; 12.8x8x8.5 cm
 BARG; DETD 161 IFMN

Pieta c 1450 ptd wood
 MYBS 35 (col) -EHu
Processional Cross, Tuscan
 gilt copper
 BARG IFBar
Putto with Horn, Florence
 bronze; 1-3/4
 ASHS pl 20 ELV
Reliquary, Tuscan gilt copper
 BARG IFBar
Reliquary of St. Blaise,
 Naples, Treasury 1402
 enameled and gilded silver
 CAL 44 (col) IRP
Reliquary Supported by Two
 Angels copper and gilded
 bronze
 MONT 399 IBoD
Rhetoric, Chapel of the Arts
 and Sciences after 1457
 marble SEY 66B IRiP
Roberto Malatesta, equest
 relief marble; 1.57x1.46 m
 CHAR-1:338 FPL
St. Catherine of Siena, head
 FEIN pl 20 UNNMM
St. Sebastian, Umbria ptd
 wood
 CHAS 312 IPeG
Savonarola, medal
 TAYFF 63 (col) UNNMM
Silver Cross
 LARR 82 IFOp
Tazza, with Putti c 1490
 enameled blue glass
 CLE 93 UOClA (60.38)
Three Barbuti; Salet
 COOP 52 IBrMA
Virgin and Child ptd terra-
 cotta; 102 cm
 POPG pl 92 UDCN (A 147)
Virgin and Child, Florentine
 c 1425 terracotta; 29
 VICF 37 ELV (7573-1861)
Virgin and Child, household
 shrine terracotta
 HALE 64 (col) IFDa
Virgin and Child, relief
 GUIT 84 IFaC
Voghera Monstran
 Lombardy 1406
 WHITJ pl 185B IMS
Wall Detail 1492/97
 BOE pl 154 IMMG
Whorl Motif, door panels
 wood
 LARB 315 IPC

Woman-headed winged monster,
 torch holder
 ROOS 99D IFS
--15/16th c.
Barbuta gilt copper on red
 velvet
 COOP 50 (col) IBrMa/
Cassone: Demeter and Hecate
 Searching for Persephone
 1450/1500 gilded wood
 ROOS 154D UNNMM
Combs ivory
 BURC pl 24 IFMN
Entombment Group: Virgin,
 St. John, Mary Magdalene
 ptd and gilded terracotta;
 36-1/2; 35; 35-1/2
 ALB 161-63 UNBuA
Eros, Venice bronze
 CHICC 34
Goat bronze
 BRIONA 81 FPL
Maesta: Christ Resurrected;
 reverse: Pieta enameled
 gold; c 8
 DETD 160 IMP
Pax 1492/1503 gold, silver
 gilt, enamel and crystal
 jewels; 8-5/8x5-1/8
 DETD 164 UNNMM
--15/17th c.
Armor
 ROOS 154A ITAR
--16th c.
Anatomical Trotting Horse
 bronze; 35-1/2x34
 SCON 59 ScEN (No. 165B)
Apollo, Venice (copy of Roman
 figure) c 1500 bronze; 15-1/4
 HUNT pl 1-2; HUNTV back
 cov UCSmH
Armor, Milan
 BARG IFBar
Bacchus, Florence bronze
 SOTH-2:218
Bearded Bust marble; .60 m
 FAL pl 4 IRB (CCLXIV)
Bearded Man, bust bronze;
 17-9/16
 DETD 101 UMdBW
Bird-Shaped Ewer rock crystal,
 enameled gold mount; 10-1/4
 CHAR-2:91 FPL
Black Venus, Florence c 1575
 lacquered bronze; 12-1/2
 CHAR-2:29 FPL
Bonaventura Costacciario,

General of the Order of
Conventuals 1543/49 bronze;
Dm: 60 mm
DETD 131 UCStbMo
Bust of Man marble; 20-1/4
EXM 34 IVA
Cameo c 1580 Asate
ENC 150
Cassone partly gilded walnut;
29-3/4x71-1/2x24
CPL 90 UCSFCP
Cassone, Florence c 1540
wood
BURC pl 20 IFMN
Cassona, Sienna c 1480 wood
BRUC pl 20 ELV
Cassone, Venice wood
KUH 106; ROOS 154F
UNNMM
Cassone, Venice walnut
CLE 99 UOClA (42.607)
Cassone: Medici-Strozzi
Casket--Bridal Chest of
Maria de'Medici 1512
PRAEG 294
Cassone: Scenes from Roman
History walnut; 35x74
COOPF 24 IRCol
Cassone Frontal walnut
CLE 97 UOClA (236.15)
Centaur, head bronze; 4-1/4
DETD 73 UOTW
Cheetah bronze
BRIONA 88 FPL
Christ Bearing the Cross,
relief, Venice bronze;
6-3/4x9-1/4
SOTH-1:209
Christ on the Road to Calvary
c 1500 enameled gold in
high relief; 69 mm
DETD 142 UNNGutm
Coat of Arms Istrian stone;
33-1/2x22
VICF 53 ELV (7674-1861)
Courtyard Decoration 1556/60
BOE pl 156 IRSp
Credenza, Brescia
CLE 96 UOClA (39.188)
Crozier of Pope Clement VII
c 1525 silver, gilt metal
and jewels
BURC pl 31 IFMN
The Dance, Florentine, chess
board detail ivory
BURC pl 77 IFMN
Dancers, Padua early 16th c.
bronze; 7-1/4
DETD 117 FPL

Diana, copy of Roman figure
bronze
HUNTV back cov UCSmH
Dragon-stem Goblet, Venice
glass
NEWTEA 164 (col) UNCorC
Elephant, Padua 1st Q 16th c.
bronze; 5
DETD 124 UNNErl
Elephant; Mouth of Hell,
Gardens of Bomarzo c 1565
rock sculpture
BAZINW 365 (col) IBomaO
Female Figure, Florence,
Omphale cast bronze
ELIS 99 UNNMM
Florentine Cabinet, used as
strong-box 1560
BURC pl 21 IFMN
Florentine Cassapanca, settee
c 1550
BURC pl 20 IFMN
Fountain of the Organ begun
1550
UPJ 337 ITiE
Garden Gate 1593
BOE pl 158 IRZ
Giovanni da Verrezano
AMHP 15 (col)
God the Father, after Lorenzo
Ghiberti, medallion bronze;
3-5/8
YAP 216 -USe
Gold Bull ('Bola d'Oro'): St.
Mark Handing a Banner to
Andrea Gritti, medal Dm:
36 mm
DETD 100 UNNSa
Helmet iron
GAF 158 FPArm
Helmet c 1540 steel, etched
and gilded; 18x7-1/4xc 16
DETD 90 UNNMM
Hercules, Florentine(?), copy
of Roman figure bronze;
14-5/8
HUNT pl 3-4; HUNTV front
cov UCSmH
Hermes, copy of Roman figure
bronze
HUNTV front cov UCSmH
Jeweled Pendant gold, enamel,
precious stones, pearls;
7-1/4x3-1/4
COOP 83 UNNLeh
Kiss of Peace, Tabernacle
gilded silver, paintings under
crystal; 14
CHAR-2:93 (col) FPL

Kneeling Virgin wood
 NM-12:201 UNNMMC
Kneeling Woman bronze
 SOTH-2:218
Large Vase: Two Relief Masks
 and Grotesque Female
 Figure Handles, Venice
 ceramic; 11-1/2; Dm: 15
 DETD 50 UCtHWA
Lorenzo de'Medici, bust
 c 1530 plaster; 61 cm
 BERLEI 8 GBSBe (184)
Lion, Florentine c 1500 bronze;
 14x16-1/4
 USNK 193; USNKP 425;
 USNKS 41 UDCN (A-153)
Male Figure bronze
 CLE 92 UOClA (47.509)
Marie de'Medici Mirror c
 1600 jeweled and enameled
 rock crystal, agate and
 sardonyx frame; 16
 BAZINL pl 339; CHAR-2:
 92; GAF 109 (col); 151;
 LARR 300 FPL
The "Martelli Mirror" c 1475/
 80 bronze, encrusted with
 gold and silver; 9-1/4;
 Dm: 7-7/8
 ASHS pl 22: DETD 113;
 VICF 61 ELV (8717-1863)
Mermaid, jeweled pendant
 BAZINL pl 300 IFArg
Michelangelo, head bronze
 CHAR-2:40; LOUM 87
 FPL (698)
Milanese Embossed Parade
 Helmet c 1540
 CHRP 254 UDCN
Minerva Pendant enameled
 and jeweled gold; 10x3.8
 cm
 DETD 142 NAR
Mouths of Truth (Bocche di
 Leone): Masks
 HALE 36 IVP
Negress, head c 1500 black
 marble; 17
 COOP 173 FPRoths
Neptune on a Dolphin, Venice
 c 1575
 YAP 218 -UTh
Paduan Candelabrum bronze;
 64-3/4
 DEYE 66 UCSFDeY
 (61.35)
Panther c 1500 bronze; 7-3/4
 x10-3/4
 DETD 124 UOTA

Pegasus and Perseus, relief,
 Caraffa Capella c 1512
 SEZ 210 IND
Pendant: Madonna and Child
 with Saints enameled gold,
 pearls and emeralds
 CLE 95 UOClA (59.337)
Pendant: Siren baroque pearl /
 COOP 168 FPRoths
Pendant, with Byzantine cameo
 CON-1:pl 79 EEQ
Pendants jeweled and enameled
 gold
 DETD 148 (col), 149 (col)
 UNNGutm
Pietro Bembo, medallion
 ENC 83
Pseudo-classical Relief c 1525
 PANM il 88; PANR front
 AVK
Raphael's Workshop Members
 Decorating Loggia, relief
 c 1518 stucco
 GOMB 236 IRV
Rearing Horse bronze
 BAZINW 341 (col) UNNMM
St. Sebastian terracotta
 CHENSN 383 UNNMM
Side Table
 ST 315
Spinario (Cavaspina) marble;
 .85 m
 FAL pl 5 IRB (CLXXVI)
Table-knife ivory, ebony
 handle
 BURC pl 26 ELV
Two Equerries bronze; 18
 DETD 126 IRC
Two Suits of Tilting Armor
 COOP 53 IBrMa
Venus Fountain (Fontana
 della Venere)
 MINB 87 IRB
Venus Prudentia(?) gilt bronze
 CLE 91 UOClA (48.171)
Vulcan bronze; 10-1/2
 YAP 220 -UFo
Young Florentine, bust
 GAF 140 FPL
Youth, profile relief head
 marble
 READM pl 12 ELV
--16/17th c.
Sleeping Putti marble; .90x
 .65 m
 FAL pl 6 IRB (CLXXXIV)
Stool: Carved Face Decoration
 wood
 ROOS 154E UNNMM

--17th c.
Adrian, bust marble .67 m
 FAL pl 11s IRB (CXXIV)
Agrippa, bust marble .72 m
 FAL pl 11b IRB (CXXXVI)
Armor, engraved and gilded
 with arms of House of
 Savoy c 1625/35
 LARR 300 ELWal
Augustus, bust marble; .70 m
 FAL pl 11d IRB (CXXXIX)
Caligula, bust marble; .70 m
 FAL pl 11f IRB (CLVII)
Cassone wood; 39x80-3/4x29-
 3/4
 YAH 34 UCtY
Chiaro da Verrazano, bust
 marble; 36x37-1/8
 USNKP 437 UDCN (K-448)
Cicero, bust marble; .74 m
 FAL pl 11a IRB (CXXXVIII)
Claudius, bust marble; .78 m
 FAL pl 11g IRB (CXXVII)
Crouching Boar, Florence
 bronze; 6-1/2
 YAP 220 UNNLeh
Domitian, bust marble; .7 m
 FAL pl 11r IRB (CLIV)
Dragon-form Goblet c 1650
 rock crystal, enameled
 gold mount; 14-1/8
 LARR 300; RIJA pl 133
 NAR
Eagle Fountain
 MINB 87 IRB
Equestrian bronze
 SOTH-3:262
Ewer: Minerva; Dragon
 Handle sard and onyx,
 enameled gold mount; 11
 CHAR-2:105 (col) FPL
Facade 1549/1695
 BAZINW 402 (col) ILeC
Fountain
 MINB 89 IRB
Galba, bust marble; .7 m
 FAL pl 11i IRB (CXXVII)
Giovanni da Verrazano, bust
 marble; 34-7/8x27-1/8
 USNKP 436 UDCN (K-449)
Hanukkah Lamp c 1600 bronze
 ROTH 340 ELHow
Harpsichord, Rome gilded
 wood; 105
 MU 180-81; NMA 178
 UNNMM
Madonna and Child boxwood;
 11-5/8 DETI 60 UMiD

Minerva, bust marble; .82 m
 FAL pl 9 IRB (CCXXXI)
Nero, bust marble; .74 m
 FAL pl 11h IRB (CXXXIX)
Old Woman, bust marble; .60 m
 FAL pl 10; MATTB pl 35
 IRB (CCLXVII)
Otto, bust marble; .75 m
 FAL pl 11(1) IRB (CLII)
Oval Fountain (Fontana Ovale)
 MINB 83 IRB
Pendentive and Arch, Cappella
 Paolina 1610/12
 WIT pl 4B IRMMag
Perfume Bottle Pendant,
 Venice c 1600 rock crystal,
 enameled and jeweled gold
 mounts; 64 mm
 DETD 142 UNNGutm
Portable Pinciana
 MINB 82 IRB
Princess Anna Colonna Bar-
 berini, bust c 1658 gilt
 bronze and black marble;
 figure: 31; plaque: 33-3/4
 ALB 159; ALBA; FAIY 4
 UNBuA
Rustic Fountain, secret garden
 MINB 89 IRB
Sarcophagus marble
 MINB 96 IRB
Scipio Africanus, bust marble;
 64 cm
 FAL pl 8 IRB (LXXVI)
Scipio Africanus, bust marble;
 .65 m
 FAL pl 11c IRB (CXXXV)
Settimius Severus, head
 marble; .38 m
 FAL pl 7 IRB (LX)
6-ducats: Charles Caspar of
 Trier 1659 gold
 SOTH-4:254
Sphinx, Piazalle Scipione
 Borghese
 MINB 89 IRB
Sphinx Pendant enameled and
 jeweled gold; 8.5 cm
 DETD 142 NAR
Tiberius, bust marble; .74 m
 FAL pl 11e IRB (CLXII)
Tiberius, bust marble; .75 m
 FAL pl 11q IRB (CXXXXIV)
Vase
 MINB 92 IRB
Vespasian, bust marble; .66 m
 FAL pl 11p IRB (CLV)
Vespasian, bust marble; .70 m
 FAL pl 11o IRB (CLI)

Viale dei Mascheroni Gate
 MINB 93 IRB
Vitellius, bust marble; . 68 m
 FAL pl 11m IRB (CLVII)
Vitellius, bust marble; . 68 m
 FAL pl 11n IRB (CXL)
Wrought Iron Gates 13'x9'10''
 TOR ep CTRO (922.5.1)
--17/18th c.
Negro Slave, Venetian black
 marble and ptd wood; 76
 DEYE 171 UCSFDeY (3888)
--18th c.
Amore Vincitore, plaque
 marble; . 70x. 60 m
 FAL pl 14 IRB (LXXIV)
Apollo and Marsias, relief
 marble; . 54x. 58 m
 FAL pl 15 IRB (XXVI)
Chimneypiece, detail c 1720/30
 plaster
 WHINN pl 105B EBarn
Coach of King John V
 LARR 359 PoLCo
Commedia dell'Arte Figures,
 Venice c 1770
 ENC 199
Console Table Supported by
 Fish
 SOTH-2: 228
Decorative Sculpture:
 Musicians
 BEREP 122 IBagP
Diana Fountain after 1732
 BUSB 168 ICaseC
Erma di Bacco, bust bronze
 and alabaster; 1. 75 m
 FAL pl 13 IRB (CXXXXV)
Gateway Entrance of Piazzale
 Brasile c 1796
 MINB 73 IRB
Giunone, bust redantico and
 alabaster; . 68 m
 FAL pl 12 IRB (CXXXXVI)
Harpsichord--Triton legs
 FAUL 120 UNNMM
Lion of St. Mark, Venetian
 cannon ornament 1709 L:
 73 cm
 BOES 115 DCTo
Martyrdom of John the Bap-
 tist, reliquary silver
 FAUL 171 UNNMM
Maschere Fountain
 MINB 81 IRB
Naples Porcelain Group
 ENC 657
Neopolitan Presepio (creche);

detail: Feasting
 BAZINW 404 (col) GMBN
Octagonal Table marble and
 metal; . 93x1. 40x. 88 m
 FAL pl 28 IRB (CCLXXXII;
 CCLXXXIII)
Philip von Stosch, bust (after
 P. E. Ghezzi)
 TAYFT after 336
Spaghetti Eaters, Capodimonte
 INTA-2: 215
Standing Woman, Capodimonte
 CLE 147 UOClA (50. 570)
Table, entwined Dolphin Sup-
 ports wood, red granite;
 1. 01x2. 05x1. m
 FAL pl 27 IRB (CCLXXX;
 CCLXXXI)
Table, Winged-Lion Supports
 wood and marble; 1. 02x2. 28
 x1. 04 m
 FAL pl 25 IRB (CCLXXVIII;
 CCLXXIX)
Table, Winged-Lion Supports
 wood and alabaster; 1. 03x
 2. 18x. 96 m
 FAL pl 26 IRB (CXXXI;
 CLIX)
Time Exalting Virtue and the
 Arts, Marly c 1700
 LARR 349 IBolbG
Torah Scroll Finials, Venice
 ROTH 319 ELULJ
Vase
 MINB 92 IRB
Woman and Man, Capodimonte
 CLE 147 UOClA (50. 569)
--19th c.
Luigi Canina, bust
 MINB 104 IRB
ITALIAN, or GERMAN--18th c.
 Neptune and Amphitrite ptd
 wood, partly gilded; 25
 BOSMI 135 UMB (57. 665)
Italian Boy. Ehrlich
Italian Girl. La Fresnaye
Italian Girl II. Butler
Italian Venus. Canova
Italian Woman
 La Fresnaye. Italian Girl
Italica Gens. Calori
Italienisches Madchen. Hubacher
ITALO-BYZANTINE
 Raising of Lazarus, tablet
 ivory; 7-1/2x3-1/2
 GRIG pl 112 ELBr
ITALO-FLEMISH
 Man Carrying a Child c 1600

HUNT pl 12-14 UCSmH
Woman Combing her Hair
c 1600 bronze; 5-1/2
HUNT pl 18 UCSmH
Woman Returning from Market
c 1600 bronze; 8-1/8
HUNT pl 19-20; HUNTA 15
UCSmH
Woman Touching her Foot
c 1600 bronze; 5
HUNT pl 15-16; HUNTA 15
UCSmH

IZSO, Miklos (Hungarian 1831-75)
Csokonai-Vitez Memorial,
sketch plaster
GAD 47 HDCa
Dancing Peasant 1870 terra-
cotta; 28.2 cm
GAD 46 HBA
Good Shepherd 1862 marble;
95 cm
GAD 45 HBA

Ivan, Saint
Brokoff, F. M. St. John of
Mathy, St. Felix of Valois,
and St. Ivan

Ivan IV Vasilievich (Czar of Russia
1530-84), called Ivan the
Terrible
Antokolski. Ivan the Terrible,
seated figure

Ivanyi-Grunwald, Bela (Hungarian
Painter)
Kisfaludi-Strobl. Bela Ivanyi-
Grunwald, bust

Ivie, Jonathan and Elizabeth
Weston. Relief and skulls,
detail, Jonathan and
Elizabeth Ivie Monument

Ivo, Saint
Braun, M. B. St. Ivo

L'Ivresse. Lambeaux

Ivy
Early Christian. Balusters
with Acanthus and Ivy Leaf
Scrolls

Ixion
Austrian--13th c. Sisyphus,
Tantalus, Ixion

J. P.
The Fall (Der Sunderfall),
Salzburg 1520/25 pearwood;
64x46 cm
MUL 56 GGLM

Jobotinsky, Vladimir Evgenevich
(Zionist Leader 1880-1940)
Leschnitzer. Jabotinsky, head

JACKSON, C. d'O (Scottish) See
PILKINGTON-JACKSON, C. d'O

Jacob
Epstein. Jacob and the Avenger
French--12th c. Jacob the
Elder, and Paul
German--17th c. Tray (Lokhan):
Reconcilliation of Joseph and
Jacob
Ghiberti. Baptistry Doors--
East: Esau
Italian--13/14th c. Altar of S.
Jacopo
Loeb. Jacob and Rachel
Martini, A. San Giacomo
Master of Rabenden. St.
Jacob, seated figure

Jacob van Sierck
Gerhaerts. Archbishop Jacob
von Sierck, effigy

JACOBELLO DALLE MASEGNE
(Italian fl 1383-1400), and
PIERPAOLO DALLE MASEGNE
High Altar 1388/92
WHITJ pl 189B IBoF

Jacob's Ladder
Maitani--Foll. Jacob's Ladder,
pillar

JACOBSEN, Niels Hansen (Danish 1861-
1941)
Dryad 1918 bronze
VEN-38: pl 44 DCSt
A Shade bronze
MARY pl 66 DC
Troll Scenting Christian Flesh
1895/96 bronze; 157 cm
BOES 203 DVJ

JACOBSEN, Robert (Danish-French
1912-)
La Cathedrale d'Hircan 1965
iron; 75
EXS 87
Composition
FPDEC il 11
Construction 1950/54 iron;
18-1/8x20-1/2x20-1/2
TRI 202 NAS
Le Crapaud Amoureux 1959
iron; 5-3/4
NEW pl 170 SnSN
Figurine
KEPS 149
Head with Keys 1957 iron; 27
SEITA 146 UICM
Hengesit 1953 wrought iron;
30x17-3/4
GIE 250
BLL

•

--1958 iron
 MARC pl 68 BLMB
Machine Pacifique 1962 iron;
 62
 SEITC 43 FPFr
Noir Rouge 1962 wood and iron;
 23-1/4x21-5/8
 READCON 247 (col) FPFr
La Nuit de la Peur 1960
 24. 8x32
 CARNI-61:#179 FPFr
Polychromed Sculpture 1960
 iron; 92-1/2x42-1/2x30
 GUGE 69 UNNCh
The Right-hand Robber 1957
 iron; 108 cm
 BOES 140 DHuL
Satellite Man 1964 104x32-3/4
 CARNI-64:#46
Sculpture 1957
 BERCK 127
--1957
 BERCK 128
--1957 iron
 BERCK 127
Sculpture No. 88 1958 iron
 MAI 142
Sculpture en Fer 1956
 ABAM 53 FPRe
Scultura in Tono Maggiore
 1956 iron
 VEN-66:#160
Spatial Sculpture in Space
 LARM 391 BBD
Statique II 1959 iron; 91 cm
 BOES 188 DAA
Structure 1950 iron; 22
 SCHAEF pl 120
Vertical Pressure 1959 iron;
 44x20-1/2
 SEAA 144
Vibrazione Spaziale 1964 iron
 VEN-66:#161
Jacobus Major, Saint
 French--13th c. St. Jacobus
 Major
JACOME FLORENTIN See JACOPO
 FLORENTINO
JACOPINO DA TRADATE
 Pope Martin V 1421 marble;
 c twice LS
 POPG pl 63 IMC
JACOPO DA TREZZO(?) (Italian
 c 1515-89)
 Philip II, King of Spain,
 cameo
 CON-1:pl 79 EEQ

Jacopo di Portogallo
 Rossellino, A. Cardinal
 Jacopo of Portugal Tomb
JACOPO FLORENTINO (Jacome
 Florentin; Jacopo Florentino;
 Jacopo L'Indaco; Torni
 L'Indaco) (Florentine d 1526)
 Entombment of Christ, detail:
 Head of Joseph of
 Arimathea c 1530/25
 GOME pl 2-6; KUBS pl 65A
 SpGB
JACOT-GUILLARMOD, Robert (Swiss
 1918-)
 Taureau 1954 copper; 170 cm
 JOR-1: pl 36
JACQUE DE BAERZE (French)
 Altar, Chartreuse de
 Champmol 1390/99
 MULS pl 15B, 16 FDM
Jacqueline. Belmondo
Jacqueline. Wlerick
JACQUEMON DE NIVELLES (Flemish
 1298-)
 Angel with Musical Instrument
 DEVI-2 BNG
JACQUERMAT, A. (French)
 Hunter and Hounds
 REED 122 UCBe
Jacques, Saint
 French. St. Jacques, seated
 figure
JACQUES, Marcel (French)
 Bust of an Old Woman
 TAFTM 49
JACQUES DE GERINES (Netherland-
 ish d 1463), and RENIER VAN
 THIENEN, THE ELDER
 Isabella of Bourbon Tomb 1476
 MULS pl 106 BAC
--Figures: Philippe de Neveu;
 Anne of Burgundy;
 Margaret of Burgundy c 1476
 MULS pl 107A-C NAR
--Statues 1476 bronze; c 22
 JANSK 600; POST-1: 89
 NAR
--Two Figures c 1476 cast
 brass; 21-5/8; 22-13/16
 DETF 264 NAR (Cat. 1915,
 #213)
JACQUET, Alain (French 1939-)
 Grey Smoke 1967
 KULN 179
 La Source 1966
 KULN 35
JACQUET, Mathieu (French fl 1610)

Henry IV, head bronze; 12
 CHAR-2:106; LOUM 143
 FPL (407)
JACQUOT, Charles (French)
 Le Soir
 TAFTM 48
JAECKEL, Joseph
 Angela 1950 hammered
 copper
 GERT 99
 Summer (Der Sommer) 1952/53
 hammered copper
 GERT 98
JAECKEL, Matthaus Wenzel (Matej
 Vaclav Jokl) (Czech 1655-)
 Altar, detail 1698/1702
 STECH pl 35 CzPL
 Altar: Holy Trinity 1701/02
 STECH pl 36-7 CzPKn
 Madonna with St. Bernard
 1709
 HEMP pl 81; STECH pl 38
 CzPCh
 Madonna with St. Thomas of
 Aquino and St. Dominic
 1708
 BUSB 119 CzPCh
JAENISCH, Hans (German 1907-)
 Lying Ox (Liegendes Rind)
 1952 bronze
 GERT 179
 Mother and Child (Mutter und
 Kind) 1952 bronze
 GERT 178
 Pelican 1952 bronze; 5-5/8
 KUHNG pl 124 UMCB
 (1955.1)
Jagello, Friedrich Kasimir
 Vischer, Hermann, the
 Younger. Friedrich
 Kasimir Jagello Tomb
JAGGER, Charles Sergeant (English
 1885-1934)
 The Artillery Memorial 1925
 Portland stone, bronze
 figures
 CASS 105; GLE 57; HOF
 203; MARY pl 82 ELHy
 Christ bronze
 MARY 153 EKeM
 Modern Building Construction
 Portland stone
 MARY pl 83 EL
 Shackleton bronze
 MARY 72 ELRG
JAGGI, Luciano (Swiss)
 Torso of Youth marble
 VEN-20:22

Jagiello
 Wiwulski. Jagiello, equest
Jagna. Droste, K. H.
Jaguars
 Barye. Jaguar Devouring a
 Crocodile
 Barye. Jaguar Devouring a
 Hare
 Harth. Jaguar
 Matisse. Jaguar (copy of
 Barye's Jaguar)
JAHN-GERMANN, Charlotte (Swiss
 1921-)
 Engel bronze; 45 cm
 JOR-1:pl 39
Jairus' Daughter
 Early Christian. Santa Giulia
 Casket
JAKOB VON LANDSHUT, and HANS
 VON AACHEN
 St. Lawrence Gate (side figures
 by Hans von Aachen) c 1495/
 1505
 BUSR 126 FStrC
Jakopic, Rihard
 Dolinar. The Painter Rihard
 Jacopic
JALEA, Ion (Rumanian)
 Centaur stone
 VEN-42:pl 101
JALEY
 La Priere marble
 HUBE pl 36 FPL
James, Saint, the Greater
 Burgundian--15th c. St. James
 English--15th c. St. James
 Preaching
 Flemish--16th c. St. James
 French--12th c. Facade of St.
 Trophime
 --Paul and James, main portal
 French--13th c. Chartres
 Cathedral, south transept
 --St. James altar, frontal
 relief
 German--13th c. Shrine of
 Charlemagne
 Mantegazza, C. and A.--Foll.
 St. James
 Master Matteo. Portico de la
 Gloria: St. James
 Master of the Mascoli Altar.
 Virgin and Child between
 SS Mark and James
 Medieval. St. James
 Mosto. Glorification of St.
 James
 Nicholas of Verdun. Shrine

of the Three Kings: Apostle
James
 Sansovino, A. Corbinelli Altar
 Sansovino, J. St. James
 Spanish--13th c. St. James(?),
 head
 Spanish--15th c. St. James
James, Saint, the Less
 Berg, K. Apostle St. James
 the Less
 French--12th c. St. James
 the Less, and St. Paul
 German--13th c. St. James
 the Less
 Rhenish--15th c. St. James
 the Less
 Riemenschneider. St. James
 Minor
James, Son of Zebedee
 Leinberger, H. James, Son
 of Zebedee
James I (King of England 1566-1625)
 English--15th c. Arms of
 James I
James II (King of England 1633-1701)
 English--17th c. James, Duke
 of York
 Gibbons. James II#
JAMES, Isaac
 Henry Lord Norris and Lady
 Norris Monument 1601
 MOLS-2: covs; WHINN 10B
 ELWe
James, William (British Naval
 Officer)
 Dobson. Admiral Sir William
 James, bust
James of Alcala, Saint
 Cano, A. St. Diego of
 Alacala
 Mena. St. Diego of Alacala
JAMNITZER, Christophoro (German
 1563-1618)
 Ewer and Basin, Nuremberg
 1603 silver gilt; ewer:
 c 17-1/8; basin L: 25-1/2
 CHRP 255; ARTV pl 39
 AVK
JAMNITZER, Wenzel (Austrian 1508-
 85)
 Ewer
 ENC 499
 Spring bronze; c 28
 BAZINW 369 (col); MAR
 124 (col) AVK
JAMNITZER WORKSHOP
 Scales c 1565/70 gilt bronze
 CLE 113 UOC1A (50.382)

JAN VAN MANSDALE
 Soldier in Armor, relief
 1377/85
 HARVGW 48 BME
JAN VAN MECHELN (Netherlandish
 fl 1467/81)
 Choir Stalls c 1480
 MULS pl 153A SpLeA
JANCIC, Olga (Yugoslav 1929-)
 Doubled Form 1962 plaster;
 11x24
 READCON 191
 Maternity 1957 stone
 VEN-62: pl 162
 Mourning Woman 1954
 BIH 183 YB
 Seated Figure 1954 plaster
 BIH 182 YBMG
 Small Torso 1960 stone;
 13-3/4
 ARTSY #101; MAI 143
 Two Figures
 BERCK 1957
JANCO, Marcel See YANCO, Marcel
Janick, Mme.
 Despiau. Mme. Janick, bust
Janina. Stasinska
JANNIOT, Alfred Auguste (French
 1889-)
 Apollo, torso, study for Nice
 Fountain
 BAS 64 FPM
 Bas Relief
 BAS 70 FPCol
 Europa
 BAS 71
 Facade
 BAS 68, 69 FPTo
 Female Figure, study for
 Bibliotheque Nationale
 figure
 BAS 66
 Fontaine de Nice, detail
 BAS 73
 French Equatorial Africa,
 relief
 HOF 200 FPAf
 La Justice, relief
 BAS 72 FPutM
 Melpomene
 BAS 63
 Thalie
 BAS 63
 Trois Jeunes Filles
 BAS 67
 Venus, relief
 BAS 65 FPCol
 Woman's Torso bronze
 VEN-38: pl 50

Janosik
Firk. Janosik and the Mountain
Cock
JANOUSEK, Vladimir (Czech 1922-)
Boats 1965 polyester; 35-3/8
NEW pl 249
JANOUSKOVA, Vera (Czech 1922-)
Staubling 1965 Asbertzement;
87 BER 37
JANSZ, Rintie (Dutch)
Ewer 1671 silver; 38.5 cm
GEL pl 136 NLeF
Janus
French--13th c. Janus at New
Year's Feast, relief
Japanese (Subject)
Kolbe. Kauernde Japanien
Japanese War God. Paolozzi
Jaracz
Puget, J. Jaracz, head
Jardin de Pins
Primaticcio, F. Grotte,
Jardin de Pins
JAREMA, Maria (Polish 1908-58)
Dance 1955 plaster
JAR pl 34
JARNUSZKIEWICZ, Jerzy (Polish
1919-)
Marcinelle (Tragic Group)
1958 patinated plaster
JAR pl 31
Rhythms II 1965/66 stainless
steel; 44-1/2x35x42-1/2
GUGE 77
Jarrett, William d 1633
English--17th c. Cartouche
to William Jarrett
Jars
Tooth. Tobacco Jar and Cover
Jason
Bertoldo di Giovanni. Jason
Resting after Slaying the
Dragon
Paolozzi. Jason
Thorvaldsen. Jason with
Golden Fleece
Jasperware See Wedgwood
Jaucourt, Mme.
Houdon. Mme. Jaucourt
JAVACHEF, Christo See CHRISTO
Javanese Panther. Hernandez, M.
Jay
German--18th c. Jay
Je Suis Belle
Rodin. I am Beautiful
Jean, head. Botzaris
JEAN, Marcel (French 1900-)
Spectre of the Gardenia 1936

plaster, covered with black
cloth, with zippers and
movie film; 10-1/2
NMFA 176; SEITA 64
Jean Claude. Osouf
Jean de Berry See Jean of France
(1st Duc de Berry)
Jean de Bologne See Bologna,
Giovanni
JEAN DE CAMBRAI (Jean de Rupy)
(French)
Apostle, head, Chapel,
Chateau-sur-Yevre 1408/16
stone
LARB 374; MULS pl 23B
FPL
Jean, Duc de Berry, effigy, Sainte
Chapelle begun 1405
HARVGW 41; MULS pl 22
FBouCa
Virgin and Child c 1408
MULS pl 20A FMarcC
JEAN DE CHARTRE See GUILLAUMET,
Jean
Jean de Cromoy
Flemish--14th c. Jean de
Cromoy, effigy
JEAN DE LIEGE (French fl 2nd
half 14th c., d 1383)
Charles V of France, as St.
Louis 1382 stone; 80
KO pl 43; LARB 356 FPL
Jeanne de Bourbon (Joanna of
Bourbon), as Marguerite of
Provence c 1382 stone; 78
BUSR 13; GAU 150; KO pl
43; LARB 356 FPL
Jeanne d'Evreux, effigy
LARB 389
Marie de France, bust c 1382
marble; 12-1/4
NM-7:41; NMA 55 UNNMM
(41.100.132)
Philippa of Hainault, effigy
c 1355/57 marble
STON pl 148 ELWe
JEAN DE LOUP
Grape-Harvest Capital, nave
c 1230
BAZINW 297 (col) FRhC
Jean de Mathy, Saint (French Priest
1160-1213)
Brokoff, F. M. St. John of
Mathy, St. Felix of Valois,
and St. Ivan
Jean de Merode
Flemish--16th c. Jean de
Merode Tomb

Jean de Reome, Saint
 French--15th c. St. Jean de
 Reome
JEAN DE ROUEN (Joao de Ruao)
 (French-Portuguese c 1495-
 1580)
 Retable of Varziela
 SANT pl 87
 Virgin and Child c 1535/50
 KUBS 96A PoLV
JEAN DE RUPY See JEAN DE CAM-
 BRAI
JEAN DE VALENCIENNES (Flemish
 fl 1378-86)
 Zachariah and the Archangel
 Gabriel; Tristan and Iseult,
 corbels, Bruges City Hall
 limestone; 11-7/16x21-1/4
 x9-7/8; and 10-5/8x15-
 5/16x9-7/8
 DETF 230, 231 BBrG
 (Inv. II 404, 405)
Jean de France (1st Due de Berry
 1340-1416)
 Jean de Cambrai. Jean, Duc
 de Berry, effigy
Jean Sans Peur See John (Duke of
 Burgundy), called John the
 Fearless
Jeanes, Mlle.
 Despiau. Mlle. Jeanes
Jeanne, head. Despiau
Jeanne de Boulogne See Bourbon,
 Jeanne de
Jeanne de Bourbon (Consort of
 Charles V of France) See
 Bourbon, Jeanne de
Jeanne de Bourbon d'Auvergne
 d 1521
 French--16th c. Jeanne de
 Bourbon d'Auvergne, effigy
Jeanne d'Evreux See Evreux,
 Jeanne d'
Jeanne de Flandres (Wife of Enguer-
 rand IV, Sire de Coucy)
 French--14th c. Jeanne de
 Flandres
Jeannette
 Matisse. Jeannette#
Jedburgh Slab. Anglo-Saxon
Jefferey, John d 1611
 English--17th c. Sir John
 Jeffrey Monument
Jefferson, Thomas (Third President
 of the U. S. 1743-1826)
 David D'Angers. Thomas
 Jefferson
 Houdon. Thomas Jefferson,
 bust

JEHAN BARBET DE LYON
 Wind-Vane: Angel, Chateau du
 Lude, Sarthe 1475 bronze
 EVJL pl 28 UNNF
JEHAN DE BOULLOGNE See BOLOG-
 NA, G.
JELIN, Christopher, and Antoni
 KELLER
 Portal, Tubingen Castle 1606
 BAZINW 372 (col) GTuIU
Jelky, Andras
 Medgyessy. Andras Jelky
Jellinge Rune Stone. Viking
Jellinge Style
 Danish--11th c. Golden
 Treasure of Hiddensee
Jemand. Hafelfinger
JENDRITZKO, Guido (Polish-Italian
 1925-)
 Composition (Komposition) II
 1959 plaster, for bronze; 25-
 5/8x17-3/8 TRI 153
 --III 1959 bronze
 MAI 144
 --XV for bronze; 2.11x1.35 m
 OST 108 GBSp
 --XVII 1960 bronze; 68x47 cm
 KUL pl 25
JENKINS, F. Lynn (English)
 Diana bronze NATSA 120 UNNMM
Jennes, R.
 English--18th c. Sir R. Jennes,
 effigy
JENNINGS, Leonard (English)
 Paola and Francesca bronze
 VEN-12:pl 89
Jenny. Wlerick
Jensen, C. A. (Danish Portrait
 Painter 1792-1870)
 Freund. C. A. Jensen, head
JENSEN, Garrett (English) See
 BULLOCK, George
JERACE, Francesco (Italian)
 Francesco Crispi, bust marble
 VEN-26:pl 41
 Princess Galatro-Colonna, bust
 marble
 VEN-3:pl 43
 Princess Ruprescht marble
 VEN-20:29
JERACE, Vincenzo (Italian)
 Count Giuseppe Volpi di
 Misurata, bust bronze
 VEN-28: pl 102
Jeremiah
 Donatello. Jeremiah
 French--12th c. Jeremiah,
 trumeau figure
 French--12th c. North Portal
 Figures

French--13th c. Chartres
Cathedral, north transept
German--12th c. Jeremiah,
detail, Three Kings Shrine
Niccolo. Jeremiah, relief
Niederhausern. Jeremiah
Rude. The Prophet Jeremiah
Sluter and Werve. Well of
Moses
JERICHAU, Jens Adolphe (Danish
1842-64)
Badende Piger c 1862 braendt-
ler; 36 cm
COPGM 45 DCN (I. N. 378)
Hvilende Havfrue med to
Saelhunde braendtler; 41.5
cm
COPGM 46, 47 DCN (I.N.
2587)
Penelope 1843/46 marble;
182 cm
COPGM 43 DCN (I.N.366)
Jerome, Saint
Becerra. St. Jerome
Bellano. St. Jerome, Kneel-
ing Figure
Bernini, G. L. St. Jerome
Braun, M. B. St. Jerome#
Desiderio da Settignano.
St. Jerome in the Desert,
relief
Francesco di Giorgio Martini.
St. Jerome, plaque
French--13th c. Sts. Martin,
Jerome, and Gregoire le
Grand
German--8th c. Dagulf's
Psalter: King David and
St. Jerome
German--16th c. St. Augustine
and St. Jerome
Juni. St. Jerome
Kohl, H., and F. Preiss. St.
Jerome, altar figure
Laurana. St. Jerome and St.
Gregory, relief
Martinez Montanes. Altar of
San Isidoro del Campo
Pilgram. St. Jerome, pulpit
detail
Riemenschneider. St. Jerome
and the Lion
Siloe, D. St. Jerome, seated
figure
Spanish--16th c. St. Jerome
Sturm, J. A. St. Jerome
Torrigiani, P. St. Jerome
Vittoria. St. Jerome#

Vivarini, A. and D'Alemagne.
Altarpiece
Zarcillo y Alcarez. St. Jerome
Jerusalem
French--12th c. Altar Retable
German--12th c. Angel's Choir
Screen, detail: Apostles,
beneath representation of
Jerusalem
Gothic-French. St. Matthew
Writing at Command of an
Angel, surmounted by
Heavenly Jerusalem
Russian--15th c. "Jerusalem",
or Tabernacle of Jesus
JESPERS, Floris (Belgian 1889-)
Negresses 1957 bronze; 12x52
MID pl 87 BAM
JESPERS, Oscar (Belgian 1887-)
American Sailor (Marin
Americaine) stone
MARTE pl 14
Bather (Baigneuse) granite
MARTE pl 40
Belgium at Work 1937 chiselled
brass; 81
MID pl 37 BAM
Birth (Geboorte) 1932 granite;
L: 125 cm
STM BAM
Edgard Tytgat, head 1930
granite
VEN-60: pl 150 BBR
Head sandstone
MARTE pl 14
In the Sun 1948 bronze; 81
MID pl 39 BAM
Nude Seated stone
MARTE pl 45
The Object marble
MARTE pl 45
The Prisoner granite
MIA 145 BBR
Relief, Belgian Pavilion, Paris
World's Fair 1935 hammered
copper
GOR 58, 59
Seated Nude polished granite
MARTE pl 40
Sitting Woman
DEVI-2 BBR
Sleeping Child (Enfant Endormi)
stone
MARTE pl 40
Standing Figure
GOR 67
Temptation of St. Anthony 1934
L: 57 GOR 66; NNMMARO
pl 286; SGO-4: pl 40 UNNMMA

Torso c 1921 firestone; 48-1/2
 READCON 180 NOK
Torso de Mulher 1935 granite
 SAO-1
The Toy (Le Jouet) stone
 MARTE pl 45
Waiting Woman 1954 bronze;
 20 MID pl 40 BAM
Young Girl, head marble
 MARTE pl 45
JESPERS, Oscar, and Henri PURVEZ
 Belgium at Work, relief L:
 100 GOR 64, 65 UVRVU
Jesse
 Flemish--16th c. Jesse,
 seated figure with Tree
 Welsh. Sleeping Jesse
Jesse Tree See Tree of Jesse
The Jester. Picasso
Jesus Christ
 Anglo-Saxon. Ruthwell Cross
 Belgian--12th c. Christ, head
 Bologna. Altar of Liberty:
 Christ
 Byzantine. Christ Crowning
 Romanus and Eudoxia
 Byzantine. Medallion: Christ,
 bust
 Danish--10th c. Runic
 Inscription Memorial Stones
 Danish--12th c. Jesus Christ,
 head
 Darde. Christ, head
 Daucher, A. Christ with Mary
 and St. John
 Early Christian. Medallion:
 Christ
 English--11th c. Christ#
 English--12th c. Christ, frag-
 ment
 --Jesus Christ, fragment
 English--15th c. Christ
 Visiting St. Catherine in
 Prison, relief
 Epstein. Christ
 Flemish--16th c. Christ, head
 Fontana, L. Christ
 French. Christ, head
 French--12th c. Christ, head#
 --Types of Christ
 French--13th c. Christ#
 French--14th c. Christ#
 French--14/15th c. Reliquary
 of the Holy Thorn: Christ
 Seated on Rainbow
 French--15th c. Christ, head#
 --Christ in Prayer
 French--16th c. Christ, head#

Garbe, H. Christus and Maria
German--6/7th c. Christ, pyx
 relief
German--10th c. The Annuncia-
 tion, relief
--Christ and Attendants, plaque
German--11th c. Book Cover:
 Gospel of Bishop Bernward
 of Hildesheim
German--12th c. Christ between
 Peter and Bishop Albero
German--13th c. Choir Pillar
 Figures
--Christ and St. John
German--14th c. Christ and St.
 John the Baptist
German--15th c. Christ, bust
Gothic--German. Christ, head
Henry of Constance. Christ--
 St. John
Holzinger. Christ with Support-
 ing Figures, High Altar
Italian--4th c. Jesus Christ,
 head
Italian--10/11th c. Magdeburg
 Antependium: An Emperor
 Offering a Church to Christ
Italian--15th c. Christ, bust
Junge--Attrib. Christ, head
 detail
Kenar. Christ in Meditation
Kralj. Christ
Maitani. Christ, head
Master, H. L. High Altar:
 Christ from Coronation of
 the Virgin
Medieval. Jesus Christ, head
 detail
Michelangelo. Christ de Pitie
Millan. Christ in Pity
Narcisco da Bolzano. The
 Trinity; Christ
Nicholas of Verdun. Seated
 Christ, of Apostle
Pisano, Giovanni. Pisa Pulpit:
 Christ
Pisano, Giulio. Christ
Polish. Christ of Nowy Targ,
 seated figure
Richier, L. Joseph of
 Arimathea with head of
 Christ
Riemenschneider, T. Retable:
 Christ
Robbia, A. della--Foll. Christ,
 majolica tondo
Robbia, Giovanni della. Christ,
 bust

Rodin. Christ et Madeleine
Romanesque--French. Christ,
 seated figure
Romanesque--French, or
 Spanish. Christ, head
Sansovino, J. The Savior
Saxon. Christ, head detail of
 Crucifix
Saxon. Romsey Christ
Schneider, G. Christ
Slanzovsky. Christ at the
 Pillar
Sluter. Christ, head
Swiss--14th c. Christ and St.
 John
Thorvaldsen. Christ
Verrocchio. Forteguerri
 Monument: Christ
--Adoration
Abruzzi Master. Adoration of
 the Magi
Antelami. Adoration of the
 Kings
Berruguete. Adoration of the
 Magi
Bidder. Venite Adoremus,
 relief
Bologna. Doors: Visit of the
 Magi
Braun, M. B. Adoration of
 the Shepherds, relief
Byzantine. Adoration of the
 Magi, Epiphany relief
Danish--13th c. Adoration of
 the Magi
Early Christian. Diptych
 Panel: The Adoration;
 Nativity
Early Christian. Pyxis:
 Adoration of the Magi;
 Raising of Lazarus
Early Christian. Sarcophagus:
 Three Magis with Mary and
 Christ Child
Early Christian. Sarcophagus
 of Adelphia
English--12th c. Adoration of
 the Magi, whalebone
English--14th c. Adoration of
 the Magi, reredos detail
English--15th c. The Adora-
 tion
Flemish--15th c. Adoration
 of the Magi
--Adoration of the Shepherds
Fontana, A. Adoration of the
 Shepherds, relief
French--11th c. Adoration/of
 the Magi

French--12th c. Adoration of
 the Kings, tympanum
--Adoration of the Magi over
 Dragons, tympanum
--Capital: Adoration of the Magi
--Church Portal
--Royal Portal: Adoration of
 the Shepherds
French--13th c. Adoration of
 the Magi
French--15th c. Adoration of
 the Magi
--Christ of Pity, Adored by
 Donors, with St. Michael,
 and St. William of Aquitaine
German--9th c. Book Cover:
 Annunciation, Adoration of
 the Magi
German--9/10th c. Book Cover:
 Adoration of the Magi
German--11th c. Basle Ante-
 pendium: Christ Adored
--Cologne Doors; Adoration of
 the Magi
--Hildesheim Cathedral Door:
 Right Door--Adoration of the
 Three Kings
German--12th c. Archangel
 Michael; Adoration of
 Magi, relief
German--15th c. Adoration of
 the Magi
--Agnus Dei Box Pendant
German--17th c. Adoration of
 the Shepherds
Gerthner. South Porch tympanum;
 Adoration of the Three
 Kings
Ghiberti. Baptistry Doors--
 North: Adoration
Guido da Como. Pulpit:
 Annunciation; Adoration of
 Magi
Hans von Schwabisch Gmund.
 Adoration of the Magi, High
 Altar, detail
Italian--8th c. Adoration of
 the Magi, altar fragment
Italian--15th c. Adoration of
 the Christ Child
Jordan. Christmas Relief,
 rood loft
Leonardo, Donati di. Pax:
 Adoration of the Child
Lombard Master. Adoration of
 the Magi, relief
Martinez Montanes. Adoration
 of the Shepherds
Michele da Firenze. Adoration

of the Magi
Netherlandish. Adoration of
the Child
Ordonez. The Epiphany
Pisano, Giovanni. Pistoia
Pulpit: Adoration of the
Magi, relief
Pisano, Giovanni--Foll.
Adoration of the Kings
Pisano, Niccolo. Pisa Bap-
tistry Pulpit: Adoration of
the Magi
Pisano, Niccolo. Siena Pulpit:
Adoration of the Magi
Ravy and Bouteiller. Adoration
of the Kings
Riccio. Adoration of the Magi
Robbia, A. della. Adoration
of the Child, relief
Robbia, A. della--Foll.
Adoration of the Child#
Robbia, Giovanni della.
Adoration of the Kings
Robbia, L. della. Adoration
of the Magi, tondo relief
Robbia, L. della. Adoration
of the Shepherds
Rossellino, A. Adoration of
the Child, tondo
Rossellino, A. Adoration of
the Shepherds
Sammartino. Sicilian Crib
Sansovino, A. Adoration of
the Shepherds
Spanish--12th c. Adoration
of the Magi
Spanish--13th c. Adoration
of the Magi
Spanish--15th c. Adoration
of the Kings
Verrocchio. Adoration of the
Shepherds, relief
Zumbo. Adoration of the
Shepherds
Zurn, Martin and Michael.
Rose Garland Altar:
Adoration of the Shepherds
--Apostles
Belgian--10/11th c. Christ
in Majesty, between the
Four Evangelists, relief
Burgundian. Christ with
Apostles, portal of narthex
Byzantine. Christ Between Two
Apostles#
Byzantine. Diptych: Christ
with Peter and Paul
Early Christian. Christ Giving
Law to Apostles, relief
fragment

Early Christian. Christ Giving
Law to St. Paul, sarcopha-
gus relief
Early Christian. Oil Lamp:
Christ and St. Peter in Boat
Early Christian. Sarcophagus:
Christ among Apostles
Early Christian. Sarcophagus:
Christ between SS Peter and
Paul
French--11th c. Christ between
Apostles, lintel
French--12th c. Christ with
Evangelists
German--9th c. Codex Aureus
of St. Emmeram, showing
Christ in Majesty, Four
Evangelists
German--10th c. Christ in
Majesty, between the Four
Evangelists, relief
German--12th c. Portable
Altar Retable: Christ above
the Apostles
Italian--12/13th c. Book Cover:
Christ and the Apostles
Romanesque--French. Christ
with Symbols of Evangelists
Tuotilo. Ivory Book Cover for
Evangelium Longum: Christ
in Majesty with Four
Evangelists
Verrocchio. Christ and St.
Thomas
--Appearances
Belgian--12th c. Cathedral
Doors
Bernward of Hildesheim. Door:
Abel; "Noli me Tangere"
French, or Spanish--12th c.
Christ Appearing to Two
Apostles, and Mary
Magdalene
German--11th c. Hildesheim
Cathedral Doors: Right
Door--Noli me Tangere
Gislebertus. Noli me Tangere
Keime. Noli me tangere
Riemenschneider. Christ
Appearing to Mary Magdelen
Spanish--12th c. Diptych Leaf:
Christ on the Road to
Emmaus; Noli me Tangere
Spanish--15th c. Christ Appear-
ing to St. Martin, retable
detail
--Ascension
Byzantine. The Ascension#
Donatello. Ascension with
Christ Giving the Keys to

Ancheta, M. de. Crucifix
Anglo-Saxon. Christ on Cross#
Anglo-Saxon. Crucifixion
 Panel
Anglo-Saxon. Langford Rood
Anglo-Saxon. Rood; Cruci-
 fixion Panel
Antelami. Soldiers Throwing
 Dice for Christ's Robe
Asam, E. Q. Mercy Seat
Austrian--12th c. Crucifix
Austrian--14th c. Crucifix,
 forked cross
Austrian--18th c. Crucifixion#
Backoffen. Crucifixion
Berlinghiero. Crucifix
Bertoldo di Giovanni. Cruci-
 fixion
Borman, J., the Elder--Foll.
 Crucifixion Group
Bossi, Aurelio. Cross
Braun, A. Calvary
Braun, M. B. Crucifix
Brokoff, F. M. Calvary
Brunelleschi. Crucifix
Byzantine. Book Cover:
 Crucifixion
Byzantine. Christ on Cross
Byzantine. Crucifixion#
Byzantine. Paten: Crucifixion
Byzantine. Triptych: Christ on
 the Cross
Carolingian. The Crucifixion,
 book cover
Castelli. Crucifixion
Cellini. Christ
Cellini. Crucifixion (Nude
 Christ)
Celtic. Book Cover(?):
 Crucifixion
Copnall. Crucifixion
Czech--17th c. Crucifix
Danish--11th c. Crucifix
Danish--13th c. Christ,
 crucifixion detail
--Crucifix
Danish--14th c. Crucifix
Desiderio da Settignano. St.
 Jerome in the Desert
Donatello. Crucifixion, relief
 panel
Donatello. The Flagellation
 and the Crucifixion
Dutch--10th c. Christ on Cross
Early Christian. Crucifixion,
 carved door panel
Early Christian. Death of
 Judas; Crucifixion

Early Christian. Lozenge-form
 Crucifixion
Ebneth. Crucifix
Egbert of Treves--Foll. Codex
 Aureus of Echternach
English--10th c. Crucifix,
 Rhenish background
English--11th c. Crucifixion#
--Draped Crucifixion, headless
 relief
English--12th c. Christ on
 Cross#
--Crucifix
English--14/15th c. Crucifixion
English--15th c. Dean Hussey
 Tomb
English, or Danish--13th c.
 Christ from Cross
European--Western. Crucifix of
 San Isidoro
Feron, L. Crucifix
Flemish--15th c. Calvary:
 Virgin and St. John
--Crucifix of Nivelles
--Crucifixion Group, detail
--Geel Altarpiece
Folk Art--French. Crucifix de
 Cancale
Fontana, L. Crucifixion
Frankish-Alemmanic. Christ on
 the Cross, relief
French--9th c. Crucifixion
French--12th c. Beau Dieu Noir,
 head detail
--Christ Courajod
--Christ on the Cross, head
 detail
--Crucifix
--Romanesque Crucifix
French--13th c. Crucified
 Christ
--Crucifix#
French--14th c. Crucifix(ion)#
--Le Devot Christ
French--15th c. Christ on the
 Cross
--Crucifixion#
French--16th c. Processional
 Cross
Gerhaerts. Crucifix
German--9th c. Crucifix(ion)#
--Lindau Gospels
German--9/10th c. Book Cover:
 Crucifixion
German--10th c. Codex Aureus
 Epternacensis: Christ on the
 Cross between Longinus and
 Stephaton

--Cross of Mathilda
--Crucifix(ion)#
--The Gero Cross
German--11th c. Book Cover:
　Christ on the Cross
--Crucifix, head detail#
--Cross of Heriman
--Crucified Christ
--Werden Crucifix
German--12th c. Calvary,
　rood screen
--Christ on the Cross#
--Christus
--Christus#
--Walsdorf Crucifix
--Wilten Chalice
German--12th and 16th c.
　Cross
German--13th c. Christ
--Crucifix Corpus
--Crucifixion--Triumphal
　Cross#
--Naumberg Crucifixion
German--14th c. Cross with
　Mourning Virgin and St.
　John
--Forked Cross Crucifixion
--Hungarian Cross
--Mystic Cross
German--15th c. Crucifix(ion)#
--Lorsch Crucifixion
German--17th c. Roadside
　Christ
Gies. The Cross
Gill, E. Bisham Crucifix
Gill, E. Crucifixion
Gothic. Crucifix, bronze
Guido. Crucifix
Hiquily. Calvary
Hispano-Moresque. Cross
Italian--8th c. Diptych:
　Crucifixion and Biblical
　Scenes
Italian--10th c. Diptych:
　Crucifixion
Italian--13th c. Crucifix
Italian--14th c. Crucifix
Italian--15th c. Crucifix
Jagger. Christ
Leinberger, H. Crucifixion
Leoni, L. and P. Calvary
Liuthard. Book Cover:
　Crucifixion
Loguin. Crucifixion Altar
Manzu. Crucifixion
Martinez Montanes. Christ of
　Clemency
Master of Imerward Crucifix.
　Crucifix

Matare. Processional Cross
Matisse. Crucifix
Merovingian. Crucifix
Mesa. Christ of Love
Mesa. Christ of the Good Death
Mettel, H. Kruzifix als
　Kriegerehrung
Moderno. The Crucifixion,
　plaquette
Mora. Christ on the Cross,
　detail
Myslbec. Crucifix
Naumberg Master. The
　Crucifixion
Netherlandish. Crucifixion#
Netherlandish. Dicing Soldiers
Nicholas of Verdun. Shrine of
　Virgin
Norwegian--13th c. Christ of
　the Cross, detail
Pacak, J.--Foll. Calvary
Petel, J. Crucifix
Pisano, G. Crucifix
Pisano, G. Pisa Pulpit:
　Crucifix
Pisano, G. Pistoia Pulpit
Pisano, Niccolo. Pisa Bap-
　tistry Pulpit: Crucifixion
Pisano Niccolo. Siena Pulpit:
　Crucifixion
Polish. Crucifixus
Porta, Guglielmo. Crucifixion
Portuguese--14th c. Christ,
　Crucifixion detail#
Preault. Christ on the Cross
Quitainer. Calvary
Reichle. Crucifix
Richier, G. Crucifix
Richier, L. The Passion
Riemenschneider. Christ on
　the Cross
Robbia, L. della. Crucifixion
Roger of Helmarshausen--Foll.
　Christ on Cross
Romanesque. Crucifix Corpus
Romanesque--French. Christ
　on the Cross, panel relief
Romanesque--Italian. Christ
　on the Cross, relief
Romanesque--Italian. Christ
　on the Cross, relief
Romanesque--Italian. Crucifix
Rosandic. Ecce Homo
Rude. Christ Crowned with
　Thorns, half figure
Sheridan. Crucifix
Sifer. Crucifixion, rood
　screen
Sluter. The Calvary: Head of
　Christ

Spanish--11th c. Christ on the
 Cross
--Crucifix
Spanish--12th c. Christ
--Crucifix#
--Majestad de Battlo
--Processional Cross
Spanish--13th c. Deposition;
 Crucifixion
--Romanesque Crucifix
--Virgin and St. John Mourn-
 ing, Crucifixion figures
Spanish--15th c. Crucifix
Stoss. Crucifix
Swabian. Christ on Cross
Tacca, P. Crucifix
Teutonic. Crucifixion
Theny. Calvary
Vigarny de Borgona. The
 Crucifixion
Viking. Jellinge Rune
 Stone: Crucifixion
Welsh. Christ, rood figure
Welsh. Pax Board:
 Crucifixion
--Death
Bandinelli, B. Dead Christ
 with Nicodemus
Delcour. Dead Christ#
Desiderio da Settignano.
 Altar of the Sacrament:
 Dead Christ with Virgin
 and St. John
Fernandez. Christ of the
 Filipini
Fernandez. Dead Christ
Fernandez. Pardo Christ
French--15th c. Christ
 Awaiting Death, seated
 figure
--Holy Sepulchre
German--13th c. Christ in
 Coffin, head detail
German--14th c. Holy
 Sepulchre
German--15th c. Dead Christ
 with Angel
Giovanni da Nola, or Giovanni
 da Mirigliano. Lamentation
 over the Dead Christ,
 relief
Mantegazza, A. Lamentation
 over the Dead Christ
Mazza. Mourning over the
 Dead Christ
Mesa. Christ Recumbent
Netherlandish. Mercy Seat
Pisano, G. Dead Christ with
 Angels, relief

Rhenish. The Dead Christ Sup-
 ported by an Angel
Riemenschneider. God the
 Father with Body of Christ
Romanesque. Dead Christ
Sammartino. Dead Christ in
 Shroud
Siloe, D. Dead Christ
Trentacoste. Dead Christ
Vitullo. Dead Christ, head
--Deesis: Christ Enthroned
 between The Virgin and St.
 John the Baptist
Byzantine. Deesis#
Byzantine. Harbaville Triptych:
 The Deesis
--Deposition
Antelami. Deposition
Barisanus of Trani. Door
 Panels
Belgian--12th c. The Deposition
Czech--18th c. The Deposition
Danti. Descent from the Cross
Daucher, H. Deposition
Donatello. The Deposition
Donatello. Pulpit: Deposition
 from the Cross
English--14th c. Descent from
 the Cross#
English--15th c. The Deposi-
 tion, panel
Francesco di Giorgio Martini.
 Deposition
French--12th c. Descent from
 The Cross
French--13th c. Descent from
 the Cross
French--13/14th c. The
 Deposition
French--14th c. The Deposi-
 tion
German--11th c. Descent from
 the Cross
German--12th c. Extern Stones,
 outdoor relief: The
 Deposition
Gill, E. The Deposition
Goujon. The Deposition, relief
Hatwell. Deposition from the
 Cross
Hitzberger. Descent from the
 Cross
Kraft. The Deposition
Leinberger, H. Deposition
Mantegazza, C. The Deposition
Manzu. Cardinal and Deposition
Manzu. The Deposition
Michelangelo--Foll. Descent
 from the Cross

Netherlandish. Descent from the
Cross
Pilon. The Deposition
Richier, L. The Passion
Roldan, P. High Altar of La
Caridad: Descent from the
Cross
Romanelli. The Deposition
Romanesque--Italian. Deposi-
tion from the Cross
Rubino, N. Deposition, tondo
Sansovino, J. Deposition from
the Cross
Spanish--11th c. Descent from
the Cross
Spanish--12th c. Christ of
Mitgaran, Deposition frag-
ment
Spanish--13th c. Deposition
--Descent from the Cross
--Descent into Hell
Bruggemann. High Altar:
Christ in Purgatory
Donatello. Pulpit: Christ in
Limbo
Italian--12th c. Christ:
Descending into Hell, lintel
relief
Riccio. Paschal Candlestick
Wiligelmus. Pulpit: Christ in
Limbo
--Emmaus
Spanish--11th c. Christ and
Two Disciples on Road to
Emmaus
Spanish--12th c. Diptych Leaf:
Christ on the Road to
Emmaus
--Journey to Emmaus
--Enthroned
Anglo-Saxon. Christ in
Majesty
Anglo-Saxon. Christ in
Mandorla
Belgian--10/11th c. Christ in
Majesty, relief
Byzantine. Christ Enthroned#
Byzantine. Christ Pantocrator,
plaque
Byzantine. Cover: Justinian
II; reverse: Christ, King
of Kings
Byzantine. Enthroned Christ,
book cover
English--9th c. Christ in
Majesty
English--10th c. Christ in
Majesty
English--12th c. Christ as

Lord of the Universe, in
Mandorla
--Christ in Majesty, tympanum
detail
--Christ Supported by Angels,
tympanum
English--13th c. Christ in
Majesty
French--10th c. Christ in
Majesty, cover of Gospels
of Marchiennes
French--11th c. Christ in
Majesty, with Symbols of
the Evangelists, relief
--Christ in Mandorla
French--12th c. Abbot Suger's
Chalice: Christ Pantocrator,
repoussee medallion
--Christ in Majesty#
--Royal Portal: Christ in
Majesty
German--7th c. Christ in
Glory, book cover
German--9th c. Codex Aureus
of St. Emmeram: Christ in
Majesty
German--10th c. Christ in
Majesty#
German--11th c. Book Cover:
Codex of Abbess Uota--
Christ in Majesty
--Christ in Majesty
German--12th c. Christ
Enthroned
German--13th c. Christ, rood
screen
--Triumphal Cross
Hungarian--12th c. Christus aus
Taban, tondo
Italian--6th c. Multiple Diptych:
Biblical Scenes--Christ
Enthroned
Italian--10th c. Ivory Panel:
Christ in Majesty
Italian--11th c. Christ in
Majesty
Mesa. Christ of Great Power,
head detail
Ottonian. Christ in Majesty
Petel, G. Salvator Mundi
Pilon, Christ on Mount of
Olives, relief
Roger of Helmarshausen.
Portable Altar
Romanesque--French. Christ
in Glory, relief in Mandorla
Romanesque--French. Christ
in Majesty
Romanesque--Italian. Christ

in Mandorla, with angels,
relief
Spanish. Christ Imperator
Spanish--12th c. Majesty
Capital
Spanish--13th c. Puerta de
Sarmental: Tympanum
Tuotilo. Ivory Book Cover for
Evangelium Longum: Christ
in Majesty
--Entombment and Lamentation
Andalusian Master. Entombment
of Christ
Bertoldo di Giovanni. The
Entombment
Cozzarelli. Bewailing of
Christ
Daucher, A. The Entombment
Desiderio da Settignano. Altar
of the Sacrament: Dead
Christ Mourned by Virgin
and St. John
Donatello. Entombment of
Christ
Donatello. High Altar: The
Entombment
Donatello. High Altar:
Lamentation over the Dead
Christ
Donatello. The Lamentation
Donatello. Pulpit: Lamentation
Donatello. Tabernacle of the
Sacrament: The Entombment
Dutch--16th c. Burial of Christ
English--15th c. Altar Panels
French--16th c. Mourning over
Dead Christ
--Lamentation at the Tomb
Fernandez. Entombment,
detail
Flemish. Entombment
Francesco di Giorgio Martini.
Oratorio di S. Croce:
Bewailing Christ
French--14th c. The En-
tombment
French--15th c. Entombment#
--Holy Sepulchre (Sepulchre
of Semur)
--Lamentation at the Tomb
French--16th c. Entombment#
Georgii. Entombment
Gothic-German. Mourner,
Lamentation figure
Goujon. Lamentation
Guido. Lamentation over the
Body of Christ
Hurtrelle. Lamentation
Italian--15/16th c. Entombment
Group

Jacopo Florentino. Burial of
Christ
Juni. Burial of Christ
Juni. The Entombment#
Kraft. Entombment
Lespaignol. Entombment
Mazzoni. Lamentation over
the Dead Christ
Medieval. The Entombment
Meit. Entombment
Meit. Lamentation of Christ
Michelangelo. Entombment
Minelli. The Entombment,
relief
Nicollo dell'Arca. The
Lamentation
Pilon. Lamentation
Porta, G. Uglielmo. The
Entombment, plaque
Reynolds-Stephens. The Gate-
way to Life
Riccio. The Entombment
Richier, L. Holy Sepulchre
Roldan, P. High Altar of La
Caridad: Burial of Christ
Spanish--11th c. Entombment
Spanish--12th c. The Entomb-
ment
Syfer. Entombment
Verrocchio. The Entombment
--Entry into Jerusalem
Byzantine. Entry into
Jerusalem#
Early Christian. Sarcophagus
of Adelphia
Early Christian. Sarcophagus
of Junius Bassius
German--15th c. Christ on the
Ass (Palmesel)
Italian--13th c. Candlestick:
Temptation, and Entry into
Jerusalem
Langeisen. Christ Entering
Jerusalem
--Family
German--14th c. Christ with
Soul of Mary
Pacak, P. Christ Taking Leave
of His Mother
--Gethsemane
Daucher, A. --Attrib. Christ in
the Garden of Gethsemane
Franco-Flemish. Christ Seated
on Calvary
French--15th c. Christ Seated
on Calvary
German--11th c. Cologne Doors:
Christ on the Mount of Olives
Greco, El. Casting of Lots

for Christ's Garments
Leinberger, H. Agony of Christ
Robbia, A. della. The Agony
 in the Garden, altarpiece
Sluter and Werve. Well of Moses
Theny. Christ in the Garden
 of Gethsemane
Vigarny de Borgona. Agony in
 the Garden, choir screen
 detail
Zarcillo y Alcarez. Agony in
 the Garden
Zarcillo y Alcarez. Christ on
 the Mount of Olives
--Infancy and Youth see also
 Mary, Virgin--Madonna
 and Child; St. Christopher
Belgian--14th c. Childhood of
 Christ, scenes, tympanum
Cano, A. Child Jesus of the
 Passion
Cano, J. , and Mena, P. St.
 Joseph with the Infant Jesus
De Martino. Pastorello Divino
Desiderio da Settignano. The
 Boy Christ and St. John
 Baptist
Desiderio da Settignano.
 Christ and St. John the
 Baptist as Children, tondo
Desiderio da Settignano. The
 Christ Child
Desiderio da Settignano. The
 Christ Child, right hand
 raised in blessing
Desiderio da Settignano. The
 Young Christ with St. John
 the Baptist
Donatello. Jesus as Infant,
 bust
Flemish--16th c. The Infant
 Christ, fragment
French--12th c. Portal of
 St. Anne
French--13th c. Simeon with
 Christ Child, and John the
 Baptist
French--15th c. Education of
 the Child
German--9/10th c. Box of the
 Infancy of Christ
German--15th c. Angel with
 Infant Jesus
German--18th c. St. Joseph
 and the Christ Child
Ghiberti. Baptistry Doors--
 North
Italian. The Holy Child,
 jeweled Figure

Italian--12th c. Childhood
 of Christ, font relief
Labenwolf. Christ Child Bless-
 ing
Master of Osnabruck--Foll.
 Twelve-year old Jesus in
 the Temple
Montelupo. Christ Child
Quesnoy. Christ and Madonna,
 busts
Ribas. Infant Christ
Robbia, A. della. Christ
 Child, bust
Robbia, A. della. Christ in
 Swaddling Clothes (Bambino)
Robbia, Giovanni della. Young
 Christ, bust
Robbia, Luca della. Boy Christ,
 bust
Rossellino, A. Boy Christ, bust
Spanish--12th c. God the Father
 with the Christ Child, door
 detail
Swabian. Christ Child
--Last Judgment See also Last
 Judgment
Anglo-Saxon. Christ Panel
Antelami. Last Judgment,
 tympanum
Early Christian. Sarcophagus
 of Junius Bassius
French--12th c. Christ at Last
 Judgment, tympanum
--Christ of Last Judgment, west
 door
--Royal Portal, west: Kings,
 Queens, Saints; Christ of the
 Apocalypse
French--13th c. Judgment Pil-
 lar, south transept: Christ
 as the Merciful Judge of the
 World
German--11th c. Christ, relief
 detail, Last Judgment
--Christ with Key and Book
Gislebertus. Tympanum: Last
 Judgment
Master of the Last Judgment.
 The Last Judgment, tym-
 panum
--Last Supper
Antelami. The Last Supper
English--12th c. Last Supper,
 font
Flemish. Last Supper, mantel-
 piece relief
French--11th c. Last Supper,
 frieze detail
French--12th c. Capital: The

Last Supper
--Christ in Majesty; Last
 Supper, tympanum
--Last Supper, capital#
German--11th c. Last Supper
German--16th c. The Lord's
 Supper (Abendmahl)
Minerbi. Last Supper
Naumberg Master. The Last
 Supper
Rickenbacker. Last Supper,
 relief
Riemenschneider, T. Altar
 of the Holy Blood: Last
 Supper
Russian--19th c. Last Supper,
 relief
Zarcillo y Alcarez. Last
 Supper
--Life
Byzantine. Life of Christ
 Scenes, 3 register panel
Early Christian. Ciborium
 Column: Life of Christ
Early Christian. Five-part
 Diptych: Life of Christ
Early Christian. Life of
 Christ: 3 scenes
Early Christian. Santa Giulia
 Casket
French--9th c. Book Cover
French--12th c. Door: Life
 of Christ, scenes
French--14th c. Diptych:
 Life of Christ
--Life of Christ, scenes#
German--9th c. Life of
 Christ: 3 scenes
Ghiberti. Baptistry Door--
 North: Life of Christ
Master Buvina. Door, panel
 details: Life of Christ
Romanesque--Italian. Life of
 Christ, scenes, doors
--Man of Sorrows
French--15th c. Man of
 Sorrows, half figure
German--15th c. Man of
 Sorrow, double figure
Marcks. Man of Sorrow
Multscher. Man of Sorrows
Solari. Man of Sorrows,
 relief
Strayff. Man of Sorrows
--Marys at the Tomb
Belgian--12th c. Marys at
 Tomb
Byzantine. Holy Women at
 the Sepulchre#

Donatello. Pulpit: Three Marys
 at the Sepulchre
Early Christian. Ascension of
 Christ, and Women at the
 Tomb, relief
French--12th c. Capital: Three
 Marys and the Angel at the
 Sepulchre
--Descent from the Cross;
 Holy Women at the Tomb,
 rood screen
--Holy Women at the Tomb
--Women at the Tomb, choir
 capital
French--16th c. Holy Sepulchre
German--11th c. Hildesheim
 Cathedral: Right Door--
 Three Marys at the Tomb
Netherlandish. Women at the
 Sepulchre
Nicholas of Verdun. Shrine
 of Virgin
Riemenschneider. The
 Lamentation
Romanesque--French. Holy
 Women at the Sepulchre,
 capital
Spanish--12th c. Marys at
 the Tomb, capital
--Miracles
Bernward of Hildesheim.
 Column: Marriage at Cana
Byzantine. Christ Enthroned;
 Woman of Samaria; Raising
 of Lazarus, diptych
Byzantine. Throne of Maximian
Cascalls. Miracle of Whitsun,
 relief
Donatello. High Altar: Miracle
 of the Resplendent Son
Early Christian. Book Cover:
 Miracles of Jesus
Early Christian. Columnar
 Sarcophagus: Moses Striking
 the Rock, and Woman with
 the Issue of Blood
Early Christian. Flagon:
 Healing of the Blind
Early Christian. Healing of
 Man Sick of Palsy
Early Christian. Miracles of
 Christ, sarcophagus relief
Early Christian. Pyxis:
 Adoration of the Magi;
 Raising of Lazarus
Early Christian. Santa Giulia
 Casket
Early Christian. Sarcophagus:
 Creation and Fall of Man;

Miracles of Christ
Early Christian. Sarcophagus,
No. 178: Scenes from Old
Testament; Miracles
Early Christian. Sarcophagus
of Adelphia: Feeding the
Five Thousand, and Raising
the Widow's Son
Early Christian. Sarcophagus
of Junius Bassius
English--12th c. Capital: The
Miraculous Draught of
Fishes
--Raising of Lazarus, relief
French--5th c. Plaque:
Scenes of Life and Miracles
of Christ
French--12th c. Christ in
Miracle of the Pentecost
German--9th c. Codex Aureus
of St. Emmeram
German--11th c. Cologne Doors:
The Healing of the Blind
Italo-Byzantine. Raising of
Lazarus, pierced tablet
Italian--11th c. Doors:
Exorcism (Healing of the
Woman Possessed by a
Devil)
Romanesque--English. Book
Cover: Scenes of Life and
Miracles of Christ
Saxon. Raising of the Widow
of Nain's Son, pierced
tablet
Spanish--11th c. Crypt
Capitals: Raising of
Lazarus
Spanish--12th c. The
Miraculous Fishing, relief
--Mocked and Scourged
Bologna. Ecce Homo, relief
Civitali. Ecce Homo
Dalmatinac. The Flagellation
Donatello. The Flagellation
English--14/15th c. Flagel-
lation of Christ
Epstein. Ecce Homo
Folk Art--German. Christ
Crowned with Thorns
Francesco di Giorgio Martini.
Flagellation of Christ,
relief
Franco-Flemish. Christ
Seated on Calvary
French--15th c. Ecce Homo
--Jesus Crowned with Thorns,
bust fragment

French--16th c. The Flagellation,
altarpiece detail
French--17th c. Christ with
Column
German--17th c. Christ
Crowned with Thorns
Hagenauer, J. B. Christ on
the Column
Leonardo da Vinci. The
Flagellation
Master Requinus. Door
Petel, G. Ecce Homo
Rosandic. Ecce Homo
Siloe, D. Scourging of Christ
Slanzovsky. Flagellation of
Christ
Witten. The Flagellation,
tree-form pillar (Pillar of
Chastisement)
--Monograms
Early Christian. Cross:
Monogram of Christ with
pendant Alpha and Omega
Early Christian. Funeral
Stele: Fish of Christ and
Anchor of Faith
Early Christian. Sarcophagus
from Sariguzel: Two Angels
Holding Monogram of Christ
Early Christian. Sarcophagus
of St. Theodorus: Symbols
and Monogram of Christ
--Nativity
Anguier, M. Nativity
Borman, J., the Younger.
Reredos of the Nativity
Breton. Nativity, Calvary
detail
Burgundian--12th c. Nativity,
relief
Byzantine. Throne of Maximian
Degler. Birth of Christ
Early Christian. Nativity,
Gospel cover detail
English--10th c. Nativity,
relief
English--12th c. Poor Father,
Legend of St. Nicholas, and
Nativity, crozier head
detail
Faydherbe. The Nativity
French--13th c. The Nativity,
rood screen
French--15th c. Calvary:
Virgin in Child-Bed
--Capital: The Nativity
--The Nativity#
Gagini, D. The Nativity, relief

German--9th c. Book Cover:
 Virgin and Child Enthroned;
 The Nativity
German--9/10th c. Nativity,
 coffer panel
German--12th c. The Nativity,
 plaque
German--16th c. The Nativity
Ghiberti. Baptistry Door--
 North: The Nativity
Italian--13th c. Nativity,
 relief
Maitani. The Nativity, facade
 relief
Martinez Montanes. Altar of
 San Isidoro del Campo
Mazzoni. Nativity
Mercadente. The Nativity
Netherlandish. Nativity
Pisano, Giovanni. Pisa
 Pulpit: The Nativity
Pisano, Giovanni. Pulpit:
 Annunciation and Nativity
Pisano, Niccolo. Pisa Bap-
 tistry Pulpit: Nativity
Polish. Nativity, relief
Rauch, E. A. Birth of
 Christ, panel
Rhenish. The Nativity#
Riemenschneider. Birth of
 Christ
Robbia, L. della. Nativity,
 relief
Rossellino, A. Nativity
 Altarpiece
--The Passion
Dutch--16th c. Passion Altar
Early Christian. Casket:
 Scenes from Passion
Early Christian. Sarcophagus:
 Scenes of the Passion
English--5th c. Casket Panels:
 Christ's Passion
English--14th c. The Passion,
 scenes, retable panels
English--15th c. The Passion,
 retable panel detail
Evesham. Hester Salisbury
 Tomb: Escutcheon with
 Emblem of the Passion
Flemish--15th c. Passion of
 Christ, altarpiece details
Flemish--16th c. Passion Altar
French--12th c. The Passion,
 Scenes
French--13th c. The Passion
 of Our Lord, diptych relief
--The Soissons Diptych: The
 Passion

French--14th c. Passion
 Scenes, diptych
French--16th c. Choir Screen,
 Chartres: Christ's Passion
French--17th c. Passion
Gill, E. Stations of the Cross,
 No. 1, relief
Italian--9th c. Ivory Diptych:
 Passion and Resurrection of
 Christ
Italian--10th c. The Basilewsky
 Situla
Kraft. Seven Stations of the
 Cross
Naumberg Master. Founders
 Choir Screen: Scenes of
 Passion
Richier, L. The Passion
Rucki. Stations of the Cross
Vezien. The Passion: One
 Station of the Cross, relief
--Pieta
Austrian--15th c. Pieta#
Belmondo. Pieta
Canova. Pieta
Capuz. Pieta, relief
Carmona. Pieta
Dick. Kitchener War Memorial:
 Pieta
Durst. Pieta
Dutch--16th c. Pieta
Fernandez. Pieta#
French--15th c. Dijon Pieta
--Pieta#
--Virgin of Pity
French--16th c. Pieta
Georgii. Pieta
German--14th c. Pieta
--Rottgen Pieta
--Scheuerfeld Pieta
--Vesper Group
German--15th c. Pieta#
German--16th c. Pieta
German--18th c. Pieta
Goujon. Pieta
Guenther, F. I. Pieta
Hispano-Flemish. Pieta
 (Lamentation)
Hitzberger. Pieta
Italian--15th c. Pieta
Italian--15/16th c. Maesta
Judenburg. Pieta
Juni. The Pieta
Kolbe. The Pieta
Kollin. Pieta
Kollwitz. Pieta
Leonardo da Vinci. Pieta
Master of Rabenden. Pieta
Master of the Beautiful

Madonnas--Foll. Vesper
Picture: Pieta
Messina. Pieta
Michelangelo. Palestrina Pieta
Michelangelo. Pieta#
Michelangelo. Pieta Roncalli
Minkenberg. Pieta
Minne, G. Pieta
Netherlandish, or French.
Pieta
Niccolo dell'Arca. Pieta
Pacak, F. Pieta
Pellisier. Reredos Group--
Pieta
Polish. Pieta
Rhenish. Pieta
Robbia, Giovanna della. Pieta
Robbia, Giovanni della--
Foll. Pieta
Rosandic. Pieta, relief
Schluter, A. Youth, head
Spanish--14th c. Calvary:
Pieta, King Pedro Tomb
Spanish--15th c. Pieta
Witten. Vesper Group
--Presentation in the Temple
Agostino di Duccio. Return
of Jesus from Dispute with
Doctors in the Temple
Amadeo--Foll. Arca di S.
Lanfranco: Presentation in
the Temple
Beauneveu. Presentation in
the Temple
Bigarny, and D. de Siloe.
Retable; Presentation in
the Temple
Buggiano. Pulpit: Presentation
of Christ in the Temple
English--13th c. Christ and
the Doctors
French--13th c. Facade, Ami-
ens
--Presentation in the Temple
German--9/10th c. Book
Cover: Adoration of the
Magi; Presentation in the
Temple
Niclaus von Hagenau.
Presentation of Christ in
the Temple
Pisano, G. Pisa Pulpit:
Presentation of Jesus in
the Temple
Pisano, Niccolo. Pisa Bap-
tistry Pulpit: Presentation
in the Temple
--Procession to Calvary
English--15th c. Christ Bear-

ing the Cross, retable panel
Floris. Christ Carrying the
Cross, rood screen detail
French--15th c. Christ Carry-
ing the Cross
German--15th c. Christ on Way
to Calvary
German--16th c. Way to
Calvary
Italian--16th c. Christ Bearing
the Cross, relief
--Christ on the Road to
Calvary
Kraft. Sebald Schreyer Tomb:
Christ Carrying the Cross
Richier, L. The Passion: Way
of the Cross
Romanesque--Spanish. Capitals:
Via Dolorosa
Ubac. The Calvary
Zarcillo y Alcarez. Christ
Carrying his Cross
Zarcillo y Alcarez. Fall on
the Road to Calvary
--Resurrection
Andreotti. Cristo Risorto
Andreotti. Resurrection
Berruguete. The Resurrection
Biderle. Fountain with
Resurrection of Christ
Cattaneo. Fregosi Altar;
Risen Christ
Donatello. Pulpit: Resurrection
Early Christian. Christ's
Resurrection, panel
English--14th c. The Resur-
rection
English--15th c. "Image of
Pity": Risen Christ, half
figure
English--16th c. St. Thomas
More's Pendant
Flemish--15th c. Reliquary:
The Resurrection
French--16th c. Retable:
Resurrection Scenes
Greco, El. Christ Resurrected
Greco, El. The Risen Christ
Hastings. The Risen Christ
Hernandez, Jeronimo.
Resurrected Christ
Italian--9th c. Ivory Diptych:
Passion and Resurrection
of Christ
Italian--10th c. The
Basilewsky Situla
Italian--15/16th c. Maesta:
Christ Resurrected
Michelangelo. Risen Christ
with Cross

Netherlandish. Resurrection,
fragment
Pilon. The Risen Christ#
Pirrone. Resurrection, tondo
Robbia, L. della. The
Resurrection, tympanum
Sansovino, J. Sacristy Doors:
The Resurrection
Spanish--12th c. Portico de la
Gloria
Tino di Camaino. Cardinal
Petroni Monument: Nole me
Tangere
Vecchietta. Resurrection,
relief
Vecchietta. Risen Christ
--Teachings
Byzantine. Christ Enthroned;
Woman of Samaria
Byzantine. Christ Teaching
the Apostles, plaque
Early Christian. Christ Giving
Law to the Apostles, relief
Early Christian. Christ the
Teacher
Early Christian. The Great
Berlin Pyxis
Early Christian. Sarcophagus
of Stilicho
Early Christian. Youthful
Christ Teaching, seated
figure
English--16th c. Hat Badge:
Christ and the Woman of
Samaria
French--12th c. Church Portal
--The Mission to the Apostles,
tympanum
French--13th c. Chartres
Cathedral, south transept:
Christ Teaching
--Christ Preaching, head
detail
German--13th c. Christ
Teaching, tympanum detail
Giovanni dei Grassi. Christ
and the Woman of Samaria,
relief
Italian--10/11th c. Magdeburg
Antependium: Christ
Teaching in the Temple
Italian--12th c. Portal Relief:
Christ Instructing Disciples
Lorenzetto. Christ and
Woman Taken in Adultery,
relief
Panzer. Jesus Preaching to
Peasants

Riemenschneider. Christ in the
House of Simon
--Temptation
French--11th c. Capital:
Temptation of Christ
French--12th c. Capital:
Christ and the Tempter
--Capital: Temptation of
Christ#
Italian--13th c. Candlestick:
Temptation
Romanesque--French.
Temptation of Christ, capital
Rucki. Stations of Cross; Life
of Christ Scenes
--Transfiguration
Belgian--12th c. The Trans-
figuration
Berruguete. Transfiguration
Bulla, G. B., J. P.
Cechpauer, and J. Rohr-
bacher. Column: Trans-
figuration of the Lord
English--13th c. Transfiguration
French--12th c. The Trans-
figuration, over-portal
German--11th c. Easter
Column: Transfiguration
--Treading the Beasts
Belgian--11th c. Shrine of
Hadelin: Christ Trampling
Lion and Dragon
French--9th c. Book Cover:
Christ Trampling the Beasts
German--8/9th c. Christ
Treading the Beasts#
German--9th c. Book Cover:
Christ Treading the Beasts
Mosan. Christ Trampling the
Beasts (Lion and Dragon),
Reliquary end relief
--Trial
Donatello. Christ Before
Caiaphas and Pilate
German--11th c. Hildesheim
Cathedral: Right Doors
Naumberg Master. Christ
Before Pilate
--Visiting Mary and Martha
English--12th c. Christ at
the House of Martha and
Mary
French--13th c. Facade
(Amiens), south portal
--Washing Feet of Disciples
French--16th c. Calvary:
Christ Washing Feet of
Disciples

The Jewish Scholar. Antokolski
Jewish Youth
 Rosso, M. Little Jewish Boy
Joab See Abner
Joachim, Saint
 Austrian, or German. St.
 Joachim, half figure
 Carlone. St. Joachim
 Feuchtmeyer. St. Joachim
 French--12th c. Portal of St.
 Anne: The Madonna; Infancy
 of Christ; Story of Joachim
 and Anna
 Juni. Meeting of Joachim and
 Anne
 Kohl, H., and F. Preiss. St.
 Joachim
 Master of Joachim and Anne.
 Joachim and Anne at the
 the Golden Gate
 Netherlandish. Meeting of
 Joachim and Anna
 Pacak, J. St. Joachim
Joan of Arc
 Chapu. Joan of Arc
 Dubois, P. Jeanne d'Arc,
 equest
 Foyatier. Joan of Arc, equest
 Fremiet. Jeanne d'Arc#
 Rude. Joan of Arc Listening
 to the Voices
Joan of Navarre (Queen of England
 1370?-1437)
 English--15th c. Henry IV and
 Joan of Navarre Tomb
Joanna of Bourbon See Bourbon,
 Jeanne de
Joanna the Mad See Juana la Loca
JOAO DE RUAO See JEAN DE ROUEN
Job
 French--12/13th c. Job, relief
 French--13th c. Chartres
 Cathedral, north transept:
 Job plagued by the Devil
 --Sufferings of Job
 Noll. Job
Jockeys
 Degas
 Laurens. Jockey
Joel, Prophet
 Master Bertram. Prophet
 Joel, head
 Nicholas of Verdun. Shrine
 of the Three Kings
JOHAN, Pedro (Spanish 1418-36)
 High Altar 1425/36
 MULS pl 62 SpTaC
JOHAN DE VALLFOGONA, Pere
 (Pere Johan)

Martyrdom of St. Thecla,
 retable panels
 POST-1:133 SpTaC
--detail
 CHASEH 278
Johanna of Polanen See Engelbrecht
 of Nassau
John, Saint
 Borman, J., the Elder--Attrib.
 St. John
 English--12th c. St. John
 French--13th c. Angel Pillar:
 St. John
 --Chartres Cathedral, south
 transept
 St. George, equest relief 1418
 HARVGW 107 SpBaD
John, Saint, The Baptist
 Auvera. St. John the Baptist
 Benedetto da Maiano. Birth of
 St. John the Baptist, relief
 Benedetto da Maiano. St. John
 the Baptist
 Benedetto da Maiano--Foll. St.
 John the Baptist, bust
 Bernini, P. St. John the Baptist
 Berruguete. St. John the Bap-
 tist, choir stall
 Bouts. St. John the Baptist
 Brokoff, F. M. St. John the
 Baptist
 Burgundian--15th c. St. John
 the Baptist
 Byzantine. Casket
 Byzantine. St. John the Baptist#
 Byzantine. Throne of Maximian
 Byzantine. Virgin and Child,
 with St. John the Baptist and
 Bishop Saint
 Cano, A. St. John the Baptist,
 seated with Lamb
 Danti. Decollation of St. John
 the Baptist
 Daucher, A. Christ with Mary
 and St. John
 Desiderio da Settignano. The
 Boy Christ and St. John
 Baptist
 Desiderio da Settignano. St.
 John the Baptist as a Child
 Desiderio da Settignano. The
 Young Christ with St. John
 the Baptist
 Donatello. St. John the Baptist#
 Donatello--Foll. St. John the
 Baptist
 Dubois, P. St. John the Baptist
 English--13th c. St. John
 English--15th c. Henry V's
 Chantry

--John the Baptist, head
--St. John, head
English--15/16th c. Dead St.
John, head
Fernandez. Baptism of Christ
Ferrucci. Beheading of St.
John the Baptist
Fiorentino, D. St. John the
Baptist
Francesco di Giorgio Martini.
St. John the Baptist
French--12th c. Facade of St.
Trophime
--North Portal Figures
--Royal Portal
--St. John the Baptist, west
porch
French--13th c. St. John the
Baptist#
--Simeon with Christ Child,
and John the Baptist
French--14th c. St. John the
Baptist#
French--15th c. St. John the
Baptist#
Gagini, D. Life of St. John
the Baptist, panel detail
German--9th c. Book Cover:
Virgin and Child Enthroned
between Zacharias and St.
John
German--12th c. Mary and John
German--13th c. Triumphal
Cross: St. John
German--14th c. Christ and
St. John (the Baptist)#
German--15th c. St. John the
Baptist, head
German--16th c. St. John, head
Ghiberti. St. John the Baptist
Ghiberti, and G. di Ser Andrea.
Font: St. John the Baptist
Preaching before Herod
Giovanni di Agostino. Angel
Appearing to St. John
Giovanni di Agostino. Madon-
na and Child with SS Cath-
erine and John the Baptist
Giovanni di Agostino. St.
John the Baptist Entering
the Wilderness, relief
Glesker. John the Baptist
Guibert--Attrib. St. John the
Baptist
Holzinger. John the Baptist,
head
Houdon. St. John the Baptist
Italian--11th c. St. John the
Baptist

Italian--13th c. St. John Story,
Pisa
--Virgin and St. John
Italian--18th c. Martyrdom of
St. John the Baptist,
reliquary
Juni. St. John the Baptist
Lienberger, H.--Foll. St.
John the Baptist
Leonardo di Giovanni and
Betto di Geri. Baptistry
Altar: Life of St. John the
Baptist
Martinez Montanes. Altar of
San Isidoro del Campo
Martinez Montanes. St. John
the Baptist, High Altar
Martinez Montanes and Ribas.
Altar of St. John the Bap-
tist
Mesa. John the Baptist, head
Michelangelo. Madonna and
Child with Young St. John
the Baptist, tondo
Michelangelo. Virgin and
Child with Infant St. John
the Baptist
Michelozzo--Foll. St. John
the Baptist
Minne, G. St. John the
Baptist
Mino da Fiesole. Altar, with
Our Lady and Saints
Netherlandish. St. John, head
Ordonez. St. John the Baptist
Pisano, A. Baptistry--South
Doors: Life of St. John
the Baptist
Pisano, G. Pisa Pulpit:
Birth of St. John the
Baptist
Pollaiuolo, A. Baptistry
Altar Crucifix, base
detail: St. John the
Baptist
Reiner von Huy. Baptismal
Font: John Preaching and
Baptizing
Robbia, A. della. St. John
the Baptist, bust
Robbia, Giovanna della.
Pieta with St. John and
the Magdalen
Robbia, L. della, and
Michelozzo. Altar of the
Holy Cross
Rodin. St. John the Baptist#
Rodin. Walking Man, study
for St. John the Baptist

Rossellino, A. The Young St.
John the Baptist, bust
Rossellino, B. St. John the
Baptist
Rustici. Preaching of the
Baptist
Rustici. Virgin and Child with
the Young Baptist, tondo
Sansovino, J. St. John the
Baptist
Siloe, D. St. John the Baptist,
choir stall
Siloe, D. Throne of Benedic-
tine Abbot of Burgos: St.
John the Baptist
Sluter. Portal: Philip the Bold
Commended to the Virgin
by St. John
Spanish--13th c. Mary; John
Spanish--16th c. John the
Baptist
Theny. St. John the Evangelist
Verrocchio. Baptistry Altar:
Beheading of St. John the
Baptist
Villabrille y Ron. St. John the
Baptist, head
Vittoria. St. John the Baptist
Zamoyski. St. John the Baptist
Zanetti. St. John, as a Boy
Zanetti. St. John the Baptist
John, Saint, the Evangelist See also
Mary, Virgin
Anglo-Saxon. Mary and John
Anglo-Saxon. St. John the
Evangelist, crucifix figure
Austrian--13th c. Mourning
St. John
Austrian--18th c. Crucifixion
with Virgin and St. John
the Evangelist
Auvera. St. John the
Evangelist
Bendel, St. John the
Evangelist
Benedetto da Rouezzano. St.
John the Evangelist
Berruguete. St. John
Byzantine. St. John the
Evangelist, and St. Paul,
panel
Cozzarelli. St. John the
Evangelist
Daucher, A. St. John the
Evangelist
Desiderio da Settignano. Altar
of the Sacrament, details
Domenico di Niccolo. Virgin
and St. John the Evangelist

Donatello. Pazzi Chapel,
detail
Donatello. St. John the
Evangelist#
Donatello, or Desiderio da
Settignano. San Giovannino,
head detail
English--11th c. Virgin and
St. John
English--13th c. St. John the
Evangelist
English--15th c. St. John the
Apostle, bust detail
English--16th c. Henry VII
Tomb, grille figure: St.
John the Evangelist
Flemish--13th c. The Virgin
and St. John, crucifix
figures
Flemish--15th c. Calvary;
details: Virgin and St.
John
--St. John, head
Francheville. St. John the
Evangelist
French--12th c. Portal
Figures: St. Peter; St.
John the Evangelist
--St. John of Patmos,
tympanum
French--13th c. St. John the
Evangelist
--Virgin; St. John the
Evangelist
French--15th c. St. John#
--Virgin and St. John
French--16th c. Virgin and
St. John
French--18th c. Young St.
John and the Lamb
German--11th c. Book Cover:
Gospel of Bishop Bernward
of Hildesheim
German--12th c. Luke and
John
German--13th c. Christ and
St. John
German--14th c. Christ and
St. John (the Evangelist)#
--Sleeping St. John
German--15th c. St. John the
Evangelist
--Virgin and St. John
German--16th c. Mary and
St. John the Evangelist
Goujon. Apostles John and
Matthew, relief
Heide. John the Apostle
Henning von der Heyde. St.

John the Evangelist
Joseph Master. St. John the
 Evangelist
Knappe. Johannes auf Patmos
Kuen, F. A. Facade Figures
Lederer, J. St. John
Leinberger, S. St. John the
 Evangelist
Leoni, L. and P. Calvary,
 with Virgin and St. John
Marchini. St. John
Master, H. L. High Altar
Master of the St. John Busts.
 St. John, bust
Master of the Statuettes of St.
 John. St. John
Multscher. St. George; St.
 John the Evangelist
Naumberg Master. Founders'
 Choir Screen: St. John,
 head
Netherlandish. St. John the
 Evangelist#
Niccolo dell'Arca. St. John
 the Evangelist, Deposition
 figure
Notke, or Heide. St. John the
 Evangelist, head detail
Opizari. Bertsk Gospel Cover:
 St. John
Pacak, J. St. John the
 Evangelist
Pisano, G. Pisa Pulpit: St.
 John the Evangelist
Portuguese--18th c. St. John
 the Evangelist
Riemenschneider. St. John the
 Evangelist*
Robbia, Giovanni della. St.
 John, bust
Sansovino, J. Madonna and
 the Young St. John
Sansovino, J. St. John the
 Evangelist
Spanish--13th c. Mourning
 St. John
Spanish--14th c. St. John the
 Evangelist, bust
Stoss. Altar of Our Lady:
 St. John the Evangelist,
 head
Swabian. St. John the Evange-
 list
Swiss--14th c. Christ and St.
 John
Zurn, Michael. St. John the
 Evangelist

JOHN XXIII (Pope 1360?-1419)
 Donatello and Michelozzo.
 John XXIII Monument
John (Duke of Burgundy 1371-1419),
 called John the Fearless
 (Jean sans Peur)
 French--15th c. John the
 Fearless Tomb
John II (King of Castile 1405-54)
 Siloe, G. Juan II of Castile
 and Isabella of Portugal
 Monument
John (King of England 1167?-1216)
 English--13th c. King John,
 effigy
John I (King of Portugal 1357-1433)
 Portuguese--15th c. John I
 and his Queen Philippa of
 Lancaster, effigies
John, Augustus Edwin (British
 Painter 1876-1961)
 Seale. Augustus John, head
JOHN, William Goscombe (English
 1860-1952)
 The Elf
 BROWF-3:86 ELBur
John III de Merode
 Floris. Jean III de Merode and
 Anne de Ghistelle Tomb
John VII Palaeologus (Eastern Roman
 Emperor 1360-1412)
 Pisanello. Medal: John VII
 Palaeologus
John VIII Palaeologus (Eastern
 Roman Emperor 1391-1448)
 Pisanello. Medal: John VIII
 Palaeologus
John Chrysostom, Saint
 Byzantine. Casket
JOHN OF BATTLE, designer, and
 WILLIAM OF IRELAND,
 figures
 Eleanor Cross 1291
 EVJE pl 2 ENorH
John of Calabria
 Italian--15th c. John of
 Calabria, son of Rene
 d'Anjou, medallion
John of Constantinople See John VIII
 Palaeologus
John of Eltham (fl 14th c.)
 Alexander of Abingdon.
 Prince John of Eltham
 Tomb
John of God, Saint (real name: Juan
 Ciudad) (Spanish Religious
 1495-1550)

Cano, A. St. John of God,
 head
John of Nepomuk, Saint (Ecclesiastic
 and patron saint of Bohemia
 1340?-93?)
 Austrian, or Southern German.
 St. John Nepomuk Confess-
 ing the Queen of Bohemia
 Braun, N. B. Miner Adoring
 Tomb of St. John of
 Nepomuk
 Brokoff, M. J. J. St. John of
 Nepomuk#
 Brokoff, M. J. J. St. Vitus;
 St. John of Nepomuk
 Brokoff Workshop. St. John of
 Nepomuk
 Czech--18th c. Fountain with
 statue of St. John Nepomuk
 Glaz. St. John Nepomuk
 Gunther, F. I. John of
 Nepomuk
 Pacak, J. St. John of
 Nepomuk
 Rauchmiller. St. John of
 Nepomuk
 Rauchmiller, and J. Brokoff.
 St. John of Nepomuk
 Sussner. St. John Nepomuk
 Theny. Church Interior:
 Glorification of St. John of
 Nepomuk
John of Patmos, Saint See John,
 Saint, the Evangelist
Johnes, Marianne
 Chantrey. Marianne Johnes
 Monument
JOHNSON, Garret (Gerard Johnson)
 (English)
 4th Earl of Rutland Monument
 1591 MERC pl 83a; WHINN
 pl 8B ELeiB
 Lord William of Thame and
 his Wife, effigies
 MERC
 2nd Earl of Southampton Tomb
 1592 WHINN pl 8A ETi
JOHNSON, Rikhardour (Icelandic)
 Gavel, General Assembly
 First (Political) Icelandic
 birch BAA pl 34 UNNUN
Johnson, Samuel (English Lexicograph-
 er and Critic 1709-84)
 Bacon, J. Samuel Johnson, bust
 Bacon, J. Samuel Johnson
 Monument
 Nollekens. Samuel Johnson, bust

JOHNSON, Thomas
 Girandole gilt wood
 SOTH-1: 247
JOHNSSON, Ivar (Swedish 1885-)
 Fugitive Woman 1935 bronze
 RAMT pl 60
 Prince Eugene, bust plaster
 VEN-42: pl 87
 Tycho Braha 1936 bronze, for
 granite
 RAMS pl 12a SnSN
 Woman Beside the Sea
 VEN-38: pl 86
JOHNSTON, Arnrid (Swedish-English
 1895-)
 Boy and Dog Palambino
 marble AUM 155
 Children, Courtyard relief
 AUM 157 ELWa
 Obelisk stone
 PAR-1: 125 ELWa
 Pastoral blue Belgian marble
 AUM 155
Johnstone, Edward
 Chantrey. Edward Johnstone,
 bust
JOHNSTONE, Elizabeth (English)
 Gay Bandolero
 JOHT pl 213
La Joie de Vivre. Drivier
Joigneaux, Pierre
 Moreau, M. Joigneaux Monu-
 ment
Joigny, Countess of See Adelais de
 Champagne
Joint Cover
 Flemish--16th c. Joint Cover:
 St. Anthony Hermit
JOJON, Mlle (French)
 Child with Balloon
 TAFTM 41
JOKL, Matej Vaclav See JAECKEL,
 Mattaus Wenzel
JOLI, Gabriel (Italian d 1538)
 Apostle, head, High Altar
 1536/38 wood
 KO pl 84 SpTeC
Jonah
 Bellano. Jonah Thrown into
 the Sea
 Byzantine. Jonah and the
 Whale, relief
 Early Christian. Book Cover:
 Miracles of Jesus; Hebrews
 in the Furnace; Story of
 Jonah
 Early Christian. Jonah

Sarcophagus: Jonah and
the Whale
Early Christian. Jonah under
the Gourd Vine
Early Christian. Sarcophagus;
Orans and Philosopher
German--13th c. St. George's
Choir Screen: Jonah and
Hosea
Italian--6th c. Multiple Dip-
tych: Biblical Scenes
Italian--13th c. Jonah and
the Whale, relief
Lorenzetto. Jonah
Milles. Jonah and the Whale
Nicholas of Verdun. Altar of
Verdun: Jonah and the
Whale
Nicholas of Verdun. Shrine
of the Three Kings
Raphael. Jonah, after design
JONAS, Siegfried (Swiss-French
1909-)
Song of the Hours 1953 bronze
MAI 146
JONES, Adrian (English 1845-1938)
The Quadriga: Peace 1912
bronze GLE 56; WHITT
147 ELHy
JONES, Arne (Swedish 1914-)
Cathedral III 1947/48 bronze
and silver
MAI 146
Dodeka 1962 aluminum
LARM 392
Fountain 1950
DAM 148 SnSS
Primary School Wall Relief
DAM 105 SnVax
School Entrance Relief brick
DAM 105 SnS
Jones, John Paul (American Naval
Hero 1747-92)
Houdon. John Paul Jones#
Jones, William
Flaxman. Sir William Jones
Monument
Le Jongleur
Rodin. The Juggler
JONK, Nic (Dutch 1928-)
Nereid and Triton III 1962
bronze; 50 cm
SAO-7
JONSSON, Einar (Icelandic)
Dawn
MARY pl 123 IcR
In the Hands of the Trolls
MARY pl 123 IcR

King of Atlantis bronze
MARY pl 111 IcR
New Life
MARY pl 43 IcR
Thorfinnur Karlsefni
MARY pl 83
JONZIN, Karin (English)
Terracottas
NEWTEB pl 42, 43
JOOSTENS, Paul (Belgian 1899-1960)
La Paradis Terrestre, as-
semblage 1958 39-3/8x
29-1/4
NEW pl 184
JORDAN, Estaban (Spanish 1534-1600)
Christman Relief, rood loft
detail c 1578
BUSR 177 SpLe
Main Altar; detail: St. Peter
and St. Paul c 1571
BAZINW 380 (col) SpVMad
Retrochoir, detail
CIR 40 SpLeA
Two Saints
LARR 225 SpVMad
Jordan, Mrs.
Chantrey. Mrs. Jordan
JORHAN, Christian, the Elder
St. Nicholas, detail c 1760/67
ptd wood
KITS 31 (col) GAlte
Joseph, Saint
Cano and Mena. St. Joseph
with the Infant Christ
Fiamberti--Attrib. St. Joseph
Foley, M. St. Joseph
French--12th c. Capital: Joseph
Reassured
French--13th c. Joseph, head
Presentation Group
German--11th c. Hildesheim
Cathedral Doors: St. Joseph
German--18th c. St. Joseph and
the Christ Child
Ghiberti. Baptistry Doors--
East: Joseph
Joseph Master. St. Joseph
Marcks. Josep und Maria
Spanish--13th c. St. Joseph,
seated figure
Wenzinger. St. Joseph
Wesel, A. van. St. Joseph
with Music-making Angels
Joseph, the Patriarch
Byzantine. Joseph Distributing
Corn in Egypt; Meeting of
Jacob and Joseph
Byzantine. Joseph Story Scene(s)#

Byzantine. Throne of Maximian
French--12th c. Joseph Accused
by Potiphar's Wife,
capital
French--13th c. Hercules;
Joseph Cast into Pit
--Joseph
German--17th c. Tray (Lokhan):
Reconciliation of Joseph and
Jacob
Kriechbaum. Winged High
Altar: Joseph
Ordonez. Sale of Joseph,
choir stall
Rossi, P. de. Joseph and
Potiphar's Wife
Joseph I (Holy Roman Emperor 1678-
1711)
Steinl. Joseph I, equest
Joseph II (Holy Roman Emperor
1791-1850)
Zauner. Emperor Joseph II,
equest
JOSEPH, Samuel (English 1791-1850)
Lady de L'Isle and Dudley,
bust marble; 31
CON-5: pl 40 -ELi
William Wilberforce, seated
figure holding book 1838
marble BOASE pl 53A; GUN
pl 14; MOLE 263; MOLS-2:
pl 52; UND 100 ELWe
Joseph Emanuel (Jose Manuel) (King
of Portugal 1715-77)
Almeida. Jose Manuel, equest
Machado de Castro. Monu-
ment to Joseph I, equest
JOSEPH MASTER
The Angel of Nicasius c 1250/
60 NEWTEM pl 84 FRhC
St. John the Evangelist, west
front c 1240/50 stone
NEWTEM pl 83 FRhC
St. Joseph c 1250 limestone
NEWTEM pl 81 FRhC
Joseph of Arimathea, Saint
German--15th c. Joseph of
Arimathea#
Jacopo Florentino. Burial of
Christ; detail: Head of
Joseph of Arimathea
Juni. Joseph of Arimathea
Richier, L. Joseph of Ari-
mathea with Head of Christ
Josephine, Empress See Beauharnais,
Josephine de
Joshua
Byzantine--Joshua, Life scenes

Ghiberti. Baptistry Doors--
East: Joshua
Jossonne, Mlle.
Drivier. Mlle Jossonne#
JOUBERT, Francois (French fl 1749-
79)
Dish 1761-52 silver; 9-1/2x
15-1/4 CHAR-2: 202 FPL
Jouet Nocturne Nacthliches Spielzeug.
Muller, R.
"Le Jour se Leve". Franchina
Jousting See Games and Sports
JOUVET, L'Entreprise (French)
Monument de Douamont
AUM 57
JOVANOVIC, Djordj (Yugoslav 1861-
1953)
Marko Stojanovic, bust bronze
BIH 31 YBN
Jovanovic, Jovan (Pseudonym: Zmaj)
(Serbian Writer 1833-1904)
Bakic. Jovan Jovanovic--Zmaj
Monument
The Jovial One. Dubuffet
Joy. Visser
Joy-Box. Tilson
Joyce, James
Botzaris. James Joyce, head
Jozsef, Attila
Beck, A. Attila Jozsef
Memorial
Juan, Don
Chauvin, L. Don Juan
Liegme. Don Juan
JUAN DE LA CONCEPCION See
EUGENIO DE LA CRUZ
JUAN DE LA CRUZ
Facade
WES pl 1 SpVP
JUAN DE LA HUERTA (Spanish)
Virgin, reredos 1448
MULS pl 7 FRouvC
Juan of Aragon
Fancelli, D. A. Infant Don
Juan of Aragon Monument
Juana la Loca (Consort of Philip I of
Spain 1479-1555)
Ordonez. Philip of Burgundy
and Joanna the Mad Tomb
Juana of Austria
Leoni, P. Infanta Juana of
Austria
Judah, Kings and Queens of
French--12th c. Royal Portal:
Ancestors of Christ
Judas See Also Jesus Christ--Betrayal
Early Christian. Death of
Judas

Justinian II (Eastern Roman Emperor
669-711)
Byzantine. Coin: Justinian II
JUVIN
La Creation
FPDEC il 12
Juxtaposition Superimposition C.
Sobrino

Kaempende bjorne. Barye
KAENDLER, Johann Joachim See
KANDLER, Johann Joachim
KAFKA, Bohumil (Czech)
After the Bath marble
PAR-2: 117
Awakening marble
CASS 79
Elephant bronze
VEN-28: pl 177
The Eternal Drama
MARY pl 180
The Foal bronze
MARY pl 135
Supplication marble
MARY pl 103
Kairos
Italian--12th c. Kairos,
relief
Kaiserpokal. German--13th c.
KALIN, Boris (Yugoslav 1903-)
The Hostage 1945 bronze
BIH 133 YKam
Nives, the artist's daughter,
head 1939 marble
BIH 135
The Painter Pengov, head
1936 plaster
BIH 134 YSkMG
KALIN, Zdenko (Yugoslav 1911-)
Boy's Head 1945 bronze
VEN-52: pl 86
Child Playing II 1952
BIH 141 YBMG
The Liberation Struggle,
relief detail
BIH 138 YL
Little Shepherd 1939 bronze
BIH 140 YLT
Marion 1940 marble
BIH 139
Memorial to the Fallen,
details including: The
Hostage
BIH 142-44 YU
KALINOWSKI, Horst Egon (German-
French 1924-)
Diptique "Plessis-les-Tours",
assemblage 1960/62 wood,
leather, iron: 27-1/8x

25-1/4
NEW pl 290
Oratoire pour la Moisson 1953
H: 57
SEITC 170 UNNLi
Ostensoire de la Volupte 1958
39-3/8x31-7/8
NEW col pl 27 (col)
Stela for a Saint 1966
112-1/2x24-1/2x9-1/2
CARNI-67: #103 UNNCor
KALLOS, Ede (Hungarian 1866-1949)
David bronze; 180 cm
GAD 62 HBA
Kamburg, Wilhelm von
Naumberg Master. Founders'
Choir Screen: Hermann and
Wilhelm von Kamburg
Kamecke House. Schluter
Kamienska, Jeanne
Despiau. Jeanne, head
Kamp Mellem Nordamerikansk og
Indisk Bjorn
Barye. Kaempende Bjorne
KAMPMANN, Rudiger-Utz (German/
Swiss 1935-)
Exposition Zurich 1966
KULN col pl 9 (col)
Farbobject 64/15 1964 wood;
18-7/8x18-7/8x6-1/4
NEW pl 329 GStP
KANDLER, Johann Joachim (Austrian
1706-75)
Bittern Meissen porcelain;
14-1/2
SOTH-4: 189
Cockatoo 1734 Meissen porce-
lain; 13-5/8
RIJA pl 26 (col) NAR
Crinoline Group Meissen
porcelain
SOTH-4: 187
Crinoline Group: Columbine
and Beltrane c 1740 Meis-
sen porcelain; 7-1/8
DEYE 174 UCSFDeY (60.31)
Four Meissen Commedia dell'
Arte Figures: The Dancer;
Frightened Harlequin;
Greeting Harlequin; Mez-
zetin
SOTH-2: 147 (col)
Gout Sufferer (Podagrakranke)
Meissen porcelain
SOTH-4: 186
Green Parrots c 1741 Meissen
porcelain
INTA-2: 124

Sense of Sight; Sense of
 Touch ceramics
 HOW UCSFCP
Singer c 1744 porcelain
 HEMP pl 124 GCeS
Squirrel Meissen porcelain
 SOTH-1: 152
Swan Service 1737/41 Meissen
 porcelain
 ENC 614; HEMP pl 124 GDP
Two Freemasons Contemplat-
 ing a Globe 1744. Meissen
 porcelain; 9
 JANSK 855 UNNUn
KANDLER, Johann Joachim--FOLL
 Turkish Man and Woman
 c 1760 salt glazed stoneware
 CON-4: pl 41 ELV
Kangaroos
 Bentham. Steamship Office
 Panels: Fiji; Babylon;
 Australia
 Trapman. Kangaroo with
 Young, panel
KANIARIS, Vlassis (Greek-French
 1928-)
 Ni Accident, Ni Drame 1964
 NEW col pl 101 (col)
Kanonier. Muller, R.
Kant, Immanuel
 Bardou. Immanuel Kant, bust
KANTOCI, Ksenija (Yugoslav 1909-)
 Woman Sewing 1945 terracotta
 BIH 105
Kappenberg, Gottfried von, and Otto
 von Kappenberg
 German--14th c. Gottfried
 and Otto von Kappenberg
Karadzic, Vuk Stefanovic (Serb
 Scholar 1787-1864)
 Ubavkic. Vuk Karadzic, bust
Karakas. Paolozzi
Karl Theodor of Bavaria
 Hildebrand. Duke Karl
 Theodor of Bavaria, bust
KARNY, Alfons (Polish 1901-)
 Jumpers bronze
 VEN-34: pl 173
 Wawila, head 1947 plaster
 JAR pl 8
KARSCH, Joachim (German 1897-
 1945)
 Hockende 1930 bronze; 40 cm
 HENT 112
 Junges Madchen 1930 bronze;
 1.545 m
 OST 55 GHaL

Praying Disciple (Betender
 Junger) 1931 bronze
 GERT 118
Schreitende Junger 1931 plaster,
 for bronze; 1.10 m
 HENT 113
KARSH, Joseph
 The Undrained Glass (Das
 Ungetrunkene Glas) 1940
 bronze
 GERT 119
KASCHAUER, Jakob (Austrian 1429-63)
 Virgin and Child, Freising
 Cathedral High Altar 1443
 MULS pl 88 GMB
KASPER, Ludwig
 Arethusa 1940 stucco
 GERT 78
 Seated Female Figure (Sitzende)
 1948 stucco
 GERT 79
Kastalia. Marcks
Kastenmayr, Ulrich (Burgomaster of
 Straubing)
 German--15th c. Ulrich
 Kastenmayer, effigy
KASTNER, Fenton
 Air Form
 LYNCMO 80
 --
 LYNCMO 67 UNNMMA
 Caterpillar
 LYNCMO 77
 Gregorian, mobile
 LYNCMO 105
Kathleen. Epstein
Katze See Cats
Kauernde. Sporri, E.
Kauernde mid Draperie. Banninger
KAUFMAN, Herbert (German 1924-)
 Litfass-Saulen 1964 columns
 collage and oil on plywood
 construction; 67-5/8; Dm:
 24 NEW pl 318
KAYSER, Victor (German)
 Susanna at her Bath, relief,
 Augsberg 1525/30
 Solnhofener stone; 44.9x
 29.7 cm
 MUL 29 GBS
KAYSSER, Hans
 Armor Suit, etched in black
 1609
 LOH 209 GNG
Kazinczy, Ferenc (Hungarian Writer
 and Linguistic Reformer
 1759-1831)

Fernczy, I. Ferenc
 Kazinczy, bust
KEDL, Rudolph (Austrian 1928-)
 Coppia 1962
 VEN-66:#143
Kegelplastik VII. Distel
KEIME (German c 800-1200)
 Madonna and Child, Pustertal
 LIL 24 GMB
 Noli me Tangere, relief
 LIL 20 GHiC
KELDER, Toon (Dutch 1894-)
 Bird wood; 37-3/8
 TRI 143
 Bust copper on wood
 MAI 147
 Woman 1956/57 sheet iron,
 wood core; 49x19x22
 CARNI-58:pl 72
KELDERMANS, Rombout (Dutch)
 St. Christopher, chimney
 piece, Maakiezenhof
 1521
 GEL pl 95 NBeT
KELLER, Gottfried (Swiss 1910-)
 Cavalier 1956
 JOR-2:pl 223
 --1957/58
 JOR-2:pl 224
 Selbstbildnis plaster; 75 cm
 JOR-1:pl 50
KELS, Hans (German)
 Medal: George Hermann;
 Weapons under Cande-
 labrum 1538 wood; Dm:
 24
 BERL pl 160; BERLES
 160 GBSBe
 Two Muses, Augsburg, gold-
 smith's models 1540 pear-
 wood; 6.6 cm
 MUL 13 GNG
KEMENY, Zoltan (Hungarian-Swiss
 1907-65)
 Armourium: Sculpture Num-
 ber 123, detail 1961 red
 copper; 78-3/4
 BOW 75
 Banlieu des Anges 1958
 copper; 26-3/4x37-3/8
 READCON 268; TRI 47
 FPFa
 The Bell (La Cloche),
 soldered assemblage 1964
 brass; 30-1/2
 GUGE 44 FPMa
 Birth of Structures 1959 brass;
 40
 MINE 19 UDCL1

Chercheur d'Amitie 1957
 JOR-2:pl 156
Couleur-Douleur 1960 brass;
 35-5/8x35-5/8
 ALBC-3:74; TOW 111
 UNBuA
Color Without Weight 1959
 brass; 35-1/2x51
 MINE 22
Cristal d'Esprit 1957
 JOR-2:pl 226
Electra-lectron 1958
 JOR-2:pl 225
Fluctuations 1959
 GOMB 459 IMLor
Formations 1958
 JOR-2:pl 157
--1958 iron
 MAI 148 -LeG
Gravitations Sentimentales
 1958
 JOR-2:pl 227
Image with Four Sides 1962
 iron, copper, wood;
 27-3/4
 GUGE 43 FPMa
Involuntary Velocity, relief
 1962 brass; 100x100 cm
 JOO 204 (col) NOK
Matiers 1958 aluminum square
 pipe embedded in plastic
 MEILD 173 ELH
North Wind 1963 brass and
 copper
 VEN-64:pl 193 SwZMe
Petit Jour le Soir 1959
 36.25x39.5
 CARNI-61:#196 UNNWo
Petit Soir le Matin 1959
 aluminum and brass
 MEILD 150 UICA
Sculpture No. 18 1957 brass;
 33-3/4x23
 CARNI-58:pl 123 UPPiT
Signes-Lines 1958 brass;
 26-3/4
 MINE 20 FPFa
Spirit Converter 1963 brass;
 128x74 cm
 LIC pl 333
Sun Suite 1960
 PEL 274 FPFa
Synthetic Spirit 1962 copper
 and iron; 70
 EXS 88 FPMa
Thousand Souls 1957 colored
 copper; 46x36
 BERCK 285

Trois Vents 1963 colored
aluminum
LARM 386 BBL
$V^{1+T^2+E^{3+}C^4}$ 1958
JOR-2: pl 155
Visualization of the Invisible
1960 brass; 72-1/2x106
GUGE 42 UNNH
Vitesses Involuntaires 1962
brass; Sq: 39-3/8
NEW pl 289 NOK
Will Energy Tension Creation
1958 copper
MAI 148
Zephyr, relief 1964 brass,
colored polyester; 53x
42-1/2
GUGE 45 (col)
KEMPE, Peter (Swedish)
Ampulla: Horn with Figure
of Justice 1607 gold,
with rubies and diamonds
GRAT 95 SnSB
KENAR, Antoni (Polish 1906-)
Christ in Meditation, tomb-
stone 1958 ceramic
JAR pl 16 PZ
Swineherd 1954 plaster
JAR pl 17
KENDRICK, Josephus
Monument to Col. Sir William
Myers c 1811
WHINN pl 163B ELPa
Kennedy, John F.
Catterall. John F. Kennedy
Memorial
KENNET, Kathleen Hilton Young
Scott (nee Bruce)
(English 1881?-1947)
Captain Scott
GLE 23 ELWat
Lord Woolton, bust
NEWTEB pl 13
KENNINGTON, Eric (English 1888-
1960)
Bollard for Canal Barge
brass AUM 140
Decorative Panels
AUM 145 ELIHT
Diver polished metal
CASS 74
Earth Child
CASS 65 ELT
Female Figure burnished
brass
AUM 140
Hearth Figure polished brass
AUM 135

Horseman, head
HUX 94
Jocelyn Herbert, head bronze
CASS 45
The Man Child
AUM 135
Mercy 1934 Portland stone;
62x28
LOND-5: #25
Prayer, detail hardstone
PAR-1: 118
T. E. Lawrence, recumbent
effigy 1939/54 ciment
fondu; L: 82-1/2
ROTJB pl 42 ELT
Treachery, War, Love,
reliefs brick
CASS 97; RICJ pl 55
EStratS
24th (East Surrey) Division
Memorial 1924 stone;
figure: c 84
CASS 65; GLE 171 ELBat
War Memorial to the Missing
AUM 139 FSoi
KENNY, Michael (English 1941-)
The Empress 1965/66 plastic,
for aluminum; 90x126x78
LOND-7: #20
KENT, William (English 1684-1748)
See RYSBRACK, J. M.;
SCHEEMAKERS, Peter (Figure
of Shakespeare, Westminster
Abbey)
KEPINOV, Andrei (Russian)
J. V. Stalin, bust bronze
BLUC 255
KEPINOV, G.
Mettalurgy, detail
CASS 102
Kerckhoven, Johannes Polyander van
Verhulst, R. Johannes
Polyander van Kerckhoven
Kerdeston, Roger de 1337
English--14th c. Sir Roger de
Kerdeston Tomb
KERDIC, Ivo (Yugoslav 1881-1952)
The Goldsmith's Gold 1929
bronze
BIH 37 YZS
Medal: Ksaver Sandor Djalsky,
profile head 1925 bronze
BIH 38 YSMG
Medal, obverse, to Memory
of August Cesarec 1946
bronze
BIH 38 YSMG

Kerempuh, Petrica
 Radaus. Petrica Kerempuh
KERENYI, Jeno (Hungarian 1908-)
 Balzac Medal 1949 bronze;
 Dm: 10.5 cm
 GAD 129 HBA
 Capt. Ostapenko Memorial
 1951 bronze; 430 cm
 GAD 105 HBBu
 On the March 1953 bronze;
 60 cm
 GAD 120
 Socialist Art 1952 plaster;
 200 cm
 GAD 115
KERIM, Salah Abdel (Egyptian
 1925-)
 Cry of the Animal 1960
 screw bolts and machine
 pieces
 LARM 253
 Goat (Capra) iron
 VEN-60: pl 191
 Gravidanza
 VEN-66: #205
KERN, Erasmus (German fl 1624-
 c1650)
 St. Sebastian c 1625/50
 ptd lindenwood on pine
 pedestal; 49 (with 6-1/4
 pedestal)
 KUHN pl 52 UMCB
 (1964. 4)
KERN, Hans
 Sculptor at Work, relief
 1512
 GOLDF pl 51 GBadeS
KERN, Leonhard (German 1588-
 1662)
 Adam and Eve mid 17th c.
 wood
 KO pl 85 (col) GStLa
 --1646 ivory; 23 cm
 BSC pl 132 GBS (713)
 Diana mid 17th c. boxwood;
 108
 MOLE 219 ELV
 Knabengruppe 1640 hornbeam
 MUL 20 GWeiG
 Main Door, west wing;
 Allegories of Justia and
 Prudentia 1616
 BOE pl 169 GNR
 Tankard, silver mounts by
 E. Busch, c 1703 c 1640
 ivory
 COOPF 177 GDonF

KERRICZ, Guillaume (Flemish 1682-
 1745)
 St. Augustine 17/18th c.
 terracotta; 22
 ASHS pl 30 ELV
Kerschensteiner, August
 Belling. August Kerschensteiner,
 head
Keter
 Jewish--16th c. Bimah Crown
 Polish. Keter
KEY, Kieven de (Dutch)
 Meat Market Gable, Haarlem
 (line drwg) 1602/03
 CHRP 249
Key-box. Tilson
Keys
 French--9th c. Key of St.
 Servatius
 German--13th c. Key of St.
 Elizabeth
KEYSER, Hendrik de (Dutch 1565-
 1621)
 Abraham van Goorle,
 medallion
 HAMF 71 NHM
 Erasmus 1621 bronze
 GEL pl 102; LARR 254
 NRH
 Man, bust 1606 ptd terracotta;
 24-3/8
 RIJ 133 (col); RIJA pl
 118 (col); ROS pl 204A
 NAR
 William the Silent Monument
 1614/44 marble
 BAZINW 397 (col); BUSB
 53; GEL pl 98; HAMF 71,
 268; POST-2:47; ROS pl
 204B NDN
KEYSER, Hendrik de--ATTRIB
 Fortune, residence facade
 figure sandstone; 34-1/2x
 32-1/4
 HAMF 269 NAR
Keystones
 Aumonier, E. Office Building
 Keystones
 Schluter. Courtyard Keystone
Khalil, Mohamed Mahmoud
 Hassan. Mohamed Mahmoud
 Khalil
The Khamasin. Mikhtar
KINOPFF, Fernand
 Sybil, bust
 MARY 150
KIDNEY, William

Wanderer 1950 bronze; 25-1/2
NNMMAG 180
KIRCHNER, Johann Gottlob
 Meissen Porcelain Fountain
 1827/28 H: 25-1/16
 NM-8:23 UNNMM
 (54.147.65a-c)
KIRCHNER, Johann Gottlob, and
 J. J. KANDLER
 Monkey 1730 Meissen
 porcelain; 19
 BOSMI 143 UMB (58.1190)
Kirghiz Man and Woman, Gardner
 porcelain.
 Russian--19th c.
Kirk, Percy
 Scheemakers, P. Gen. the
 Hon. Percy Kirk Monument
Kirov, Sergei Mironovich (Russian
 Leader 1888-1934)
 Vilensky. Kirov
Kischka's Breakfast. Spoerri
KISFALUDI-STROBL, Zigmond
 (Hungarian 1884-)
 Bather bronze
 VEN-12:pl 88
 Bela Ivanya-Grunwald, bust
 bronze; 42 cm
 GAD 92 HBA
 Franz Rakoczi II 1954
 bronze; 280 cm
 GAD 102
 Freedom Memorial 1947
 bronze; main figure: 14 m
 GAD 99 HBG
 G. B. Shaw, head c 1932
 bronze; 46 cm
 GAD 83 HBA
 George Slocombe, head
 CASS 48
 Miklos Horthy, bust bronze
 VEN-40:pl 108
 Mrs. Gizi Bajor, bust
 marble
 CASS 59
 Nude marble
 VEN-32:pl 169
 Nude Woman marble
 VEN-24:pl 94
KISFALUDI-STROBL, Zigmond,
 Andras KOCSIS, and Lajas
 UNGVARI
 Kossuth Memorial 1951
 bronze; main figure: 5 m
 GAD 101 HBK
KISS, August (German 1802-65)
 Amazon Attacked by Tiger
 zinc and bronze
 VICG 133 ELV

KISS, Istvan (Hungarian 1927-)
 We Want Freedom 1953 plaster;
 210 cm
 GAD 128
KISS, Zoltan Olcsai (Hungarian 1895-)
 We are Building our Future
 1952 plaster; 64 cm
 GAD 107 HBA
The Kiss. Brancusi
The Kiss. Dick
The Kiss. Drury
The Kiss. Gonzalez
The Kiss. Lambeaux
The Kiss. Rodin
The Kiss. Thornycroft, H.
KISS-KOVACS, Gyula (Hungarian
 1922-)
 Peace Medal 1953 Dm:9.9 cm
 GAD 134 HBA
Kiss of Peace, tabernacle. Italian--
 16th c.
The Kiss on the Tomb. Rosso,
 Medardo
KISSLING, Ernst (Swiss 1890-)
 Adam and Eve in Paradise,
 relief stone
 PAR-2:76
Kistritz, Timo von
 Naumberg Master. Founders'
 Choir Screen: Timo von
 Kistritz
Kitchener, Horatio Herbert (British
 Soldier 1850-1916)
 Dick. Kitchener Memorial
 Chapel: Kitchener Coat of
 Arms
Kitchener War Memorial. Dick
Kite Rider. Roberts-Jones
Kitty. Epstein
Kitty with Curlers. Epstein
KIVIJARVI, Harry (Finnish 1931-)
 Lastra di Pietra 1966
 diorite
 VEN-66:#164
 Sculpture*
 EXS 45
Kivotion
 Rumanian--15/16th c. Tran-
 sylvanian Kivotion
 Rumanian--17th c. Kivotion:
 Church
Klage. Herzog
Klage
 Kolbe. Grief
Klage
 Kollwitz. Grief
Klagende Maria See Mary, Virgin--
 Mourning

KLAUSENBERG, Georg and Martin
 von See KOLOSVARI, Marton
 and Gyorgy
KLEE, Paul (Swiss 1879-1940)
 The Mocker Mocked 1930 wire
 LYNCM 31 UNNMMA
KLEIN, Yves (French 1928-62)
 Double Sided Wall of Fire
 BURN 243
 Lecteur I. K. B. 1960
 (No. 1); Lecteur I. K. G.
 1960; Lecteur I. K. B.
 (No. 2) ptd sponges with
 brass bases; 47; 38-1/2;
 and 46-1/2
 TOW 111 UNBuA
 Monochrome Bleue 1960
 H: 78
 SEITC 76 UNNI
 Portrait Relief Airman 1962
 KULN 11
 Untitled 1957 sponge; 47-1/2;
 base: 7-1/4
 AMA 62
Kleine Dangolsheimer Heilige
 German--15th c. Little Saint
 of Dangolsheim
Kleine Kniende mid Erhobenen
 Armen. Blumenthal
Kleine Sinnende. Lehmbruck
Kleine Stehende. Picasso
KLIMSCH, Fritz (German 1870-)
 Bather bronze
 AGARN il 7 GFFarb
 Marianna Hoppe, head
 marble
 VEN-42: pl 78
 Olimpia bronze
 VEN-42: pl 79 GBCha
 Olympia 1937
 CASS 83
 Wilhelm von Bode, head
 1923 bronze; LS
 HENT 69 GBK
KLINGER, Max (German 1857-1920)
 Beethoven, seated figure
 1899/1902 marble, bronze,
 ivory; 300 cm
 LIC pl 150; MARY pl 108;
 POST-2: 177; TAFTM 54
 GLB
 Cassandra, half figure 1895
 colored marbles; 37
 RAMS pl 15b GLB
 Nietzsche, bust
 LARM 225 GFSt
 Salome, half figure colored
 marbles
 MARY pl 52; TAFTM 54
 GL

Wilhelm Wundt, bust 1908
 bronze
 SELZJ 145 GMaM
KLINGHE, Goteke (German)
 Baptismal Font 1483 brass;
 43
 BOSMI 123 UMB (41.561)
KLODT, P. K. (Russian 1805-67)
 Equestrian Figure 1839 bronze
 TRCT 197 RuLA
Klosterneuberg Madonna. Master of
 the Klosterneuberg Madonna
Knabengruppe. Kern, L.
KNAPPE /Karl (German 1884-)
 The Annunciation
 AUM 18
 Johannes auf Patmos 1946
 wood; c 36x22x10.5 cm
 SP 110 GHaS
 Kriegerehrenmal: Das Grab;
 detail: Das Heer 1925
 HENT 78-79 GM
 Maria im Garten, relief
 c 1925/28 gilded bronze;
 9.5/10.5x10/11 cm
 SP 108 GHaS
 Painter Max Liebermann,
 torso 1925 bronze; 64 cm
 OST 61
 Turmengel 1935 wood; 32x12x
 8 cm
 SP 109 GHaS
Knauer, Georg
 Dell. Georg Knauer, plaque
KNEALE, Bryan (English 1930-)
 Croga 1965 steel; 108x60
 ARTSB-66: pl 3
 Crucifix 1961 forged steel and
 wood; 92x50x24
 LOND-6: #25
 Head 1962 iron; 34
 READCO pl 15b ELR
 Head in Forged Iron 1961
 24x8
 READCON 248 ELR
 Iron Pig 1962 iron; 15x20x14
 ARTSS #31 ELBrC
 Knuckle 1964 steel
 MEILD 28 ELT
 O and A 1965 steel; 18x14x8'
 LOND-7: #21 ELR
 Revolve 1964 iron; 46
 WHITT 158 ELR
 Shadow 1965 steel; 70
 MAE 68
 Voice 1964 steel; 34
 MAE 69
Kneeling Angel. Alamanno
Kneeling Angel. Amadeo

Kneeling Angel. Niccolo dell'Arca
Kneeling Boy. Minne, G.
Kneeling Boy. Schacherl-Hillmann
Kneeling Figure. Kolbe
Kneeling Figure. McWilliam
Kneeling Figure. Ziffer
Kneeling Figure Eos. Stadler
Kneeling Girl. French--14th c.
Kneeling Girl. Haller
Kneeling Girl. Henri, S.
Kneeling Girl. Maillol
Kneeling Girl. Stursa
Kneeling Prophet. Marcks
Kneeling Woman. Fiori
Kneeling Woman. Grzimek
Kneeling Woman, Hernandez, M.
Kneeling Woman. Kolbe
Kneeling Woman. Lehmann, K.
Kneeling Woman. Lehmbruck
Kneeling Woman. Lenotre
Kneeling Woman. Maillol
Kneeling Woman. Manolo
Kneeling Youth. Blumenthal
Kneeling Youth. Lehmann, K.
Kneeling Youth. Minne, G.
KNELLER, Godfrey (German Painter
 1646-1723)
 Bird. William Congreve
 Monument, with copy of
 Kneller's Kit Kat Portrait
 Portraits
 Cavalier. Gothofridus Kneller,
 medallion
KNEULMAN, Carel (Dutch 1915-)
 The Europeans 1952 H: 100
 BERCK 179
KNIEBE, Walther (German 1884-)
 Woman's Torso wood
 PAR-2:48
Kniende
 Lehmbruck. Kneeling Woman
Knife Edge. Moore, H.
Knight, Mr. and Mrs.
 Rysbrack. Mr. and Mrs.
 Knight, seated effigies
Knight of Darkness. Dubuffet
Knightley, Richard
 English--16th c. Sir Richard
 Knightley Tomb
Knights See also Games and Sports--
 Jousting, and Names of
 Knights, as Arthur
 Albert of Soest. Door Frames
 of Council Chamber
 Bacque. Pothon de
 Xaintrailles
 Bayes. A Knight on his War
 Horse

English--12th c. Galloping
 Knight, seal of Robert Fitz-
 walter
--Knight, chess figure
English--13th c. Edmand
 Crouchback, canopy detail:
 Knight, equest, trefoil
--Figures, west front: Knight
--Knight, effigy#
--Knight's Tomb
--Thomas de Cantiloupe Tomb:
 Knight Weepers
English--14th c. Aymer de
 Valence Tomb: Canopy
 relief--Galloping Knight
--English Knight, effigy
--Knight, effigy#
--Knight Falling from Horse,
 misericord
Flemish--15th c. Misericords
French--12th c. King Arthur
 and his Knights, portal
 archivolt
--Knights in Combat
French--14th c. Knight and
 Lady Riding to the Hunt,
 mirror case
--Siege of the Castle of Love
French--15th c. Knights Jousting
French, or Flemish--16th c.
 Legend of St. George
German--13th c. Aquamanile:
 Knight on Horseback
--Bamberg Rider
--Mounted Knight, choir stall
--Shrine of Charlemagne
German--14th c. Choir Stall:
 Mary and Child Adored by
 Knight
--Misericord: Falling Knight
German--15th c. Altar Taber-
 nacle: Madonna and Child;
 Horse and Knight
Guillaume d'Auniers. Bur-
 gundian Knight
Leoni, P. Kneeling Knight,
 Spanish Tomb
Meredith-Wilson. The Spirit
 of the Crusades
Swedish--14th c. Drinking
 Horn, with armed knights
The Knight's Communion
 French--13th c. Abraham and
 Melchizedek (The Knight's
 Communion)
Knights Templar
 English--13th c. Knights
 Templar, effigies

Knittel, Margaret
 Stadler. Portrait of
 Margaret Knittel
Knives
 German--17th c. Knife Sheath
 Italian--16th c. Table Knife
KNOBELSDORFF, Georg Wenzeslaus
 von (German 1699-1753)
 Atlantes, south front sup-
 porting columns 1745/47
 BAZINB 229 GPoS
KNOOP, Guitou (Russian-French
 1902-)
 Torso
 FEIN pl 114
 --1950 marble
 RAMS pl 80a UMoSL
 Vayu II 1958 marble
 MAI 149 FPRoth
The Knot. Muller, R.
Knotengedicht. Kolar
Knox, John (Scottish Reformer
 1505-72)
 Landowski and Bouchard.
 Reformation Monument
Knuckle. Kneale
Knyvett, Thomas, Lord
 Stone. Thomas, Lord
 Knyvett, Tomb
KOBLASA, Jan (Czech 1932-)
 Head 1961 plaster
 SEAA 145
KOBLICK, Freda
 External Wall cast acrylic
 resin, agate imbedments
 MILLS pl 81
 Illuminated Pillar acrylic
 resin: 10'
 MILLS pl 82
Kobza. Folk Art--Russian
KOCH, B. (Swiss)
 Owl, vessel 1590 silver
 LARR 176 SwBK
KOCH, Odon (Swiss 1906-)
 Figure 1950 stone; 70 cm
 JOR-1: pl 103
 Instrument a Cordes 1956
 JOR-2: pl 231
 Nenuphar 1958
 JOR-2: pl 137
 Sculpture*
 EXS 45
 Sculpture 1951 Belgian
 granite; 65 cm
 JOR-1: pl 104; MAI 150
 Sculpture 1954 stone; 85 cm
 JOR-1: pl 102
 Sculpture 1957
 JOR-2: pl 232

 Water Lily 1956 granite; 80
 BERCK 169 SwLaV
KOCK, Hans (German 1920-)
 Granite Stele 1957/58 H: 128
 TRI 261 GHP
KOCKS, Pieter Adrianenz
 Delft Dore Candlestick
 SOTH-2: 154 (col)
KOCSIS, Andreas (Hungarian 1905-)
 See KISFAULUDI-STROBL
Kodolanyi, M. (Hungarian Writer)
 Kunvari. M. Kodolanyi, head
Koeberle
 Bourdelle. Koeberle, bust
KOELLE, Fritz (German 1895-)
 Bergarbeiter 1927 bronze;
 1.97 m
 HENT 81 GBN
KOENIG, Fritz (German 1924-)
 Animal
 FPDEC-German il 4
 Carmague X 1958
 FAUL 458 UNNMMA
 The Chariot 1957 bronze;
 19-3/4x13x13
 CALA 209; GUGP IVG
 The Couple (Paar) 1949 bronze
 GERT 228
 --1958 bronze
 VEN-58: pl 149
 Derby I 1960 bronze; 33x58.5
 x68 cm
 OST 13
 Domus 1963 bronze; 17-1/2
 NEW pl 326
 Flight 1950 bronze; 5-1/8
 GERT 228; SCHAEF pl 56
 Gondelherde 1958 bronze; 52 cm
 OST 93
 Herd X 1958 bronze; 17-3/4
 READCON 214 UNNMMA
 Horsemen (Group of Horsemen;
 Group of Riders) 1956
 bronze; 11-3/8x21-5/8x
 11-3/4
 MAI 150; MID pl 127; TRI
 112 BAM; GDuK
 The Meeting (Begegung) 1952
 bronze
 GERT 228
 The Night Riders 1959 bronze
 WCO-3: 11
 Palm Sunday 1953 bronze; 34
 SCHAEF pl 57
KOFRANEK, Ladislav
 Madonna
 MARY pl 72
KOGAN, Moissej (Dutch-French 1879-
 1942)

Female Figure stone
 SCHW pl 19
--1933 bronze; 37 cm
 LIC pl 206 NRBoy
Nude
 ROTH 875
KOHL, Johann Fredrick (Czech
 1681-1730)
 St. Augustine
 STECH pl 43 CzPCh
 St. Nicholas 1708
 STECH pl 42a CzPCh
KOHL, Hieronymus (Czech)
 See also Torre, F. de
 Bear Fountain, Slavata Family
 Summer House 1689
 STECH 32 CzP
 St. Augustine, entry figure
 1684
 STECH pl 12b CzPTh
 St. Thomas, the Apostle,
 entry figure 1684
 STECH pl 12a CzPTh
KOHL, Hieronymus, and Franz
 PREISS
 Left-hand Altar; Right-hand
 Altar 1701/08
 STECH pl 13, 14 CzLoN
 St. Jerome, altar figure
 1701/06
 STECH pl 16 CzLoN
 St. Joachim 1701/06
 STECH pl 15 CzLoN
KOKOSCHKA, Oskar (Austrian
 1886-)
 Self Portrait as a Warrior,
 bust 1908 ptd clay; 16-1/2
 BOSMI 163 UMB (60.958)
 Portraits
 Hrdlicka. Oskar Kokoschka,
 head
 Zschokke. Oscar Kokoschka,
 half figure
KOLAR, Jiri (Czech 1914-)
 Apple and Pear 1964
 KULN 65
 Knotengedicht 1963
 verglaster schankchen mit
 verschiedenen Gagenstand-
 en; 80x60 cm
 BER 21
KOLAREVIC, Iliga (Yugoslav 1894-)
 Head of a Girl bronze
 BIH 121 YBN
KOLBE, Georg (German 1877-1947)
 Adagio
 NEUW 47 GMarU
 --1923 bronze
 GERT 55

--1923 bronze; 32-1/2
 CHICP-1: pl 93 UICWo
Ariadne
 AGARC 168
Ascending Girl bronze; 16-1/4
 KUHNG pl 111 UMCB
 (1955. 7)
Ascending Woman 1926 bronze;
 62
 ALBC 185; NNMMARO pl
 278 UNBuA
Assunta 1921 bronze; 95 m
 CASSTW pl 14
--1921 bronze; 76
 DETT 172; HENNI pl 21;
 NMG #108; NNMMAG 163;
 NNMMARO pl 274; RIT 94;
 VALE 159 UMiD (29.331)
Aufstahender Jungling 1932
 plaster, for bronze
 HENT 39
Aufstiegende Menschen 1931
 plaster, for bronze
 HENT 38
The Awakening
 TAFTM 70
Cloud Journey (Wolkenfahrt)
 1929 bronze
 GERT 54
The Couple 1937
 CASS 76 GHa
Crouching Girl c 1925 terra-
 cotta; 18-1/4
 KUHNG pl 113 UMCB
 (1932.57)
The Dancer
 CHENSP 261; TAFTM 70
--1911/12 bronze; 60-5/8
 BERL pl 249; BERLES 249;
 CASSTW pl 13; CHENSW
 476; KO pl 103; MARY pl
 97; NNMMAG 162; RAMS
 pl 47a GBSBe (B 317)
--1922 bronze; c 27-1/4
 MCCUR 254 GCoW
Dancer (Male Figure) 1914
 bronze; 30
 KUHNG pl 110 UMCB
 (1932.64)
Figure 1935 bronze
 MAI 152
Figure, German Pavilion, Inter-
 national Exposition, Barce-
 lona 1929
 DAM 32
Figure of a Woman
 ENC 529
Frau M. F., head 1933 bronze;
 LS HENT 41

Garden Figure
 TAFTM 70
Genius of Beethoven 1926
 bronze
 RAMT pl 36
Girl Looking Up bronze; c 42
 RICJ pl 27 -UBe
Gottesstreiter 1933 bronze
 HENT 42
Grief (Klage)
 HOF 58 UNNCoh
--
 PANA-2: 99 UMWA
--1921 bronze; 15-3/4
 NMG #109; UNNMMAM
 #170 UNNCoh
--1921 bronze; 15-3/4
 NNMMAP 211 UNNMMA
--1921 bronze; 17
 BOSME pl 111 UMoSLS
--1926 bronze; 24
 WALKE UNNCoh
Heinrich Heine Monument,
 Frankfort am Main, model
 1913 bronze; 10-1/4
 BOSME pl 40 UMBSwa
Henry van de Velde, head
 DEVI-3
Kauerende Japanerin 1911
 bronze; 46 cm
 OST 23 GBremK
Kneeling Figure bronze;
 11-1/2
 NCM 232 UNcRV
Kneeling Woman artificial
 stone
 VEN-22: 118
--bronze; 20-1/4
 NM-15: 85
Male Stadium Figure bronze
 VEN-34: pl 156
Mermaid 1922 bronze
 VALE 58
Nijinsky 1912
 RICH 188 UMiDK
--1913 bronze; 75 cm
 OST 22 GHaK
Painter Max Slevogt, head
 OST 62 GHaL
Pieta 1930 bronze; 1.5 m
 OST 24 GHaSt
--1930 bronze; 1.5 m
 HENT 37 NoONas
Seated Figure 1929 bronze
 RAMS pl 46 GBKo
Self Portrait, head 1925
 bronze
 GOLDF pl 368

--1934 bronze; LS
 HENT 43
Sitting Figure 1939 bronze; 39
 MID pl 45 BAM
Sitting Nude
 DEVI-2 BAM
Small Kneeling Girl bronze;
 11-3/4
 KUHNG pl 112 UMCB
 (1955. 333)
Standing Figure (South Sea
 Maiden) bronze
 PRAEG 489
Standing Girl (Stehendes
 Madchen) 1915 bronze;
 1.78 m
 HENT 36; TAFTM 70
Standing Woman bronze
 BALD 95
--1935 bronze
 SFGC 9 UNNBu
W. R. Valentiner, head 1920
 bronze; 11
 NCM 233 UNcRV
Woman Descending c 1927
 bronze; 28-3/8
 NMG #111 UNNWe
Woman Looking Up
 CHENSE 396
Wounded Flyer
 NEUW 157
Young Girl bronze; 50
 JLAT 25 UCStbM
Young Girl Standing 1915
 bronze; 50-3/8
 READCON 22; SELZJ 142
 GMaM
Young Man Stepping Forward,
 detail 1928 bronze
 RAMT pl 35
Zehnkampfmann 1933 bronze
 HENT 40
KOLIBAL, Stanislav (Czech 1925-)
 The Table 1965 aluminum;
 34x48x38
 GUGE 98
KOLLIN, Peter (German 1479-1502)
 Pieta, Weil 1471 wood
 MULS pl 125 GStWL
KOLLWITZ, Kathe (German 1867-
 1945)
 The Circle of Mothers 1937
 bronze
 MAI 152
 The Complaint 1938 bronze;
 10-1/4x9-7/8
 READCON 26
 GMB

--1938 bronze; 11
MID pl 23 BAM
Grief (Klage) 1938 bronze;
11-1/4
PUL-2: pl 94
--1938/39 plaster; 27x25 cm
OST 47 GCoW
Memorial to the Flanders Dead
(Gefallenmal auf dem
Soldatenfriedhof): The
Father The Mother 1924/35
granite model; 1.52; and
1.24 m
HENT 20-21; OST 14
--The Father
CASS 102 BES
Memorial to Son, Peter 1932
granite
RAMS pl 11b BF
Mourning, relief 1938 plaster;
11x9-7/8
HAMP pl 57B GHK
Pieta 1936 bronze
GERT 114
Self Portrait, head 1926/36
bronze LIC pl 210 GBKol
--1936 bronze; 14-3/4
DETS 50 UNNH
War Monument for Roggevelde
(Flanders), unexecuted
model 1917 plaster; 31
BOSME pl 79 UMBSw
KOLOZSVARI, Marton (Hungarian),
and Gyorgy KOLOZSVARI
(Martin and Georg KLAUSEN-
BERG)
St. George and the Dragon,
courtyard 1373 bronze;
200 cm (excl lance)
BUSR 7; GAD 27; HARVGW
118 CzPH
KOMAN, Ilhan (Turkish 1921-)
Impetuous 1961 iron
VEN-62: pl 97
Miroir II 1962 iron; 31-1/2
READCON 261
KONPANEK, Vladimir (Czech 1927-)
Two Village Women 1963
bronze NEW pl 248
Woman with Bucket 1963
bronze
VEN-64: pl 138
KONENKOV, Sergei (Russian 1874-)
Bee Master wood
SGO-4: pl 43
Dostoyevsky, bust
ENC 530

Self Portrait, bust marble
CHAM pl 31 RuMT
Standing Woman wood
PAR-2: 144
The Thinker 1898 marble
VEN-62: pl 201 RuLR
KONIGER, Viet (Austrian 1729-92)
Virgin of the Annunciation
1756
HELM pl 184 AGLG
Konrad III, Archbishop, Count von
Daun d 1439
Gerthner. Archbishop Konrad
III Tomb
Konrad von Weinsberg
German--14th c. Konrad von
Weinsberg Tomb
Korbtragerin. Burckhardt
Kore. Hartung
Korean Youth. Smogyi
KORMIS, F. I.
Reclining Figure cold cast
bronze
PER 38
Korosi Csoma, Sandor (Hungarian
Orientalist)
Antal, K. Sandor Korosi
Csoma, riding Buffalo
Korsun Gate. Avraam
Korwa Tribe, India
Milward. Korwa Woman, head
KOS, Tine (Yugoslav 1894-)
Girl with a Rose 1942 wood
BIH 131
Little Shepherd 1943 wood
BIH 130
KOS-DENSHINA (Russian) See
PENKINA, E.
KOSSO (Dosso Eloul; Kosso Elul)
(Israeli 1920-)
Altar 1964 Jerusalem stone;
20-1/8x37-1/4x24-1/2
SEIT 45
Basic 1963 Jerusalem stone;
26-1/4x19-1/2x15-1/2
SEIT 44 UNScK
Doubleself 1962 Travertine
stone; 70-7/8x20-1/2x
5-5/8
SEIT 43 UNScK
Eve wood
GAM pl 124
Leda and the Swan, relief
wood
GAM pl 123
My Ancestor 1947 stone
SCHW pl 109

Shulamit 1951 wood
SCHW pl 110
Statement 1962 bronze; 21x18x
9-3/4
SEIT 43
Kossuth, Lajos (Hungarian Patriot
1802-94)
Kisfaludi-Strobl, A. Koksis,
and L. Ungvari. Kossuth
Memorial
KOSTER, Betty (English)
Cat 1943 terracotta; 10-1/2
BRO pl 19
KOSTKA, Jozef (Czech 1912-)
Villanelle 1949
VEN-58: pl 139
KOTRBA, Karel (Czech 1893-)
Singer bronze
VEN-34: pl 143
Woman-s Torso bronze
VEN-36: pl 54
KOUNELLIS, Jannis (Greek/Italian
1936-)
Margherita con Fuoco 1967
KULN 186
Kovacic, Ivan Goran
Bakic. Poet Ivan Goran
Kovacic, head
KOVACS, Ferenc (Hungarian 1926-)
Reading Girl 1953 marble;
100 cm
GAD 126 HBA
KOVATS, Georg
Head (Kopf) 1948 wood
GERT 247
Reclining Female (Liegende),
rear view 1950/51
plaster
GERT 247
KOWALSKI, Piotr (Polish-French
1927-)
Calotte 4 1961 concrete;
5 pieces
READCON 190 SwBeK
Cube V 1967 steel and
plaster; 35 Sq
GUGE 105
Now
SUNA 132 UCLonC
KOWARIK, Hubert (German)
Salome
TAFTM 65
KOZARIC, Ivan (Yugoslav 1921-)
Little Girl 1953 bronze
BIH 162
The Man of Lika bronze
MAI 153 -Mag
Torso 1956 bronze
BERCK 288

KOZLOVSKI, Michael Ivanovich
(Russian 1753-1802)
Caryatids, Throne Room 1798
HAMR pl 150A RuP
General Suvorov as Mars,
monument bronze
RTCR 194 RuL
Minerva and the Genius bronze
BLUC 220 RuLAc
KRACKER, Tobias
Parnassus Fountain 1696
STECH pl 27 CzBV
KRAFFT, Adam See KRAFT, Adam
KRAFT, Adam (Adam Krafft) (German
1455-1509)
The Deposition stone
POST-1: 107 GNG
Entombment 1507/08 sandstone
LARR 79 GNH
Sacrament Tabernacle, center
portion of choir 1493/1500
BUSR 106; MAR 118 (col)
GNL
--Self Portrait, kneeling figure
GOLDF pl 54; MULS pl 182;
PRAEG 210
Sebald Schreyer Tomb: Christ
Carrying the Cross 1490/92
MULS pl 181B GNS
--Self Portrait, kneeling support
figure
ENC 531; GOLDF pl 53;
MOLE 12 (col)
Seven Stations of the Cross:
--Christ Carrying the Cross
BAZINW 354 (col) GNG
--Fifth Station
LIL 136
--Station
CHRC 195
--Two Stations
CHASEH 262
KRALJ, Tone (Yugoslav 1900-)
Christ, torso wood
MARY pl 179
Matija Gubec Cycle, relief
detail 1924/44 plaster
BIH 132 YSkMG
KRAMER, Harry (German-French
1925-)
Drahtplastik 1962/64 knotted
iron wire, with small motor
and rubber bands as driving
mechanism; 35-3/8
NEW pl 297 GHaB
Endless Track 1960 iron and
motors; D: 37-1/2; Dm:
7-1/2
SELZP 40 SwZBr

Foot 1965 iron wire and
 motors; 48
 SELZP 39 SwZBr
Rainier's Chair 1965 iron
 wire and motors; 40-5/8
 x17-3/8x15-3/8
 SELZP 40 UNNLoe
Stovepipe 1965 iron wire and
 motors; 73-5/8x14-5/8x
 13
 SELZP 41 UNNLoe
Torso 1964 wire construction
 MEILD 78 ELT
KRAMER, Jacob (English Painter,
 Leeds)
 Epstein. Jacob Kramer, bust
KRASINSKI, Edward (Polish 1925-)
 No. 7, 1967 aluminum,
 plastic, wood, ptd;
 98-1/2
 GUGE 99
KRATOHVIL, Jovan (Yugoslav 1924-)
 Composizione 7/64 1964
 bronze and iron
 VEN-66:#193
KRAUS, August (German 1868-1934)
 Selbstbildnis, head 1933
 bronze; LS
 HENT 68
 Krefeld Monument, model. Armitage
KREITZ, Willy (Belgian 1903-)
 Adolescence
 GOR 83 BAR
 Sitting Woman 1955 blue
 granite; 51
 MID pl 89 BAM
 Torso
 GOR 84
KRETZ, Leopold (Polish-French
 1907-)
 Group 1958
 MAI 154
Kreuzabnahme Christ See Jesus
 Christ--Deposition
KRIBBE, Melchior (German d 1635)
 Otto von Dorgelo Epitaph
 1614
 BUSB 35 GMuC
KRICKE, Norbert (German 1922-)
 Grosse Kasseler 1958 steel;
 285 cm
 KUL pl 60 GLe
 Space Sculpture (Raumplastik;
 Raumplastik Mannesmann;
 Sculpture Spatiale;
 Spatial Sculpture) 1958
 stainless steel; 112-1/4x
 78-3/4x70-7/8
 GIE 223; TRI 198 GLeM

--1958/61 steel; 800 cm
 KUL pl 59; OST 106 GDusMa
--1960/66 steel; 27-5/8
 LARM 376; READCON 243
 (col) FPBeau
--1961 chromium steel; 23-5/8
 NEW pl 331 GHaB
--1961 stahldraht, geschweisst;
 28 cm
 SP 111 GHaS
--1961 stainless steel; 57x
 88-1/2x88-1/2
 SEAA 147 FPF1
--1961 steel
 VEN-64:pl 151
 Space Time 1957 L: 90
 BERCK 163
 Space Time Sculpture, Red
 and White 1954 steel rod;
 23-1/2x27-1/2x15-3/4
 GIE 222 GWuM
 Surface Way in Two Planes
 1957/59 steel; L: 111'7"
 TRI 251 GGelT
 Theatre Facade (Stahlplastik)
 1957/59 steel: L 3400 cm
 KUL pl 61; MAI 155 GGelT
 Water Sculpture (Wasserplastik;
 Wasserwald) 1963 plexiglas
 and water; 1400x1400x300 cm
 KUL pl 62; KULN 174
 GDusRG
 Wires (Steel Wire) 1957
 BERCK 163; MAI 155
KRIECHBAUM, Martin (Austrian)
 Winged High Altar; detail:
 St. Christopher c 1491/98
 MULS pl 175, 174A AKe
 --details: Joseph; Sts. Peter,
 Wolfgang, and Christopher
 BUSR 108, 109
Kriguna. Olafsson
KRIKAWA, Karl (German)
 Fruitfulness
 TAFTM 70
Krizanic, Pjer
 Bodnarov. Painter Pjer
 Krizanic, head
KRIZEK, Jan (Czech 1919-)
 Head
 MAI 156
KROGH, Henrik (Swedish)
 Drinking Fountain ceramic
 AUM 106
 Drinking Fountain ceramic
 AUM 107 SnSC
KROP, Hildo (Dutch 1884-)
 Aspiration to Life 1949/51
 MID pl 78 BAM

Bridge Column Figure granite
CASS 127 NA
Female Figure limestone
RAMT pl 42 NAG
Girl's Torso granite
PAR-1:205
Horse, direct cutting marble
MARTE pl 27
Pillar Crown on Bridge
granite
AUM 110 NA
Woman and Child marble
MARTE pl 27
KRSINIC, Frane (Yugoslav 1897-)
The Awakening 1928 marble
BIH 73 YBN
Dancer bronze
VEN-40:pl 96
Diana 1930 bronze
BIH 74, 75 YZMG
Fisherman, relief bronze
BIH 64 YBN
Frane Bulic 1935 plaster
BIH 71 YZ
Girl 1930 stone; 60
TATEF pl 33g ELT (4537)
Girl with a Book 1940 marble
BIH 66
Memories 1941 marble
BIH 70
Mother at Play 1942 plaster
sketch
BIH 69
Oil Pressing, relief 1934
bronze
BIH 64
Repose 1940 marble
BIH 72 YBN
Sculptor, hand detail plaster
BIH 24
Spinning Woman 1939 bronze
BIH 68
Standing Nude marble
BIH 67
KRUG, Ludwig (German 1488/90-
1532) See also Flotner, P.
Adam and Eve 1515 bronze
CLE 106 UOC1A (48.359)
The Fall (Der Sundenfall),
relief 1514 14.9x9 cm
BSC pl 104 GBS (805)
--1520/25 marble; 35.7x
27.2 cm
MUL 46 GMBN
KRUGER, Wilhelm (German)
Beggar c 1730 ivory; 4-1/2
KUHN pl 57 UMCB
(1956.37)

Krumau Virgin. Austrian--14/15th c.
Krumlov Madonna. Bohemian
KRUMPER, Hans (German c 1570-1654)
Justice early 17th c. bronze;
over LS
MOLE 221 GMR
Ludwig of Bavaria Tomb:
Duke Wilhelm IV 1619/22
BUSB 54, 55; MUL 79 GMF
Patrona Bavariae--Patron
Virgin of Bavaria 1615
bronze; c 3 m
HEMP pl 19; LIL 180;
MUL 75 GMR
Kruzlow Madonna. Polish--15th c.
KUCHEL, J. M. See BENKERT, J. P.
KUDO, Tetsumi (Japanese-French
1935-)
L'Amour 1964
KULN 40
Confluent Reaction in Plane
Circulation Substance 1960
PEL 257
For Your Living Room, For
Nostalgic Purposes 1965 bird
cage assemblage
KULN 52
Portrait 1964
KULN col pl 2 (col)
Your Portrait 1962 assemblage;
23-1/4x25-5/8
NEW pl 56 FPY
Your Portrait--P 1965
KULN 85
KUEN, Frantisek Antonin (Czech)
Facade Figures, details: Sts.
Luke, Matthew, Mark, and
John 1712/18
STECHS pl 191-93 CZOsC
KUENE, Konrad (German fl 1443-69)
Archbishop Dietric von Moers
Monument: St. Peter and
Archbishop; Virgin and
Child 1460
MULS pl 79 GCoC
KUHN, Jean
Transept Decoration 1632 stucco
GAF 183 FMoiM
KULIBIN, I. P.
Watch--egg-shaped 1765/69
embossed metal
HERM il 7 RuLH
Kummer's Plane Surface
Ray. Mathematical Object
KUNA, Henryk (Polish)
Polish Pavilion, Paris Ex-
hibition 1925
AUM 24

R. K. Witkoroski bronze
VEN-32:pl 127
Kunigunde, Saint (Consort of Henry
II of Germany d c 1039)
German--11th c. Basle Ante-
pendium: Christ Adored by
Emperor Henry II and
Empress Kunigunde
German--13th c. Adam Portal
German--18th c. Kunigunde
Riemenschneider. Henry II
and Kunigunde
KUNST, Ernst (German 1896-)
Fraulein L., head 1930
bronze; LS HENT 70
KUNST, Mauro (English)
Bones 1965
KULN 30
KUNSTGEWERBSCHULE
Buffalo (Buffle) pottery
MARTE pl 41
Seated Figure# terracotta
MARTE pl 41
Kunt-Tiger Enroberer. Pacik, F.
KUNVARI, L. L. (Hungarian)
M. Kodalanyi, head bronze
CASS 34 HBMA
Kutuzov, Mikhail Ilarionovovich
(Russian Field Marshal 1745-
1813)
Orlovski. Marshall Kutuzov
Tomb
Kvindelig Torso. Leplae
Kvosh (Handled Wine Taster)
Folk Art--Russian. Kvosh:
Animal-form
Russian--17th c. Kvosh
Russian--19th c. Kvosh,
with stylized horses' heads
Kyffhauser Plateau Monument.
Schmitz, Hundreiser, and
Geiger
Kymer Family Monument. English--
17th c.
Kyrle, John d 1633
English--17th c. Sir John
Kyrle Tomb; detail:
Crest

L., Fraulein
Kunst. Fraulein L.
L., Mrs.
Funeff. Mrs. L., half figure
LX/62. Reich
Le Labbra Rosse. Pascali
Label Stops
English--12th c. Nave Label
Stop

LABENWOLF, Pancraz (German
1492-1563)
Christ Child Blessing bronze;
19
VICF 34 ELV (411-1854)
Gansemanchen Fountain (Man
with Geese) 1556
LARR 253 GN
Labilliere, Bishop
Ledward. Bishop Labilliere
Labor and Laborers See also
Guilds; and types of work,
as Agricultural Themes
Andriessen. The Docker
Barye. Fortitude Protecting
Labour
Blay. Chavarri Monument:
Laborers
Bouchard. The Master Work-
man
Butti. Il Lavoro
Chadre. Stones are the Arms
of the Proletariat
Dalou. Labour Monument
De Lotto. Laborer
English--13th c. Workman
Geiser. Monument au Travail
Gerome. Iron Worker
Goldman. Head of a Worker
Goldman. Seated Worker
Groot. Labour
Hess. Labour
Italian--12th c. A Craft,
seated figure
Kerenyi. On the March
Koelle. Bergarbeiter
Meunier. The Docker
Meunier. Monument to Labor:
The Harvest
Mukhina. Machine Tractor
Driver and Collective
Farm Girl
Rodin. Labor Monument,
Project
Schneider, G. L'Ouvrier
Segesdi. Partisan
Toft. The Metal-pourer
Vela. Victims of Labour
Voll. Junger Arbeiter
Labors of the Months See Months
LABROUREUR, Massimiliano
(Italian 1739-1812), and
Lorenzo CARDELLI
Season Vases: Spring, Summer,
Autumn, Winter FAL pl
55A-D IRB (CXXXVII; CL;
CLII; CLVI)
Lacerazione 18 A. Pierluca

LACEY, Edward Hill (English
 1892-)
 Child, head bronze
 CASS 45
 Figure Wading
 CASS 77
LACHAT, Joseph (Swiss-Spanish
 1908-)
 B'Wana-Ke, mosaic relief
 JOR-1: pl 49
 Les Uelees 1958
 JOR-2: pl 230
LACKNER, Andreas (Austrian fl
 1500)
 Rupertus; Blasius, Abtenau
 Altar figures 1518 ptd lime-
 wood; 47; and 52
 KO pl 68 AVO
LACOMBE, (French 1868-1916)
 The Dream (La Reve), bed,
 headboard 1892 wood; 27-
 1/4x55
 SELZPN 60 FPMo
Lacy Gothic
 Gothic-French. Facade
 Decoration, detail: Lacy
 Gothic
Ladbroke, Richard
 Rose. Richard Ladbroke
 Monument
Ladislas I (King of Hungary 1040?-
 1095), called The Saint
 Hungarian--15th c. King
 Ladislaus, reliquary bust
 Hungarian--16th c. Ladislaus
Ladislaw II Jagello (King of Poland
 1350-1434)
 Polish. Vladislav II Jagiello,
 effigy detail
Ladles
 Folk Art--Russian. Ladle,
 with Ducks on Handle
 Russian. Silver Dipper
Lady Chapel. English--14th c.
The Lady of Bagneux. Hajdu
Lady with a Veil. Rosso, M.
Lady with Bunch of Flowers.
 Verrocchio
Lady with Bunch of Primroses.
 Verrocchio
Lady with Flask. Bustelli
Lady with Hat. Brenninger
Lafayette, Marquis de Marie
 (French Military Leader
 1757-1834)
 Bartholdi. Lafayette and
 Washington

Bartholdi. Marquise de
 Lafayette
David D'Angers. General
 Lafayette, bust
Houdon. Lafayette, bust#
Persico, E. L.--Attrib.
 Marquis de Lafayette, bust
Lafcadio. Santoro
LA FRESNAYE, Roger de (French
 1885-1925)
 Grand Nu 1949, from plaster
 of 1911 bronze; 45-3/4
 SOTH-4: 74
 Italian Girl (Italian Woman)
 1912 bronze; 24-3/8
 ROSE pl 189; SELZJ 186
 FPMa
 --1912 bronze; 24x12
 DETS 51; READCON 72
 UNNH
 Young Girl Removing her Dress
 1912 bronze
 SELZJ 186 FPMa
LAGAE, Jules (Belgian 1862-1931)
 Mother and Child
 GOR 55; ROOSE 299 BBMu
 Hugo Verriest, head plaster
 VEN-22: 88
 Leon Leqvime, bust
 CHASEH 471
 Sculptor's Parents, busts
 POST-2: 190
Laggiu. Carlo
LAGNEAU, Jacques (French)
 Martyrdom of St. Bartholomew
 1638 ivory
 LARR 302 FA1bT
Legrange, Cardinal de
 French--15th c. Cardinal de
 Legrange Tomb
Laignes, Jacqueline de
 French--16th c. Entombment
 Group, given by Nicolas du
 Moustier, and his wife,
 Jacqueline de Laignes
LAINBERGER, Hans See LEINBERG-
 ER, Hans
LAINBERGER, Simon (Master of the
 Upper Rhine)
 Dangolsheim Madonna,
 Alsace 1470 ptd walnut;
 40-1/8
 BAZINW 321 (col); BSC pl
 52-53; BUSR 93; CHRC
 fig 116; FREED pl 19; KO
 pl 61 (col); MOLE 85;
 MULS pl 120; NEWTEM

pl 106; PRAEG 205 (col);
ROTHS 127; ST 251 GBS
(7055)
LALANNE, F. X. (French)
Le Rhinoceros 1966
KULN 60
LALIQUE, Rene (French 1860-1945)
Art Nouveau Brooch: Woman-
Butterfly
SOTH-3: 227
Brooch: Floral form c 1900
gold, enamel and pearls
SCHMU pl 154 AVOG
Brooch: Peacock 1899
enameled and jeweled gold
CAS pl 246 FPDec
Decorative Comb c 1920 horn,
gold and enamel; L: 6-1/8
SELZPN 102 DCK
Necklace 1900 gold with
enamel and diamonds
CAS pl 247 FPDec
Oval Brooch c 1900 gold and
enamel; 3-7/8x1-1/8
SCHMU pl 275 FPDec
Pendant c 1900 gold, enamel,
brilliants and pearls; 2-3/8
SCHMU pl 277 GLanzW
Pendant 1900
CAS pl 245; LARM 213
FPDec
LAMAISON, Pedro (Spanish), and
Damian FORMENT
Monstrance 1537/41
CIR 52 (col) SpSarC
Lamani Tribe, India
Milward. Chitabai, Lamani
Woman, head
Milward. Lamani Man, head
Lamb, Euphemia
Epstein. Euphemia Lamb,
bust
Lamb of God See also Good
Shepherd
Early Christian. Diptych:
Lamb of God
French--12th c. Rivers of
Paradise; Lamb of God
German--11th c. Cross of
Holy Roman Empire
German--12th c. Rivers of
Paradise; Lamb of God
LAMBEAUX, Jef (Belgian 1852-1908)
La Folle Chanson, Palmers-
ton Avenue Stationery
Group
CHASEH 470 BB

Fontaine de Brabon
ROOSE 296 BAG
"L'Ivresse"
POST-2: 187
The Kiss
GOR 40; ROOSE 296 BAR
--
DEVI--2
Wrestlers 1895 bronze; 91
MID pl 19 BAM
LAMBERT, Godecharle (Belgian
1750-1835)
Eros, model terracotta
GOR 22 UMdBW
LAMBERT-Rucki, Jean (Polish-
French 1888-)
The Constellation Virgin
wood
BERCK 289
LAMBERTI, Niccolo di Pietro (also
di Piero; Il Pela; Niccolo
d'Arezzo) (Italian 1370/75-
1451)
Facade Sculpture
POPG fig 46 IVM
Judgment of Solomon, relief
c 1430
BOE pl 147; POPG fig
100, pl 102-3 IVP
--St. Luke c 1400 marble
MAR 11; POPR fig 14
IFMN
St. Mark, detail 1408/15
marble POPG fig 36;
SEY pl 15B IFOp
LAMBERTI, Niccolo di Pietro--
ATTRIB
Hercules--Fortitude,
decoration detail, Porta
della Mandorla 1393
SEY pl 4B IFCO
LAMBERTI, Niccolo di Pietro, and
GIOVANNI DI MARTINO
Tommaso Mocenigo Monu-
ment
BUSR 133; POPG fig 43
IVGP
LAMBERTI, Niccolo di Pietro, and
Piero di Giovanni TEDESCO
Two Doctors of the Church
redone as Poets Laureate
MCCA 19 IFOp
LAMBERTSZ, Geraert (Dutch fl 1610)
Madwoman (Frenzy), from
former Madhouse 17th c.
sandstone
BUSB 42; ROS pl 205A NAR

LAMBRECHTS, Frans (Belgian 1909-)
 Aquatic 1957 bronze
 MAI 158
 Genesis 1950 stone; L: 31
 BERCKS 290
Lamennais, Felicite Robert de
 (French Priest and
 Philosopher 1782-1854)
 David D'Angers. Lamennais,
 bust
LAMERAS, Lazaros (Greek 1913-)
 Daughter of God (La Figlia
 di Dio) 1953 marble
 VEN-60;pl 177
LAMERIE, Paul de (French-English
 1688-1751)
 Rococo Cup silver gilt
 NM-11:51 UNNMM
 Sideboard Ewer silver gilt
 ENC 540
 Tea Caddy silver gilt ENC 540
Lamia. Frampton
Lamia. Sargant
Lamoriciere, Louis (French
 Military Leader 1806-65)
 Dubois, P. General
 Lamoriciere Tomb
Lamp Bracket. French--13th c.
Lamp Without Light. Martinez, G.
Lamps
 Alving. Lamp base
 Byzantine. Lamp
 Byzantine. Lamp Stand
 d'Oliveira. Sabbath Lamp
 Early Christian. Lamp#
 Early Christian. Oil Lamp#
 Early Christian. Ship-form
 Lamp
 Eckmann. Electric Table
 Lamp
 Hann. Sanctuary Lamp
 Horta. Wall Lamp
 Italian--17th c. Hanukkah
 Lamp
 Jewish. Alexandrine Lamp
 Jewish. Hannukkah Lamp
 Jewish--17th c. Eternal Light
 Larche. Loie Fuller, lamp
 Larche. Loie Fuller Dancing,
 table lamp
 Taca, P. Lamp: Vulcan
 Seated at a Forge
 Winfield. Standard Lamp
Lancelot
 French--14th c. Casket:
 Matiere de Bretagne
 (Arthurian Cycle): Lance-
 lot; Gawain
 Manes, Pablo. Lancelot and
 Guenivier, relief

LANCERE (Russian)
 Standard Bearer, equest
 bronze
 MARQ 254
Land
 Cellini. Salt of Francis I
Land of Great Fire. Miro, J., and
 L. Llorens Artigas
The Land Surveyor's Table.
 Pomodoro, A.
La Landaise. Wlerick
LANDI, Edoardo (Italian 1937-) See
 GROUP N
Landing of the Pilgrims. Causici
LANDINI, Taddeo (Italian 1550?-96)
 See also Porta, Giacomo
 della
 Moses Fountain (Fontana del
 Mose)
 MINB 107 IRB
Landmark. Arp
LANDOWSKI, Paul Maximilien
 (French 1875-)
 L'Accueil Monument, for the
 city of Schaffhouse after
 1918
 BAS 95
 Admiral de Grasse, detail
 BAS 96
 The Architect
 TAFTM 44
 Le Docteur Legueu, head
 BAS 97
 Les Fantomes, monument to
 the Second Victory of the
 Marne
 BAS 101
 Le Heroes, wall of Legends,
 Temple de l'Homme
 BAS 99
 Hymn to the Dawn bronze
 MARY pl 61 FPPP
 Mme Paul Landowski, head
 BAS 96
 Marshal Foch Tomb
 BAS 103 FPHI
 Montaigne, detail
 BAS 97
 St. Genevieve
 BAS 100 FPTou
 The Shepherd 1906 bronze;
 91
 MID pl 31 BAM
 Song of Songs (Le Cantique
 des Cantiques)
 BAS 93
 The Sons of Cain (Les Fils de
 Cain) bronze
 BAS 98; MARY pl 61;
 TAFTM 45 DC

Victory Monument, Algeria
(Monument aux Morts de la
Ville d'Alger)
AUM 58; BAS 102
Wall of Prometheus, Temple
a la Pensee
AUM 51
LANDOWSKI, Paul Maximilien, and
Henri BOUCHARD
Reformation Monument:
Theodore de Beze,
Guillaume Farel, John
Calvin, John Knox
AGARN il 40; CHENSW
485; NATSE; TAFTM 45
SwGU
--Coligny
BAS 93
Landscape. Arp
Landscape I. Cimiotti
Landscape Sculpture# Hepworth
Landscapes
Agostino di Duccio. Neo-
platonic World
Holmgren. Landscape
Lane, Lady
Simon. Medal: Lady Lane
LANELLI, J.
Alexander Hamilton, bust
(after Giuseppe Ceracchi)
plaster; 24 AP 131 UPPA
LANGE, Arthur (German)
Half Figure of a Girl
TAFTM 71
LANGEISEN, Christophorus
(German fl 15th c.)
Christ Entering Jerusalem
ptd limewood; 57
DETT 153 UMiD (59.97)
LANGER, Richard (German)
Mother and Child colored
ceramic
AUM 19
Shepherd Boy
TAFTM 69
White Madonna, half figure
Dresden porcelain
AUM 8; VEN-26:pl 75
Langford Rood. Anglo-Saxon
Langouste. Muller, R.
Languedoc Tympanum. French--
12th c.
Lani, Maria
Despiau. Maria Lani, head
Lanleff, demeure No. 4, Martin, E.
Lannoy, Raoul de d 1513
Porta, A. della and P.
Gaggini. Raoul de Lannoy
Tomb

LANNUIER, Charles Honore
Well-Carved Sofa Table,
sphinx support
WHITEH 67 UDCW
LANSERE, E. A. 1848-86
Troika 19th c. bronze
HAR pl 148B
LANZ, J. W.
Strasbourg Duck Tureen
SOTH-2:151 (col)
Laocoon
Juni. St. Jerome, after the
Laocoon
Laokoon. Ernst, M., and H. Arp
LAPAUTRE, Pierre (French 1660-
1744)
Louis XVI Table Clock, with
supporting figures and
surmounting cherub ormolu
and bronze
SOTH-1:216
Lapidation
Byzantine. Veroli Casket
Ferrata, and L. Retti. Ston-
ing of St. Emerenziana,
relief detail
German--12th c. Stoning of
St. Stephen
German--13th c. Jew Stoning
St. Stephen
Gibbons. Stoning of St.
Stephen
Lapith
Barye. Lapith and Centaur
Michelangelo. Battle of
Centaurs and Lipithae
LAPLAE, Charles (Belgian 1903-62)
Dancer
DEVI-2 BA
"Henri", head
GOR 79 NAS
Kvindelig Torso 1942 terra-
cotta; 65 cm
COPGM 67 DCN (I.N.2623)
Luco bronze
RAMT pl 16 BBR
--1944 bronze; 65
MID pl 86 BAM
Mrs. De Kinder, Head
GOR 78
Two Pregnant Women 1952/53
bronze; 89
MID pl 85; STM BAM
Young Boy
GOR 77
Young Girl Kneeling 1951
bronze
MAI 170 BBB

LARCHE, Francois Raoul (French
 1860-1912)
 Corot Monument 1904 marble
 SELZJ 3; TAFTM 33 FP
 Loie Fuller, lamp gilt bronze
 SOTH-4: 242 UMProC
 Loie Fuller Dancing (Veil
 Dancer), table lamp
 c 1900 bronze; 21-5/8
 LARM 262; SCHMU pl
 168 FPDec
 Violets
 MARY pl 153 FPLu
Larcheveque, Guillaume
 French--12th c. Horseman
 with Falcon
LARCHEVESQUE, Pierre Hubert
 (French 1721-78)
 Self Portrait, detail
 GOLDF pl 324 SnSAc
LARDERA, Berto (Italian-French
 1911-)
 Amore delle Stellen 2
 1959/60 steel
 VEN-60: pl 67
 Antique Goddess No. 3
 (Ancient Diety No. 3)
 1958 iron and steel
 LARM 304; SAL pl 78
 (col)
 Archangel No. 1 1953
 iron and copper
 BERCK 129 UNNK
 Cathedral of Pain V 1956
 iron and mosaic; 52x53-
 1/8
 TRI 194
 Il Cavallo di Troia 1945
 aluminum; .50 m
 SCUL pl 50 ILegP
 Dramatic Occasion 1952
 iron; 54
 SCHAEF pl 117
 Dramatic Occasion No. 3
 1952 iron; 20
 BERCK 129
 Dramatic Occasion No. 11
 1965 metal; 88
 EXS 89 CMC
 Heroic Age (Epoca Eroica)
 1949/50 iron
 VEN-64: pl XXVIII
 GKrefW
 Heroic Rhythm (Rhythme
 Heroique) 1953 iron
 ABAM 53; FPDEC il 13
 Heroic Rhythm No. 3 1957/58
 iron and copper
 MAI 159 GHKG

The Hours and the Days No.
 1 1958/59 stainless steel
 and iron; 138x138
 TRI 226
Impetuous Dare-Devil No. 2
 (Slancio Temerario, No. 2)
 1958/59 iron, steel and
 copper
 READCON 246 (col); VEN-
 60: pl 66 YZZ
Love of the Stars II 1959/60
 steel and iron
 SELZJ 14
Rhyme Contest
 MEILD 28
Sculpture 1950 iron; 78x78
 GIE 251 ILegP
--1952 iron; 20
 BERCK 130; SCUL pl 51
 ILegP
--1954 copper and iron
 VEN-54: pl 26
Sculpture No. 1 1953 iron
 SAL pl 77
Two-dimensional Sculpture
 1946 copper
 MAI 158 UNNK
Wall-Sculpture, Villa steel
 and copper
 DAM 201 ILe
Large and Small Forms. Hepworth
Large Bather# Greco, E.
Large Bleeding Martyrdom. Somaini
Large Couple. Martin, E.
Large Disc. Pomodoro, A.
Large Dragon
 Martin, E. Great Dragon
Large Flat Bird. Meadows
Large Frog. Paolozzi
The Large Glass. Duchamp
Large Group of Three Figures.
 Avramidis
Large Head with Round Eye. Picasso
Large Horse. Duchamp-Villon
Large Kneeling Figure. Heiliger
Large Kneeling Woman. Heiliger
Large Multiple Figure. Negri
Large Musician. Laurens
Large Nude. Adams, H. G.
Large Object. Dalwood
Large Object. Gigon
The Large Penelope. Bourdelle
Large Screen Form# Adams, R.
Large Seated Figure with Chair.
 Thornton
Large Seated Nude. Matisse
Large Torso (Arch). Moore, H.
Large Vegetative Sculpture.
 Heiliger

Large White Interior. Pezzo
Largesse
 Amadeo. S. Imerio Giving
 Alms
 Caffa. St. Thomas of Villa-
 nova Distributing Alms
 German--12th c. Shrine of
 St. Elizabeth: Landgravine
 Distributing Alms
 Slodtz. St. Louis Giving
 Alms to the Poor, relief
LA RUE, Louis Felix de (French
 1731-65)
 Boy with Grapes marble;
 17-1/8
 HUNT pl 26 UCSmH
 Girl with Doves marble;
 18-1/8
 HUNT pl 25 UCSmH
Larva. Muller, R.
La Salle, Rene Robert
 Causici and Capellano. La
 Salle, relief bust
Last Construction, No. 8 Taeuber-
 Arp
Last Curve. Hussmann
The Last Judgment See also Jesus
 Christ--Last Judgment
 Berruguete. Toledo Cathedral
 Choir Stalls
 Dutch--12th c. Shrine of St.
 Servatius
 English--12th c. Torments
 of Hell
 English--16th c. Babington
 Tomb: Last Judgment
 French--12th c. Capital:
 Weighing of Souls
 --The Damned Seized by
 Devils
 --Last Judgment#
 --Three Devils Bearing
 Away Soul, capital
 French--13th c. Chartre
 Cathedral, South Transept:
 The Last Judgment
 --Judgment Portal
 --Last Judgment#
 --Portal, Central West,
 Archivolts: The Heavenly
 Jerusalem; Tympanum:
 The Last Judgment
 French--18th c. Altarpiece:
 Last Judgment
 French, or Italian--14th c.
 Hanukkah Lamp
 German--13th c. Princes
 Portal: Last Judgment

Gislebertus. Tympanum:
 Last Judgment
Groninger, H. Last Judgment
Italian--14th c. Last Judgment
Maitani. Last Judgment
Master of the Visitation,
 Bamberg. Princes Portal,
 tympanum detail: Judge
 of this World
Pisano, Niccolo. Siena Pulpit:
 Damned Soul
Portuguese--14th c. Ines de
 Castro Tomb: Last Judg-
 ment
Spanish--13th c. Last Judg-
 ment
The Last of the Acrobats. Coulen-
 tianos
Last Supper See Jesus Christ--
 Last Supper
LASZCZKA, Konstanty (Czech)
 The Enchanged Princess
 bronze
 MARY pl 69
 Portrait bronze
 VEN-10: pl 61
 Portrait of a Lady, bust
 plaster
 MARY pl 160
La Tene Torc. Celtic
LATHAM, Jasper (English)
 Captain Richard Maples,
 1689 stone; LS, on 48
 pedestal
 GLE 199; WHINN pl 33A
 ELTr
 Dr. Plot Monument 1671
 ESD pl 109 EKenBo
 Sir Thomas and Lady Went-
 worth Tomb
 ESD pl 48, 99 EYoS
Latham Memorial Fountain. Payre
Latin Language
 Bernini, G. L. Apollo and
 Daphne
 Cardelli, L. Apollo and
 Daphne
Latona
 Marsy, G. and B. Fountain
 of Latona
LATORRE, Jacinto (Spanish-French
 1905-)
 Sculpture
 MAI 161
LAUDA, Jan (Czech 1898-)
 Old Man, head bronze
 RAMT pl 18
Lauder, Harry

Burton. Music-room Panels:
St. George; Harry Lauder
Lauernde Katze. Matare
LAUGER, Max
Female Figure glazed ceramic
AUM 8
Tondo Relief: Equestrians
glazed ceramic
AUM 10
Laughing Boy. Desiderio da Settig-
nano
Laughing Buttocks. Gordine
Laughing Woman. Rosso, M.
Laughton, Charles
Botzaris. Charles Laughton,
head
The Laundress. Maillol
Laundress. Pradier
Laura. Fleer
LAURANA, Francesco (Italian
c 1420-1502)
Battista Sforza, bust 1474/77
marble; 20
BARG; KO pl 76; MONT
386; SEY pl 102A IFBar
Beatrice of Aragon, bust
CHASEH 332; POST-1: 212
IPalM
--marble
BODE 131 FPD
Bust of a Woman
MACL 190 UNNF
Bust of a Young Woman marble
LOUM 117 FPL (721)
Chapel of St. Lazare 1475/81
BLUA pl 2A FMaL
Eleanor of Aragon, bust
c 1470 marble; 17
BAZINW 339 (col); BEREP
88; BR pl 9; NMI 25;
SFGM # 61 IPalM
Federigo da Montefeltro,
Duke of Urbino, tondo mar-
ble; Dm: 19-3/4
NCM 40 UNcRA
A Girl, bust colored marble
BODE 130 AVH
Isabella of Aragon(?), bust
c 1490 marble
POPR pl 105 IVK
--c 1490 marble
SEY front (col); pl 101
IPalM
Madonna, Chiesa dei Minori
Osservanti c 1474
BEREP 89 ISyA
Neopolitan Princess, bust
CHENSN 344 GBS

A Princess of the House of
Aragon, bust c 1475 mar-
ble; 17-15/32x17-25/32x
8-11/16
CHENSW 381; SEYM 86,
89-90; SHAP pl 79;
USNI 230; USNP 153 UDCN
(A-8)
St. Jerome and St. Gregory,
relief marble
POPR pl 106 IPalF
Virgin and Child marble
POPR pl 104 INMM
LAURANA, Francesco, and Piero di
Martini
Triumphal Arch of Alfonso of
Aragon (Triumphal Arch
of Alfonso V), Gateway of
Castelnuovo 1453/80
BOE pl 153; BURC pl 13;
CHAS 93 INAr
--Alphonso of Aragon
LARR 111
--Alphonso of Aragon Prepar-
ing for Battle, right
interior relief
SEY pl 68B
--Alphonso of Aragon in Tri-
umph with his Court, relief
marble; 1/2 LS
MOLE 142; POPR fig 113-
14, pl 107
--Griffin
CHAS 94
Laurencin, Marie
Haller. Marie Laurencin,
head
LAURENS, Henri (French 1885-1954)
L'Adieu 1941 bronze; 29x34
x26
GIE 73 FPM
Amphion 1952 bronze; 13'3"
GIE 74-75 VCU
Aurora 1950
MINF -Masl
Autumn 1948 white marble;
35-3/4
SCHAEF pl 90
Baigneuse, half figure 1931
bronze
LARM 320 ELT
Bathing Girl 1947 bronze; 64
KO pl 105
Bottle of Beaune 1917 collage;
20-1/2x20-1/2
ROSE pl 205 FPZ
--1918 wood
SELZJ 237 UICM

Bottle and Newspaper 1919
 ptd wood and metal: 20-
 1/8x15-3/4x8-5/8
 TRI 49 NAS
Boxer 1920 stone; 12-1/4
 ROSE pl 213 FPLe
Bunch of Grapes 1922
 BAZINW 432 (col) FPM
Composition 1914 black and
 red sheet iron; 8x11-3/4
 GIE 65; LIC pl 231;
 READCON 116 (col) FPRa
Crouching Figure 1941
 bronze
 MAI 165
Crouching Woman (Femme
 Accroupie) stone
 MARTE pl 24
--1931 wood
 GIE 67 FPLau
Dance 1915
 ROOS 280B
Draped Woman 1957 bronze
 MAI 162
L'Epinette 1940 bronze;
 c 13x17.5x6.5 cm
 SP 118 GHaS
Farewell 1941 bronze; 30
 EXS 90; MARC pl 28 (col)
 FPM
Femme a la Grappe
 (Bacchante) 1952 bronze;
 57 cm
 SP 121 GHaS
Femme Couchee 1921 bronze;
 14x39
 SP 116 GHaS
Femme Couchee, de dos,
 relief 1921 bronze;
 14.5x39.5
 SP 116 GHaS
Femme Couchee, relief 1922
 bronze; 56x160 cm
 SP 116 GHaS
Femme Debout au Miroir 1949
 bronze; 28 cm
 SP 120 GHaS
Le Grand Poseur 1920 stone;
 32
 RIT 143 FPLe
La Grande Nuit 1953 bronze;
 27x69x29 cm
 SP 120 GHaS
Great Amphion 1952 bronze;
 86-5/8
 BERCK 39 FPLe
--1952 bronze; 86-5/8
 TRI 84 GDuK

The Great Musician 1938
 plaster; 84x48
 GIE 72 FPM
The Guitar 1919 ptd terra-
 cotta; 11
 BERCK 38 FPSi
--1920 stone; 15-1/8
 ROSE pl 214 FPLe
--1920 cast stone; 15-3/4
 NMAC pl 105 FPSi
Head 1917 stone; 25-5/8
 READCON 73 NAS
--1918 (1915?) ptd wood
 construction; 19-5/8
 NMAC pl 104 FPSi
--1918 stone
 MAI 162
--1918 ptd wood construction;
 20
 NNMMM 78; RIT 145;
 ROSE pl 206; UPJH pl
 243 UNNMMA
Head of a Girl 1920 terra-
 cotta; 13-3/8
 CALA 95; GUGP 26 IVG
Jockey 1921 terracotta
 RAMT pl 32 UNNBu
Kneeling Woman (Femme
 Agenouillee) stone
 MARTE pl 1
Large Musician (La Grande
 Musicienne) 1950 bronze;
 1.95x1.10x.85 m
 MARC pl 30 (col); MOD
 FPM
Little Siren 1944 bronze; 9
 BERCK 39 FPLe
Luna 1948 bronze; 35-3/4
 BOSME pl 80 UNNFi
--1948 marble; 35-3/4
 GERT 150; RIT 183 UNNV
Man with a Pipe 1919 stone;
 14-1/2x9-1/2
 LIC pl 230 FPLe
--
 GIE 64 UNNFi
--1919 stone
 MARC pl 27 UNNGe
Man with Clarinet (Mann mit
 Klarinette) 1919 stone
 GERT 147; STA 207
--
 BERCK 37 FPLe
--1919 H: 23
 SEITC 68 -UTho
--1919 stone; 23-1/2
 BOSME pl 21
 UPPiT

Marthe Girieud, head 1912
stone
SELZJ 227 FPLe
Le Matin (Le Grand Matin)
1944 bronze; 125 cm
SP 119 GHaS
Mermaid 1945 bronze; 45-1/4
SCHAEF pl 89; MAI 163;
RIT 182 FPM UNNV
Metamorphose 1940 bronze;
8x23x8
SP 118 GHaS
The Moon bronze
VEN-48: pl 75
Morning 1944 bronze
VEN-50: pl 106
The Mother 1935 bronze; 24
GIE 70 SwZGi
La Nuit 1943 bronze; 24x32x21
cm
SP 118 GHaS
Oceanide 1932 plaster
READAN #40
--(Ozeanide) 1933 bronze
GERT 148
--1933 bronze; 66
MID pl 54 BAM
La Petite Musicienne 1937/38
bronze; 41 cm
SP 117 GHaS
Reclining Woman 1927 alabaster;
6-1/4x12-3/4
DETS 53 UNNH
--1927 stone; L: 17.25
MYBS 67 FPLe
Reclining Woman with Raised
Arms 1949 bronze; L:
10-1/2
READCON 85 ELH
Sculpture*
EXS 16
Seated Woman marble; 162
NNMMARO pl 307 UNNMat
--1932 bronze
MARC pl 29
Siren
ENC 547
--1944 bronze
SAO-2
--1944 bronze; 70-7/8
GIE 71; NEWTEM pl 167;
PM FPM
The Sisters (Schwestern)
1950 bronze
GERT 149; PRAEG 458
Small Amphion (Le Petit
Amphion) 1937 bronze;
57 cm
MAI 164; SP 117 GHaS

Standing Nude 1921 stone; 17
SELZS 72 UNNWad
Standing Woman (Femme De-
bout) stone
MARTE pl 1
Statue
KULN 154 VCU
Still Life 1918 (1916?) wood
and plaster construction;
9-7/8
ROSE pl 204
Tomb of the Artist and his
Wife 1941 design bronze
LIC pl 232 FPMont
Torso 1925 terracotta; 16
BERCK 291 FPLe
The Water 1937 terracotta
GIE 69
Winged Siren 1938 bronze; 23
BERCK 39 FPLe
Woman 1918 ptd wood and
metal
SELZJ 240 (col) FPLe
Woman, head
MARTE pl 24
Woman at a Mirror 1931 wood
MAI 163
Woman Bathing (The Wave)
1933 terracotta; 39 cm
BOES 55 DCSt
Woman with a Bird 1943
marble
LARM 291
Woman with a Guitar 1919
stone
SELZJ 228 FPLe
Woman with an Accordion
1921 stone; c 29-1/2
MCCUR 262 FPLe
Woman Seated
FEIN pl 136
Laurens, Jean Paul (French Painter
1838-1921)
Rodin. Jean Paul Laurens,
bust
Lauriston, Marquis de Jacques
Alexandre Bernard Law
(French Soldier 1768-1828)
Bosio. Marshal Lauriston,
bust
LAURITZEN, Theo (Swiss 1911-)
Le Crieur de Journeaux
Zeitungsverkaufer 1952
plaster; 225 cm
JOR-1: pl 64
Retour a la Terre zur Erde
Zuruck 1951 plaster; 170
cm
JOR-1: pl 63

Lava. Lipsi
Lava Sculpture. Lipsi
Lavabo. Brunelleschi and Buggiano
Lavabo. Buggiano
La Valette, Marquise de
 Carpeaux. Marquise de la
 Valette, bust
La Laveuse
 Renoir. The Washerwoman
LAVIADA, Manuel A.
 Dryad, group detail
 CASS 66
La Vigne. Niclausse
LAVONEN, Ahti (Finnish 1928-)
 Composition 1964 mixed
 media; 51-1/8 Sq
 NEW pl 182
Law, John
 Stone, N. John Law Monument
LAWLOR, John (Irish-English 1821-
 1901)
 The Bather 1855 marble; 51
 LONDC EWind
Lawrence, Saint
 Donatello. SS Stephen and
 Lawrence
 German--13th c. St.
 Lawrence, head detail
 German--15th c. Martyrdom
 of St. Lawrence
 --St. Lawrence
 Gothic-German. St. Lawrence
 Italian--14th c. Virgin and
 Child with SS Lawrence and
 Francis, lunette
 Quercia, J. della. Trenta
 Altar: Martyrdom of St.
 Lawrence, predella panel
 Riemenschneider. St.
 Lawrence and St. Stephen
Lawrence, T. E. (English Author
 1888-1935)
 Kennington. T. E. Lawrence,
 recumbent figure
Laying Duck. Heerup
Lazare, Saint See Lazarus
LAZAROV, Ivan (Ivan Lazaroff)
 (Bulgarian 1889-1952)
 Macedonian Refugees
 BOZ 97 BulSN
 Peasant Girl
 CASS 86
Lazarus See also Jesus Christ--
 Miracles
 English--11/12th c. Raising
 of Lazarus, relief detail
 Epstein. Lazarus

German--11th c. Easter
 Column: Lazarus at the
 Table of Dives
Guerrisi. Resurrection of
 Lazarus
Martin, Burgundian Monk.
 St. Lazare Tomb
LAZONI, Giovanni (Italian 1618-88)
 Olimpia Aldobrandini, bust
 1680 marble
 COOPF 51 IRPam
Lazzari, Marino
 Monteleone. Marino Lazzari,
 head
LAZZARO, M. M. (Italian 1905-)
 Head terracotta
 VEN-34: pl 94
 Portrait, male head* stone
 VEN-40: pl 50
 Versailles stone
 VEN-38: pl 138
The Leader. Bleker
Leaf Form No. 1. Bakic
Leah
 Michelangelo. Julius II Tomb:
 Leah
Leaping Figure. Seger
Learning
 French--12th c. House
 Tympanum: Learning;
 Strength of Love
Leather Worker: St. Crispin.
 French--15th c.
Leathersellers' Company Coat of
 Arms. Aumonier, W.
Leaves and Navels, relief. Arp
Lebretto, Cardinal
 Bregno, Andrea. Cardinal
 Lebretto Tomb
LE BRUN, Andrzej (Polish)
 Jan Zamoyski, bust bronze;
 95 cm
 WPN pl 130 PWN (158401)
LE BRUN, Charles (French Painter
 1619-90)
 See also Coysevox, Antoine;
 Tuby.
 Fountain of Apollo
 Portraits
 Coysevox. Charles Le Brun,
 bust
Lechmere, Lady
 Walsh. Lady Lechmere, bust
LECLERC, George Louis See G. L.
 BUFFON
LECLERC, Nicolas (French), and
 Jean de SAINT PRIEST, and

Jean LEPERE
Anne of Brittany, medal
1499
LARR 81 FPBN
LECOMTE, Felix (French 1737-
1817)
Marie Antoinette, bust 1783
marble; 28-3/8
CHICT #137 FV (M.V. 2123)
LE CORBUSIER (Charles Edouard
Jeanneret-Gris)(French 1887-)
Chapel at Ronchamp (Pilgrim
Church of Notre-Dame du
Haut; Ronchamp Chapel)
1953 H: 49'
DAM 159; GIE 231; TRI
239 FRon
Free Forms, apartment house
roof
DAM 192, 193 FMa
Le Modulor, relief, apartment
house entrance cast
concrete
DAM 190 FMa
The Open Hand (Le Main
Ouverte) 1964
KULN 46
--sketch 1952 54' 8'
GIE 233 InCh
Ozon, Op. 1 1947 ptd wood;
27-5/8
READCON 102
Ozon 2 1948 ptd wood; 43-1/2
GIE 232
Totem 1945 wood; 47-1/2
GIE 302
Unite d'Habitation: "La
Glorification du Modulor"
1947/52 concrete
BOE pl 208 FMa
-- : Safety Staircase
BOE pl 208
-- : Terrace Roof with
Ventilation Shafts
GIE 233
Lecterns See also Pulpits
Flemish--15th c. Messina
Lectern
--Pelican Lectern
Frink. Eagle, lectern
German--12th c. Four
Evangelists Lectern
Hermes. Lectern
Lecteur I. K. B. #Klein
LECURT, Giusto See CORTE,
Josse de
Leda
Austrian. Leda and the Swan
Boggild. Leda and the Swan

Brancusi. Leda
Falconet. Leda and the Swan
Forrest. Leda
Kosso. Leda and the Swan
Maillol. Leda
Maraini. Leda
Nielsen, K. Leda and the
Swan
Thierry. Leda and the Swan
LEDERER, Hugo (Austrian)
Bismark granite
MARY pl 30 GH
Bismark, seated figure
TAFTM 56
Bismark Monument; figure
detail
TAFTM 55, 57 GH
Fate
TAFTM 57
Frederick III
TAFTM 53 GAa
Richard Strauss, bust
TAFTM 66
Wrestler
TAFTM 66
LEDERER, Jorg (Germanc 1475-1550)
Mourning Virgin ptd wood;
53
DETT 153 UMiD (43.3)
St. John ptd wood; 52-3/4
DETT 153 UMiD (26.14)
Ledger Stones
English--17th c. Heraldic
Ledger Stone
--Ledger Stone to Elizabeth
Wiseman
--Ledger Stone to Jeremy
Whichcot
LEDNICKA SZCZYTT, Maryla
(Polish)
Countess Orietta Borromeo,
head marble
VEN-32: pl 128
Kneeling Nude marble
VEN-30: pl 69
Young Man bronze
SGO-4: pl 47
LEDWARD, Gilbert (English 1888-)
Awakening 1922/23 bronze;
73x15x15
LOND-5: #28
Bishop Labilliere
HUX 85
Caryatid Figures Roman
Stone
AUM 124; PAR-1: 60
Ceres stone; LS
HOF 57

Earth Rests 1930 Roman
 stone; 32x60x15
 LONDC pl 19
Mother and Child stone
 PAR-1: 61
Sir Arthur Crosfield Memorial:
 Urn 1941 Roman stone;
 37-1/2
 BRO pl 20
The Sunflower Portland stone
 CASS 79 -EKel
Leech. Muller, R.
LEEUW, Bert de (Belgian 1926-)
 Les Baigneurs de Baden-
 Baden 1963 mixed media;
 71-5/8x60-1/4
 NEW pl 191 SwGK
Leeuwenhoek, Anton van (Dutch
 Naturalist 1632-1723)
 Dutch--18th c. Medal:
 Anthonie van Leeuwenhoek,
 bust
Lefebre, Jacques
 Daumier. Jacques Lefebre,
 "L'Esprit Fin et Trenchant",
 bust
LEFEBVRE, Hippolyte
 Au Printemps
 TAFTM 43
LEFEVRE, Camille (French)
 Happiness
 TAFTM 39
 Levassor, Porte Maillot
 GAF 137 FPLu
Left-Hand Dagger. Spanish--17th c.
The Leg. Giacometti
Legend of St. Gall
 Tuotilo. Ivory Book Cover:
 Legend of St. Gall
Legendary Personnage. D'Haese,
 Roel
LEGER, Fernand (French 1881-1955)
 Child with a Flower 1952
 ceramic
 MAI 166
 Children's Garden 1930
 MAI 166; MYBS 66 FBioL
Legh, Ellen
 Wyatt, R. J. Ellen Legh
 Monument
Legh, Margaret, Lady d 1605
 Colt. Margaret Lady Legh
 Monument
Legrand, M.
 Drivier. M. Legrand, head
Legros, Alphonse (French Painter
 and Etcher 1837-1911)
 Belmondo. M. Legros, head
 Dalou. Alphonse Legros, head

LEGROS, Pierre (French 1629-1714)
 Aesop 1672/74 lead; 58-1/4
 CHICT #138 FV (M.V.
 7930)
 Cherubs and Lyre lead; 43
 USNI 219; USNP 171
 UDCN (A-42)
LEGROS, Pierre, the Younger
 (French 1666-1719)
 San Luigi Gonzaga in Glory,
 Altar relief 1698/99
 MATTB pl 39; WIT pl
 159A IRI
 San Luigi Gonzaga in Glory,
 relief c 1698 terracotta;
 34x16
 DETI 71; DETT 194; VALE
 157 UMiD (45.25)
 St. Stanislas Kotska on his
 Death Bed, detail colored
 marble
 LARR 353; MATTB pl 44-
 45 IRAnd
Legueu, Dr.
 Landowski. Le Docteur Legueu,
 head
LEHMANN, Kurt (German 1905-)
 Cat (Katze) 1950 iron; L: 14
 GERT 214; SCHAEF pl 52
 Johannes Frerking, head 1958
 bronze; 22 cm
 OST 60 GHaL
 Kindergruppe (Brunnen) 1954
 bronze; 1.68 m
 OST 73 GHaG
 Kneeling Woman 1956/58
 limestone; 2.6 m
 OST 77 GHaA
 Kneeling Youth (Kniender
 Jungling) 1953 shell lime
 GERT 216
 Listening Woman (Horchende)
 1950 bronze
 GERT 215
 Man Resting 1952 bronze;
 7-3/4
 SCHAEF pl 53
 Mother and Child 1957
 MAI 167
 Reclining Man (Ruhender)
 1952 bronze
 GERT 214
 Woman Looking Back 1956/57
 bronze; 71
 MID pl 105 BAM
 Woman Resting, relief 1935
 PRAEG 19
 Youth Playing the Flute
 (Flotender Junge) 1950
 bronze GERT 215

LEHMANN, Rudolph (German-
 Israeli 1903-)
 Cat wood
 ROTH 946
 Frog
 GAM pl 108
 Horse wood
 GAM pl 107
LEHMBRUCK, Wilhelm (German
 1881-1919)
 Adolescent Standing 1913
 bronze; 241 cm
 CAS pl 182
 Attacking Figure 1914/15
 bronze; 17-3/8
 TRI 21 GHaS
 Bather 1914 stone
 SELZJ 159 GMaM
 Bathing Woman 1911 cast
 stone
 CHENSW 494
 Bowing Female Torso 1913
 cast stone; 33
 SELZS 47 UNNKen
 --1913 terracotta; 35-1/2
 NNMMAG 158 UMoSLMa
 Bust stone
 RAMT pl 37 UNNBu
 Bust of a Woman, from
 Kneeling Woman, Museum
 of Modern Art, New York
 cast stone
 FAIN 165 UMWelC
 Bust of Kneeling Girl 1911
 cast stone; 19-3/4
 GIE 14 UICA
 Dancer 1913/14 bronze;
 10-3/4
 UNNMMAM #175 UNNWarb
 --1913/14 terracotta; 11-1/2
 NNMMARO pl 268 UNNRo
 Draped Female Figure
 terracotta; 19-3/4
 DETT 169 UMiD (29.347)
 Draped Figure
 RICH 188 UMiD
 The Fallen (The Dying War-
 rior; Fallen Man; Der
 Gesturtze) 1915/16
 synthetic stone
 GERT 51; PRAEG 491
 --1915/16 synthetic stone;
 30x96
 GIE 36; MCCUR 254 GTuL
 --1915/16 Steinguss; .72x.39
 m
 OST 36, 37; ST 427 GStF
 Female Nude 1910 baked

concrete; 193 cm
 JOO 183 (col) NOK
Female Torso 1918 bronze;
 78 cm
 LIC pl 205 GDuK
Figure 1914 ptd stone; 36-
 1/2x17x13-1/2
 UCIT 21 UCLUC
Fritz von Unruh, head 1918
 tinted plaster; 16
 BOSME pl 38; KUHNG
 pl 104 UMCF (1956.59)
Geneigter Frauentorso
 bronze
 SEYT 39 UDCK
Gesenkter Frauenkopf 1910
 Rotlicher Steinguiss;
 42 cm
 SP 128 GHaS
Girl, bust 1913/14
 BAZINH 485
Girl Meditating 1911 bronze;
 21
 PUL-1: pl 59
Girl's Torso 1913/14 cast
 stone; 50
 KO pl 101 GMaM
Grosse Stehende 1910 Kunst-
 stein; 1.95 m
 OST 34 GLuH
Head cast stone
 RAMT pl 38 UNNBu
Head, study for Kneeling
 Female Figure plaster;
 17x14
 NCM 233 UNcRV
Head of a Girl 1910 stone
 composition; LS
 RAMS pl 39 -ESan
--1913/14 terracotta; 17-1/2
 KUHNG pl 103 UMCB
 (1934.196)
Head of a Thinker with Hand
 1918 synthetic stone;
 24-1/2
 GIE 106
Head of an Old Lady 1913
 plaster; 20-1/2
 GIE 84 GDuK
Head of a Young Girl
 DIV 49
Kleine Sinnende 1911 bronze;
 53 cm
 SP 127 GHaS
Kneeling Woman (Femme a
 Genoux; Kneeling Figure;
 Kniende)
 CHENSP 296; TAFTM 62

--1911 bronze
 BERCK 48; GERT 50
--1911 bronze; 1.78 m
 OST 32 GDuK
--1911 cast stone; 69-1/2
 BAZINW 428 (col); CANM
 442; CHAN 150; CHENSN
 645; CHENSW 494; CHRP
 378; ENC 553; FEIN pl
 133; GIE 34; LARK 365;
 LIC pl 204; LYN 106;
 MCCUR 254; NNMMAG 159;
 NNMMAP 124; NNMMARO
 pl 270; NNMME 37; NNMMM
 65; OST 33; PANA-1:134;
 RICJ pl 58; RIT 84-7;
 UPJH pl 241; VALE 47;
 ZOR 51 UNNMMA
--1911 cast stone; 70-1/2
 BOSME pl 36 UNNChr
--1911 cast stone; 70-3/4
 ALBA; ALBC 187;
 FAIY 7; HAMP pl 62;
 MUNSN 86; SPA 60 UNBuA
--1911 gypsum; 70
 MID pl 27 BAM
--1911 kunststein; 1.79 m
 HENT 33 GBN
--1911 plaster
 BROWMS cat 600
--head cast stone; 19-3/8
 CHICS UICA
Madchen Kopf auf Schlanken
 Hals 1913/14 bronze;
 32.5 cm
 SP 131 GHaS
Mother and Child (Mutter
 und Kind)
 CHENSP 299
--1907 bronze; 84 cm
 HENT 27 GEF
--1917/18 kunststein; 52 cm
 HENT 31 GBN
--1918 steinguss; 52 cm
 SP 129 GHaS
Nude stone
 HAM NOK
Seated Man 1917 plaster; 40
 BOSME pl 43 UNNChr
Seated Youth (Sitzender
 Jungling; Young Man Seated)
 1918 bronze; 41-1/2
 GARDH 7; GERT 52;
 HAMP pl 63; LARM 375;
 RIT 90; READCON 24;
 SELZJ 158 GDuK
--1918 cast stone; 41-1/2
 OST 31, 33; RAMS pl 37;
 RIT 91 GFSt

--1918 cast stone; 44-1/2
 NNMMAG 160 GDuK
Sinnende 1913/14 bronze; 82
 EXS 91
Standing Female Figure 1910
 bronze; 76
 CHICP-1:pl 93 UNNMMA
Standing Figure of a Girl
 1914/15 cast stone; 36
 BMAF 48 UNNMa
Standing Woman 1910 bronze;
 76
 CANM 442; FAUL 463;
 NNMMM 64; RICJ pl 27;
 RIT 83; UNNMMAM #174
 UNNMMA
Standing Woman (Jeune Femme)
 1910 bronze; 76
 NUNSM 46 UNNWe
Standing Woman 1910 bronze,
 cast 1916/17; 76
 NNMMAG 157 UMoSL
Standing Youth 1913/14 cast
 stone; 92
 BERCK 49; BR pl 15;
 GARDH 751; GIE 37;
 JANSH 511; JANSK 983;
 LIC pl 202; MAI 168;
 NNMMAG 160; NNMMAP
 125; NNMMARO pl 271;
 NNMMM 65; RICJ pl 58;
 RIT 88-9; VALE 48;
 ZOR 148 UNNMMA
Stehende 1910 kunststein;
 1.95 m
 HENT 28 GH
Sturmender Getroffenei
 Jungling(Sturmender)
 1914/16 bronze; 44 cm
 SP 130 GHaS
--1914/15 bronze; 45 cm
 HENT 32 GDuK
The Tall Kneeling Woman
 1911 H: 70-1/8
 NEWTEM pl 160 UNNMMA
Torso c 1910 cast stone
 RAMS pl 35b
--1910 cast stone (kunststein);
 1.20 m
 HENT 29 GBN
--1910/11 bronze; 26-1/2
 DETS 56 UNNH
--1910/11 cast stone; 27-1/4
 KUHNG pl 102 UMCF
 (1953.40)
--1913/14 cast stone; 36-1/2
 NMASO 50
--1913/14 cast stone; 44
 SCHAEF pl 5

Torso der Sinnenden 1913/14
 steinguss; 1.25 m
 OST 35 GMaM
Torso of a Woman terracotta;
 27-1/2 NM-15:64
--1910 cast stone: LS
 SCHAEF pl 4
Woman, head
 CHENSE 387 UNND
Woman, torso artificial stone
 SLOB 243 UNNSA
Woman's Head c 1910 cast
 stone; 16-1/2
 NMASO 51
Young Woman, torso terra-
 cotta
 SLOB 242 UNNMMA
Youth
 PANA-1:134 UNNMMA
LE HONGRE, Etienne (French
 1628-90) See also Coysevox, A.
 The Marne 1689/90 lead
 BAZINW 396 (col); NEWTEM
 pl 143 FV
LEIGH, Roger
 Counterthrust II cold cast
 copper
 PER 50
LEIGHTON, Frederic (English
 1830-96)
 Athlete Struggling with
 Python
 BR pl 13; MILLER il 186
 ELT
 --1877 bronze
 ROTHS 229 ELRA
 Needless Alarms
 RAY 58 UNNMM
 The Sluggard bronze
 MARY pl 40 ELN
 --bronze; LS
 UND 112 ELT
LEINBERGER, Hans (Hans Lainberger)
 (German 1480/85-1531/35)
 See also Godl, S.
 Agony of Christ (Christus im
 Elend) 1525/30 lindenwood;
 75 cm
 BSC pl 69 GBS (8434)
 Crucifix c 1525/30 lindenwood
 CLE 110 UOC1A (38.293)
 Crucifixion (Kalvarienberg)
 1516 pear wood; 19.9x
 15.2 cm
 MUL 53 GMBN
 Death (Todlein) 1520 pearwood;
 22.5 cm
 MUL 52 AIA

Deposition (Kreuzabnahme
 Christi), relief 1520/25
 boxwood; 16.5x12 cm
 BSC pl 70 GBS (5941)
James, son of Zebedee c 1525
 ptd limewood; 74
 KO pl 68 GMBN
Maximilian I Tomb, detail:
 Count Albrecht of Hapsburg
 1518 bronze
 VEY 138; 43 AIH
St. George, c 1520 ptd
 limewood; 60-3/4
 BERL pl 195 (col);
 BERLES 195 (col) GBSBe
 (3066)
Virgin (Muttergottes) 1519
 bronze; 46 cm
 BSC pl 71 GBS (381)
Virgin and Child
 LIL 148 GPo1M
LEINBERGER, Hans--FOLL
 St. John the Baptist c 1515
 ptd lindenwood; 33-7/8
 KUHN pl 28 UMCB
 (1957.124)
LEINBERGER, Simon(?)
 St. John the Evangelist, High
 Altar c 1480
 BUSR 92 GNoG
LEINFELLNER, Heinz (Austrian
 1911-)
 Concerto, relief
 SAO-2
 Head (Kopf) 1955 bronze
 GERT 237
 --1960 blackstone
 SOT pl 89
 Male Head 1949 terracotta
 VEN-50:pl 72
 The Musicians (Musiziernde),
 relief 1954 bronze
 GERT 236
 Reclining Woman with Drapery
 1959 bronze; L: 45 cm
 SOT pl 88
 Seated Figure 1956 limestone;
 47x43
 BERCK 165
 Seated Figures 1955 limestone
 MAI 168
 Sitting Figure 1948 brick-
 maker's clay: LS
 SCHAEF pl 48
 Two Sitting Women 1952/55
 sandstone; 35
 MID pl 108
 BAM

Woman with Shell (Donna con
Conchiglia) 1953 arenaria
calcarea
VEN-54: pl 73
Leipsig Monument. Metzner
LEIRNER, Felicia
Two Figures
BERCK 201
LEJEUNE, Pierre Francois (French
1721-90)
Voltaire with Laurel Crown,
bust c 1760 marble; 24
KO pl 98 GStLa
LELEU, Jean Francois (French
1729-1807)
Commode 1772 marquetry and
bronze; 34x46
CHAR-2: 240 FPL
Sisyphe
FPDEC il 14
LE LORRAIN, Robert (French
1666-1743)
The Dew marble; 71x30-3/8
USNKP 448 UDCN (A-1630)
Galatea, seated figure 1701
marble; 31-17/32x14-15/16
x18-7/16
KRA 177-8; USNKP 447
UDCN (A-1629)
Sun Horses (Horses of the
Sun; Horses of the Sunset)
Drinking Trough, relief
detail c 1740
CHENSW 459; BAZINW
397 (col); JAL-5: pl 8;
LARR 387; MARQ 226
FPRoh
Lehman, Robert d 1637
Christman, J. and M. Sir
Robert Leman, Lord Mayor
of London, Tomb
LE MAR, Marcel (French 1892-)
Bear
CASS 121
LEMARCHAND, David 1674-1726
Sir Isaac Newton, medallion
ivory; 7-3/4x5-1/8
SOTH-2: 216
Lemire, L'Abbe
Hanin. L'Abbe Lemire, bust
LE MOITURIER, Antoine See
MOITURIER, Antoine le
LEMOT, Francois Frederic (French
1773-1827)
Henry IV, equest, Pont Neuf
1818
GAF 137 FP

LEMOYNE, Jean Baptiste (French
1704-78)
Child, bust 1743 terracotta
SOTH-4: 279
Flore-Baigneuse marble; 29-
3/4
HUNT pl 24; HUNTA 95
UCSmH
Gabriel, bust
CHASEH 388; POST-2: 30
FPL
Louis XV, bust bronze; 19-1/2
(with base)
CPL 76; REED 131
UCSFCP (1927.210)
--1757 marble; 34-1/4
NMA 184 UNNMM
(41.100.244)
Mlle. Dangeville as Thalia,
bust
ENC 554
Montesquieu, bust 1760
LARR 375 FBorA
Noel Nicolas Coypel, bust
1728(?) terracotta
SOTH-2: 220
--1730 terracotta; 25-5/8
LAC 205; ST 362 FPL
The Ocean, Bassin de
Neptune 1740 lead and
bronze
ROTHS 201 FV
The Regent, bust marble
BAZINB 193 FV
Voltaire, bust 1745 marble;
LS
KITS 130 FChaa
Woman, bust
RAY 50 UMdBW
Woman, bust terracotta
CLE 136 UOC1A (52.566)
Portraits
Pajou. J. B. Lemoyne, bust
LEMOYNE, Jean Louis (French
1665-1755)
Diana marble; 71-3/4 (with
plinth)x30-1/4x22-3/4
SEYM 154, 155-57 UDCN
Duke of Orleans, bust 1715
LARR 375 FV
Pomona c 1770 limestone; 85
DEYE 185 UCSFDeY
(60.12)
LE MUET, Pierre (French 1591-1669)
Residence Door c 1623
BLUA pl 76B FPChal
Residence Door c 1645
BLUA pl 76A FPCom

LENHENDRICK, Louis Joseph
 Louis XV Table Candlestick
 1753/54
 SOTH-2:167
Lenin, Nikolai (Communist Russian
 Leader 1870-1924)
 Andreyev. Lenin the Leader,
 half figure
 Russian--20th c. Lenin
 Wnuk. Lenin
LENK, Kaspar Thomas (German
 1933-)
 Dialektisches Object 10 1962
 lead in wood; 20x55x40 cm
 KUL pl 27
 Farb-Raum-Objekt 8 1964/65
 KULN 161
 Object 16 1962 glazed plaster
 on wood; 60x80x30 cm
 KUL pl 21
 Strata, No. 10 1964/65
 55-3/8x55-3/8
 CARNI-67:#104 GStMu
 Stratification 21a (Schichtung
 21a) 1964/67 plexiglass;
 83-1/2x61-3/4x16-3/4
 GUGE 118 GStMu
Lennox, Margaret, Countess of
 English--16th c. Margaret,
 Countess of Lennox,
 Monument
LENOTRE, Andre (French 1613-1700)
 Kneeling Woman
 CHRC fig 213 FV
 Park, detail
 ENC 555 FV
 The Rivers, detail
 GAF 137 FPTu
Lens Picture. Gerstner
Leo III (Pope 750?-816)
 German--13th c. Shrine of
 Charlemagne
Leo X (Pope 1475-1521)
 Bandinelli, B. Leo X
 Monument
 Spinelli. Pope Leo X as
 Cardinal Giovanni de'
 Medici, medal
Leo XI (Pope 1535-1605)
 Algardi. Leo XI Monument
Leo I (Eastern Roman Emperor
 400-74)
 Algardi. Meeting of Attila
 and Leo I
Leo III (Eastern Roman Emperor
 680?-741)
 Byzantine. Coin: Leo III;
 reverse: Constantine V

Leo VI (Eastern Roman Emperor
 866-912)
 Byzantine. Coin: Leo VI
 Byzantine. "Grotto of the
 Virgin", vase on crown of
 Leo VI
 Byzantine. Leo VI#
Leonard, Saint
 Flemish--15th c. St. Leonard
 Altarpiece
 Netherlandish. St. Leonard
 Altarpiece
 Renier van Thienen. Paschal
 Candlestick
LEONARDI, Leoncillo See LEONCILLO
Leonardi, Viola
 Lucarda. Viola Leonardi,
 head
LEONARDI DI SER GIOVANNI, and
 BETTO DI GERI
 Baptistry Altar after 1377
 silver
 WHITJ pl 184 IFOp
 --Life of St. John the Baptist
 POPG fig 30
LEONARDO, Donato di
 Pax: Adoration of the Child
 2nd half 15th c. silver
 gilt; 11-1/2
 DETD 165 FPL
 Pax: Death and Assumption
 of the Virgin 2nd half 15th
 c. silver gilt; 11-1/2
 DETD 164 UMdBW
LEONARDO DA VINCI (Italian 1452-
 1519)
 Battle of Anghiari, sketch,
 detail terracotta; c 18
 STI 585 FPL
 The Flagellation, relief
 bronze
 BODE 210 IPeU
 The Judgment of Paris,
 relief bronze
 BODE 214 FPD
 Pieta, relief bronze
 BODE 209 IVC
 Riding Warrior c 1506/08
 bronze
 CHENSW 392; GAUN pl 38
 HBA
 St. George and the Dragon
 bronze, after wax model
 VALE 113
 St. George Fighting the
 Dragon bronze; 4
 NCM 52 UNcRV
 Strife, relief plaster
 BODE 208 ELV

Trivulzio Monument, project
c 1506/08
SEY pl 120B EWindR
Trotting Horse (Cavallino
Scorticato) bronze;
8-3/4x8-1/4
DETD 107 UNNFre
The Virgin with the Laughing
Child c 1470/80 terracotta;
19
MACL 174; NEWTEM pl
124 ELV
Portraits
Ferenczy, B. Leonardo da
Vinci, medal
LEONARDO DA VINCI--ATTRIB
Horse and Rider (Mounted
Warrior) c 1506/08 bronze
LARR 122; POPRB fig 127
HBNM
LEONARDO DA VINCI--FOLL
Flora, bust 1501/06 wax;
67.5 cm
BSC pl 85 GBS (5951)
Negro on Horseback Fighting
Lion 16th c. bronze; 11-1/2
DETD 120 UPPPM
Leonatus, Abbot 1152-92
Italian--12th c. Abbot Leonatus
Offering Church to Pope
Clement III, tympanum
LEONCILLO (Leoncillo Leonardi)
(Italian 1915-)
Arbusti 1957 ceramica smaltata;
.71x.56 m
SCUL pl 42 IRLu
Black Cut 1959 ceramic
SAL pl 54 (col)
Edge of the Night 1957
terracotta
BERCK 293
Mary 1953 colored ceramic
VEN-54: pl 23
Minotaur 1950 ceramic
VEN-50: pl 50
Omen (presagio) 1960
VEN-60: pl 108
La Partigiana 1955, 1st
version ceramica smaltata;
2.07 m
SCUL pl 43 (col)
San Sebastian 1962 55-1/8x
21-5/8x11-3/4
NEW col pl 61 (col)
IRO
San Sebastian in White sand-
stone and enamel; 80x20x
20
ARTSI #11

Sentimento del Tempo 1961 red
sandstone and enamel; 63x
19-5/8x21-5/8
READCON 266 (col)
Walls on Asphalt 1957 ceramic
MAI 169
White Cut (Taglio Bianco) 1959
ceramic
SAL pl 53; VEN-60: pl 109
ISpMC
LEONI, Leone (Known as Il Cavaliere
Aretino) (Italian 1509-90)
Barbarian Captives
POPRB pl 105 IMO
Charles V, bust
POPRB fig 125 SpMaP
--bronze; 43-1/8x22
SHAP 33; UNSKP 430
UDCN (A-1628)
Charles V Restraining Fury
POPRB fig 141 SpMaP
Empress Isabella, medal
bronze; Dm: 72 mm
DETD 139 UNNSa
Ferrante Gonzaga Triumphant
over Envy
POPRB fig 142 IGuR
Gian Giacomo de' Medici
POPRB fig 70; pl 103 IMC
Giovanni Capponi, bust
marble; 23-5/8x23-1/4
USNK 199; USNKP 431
UDCN (A-59)
Mary of Hungary bronze; 166
cm
POPRB pl 106 SpMaP
Satyr Attacked by Lion stone
POPRB pl 105 IMO
Triton on a Tortoise bronze;
6-1/2
DETD 125 UNNUn
LEONI, Leone, or DA TREZZO
Philip II; Fountain of the
Sciences, medallion 1547
VER pl 68 UMCB
LEONI, Leone and Pompeo LEONI
Calvary, with Virgin and St.
John, and SS Peter and
Paul 1588 gilded bronze
ESC 47 SpE
LEONI, Pompeo (Spanish-Italian
1533-1608) See also Leoni,
Leone
Charles V and his Family at
Prayer, High Altar and
Tabernacle (Capilla Major)
c 1595
CIR 31 (col); ESC 36 (col);

Bacchanale Vase bronze
VEN-7: pl 13
Bjornstjerne Bjornson, bust
bronze
VEN-7: pl 18
Canottieri del Tevere medal
VEN-14: 106
Somnambulist (La Sonnambula)
bronze
VEN-5: pl 45
LE ROUX, Rouland, and Pierre
d'AUBEAUX
Amboise Cardinals Tomb
begun 1515
BLUA pl 15; GAF 53; ST
330 FRC
LE ROY, Pierre Francois (Belgian
1739-1812)
Henri van der Noot, bust
18th c.
DEVI-2 BBV
Leschman, Prior d 1481
English--15th c. Prior
Leschman, effigy
LESCHNITZER, Georg (Spanish-
Israeli 1885-1951)
Jabotinsky, head plaster
GAM pl 103
LESCOT, Pierre (French 1510-71)
Fountain of the Innocents
1549
GAF 135; JANSK 734 FP
LESLIE, Lionel (English)
African, head 1946 Derbyshire
limestone; over LS
NEWTEB pl 44A
LESPAIGNOL, J. (French)
Entombment 1699/1707 ptd
wood
GAF 244 FStTh
Lesson. Belsky
LESSORE, F. (English)
Office Building Main Entrance
AUM 147 ELBM
LE SUEUR, Herbert (French-English
1580-1670)
Charles I, bust bronze
CON-2: pl 44 ESton
--1631 marble; 35-1/2
BROWF-3: 48; GARL 53;
VICK 12 ELV (A. 35-1910)
--1636
WHINN pl 24B EOB
Charles I, equest 1633 brass;
92 figure on pedestal:
13' 8'x9' 11'x5' 7'
GARL 197; GLE 1; HUX
169; MOLS-2: pl 7; WHINN
pl 27 ELChar

Charles I in Dragon Helmet,
bust bronze; 27
WHIN pl 30a EStou
Gladiator (cast of Borghese
Gladiator) c 1630 bronze;
LS
COOPF 227 ENorfH
Henrietta Maria 1634 bronze;
76
WHIN pl 70b; WHINN pl
26A EOJ
William 3rd Earl of Pem-
broke c 1629 bronze
CON-2: pl 42 EOSc
Let us Beat Swords into Plowshares.
Vuchetich
The Letter "d"
Bertoni. D (Imaginary
Alphabet)
Lettering See Inscriptions
LEUBE, Max (German 1908-)
Head of a Woman 1929
beaten metal
RAMS pl 44a
Leuchterweibchen
German, or Swiss--16th c.
Chandelier: Woman Playing
Lute
Levassor. Lefevre
LE VAU, Louis, the Younger (French
1612-70)
Chateau Fountain 1657/61
BLUA pl 103 FVa
Levericus, Bishop
English--13th c. Bishop
Levericus
Levertin, Oscar
Milles. Oscar Levertin
LEVI, Joel ben Lipman (Dutch)
Eleazer ben Samuel
Schmelka, medal 1735
ROTH 530
Levin, Shmarjahu
Ben-Zvi. Shmarjahu Levin,
head
Levis-Mirepoix, Guy II
French--13th c. Guy II de
Levis, Mirepoix, effigy
Levisham Group Slab. Anglo-Saxon
Levite. Rustici. Preaching of the
Baptist; details: A Levite
Levitoux, Henri
Oleszczynski. Henri Levitoux,
head
Levy, Mme. Leopold
Despiau. Mme. Leopold Levy,
head
Levy, Mervyn
Gray. Mervyn Levy, head

LEWANDOWSKA-CZERWINSKA,
 Krystyna (Polish 1921-)
 Maternity 1957 plaster
 JAR pl 38
LEWERS, Gerald (English)
 Totem Head bog wood
 NORM 88
Leweston, John d 1584
 English--16th c. John
 Leweston Monument
Lexington, Lord
 Palmer. Lord Lexington
 Monument
Leyden, Heinrich Ferdinand von der
 Groninger, J. M. Dean
 Heinrich Ferdinand von der
 Leyden Tomb
LEYGUE, Louis (French 1905-)
 Monument to the Unknown
 Political Prisoner, project
 1953
 BERCK 143; MAI 171
 Sao Sebastiao ou o Fuzilado
 130 cm
 SAO-4
Leyre Coffer. Hispano-Moresque
Li Cuocio Sempre al Burro.
 Reinhoud
Lia. Drei
Libations See Sacrifices, Offerings,
 and Libations
LIBENSKY, Stanislav (Czech 1921-)
 and Jaroslava BRYCHTOVA
 Kopf IV 1964 glass; 46 cm
 BER 33
LIBERAKI, Aglaia (Greek 1923-)
 Bas Relief 1960 bronze
 MAI 172
Liberal Arts. French--12th c.
Liberation. Perrin
Liberation. Stojanovic
Liberation from Error
 Queirolo. Deception
 Unmasked
Liberation Monument. Dunikowski
The Liberation Monument. Saloun
The Liberation of Belgrade.
 Stankovic
The Liberation Struggle. Kalin, Z.
Liberty
 Albigaard. Freedom Memorial
 Bartholdi. Statue of Liberty
 Blake. Le Plan d'Orgon War
 Memorial
 Bourdelle. Alvear Monument,
 study: Liberty
 Causici. Liberty and the
 Eagle

 Kisfaludi-Strobl. Freedom
 Memorial
 Kiss, I. We Want Freedom
 Wagner, J. P. A. Freedom
Liberty Enlightening the World
 Bartholdi. Statue of Liberty
Liborius, Saint
 Roger von Helmarshausen.
 Portable Altar
Librarians
 Stilp. The Librarian
Lichfield, 3rd Earl of
 Tyler. 3rd Earl of Lichfield
 Monument
Lichtenberg, Count von
 Gerhaerts. Count von Lichten-
 berg, head
Licthregen. Uecker
LICUDIS, Oreste (Italian)
 Count von Axel, head
 VEN-12: pl 107
 Male Head ptd plaster
 VEN-14: 139
 Silvia bronze
 VEN-20: 84
LIE, Emil (Norwegian 1897-)
 Seated Boy 1933 marble
 RAMT pl 49
 Torso 1934
 CASS 67 NoONaS
Liebermann, Max
 Knappe. Painter Max
 Liebermann, torso
Liegende. Zimmermann, K.
Liegende Antilope. Wrampe
Liegender Junge. Marcks
Liegender Jungling. Edzard
Liegender Mann. Fiori
LIEGME, Adrien (Swiss-French
 1922-)
 Don Juan 1958
 JOR-2: pl 233
 Sculpture 1958/59
 JOR-2: pl 234
 --1959 plaster
 MAI 173
LIENHARD, Robert (Swiss 1919-)
 Hirt zu Pferd 1954 bronze;
 40 cm
 JOR-1: pl 71
 Patineurs
 JOR-2: pl 236
 S. B. B. Monteure 1953
 bronze; 60 cm
 JOR-1: pl 70 SwZKa
 Ulysse 1956
 JOR-2: pl 235
Lievre, M.
 Despiau. M. Lievre, head

Lifar, Serge (Russian Choreographer
 1905-)
 Zamoyski. Serge Lifar, head
Life and Death. Bonnesen
Life of Man III. Trsar
Life Study. Armitage
Lifeguard. Marcks
Lifting. Hanak
Ligeti, Antal (Hungarian Painter)
 Zala. Antal Ligeti, bust
LIGETI, Miklos (Hungarian 1871-
 1935)
 Anonymus, Memorial to the
 Unknown Verfassers of
 Hungarian History 1902
 bronze; 190 cm
 GAD 66 HBBP
 Bela Grunwald, seated
 figure bronze
 VEN-5: pl 31
 Jozsef Rippl-Ronai, bust
 c 1902 bronze; 45 cm
 GAD 67; VEN-30: pl 168
 HBA
 Soldiers, Turin Exposition
 TAFTM 91
Light. Hoetger
Light. Pogliani, M.
Light Relief. Mack
Lightdynamo. Mack
Lighting Fixtures See Candelabras
 and Candlesticks; Chandeliers;
 Electric Lamps and Fixtures
Lightning. Biancini
Lignes-Forces d'une Bouteille.
 Boccioni
LIGORIO, Pirro (Italian c 1510-
 c 1562)
 Facade of the Loggia, Casina
 of Pius IV 1558/62
 BAZINW 368 (col) IRV
LIIPOLA, Yrjo (Finnish 1881-)
 Awakening Strength 1911
 bronze
 RAMT pl 20 FiHA
LIISBERG, Hugo (Danish 1896-)
 Eagle 1931 bronze; 118
 MID pl 74 BAM
LIJN, Liliane (French)
 Liquid Reflections 1966/67
 KULN 173
Lilac Chair. Schippers
Lilies. Crook
Den Lille Cyclerytter
 Maillol. Le Petit Coureur
 Cycliste
Lilly. Gelles

LIM, Kim (Chinese-English 1936-)
 Day 1966 steel, shot-blasted,
 ptd; 84
 LOND-7: # 22
LIMBURG, Josef (German)
 The Lorelei
 TAFTM 71
Limoges Casket. Early Christian
LINCK, Konrad (German 1730-93)
 Oceanus and Thetis c 1765
 Frankenthal porcelain
 KO pl 95 ECam
LINCK, Walter (Swiss 1903-)
 Cheval Trieste 1945 bronze;
 60 cm
 JOR-1: pl 96
 Construction Mobile 1958
 JOR-2: pl 239
 Jeu d'Eau
 JOR-2: pl 237
 Lyrique 1952
 JOR-2: pl 165
 Mobile. H: 28
 BERCK 174
 --H: 30
 BERCK 174
 Pendule 1953
 JOR-2: pl 166
 Points Opposes 1958
 JOR-2: pl 168
 Punti Opposti 1958 iron and
 steel
 VEN-66: # 218
 Rhythmic Plant, mobile 1954
 ptd iron; 40x30x16 cm
 JOR-1: pl 97; SAO-7
 SwBeKoR
 Rhythmic Plant, in Movement,
 of Night (Plano Rhythmique,
 en Mouvement, de Nuit)
 JOR-1: pl 98
 Sculpture*
 EXS 43
 Sculpture Mobile 1959 steel and
 iron; 59x157-1/8
 TRI 37
 Signe 1952
 JOR-2: pl 165
 Vegetatif 1955
 JOR-2: pl 167
 Window Open on the Sky
 (Fenetre vers le Ciel),
 mobile 1958 iron and steel
 JOR-2: pl 238; MAI 173
 SwChA
Lincoln, Abraham (16th President of
 the U. S. 1809-65)

Bartoli. Lincoln, seated
 figure
Bergen. Lincoln
O'Connor. Abraham Lincoln,
 head
Zelezny. Lincoln
Lindau Gospels. German--9th c.
Lindbergh, Anne Morrow
 Despiau. Anne Morrow
 Lindbergh, head
Linenfold Tudor Chair. English--17th
 c.
Lines in Space No. 5. Vezelay
Ling, Rita
 Skeaping. Rita Ling
Lintels
 French--11th c. Lintel#
 French--13th c. The Resur-
 rection of the Dead, lintel
 Spanish--11th c. Lintel: Christ
 in Mandorla
The Lion in Love
 Geefs. "Love, when thou
 Holdest Us"
Lion of Belfort. Bartholdi
Lion of Lucerne. Thorvaldsen
Lion of St. Mark See Symbols--
 Evangelists
Lion Woman. Giacometti
Lions See also Daniel; David;
 Hercules; Samson
 Almquist. Lion, column
 support
 Anglo-Saxon. Lion Devouring
 Man
 Antico. Hercules and the
 Nemean Lion, plaque
 Austrian--12th c. Man Fight-
 ing Lion, apse relief
 Barberton. Lioness
 Barisanus of Trani. Door
 Panels
 Barlach. The Fighter of the
 Spirit (Der Giestkampier)
 Barye. Kaempende bjorne
 Barye. Lion and Serpent
 Barye. Lion Vanquishing an Ibex
 Barye. Mounted Arabs
 Killing a Lion
 Barye. Walking Lion
 Bernini, G. L. Prophet
 Daniel
 Bertoldo di Giovanni. Hercules
 Slaying the Lion
 Bertoldo di Giovanni. Negro
 and Lion
 Bulgarian--9th c. Lion
 Rampant

--Lionness, head
Byzantine. Gladiators and
 Lions
Canina. Lion Fountain
Ceracchi. Capellen Monument
Danish--17th c. Coronation
 Chair and three silver
 Lions
Donatello. The Marzocco
Dutch--12th c. Lion Aquamanile
English. Font: Lion Surrounded
 by Magic Plait-work
English--12th c. Durham Door
 Knocker: Lion Head as
 Mouth of Hell
--Flabellum, detail: Lioness
 Vivifying her Whelps
--Hercules Wrestling with
 Lion
--Lion, font detail
--Lion-head Door Knocker
Fernkorn. Lion of Aspern
Flemish--14th c. Lion,
 aquamanile
Flemish--15th c. Andirons;
 detail: Lion Holding Shield
Folk Art--Russian. Lion, re-
 lief, Tikhvin
Franco-Flemish. Jean Sans
 Peur Tomb
French--11th c. Central Door-
 post: Endorsed Lions
--Porch Capital: Lion
French--12th c. Capital:
 Samson and the Lion#
--Lion, aquamanile
--Lion (The Devil) Devouring
 Sinner
--Man Fighting Lion
--Pier: Crossed Lions and a
 Prophet
French--13th c. Amiens
 Cathedral Relief, west
 front
--Aquamanile: Lion
--Candlestick: Figure Seated
 on Lion
French--18th c. Louis XV Lion
 Chenet
Gaul. Lion
Geefs. "Love, when thou
 Holdest Us"
Georgian. St. Mamas Riding
 Lion, tondo
German--9th c. Lion's Head
 Medallion
German--12th c. Crouching
 Lion

--Door Knocker: Lion's Head
--Lion of Henry the Lion
--Lion Striking Lamb--
 symbolizing persecution of
 goodness
German--13th c. Aquamanile:
 Lion#
--Choir Stall: Lion's Head
--Cornice: Lion, detail of
 Resurrection
--Samson Candlestick
German--14th c. Lion Reviv-
 ing Stillborn Young by his
 Breath, symbol of
 Resurrection
German--15th c. Aquamanile:
 Lion
German--16th c. Automaton
 Table Clock, with Lion
 figure
Gofridus. Choir of St. Pierre:
 Grotesque Capitals
Italian. Odescalchi Chigi
 Family Tomb
--Socle, lion-form
Italian--11th c. Abbot's Throne
--Font, detail: Lions
--Lion, column base
--Pulpit: San Giulio
Italian--12th c. Lion#
Italian--13th c. Baptismal
 Font: Lombard Lion
 Support
--Pulpit: Lions
Italian--15th c. Capital:
 Seated Figure with Lion
--Lion-Headed Display
 Barbute
Italian--16th c. Lion
Jewish. Lion#
Kandler, J. J. Lion and
 Lioness
Leonardo da Vinci--Foll.
 Negro on Horseback
 Fighting a Lion
Leoni, L. Satyr Attacked by
 Lion
Master Oderisius of Bene-
 vento. Door Knockers:
 Dragons and Lions
Master Radovan. Door, de-
 tail: Adam on a Lion
Merovingian. Capital, detail:
 Lion
Mirko. Lion of Damascus
Mosan. Christ Trampling
 the Beasts

Negroli. Charles V Round
 Shield: Lion's Head
Nicolo da Fogia. Pulpit
Ottavio da Campione--Foll.
 Porta Regia, detail: Lion
Pauschinger. Lion's Head
Pigalle. Marechal de Saxe
 Tomb: Lion of Flanders
Pisanello. Nuptial Medal:
 Lenello d'Este; Singing
 Lion
Pisano, G. Pistoia Pulpit
Puget. Milo of Crotona
Rodin. Weeping Lion
Roger of Melfi. Lion's Head
Russian--17th c. Comb:
 Griffin, Lion, Human Heads
Spanish--16th c. St. Jerome
Swedish--17th c. Wasa War-
 ship Ornaments
Thomas. Lioness, garden
 figure
Wheeler, C. War Memorial
 in Halfarga, North Africa:
 Lions
Lipari. Nicholson
The Lips. Arp
LIPSI, Maurice (original name:
 Morice Lipszyc) (Polish-
 French 1898-1958)
 Lava 1960 volcanic stone
 SELZJ 10 FPRe
 Lava Sculpture 1961 lava
 MARC pl 58
 Sculpture 1956 stone
 BERCK 126
 --1957 lava
 BERCK 126
 --1957/68 marble; 58 cm
 STM BAM
 --1958 lava
 MAI 178
 --1958 lava; 17x18x7-3/4
 GIE 242
 Structure 1961 lava
 MARC pl 59 (col)
 Volvic Stone 1958 H: 45-1/4
 READCON 183; TRI 174
 FPRe
Liquid Reflections. Lijn
Liquor Containers
 Austrian--19th c. Austrian
 Spirit Wagon
Lisbjerg Altar. Danish--12th c.
LISHANSKY, Batya (Russian-
 Israeli 1901-)
 Asleep stone
 GAM pl 105

Little Shepherd. Perez Comendador
Little Siren. Laurens
Little Venus. Gonzalez
Liturgic Vegetale
 Penalba. Plant Liturgy
LUTHARD (French)
 Book Cover: Crucifixion and
 Other Scenes 9th c. ivory
 GARDH 223 GMS
Livertin, Saint (Healing Saint for
 Headaches)
 French. Healing Saints;
 detail: St. Livertin
Livy (Titus Livius) (Roman
 Historian 59 B. C.-17 A. D.)
 Marini, A. Livy
 Riccio, A.--Foll. Livy, head
Liz. Horn
Llama
 Schwerdtfeger. Llama
 Turnbull. Llama
Llangan Cross. Celtic
Llanhamlach Slab. Celtic
The Load. Adsuara
Lobende Afrikansk Elefant. Barye
LOBO, Balthazer (Spanish-French
 1911-)
 Lullaby 1957 stone; 20
 BERCK 297 FPVG
 Reclining Nude 1958 bronze
 MAI 180 VCMC
Lobsters
 Muller, R. Langouste
LOCHNER, Kunz (German 1510-67)
 Knight and Horse Armor of
 Johann Ernst, Duke of Saxony,
 Nuremberg 1548 steel; knight's
 armor: 65 NM-3:10; NM-11:95;
 NMA 175 UNNMM (29.151.2;
 and 32.69)
Lock. Caro
Locke, John (English Philosopher
 1632-1704)
 English--18th c. John Locke,
 ivory portrait bust
 Rysbrack. John Locke
Locked Figure. Startup
Locking Piece. Moore, H.
Locks
 English--16th c. Lock, with
 Royal Arms used by
 Henry VII and Henry VIII
 French--18th c. Louis XV
 Ormolu Door Lock
LODZIANA, Tadeusz (Polish 1920-)
 Composition 1954 plaster
 JAR pl 27
LOEB, Jacob (Leb Low) (Austrian-
 Israeli 1887-)

 Jacob and Rachel terracotta
 SCHW pl 32
LOEDEWICH, Master (German)
 High Altar, detail 1498/1500
 MULS pl 164A GKa1N
LOEFFLER-ZBROZYNA, Barbara
 (Polish 1923-)
 Erotic 1957 patinated plaster
 JAR pl 23
Loggetta. Sansovino, J.
A Logica e o Silogismo. Fernandes
 de Silva
LOGUIN, Jacques (French, or
 Flemish d 1559)
 Crucifixion Altar 1541
 KUBS 95B SpCoC
 Pulpit 1520/22
 KUBS 94B PoCC
LOHSE, Richard P. (Swiss)
 Wall Relief, Furniture
 Building wood
 DAM 144 SwZA
LOUISEAU-BAILLY, Georges (French)
 Monument to Carnot
 TAFTM 35 FBeau
LOISEL, Robert See PRIVE, Thomas
Lokhan
 German--17th c. Tray#
LOMBARD
 Capital, southwest portal
 c 1100
 BOE pl 44 GMaiC
 Chancel Frieze Detail: Fairy
 Tale Motifs; Hares Bind-
 ing Hunter and Classical
 Ornament
 BOE pl 45 GKonC
 Fibula, Austria 6th c.
 CHRC fig 66 AVNM
 Hen and Chicks 8th c. silver
 gilt
 BAZINW 215 (col IMonC
 Madonna and Child late 12th
 c. ptd stone; 29
 BOSMI 113 UMB (57.583)
LOMBARD MASTER (fl last Q 15th c.)
 Adoration of the Magi,
 relief marble; 24x24
 USNKP 412 UDCN (A-1614)
 Flight into Egypt marble;
 24x24
 USNKP 413 UDCN (A-1615)
LOMBARDI, Alfonso (Italian c 1497-
 1537)--FOLL
 Portrait Bust terracotta; 30
 BOSMI 131 UMB (56.12)
LOMBARDO, Antonio (Italian c 1458-
 1516)

Miracle of St. Anthony of
 Padua, relief, Capello del
 Santo 1505 marble
 MAR 137 IPadAn
Mythological Scenes, relief
 POPR fig 153 RuLH
Testimony of the Innocent
 Babe 1505 marble; 60
 KO pl 78 (col) IPSa
Zen Altar; detail: Virgin and
 Child bronze
 POPR fig 163 IVM
LOMBARDO, Antonio--ATTRIB
 Candelabrum Bearing Angel,
 detail c 1485 marble
 SEY pl 140B UDCN
Giovanni Mocenigo Monument,
 relief detail: Baptism of
 Christ c 1500 marble
 SEY pl 142A IVGP
LOMBARDO, Girolamo
 Frieze
 BOE pl 157 IVLib
LOMBARDO, Pietro (Pietro Antonio
 Solari) (Italian c 1435-1515)
 Angel, Capella Maggiore
 marble
 POPR pl 133 IVGio
Column Base
 MARQ 202 IVMM
Leonardo Loredano Before
 the Virgin, relief
 POPR fig 161 IVP
Madonna and Child, relief
 stone
 NCN 272 UNNMM (13.199)
Malipiero Monument
 POPR fig 157 IVGP
Marcello Monument
 POPR fig 160 IVGP
Pietro Mocenigo Tomb c 1476/
 81 marble
 BAZINW 342 (col); CHAS
 203; CHASEH 327; LARR
 139; MURA 133; POPR fig
 155, pl 134-5; POST-1:
 197; SEY pl 139 IVGP
--St. Mark
 SEY pl 140A
Roselli Monument 1467
 POPR fig 156 IPadAn
A Singing Angel c 1480
 marble; 33-7/8x11x11-
 27/32
 KRA 56; USNI 230;
 USNK 194; USNKP 414;
 SEYM 124-6 UDCN
 (A-47)

Zanetti Monument, detail:
 Giovanni Zanetti Kneeling
 Before God the Father
 marble
 POPR fig 159, pl 136 ITreC
LOMBARDO, Pietro--FOLL
 Decorative Relief, triumphal
 arch after 1481
 BAZINW 342 (col) IVMM
LOMBARDO, Tullio (Tullio Solari)
 (Italian c 1435-1532)
 Adam c 1490/95 marble;
 75-1/2
 BAZINW 343 (col); MAR
 138; POPR pl 141; SEY
 pl 143B; UN-8:4 UNNMM
 (36.163)
Andrea Vendramin Tomb c
 1390 marble
 MAR 138; IVGP
--Bust of Warrior
 CHAS 286
--Warrior in Swine Helmet
 POPR fig 162, pl 140
Bacchus and Ariadne, busts
 1520's marble; 22
 MOLE 137; POPR pl 139
 AVK
Coronation of the Virgin,
 relief marble
 POPR pl 138 IVGC
Giovanni Mocenigo Monument:
 St. Mark Baptizing c 1500
 marble
 SEY pl 142B IVGP
Guidarello Guidarelli Tomb
 1525 marble
 NATSE IRaP
--Guidarello Guidarelli
 effigy
 HALE 179; LARR 144
Miracle of the Miser's Heart
 marble
 POPR pl 142 IPadAn
Miracle of the New-born
 Child marble
 POPR pl 143 IPadAn
St. Mark Baptising Amianus,
 relief marble; 107x154 cm
 POPR pl 137 IVGP
Two Heads
 MACL 182 IVA
LOMME DE TOURNAI, Janin
 Prince of Viana as a
 Mourner at Tomb of Kings
 of Navarre c 1450
 BUSR 54 SpPamC
The Lone Singer. Wheeler, C.

Long, Henry Alfred
 Shannon. Henry Alfred Long,
 bust
Long Head. Giacometti
Longespee, William, Earl of Salisbury,
 d 1226
 English--13th c. William Long-
 espee, Earl of Salisbury,
 effigy
Longfellow, Henry Wadsworth
 Brock. Longfellow, bust
Longhi, Guglielmo
 Italian--14th c. Cardinal
 Guglielmo Longhi Monument
Longing
 Maillol. Desire
Longinus, Saint
 Bernini, G. L. St. Longinus
 Flemish--15th c. Geel Altar-
 piece
 German--10th c. Codex Aureus
 Epternacensis: Christ on
 the Cross Between Longinus
 and Stephaton
Longshoreman. Meunier
Longton Hall Shepherd. English--
 18th c.
LONGUET, Karl Jean (French 1904-)
 Fountain 1958 stone MAI 181
LONGUEVILLE (French)
 Adam and Eve Fountain 16th c.
 GAF 409 FRi
Longueville, Dukes
 Anguier, F. Dukes of Longue-
 ville Monument
Looms
 Folk Art--Russian. Loom#
LOPES, Teixeira
 The Widow
 CASS 82 PoLA
LOPEZ DE GAMIZ, Pedro (Spanish)
 High Altar 1551/69
 KUBS 76A SpBrC
Lopokova, Lydia
 Dobson. Lydia Lopokova, bust
LORCHER, Alfred (German 1875-
 1962)
 After the Bath (Nach dem Bad)
 1950 clay GERT 64, 65
 Chor, plaque 1954/56 bronze;
 Dm: c 13 cm SP 132 GHaS
 SP 132 GHaS
 Conference 1958 bronze;
 plaque: 41.5x41.5 cm;
 figures: 5 cm
 OST 92
 Horses, relief terracotta
 MAI 181
 Troy in Ruins 1958 bronze;
 11-3/4x9-7/8 TRI 113 GDuK

Zwei Redende mit Krugen 1951
 bronze; 12x16x5.5
 SP 132 GHaS
"The Lord is My Shepherd" (Negev
 Sheep). Danziger
Loredon, Leonardo (Duke of Venice
 1438-1521)
 Cattaneo. Doge Loredan Tomb
 Lombardo, Pietro. Leonardo
 Loredano Before the Virgin
 and Child, relief
Loredano Monument. Grapiglia
"Die Lorelei"
 Herter. Heinrich Heine
 Memorial: Fountain with
 Figure of "Die Lorelei"
The Lorelei. Limburg
LORENZETTI, Carlo (Italian)
 Female Figure bronze
 AUM 40
 Luigi Borro, bust
 VEN-22:116
 Lupetto di Mare bronze
 VEN-26:pl 92
 Le Marangona
 VEN-12:pl 121
LORENZETTI, Lorenzo (Italian
 1489-1541)
 Christ and the Woman Taken in
 Adultery, relief bronze;
 65.5x2.2 cm
 POPRB fig 79, pl 41 IRMP
 Dead Boy on a Dolphin marble;
 L: 106 cm
 HERMA 18 RuLH
 Jonah, Chigi Chapel
 MACL 227; POPRB fig 44
 IRMP
LORENZI, Battista
 Alpheus and Arethusa 1568/84
 marble 58-1/2
 NM-8:6 UNNMM (40.33)
LORENZI, Stoldo
 Amphitrite
 POPRB fig 133
LORENZO DI GIOVANNI
 D'AMBROGIO (Italian fl
 1396-1405)
 Prophet, Porta della Mandorla
 1396/97 marble
 SEY pl 2 IFCO
LORENZO DI PIETRO See
 VECCHIETTA
LORILLEN, Pierre Benoit See
 BIENNAIS, M. G.
LORING, Frances (English)
 Sir Frederick Banting, head
 NEWTEB pl 27
Lorrain, Claude

Rodin. Claude Lorrain
Monument
Lorsch Crucifixion. German--15th c.
Lorsch Gospels
German--9th c. Book Cover:
Christ Treading the Beasts
Losange. Speck
LO SAVIO, Francesco (Italian-French
1935-63)
Spazio Luce 1959/60
KULN 132
LOSCHER, Sebastian (German fl 1510-
48)
Female Bust before 1518 pear
wood; 23
BERL pl 196; BERLEK pl
25; BERLES 196 GBSBe
(451)
Lucretia, candelabra figure
with Crest of Sterzing,
Augsburg 1524 ptd wood;
75 cm
MUL 31 GSterR
Prophet, bust, Augsburg
lindenwood; 24
BOSMI 131 UMB (49.4)
LOTH, Matthias(?) (German 1675-
1738)
Alexander early 18th c.
boxwood; 14
VICF 85 ELV (169-1864)
Roman Emperor boxwood; 14
ASHS pl 31 ELV
LOTH, Wilhelm (German 1920-)
Head (Kopf; Tete)
FPDEC--German il 5
--1950 burned clay; 10
SCHAEF pl 67
--1954 cast iron
GERT 230
Head of a Woman (Frauenkopf)
1953 bronze
GERT 231
Relief Nr. 1 (from the
Series: "Sieben Reliefs zum
Thema Torso") 1959 bronze;
60x49 cm
KUL pl 27; OST 88 GCoW
Relief V 1959 bronze; 17-3/4
x25-5/8
TRI 73 GDaI
Relief Torso (An M. D.)
1959/60 bronze; 56x45 cm
KUL pl 28 GRecS
Lothair I (King of Germany and
Holy Roman Emperor 795?-
855)

Belgian--11th c. Psalter
Cover: Lothair I
Lothair II (King of Lotharungia
855-62)
German--9th c. Story of
Suzanna, carved rock
crystal for Lothair II
German--10th c. Lothar
Crucifix, with Seal of
Lothair
Lothar Crucifix. German--10th c.
Lot
Milcz. Religious Medal:
David and Bathsheba; Lot
and his Daughters
Lot's Wife. Fleischmann
Lot's Wife. Thornycroft, H.
LOTTI, Carlo (Italian)
Il Porta Bandiera, detail
wood
VEN-30: pl 103
"Scendea della Soglia..." wax
VEN-24: pl 68
Lotus. Paolozzi
LOUCOPOULOS, Clearchos (Greek
1908-)
Ciclopico 1966 iron
VEN-66: #186
LOUGH, John Graham (English
1798-1876)
Thomas Middleton, Bishop of
Calcutta 1832
BOASE pl 5B ELPa
Louis, Saint See Louis IX (King of
France)
Louis, Saint (Bishop of Toulouse
1274-97)
Donatello. St. Louis of
Toulouse#
French--14th c. Hand
Reliquary of St. Louis of
Toulouse
Louis, son of St. Louis, Louis IX
of France d 1260
French--13th c. Louis of
France Tomb
Louis, called Le Grand Dauphin
(Dauphin of France 1661-1711)
Coysevox, A. Louis of France,
The Grand Dauphin, son of
Louis XIV, bust
Louis I
Hermann and Heinz. Louis I,
head detail
Louis IX (King of France 1214-70),
known as St. Louis
French--13th c. Crown of
Saint Louis ·

Portrait of a Painter, head
1932 marble
SCHW pl 14
Love Among the Ruins. German--
18th c.
Love Crowned by Fidelity. Falconet
Love Flies. Rodin
Love in Agony. Bourdelle
Love of the Stars II. Lardera
"Love, when thou Holdest Us". Geefs
LOVELL, Margaret (English 1939-)
Bronze Box 1961 bronze;
12x13x7
ARTSS # 32 ELBrC
Lovers
Brown, R. Lovers
Duchamp-Villon. The Lovers
French--12th c. House
Tympanum: Learning;
Strength of Love
French--14th c. Lovers Casket
Kandler. Lovers
Manzu. The Lovers
Mastroianni. The Lovers
Messina. Lovers
Romanesque--German. Lovers,
mirror handle
Romanesque-German. Schotten
Portal; Sirens; Lovers
Spoerri. The Lovers
Wright, A. The Lovers
Lower Rhenish School
Death of the Virgin 15th c. wood
ROTHS 137 GBD
Virgin and Child with St. Anne
latter half 15th c. wood
ROTHS 135 GBD
Lowestoft Putti. English--18th c.
Lowther, Barbara
Flaxman. Barbara Lowther
Monument
LOYAU, Marcel (French)
Buckingham Memorial Fountain;
detail: Sea Horse
AUM 56, 53 UICG
Monument aux Morts de Vernou,
relief detail
AUM 54
LOYET, Gerard (Flemish fl 1466-95)
Charles the Bold Reliquary
gold enamel, silver gilt
base; 20-7/8x20-7/8x
13-3/8
DETF 299 (col); DEVI -2
BLC
LOZICA, Ivo (Yugoslav 1910-43)
My Brother, head 1940
bronze BIH 103

Dalmation Woman with a Wine
Skin 1939 bronze
BIH 102
LUCARDA, Tony (Antonio Lucarda)
(Italian 1904-)
Balilla terracotta
VEN-34: pl 76
Countess Elisabeth Furstenberg,
head terracotta
VEN-36: pl 35
Countess Madina Visconti di
Madrone, head terracotta
VEN-42: pl 49
New Facciata del Padiglione
Italiano, detail
VEN-32: pl 1
Princess Esmeralda Ruspoli,
bust terracotta
VEN-40: pl 33
Viola Leonardi, head wax
VEN-38: pl 131
Lucca. Dalwood
LUCCHESI, Andrea Carlo (Italian)
Accolita
VEN-99
LUCCHESI, Bruno
Priest 1964 H: 13
SEITC 182
LUCENTI, Girolamo (Italian 1627-
98)--ATTRIB
Pope Clement IX, bust
bronze; 29-3/4
DETI 58 UMiD
LUCHANSKY, Jacob See LOUT-
CHANSKY, Jacques
Luchian, bust. Paciurea
LURHSPERGER, Lorenz
Apostle Figure Nave Pier: St.
Peter c 1495 wood
BUSR 161 AVNeP
Lucifer See Satan
Lucinda
Bustelli. Lucinda and Ottavio
LUCK, Karl Gottleib
Lady at Hairdresser
Frankenthal porcelain
SOTH-4: 187
LUCK, P.
Bear wood; L: c 16
NORM 55
St. George and the Dragon,
relief H: 24
NORM 47
LUCKE, Ludwig von (German c 1703-
80)
George II, relief ivory; 7-1/2
VICK 31 ELV (A. 18-1932)
Luco. Leplae

Lucrece See Lucretia
Lucretia
 Campeny. Dead Lucretia
 Dutch/German--16th c.
 Lucretia
 Gerhard. Sextus Tarquinius
 Threatening Lucrece
 German--16th c. Lucretia
 Loscher. Lucretia,
 candelabra figure
 Moreau, G. Lucretia
Lucy, Saint
 Portuguese--15th c. St. Lucie
Lud, King
 English--16th c. King Lud
 and his Two Sons
Ludena, Juana de
 Leoni, P. Juan de
 Cardeness, Duke of
 Maqueda and Juana de
 Ludena, Duchess, kneeling
 effigies
Ludi Armilustrium. Trubbiani
Ludmila, Saint (Patron Saint of
 Bohemia d 921)
 Braun, M. B. High Altar;
 details: with Sts. Ludmila
 and Wenceslas
 Braun, M. B. St. Ludmilla,
 with young St. Wenceslas
 Slanzovsky. Organ Figures,
 detail: St. Ludmilla and
 King David
Ludogoshchinsk Cross
 Russian--14th c. Ludogosh-
 chinsk Cross, roundel
 detail: Samson and the
 Lion
Ludolf of Wichmann, Archbishop
 German--12th c. Ludolf of
 Wichmann Tombstone
Ludwig (Emperor of Bavaria)
 German--15th c. Ludwig of
 Bavaria Monument
Ludwig, Duke of Bavaria See
 Louis IV (King of Germany)
Ludwig the Bearded
 Multscher. Duke Ludwig
 the Bearded, tomb lid
 model
Ludwigsburg Ballet Dancers.
 German--18th c.
Ludwigsburg Porcelain Group.
 German--18/19th c.
LUGINBUHL, Bernhard (Swiss
 1929-)
 Agression 1957 iron
 MAI 182; JOR-2: pl 244

Agression "Ammann" 1964
 186x30-1/2
 CARNI-64: #227 UNNB
Bull Dog 1963 iron
 VEN-64: pl 194 SwWK
Composition 1959 iron; 17-3/4
 x13-3/8x13-3/8
 TRI 204 SwBeKM
Element 100 1954 iron; 180
 cm
 JOR-1: pl 95
Enseigne au Carre 1958
 JOR-2: pl 242
Figure C 2 I 1928
 JOR-2: pl 149
Figure C 2 II 1958
 JOR-2: pl 243
Grosse Aggression 1957 iron;
 2.55 m
 JOR-2: pl 150; OST 111
 AVT
Grosser Bulldog 1964 iron;
 29-7/8
 NEW pl 293
Little Giraffe (Kleine Giraffe)
 1965 ptd iron; 97-1/2
 GUGE 112 (col) SwZ
Two Aggressions
 EXS 39
USRH (Space Clasp) 1962
 iron; 16-1/4
 READCON 211 UNNSc
Luigi Gonzaga, Saint See Louis
 Gonzaga, Saint
Luitgarde, Saint
 Braun, M. B. St. Luitgarde
 at the Foot of the Cross
Luke, Saint
 Balmaseda. St. Luke
 Braun, M. B. St. Luke
 Diesnis. Un Samaritain Le
 Vit et Fut Touche de
 Compassion (St. Luc)
 French--13th c. Judgment
 Pillar: Sts. Matthew and
 Luke
 German--12th c. Lectern:
 St. Luke, head
 --Luke and John
 Kuen, F. A. Facade Figures
 Lamberti, Nicolo di Piero.
 St. Luke
 Maraini. St. Luke, seated
 figure
 Master H. L. High Altar:
 Angel: St. Luke;
 Gervasius
 Nanni di Banco. St. Luke

Riemenschneider. The
Evangelist Luke, seated
figure
Riemenschneider. St. Luke,
kneeling figure
Robbia, L. della. St. Luke
with the Bull, tondo
pendentive
LUKSCH, Richard (German 1872-)
Nessus
MARY 75
Squatting Woman 1913 alabaster
PAR-2:88
LUKSCH-MAKOWSKA, Elma (Austrian)
Burger Theater Relief
TAFTM 63 AV
Lullaby. Lobo
Lullingstone Bowl. Anglo-Saxon
Lumumba
D'Haese, Roel. "A Lumumba"
Luna. Laurens
Luna, Rinaldo della
Mino da Fiesole. Rinaldo
della Luna, bust
Lunaire, Caverneux, Spectral
Arp. Moon-like, Hollowed-
out, Ghostly
Lunar Asparagus. Ernst
Lunar Being. Fabbri
Lunar Bird. Poncet, A.
Lunar Caprice. Cappello
LUNTERN, J. van
Asia, facade figure
AUM 113 NRP
Lupetto di Mare. Lorenzetti
LUPOLA, Yujo (Finnish 1881-)
Foolish Virgins marble
PAR-2:181
LUPPI, Ermenegildo (Italian)
Anguish (Angocia)
VEN-22:36
Anime Sole bronze
VEN-20:58
Lure of the Pipes of Pan, relief.
Bayes
Lushington, Mary
Flaxman. Mary Lushington
Monument
Lust
French--11th c. Lust, arch
moulding
French--12th c. Lust, porch
figure
French--13th c. Lust, bracket
Lusterweibchen
German--15th c. Luster-
weibchen

Syrlin, J., the Elder.
Lusterweibchen Reliquary
Bust
Lustra di Pietra. Kivijarvi
Lute See Musicians and Musical
Instruments
Luther, Martin
Brullman. Martin Luther,
seated figure
LUTMA, Johannes (Dutch 1585-1669)
Basin 1647 silver; Dm: 70
cm
GEL pl 137 NAR
Basin and Ewer 1655 silver;
21 cm; Dm: 60 cm
GEL pl 133 NAR
Choir Screen c 1650
GEL pl 115 NAN
Dish 1647 silver
LARR 319 NAR
Pitcher (Ewer; Lampetkan)
1647 silver; 50.4 cm
GEL pl 134; RIJ 141 NAR
Two Salt Dishes 1639 partly
gilded silver; 9-1/2
RIJA pl 126 NAR
Luttrell, Geoffrey
English--14th c. Geoffrey
Luttrell Tomb
LUTYENS, Edwin (English Designer)
The Cenotaph, Whitehall
NATSE ELWh
Lutzow, Countess von
Canonica. Countess von
Lutzow, bust
LUX, Alessio (Hungarian)
Dancer
VEN-26:pl 102
Lux* Schoffer
Luxembourg Garden Fountain.
Carpeaux
La Luxure
Gaugin. Caribbean Woman
La Luxure
Rodin. Crouching Woman
Luxury
Franco-Flemish. Luxuria
French--12th c. Luxury, door
jamb
French--14th c. Luxuria, cor-
bel figure
LUZANOWSKY-MARINESCO, Lydia
Man and Woman*
MARTE pl 18
Woman*
MARTE pl 23
Woman and Child*
MARTE pl 18

Lycas
 Canova. Hercules and Lycas
Lydia. Epstein
Lydie. Wlerick
Lyere, Willem van
 Verhulst. Willem van Lyere
 and Maria van Reygensberg
 Monument
Lying Down Figure. McWilliam
Lying Ox. Jaenisch
Lynch, General
 Rodin. General Lynch
 Monument, equest
Lynch, Lady
 English--18th c. Lady Lynch,
 panel monument
LYNGWODE, William (English)
 Falconer, stall spandrel
 1308/09 wood
 STON pl 107 EWinC
Lynn Cup. English--14th c.
Lynxes
 Mantynen. Lynx in Repose
 Wederkinch. Lynx Awakening
 Wederkinch. Lynx in Love
Lyons, John
 English--14th c. Sir John
 Lyons, effigy
Lyre See Musicians and Musical
 Instruments
Lyrique. Linck, W.
"Lysistrata", relief. Roeder
Lyttleton, John and Thomas
 Stone. John and Thomas
 Lyttleton Monument

M. E. P. Despiau
M. F., Frau
 Kolbe. Frau M. F., head
M. K. III. Tinguely
M. M.
 D'Altri. Portrait of the
 Singer M. M., head
M. M., Monsieur
 Rosso, M. The Bookmaker
M. M. B. Martin, R.
MN/62. Reich
M. R., Mrs.
 Rubino, E. Mrs. M. R.,
 half figure
Ma Fille. Martin, R.
MAASTRICHT, Jan Aert van See
 AERT VAN MAASTRICHT,
 Jan
McAlevey, H.
 Schotz. M. McAlevey, bust
MACCAGNANI, Eugenio (Italian)
 Similia Similibus marble
 VEN-14:51

MCCARTHY, John
 Fountain concrete
 MILLS pl 69-70
MACDONALD, Frances See MAC-
 DONALD-MACKINTOSH,
 Margaret
MacDonald, James Ramsay
 (British Statesman 1866-1937)
 Epstein. Right Hon. J.
 Ramsay MacDonald, bust
MacDonald, Margaret 1870-1911
 Goulden. Margaret Macdonald
 Memorial
MACDONALD-MACKINTOSH,
 Margaret (Scottish 1865-1933)
 Candle Holder c 1897 copper;
 29-7/8
 SCHMU pl 251 ScGG
 Mirror Frame: Honesty c 1896
 embossed pewter; 71x74
 cm
 CAS pl 292
Macdougal, James
 Huxley-Jones. James Mac-
 dougal, Esq., head
MACDOWELL, Patrick (Irish-
 English 1799-1870)
 Eve
 UND ELV
 A Nymph 1846 marble; 60
 LONDC ELRA
Mace, Jean
 Massoule. Monument to
 Mace
Mace Head. Anglo-Saxon
MACEDONIAN
 Adam and Eve Legend,
 Iconostasis 19th c.
 BIH 19 YSkS
Macedonian Refugees. Lazarov
MCFALL, David B. (Scottish-English
 1919-)
 Bull Calf 1943 Portland stone;
 LS
 BRO pl 21
 Pocahontas, reclining figure
 1955 bronze; L: 66
 LONDC pl 20; WHITT 151
 ELRed
MACHADO DE CASTRO, Joaquim
 (Portuguese 1731-1822)
 Monument to Joseph I, equest
 1770/1803
 KUBS pl 100 PoLPC
MACHIN, Arnold
 Pig London plane
 NORM 52 -EWed
The Machine. Dallegret
Machine Pacifique. Jacobsen, R.

Machine Tractor Driver and Collective Farm Girl. Mukhina

MACK, Heinz (German 1930-)
Cardiogram of an Angel 1964 aluminum on wood; 69x39-1/2
CALA 222 IVG
Light Relief 1963 63x39-1/2
CARNI-64:#101; PEL 264 GDusSc
Lightdynamo (Lichtdynamo) 1961 aluminum and glass; 100x 100 cm
KUL pl 63 GLeM
--No. 2 1966
BURN 262 UNNWise
Moving Light Line 1965 chromed brass and water; 100; base Dm: 13
SELZP 49 UNNWise
Revolving Disk 1965 polished aluminum, motorized; 11-3/4x11-1/2
SELZP 49 UNNWise
Rotor IV: Silbersonne 1965 glass, aluminum, wood-- motorized; 22x22x7-7/8
NEW pl 288 GDusSc
School Light (Lichtwand) 1961 beton; 24x8 m
KUL pl 64 GLeMa
Silver-Dynamo 1960 aluminum and glass, with motorized rotor
LARM 376
White Light Dynamo, motorized construction 1964 wood and glass; 59-1/2x59-1/2x12
ALBC-4:61 UNBuA

MACKAY, Helen V. (English)
Alabaster Fish 1946 rose- pink white alabaster; L: 12
NEWTEB pl 15A

MACKEN, Mark (Belgian 1913-)
April 1957 bronze; 190 cm
MID pl 114 BAM
Finery 1952 bronze; 130 cm
MID pl 113 BAM

MACKENNAL, Bertram (English 1863- 1931)
Islingtonians Monument. Boer War Memorial 1905
GLE 194 ELHF
Madonna
MARY pl 51
Tragedy Enveloping Comedy 1909
TAFTM 76

MACKINTOSH, Charles Rennie (Scottish 1868-1928)
Door to "Room de Luxe" 1904 ptd wood, metal, and colored glass; 77-1/8x 27-1/8
SCHMU 243 (col) ScGW
Doors 1904 ptd wood, beaten metal, leaded and mir- rored glass; ea wing: 195.5 x68.5 cm
CAS pl LI (col)
Mirror, Room de Luxe 1904 leaded, colored and mir- rored glass; 31-1/2x 9-7/8
SCHMU pl 18 ScGU
Pendant, with Chain 1902 silver and pearls; 5x11.5 cm
CAS pl 290
Staircase Emblem 1906/09 wrought iron
CAS pl 294 ScGA
Wall Bracket Lighting Fixture 1900/02
SCHMU pl 19 ScOU

Maclou, Saint
French--12th c. Phylactery Reliquary of the Tooth of St. Maclou

Macloughlin, Eliza
Gilbert, A. Eliza Macloughlin, bust

MACMILLAN, William
The Birth of Venus stone
UND 173 ELT

MACPHERSON, Hamish (English)
Betty Davies, head
CASS 50

MCWILLIAM, F. E. (Irish-English 1909-)
Baal 1960
ENC 585
The Communicant 1958 bronze; 78 ARST #24
Complete Fragment: Hieratic Head 1940 Hoptonwood stone; 37-1/2x31
BRO pl 22
Complete Fragment: Nose, Eye and Cheek 1941 Hop- tonwood stone; 52-1/2x 47-1/2
BRO pl 24
Complete Fragment: Reclining Head 1940 Derbyshire "Bird's Eye" maple;

27-1/2x27-1/2
BRO pl 23
Corner of Studio 1946
 NEWTEB pl 46
Crankshaft Figure II 1963
 bronze
 LARM 369 ELW
Elisabeth Frink 1956 bronze;
 72x23x16
 LONDC pl 21; PRIV 97
Eve Molesworth bronze
 HUX 93
Father and Daughter
 WILMO pl 55
Head and Shoulders 1960
 bronze; 20
 ARTS #29
Head with Extended Surface
 1960 bronze; 20
 ARTS #31
Icon 1960 bronze; 63
 ARTSB-65:pl 4 ELW
Kneeling Figure
 WILMO pl 51
Lying Down Figure 1961
 bronze; 16-1/2x26
 SFMB #115 UCSFHa
Man and Dog 1949 reinforced
 plastic wood; 15
 RAMS pl 82a ELS
Man and Wife, version 2 1960
 bronze; 32
 ARTS #28
Man at Ease 1961/62 bronze;
 L: 65
 ARTSB-64:pl 3 ELW
May Day 1965 polished
 bronze; 7x33x21
 LOND-7:#23 ELW
Mother and Daughter bronze;
 45
 ARTSB-58:15
The Orator, version 2 1959
 bronze; 14
 ARTS #27
Parents and Child 1950
 bronze; 54
 RAMS pl 83 ELBrC
Parents and Children 1951/52
 metal cement; 59
 MID pl 82 BAM
Pastoral Head 1960 bronze; 18
 ARTS #30
The Patriarch 1953 bronze; 96
 ARTSB-62:pl 4
Princess Macha 1957 bronze;
 96
 MAI 183; ROTJB pl 142
 IreLN

Puy de Dome Figure 1962
 bronze; 48x96x51
 READCON 183 ESA
--1962 plaster, for bronze;
 48x96x51
 LOND-6:#27
Reclining Woman 1946 terra-
 cotta; 17
 NEWTEB pl 47
--1947 terracotta
 RAMT pl 12
Sitting up Figure 1963 bronze;
 21x17
 PRIV 97
Standing Relief, No. 3 1958
 26.5x17
 CARNI-61:#256
Standing Relief, version 5 1958
 bronze; 27
 ARTS #25
Triad 1961 bronze; 43
 ARTS #26: READCO pl 10
 ELW
Tripodal Form 1960 bronze;
 17x12x10
 ARTSS #34 ELBrC
Two Forms 1938 Hoptonwood
 stone; L: 21
 ARTSBR 25
William Scott, head 1956
 bronze; 26-1/4x18-1/4x
 10-3/4
 TATEB-2:3; TATES pl 8
 ELT (T.120)
Witch of Agnesi 1959 bronze;
 96
 LOND-5:#30
Woman with Folded Arms 1937/
 38
 PRIV 96 (col)
Mad Virgin. Wouters
Madame Torso with Wavy Hat. Arp
Madame X. Rosso, M.
Madara Horseman. Bulgarian--9th c.
MADRASSY, Walter (Hungarian 1909-)
 Lajos Huszar, medal:
 reverse: Bird 1935 bronze;
 Dm: 7.3 cm
 GAD 96 HBA
 Self Portrait, profile medal
 1939 bronze; Dm: 6.6 cm
 GAD 96 HBA
The Madcap. Dubuffet
Madchen Kopf auf Schlanken Hals.
 Lehmbruck
Madchen mit Taube. Stadler
Madeleine, Saint
 French. St. Madeleine
 French--14th c. St. Madeleine

French--16th c. St. Madeleine
Madeleine I. Matisse
MADERNA, Carlo (Italian)
 Facade 1603 stone
 RAMS pl 2b IRSu
 Fountain
 SCHERM pl 206 IR
MADERNO, Stefano (Italian 1576-
 1636)
 Hercules and Cacus c 1610
 WIT pl 40A GDA
 St. Cecilia, recumbent figure
 1599 marble
 MACL 248; MAL pl 41;
 MATTB pl 2, 3; POPRB
 pl 159 IRCec
The Madman. Picasso
Madonna See Mary, Virgin
Madonna del Buon Riposo. Gagini, A.
Madonna del Latte. Pisano, Nino
Madonna della Scala
 Michelangelo. Madonna of
 the Steps
Madonna of Bruges
 Michelangelo. Bruges Madonna
Madonna of Humility. Quercia
Madonna of St. Luke. Byzantine
Madonna of the Architects. Robbia,
 A. della
Madonna of the Lillies. Robbia, L.
 della
Madonna of the Niche. Robbia, L.
 della
Madonna of the Pillow. Robbia, A.
 della
Madonna of the Rose. Robbia, L.
 della
Madonna of the Rosebush. German--
 14th c.
Madonna of the Steps. Michelangelo
Madonna Portal. Spanish--13th c.
Madonna with the Protecting Mantle.
 Erhart, Gregor
Madrone, Madina, Visconti di
 Lucarda. Countess Madina
 Visconti di Madrone, head
Madwoman. Lambertsz
Made in U. S. A. , No. 12. Tajiri
Mae. Brenninger
Maenads See Bacchante
Maesmynis Pillar-Cross. Celtic
Maesta
 Italian--15/16th c. Maesta:
 Christ Resurrected; reverse:
 Pieta
MAESTRO See MASTER..., and desig-
 nations, as ANDREA, MASTER

Maestro. Dubuffet
Maffu, Maffio
 Romanelli. Maffio Maffu, bust
Maga. Sochos
Magdeburg Antependium. Italian--
 10/11th c.
Magdeburg Rider. German--13th c.
Magens, Nicholas
 Read. Nicholas Magens
 Monument
MAGGESI, Domenico (Italian 1818-)
 Count de Tournon, bust
 marble
 HUBE pl 74 FBorAr
Maggy. Duchamp-Villon
Magi See also Jesus Christ--Adora-
 tion
 Bonannus of Pisa. Porta San
 Ranieri
 Breton. Pleyben Calvary:
 The Magi
 Byzantine. Visitation; Magi
 Before Herod
 Early Christian. Chancel
 Fragments; details: One
 of Magi
 English--13th c. Ciborium of
 St. Maurice: Journey of
 the Magi
 French--12th c. Angel Ap-
 pearing to Magi in a
 Dream, relief
 --Capital: Angel Appearing
 to the Magi
 --Three Magi
 French--13th c. Magi Warned
 by Angel, choir screen
 --A Magus(?)
 German--9th c. Book Cover:
 Christ Treading the Beasts,
 between Angels; below,
 Magi before Herod
 German--12th c. Domed
 Reliquary, Cologne:
 Journey of the Magi
 German--15th c. The Three
 Kings, retable figures
 Italian--12th c. Magi before
 Herod(?)
MAGNELLI, Alberto (Italian 1888-)
 Rhythms 1914 plaster and
 copper
 SELZJ 200
 Still Life 1914, plaster,
 glass, stone
 SELZJ 200
Magnes, Judah Leon (President,

Hebrew University, Jerusalem
1877-1949)
Ben-Zvi. Dr. Magnes, head
Magnetic Surface. Boriani
MAGNI, Pietro (Italian 1817-77)
Commemorative Monument to
Cutting of the Suez Canal
1858/63 marble; 190x143
x143 cm; base: 103x162
x162 cm
LIC pl 97 ITrMCR
Magnus
Byzantine. Diptych of Magnus
Magog. Evans, D.
Magpies
German--18th c. Meissen
Magpies
MAGRITTE, Rene (Belgian 1898-)
Bottle ptd bottle with carved
wooden stopper; 12
SEITA 60 UIOS
MAGT, Leonhard See GODL
Magyar Peasant. Barbereki
Mahler, Gustave (Bohemian Com-
poser 1860-1911)
Rodin. Mahler, head
Mahomet See Mohammed
Maiastra. Brancusi
Maidalchini, Olimpia See Pamphili,
Olimpia Maidalchini
MAIDBURG, Franz See WITTEN, H.
Maids
Bustelli. Lady's Maid and
Valet
MAIER, Professor
Head, vessel wrought tin
CASS 54
Stag metal
CASS 125
Maiestas Domini
French--12th c. Door, south:
Christ in Glory (Maiestas
Domini)
Maigny, Charles de
Bontemps. Charles de Maigny,
effigy
MAILLOL, Aristide (French
1861-1944)
Air 1938/39 lead; 140x255 cm
JOO 185 (col) NOK
--1939/43
ENC 587 FPM
Bas Relief terracotta
MUNSN 178
Bather with Drapery c 1900
bronze; 31-1/2
SELZS 25 UNNR

--1905 bronze
SELZJ 151 FPV
La Catalane (Ung Katalanerinde)
c 1905 terracotta; 33 cm
CLPGM 119 DCN (I.N.2808)
Cezanne Monument: Figure
Study
BAS 19; SELZJ 155 FPV
Chained Action (L'Action
Enchainee; Action in
Chains; Blanqui Monument;
Energy Enchained; Fettered
Action; Torso of Monument
to Louis Auguste Blanqui),
created as Monument to
Louis Auguste Blanqui at
Puget Theniers 1905
PUT 174; SCHN 5
--bronze
VALE 35 UCStbL
--c1905/06 lead; 47-1/2
BAZINL pl 413; GIE 27;
RAMS pl 34a-b; READCON
19; ROTJG pl 9; ROTJT
22; TATEF pl 35g ELT
(4415)
--c 1906 bronze; 47
NNMMAP 121 UNNBu
--c 1906 bronze (replica of
lead original); 47
BR pl 16; FEIN pl 135;
MCCUR 252; READAS pl
130-31; RIT 76, 77; UPJH
pl 240 UNNMMA (extended
loan from UNNMM)
--1906 bronze; 212x77x96 cm
CAS pl 119; MAI 184; PM
FPM
--third example 1929 bronze;
47
NMA 181; ROTHS 239
UNNMM (29.138)
Crouching Woman
TAFTM 44
Desire (Begaer; Le Desir;
Longing; Man and Woman;
Mand og Kvinde), relief
CHENSP 308 FPDru
--1901 terracotta; 48
KO pl 100 FPM
--c1904 plaster; 47x45
CHRC fig 244; LIC pl
166; NNMMARO pl 260;
NNMME 35; NNMMM 42;
RICJ pl 16; RIT 78;
UNNMMAM #178; UPJH
pl 240 UNNMMA

--1905/08 lead; 48
 EXS 93 FPM
--1907/09 terracotta; 115x
 106 cm
 BOES 87; COPGG 102;
 COPGM cov DCN (I.N.1558)
Draped Figure
 TAFTM 44
Etienne Terrus, head
 HUX 77
Etude de Nu bronze
 CASSM 54
Eve c 1902 bronze; 22-7/8
 SCON 73 ScEN (No. 2178)
Female Torso
 CRAVR 196 UNNMM
Figure Study
 AUM 58
Flora, detail
 AGARC 151; TAFTM 44
 FP
Graces, first study for one
 of the Graces
 BAS 15
Harmonie
 BAS 23
Head of a Girl bronze;
 14-3/4
 RICJ pl 26 UNNMMA
Head of a Woman bronze; 13
 PH pl 152 UDCP
Ile de France bronze
 VEN-48: pl 74
-c 1910 bronze; 64
 BOSME pl 73 UPPeI
--1910 bronze
 BAZINH 480 FPM
--1910 bronze; 43
 RIT 79; SELZS 47; SLOB
 244 UNNMMA
--1920/25 bronze
 MAI 185
--1920/25 stone; 1.52x.35x
 .55 m
 BAZINW 426 (col); MARC
 pl 5 (col); MOD FPM
Jeune Fille qui Marche dans
 l'Eau c 1910 bronze; 44
 SOTH-4: 74
Jeunesse 1910 bronze;
 39-3/4
 DETS 60 UNNH
Juno bronze
 SEYT 31 UDCK
Kneeling Girl (Girl Kneeling)
 WB-17: 205
--Knaelende Pige c 1900
 bronze; 17 cm
 COPGM 117 DCN (I.N.2716)

Kneeling Woman: Debussy
 Monument bronze; 36
 NNMMARO pl 263 UNNGo
The Laundress c 1893 bronze;
 7-7/8
 SCHMU pl 171 GFG
Leda c 1902 bronze; 11-1/2
 NMASO 51
--1902 bronze; 11-1/2
 KO pl 100 GHK
--bronze
 SEYT 34 UDCB
--1902 H: 11-1/2
 MU 227 UMWesD
--1902 bronze; 11-1/2
 CANM 359 UPPPM
Mme. D.
 BAS 14
Mediterranean (La Pensee;
 Seated Nude; Seated
 Woman; The Thinker;
 Thought)
 BAS 13; MARY pl 116;
 PRAEG 492
--plaster
 ZOR 6, 7
--1900 terracotta
 CASSM 56
--c 1901 bronze; 41
 MCCUR 251; RIT 72-74
 UNNC1
--c 1901 bronze; 41
 LIC pl 165; NNMMM 43
 UNNMMA
--c 1901 marble; 40-1/2
 BR pl 16; TRI 77; UPJ
 635 FPTu
--c 1901 marble; 41-1/2
 BALD 146; GARDH 756;
 HAMP pl 49; JANSH 510;
 JANSK 973; KO pl 100
 SwWR
--c 1901 plaster
 BALD 146
--c 1901 plaster; c 40
 BOW 20
--1901 bronze; 41
 MIDpl 9 BAM
--1902
 ROBB 401 UDeWi
Memorial 1921/23
 STA 214
The Mountain (La Montagne)
 BAS 20 FPM
Night
 MYBA 656
--c 1902 stone; 38
 GIE 26 SwWK

--1902 plaster; 105x56x
 104 cm
 CAS pl 120 FPRud
--1902/06 bronze
 MAI 185
--1902/09, cast 1939 lead;
 41-1/2
 ALBC 181; FAIY 7 UNBuA
--1905 terracotta
 SELZJ 139 (col) FPV
Nude
 CASS 78; HOF 40
--lead
 MILLER il 200 ELT
Nymph 1936/38 bronze; 60-3/4
 DETS 61 UNNH
Pendule
 AUM 54
Le Petit Coureur Cycliste
 (Den Lille Cyclerytter)
 c 1907/08 bronze; 98 cm
 COPGM 120-21 DCN
 (I. N. 2762)
Pomona 1910 bronze; LS
 LIC pl 167; SELZJ 152
Pomona, with Lowered Arms
 (Pomone aux Bras Tombants)
 1937--1 of 4 casts made
 before 1944 from original
 plaster and marble bronze;
 65-3/4
 GUG 210 UNNG
Racing Cyclist (Coureur
 Cycliste) 1909 bronze; 38
 RAMS pl 33; VEN-28:pl
 135 FPLu
Reclining Figure*
 ARN 196
Reclining Nude, Jeu de Paume
 Terrace
 GAF 137 FP
Reclining Nude, Cezanne
 Monument Study plaster;
 4-1/2x6-1/2
 NCM 202 UNcRV
--1912 bronze; 7-1/2
 BOSME pl 37 UMB
Renoir, head
 HUX 76
The River (Der Fluss) 1940
 bronze
 GERT 49
--1939/42 lead
 MARC pl 6, 7 (col) FPM
--c 1939/43 lead; 90x
 53-3/4
 LARM 319; MCCUR 252;
 NNMMM 44; READAS pl
 186; RIT 80, 81 UNNMMA

--1939/43 lead; 96
 MID pl 10 BAM
--1943 bronze
 MAI 186 FPM
Seated Figure terracotta
 ZOR 74 UNNAmM
--1930 terracotta; 108
 AUES pl 37; CHENSP 266;
 NNMMAP 122; RIT 82
 UNNMMA
Seated Nude
 KUH 90 UICA
--bronze
 WATT 170 FPTu
--bronze
 SLOB 245 UNNWe
--marble; 12-1/2
 YAP 229 UNNC1
--1931 stone; 12
 CHENSE 390; CHENSW
 473; SEITC 66 UNNMatC
Seated Woman
 CHASEH 452; PUT 175;
 TAFTM 44
--bronze; 11
 NM-15:65
--bronze; 11-1/8x4x4
 SDF 113 UCSDF
Small Nude 1910 bronze;
 20 cm
 LIC pl 169 FPV
Spring c 1910 plaster washed
 with blue; 146 (with base)
 x41x25 cm
 LIC pl 168 UNNMM
Squatting Woman
 POST-2:155
Standing Bather bronze, after
 plaster original of c 1900;
 30-1/2
 JLAT UAzPhA
Standing Figure 1925 bronze;
 10-1/2
 SELZS 98 UNNChan
Standing Nude limestone;
 68-1/2
 CAN-2:189 CON
Summer (Sommeren, Kvindelig
 Torso; Torso de l'Ete)
 c 1910 bronze; 86.5 cm
 COPGM 123 DCN (I. N. 2706)
"Summer", study 1910/11
 bronze
 LOWR 135 UMdBWu
The Three Graces
 ST 414 ELT
-- : center figure plaster,
 for bronze
 CASS 63 ELT

The Three Nymphs (Les Trois
Nymphes) 1930/37 bronze
GAUN pl 54 ELT
--1930/38 lead; 62-3/4
BOW 23; RAMT pl 27;
TATEF pl 15 ELT (5022)
--1937 bronze; 63-3/4
NEWTEM pl 157 FPM
Torso
HOF 149; ROOS 277G
UNNMM
--Clay
ELIS 46 UNNMM
--1906
ENC 587 ELT
--1910 bronze; 43
NNMMARO pl 261; NNMME
34; UNNMMAM #177
UNNMMA
--c 1933 bronze; 34
HAMP pl 48B UCtY
Venus bronze
GERT 48; VEN-34:pl 149
Venus with Necklace (Femme a
au Collier; Venus au
Collier; Woman with Neck-
lace)
BAS 18
--bronze; 69
NNMMARO pl 262; RICH
187 UNNBru
--c 1918/28 bronze; 69-1/2
AUES pl 36; BOW 22;
LARM 267; LIC pl 170;
MYBS 60; TATEF pl 35h
ELT (4576)
--c 1918/33 bronze; 69-9/32
AGARC 21; HENNI pl 58
UMoSL
Washerwoman c 1893 bronze;
8
SELZPN 60 ELWhi
Woman Dressing her Hair
(Woman Arranging Her
Hair) c 1898 bronze;
10-3/4
NMASO 51; RAMS pl 32;
RAMT pl 28 ELGre
Woman Standing
CHENSP 269 FPDru
Woman with a Dove 1905
bronze
SELZJ 151
Wrestlers 1901 bronze; 7
SCHAEF pl 3
Young Cyclist c 1904 bronze;
38
RIT UNNV

--1907 bronze; 38
UMCF (1962.199)
Young Girl Sitting 1900
terracotta
SELZJ 154 FPV
Young Runner bronze
CASSM 55 FPLu
Maimed and Stateless. Arp
Main de Justice
French--14th c. Gold
Scepter with Ivory
Handle: Main de Justice
Le Main d'Oedipe. Papa
La Main et la Rose. Cavaliere
MAINI, Giovanni Battista (Italian
1690-1752)
Monument to Cardinal Neri
Corsini, Capella Corsini
1732/35
WIT pl 166A IRGio
MAISON, Rudolf (German 1854-1904)
Teichmann Fountain
CHASEH 460 GBrem
MAITANI, Lorenzo (Italian c 1275-
1330)
Angel of St. Matthew 1329/30
WHITNJ pl 134B IOrC
Baptism of Christ c 1310/30
WHITNJ pl 137 IOrC
Cain Killing Abel, 1st pier
c 1310/30
WHITJ pl 138A IOrC
Christ, head 1st Q 14th c.
LARR 32 IOrF
The Creation c 1275/1330
BAZINW 310 (col); CHASEH
289; FOC-2:pl 111; POPG
fig 65; POST-1:148 IOrC
--Creation of Eve marble
CLAK 287; POPG pl 39
--Creation of Eve: Angels
WHITJ pl 139B
Last Judgment, facade detail
c 1320 CLAK 316; JANSH
262; JANSK 535; NEWTET
108; POPG fig 66 IOrC
--The Damned (Inferno)
FOC-2:pl 112; POPG pl 41;
ROOS 97H-I; WHITJ pl 138B
The Nativity, facade relief
1320/30
LARB 321 IOrC
Tree of Judgment, facade
relief 1330
STI 452 IOrC
Two Angels, facade relief
1310/30 marble; c 24
MOLE 103 (col); POPG pl
40 IOrC

Virgin and Child Enthroned
with Angels; details: Three
Angels; Virgin and Child
POPG fig 61; pl 36, 37
IOrC
Wall Decoration: Scenes from
Life of Christ; Prophecies
of the Redemption
POPG fig 63, 64 IOrC
MAITANI, Lorenzo--FOLL
Christ in Benediction
POPG fig 17 IOrM
Jacob's Ladder, pillar, west
facade 1310/30
BOE pl 116 IOrC
Wall Decoration, detail: The
Visitation marble
POPG pl 38 IOrC
MAITRE, Jacques
Shrine of St. Gertrude 1272/98
HARVGW 48 BNG
Maiuscola, B.
Bertoni. B. Maiuscola
Maja. Marcus
Majestad de Battlo. Spanish--12th c.
Majestas Domini See Jesus Christ--
Enthroned
Majestic March. Wotruba
Majesties See Mary, Virgin--
Madonna and Child
Majolica
Fontana, D.--Foll. Maiolica
Wine Cooler
MAJORELLE, Louis (French 1859-
1926)
Bannister c 1900 forged
iron
SELZPN 98 FPDec
Makroko. Tinguely
Malanggan I. Berke
Malatesta, Domenico Novello (Lord
of Cesena)
Pisanello. Medal: Domenico
Novello Malatesta
Malatesta, Paolo
Rodin. Paolo Malatesta and
Francesca da Rimini with
Clouds
Malatesta, Roberto
Italian--15th c. Roberto
Malatesta, equest relief
Malatesta, Sigismondo Pandolfo
(Lord of Rimini 1417-68)
Pasti. Medal: Sigismondo
Pandolfo Malatesta
Malatesta, Signora

Matteo de' Pasti. Medal:
Signora Malatesta;
Elephant
Malayan Sultana, head. Gordine
Malberg Virgin. Master of the
Malberg Virgin
Malchus
English--16th c. Malchus and
his Severed Ear, boss
French--12th c. The Passion
Scenes: Peter, Malchus,
and the Guards of Geth-
semane
Zarcillo. Peter Striking
Malchus
Malesherbes, Chretien Guillaume de
Lamoignon de (French States-
man and Writer 1721-94)
Bosio. Malesherbes Memorial,
details
MALEVICH, Kasimir (Russian 1878-
1935)
Architectonics (Arkhitektonics)
1924/28 plaster, cardboard,
wood, paint
GRAYR pl 112, 113;
READCON 95
Dynamic Architecture 1920/22
wood
GIE 163
Suprematist Architecture 1920/
22 wood
GIE 163 PWS
MALFRAY, Charles (French 1887-
1940)
Torso of a Swimmer bronze
SELZJ 148 FPV
--1936 stone
MAI 187
Two Swimmers 1940 bronze
SELZJ 149 FPV
MALICH, Karel (Czech 1924-)
Black and White Sculpture
1964/65 plastic, wood,
aluminum; 82-1/2
GUGE 94
Black White Sculpture 1964/65
iron; 45x26x22 cm
BER 49
MALINES
Madonna and Child c 1500
ptd nutwood; 14-1/8
KUHN pl 32 UMCB (1964.22)
Malpiero, Pasquale d 1462
Lombardo, Pietro. Malipiero
Monument
MALLO, Cristino (Spanish 1908-)

Bull
VEN-52: pl 91
Malmsbury, 1st Earl of
Chantrey, F. 1st Earl of
Malmsbury Monument
MALTWOOD, Katharine (English)
The Vision alabaster
PAR-1: 122
Malua. Oakley
Mamas, Saint
Georgian. St. Mamas Riding
Lion, tondo
Man Aflame. Hanak
Man Alone. Barlach
Man and Child. Brown, R.
Man and Dog. McWilliam
Man and Nature. Milles
Man and His Thought. Rodin
Man and Wife, version 2. McWilliam
Man and Woman
Maillol. Desire
Man and Woman. Marcks
Man and Woman. Miro
Man and Woman. Wheeler, C.
Man and Woman. Wotruba
Man at Ease. McWilliam
Man Awakening to Nature
Rodin. Age of Bronze
Man-Cactus
Gonzalez. Cactus-Man
Man Carrying a Child. Italo-Flemish
Man Carrying a Woman. Marini
The Man-Child. Dobson
The Man Child. Kennington
Man Drawing a Sword. Barlach
Man Drinking. Martini, A.
Man Holding his Foot. Caro
Man in a Spider's Web. Cesar
Man in Arm Chair. Schreiter
Man in Cloak. Barlach
Man in the Stocks. Barlach
Man Lighting a Cigarette. Caro
The Man of Lika. Kozaric
The Man of Saint-Denis. Cesar
Man of Sorrow(s) See Jesus Christ--
Man of Sorrows
The Man of Villetaneuse. Cesar
Man Pointing. Giacometti
Man Reading. Medardo, R.
Man Renews Himself. Guerrini
Man Resting. Lehmann, K.
Man Sitting on a Stump. Blumenthal
Man Walking. Giacometti
Man Walking
Rodin. Walking Man
Man Walking Across a Square in
Sunshine. Giacometti
Man Who Walks I. Giacometti

Man with a Door. Serrano
Man with a Pipe. Laurens
Man with a Rooster. Minguzzi
Man with a Wheel. Paolozzi
Man with Broken Neck. Ambrosi
Man with Clarinet. Laurens
Man with Geese
Labenwolf. Gansemancher
Fountain
Man with Horse. Mettel
Man with Lamb. Picasso
Man with the Broken Nose. Rodin
Man with the Sword. Stappen
Mancini, Antonio (Italian Painter
1852-1930)
Glicenstein. Antonio Mancini,
bust
MANDL, Michael Bernhard (Austrian
1660-1711)
Horse Pond Monument 1695
HEMP pl 60 ASSt
--a groom
BUSB 123
Mandolin See Musicians and Musical
Instruments
Mands Portraet. Osouf
MANES, Pablo Curatella (Spanish
1891-)
The Acrobats (Les Equilibristes)
terracotta
MARTE pl 50
Double Bass Player (Contre
Bassiste) terracotta
MARTE pl 9
Guitarist terracotta
MARTE pl 9
Lancelot and Guenivier, relief
stone
MARTE pl 50
Manfredi, Barbara
Ferrucci, F. Barbara
Manfredi Monument
Mangle Board, detail: Adam and
Eve.
Folk Art--Danish
The Mango. Muller, R.
Manifestants
Trsar. Demonstrators
Manifestations. Trsar
The Manipulator. Butler
Mankind. Gill, E.
Mankind and Hope. Juhl
MANLEY, Edna (English 1900-)
Eve Jamaica mahogany
PAR-1: 104
Horse of the Morning wood;
LS
NORM 94

Rachel mahogany; c 1/2 LS
 DURS 65
Mannequin. Dali
Mannequin. Paalen
Mannequin# Vigneau
MANNERHEIM, Carl Gustaf Emil
 von (Finnish Soldier and
 Statesman 1867-1951)
 Fischer, F. Marshal
 Mannerheim Monument
Mannheim Altar. Egell
MANNING, Charles (English 1776-
 1812)
 Capt. George Hardinge
 Memorial 1808
 GUN pl 16 ELPa
Mannlich, David
 Schluter. David Mannlich
 Monument
MANNONI, Gerard (Italian-French
 1928-)
 Horizontal Development 1959
 iron
 MAI 187
 Sculpture*
 EXS 39
MANNUCCI, Edgardo (Italian 1904-)
 Dilatrazione della Materia
 bronze; .80 m
 SCUL pl 67
 Idea No. 1 1961/62 bronze
 VEN-62: pl 28
 Idea No. 6 1961/62 bronze
 VEN-62: pl 29
 Idea No. 12 1960 bronze
 SAL 49
 Idea No. 16 1958 bronze;
 57-1/2
 ALBC-3: #70 UNBuA
 International Red Cross
 Monument, Solferino 1959
 MAI 188 ISo
 Materia e Energia 1954
 bronze; 1.10 m
 SCUL pl 66
 Medaglia N. 2 1954 bronze
 VEN-54: pl 31
 Medaglia N. 13 1956 bronze
 VEN-56: pl 40
 Opera N. 3 1956 ptd gesso
 VEN-56: pl 39
 Opera N. 13 1964 bronze;
 43-1/4x13-3/4x19-5/8
 NEW pl 109 IRO
 Resumption of Idea, No. 3
 1951/57 aluminum;
 55-1/8x51-1/4x19-3/4
 READCON 249 NOK

Manoa Tupapau--She is Thinking about
 the Spirit of the Dead Man.
 Gauguin
MANOLO (Original name: Hugue,
 Manuel Martinez) (Spanish
 1887-1940)
 Crouching Woman (Femme Nue
 Accroupie) 1914 bronze
 BROWMS cat 621; SELZJ
 170 FPLe
 In the Stable (Dans l'Etable)
 stone
 MARTE pl 22
 Kneeling Woman (Femme Nue
 Accroupie) bronze; 15-1/2
 MUNSN 45 UNBuT
 Nu Debout 1912 bronze; 9-1/2
 MUNSN 45 FPLe
 The Offering (L'Offrande) stone
 MARTE pl 22
 Woman, bust stone
 MARTE pl 22
Manrique, Gomez
 Spanish--15th c. Gomez
 Manrique
MANSART, Francois (French
 Architect 1598-1666)
 Facade 1642/46
 BLUA pl 99 FMai
 Staircase Balastrade; Vestibule
 1642/48
 BLUA pl 97 FMai
 The Visitation, dome begun
 1632
 BLUA pl 96B FP
MANSART, LEBRUN, and COYSEVOX
 Salon de la Guerre: Louis XIV,
 equest begun 1678
 JANSK 833 FV
Mansfield, Lord 1705-93
 Flaxman. Lord Mansfield
 Monument
 Nollekens. Lord Mansfield,
 bust
MANTEGAZZA, Antonio (Italian fl
 before 1473 d 1495)
 Lamentation over the Dead
 Christ marble; 196x112 cm
 POPR fig 123, pl 117
 IPavCe
MANTEGAZZA, Cristoforo (Italian
 fl 1464-1482)
 The Deposition, relief marble;
 11-5/16x7-5/8
 NCM 41 UNcRA
MANTEGAZZA, Cristoforo, or An-
 tonio MANTEGAZZA
 A Prophet 1473/89 stone; 3/4

LS
 MOLE 135 (col) IPavCe
MANTEGAZZA, Cristoforo--ATTRIB
 The Expulsion c 1480 marble
 BAZINW 342 (col); SEY
 pl 131B IPavCe
MANTEGAZZA, Cristoforo, and
 Antonio MANTEGAZZA--
 FOLL See also Amadeo
 St. James, facade figure
 CHASEH 322; POST-1: 190
 IPavCe
MANTEGNA, Andrea (Italian c 1431-
 1506)
 Self Portrait, head
 MONT 101 IManA
 Triumph of Scipio, relief
 1504
 VER pl 2 ELN
 Portraits
 Cavelli. Andrea Mantegna, bust
Mantels See Fireplaces, Chimney
 Pieces and Mantels
Manticore
 French--12th c. Manticore
Mantis
 Richier, G. Praying Mantis
MANTYNEN, John Richard (Finnish
 1886-)
 Bear on an Anthill
 PAR-2: 188
 --small version of figure in
 Public Park, Helsinki
 1928 red granite; c 30
 RAMS pl 61b
 Lynx in Repose stone
 PAR-2: 189
Manuel, Angel
 Pires-O-Moco. Angel Manuelin
Manueline Great Window. Arruda
MANUELLI, Colombo (Italian
 1931-)
 Oggetto Plastico, doppia
 struttura modulare 1966
 steel
 VEN-66: #107
Manutius, Aldus
 Italian--15th c. Aldus Manu-
 tius, profile bust, medal
Many-Faced Figure. Ehlers
MANZONI, Giovanni (Italian)
 Madonna wood
 VEN-24: pl 69
MANZONI, Piero (Italian 1933-63)
 Fiato d'Artista 1960
 KULN 179
 Pane 1962
 KULN 72

Scultura Vivente 1961
 KULN 37
MANZU, Giacomo (Italian 1908-)
 Cardinal (Cardinale) bronze;
 15
 FAIN 229 URPO
 --1938 bronze; 20-1/2
 SOBYT pl 123 IRMo
 --1947/48 bronze; 20 (excl
 wooden base)
 LARM 348; MILLS pl 17;
 ROTJG pl 20; TATEF pl
 17 ELT (5854)
 --1948
 ENC 596
 --1950 bronze
 SAL pl 24 (col); GERT 66
 --1953 bronze
 VEN-56: pl 36 NT
 --1954 bronze
 MAI 190 GCoKu
 --1955 bronze
 VEN-62: pl XXIV IVMo
 --1957 bronze; 87
 SELZS 154 UNNR
 --1958 bronze
 SAL pl 23
 Cardinal, seated figure 1950
 bronze; 60
 SCHAEF pl 15
 Il Cardinale Giacomo Lercaro
 1952 bronze; 2.6 m
 SCUL pl 13 IBoP
 Cardinal and Deposition 1941/42
 bronze; 21x16
 RIT 189 IRG
 Chair with Fruit 1962 bronze;
 48
 ARTSI #12
 Christ and the German Soldier
 1942 bronze; 11-3/4x15-
 3/4
 SOBYT pl 124 IRG
 Crucifixion 1950 bronze; 58
 MID pl 63 BAM
 Dance Step (The Dance) 1950
 bronze; 63
 DEVI-2: MID pl 61;
 SCHAEF pl 14; TRI 63;
 VEN-56: pl 35 BAM
 The Deposition (Sepulture)
 1950 bronze; 58
 MID pl 62 BAM
 Doors of St. Peter's cast
 1963 bronze; 7.4x3.6 m
 LIC pl 322 IRP
 --study bronze
 VEN-64: pl 204-5

The Execution 1950 bronze;
 13x8-1/4
 DETS 65 UNNH
Female Bust 1948 bronze
 VEN-48: pl 57
Francesca Blanc 1941 bronze
 KO pl 103
Girl in a Chair 1955 bronze;
 44-3/4
 DETS 64; READCON 219
 UNNH
--1949 bronze
 SAL pl 20 (col)
Grand Pas de Danse 1955/59
 bronze; 2.1 m
 SAL pl 19; SCUL pl 14, 15
Grand Pattinatrice 1959 H: 72
 SEITC 46 UNBuGo
Grande Cardinale 1955 bronze;
 208x115x125 cm
 LIC pl 321 IVPes
Inge, bust 1960 bronze
 SAL pl 21
The Lovers 1966 bronze; 58
 EXS 94 UNNR
Mask (Maske) 1946 terracotta
 GERT 68
Play 1966 H: 37-3/4 (excl
 base of 12-1/4)
 CARNI-67: #144 UNNRosen
Portrait bronze
 SAL pl 22 (col)
Portrait 1953 bronze
 GERT 67
Portrait of a Lady 1946
 bronze; 28
 RIT 188 IML
--1946 bronze; 28
 MCCUR 275 UNNMMA
Portrait of a Lady 1946
 bronze; 68-7/8
 SOBYT pl 125 IML
--1955 bronze; 150 cm
 LIC pl 324 UNNMMA
Seated Cardinal 1956 bronze;
 32
 BOSME pl 126 UNNWo
Seated Girl bronze; 45
 CAN-2: 199 CON
Skater 1957 bronze
 MAI 190 UNNWo
--(Pattinatrice) 1958 wood;
 63-1/2
 GUGE 63 UTxDMe
--1957 bronze; 75
 MID pl 132 BAM
Skating Girl bronze; 24
 FAIY 222 UNNMoS

Standing Cardinal 1952 bronze;
 67
 MID pl 64 BAM
--1954 bronze; 66-1/2
 DETS 63 UNNH
Susanna 1942/52 bronze;
 19-3/4x68-1/2x20
 MILLS pl 18; TATEF pl
 37b ELT (6169)
Woman's Head
 VEN-38: pl 120
Young Girl on a Chair 1953/54
 bronze; 43-1/2
 BAZINW 443 (col); MYBS
 61 ELH
Maples, Richard (English Mariner
 c 1630-80)
 Latham, J. Captain Richard
 Maples
Maps
 Rakov. Map of Wrangel Island,
 box lid
"Maquisard". Osouf
Marabou. Hernandez, M.
MARAINI, Antonio (Italian 1886-)
 The Bather
 AUM 36
 Figure, study, panel
 AUM 36
 Leda
 CASS 83
 Mourning Figure marble
 PAR-2: 21 IMCe
 St. George
 CASS 114
 St. Luke, seated figure
 AUM 42
 Weeper (Plorante)
 VEN-24: pl 45
La Marangona. Lorenzetti
MARATKA, Josef (Czech)
 The Embrace stone
 PAR-2: 120
MARATTA, Carlo See MARATTI,
 Carlo
MARATTI, Carlo (Carlo Maratta)
 (Italian 1625-1713)
 Maenad, relief, Villa
 Torlonia Albani
 VER pl 90 EWindRL (4381)
Marble Form (Core). Hepworth
Marble House Theater Decoration.
 Sieburg
Marble with Colour (Crete). Hep-
 worth
Marble Woman. Dobson
Marble Pentelique. Hajdu
MARC, Franz (German 1880-1916)

Leopard bronze; 10 cm
 HENT 35; OST 6 GHallSt
Pferde 1909 wax, for bronze;
 16.4 cm
 HENT 34 GHallSt
Zwei Pferde 1908/09 bronze;
 16.5x16 cm
 OST 6 GHallStG
Marcel, Saint
 Montreuil. St. Marcel
Marcella. Raimondi
Marcello Monument. Lombardo, Pietro
MARCH, Vernon (English)
 Pan and Psyche bronze; 11-1/2
 CAN-2:196 CON
March (month)
 French--13th c. Month of
 March: Digger in the
 Vineyard, quatrefoil
March (river)
 Donner. Providentia
 Fountain: The River March
March on Rome. Tomba
March 64 (Circle and Venetian Red).
 Nicholson
MARCHAND, David le (English 1674-
 1740?)
 George I, bust ivory; 9-3/4
 VICK 28 ELV (A.12-1931)
 Time and Opportunity c 1730/
 40 ivory; 8
 MOLS-2:pl 125 ELV
MARCHAND, Francois (French)
 Flight into Egypt, relief
 JAL-4:pl 16 FCh
MARCHAND, Francois, and Pierre
 BONTEMPS
 Monument to Francois I,
 Claude of France, and
 their Children; effigies;
 Battle Scene, from design
 by Philibert de L'Orme
 LARR 206 FPDe
Marche Funebre d'un Heros. Benet
MARCHEGIANI, Elio (American-
 Italian 1929-)
 Progretto per una Lapide
 Luminosa a James Bond
 1965
 KULN 106
 Venus# 1965
 KULN 34
MARCHESE, Giancarlo (Italian
 1931-)
 Development D (Sviluppo D)
 1964 bronze
 VEN-64:pl 72
Marching Man. Boccioni

MARCHINI, Vitaliano (Italian)
 La Amiche
 VEN-32:pl 196
 Madonna marble
 VEN-28:pl 42
 Maternal Greeting (Salutazione
 Materna), relief bronze
 VEN-30:pl 89
 St. John bronze
 VEN-34:pl 56
MARCHIORI, Giovanni (Italian
 1696-1778)
 David 1743
 WIT pl 171B IVR
Marcinelle. Jarnuszkiewicz
Marck, Count von der (Son of
 Frederick Wilhelm II of
 Prussia)
 Schadow. Count Alexander
 von der Marck Tomb
MARCKS, Gerhard (German 1889-)
 Adam 1924/25 wood
 NMG #112
 Alfred Partikel, head 1931
 bronze; LS
 HENT 118
 Almtanz 1954 bronze; 54 cm
 OST 67 GHH
 Betula 1938 bronze; 37
 BOSME pl 98 UMCR
 Bird 1961 H: 16.75
 CARNI-61:#246 UNNGe
 The Blessed Albertus Magnus,
 seated figure 1956 bronze;
 102-3/8
 ENC 597; NEWTEM pl
 161; NNMMAG 169 GCoU
 Boy Playing with Toe 1942
 bronze; 9-1/4
 YAP 245 -UBa
 Boy Sitting on the Ground 1952
 bronze; 10-5/8
 SCHAEF pl 36
 Brandstifter, Jungfrau Mutter
 mit Kind, facade 1947/48
 klinker; c 2 m
 OST 5 GLuC
 Doors bronze
 MCCL pl 51 GHaMK
 Female Figure, garden figure
 DIV 84 UNNMMA
 Fettered Prometheus
 (Gefesselter Prometheus)
 1948 bronze
 GERT 74
 Freya 1949 bronze; 65-3/4
 TOW 109 UNBuA
 --1949 bronze; 66-5/8
 READCON 23 UNNMMA

Girl with Apple 1936 bronze
RAMT pl 41 UNNBu
Girl with Braids 1950 bronze;
45
DETS 66 UNNH
Girl with Lifted Hands 1940
bronze
NEWA 50 UNjNewM
Grazing Horse bronze
VALE 119 UMiGT
Half-clothed Maja (Halbbek-
leidete Maja) 1951 bronze
GERT 77
Joseph und Maria 1927 gilded
wood; 1.15 m
HENT 115 GDA
Kastalia 1931 marble; 1 m
HENT 116
Kneeling Prophet
STA 214
Leigender Junge, Denkmal
fur Karl Ernst Osthaus
1930/31 stone
HENT 117 GEF
Lifeguard bronze; 22-1/2
CAN-2:200 CON
Maja 1942 bronze; 2.25 m
OST 66 GHaBo
--1942 bronze; 84
MCCUR 254 UPPF
--1942 bronze; 89
NNMMAG 168 UNNRo
Man and Woman
KO pl 105
Man of Sorrow ceramic
PRAEG 493 GLuC
Melusine III 1949 bronze;
43-1/2
NNMMAG 168 UMnMW
Mourning Angel, memorial
for World War II Dead
1946/49 stone; 102-1/4
NNMMAG 167 GCo
Orion 1949 bronze
GERT 76
Pair of Runners 1923 bronze;
7-5/8x7-1/2
TRI 106 GHeN
Pomona 1932 bronze; 37-1/2
BOSME pl 97 GHH
Professor Heuss 1952 bronze
GERT 75
Prometheus 1948 bronze;
30-3/4
FAIN 108; KUHNG pl 120
UMCB (1952.17)
Prometheus Bound II 1948
bronze; 78 cm
OST 65 GCoW

Reading Girls (Lesende
Madchen) 1944 bronze
GERT 73
Rooster 1952 bronze; 20
DETS 67 UNNH
Rooster Crowing 1945 bronze;
4-3/8
SCHAEF pl 35
The Runners H: 7
UPJH pl 242 UNNMMA
--1956 bronze; 90
MID pl 134 BAM
Seated Boy bronze; 17
NCM 232 UNcRV
Seated Girl 1932 bronze; 25
NNMMARO pl 278 UNNBu
--1932 bronze; 25
RIT 95 UNNV
--c 1937 bronze; 10-3/4
PUL-2:pl 127
--1938 bronze; 17x19-1/2
SELZS 116 UNNAd
Seated Nude bronze; 20-1/2
DETT 169 UMiD (44.270)
Seraphita bronze
CASS 77 GBB
--1934 bronze; 83 cm
OST 64 GMaM
Shenandoah 1932 stone; 68-3/4
destroyed
NNMMAG 167
Sich Niedertuende Kuh 1948
bronze; 26.5 cm
OST 8 GHaL
Social Consciousness 1950/52
bronze; detail H: 31-3/4
SCHAEF pl 38
Spanish Bull 1950 bronze; L:
11
SCHAEF pl 37
Standing Girl bronze; 12-1/2
KUHNG pl 119 UMCB
(1934.53)
Standing Nude 1939 bronze;
47-1/2
NNMMAP 126 UNNBu
Standing Woman with Braid
1950 bronze
VEN-52:pl 80 GHH
Standing Youth, Johannes
1936 bronze; 37-3/4
HAMP 181A GHH
Still Alein 1932 silvered
bronze; 63 cm
HENT 119 GBN
Striding Girl 1943 tin; 22
MID pl 46 BAM
Woman of the Herero Tribe
("African Queen") bronze
45-1/4 SOTH-4:71

Zwei Madchen 1933 bronze;
70 cm
HENT 120 GF
MARCO FLAMENCO (Flemish) See
DANCART, P.
MARCO ROMANO (Italian)
St. Simeon, effigy 1317
POPG fig 25 IVSi
Marcus Antonius (Roman Emperor
121-80)
Padovano. Anthony and
Cleopatra
Il Mare. Pascali
Margaret, Saint
Brokoff, F. M. St. Barbara,
St. Margaret, and St.
Elizabeth
Flemish--15th c. St.
Margaret of Antioch
Gagini. St. Margaret
Margaret (Queen of Edward I of
England 1282?-1318)
English--13th c. Queen
Margaret, ext figure
Margaret of Austria (Daughter of
Maximilian I 1480-1530)
Austrian--16th c. Maximilian
Tomb
Meit. Margaret of Austria#
Margaret of Burgundy (Queen of
Navarre 1290-1315)
Jacques de Gerines and
Renier van Thienen.
Isabella of Bourbon Tomb
Margaret of Malines
English--16th c. Two Heads
(one probably Margaret
of Malines)
Margaret of Savoy (Queen of Italy
1851-1925)
Canonica. Margherita of
Savoy, Queen Mother, bust
Margherita con Fuoco. Kounellis
Marguerite of Provence (Queen of
France 1221?-1295)
Jean de Liege. Jeanne de
Bourbon as Marguerite de
Provence
MARI, Enzo (Italian 1932-)
Dynamic Optical Deformation
of a Cube in a Sphere
1958/63 transparent
polyester resin; Dm: 4
SEITR 51
Struttura d. 724 1963
aluminum and plastic;
23-5/8x23-5/8x3-7/8
NEW pl 122

Maria. Tizzano
Maria Cristina (Regent of Austria
1858-1929)
Canova. Archduchess Maria
Cristina Monument
Maria di Mose. Pisano, G.
Maria Fedorovna (Empress of
Alexander III of Russia
1847-1928)
Russian--19th c. Maria
Fyodorovna, bust
Maria Jose (Princess of Belgium)
Rousseau, V. Princess Maria
Jose of Belgium, bust
Maria Theresa (Archduchess of
Austria 1717-81)
Moll. Sarcophagus of Franz
I and Maria Theresa
MARIANI, Camillo (Italian 1565?-1611)
St. Catherine of Alexandria 1600
stucco; over LS MOLE 172;
WIT pl 41A IRBarn
Marie Amelie (Queen of France
1782-1866)
Moine. Queen Marie Amelie
Marie Antoinette (Consort of Louis
XVI of France 1755-93)
Cortot. Marie Antoinette
Surrounded by Religion
Houdon. Marie Antoinette, bust
Lecomte. Marie Antoinette,
bust
Marie de France (daughter of Charles
IV of France d 1341)
Jean de Liege. Marie de
France, bust
Marie de Medicis (2nd Wife of Henry
IV of France 1573-1642)
Dupree. Medal: Henry IV and
Marie de'Medici
French--17th c. Angels
Supporting Coat of Arms
of Maria de'Medicis
Marie-Lou. Permeke
Marie Louise (2nd Wife of Napoleon I
of France 1791-1847)
Bartolini. Empress Marie
Louise, bust
Marieke. Wijnants.
MARIN, Joseph Charles (French 1759-
1834)
Arcadian Family c 1790 terra-
cotta; 55x51x23 cm LIC
pl 27 UNNFre
Caius Gracchus Leaving his
Wife, Licinia, relief 1801
plaster LIC pl 27 FPE
Marinai. Cappello

MARINAS, Aniceto (Spanish)
 Ursus 1932 marble
 CASS 66
Marine. Norman, P. E.
Marine Group. Dobson
Marine Knight
 Flemish--15th c. Misericords
Marine Mutation. Adam, H. G.
Marinetti
 Severini. Marinetti
MARINI, Marino (Italian 1901-)
 Angel of the Citadel 1949
 H: 65-3/4
 BAZINW 442 (col); CALA
 ep IVG
 Archangel (Arcangelo) 1943
 ptd plaster; 140 cm
 LIC pl 317 SwBKM
 Arturo Tosi, head terracotta
 VEN-42: pl 13
 Bather terracotta
 VEN-32: pl 43
 Boxer 1935 bronze; 26-1/2
 BOSME pl 123 UNcRV
 Bull 1953 bronze; 30-1/2
 WALKE UNNJ
 Bust of a Woman terracotta
 SFGC 27
 Carlo Carra, head 1947
 bronze; 9-1/8
 SOBYT pl 121
 Il Cieco 1928 bronze; LS
 RAMS pl 45 IMAM
 Composition 1956 bronze
 VEN-62: pl XXV IMMa
 Composition of Elements
 1964/65 bronze; 39-1/4x
 110-3/4x53-1/2
 GUGE 56 UNKinS
 Dancer (Danzatrice)
 MILLS pl 15 ELGol
 --1944 bronze
 CARR 184
 --1948 (cast 1949) bronze;
 69-1/2
 NMASO 52
 --1949 bronze; 68
 RIT 185 UNNV
 --1949/58 ptd bronze; 67-3/4
 TRI 89 (col) GDuK
 --1950/53 bronze; LS
 FAIY 92 UNUtM
 --1952 bronze
 GERT 189
 --1952 bronze; 60
 ALBC-1: #46; TOW 58
 UNBuA
 --1954 bronze; 65-1/2
 READCON 218 UNNH

 Equestrian Figure*, relief
 bronze
 MILLS pl 25 ELGol
 Equestrian Monument 1958/59
 bronze; 16'5'' (excl base)
 TRI 233 NHB
 Female Nude bronze
 VEN-40: pl 36
 Figures bronze
 DIV 48
 Figures and Rider, relief
 1931 bronze
 READAN #190 ELRog
 Giocoliere 1940 bronze; .97 m
 SCUL pl 10
 --detail 1944 bronze
 CARR 180
 --detail 1946 plaster
 CARR 180
 Grande Cavallo 1951 bronze
 VEN-52: pl 17
 Il Grido 1962 bronze; 68
 EXS 95
 Horse (Cavallo) 1942 bronze;
 29-1/2
 SCHAEF pl 27
 --1948 bronze; 29-1/2
 SELZS 143 UNNColi
 --1950 bronze; 45 cm
 SP 142 GHaS
 --1950 oil on wood; 150x99 cm
 SP 143 (col) GHaS
 --1951 bronze; 87
 RIT 187 UNNRo
 --1957 bronze; 12-1/2x14-1/2
 GIE 286 UNNWo
 Horse and Rider (Cavallo e
 Cavaliere)
 MYBA 663
 --bronze; 14'
 YAP 248 -UHe
 --c 1946/47 bronze; 35
 SOTH-3: 75
 --1947 bronze; 66
 SOBYT pl 119 UNNRoIII
 --c 1949 bronze
 BR pl 17; LARM 348 UMnMW
 --1949
 ENC 598
 --1949/50 ptd wood; 71
 READCON 216 (col) SwZKr
 --1950/53 bronze; 81
 DETS 68 UNNH
 --1952/53 bronze
 SAL pl 27
 --1953/54 ptd tulip wood;
 2.13 m; base: 2.05x1.21 m
 SCUL pl 11 (col), 12

--1954 bronze; 26.6 cm
 SP 144 GHaS
Horseman (Cavaliere) bronze
 SEYT 63 UNNBu
--plaster
 VEN-36: pl 16
--plaster
 VEN-48: pl 56
--1936 ptd wood
 MAI 193
--detail 1946 plaster
 CARR 180
--1946/47 bronze; 34-1/2
 NMASO 53
--1947 bronze
 CARR 180
--1947 bronze
 CARR 183 IMJu
--1947 bronze; 63-1/2
 GOMB 461; MILLS pl 16;
 MYBS 75; ROTJG pl 21;
 TATEF pl 37h ELT (6009)
--1947/48 bronze; 37-1/4
 CARR 183; CHENSN 649;
 CHENSW 501; MCCUR 274;
 NNMMM 172; SOBYT;
 UPJH pl 241 UNNMMA
--1948 plaster
 CARR 182
--1949
 NEWTEA 274 IVG
--1949 bronze; 12
 BOW 42
-- (Reiter) 1949 wood
 GERT 187
--1950
 SAO-2
--1950 bronze; 71
 MU 255 -I
--1951 bronze; 24
 BERCK 301 CTH
--1951/55 ptd wood; 212 cm
 JOO 193 (col) NOK
--1952 bronze
 MAI 194 UMnMW
--1952 bronze; 47
 BERCK 114 ELH
Horseman with Outstretched
 Arms (Rider with Out-
 stretched Arms) 1949
 wood; 70-1/2
 NEWTEM pl 163; PRAEG
 464
Igor Stavinsky, head
 HUX 88
--1950 bronze; 9
 JLAT UCSFM
--1950 bronze; 9
 GERT 188; MCCUR 274;
 RIT 186 UNNV

--1951 bronze; 12-1/2
 READCON 217 GH
--1951 bronze; 32 cm
 LIC pl 318 UMnMI
Judith 1950 bronze; 47
 MID pl 65 BAM
Juggler 1946
 MAI 192 SwZ
--1955 ptd plaster
 SAL pl 28 (col)
Little Horseman 1953 ptd
 plaster
 SAL pl 30 (col)
Little Juggler (Kleiner
 Jongleur) 1953 bronze
 GERT 189
Mme Hedy Hahnloser-Buhler
 1944 plaster
 RAMT pl 45 SwWH
Man Carrying a Woman 1950/
 53 bronze; 17-1/2
 DETS 69 UNNH
The Miracle (Horse and
 Rider; Horseman;
 Miracolo) 1953 bronze; 65
 MID pl 66 BAM
--1953/54 bronze; 26
 BOSME pl 122 ELH
--1953/54 bronze; 114
 BERCK 114 GMaM
--1953/54 stone
 SAL pl 29
--1954
 ENC 598 GMaM
--1954 bronze; 51-1/8x66-
 7/8
 TRI 91
--1958 bronze; 59x35-1/2
 SEAA 149
--1959 bronze; 92
 KO pl 103 GStLa
--1959/60 bronze; 174x245x
 125 cm
 LARM 291; LIC pl 320
 SwZK
--1961 bronze
 VEN-64: pl XXXV GMSG
Nude 1943 bronze; 52-1/2
 SOBYT pl 118 UNNBu
--1947 bronze
 CARR 184
Nude, seated figure 1947
 plaster
 CARR 184
Peasant on Horseback c 1948
 bronze; 19
 BOSME pl 124 UNNSai
Pomona 1947 bronze
 VEN-52: pl 16 IMJe

--1949 bronze
SAL pl 25
Pomona III 1943
FEIN pl 137
Popolo 1929 terracotta;
115x80 cm
LIC pl 316
Portrait, head 1947 bronze;
LS
SCHAEF pl 28
Prize Fighter 1935 bronze;
26-1/2
SOBYT pl 117 UCLV
Quadriga 1941 terracotta;
13x15
RIT 184 SwBK
Seated Figure (Figura
Seduta) 1946 plaster
CARR 184
Seated Pugilist bronze; 26-1/2
NCM 238 UNcRV
Sleeping Woman
VEN-30: pl 104
Small Horseman 1950 bronze;
11
BOW 43
--(Kleiner Reiter) 1951 bronze
GERT 186
Standing Nude 1943 bronze;
52-1/2
SCHAEF pl 26
Three Nudes 1945 bronze;
17-3/4
SCHAEF pl 29
Venus 1938 bronze; 110 cm
LIC pl 319
Warrior 1956 bronze; L: 43
BERCK 115
Woman's Head*
CASS 59
Young Girl 1943 bronze
SAL pl 26 (col)
Young Rider c 1937 bronze
STA 73
MARINO, Francesco See TEANA
Marion. Kalin, Z.
Mark, Saint
Byzantine. St. Mark and his
Followers
Dalle Masegne, J. and P.
Iconostasis
Donatello. St. Mark, niche
of Linen Workers
Gudewerth. St. Mark, High
Altar
Italian--15th c. Miracle of
St. Mark, Facade

Italian--16th c. Gold Bull
("Bolla d'Oro"): St. Mark
Handing a Banner to Andrea
Gitti
Kuen, F. A. Facade Figures
Lamberti, Niccolo di Pietro.
St. Mark
Lombardo, P. Pietro Mocenigo
Monument: St. Mark
Lombardo, T. Mocenigo
Monument: St. Mark Bap-
tizing
Lombardo, T. St. Mark Bap-
tizing Amianus, relief
Master of the Mascoli Altar.
Virgin and Child between
SS Mark and James
Riemenschneider. St. Mark,
with Book
Sansovino, J. St. Mark#
Market Vender. Wijnants
Markets See Merchants and Markets
Markham, William (Archbishop of
York)
Bacon, J., the Younger.
William Markham, Arch-
bishop of York, bust
MARKOV, Marko (Bulgarian)
Elin-Pelin, head bronze
VEN-64: pl 107 BulSN
Patriarch Euthymius bronze
BOZ 98 BulS
MARKWALDER, Hans (Swiss)
Law Courts Entrance Doors
AUM 21, 22 SwZ
Marlborough, Duchess
Epstein. Duchess of Marl-
borough, head, sketch
Marlborough, 1st Duke of
Rysbrack. 1st Duke of
Marlborough Tomb
The Marne. le Hongre
Marney, 1st Lord of
English--16th c. 1st Lord
Marney Tomb
Marney, Thomas, Lord d 1523
English--16th c. Thomas,
Lord Marney, Tomb
MAROCHETTI, Carlo (Italian
1805-67)
Emanuele Filiberto Monument,
equest 1838 bronze
LIC pl 100 ITC
Lord Clyde 1867
GLE 23 ELWat
Richard, Coeur de Lion,
equest
VICG 131 ELV

MAROT, Daniel (French)
 William III Monument, design
 ESD 29
MAROTTA, Gino (Italian 1935-)
 Albero 1967
 KULN 90
 Aleph 1964 KULN col pl 5 (col)
 Fiore 1967 KULN 77
 Naturale-Artificiale 1967
 KULN 208
Marpessa
 Flaxman. Apollo and Marpessa
MARQUES, Adolfo
 Ironworkers
 CASS 139 PoO
 --oporto
 CASS 139
 Street Singers
 CASS 139 PoO
 --oporto
 CASS 139
MARQUESTE, Laurent Honore
 (French 1850-1920)
 Perseus and the Gorgon 1876
 marble
 SELZJ 79 FVil
 Waldeck-Rousseau Monument
 TAFTM 34
Marriage of David
 Byzantine. Plate: Marriage of
 David
Marriages See Weddings
Mars See Ares
La Marseillaise
 Rude. Departure of the
 Volunteers of 1792
Marshal, Gilbert See Marshall,
 Gilbert
Marshall, Edward (English 1598-1675)
 Dr. William Harvey, bust
 marble; 27
 VICOR pl 27; WHINN pl 25A
 ELAn
 Duchess Dudley Tomb before
 1668
 WHINN pl 22B ESton
 Elizabeth, Lady Culpeper,
 recumbent effigy 1638
 CON-2: pl 43; GUN pl 16
 EHoll
 Henry Curwen Monument
 1636 c LS
 WHIN pl 29a EBuckA
 Sir Robert and Lady Barkham
 Monument d 1644
 WHINN pl 23B ETo
MARSHALL, Edward, or Joshua
 MARSHALL

Monuments to Wives of Haynes
 Barlee 1625; 1658
 ESD pl 98 EESC
Marshall, Gilbert, Earl of Pembroke
 English--13th c. Gilbert
 Marshall, effigy
MARSHALL, Joshua (English) See also
 Marshall, Edward
 Mrs. Mary Brocas Monument
 marble
 ESD pl 96; GERN pl 45;
 MOLS-2: pl 9 ELMarg
MARSILI, Emilio (Italian 1841-1926)
 Happy Age (Eta Felice)
 plaster
 VEN-26: pl 168
Marsuppini, Carlo
 Desiderio da Settignano. Carlo
 Marsuppini Monument
MARSY, Balthazar (French 1620?-74)
 See MARSY, Gaspard
MARSY, Gaspard (French 1624-81)
 Giant Enceladus, head,
 Fountain of Apollo 1746
 lead
 BUSB 140 FV
MARSY, Gaspard, and Balthazar,
 MARSY
 Fountain of Latona c 1670
 MOLE 236 (col) FV
 Horses of the Sun
 LARR 281 FV
 --maquette
 LOUM 191 FPL
Marsyas
 Foggini. Flaying of Marsyas
 Italian--18th c. Apollo and
 Marsias, relief
 Michelangelo--Attrib. Apollo
 and Marsyas, relief
 Shchedrin. Marsias
Marteau. Ray
MARTEGANA, Giuseppe (Italian)
 Giuseppe Garibaldi, bust
 marble
 USC 195 UDCCap
MARTEL, Jan and Joel MARTEL
 Cinema Reliefs
 AGARN il 6 FStJLCas
 Debussy Monument, detail
 AGARN il 41; RICJ pl 6;
 STI 747 FP
 Front Elevation, relief
 DAM 158 FB1B
 Isle of Avalon, relief stone
 MARTE pl 44
 Music, relief cement
 MARTE pl 44

Scotch Pigeon (Pigeon Ecossais)
 stone
 HOF 226; MARTE pl 17
Vendean Accordionist
 (Accordeoniste Vendeen)
 MARTE pl 17
Martelli Mirror. Italian--16th c.
Martens
 Norman, P. E. Marten
Martha, Saint
 Austrian--15th c. St. Martha,
 patron saint of housewives
 French--15th c. St. Martha
 French--16th c. St. Martha
Martin, Saint
 Donner. St. Martin and the
 Beggar
 French--11th c. Capital: St.
 Martin and the Miracle of
 the Sacred Tree
 French--12th c. Apotheosis of
 St. Martin
 --Capital: St. Martin and
 Pagan Tree
 --Capitals: St. Martin
 --Porch Capital; Capitals:
 St. Martin
 French--13th c. Sts. Martin,
 Jerome, and Gregoire Le
 Grand
 French--14/15th c. Reliquary
 bust of St. Martin de
 Soudeillier
 French--15th c. St. Martin
 and the Beggar, equest
 German--15th c. St. Martin
 German--16th c. St. Martin
 and the Beggar
 Gilioli. St. Martin
 Italian--13th c. St. Martin
 Sharing his Mantle with a
 Beggar
 Master Hartmann. St. Martin
 Riccio(?). St. Martin and
 the Beggar, plaque
 Spanish--12th c. St. Martin
 Spanish--15th c. Christ
 Appearing to St. Martin,
 retable
 Stammel. St. Martin and the
 Beggar, equest
 Sussner. St. Martin
 Vischer Family--Foll. St.
 Martin, equest
MARTIN (Burgundian Monk fl 1170-
 89)
 St. Lazare Tomb, figure detail
 LARB 283 FAutR

Martin III (Pope 942-46)
 Gabel. Son of Martin III
Martin V (Pope 1368-1431)
 Donatello and Filarete--Foll.
 Martin V Monument
 Jacopino da Tradate. Pope
 Martin V
Martin, Christopher
 Moore, H. Christopher
 Martin Memorial
MARTIN, Etienne (Etienne-Martin)
 (French 1913-)
 Anemone 1955 elm; 43-1/2
 GUG 211 UNNG
 The Beak (Le Bec) 1964
 bronze; 26-1/4x58-1/2x26
 GUGE 72 UNNLef
 Booz 1955 bronze; 24x18x20
 LOND-5:#29
 Couple
 FPDEC il 16
 The Cry (Le Grand Cri; Il
 Grido) 1963 wood
 VEN-66:#165 SwGGi
 --1963 wood; 130x75x39
 CARNI-64:#65; CHICSG
 FPGiv
 Demeter No. 3 1960 plaster;
 98-3/8x196-3/4x88-5/8
 NEW pl 72
 Demeure No. 3
 SEITC 44 FPBr
 Dragon 1956 wood
 MARC pl 74
 From Them (D'Eux) 1955/56
 wood; 56
 GIE 291 FPSp
 Homage to Lovecraft 1956
 plaster
 MAI 90
 Lanleff 1961 plaster; 47-1/2
 x127
 SEAA 142
 Lanleff, Demeure No. 4 1962
 plaster; 126x51-1/8
 READCON 204 FPB
 Large Couple (Le Grand Cou-
 ple) 1945/49 elmwood;
 78-3/4x31-1/2
 READCON 204 (col);
 SCHAEF pl 112; TRI 96
 FPB
 Large Dragon (Great Dragon)
 1945/47 wood; 60
 BERCK 135; MARC pl 75
 IMMa
 La Nuit 1951 bronze; 53-1/2x
 31-1/2 READCON 204 (col)
 FPB

La Nuit 1957
READAN # 192
Nuit Nina 1951 bronze; 55
EXS 77 UNNLef
Open Night 1951 bronze;
27-1/2x31-1/2x31-1/2
SELZS 142 UNNLef
Sources of Life and Thought
1951/52 wood; 36-1/2x
22-1/2x27-1/2
CARNI-58: pl 40 UPPiS
Two 1956 wood
MAI 89 FPSp
MARTIN, Kenneth (English 1905-)
Fountain, Brixton Day College
PRIV 187
Fountain in Stainless Steel
1961 H: 60 (above water
level); Radius: 42
HAMM 104 ELC; ELBri
Marble Construction, Version
1 1955 bronze and steel
MAI 195 -EHea
Oscillation 1962 phosphor
bronze; 5-1/4x3-1/2x3
READCO pl 17a; READCON
185 ELL
Screw Mobile 1953
AMAB 12
Screw Mobile 1956/59 phospher
bronze and steel; 29
HAMM 105 (col); LARM
370 ELLan
Screw Mobile 1959 phospher
bronze; 24-7/8
TRI 213
Sculpture*
ARTSC
Small Screw Mobile 1953
bronze and steel; 25x9
MEILD 78; TATES pl 20
ELT (T. 552)
Three Oscillations 1963/64
brass; 10-1/2; 10-7/8;
and 8-3/4
HAMM 103 (col)
MARTIN, Mary (English 1907-)
Climbing Form 1956 wood;
4x9x9
BERCK 146
Relief
PRIV 187
Sculpture*
ARTSC
Spiral 1963 formica and
stainless steel relief on
wood support; 21x21x4
TATES pl 19 ELT (T. 645)

The Waterfall, reverse side
of architectural model
(6-3/4x1-1/2), Musgrave
Park Hospital 1925 6. 8x7. 6
BERCK 220
MARTIN, Phillip (English-French
1927-)
Relief No. 3 1964 wood, metal,
and assorted materials
NEW pl 61
MARTIN, Priska von (Swiss 1912-)
Caribou 1959 bronze
MAI 195
Goat 1954 bronze; 13-3/8
SCHAEF pl 19
Head of a Young Woman
(Madchenkopf) bronze
GERT 110
Hind (Hirschkuh) 1952 bronze
GERT 111
Ox (Rind) 1949 bronze
GERT 111
Reindeer (Ren) 1954 bronze;
29x47 cm
OST 12 GHaL
MARTIN, Raymond (French 1910-)
M. N. B., head
BAS 126
Ma Fille, head
BAS 126
Meditation 1947 bronze; 57
MID pl 103 BAM
Torse d'Homme
BAS 125
Vaincu
BAS 128-29
Wall Decoration
BAS 127 FChE
MARTIN BROTHERS: Robert Wallace
1843-1923; Walter 1859-1912;
Edwin 1860-1915 (English
Potters)
Grotesque Pitcher
ENC 602
MARTINEZ, Gaetano (Italian 1892-)
Dancer bronze
VEN-42: pl 34
Lamp without Light (Lampa da
Senza Luce) plaster
VEN-28: pl 61
Young Siren
AUM 40
MARTINEZ HUGUE, Manuel See
MANOLO
MARTINEZ MONTANES, Juan
(also called: Dios de la
Madera) (Spanish 1568-
1649)

Adoration of the Shepherds,
 relief 1610/13
 BAZINW 401 (col); BUSB
 60; KUBS pl 82B; VEY
 283 SpSaI
Altar of San Isidoro del
 Campo: St. Jerome; The
 Nativity; St. John the
 Baptist
 GOME pl 46-55 SpSI
Christ of Clemency 1606 ptd
 cedar
 BAZINW 400 (col); GOME
 17 (col); KUBS pl 81A
 SpSC
"La Cieguecita" ("The Little
 Blind One") after 1628 ptd
 wood; less than LS
 GOME pl 56-57 SpSC
Don Alfonso Perez de Guzman
 Sepulchre 1610/13
 VEY 194 SpSaI
Head of a Woman
 TAT sc pl 14 ELV
Immaculate Conception ptd
 wood
 WES pl 26 SpTC
--1629/31 ptd wood
 CHRC fig 196; KUBS pl
 84B; MAL pl 37; POST-
 2:74 SpSC
Madonna of Sorrows (Mater
 Dolorosa; La Virgen de
 los Dolores), bust ptd
 wood, inlaid glass tear
 drops
 CHENSW 401; MILLER il
 138; PRAEG 367; READA
 pl 36 ELV
St. Bruno ptd wood
 GOME pl 59 SpSMA
St. Bruno in Meditation ptd
 wood
 LARR 225; TAT sc pl 14;
 WES pl 27 SpCaC
St. Dominic de Guzman 1605
 ptd wood
 GOME pl 58; TAT sc pl
 14 SpSM
St. Francis Borgia 1610 ptd
 wood
 GUID 246; KUBS pl 82A
 SpSUC
St. Ignatius ptd wood
 BAZINB 52 SpMaU
St. Ignatius Loyola, head
 detail c 1610 ptd wood
 BAZINW 401 (col) SpSUC

St. John the Baptist, High
 Altar
 BAZINH 313 SpSaI
Virgin
 CHASEH 412 SpSM
MARTINEZ MONTANES, Juan, and
 Felipe de RIBAS
 Altar of St. John the Baptist
 1637/38
 KUBS pl 86A SpSP
MARTINEZ RICHIER, Luis
 (Dominican Republican-French
 1928-)
 Sepulchre 1959 wood
 MAI 196
MARTINI, Arturo (Italian 1889-1947)
 Anno Quattordicesimo, detail
 bronze
 CASS 110
 Aviator 1931 terracotta
 VEN-62:pl 11 IVadM
 Boy Drinking 1926 terracotta
 READCON 22 SwGL
 --1926 terracotta; 40
 HAMP pl 191A IMJe
 Chekhov, bust 1919 terracotta;
 17-3/4
 SOBYT pl 115 IMPa
 Chiaro di Luna 1913 terra-
 cotta; 230 cm
 CARR 168
 Clair de Lune 1932 terracotta
 SAL pl 9
 Cow 1940 bronze
 SAL 17
 Daedalus and Icarus
 SAL pl 12 (col)
 --1934/35 bronze; 24
 RIT 69 UNNMMA
 --1934/35 bronze; 24
 SOBYT pl 116 IRMart
 The Daughter 1930 terracotta;
 20
 MID pl 58 BAM
 Donna Che Nuota Sott'Acqua
 (Woman Swimming Under
 Water) 1941
 CARR 171; SAL pl 11; VEN-
 48:pl 53 IMLu
 --2nd version 1943 terracotta;
 CARR 173
 The Dream 1931 terracotta;
 230x200 cm
 LIC pl 315 IAcL
 Fisherman's Wife terracotta
 SOBYT pl 114 IFBon
 Gare Invernali
 VEN-32:pl 89

La Gitana (La Zingara) 1934
 bronze; 2 m
 SCUL pl 9 IMPe
The Gypsy 1934 bronze
 MAI 197 IMAM
Head of a Young Girl 1931
 terracotta; 14
 SCHAEF pl 8
Hercules and a Lion bronze;
 14
 NCM 236 UNcRV
Heroic Group, study 1935
 bronze; SAL pl 16
Horse (Cavallo) 1943 terra-
 cotta (destroyed)
 CARR 172
Judgment of Solomon bronze;
 21
 NCM 236 UNcRV
Livy (Tito Livio) 1939 marble
 SAL pl 13
--1942 marble
 VEN-62: pl 12 IPadU
Lorenzo Viani, head marble
 VEN-38: pl 112
Man Drinking terracotta
 VALE 46
Moonlight 1931 terracotta;
 79
 KO pl 102; MID pl 55
 BAM
Motherhood, detail 1927 wood
 SAL pl 10 (col)
Orpheus
 MARTE pl 30
Palinarus, seated figure 1946
 marble; 72
 SCHAEF pl 9
The Partisan Masaccio 1946
 marble
 SAL pl 15
Le Pisana 1930 bronze; 52
 EXS 96 IRMaz
Polychrome Figures
 HOF 60 IMJ
The Prodigal Son 1927 bronze
 KO pl 102 IAcL
Prodigal Son, relief detail
 VALE 47 IMJ
The Prostitute 1909/13
 colored terracotta; 38 cm
 LIC pl 216, 217 IVPes
Rape of the Sabine Woman
 1940 bronze
 SAL pl 14 (col)
Riposo 1944 bronze
 CARR 174

San Giacomo marble
 VEN-42: pl 51
Self Portraits (Autoritratto)
 1943 terracotta
 CARR 175
La Sete 1934 stone; .78x1.10
 m
 SCUL pl 8 IMAM
She-Wolf 1931 terracotta;
 34x55
 MID pl 56 BAM
The Shepherd 1930 terracotta;
 over LS
 RIT 68 IRN
Studio per il Costume Moderne
 1943 terracotta (destroyed)
 CARR 172
--
 CARR 173
Torso d'Uomo 1929 terracotta;
 130 cm
 CARR 170
The Vigil 1936 terracotta
 KO pl 102
Winter Sports 1932 terracotta;
 78
 MID pl 59 BAM
Woman at the Window 1941
 terracotta; 32 cm
 LIC pl 314 IRMo
Woman in the Sun 1932 terra-
 cotta; 24x55
 MID pl 57; SAL 5 BAM
MARTINI, Francesco di Giorgio See
 FRANCESCO DI GIORGIO
 MARTINI
MARTINI, Quinto (Italian 1908-)
 The Cook 1960 bronze
 SAL 33
MARTINO, Giovanni di See
 LAMBERTI, Niccolo di Pietro
MARTINS, Maria
 Prometheus 1950 bronze
 BERCK 201
MARTINUS THE PRESBYTER
 Virgin and Child 1199 poplar;
 72-1/2
 NEWTEM 11 (col) GBS
MARTINUZZI, Napoleone (Italian
 1892-)
 Bather bronze
 VEN-28: pl 115
 Canefora ptd plaster
 VEN-26: pl 153
 Figures, column of War
 Memorial
 CASS 108 IMu

Glass Workers, relief
CASS 97
Grain Man (L'Uomo del
Grano) ptd plaster
VEN-30: pl 30
Nude 1948 ptd plaster
VEN-48: pl 54
On the Sea Shore (Sulla
Spiaggia) stone
VEN-42: pl 38
Sinner (Peccatrice) wax
VEN-32: pl 184
MARTON, Laszlo (Hungarian 1925-)
Veronica 1951 bronze; 52.5
cm
GAD 116 HBA
MARTOS, Ivan Petrovich (Russian
1754-1835)
Minim and Pozharski 1804/18
HAMR pl 151B RuM
Princess Gagarina, sepulchral
monument
RTCR 194 RuLL
MARTOS, Ivan Petrovich--FOLL
Funeral Monument c 1810
HAMR pl 151A RuMV
MARTSA, Istvan (Hungarian 1912-)
L. N. Tolstoi, medal 1954
bronze; Dm: 12.5 cm
GAD 133
MARTYN, H. H. AND COMPANY
Bank Entrance Sculpture
AUM 144 ELMi
Mirror Frame limewood
AUM 136
Martyrs
Borman, J. Altar of St.
George: Martyrdom
Byzantine. Forty Martyrs of
Sebastia
French--7th c. Martyrs
Chained to the Cross
French--15th c. Martyrdom,
caryatid
Rodin. The Martyr
Somaini. Great Martyrdom
Thornton. The Martyr
MARVILLE, Jean de See also
Sluter, Claus
Virgin and Child 15th c.
CRU 116 FDC
Marx, Karl
Bakic. Marx-Engels Monument
Mary. Leoncillo
Mary, Virgin See also Flight into
Egypt; Holy Family; Jesus
Christ
Anglo-Saxon. Mary and John

Arnolfo di Cambio. Virgin of
the Nativity
Belgian. The Virgin
Bosio. Virgin Mary, head
Burgundian--15th c. Notre
Dame de Grace
Byzantine. Madonna Orans
Byzantine. Virgin#
Byzantine. Virgin Orans#
Cano, A. La Virgen
Danish (?)--12th c. Madonna
Danish--12th c. Virgin Mary
Daucher, A. Christ with Mary
and St. John
Delaplanche. Madonna
Donatello. Madonna, relief
Durst. St. Mary
Dutch--17th c. Virgin
English--11th c. Virgin and
St. John
Feuchtmayer. Mary#
Feuchtmayer. Virgin, from
"Lactato"
Feuchtmayer. Virgin Mary
Flemish--13th c. The Virgin
and St. John, Crucifix
Flemish--14th c. Virgin, head
Flemish--15th c. Calvary;
details: Virgin and St. John
Francheville. Virgin Mary
French--9th c. Mary and John
Mourning, book cover
French--11th c. Black Virgin
of Dijon
French--12th c. Royal Portal
-- Virgin#
French--13th c. Porch of the
Virgin
--Portal, north transept:
Madonna
--La Vierge Doree
--Virgin#
French--13/14th c. Virgin of
Verneuil-sur-Avre
French--14th c. Diptych:
Dormition and Coronation
of the Virgin
--Life of Christ and the
Virgin Scenes
--Madonna
--Le Virgin de Marfil
--Virgin Painting
French--15th c. Madonna
--Virgin#
French--16th c. Virgin, head
--Virgin and St. John
German--11th c. Book Cover:
Gospel of Bishop Bernward
of Hildesheim

German--12th c. Mary and
John
--Seated Madonna
German--13th c. Choir Pillar
Figures
--Mary, Triumphal Cross
Figure
German--14th c. Bride's Door
--Madonna#
--Virgin, Annunciation Group
German--15th c. Beautiful
Madonna
--Kneeling Virgin
--Our Lady of Compassion
--Seated Virgin
--Virgin#
German--16th c. Mary and
St. John the Evangelist
--Mary, Elizabeth and
Zacharias
Gilbert, A. Duke of Clarence
Tomb: The Virgin
Gunther, F. I.--Foll. Madonna
Italian--12th c. William I
Offering Church to Virgin
Italian--13th c. Virgin and St.
John
Italian--14th c. Porta della
Mandorla: Gift of the
Girdle
Italian--16th c. Kneeling
Virgin
Jokl. The Virgin and St.
Bernard
Junge. Niendorf Virgin
Juni. Virgen de los
Chuchillos
Knappe. Maria im Garten,
relief
Langer. The White Madonna,
half figure
Leoni, L. and P. Calvary
with Virgin and St. John
Master H. L. Madonna
Master of the Beautiful
Madonnas--Foll. Madonna,
head detail, Vesper Group
Multscher. Madonna
Multscher. Virgin Seated
Netherlandish. Virgin
Pacher--Foll. Virgin
Pilon. The Virgin
Portuguese--14th c. Virgin
Portuguese--17th c. Virgin
Pires-o-Velho. Virgin
Quellin, A., the Elder. Ma-
donna Araceli

Quesnoy. Christ and Madonna,
busts
Richier, L. Fainting Virgin
Robbia, A. della. Madonna
of the Architects
Robbia, A. della. Madonna
of the Pillow
Romanesque. Virgin, seated
figure
Romanesque--Danish. Virgin
Romanesque--Italian. Porta
San Ranieri: Life of the
Virgin
Russian--13th c. The Virgin
Sansovino, J. Madonna and
the Young St. John
School of Champagne. Virgin
Sluter. Portal: Madonna
Spanish--13th c. Mary
Spanish--14th c. Gothic
Madonna, head#
Spanish--17th c. Our Lady of
La Purisima
Strudel. The Virgin
Swabian. Madonna
Swedish--12th c. Madonna
from Hall
--Madonna of Mosjo
Swedish--13th c. Madonna,
plait work headdress
--The Virgin in Grief
Vischer, P., the Elder.
Nuremberg Madonna
Voort. Madonna
--Annunciation
Amadeo. Annunciation,
medallion
Amadeo (?). Virgin
Annunciate
Andrea di Jacopo d'Ognabene.
Silver Altar; Annunciation
and Visitation
Arnolfo di Cambio--Foll.
Annunciation
Austrian--18th c. Virgin
Annunciate
Balducci. Virgin Annunciate
Benedetto da Maiano. Altar
of the Annunciation
Berruguete. The Annunciation,
retable detail
Braun, M. B. Virgin Mary,
Annunciation figure
Byzantine. Throne of
Maximian
Campagna. Annunciation,
relief

Carolingian. The Annunciation, diptych leaf
Chanterene. Virgin of the Annunciation
Civitali. The Annunciation
Civitali--Foll. Virgin Annunciate
Delemer. Annunciation
Derujinsky. Annunciation
Donatello. Cavalcanti Annunciation, relief
Durst. Annunciation
Early Christian. Neckband with Medallion: Annunciation
Eligius of Liege. Archbishop Friedrich of Saarwerden Tomb
English--13th c. The Annunciation
English--14th c. Annunciation#
--Nottingham Annunciation
English--15th c. Henry V's Chantry
Epstein. The Annunciation
Erminold Master. The Virgin, Annunciation Pier Figure
Feuchtmayer. Immaculata
Flemish--16th c. Annunciation#
French--11th c. The Annunciation, apse frieze
French--12th c. Altar Retable
French--13th c. Annunciation#
--Annunciation and Visitation
--Crozier, handle: Annunciation
--facade, south portal
French--14th c. Virgin of the Annunciation
French--15th c. Annunciation
--Virgin of the Annunciation
French--16th c. Altar of Annunciation
Gaggini, A.--Foll. Virgin of the Annunciation
German--9th c. Book Cover: Annunciation
German--12th c. The Annunciation, plaque
German--14th c. The Annunciation, altar relief
German--15th c. Annunciation#
Ghiberti. Baptistry Door, north: The Annunciation
Ghiberti--Foll. Virgin Annunciate
Guido da Como. Pulpit: Annunciation

Gunther, F. I. Annunciation
Isaaco da Imbonate. Virgin Annunciate
Italian. Annunciation, capital
Italian--12th c. Monreale Capitals
Italian--15th c. Annunciation, diptych
Knappe. The Annunciation
Koniger. Virgin of the Annunciation
Master of the Mascoli Altar. Virgin and Child of the Annunciation
Master of the Molsheim Reliefs. Adoration
Master of the Pisan School. Virgin of the Annunciation
Mayer, J. U. Ambit Portal: Annunciation
Mino da Fiesole. Virgin Annunciate
Mochi. Virgin of the Annunciation
Netherlandish. Annunciation, relief
Pagni. Cathedral Doors: detail by Caccini, G.: Annunciation
Pisano, A. Virgin Annunciate
Pisano, Giovanni. Pulpit: Annunciation
Pisano, Nino. Annunciation
Pisano, Nino. Virgin Annunciate
Quercia. Virgin of the Annunciation
Riemenschneider. Virgin of the Annunciation
Robbia, A. della. The Annunciation
Robbia, A. della. La Verna Annunciation
Robbia, Luca della. Annunciation
Roldan, L. Virgin of Macerena
Romanesque--French. Capital: Annunciation
Rossellino, B. Virgin Annunciate
Sansovino, A. The Annunciation
Sansovino, A. Corbinelli Altar, tondo: Virgin Annunciate
Siloe, D. de. Main Altar: Annunciation
Spanish--13th c. Annunciation#
Stoss. The Annunciation
Thorvaldsen. Annunciation

Tino di Camaino. Virgin of
the Annunciation
Valdambrino. Virgin
Annunciate
Valle. The Annunciation,
relief
Velasquez. The Annunciation
Vittoria. Annunciation, relief
Zurn, M. and M. Rose
Garland Altar: Annuncia-
tion, detail: Virgin,
head
--Appearances
Fernandez. The Veronica
--Assumption
Asam, E. Q. Assumption
of the Virgin
Bernini, P. Assumption of
the Virgin
Donatello. Cardinal Rinaldo
Brancacci Tomb:
Assumption
Donatello and Michelozzo.
Brancacci Monument:
Assumption of the Virgin
Fontana, A. Virgin of the
Assumption
Francesco di Giorgio
Martini. Assumption and
Coronation of the Virgin,
relief
Francesco di Valdambrino.
The Assumption
French--14th c. Assumption
of the Virgin
French--14/15th c. Assumption
of the Virgin, bas relief
German--16th c. Assumption
of the Virgin
Mino del Reame. Assumption
of the Virgin
Nanni di Banco. Virgin of the
Assumption, lozenge relief
Orcagna. Tabernacle:
Burial and Assumption of
the Virgin
Riemenschneider. Assumption
of the Virgin
Robbia, A. della.
Assumption of the Virgin,
altarpiece relief
Simon Matthias de Bucy and
Pierre de Chelles. The
Virgin Carried to Heaven
by Angels
Tribolo. The Assumption
of the Virgin, relief

Tuotilo. Ivory Book Cover for
Evangelium Longum:
Assumption of the Virgin
--Cloak
Erhart, Gregor. Madonna with
the Protecting Mantle
Erhart, M. Madonna with
Cloak
German--15th c. Schutzmantel
Virgin
Schramm. Madonna with Cloak
--Coronation
Delli. Coronation of the Virgin
English--14th c. Coronation of
the Virgin#
English--15th c. Altar Panels
French. Coronation of the
Virgin
French--12th c. Coronation of
the Virgin#
French--13th c. Coronation of
the Virgin#
--Portal of the Virgin:
Coronation of the Virgin
French--14th c. Coronation
of the Virgin, door relief
French--14/15th c. Corona-
tion of the Virgin
French--15th c. Coronation
of the Virgin
--Pendant: Coronation of the
Virgin
German--15th c. Folding
Altar: Coronation of the
Virgin
German--17th c. Coronation
of the Virgin
Gothic-French. Coronation
of the Virgin
Hans von Judenburg. Corona-
tion of the Virgin
Italian--15th c. Pax: Corona-
tion of the Virgin
Lombardo, Tullio. Coronation
of the Virgin, relief
Master H. L. High Altar:
Coronation of the Virgin
Pacher. St. Wolfgang
Altar: Coronation of the
Virgin
Robbia, A. della. The
Coronation, relief
Schwanthaler, T. Coronation
of the Virgin
--Dolorosa
Austrian--13th c. Mourning
Virgin

Charlier. Mater Dolorosa
Einbeck. Weeping Madonna,
 head detail
Fernandez. Mater Dolorosa
French--13th c. Mater
 Dolorosa
German--12th c. Mourning
 Virgin
German--13th c. Mourning
 Virgin
Glesker. Mary at the Foot
 of the Cross
Juni. The Entombment: Virgin
 of Sorrows
Lederer, J. Mourning Virgin
Martinez Montanes. Madonna
 of Sorrows
Mena. Maria Dolorosa
Mena. Virgin of Sorrows
Mora. Virgin Dolorosa#
Mora. Virgin of Solitude
 (Virgin of Sorrows)
Naumberg Master. Weeping
 Madonna
Pilon. Mater Dolorosa
Polish. Lamentation
Reichle. Mourning Virgin
Riemenschneider. Mourning
 Marys
Roldan, P. Mater Dolorosa,
 bust
Sansovino, Andrea.
 Corbinelli Altar, ante-
 pendum detail: Mourning
 Virgin
Spanish--13th c. Mourning
 Virgin
Stoss. Virgin Weeping
Zurn, Michael. Mater
 Dolorosa
--Dormition
Arnolfo di Cambio. Dormition
 of the Virgin
Bavarian--15th c. Burial of
 Mary
Byzantine. Death of the
 Virgin#
Byzantine. Dormition of the
 Virgin, relief
French--13th c. Portal of
 the Virgin: Death and
 Coronation of the Virgin
--Death of Mary
French--14th c. Death of
 the Virgin, tympanum
French--15th c. Death,
 Assumption, and Coronation
 of the Virgin, triptych

French--16th c. Dormition of
 the Virgin, relief
German--9th c. Dormition of
 the Virgin, relief
German--14th c. Death of Our
 Lady
German--15th c. Death of the
 Virgin
Leonardo, Donati di. Pax:
 Death and Assumption of
 the Virgin
Lower Rhenish School. Death
 of the Virgin
Master of the Synagogue.
 Death of the Virgin
Orcagna. Tabernacle: Angel
 Announces Approaching
 Death to Virgin
Riemenschneider. Death of
 the Virgin
Russian--19th c. Dormition
 of the Virgin, icon
Spanish--13th c. Death of the
 Virgin
Stoss. Altar of Our Lady
Stoss--Foll. Dormition
 of the Virgin, altarpiece
Wesel. Sterfbed van Maria
--Education
Franconian. Education of the
 Virgin
French--16th c. Education of
 the Virgin
--St. Anne and the Virgin
German. Education of the
 Virgin
German--15th c. Instruction
 of the Virgin
Guillaumet. St. Anne Instruct-
 ing the Virgin
Guillaumet--Foll. Education of
 the Virgin
Verberckt. St. Anne Teaching
 the Virgin, relief
--Enthroned
French--12th c. Burgundian
 Virgin Enthroned
French--13th c. Enthroned
 Virgin and Child
German--10th c. Virgin
 Enthroned
German--16th c. Madonna in
 Glory, triptych
--Virgin in Glory
German--17th c. Virgin in
 Glory
Italian--13th c. Madonna and
 Child Enthroned, cameo

Italian--14th c. Enthroned
Madonna and Child
--Madonna and Child En-
throned with Angels.
Stoss. Salve Regina
--Family
English--15th c. Altar Panels
--Immaculate Conception
Austrian--18th c. Madonna
Immaculata
--Madonna of the Immaculate
Conception
Bschorer. Maria Immaculata
Cano, A. Immaculate Con-
ception
German--18th c. Immaculata
Gunther, F. I. Madonna of
the Immaculate Conception
Martinez Montanes. "La
Cieguecita"
Martinez Montanes. Immaculate
Conception
Parodi. Madonna of the Im-
maculate Conception
Segesdi. Immaculate Virgin
--Madonna and Child
Abruzzi Master. Virgin and
Child
Admont Master. Virgin and
Child
Agostino di Duccio. Madonna#
Agostino di Duccio. Madonna
and Child, relief
Agostino di Duccio. Madonna
with Angels, relief
Agostino di Duccio. Virgin
and Child with Angels,
relief
Agostino di Giovanni. Madonna
and Child with Angels
Algardi. Madonna
Amadeo. Madonna and Child
Andrea, Maestro. Madonna
and Child
Andreotti. Madonna and Child
Anglo-Saxon. Virgin and
Child in Mandorla
Arnolfo di Cambio. Virgin
and Child
Austrian--13th c. Virgin and
Child
Austrian--14th c. Madonna
and Child#
--Servants' Madonna
--Virgin and Child
Austrian-- 14/15th c. Fair
Virgin

Austrian--15th c. Salzburg
Madonna
Balducci. Madonna and Child
Bathory. Madonna and Child,
relief
Bellano. Virgin and Child,
relief
Benedetto da Maiano.
Madonna and Child#
Benedetto da Maiano. Virgin
and Child
Benedetto da Maiano--Foll.
Strozzi Madonna, tondo
Bernini, G. L. Virgin and
Child
Biberach Family--Attrib.
Kneeling Madonna with Two
Angels
Bogaczyk. Madonna
Bohemian. Krumlov Madonna
Bourdelle. Virgin and Child
Bourdelle. Virgin of Alsace
Bourdelle. Virgin of the
Offering
Buon, B. Madonna of Mercy
Protecting Members of
Guild of Misericordia,
relief
Burgundian--15th c. Madonna
and Child
--Virgin and Child
Burgundian--16th c. Madonna
Nursing Child
Byzantine. "Aniketos" ("The
Invincible")
Byzantine. Diptych: Christ
with Peter and Paul;
Madonna and Child
Byzantine. Madonna and Child
Byzantine. Stroganoff Ivory:
Madonna and Child
Byzantine. Virgin and Child#
Cano, A. Virgin and Child
Celtic. Madonna and Child,
relief
Civitale. Adoration of the
Child
Civitale. Madonna Adoring
the Child
Clark. Madonna and Child
Colombe--Foll. Virgin and
Child
Czech--17th c. Madonna
Danish--13th c. Seated
Madonna
Daucher, H. Madonna Relief
of Queen Eleanor of Portugal

Daucher, H. Virgin and Child
Daucher, H. Virgin and Nursing Child
Delcour. Bishop d'Allamont Monument: Madonna and Child
Desiderio da Settignano. Cardinal Marsuppini Monument: Madonna and Child, tondo
Desiderio da Settignano. Foulc Madonna, relief
Desiderio da Settignano. Madonna and Child#
Desiderio da Settignano. Madonna and Laughing Child
Donatello. High Altar
Donatello. Madonna and Child#
Donatello. Madonna in the Clouds
Donatello. Madonna with the Crouching Infant
Donatello. Pazzi Madonna
Donatello. Virgin and Child#
Donatello--Foll. Madonna and Child
Donatello--Foll. Virgin and Child#
Douvermann. Virgin and Nursing Child
Early Christian. Chancel Fragments
Early Christian. Madonna and Child
Early Christian. Mary with Angels, diptych
English--Madonna and Child
English--9th c. Christ in Majesty, and Virgin and Child Enthroned, oval reliefs
English--11th c. Madonna and Child, seated fragments
--Virgin and Child#
English--12th c. Madonna and Child
English--12/13th c. Virgin and Child
English--13th c. Angel Choir: The Virgin
--Boss: Virgin and Child
--Madonna and Child, vaulting boss
--Virgin and Child
English--14th c. Crozier Handle: Madonna and Child
--Flawford Madonna and Child

--Madonna and Child#
--Madonna and Nursing Child
--Salting Diptych: Madonna and Child
English--15th c. St. Anne, Virgin and Child
--Virgin and Child
Epstein. Madonna and Child
Erhart, George--Foll. Heiligenberg Madonna
Erhart, Gregor. Virgin and Child
Federighi. Madonna and Child
Ferrata. Madonna and Child
Fiamberti. Madonna and Child
Filarete. Virgin and Child Surrounded by Angels
Flemish. Virgin and Child
Flemish--12th c. Madonna of Dom Rupert
Flemish--15th c. Virgin and Child
Flemish--16th c. Virgin and Child
Francesco di Simone Ferrucci. Madonna and Child
French. Black Virgin
French. Notre Dame de Vauclair
French--11th c. Notre Dame de Claviers
French--12th c. Altar Retable
--Auvergne Virgin and Child
--Black Virgin
--Notre Dame de Claviers
--Our Lady of Jaulhac
--Portal of St. Anne
--Virgin and Child
French--13th c. Chartre Cathedral, south transept: Virgin of the Portal
--Madonna and Child#
--Notre Dame la Blanche
--Seal of Paris: Madonna and child
--Virgin and Child#
French--14th c. Choir Madonna
--Madonna and Child#
--Madonna and Nursing Child
--Metz Madonna and Child
--Notre Dame de Paris
--Pastoral Staff Handle: Virgin and Child with Angels
--Seated Madonna and Child#
--Tabernacle of the Virgin
--Triptych: Madonna and Child

--Virgin#
--Virgin of Jeanne d' Evereux
--Virgin of Paris
--Virgin of Sainte-Chapelle
--Virgin with Bird
French--14/15th c. Madonna and Child
French--15th c. Madonna and Child#
--Madonna and Nursing Child
--Miraculous Virgin
--Our Lady of Grace
--Vierge Bulliet
--Virgin and Child#
French--16th c. Madonna
--Vierge d'Olivet
--Virgin and Child#
German--9th c. Book Cover: Virgin and Child
German--10th c. Essen Madonna (Golden Madonna)
--Virgin and Child
German--11th c. Imad Madonna
--Virgin and Child
German--12th c. Madonna, fragment
--Madonna and Child
--Shrine of St. Heribert: Mary and Infant Jesus
German--13th c. Madonna
--Madonna of the Shrine of the Virgin
German--14th c. Choir Stall: Mary and Child Adored by Knight
--Madonna and Child#
--Madonna of the Rosebush
--Milan Madonna C
--Virgin and Child#
German--15th c. Madonna#
--Madonna and Child#
--Madonna with Apple
--Seeon Madonna
--Vintner's Madonna
--Virgin and Child#
--Virgin and Nursing Child
--Virgin in the Rose Bower
German--16th c. Beautiful Madonna
--Folding Altar with Virgin and Saints
--Madonna and Child
--Virgin and Child#
German--17th c. Madonna
German, or Netherlandish-- 17th c. Madonna and Child
Gerhaerts. Madonna

Gerhaerts. St. Anne, with Mary and Jesus
Gerhard. Patrona Bavariae
Ghiberti. Madonna and Child
Ghiberti--Foll. Madonna and Child
Ghiberti--Foll. Virgin and Child
Gill, E. Mater Amabalis
Giovanni di Agostino. Madonna and Child with SS Catherine and John the Baptist
Giovanni di Turino. Madonna and Child, relief
Gothic. Madonna#
Gothic. Virgin and Child
Gothic. Virgin Enthroned
Gothic--German. Madonna and Child
Grant. Madonna and Child#
Guggenbichler. Virgin and Child
Gulleson. Madonna
Hetherington. Madonna and Child
Hungarian--17th c. Buda Madonna
Isaia de Pisa. Virgin and Child with SS Peter and Paul and Two Donors
Italian. Isabella of Aragon Tomb: Madonna and Child
Italian. Virgin with Child at Breast, relief
Italian--10th c. Diptych: Crucifixion; Roman Wolf; Madonna
Italian--12th c. Madonna and Child
Italian--13th c. Madonna and Child#
Italian--14th c. Madonna della Schioppo, relief
--Virgin and Child with SS Lawrence and Frances, lunette
Italian--15th c. Madonna and Child
--Madonna of Mercy
--Madonna with Saints and Donor
--Virgin and Child#
Italian--17th c. Madonna and Child
Jaeckel, M. W. Madonna with St. Bernard
Jean de Cambrai. Virgin and Child

Jean de Rouen. Virgin and
 Child
Juan de la Huerta. Virgin
Kaschauer. Virgin and Child
Keime. Madonna and Child
Kofranek. Madonna
Kuene, K. Archbishop
 Dietrich von Moers
 Monument
Lainberger, S. Dangolsheim
 Madonna
Laurana. Madonna
Laurana. Virgin and Child
Leinberger, H. Virgin
Leinberger, H. Virgin and
 Child
Leonardo da Vinci. The Virgin
 with the Laughing Child
Lombard. Madonna and Child
Lombardo, Antonio. Zen
 Altar, detail
Lombardo, Pietro. Leonardo
 Loredano before the Virgin,
 relief
Lombardo, Pietro. Madonna
 and Child
Lower Rhenish School.
 Virgin and Child with St.
 Anne
Mackennal. Madonna
Malines. Madonna and Child
Manzoni. Madonnina
Marchini. Madonna
Martinez Montanes. Virgin
Martinus the Presbyter.
 Virgin and Child
Marville. Virgin and Child
Mascoli Master. Madonna
 with Angel
Master Bartomeu. Virgin
 and Child
Master of Salzburg. Virgin
 and Child
Master of the Beautiful
 Madonnas. Virgin and
 Child
Master of the Beautiful
 Madonnas. Foll. "Beautiful
 Madonnas--Foll.
Master of the Klosterneuberg
 Madonna. Virgin and
 Child
Master of the Krumau Madon-
 na. Krumau Madonna
Master of the Marble
 Madonnas. Madonna and
 Child, relief

Master of the Mercy Gate.
 Mercy Gate, tympanum
Mauch. Virgin and Child
Meit. Madonna and Child, half
 figure
Mena. Virgin of Bethlehem
Mena. Virgin of the Grotto
Michelangelo. Bruges Madonna
Michelangelo. Madonna and
 Child with Young St. John
 The Baptist, tondo
Michelangelo. Madonna of the
 Steps
Michelangelo. Madonna with
 the Book
Michelangelo. Medici Madonna
Michelangelo. Virgin and
 Child with Infant St. John
 the Baptist (Taddei Tondo)
Michele da Firenze. Madonna
 and Child
Michelozzo. Madonna and
 Child, arched relief
Michelozzo. Madonna with
 Sleeping Child
Mino da Fiesole. Altar, with
 Our Lady and Saints
Mino da Fiesole. Madonna and
 Child#
Mino del Reame. Madonna and
 Child
Moore, H. Madonna and Child
Mosan. Virgin and Child
Multscher. Altar: St. Ursula;
 Virgin and Child
Multscher. Madonna and Child
Mutschele. Madonna of Victory
Netherlandish. Virgin and
 Child#
Oberrheinischer Meister.
 Virgin and Child
Orcagna. Madonna and Child
Pacak, F. Our Lady of the
 Rosary
Paolo di Giovanni Fei. Ma-
 donna and Child between
 St. Peter and St. Paul
Pereyra. Virgin of the Rosary
Picardy. Virgin and Child
Pisano, A. Madonna and Child
Pisano, G. The Arena Madonna
Pisano, G. Virgin and Child
Pisano, Niccolo. Siena Pulpit:
 Madonna and Child
Pisano, Nino. Cornardo
 Monument
Pisano, Nino. Madonna del
 Latte

Sluter--Foll. Virgin and Child
Solari. Madonna and Child#
Spanish, Virgin of the Tower
of Belem
Spanish--12th c. Madonna
--Virgin and Child
Spanish--13th c. Madonna and
Child#
--The White Virgin
Spanish--15th c. Fair Virgin
Sperando. Pope Alexander V
Monument: Virgin and
Child
Stone. Virgin and Child
Stoss. Virgin and Child#
Swabian. Madonna and Child
and St. Anne
Syrlin, J., the Younger.
Virgin and Christ
Tabernacles of Virgin Atelier.
Virgin and Child and Two
Angels
Tennant. Madonna and Child
Tino da Camaino. Bishop
Antonio degli Orsi Monu-
ment: Virgin and Child
Tino da Camaino. Madonna
and Child
Tirolean. Madonna and Child
Vazquez. Seminary Madonna
Verrocchio. Madonna and
Child, relief
Verrocchio. Virgin and
Child, relief
Wenzinger. Virgin and Child
Wheeler, M. Madonna and
Child
Zurn, Martin and Michael
Zurn. Rose Garland Altar
--Madonna and Child on
Crescent Moon
Flemish--16th c. Madonna
Standing on Half Moon
French--15th c. Virgin and
Child on Crescent Moon
German--15th c. Madonna
and Child on Crescent
Moon#
German--16th c. Virgin and
Child on Crescent Moon
German--17th c. Virgin and
Child, seated figures on
Crescent Moon
Italian(?). Madonna and
Child on Crescent Moon
Krumper. Patrona Bavariae
Riemenschneider. Madonna
and Child on Crescent Moon

Zurn, Martin and Michael Zurn--
Foll. Virgin on the Crescent
Moon
--Marriage
Belgian--16th c. Marriage of
the Virgin, altar detail
French--15th c. Marriage of
the Virgin, altarpiece
detail
Orcagna. Tabernacle: Mar-
riage of the Virgin
(Sposalizio)
--Miracles
Corte. Queen of Heaven
Expelling the Plague
--Nativity
Dutch--15th c. Birth of the
Virgin
German--16th c. Birth of the
Virgin, relief
Orcagna. Tabernacle: Birth
of the Virgin
Pisano, Giovanni. Pistoia
Pulpit: The Nativity
--Presentation in the Temple
French--16th c. Presentation
of Mary in the Temple,
rood Screen
--Resurrection
French--12th c. Capital:
Resurrection of the Virgin
--Resurrection of the Virgin,
tympanum detail
--Visitation
Amadeo and Pupils of the
Mantegazzi. Certosa of
Pavia, south side facade:
Visitation
Byzantine. Visitation
Epstein. The Visitation
Flemish--10th c. Visitation
French--11th c. Visitation
French--12th c. The Visita-
tion#
French--13th c. Annunciation
and Visitation
--The Visitation
French--15th c. The Visitation
French--16th c. The Visitation
German--13th c. Visitation#
Haslin. The Visitation
Italian--8th c. Visitation
Italian--14th c. Visitation
Maitani--Foll. Wall Decora-
tion: The Visitation
Mansart. The Visitation, Dome
Master of the Sixtus Portal.
The Visitation

Sangallo, F. Angelo Marzi
Monument
The Marzocco. Donatello(?)
Masaryk, Tomas Garrigue (Czech
Statesman and Philosopher
1850-1937)
Stursa. T. G. Masaryk
Masaccio
Martini, A. The Partisan
Masaccio
MASCAUX, C.
Four Medals for Sports Prizes
CASS 140
Maschere Fountain. Italian--18th c.
MASCHERINI, Marcello (Italian 1906-)
Archangel Warrior 1962
VEN-62: pl 38
Awakening Spring (Risveglio
di Primavera) 1954 bronze;
L: 75
TRI 62; VEN-54: pl 6
Chimera 1960 bronze
MAI 198; SAL pl 34 (col)
Cock 1948 bronze; 19-3/4
SOBYT pl 122
Corrida 1960 bronze
SAL pl 33
Doric Figure (Figura Dorica)
1961/62 bronze; 116x22
ARTSI #13; VEN-62: pl XXVI
Faun 1953/54 bronze; 51
MID pl 68 BAM
--1954 bronze
GERT 235
--1958 bronze
SAL pl 31
Faunetto 1950 bronze
VEN-50: pl 45
The First Swallow (La Prima
Rondine) bronze
VEN-38: pl 117
Heroic Torso 1952 bronze;
79
MID pl 67 BAM
--1959 bronze; 63
TRI 62
Icarus 1956 bronze
VEN-56: pl 20
--1959 bronze
MAI 198
Minerva 1958 bronze; 14'9"
MID pl 131 BAM
My Mother bronze
VEN-40: pl 77
Orpheus 1954 bronze
GERT 234
Perseus bronze
VEN-42: pl 50

St. Francis 1956 bronze;
.80 m
SCUL pl 27
--1957 bronze; 89
MID pl 69 BAM
Sappho, detail 1958 bronze
SAL pl 32 (col)
La Terra 1943 bronze; 1.5 m
SCUL pl 26
Warrior 1961
VEN-62: pl 37
Woman Bather 1957 bronze;
59
BERCK 151
Woman Bathing 1957 bronze;
51-1/8
NEWTEM pl 164
MASCOLI MASTER (Master of the
Mascoli Altar) (Italian fl
1424-30)
Madonna with Angel, corner
chapel c 1430/35
SEY pl 43B IVF
Retable c 1430 marble
SEY pl 42 IVM
St. Paul marble; 23-5/8x
8-3/8
USNKP 395 UDCN (K-319)
St. Peter marble; 24-1/4x
8-1/2
USNKP 394 UDCN (K-318)
Virgin and Angel of the
Annunciation marble;
24-1/8x8-3/8; and
24-1/4x9
USNKP 392, 393 UDCN
(K-317, K-316)
Virgin and Child between SS
Mark and James 1430
marble; 130 cm
POPG pl 104 IVM
Virgin and Child with Two
Angels 1422 Istrian stone;
149x160 cm
POPG pl 105 IVMF
MASEGNE, Jacobello dalle (Italian
fl 1383-1409) See also Quercia,
J. della
MASEGNE, Jacobello dalle--ATTRIB
Miracle of the Stigmata,
predella relief, High Altar
1388/92 marble
SEY pl 1A IBoF
MASEGNE, Jacobello dalle and
MASEGNE, Pierpaolo dalle
Apostles, choir screen figures
1394 marble; c 53 JANSH
263; JANSK 539; MOREYM
pl 140 IVM

MASEGNE, Pierpaolo dalle (Italian)
 See MASAGNE, Jacobello
 dalle
MASIAK, Franciszek (Polish 1906-)
 Heroes of Warsaw Monument,
 2nd prize, 1958 competition
 JAR pl 11
Mask of Child. Penic
Mask of Montserrat Screaming.
 Gonzalez
Masked Man. Perez
Masker. Fontana, L.
Masks
 Angermair. Satyr Mask
 Arp. Mask
 Danish--11th c. Aarhus Runic
 Stone: Magic Mask with
 Inscriptions
 Despiau. Mask
 English--17th c. Samuel
 Butler Monument: Mask
 Flemish--16th c. Mask,
 expiatory symbol of con-
 demned prisoner
 Folk Art--Austrian. Devil
 Mask, Tyrol
 Folk Art--Swiss. Mask
 French--13th c. Funeral Mask
 French--14th c. Funerary Mask
 French(?)--19th c. Frederic
 Chopin, death mask
 --Napoleon, death mask
 Freundlich. Mask#
 Gargallo. Small Mask
 German--13th c. Capital:
 Leaf-framed Mask
 --Mask of Damned
 German--15th c. Centurion
 Group, altar detail
 Gonzalez. Mask
 Italian--13th c. Capital:
 Egyptian Mummy Mask
 --Mask in Foliage, pillar base
 Italian--15th c. Death Mask
 Italian--16th c. Mouths of
 Truth (Bocchi di Leone):
 Masks
 Manzu. Mask
 Medieval. Mystery Play Masks
 Michelangelo. Giuliano de'
 Medici Tomb: Night, detail
 --Mask
 Mills. Mask of Van Rijn
 Moore, H. Mask
 Permoser. Giant Mask
 Picasso. Mask
 Rodin. Hanako, mask

 Schluter. Courtyard Keystone:
 Dying Warrior Mask
 Stadler. Mask
MASO DI BARTOLOMMEO (Italian)
 Bronze Grille, detail
 POPR fig 135 IPrD
Mason, Thomas d 1559
 English--16th c. Thomas
 Mason Tomb
Mason, William d 1797
 Bacon, J. William Mason
 Monument
Masons (association) See Freemasons
Masons and Carpenters
 Flemish--14th c. Hakendover
 Altarpiece: Ladies and
 Masons
 German--14th c. Mason at
 Work, leaf corbel
 Robbia, L. della. Three
 Guild Emblems
Masque See Masks
MASRIERA, Luis
 Art Nouveau Brooch,
 Barcelona c 1909/10
 SOTH-2:185
The Mass See also Communion
 Arnoldi. The Eucharist,
 lozenge relief
 Foggini. Mass of S. Andrea
 Corsini
 French--9/10th c. Book
 Cover
 German. Carolingian Book
 Cover: High Mass
 Pisano, A. The Mass, relief
Massacre. Preault
Massacre of the Innocents
 Croatian. Massacre of the
 Innocents
 Franco-Flemish. Massacre of
 the Innocents
 French--11th c. Massacre of
 the Innocents
 French--13th c. Massacre of
 the Innocents
 --Porte Mere Dieu
 --St. Firmin Portal
 French--16th c. Massacre of
 the Innocents
 German--9th c. Book Cover:
 Annunciation; Adoration of
 the Magi; Massacre of the
 Innocents
 Gines. Massacre of the
 Innocents
 Pisano, G. Pistoia Pulpit:
 Massacre of the Innocents

1520 lindenwood; 147 cm
BERLE pl 64, 65 GBSBe
(8685)

MASTER OF ERISKIRCH (German fl 1400)
Mourning Woman c 1430
KO pl 58 GRotL

MASTER OF IMERWARD (German)
Crucifix, head detail
c 1160/70
BUSRO pl 111 GBrC

MASTER OF JOACHIM AND ANNE
(Dutch fl 1460/80)
Joachim and Anne at the
Golden Gate oak; 18-1/4
HAMF 262; RIJA pl 115
NAR

MASTER OF OSNABRUCK (German)--
FOLL
Twelve-year Old Jesus in the
Temple, Westphalia 1517/
20 oak; 40 cm
BERLE pl 77 GBSBe (436)

MASTER OF PASSAU
St. Christopher, High Altar
c 1490 wood
KO pl 63 GKe

MASTER OF RABENDEN (German)
Pieta, Bavaria c 1515 ptd
lindenwood
CLE 76 UOC1A (38.294)
St. Jacob, seated figure 1520
lindenwood; 103 cm
BERLEK pl 28 GBSBe
(3025)
St. Peter (Apostel Petrus),
Olbegruppe-figure, head
detail 1510 lindenwood;
101 cm
BERLE pl 60, 61 GBSBe
(3025)

MASTER OF SALZBURG
Virgin and Child c 1420
wood; 38-3/8
NEWTEM pl 99 SwZC

MASTER OF SAN TROVASO
Angels with Instruments of
the Passion, relief detail
c 1470 marble; 70x33 cm
POPR pl 132 IVT

MASTER OF SILOS
Sacred Figures, cloister
relief 11th c. stone
GUID 66 SpBD

MASTER OF THE BEAUTIFUL
MADONNAS (German fl
1390-1415)

Virgin and Child; detail, St.
Elizabeth Church, Wroclaw
c 1410 ptd artificial stone;
119 cm
WPN pl 75, 76 PWN (SR 8)

MASTER OF THE BEAUTIFUL
MADONNAS--FOLL
"Beautiful Madonna" c 1400
BUSR 32, 33 AVK
Madonna, head detail, Vesper
Group c 1410
BUSR 39
Vesper Picture: Pieta c 1400
BUSR 35 IBolS

MASTER OF THE BERNE CHOIR
STALLS
Master at Work c 1500
GOLDF pl 49 SwBeMu

MASTER OF THE CHURCH AND
SYNAGOGUE See MASTER OF
THE SYNAGOGUE

MASTER OF THE JUDGMENT PILLAR
See MASTER OF THE
SYNAGOGUE

MASTER OF THE KLOSTERNEUBERG
MADONNA (Austrian)
Virgin and Child (Klosterneu-
berg Madonna) c 1310
sandstone; 67-3/4
KO pl 55; NEWTEM pl 92
AVK

MASTER OF THE KRUMAU
MADONNA (Austrian fl 1400)
Krumau Madonna c 1410
KO pl 57 AVK

MASTER OF THE LAST JUDGMENT
The Last Judgment, tympanum,
main door 13th c.
GUID 131 SpLeA

MASTER OF THE MALBERG VIRGIN
Anne with Virgin and Child,
Wissembourg c 1480
stone
MULS pl 114A GBSBe

MASTER OF THE MARBLE
MADONNAS (Florentine fl 1312-
37)
Madonna and Child, relief
USNI 231 UDCN (A-38)

MASTER OF THE MASCOLI ALTAR
See MASCOLI MASTER

MASTER OF THE MERCY GATE
Mercy Gate, tympanum: Our
Lady with St. George and
St. Peter, and Emperor
Henry II and Empress
Kunigunde; Artist at the

Feet of Mary c 1210
BUSRO pl 149 GBaC
MASTER KO THE MOLSHEIM RELIEFS
(Netherlandish)
Adoration c 1465/70 limewood
MULS pl 115A FStrF
MASTER OF THE OSWALD
RELIQUARY (German)
Paten of St. Bernward, Guelph
Treasure, with German--
14th c. Monstrance 12th c.
silver gilt and niello
CLE 49 UOC1A (30.505)
MASTER OF THE PELLIGRINI
CHAPEL See MICHELE DA
FIRENZE
MASTER OF THE PISAN SCHOOL
Virgin of the Annunciation
c 1360 wood; 63-3/4
NEWTEM 17 (col)
IPisaMN
MASTER OF THE POEHLDE CHOIR
STALLS
Self Portrait: At Work 14th c.
GOLDF pl 8 GHaW
MASTER OF THE ROOD SCREEN
Wilhelm von Camburg, west
choir after 1249
BUSGS 81 GNaC
MASTER OF THE ST. JOHN BUSTS
St. John , bust c 1480
terracotta; 19-1/4
TOR 125 CTRO (956.182)
MASTER OF THE SCHONNEN
BRUNNEN
Prince (Furst), Nurnberg
1390 terracotta; 113 cm
BERLEK pl 9 GBSBe (366)
Prophet's Head 1390 sand-
stone; 21 cm
BERLEK pl 12 GBSBe (365)
MASTER OF THE SIXTUS PORTAL
The Visitation; details:
Elizabeth, head; Virgin,
head 1220
BUSGS 54-57 FRhC
MASTER OF THE STATUETTES OF
ST. JOHN
St. John 15th c. terracotta
CLE 82 UOC1A (42.781)
MASTER OF THE SYNAGOGUE
(MASTER OF THE CHURCH
AND SYNAGOGUE; MASTER
OF THE JUDGMENT PILLAR)
Angel with the Cross, head,
Judgment Pillar c 1220
red sandstone
KO pl 51 FStrMu

Angel with Trumpet, Judgment
Pillar c 1220 red sandstone
FO pl 51 FStrMu
Death of the Virgin, tympanum
BUSG 20-21; MOREYM pl
127 FStrC
--Apostles
BUSGS 23
Synagogue, Personification
of the New Testament, south
transept portal 1220/30
red sandstone; 77
AUBA 141 (col); KO pl 51;
MOREYM pl 125 FStrC
MASTER OF THE UNRULY CHILDREN
Quarreling Children--2 groups
MACL 125 ELV; GBK
MASTER OF THE UPPER RHINE
See LAINBERGER, Simon
MASTER OF THE VISITATION
(HEIMSUCHUNGSMEISTER)
Prince's Portal, tympanum
detail: Judge of This
World c 1230
BUSGS 64 GBaC
MASTER, P. E. (Peter Ehemann?)
(German 1510-58)
Cleopatra, relief 1532
alabaster; 22.4x15.9 cm
BSC pl 103 GBS (806)
MASTER RADOVAN
Door, detail: Adam on a
Lion c 1240
BUSRO pl 166 YTC
MASTER RIQUINUS
Door, details: Virtues
Trampling Vices; The
Flagellation 1152/54
bronze
BUSRO pl 100, 101 RuNS
MASTER ROBERTUS
Events from Life of Moses,
font detail c 1190 marble;
c 30
DECR pl 51; JANSK 437
ILuF
MASTER ROMUALD
Throne of Archbishop Urso,
Elephant supports 1078/89
BUSRO pl 32; DECR pl 202
ICanP
MASTER VOLVINIUS
Altar Antependium, back: Life
of St. Ambrose 835
KIDS 23-25 (col) IMA
MASTER WILHELM See WILIGELMUS
The Master Workman. Bouchard
Master Plaque. English--12th c.

Decorative Figure, seated
woman 1903 bronze; 29
DETS 73; READCON 34;
SELZJ 140 (col) UNNH
Deux Negresses 1908 bronze;
18-1/2
INTA-1:101
L'Escargot
ROTJT inside fr cov ELT
Female Figure, rear view,
high relief plaster
FRY 9; MILLER illus 196
Grosse Tete 1927 bronze;
12-5/8
CAN-2:190 CON
Group
TAFTM 26
Holy Water Fountain 1951
glazed ceramic
DAM 153
Jaguar (copy of Barye's
Jaguar) 1899/1901 bronze;
23x54 cm
LIC pl 182 -SwA
Jeannette I, III, IV, V (Jeanne
Valderin 1st-, 2nd-, 3rd-,
4th-state), head 1910/11
bronze; 13; 23-3/4;
24-1/8; 22-7/8
NNMMM 50 UNNMMA
--Jeannette I
LYN 102; MCCUR 253
--Jeannette II 1910 bronze;
10-3/8
LYN 102 UNNMMA
--Jeannette III
SELZJ 183
--Jeannette IV
HAMP pl 55A
--Jeannette V 1911
BAZINW 430 (col); LYN
102; MCCUR 253; READCON
36; RIT 132-3; SELZS 59
Jeanette V, head 1910/11
bronze; 22-7/8
GIE 21; HAMP pl 55B;
TORA 64 CTA (40/45)
Large Seated Nude (Grand Nu
Assis) 1907 bronze; 16-1/2
DETS 74; READCON 36
UNNH
Madeleine I 1901 bronze;
23-1/2x9x7
UCIT 27 UCSFM
--1901 bronze; 23-5/8
READCON 34 UMdBM
Nude 1929 bronze
LARM 282

Reclining Nude (Nu Couche)
bronze; 11
NM-14:49
--1907 bronze; L: 14
BERCK 23; MARC pl 10,
11 (col) FPM
--1918 bronze; 5-1/4
YAP 241 -UCr
Reclining Nude I (Nu Couche
ler etat) 1907 bronze; L: 19
ALBC-1:#183; TOW 65
UNBuA
--1907 bronze; 13-1/2
UPJH pl 240 UMdBM
--1907 bronze; 13-1/2
LOWR 199; RIT 59 UNNMMA
--1907 bronze; 29
READCON 39 UNNH
Reclining Nude II (Nu Couche
2me etat) c 1929 bronze;
11-1/8
READCON 39; TATEF pl
38h ELT (6146)
Reclining Nude III (Nu Couche
3me etat) 1929 bronze;
7-7/8
LIC pl 183; READCON 39
UMdBM
Reclining Woman
TAFTM 26
--(Woman Reclining) 1907
FEIN pl 138
Seated Nude bronze; 29-1/2
CLEA 5 UPPeI
--1925
ENC 609
--1925 bronze; 21-1/2
PUL-1:pl 64
--1925 bronze; 21-1/2
BOSME pl 71 UMoSLP
--1925 bronze; 31-1/2
YAP 240 -UD
--1925 bronze; 31-1/2
BMA 62; HAMP pl 169A;
READCON 37 UMdBM
Seated Nude, with Arms
behind Head 1904 bronze
SELZJ 182
Seated Woman 1908 bronze;
73 cm
COPGG 103 DCN (701A;
I. N. 2756)
Le Serf c 1900/05 bronze; 36
SOTH-3:76
La Serpentine (La Serpentina)
1909 bronze
MAI 200

--1909 bronze; 56x25x18 cm
 CAS pl 175
--1909 bronze; 22-1/4
 BOW 29
--1909 bronze; 22-1/4
 GIE 19; LIC pl 184;
 ST 427 UNNMMA
--1909 bronze; 22-1/4
 BMA 62; JLAT 31;
 READCON 35; TRI 20 UMdBM
The Slave 1900/03 bronze; 36
 EXS 97 UNNH
--1900/03 bronze; 36-1/4
 KUHB 36; RIT 58;
 SELZJ 182 UICA
--1900/03 bronze; 36-1/4
 CANM 402; MCCUR 253;
 READCON 34; UPJH pl 240
 UMdBM
--1900/03 bronze; 36-1/2
 BOSME pl 11 UMCF
--1900/03 bronze; 36-1/2
 SELZS 24 UNNBene
--1900/03 bronze; 95 cm
 LIC pl 181 UNNMMA
Standing Woman bronze;
 22-1/4
 CLEA 18 UPPeI
--c 1914 bronze; 22-1/4
 UNNMMAM #181 UNNMMA
--c 1914 bronze; 22-1/4
 NNMMARO pl 303 UNNRojM
Statuette 1945/47 bronze;
 5-3/4
 GIE 18 UPPiT
Tiare with Necklace (Tiare;
 The Tiera) 1930 bronze
 MAI 201 SnSA
--1930 bronze; 8
 BOW 30 ELGro
--1930 bronze; 8-1/2
 LIC pl 185; READCON 38
 UMdBM
--1930 bronze; 8-1/2
 GIE 22 UNNB
Torch of Hope 5-1/2x8-1/2
 BAA pl 35 UNNUN
Torso 1906 bronze; 8-5/8
 GIE 18 UNNV
Venus in a Shell (Venus on
 a Shell) 1931 bronze; 13
 DETS 75 UNNH
--1931 bronze; 13
 BMA 63; GIE 22;
 READCON 38; SEYT 47
 UMdBM
Woman Sitting
 TAFTM 26

Young Girl
 TAFTM 26
MATONS, Juan (Spanish) See ROIG,
 Juan
Matthew, Saint
 Adam, H. G. St. Matthew
 Brunelleschi(?). St. Matthew,
 tondo
 Ciuffagni. St. Matthew,
 seated figure
 Donatello. Pazzi Chapel,
 detail
 English--16th c. St. Matthew
 Wearing Spectacles
 Flemish--15th c. Apostles:
 St. Matthew, St. Andrew,
 St. Bartholomew
 French. St. Matthew
 French--13th c. Judgment
 Pillar: Sts. Matthew and
 Luke
 --St. Matthew, Limoges
 enamel
 --St. Matthew Writing his
 Gospel, relief
 --St. Simon, and St. Matthew
 German--12th c. Apostle
 Matthew, head
 German--15th c. St. Matthew
 Ghiberti. St. Matthew
 Gothic-French. St. Matthew
 Writing at Command of an
 Angel
 Goujon. Apostles John and
 Matthew, relief
 Italian--10th c. St. Matthew,
 ivory panel
 --St. Matthew, ivory situla
 Juni. St. Matthew
 Kuen, F. A. Facade Figures
 Michelangelo. St. Matthew
 Mucchi. St. Matteo
 Robbia Family--Foll. St.
 Matthew, tondo relief
 Rusconi, Camilo. St. Matthew
 Vigarny de Borgona. Royal
 Chapel Altar
Matthias, Saint
 Robbia, L. della. St.
 Matthias, tondo
Matthias (Holy Roman Emperor
 1557-1619)
 Fadrusz. Memorial to King
 Matthias, equest
Matthias Corvinus (King of Hungary
 1440-90)
 Foppa. Matthias Corvinus,
 King of Hungary, medallion

MATTHITJAHU
 Schatz, B. Matthitjahu, the
 father of the Maccabees
MATTIELLI, Lorenzo (Italian-
 Austrian 1682/88-1748)
 Old Woman with Pig 1712/38
 BUSB 139 AVSc
 Pluto and Proserpino 1719/24
 HEMP pl 61 AVSc
 Roof Figures 1738/48
 BOE pl 179 GDH
 Winter 1719/24
 HEMP pl 61 AVSc
Mattina. Haivaoja
MAUCH, Daniel (German)
 Virgin and Child 1530 ptd
 lindenwood; 75 cm
 MUL 32 GDalP
MAUDE-ROXBY, Jean (English
 1916-)
 Fish green Hornton stone
 BED 113
Maupassant, Guy de (French Writer
 1850-93)
 Verlet. Guy de Maupassant,
 bust
 Verlet. Maupassant Monument
Maurelio, Saint
 Baroncelli, and Domenico di
 Paris. St. Maurelio
Maurice, Saint
 Bamberg Master. St. Maurice
 as a Knight
 German--13th c. St. Maurice
 Italian--10th c. Ivory Panel
 Showing Christ in Majesty
 between Virgin and St.
 Maurice
 Romanesque. Shrine of St.
 Maurice
Maurice Tiberius (Eastern Roman
 Emperor 539-602)
 Byzantine. Medallion:
 Maurice Tiberius
Mausoleums See also Monuments
 and Memorials; Tombs
 Baudrenghien. Mausoleum
 Cavino. Artemesia; and
 Mausoleum of Halicarnassus,
 medallion
 German--17th c. Boimow
 Mausoleum
 Mirko. Mausoleum of the
 Fosso Ardeatine
Mauve Inside. Morland
MAWLA, Anwar Abdel (Egyptian
 1920-)

Maternity; detail
 SAID pl 11, 10 EgCS
--limestone; 41 cm
 SAID pl 14 EgCS
--limestone; 52.5 cm
 SAID pl 15 EgCS
Protestation against Atomic
 Bombs limestone; 100 cm
 SAID pl 12-13 EgCS
Maximian (Bishop of Ravenna
 546-556)
 Byzantine. Throne of Maximian
Maximilian, Archduke of Austria
 Flemish--15th c. Privilege
 Seal of Maximilian, Arch-
 duke of Austria
Maximilian I (Holy Roman Emperor
 1459-1519)
 Colin. Maximilian I Tomb
 Giusti, A. and G. Maximilian
 I Tomb
 Muskat. Maximilian, head
 Vischer, P., the Elder.
 King Arthur, Tomb of
 Emperor Maximilian
Maximilian I Joseph (Elector of
 Bavaria 1756-1825)
 Groff. Elector Maximilian
 Joseph of Bavaria
Maximilian Armor
 German--16th c. Armor,
 Maximilian Style#
MAY, Georg, II (Rumanian fl 1684-
 1712)
 Book Cover 1707 silver gilt
 repousse; 30x25 cm
 ARTSR pl 41-42 RBMN
 (Tp 31)
May, Lady d 1681
 English--17th c. Lady May
 Monument
May Day. McWilliam
MAYER, Giovanni (Italian)
 Amor Nostro marble
 VEN-10:pl 69
 Stille Iridescenti jeweled
 marble
 VEN-10:pl 68
MAYER, Johann Ulrich (Czech
 c 1666-1721) See also
 Aliprandi, Giovanni
 Ambit Portal, detail:
 Annunciation 1710
 STECH pl 40 CzBiO
 House Facade 1710
 STECH pl 39 CzPG
 St. Anthony of Padua 1707
 STECH pl 41 CzPCh

St. Jude Thaddaeus 1708
 STECH pl 42 CzPCh
MAYER, Johan Ulrich, and Johann
 BROKOFF
 Prague Portal with Statues
 1702/05
 STECH pl 17a CzPr
MAYER-MICHAEL, Wolfgang
 (Wolfgang Meyer-Michael)
 (German-Israeli 1890-)
 Zion bronze
 SCHW pl 40
Maynard, Lord d 1741
 Stanley, C. Lord Maynard
 Monument
Mazarin, Jules (French Statesman
 1602-61)
 Coysevox. Cardinal Mazarin
 Tomb
Mazer
 English--17th c. Temple
 Newsam Mazer
MAZZA, Giuseppe (Italian 1653-
 1741)
 Mourning over the Dead Christ
 terracotta; 26
 BOSMI 135 UMB(62.984)
 Rest on the Flight into Egypt
 terracotta
 CLE 143 UOC1A (64.427)
 St. Dominic Baptizing c 1720
 WIT pl 169B IVGP
MAZZACURATI, Marino (Italian
 1908-)
 Gerarchie 1954 bronze;
 1.50 m
 SCUL pl 35
 Monument to the Resistance
 in Parma 1955 bronze
 SAL pl 47, 48 (col);
 VEN-56: pl 29
 Nudo di Fanciulla 1953
 bronze; 1.25x.44 m
 SCUL pl 34 IRSen
MAZZETTI, Carpoforo, and
 Abondio STATIO
 Stucco Work, Palazzo Sagredo
 Bedroom c 1718
 NMA pl 186 (col)
 UNNMM (06.1335.1a-d)
Mazzini, Giuseppe (Italian Patriot
 1805-72)
 Turini. Giuseppe Mazzini,
 bust
MAZZONI, Guido (called: Il
 Modanino) (Italian fl 1473-
 1518)

Lamentation over the Dead
 Christ 1477/80 terracotta;
 LS
 MOLE 128; POST-1: 202
 IMoGi
Lamentation over the Dead
 Christ c 1492 terracotta;
 partially pigmented
 POPR fig 128, pl 120;
 SEY pl 127 ANAn
Man, head terracotta
 DEVI-2 BGMS
Nativity c 1480/85 ptd
 terracotta
 CHASEH 328 IMo
--Nativity, with "Suor Papina"
 terracotta
 MACL pl 187 IMo
--Donor as Shepherd
 SEY pl 128A
Old Man, detail 1490 ptd clay
 BURC pl 49 INMO
Stucco Decoration of Salon
 16th c.
 MATTB pl 1 IRSp
MAZZULLO, Giuseppe (Italian 1913-)
 Cranio 1966
 VEN-66: # 76
 Danzatrice 1952 bronze; .70 m
 SCUL pl 37 IRGiof
 Dormiente 1952 bronze; 1.20 m
 SCUL pl 36 IMeDo
 Fucilazione 1964
 VEN-66: # 75
 Woman Jumping 1957 bronze
 BERCK 303
MAZZUOLI, Giuseppe (Italian 1644-
 1725)
 Angels Carrying the Ciborium
 c 1700
 WIT pl 160A ISMa
 Death of Adonis marble;
 193 cm
 HERMA 19 RuLH
MEADOWS, Bernard (English 1915-)
 Armed Figure (Figura Armata
 in Piedi) 1963
 VEN-64: pl 159
 Bird 1956 bronze; 44
 LONDC pl 22
 Black Crab 1954 bronze; 17
 ARTS # 33 IreCP
 --1953 bronze; 17
 MYBS 85; WILMO pl 63
 ELG
 Brutus I (Opus 74) 1963
 H: 17 PRIV 88-89

Cock 1956 bronze; 36
 ARTSB-61:pl 4; GBA pl 4
--1957 bronze; 34x22-1/2x
 10-3/4
 CARNI-58:pl 79
Cockerel 1954
 ARTS #32
--1954 bronze; 12
 ARTS #32 EA
--1955 bronze; 24x30
 ARTSS #35 ELBrC
Crab bronze
 MAI 202; WILMO pl 64
--1955 bronze; 13
 ARTS #34; ROTJB pl 145
 ECamJ
Crowing Cock 1955 bronze;
 29-7/8
 TRI 148
Figure of a Woman 1950 iron;
 8-3/4
 RAMS pl 80b
Four Reliefs 1958 bronze
 TATEB-2:2 ELT (T.329)
Four Reliefs on a Cock Theme
 1959 bronze; L: 62
 ARTS #38
Frightened Torso (Opus 53)
 1961 bronze; 14-1/2
 HAMM 118
Head of Wounded Bird 1960
 bronze; 41
 ARTS #37
Large Flat Bird 1957 bronze;
 44
 READCON 226 ELG
Pointing Figure with Child
 1966 plaster, for bronze;
 30x30x30
 LOND-7:#26 ELG
Running Bird-Totem 1958 bronze;
 48
 ARTS#36 ELCont
The Seasons--Cock 1955 bronze;
 36
 ARTS #35 EWakeA
Seated Armed Figure 1962
 bronze; 15
 READCO pl 9b ELG
--"Personnage Tres Important"
 1962 bronze; 23-1/2
 SFMB #117
Shot Bird 1960 bronze; 45x48
 CARNI-61:#257; LOND-5:
 #31 ELG
Standing Armed Figure 1962
 bronze; 67-1/2
 LOND-6:#28 ELG

Standing Figure 1950/51 elm-
 wood; 61
 RIT 197 EA
--1951 elmwood; 61x18x15
 TATES pl 11 ELT (6208)
Startled Bird 1955 bronze; 23
 ALBC-2:#48 UNBuA
Tycoon (Opus 54) 1961 bronze;
 20-1/2
 HAMM 119 (col) SwGW
Watchers, detail 1966 plaster,
 for polyester resin; 18x
 36x60
 LOND-7:#25
Mechanical Energy. Pomodoro, A.
Mechanical Head. Hausmann
Mechlin Cabinet. Belgian--16/17th c.
Mechthild, Countess
 Multscher. Countess Mechthild
 of the Palatinate, effigy
 detail
"MEDALIST OF THE ROMAN
 EMPRESSES" (Italian
 c 1450-1500)
 Nero, medallion
 VER pl 43 UDCN
MEDALLA, David (Filipine-English
 1942-)
 Cloud Canyons, detail 1964
 ARTSM
 Cloud Canyons No. 2 1964
 KULN 184
 The First Sand Machine 1964
 KULN 184
Medals and Medallions See also
 Spinelli, Niccolo
 Abeele. William III, Prince of
 Orange, at the age of four
 Alberti. Self Portrait
 Amadeo. Annunciation
 Andrieu. Medal: Baptism of
 King of Rome
 Arondeaux. Medal: Coronation
 of William III and Mary II
 Austrian--18th c. Medal of
 Leopold I
 Beck, A. Aladar Schofflin
 Beck, F. O. Budapest Music
 School Medal
 Beck, F. O. Istvan Csok
 Beck, F. O. Istvan Ferenczy
 Beran. Ignac Alpar, medal
 Bertoldo di Giovanni. Alfonso
 of Aragon
 Bertoldo di Giovanni.
 Mohammed II
 Bertoldo di Giovanni. Pazzi
 Conspiracy Commemorative
 Medal

Bertolino. Mary Magdalene
Bertolino. Medal: Consiglio
 Provinciale dell' Economia
 di Roma
Bertolino. St. Christopher
Bertolino. V. E. Orlando
Bidischini. Medal
Boldogfai-Farkas. Professor
 Ferenc Czeyda-Pommersheim
Boldu. Youthful Caracalla
Borsos. Herkules Segers
Borsos. Rembrandt
Borsos. Vivaldi
Bourdelle. Czechoslovakian
 Crois de Guerre
Brescia. Niccolo Michiel
Burgundian. Medal of Con-
 stantine
Burgundian. Medal of
 Heraclitus
Bylaer. Medal: "Tandem Fit
 Surculus Arbor", reverse
Byzantine. Constantinople
 Founding Commemorative
 Medal: Constantinople,
 personification
Byzantine. Medallion#
Byzantine. Two Medallions:
 Life of Christ
Caradosso. Gangiacomo
 Trivulzio, square medal
Caradosso. Medal: Bramente's
 Design for St. Peter's
Caradosso. Attrib. Medal:
 Lodovico Sforza
Cavino. Artemesia; and
 Mausoleum of Halicarnassus
Cellini. Medal: Pietro Bembo;
 Pegasus
Clemente da Urbino. Medal:
 Frederico da Montefeltro
Coradino. Medal: Ercole d'Este
Dadler. Arrival of Princess
 Mary in Holland
David D'Angers. Alfred de
 Musset
David D'Angers. Delacroix
 Medal
Dupree. Medal: Henry IV and
 Marie de'Medici
Early Christian. Constantius
 II, in Chariot Crowned by
 Victories
Early Christian. Constantine II
 Enthroned between his Two
 Brothers
Early Christian. Medallion:
 Christ

Early Christian. Medallion:
 Justinian I
Early Christian. Necklaces
 and Medallions
English--16th c. The "Dangers
 Averted", or "Armada",
 Medal
--Henry VIII
English--18th c. George III
 Medal; reverse: Iroquois
 Hunter
--Royal Society Medal given to
 Franklin
Ferenczy, B. General Josef
 Bem
Ferenczy, B. Goya
Ferenczy, B. Leonardo da
 Vinci
Fiorentino, N. S. Girolamo
 Santucci
Fiorentino, N. S. Medal:
 Giovanna Albizi Tornabuoni;
 Three Graces
Fiorentino, N. S. Medal:
 Lorenzo de'Medici
Foppa. Matthias Corvinas
Francesco di Giorgio Martini.
 Medal: Alfonso of Aragon
French--12th c. Abbot Suger's
 Chalice: Christ--Pantocrator,
 repousse medallion
French--16th c. Charles IX,
 equest
French--20th c. Champlain
 Tercentary Medal
Gabel. Son of Martin III
 Geuder
German--16th c. Good King
 Rene
German--17th c. Elector
 Johann Sigusmund of
 Brandenburg, badge
Giambello--Foll. Medal:
 Agostino Barbarigo
Guazzalotti. Medal: Sixtus IV
Hagenauer, F.--Attrib.
 Portrait Medallion
Italian--15th c. Aldus Manutius,
 profile bust
--Ficino, medal
--Lorenzo de'Medici in
 Antique Armour
--Medal: Alexander VI
--Medal: Cosimo Vecchio
 de'Medici
--Nature and Grace, with
 Fountain of Life, medal of
 Constantine

Victoria and Albert,
profile heads
Zacchi, G. Medal of Doge
Andrea Gritti: Fortune
Medea
Paolozzi. Medea
MEDGYESSY, Ferenc (Hungarian
1881-)
Andras Jelky, model for
monument 1936 plaster;
185 cm
GAD 74 HBa
Dancer 1923 bronze; 100 cm
GAD 73
Equestrian 1927 bronze;
100 cm
GAD 76
Girl in Repose 1933 stone
VEN-58: pl 185 HBNG
Mother and Child 1917 stone;
40.5 cm GAD 75 HBA
Medical Inspection. Pettersen
Medici, Catherine de'
Robbia, Girolamo della.
Catherine de'Medici,
effigy
Medici, Catherine de' (1519-89)
Pilon. Henri II and Catherine
de'Medici Monument
Medici, Cosimo I de' (1519-74),
known as "The Great"
Bandinelli. Cosimo de'
Medici, bust
Bologna, Cosimo I, equest
Bologna, Cosimo I Receiving
Homage, relief
Cellini. Cosimo I de'Medici,
bust
Pierino da Vinci. Cosimo I as
Patron of Pisa, bust
Rossi, G. A. de'. Cosimo I
de'Medici and Eleanora of
Toledo and their Children,
relief
Medici, Cosimo Vecchio de' (1389-
1464), known as "Cosimo the
Elder"
Italian--15th c. Cosimo
Vecchio de'Medici, profile
bust
Verrocchio--Foll. Cosimo de'
Medici, profile bust
Medici, Ferdinand I de' (Grand Duke
of Tuscany 1549-1609)
Bandini and P. Tacca. Ferdi-
nand I
Bologna. Ferdinand I, equest

Medici, Fernando de'
Foggini. Fernando de'Medici,
bust
Medici, Francesco de (1541-87)
Poggini. Francesco de'Medici,
bust
Medici, Gian Giacomo de'
Leoni, L. Gian Giacomo
de'Medici Tomb
Medici, Giovanni de' (1360-1429)
Mino da Fiesole. Giovanni
de'Medici
Medici, Giovanni de' (Gian Carlo
de'Medici) (1475-1521)
See also Leo X
Foggini. Cardinal Gian Carlo
de'Medici, bust
Medici, Giuliano de' (1435-78)
Bertoldo di Giovanni. Pazzi
Conspiracy Commemorative
Medal (Murder of Giuliano
de'Medici)
Michelangelo. Giuliano
de'Medici Tomb
Pollaiuolo, A. Giuliano de'
Medici(?), bust
Verrocchio. Giuliano de'
Medici
Medici, Leopoldo de' (Cardinal
1617-75)
Bernini, G. L. Leopoldo de'
Medici, bust
Foggini. Cardinal Leopoldo de'
Medici
Medici, Lorenzo de' (1449-92), known
as "Lorenzo the Magnificent;
Il Magnifico
Benintendi--Attrib. Lorenzo
de'Medici, bust
Fiorentino, N. S. Medal:
Lorenzo de'Medici
Italian--15th c. Lorenzo
de'Medici
Michelangelo. Lorenzo
de'Medici Tomb
Niccolo Fiorentino--Attrib.
Lorenzo de'Medici, profile
bust
Verrocchio. Lorenzo de'Medici,
bust
Medici, Lorenzo de', the Younger(?)
(1463-1507)
Italian--16th c. Lorenzo
de'Medici, bust
Medici, Maria de' See Marie
de'Medicis
Medici, Piero de' (1414-69), known

as "Piero the Gouty"; "Il
Gottoso"
Mino da Fiesole. Piero de'
Medici, bust
Verrocchio. Piero de'Medici,
bust
Medici del Vascello, Marquesa
d'Antino. Marquesa Medici del
Vascello, bust
Medici Fountain. Brosse
Medici Madonna. Michelangelo
Medici Monument. Verrocchio
Medici Tombs. Michelangelo
See also Michelangelo.
Giuliano de' Medici Tomb;
Lorenzo de'Medici Tomb
Medici-Strozzi Chest
Italian--16th c. Cassone
Medicine See Physicians
Medicine Seller. Feilner
MEDIEVAL
Aquamanile:Dragon 12/13th c.
TAYFF 34 (col) UNNMM
Coins: Talers
BERLES 158 GBSBe
The Entombment, Chateau de
Biron
NM-11:13 UNNMM
Jesus Christ, head detail
12/14th c.
TAYFF 35 (col) UNNMM
Mirror Case: Hunting Scene
ivory
NM-11:12 UNNMM
Mystery Play Masks: Roman
Comic Slave; Roman Comic
Senex; Roman Soldier;
Tibetan Devil as Christian
Devil
STI 473
St. James 12/14th c.
TAYFF 35 (col) UNNMM
Visitation 12/14th c.
TAYFF 35 (col) UNNMM
Medieval Sports, ivory relief.
French--14th c.
Meditating Youth. Blumenthal
Meditation. Bernkopf-Colmar
Meditation. Martin, R.
Meditation. Rodin
Mediterranean. Anthoons
Mediterranean. Maillol
Mediterranean Group. Arp
Mediterraneo. Pinazo
MEDREA, Corneliu (Rumanian)
Torso bronze
VEN-42:pl 100

MEDUNETZKY, Kasimir (Russian
1899-)
Construction No. 557 1919
tin, brass, iron; 17-3/4
GIE 169; GRAYR pl 179;
READCON 91 UCtY
Medusa
Canova. Perseus with Head
of Medusa
Cataldi. Medusa
Cellini. Perseus with Head
of Medusa
Hungarian--14th c. Medusa
Head
Marqueste. Perseus and the
Gorgon
Nost. Perseus
Puget. Medusa, head
Schluter. Courtyard
Keystone: Medusa Head
Stahly. Medusa
Wolfers. Canova
Meekness. Canova
The Meeting. Koenig
Meeting Again
Barlach. The Reunion
Meeting of Leo I and Attila. Agardi
Meeting of the Waters Fountain.
Milles
MERGERT, Christian (Swiss 1936-)
Fountain 1965
KULN 177 SwI
Glass Sculpture 1964
KULN 160 SwLaL
Mehlmarkt Brunnen
Donner. Providentia Fountain
(Fountain of Mehlmarkt)
MEHUTAN, Hava (Israeli 1925-)
Procissae (5) 1962 wood;
85x69x12 cm
SAO-8
MEIER-DENNINGHOFF, Brigitte
(German-French 1923-)
Angel 1958 brass and zinc; 51
BERCK 164
Form in Tin Nr. 27 1957 tin;
60 cm
KUL pl 56
Form in Tin Nr. 56 1959
tin; 33x26 cm
KUL pl 58
Gust of Wind 1949 bronze
MAI 203
--1960 brass and tin;
44x41-1/4
READCON 241 UNNSt
Horus 1960
VEN-62:pl 144

Hurricane (Windsbraut) 1959
brass and tin; 1.25 m
KUL pl 57; OST 110 GDusB
Pharoa I 1961 36x12x14
CARNI-61:#259 ELNL
65/1 1965 brass; 27-5/8x
20-7/8x18-1/8
NEW pl 332 ELMa
Upward Movement (Bewegung
Aufwarts) 1956 brass and
tin; 90 cm
KUL pl 55 GNevS
Victory 1958 brass and tin;
70
BERCK 304
Wings 1958 H: 70-1/8
TRI 197
"Mein Ball". Steger
Meissen, Friedrich von (Bishop
1063-84)
German--11th c. Female
Saint, relief, east tower,
Church of St. Maurice,
built by Bishop Friedrich
von Meissen
Meissen China See German--17th c.
German--18th c. Kandler,
J. J.
MEISSONIER, J. A.--FOLL
Louis XV Candlestick, with
putto ormolu
SOTH-2:223
MEISTER DER SCHONEN MADONNEN
See MASTER OF THE
BEAUTIFUL MADONNAS
MEIT, Konrad (Swiss-Belgian c
1480-1551)
Adam and Eve beechwood; 10
HAMF 84; KO pl 85 AVK
--boxwood
CLE 106 UOC1A (46.491)
Charles V, bust 1519/20
ptd wood
DEVI-2: LARR 207 BBrG
Entombment 1496
MULS pl 192A GMBN
Falconer 1500 pearwood;
31.3 cm
MUL 58 AVK
Judith, Mecheln 1515 bronze;
22.5 cm
MUL 59 GCoKK
Judith (Judith with Head of
Holofernes) c 1520 ptd
alabaster; 11-3/4
BUSR 194; CLAK 325;
KO pl 85; LIL 160; MOLE
93 (col); VEY 150 GMBN

Lamentation of Christ 1526/28
alabaster; 180 cm
MUL 65 FBesC
Madonna and Child, half
figures, Maes Chapel 1525
marble; 62 cm
MUL 64 BBGu
Margaret of Austria 1531
marble; over LS
MUL 62 FBrK
Margaret of Austria
(Erzherzogin Margarethe
von Osterreich), bust 1518
boxwood; 7.4 cm
MUL 6 (col) GMBN
Margaret of Austria Tomb
1526/31 marble; 228x
137-3/4
BUSR 197; HAMF 263;
MUL 63 FBrK
Nude Man c 1510
BUSR 195 AGJ
Philibert the Handsome
(Philibert le Beau;
Philibert der Schone),
Duke of Saxony, bust 1520
boxwood; 11.6 cm
BSC pl 100 GBS (818)
Philibert the Handsome Tomb
1528/31 marble
MILLER illus 101; MOLE
91; MUL 60, 61 FBrK
--Sibyl
BAZINW 320 (col)
Young Man, bust
POST-1:251 ELBr
Mekanik Zero. Paolozzi
Melancholy. Stursa
Melancholy Girl
Stursa. Melancholy
Melancholy Madness. Cibber
Melbury Bubb Font. Anglo-Saxon
Melchior, King
Netherlandish. King Melchior
Melchizedek
French--13th c. Abraham and
Melchidedek
French--13th c. Melchizedek
Meleager
Antico. Meleager
Byzantine. Atlanta and
Meleager
Flemish--17th c. Meleager
Meleager Sarcophagus. Italian--14th c.
MELI, Salvatore (Italian 1929-)
Corpo Sospeso 1958 ptd
terracotta
VEN-58: pl 56

Forma Sospesa ceramic;
2.44 m
SCUL pl 74 (col)
Vaso Uccello 1957 ceramic
SCUL pl 75
MELIDAY ALINARI, Arturo (Spanish
1848-1902)
Tomb of Christopher Colombus
LARM 218 SpSC
MELIOLI, Bartolommeo (Italian)
Personification of Health,
medal 1480's
PANB 22
MELIORANZIO, Gregorio (Italian)
Facade Detail: Atlantean
Figure; Winged Lion 12th c.
DECR pl 86 ISpM
MELLER, Willi (German)
Chimney Piece, private house
AUM 6
Commercial Building Doorway
AUM 2, 3 GEAr
Commercial Building Figures
AUM 2, 3 GDusMe
Commercial Building Sculptural
Decorations
AUM 7 GEV
MELLI, Roberto (Italian 1885-1958)
Adolescente (Giovinetta) 1911
sbal zo su rame; .97x.67 m
SCUL pl 6
Vincenzo Costantini 1913 bronze;
.58 m
SCUL pl 7
--relief head 1913 stone
SAL 13
Woman in a Black Hat (La
Signora col Cappello Nero)
1913 bronze
SAL 13; VEN-60:pl 28
IRMo
Mellini, Pietro
Benedetto da Maiano. Pietro
Mellini, bust
Mellish, Joseph
Hancock, J. Joseph Mellish,
recumbent effigy
MELNIKOFF, Aaron (Aaron Melnikow)
(Russian-English 1903-)
Joseph Trumpeldor Monument
SCHW pl 62 IsTel
Lord Conway, bust bronze
CASS 36
"Melody". Augustincic
Melon Capitol: Foliate Surface.
Byzantine
MELOTTI, Fausto (Italian 1901-)

Composizione Astratta in
Gesso 15 1935 plaster
VEN-66:#15
Melpomene
Janniot. Melpomene
Melun, Jan de
Flemish--16th c. Jehan de
Melun and Two Wives Tomb
Melusine III. Marcks
Melville, Viscount See Dundas, Henry
MEMLING, Hans (Flemish 1430?-94)
Niccolo di Forzore Spinelli,
Florentine Medallist
BODE 215 BA
Reliquary of St. Ursula 1489
LARR 83 BBrJe
Portraits
Wiener, L. Hans Memling,
medal
Memorials See Monuments and
Memorials
"Memorienpforte". Gerthner
Memories. Krsinic
The Memories Comforting Sorrow,
relief. Bistolfi
Memory of the Men in Concentration
Camp No. 4 Minguzzi
Memphis. Tucker
MENA, Pedro de (Pedro de Meno)
(Spanish 1656-1704)
Boy Saint 17th c. ptd wood;
LS
MOLE 228
Maria Dolorosa, half figure 1673
GOME front (col); VEY 194
SpMaD
Mary Magdalene (Penitent
Magdalen) 1664 ptd cedar;
c LS
CIR 108 (col); GOME pl
69-70; GUID 250; MOLE
228 SpVME
St. Diego of Alcala 1654/58
KUBS pl 83B SpGAnt
St. Francis of Assisi c 1663
ptd cedar; c 1/2 LS
BUSB 88; CHENSW 400;
GARDH 416; GOME 23
(col); KUBS pl 83C; LARR
187; MOREYC 119; POST-
2:75; VEY 285; WES pl 28
SpTC
St. Peter of Alcantara ptd
wood; 33-1/2
GOME pl 71-72 SpBaG
Virgin of Bethlehem, tondo c
1664 (destroyed 1931)

CHASEH 413; KUBS pl 85
SpMalD
Virgin of Sorrows mid 17th c.
ptd wood; 16-3/4
MOLE 229; VICF 73 ELV
(1284-1871)
Menas, Saint
Byzantine. Pyx, details:
Martyrdom of St. Menas;
Sanctuary of St. Menas,
with Camel Heads
MENDELSOHN, Erich (Architect)
Einstein Tower (Einstein
Observatory) 1921
BOE pl 204 GPo
MENDES DA COSTA, J. See COSTA,
Joseph Mendes da
Mendicant. Cherchi
Mendoza, Mencia de (Wife of Don
Pedro Hernandez de Velasco)
Spanish--16th c. Dona Mencia
de Mendoza, effigy
MENELAUS, Adam (Adam Menelas)
(English d 1831)
Egyptian Gate, detail c 1829
HAMR pl 167A RuPet
Menhirs
French--17th c. Christianized
Menhir of St. Duzec
Menhirs
Hepworth. Two Figures
Menin Gate. Aumonier, W.
MENO, PEDRO DE See MENA,
Pedro de
Menorah
Elkan. Menorah
Jewish--2nd c. Man in Armor
Carrying Menorah on Head
Palestinian. Menorah
La Mer. Conde
MERCADENTE, Lorenzo (Flemish fl
1454-67)
The Nativity 15th c. terra-
cotta
GUID 142 SpSC
Saint c 1460
MULS pl 150A SpGerC
MERCANTE, Luciano (Italian 1902-)
L'Incubo medallion 1952
bronze
VEN-52: pl 54
St. Paul, medallion 1950
bronze
VEN-50: pl 36
Merchants and Markets
French--16th c. Pillar of
the Merchants

Robbia, L. della. Arms of
the Guild of Silk Weavers
and of Merchants
Verhulst, R. Purchase of
Butter
Wijnants. Market Vendor
MERCHI, Gaetano (Italian)
La Guimard, bust terracotta
HUBE pl 1 FPDec
MERCIE, Antonin (French)
Baudry Monument
TAFTM 31
Gounod Monument
TAFTM 35
Quand Meme marble
MARY pl 54 FP
Mercury See Hermes
Mercy
Gibson. Queen Victoria between
Justice and Mercy
Kennington. Mercy
Mercy Altar. German--18th c.
Mercy Gate. Master of the Mercy
Gate
Mercy Seats
Asam, E. Q. Mercy Seat
English--15th c. Dean Hussey
Tomb
French--15th c. Holy Trinity
(Mercy Seat)
Netherlandish. Mercy Seat
MEREDITH-WILSON, Alice
The Spirit of the Crusades,
World War I War
Memorial plaster, for
bronze
MARY pl 130 ScPa
Meridian. Hepworth
MERKEFF, Marco
Male Head
CASS 59
MERLIER, Pierre (French 1931-)
Seated Woman 1959 terracotta
MAI 204
Mermaids
French--11th c. Capital:
Mermaid with Double Tail
French--12th c. Romanesque
Roundels: Dog; Acrobat;
Siren
German--16th c. Pendant:
Mermaid
German, or Austrian--17th c.
Chandelier: Mermaid
Italian--16th c. Mermaid,
Jeweled pendant
Jerichau. Hvilende Havfrue med
to Saelhunde

Kolbe. Mermaid
Laurens. Mermaid
Milles. Fountain: Mermaid
Schwitters. Mermaid's Purse
Mermen
Tacca. Mermen, fountain
MEROVINGIAN
Animal Fibula 7th c.
TAYFF 34 (col) UNNMM
Buckle c 7th c. bronze,
silvered and engraved
FAIN 187 UMWA
Buckle, with interlacing and
styled animal heads and
feet, Bourgogne 7th c.
LARB 85
Capital, detail: Lion 6th c.
CHAR-1:246 FPL
Capitals, Jouarre 7th c.
marble
BAZINW 209 (col)
Crucifix Athlone c 800
bronze
MOREYM pl 59 IreDNB
"Eye Coin" gold
MALV 225 FPMe
Fibula gold
MOREYM pl 57 GKo
Fibulae: Birds 5/6th c. gilt
bronze
NCM 287, 288 UNNMM
(11.192.44 and 45)
Throne of Dagobert, lion
legs 7th c.
ROOS 73F FPL
"Translation of Relics", scene,
bas relief 7th c.
LARB 100 FVi
Meru II. Tucker
Merz Construction. Schwitters
Merz Relief. Schwitters
Merzbau. Schwitters
Merzbau I. Schwitters
Merzbild. Schwitters
MERZER, Arieh (Polish-Israeli
1905-)
Eve, relief silver
GAM pl 112
MESA, Juan de (Spanish 1583-1627)
Christ of the Great Power,
head detail ptd walnut;
larger than LS
GOME 20 (col) SpSL
Christ of Love 1618 ptd
wood
VEY 283 SpSS
Christ of the Good Death c 1619
KUBS pl 81B SpSUC

Christ Recumbent
VEY 195 SpSG
Figure terracotta; 11.5 cm
SAID pl 75 EgCH
John the Baptist, head 1625
ptd wood
GOME pl 60 SpSC
Virgin of the Grotto (Virgen
de las Cuevas) ptd cedar;
less than LS
GOME pl 61 SpSMA
MESAK, Seyada (Egyptian 1929-)
Peasant Woman, detail
terracotta
SAID pl 74 EgCH
MESSEL, Alfred (Architect)
Doorway 1897/1904
BOE pl 193 GBW
MESSERSCHMIDT, Franz Xavier
(German 1736-83)
The Archfiend, character
head after 1770
KO pl 94 AVBa
"Character Head"
LARR 373 AVO
Gerard van Swieten, bust
1769 gilded lead
HELM pl 185 AVBa
Male Head mid 18th c. lead
MOLE 252 ELV
Old Man Smiling c 1770 lead
HELM pl 185 AVBa
A Rascal c 1780 lead; 11-1/2
NOV pl 182a AVO
Self Portrait, head c 1770
GOLDF pl 349, 350 CzBrN
Self Portrait: "Dismal Gloomy
Man", character Heads
Series c 1770
GOLDF pl 351 AVBa
Self Portrait: "Man in
Distress", Character Heads
Series c 1770
GOLDF pl 352 AVBa
MESSINA, Francesco (Italian 1900-)
Beatrice 1959 bronze
SAL pl 18 (col)
Bianca wax
VEN-40:pl 37
--1938 ptd terracotta
SAL pl 17
The Boxer
HOF 59
Cardinal Ildefonso Schuster,
Archbishop of Milan gilded
bronze
VEN-42:pl 10
Countess Edda Ciano, head
CASS 41

Eva, detail 1948 bronze; 2 m
 SCUL pl 19
Fiorella Rasini, head 1956
 terracotta
 VEN-56: pl 2
Head of a Fisherman bronze
 HUX 94
Lovers 1927 bronze
 VEN-28: pl 60
Luigi Federzoni, head bronze
 CASS 58; VEN-36: pl 4
Narciso 1945 bronze; 1.10 m
 SCUL pl 18
Nude Boy bronze VEN-34: pl 77
Pieta bronze VEN-26: pl 38
Pugilist, detail bronze
 VEN-30: pl 142
Swimmer (Nuotatore) bronze
 VEN-32: pl 185
Messkin
 Ben-Zvi. Actor Messkin, head
MESZAROS, Laszlo (Hungarian 1905-
38)
 Self Portrait, head 1927 bronze;
 30 cm
 GAD 92 HBA
 Young Peasant 1930 bronze;
 180 cm
 GAD 90 HBA
Meta-Mechanic Relief. Tinguely
Metabus (King of Volsques)
 Raggi, N. B. Metabus
Metal Construction with Planes in
 Color. Constant
Metal Sculpture# Dzamonja
Metal Sculpture. Picasso
Metal Sculpture. Teana
Metallurgica. Franchina
Metallurgy
 Kepinov, G. Metallurgy
 Pisano, Andrea. Arts, reliefs
Metamechanical Sculpture. Tinguely
Metametic No. 17. Tinguely
Metamorphose. Laurens
Metamorphosis. Baum
Metamorphosis. Guerrini
Metamorphosis. Masson, A.
Metamorphosis
 Picasso. The Bull
 (Metamorphosis)
Metamorphosis. Rivera
Metamorphosis of Daphne
 Bernini, G. L. Apollo and
 Daphne
Metamorphosis of Ovid. Rodin
Metaphysical Box, Number 1. Oteiza
Metronus, Saint
 German--11th c. St. Metronus,
 head fragment

METTEL, Hans (Swiss-German
 1903-)
 Entrance Facade 1954 brick
 DAM 162 GFSTs
 Kruzifix als Kriegerehrung 1934
 wood; 2.10 m
 HENT 109 GSch
 Man with Horse (Mann mit
 Pferd) 1951 bronze; 16-1/8
 GERT 213; NNMMAG 180
 GH
 Das Paar II 1952/53 elm;
 1.60 m
 OST 81
 Seated Man 1954 plaster, for
 bronze; 25-1/4x10-5/8x
 16-1/2
 TRI 78
METTERNICH, Karl von d 1636
 Rauchmiller. Bishop Karl von
 Metternich Tomb
Metternich, Klemens (Austrian
 Diplomat 1773-1859)
 Thorvaldsen. Prince Clemens
 Metternich, bust
METZNER, Franz (Austrian 1870-)
 The Abbess
 TAFTM 58
 "Battle of the Nations" Monu-
 ment, interior detail
 c 1905
 STI 745 GL
 Bust of a Lady
 TAFTM 60
 Buttress: Human Face, and
 Figures
 JAG 77 GBRe
 A Child
 TAFTM 60
 Column Figures
 AGARN 162 GBNew
 The Dance
 TAFTM 61
 Fountain Detail: The Earth
 TAFTM 58 GRei
 Hans Teitz: Decorative
 Details
 TAFTM 59 GDus
 Industry
 TAFTM 61
 Leipsig Monument, interior
 detail
 CHASEH 459 GL
 The Mother
 TAFTM 62
 Music
 TAFTM 61
 Otto II, bust
 TAFTM 58

Peasant Woman
 CHENSP 283
Rheingold Haus: Details of
 Decoration
 TAFTM 58, 59 GB
Sitting Female Figure
 TAFTM 60
Sorrow Burdened
 TAFTM 60
Stelzhamer Monument
 TAFTM 61
Volkerschlacht Monument
 1912 granite
 MARY pl 81; TAFTM 55,
 57, 59 GL
Willing Sacrifice
 AGARN il 33 GLVo
Meum I. Epstein
MEUNIER, Constantin (Belgian 1831-
 1905)
Antwerp Docker 1893 bronze
 DEVI-2: GOR 31; MARY
 pl 33; TOW 38 BAR
The Docker (Dockhand;
 Stevedore)
 ENC 621; TAFTM 78
--bronze; 47 cm
 WPN pl 64 PWN (131575)
--1890/93 bronze; 19-1/4
 ROTHS 233; STI 725 FPLu
--1903
 LIC pl 110 NASu
--1905 bronze
 MAI 206
--1905 bronze; 87
 MID pl 3 BAM
Firedamp (Coal Damp; Le
 Grisou) 1903 bronze;
 120 cm
 BAZINW 423 (col); GOR
 29; LIC pl 111; MARY pl
 122 BBM
The Hammerman
 GOR 28 UICA
--1884
 TOW 38 UNBuA
--rear view
 ALBA
--1886 bronze; 19-1/2
 RAMS pl 18b EBradC
The Ironworker 1896 bronze;
 57
 HAMF 278; TAFTM 78 BBR
Longshoreman 1893 bronze;
 c 86
 JANSK 971 FPL
--1905 bronze; c 40-1/2
 MCCUR 250 GF

Marteleur LS
 UPJH pl 201 FPLu
Maternity
 VEN-7: pl 79
Miner 1896 bronze
 ROTHS 233 BBR
Miners
 TAFTM 78
Mineur au Travail c 1890
 HERB pl 19
Monument to Labor, detail:
 The Harvest 1898 stone;
 94-1/2x165-1/2
 HAMF 279; RAY 59 BBM
--detail: Industry
 HAMF 303; PRAEG 425;
 ROTHS 237
--Miner Working a Vein
 ROTHS 235
The Porter
 STA 115
--c 1900 bronze; 90
 NOV pl 191a AVK
The Prodigal Son bronze
 MARY pl 70 BG
The Puddler
 GOR 30; LARM 151 BBR
The Reaper bronze
 SELZJ 86
Return of the Miners
 BARSTOW 197; CHASEH
 469; POST-2:186
The Smith, relief
 ROOSE 295 BBMu
The Soil bronze
 SELZJ 87
The Sower
 ROOSE 295 BBBo
--1896 bronze; 91
 MID pl 4 BAM
 Portraits
Rousseau, V. Constantin
 Meunier, bust
Meyer, Agnes
 Despiau, Charles. Mme.
 Agnes Meyer, head
Meyer, Mrs. Eugene
 Despiau, Charles. Mrs.
 Eugene Meyer, head
MEYER FASSOLD, Eugen (German)
 Two Women bronze
 VEN-24: pl 110
MEYER-MICHAEL, W. See
 MAYER-MICHAEL, W.
MEYLAN (Swiss 1920-)
 Sculpture iron
 MAI
 206

MEYNAL, Bertrand de (Genoese fl
 1508)
 Fountain from Gaillon 1508
 BLUA pl 2B FLar
La Mezzana. Rosso, M.
Mezzetin See Commedia dell'Arte
Mice
 Romanesque--Spanish.
 Capital: Fable of the Cat
 and Mice
Michael, Saint, the Archangel
 Andri. Angel Michael
 Byzantine. Archangel Michael#
 Byzantine. Pala D'Oro
 Czech--17th c. St. Michael
 the Archangel
 Danube School. St. Michael
 Dreyer. St. Michael
 Duret. St. Michael Overcom-
 ing the Devil
 English--11th c. Tympanum:
 Archangel Michael
 --Tympanum; David and Lion;
 St. Michael and Dragon
 English--12th c. St. Michael
 Fighting the Dragon, lintel
 relief
 --Tau Cross: St. Michael
 Fighting the Dragon, head
 detail
 --St. Michael and the Dragon,
 tympanum
 --Tympanum: Archangel
 Michael#
 --Tympanum: St. Michael and
 the Dragon
 English--16th c. St. Michael#
 Epstein. St. Michael and the
 Devil
 Flaxman. Satan Overcome by
 St. Michael
 French--12th c. Archangel
 Michael
 --Royal Portal: Archangel
 Michael
 --St. Michael, relief
 French--13th c. Last Judg-
 ment: St. Michael Weighing
 Souls
 French--14th c. St. Michael
 French--15th c. Christ of
 Pity, Adored by Donors,
 with St. Michael, and St.
 William of Aquitaine
 French--15th c. St. Michael
 French--16th c. St. Michael
 Killing the Dragon

Gerardi. L'Arcangelo Michele
 e il Dragone
Gerardi. St. Michael, study
Gerhard. Archangel Michael
Gerhard. St. Michael Slaying
 the Devil
German--9th c. St. Michael,
 relief
German--11th c. Basle Ante-
 pendium
German--12th c. Archangel
 Michael
--Michael, cross base
German--13th c. Archangel
 Michael, choir relief
German--14th c. Archangel
 Michael
German--15th c. St. Michael#
German--18th c. St. Michael
Gilbert, A. Duke of Clarence
 Tomb
Gunther. Archangel Michael
Master H. L. Altarpiece:
 Michael Weighing Souls
Millan. St. Michael
Pacak, J. St. Michael the
 Archangel
Pacher. St. Michael, head
Portuguese--15th c. St.
 Michael
Reichle. Archangel Michael
 Victorious over Satan
Robbia, A. della. St. Michael
Romanesque--English. Tym-
 panum: Beasts Feeding on
 Tree of Life; St. Michael
 Fighting the Dragon
Russian--13th c. Helmet of
 Yaroslav, Russian Prince,
 with medallion of St.
 Michael
Weiss, F. I. St. Michael
Zurn, Marin and Michael.
 Rose Garland Altar: St.
 Michael
Michael VII Dukas (Eastern Roman
 Emperor fl 1067-81)
 Byzantine. Holy Crown of
 Hungary
MICHAHELLES, Ruggero (Italian
 1898-)
 Il Duce, head bronze
 VEN-36: pl 1
MICHEL, Claude See CLODION
MICHEL, Gustave (French)
 Beethoven Monument
 TAFTM 47

Jules Ferry Monument
TAFTM 34
MICHEL, Jean (French), and
Georges DE LA SONNETTE
Entombment: Mary Magdalen;
Joseph 1451/ 54
MULS pl 66, 67 FToH
-- : Virgin, head
BAZINL pl 248
MICHELANGE See SLODTZ, R. M.
MICHELANGELO (Italian 1475-1564)
Angel Bearing Candlestick,
Arca di San Domenico
Maggiore 1494/ 95
marble; 20-1/2
MACL 185; MOLE 148;
POPRB pl 1 IBoD
Apollo (Apollo-David; David-
Apollo marble; 146 cm
CLAK 65; POPRB pl 22;
SEYT 22; WOLFFA 55;
WOLFFC 47 IFBar
Apollo with Violin marble
BODE 190 GBK
Atlas Slave marble; 277 cm
POPRB pl 17 IFA
Awakening Slave marble;
267 cm
POPRB pl 19 IFA
Bacchus and Faun 1497/ 99
marble; 80
BARG; KO pl 82; MAR
73; NEWTEM pl 126;
POPRB pl 10, 11; ROOS
115A; SCHERM pl 12;
SEY pl 159 IFBar
Battle of Centaurs and Lapiths
c 1490/ 93 marble; 84.5x
9.5 cm
BODE 191; CANK 162;
CHENSW 384; CLAK 203;
MONT 109; POPRB pl 2;
SEY pl 153A IFB
Bearded Men, kneeling figures
16th c. marble; 44x22
DETD 70 UNNFre
Bearded Slave marble; 263 cm
POPRB pl 18 IFA
--unfinished 1519 marble
GARDH 6 IFA
Bound Slave (Dying Captive;
Dying Slave; Sleeping
Captive) 1513/19 marble;
c 89
BAZINH 256; BAZINW 347
(col); BUSR 219; CHAR-2:
53; CHASEH 337; CLAK
245; FELM 379; GAF 141;

GOMB 228; HOF 37; HUYA
pl 51; HUYAR 82; JANSH
358; JANSK 690; KO pl 82;
LOUM 87; MACL 201; MOLE
155 (col); MONT 111;
MOREYC 116; MYBU 379;
MYRS 43; NEWTEM pl
130; POPRB pl 16; POST-
1:221; RAMS pl 22a; RAY
6, 43; READAS pl 9-5;
ROBB 328; ROOS 115D;
ROTHST pl 14; RUS 72;
SEW 607; STI 587; TAYFF
67 (col); UPJ 296; UPJH
pl 123; VALE 18; WOLFF
71 FPL (696)
Bruges Madonna c 1506 marble;
50
CANK 48; CHRP 202; DEVI
2; GARDH 287; GUIT 81;
MOLE 151; POPRB pl 7, 8;
ROBB 377; ROOS 114D;
STA 81; VER pl 54;
WOLFFA 48; WOLFFC 42
BBrN
Brutus, unfinished figure
c 1539 marble
BARG; BAZINL pl 250;
MALV 634; MCCA 27;
MILLER illus 129 IFBar
Christ de Pitie Supported by
Two Angels, between
Adoring Saints, retable 15th
c. stone
LOUM 80 FPL (631)
Crouching Boy early 1530's
marble; 54 cm
HERM il 47; HERMA 17;
WOLFFA 191; WOLFFC
194 RuLH
Crucifix, Sacristy 1492 wood
BAZINW 346 (col) IFSp
Cupid ("The Giant") 1501/04
marble; 18'
AUES pl 20; BARSTOW
148; BAZINW 346 (col);
BIB pl 165; BR pl 8;
BROWF-3:19; BUSR 218;
CHENSW 385; CRAVR 82;
DIV 27; ENC 623; FAYFF
66 (col); FREEMR 173;
GARDH 348; HALE 114
(col); HAUSA pl 30; JANSH
357; JANSK 688; LARR
196; MAR 74; MCCA 25;
MILLER il 127; MURRA 274;
MYBA 403; MYBU 377;
NEUW 57; POPRB pl 12, 13;

RAD 343; READAS pl 96-98;
ROBB 359, 376; ROOS
114H-J; RUS 70; SIN 276;
ST 302; UPJ 295; UPJH pl
122; WOLFFA 54; WOLFFC
47 IFA
--head detail
BAZINL pl 253; FAUL 471;
MARQ 211
--torso detail
CLAK 62
David 1529 stone
BARG; CHENSW 385 IFBar
David, model marble; 14-1/2
NCM 42, 43 UNcRV
David, reproduction
REED 70 UCGF
Descent from the Cross,
relief bronze; 287x220 mm
DETD 140 UCStbMo
Entombment
AUES pl 22 IF
Giovannino c 1495 marble
BODE 179; WOLFFA 265;
WOLFFC 270 GBS
Giuliano de' Medici Tomb
1524/33 marble; central
figure: 71
BAZINW 348 (col); CHRC
fig 164; ENC 623; FLEM
381; FREEMR 177; GARDH
364; GAUM pl 43; JANSH
361; JANSK 691; MONT
389; NEWTEM pl 132; PANS
155; POPRB fig 17;RAY
43; TAYFF 69 (col); UPJ
297; UPJH pl 122; WOLFFC
184 IFLo
--central figure
RAMS pl 17a; RUS 70
--Entablature: Fresco of the
Brazen Serpent in the
lunette, The River Gods
(reintegration by A. E.
Popp)
PANS 145
--Giuliano de' Medici, bust
marble; 173 cm
HALE 172; POPRB fig 17,
pl 24, 26; ROOS 115H;
SEW 614
--Night and Day
ROBB 380; ROOS 115E
--Day (Il Giorno), right
figure marble; L: 185 cm
BAZINW 349 (col); CHASE
199; CHENSN 380; CHENSW
389; CLAK 248; CRAVR 86;

GARDH pl 41, 43; HAUS
pl 17; MACL 209; MILLER
il 123; NEWTEA 151;
POPRB fig 26, 28, pl 29,
31; ROTHS 167; UPJH pl
122; WOLFFC 189
--Day, wax model
MILLER il 121
--Night, left figure marble; L:
76
AUES pl 21; CHENSN 381;
CHENSW 388; CLAK 251;
FREEMR 184; MACL 211;
MALV 64; NEWTEE pl
32a; POPRB pl 28; UPJ
298; WOLFFC 190
--Night: Mask marble; c 12
POPRB pl 30; STI 587
Henry VII Tomb
BROWF-1: 53 ELWe
Hercules and Cacus clay
MACL 203; POPRB fig 34
IFB
Julius II Tomb 1512/16 marble;
235 cm
MYBU 7; POPRB fig 30
IRPi
--Moses, Rachel and Leah
LARR 128
--Moses, Rachel and Leah:
Leah marble; 209 cm
POPRB pl 34
--Moses, Rachel and Leah:
Moses marble; 100
BARSTOW 156; BAZINH
256; BAZINW 347 (col);
BEREP 35; BIB pl 118;
BROWF-3: 19; BUSR front
(col); CHENSW 387; CHRC
238; CRAVR 84; DIV 31;
ENC 623; FLEM 380; JANSH
357; JANSK 689; KO pl 82;
MACL 200; MONT 388;
MYBU 133; NEUW 46;
NEWTEM pl 127; POPRB
pl 15; RAY 42; REED 72;
ROOS 115B-C; ROTHS 169;
SIN 292; ST 270; STA 73;
STI 586; TAYFF 68 (col);
UPJH pl 122; WOLFFC 71
--Moses, Rachel and Leah:
Rachel marble; 197 cm
POPRB pl 35
--Victory; (Genius of Victory)
Victory and Vanished; Virtue
Triumphant over Vice)
marble; 261 cm
BR pl 8; CLAK 212; ENC

205; HAUS pl 10; MACL
205; PANS 173; POPRB pl
21; PRAEG 273; VER pl
58 IFV
--Reconstruction of First
Project, front elevation;
side elevation 1505
PANS 131, 132
--Reconstruction of Second
Project, front elevation:
Moses and Two Slaves (in
Louvre) in place; side
elevation: Rebellious
Slave in place 1513
PANS 136, 137
--Revised Tomb: "Boboli
Captive" c 1530/40 marble;
90-1/2
FLEM 379 IFA
--Revised Tomb: Male Figure
with Right Leg Crossing
at Knee, unfinished figure
FLEM 379 IFA
Lorenzo de' Medici Tomb
1520/34 marble
BUSR 223; CHASEH 338;
FREEMR 178; LARR 129;
MACL 207; MARQ 213;
MARY pl 31; MYBU 54;
POPRB fig 18; POST-1:
222; RAY 7; ROOS 115F;
I, J; ROTHS 165; SIN
286; ST 305; UPJH pl
122; WOLFFA 187; WOLFFC
185 IFLo
--Evening (Il Crepusculo;
Sunset; Twilight) marble;
L: 195 cm
CHENSW 5; MACL 211;
MILLER il 119; POPRB
pl 32; RICJ pl 44; WOLFF
C 190
--back view
POPRB fig 27
--wax model
RICJ pl 44 IFA
--Lorenzo de' Medici ("Il
Pensiero") 1524/25 marble;
178 cm
BUSR 221, 223; FREEMR
184; NATSE; PANS 154;
POPRB pl 25, 27; STA 81
--Lorenzo de' Medici: Box
Held by Lorenzo marble;
178
RAD 349
--Morning (Aurora; Dawn)
marble; L: 203 cm

BAZINW 349 (col); BUSR
222; CHENSW 366; CLAK
250; CRAVR 86; HAUS pl
16; KO pl 82; LARR 87;
MACL 209; MCCA 28;
MILLER il 120, 123;
NEWTEM pl 129; POPRB
fig 29, pl 33; ROTHS 167;
SLOB 53; WOLFFC 189
--Reintegration by A. E. Popp :
Entablature and River Gods
PANS 144
Madonna and Child stone
CHENSW 391 IFMe
Madonna and Child with Young
St. John the Baptist, tondo
(Bargello Tondo; Pitti
Madonna) c 1504 marble;
Dm: 38-1/4
BARG; BR pl 8; MARY pl
18; MILLER il 124;
NEWTEM pl 128; NMI 33;
POPRB pl 4; RICJ pl 40;
ROTHS 173; SFGM # 62;
WOLFF 44 IFBar
Madonna of the Steps (Madonna
della Scala; Madonna of the
Stairs), relief 1490/93
marble; .55x.40 m
BODE 55; BUSR 215; CHAS
295; POST-1:220; ROOS
116A; SEY pl 151B IFB
Madonna with the Book, un-
finished figure
ROOS 115G IFBar
Medici Madonna (New Sacristy
Madonna) 1521/34 marble;
81-1/2
BAZINW 350 (col); BODE
56; CHENSN 382; JANSK
692; MACL 213; MILLER
il 128; NEWTEM pl 131;
POPRB pl 20; RAY 43;
ROBB 379; ROOS 114K;
SLOB 234; WB-17:201;
WOLFFA 190; WOLFFC
193 IFLo
--Figure, broken sketch
terracotta
SLOB 235 IFB
Medici Tombs: The Sepultura
in Testa--Double Tomb of
the Magnifici Medici:
Lorenzo the Magnificent
(d 1492), and Giuliano
(killed by Pazzi 1478)
(reintegration by A. E.
Popp, showing David

(Bargello) in place and fresco
of Resurrection in the lunette
PANS 153
Palestrina Pieta c 1556
BEREP 185; CLAK 257 IFA
--c 1556
MU 159 IPaleR
Pieta c 1550
BARSTOW 151; WOLFFA 47
Pieta c 1550
BEREP 176; ROTHS 175
IFF
Pieta 1497/99 marble; 69 BARD
143; BAZINW 346 (col); BR
pl 9; BUSR 216, 217; CAL 95
(col); CHASEH 336; CHENSN
379; CHENSW 386; CLAK
241; CRAVR 85; EN 623;
FREEMR 171; FLEM 374;
LARR 128; MACL 195;
MAR 78; MILLER il 125,
126; MONT 110; MU 155;
MURRA 274; MYBA 404;
MYBU 377; MYRS 42;
NEWTEM pl 125; NEWTET
144; NOG 44-6; POPRB
pl 6; READAS pl 92, 93;
ROOS 114G, I; RUS 71;
SEW 602; SEY pl 158;
UPJH pl 123; WOLFFC 40
--Christ
SEY 157 IRP
Pieta 1550/55 marble; 88-7/8;
base W: 48
BAZINW 351 (col); BUSR
224; CLAK 258; FLEM
445; GUIT 109; LOWR 94,
95; MARY pl 27; MCCA
80; MOLE 163; MYBU 383;
PEP pl 16; RAY 43;
READAS pl 99-101; IFCO
--Head of Christ
MOLE 15
--Self Portrait (Joseph of
Arimathea; Nicodemus?)
1550/55
GOLDF pl 112; LOWR 136;
MACL 215; UPJH pl 123
Pieta Roncalli (Pieta
Rondanini)
MALV 490 IRSe
Pieta Rondanini c 1555/64
marble; 77-1/2
BAZINW 351 (col); BUSB 1;
CLAK 258; GAUM pl 45;
HAUS pl 25; HAUSA pl 31;
JANSH 369; LARR 128;
MILLS pl 3; MONT 114;

NEWTER 159; NEWTET
145; POPRB fig 37;
PRAEG 17; SEW 168; STA
81; UPJH pl 123; VALE 53;
WOLFFC 195 IMS
--Christ and Nicodemus, heads;
Nicodemus marble; 226 cm
POPRB fig 35, pl 36, 37
IFOp
The Rebellious Slave (Heroic
Captive) 1513/16 marble;
82-1/2
CHAR-2:52; CLAK 245;
COL-20:541; FLEM 379;
JANSH 358; JANSK 690;
KO pl 82; LOUM 87;
POPRB pl 16; VER pl 57
FPL (697)
--Ape
PANS pl 140
Risen Christ (Resurrected
Christ) marble; 205 cm
POPRB pl 23; VALE 19;
WOLFFA 192; WOLFFC
IRMM
River God, fragment
CLAK 349
--model
POPRB fig 25 IFA
St. Matthew, unfinished figure
1506 marble; 107
JANSH 11; MILLER il 117;
POPRB fig 9-10, pl 14 IFA
St. Peter, detail marble; c
120 cm
POPRB fig 4, pl 9 ISC
St. Petronius
POPRB fig 3 IBoD
Slave (Captive; Prisoner),
unfinished figure intended
for Julius II Tomb
BAZINW 350 (col); BATT
94, 95; GARDHU pl 44
--1514/22
BEREP 184; BRpl 9;
MILLER il 130; MONT
111; ROTHS 171; SEW
607; SLOB 235 IFA
--stone
CHENSW 390; CLAK 247
IFBar
A Slave, study c 1516 dark
red wax; 6-1/2
ASHS pl 23; MACL 201;
MILLS pl 10 ELV
Slaves, intended for Julius II
Tomb c 1513/16 marble
ROTHS 171 FPL

Two Figures in Combat, model
for figures on Piazza della
Signoria, reintegrated by
J. Wilde
PANS 172 IFB
Victory c 1515 marble
STA 81 IFMN
Virgin and Child with Infant
St. John the Baptist (Holy
Family; Taddei Tondo),
unfinished c 1504 marble;
41-1/2x30-1/4
GAUN pl 44; KO pl 83;
MACL 199; MONT 111;
PANS 127; POPRB fig 5-6,
pl 3, 5; WHITT 175 ELRA
Young Slave marble; 256 cm
POPRB pl 17 IFA
 Portraits
Bandini. Michelangelo
Monument
Italian--16th c. Michelangelo
head
Moschi. Michelangelo Direct-
ing Fortification of
Florence
Pomodoro. Homage to
Michelangelo
Viani. Homage to Michelangelo
Volterra. Michelangelo, bust
Zocchi, E. Michelangelo at
Work on First Sculpture
MICHELANGELO--ATTRIB
Apollo and Marsyas, relief
marble; 15-3/4x11-3/8
USNKP 422 UDCN (K-144)
MICHELANGELO--FOLL
Samson Defeating Philistines
CLAK 213 IFB
MICHELE DA FIRENZE (Master of
the Pellegrini Chapel)
(Italian fl 1st half 15th c.)
Adoration of the Magi, relief
c 1435 terracotta
POPG fig 97; SEY pl 40
IVeA
Madonna and Child in
Tabernacle with Angels,
relief 1430 113x63 cm
BSC pl 41 GBS (1/58)
MICHELE DI GIOVANNI DA FIESOLE
See GRECO, IL
MICHELOZZO (Michelozzo di
Bartolommeo) (Italian 1396-
1472) See also Donatello;
Robbia, L. della
Angel
MACL 128 ELV

Bartolommeo Aragazzi Monu-
ment: Faith c 1430 marble
SEY pl 35A IMontC
--Farewell of Bartolomeo
Aragazzi, relief
BODE pl 33; KO pl 77;
POPR pl 40
--Relief
SEY pl 36B
Madonna and Child, arched
relief 1437 marble;
40x28
BARK; KO pl 80 IFBar
Madonna with Sleeping Child
glazed terracotta;
23-3/8x22-9/10x8-7/16
SEYM 64, 65 UDCN
S. Bartholomew marble
POPR pl 39 IMontC
MICHELOZZO, and DONATELLO
Outdoor Pulpit of Holy
Girdle 1428/38 marble,
mosaic, and bronze; ea
relief: 29x31
JANSK 626; LARR 100;
MCCA 89; SEY pl 37 IPrC
MICHELOZZO--FOLL
St. John the Baptist bronze;
18
DETD 111 IFMN
MICHIELI, Valerije (Yugoslav 1922-)
Thomas plaster
BIH 163
Mickiewicz, Adam (Polish Poet
1798-1855)
Bourdelle. Adam Mickiewicz
Monument
Dunkowski. Mickiewicz, head
Patzay. Adam Mickiewicz,
medal
Un Microbe Vu a Travers un
Temperament. Ernst
Microtemps 10. Schoffer
Mid-Day. Caro
Middleton, Thomas
Lough. Thomas Middleton,
Bishop of Calcutta
Middleton Cross. Anglo-Saxon
Miegeville Door
French--12th c. Porte Miege-
ville
Mignard, Pierre (French Painter
1612-95)
Desjardin. Pierre Mignard,
bust
Migrants. Daumier
MIHANOVIC, Robert Frances
(Yugoslav 1872-1940)

The Reconcilement; detail
bronze
BIH 32-34 YZMG
MIKENACE, Yuosace (Juozas
Mikenas) (Russian 1901-64)
First Swallows 1964 bronze;
170
EXS 98 RuMM
Fisherman and Daughter (Il
Pescatore, la Figlia del
Piscatore) 1961 wood
VEN-62: pl 200
MIKLOS, Gustav (Greek)
Architectural Sculpture in
Honor of Franz Liszt bronze
MARTE pl 2
Bronze
MARTE pl 2
Clown polychrome bronze
MARTE pl 47
Female Head* bronze
MARTE pl 47
Figure* bronze
MARTE pl 47
Figure wood
HOF 61
Woman with Bird (Femme a
l'Oiseau), relief pink
cement, inlaid enamel
disks; iron frame
MARTE pl 2
MIKUS, Sandor (Hungarian 1903-)
Bathing Woman 1942 bronze
VEN-60: pl 207 HBNG
Jozsef Rippi-Ronai, medal
1946 bronze; Dm: 7 cm
GAD 129 HBA
Stalin Memorial 1950
bronze; figure: 8 m
GAD 100 HBS
Young Girl 1947 bronze; 25 cm
GAD 110 HBA
MILANESE--15th c.
Diptych ivory
CHRC fig 131 UDCN
MILANI, Umberto (Italian 1912-)
Ascesa 1962 bronze
VEN-62: pl 18
Ceiling Sculpture, entrance
lobby 1951
DAM 138-140 IMT
Colloquy 1961/62 bronze
VEN-62: pl 17
Hermetic Vision 1953 stone
SAL pl 79
Mode 1959 bronze
SAL pl 80 (col)

Modo N. 4 1955 bronze
VEN-58: pl 34
Two-Front Sculpture No. 2
1958 bronze; 24-3/8x
26-3/4
TRI 189 IMMi
MILICZ, Nickel (German)
Religious Medal: David and
Bathsheba; Lot and his
Daughters 1540/60 silver;
Dm: 1-13/16
BERL pl 161; BERLES
160 GBSBe
Military Courage. Dubois, P.
Military Glory. Bertoldo di
Giovanni--Foll
Military Life, relief. Dutch--16th c.
Milkman. Loutchansky
Mill of God
French--12th c. Capital:
The Mystic Mill
MILLIAN, Pedro (Spanish fl 1487-
1526)
Christ in Pity c 1490
MULS pl 153B SpElgCh
St. Michael ptd terracotta
WES pl 7
Miller. Arp
Miller, Alastair
Miller, A. Alastair Miller,
bust
MILLER, Alec (Scottish 1879-)
Alastair Miller, bust lime-
wood
MILLER il 204
Betty Bardsley, bust lime-
wood
MILLER il 205
Charlotte Heberden Wilgress,
bust 1946 under LS
NEWTEB pl 48
Family Group basswood
PAR-1: 48
MILLES, Carl (Swedish 1875-1955)
Aganippe Fountain, Lamont
Wing bronze
DIV 85 UNNMM
--Aganippe bronze; 37
UNNMMAS 121, 122
UNNMM (54.198.2)
--Architect bronze; 108
UNNMMAS 121, 122
UNNMM (54.198.3)
--Centaur bronze; 42
UNNMMAS 123 UNNMM
(54.198.7)
--Faun bronze; 55-1/2

UNNMMAS 123 UNNMM
(54. 198. 8)
--Musician bronze; 105
UNNMMAS 121, 123 UNNMM
(54. 198. 4)
--The Painter, representing
Eugene Delacroix bronze;
117
UNNMMAS 122 UNNMM
(54. 198. 5)
--Poet Carrying a Bluebird
bronze; 114
UNNMMAS 121 UNNMM
(54. 198. 1)
--The Sculptor bronze; 120
UNNMMAS 123 UNNMM
(54. 198. 6)
Ages of Commercial Barter:
Age of International Ex-
change; Age of Barter 1913
black granite
RAMS pl 7a-b SnSEn
Apollo, orchestra platform
figure stucco
AUM 107 SnSC
The Archer
AUM 108 SnSA
--bronze and marble
MARY pl 169 SnHN
Cerberus stone
PAR-2: 209
Dancing Girls
LARK 444 UMiBC
Diana Fountain; with faun,
doe, and boar 1928 bronze
CASSTW pl 6 SnSSM
Elephants
TAFTM 81
Europa and the Bull
CASS 109; 110 UMWA
--bronze, green patina
MARY pl 152 SnHa
--c 1895
LARM 232; ROOS 278B
SnGK
--1923/24 bronze; 30-1/2
CASSTW pl 4; ENC 628;
TATEF pl 40e
SnG; SnLi; ELT (4247)
Ferdinand Boberg, bust 1906
bronze
SELZJ 158 SnLM
Folke Filbyter
AGARN il 24 SnLM
--bronze
VALE 118 UMoSL
--equest c 1924 bronze; 28-3/4
AUES pl 49; RAMT pl 61;

TATEF pl 40f ELT (4248)
Folke Filbyter Fountain and
Water Trough 1927 bronze;
main basin L: 16. 5 m
CASSTW pl 5 SnLi
--Folke Filbyter, equest,
small version central
fountain figure 1927
bronze; c 33
RAMS pl 13b ELV
Folkunga Fountain; panel
details
AUM 98, 99 SnLi
--Equestrian Figure bronze
CHENSW 483 UMoSL
Fountain cast pewter; 66-1/2
x77x35
WORC 93 UMWA
Fountain: Man and Fish
CASS 84
Fountain: Mermaid 1930
ROOS 278C SnG
Fountain Figure
AUM 100
Fountain Motif
AUM 108
Fountain of Industry
AUM 101; NATSE SnS
Garden Fountains
AUM 100 SnLM
Girl Musicians, orchestra
platform marble
AUM 105 SnSC
Girls Dancing
TAFTM 81
Gustav Vasa, seated figure
polychrome oak
AUM 108; MARY pl 110;
PAR-2: 208 SnSNo
Johannes Rudbeckius Memori-
al 1925 bronze; 10
RAMS pl 13a SnVas
Jonah and the Whale bronze
PUT 339
Man and Nature, detail 1940
wood
MAI 207 UNNRadT
Meeting of the Waters, Aloe
Memorial Fountain 1940
bronze; 200x35
CHRP 377;GARDH 755; PIE
390 UMoSLA
Orpheus, head iron
JOH 79 UNNMMA
--1934 cast iron; 28-1/2
UNNMMAS 120 UNNMM
(40. 149)

Orpheus Fountain 1930/36
 bronze on granite base; 38
 AGARC 171; AUES pl 47;
 HAMP pl 47A; ROBB 394,
 404; VALE 91 SnSMi
--Orpheus
 ROOS 278F; WB-17:204
--Two Figures
 CASS 84
--Orpheus, model for Stock-
 holm Fountain clay
 CASS 85
Oscar Levertin
 TAFTM 81
Peace Memorial: Indian Chief
 Smoking Peace Pipe,
 rotates on base on c 2-1/2
 hr circuit 1936 Mexican
 onyx; 38'
 CASS 101; FAUL 81; GRID
 8; LIC pl 161 UMnStPC
Pegasus 1951 bronze; 98
 MID pl 24 BAM
Poseidon Fountain bronze
 AUM 102-3; GRAT 165
 SnGG
Prehistoric Monsters
 TAFTM 81
Resurrection Monument, study
 detail bronze
 SELZJ 162 SnLM
Rudbeckius bronze
 MARY pl 146 SnW
Running Horse
 AUM 105
Siren bronze
 CASSTW front
Solglitter
 MARY pl 53
The Spirit of Transportation
 1960 bronze figure (LS);
 black granite pillar
 GRID 16 UCoDC
Sten Sture, monument
 MARY pl 131
Sten Sture Monument, sketch
 MARY 179 SnU
The Sun Singer, monument to
 Esaias Tegner
 AUM 108; NATSE SnS
--1926 bronze
 RAMT pl 62 UCtY
--torso bronze
 AUM 109 SnLM
Susanna, fountain 1914/16
 black granite
 CASSTW pl 2 SnLi

Triton Fountain bronze
 MARY pl 151, 152 SnSLi
--bronze; 70
 AGARC 170; CHICS UICA
Young Elk 1925 bronze; 80 cm
 CASSTW pl 1 -EWa; SnLi;
 SnSN
MILLET, Aime (French 1819-91)
 Ariadne 1857 marble
 SELZJ 44 FPHI
Millington 1965 (1). Sanderson
MILLS, John W.
 Mask of Van Rijn cast
 aluminum
 MILLS pl 22
 Study of Buonarotti, head
 bronze
 MILLS pl 23
Milo of Crotona
 Falconet. Milo of Crotona
 Puget. Milo of Crotona
MILSON, Geoffrey Austin
 (Welsh 1917-)
 Torso, Welsh Collection
 Portland stone; 20
 BED 114 EA
 Weeping Woman terracotta; 20
 BED 114
Milton, John
 Pierce--Attrib. John Milton,
 bust
MILWARD, Marguerite (English)
 Bhat Woman, bust
 CASS 38
 Bhil Man, head
 CASS 39
 Chenchu Boy, head
 CASS 39
 Chibabai, Lamani woman,
 head
 CASS 39
 Gond Man, head
 CASS 38
 Haran Shikari Man, head
 CASS 39
 Irula Man, head
 CASS 39
 Korwa Woman, head
 CASS 38
 Lamani Man, head
 CASS 39
 Mathura Woman, head
 CASS 39
 Pandhi Man, head
 CASS 38
 Toda Man, head
 CASS 39

Toda Men, two heads
 CASS 38
Waddar Man, head
 CASS 39
Mindenar Altar
 German--13th c. Mindenar
 Altar
 German--15th c. Mindenar
 Altar
MINELLI, Giovanni (Italian c
 1460-1527?)
 The Entombment, relief
 terracotta
 MACL 180 UMBGa
Minerbetti Family
 Donatello. Coat of Arms of
 the Minerbetti Family
MINERBI, Arrigo (Italian)
 Last Supper
 VEN-32: pl 193
 La Vittoria del Piape 1917
 Botticino stone
 VEN-24: pl 25
Miners and Mining
 Braun, M. V. Miner Adoring
 Tomb of St. John of
 Nepomuk
 English--15th c. Robert
 Greyndour Brass: Free
 Miner of Forest of Dean
 Listopad. Miner
 Meunier. Miner(s)#
 Meunier. Mineur au Travail
 Meunier. Return of the
 Miners, relief
 Sortini. Miners
Minerva See Athena
Minerva Obelisk. Bernini, G. L.
MINGUZZI, Luciano (Italian 1911-)
 Acrobat No. 1 (Acrobatas
 No. 1) 1952 bronze
 SAO-3
 Acrobat on Trapeze 1953 bronze;
 70-7/8
 NMAD 92
 Boxers in a Clinch
 VEN-34: pl 60
 Contortionist No. 1 1950
 bronze; 1.20x.60 m
 SCUL pl 30
 Contortionist No. 2 1956
 bronze
 VEN-56: pl 21
 Dog Among the Canes (Dog
 Among the Reeds; Il Cane
 fra le Canne) 1951 bronze
 VEN-52: pl 15
 --1951 bronze; 27-1/8
 NMAD 92 UNNMMA

--No. 2 1964 bronze; 58x48
 ARTSI #15
Door of the Cathedral, fifth
 and last bronze; 27'
 DIV 111 IMC
The Dragons 1958 iron and
 bronze; 157-1/2
 TRI 196
Echo II, study bronze; W: 58
 MAI 208; SG-3
End of the Warrior No. 1
 (La Fine del Guerriero N. 1)
 1959 bronze
 VEN-60: pl 58
Forms 1959 bronze
 VEN-60: pl 56
Gallo 1951 bronze; 1x.40 m
 SCUL pl 31
Gato Persa 1949 bronze;
 100 cm
 SAO-1
Goat 1951 bronze; L: c 45
 NMAD 91
Man with a Rooster (Uomo
 con Gallo) 1953 bronze; 72
 PUL-1: pl 58
Memory of the Man in the
 Concentration Camp, No. 4
 1966 35-1/2 (excl 15-1/8
 base)x27-1/2
 CARNI-67: #146 IMMi
My Mother stone
 VEN-42: pl 43
Il Primograna dell'Impero,
 relief
 VEN-38: pl 36
Prisoner in the Lager
 SAL pl 58 (col)
Shadow in the wood (Ombre
 nel Bosco) 1957 bronze; 82
 BERCK 151
--No. 2 1957 wood and bronze
 VEN-64: pl 37 IVMo
The Shadows 1956/57 bronze;
 70
 READCON 184 UNNH
Shadows in the Wood 1956
 bronze
 SAL pl 57
Two Forms plaster
 SAL pl 56 (col)
Two Shadows 1957 bronze
 SAL pl 55
The Unknown Political
 Prisoner: Figure Enmeshed
 1952 bronze; 22x26-1/2x
 13-1/2 GIE 257; TATEF
 pl 40h ELT
 (6165)

Washerwoman 1947 plaster
 VEN-48: pl 58
Woman Jumping Rope 1954
 bronze; 70-7/8
 MCCUR 275; NMAD 93
 UCtSB
Wooden Lights No. 6 (Luci
 nel Bosco N. 6) 1962
 bronze
 VEN-62: pl 28
Miniature Sculpture. Hoflehner
Minim
 Martos. Minim and Pozharski
MINKENBERG, Hein (German 1889-)
 Pieta wood; 2.30 m
 HENT 24 GNeusM
 Tanzendes Paar terracotta;
 60 cm
 HENT 25 GBN
MINNE, Georges (Belgian 1866-1941)
 The Bricklayer
 TAFTM 80
 Fountain, project
 TAFTM 80
 Fountain, with four Kneeling
 Boys 1898/1906 marble;
 figure H: 30-3/4
 CHASEH 473; POST-2:191;
 SCHMU pl 143 GHagF
 Kneeling Boy 1925
 HAMF 84 GMaM
 Kneeling Boy (Kneeling Figure)
 1896 marble; 30-3/4x12-1/4
 HAMF 281; JANSH 511;
 JANSK 982; SELZPN 72
 BGMS
 Kneeling Youth
 GOR 35 BBR
 --1898 plaster; 30-1/2
 HAMP pl 48A UNNMMA
 Little Relics Carrier (Le
 Petit Porteur de
 Reliques; Relic Bearer;
 Reliquary Carrier) 1897
 bronze; 26-3/8
 SCHMU pl 144 BGM
 --1897 marble; 26
 MID pl 18 BAM
 --1897 plaster; 67
 CAS pl 181
 --1897/98 bronze; 25-1/2
 SELZS 25 SwLaJ
 --1929 bronze; 40
 GOR 38; RAMS pl 36;
 RAMT pl 14; SELZJ 148;
 VEN-40: pl 86 BBR
 Male Bust
 GOR 39 BBR

Male Torso plaster
 VEN-14: 28
Man's Torso 1910 bronze; 41
 MID pl 17 BAM
Mother and Child
 VEN-26: pl 146
--
 GOR 37 BBR
Mother and Child (Queen
 Astrid Monument) 1936
 stone; 69
 MID pl 129 BAM
Mourning Woman (Weeping
 Woman) 1896 wood;
 25-1/4
 GOR 33; NNMMAG 146 GH
The Nun, head wood
 PAR-1: 204
Pieta
 DEVI-2 BA
St. John the Baptist 1895
 bronze; 71 cm
 LIC pl 203 BGMS
--1895 stone; 28x19-1/4
 HAMF 282; LARM 357
 BGMS
Solidarity 1898 bronze;
 26-1/4x26-3/4
 HAMF 283 BBR
Volder Monument
 TAFTM 80
The Well
 GOR 34 BBP; BG
Woman's Head marble
 VEN-7: pl 75
Worker, half figure
 GOR 36 BBR
MINNE, Joris (Belgian 1897-)
 Red Woman 1954 Jarrah wood;
 39
 MID pl 90 BAM
Minne Scene
 French--14th c. Mirror Back:
 Minne Scene
MINO DA FIESOLE (Mino di Giovanni)
 (Italian 1431-84) See also
 Isaia da Pisa
 Alfonso of Aragon, relief
 bust c 1455/56 marble
 SEY pl 70B FPL
 Altar
 CHASEH 313 IFBad
 Altar with Our Lady and
 Saints 1465 marble
 BUSR 134; KO pl 78 IFiC
 Bishop Leonardo Salutati, bust
 MARQ 191 IFiC

Misericords
 English--14th c. Knight Fall-
 ing from Horse
 --Misericords#
 --Shepherd
 --Stylized Triple Head and
 Grotesque Animals
 English--15th c. Misericord#
 --Samson Carrying Gates of
 Gaza
 --Tapster
 Falaise. Misericords
 Flemish--15th c. Misericords
 French--12th c. Slaughter of
 Sow
 French--16th c. Corsair Head
 Netherlandish. Misericord:
 Female Head
 Nicolas de Bruyn and G.
 Goris. Misericord: Head
Den Miskendte Sandhed
 Dalou. La Verite Meconnue
MISSFELDT, Heinrich (German)
 After the Bath
 TAFTM 71
Mission of the Apostles. French--
 12th c.
Missionaries
 Benedetto da Maiano. Pulpit:
 Martyrdom of Franciscan
 Missionaries
Il Mister. Ceroli
Mr. Knife and Miss Fork. Ray
MITCHELL, Denis (English 1912-)
 Gew Form 1960 bronze; 12
 READCON 185 ELW
 Porthcressa 1961 polished
 bronze; 36
 READCO pl 17b ELW
MITCHELL, William
 Wall Relief 1963 cold cast
 bronze from a polyurethane
 mould
 PER 43 EMaC
Mithras
 Italian--12th c. Monreale
 Capitals
Mo Ting Yuem
 Armour, Helen. Mo Ting
 Yuem, head
Mobiles
 Beothy. The Sea, Opus 67
 Brancusi. Sculptured Mobile
 Chadwick. Dragon Fly
 Chadwick. Mobile
 Holwerk. Mobile
 Linck, W. Mobile#

 Linck, W. Sculpture Mobile
 Linck, W. Window Open on
 the Sky
 Martin, K. Mobile Construction
 Martin, K. Small Screw
 Mobile
 Peyrissac. Mobile Sculpture
 Stepanov. Mobile
 Turnbull. Mobile-Stabile
 Ultvedt. Mobile Sculpture
 Zollner. Mobiles Objekt
Mocenigo, Alvise
 Bushnell. Alvise Mocenigo
 Monument
Mocenigo, Pietro (Doge of Venice
 1474-76)
 Lombardo, P. Pietro Mocenigo
 Monument
Mocenigo, Tommaso
 Lamberte and Giovanni di
 Martino. Tommaso
 Mocenigo Monument
MOCHI, Francesco (Italian 1580-1654)
 Alessandro Farnese, equest
 1620/25 bronze
 BAZINW 387 (col); POPRB
 fig 140, pl 162-3; WIT
 pl 42 IPiacC
 Angel of the Annunciation 1605
 marble; over LS
 MOLE 172 IOrC
 Cardinal Richelieu, bust
 marble; 33
 CHAR-2:134; LOUM 153
 FPL (1545)
 Christ, from Baptism after
 1634
 WIT pl 41C IRPM
 Ranuccio Farnese, equest 1612/
 20 bronze; over LS
 POPRB fig 139 IPiacC
 --Allegory of Good Govern-
 ment, base detail bronze;
 c 12
 MOLE 173
 St. Veronica 1629/40 marble;
 c 180
 BAZINB 28; BUSB 67;
 ENC 633; KO pl 89;
 POPRB pl 161 IRP
 Virgin of the Annunciation
 1603/08
 WIT pl 41B IOrM
The Mocker Mocked. Klee
IL MODANINO See MAZZONI, Guido
Mode (Modo)# M̄il̄ani

Model for a Garden. Giacometti
Model for a Square. Giacometti
Modello SR 319. Baj
Moderation
 Ceracchi. Capellen Monument
Modern Building Construction. Jagger
A Modern Venus. Dazzi
MODERNO (Italian fl 15/16th c.)
 The Crucifixion, plaquette
 silver; 235x128 mm
 DETD 141 UNNSa
Modesta, Saint
 French--13th c. St. Modesta
Modesty
 Corradini. Allegorical Figure
 of Modesty
Modifiable Sculpture. Ferrant
MODIGLIANI, Amedeo (Italian-French
 1884-1920)
 Caryatid c 1914 limestone;
 36-1/4
 LIC pl 198, 199; NNMMM
 104; RIT 116; SCHW pl 27
 UNNMMA
 Caryatid 1915(?) stone
 SAL pl 7
 Caryatid c 1919 stone; 36-1/4
 SOBYT pl 47 UNNBu
 Full Length Figure 1908 lime-
 stone; 160 cm
 LIC pl 197 UNNSchi
 Head bronze
 NEWA 50 UNjNewM
 --limestone
 RICJ pl 47 ELV
 --limestone; 27
 CANM 441 UPPPM
 --(Kopf; Testa) stone
 GERT 146
 --stone
 DETS 77 UNNH
 --c1912
 MAI 211 ELT
 --1912 limestone; 18
 BAZINW 430 (col) FPM
 --1912(?) limestone; 25
 CLEA 17; GUG 214;
 READCON 79 UNNG
 --1912 stone
 BERCK 306 FPM
 --1913 Euville stone; 24-3/4
 (excl base)
 CAS pl 201; HAMP pl
 162A; LIC pl 201; TATEF
 pl 16; WHITT 52 ELT (6097)
 --1913(?) stone
 SAL pl 8 (col)

--1913 stone; 34-1/2
 BERCK 50; GIE 39; ROTJG
 pl 10 ELT
--1913 stone
 CARR 96 UNNMMA
--1913 stone; 34-1/2
 CHENSW 503; CASSM 106;
 MARY pl 119; RAMS pl
 20; WILM 109 ELV
--1914 limestone; 18-1/8
 BMAF 50; LIC pl 200
 UNNPer
--1915(?) stone; 22-1/4
 CARR 96; FLEM 715;
 MCCUR 274; NNMMM
 104; SEITC 67; SOBYT pl
 48 UNNMMA
Head of a Woman (Testa di
 Donna) stone
 CARR 97
--stone; 26-1/2
 NNMMARO pl 302 UNNSu
--1912 stone; 23x5
 GIE 41 FPMo
--1913 stone
 CARR 97
--1919 Euville stone; .58x.12x
 .16 m
 MOD; SELZJ 195 FPM
Head of a Woman (Anatolia)
 after 1909 limestone;
 26-3/8
 BOSME pl 15; PUL-1:pl 62;
 VALE 158 UMoSLP
Head of a Young Girl 1913
 bronze; 25x20 cm
 LIC pl 196 UWaSA
Testa Femminile c 1913 mar-
 ble; .5 m
 SCUL pl 1 FRouM
Woman's Head 1913 wood; 22
 GIE 42 FPDel
Modulated Plane Construction II.
 Ernest
Modulation of Space II. Chillada
Le Modular. Le Corbusier
MOELLER, Edmund (German 1885-)
 Echo stone
 PAR-2:45
MOESMAN, C.
 Vlissingen Shipbuilders Man-
 of-War Model 1698 12'11"
 x15'x6'9"
 RIJA pl 155, 155a NAR
Moggio Pyxis. Early Christian
Mohammed II (Sultan of Turkey
 1430-81), called "The

Conqueror; The Great"
Bertoldo di Giovanni. Mohammed
 II, medallion
Mohammed XI See Boabdil
MOHAMMED IBN EL-ZAIN
 Baptistry of St. Louis:
 Hunting and Feasting
 Scenes 14th c. copper,
 encrusted with gold and
 silver; 9
 HUYAR 95 FPL
MOHLER, Fritz
 Arms of the Town of Stuttgart:
 Rearing Horse metal
 CASS 127
MOINE, Antonin (French 1796-1849)
 Queen Marie Amelie, bust
 marble
 LARM 43 FPCarn
MOITURIER, Antoine le (French fl
 1465-94)
 Mourner, tomb of Duke John
 the Fearless c 1462
 Vizelle alabaster
 CLE 74 UOC1A (40.129)
 Philippe Pot Tomb, Senechal
 de Bourgogne, Abbey of
 Citeaux c 1480 ptd stone;
 71x104-1/2
 BUSR 85; CANK 66; CHAR-
 1:268; EVJF pl 213B; GAF
 140; GLA pl 39; HUYA pl 42;
 HUYAR 13; LAC 193; LARR
 79; LOUM 43; MULS pl
 143B; REAU pl 116 FPL
 (244)
 St. Bernard c 1465
 MULS pl 59A FFonCh
MOKHTAR, Mahmoud (Egyptian
 1891-1934)
 By the Nile 1928 marble;
 40.5 cm
 SAID pl 4-5 EgCMu
 The Khamasin 1929 limestone;
 55 cm
 SAID pl 2 EgCMu
 Peasant Woman 1928 marble;
 74.5 cm
 SAID pl 9 EgCMu
 Peasant Woman Drawing
 Water 1929 limestone; 39 cm
 SAID pl 6 EgCMu
 Queen of Sheba 1922 bronze;
 66 cm
 SAID pl 1 EgCMu
 Toward the River 1928
 limestone; 50 cm
 SAID pl 7 EgCMu

Towards the Sweetheart 1928
 marble; 77.5 cm
 SAID pl 8 EgCMu
Wife of the Shiekh El Balad
 1929 bronze; 53 cm
 SAID pl 3 EgCMu
MOLA, Antonio, and Paolo MOLA--
 ATTRIB
 Ceiling, "Grotta", Studiolo of
 Isabella d'Este gilt wood,
 blue ground
 BAZINW 345 (col) IManD
MOLA, Gasparo (Italian 1580-1640)
 Parade Shield and Helmet
 of Cosimo II de'Medici
 early 17th c. steel
 and silver gilded; shield:
 c 25
 BARG; DETD 97, 94 IFBar
Moldau
 Sucharda. Prague and Molda
Moldavia
 Rumanian--15th c. Moldavian
 Circular Tile: Arms of
 Moldavia
Molds
 Folk Art--Polish. Gingerbread
 Mold
 Folk Art--Russian. Circular
 Mold
 Folk Art--Russian. Ginger-
 bread Mold
Moles
 Pompon. The Mole
Molesworth, Eve
 McWilliam. Eve Molesworth
MOLL, Balthasar Ferdinand
 (Austrian 1717-85)
 Sarcophagus of Franz I and
 Maria Theresa begun 1753
 HELM pl 184 AVC
Le Mollard. Coulentianos
MOLLER-NIELSEN, Egon (Swedish)
 Play Sculpture, parks
 DAM 208, 209 SnS
 Subway Bench, project
 DAM 207
Moltke, Helmuth von (Prussian
 Military Leader 1800-91)
 Hahn. Moltke Memorial,
 equest
A Moment of Peril. Brock
Mompesson, Giles d 1631
 English--17th c. Sir Giles
 Mompesson and Wife
 Monument
MONARD, Louis de
 Aux Aviateurs
 TAFTM 48

Arfe y Villafane, J. de.
 Monstrance
Arphe. Monstrance
Flemish--15th c. Tower
 Monstrance
German--15th c. Monstrance
Italian--15th c. Voghera
 Monstrance
Lamaison, P., and Damian
 Forment. Monstrance
Spanish--16th c. Torrecilla
 Monstrance
Spanish--16/18th c.
 Monstrance
Monstranz. Tinguely
Montagne, M.
 Belmondo. M. Montagne
Montagu, 2nd Duchess of
 Roubiliac, L. F. 2nd
 Duchess of Montagu
 Monument
Montagu, 3rd Duchess of d 1771
 Van Galder. Tomb of 3rd
 Duchess of Montagu
Montaigne, Michel de (French
 Essayist 1533-92)
 Landowski. Montaigne, detail
Montal, Dieudonne de
 French--16th c. Dieudonne de
 Montal
MONTANES, Juan See MARTINEZ
 MONTANES, Juan
Montaperto, Giovanni
 Gagini, D.--Foll. Giovanni
 Montaperto Monument
Monte, Antonio del
 Ammanati. Antonio del Monte
 Tomb
Montefeltro, Federigo da (Duke of
 Urbino 1444-82)
 Clemente da Urbino. Medal:
 Frederico da Montefeltro
 Laurana. Federigo da
 Montefeltro, Duke of Urbino,
 tondo
Monteith. English--17th c.
MONTELEONE, Alessandro (Italian
 1897-)
 Marino Lazzari, head
 bronze
 VEN-40: pl 31
MONTELUPO, Baccio da (Italian
 c 1469-1533)
 Christ Child marble
 CLE 81 UOC1A (42.799)
Montesquieu, Charles (French
 Political Philosopher 1689-
 1755)

Clodion. Montesquieu, seated
 figure
French--18th c. Montesquieu,
 bust
Lemoyne, J. B. Montesquieu,
 bust
MONTEVERDE, Giulio (Italian 1837-
 1917)
 The Genius of Franklin 1872
 bronze; 26-3/4
 AP 172 UPPA
Months
 Antelami. Labors of the
 Months
 Antelami--Foll. Door of the
 Months
 Caro. Month of May
 French--12th c. Christ in
 Miracle of the Pentecost:
 Signs of Zodiac and Labors
 of the Months
 French--12th c. Royal Portal:
 Months
 --Signs of Zodiac; Labors of
 Months
 French--13th c. Columnar
 Figures, west portal
 facade; detail: The Months
 --Harvest, quatrefoil
 --Labors of the Months:
 September--The Fruit
 Gatherer; March--Digger
 in the Vineyard, quatrefoil
 reliefs
 --Portal of the Virgin
 --St. Firmin Portal
 Goujon. July, relief
 Italian--13th c. July, relief
 --Main Portal, detail:
 Months--November (Bird
 Hunting); December
 (Butchering a Pig)
 Master Nicholas. Vestibule
 Archivolt: Months of
 September, October,
 November
 Pisano, Niccolo. Fontana
 Maggiore: Month of
 February
 Radovan. Portal, detail:
 Month of March
MONTI, Gaetano (Italian 1776-1847)
 Allied Sovereigns Arrive
 at Leipzig, relief 1826
 bronze
 LIC pl 18 IMAP
MONTI, Raffaele (Italian 1818-81)

Philip. Albert Memorial,
 frieze detail: Pugin, Scott,
 Cockerell, Barry
Picasso. Hommage a
 Guillaume Apollinaire
Picasso. Monument, design
Pigalle. Louis XV Monument
Piron, E. D. Monument
 to Piron
Poisson. Monument to the
 Dead
Priver. In Memoriam to Our
 Heroes
Quellinus, Arnold. Assassina-
 tion of Tom Thynne
Raedecker. War Memorial
Rapoport. Death Walk,
 Memorial to Warsaw
 Ghetto Victims
Rapoport. Negba Monument
Renaud. War Memorial
Roche. Monument to Dalou
Rodin. Balzac
Rodin. Burghers of Calais
Rodin. Labor Monument,
 project
Rodin. Lynch Monument,
 equest
Rodin. Victor Hugo
 Monument
Roeder. "Lysistrata", relief
 design for Peace Memorial
Rosa. Cairoli Brothers
 Monument
Rosandic. Dalmation Monu-
 ment
Roubiliac. George Frederick
 Handel Monument
Rude. Departure of the
 Volunteers
Rude. The Imperial Eagle
 Watching over Napoleon
Rude. Marshal Ney
 Monument
Russo, G. Christopher
 Colombus Monument
Saint-Marceaux. Daudet
 Monument
Saint-Marceaux. Dumas
 Monument
Saloun. Jan Hus Memorial
Saloun. The Liberation
 Monument
Saloun. The Union Monument
Sarrazin. Henri de Bourbon
 Monument
Scharff. War Monument

Scheibe. Ehrenmal auf dem
 Friedhof
Schilling, J. Germania--
 Niederwald Monument of
 German Unity
Schlor. Armed Figures, choir
 monuments to Counts of
 Wurtemberg
Schluter. Friedrich Wilhelm,
 Great Elector
Schmits, Hundreiser, and
 Geiger. Kyffhauser Plateau
 Monument
Scott, G. G. Albert Memorial
Sicard. Barbey Monument
Sicard. George Sand Monument
Siemering. Washington Monu-
 ment
Skeaping. Memorial
Stevens. Great Exhibition
 Memorial Model
Stevens. Wellington Memorial
Strynkiewicz. Heroes of
 Warsaw Monument
Stursa. Memorial
Sucharda. Palacky Monument
Tacca, P. Four Moors in
 Chains, Ferdinand I of
 Tuscany Memorial
Tatlin. Monument to the
 Third International
Tegner. The Finsen Monument
Terragni, G. and A. Monu-
 ment to the Fallen
Theed, W., the Younger.
 Albert Memorial: Africa
Tilgner. Mozart Memorial
Uhlmann. Memorial
Vela. Victims of Labour
Verlet. Maupassant Monument
Verrocchio. Condottiere
 Bartolommeo Colleoni
Viking. Memorial Picture
 Stone
Villeneuve, J. Rabelais
 Monument
Walker, A., J. Bell and
 J. H. Foley. Crimean
 Memorial Group
Webber. David Garrick
 Monument
Wilton. Death of General
 Wolfe
Wiwulski. Jagiello, equest,
 Grunwald Monument
Wnuk. Polish-Soviet
 Friendship Monument

Wolff, H. Auschwitz Monument,
 model
Wright, F. A. War Memorial
Wright, W. Resurrection
 Monument to Lady Deane
Moon See also Mary, Virgin--
 Madonna and Child on Crescent
 Moon
 German--15th c. Vintner's
 Madonna, standing on
 Crescent Moon
 Laurens. The Moon
Moon Figure. Armitage
Moon-Like, Hollowed Out, Ghostly.
 Arp
Moon Mad. Ernst
Moon of Alabama. Chadwick
Moon of Habana. Chadwick
Moonbird. Penalba
Moone Cross. Celtic
Moonlight. Martini, A.
The Moor Fountain. Bernini, G. L.
Moor-Hen. Pompon
MOORE, Esther M.
 The Charmed Circle of Youth
 MARY pl 38
MOORE, Henry (English 1898-)
 Abstract Sculpture 1937 Hop-
 tonwood; 20
 COOP 298 UMiBiW
 Animal Head 1951 bronze;
 7-1/2
 READO 49; SCHAEF pl 85
 --1951 bronze; 7-3/4x11
 SELZS 142 UNNColi
 --1951 bronze; 8-1/2
 HAMM 70
 Atom Piece 1964 bronze; 48
 HAMM 80; MAE 80; NEW
 pl 103
 Bird and Egg 1934 Cumberland
 alabaster; L: 22
 SOTH-4:82
 Bird Basket Lignum Vitae and
 string; 17x13-1/2
 AUES pl 59; LIC pl 292;
 MYBS 73 ELT
 --1939 Lignum Vitae and
 string; 17x13-1/2
 BERCK 92; HAMM 68;
 READCON 173 EM
 Brick Relief 1955
 BOE pl 200 NRBo
 The Bride 1940 cast lead and
 copper wire; 9-3/8
 JANSK 1028; KEPS 63;
 LYNC 8; NNMMM 148; RIT
 129; ROOS 282F; UPJH pl
 244 UNNMMA

Carving 1933 alabaster; 13-1/2
 SCHAEF pl 83
--1934
 READS pl 60
--1934 stone
 JOHT pl 196
--1935 alabaster; 11-1/2
 DETS 78 UNNH
--1937 Hoptonwood stone
 CASS 132
Carving in Three Positions
 1933
 READS pl 59
Christopher Martin Memorial
 1945/46 Hornton stone;
 L: 56
 BALD 150 EDeD
Composition
 WILM 160
--
 CARTW 174 UGAA
--1931 Blue Hornton stone; 19
 READCON 169 EMM
--1931 Cumberland alabaster;
 L: 16-1/2
 HAMM 63 (col); HAMP pl
 192A; READCON 167 EM
--1934 H: 17
 SEITC 187 UNNH
Dead Warrior 1956/57 bronze
 VEN-64:pl 39 GMSG
Divided Head 1963 bronze;
 13-1/4
 HAMM 75 (col) SwBKM
Double Standing Figure 1950
 bronze; 87
 RAMS pl 87; VEN-52:pl 81
--
 READAS pl 209 ELBrC
--
 GIE 148 UNNSal
--
 RIT 195 UNNV
Draped Figure Against a Wall
 1957 bronze; 13-3/4
 SOTH-3:96
Draped Reclining Figure
 1952/53 bronze; L: 5.2'
 BERCK 94 ELTLC
--Head detail bronze; 11
 BOW 119
Draped Reclining Woman 1957
 bronze; 53-1/8x81-1/8
 TRI 86 GMB
Draped and Seated Figure
 Against a Wall 1956/57
 plaster
 MAI 216

Internal and External Forms
1951 bronze; 24-3/8
TRI 17 SwBKM
--1951 bronze; c 25
RAMS pl 88
--1951 bronze; 25
JLAT 32 UTxDMa
--(Innere und Aussere Form)
1952/53 clay
GERT 190
--Internal and External Forms
1953/54 elm wood; 103;
Circ: 109
ALBA; ALBB 23; ALBC-1:
#45; BERCK 95; CANM
500; CLEA 77; FAIY 4;
LARM 365; READCON 164
UNBuA
Internal and External Forms
(Maternity 1951)
INTA-2:118
Interior-Exterior bronze
PANA-2:42 URPD
Interior-Exterior Reclining
Figure 1951 bronze; L: 21
DETS 79 UNNH
King and Queen
EXS 31
--1953/53
ENC 642 ELT
--1952/53 bronze (5 casts);
64-1/2
BAZINW 438 (col); BERCK
93; KO pl 104; LIC pl
295; MAI 215; MID pl 81
BAM
--
ROTJB pl 116 EShaK
--
BRION pl 121; GAUN pl
58; READAN #43; READCON
175 ScGK
--1952/53 bronze; 64-1/2
DETS front; HAMM 76 ;
MYBA 660 UNNH
--1852/53 bronze; 64-5/8
TRI 80
Knife Edge, working model
1961 bronze; 42
PRIV 34 (col), 49 (col)
Large Torso (Arch) 1962/63
bronze; 78
ARTSB-65:pl 5
Locking Piece plaster master
cast for bronze
MILLS pl 53, 54
--1962 bronze; 42
ARTSB-64:pl 3; BURN 99;
READCON 178

--working model 1962 bronze;
42
SELZS 162 UNNK
--1962 bronze; 64
PRIV 34-5 (col), 39 (col)
--1963/64 bronze
LARM 365
--1963/64 bronze; 115
HAMM 77 (col) BBLa
Madonna and Child, maquettes
1942
ENC 596
Madonna and Child 1943
bronze; 5-1/2
SOTH-3:97
--1943/44 Hornton stone; 59
AUES pl 66; BOW 91;
ENC 642; NEWTET 281;
READAN #42; READAS
pl 200; 201; RIT 192-3
ENorM
Marble Sculpture 1936
MOHV 217
Mask concrete
AUM 141
--1924 H: 61-1/2
SOTH-2:76
--1929 stone; 5
HAMM 60 EMM
Mother and Child
WILM 93
--ironstone
MARY pl 25
--rock chalk
PAR-1:132
--Ham Hill stone
MARY pl 23
--1924/25 Hornton stone;
22-1/2
HAMM 64A EMaM
--1931 Burgundy stone; 14
HAMM 64C; RAMT pl 7;
SCHAEF pl 82 ELMc
--1931 Cumberland alabaster;
16
HAMM 64B ELAnd
--1931 Cumberland alabaster;
18
RAMS pl 89 -EK
--1936 green Hornton stone
VALE 124 ELP
--1953 bronze; 20
HAMM 67 (col) ELT
--1959 bronze; 14-3/4
ALBC-3:#62 UNBuA
Mother and Child in Ladder-
back Chair 1952 bronze; 16
SCHAEF pl 86

Mountains
 WILM 161
The North Wind, relief
 BOE pl 198 ELUR
Quadripartite Leaf-Figure
 (Vierteilige Blatt-Figur)
 1952 bronze
 GERT 193
Reclining Female Figure
 alabaster; 18-1/2
 INTA-1:104
Reclining Figure
 NEWTEE pl 32b; PEP pl
 15; PRAEG 16; UND 166;
 VEN-48:pl 77
--alabaster
 MARY pl 24
--bronze; 4-1/2
 INTA-2:118
--elm; L: 75
 BALD 150; ROBB 406
 UNNBu
--Hoptonwood stone
 SGO-4:pl 57
--Hornton stone
 AUM 129
--lead; L: 5-1/2
 CHENSN 599; CHENSS
 703 -UWi
--lead; 6x11-1/2x4
 ASHS pl 38 ELV
--1907 bronze
 LOWR 200 UMdBWu
--1929 brown Hornton stone;
 L: 32
 READAS pl 205; READCON
 171 ELeC
--1930
 ENC 641 CON
--1931 lead; 9x18-1/4
 NMFA 189
--1933 concrete
 READS pl 58
--1935 elm; 19x35x17-1/4
 ALBA; ALBC-1:#177;
 BOSME pl 110; CANM
 499; FAUL 467; RIT 126;
 ROOS 280A; SEW 919;
 TOW 63; UPJH pl 244;
 WB-17:193 UNBuA
--1936 elm; L 42
 ARTSBR 21; HAMM 66
 EWakeA
--(Figure Etendue) 1937
 DAM 61 EHall
--1937 Hoptonwood stone;
 L: 33
 RIT 127 RIND

--c 1938
 CHENSW 4 UCHW
--1938 bronze; 5-1/2x12-3/4
 CALA 198; GUGP 89;
 READCON 56 (col) UVG
--1938 Hoptonwood stone; L:36
 NNMMARO pl 321
--1938 Hornton stone; L: 56
 SCHAEF pl 84
--1938 lead
 MAI 214 UNNMMA
--1939
 KEPS 62 EHyC
--1939/40 elm; L: 81
 BOW 95; BRO pl 25;
 RAMT pl 8; VALE 125 -EO
--1939/40 lead; 11
 BRO pl 26; SELZJ 6 ELC1
--1945 bronze; 17-1/2
 READAS pl 206
--1945/46 L: 75
 MU 253 ELT
--1945/46 elm; L: 74
 NEWTEB pl 50, 51 UNNBu
--1945/46 elm; L: 75
 MCCUR 271; READCON
 169 EO
--1945/46 elm; 34x75x20
 BERCK 92; BR pl 17;
 CLAK 369; GARDH 762;
 GIE 149; HAMP pl 192B;
 HENNI pl 97; MAI 214;
 READAN #21 UMiBloC
--1945/46 wood
 GROSS fig 42
--1951 bronze
 READAS pl 224b ELTL
--(Liegende) 1952/53 bronze
 GERT 192
--(Liegende) 1952/53 bronze
 GERT 197
--1952/53 bronze; L: 8
 ARTS #48C; SFMB #120
 ELMa
--1953/54 bronze
 READAN #121
--(Liegende) 1954/55 bronze
 GERT 196
--1957 bronze; L: 27-1/2
 HAMM 73 (col)
--UNESCO House Piazza
 1957/58 Roman travertine;
 L: 16'5"
 DIV 99; TRI 270-271 FPU
--working model 1957 bronze;
 55x94x48
 CARNI-58:pl 102

--1959/60 elm; L: 90
 BOW 122
--1959/64 wood
 CHENSW 491
--1960 bronze, from an
 edition of 12; 7-1/2
 SOTH-1: 86
--1963/64
 KULN 7
Reclining Figure, study
 1945/46 terracotta
 KUHB 117
Reclining Figure II 1960
 bronze
 BURN 99; FAUL 467
 UNNMMA
--1960 bronze; 129.5x259 cm
 JOO 197 (col) NOK
--maquette 1952 bronze; L: 9
 ARTS # 48a
Reclining Figure, No. 3
 maquette 1952 bronze; L: 8
 ARTS 48b
Reclining Figure iii 1961
 bronze; 59x94x44-1/2
 SEAA 148 ELMa
Reclining Figure, No. 5
 1963/64 bronze; 96x150x72
 GUGE 52
Reclining Figure (External
 Forms) 1953/54 bronze;
 1.7'
 BRION pl 123
Reclining Figure (Internal
 External Form) 1952/53
 bronze; L: 84
 BERCK 94 -USt
Reclining Figure (Three Piece:
 Bridge Prop) 1963 bronze;
 L: 99
 CHENSW 481: GAUN pl 56
 (col); MAE 81 ELeC
Reclining Figure (Two piece)
 1960 Bronze; 51x102
 SCOM pl 10 ScEM
Reclining Figure with
 Pedestal 1960 bronze; L: 39
 ARTS # 46
--1960 bronze; 52
 EXS 100 CMD
Reclining Mother and Child
 1960/61 bronze; 33-1/4
 x86-1/2
 BOW 93; ENC 641; HAMM
 69(col); NEW pl 104;
 READCON 167 ELMa;
 SnHH; UCBeSc; UDCSw;
 UMnMW; UNNLi

Reclining Nude bronze; L:
 6-1/2
 NCM 234 UNcRV
--bronze; 4-1/8x8-1/4
 BMA 72 UMdBM
Reclining Woman (Mulher
 Inclinada; Woman Reclining)
 SAO-2; FEIN pl 140
--
 FEIN pl 141 UNNMMA
--blue Hornton stone
 MARY pl 24
--1930 green Hornton stone;
 L: 36
 BOW 94; CAN-2: 197 CON
--1930 Hornton stone
 MILLER il 199 EWa
--1932 L: 37
 SEITC 69 UNNZw
--1945/46 Hornton stone;
 L: 58
 NEWTEB pl 52
Recumbent Figure 1938 green
 Hornton stone; 35x52-1/4
 x29
 AUES pl 64; CLAK 368;
 GOMB 446; JANSH 532;
 JANSK 1026; LYN 120-1
 (col); NNMMAP 139; RAMS
 pl 86; RIT 128; ROTJ pl
 18; TATEB-2: 10; UPJ
 640; VALE 125; ZOR 290
 ELT (5387)
--1953/54 bronze
 ST 448
Relief, Commercial Building
 BOE pl 199 ELTL
Relief, No. 2 1959 H: 92
 PRIV 39 (col)
Sculptural Object 1960 bronze;
 18
 ARTS # 45; PRIV 39 (col)
Sculpture, UNESCO Conference
 Building
 DIV 99 FPU
--1934 marble; 19
 BERCK 92 -La
--1937 Hoptonwood stone
 VALE 123
--1937 stone; 20
 GIE 145
Seated Figure, maquette 1952
 bronze; 8
 ARTS # 48d
--maquette 1954 bronze; 5
 ARTS # 48e
--1962
 ENC col pl 79

Seated Figure Against a
 Carved Wall 1957 bronze;
 22x36x21
 ARTSS #38 ELBrC
Seated Garden Figure bronze
 DIV 83
Seated Girl, maquette 1956
 bronze; 8
 ARTS #48f
Seated Nude 1957 bronze;
 58-1/2
 SOTH-4:86
Seated Warrior bronze; 60
 TORA 65 CTA (54/12)
Seated Woman bronze; 41
 SOTH-4:87
--1957 bronze; 57
 BOW 100, 101
Square Form 1936 brown
 Hornton stone; L: 21
 HAMM 62 NAW
--1936 brown Hornton stone;
 L: 24
 GIE 147
--1936 green Hornton stone;
 16
 RIT 124 ELS
--1936 stone
 MAI 213 -EMo
Standing Figure (Stehende
 Figur) bronze; 112
 DIV 89 EHereH
--1950 bronze; 87
 ARTS #40; ARTSB-62:pl
 5; HAMM 74 NAW; ScSK
--1952 bronze
 GERT 193
Standing Figure, No. 3 1952
 bronze; 21 cm
 SP 149 GHaS
Standing Figure: Knife Edge
 1961 bronze; 64
 BOW 98
--1961 bronze; 112
 CARNI-64:#253; LOND-6:
 #29; READCON 165 (col)
 UNNK
Standing Woman
 AUM 129
--1947/48 stone; 85-1/2'
 KO pl 104 ELBat
String Figure 1938 bronze
 and cord; 1-5/8x2-3/4
 CALA 198 IVG
--1938 Lignum Vitae wood
 and string
 READAN #85 -BUR

String Figure, No. 3 1938
 READP 208
Stringed Figure 1939 bronze;
 7-1/2x10x4-1/2
 SELZS 111 UNNEmi
Terrace Figure
 DAM 88, 89 ELTL
Three Motives Against a Wall
 1959 bronze; L: 42
 ARTS #44
Three Motives Against a Wall
 II 1959 18.5x42
 CARNI-61:#268 UNNK
Three-Part Reclining Figure
 1961/62 bronze; 113x64
 LYT inside bk cov
 UCLLy
Three-Piece Reclining Figure
 1961/62 bronze; 59x114
 READCON 177; SEITC
 38-39
--c 1961-62 bronze; 64x114x
 53-1/4
 HENNI pl 145 UNNK
Three-Piece Reclining Figure,
 No. 1; detail 1961/62
 bronze; L: 113
 HAMM 79 (col), 78 CMN;
 UCLLy; UNNWein
--1961/62 bronze; 114x59
 CHICSG UNNMa
Three Standing Figures
 1947/48
 READP 209
--1947/48 Darley Dale stone
 READM pl 63 ELC
--1953 bronze; 28-3/8x
 26-3/4x11-3/8
 CALA 200; GUGP 90 IVG
Three Way Piece: Archer 1964
 bronze; 24
 MAE 84
Three Way Piece: Points 1964
 bronze; 25x27
 MAE 82
--1964 bronze; 76x93x85
 LOND-7:cov (col), 29
Time-LIFE Facade Screen
 1953/53 Portland stone;
 10x26-1/2'
 DAM 86, 87; KULN 157;
 READAS pl 11; READCON
 172; WHITT 150 ELTL
--working model 1952
 KULN 157
Two Forms 1934 ironstone
 READAN #114 -Od

--1934 Pynkado wood; 11
GIE 144; MCCUR 266;
NMAC pl 223; NNMMM 148;
RIT 125 UNNMMA
--1936 H: c 42
JANSH 532; JANSK 1025
ELSad
--1966 37x48x59
CARNI-67:#228 ELMa;
UNNK
Two-Piece Reclining Figure
bronze
MILLS pl 56
--1959 bronze
VEN-62:pl 29
Two-Piece Reclining Figure,
No. 1 1959 bronze; 51x76
BOW 104-105; READCON
57 (col)
Two-Piece Reclining Figure,
No. 2 1960 bronze; 49-1/2
x101-1/2x42-3/4
BOW 96, 97; ROTJB pl
115; TATEB-2:11; TATES
pl 1; WHITT 56 ELT (T.
395)
--1960 bronze; 51x102
READCO pl 1 UNNMMA
Two-Piece Reclining Figure,
No 4, half-size model
1963/64 bronze; 9x14
LOND-7:#27 UNNLinc
Two-Piece Reclining Figure,
No. 5 1963/64 bronze;
8x12-1/4'
LOND-7:#28
Two Seated Figures (King
and Queen) (Zwei Sitzende
Figuren (Konig und
Konigen)) 1952/53 clay
GERT 194, 195
Two Wall Lights
AUM 129
Upright Internal and External
Forms (Upright External/
Internal Form) 1951 bronze;
24
ARTS #41
--working model 1951 bronze;
24-1/2
HAMM 71 (col) CTA;
SwBKM; URPD
Upright Motive, No. 5 1956
bronze; 84 ARTS #42
Upright Motive, No. 8 1954
bronze; 87 UMCF
UMCF (1959.42)

--1956 bronze; 78
BOW 103
Upright Motives 7, 2, and 1:
Glenkiln Cross 1956 bronze;
126
BOW 102; TRI 232
Wall Relief brick; c 28-1/4
x63'
TRI 242 NRBo
Wall Relief, No. 3 1955
bronze; 33x48.5 cm
SP 151 GHaS
The Warrior (Krieger) 1953
bronze; 62
BOSME pl 121 UMnMI
--1953 bronze
GERT 191
--1953/54 bronze; 150 cm
LIC pl 294 UMnMI
Warrior with Shield 1953/54
bronze; 60
BOW cov (col), 36, 38;
KO pl 104; LARM 365;
LONDC pl 23; MYBS 91
CTA; EB; GMaM;
UMnMI
West Wind
AUM 128 ELUR
Woman 1957/58 bronze; 60
ARTSB-61: fr cov
MOORE, Joan (English)
Reclining Figures 1945
Hoptonwood; L: 36
NEWTEB pl 3
Moore, John (British General
1761-1809)
Bacon, J. the Younger. Sir
John Moore Monument
MOORE, John Francis (English
d 1809)
William Beckford Monument
c 1767
GUN pl 15; WHINN pl 133A
ELIH
Moore, Thomas
Carter, T. I. Col. Thomas
Moore Monument
Moors
Cordieri. Moor with Child
and Dog
Tacca, P. Four Moors in
Chains
Vigarny de Borgona. Royal
Chapel Altar: Baptism of
the Moors
MOOY, Jap (Dutch 1915-)
Agression 1959 iron
VEN-64:pl 173

Icarus iron; 29-1/2
 TRI 138 GRecS
Sentinel 1961 iron; 102-3/8
 NEW pl 160 NAS
MORA, Jose de (Spanish 1642-1724)
 Christ on the Cross, detail
 VEY 196 SpGJ
 St. Bruno c 1707 ptd wood
 GOME pl 78 SpGS
 St. Pantaleon ptd wood
 GOME pl 76-77 SpGAn
 Virgin Dolorosa, bust ptd
 wood
 GOME pl 73 SpGZ
 --half figure ptd wood
 GOME 26 (col) SpMM
 Virgin of Solitude (Virgin of
 Sorrows) 1671 ptd wood
 GOME pl 74-75;VEY 286
 SpGAn
MORAL, Lesmes del (Spanish)
 See ARFE Y VILLAFANE,
 J. de
Mordaunt, John d 1675
 Bushnell. John, Lord
 Mordaunt, Monument
Mordovinian Woman
 Russian--18/19th c.
 Mordovinian and Cheremetian
 Woman
More, Thomas (English Statesman
 and Author 1478-1535)
 English--16th c. St. Thomas
 More's Pendant
MOREAU, Gustave (French 1826-98)
 Hercules c 1875/80 wax
 SELZJ 166 FPMor
 Lucretia 1875/80 wax; 20 cm
 LIC pl 145 FPMor
MOREAU, Mathurin (French)
 Joigneaux Monument
 TAFTM 35 FBeau
MOREL, Jacques (French fl 1448-59)
 Charles de Bourbon and Agnes
 de Bourgogne Tomb
 1448/53
 EVJF pl 213A; MULS pl
 64 FSouP
 Duc de Berry Tomb:
 Mourners c 1449
 EVJF pl 212; EVJL pl 86
 FBouM
 Louis II de Bourbon, head
 1448
 EVJF pl 211C FSou
MORELLET, Francois (French)
 Sphere-Web (Sphere-Trames)
 1962 BURN 260 UNNCon

Successive Illuminations 1963
 BURN 301 UNNCon
MORESCALCHI, Bernardo (Italian
 1895-)
 Shepherd bronze
 VEN-34: pl 61
Moretti, Signorini
 Carminati. Signorini Moretti
MOREY, Guillermo
 Countess Ermesindis, head
 detail 14th c. marble
 GUID 137 SpGerC
Morgan, Charles d 1642
 Dieussart. Charles Morgan
 Tomb
MORICE, Leopold (French 1846-1920)
 Diana and Endymion c 1900
 plaster
 SELZJ 3 FP
Moricz, Zsigmond (Hungarian Author
 1879-1942)
 Beck, F. O. Zsigmond
 Moricz, head
Morison, Charles d 1619
 Stone. Sir Charles Morison
 Tomb
MORLAND, Francis (English 1934-)
 Brancusi's Breakfast 1963
 plastic; 62
 HAMM 150
 Cork Float Figure 1961 bronze;
 24x6x7
 ARTSS #39 ELBrC
 Mauve Inside 1966 polyester
 resin and fibreglass, ptd;
 78x48x72
 LOND-7: #30
Morley, Sarah
 Flaxman. Sarah Morley
 Monument
Morning
 De Strobl, Zsigmund. Morning
 Dobson. Morning
 Fehr. Morning
 Michelangelo. Lorenzo de'
 Medici Tomb
 Renvall. Morning
 Rodin. Morning
 Thorvaldsen. Morning, relief
Morning Hour. Stursa
Morning Sun. Hanak
Moroa. Nepras
Moroccan Woman. Lepage
Morosini, Francesco
 Parodi. Bishop Francesco
 Morosini Tomb
MOROZZI, Dante (Italian 1899-)
 Comedy
 VEN-32: pl 179

Portrait, male head* terracotta
VEN-40: pl 63
Woman, half figure
VEN-36: pl 23
Morphologie. Altri
MORRIS, Frank
Sculpture*
EXS 20
Morris Dancer. Grasser
MORSE, Edna
Hand Sculpture 1937 wood
MOHN 42
Morses See Brooches
La Mort d'Adonis
Rodin. Death of Adonis
Mort de l'Arlequin. Stanzani
Mortars
Daverazzo. Mortar
Flotner. Mortar plaquettes
Horst. Mortar
O Morto. Adam, H. G.
MORTON, Joselyn (English 1934-)
Standing Figure 1954 cement;
2/3 LS
BED 116
MORYCE-LIPSZC
Young Girl with Fish wood
MARTE pl 23
MOSAN
Christ Trampling the Beasts
(Lion and Dragon), reliquary
end relief 11/12th c.
embossed silver gilt in
enamelled copper gilt frame;
23-1/16x14-7/8
SEAM 27 UMdBW
Aquamanile: Winged Beast
c 1130 gilt bronze; 7-1/4
JANSH 224 ELV
Baptismal Font 1107/18 brass
BAZINW 279 (col) BLB
Enamelled Cross 12th c.
KIDS 85 (col) BBRA
Fabulous Bird, Ewer early
13th c. gilt bronze,
cast and chased, with
niello and silver
READAS pl 52 ELV
Portable Altar, Stavelot mid
12th c. silver gilt,
champleve enamel, bronze
gilt; 4x6x9-3/4
KIDS 36 BBRA
Virgin and Child c 1250 gilded
bronze, engraved; 2-3/8
BOSMI 113 UMB (47.1439)

MOSCA See PADOVANO, Z. M.
MOSCHI, Mario (Italian 1896-)
Arnoldo Mussolini, medallion
VEN-40: pl 6
Calciatore, medal bronze
VEN-34: pl 32
Ice Hockey Medal
CASS 141
Michelangelo Directing
Fortification of Florence,
relief
CASS 98 IFR
Monument: Central Group
AUM 41
Moses
Barlach. Moses
Berruguete. Moses, choir
stall
Brazza. Finding of Moses
Byzantine. Moses Receiving
the Law, stele relief
Byzantine. Moses Story
Scenes, box
Chagall. Moses, relief
Danti. Moses and the Brazen
Serpent, relief
Dosio. Niccolini Chapel:
detail by Francavilla:
Moses with Tablets
Early Christian. Columnar
Sarcophagus: Moses
Striking the Rock
Early Christian. Moggio Pyxis:
Moses Receiving Tables of
Laws
Early Christian. Oil Lamp:
Moses Striking the Rock
English--13th c. Moses
French--12th c. Capitals:
Moses
--Moses, head
--Moses with Tablets of the
Law
German--10th c. Moses Re-
ceiving the Law
German--11th c. Cathedral
Door: Moses and the
Serpent
--Thomas, and Moses
German--12th c. Chalice:
Moses at the Burning Bush
Ghiberti. Baptistry Door--East:
Moses
Italian--5th c. Moses, Life
Scenes
Landini. Moses Fountain
Master Robertus. Events
from life of Moses, font
detail

Michelangelo. Julius II Tomb:
Moses
Pisano, G. Moses
Romanesque--English. Moses
Romanesque--German. Door
Panel: Moses Fleeing from
the Serpent
Schotz. Moses Hammering
out the Ten Commandments
Sluter, and Werve. Well of
Moses
Moses Fountain. Landini
Moses Fountain
Sluter, and Werve. Well of
Moses
MOSS, Marlow (English 1890-1958)
Balanced Forms in Gun
Metal on Cornish Granite
1956/57 H: 12
HAMM 58B ELBra
Construction 1956 wood, for
aluminum
HAMM 58A
Relation of Spherical Forms
1948 phosphor bronze; 11
RAMS pl 98b
Sculptural Form white
marble; 7-1/2
HAMM 59
Moss Gatherer. Dubuffet
Mosse, Captain
Rossi, J. C. F. Captains
Mosse and Riou Monument
MOSTO, Ottavio (Italian 1659-1701)
Angel, Tuscany Palace 1700
STECH pl 23 CzPHC
Glorification of St. James,
facade c 1700 stucco
STECH pl 22 CzPJ
St. Wenceslas, Charles Bridge
figure c 1698
STECH pl 21 CzPN
Mother
Boccioni. Antigrazioso
Mother. Iocubonis
The Mother
Kollwitz. Memorial for the
Flanders Dead
The Mother. Laurens
The Mother. Metzner
The Mother. Paganin
Mother. Pasztor
The Mother. Romagnoli
The Mother. Rubino, E.
The Mother. Shapshak
Mother. Strobl
Mother and Child
Ayrton. Mother and Child
Bathing

Bernard. Mother and Child,
lunette panel
Bourdelle. Mother and Child
Brown, R. Mother and Child
Clack. Mother and Child
Dobson. Mother and Child
Epstein. Mother and Child
Fabbri. Mother with Son
Francesconi. Mother and Child
Garbe, H. Mother and Child
Gies. Mother and Child
Gilbert, A. Mother and Child
Gill, E. Mother and Child,
relief#
Hepworth. Mother and Child
Huxley-Jones. Mother and
Child
Jaenisch. Mother and Child
Lagae. Mother and Child
Langer. Mother and Child
Ledward. Mother and Child
Lehmann, K. Mother and
Child
Lehmbruck. Mother and Child
McWilliam. Mother and
Daughter
Medgyessy. Mother and Child
Minne, G. Mother and Child
Moore, H. Mother and Child
Renoir. Mother and Child
Rosandic. Mother and Child
Schotz. Mother and Child
Shelley. Mother and Child
Stemolak. Mother and Son
Stojanovic. Mother and Child
Tennant. Mother and Child
Traverse. Mere et Enfant
Willumsen. Mother and Son
on Seashore
Wheeler, C. Mother and Child
Mother at Play. Krsinic
Mother Goddess, seated figure. Celtic
Mother of Animals. Muller, E.
Mother of Beloyannis. Horno-Poplawski
Mother of Silesia
Augustincic. Silesian Revellion
Memorial
Mother Tree. Stahly
Motherhood See Maternity
Mother's Kiss. Nicoloff
Motion in Space. Boccioni
Motivo Ancestrale Grande. Mirko
Motor 4. Cesar
Mouchy, Anna, Duchess of
Carpeaux. Duchess de Mouchy,
bust
Mouettes. Witschi
Mount of Olives See Jesus Christ--
Gethsemane

MUCCHI, Genni
St. Matteo, portal to the
Tabernacle 1951
GERT 123
Il Torturato, detail wood
NORM 93
MUEHL, Otto (Austrian)
Materialaktion 1964
KULN 37
Materialaktion Stilleben# 1964
KULN 75
MUELLER, Augustus Max Johannes
(German)
Mozart, bust 1897 bronze
SALT 140 UNBP
Muirdach's Cross. Celtic
MUKHINA, Vera (Russian 1889-1953)
Boy, head 1934 bronze
VEN-60:pl 211 RuMT
Diver CASS 103
Machine Tractor Driver and
Collective Farm Girl
stainless steel
BLUC 255
Partisan Woman 1942 bronze
VEN-56:pl 145 RuMT
Peasant Woman
BLUC 253
Mules
Dazzi, A. Soldiers, arch
detail
Il Muletto e l'Alpino. Canonica
MULLER, Erich (Swiss 1927-)
Einhorn 1952/53 oak; 148 cm
JOR-1:pl 61
Mother of Animals 1951 wood;
44
SCHAEF pl 102
Ruben 1954 H: 40 cm
JOR-1:pl 60
Sabine 1954 rose geranium;
65 cm
JOR-1:pl 62
Die Saule 1953/54 oak; 148 cm
JOR-1:pl 59
Woman 1951 wood; 26-3/4
11-3/4
GIE 285
MULLER, HANS OF BRESLAU
(Fl 1588-1606)
Coconut Goblet: Story of
Samson c 1600 gilded
silver; 11-3/4
KUHN pl 40 UMCB
(1961.58)
MULLER, Juana (Chilean-French
1911-52)

Head of a Child 1950 wood; 6
GIE 285 FPGM
Sculpture plaster
MAI 217
MULLER, Robert (Swiss 1920-)
Aaron's Rod (Aaronstab) 1958
iron; 56
GIE 309; JOR-2:pl 148
--c 1958 welded metal; 56
HENNI pl 136; MINE 33
UNNLoe
Archangel (L'Archange) 1963
iron; 31-1/2x63x63
LARM 327; MEILD 108;
NEW pl 71; READCON 238
FPFr
L'Avaleur 1959 iron
MEILD 87 UOC1A
La Broche 1953/54 iron; 120
cm
JOR-1:pl 105
Le Bucher 1959
JOR-2:pl 250
Ex Voto 1957 metal: 83-1/2
x20-1/2x20-1/2
CARNI-58:pl 46 UNNMMA
Gunner 1959 iron; 51
SEAA 150 FPFr
The Heart 1963 iron; 165x
100 cm
JOO 207 (col) NOK
Hermit 1962 H: 51
SEITC 50 UNNH
Jouet Nocturne Nachliches
Spielzeug 1951 iron; 50 cm
JOR-1:pl 106
Kanonier 1959
JOR-2:pl 249
The Knot 1956 wrought iron;
L: 51
BERCK 171 FPFr
Langouste 1956
JOR-2:pl 146
Larva 1957 steel; L: 21-1/4
GIE 265
Leech 1958 welded metal;
31-1/2x40-1/2
SELZS 163 UNNLoe
The Mango 1956 wrought iron;
40
BERCK 309; JOR-2:pl 145
-Sw
O No 1956 forged iron; 140 cm
SAO-4 FPFr
Organ (L'Orgue) iron; 83
GUGE 82 NAS
The Pyre 1959 iron
SELZJ 11 FPPr

Le Rapt (Die Entfuhrung)
 1953/54 iron; 150 cm
 JOR-1: pl 107
Il Ratto 1954 iron
 VEN-56: pl 143
Relief 1957 iron
 MARC pl 66 FPFr
Rittersporn 1958 welded
 iron; 46-1/2
 MINE 33 FPFr
Rubezahl 1958
 JOR-2: pl 147
Sculpture 1958
 JOR-2: pl 248
--1958 wrought iron
 MAI 217
Sheba 1958 iron breadth;
 30-1/4
 TRI 170 -Roth
The Spit 1953 wrought iron
 LARM 253
--1955 wrought iron
 MAI 218
Usurper (L'Usurpatore) 1958
 iron
 MARC pl 67 UNNMMA
--1959 cast iron
 VEN-60: pl 206 UNNLoe
MULLER-OERLINGHAUSEN,
 Berthold (German 1893-)
 Der Komponist R. Oboussier,
 head 1930 bronze
 HENT 114
 Portrait 1952 clay
 GERT 89
MULLNER, Josef (Austrian 1879-)
 Fountain Figure ptd plaster
 VEN-34: pl 178
 Horseman lead
 VEN-38: pl 55
MULLNER, Matthaus
 Church Door 1725
 BOE pl 178 GDur
Multiform Sculpture. Hermanns
MULTSCHER, Hans (German fl
 1427-67)
 Altar, details: St. Ursala;
 Virgin and Child; St.
 Apollonia c 1456/58
 MULS pl 87 IVipF
 Countess Mechthild of the
 Palatinate, effigy detail
 c 1450
 MULS pl 86B GTuS
 Duke Ludwig the Bearded
 tomb lid model 1435 stone
 MULS pl 84 GMB

German Yeoman 1427
 LOH 172 GUU
Madonna after 1456 wood
 KO pl 59 GSter
Madonna and Child 1456/58
 MAR 109 IVipF
Man of Sorrows, west portal
 1429 stone; 67-3/8
 BUSR 62; KO pl 59; LOH
 155; MULS pl 85; ST 252;
 VEY 135 GUM
Page, Town Hall Window
 c 1427/30
 MULS pl 83B GUU
St. Catherine, bust c 1460
 MULS pl 86A UNNF
St. George; St. John the
 Evangelist mid 15th c.
 stone
 MOLE 80 (col) GUC
St. Magdelene Borne by
 Angels 1435 lindenwood;
 133 cm
 BSC #47 GBS (5923)
St. Mary Magdalen c 1450
 wood
 KO pl 59 (col); LIL 100
 GRotL
Shield-Bearer of Emperor
 Charles c 1420 stone
 KO pl 59 GUU
Virgin Seated c 1430 lime-
 wood; 22
 NEWTEM 19 (col) GMBN
The Mummer. Garbe, R. L.
MUNARI, Bruno (Italian 1907-)
 Concavo-Convesso 1960
 KULN 188
 Polariscope N. 3, programmed
 kinetic object 1965
 PEL 165
 Useless Machine (Macchina
 Inutile) 1933/34 wood
 VEN-66: #16
 Useless Machine N. 74 (in
 movement) 1946
 PEL 164
Mungo, Saint
 Frampton. St. Mungo, seated
 figure
MUNRO, Alexander (English 1825-61)
 Mrs. Henry Acland, relief
 head marble
 MILLER il 163 EOC
 Paolo and Francesca 1852
 LIC pl 68 UA1BC
MUNSTERMANN, Ludwig (German
 c 1575-1638)

Adam and Eve, font corner
 fragment 1623/24 linden-
 wood; 26 cm
 BUSB 37; HEMP pl 24;
 MUL 96 GO1L
Altar c 1623
 HEMP 25 RuCL
Angel's Head, organ prospect,
 Rotenburg 1608 wood
 BUSB 38 GBremF
Apollo 1615/16 oak; 98 cm
 BSC pl 112, 113 GBS
 (2/63)
Apostle
 LIL 176 GO1V
Hercules, head, facade
 figure c 1600 sandstone
 BUSB 39 GBremF
Pulpit Sounding-Board,
 canopy detail: Descent of
 the Holy Ghost 1631
 LOH 216 GO1R
Mural Composition. Descombin
Mural Relief. Duprey
Mural Sculpture. Cesar
Murals See Wall Decoration
MURANYI, Gyula (Hungarian 1881-
 1920)
 Pablo Casals, relief bronze;
 5.3x7.1 cm
 GAD 95 HBA
Murat, Princess
 Despiau. Princesse Murat,
 head
Murmur of Boundaries
 Chillada. Whispering of
 the Limits
Muro del Sonno. Pascali
Murray, William, 1st Earl of
 (British
 Parliamentarian and Jurist
 1705-93)
 Flaxman. Lord Mansfield
 Monument
Muscles in Action. Boccioni
Muses See also names of Muses, as
 Calliope; Melpomene;
 Terpsichore; Thaleia
 Bourdelle. Apollo and the
 Muses, relief
 Bourdelle. Les Muses, detail
 Brancusi. Muse#
 Brancusi. Sleeping Muse#
 Byzantine. Muse and Poet
 Ceracchi. Anne Seymour
 Damer as the Muse of
 Sculpture

Italian(?)--6th c. Diptych of
 the Muses
Kels. Two Muses
Milles. Aganippe Fountain
Puech. The Muse of Andre
 Chenier
Rodin. The Muse
Rodin. La Poete et la Muse
Wijnants. Muse
Music Stand
 Charpentier, A. Revolving
 Music Stant
Musical Wire Sculpture IV. Takis
Musicians and Musical Instruments
 Adriaen van Wesel. St.
 Joseph and Music-Making
 Angels
 Agostino di Duccio--Foll.
 Musician, decorative relief
 Almquist. Musician Triton
 and Nymph, balustrade
 figures
 Bertoldo di Giovanni. Apollo
 Bourdelle. Music
 Bradford, A. T. Theatre
 Panel: Musical Instruments
 Clodion. Poetry and Music
 Donatello. High Altar;
 Angels Playing Musical
 Instruments
 English--12th c. Crypt
 Capital: Animal Musicians
 English--13th c. Angel Choir:
 Angel with Pipe and Tabor
 English--14th c. Angel, choir
 vault
 English--18th c. Chelsea
 Chinese Musicians
 --The Music Lesson, Chelsea
 Porcelain
 English--19th c. Pearlware
 Figures: Mars; Spring
 and Autumn; Two Musicians
 Falconet. Music
 French--11th c. Ambulatory
 Capitals: Plainsong--4
 tones: Lute, Timbrels,
 Psaltery, Chime Bells
 --Apocalyptic Elder, book
 cover
 French--12th c. Virgin Portal
 Tympanum: Grammar;
 Pythagorus; Music
 French--13th c. Music, portal
 figure
 --Musician
 --Tympanum; Musicians of
 the Apocalypse

Douvermann. Altar of the
 Virgin of the Seven Sorrows:
 King David at the Root of
 the Tree of Jesse
French--12th c. Capital: Sheep
 Playing Harp
German--13th c. Harpist
Gibbons. King David Playing
 the Harp
Riccio. Arion
Romanesque--Spanish. King
 David
Rosandic. The Harp Player
--Harpsichord
Italian--17th c. Harpsichord
Italian--18th c. Harpsichord--
 Triton Legs
--Horn
Achiam. Shepherd with a
 Horn
French--14th c. Trumpeting
 Angel
Szczepkowski. Musical Angels
--Hurdy-Gurdy
Orcagna. Angel with Hurdy-
 Gurdy
--Kobza
Folk Art--Russian. Kobza
--Lute
Bruggemann. Lute-Playing
 Angel
Feuchtmayer. Angel with
 Lute
German--16th c. Angel with
 Lute
German, or Swiss--16th c.
 Chandelier: Woman Playing
 Lute
Gilcenstein. The Lute Player
Robbia, L. della. Orpheus
 Playing to the Animals,
 campanile relief
Stosz. The Annunciation:
 Flying Angel
--Lyre
Dupre. Sappho
Feigin. Lyre Player
Frampton. Music
Gunther, F. I. Raphael
Laurens. Small Amphion
Legros, P. Cherubs and a
 Lyre
Mascherini. Orpheus
Milles. Orpheus Fountain
Pradier. Sappho
Rodin. Orpheus
Roubiliac. George
 Frederick Handel, 1938

Sicard. Archibald Fountain
Szwarc. David
Theed, W., the Younger.
 The Bard
--Mandolin
Gargallo. Harlequin with
 Mandolin
Picasso. Mandolin
--Oliphant
Italian--11th c. Oliphant:
 War or Hunting Horn
--Organ
English--16th c. Matthew
 Godwin Monument
Christian, J. J.; M.
 Hermann; Riepp. Organ
--Piano
Benet. Marche Funebre d'un
 Heros
--Pipes
Bayes. Lure of the Pipes of
 Pan
French--12th c. Pan Pipes
Kalin, Z. Little Shepherd
Kos. Little Shepherd
Mascherini. Faun
Perl. Pied Piper of Hamlin
 medallion
Sicard. Archibald Fountain
Thorvaldsen. Mercury Putting
 Mars to Sleep with his
 Pipes
--Psaltery
French--11th c. Ambulatory
 Capitals: Plainsong--Third
 Tone (Psaltery)
--Ruilya
Folk Art--Russian. Ruilya
--Singers
Barlach. Singende Kloster-
 schuler
Barlach. Singing Boy
Barlach. Singing Man
Batten. Singing Negress
Bernard. La Chanteuse
Donatello. Cantoria
Du Bois, P. Florentine
 Singer
Du Bois, P. Florentine
 Street Singer
French--13th c. Requiem
Gaudier-Brzeska. La
 Chanteuse Triste
Greco, E. The Singer
Hartwell. The Chorister
Kandler. Singer
Kotrba. Singer
Lombardo, P. A Singing Angel

Lorcher. Chor
Marques. Street Singers
Milles. Sun Singer
Peric. The Singers
Robbia, L. della. Cantoria
Robbia, L. della. Singing
 Boy, head
--Spinet
Kandler. Pair of Lovers by
 Spinet
Laurens. L'Epinette
--Tambourine
Carpeaux. Dancer with
 Tambourine
Clodion. Satyr with
 Tambourine
Donatello. Putto with
 Tambourine
Orcagna. Angel with
 Tambourine
--Timbrels
French--11th c. Ambulatory
 Capitals: Plainsong--
 Second Tone (Timbrels)
--Trumpet
Nicolas of Verdun. Altar of
 Verdun: Angels Sounding
 Trumpets of Last Judgment
Parbury. Four Angels
Robbia, L. della. Cantoria
--Viola
German--16th c. Angel with
 Viola
--Violin
Barlach. Village Fiddler
Bertoldo di Giovanni. Arion
Carpeaux. The Violinist
Charoux. Violinist
Dantan. Paganini
English--12th c. Crypt
 Capital: Animal musicians
 --Goat Fiddler
Gargallo. The Violinist
Kandler. Harlequin Group,
 Meissen
Stuza. Ukranian Fiddler
Musidora. Theed, W., the Younger
MUSKAT, Jorg (Jorg Muscat)
 (Austrian c 1450-1527)
 Emperor Hadrian, bust c
 1510/15 bronze; 17-3/4
 EXM 36 AVK
 Maximilian I, head 1500
 bronze; 34 cm
 MUL 22 AVK
Musset, Alfred de (French Poet
 1810-57)
 David D'Angers. Alfred de
 Musset, medallion

Moncel. Alfred de Musset
 Memorial
Mussolini, Arnoldo
 Moschi. Arnoldo Mussolini,
 medallion
Mussolini, Benito (Italian Dictator
 1883-1945)
 Bednorz. Mussolini, head
 Berti. Il Duce, half figure
 Drei. Il Duce, head
 Michahelles. Il Duce, head
 Righetti. Il Duce, half figure
 Tomba. March on Rome
 Troubetzkoy. Mussolini, head
 Vecchi. Precipice of Empire
 in the Mind of Il Duce
 Wildt. Benito Mussolini, bust
Mussolini, Bruno
 Sabbatini. Bruno Mussolini,
 medal
Mustard Pots
 Kandler. Meissen Mustard Pot
 and Oil Jar: Woman and
 Chicken
Mute Music. Chillada, E.
Muti, Giovan Andrea
 Cametti. Giovan Andrea Muti
 Tomb
Mutile et Apatride
 Arp. Maimed and Stateless
MUTSCHELE, Johann Martin
 (German 1733-1804)
 Madonna of Victory 1771
 white glazed faience;
 48-1/2
 BOSMI 137 UMB (61.1185)
Mutter und Kind
 Lehmbruck. Mother and Child
Mutterschaft. Rehmann
My Ancestor. Kosso
My Son. Orloff
My Son. Puvrez
Myers, William
 Kendrick. Monument to
 Col. Sir William Myers
MYSLBEC, Josef V. (Czech 1848-
 1922)
 Cardinal Schwartezenburg
 1898 bronze; 84
 RAMS pl 10d CzPV
 Crucifix 1890 bronze; 11'
 CASS 107; RAMS pl 54a
 CzPM
 St. Vaclave bronze and
 granite
 MARY pl 142 CzP
Mystery Plays
 Sluter and Werve. Well of
 Moses: Prophets, from

Leonardo da Vinci--Foll.
Negro on Horseback Fight-
ing a Lion
Matisse. Deux Negresses
Norman, P. E. Head of
Negress
Renaissance. Negress,
seated figure examining
foot
Riccio--Foll. Negro Boy
Riding a Long-Haired
Goat
Sansovino, J. Negress with
a Looking Glass
Underwood. African Madonna
Venetian. Blackamoor
NEGROL, Jacobo Felipe (Spanish)
Carlos I, helmet with curled
hair and beard 1533
SMIBS 162 (col) SpMaAr
Charles V Round Shield:
Lion's Head 1533
SMIBS 163 (col) SpMaAr
NEGROLI, Filippo (Philip de
Negroli) (Italian)
Parade Helmet-Embossed
Casque of Francis I,
Milanese 1543 steel,
embossed in high relief;
10x7-1/4x13-1/2
BURC pl 33; DETD 96;
MU 159; NM-3:11; NM-
11:98 UNNMM (17.190.
1720)
Three Saddle Steels and a
Chanfron
COOP 55 (col) IBrMa
NEGROLI, Filippo--ATTRIB
Espalier Plates 16th c.
CLE 98 UOC1A
(16.1517; 16.1518)
NEGROLI, Paolo de (Milanese)
Breastplate c 1540 steel
embossed in high relief
and chased; 23-1/4x
16-3/8
DETD 12 UNNMM
NEIHARDT, Wolfgang See RIECHLE,
H.
Nel with a Chignon. Wouters
NELE, Eva Renee (German 1932-)
Architektur Kopf 1964
bronze; 11-3/4x15-3/4
NEW pl 330 GMVan
The Couple 1961 bronze;
21-1/2x13-3/8
READCON 235 GMB

Relief 1958 iron; c 47-1/4x
27-5/8
TRI 220 SwZBe
Nella Raffica. Girelli
NELSON, Helen
Gas Attack plaster
CASS 86
Nelson, Horatio (British Naval
Hero 1758-1805)
Andras. Admiral Lord
Nelson, effigy
Flaxman. Nelson Monument
Nenuphar. Koch, O.
Neo-Geometric Relief. Arp
Neoplatonic World. Agostino di
Duccio
NEPRAS, Karel (Czech 1932-)
Hlava 1964
KULN 42
Moroa 1965/66 wire and
textile, lacquered
BER 65
Neptune See Poseidon
Neptune Fountain. Bologna
Nere, Giovanni dalle Bande
Bandinelli, B. Giovanni delle
Bande Nere
Sangallo, F. Giovanni dalle
Bande Nere, bust
Nereids
Byzantine. Nereid on Sea
Monster, ewer
Jonk. Nereid and Triton III
Rodin. Nereides
Russian--2nd c. Dish:
Nereid Riding Hippocampus
Woodford. Nereid, fountain
group
Nerenska, Pola
Epstein. Pola Nerenska, head
Nerli Cassone. Italian--15th c. (?)
Nero
Italian--17th c. Nero, bust
"Medalist of the Roman
Emperors". Nero,
medallion
Porta, G. B. della. Nero,
bust
NEROCCIO DEI LANDI (Italian fl
1447-1500)
St. Catherine of Siena 1470
ptd wood
POPR fig 100; SEY pl
84B ISCa
Neroni, Dietisalvi (Florentine
Condottiere)
Mino da Fiesole. Dietisalvi
Neroni, bust

NESCH, Rolf (German 1893-)
 Minotaur 1952/57 copper,
 brass, zinc, glass
 VEN-64:pl 42 GHK
NESJAR, Carl (Norwegian-French
 1920-)
 Relief, Norwegian Pavilion,
 International Garden,
 Architecture Exposition,
 Hamburg 1963 sandblasted
 concrete; 86-5/8x258
 NEW pl 173
Nessus
 Bologna. Hercules and Nessus
 Bologna. Nessus and Deianira
 Luksch. Nessus
 Traverse. Nessus and
 Deianira
The Nest. de Rudder
The Net Carrier. Hildebrand
Netherland Memorial Flagpole,
 pedestal.
 Eynde, H. A. van den
NETHERLANDISH
 Adoration of the Child,
 votive stone of Ditmar de
 Breme d 1439
 MULS pl 70 BAndCh
 Altar of the Passion 1466
 walnut
 MULS pl 111B FAmbP
 Altarpiece, Rieden c 1450
 MULS pl 109A GStWL
 Annunciation, relief, Brabant
 c 1500/10 oak; 13x12
 KUHN pl 32 UMCF (1943.
 23)
 Burgundian Court Goblet
 c 1425/50 rock crystal,
 jeweled gold and enamel
 mounts; 18
 ARTV pl 40 AVK
 Console: Angel Holding
 Shield c 1425/50 sand-
 stone; 5-5/8x6-3/4x
 4-3/4
 KUHN pl 4 UMCF
 (1949.47.45)
 Crucifixion, Nivelles wood
 MULS pl 159 FPL
 Crucifixion, details, St.
 Pierre, Louvain c 1490
 wood
 MULS pl 158 BLouP
 Democritus, bust early 18th
 c. ptd lindenwood; 9-7/8
 (excl marble base)
 KUHN pl 60 UMCF
 (1943.1294)

Descent from the Cross,
 Brabant c 1460/70
 MULS pl 110A UMiD
Dicing Soldiers, Crucifixion
 detail, Antwerp c 1490/
 1500
 MULS pl 160 GM
Englebrecht of Nassau and
 Johanna of Polanen
 Monument
 MULS pl 71B; POST-1:
 247 NBG
Five Triumphs: Justice;
 Folly; Church; Humility;
 Poverty, reliefs end
 16th c. bronze; 2-7/8x5
 to 2-5/8x4-1/8
 KUHN pl 38 UMCF
 (1934.85-1934.89)
Flight into Egypt c 1500 ptd
 oak; 41-3/4
 RIJA pl 116 NAR
Friar Jehan Fiefves Monu-
 ment d 1425
 MULS pl 68 BBCi
Heraclitus, bust early 18th c.
 ptd lindenwood; 9-7/8
 (excl marble base)
 KUHN pl 61 UMCF
 (1943.1293)
High Altar c 1420/25
 MULS pl 19 GDorR
King Melchior, Adoration
 Figure c 1490
 MULS pl 113B GCoS
Meeting of Joachim and Anna
 c 1460 oak
 MULS pl 105B NAR
Mercy Seat, Tabernacle of
 Mathieu de Layen 1450
 MULS pl 72B BLouP
Misericord: Female Head
 c 1493 wood
 MULS pl 161B BDieS
Nativity, Colmar c 1470/80
 MULS pl 115B NAR
Resurrection, fragment
 c 1550 sandstone; 11-1/8
 x31-1/4x7-1/8
 KUHN pl 4 UMCF
 (1949.47.48)
Retable Group, High Altar
 c 1410/20
 MULS pl 18 BHakS
Rood Screen 16th c.
 CHASEH 247 BLiG
St. Adrian c 1460 stone
 MULS pl 95B
 BBR

St. Bavo c 1460
 MULS pl 96B UNNMM
St. George c 1455/60
 MULS pl 96A NUC
St. Gertrude 15th c. oak
 MULS pl 162C BEtG
St. John, head c 1500 wood
 PANS 4 GHKG
St. John the Evangelist c 1550
 gilded bronze; 5-3/4
 KUHN pl 39 UMCF
 (1954.59)
St. John the Evangelist
 c 1575/1600 bronze; 11
 KUHN pl 46 UMCF (1949.90)
St. Leonard Altarpiece
 (1479?)
 MULS pl 109B NZoL
St. Servatius Legend, relief,
 Maestricht 1403 silver
 gilt
 MULS pl 12B GHKG
St. Ursula, Bruges c 1490
 oak
 MULS pl 162A GBS
Standing Warrior c 1530
 nutwood(?); 12-5/8
 KUHN pl 33 UMCF
 (1949.65)
Virgin c 1400/10 stone
 MULS pl 10 BLJ
Virgin and Child 15th c.
 alabaster
 MULS pl 21A NAR
Virgin and Child c 1470 oak
 MULS pl 138B SnV
Virgin and Child, Brussels
 c 1490/1500
 MULS pl 162B FPL
A Woman Holding a Heart,
 Antwerp c 1630 pearwood;
 12-1/4
 VICF 69 ELV (344.1885)
Women at the Sepulchre,
 detail c 1440/50 stone
 MULS pl 72A BSV
NETHERLANDISH, or FRENCH
 Pieta 16th c. wood; 43
 TOR 133 CTRO (924.25.3)
NEUMANN, Balthaser
 Baroque Staircase; with
 children's statues by J. P.
 Wagner 1719/44
 CHRP 265; LOH 241
 GWuP
NEUMANN, J. B., and others
 (German 1687-1735)

Wall Decoration
 MOLE 247 GV
NEUSEL, Gunter (German 1930-)
 Sculpture 1956 plaster, for
 bronze; 19-5/8x19-5/8
 TRI 219
The New Age. Howes
New Babylon. Constant
The New Born. Brancusi
New Life. Jonsson
New Reality. Franchina
New Sacristy Madonna
 Michelangelo. Medici Madonna
The New Spirit. Underwood
Newborough Font. Celtic
Newdigate, Ladies
 Bacon, J., the Younger.
 Third Lady Newdigate
 Monument
 Hayward. Ladies Newdigate
 Monument ('Storied Urn')
Newent Cross Shaft. Anglo-Saxon
Newhaven, Viscount
 Woodman. Monument to
 Viscount Newhaven
Newton, Isaac (English Scientist
 and Mathematician 1642-1727)
 English--18th c. Sir Isaac
 Newton, ivory portrait
 bust
 Lemarchand. Sir Isaac
 Newton, medallion
 Roubiliac. Sir Isaac Newton
 Rysbrack. Sir Isaac Newton
 Monument
Ney, Michel (French Soldier
 1769-1815)
 Rude. Marshal Ney Monument
Ni Accident, No Drame. Kaniaris
ni/62. Reich
Nicaise, Saint
 French. St. Nicaise between
 Two Angels
Nicator. Tinguely
NICCOLINI, Giovanni (Italian 1872-
 1956)
 Il Bruto, marble
 VEN-22:13
 Goloso! bronze
 VEN-20:85
 Satyr Family Fountain
 (Fontana della Famiglia
 Satiri; Fontana Gaia)
 1929
 MINB 79 IRB
Niccolini Chapel. Dosio
NICCOLO DA BARI See NICCOLO
 DELL'ARCA

NICCOLO, Italian
 Jeremiah, relief, west door
 1135/41
 BECKM 191 IFeC
NICCOLO, Pietro di See LAMBERTI,
 Niccolo di Pietro
NICCOLO D'APULIA See PISANO,
 Niccolo
NICCOLO DA RAGUSA See PISANO,
 Niccolo
NICCOLO D'AREZZO See LAMBERTI,
 Niccolo di Pietro
NICCOLO DE PERICOLO See
 TRIBOLO, IL
NICCOLO DELL'ARCA (Niccolo
 d'Antonio dall'Arca; Niccolo
 da Bari, also identified with
 Pisano, Niccolo, which see)
 (Italian c 1435-94)
 Angel with Candlestick
 MACL 185 IBoD
 Kneeling Angel, candelabrum
 NEUW 25
 The Lamentation, detail
 c 1485/90 terracotta; LS
 JANSH 341; JANSK 639;
 POPR fig 127, pl 121;
 SEY pl 124B, 125-6 IBoM
 Pieta, detail: Mourning
 Woman 1463 terracotta
 BR pl 6; LARR 111;
 MACL 183 IBoM
 Prophet in Turban 1473/94
 marble; c 20
 MOLE 127 IBoD
 St. John the Evangelist,
 Deposition figure c 1485
 terracotta
 CHAS 173 IBoM
NICCOLO DELL'ARCA, and
 MICHELANGELO
 Shrine of St. Dominic;
 detail 1469/96 marble
 SEY pl 122, 123B IBoD
 --Angel
 SEY pl 124A
 --God the Father
 SEY pl 123A
NICCOLO DI BARTOLOMEA DA
 FOGGIA See NICOLO DA
 FOGGIA
Niccolo di Forzore
 Memling. Niccolo di
 Forzore
NICCOLO DI GUADIAGRELE See
 ABRUZZI MASTER
NICCOLO DI PIETRO LAMBERTI
 See LAMBERTI, Niccolo di
 Pietro

Niccolo Michiel of Venice
 (Philosopher and Procurator
 of St. Mark's)
 Brescia. Niccolo Michiel,
 medal
Niccolo Palmieri (Bishop of Orte)
 Guazzalotti. Niccolo
 Palmieri, Bishop of Orte,
 medallion
NICHITA (Rumanian)
 Wallachian Doors, Tismana
 Monastery 1698 pearwood;
 199x110 cm
 ARTSR pl 46 RBMN (106)
Nicholas, Saint
 Barisanus of Trani. Door
 Panels: Nicholas
 Peregrinus
 Christian. St. Nicholas
 English--12th c. Poor
 Father, Legend of St.
 Nicholas, and Nativity,
 crozier head
 --St. Nicholas Story
 German--16th c. St. Nicholas,
 seated figure
 Jorhan. St. Nicholas
 Kohl, J. F. St. Nicholas
Nicholas IV (Pope)
 Fontana, D. Nicholas IV
 Tomb
Nicholas of Bari, Saint
 English--12th c. Crozier
 Head: Miraculous Birth
 of St. Nicholas of Bari
NICHOLAS OF VERDUN (Nicolas
 of Verdun; Nikolaus Von
 Verdun) (French 1150-
 1210/20)
 Altar of Verdun: Angels
 Sounding Trumpets of the
 Last Judgment 1180 nielloed
 metal plate
 BUSRO pl 174 AK
 --Jonah and the Whale
 LARB 310
 --Samson and the Lion
 CHRC 162
 Seated Christ or Apostle
 c 1200 bronze; 9-1/4
 FREED pl 2 GBS
 Shrine of the Three Kings
 (Shrine of the Magi) 1186/
 1220 gold and silver gilt
 enamel, and precious
 stones on wood; 68x72x52
 KO pl 49; VEY 145 GCoC
 --detail
 KIDS 105

--Apostle James
 LOH 110; ST 199
--Daniel
 SWA pl 221
--Inhabited Scrolls--Dragons;
 Centaur
 SWA pl 222
--James the Elder; Prophets
 Jonah and Joel
 BUSRO pl 176, 178-9
--King Solomon
 BUSGS 1, 14
--Prophet, seated figure
 with streamer oak; 51-1/2
 AUBA 114, 115 (col)
--Prophet Aaron gold leaf;
 15-3/4
 NEWTEM 13 (col)
Shrine of Virgin, detail:
 Flight into Egypt 1205
 silver gilt; 90x126x70 cm
 SWA pl 220 BTouC
--Three Marys at the Tomb;
 Crucifixion
 SWA pl 219
--The Visitation
 BUSRO pl 175
Nicholas von Flue, Saint
 Folk Art--Swiss. The
 Peasant St. Nicholas von
 Flue
NICHOLSON, Ben (English 1894-)
 December 65 (Amboise),
 relief 1965 73-1/4x48
 CARNI-67:#229 ELG
 February 1956 (Menhir),
 relief 1956 ptd hardboard;
 38-5/8x11-3/4
 CALA 227; GUGP 35 IVG
 March 64 (Circle and
 Venetian Red), relief
 1964 oil on fibreboard;
 17-1/2x11
 NEW col pl 43 (col)
 -Vog
 Lipari, relief 1957 23-1/4
 x29
 SFMB #60 ELBrC
 Painted Relief 1944/45
 READAN #56 -Gar
 Relief 1934 ptd wood; 47x24
 NMAC pl 221
--1937
 MOHV 149
--1939 ptd wood; 32-7/8
 x45
 CANM 494; LARM 262;
 MCCUR 265; RIT 155;
 ROTJB pl 136 UNNMM

Relief (Paros) 1962 24-1/2
 x25-1/8
 SCOM pl 5 ScEM
Roseveor 1956
 BERCK 217
Untitled (Ohne Titel), relief
 cardboard and wood; 33.5
 x30.5 cm
 SP 164 GHaS
White Relief 1935 mahogany
 mounted on plywood and
 ptd white; 40x65-1/2
 ENC 664; HAMP pl 140;
 ROTJT 12; TATEB-2:15
 ELT (T.49)
--1937/38 ptd wood; 25-1/4
 x49-1/2
 ALBC-3:#63 UNBuA
--1938 wood; 41-1/2x43-3/8
 HAMM 31 NOK
--1939
 CANK 179
NICLAUS VON HAGENAU (German
 fl 1486-1526)
 Gallery, south transept of
 Munster begun 16th c.
 BOE pl 134 FStrMu
 Presentation of Christ in the
 Temple (Darstellung Christi
 in Tempel), relief; detail
 1400 lindenwood; 70x95 cm
 BSC pl 55, 54 GBS (M247)
 St. Augustine, and Donor,
 Isenheim Altar 1500/10
 MULS pl 170 FCo1U
 Self Portrait, half figure,
 above portal bust, St.
 Andrew's Chapel c 1495
 MULS pl 168A FStrMu
NICLAUSSE, Paul Francois (French
 1879-1958)
 Briarde
 BAS 137 FLM
 Le Bucheron, fragment
 BAS 138 FPLev
 La Vigne
 BAS 140
 Mme F., head
 BAS 138
 Monument to the Dead
 Soldiers of Metz, fragment
 BAS 135
 L'Orphelin
 BAS 141 FCahE
 Paul Valery, head
 BAS 139 FPM
--bronze
 MAI 222 A1

NIELSEN, Jais (Danish)
 Potter stoneware
 CASS 113 DCR
 St. Paul sandstone
 MARTE pl 25
NIELSEN, Kai (Danish 1882-1924)
 Eve and the Apple bronze;
 c 69
 RICJ pl 27 UNBB
 --buff limestone; LS
 CASSTW pl 33 SnSN
 Leda and the Swan (Leda Uden
 Svanen)
 VEN-32:pl 165
 --1919/20 metallic cement;
 97x166.5 cm
 COPGM 51 DCN
 (I.N. 1889)
 Mads Rasmussen 1912/14 black
 granite; 242 cm
 BOES 163 DFaM
 N. Larsen Stevns, head 1914
 plaster; 31 cm
 COPGM 49 DCN
 (I.N. 2752)
 The Shipwrecked
 (Sofartsmonumentet) 1924
 bronze; 94.5 cm
 COPGG 108; COPGM 53
 DCN (I.N. 1887)
 Venus and Cupid marble
 PAR-2:200
 Venus with the Apple
 MARY pl 150 UNB
 Woman in Repose
 VEN-36:pl 38 DAA
 Woman Standing bronze
 RICJ pl 27
 --bronze
 CASS 63 DAR
NIELSON, Egon Moller (Swedish)
 See ERIKSSON, Elis
Nietzsche, Friedrich
 Klinger. Nietzsche, bust
NIEUWENHUYS, Constant See
 CONSTANT
Nigger, head. Botzaris
Night
 Braun, A.--Foll. Allegory
 of Night
 Brokoff, F. M. Palace
 Portal: Day; Night
 Brutt. The Night
 Epstein. Night
 Genucchi. La Notte
 Maillol. Night
 Michelangelo. Giuliano de'
 Medici Tomb: Night and Day

 Prouve. Bowl: Night
 Tapper. Night
 Thorvaldsen. Night
 Turnbull. Night
Night Bird. Fabbri
A Night in May. Rodin
Night Plant. Bechteller
Night Ride. Zwobada
The Night Riders. Koenig
Nightingale, Elizabeth d 1751
 Roubiliac. Lady Elizabeth
 Nightingale Monument
Nijinsky, Waslaw (Russian Dancer
 1890-1950)
 Kolbe. Nijinsky
 Rodin. Nijinski, study
 Rosales. Nijinsky
Nike See Victory
NIKOLAUS See NICOLAUS
NIKOLOV, Andrei (Bulgarian 1878-
 1959) See NICOLOFF,
 Andrei
Nile River
 Bernini, G. L. Fiumi
 Fountain
 Braque. The Nile
Nilometer
 Early Christian. Dish:
 Putti Marking Nilometer
Nilsson, Ada
 Derkert. Ada Nilsson
NILSSON, Gunnar (Swedish-French
 1904-)
 The Family 1959 bronze
 MAI 222
Nimbus
 Russian--16th c. Nimbus
 (Halo) of Vladimir Virgin
NIMPTSCH, Uli (German-English
 1897-)
 Fountain: Birth of Venus
 1959 bronze; 48x28x36
 LOND-6:#31
 Olympia c 1953/56 bronze;
 23x43-1/2x24
 LOND-5:#33; ROTJB pl
 39; TATEB-2:19; TATES
 pl 24 ELT (T.97)
Nimrod. Danziger
Nina. Cornet
Nine Balls on an Inclined Plane.
 Bury
Nine Balls on Five Planes. Bury
Nine Elements. Tilson
Nine Heroes. German--14th c.
"Nine Malic Molds"
 Duchamp. The Large Glass
"959 Jul". Ferrant, A.

Ninfa, bust, medallion. Donatello--
 Attrib.
NINI, Giovanni Baptiste (Italian
 1717-86)
 Benjamin Franklin, medallion
 terracotta; Dm: 4-1/2
 SMITR fr cov (col)
 UDCNMSP
Niniche. Ernst
Niobe
 Grard. Niobe
 Raphael (Mafai). Niobe
Niobids
 Sant'Agata. Niobid
NITSCH, Ludwika (Polish 1889-)
 Copernicus 1954 stone
 JAR pl 10 PWP
NIZZA, Lorenzo (Italian), and
 Lorenzo CARDELLI
 Vases porphyry; 70; Dm:
 45 cm
 FAL pl 56A, 56B IRB
 (CXXV; CXXXVIII)
O No. Muller, R.
No Faces. Bauermeister
NOACK, Astrid (Danish 1888-1954)
 Anna Ancher 1939 bronze; 92
 MID pl 30 BAM
Noah
 Buon, B. and G. Porta della
 Carta: The Drunken Noah
 English--12th c. Noah
 Building Arc, facade panel
 French--12th c. Capital:
 Noah's Arc on Mt. Ararat
 French--13th c. Embarkation
 of Noah, cameo
 Italian--14th c. Drunkenness
 of Noah
 Ghiberti. Baptistry Doors-
 East: Noah
 Quercia. San Petronio Door-
 way: Drunkenness of
 Noah
 Quercia. San Petronio Door-
 way: Noah and his Family
 Leaving the Arc
Noah's Arc. English--19th c.
Noble Burdens. Bourdelle
Noblet, Mme.
 Rosso, M. Madame Noblet
Noceta, Piero da
 Civitali, M. Piero da
 Noceto Monument
Nocturnal Leaf. Ghermandi
Nocturne. Beclemicheff
Nocturno. Beothy
Nodding Manderin, Meissen.
 German--18th c.

Noelle. Belmondo
Noir Rouge. Jacobsen, R.
Noix Sculpture. Gauguin
Nola. Gonzalez
Noli me Tangere/See Jesus Christ
 --Appearances
NOLL, Alexandre (French 1890-)
 Cross Wood
 MAI 225
 Job 1957 elm
 BERCK 123
NOLLEKENS, Joseph (English
 1737-1823)
 Castor and Pollux 1767
 CON-4: pl 21 ELV
 Charles James Fox, bust
 1792
 WHINN pl 121 EHo
 --1803
 IRW pl 155 EHow
 Charles Townley, bust 1802
 WHINN pl 125A ELBr
 Countess of Yarborough,
 effigy 1787 marble; LS
 MOLE 256 EBro
 Dr. Charles Burney, bust
 1802
 WHINN pl 124B ELBr
 Dr. Samuel Adams Monu-
 ment, detail
 GERN pl 59 ELWe
 4th Earl of Gainsborough
 Monument 1790
 WHINN pl 119B EExt
 Frederick, Duke of Dorset,
 Monument 1815
 ESD pl 132 EWith
 George III, bust 1773
 GUN pl 18; WHINN pl
 128A ELRS
 Laurence Sterne, bust
 marble
 UND 86 -EHo
 --1766
 CON-4: pl 32; WHINN pl
 120 ELNP
 Lord Mansfield, bust
 ENC 668
 Mrs. Pelham, bust c 1778
 WHINN pl 122 EBro
 Mourning Figure 18/19th c.
 terracotta; 17-3/4
 ASHS pl 34 ELV
 Oliver Goldsmith Monument
 BROWF-3: 65; ESD pl 23
 ELWe
 Robert Cunliffe Monument,
 medallion portrait detail
 1778 WHINN pl 119A EBru

Samuel Johnson, bust plaster;
23-1/2
YAP 223
Samuel Whitbread, bust 1814
WHINN pl 125B ELDL
2nd Marquess of Rockingham
c 1784
WHINN pl 123 EB
Sir George Savile, bust 1784
marble; 30-1/2
MOLS-2:pl 40; VICF 97
ELV (A.16-1942)
Sir Thomas and Lady Salus-
bury Monument 1777
marble
MOLE 260; MOLS-2:pl 41;
WHINN pl 117B EOf
--Troth Renewed
ESD pl 130
Venus Chiding Cupid 1778
IRW pl 60; WHINN pl
118A ELinU
Venus Tying Her Sandal 1773
WHINN pl 118B EWen
William Pitt, bust 1807
WHINN pl 124A EWindC
William Weddell, bust 1789
H: 34
GARL 204 ERipC
Portraits
Chantrey. Joseph Nollekens,
bust
Nomellini, Plinio
Griselli. Plinio Nomellini,
bust
Non Lasciarmi. Garelli
Norbert, Saint
Gunther, F. I. St.
Norbert and St. Augustine
Norbury Cross Shaft. Anglo-Saxon
Nordstrom, Karl
Eldh. Karl Nordstrom
Norfolk, 3rd Duke of
English--16th c. 3rd Duke
of Norfolk Tomb
Norfolk, Thomas, 2nd Duke of
d 1554
English--16th c. Thomas,
2nd Duke of Norfolk,
Tomb
Norfolk Pomander. German--16th c.
NORMAN
Capital, Old Sarum 12th c.
BOAS pl 43b ELiC
Conical Helmet with Nasal
11/12th c.
COOP 51 IBrMa

NORMAN, Percival Edward (English)
Abstract plaster
NORM 43
The Dancer Lignum Vitae; 7
NORM 52
Faun, H. M. S. Queen
Elizabeth mahogany; 30
NORM 62
Head of Negress rosewood;
12
NORM front
Marine limewood; L: 11
NORM 88
Marten boxwood; 13
NORM 49
Swimming Fish, H. M. S.
Queen Elizabeth mahogany;
30
NORM 39
Walking Leopard Scotch fir;
L: 27
NORM 41
Noronha, Joao de
Chantrene. Joao de Noronha
Tomb
Norris, Henry, Lord and Lady
James, I. Henry Lord and
Lady Norris Monument
NORSE See VIKING
North Sea. Anthoons
North Wind. Kemeny
The North Wind. Moore, H.
NORWEGIAN
Church Portal
CHRC 156 NoTi
--1st c.
Rock Drawing, incised c
1000
BAZINH 511 NoR
--7th c.
Sword Hilt, detail gold leaf
ST 128 SnOUO
--11th c.
Sculptured Portal, stave
church c 1050
BAZINW 208 (col);
CHENSW 320; JANSK 393
NoU
--Stylized Beast
MOLE 20
Weathervane: David Rescuing
Lamb from Lion copper;
225x290 mm
SWA pl 93 NoTin
--12th c.
Plait-Work, right jamb, west
portal FOC-1:pl 122 NoA

Tale of Sigurd the Dragon-
killer, Volsung Saga, door
frame detail, Hyllestad
Church c 1200 wood
BUSRO pl 45; NORM 68
NoOUO
--13th c.
Bearded Man, head c 1240
BUSGS 69 NoTC
Christ on the Cross, detail,
Spydeberg c 1260 wood
NORM 66 NoOUO

Nose, Eye, and Cheek
McWilliam. Complete Frag-
ment: Nose, Eye, and
Cheek

NOST, John (John van Ost) (German-
English fl 1686-1729)
Car of Venus, chimneypiece
detail, Cartoon Gallery
c 1700
CON-2: pl 46; WHINN pl
47 EHam
Duke of Queensberry, reclin-
ing effigy 1711
GUN pl 17 ScD
Garden Figures: Putti
1699/1705
WHINN pl 46 EMe
John Digby, 3rd Earl of
Bristol, Monument 1698
marble
GARL 200; WHIN pl 73a;
WHINN pl 43B ESh
Perseus 1699/1705
WHINN pl 43A EMe
Quarreling Cupids early 18th
c. lead
MOLS-2: pl 56 EMe
Sir William Gore Tomb
ESD pl 115 EHeT
William III 1695 terracotta;
20
MOLS-2: pl 19 ELV

Nostalgia. Beothy
NOTKE, Bernt (German 1440-1509)
Dead Man, head ptd oak and
parchment; 16-1/2
GRAT 91 SnSNi
Eve 1493/94 oak
NEWTEM pl 105 GLuCa
Hermen Hutterock, Burgo-
master of Lubeck, tomb-
stone c 1508
LOH 200 GLuA
High Altar 1483
MULS pl 139A GTaH
Mary Magdalen, Triumphal
Cross figure 1477
MULS pl 138A GLuA

Reliquary Cross of St. George,
Elbag c 1490 silver, part
gilt, and precious stones;
18-1/4
MULS pl 139B; VEY 150
GHKG
St. George 1489
MULS pl 137 SnSSto
St. George and the Dragon
1488
BAZINL pl 239; BAZINW
320 (col); SnSSto
--1488 ptd sculpture
LARR 17 SnSCa
--c 1489 ptd oak; 131-1/4
(excl plinth)x111-1/2;
real elk antlers
BUSR 97, 99; GRAT 89
(col); JANSK 602; VALE
114-115 SnSNi
St. George and the Dragon
(reproduction) 1489 H: over
108
CHRC fig 120 GLuC
NOTKE, Bernt, or HEIDE, Henning
von der--ATTRIB
St. John the Evangelist, head
after 1500
BUSR 117; LOH 183 GLuA
Notker, Bishop of Liege (972-1008)
Belgian--10/11th c. Christ
in Majesty, between Four
Evangelists, Adored by
Bishop Notker
Notre Dame du Mont Cornador.
French--12th c.
Notre Dame la Blanche. French--
13th c.
Nottingham, Earl of See Finch,
Daniel
Novak, Lujo
Augustincic. Dr. Lujo Novak,
head
Novelli, Ermete (Italian Actor
1851-1919)
Cifariello. Ermete Novelli,
bust
Novello, Malatesta
Pisanello. Medal:
Malatesta Novello
Now. Kowalski
Nu de Dos
Matisse. The Back
Nu Debout. Manolo
Nuance in Space. Vardanega
Nucleus. Vantongerloo
Nude Christ
Cellini. Crucifixion
(Nude Christ)
Nude of Saint-Denis# Cesar

Objects Arranged According to Law
 of Chance (Navels). Arp
Objet. Miro
Objet a Fonctionnement: "Morphologie
 du Desir". Bryen
Objet Dad'Art. Ernst
Objet Dard. 4/8. Duchamp
Objet-Poeme. Breton, A.
Objet Poetique. Miro
Oboussier, R.
 Muller-Oerlinghausen. Der
 Komponist R. Oboussier,
 head
Obradovic, Dimitrije (Serbian
 Writer 1742?-1811), religious
 name Dositheus
 Valdec. Dositej Obradovic,
 head
OBRIST, Hermann (Swiss-German
 1863-1927)
 Design for a Monument
 before 1902 plaster; 36
 GIE 164; OST 82;
 SCHMU pl 196; SELZPN
 84 SwZKu
 Evolution 1914 plaster
 MAI 227
 Fountain 1913
 SCHMU pl 215 GEK
 Monument to the Pillar 1898
 SCHMU pl 325
OBROVSKY, Jakub (Czech 1882-)
 Summer marble
 PAR-2:116
Observatory Fountain. Carpeaux
OBSIEGER, Robert (Austrian
 1884-1958)
 Apartment Fountain and
 Reliefs
 AUM 83 AV
 Entrance Figures
 AUM 86 AVVC
 Girl Dancer c 1910 ceramic,
 after Obsieger Design
 SOT pl 87 AVOA
 Woodworkers' School:
 Entrance; Staircase
 Fountain
 AUM 88 AVW
 --Courtyard Fountain
 AUM 89
Occhio-Visione. Andreou
Ocean
 Lemoyne, J. B. The Ocean
Oceanide. Laurens
Oceanides. Rodin
Oceanus and Thetis. Linck, K.
Oceanus Fountain. Bologna
O'CONNOR, Andrew (English)

Abraham Lincoln, head
 CASS 52 ELRE
Desolation, Boy of Dublin
 Monument detail
 CASS 106
The Golden Head bronze
 CASS 43 ELT
Lord d'Abernon, head
 CASS 53 ELT
Mrs. O'Connor, bust bronze
 CASS 41
OCTOBRE, A.
 Remorse marble
 MARY pl 44 FPPP
Odalisca. Berrocal
ODARTE, F. See HODART, F.
ODERISI, Pietro (Italian)
 Tomb of Clement IV,
 effigy head 1271-74
 Cosmati Work (inlaid
 marble)
 WHITJ pl 23A, 22A IVitF
Odescalchi Chigi, Princess of
 Italian. Princess of the
 Odescalchi Chigi Family
 Tomb
Odin. Freund
Odysseus See Ulysses
OEBEN, Francois (French), and
 Jean RIESENER
 Cylinder Bureau of Louis
 XV 1760/69 57x71
 CHAR-2:210 FV
Oedipus
 Ernst. Oedipe
 Ernst. Tete Double: Oedipus
 Turnbull. Oedipus
OEGG, Johann Georg
 Wrought Iron Gate c 1750
 CHRP 267 GWuE
Ofen Platte See Stoveplates
The Offering. Bistolfi
The Offering. Manolo
Offering. Scalvini
The Offering. Storck
Offerings See Sacrifices, Offerings,
 and Libations
Oggetto Plastico, Doppia Struttura
 Modulare. Manuelli
Ogier the Dane
 French--17th c. Ogier the
 Dane, head
OGNABENE, Andrea
 Altar, relief detail:
 Equestrians 1326 silver
 BUSGS 40 IPi
Ogre. Richier, G.
O'Higgins Monument, equest bronze
 MARY pl 136 ArB

Oil Pressing. Krsinic
L'Oiseau de Feu. Franchina
Ojetti, Paola
 Berti. Paola Ojetti, bust
OLAFSSON, Sigurjon (Icelandic
 1908-)
 Kriguna 1954 H: 47
 BERCK 181
OLBRICH, Joseph Maria (Austrian
 1867-1908)
 Candlestick c 1900 pewter;
 14-1/8
 SELZPN 118 GHKG
The Old Courtesan
 Rodin. La Belle Heaulmiere
An Old Man. Aronson
Old Man, head. Lauda
Old Man Smiling. Messerschmidt
Old Silesian Woman. Aronson
Old Testament Doors
 Ghiberti. Baptistry Doors--
 East
Old Town of Provence. Preclik
Old Woman Seated. Riccio--Attrib
Old Woman with a Stick. Barlach
Oldenburg Horn. German--18th c.
OLESZCZYNSKI, Wadyslaw (Polish)
 Henri Levitoux, bust bronze;
 53 cm
 WPN pl 131 PWN (127490)
Olga. Serrano
Olimpia. Klimsch
Oliphants
 Byzantine. Oliphant
 Italian--11th c.
 Oliphant#
Olive. Zongolopoulos
Olivet Virgin
 Colombe--Foll. Virgin and
 Child
Olivier, Fernande
 Picasso. Fernande Olivier,
 bust
OLIVIERI, Maffeo (Italian 1484-
 1543/44)
 Running Woman (Atlanta?)
 bronze
 CLE 93 UOC1A (63.92)
Olymp. Haese, G.
Olympia. Nimptsch
Olympia. Tinguely
L'Ombre. Rodin
Omen. Leoncillo
OMODEO See AMADEO, G. A.
On an Accordion Tune. Chauvin, L.
On the March. Kerenyi
I-58 Ailes. Zurcher
107 Balls of Different Volumes. Bury

182 Balls on Two Opposing Planes.
 Bury
1 Metro Cubo di Terra. Pascali
Ongley, Sir Samuel
 Scheemakers, P. , and L.
 Delveaux. Sir Samuel
 Ongley, monument
Onlookers. Folkard, E.
Onnis, Malgari
 Greco, E. Malgari Onnis
Onofrius, Hermit
 Braun, M. B. Hermit
 Garinus
Opalinska, Catherine
 Adam, N. S. Catherine
 Opalinska Mausoleum
The Open Hand. Le Corbusier
Open Night. Martin, E.
Open Song. Somaini
Open Square. Dalwood
Open-Work Screen. Vasarely
Opening Bud. Bedford
Opera Houses
 Carpeaux. The Dance,
 facade, Paris Opera
 Garnier, Charles. Grand
 Staircase, Paris Opera
 Straub and Dietrich. Opera
 House: Left Proscenium
 Box
 Uhlmann. Berlin Opera
 House Sculpture
Ophelia
 Preault. Ophelia
Ophelia A (Alice). Butler
Ophelia 2. Butler
OPITZ, Ferdinand (Austrian 1885-)
 Apartment House Facade
 AUM 82 AV
 Prayer limewood
 PAR-2: 92
OPIZARI, Beshken
 Bertsk Gospel Cover: St.
 John, Deesis Group 1184/
 93
 RTC 243
OPPENHEIM, Meret (Swiss 1913-)
 Object: Fur-Dovered Cup,
 Saucer, and Spoon 1936
 BALD 14; ENC 673;
 LIC pl 260; MOHV 332;
 MU 268; NMFA 192;
 NNMMM 145; READS pl
 69; ROOS 281B; SEITA
 60; UPJH pl 242 UNNMMA
 Squirrel: Glass Beer Mug,
 Plastic Foam, Fur 1960
 H: 8-5/8 SEITA 60 IMSc

OPPLER, Alexander (German 1869-
 1937)
 Eve marble
 SCHW pl 7 IsTT
 The Slave marble
 PAR-2:44
Ops. Ammanati
OPSTAL, Gerard van (Flemish
 1597-1668)
 Infant Hercules and Serpent
 ivory; 3-1/2
 DEYE 142 UCSFDeY
 (52.6.4)
Un'Ora del Passato. Cascella, A.
Oracle. Butler
Oracle of the Chelsea Hotel.
 Consagra
Orange and Lemons. Sandle
Orans
 Early Christian. Sarcophagus:
 Orans and Philosopher
Oratoire pour la Moisson. Kalinowsky
The Orator, Version 2, McWilliam
Oratorio di S. Croce. Francesco di
 Giorgio Martini
Orators
 Daumier. The Orator
 Italian--15th c. Rhetoric
Orazio Coclite. Galleti
Orbit No. 1. Tajiri
Orbs
 Russian--17th c. Imperial
 Orb of Tsar Michael
ORCAGNA, Andrea (Andrea di
 Cione) (Italian c 1308-c1368)
 Angel with Hurdy-Gurdy
 marble; 21-1/8x8-3/8
 USNKP 389 UDCN (K-312)
 Angel with Tambourine mar-
 ble; 21-1/4x8-1/2
 USNKP 388 UDCN (K-313)
 Madonna and Child, relief
 1348/59 marble
 KO pl 75 IFO
 Tabernacle 1349/59 marble
 BR pl 2; BROWF-3:28;
 BUSG 137; FOC-2:pl 115;
 FREEMR 47; POPG fig
 70 IFO
 --detail
 ENC 679
 --Angel Announces Approach-
 ing Death to Virgin
 MOREYM pl 141; ROOS
 97G
 --Betrothal of the Virgin
 MARQ 151

--Birth of the Virgin after
 1355 marble; c 48
 BUSR 16; GUIT 14-15; KO
 pl 75; MOLE 104; POPG
 pl 52-53
--Burial and Assumption of
 the Virgin (Death and
 Ascension of the Virgin;
 Death and Translation of
 Virgin)
 BAZINW 312 (col); POPG
 fig 71; PRAEG 209;
 WHITJ pl 182A
--Marriage of the Virgin
 (Sposalizio)
 FREEMR 48; MACL 60;
 ROOS 97F
--Self Portrait, back relief
 detail
 GOLDF 16
--Virgin Mary, detail
 BAZINW 312 (col)
ORCHARD, John
 Edward III Tomb Purbeck
 marble c 1377/80
 BROWF-3:31; POST-1:
 120 ELWe
 --Effigy gilt copper; LS
 CHASEH 271; KIDS 159
 (col)
 --Effigy, head detail
 CARP 256; GERN pl 35;
 MOLE 67; READAS pl 157;
 STON pl 150
 --Effigy Shoes
 GERN pl 34
 --Weepers
 STON pl 149
ORDONEZ, Bartolome (Spanish
 c 1480-1520)
 Choir Entrance 1517/19
 KUBS pl 66A SpBaC
 The Epiphany c 1514/15
 KUBS pl 63B INGio
 Philip of Burgundy and
 Joanna the Mad Tomb,
 Royal Chapel c 1519
 marble
 GOME pl 8-11; GUID
 212; POST-1:259 SpGC
 St. Eulalia Before the Roman
 Prefect, relief 1517/20
 marble
 VEY 276; WES pl 12
 SpBaC
 St. John the Baptist,
 detail, Philip of Burgundy

Tomb
 BAZINW 356 (col); KUBS
 pl 66B SpGC
Sale of Joseph, choir stall
 1517/19
 VEY 199 SpBaC
Ordonne, Madame J'
 Dubuffet. Madame J'Ordonne
ORDUNA, Fructuoso
 Nude black stone
 CASS 89
Orestes, Rufus Germodius Probus
 Byzantine. Consular Diptych
 of Rufus Germodius Probus
 Orestes
Organ
 English--16th c. Matthew
 Godwin Monument
Organ. Muller, R.
Organ-Case. Campen
Organic Construction No. 3.
 Benevelli
ORGEIX, Christian d' (French
 1927-)
 La Confidante, object 1965
 H: 8-5/8
 NEW pl 70 FPDr
Oriental Dancer. Rousseau, V.
The Origin of Movement in Space.
 Boccioni
ORIGO, Clemente (Italian)
 Death of a Stag bronze
 VEN-7: pl 80
 The Surprise (La Sorpresa),
 fountain group bronze
 VEN-20: 17
Orion
 Marcks. Orion
 Montorsoli. Fountain of
 Orion
ORION, Ezra (Israeli 1934-)
 High Night I 1963 welded
 iron; 77-3/4x18x15
 SEIT 60
 High Night II 1963 welded
 iron; 74x14-1/2x13-1/2
 SEIT 61
ORLANDI, Conte di Lellio
 Nave Screen, detail 1337/38
 wrought iron
 WHITJ pl 140B IOrC
Orlando, Vittorio Emanuele (Italian
 Statesman 1860-1952)
 Bertolino. V. E. Orlando,
 medal
Orlando Furioso
 Duseigneur. Orlando Furioso

Orleans, Dukes of
 Lemoyne, J. L. Duke of
 Orleans, bust
 Viscardi. Dukes of Orleans
 Tomb
Orleans, Louis I (Louis de
 Chatillon) (1372-1407)
 French--15th c. Louis de
 Chatillon
ORLOFF, Chana (Russian-Israeli
 1888-)
 Bather (Baigneur) bronze
 MARTE pl 28
 Bird bronze
 MAI 228
 Dancing Figures, study
 AUM 52
 Fish alabaster
 AUM 53
 M. J. E. Laboureur, head
 ZOR 284
 Maternity wood
 PAR-2: 164
 Maternity (Maternite) 1948
 plaster, for bronze
 SCHW pl 33
 Miss S, head 1924 marble
 SCHW pl 34
 My Son (Mon Fils) cement
 HOF 62; MARTE pl 8 FGM
 Portrait cement
 MARTE pl 8
 Portrait bronze
 MARTE pl 28
 Rubin, bust
 CASS 47 UNNSter
 Sleeping Woman
 AUM 52
 Spandril Pieces: Bird; Fish
 wood
 AUM 52
 A Young Girl
 AUM 55
 Young Woman bronze
 MAI 228
Orlovski, A. G., Count
 Shubin. Count A. G.
 Orlovski, bust
ORLOVSKI, Boris Ivanovich
 (Russian 1793-1837)
 Marshal Kutuzov Tomb 1832
 HAMR pl 152A RuKaC
 Winged Victories, Moscow
 Gate 1833/38
 HAMR pl 137B RuM
Ormside Bowl. English--9th c.
The Orphans. Stanton, W.

L'Orphelin. Niclausse
Orpheus
 Anastasijevic. Orpheus
 Byzantine. Orpheus Charming
 Animals
 Conne. Orphee
 Conne. Orphee aux Enfers
 Dejean. Orphee Mort
 Early Christian. Pyxis: Orpheus
 Francheville. Orpheus
 French--17th c. Orpheus
 Hepworth. Stringed Figure
 (Orpheus)
 Martini, A. Orpheus
 Mascherini. Orpheus
 Milles. Orpheus#
 Mirko. Orpheus
 Robbia, L. della. Orpheus Play-
 ing to the Animals,
 Campanile relief
 Rodin. Orpheus
 Rodin. Orpheus and Eurydice
 Rodin. Orpheus and Maenads
 Verbanck, G. Orpheus
 Vischer, P., the Younger.
 Orpheus and Eurydice
 Wolff, G. H. Orpheus and
 Eurydice
Orpheus Fountain. Milles
Orpington Cock. Piffard
ORSI, Achille D' (Italian 1845-1929)
 Fantasy-Sleep terracotta; 28x
 24 cm LIC pl 95, 96 IFiD
 Homer, seated figure c 1915
 bronze VEN-20: 76
Orsi, Pietro
 Pelliccioli. Count Pietro Orsi
Orsini, Napoleone
 Arnolfo di Cambio. Arca of St.
 Dominic: Raising of
 Napoleone Orsini
Orsini, Senator
 Bistolfi. Senator Orsini
 Monument
Orso, Antonio (Bishop of Florence
 d 1320/21)
 Tino di Camaino. Bishop Antonio
 degli Orsi Monument
Orsola. Genucchi
ORSOLINI, Gaetano (Italian)
 La Schiapa bronze
 VEN-26: pl 103
 The Sower (Il Seminatore)
 plaster VEN-30: pl 74
ORTELLI, Jose
 Bust
 CASS 50
ORTIZ, Pablo (Spanish fl 15th c.)
 Saint in Niche alabaster;

26-1/4x10x3 SDF 114; SDP
 # 148 UCSDF
Osanna, Saint
 French--13th c. St. Osanna,
 effigy head
OSBORNE, Charlotte E. See GIBSON
 (Osborne), Charlotte E.
Oscillation. Martin, K.
OSLER, F. and C.
 The Crystal Fountain, Palace
 of Glass, Great Exhibition
 VICG 111
Oseberg Funeral Ship. Viking
OSMAN, Ahmed (Egyptian 1908-)
 Walkers, sketch
 VEN-38: pl 48
Osorio Pimentel, Maria
 Giovanni da Nola. Don Pedro da
 Toledo Monument: Maria
 Osorio Pimentel Reading
OSOUF, Jean (French 1898-)
 Catalane
 BAS 194
 Coralie, head
 BAS 194
 --BAS 188 FPM
 Le Deporte
 BAS 197
 L'Eveil
 BAS 190
 Jean Claude, head
 BAS 192
 Head after Coralie
 BAS 189
 M. E. Gouin, head
 BAS 196
 Mlle. Antoinette Berard, head
 BAS 195
 Mands Portrait: "L'Industriele"
 1944/45 bronze; 39.5 cm
 COPGM 125 DCN (I.N. 2605)
 "Maquisard", young Catalan
 BAS 196
 Nicole
 BAS 191 FLeHaM
 Petite Vierge
 BAS 193
 Tounette, head
 BAS 195
 Vierge aux Mains Jointes
 BAS 193
Ospedale Maggiore. Filarete and
 G. Solari
OST, John van See NOST, John
Ostapenko, Sowjethruptmanns
 Kerenyi. Capt. Ostapenko
 Memorial
Ostensoire de la Volupte. Kalinowski
Ostrich Eggs

German--13th c. Dragon Mount,
 ostrich egg
Ostriches
 Austrian. Ostrich, jewel casket
 Gaul. Ostrich
OSTROGOTHIC
 Eagle Brooch, Cesena c 500
 gold cloissone
 ENC 30, 192; LOH 34; ST
 121 GNG
OTEIZA (Jorge de Oteiza Embil)
 (Spanish 1928-)
 Dynamic Conjunction of Two
 Parts of Light Segments
 1957 iron; 13-3/8
 NMS 34 UDCGr
 Empty Suspension (Funeral
 Cortege, Homage to Aero-
 nautical Engineer), 1957
 iron; 21-1/4 NMS 34 UDCGr
 Metaphysical Box, Number 1
 1958 aluminum; 15-1/4
 NMS 35 UDCGr
 Slow Forms Before Closing
 Space 1958 iron; 27-1/2
 NMS 35 UDCGr
Otis, Harrison Gray
 Troubetsky. General Harrison
 Gray Otis
Otley Cross. Anglo-Saxon
Ottavio
 Bustelli. Lucinda and Ottavio
OTTAVIO DA CAMPIONE--FOLL
 Porta Regia, detail: Lion
 1209/31 BOE pl 38 IMo
OTTE, Valentin (German)
 High Altar 1664
 HEMP pl 40 GLeiM
Ottenstein, Heinrich von
 German--16th c. Heinrich von
 Ottenstein and Wife Tomb
Ottheinrich von der Pfalz
 Schro. Kurfurst Ottheinrich
 von der Pfalz, bust
Otto I (Holy Roman Emperor 912-73)
 German, or Italian--10th c.
 Otto I Presenting a Church
 to Christ, plaque
 Italian--17th c. Otto, bust
 Porta, G. B. della. Otto, bust
Otto II (Holy Roman Emperor 973-83)
 German--13th c. Otto II
 --Magdeburg Rider, Monument
 to Emperor Otto II
 Italian--10th c. The Basilewsky
 Situla...bearing an in-
 scription referring to
 Otto Augustus
 --Ivory Panel: Christ in
 Majesty Adored by Emperor

Otto II
 Metzner. Otto II, bust
 Ottonian. Symbolic Crowning
 of Otto II and Theophana
Otto III (Holy Roman Emperor 983-1002)
 Byzantine--10th c. Death of
 the Virgin panel, Gospel
 Book of Otto III
 --Ivory Panel
OTTO, Lothar (German 1893-)
 In the Sun 1953 stucco; 24
 KO pl 103
 Zwei Madchen 1933 cement;
 60 cm HENT 86
OTTONIAN
 Ascension of Christ, plaque
 10th c. ivory BAZINW 220
 (col)
 Christ in Majesty, capital
 11th c. LARB 235 GHiM
 Christ in Majesty, plaque 950/
 1000 ivory; 5-1/8 CHENSW
 306; NM-7:15 UNNMMM
 (41.100.157)
 Crucifix, detail wood; 74
 KIDS 30 (col) GCoC
 Reliquary Arm of St. Sigismund
 11th c. LARB 255 GBSS
 Symbolic Crowning of Otto II
 and Theophana, plaque 982/
 83 ivory; 7x4 KIDS 41 FPC1
 Two Angels, Basle Antependium
 1002/19 BAZINW 222 (col)
 FPC1
OUCHEMAN, Thomas
 King Henry VIII Chapel, detail:
 figure c 1510 stone BUSR
 168 ELWe
OUDOT, Georges (French 1928-)
 Flying Torso 1957 plaster
 MAI 229
Our Lady of Compassion. German--
 15th c.
L'Ouragane. Richier, G.
Ouranos II. Hajdu
Outrance d'une Outre Mythique
 Arp. Extremity of a Mythical
 Wineskin
Ouvert-Ferme. Witschi
L'Ouvrier. Schneider, G.
Oval Form (Trezion). Hepworth
Oval Fresco. Pevsner
Oval Sculpture# Hepworth
Oval Wheel. Benquet
Overgrowth. Uecker
Overturned Blue Shoe with Two Heels
 Under a Black Vault. Arp
Ovid
 Rodin. Metamorphosis of
 Ovid

Owen, Alice
Frampton. Dame Alice Owen
Owls
Celtic. Owl Head, cauldron
fragment
Ehlers. Owl
English. Staffordshire Slipware
Jug and Cover: Owl
English--18th c. Chelsea White
Owls
English--18/19th c. Miniature
Derby Owl
French--12th c. Balaam on his
She-Ass; Hanging of Judas;
Owl of Minerva
German--16th c. Owl
Heerup. Owl Pillar
Koch, B. Owl, vessel
Picasso, Owl
Picasso. Red and White Owl
Pompon. Little Owl with Sunken
Eyes
Pompon. Owl
Vingler. Owl
Wostan. Great Horned Owl
Oxholm, Ellen (O'Kelly)(1813-51)
Bissen. Ellen Oxholm, head
Ozon# Le Corbusier

P. L. W., Mme
Despiau. Mme P. L. W., bust
P. M., Mme
Despiau. Mme. P. M., bust
PSI. Tunnard
PX II/3010-59/64. Pohl
PAALEN, Wolfgang (Austrian 1905-)
The Exact Time 1935(?) construc-
tion in wood: 27-1/4 NMFA 192
Mannequin
SEITA 58
Das Paar II. Mettel
Pacaca Tomb. Uprka
PACAK, Frantisek (Czech 1680-1756)
Christ Taking Leave of his
Mother 1737 wood STECH
pl 169 CzPolC
Our Lady of the Rosary 1737
STECH pl 168 CzDoU
Pieta 1737
STECH pl 170 CzPolC
St. Anne, Cartouche
STECH pl 171 CzZi
St. Anne, column detail
STECH pl 162 CzPol
PACAK, Jiri (Czech 1663-1740)
Altar Figures: St. Zacharias and
St. Anne STECH pl 166 CzSm
St. Florian 1720/30
STECH pl 158 CzZir

--cast 1734
STECH pl 165 CzOp
St. Francis Xaverius 1720/30
ptd wood STECH 113 CzZ
St. Joachim wood
STECH pl 163
St. John of Nepomuk
STECH pl 159 CzZir
St. John the Evangelist wood
STECH pl 160 CzBes
St. Michael the Archangel
STECH pl 164 CzPol
PACAK, Jiri and Frantisek PACAK
Marion Column 1731
STECH pl 161b CzPol
PACAK, Jiri--FOLL
Calvary before 1737 ptd wood
STECH pl 167 CzPa
Pacheco Tomb. Portuguese--14th c.
PACHER, Michael (Austrian c 1435-98)
St. Florian
LIL 104 AStW
St. George
NM-11:14 UNNMM
St. Michael, head late 15th c.
ptd wood MOLE 82 GMBN
St. Wolfgang Altar (Winged
Altar: Wolfgang Altar) 1471/
81 ptd wood; shrine: c 126x
150 KO pl 63; MOLE 84;
PRAEG 98 AStW
--detail
STA 47
--Coronation of the Virgin,
between Church Patrons--
St. Wolfgang and St. Bene-
dict, center shrine, winged
altar figures: LS BAZINW
322 (col); BUSR 102-3;
JANSH 302; JANSK 604;
LARR 74; MAR 117 (col);
MULS pl 133
--St. Wolfgang
MULS pl 132
--Virgin
MULS front (col)
PACHER, Michael--FOLL
Virgin, Crucifixion Group
figure 15th c. white fir; 67
cm BSC pl 68 GBS (8114)
PACHEROT, Jerome See COLOMBE,
Michel
Pacifico, Beato
Italian--14th c. Beato Pacifico
Monument
PACIK, Frantisek (Czech 1927-)
Kunt-Tiger Eroberer 1965 Gus-
seissen; 66x124 cm BER 53
PACINO DI BONAGUIDA (Italian)

Communion of the Apostle, relief
14th c. gold WHITJ pl 115B
UNNWil
PACIO DA FIRENZE (Italian fl 1343-45)
See GIOVANNI DA FIRENZE
PACIUREA, Dum (Rumanian)
Luchian, bust
CASS 48 RCP
Sphinx bronze
VEN-24: pl 128
Packed LIFE Magazine. Christo
Padilla, Juan Lopez de (Spanish
Revolutionist 1490-1521)
Siloe, G. de. Juan de Padilla
Monument
PADOVANO, Zuan Maria (Called
Mosca)(Italian fl 1515-30)
Anthony and Cleopatra, relief
1512 marble; 33x38 cm BSC
pl 84 GBS (2/58)
Pagan, Gordine
PAGANIN, Giovanni (Italian 1913-)
Adam 1962
VEN-64: pl 1 IMCi
Man (uomo) 1947 plaster; 45 cm
CARR 318 IMBor
The Mother (La Madre) 1962
VEN-64: pl 2
PAGANINI, Nicolo (Italian Violinist
1782-1840)
Dantan. Paganini
David D'Angers. Nicolo
Paganini, head
David D'Angers. Nicolo Paga-
nini, medallion
Page, Sir Francis and Lady
Scheemakers, H. Sir Francis
and Lady Page, reclining
effigies
PAGELS, Hermann Joachim (German)
Exiles
CASS 115
Pages
Multscher. Page
PAGNI, Raffaele
Cathedral Doors; detail by Cac-
cini, G.: Annunciation 1595/
1604 bronze POPRB fig 90-
91, 93 IPisaC
Pagoda Fruit. Arp
The Pail is Not Arman's. Spoerri
Pain. Blind Sculptor--congenitally
blind, age 18
Painted Structures. Fangor
Painters and Painting
Breese. Painter
Grassi. The Portrait Painter
Italian--16th c. Raphael's
Workshop Members
Decorating Loggia, relief

Milles. Aganippe Fountain:
The Painter, representing
Eugene Delacroix
Pisano, Andrea. Arts, reliefs
Tassaert. Painting and Sculp-
ture
Painting Relief: Selection of Materials.
Tatlin
Pair of Runners. Marcks
PAJOU, Augustin (French 1730-1809)
Buffon, seated figure bronze; 11
CHICT #141 FV (M.V.2155)
Calliope marble; 62-1/8x
23-7/8 USNKP 450
UDCN (A-1631)
Danican-Philidor, bust 1783
terracotta JAL-5: pl 12
J. B. Lemoyne, bust
ENC 689
Mme du Barry, bust
CHASEH 393 UNNBlu
--1773 marble; 27
CHAR-2: 234 FPL
La Naissance du Dauphin, ter-
racotta INTA-2: 117
Psyche Abandoned 1783/90
marble; c 72 BAZINW
418 (col) FPL
Pakenham, General
Westmacott. Generals Paken-
ham and Walsh, monument
Pala d'Oro. Byzantine
The Palace at 4 A. M. Giacometti
Palacky Monument. Sucharda
PALADINO ORLANDINI, Orlando
(Italian 1905-)
Bull, medallion 1954 bronze
VEN-54: pl 30
PALAVICINI, Petar (Pera Palavicini)
(Yugoslav 1888-)
Don Quixote, bust
MARY pl 119
Girl with a Bowl 1928 marble
BIH 106 YBN
Spring 1939 bronze
BIH 108 YBN
Woman from the Hills 1933
plaster BIH 107 YCM
PALESTINIAN
Capital, Nazareth 12th c.
BAZINW 282 (col) IsNG
Fruits and Flowers, frieze
detail, Capernaum Syna-
gogue 3rd c. KAM 18
Menorah, Synagogue, Tiberias
incised stone KAM 146
Synagogue Stone, Jerusalem
before 70 C. E. KAM 5
Palestrina Pieta. Michelangelo
Palinurus

Martini, A. Palinurus,
 seated figure
PALISSY, Bernard (French 1510?-90)
 Faience Plate: Sea Life--
 Fishes, Snake, Lobster
 polychrome ceramic; L: 24
 HUYA pl 48; HUYAR 96 FPL
 Palissy Plater: Snake
 ENC 690
PALISSY, Bernard--FOLL
 Footed Dish 16th c. earthen-
 ware; Dm: 9-1/4 CPL 89
 UCSFCP (1945.668)
 Handled Ewer: Reclining
 Nudes in Medallions
 16th c. faience; 9-3/4
 CHAR-2:71 FPL
Pallas with Drapery. Bourdelle
PALLEZ, Luciano (Italian 1853-)
 Victor Hugo Monument 1905
 MINB 102 IRB
PALLISER, Herbert William
 (English 1883-)
 Chancel Carving
 AUM 150 EGuU
 Decorative Figure, garden
 wall AUM 137
 Reredos Group: Pieta 1940
 plaster; 37x54 BRO pl 27
 Stag, relief Portland stone
 PAR-1:64
 Statuette 1946 Bianco de Mare;
 19 NEWTEB pl 35
 Torso 1943 plaster; LS
 BRO pl 28
Palloncini. Pavanati
Palm. Paolozzi
Palm Sunday. Koenig
PALMER, William
 Lord Lexington Monument 1726
 WHINN pl 102B EKe
Palmesel
 German--15th c. Christ on the
 Ass
Palmieri, Matteo
 Rossellino, A. Matteo Palmi-
 eri, bust
Pamphili, Camillo(?)
 Algardi. Camillo(?) Pamphili,
 bust
Pamphili, Olimpia Maidalchini
 Algardi. Olimpia Maidalchini
 Pamphili, bust
Pamplona
 German--13th c. Shrine of
 Charlemagne: Collapse of
 the Walls of Pamplona
 Raggi, N. B. Surrender of
 Pamplona

Pan
 Bayes. Great Pan
 Bayes. Lure of the Pipes of Pan
 Fremiet. Pan and the Bears
 Fremiet. Young Pan and Bear
 Cub
 Gies. Pan
 March. Pan and Psyche
 Riccio. Inkstand: Pan Listening
 to Echo
 Riccio. Seated Pan
 Sicard. Archibald Fountain
 Tribolo. Pan
PAN, Marta (Hungarian-French 1923-)
 Equilibrium 1958 wood
 MAI 230
 Floating Sculpture "Ollerlo"
 1960/61 plastic; 180x226 EXS
 23; JOO 203 (col) NOK
 Hinge No. 4 1953 terracotta; L:
 34 (closed) BERCK 313
 Sculpture 53: Equilibrium 1958
 ebony; 13 TRI 185 UOCiWi
 The Teak 1956 teakwood; L: 55
 BERCK 138
Panagia, Pectoral Cross
 Russian--18th c. Panagia
Panagia Blachernitissa
 Byzantine. Constantinople Coin:
 Empresses Zoe and Theo-
 dora; reverse: Panagia
 Blachernitissa
Panaghiarion
 Rumanian--15th c. Panaghiarion:
 Deesis
Pandarus# Armitage
Pandora
 Bates, H. Pandora
 Cortot. Pandora
 Flaxman. Pandora Brought to
 Earth by Mercury, relief
 Gibson, J. Pandora
 Gonda. Pandora
 Scharff. Pandora
 Vries. Mercury and Pandora
Pane. Manzoni, P.
Panels
 Bayes. Panel
 Cesar. Panel
 Hispano-Moresque. Panel: Birds
 and Beasts in Foliage
 Reynolds-Stephens. Decorative
 Panel
 Szczepkowski. Panel
Panic-Stricken. Barlach
PANISSERA, M. (Italian 1830-85), and
 Luigi BELLI
 Monument to Completion of the
 Frejus Tunnel, designed by

Panissera, modelled by
Belli 1879 LIC pl 109 ITS
Panneau de Marbre. Schorderet
Pantaleon, Saint (Roman Physician
d 305)
Mora. St. Pantaleon
Pantaloon See Commedia dell'Arte
Pantheon of Kings. Bautista Crezenci
Pantheon Pediment. David D'Angers
Pantheresque. Geibel
Panthers
Barye. Panther Seizing Stag
Bugatti. Panther Walking
Constant, J. Black Panther
Cuairan. Black Panther
Danneker. Ariadne on a Panther
Hernandez, M. Javanese
Panther
Italian--16th c. Panther
Sandoz. Panther Head
PANZER, Hans (German)
Baptistry Grille iron
AGARN il 30; RICJ pl 6
GObP
Church Entrance
AUM 1 GM
Church Window Panel iron
AUM 15 GM
Jesus Preaching to Peasants
AGARN il 29 GObP
Tympanum
AGARN il 28 GObP
Paoli, Paolo
Gisiger. Homage to Paolo Paoli
Paolo and Francesca
Arp. Paolo and Francesca
Jennings. Paolo and Francesca
Munro. Paolo and Francesca
Rodin. The Kiss
PAOLO ARETINO (Italian) See
PIETRO ARETINO
PAOLO DI GIOVANNI FEI (Paolo di
Maestro Giovanni) (Italian fl
1372-1410)
Madonna and Child between St.
Peter and St. Paul, Porta
Romana BARG; MCCA 20
IFBar
PAOLO DI MAESTRO GIOVANNI See
PAOLO DI GIOVANNI FEI
PAOLO ROMANO (Paolo di Mariano di
Tuccio Taccone)(Italian fl
1445?-70) See also Dalmata, G.;
Isaia da Pisa
St. Paul 1464 marble
SEY pl 93 IRPA
PAOLO ROMANO--FOLL
Pius II Tomb, central relief:
Reception of the Relic of
St. Andrew c 1464

SEY pl 92B IRAndrV
PAOLOZZI, Eduardo (Scottish-English
1924-)
Ace 1962 H: 63
PRIV 76 (col); SEITC 86
(col) ELFr
The Age of Steam 1960/61 20.75
x12 CARNI-61
Artificial Sun 1964 welded
aluminum; 94
HAMM 134 ELFr
Bishop of Kuban 1962
aluminum; 209.5x91.5x61 cm
HAMM 132; SAO-7 EKink
Box-Headed Figure 1956/57
bronze; 49-1/4x12x8 CARNI-
58: pl 58; MINE 44 UNNPa
The Cage 1950/51 bronze;
72x48
GIE 260; RIT 217 ELBrC
Chinese Dog 2 1958 bronze; 37x
25x11
CALA 202; GUGP 92 IVG
City of the Circle and the Square
1963 aluminum; 82x40-1/4x
26-1/4 READCON 237;
TATES pl 14; WHITT 56 ELT
(T. 638)
Cyclops 1957 bronze; 43-3/4x
12x8 TATES pl 13 ELT (T. 225)
Diana as an Engine 1963
PRIV 78-79
Durunmal 1966
KULN 129
Eko-Akai 1965 crome plated
steel; 32x31x55-1/2
CHICSG UNNPac
Forms on a Bow 1949 cast brass;
19x25x8-1/2 HAMM 131 (col);
TATES cov ELT (T. 227)
Frog Eating a Lizard 1957 bronze
MEILD 21 UNNJ
Hamlet in a Japanese Manner
1966 welded aluminum, ptd;
three sections: 66x69x42;
61x90x50; 43x35x43
LOND-7:#33 ELFr
Head 1957 bronze
KUHB 128 UMiBiW
--1957 bronze; 38
READCON 234
Hermaphroditic Idol No. 1 1962
MYBS 83 (col) ELFr
--1962 aluminum; 72
READCON 236
--1962 aluminum; 72
LARM 370 BrSpM
Icarus II 1957 bronze; 60
SELZN 120 UNNPa

Inversion (Umkehrung) 1966
steel, chrome plated; 29-
1/4x49-3/4x29-3/4
GUGE 95 UNNPac
Japanese War God 1958 bronze;
64-1/2 ALBB 21; ALBC-3:
#64; MAI 230; READCON
235; TOW 72 UNBuA
Jason 1956 bronze; 66-1/2
ROTJB pl 146; SELZN 119
UNNMMA
Karakas 1964 48x85-1/2
CARNI-64: #255 UNNMa
Large Frog 1958 bronze; L: 34
BOW 76; ENC 693 ELBrC
Little King 1958 bronze; 61
MINE 44; SELZN 121 ELH
Lotus 1964 H: 90
PRIV 79
Man with Wheel 1956
KULN 42
Medea 1964 welded aluminum
LARM 304 ELFr
Mekanik Zero 1958/59 bronze;
75x35 LOND-5:#34
Palm 1965 welded aluminum
ptd; 66x67x104 LOND-7:#32
Parrot 1964 H: 83
SEITZ 162 ELFr
--1964 welded aluminum; 80x
60x33 SELZS 173 UNNPac
Poem for the Trio MRT 1964
welded aluminum; 85x86x44
MYBS 82; NEW pl 89 ELFr
St. Sebastian 1957 bronze;
84-3/4 BURN 326; GUG
216 UNNG
St. Sebastian III 1958/59
bronze; 87 HAMM 33, 130;
VEN-60: pl 176 NOK
St. Sebastian IV 1957 bronze;
90-1/2 TRI 136 ELGom
Tokio 1964 welded aluminum
ptd; 73x81x67 LOND-7:#31;
PRIV 77; SEITC 161 ELFr
Town Tower 1962 bronze; 62
READCO pl 13a ELPo
--1962 bronze, gun metal,
brass; 77-1/2 SFMB #122
Twin Tower of the Sfinx-State
1962 aluminum; 69-1/2
HAMM 133
Two Forms on a Rod 1948/
49 cast brass; 20-3/4x
25-1/4x12-3/4
TATEB-2: 20 ELT (T.456)
Very Large Head 1958

bronze; 72
SELZN 122 UDCLe
PAPA, Maria (French)
Le Main d'Oedipe 1966
KULN 46
PAPAS, John (Greek)
D. Hypsilantis, bust
CASS 35
Paper Knives
Peat. Paper Knife: Fish
Paper-Weights
Austrian--20th c. Paper
Weight
PAPI, Federico (Italian 1897-)
I Vaganti, medallion 1953
bronze
VEN-54: pl 29
PAPINI, Giovanni (Italian
Philosopher and Writer
1881-1956)
Romanelli. Giovanni Papini,
bust
PAPINI DE KUZMIK, Livia
(Hungarian-Italian 1898-)
Il Riposo in Egitto, detail
VEN-36: pl 22
Paquier. Giglioli
Parable of the Blind, relief
Touret
Parable of the Fig Tree
German--11th c. Easter
Column
La Paradis Terrestre. Joostens
Paradise
Pisano, Niccolo. Pisa
Baptistry Pulpit:
Paradise
Parallelen I. Uher
Parasols. Taeuber-Arp
PARBURY, Kathleen
Four Angels, detail 1960
aluminum; 64
PER 45, 47
Pardhi Tribe, India
Milward. Pardhi Man, head
Pardo Christ. Fernandez
The Pardon. Andreotti
The Pardon. Dubois, E.
Parents and Child. McWilliam
Parents and Children. McWilliam
Parian Ware
Foley. Innocence
Theed, W., the Younger.
Musidora
Paris
Antico. Paris
Donner. Judgment of Paris

Francesco di Giorgio Martini.
Judgment of Paris
German--16th c. Judgment of
Paris, relief
Gillet. Paris Holding the
Apple
Hering, D. Judgment of
Paris
Leonardo da Vinci. Judgment
of Paris
Renoir. Petit Judgment de
Paris, relief
Renoir, and Guino. Judgment
of Paris, relief
Schwarz. Judgment of Paris
Paris (city)
Canova. Paris, head
Paris Air
Duchamp. Ready Made: 50 cc
Air de Paris
The Parisian Woman. Ernst
Parizzi, Colonel
Fazzini. Colonel Parizzi,
head
Park Figure. Haller
Parker, Charles
Bacon, J., the Younger.
Tree of Life, monument
to Charles Parker
PARKER, H. Wilson (English)
Lamb 1940 bronze; LS
BRO pl 29
Nightjar 1943 walnut; L: 12
BRO pl 30
Parker, Peter
Gothic. Peter Parker, bust
PARKER, Richard (English)
1st Earl of Rutland Tomb
1543/44
CON-1: pl 30; MERC pl
81b; WHINN pl 3B ELeiB
PARLER, Peter (German 1330-99)
Anna von Schweidnitz,
Triforium bust 1370/80
stone
BUSR 3; KO pl 56 CzPV
St. Vitus between Charles
IV and Wenzel IV,
Bridgetower, Old Town
Side
BOE pl 125 CzPMoz
Self Portrait, bust, chancel
north Triforium c 1375
stone
BOE pl 126; BUSR 4;
GOLDF pl 5; GOMB 156;
PRAEG 210; VEY 151
CzPV

PARLER, Peter--FOLL
Womans Head, console c 1370
stone
KO pl 56 GUM
Parnassus Fountain. Kracker
PARODI, Filippo (Italian 1630-1702)
Bishop Francesco Morosini
Tomb, detail 1678
WIT pl 161B IVN
Madonna of the Immaculate
Conception ptd stucco; 39
DENV 55 UCoDA (E-392)
Parrots
Bow Porcelain. Parrots
English--18th c. Chelsea
Green Parakeet
German--18th c. Parrot
Kandler. Green Parrots
Kandler. Parrot
Kandler. Parrot Eating
Cherries
Paolozzi. Parrot
Perchin. Faberge Parrot
Russian--19th c. Kvass--
Jug: Parrots
Parthenon
Pistrucci. Medal Commemorat-
ing Aquisition of Parthenon
Marbles
La Partigiana. Leoncillo
Partikel, Alfred
Marcks. Alfred Partikel,
head
Parting. Hanak
Partisan. Segesdi
Partisan Girl. Augustincic
The Partisan Masaccio. Martini, A.
Partisan Woman. Mukhina
PARTRIDGE, David
Vertebrate Configuration 1963
colored, shaped nails
MEILD 184 ELT
Le Pas de Deux. Rodin
Pascal, Blaise (French Scientist and
Philosopher 1623-62)
French--17th c. Pascal,
death mask
Pascali. Armi
PASCALI, Pino (Italian 1935-)
Al Muro: 1 Metro Cubo di
Terra; per terra: 12
metri quadri di pozzang-
here 1967
KULN 176
Armi 1966
KULN 112
Barca 1965
KULN 89

PASZTOR, Janos (Giovanni Pasztor; Jean Pasztor) (Hungarian 1881-1945)
 Driving Away plaster
 VEN-34: pl 181
 Farewell 1906 wood; 79.5 cm
 GAD 71 HBA
 Mother plaster, after bronze original in Mako
 GAD 70
 Temptation marble
 PAR-2: 93
Pate-sur-Pate
 Solon. Vase, Minton Pate-sur-Pate
Patens See Plates
The Path. Forani
The Pathetic Soul. Bourdelle
Patience
 Agostino di Duccio. Patience
Patineurs. Lienhard
Patriarchs
 German--18th c. Patriarch
 McWilliam. The Patriarch
The Patriot. Fullard
Patrona Bavariar. Gerhard
PATZAY, Pal (Hungarian 1896-)
 Adam Mickiewicz, medal 1935 bronze
 GAD 96 HBA
 Budapest bronze
 VEN-36: pl 84
 Equestrian Memorial 1939 bronze; 300 cm
 GAD 87 HSz
 Sadness stone
 VEN-38: pl 92 HBA
 Woman Combing Her Hair 1919 bronze; 22 cm
 GAD 89 HBA
 Woman Cutting Bread 1950 bronze; 54 cm
 GAD 106 HBA
Paul, Saint
 Algardi, A. Martyrdom of St. Paul
 Austrian--14/15th c. Singertor: Fall of St. Paul
 Benkert. High Altar, after design of J. M. Kuchel; detail: St. Paul, head
 Bird. Conversion of St. Paul
 Brabender. St. Paul
 Burgundian--15th c. St. Paul
 Byzantine. Diptych: Adam in Garden of Eden; St. Paul, scenes from Life
 Byzantine. St. John the Baptist with Apostles

Byzantine. St. John the Evangelist, and St. Paul, panel
Cano, A. St. Paul, bust
Early Christian. Christ Between SS Peter and Paul
Early Christian. Christ Giving Law to St. Paul, sarcophagus relief
Early Christian. St. Paul, panel
Early Christian. Sarcophagus: Christ Among Apostles; detail: Giving Law to St. Paul
Early Christian. Sarcophagus: Christ between SS Peter and Paul
Early Christian. Sarcophagus: Giving the Law
English--14th c. Travelling Altar, including figures of Saints
English--15th c. St. Paul, east end screenwork figure
Filarete. Basilica Doors: St. Paul
Flemish--15th c. St. Paul
French--7th c. Crypt of St. Paul
French--12th c. Apostles Paul and Andrew
--Capital: Mystic Mill
--Jacob the Elder, and Paul
--Paul and James, main portal
--St. Paul the Apostle, trumeau figure
French--13th c. Chartres Cathedral, south transept
French--14th c. St. Paul
French--15th c. St. Paul
German--11th c. Paul Let Down by the City Wall of Damascus
German--12th c. Apostle Paul
Gislebertus. Peter and Paul, Chapter House Door
Isaia da Pisa. Virgin and Child with SS Peter and Paul
Jordan, E. Main Altar
Leoni, L. and P. Calvary with Virgin and St. John, and SS Peter and Paul

Mascoli Master. St. Paul
Mercante. St. Paul,
 medallion
Nielsen, J. St. Paul
Paolo di Giovanni Fei.
 Madonna and Child Between
 St. Peter and St. Paul
Paolo Romano. St. Paul
Roger von Helmarshausen.
 Abinghof Altar, side
 detail: Scene from Life of
 St. Paul
Rossi, V. de'. St. Paul
Thorvaldsen. St. Paul
Vecchietta. St. Paul
Villabrille y Ron. St. Paul,
 head
Vischer, P., the Elder;
 Vischer, P., the Younger;
 Vischer, Hermann, the
 Younger. St. Sebaldus
 Tomb: St. Paul
Paul II (Pope 1417-71)
 Nino da Fiesole, and
 Giovanni Dalmota.
 Pope Paul II Monument
Paul III (Pope 1468-1549)
 Porta, Guglielmo. Paul III,
 bust#
 Porta, Guglielmo. Paul III
 Tomb
Paul V (Pope 1552-1621)
 Bernini, G. L. Pope Paul V,
 bust
 Buzio. Coronation of Pope
 Paul V
 Ponzio. Paul V Tomb
Paulding, John (1792-1834)
 Browere. John Paulding,
 life mask
Paulette. Despiau
Paulette. Fontana, L.
PAUSCHINGER, Rudolph
 Bear, garden figure colored
 sandstone
 AUM 16 GSt
 Leopard black granite
 AUM 16
 Lion's Head terracotta
 AUM 16
 Woman with Monkey bronze
 AUM 13
PAUWELS, Joos, the Younger
 (Flemish fl 1474-1509)
 Chrismatory: Turret silver;
 5-7/8
 DETF 308
PAVANATI, Luigi (Italian 1915-)

Fishermen, medallion 1950
 plaster
 VEN-50: pl 35
 Palloncini 1952
 VEN-52: pl 50
Pax
 Dobson. Pax
 Italian--15th c. Pax: Corona-
 tion of the Virgin
 Italian--15/16th c. Pax
 Leonardo, Donati di. Pax#
 Spanish--15th c. Pax
Pax Board: Crucifixion. Welsh
PAYRE (French)
 Latham Memorial Fountain
 REED 143 UCOL
Paysan See Peasants
Pazzi Conspiracy
 Bertoldo di Giovanni. Pazzi
 Conspiracy, commemorative
 medal
Pazzi Madonna. Donatello
Pea. Bedford
Peables, John and Elizabeth
 English--17th c. John and
 Elizabeth Peables
 Monument
Peace
 Augustincic. Peace (Mir)
 Ford, E. O. Peace
 Jones, Adrian. The Quadriga:
 Peace
 Kiss-Kovacs. Peace, medal
 Persico, E. L. Peace, with
 Olive Branch
 Sansovino, J. Peace
Peace Column
 Pevsner. Column Symbolizing
 Peace
Peace Memorial. Milles
Peacham's "Minerva Britanna"
 English--17th c. Ceiling,
 central panel, taken from
 Peacham's "Minerva
 Britanna"
Peacocks
 Antico. Hercules and the
 Serpents, plaque
 Byzantine. Capital: Peacock
 and Foliate
 Byzantine. Chancel Plate:
 Peacocks
 Byzantine. Confronted Pea-
 cocks, relief
 Byzantine. Peacocks, slabs
 Byzantine. Peacocks Drinking
 Early Christian. Sarcophagus of
 St. Theodorus: Symbolic Pea-
 cocks Facing Sacred Emblem

Bertoldo di Giovanni.
 Bellerophon Mastering
 Pegasus
Bourdelle. Theatre de
 Champs-Elysees Proscenium
Cellini. Medal: Pietro Bembo;
 Pegasus
Italian--16th c. Pegasus and
 Perseus, relief
Martini, A. Heroic Group
Milles. Pegasus
Riccio. Pegasus
Tietz. Pegasus
Peguy, Charles Pierre (French
 Writer 1873-1914)
 Niclausse. Peguy, head
PEHRSON, Karl Axel (Swedish)
 High School Wall Relief
 1952 cast concrete
 DAM 108 SnB
Peirson, Samuel d 1714
 English--18th c. Samuel
 Peirson, cartouche
IL PELA See LAMBERTI, Niccolo di
 Pietro
Pelagos. Hepworth
Pelayo, Saint
 Spanish. St. Pelayo
Pelham, Mrs.
 Nollekens. Mrs. Pelham,
 bust
Pelican Fountain. Hardt
Pelicans
 English--12th c. Capital: The
 Pelican
 Flemish--12th c. Pelican
 Lectern
 German--17th c. Pendant:
 Pelican
 Jaenisch. Pelican
 Pisanello. Medal--obverse;
 reverse: Pelican Feeding
 Young on Own Body
 Pompon. Pelican
 Vuilleumier. Pelican
PELLE, Honore (fl 1679-1716)
 Charles II, bust 1684
 marble; 51
 MILLER il 141; VICF
 78; VICK 17 ELV (239-
 1881)
PELLEGRINO
 Virtues, Easter Candlestick,
 relief 1250
 DECR pl 133 ISeP
PELLEGRINO and TADDEO
 Pulpit; details--Capital:
 Sin: Male Figure Attacked

by Eagle and Serpent
1250/70
 DECR pl 131-2, 136 ISeP
PELLICCIOLI, Ferruccio
 (Italian 1907-)
 Count Pietro Orsi marble
 VEN-40: pl 82
PELLICER, Jeronimo See HERNANDEZ,
 Juan Rodriguez Blas
PELLINI, Eugenio (Italian)
 My Wife, bust marble
 VEN-24: pl 50
 Primavera marble
 VEN-22: 69
Pelta Ornament. Anglo-Saxon
Pembroke, William 3rd Earl of
 Le Sueur. William, 3rd Earl
 of Pembroke
Pembroke, 9th Earl of
 Roubiliac. The 9th Earl of
 Pembroke, bust
Pembroke, 11th Earl of
 Westmacott. Earl of
 Pembroke, 11th, Monument
PENALBA, Alicia Perez (Argentine-
 French 1918-)
 Butterfly Ancestor 1956
 bronze; 30x9-1/2x11
 CARNI-58: pl 32 UNNZ
 Cathedral 1958 bronze
 MARC pl 76
 Chrysalid 1956 bronze
 MAI 233 UNNZ
 Chrysalide 1961 bronze;
 16-1/8x30-3/4x18-7/8
 ALBC-4: 78 UNBuA
 Faun des Mers bronze; 16-1/2
 CLEA 83 UNNGe
 Foret Noir, No. 2 1960 bronze;
 38-1/8x15-3/4
 READCON 186 SwZL
 Great Sparkle (Grande Faisca)
 1957 bronze; 44
 EXS 102; SAO-6 FPB
 Homage to Vallejo 1957 bronze;
 118-1/8
 TRI 152 FPB
 Incognito 1961/62 bronze;
 42-3/4
 NEW pl 216; WALKA 33
 UNNMa
 Moonbird bronze; 41-3/8
 (with base)
 CLEA 83 UOC1A
 Plant Liturgy (Liturgie
 Vegetale) bronze base; 32
 CLEA 82 UNNWise
 Plant Liturgy No. 1

(Liturgie Vegetale No. 1)
1956 bronze; 26-1/2
GIE 310 FPB
Sculpture Project for a
Children's Playground
1961 stone
MARC pl 77
Sculptures in Concrete 1963
LIC pl 338 SwSGH
The Spark 1957 terracotta
BERCK 314
This Answers 1965 31-1/2x
57-1/2
CARNI-67: # 59
Penate. Hafelfinger
Pendants. See also Bracteates
Ashbee. Pendant
Byzantine. Madonna of
St. Luke
Byzantine. Pendant: Intaglio
Portrait
Danish--11th c. Golden
Treasure of Hiddensee
Dutch--16th c. Chain of
Dordrecht Militia
Early Christian. Neckband
with Medallion, showing
Annunciation
English--16th c. Pendant
Jewel
--St. Thomas More's
Pendant: St. George;
reverse: Resurrection
French--15th c. Figured
Medallion
--Pendant: Coronation of
the Virgin
French--16th c. Pendants:
Triton, Dragon, Lamb
German--16th c. Elephant
Jewel
--Pendant#
German--17th c. Pendant#
Italian--16th c. Jewelled
Pendant
--Minerva Pendant
--Pendant(s)#
Italian--17th c. Perfume
Bottle Pendant
--Sphinx Pendant
Lalique. Pendant#
Mackintosh. Pendant
Russian--11/12th c. Pen-
dants: Horseman with Bow;
Bird
Russian--19th c. Chudov
Reliquary Pendant
Spanish. Pendant: Galleon

Vever. Pendant
Wolfers. Medusa, pendant
Pendour. Hepworth
Pendule. Linck, W.
Pendule. Maillol
Penelope
Bourdelle. The Large Penelope
Bourdelle. Penelope
Hajdu. Penelope
Jerichau. Penelope
Wyatt, R. J. Penelope
Pengov
Kalin, B. The Painter
Pengov
Penguins
Brancusi. Penguins
PENIC, Dujam (Yugoslav 1891-)
Mask of Child marble
PAR-2:132
Peniten Souvenir marble
PAR-2:132
Penitent Mary Magdalen. Erhart,
Gregor
Penitent Son
Donatello. High Altar:
Miracle of the Penitent
Son
PENKINA, E. (Russian), and KOS-
DENSHINA
Kid and Grey Wolves, toy clay
BLUC 178
Penmon Pillar-Cross. Celtic
Penrise, Henry d 1752
Taylor. Sir Henry Penrice
Monument
PENROSE, Roland
Captain Cook's Last Voyage
1936
READS pl 75
Pensatore de Stelle. Cascella
La Pensee. Drivier
La Pensee
Maillol. Mediterranean
La Pensee. Rodin
Le Penseur
Rodin. The Thinker
"Penseur"
Wotruba. Seated Figure
("Penseur")
"Il Pensiero"
Michelangelo. Lorenzo de'
Medici Tomb: Lorenzo
de' Medici ('Il Pensiero")
Pentecost
Burgundian--12th c. Pente-
cost, tympanum of main
portal

English--14th c. Pentecost,
 boss
French--12th c. Christ in
 Miracle of the Pentecost
French--14th c. Pentecost,
 relief
French--16th c. Choir
 stalls: Miracle of Whitsun
German--11th c. Cologne
 Doors: The Healing of
 the Blind, Whitsun
 Miracle
Spanish--11th c. Gift of the
 Holy Ghost at Pentecost,
 relief
Pentelican Marble. Hajdu
Penwith
 Hepworth. Hollow Form
 (Penwith)
The People
 Pigalle. Louis XV Monument
People in a Wind. Armitage
People in the Piazza. Giacometti
The People Mourn. Biesbroeck
PEPE, Lorenzo (Italian 1916-)
 Donkey 1956 bronze
 SAL 26
 Germinazione 2 1965 bronze
 VEN-66:#82
 La Rossa, seated figure
 1955 bronze
 VEN-58:pl 44
 Spagna I 1964 bronze
 VEN-66:#81
Pepete a Piombo. Ghermandi
Pepin Reliquary. French--9th c.
Percevel, Spencer d 1812
 Westmacott. Spencer
 Perceval Monument
PERCHIN, Michael
 Faberge Parrot
 SOTH-4:238
 Miniature Sedan Chair
 Faberge gold and enamel;
 L: 3-1/8
 SOTH-2:194 (col)
 Serpent Head, Faberge cane
 handle
 SOTH-4:240
PERCIER, Charles (French 1764-
 1838), and P. F. L.
 FONTAINE
 Arc de Triomphe du
 Carrousel 1806
 FLEM 607 FPA
 Vendome Column 1806/10
 marble, with bronze
 spiral frieze; 142

(destroyed 1871; replaced
 1875) FLEM 608; WATT
 169; WHEE 181 FP
Percy Tomb
 English--13th c. Choir, with
 Percy Tomb
PERE JOHAN See JOHAN DE
 VALLFOGONA, PERE
Peregrinations of Georges Hugnet.
 Dominguez
Pereira, G.
 Pero of Coimbra and Telo
 Garcia. Bishop G.
 Pereira, effigy
PEREIRA, Manuel See PEREYRA,
 Manuel
PERELMAN, Mordechai (Russian-
 French 1901-)
 Prophet, fragment clay
 SCHW pl 61
Perepoynt, E.
 English--16th c. E. Pere-
 poynt, effigy
PEREYRA, Manuel (Manuel Pereira)
 (Spanish 1588-1683)
 St. Bruno c 1635/40
 KUBS 79B SpMaH
 --1650/60
 BUSB 88 SpMaF
 --1646/67 stone; 65
 BAZINW 400 (col);
 CIR 109 (col); GOME 16
 (col) SpBMir
 --detail
 CHENSW 401
 Virgin of the Rosary 1632
 KUBS 79A PoLD
PEREZ, Augusto (Italian 1929-)
 Great Queen, detail 1959
 black concrete
 SAL pl 93
 Hero (Eroe), detail 1960
 bronze
 VEN-60:pl 103
 The King 1964 9-1/2x12-1/2
 x19-1/4
 CARNI-67:#151 IROb
 King and Queen 1959 bronze
 SAL pl 94 (col)
 Masked Man 1960 bronze
 MAI 233
 --detail
 VEN-60:pl 102
 Narciso 1966 bronze
 VEN-66:#92
 Testa 1966 bronze
 VEN-66:#91

PEREZ COMENDADOR, Enrique
(Spanish 1901-)
Female bust
VEN-38:pl 81
Little Shepherd, head
CASS 44
PEREZ MATEO, Francesco
Bather
CASS 89
Perfume Containers
Chelsea Porcelain. Bonbon-
nieres and Scent Bottles
English--18th c. Chelsea
"Fable" Scent Bottles
--Chelsea Scent Bottles
Perfume Brazier
French--18th c. Blue Perfume
Brazier
PERIC, Pavao (Yugoslav 1907-)
The Singers 1941 terracotta
BIH 104
PERICOLI, Niccolo See TRIBOLI, IL
PERINCIOLI, Mercel (Swiss 1911-)
Starter 1952 bronze; 23 cm
JOR-1:pl 21
Periods and Commas. Arp
PERL, Karl (Austrian 1876-)
Pied Piper of Hamlin,
medallion c 1905 bronze
THU 111
PERMEKE, Constant (Belgian 1886-
1952)
Female Figure*
GOR 60
Marie Lou 1936 bronze; 114
BERCK 315; LIC pl 326;
MAI 234; MID pl 36 BAKO
Self Portrait, head
GOR 61
Standing Nude
GOR 62
Torso
GOR 63
Portraits
Puvrez. Constant Permeke,
bust
PERMOSER, Balthaser (German
1651-1732)
Apotheosis of Prince
Eugen 1718/21 marble;
90-1/2
BUSB 143; ENC 704;
LARR 354; NEWTEM pl
146; ST 365; STA 47
AVBa
--Self Portrait: Crouching
Figure of Conquered Turk
GOLDF pl 295

Caryatids, wall pavilion 1709
BUSB 141
Columnar Figures early 18th c.
stone
BAZINW 409 (col); MOLE
249 GDZ
"Damnation" after 1722 marble
BUSB 146 GLS
Flora 1724
HEMP pl 123 GDZ
Giant Mask
BOE pl 174 GDZ
Head of one of the Damned
c 1720
HEMP pl 122 GLB
Hercules 1720/24 sandstone;
205 cm
BERLE pl 86; BUSB 145
GBSBe
Hermae, Rampart Pavillion
1716/17
BOE pl 173 GDZ
St. Augustine c 1720
HEMP pl 123 GBauS
Zwinger Pavillion Atlantes
LARR 354 GDZ
PERNEVI, Palle (Swedish)
House Exterior Wall Sculpture
steel
DAM 201 SnG
Window Railing 1951
DAM 122, 123 SnSM
PERO OF COIMBRA (Portuguese),
and TELO GARCIA
Bishop G. Pereira, effigy
14th c.
SANT pl 67 PoBr
Perrault, Charles (French Writer
1628-1703)
Puech. Perrault Monument
Perret, Auguste (French Architect
1874-1954)
Bourdelle. August Perret,
head
PERRIN, Leon (Swiss 1886-)
Liberation bronze; 60 cm
JOR-1:pl 10
Perrotta, head. Lazzaro
Perry Tomb. English--14th c.
Persephone See also Hades
Bernini, G. L. Rape of
Persephone
Elkan. Persephone
German--17th c. Rape of
Persephone
Girardon. Rape of Persephone
Italian--15/16th c. Cassone:
Demeter and Hecate Search-
ing for Persephone

Kandler. Rape of Persephone,
 Meissen China
Tucher. Persephone
Perseus
 Canova. Perseus with Head
 of Medusa
 Cellini. Perseus#
 Gilbert, A. Perseus#
 Italian--16th c. Pegasus and
 Perseus, relief
 Marqueste. Perseus and the
 Gorgon
 Mascherini, M. Perseus
 Nost. Perseus
The Pershore Censer. English--
 10/11th c.
Persian Explosion. Dalwood
PERSICO, E. Luigi (Italian 1791-1860)
 Capitol East Front, central
 portion: Pediment
 Figures; Discovery
 Group; details 1844
 FAIR 49, 108 UDCCap
 --Discovery Group
 USC 365
 Genius of America (Justice;
 America; Hope) 1826
 marble; 108 (restored
 1959/60)
 CRAVS 80; USC 378
 UDCCap
 Peace, with Olive Branch
 1833 (1959/60 copy)
 marble
 USC 367 UDCCap
 War, as Roman Warrior
 1833 (1959/60 copy)
 marble
 USC 367 UDCCap
PERSICO, E. Luigi--ATTRIB
 Marquis de Lafayette, bust
 1824 plaster; 24-1/2
 AP 132 UPPA
 Nicholas Biddle, bust c 1837
 plaster 21-1/2
 CRAVS 80 UPPA
PERSICO, Paolo (Italian), Angelo
 BRUNELLI, and Pietro
 SOLARI
 Diana and Actaeon, fountain
 group 1790 marble
 BAZINL pl 329; LARR
 360 ICaseP
Person Standing. Gonzalez
Personage. Butler
Personaggio. Castelli
Personaggio. Mastroianni
Personnagio D'Oriente. Mirko

Personifications See also Architects
 and Architecture; and names,
 as Astronomy; Charity; Faith;
 Hope; Justice
 Byzantine. Plate: India,
 personification: Seated
 Female Figure with Horn-
 like Headdress
 Donner. Providentia Fountain
 German--9th c. Resurrection
 of the Dead, with
 Personifications of Roma,
 Sea, Earth
 German--17th c. Personnifica-
 tion of Death#
Personnage. Giacometti
Personnage. Miro, J.
Personnage II. Delahaye
Personnage Debout
 Gonzalez. Standing Figure
PERUZZI, Baldassare (Italian 1481-
 1536)
 Adrian VI Monument
 POPRB fig 61 IRMAni
Pesaro, Lino
 Cifariello. Lino Pesaro, head
PESCHI, Umberto (Italian)
 Aerial Sculpture of War
 wood
 VEN-42: pl 63
Pesenti, General
 Rivalta. General Pesenti,
 head
Pestkreuz
 German--14th c. Forked
 Cross Crucifixion
Pestsaule. Rauchmiller, M., and
 Fischer von Erlach, J. B.
PETEL, Georg (Jorg Petle)
 (German 1590-1634)
 Ecce Home 1630 lindenwood;
 175 cm
 MUL 93 GAuC
 Mary Magdelen at the Cross,
 Augsburg 1625/30 bronze;
 137 cm
 BUSB 61; MUL 90; ST
 364 GRegN
 Peter Paul Rubens, bust
 DEVI 2 BA
 St. Helena 1625/30 bronze;
 165 cm
 MUL 91 GBoM
 St. Sebastian 17th c. bronze
 CLE 114 UOC1A (40.585)
 --1630 ivory; 30.5 cm
 MUL 92 GMBN
 Salvator Mundi c 1633
 HEMP pl 19 GAuM

PETEL, Georg

Thief on the Cross, detail
1625 bronze; 29; and
34 cm
BSC pl 133 GBS (8396/97)
Venus and Cupid 17th c.
ivory; 16
MOLE 221 EOA

PETEL, Jurgen (German)
Crucifix c 1630 ivory;
83.5 cm
BOES 124 DHiNF

Peter, Saint
Aleman, R. St. Peter
Arnolfo di Cambio. St. Peter#
Bandinelli, B. St. Peter
Cordier, N. St. Peter, bust
Dalmata, G.--Foll. Martyr-
dom of St. Peter
Donatello. Ascension with
Christ Giving the Keys to
St. Peter, relief
Donatello. St. Peter Receiv-
ing the Keys from Christ,
relief
Early Christian. Ampoule:
St. Peter
Early Christian. Ananias and
Wife Struck Dead by St.
Peter
Early Christian. Christ
between SS Peter and Paul#
Early Christian. Columnar
Sarcophagus: Christ
Giving Law to SS Peter
and Paul
Early Christian. Oil Lamp:
Christ and St. Peter in
Boat
Early Christian. St. Peter,
plaque
Early Christian. Sarcophagus:
Christ between SS Peter
and Paul
Early Christian. Sarcophagus
of Junius Bassius
English--11th c. St. Peter,
with Key, relief
English--12th c. St. Peter,
seal of Cathedral Priory
English--14th c. Travelling
Altar, including figures
of Saints
Filarete. Basilica Doors:
Eugenius IV Receiving
the Keys from St. Peter
Flemish--15th c. St. Peter,
beam bracket
French--12th c. Crucifixion
of St. Peter

--The Passion, scenes: Peter,
Malchus, and the Guards of
Gethsemane
--Porte Miegeville: St. Peter
--Portal Figures: St. Peter
--Royal Portal
--St. Peter#
French--13th c. St. Peter#
French--14th c. St. Peter
French--15th c. St. Peter
French--16th c. Bishop's
Throne: St. Peter
Feuchtmayer. St. Peter
Gargallo. St. Peter
German--12th c. Christ
between Peter and Bishop
Albero
--St. Bartholomew and St.
Peter
--St. Peter#
--Shrine of Anno
German--13th c. Adam Portal
German--15th c. St. Peter#
German--16th c. St. Peter
Gislebertus. Peter and Paul,
Chapter House door
Grasser. St. Peter
Isaia da Pisa. Virgin and
Child with SS Peter and
Paul
Italian. St. Peter, seated
figure
Italian--15th c. Crucifixion
of St. Peter, relief
Jordan, E. Main Altar
Kandler. St. Peter and the
Apostles, Meissen
Kriechbaum. Winged High
Altar
Kuene, K. Archbishop
Dietrich von Moers Monu-
ment
Leoni, L. and P. Calvary,
with Virgin and St. John,
and SS Peter and Paul
Luchsperger. Apostle Figure
Nave Pier: St. Peter
Mascoli Master. St. Peter
Master of Rabenden. St.
Peter (Apostel Petrus),
head detail
Master of the Mercy Gate.
Mercy Gate, tympanum
Michelangelo. St. Peter
Naumberg Master. Founders'
Choir Screen: Peter and
the Maid
Paolo di Giovanni Fei.
Madonna and Child between
St. Peter and St. Paul

Portuguese--15th c. St. Peter
Quellinus, A. , the Elder.
 St. Peter
Robbia, A. della. St. Peter,
 half figure
Sagrera. St. Peter
Spanish--12th c. St. Peter
Spanish--13/15th c. St. Peter,
 seated figure
Vecchietta. St. Peter
Wagner, V. St. Peter
Werve. St. Peter
Zarcillo. Peter Striking
 Malchus
Peter I (Czar of Russia 1672-1725),
 known as "Peter the Great"
 Falconet. Peter the Great,
 equest
 Rastrelli, C. B. , the Elder.
 Peter the Great, bust
Peter Martyr, Saint (Patron Saint
 of Spanish Inquisition 1206-52)
 Balducci. Arca of St. Peter
 Martyr
Peter of Aigueblanche (Peter Aqua-
 blanca)(1240-68)
 English--13th c. Bishop
 Peter of Aigueblanche
 Tomb
Peter of Alcantara, Saint
 (Spanish Ecclesiastic 1499-
 1562)
 Mena. St. Peter of Alcantara
Peter Pan. Frampton
PETERSSON, Axel See DODORHUL-
 TARN
Le Petit Amphion
 Laurens. Small Amphion
Petit Cheval--Gelinotte. Braque
Le Petit Coureur Cycliste. Maillol
Petit Jour le Soir. Kemeny
PETIT JUAN; RODERIGO THE
 GERMAN, and others
 Altar 1482/1504
 BUSR 121 SpTC
Petit Panneau. Cesar
Le Petit Porteur de Reliques
 Minne, G. Little Relics
 Carrier
Petit Soir Le Matin. Kemeny
Petite Architecture Lumiere. Yanco
Petite Bigoudaine. Quillivic
Petite Bretonne. Aronson
Le Petite Danseuse de Quatorze
 Ans
 Degas. Little Dancer of
 Fourteen Years
Petite Fille des Landes. Despiau

Le Petite Laveuse Accroupie. Renoir
Petite Masse. Speck
La Petite Musicienne. Laurens
Petite Vierge. Osouf
PETLE, Jorg See PETEL, Georg
Petolfi, Sandor (Hungarian Poet
 1823-49)
 Huszar. Poet Petofi Memorial
PETRASCU, Militza
 Equestrian* terracotta
 MARTE pl 35
 Figure*
 MARTE pl 42
Petrelle, M.
 Wlerick. Painter Petrelle,
 head
PETRI, Ludovico (Hungarian)
 R. A. , head marble
 VEN-32: pl 168
PETRIE, Maria
 C. H. Sharp of Abbotsholme,
 bust
 CASS 58
Petrie, Mrs.
 Banks. Mrs. Petrie Monument
Petrification Semantique. Schreib
Petrified Crowd. Viseux
PETRIZ, Peter (Architect)
 Rib Abutment Figures,
 northwest central pillar
 3rd Q 12th c.
 BOE pl 63 SpSalO
Petroni, Cardinal d 1314
 Tino di Camaino. Cardinal
 Petroni Monument
Petronius, Saint
 Michelangelo. St. Petronius
 Quercia. St. Petronio
PETROVIC, Zoran (Yugoslav 1921-)
 Escombros 1960/61 H: 100 cm
 SAO-6
Petrus Maria, medal. Spinelli
PETRUS VASSALIETTUS See ANGELO,
 Nicolo d'
PETTERSEN, Axel See DODOR-
 HULTARN
PETTRICH, Ferdinand (Chevalier
 Friedrich August Pettrich)
 (German 1798-1872)
 Dying Tecumseh 1865
 USC 392 UDCNM
Peut Etre No. 11. Tinguely
PEVSNER, Antoine (Ukranian-French
 1886-1962)
 Abstraction 1927 brass;
 23-3/4x24-5/8
 RIT 149 UMoSW

37-1/2x77-3/4
HAMP pl 139 UMdPW
--1950/51 brass and
oxydized bronze; 100x88
GIE 191 VCU
--1950/51 bronze
VEN-64: pl 45
--1950/51 bronze; 40x80x36
SCHAEF pl 122
Embryonic Construction 1948
bronze
MARC pl 48 FPPe
Extensible Surface Con-
struction 1941 plaster
and bronze
MARC pl 47 (col) IVG
--1941 silvered bronze
MARC pl 49 (col) IVG
Fauna of the Ocean 1944
brass and oxydized tin;
20-3/4x28
COOP 299; KUHB 112
UMiBiW
Fenice 1957 bronze
VEN-58: pl 145
Germ-Construction 1949
16x23x14
BERCK 68
Half Figure of a Woman
FEIN pl 139
Head of a Woman
(Construction) 1922/23
wood and plastic; 14-3/4
x9-1/2x9-1/2
READCON 98; SELZJ
247 FPLef
Kinetic Construction 1953
metal pipes
SELZJ 14
Marcel Duchamp 1926
ENC 708
Marcel Duchamp (Abstract
Portrait of Marcel
Duchamp) 1926(?)
celluloid; 27-1/2x17
NMAC pl 134 UNNMMA
--1926 celluloid on copper
(zinc); 37-1/2x25-5/8
LARM 328; READCON
97; TRI 123; UPJ 639
UCtY
Monument for an Unknown
Political Prisoner 1955
bronze
ABAM 93; BAZINW 443
(col) FPM
Monument Symbolizing the
Liberation of the Spirit

1952 bronze; 18
BOW 143; ROTJG pl 24 ELT
Oval Fresco 1945 brass;
51-1/8x34-1/4x13
TRI 206 NAS
The Phoenix (Le Phenix)
1957 bronze; 40
EXS 103 SwZBe
--1957 gilded bronze; 33-1/2
x13-3/4
WATT 181 FPB
Plane Surface, a Tangent
Emerges from the Left
Curve
PRAEG 463
Projection in Space (Flache,
die in Linker Kurve eine
Tangente Entfaltet) 1938/39
GERT 167
Projection into Space 1924
oxydized bronze; 20-1/2x
23-1/4
READCON 133 UMdBM
--1938/39 bronze; 19-1/4
GIE 187; MAI 235 SwBS
Relief Construction 1930
copper on Ebonite base;
37-5/8x27-3/4
NMAC pl 136
Sculpture
KULN 154 VCU
Sense of Movement: Spatial
Construction 1956
LARM 262
Spectral Vision 1959 oxydized
bronze
CANK 173; MAI 237
Torso celluloid and copper;
30
UNNMMAM #184 UNNDr
--1924/26 brass and plastic
RIT 148 UD
--1924/26 plastic and copper;
29-1/2
BURN 209; JANSH 534;
JANSK 1018; LIC pl 244;
NNMMM 126; READCON
99; ROSE pl 198 UNNMMA
Twinned Column (Colonne
Jumelee) 1947 bronze;
40-1/2
CLEA 71; GIE 229; GUG
217; READI pl 84 UNNG
World Construction 1947 brass
and oxydized tin; 28
GIE 189; LIC pl 249;
RAMS pl 100b-c FPM
--1947 bronze; 31-1/4
SCHAEF pl 121

PEYRISSAC, Jean (French 1895-)
 Dances 1960 iron
 MAI 238
 Mobile Sculpture 1949
 BERCK 317
PEZET, Genevieve See GENEVIEVE
PEZZO, Lucio del (Italian) Large
 White Interior 1963 paint
 and plaster on canvas;
 c 57x45
 LIP 188 IMSc
PFAHLER, Georg Karl (German
 1926-)
 Color Space Object
 (Farbraumobject) 6
 1965/66
 KULN 131
 Color Space Object
 (Farbraumobject) 13
 1966/67 steel polychromed;
 GUGE 101 (col) GStMu
Phantoms. Mastroianni
Pharoa I. Meier-Denninghoff
Pheasants
 English--18th c. Bow Pheasant
 --Bow White Pheasant
Philibert II (Duke of Savoy), called
 "Philibert Le Beau"
 Meit. Philibert the Handsome
Philidor, Francois Andre (French
 Musician and Composer 1726-
 95)
 Pajou. Danican-Philidor,
 bust
Philip, Saint
 Austrian--16th c. St. Philip
 with Book
 Belgian--12th c. Portable
 Altar of Staveld:
 Martyrdom of SS Andrew
 and Philip
 Colijns de Nole. St. Philip
 French--14th c. St. Philip,
 head detail
 Riemenschneider. St. Philip
 the Apostle, head
Philip (Brother of Louis XI, King
 of France)
 French--13th c. Philip
 Tomb
Philip II (King of France 1165-
 1223)
 French--13th c. Philip
 Augustus, head
Philip III (King of France
 1245-85), called "Philip
 the Bold"

 Chelles, P. de. Philip the
 Bold Tomb
 French--13th c. Philip III,
 effigy head
Philip IV (King of France 1268-1314),
 called "Philip the Fair"
 Chelles and Arras. Philippe
 le Bel, head
Philip VI (King of France 1293-1350)
 French--14th c. Double d'Or:
 Philip VI on Gothic Throne
Philip I (King of Spain 1378-1506)
 Ordonez. Philip of Burgundy
 and Joanna the Mad Tomb
Philip II (King of Spain 1527-98)
 Leoni, L. Philip II
 Leoni, P. Philip II
 Leoni, P. Philip II and his
 Family at Prayer
 Reynolds-Stephens. A Royal
 Game
Philip III (King of Spain 1578-1621)
 Bologna, and P. Tacca.
 Philip III, equest
Philip IV (King of Span 1605-65)
 Tacca, P. Horse and Rider
 (Philip IV)
 Tacca, P. Philip IV, equest#
PHILIP, John Birnie (English
 1824-75)
 Albert Memorial, frieze detail:
 Pugin, Scott, Cockerell,
 and Barny
 BOASE pl 90A ELA1
Philip Augustus See Philip II (King
 of France)
Philip of Burgundy See Philip I
 (King of Spain)
Philip the Bold (Duke of Burgundy
 1342-1404)
 Flemish--14th c. Equestrian
 Seal of Philip the Bold
 French--13th c. Philip III,
 Le Hardi, Tomb
 Sluter. Philip the Bold
 Commended to the Virgin
 by St. John
 Sluter and Werve. Philip the
 Bold Tomb
Philip the Good (Duke of Burgundy
 1396-1467)
 French--15th c. The
 Falconer: Philippe le Bon
 Godl. Philip the Good
Philipp von Freising (Bishop of
 Freising and Naumberg 1498-
 1541)

Hagenauer, F. Philipp von
Freising
Philippa of Hainault
Jean de Liege. Philippa of
Hainault, effigy
Philippa of Lancaster (Queen of
John I of Portugal 1359-1415)
Portuguese--15th c. John I
and his Queen Philippa
of Lancaster, effigies
Philippe (Duc d'Orleans)
Prou, J., the Younger.
Philippe, Duc d'Orleans,
bust
Philippe de Morvillier (President of
Parliament of Paris d 1438)
French--15th c. Philippe de
Morvillier, effigy
Philippe de Neveu
Jacques de Gerines and
Renier van Thienen.
Isabella of Bourbon Tomb
PHILLIPS, John (Titanic Telegrapher)
Turner, H. T. Phillips
Memorial Tablet
PHILLIPS, Peter (English 1939-)
See also Laing, Gerald
Tricurvular II 1966/67
KULN col pl 7 (col)
PHILOLAOS, Tloupas (Greek 1923-)
Politrevo 1962 acoinoxidavel
martelado
SAO-8
Philosophical Argument, relief
fragment. Early Christian
Philosophers and Philosophy
Early Christian. Sarcophagus:
Orans and Philosopher
English--16th c. A Philosoph-
er and St. Agatha
Italian--15th c. Natural
Philosopher Amidst the
Elements
Pollaiuolo, A. and P.
Sixtus IV Monument
Philosophy
Robbia, L. della. The
Philosophers, panel
Philoxenus
Byzantine. Diptych of
Philoxenus
Phipps, William d 1748
Taylor William Phipps
Monument
Phoenix
Byzantine. Casket: Hunting
Scenes, Mounted
Emperors, Phoenix

Matare. Phoenix
Pevsner. The Phoenix
Skinner. Phoenix
Phrygian Bonnet
Early Christian. Child in
Phrygian Bonnet
Phrygian Sibyl
Syrlin, J., the Elder. The
Phrygian Sibyl
Phryne. Brutt
Phryne. Pradier
Physical Energy. Watts
Physicians
Duszenko. Woman Doctor
French. Healing Saints
Robbia, L. della and A. della.
Three Guild Emblems,
plaques
Physon
German--13th c. Font
Piano
Benet. Marche Funebre d'un
Heros
Smith, R. Piano
Piastra# Calo
Piastre
Calo. Great Slab
Piazza
Giacometti. The Square
Picador. Gargallo
PICARDY
Virgin and Child
REED 126 UCSFCP
PICASSO, Pablo (Spanish-French
1881-)
Absinthe Glass (Glass of
Absinthe) ptd bronze and
plaster; 8-3/4
BMAF 66; CLEA 12; ROSE
pl 202 UPPPM
--1914 bronze; 8-3/4x3
GIE 88 SwZBur
--1914 bronze ptd
MAI 240
--1914 ptd bronze
SELZJ 197 (col) FPBe
--1914 ptd bronze; 8-3/4
READCON 61 (col) FPK
--1914 ptd bronze, with
silver spoon; 8-1/2
BOW 135; LIC pl 257
UNNMMA
The Arm bronze
MILLS pl 65 ELH
Baboon and Young 1951 bronze;
21
BOW 86

--

CANM 540; CHICSG; ENC 711; LIC pl 329; READCON 234 UNNMMA

--

SELZS 143 UNNGan

Baboon with Young 1951 bronze; 21-3/4
BOSME pl 129 UPPeI

Baigneuse Jouant 1958 bronze; 44-1/2x15-1/2x25-1/2
ALBC-4: 67 UNBuA

The Bathers: Homme aux Mains Jointes; Bather#; La Plongeuse; L'Homme Fontaine; Tete 1956/57 bronze; 53-1/8 to 104
EXS 104; GIE 304; LOND-5:#35; TRI 119 FPLe

Bathing Woman, design for a Monument, Cannes, charcoal drwg 1927 11-3/4x8-5/8
READCON 168

Beggar, head 1903 bronze
SELZJ 190 FPBe

Bouquet 1953 bronze; 24
READCON 55 UNNMa

Bronze Figure
FEIN pl 142

The Bull (Bull's Head; Metamorphosis), 1943 handlebars and seat of bicycle; 16-1/2
BOW 85; GIE 92; JANSH 10; MAI 240; MYBS 80 FPLe

Bust of a Woman 1932? plaster; 30-3/4
RIT 157

The Cock (Le Coq*) 1932 bronze; 32
SOTH-4: 76

--1932 bronze; 25-3/8
MILLS pl 64; READAS pl 53; ROTJG pl 17; SCHAEF pl 64; TATEF pl 43e ELT (6023)

Construction 1930 iron; 88
BOW 147

--1930/31 wrought iron; 82-3/4
GIE 214

Construction (Head) 1930/31 wrought iron; 39-3/8
READCON 64

Construction in Iron Wire (Construction in Wire)

1930 H: 12-5/8
MAI 240; READCON 68

Crouching Woman 1906 bronze
SELZJ 190 FPBe

Design for a Construction in Iron Wire 1928 H: 30
GIE 171; ROSE pl 216

Design for a Monument 1929 bronze; 10-5/8
READCON 168

Female Head 1910 bronze; 16-1/4
GIE 47 SwZK

--1910 bronze; 16-1/2
TRI 122

--1932 bronze; 34-1/2
GIE 20

Femme Assise 1945 bronze; 5-1/4x2-1/4x2-1/2
UCIT 34 UCLP

Femme aux Mains Craissees 1945 bronze; 7-3/4x2x1-1/2
UCIT 34 UCLP

Femme Debout bronze; 8x1-3/4 x1-1/4
UCIT 34 UCLP

Fernando Olivier, bust 1905 bronze; 14-1/2
INTA-1:101; SELZJ 191 FPPP

Figure 1927/28
READS

--1931 bronze
SELZJ 194 FPCal

--1943 plaster; 14-1/4
HAMP pl 174A

Figure (Seated, elongated female) 1931 bronze; 23-3/4
RIT 156 UNNCa

Goat 1950 bronze
CANK 131; KULN 54; MAI 240

--1950 bronze; 56
SCHAEF pl 65

--1951 bronze; L: 58
RIT 175 UNNV

Goat's Head and Bottle 1951/52 ptd bronze
MAI 241 UNNMMA

Le Grand Coq 1932 bronze
MYBU 437 UNNWat

Guitar 1912 construction: colored papers and string; 13x6-3/4
SEITA 10

--1912 paper construction; 9-1/2x5-1/2 ROSE pl 199

--1926 sackcloth with string,
pasted paper, oil paint, and
cloth pierced by two-inch
nails; 51-1/4x38-1/4
SEITA 24
Head
MALV 538
--1909 bronze
RAMT pl 59 ELZ
--1909 bronze
ROOS 280G UNNMMA
--1909 bronze; 16-1/4
BOW 31
--1909 bronze; 16-1/4
NNMMARO pl 304 UNNWe
--1931 wrought iron; 39-1/2
LYN 132
Head of a Woman, relief
1906 bronze; 4-1/2
DETS 85 UNNH
Head of a Woman 1907
bronze; 5-7/8
READCON 45
--1909 bronze
MYBS 62
--1909 bronze
FAIY 10 UNBuA
--1909 bronze; LS
RAMS pl 67a CTA
--1909 bronze; 16-1/4
SELZS 58 UDCKr
--1909 bronze; 16-1/4
MCCUR 261; RIT 130-31
UNNMMA
--1909/10
UCIT 3
--1909/10 bronze; 42 cm
LIC pl 219; SELZJ 198
(col) FPBe
--1909/10 bronze; 16
READCON 60 UNNH
--1931 iron construction; 40
BOW 88
--1932 bronze
MAI 239
--1932 copper
GERT 156
--1951 bronze; 21-1/8
BR pl 18; MU 252-53
UNNMMA
--1951 bronze; 21-1/2
DETS 86; JLAT 38;
READCON 46 UNNH
Hommage a Guillaume Apol-
linaire 1958 bronze
WATT 175 FPGe
--Woman's Head
MARC pl 21 (col)

The Jester 1905 bronze; 41
cm
LIC pl 218 FPLe
--1905 bronze; 16
PH pl 163a UDCP
--1905 bronze; 16-1/4
GIE 46 SwWK
Hester, head 1905 bronze;
6-3/4
DETS 84 UNNH
--1905 wax original
RIT 61 FPJ
Kleine Stehende c 1945
bronze; 13-3 cm
SP 192 GHaS
Large Head with Round Eye
1932 plaster
READAN # 134
The Madman 1905 bronze; 41
CAS pl 122 UDCP
Man with Lamp (Man with
Sheep; Shepherd Holding
Lamb) 1944 bronze;
220 cm
LIC pl 328 UPPPM
--1944 bronze; 88
MCCUR 273; MYBU 439;
RIT 172-74; UPJH pl 241
UPPeI
--1944 bronze; 86-1/2
BAZINW 440 (col); GAF
33; MARC pl 20 FVal
Mandolin 1914 wood construc-
tion; 23-1/2
LYN 88 (col); MCCUR 261;
READCON 86 (col); RIT
144
Mask 1901 bronze; 7-3/4
READCON 45 UNNMa
Metal Sculpture 1932
READAN #111
Le Minotaur c 1953 bronze,
with gold patina; 5x2-1/2x3
UCIT 33
Monkey and her Baby 1951
bronze; 22-1/2x13-1/8x24
HENNI pl 112 UMnMI
Monument, design, pen and
ink drwg 1928
GIE 300
Nu 1945 bronze
MILLS pl 8 ELH
Owl 1950 bronze; 14-1/2
YAP 244 -UBa
--(Eule) 1950 bronze; 14-1/2
GERT 157; MCCUR 273;
RIT 177 UNNRoIII
--1953 bronze; 15-1/2
SCHAEF pl 66

--1953 bronze; 39 cm
 LIC pl 330 UNNV
Project for a Sculpture 1928
 iron
 RIT 163
Red and White Owl 1953
 ceramic
 MYBU 439 FPLe
Relief Construction (destroyed)
 1914 wood collage
 BOW 133
Scooter and Feather 1942
 iron construction; 25
 BOW 87
Sculpture (Fabulous Beast
 Biting Tail) 1929 bronze; 9
 GIE 297
The She-Goat 1950 bronze
 (cast in May 1952); 46-3/8
 x56-3/8
 JANSK 1020 UNNMMA
Skull 1943 bronze; 11-1/2
 RIT 176
--1944 bronze; 29 cm
 LIC pl 327
Standing Figure 1945/47
 bronze; 3-1/2x1-1/4x1
 UCIT 34 UCLL
--1958 H: 13
 BERCK 24 FPLe
Standing Woman (Femme
 Debout) 1961 sheet iron,
 polychromed; 70x67
 GUGE 48 UTxHA
Stick Statuettes 1931 bronze;
 16-1/8 to 20-1/2
 READCON 66-67
Still Life 1914 ptd wood with
 upholstery fringe; 10x
 18-7/8
 KULN 65; ROSE pl 201;
 SEITA 21 ELP
Three Female Figures
 FEIN pl 143
Vase and Cake Plate brass;
 33x22-3/4x13
 CARNI-58:pl 2 UNNFi
Wineglass and Die, construc-
 tion 1913 wood; 6-3/4x
 6-3/4
 HAMP pl 88A
Woman 1931 wrought iron
 MAI 241
--1943 bronze
 MAI 241
--1943 bronze
 MAI 241

Woman, head 1909 H: 21-1/8
 UPJH pl 242 UNNMMA
Woman Diving 1957 bronze;
 104
 BERCK 111 FPLe
Woman in the Garden 1929/30
 bronze, after welded iron;
 82-3/4
 BAZINW 435 (col)
Woman Reading 1952 bronze
 CHICC 45 UICGid
Woman with Apple 1943
 bronze; 70-7/8
 BAZINW 440 (col)
Woman's Head bronze; 16-1/2
 TORA 64 CTA (48/32)
--c 1909 bronze; 16-1/4
 ALBC 193; BOSME pl 17;
 FLEM 740; HAMP pl 83B;
 MUNSN 43; TOW 57 UNBuA
--1909 bronze
 MARC 23 SwZK
--1909 bronze; 16-1/4
 BR pl 15; JANSK 1018;
 LARM 271; READAS pl 191;
 ROSE pl 188 UNNMMA
Woman's Head (Bust) 1909
 bronze
 BROWMS cat 598 UICA
 Portraits
Gargallo. Picasso, head
PICCININO, Lucio (Italian)
 Burgonet, Milan 3rd Q 16th
 c. steel, embossed and
 deamascened in gold and
 silver
 DETD 97 ELV
 Target: Apollo on Mt.
 Parnassus 16th c. damas-
 cened gold
 COOP 55 (col) IBrMa
Piccinino, Niccolo, of Perugia
 (Condottiere c 1380-1444)
 Pisanello. Medal: Niccolo
 Piccinino of Perugia
Piccolellis, Elisabeta de
 Romanelli. Elisabeta de
 Piccolellis, head
PICHE, Roland (English 1938-)
 Deposition 1964 ciment fondu;
 60
 HAMM 151 (col) ELRCA
 Portrait and a Room 1965
 fibreglass; 33x36x29
 MAE 95
 Sculpture
 PRIV 137 (col)

Sunset and Deposition 1964
fiberglass; 60x54
MAE 94 ELStu
PICKETT, Edwin (English 1938-)
Elixir for "A" 1966 wood,
resin, oroglass; 75-1/4x
123-3/4x36
LOND-7:#34
Sphinx 1964 ptd aluminum;
56x58x31
ARTST fr cov
PICTISH
Aberlemno Cross-Slab
FIN 9 ScEA
Picton, Thomas
Gagahan, S. General Sir
Thomas Picton Monument
Picture in the French Style. Raysse
Picture Stones
Viking. Memorial Picture
Stones
Pied Piper of Hamlin, medallion.
Perl
PIEMONTI, Lorenzo (Italian)
Alluminio 1966
KULN 129
PIENE, Otto (German 1928-)
Corona Borealis 1965
BURN 297 UNNWise
Facade 1967
KULN 163 GCo
Light Ballet 1961
BURN 295 GLeM
PIERCE, Edward (Edward Pearce),
Jr. (English fl 1656-95)
Dr. John Hamey, bust 1675
WHINN pl 32B ELRC
Oliver Cromwell, bust c 1672
bronze; 25 (excl pediment)
NATP pl 5E ELNP
Sir Christopher Wren, bust
c 1673 marble; 26
ENC 700; GARL 202;
MILLER il 139; MOLE
254; MOLS-2:pl 15;
WHIN front; WHINN pl 32A
EOA
Sir William Walworth; head
detail 1684
WHINN pl 33b, 35 ELFH
Thomas Evans, bust 1688
CON-2:pl 44 ELPC
--1688
WHINN pl 34 ELPr
PIERCE, Edward--ATTRIB
John Milton, bust c 1660
plaster cast; 11
NATP pl 6 ELNP

Pierced Form# Hepworth
Pierced Hemisphere# Hepworth
Pierced Monolith with Colour. Hep-
worth
Pierced Vertical Form. Hepworth
PIERELLI, Attillio (Italian 1924-)
Monumenti Inox 1965
KULN col pl 6 (col)
Struttura Sonora 1965
KULN 121
PIERINO DA VINCI (Italian 1520/21,
or 1531-54)
Cosimo I as Patron of Pisa,
relief marble; 73.5x160 cm
POPRB pl 61 IRV
Fountain of Hercules and
Anteaus, detail: Child,
head
MOLE 162 (col) IFCas
River God marble; 135 cm
POPRB pl 63 FPL
Samson and the Philistines
ENC 188
--marble; c 223 cm
BAZINW 361 (col); POPRB
pl 62 IFV
Samson and the Philistines
POPRB fig 128 FPL
Sea God, relief sketch mid
16th c. terracotta; c 12
FAIY 226 UNPV
PIERLUCA (Pierluca degli Innocenti)
(Italian 1926-)
Deep Fissure (Grande
Lacerazione F. 63) 1963
aluminum
VEN-64:pl 3
Deep Fissure (Grand
Lacerazione FL 64) 1964
soldered aluminum; 80x68
40
ARTSI #16
Lacerazione 18A 1961 34x54
CARNI-61:#315 IMLo
PIERPAOLO DALLE MASEGNE See
JACOBELLO DALLE
MASEGNE
Pierre. Schumann, H. P.
Pierre, Eustace de (Hero of Calais
14th c.)
Rodin. Burghers of Calais
PIERRE DE CHELLES See SIMON
MATTHIAS DE BUCY
PIERRE DE MONTREUIL
Legend of St. Dagobert,
detail, Tomb of King
Dagobert 1263/64
BUSGS 113 FPDe

Rene de Birague, medal
bronze, gilded and
chased LARR 167
Risen Christ c 1580
BUSB 11 FPL
--c 1583 H: 67
MAR 133; UPJ 345 FPLou
The Three Graces (Three
Theological Virtues) bearing
reliquary for Heart of
Henri II 1559/63 marble;
59
BLUA pl 63; CHAR-2: 59;
ENC 714; JAL-4: pl 20;
LOUM 75; ST 331; STA
166 FPL (413; 414)
Valentine Balbiani, recumbent
effigy 1583 marble
BLUE pl 65; BUSR 14; 15;
LOUM 77; MOLE 208 FPL
(418-423)
Valerie Balbiani Monument,
detail c 1572
GAF 141 FPL
Vierge de la Couture au Mans
1571 polychrome bronze
JAL-4: pl 23 FPL
The Virgin
HAUS pl 209 FPL
--1571
GAF 285 FLeMN
The Virgin, seated figure end
16th c. terracotta; LS
MOLE 210 FPL
--c 1580/85 H: 70
BLUA pl 66 FPL
PILON, Germain--ATTRIB
Seated Woman and Two Chil-
dren (Charity?) alabaster
CLE 103 UOC1A (51.541)
PILON, Germain--FOLL
Fountain with Nymphs bronze;
27-1/2 BOSMI 133 UMB
(41.56)
--Nymph FEIN pl 121
The Pilot. Loutchansky
PILZ, Otto (German 1876-)
Standing Tiger oak PAR-2: 69
PINA, Alfredo (Italian)
Adolescent Torso bronze
VEN-28: pl 67
PINAZO, Ignacio
Mediterrane CASS 89
Pinchon, Edward d 1625
Stone. Edward Pinchon
Monument
Pincio Obelisk. Italian
Pine Marten. Spurr

PINEDA, Bernardo Simon de
(Spanish fl 1641-89)
Pedro Roldan, and Juan
Valdes Leal. High Altar
(sculpture by Roldan, and
painting and gilding by
Valdes Leal) 1670/73
KUBS pl 86B SpSCar
PINELLI, Bartolomeo (Italian 1781-
1835)
Wounded Brigand c 1830
terracotta; 37 cm
LIC pl 44 IRRo
Pingre, Alexandre Gui (French
Astronomer 1711-96)
Caffieri. Canon Pingre, bust
PINI, Carlo (Italian 1902-)
La Fete, relief
VEN-38: pl 34
Pinocchio
Greco, E. Pinocchio Monument
Pins and Clasps See also Fibulae
Anglo-Saxon. Metal Ornaments
English--10th c. Bone Clasp
English--14/15th c. Pilgrim's
Badge: Thomas a Becket in
Triumph
Franco-Burgundian. The
Trinity Morse
Frankish. Fibula: Animal
Form
Russian--7th c. Clasp: Birds
and Female Figures
Viking. Animal Ornament Clasp
PINTO, Marie Therese (Chilean-
French 1910-)
The Root of the World 1958
bronze
MAI 243
The Pioneer Girl. Sabolic
The Piper (Discotheque). Ceroli
Pipes
Milles. Peace Memorial:
Indian Chief Smoking Peace
Pipe
Pipes (Music) See Musicians and
Musical Instruments
Pirandello, Luigi
Emilian. Luigi Pirandello,
head
Sever. Luigi Pirandello, head
PIRES-O-MOCO, Diogo (Portuguese
fl 1491-1530)
Angel Manuelin, kneeling figure
SANT pl 81 PoCM
Diogo d'Azambuja, effigy
SANT pl 86

PIRES-O-VELHO, Diogo (Portuguese)
Virgin
SANT pl 83 PoLV
Piron, Alexis (French Poet and
Playwright 1689-1773)
Piron, E. D. Monument to
Piron
PIRON, Eugene Desire (French)
Monument to Piron
TAFTM 33
PIRRONE, Giuseppe (Italian 1898-)
Resurrection, tondo 1953
bronze
VEN-56: pl 41
Pisa Baptistry Pulpit. Pisano,
Giovanni
Pisa Baptistry Pulpit. Pisano,
Niccolo
Pisa Pulpit. Pisano, G.
La Pisana. Martini, A.
PISANI, Giuseppe, of Carrara
(Italian)
Pius VI, bust (after Ceracchi)
1818 marble
HUBE pl 2 FBesC
PISANELLO (Antonio Pisano; Vittore
Pisano) (Italian c 1395-1455)
See also Giotto
Medal--obverse; reverse:
Pelican Feeding Young on
Own Body
NATSE ELBr
Medal: Alfonso V d'Aragona;
Eagles
BARG IFBar
Medal: Bearded Head, medal
PUT 53
Medal: Cecilia Gonzaga 1447
bronze
SEY pl 47A UDCN
Medal: Domenico Novello
Malatesta, Lord of Cesena
bronze; Dm: 3-3/8
SEYM 317; SHAP 26;
WALK UDCN
Medal: Filippo Maria
Visconti bronze; Dm:
4-1/8
SHAP 26 UDCN
Medal: Isotta da Rimini 1446
ROOS 114E IFBar
Medal: John VII Palaeologus,
Emperor of Byzantium,
medallion commemorating
Emperor's Visit to Italy
1438/39 c 1447 bronze
BAZINH 221; ROOS 114F;
SEY pl 46A IFBar

--and obverse: Portrait of
Emperor
BARG; SEW 437
Medal: John VIII Palaeologus
(John of Constantinople)
c 1438 bronze; Dm: 4-1/8
CHAS 17; JANSK 605 ELBr
--1438
SUNA 118 USCBC
Medal: Leonello d'Este,
Marquis of Ferrara bronze;
Dm: 2-3/4
BOSMI 129; VER pl 41
UMB (57.174)
Medal: Malatesta Novello
c 1445 Dm: 3-1/4
LARR 83; MAR 66 IFMN
Medal: Niccolo Piccinino of
Perugia c 1441 bronze; Dm:
8.8 cm
BOES 46 DCNM
--bronze; Dm: 89 mm
DETD 137 UCStbMo
Medal: Niccolo Piccinino of
Perugia; Griffin c 1441
lead; Dm: 3-1/2
YAP 217 -USch
--Griffin
CHENSW 396 ELBr
Medallion: Self Portrait
MONT 128 IFBar
Medals
CHENSN 46; CHENSW 396
ELBr
Nuptial Medal: Leonello
d'Este; Singing Lion 1444
bronze; Dm: 4-1/8
SHAP pl 57 UDCN
PISANO, Andrea (Andrea da Ponte-
dera) (Italian 1270?-1348)
Architecture, relief
ROOS 97E IFC
Arts, reliefs: Music; Paint-
ing; Metallurgy; Pastoral
Life 1334/87 marble
MCCA 99 IFC
--Agriculture, panel
BUSGS 142; POPG pl 47
--Painting, relief
ROOS 97D
Baptistry South Doors 1330/39
bronze; 18-1/2'
BAZINW 311 (col); FOC-
2: pl 114; MONT 129;
POPG fig 67; UPJ 221;
WHITJ pl 143 IFBap
--two panels, detail
MARQ 149

Isaiah, head detail c 1285/97
 WHITJ pl 30B ISC
Horse, detail
 CARL 65 ISC
Madonna (della Cintoia) c 1315
 marble; 27
 BAZINW 309 (col); JANSH
 262; JANSK 533; ST 243
 IPrC
Madonna and Child
 ROOS 97A; UPJH pl 89
 IPisaC
--c 1299(?) ivory
 WHITJ pl 37A IPisaC
--Madonna and Child c 1300(?)
 WHITJ pl 37B IPisaC
--1312/13
 WHITJ pl 37C IPisaMC
Mary di Mose (Maria Moise;
 Miriam), sister of Moses,
 1285/96
 BAZINL pl 220; CARL 60,
 61; POPG fig 8; WHITJ
 pl 30A ISC
Massacre of the Innocents,
 relief 14th c.
 CRU 110 IPisaMC
Moses
 BOE pl 115; CARL 64 ISC
Musicians, pulpit pilasters
 RAY 39 UNNMM
Pisa Baptistry Pulpit, detail:
 Nativity marble
 JANSK 530; 531; MYBA
 335; MYBU 352 IPisaB
Pisa Pulpit 1302/12
 BUSGS 139; MONT 130;
 WHITJ pl 34 IPisaC
--Adoration of the Magi
 LARR 31; STA 72
--Birth of St. John the Baptist
 LARR 23
--Christ marble
 POPG pl 18
--Crucifixion, relief
 SEW 451; WHITJ pl 35B
--Dialectic and Rhetoric
 marble; 10x15
 KO pl 72
--Flight into Egypt
 BUSGS 138
--Charity and the Four
 Cardinal Virtues
 MARQ 147
--Fortitude and Chastity
 PANS 113
--Strength and Prudence
 (Fortitude and Temperance)

marble
 JANSK 532; KO pl 72;
 POPG pl 19; WHITJ pl 36B
--Temperance, or Chastity
 CLAK 94
--Hercules
 BAZINW 309 (col); WHITJ
 pl 36A
--Madonna and Child
 BR pl 2; SEW 450; WHITJ
 pl 28B
--The Nativity and Annunciation
 to the Shepherds marble
 FLEM 304; JANSH 261;
 POPG fig 50, pl 2
--The Nativity
 JANSK 531; RUS 58; ST
 249; WHITJ pl 35A
--Presentation of Jesus in the
 Temple
 BUSG 138; GUIT 58-59
--St. John the Evangelist
 POPG fig 7
Pisa Pulpit (reproduction)
 FREEMR 44 IPisaMC
Pistoia Pulpit 1298/1301
 BUSGS 137; CHRP 155;
 FOC-2:pl 113; KIDS 120
 (col); POPG fig 49;
 WHITJ pl 32 IPiA
--Adoration of the Magi, relief
 marble BAZINH 172; WHITNJ
 pl 33A
--Annunciation, Nativity and An-
 nunciation to the Shepherds
 marble; 84x102 cm POPG
 pl 14
-- -- Annunciation marble; 33x
 40-1/4 READAS pl 72, 74
-- -- Annunciation and Nativity
 marble; 31-1/4x39-3/8 MONT
 130, 372; MOREYM pl 137
-- --Nativity
 MACL 51; WHITJ pl 31A
--The Crucifixion
 KIDS 143
-- --Virgin Mary
 READAS pl 73
--A Deacon marble; 35
 MOLE 100; POPG pl 17
--Massacre of the Innocents
 MACL 53; POPG pl 15;
 WHITNJ pl 33B
--The Nativity (Birth of
 Christ)
 CHENSW 370
--St. Andrea marble; 37
 KO pl 72

--A Sibyl marble; 24-1/2
BAZINW 308 (col); LARR
30; MACL 51; MAR 13;
MOREYM pl 138; POPG pl
16; POST-1:141; WHITJ
pl 31B
--Supporting Figure
BUSGS 136
A Prophet, fountain figure
1278 marble; 24-1/2
MOLE 102 (col) IPe
Simon; head detail
BAZINW 309 (col); CARL
62-63 ISC
The Sybil, middle porch
marble; 180 cm
BOE pl 113; CARL 64;
POPG pl 12 ISC
Two Pilasters, pulpit parapet
marble
NCM 268 UNNMM
(10.203.1 and 2)
Virgin and Child c 1317
marble; 27-1/2
READAS pl 76 IPrC
PISANO, Giovanni--FOLL
Adoration of the Kings, S.
Michele in Borgo c 1340
BUSGS 141 IPisaC
PISANO, Giulio (Italian)
Christ, altar detail 1287/1396
silver; 84
KIDS 116 (col) IPiC
PISANO, Niccolo (Nicola da Pisa;
Niccolo d'Apulia; Niccolo da
Ragusa; also identified with:
Niccolo dell'Arca, which see)
(Italian c 1206-84)
Crowned Bearded Head
c 1260/80 marble; 4-1/8
BOSMI 115 UMB (47.1446)
Fonte Maggiore
POPG fig 51; WHITJ pl
20B IPe
--Caryatids bronze; overall:
125 cm
POPG pl 11
--Month of February
POPG fig 53
Pisa Baptistry Pulpit 1259/60
marble
BARSTOW 116; BR pl 2;
BUSGS 93; CHASEH 282;
CHENSN 339; CHENSW
369; FLEM 304; FREEMR
40; JANSK 529; LARR 30;
MACL 41; PANR fig 106;
POPG pl 1; POST-1:137;
PRAEG 84; WHITJ pl 16
IPisaB

--panel details
MILLER il 113; RAY 38
--Adoration of the Magi
BAZINW 307 (col);
BAZINH 171; CRU 108;
ENC 717; LARR 30; MACL
45; NEWTET 131; VER
pl 24; WHITJ pl 17B
--Adoration of the Shepherds
GOMB 142; POPG pl 3
--Annunciation and Nativity
BUSGS 92; GOMB 142;
MYBU 351; POPG pl 2
--The Crucifixion marble;
c 34
KIDS 142; MOLE 98;
ROOS 96A
--Faith
POPG pl 4
--Fidelity
MOLE 100
--Fortitude
BR pl 2; CLAK 53; PANR
fig 48
--Nativity
ENC 717; GARDH 273;
JANSH 261; MARQ 144;
MONT 369; MU 132;
MYBS 33; ROBB 360;
ST 249; UPJ 219; WHITJ
pl 17A
--Presentation in the Temple
1260 marble; 33-1/2x
45-1/2
MALV 269; MONT 370;
MOREYM pl 135; MYBA
334; PANR fig 46; SEW
449
--Samson
FREEMR 42
--Strength
POPG pl 5
Pisa Pulpit: Adoration of the
Magi wood
CHRC 197 IPisaC
Pistoia Pulpit 1298/1302
ROOS 96F IPiA
Prophet
POPR fig 131 IBoD
Siena Pulpit--octagonal with 4
supporting lions 1266
marble
AUBA 161 (col); CHENSW
365; MOREYM pl 136;
POPG fig 47; ROOS 96C
ISC
--detail
CHASEH 283; MILLER il
114; POST-1:140

--Adoration of the Magi
CHENSW 370; MACL
45; WHITJ pl 20A
--Crucifixion marble; 85x97
cm
POPG pl 6
--Damned Soul
BAZINL pl 222; BAZINW
308 (col)
--Inferno
ROOS 96D
--Justice marble; 61 cm
POPG pl 9
--Madonna and Child
WHITJ
--Massacre of the Innocents
marble
MONT 131; POPG pl 7;
ROOS 96E
--Paradise
VER pl 25
--Three Angels marble; 85
cm
POPG pl 10
--A Virtue marble; 61 cm
POPG pl 8
PISANO, Niccolo, and ARNOLFO DI
CAMBIO, and WILIGELMUS
(FRA GUGLIELMO)
Pillar: Deacon and Acolytes,
Tomb of St. Dominic,
Bologna marble; 40-1/8
BOSMI 115 UMB (47.1290)
PISANO, Niccolo, and Giovanni
PISANO
Fonte Maggiore: Months and
Zodiac c 1275/78
ST 244 IPe
Siena Pulpit 1268
DUR fig 44; GAUM pl 34;
WHITJ pl 18 ISC
--Nativity
UPJ 220
PISANO, Niccolo--FOLL
Arca of St. Dominic
POPG fig 48 IBoD
PISANO, Nino (Italian 1315?-1368?)
Angel of the Annunciation
c 1350/68 pigmented wood;
c LS
MOLE 101 ELV
Annunciation polychrome
GAF 431 FLM
--and detail: Virgin, head
1360/68 ptd and gilded
wood; excl bases--
archangel: 62-3/4x
18-5/8x14-1/8; The

Virgin: 63-7/8x21-3/8x
15-1/2
KRA 10, 9 (col); USNKP
391 UDCN (A-1632; A-1633)
(K280)
Annunciatory Angel
POPG fig 19 IPisaMN
--1370 marble; 168 cm
POPG pl 51 IPisaCa
Archangel Gabriel wood, ptd
and gilt; 62-3/4x18-5/8
USNKP 390 UDCN (K-279)
Bishop Simone Saltarello
Monument 1341/42
PANS 133 IPisaCa
Cornardo Monument: Virgin
and Child marble; 123 cm
POPG fig 68, pl 48 IVGP
Madonna and Child
POST-1:146 IOrM
--polychrome marble
VALE 51; NYWC pl 9 UMiD
--14th c.
LARR 23 IFMar
--2nd half 14th c.
LARR 31 IFMar
Madonna del Latte (Nursing
Madonna) c 1360 marble; 36
BUSR 2; MOLE 103; POPG
fig 69, pl 49; READAS pl
80, 81; WHITJ pl 181A
IPisaMS
Virgin and Child 1348 marble
POPG pl 50 IFMar
Virgin Annunciate c 1350/68
POPG fig 18; WHITJ pl
181B IPisaMN
PISANO, Nino--FOLL
Madonna
BEREP 112 ITraA
Madonna 1350 alabaster; 35 cm
BSC pl 40 GBS (34)
Virgin Annunciate 14th c.
wood; 71.7
GAU 155; LOUM 119 FPL
(590)
PISANO, Vittore See PISANELLO
Pistoia Pulpit. Pisano, G.
PISTOLETTO, Michelangelo
(Italian 1933-)
Pistoletto's New Work 1965
KULN 76
PISTRUCCI, Benedetto (Italian
1784-1855)
Medal Commemorating
Aquisition of Parthenon
Marbles 1816
VER pl 127 IRZe

St. George and the Dragon,
 medallion VER pl 128
 IRZe
Waterloo Medal, models 1815
 VER pl 126 IRZe
Pitchers See also Aquamaniles
 English--18th c. Egyptian
 Black Pitcher
 Gauguin. Pitcher
 Lutma. Pitcher
 Martin Brothers. Grotesque
 Pitcher
Pitman Memorial. English--17th c.
PITOIN
 Andiron, with Winged Sphinxes
 1784 chased and gilt
 bronze; 18-1/8x15-3/4
 CHICT #156 FV (M.V.3535)
Pitt, William (Earl of Chatham
 1708-78), called "The Elder
 Pitt"
 Bacon, J. William Pitt, the
 Elder, Sarcophagus
 Chantrey. William Pitt
 English--18th c. William Pitt
 in Toga of Roman Senator,
 headless figure
 Westmacott. William Pitt
 Monument
 Wilton, Joseph. William Pitt,
 New York City Statue,
 mutilated by Revolutionary
 War Soldiers
Pitt, William (1759-1806), called
 "The Younger Pitt"
 Flaxman. William Pitt
 Nollekens. William Pitt, bust
Pitti. Ris
The Pitti Madonna
 Michelangelo. Madonna and
 Child with Young St. John
 the Baptist
Pius V (Pope 1504-72)
 Fontana, D. Pius V Tomb
Pius VI (Pope 1717-99)
 Pisani. Pius VI, bust
 Sibilia. Monument of Pius VI
Pius XI (Pope 1857-1939)
 Wildt. S. S. Pio XI
Une Place au Soliel. Cesar
Place of Silences. Chillada
Plague Column. Baugut
Plague Column
 Benkert, J. P., P. Strudel;
 and M. Rauchmiller
Plague Cross
 German--14th c. Forked
 Cross Crucifixion

Plaintiff V. Bertoni
Plane Combat, study. Hajdu
PLANES, Jose
 Youth
 CASS 114
Planes Defined by a Line. Bill
Planetario. Rygh
Planets
 Italian--14th c. Capital: The
 Planets and their
 Children
Plant. Tajiri
Plant Composition II. Bertoni
Plant Liturgy. Penalba
Planting the Cross in the Western
 World
 Zocchi, A. Columbus Statue
Plantlike Form. Uhlmann
Plastik. Isenrath
Plat de Menage
 Kandler. Meissen Sugar
 Caster: Chinese Lovers
 Kandler. Meissen Mustard
 Pot and Oil Jar: Woman
 and Chicken
Plate on Table. Puni
Plate Tracery See Window Tracery
PLATERESQUE
 Portal Facade c 1525/30
 GARDH 390; GUID 207
 SpSalU
 Spanish--16th c. Plateresque
 Portal
Plates
 Byzantine. Paten#
 Byzantine. Plate#
 Byzantine. Riha Paten
 Byzantine. Stuma Paten
 Early Christian. Plate#
 German--12th c. Wilten
 Chalice and Paten
 Master of Oswald Reliquary.
 Paten of St. Bernward
 Puni. Plate
 Staderini, Giovanni, and
 Gaspare Mola. Plate Com-
 memorating Reform of
 Gregorian Calendar
Platters
 Courtneys. Platter
Play. Manzu
Play Sculpture
 Altri. School Play Sculpture:
 Giraffes
 Moller-Nielsen. Play Sculpture
 Penalba. Sculpture Project for
 a Children's Playground
Playmates. Stursa

Plectrudis, Saint (Frankish Queen)
 German--12th c. St. Plectrudis,
 tomb relief
PLEDGE, C. T. (English)
 Wood Paneling, details: Three
 Birds; Flower, Committee
 Room 8, General Assembly
 Building English oak
 BAA pl 27, 28 UNNUN
Plenitude. Grard
Plenty. Robbia, Giovanni della
Pleurant
 Sluter and Werve. Philip the
 Bold Tomb
La Pleureuse
 Rodin. Weeping Woman
PLERSCH, Jan Jerzy (Polish)
 Term marble; 102 cm
 WPN pl 129 PWN (189023)
Pleyben Calvary. Breton
La Plongeuse
 Picasso. The Bathers
Plot, Dr.
 Latham, J. (?) Dr. Plot
 Monument
Plow. Comazzi
Plows and Plowing
 Bouchard. Plowing in
 Burgundy
 Ghiberti. Baptistry Doors--
 East: Cain and Abel
 Italian--12th c. Ploughman
 Driving Oxen, relief
 Pisano, A. Agriculture,
 panel
 Pisano, A. Ploughing
Plozk Doors. German--12th c.
PLUMIER, Denis (Belgian 1688-1721)
 Monument to Spinola 1715
 GER pl 28A BBN
PLUMIER, Denis; Laurent DELVAUX;
 and Peter SCHEEMAKERS
 Monument to John Sheffield,
 Duke of Buckingham and
 Normandy c 1721
 MOLS-2: pl 22; WHINN
 pl 54B, 55 ELWe
Plurimi di Berlino. Vedova
Plurimo N. 8. Feet on Top. Vedova
Pluto See Hades
Plymouth, 7th Earl of
 Chantrey. 7th Earl of
 Plymouth Monument
PO, Lena (Russian)
 The Sprite
 BLUC 253
Pocahontas (American Indian
 Princess 1595?-1617)

Capellano. Preservation of
 Capt. John Smith by
 Pocahontas
 McFall. Pocahontas
POELZIG, Hans (German 1869-1936)
 Reese-Brunnen 1929 Majolica;
 c 2.5 m
 OST 3 GHaN
Poem for the Trio MRT. Paolozzi
Poeme-Objet. Breton, A.
Poets and Poetry
 Byzantine. Muse and Poet
 Clodion. Poetry and Music
 Ernst. The Poet
 Lamberti, Niccolo di Pietro,
 and Tedesco. Two Doctors
 of the Church redone as
 Poets Laureate
 Rodin. La Poete et la Muse
 Tanavoli. Poeta come
 Simbolo della Liberta
 Wagner, J. Poetry
 Zogolopoulos. The Poet
Pogany, Mlle
 Brancusi. Mlle. Pogany
POGGINI, Domenico (Italian)
 Francesco de'Medici, bust
 POPRB fig 123 IFMN
 Pluto
 POPRB fig 132 IFV
 Virginia Pucci Ridolfi, bust
 POPRB fig 124 IFMN
POGLIANI, Maria Antonietta
 (Italian)
 Light (La Luce) bronze
 VEN-14: 58
POGLIANI, Tarcisio (Italian)
 Maternity marble
 VEN-28: pl 33
POHL, Uli (Ull Pohl) (German
 1935-)
 PX II/2010-59/64 1964
 plexiglas; 27-3/4 (incl
 base)x16-7/8x3-7/8
 SEITR 4 UNNH
 Plastik 1961 plexiglas; 69 cm
 KUL pl 67 GLeM
Pointing Figure with Child. Meadows
Pointing Man
 Giacometti. Man Pointing
Points Opposes. Linck, W.
POISSON, Pierre (French 1876-1953)
 Bather
 BAS 85 FPM
 Claude, head
 BAS 82 FPM
 La Commerce Maritime,
 dining room wall decoration,
 ship Normandie BAS 84

Flora
 BAS 86
Grace
 BAS 79
Hope (L'Esperance), facade
 figure, Church St. Nicolas
 du Chardonnet
 BAS 83
Jeune Fille, head
 BAS 82
Jeune Fille aux Gras Leves
 BAS 85 FPMP
Monument to the dead; detail:
 Victory
 BAS 81, 80 FLeH
Nude of a Young Woman
 MAI 243
Youth (Jeunesse)
 BAS 87 FChai
Poisson d'Or
 Brancusi. The Golden Fish
Poitiers, Diane de See Diane de
 Poitiers
POITREAU, Dominic Francois
Louis XV Snuffbox, figures
 after Teniers mother-of-
 pearl; gold
 SOTH-2:190 (col)
Polar Bear. Pompon
Polariscope N. 3. Munari
Polearms See Fauchards; Halberds
POLET, Johan (Dutch)
Man and Child
 MARTE pl 32
Reclining Nude
 CASS 74
Torso bronze
 VEN-36:pl 71
Workman, representing
 "Industry"
 AUM 110
Poley, John
English--17th c. Sir John
 Poley Monument
Poley, Rachel, Lady d 1725
English--18th c. Rachel,
 Lady Poley, Monument
POLISH
"The Angel of the Lord Put
 Forth the Staff and
 Touched the Flesh and the
 Unleavened Cakes",
 Belgium or Poland (Judges
 VI, 21) 10th c. silver;
 W: 160 mm
 SWA pl 49 PCN
Ark of Covenant 18th c. wood
 KAM 11

Christ of Nowy Targ, seated
 figure
 MALV 560
Coins with Hebrew Inscriptions
 12th c.
 ROTH 499 ELBr
Cross of the Order of St.
 Stanislas, Polish medal
 AMHP 223
Crucifixus c 1420
 MULS pl 42A CzPTy
Dismemberment of St. Stanis-
 law, altar relief, Plawno
 Church 1514/18 ptd and
 gilded wood; 118x93 cm
 WPN pl 79 PWN (SR. 22)
Fair Virgin, with Moses;
 details: Virgin; head;
 Moses c 1390/1400 lime-
 stone
 MULS pl 47B, 48-9 PTJ
Keter, Bimah (reading plat-
 form) 16th c. wrought iron
 ROTH 270 PCO
Kruzlow Madonna, head 15th c.
 BAZINW 321 (col) PCN
Lamentation; detail: Virgin,
 Kujawy 15th c. ptd wood;
 96 cm
 WPN pl 77 PWN (SR.12)
Madonna with Apple c 1430
 BUSR 59 PDM
Nativity, relief, Pomeranian
 14th c. ptd wood; 57x66 cm
 WPN pl 74 PWN (SR.3)
Pieta 15th c. stone
 MULS pl 44A PCB
St. Dorothea, reliquary head
 c 1420 gilded silver; 44.5
 cm
 MULS pl 43A; WPN pl 151
 PWN (SZM 997)
St. Sigismond, reliquary head
 c 1370 gilded silver; 45 cm
 WPN pl 150 PWN (SZM.996)
Torah Headpieces 18th c.
 KAM 148
Torah Scroll Crown 18th c.
 silver parcel gilt
 ROTH 315 UNNJe
Virgin and Child 15th c. wood
 MULS pl 44B PCN
Vladislav II Jagiello, effigy
 detail 15th c. red marble
 MULS pl 82B PCC
Wenzel von Radecz, bust
 1374/85
 MULS pl 45A CzPV

Window Lintel, detail, Castle
of Kowno 16th c. earthen-
ware, tinglaze; 54 cm
WPN pl 157 PWN (12680)
The Polish Handkiss, Meissen.
Kandler
Polish Monument. Bourdelle
Polish-Soviet Friendship Monument.
Wnuk
Politrevo. Philolaos
POLLAIUOLO, Antonio del (Italian
1432-98)
 Baptistry Altar Crucifix, base
 detail: St. John the Bap-
 tist, seated figure 1457/ 59
 silver
 SEY pl 80B IFOp
 Giuliano de' Medici(?), bust
 1470/ 78
 ROOS 113C IFBar
 Hercules bronze; 40.5 cm
 BERLEI 7; BUSR 195
 GBSBe (3043)
 Hercules and Antaeus c 1475
 bronze; 17-3/4
 BAZINW 340 (col); AGARC
 70; BARG; BR pl 6;
 CHASEH 315; CLAK 198;
 CRAVR 60; HALE 110 (col);
 JANSH 339; JANSK 638;
 MOLE 143; MU 137; NMI
 21, 20; POPR pl 90; POST-
 1:183; ROBB 372; SEY pl
 118B; SFGM # 63; UPJ
 263; UPJH pl 111 IFBar
 Warrior, bust terracotta;
 22-1/ 2x20-1/ 2
 USNI 232; USNK 185 UDCN
 (A-49)
 A Widow, head c 1480 terra-
 cotta
 BURC pl 48 IFMN
 Young Warrior, bust terracotta
 BARG; MACL 161; MCCA
 97; WILMO pl 24 IFBar
POLLAIUOLO, Antonio--ATTRIB
 St. Eustorgio, bust
 MCCA 7 IVoD
POLLAIUOLO, Antonio, and Piero
 POLLAIUOLO
 Innocent VIII Monument
 1493/ 97
 BUSR 88; CAL 79 (col);
 MURRA 211; POPR fig 71;
 IRP
 --Effigy
 CAL 81 (col)

--Effigy, head detail
 POPR pl 87
--Pope Blessing
 CAL 80 (col)
Sixtus IV Monument 1490/ 93
 bronze
 CAL 75 (col); CHAS 102;
 MOLE 143; MURRA 211;
 NOG 50-51; POPR fig 72;
 IRVP
--detail
 SEY pl 121
--Arithmetic,relief
 BAZINW 340 (col); CHAS
 130; POPR pl 89
--Geometry, relief
 MONT 132
--Effigy
 CAL 76 (col)
--Effigy, head
 CHAS 103; POPR pl 86
--Philosophy, relief
 CAL 77 (col)
--Rhetoric, relief
 POPR pl 88
--Theology, relief
 SEY pl 119
--Two Virtues, relief
 MACL 161
POLLAIUOLO, Antonio--FOLL
 Hercules and Caecus, relief
 c 1490 stucco
 SEY pl 155A IFGu
POLLAIUOLO, Piero (Italian 1443-96)
 See POLLAIUOLO, Antonio
Polo Player. Sintenis
Polychrome Spatial Construction.
 Gorin
Polychromed Relief. Csaky
Polychromed Wood. Folmer
Polyphemus
 Brokoff, J. Courtyard
 Fountain, with Polyphemus
 and Actaeon
 Cleve. Polypheme
 Rodin. Polyphemus
Pomanders
 German--16th c. Norfolk
 Pomander
POMMEREULLE, Daniel (French
 1937-)
 Doux Cerveau 1964 ptd wood
 and wool; 19-5/ 8x25-5/ 8
 NEW pl 57 FPRan
POMODORO, Arnaldo (Italian 1926-)
 The Cube 1962 bronze; 45x
 45x26
 ALBC-4: 74 UNBuA

Il Grande Disco 1965 bronze;
Dm: 84-5/8
NEW col pl 60 (col)
Il Grande Radar 1963 bronze
VEN-64: pl 14
The Land Surveyor's Table
1958 zinc, brass, copper,
and tin; 94-1/2x53-1/8
TRI 225
Large Disc 1965 bronze; Dm:
88
ARTSI #17 IRMarl
Mechanical Energy 1955 silver
VEN-56: pl 43
Relief 1961 bronze; 19-1/4x13
CALA 210 IVG
Sphere No. 1 1963 bronze;
Dm: 73-1/4
CALA 211; GUGP 96;
VEN-64: pl 15 IVG
There Were Many of Them
1958 lead and tin; 22-1/2x
61-3/4
CARNI-58: pl 34
POMODORO, Gio (Italian 1930-)
The Barrier 1957 bronze;
25-1/2
MINE 57 FPInt
Co-Existence 1958 bronze;
59x63
TRI 172
--1960 plaster
SAL pl 92 (col)
The Crowd, study 1957
plaster
SAL pl 91
Eucalyptus 1957 bronze; 87
MINE 58 FPInt
Grandi Contatti 1962 bronze;
90-1/2x63
NEW pl 115; VEN-62: pl 55
Growing, relief 1957 black
lead; 37x27x6-1/2
CARNI-58: pl 107; MINE
50 UPPiC
Homage to Michelangelo 1962
bronze
VEN-62: pl 56
Immagine Fecondante 1955
silver
VEN-56: pl 44
Impressao de Distancia 1959
SAO-5
Radial-Homage to Builders of
Cupolas, maquette 1966
plaster, for polyester;
80x80
ARTSI #81 IRMarl

Pomona
Cornet. Pomone
Delvaux. Vertumnus and
Pomona
Lemoyne, J. L. Pomona
Maillol. Pomona
Marcks. Pomona
Marini. Pomona
Nicolini. Pomona
Probst. Pomona
Riccio. Pomona
Rousseau, V. Pomona
Wlerick. Pomone
Pompadour. Caro
Pompadour, Jeanne de (Mistress of
Louis XV of France 1721-64)
Falconet. Madame de
Pompadour as the Venus of
the Doves
Pigalle. Madame de Pompa-
dour as Goddess of
Friendship
POMPEO DELLA CHIESA
Half-Suit Italian Armor
c 1590
SOTH-2: 209
Pompey (Roman General)
French--16th c. Suit of
Armor of Henry II,
pictorial and ornamental
scenes of Pompey
POMPON, Francois (French 1855-1933)
Brown Bear 1918 bronze
SELZJ 173
Hippopotamus
AUM 53
Little Owl with Sunken Eyes
1918 bronze
SELZJ 172 FPM
The Mole granite
PAR-1: 192
Moor-Hen 1911 bronze
MAI 244 FPM
Owl
AUM 53
Pelican
CASS 122
Pigeon bronze
VEN-28: pl 134
Polar Bear (Ours Blanc;
White Bear)
NEUW 95 FPLu
--1921/22
MID pl 13 BAM
--1926 stone, after plaster in
Salon d'Automne of 1922;
1.52x2.5x.90 m BRIONA
128; HOF 226; MOD; PUT
209 FPM

Stag (Le Cerf) 1929 bronze;
 2. 6x1. 4x1. 76 m
 PM; VEN-30: pl 107
Turtle Dove
 AUM 53
Two Bears*
 MARTE pl 7
Two Pigs*
 MARTE pl 7
Water Hen
 AUES pl 45 FPM
Poncelet, Jean Victor (French
 Mathematician and Engineer
 1788-1867)
 French--19th c. Jean Victor
 Poncelet, bust
PONCET, Antoine (French 1928-)
 Abstract Head*
 EXS 20
 Forme without Name (Forme
 sans Nom) 1957 gilt
 bronze; 12
 BERCK 170; JOR-2: pl
 253 SwBH; UNNBe
 Forme Balancier sur Trois
 Pointes 1957
 JOR-2: pl 251
 Forme Claironnante 1954
 plaster; 60 cm
 JOR-1: pl 89
 Forme Confiante 1951 plaster;
 70 cm
 JOR-1: pl 90
 Forme-Cri 1956
 JOR-2: pl 142
 Forme de Hanchee 1957
 JOR-2: pl 252
 Forme S' Etirant 1954
 plaster; 60 cm
 JOR-1: pl 91
 Lunar Bird 1957 bronze
 MAI 254
 Tripatte 1958 bronze; 16-1/4
 x5-1/ 8x4
 GIE 268
 Tripatte 3 1957
 JOR-2: pl 141
 Tripatte 4 1957
 JOR-2: pl 255
PONCET, Henri
 Bas-Relief 1957
 JOR-2: pl 257
 Le Sacrifice 1958
 JOR-2: pl 258
Ponsonby, Sir William
 Theed, W. , the Elder, and
 Baily. Sir William
 Ponsonby Monument

Pont-au-Change Monument. Guillain
Ponte, Niccolo da (Doge of Venice
 1578-85)
 Vittoria. Doge Niccolo da
 Ponte, bust
Ponthieu, Count
 French--13th c. Count of
 Ponthieu, effigy
The Pony. Braque
PONZANO, Ponciano (Spanish)
 Heralds, Pantheon of the
 Infantes
 ESC 65 SpE
PONZIO, Flaminio (Italian)
 Acqua Paola 1610/14
 WIT pl 6A IR
 Clement VIII Tomb
 BAZINW 386 (col); POPRB
 fig 151 IRMMag
 Paul V Tomb 1608/15
 POPRB fig 152; WIT pl 4A
 IRMMag
POOLE, Henry (English 1873-)
 The Little Apple Portland
 stone
 JAG 79; PAR-1: 94; UND
 129 ELT
Poor Women. Smajic
POOT, Rik (Belgian 1924-)
 The Bird 1955
 BERCK 320
Pope, Alexander (English Poet
 1688-1744)
 Roubiliac. Alexander Pope,
 bust#
 Rysbrack. Alexander Pope,
 bust
Il Popolano
 Donatello. Prophet Habakkuk
Popolo. Marini
POPOVIC, Misa (Yugoslav 1925-)
 Internal Movement 1960
 bronze; 43-3/ 4
 ARTSY #107
Porch of the Virgin, west facade
 Notre Dame de Paris. French
 --13th c.
Porchaire, Saint
 French--16th c. St. Porchair
 Ewer
 --St. Porchaire Pedestal Dish
Porpoises
 Broughton. Porpoise
Porrina, Ranieri del d 1315
 Gano da Siena. Ganieri del
 Porrina, effigy
Porringers
 Germain. Covered Porringer

PORTA, Antonio della (called
Tamagnino) (Italian fl 1507),
and Pace GAGGINI
Raoul de Lannoy Tomb 1507
BLUA pl 1 FFo
PORTA, Giacomo della (Italian
Architect 1541-1604)
Altar of the Apostles; detail
by Giacomo and Guglielmo
della Porta marble
POPRB fig 143; pl 98
IGenC
PORTA, Giacomo della, and Taddeo
LANDINI
Tortoise Fountain (Fontana
della Tartarughe; Turtle
Fountain) 1581/84 marble
GIE 70; HALE 160;
NEWTEM pl 135; POPRB fig
169; ST 307 IRMat
--detail
BUSB 8
--copy of 1584 original in
Rome
REED 153 UCSFH
PORTA, Giovan Battista della
(Italian c 1542-97)
Augustus, bust marble
FAL pl 48c IRB
Caligula, bust marble
FAL pl 48e IRB
Claudius, bust marble
FAL pl 48f IRB
Domitian, bust marble
FAL pl 48n IRB
Galba, bust marble
FAL pl 48h IRB
Julius Caesar, bust marble
.78 m
FAL pl 48a IRB (LIII)
Nero, bust marble
FAL pl 48g IRB
Otto, bust marble
FAL pl 48i IRB
Tiberius, bust marble
FAL pl 48d IRB
Titus, bust marble
FAL pl 48m IRB
Vespasian, bust marble
FAL pl 48L IRB
Vitellius, bust marble
FAL pl 48b IRB
PORTA, Guglielmo della (Italian
1510?-77)
Crucifixion; detail cera su
lavagne; .68x. 46 m (excl
cornice) FAL pl 49A, 49B
IRB (CCLXXVII)

The Entombment, plaque gold
mounted on marble; relief:
7-1/4x6-11/16
DETD 150 UMdBW
Luisa Deti Aldobrandini Tomb
POPRB fig 147 IRMM
Paolo Cesi Tomb
POPRB fig 146 IRMMag
Paul III, bust bronze; 31 cm
WPN pl 61 PWN (126478)
--1546 marble; 75 cm
HALE 178; POPRB pl 101
INMC
Paul III Tomb, with Prudence
and Wisdom
LARR 218; POPRB fig 145
IRP
--Justice, head
NOG 47; POPRB pl 99
--Paul III, detail bronze
POPRB pl 100
Il Porta Bandiera. Lotti
Porta della Carta. Buon, B. , and G.
Porta della Mandorla
Italian--14th c. Porta della
Mandorla
Lorenzo di Giovanni d'Ambrogio.
Prophet
Nanni di Banco. Assumption of
the Virgin
Porta Maggiore
Quercia. San Petronio Doorway
Porta Pardiso
Ghiberti. Baptistry Doors--
East
Porta san Ranieri. Bonannus of Pisa
Portada de la Chapineria, Toledo
Cathedral. Spanish--14th c.
Portal Figure. Habich
Portal of God. Wolff, Evert, and
Jonas Wolff.
Portal of St. Anne. French--12th c.
Portal of the Gods See Portal of God
Portal of the Princes
German--13th c. Prince's
Portal
Portal of the Virgin. French--13th c.
Portale. Cascella, P.
Portals See Doorways and Gateways
PORTANOVA, Giambattista (Italian)
Fancialla Specchiantesi nell'
Acqua bronze
VEN-14: 132
La Porte de l'Enfer#
Rodin. The Gate of Hell
Porte Mere-Dieu
French--13th c. Amiens Ca-
thedral: Porte Mere-Dieu

Porte Miegeville. French--12th c.
Portes-Cocheres. See Gates and
 Gateways
Porthcressa. Mitchell, D.
Portico
 Miro, J. , and J. Llorens
 Artigas. Portico
Portico de la Gloria. Master Matteo
Portland Vase
 English--17th c. Portland Vase
Portrait and a Room. Piche
Portrait "L". Hartung
Portrait of a Lady, bust. Laszczka
Portrait of an American, head.
 Despiau
Portrait of an Electric Pater.
 Alvermann
The Portrait Painter. Grassi
Portrait-Synthesis of M. C. Z.
 Adam-Tessier
Portrait Synthetique. Indenbaum
Portugal, Cardinal of See Jacopo di
 Portogallo
PORTUGUESE
 Cabrillo
 REED 6 UCSDB
 --12th c.
 Two Capitals, Rio Mau 1151
 SANT pl 58. 59
 --13th c.
 Effigy Figure
 SANT pl 61 PoCCa
 --14th c.
 Angels
 SANT pl 72
 Capital limestone
 SANT pl 60 PoC
 Christ, Crucifixion detail
 wood
 SANT pl 79 PoAlC
 Christ, Crucifixion detail
 wood
 SANT pl 80 PoCM
 Count Barcelos Tomb granite
 SANT pl 62
 Ines de Castro Tomb; detail:
 Last Judgment; Effigy
 SANT pl 64, 65, 66 PoA
 Pancheco Tomb, effigy detail
 SANT pl 68 PoLCa
 Pedro I Tomb, detail:
 Rosace
 SANT pl 66 PoA
 St. Agatha
 SANT pl 70 PoCM
 St. Bartholomew, detail
 SANT pl 69 PoLV

St. Claire
 SANT pl 71
Virgin
 SANT pl 63 PoLV
--15th c.
John I and His Queen,
 Philippa of Lancaster,
 effigies 1433
 SANT pl 76 PoB
Manueline Style Window c 1450
 LARR 17 SpTomCh
Prophet
 SANT pl 77 PoB
St. Lucie
 SANT pl 82 PoAlhCh
St. Michael
 SANT pl 74 PoLV
St. Peter
 SANT pl 73 PoAr
Virgin and Child, seated figure
 SANT pl 78 PoBo
--15/16th c.
Renaissance Fountain, Castelo
 de Vide
 SANT pl 52
--16th c.
Baroque Angel
 SANT pl 95 PoAv
--terracotta
 SANT pl 94 PoA
St. Anne
 SANT pl 90 PoCM
--17th c.
Ewer and Basin
 LARR 310 PoLA
Holy Family, altar relief
 BAZINW 402 (col) PoCM
Retable
 SANT pl 98 PoAvM
--1697
 SANT pl 96 PoAvJ
Virgin terracotta
 SANT pl 93
--18th c.
Atlantes, High Altar
 BUSB 139 BAZINW 407
 (col); PoLN
Holy Family gilded and ptd
 BAZINW 407 (col) PoAvM
Main Altar before 1704
 LARR 310 PoOB
Nave and Main Altar c 1740
 gilded wood
 BAZINW 407 (col) PoOC
Putti, Palace Grounds
 BUSB 191 PoQ
Retable
 SANT pl 97 PoLE

St. John the Evangelist
BUSB 148 PoBrI
Poseidon (Neptune)
Adam, L. S. Neptune and
Amphitrite
Adam, L. S. Neptune Calms
the Storm
Ammanati. Neptune Fountain
Aspetti. Neptune
Bernini, G. L. Neptune and
Glaucus
Bernini, G. L. Neptune and
Triton
Bernini, G. L. --Attrib.
Neptune
Bow Porcelain. Neptune
Cellini. Neptune
Czech--17th c. Courtyard
Fountain with Neptune
English--17th c. Ceiling
with figure of Neptune
English--18th c. Derby
Porcelain Neptune
Grupello. Fishmongers' Guild
Fountain: Neptune and
Thetis
Italian--16th c. Neptune on a
Dolphin
Italian, or German. Neptune
and Amphitrite
Montorsoli. Fountain of
Neptune
Prokofiev. Neptune
Salvi, N. , and P. Bracci.
Trevi Fountain
Sansovino, J. Neptune#
Schluter. Kamecke House
Schluter. Neptune
Schweigger. Neptune
Tietz. Neptune and
Amphitrite
Vischer, P. , the Elder.
Neptune, seated figure
Vittoria. Neptune Taming
Sea Horse
Wurzelbauer--Foll. Neptune
Fountain
Poseidon Fountain. Milles
POSENENSKE, Charlotte (German
1930-)
Ohne Titel 1967
KULN 132
Possession
Italian--11th c. Exorcism
(Healing of the Woman
Possessed by a Devil)
Sansovino, J. St. Mark: Heal-
ing Woman Possessed of a
Devil, relief

Pot, Philippe (Grand Seneschal of
Burgundy d 1493)
Moiturier. Philippe Pot Tomb
Potiphar's Wife See Joseph, the
Patriarch
Pothon de Xaintrailles
Bacque. Pothon de
Xaintrailles
Potter. Nielsen
Potterne Font. Anglo-Saxon
POUGNY, Jean See PUNI, Ivan
Poulett, Hugh
Bristol Carvers. Sir Hugh
Poulett Monument
Pound, Ezra
Gaudier-Brzeska. Ezra
Pound, head
POUPELET, Jane (French 1878-1932)
Portraits
Schnegg. Poupelet, head
Poussah. Arp
POUSSIN, Nicolas (French 1594-1665)
Sleeping Ariadne (Ariadne
Endormie sur le Rivage
dans l'Ile de Naxos)
c 1625 wax; 11-1/2x21-
1/2
CHAR-2:132; LOUM 188
FPL (1452)
Portraits
Roux, C. Poussin
Pouter Pigeon. Skeaping
Power. Ayres
POWOLNY, Michael (Austrian)
Seated Woman Majolica
VEN-34:pl 179
Powys, Isabel
Epstein. Isabel Powys, bust
Powys, Thomas
Hartshorne. Sir Thomas
Powys, recumbent effigy
Poyntz Monument. English--17th c.
Pozharski
Martos. Minim and
Pozharski
POZZI, Egle (Italian)
Girl bronze
VEN-30:pl 68
POZZO, Andrea (Italian 1642-1709)
St. Ignatius Loyola Altar
gilded bronze; silver,
colored alabasters and
marble
BAZINW 393 (col) IRGe
PRADIER, James (Jean Jacques
Pradier) (Swiss-French 1792-
1852)
Atlanta at her Toilet 1830
marble SELZJ 40 FPL

Laundress c 1850 plaster;
34x14 cm
LIC pl 76 SwGA
Phryne marble
VICG 128
Sappho
LARM 69 FPL
Victory, Napoleon's Tomb
marble; c 15'
BAZINW 420 (col) FPHI
Prague
Sucharda. Prague and Moldau
Praise of Iron. Chillada
Prampolini, Enrico (Italian 1894-
1956)
Beguinage 1914 collage on
wood; 18x22 cm
CAS pl 206
PRANDTAUER, Jakob
Choir Loft and Organ
1702/36
FELM 577 AMeA
PRANTL, Karl (Austrian 1924-)
Stone Sculpture 1961 shell
lime; 220 cm
SOT pl 97
Prayer and Force. Gilioli, E.
Prayer and Worship See also
Sacrifices, Offerings and
Libations
Canova, A. Clement XIII
Monument: Clement XIII
Praying
Durst. Clergy and Choir
Stalls: Prayer
English--13/14th c. Sir
Robert de Bures,
"Westminster" Attitude of
Prayer
English--18th c. Mother and
Two Sons in Church Pew
--Pew Group: Woman Seated
Between two men
French--15th c. Praying Angel,
relief
Jaley. La Priere
Kennington. Prayer
Opitz. Prayer
Russian--8/9th c. B. C. Act
of Worship, relief
Sidlo. Prayer
Praying Disciple. Karsch, Joachim
Praying Mantis. Richier, G.
Pre-Adamic Fruit. Arp
Pre-Adamite Sculpture. Arp
Preachers and Preaching
Rodin. St. John the Baptist
Preaching

"Preaching of St. Paul"
Byzantine. St. Mark and his
Followers in Alexandria
("Preaching of St. Paul")
PREAULT, Antoine Augustin (French
1810-79)
Christ on the Cross; detail
1840 wood; 260 cm
LIC pl 63, 64 FPGP
Massacre (Carnage; Slaughter),
relief 1834 bronze; 43x
55-1/8
BAZINW 421 (col); BR pl
13; BRIO 41; BRIONR pl
40; LARM 45; LIC pl 65
FChM
Ophelia 1876 (original 1843)
bronze; 61x201 cm
LIC pl 67 FMaLo
"La Preciosa", Chapter House Door.
Spanish--14th c.
Precipiano, Bishop de
Voort. Monument of Bishop
de Precipiano
PRECLIK, Vladimir (Czech 1929-)
Old Town of Provence 1966
wood; 118
EXS 105
Preghiera sulla Tombo. Bilek
Pregnant Woman. Degas
Pregnant Woman. Dunkiowski
Prehistoric Monsters. Milles
PREISS, Franz (Czech) See also
Kohl, H.
St. Francis Sarcophagus,
Charles Bridge Figure
1708
STECH pl 26 CzPJo
Les Premieres Funerailles. Rodin
PRENTYS, Thomas, and Robert
SUTTON
Tomb of Robert Greene: Wife;
Effigy 1419 alabaster
STON pl 156, 158 ELow
Pres, Cardinal des
French--14th c. Cardinal des
Pres, effigy
PRESBYTER, Martinus
Virgin and Child 1199
ENC col pl 28 (col) GBS
Presentation au Temple. Courroy
Preseren, France
Gangl. France Preseren,
bust
PRESSET, Henri (Swiss 1928-)
Couple 1956
JOR-2: pl 256

PREST, Godfrey (English) See
BROKER, Nicholas
PRESTON, Edward Carter (English)
Figure yew
NORM 86
PRESTON, Philip A. (English
1934-)
Basic Dynamic Organization
1956 clay; 3
BED 117
Elementary Structure 1956
stone; 12-1/2
BED 115
Priam
Thorvaldsen. Priam Entreat-
ing Achilles to Deliver the
Body of Hector, relief
La Priere. Jaley
Priests
Arnolfo di Cambio. Annibaldi
Monument: Two Clerics
Bonome. Priest and
Worshiper
Early Christian. Priestess of
Bacchus, diptych leaf
English--13th c. Priest,
effigy
Italian--12th c. Parma
Capital: Fable--Fox Dressed
as Priest
Lucchesi, B. Priest
PRIEUR, Barthelemy (French fl
1540-1611)
Montmorency Family Monument
LOUM 79 FPL (443-447)
PRIMARIO, Gagliardo (Italian) See
TINO DI CAMAINO
PRIMATICCIO, Francesco (Known
as: Bologna) (Italian 1504-70)
See also Goujon, J.
Grotto, Jardin des Pins:
Giants c 1543
BLUA pl 37 FFP
Mantelpiece, Chambre de la
Reine c 1533/37
BLUA pl 22B FFP
Stucco Decoration, Galerie
Francois I 16th c.
GAF 79 FFP
Wall Decoration, Chambre de
la Duchesse d'Etampes c
1541/45 ptd stucco
BAZINH 264; BAZINW
382 (col); BLUA pl 41;
ENC 733; HAUS pl 198;
JANSH 383; JANSK 739;
LARR 200, 204; MAR 131
FFP

PRIMATICCIO, Francesco, and
Germaine PILON
Henry II and Catherine de'
Medici Tomb 1563/70
marble
BLUA pl 35; BUSR 14;
JANSK 742 FPDe
--Recumbent Effigies
JANSH 404; KO pl 84;
LAC 198; LARR 204;
MOLE 208 FPDe
--Catherine de'Medici,
effigy
JAL-4:pl 22
--Henry II (from a cast)
BLUA pl 64; JAL-4:pl 21;
LAC 71
PRIMATICCIO, Francesco--FOLL
Diana of Anet before 1554
marble; 61x98-1/2
BAZINW 382 (col); JANSK
741 FPL
Two Allegorical Figures
c 1560 ptd wood
CLE 102 UOCIA (59.346)
Primavera See Spring
Primavera God. Epstein
Prime Luce. Caro
Primeval Branchings. Hartung
Primitive Bird. Heiliger
Primo Fruto. Bellotto, E.
Primo Peccato. Ciampi
Il Primograno dell'Impero. Minguzzi
PRIMOLI, G. B. (Italian 1673-1747)
Sacristy Doorway c 1740
KUBS 52B ParT
"Prince Hal", Toby Jug. Wood
Prince of this World
French--13th c. Wise and
Foolish Virgins: Prince of
this World
German--13th c. Prince of
This World (Satan)
German--14th c. Prince of
This World, as Seducer
Prince's Portal. German--13th c.
Princess
Brancusi. The Princess
Colombe. Altarpiece of St.
George: The Princess
Laurana. A Princess of the
House of Aragon, bust
McWilliam. Princess Macha
Pringe, Martin d 1646
English--17th c. Martin
Pringle Tomb
PRINI, Giovanni (Italian 1877-)
Amadeo Sarfatti, head ptd
plaster VEN-36:pl 18

Girl Braiding her Hair
 bronze
 VEN-38:pl 108
L'Idoletto di Casa bronze
 VEN-26:pl 93
PRINNER, Anton (Hungarian 1902-)
 Evocation, garden
 DIV 84 UNNMMA
 Man wood
 MAI 246
The Printer. Guttfreund
Prior, Matthew
 Rysbrack. Matthew Prior
 Monument
PRISCUS (Frankish), and
 DOMNULUS
 Coin, Chalon-Sur-Seine c 555
 ROTH 498
Prisoners See also Slaves
 Folk Art--German. Fettered
 Man
 Folk Art--German. Votive
 Figures: Fettered Man;
 Horse
 Francheville. Prisoner
 Jespers, O. The Prisoner
 Leoni, L. Barbarian Captives
 Minguzzi. Prisoner in the
 Lager
Pritchett, John (Bishop of Gloucester
 d 1681)
 English--17th c. Cartouche
 Tablet to John Pritchett
PRIVE, Thomas, and Robert
 LOISEL
 Bertrand de Gueslin, effigy
 bust 1380/97 marble
 EVJF pl 211C; EVJL pl
 34; GARDH 382; JAL-3:
 pl 7; SEW 442 FPDe
PRIVER, Aaron (Polish-Israeli
 1902-)
 Head of Girl cast stone
 SCHW pl 64
 In Memoriam of Our Heroes,
 relief stone
 GAM pl 116
 Maternity sandstone
 GAM pl 117
 Nude marble
 GAM pl 118
 Undressing stone
 ROTH 941
Prize Fighter See Games and
 Sports--Boxing
Pro Patria. Wolff, Adolf
PROBST, Jacob (Swiss 1880-)

Columbus (Kolumbus) 1940/50
 bronze
 JOR-1:pl 12 SwBHa
Female Figure bronze
 VEN-40:pl 105
Pomono, torso bronze
 VEN-32:pl 156
Vater Rhein 1937 kalkstein
 JOR-1:pl 13 SwBKM
Young Colt 1950 bronze
 VEN-52:pl 98
Processions
 Agostino di Giovanni. Tarlati
 Monument: Funeral
 Procession
 Bertoldo di Giovanni. Bacchus
 Procession
 Byzantine. Procession
 Transporting Relics
 French--13th c. Procession of
 Canons, south porch
 Italian--8th c. Procession of
 Holy Women, oratory
Procis
 English(?)--19th c. Cephalus
 and Procis
Procissae. Mehutan
Procop, Saint (Patron Saint of
 Bohemia d 1053)
 Braun, A. St. Procopius
 Brokoff, F. M. St. Vincent
 of Ferrera and St.
 Procopius
Procopius, Bela
 Remenyi. Bela Procopius,
 medal
The Procuress. Barlach
Prodigal Son
 Barlach. The Prodigal
 Blumenthal. The Prodigal Son
 Braecke. The Prodigal Son
 Brancusi. The Prodigal Son
 Braun, M. B. Prodigal Son,
 Confessional Detail
 Martini, A. Prodigal Son,
 relief
 Meunier. The Prodigal Son
 Rodin. Prodigal Son
Progetto per una Lapide Luminosa a
 James Bond. Marchegiani
Progress
 Watts. Physical Energy
Progression. Vardanega
Project for a Monument to a
 Celebrated Person. Giacometti
Project for a Passage. Giacometti
Project for a Sculpture. Picasso

Providence
 Quellinus, A., the Elder.
 Justice; Providence
Providentia Fountain. Donner
Provincials. Cappello
Prows See Figureheads and Prows
Prudence
 Bonino da Campione.
 Prudence
 Colombe, Francis II of
 Brittany Tomb, with figure
 of Prudence
 French--11th c. Prudence
 German--12th c. Prudence
 with Snake
 Giovanni d'Ambrogio.
 Prudence, after Agnolo
 Gaddi, relief
 Italian--14th c. Porta della
 Mandorla, embrasure
 detail: Prudence
 Quellinus, A., the Elder.
 Prudence#
 Robbia, L. della. Prudence
 Robbia Family--Foll.
 Prudence, tondo with gar-
 land frame
 Rossellino, A.--Foll.
 Prudence: three-faced
 head
 Sansovino, A. Ascanio Sforza
 Monument: Prudence
Prunelle. Daumier
Psalms
 French--9th c.(?) Bookcover:
 Psalm 50
 French--9th c. XXVII
 Psalm, plaque
 German--9th c. Psalm 26
Psaltery See Musicians and
 Musical Instruments
Psyche See also Cupid
 Canova. Cupid and Psyche
 Clodion. Cupid and Psyche
 March. Pan and Psyche
 Turner, A. Psyche
 Vries. Mercury and Psyche
Psycho-Object. Raynaud
Psychomachia Capital. French--12th
 c.
Ptolemy# Arp
Ptolemy
 Syrlin, J., the Elder.
 Ptolemy
La Pucelle. Rosandic
Puckering, John and Lady
 English--16th c. Sir John
 and Lady Puckering,
 recumbent effigies

The Puddler. Meunier
PUECH, Denys (French)
 Admiral Garnier Monument
 TAFTM 32
 Class Memorial
 TAFTM 32
 The Muse and Andre Chenier
 marble
 MARY pl 35; TAFTM 32
 FPLu
 Perrault Monument
 TAFTM 34
 Siren
 TAFTM 32
Puerta de Los Leones. Aleman, J.
Puerta de Platerias. Spanish--11/12th
 c.
Puerta de Sarmental, Burgos
 Cathedral.
 Spanish--13th c.
PUGET, Jacek (Polish 1904-)
 Jaracz, head 1951 plaster
 JAR pl 30
PUGET, Pierre (French 1620-94)
 Alexander and Diogenes,
 relief 1671/93 marble;
 130-3/4x116-1/2
 BLUA pl 178; LAC 74;
 LOUM 170; VER pl 94
 FPL (1468)
 Blessed Alessandro Sauli
 WOLFFP 60 IGenM
 --terracotta
 CLE 116 UOCIA (64.36)
 Caryatid, balcony 1653
 GAF 530 FToul
 Caryatids
 ENC 737
 Hercule Gaulois c 1660 clay,
 for marble
 BR pl 10; BUSB 102 FPL
 Herm Figure, doorway 1656
 marble; LS
 JANSK 838; KITS 45
 FToulV
 Louis XIV, bust stone
 CHENSW 459 FAixM
 Louis XIV, medallion
 STA 179 FMaM
 Man Carrying Sack of Grain
 c 1656
 LAC 75 ELV
 Martyrdom of St. Sebastian
 LARR 346 IGenM
 Medusa, head
 AGARC 93; LARR 271 FPL
 Milo of Crotona 1671/83
 marble; 106-1/2x55

"Pumpkin Head"
Donatello. Prophet Habakkuk
Punctuation. Bury
PUNI (Ivan Jean Pougny) (Finnish-
French 1892-1956)
Plate 1918 oil and
assemblage
RICHT pl 107
Plate on Table c 1915
walnutwood; ptd china
plate
GRAYR pl 136 FPBog
Relief 1915 colored cardboard
SELZJ 201
Suprematist Composition
c 1915 wood, tinfoil, card-
board, oil on board
GRAYR pl 138 FPBog
Punishment See also Hanging;
Lapidation
Barlach. Man in the Stocks
French--12th c. Capitals:
Moses; An Execution
Punti Opposti. Linck, W.
La Purgatoire
Rodin, A. Les Premieres
Funerailles
Purgatory. Rodin
The Purification. French--12th c.
Purity. Csaky
Purkyne, J. E.
Spaniel. Dr. J. E. Purkyne,
head
Purrmann, Hans (Painter)
Roeder. Hans Purrmann,
head
Purses
Anglo-Saxon. Purse Lid
Pushkin, Alexander (Russian Poet
1799-1837)
Domogatsky. A. S. Pushkin,
bust
PUTRIH, Karel (Yugoslav 1910-)
Composition 1945 baked clay
BIH 145
Composition I 1952
BIH 146 YBri
Ten-Year Old Girl 1954
bronze
BIH 147 YBMG
Putti See also Cherubs
Amadeo. Putti, high relief
Baroque. Torch Holder: Two
Putti
Bernini, G. L. Flight from
Troy: Putto
Bologna. Putto
Bouchardon, E. Putti

Bregno, Andrea. Cardinal
Bartolommeo Roverella
Monument: Putto
Buon, B. Porta della Carta
Christian, J., and J. M.
Feichtmayr. Putti
Desiderio da Settignano. Carlo
Marsuppini Monument:
Putto with Shield
Dick. Kitchener Memorial
Chapel: Putti
Donatello. Cantoria: Putti
Donatello. Font: Putto
Donatello. Putto#
Donatello--Foll. Putto with
a Fish
Donner. Putto with Fish
Duquesnoy, F. Putto#
Early Christian. Dish: Putti
Marking a Nilometer
Egell. Mannheim Altar:
Back Panel
Feichtmayr. Putti
Feuchtmayer. High Altar,
detail: Putti
Feuchtmayer. Honey Thief
Feuchtmayer--Foll. Putti
Francesco di Valdambrino.
Monument of Ilaria del
Carretto Guinigi
French--17th c. Cupids
Gibbons. Dean's Canopy,
detail: Putti
Gudewerth. Putto
Gibbons. Two Cherubs' Heads
Gunther, F. I.--Foll. Putto
Hildebrandt. Cupid, staircase
detail
Italian. Putto
Italian--12th c. Putti in Vine
Scroll
Italian--15th c. Putto with Horn
Italian--16/17th c. Sleeping
Putti
Juncker, J. Putto
Legros, P. Cherubs and a
Lyre
Mino da Fiesole. Count Hugo
von Andesburg Monument:
Putto with Shield
Nahl. Reliefs, and Putto
Portuguese--18th c. Putti
Serpotta. Humility and Putto
Serpotta. Putti
Straub. Putto with Dolphins
Sturm, J. A. Putti
Torrigiano, P. Henry VII and
Elizabeth of York Tomb:
Hands; Cherub

Tribolo, N. Fountain of
Hercules and Antaeus:
Putti with Geese
Tuby. Cherubs Playing with
a Swan
Verrocchio. Boy with Dolphin
Verrocchio. Putto on Globe
Verrocchio. Reclining
Putto
Wagner, J. P. A. Putti
PUVIS DE CHAVANNES, Pierre
(French 1824-98)
Auguste Rodin, version of
head for bust
AUES pl 31
Portraits
Rodin. Puvis de Chavannes
PUVREZ, Henri (Belgian 1893-)
See also Jespers, O.
Bather, Belgian Pavilion,
Paris World's Fair 1935
GOR 56
Constant Permeke, bust
DEVI-2 BBR
Maternity stone
MAI 246 BBR
My Son, bust
GOR 57
Serenity 1947/50 blue stone;
61x73
MID pl 43 BAM
Siren 1934 marble; 41
MID pl 44 BAM
Puy de Dome Figure. McWilliam
Pygmalion
Cascella, P. Pygmalion
Falconet. Pygmalion and
Galatea
Pyramids. Chadwick
The Pyre. Muller, R.
PYRGOTELES (Venetian fl
1513-31)
Madonna and Child with
Saints, relief marble;
21-1/2x36
USNI 232; USNKP 411
UDCN (A-40)
Pythagorus
French--12th c. Royal
Portal: Pythagorus
--Virgin Portal Tympanum,
details: Grammar;
Pythagorus
Pyx
Byzantine. Pyx details:
Martyrdom of St. Menas
Byzantine. Pyxis
Early Christian. The Great
Berlin Pyxis

Early Christian. Moggio Pyxis
Early Christian. Pyxis#
French--5th c. Pyx
French--13th c. Pyx: Dove
French--17th c. Pyxis

Quadratura. Vasarely
QUADRELLI, Emilio (Italian)
Girl
VEN-97
Quadriga
Agar. Quadriga
Jones, Adrian. The Quadriga
Marini. Quadriga
Recipon. Quadriga
Schadow. Quadriga of
Victory
Quadripartite Leaf-Figure. Moore, H.
Quand Meme. Mercie
Quarrelling Cupids. Nost
Quartet. Smith, R.
Quatre Rayons Centraux de
Lumiere. Rehmann
Quattro Santi Coronati. Nanni di
Banco
The Queen. Brown, R.
Queen. Dalwood
Queen Matilda. Claughton
Queen of Juda
French--12th c. Royal Portal:
Ancestors of Christ
Queen of Sheba
French--12th c. Royal Portal:
Queen of Sheba
Queen of Swabia. Spanish--13th c.
Queens
English--13th c. Queen
English--18th c. Queen
French--12th c. Queen,
columnar figure
Spanish--13th c. The King;
The Queen
Queen's Doll House: Panel:
Broadbent
Queensbury, Duke of
Nost. Duke of Queensbury,
reclining effigy
QUEIROLO, Francisco (Italian
1704-62) See also Corradini, A.
Deception Unmasked (Allegory
of Deception Unmasked;
Disillusion; Il Disinganno;
Liberation from Error),
Antonio Sangro Tomb
1750/62 marble; over LS
BAZINB 172; BUSB 171;
LARR 353; MOLE 193;
WIT pl 172 INS
QUELING, Arnold See QUELLINUS,
Arnold

Quellgott
 Riccio. God of a Spring
QUELLIN, A. See QUELLINUS,
 Arnold; QUELLINUS,
 Artus; QUELLINUS II,
 Artus
QUELLINUS, Arnold (Arnold Queling;
 Arnold Quellin) (Dutch-
 English 1653-86)
 Angel, kneeling figure,
 Whitehall Palace altar 1686
 WHINN pl 41A EBur
 Assassination of Tom Thynne
 of Longlest in Pall Mall,
 Monument detail 1683
 ESD pl 101; WHIN pl 72a
 ELWe
 Charles II 1685
 WHINN pl 42B ELSo
 Sir John Cutler 1683
 GUN pl 18 ELGr
 Rustat Monument, medallion
 portrait c 1685
 WHINN pl 44 ECamJ
QUELLINUS, Artus (Artus Queling;
 Artus Quellin) (Flemish
 1609-68)
 Amsterdam Town Hall, back
 facade, detail 1650/64
 HAMF 91 NAR
 Atlas, pediment surmounting
 figure 1655 figure bronze:
 252; globe brass; Dm:
 126; pedestal sandstone:
 49-1/4
 HAMF 271 NAT
 Caryatid 1648/55
 ROOSE 201 BAT
 Caryatids and Relief 1652
 marble
 GER pl 15B NATJ
 --two caryatids, studies for
 Hall of Justice Figures
 c 1652
 HAMF 92 NAR
 Charity
 HAMF 92 NAR
 Decapitation of the Sons of
 Brutus, detail: Justice,
 relief 1650/64
 HAMF 91 NAR
 Diana, model 1650/70
 terracotta ST 366
 E. van Immerzeele Tomb
 GEL pl 100 NBoA
 East Pediment Decoration,
 Royal Palace, model
 c 1655 ROS pl 206B NAR

Frieze, Fireplace: Fabius
 Maximus, scene Burgo-
 master's Room c 1650
 marble
 BAZINW 398 (col) NAD
Johann de Witt, bust 1665
 marble; 34-1/16
 VICOR pl 26 EDoM
Judgment of Solomon, relief
 LARR 237 NAD
Justice; Providence; Studies
 for Hall of Justice,
 Amsterdam c 1652
 HAMF 92 ELV
Madonna Araceli, choir figure
 c 1645 marble
 GER pl 14B BBC
Our Lord
 DEVI-2 BBrS
Prudence 1652 marble
 GER pl 15A NATJ
--sketch for roof figure,
 Amsterdam Town Hall
 terracotta; 35-7/8
 RIJA pl 119 NAR
St. Peter 1658 marble;
 89-3/4x37-1/4
 GER pl 16; HAMF 272
 BAA
Samson and Delilah 1640/50
 terracotta; 37.5 cm
 BSC pl 131 GBS (545)
QUELLINUS, Artus II (Artus II
 Queling; Artus II Quellin)
 (Flemish 1625-1700)
 Bishop Capello Monument
 1676
 GER pl 18B BAC
 God the Father, rood screen
 c 1682 marble
 BAZINB 79; GER pl 20 BBrC
 St. Rosa of Lima marble
 DEVI-2; GER pl 22A;
 ROOSE 201 BAP
QUELLINUS, Artus II--ATTRIB
 Virgin and Child c 1700 ivory;
 22-7/8
 RIJA pl 121, 121a NAR
QUELLINUS, Thomas
 Thomas Thynne Tomb, detail
 GERN pl 44 ELWe
QUERCIA, Jacopo della (Italian
 1371-1438)
 The Annunciation wood
 POPG fig 33 IStG
 Baptismal Font
 UPJH pl 108 ISG

Christ Child, Madonna and
 Child 1425
 BAZINW 336 (col) ISMa
The Expulsion, panel gesso
 CHENSN 349; FREEMR 55
 ISCL
Font: Annunciation to
 Zacharias, relief 1427/30
 bronze gilt
 SEY pl 29 ISB
--: Zacharias in the Temple,
 relief 1428/30 gilt bronze;
 24
 MOLE 125; POPG pl 81
Fonte Gaia; 1409/19 marble
 CARL 49; POPG fig 89 ISP
--Acca Laurentia, with
 Romulus and Remus
 JANSK 621; POPG pl 90;
 SEY pl 20
--Adam and Eve copper
 GLA pl 34
--Creation of Adam; Expulsion
 from Paradise; Madonna
 and Child; Wisdom; Justice
 CARL 50-56
--Expulsion from Paradise
 POPG fig 91
--Rea Silvia
 POPG pl 90
--Virgin and Child; Effigy
 marble; sarcophagus:
 117x234x93 cm; effigy:
 L: 208 cm
 POPG fig 92, pl 82
--Virtue, fragment
 MAR 13
--Wisdom (Sapentia), relief
 marble; 43
 KO pl 77; MACL 67; UPJ
 255
Ilaria del Carretto Tomb
 1406/07 marble; L: 91-3/8
 BR pl 11; BUSR 44; ENC
 862; FREEMR 58; LARR
 101; MACL 65; MARQ 198;
 MOLE 124; MONT 378;
 MURRA 204; POPG fig 92;
 READO 65; RAY 39;
 ROOS 108-D-E; SEY pl 9
 ILuC
Madonna
 UPJH pl 108 ISPC
--Carmelite Convent,
 Bologna c 1400
 BUSR 43 FPL
Madonna and Child oak
 MILLER il 112 IFL

--wood
 DURS 59 FPL
--14/15th c. stone
 CHENSW 372 FPL
--14/15th c. stone
 CHENSW 372 IBoP
--1407/08 marble
 SEY pl 8 IFeMC
Madonna of Humility c 1428/35
 marble; 22-31/32x19-1/4x
 11-1/8
 KRA 12; READAS pl 82-3;
 SEYM 54-56; USNK 177;
 USNKP 397; USNKS 29-30
 UDCN (A-157)
S. Petronio 1434 marble
 SEY pl 31 IBoS
San Petronio Doorway (Porta
 Maggiore); details: Virgin
 and Child; Creation of
 Adam; Creation and
 Expulsion 1425/38 stone;
 Virgin: 211 cm; Adam:
 85x69 cm
 POPG fig 41, pl 86-90
 IBoP
--left side
 FREEMR 56
--Adam and Eve 1426/37
 marble; 39-3/8x31-1/2
 CHENSW 364; MONT 379
--Adam and Eve Toiling
 BIB pl 17
--Creation of Adam c 1430
 marble; 34-1/2x27-1/2
 CHENSN 348; CHENSW
 373; ENC 742; JANSH 311;
 JANSK 622; MCCL pl 27;
 MOLE 126; NEWTEA 81;
 NEWTEE pl 16; UPJH pl
 108
--Creation of Eve
 BAZINW 336; BR pl 4;
 BUSR 46; CHRC fig 160;
 MURRA 205; ROOS 109A;
 SEW 528; SEY pl 30
--Drunkenness of Noah
 BIB pl 30
--Expulsion 1425/29 marble;
 40
 CHENSW 364; GARDH 292;
 KO pl 77; MACL 69;
 MURRA 205; MYBA 374
--Noah and his Family Leav-
 ing the Arc
 SEY pl 32A
--Sacrifices of Cain and Abel
 stone; 85x69 cm POPG pl 91

--Sin of Adam and Eve (Fall
 of Man)
 CHASEH 321; POST-1:169;
 ROBB 366; ROOS 108F
 Seated Virgin and Child ptd
 and gilded wood
 LOUM 117 FPL (719)
 Temptation, relief 1425/38
 UPJ 254 IBoP
 Trenta Altar 1422 marble
 POPG fig 93 ILuF
--Figure
 MOLE 124
--Madonna
 ENC 742; POPG pl 84
--Martyrdom of St. Lawrence,
 predella panel
 POPG pl 84; SEY pl 21B
 Two Prophets
 POPG fig 85
 Virgin of the Annunciation
 (Maria der Verkundigung)
 1411 walnut; 152 cm
 BSC pl 72-73 GBS (M234)
QUERCIA, Jacopo della--ATTRIB,
 and Jacobello dalle MASAGNE
 Angel of the Annunciation,
 High Altar Retable
 c 1390/96 marble
 SEY pl 5B IBoF
QUERCIA, Jacopo della; Lorenzo
 GHIBERTI; DONATELLO
 Font 1417/34 marble, gilt
 bronze, enamels
 SEY pl 27 ISB
QUERCIA, Jacopo della--FOLL
 Virgin and Child
 POPG fig 95 IFBard
QUEROL, Augustin (Spanish d 1909)
 Alphonse XII Monument,
 study
 TAFTM 89
 Canovas del Castillo Tomb
 TAFTM 89
 Quevedo Monument
 TAFTM 89 SpMa
Quesnay, Francois (French
 Economist)
 Vasse. Francois Quesnay,
 bust
QUESNOY, Francois du (Flemish
 1594-1642)
 Christ and Madonna, busts
 c 1630 bronze with dark
 brown patina; 9-1/4 (with
 3-1/2 base)
 KUHN pl 54, 55 UMCF
 (1960.120; 1960.119)

St. Susanna
 LARR 237 IRML
Quevedo, Francesco de (Spanish
 Writer 1580/1645)
 Querol. Quevedo Monument
Quignon des Damoiseaux
 Flemish--15th c. Badge of
 Confraternity of Young
 Gentlemen
Quilici, Nello
 Rebecchi. Nello Quilici, medal
QUILLIVIC, Rene (French)
 Breton Mourners
 TAFTM 46
 Petite Bigoudaine
 TAFTM 48
Quinghien, Robert de
 Weyden. Epitaph of Robert
 de Quinghien
QUITAINER, Andreas Philipp
 (German d 1729)
 Calvary 1717
 STECH pl 47 CzDo
 Breznice Portal Statue 1707
 STECH pl 18 CzPrH
 St. Augustine 1720/21
 STECH pl 45 CzPTh
 St. Vitus 1720/21
 STECH pl 46 CzPTh
 St. Wenceslas
 STECH pl 44 CzPKn
Quixote, Don
 Palavicini. Don Quixote, bust
 Richier, G. Don Quixote#
 Simard. Don Quixote

R. R. R.
 Silvestri. Torso di R. R. R.
Rabbits
 Barye. Jaguar Devouring a
 Rabbit
 Behaim, H., the Elder.
 Hare Window
 Chelsea Porcelain. Rabbit
 Tureen
 English--9th c. Ormside
 Bowl: Rabbit
 English--15th c. Misericord:
 Hawk on Hare
 English--18th c. Chelsea
 Rabbit Tureen
 French--14th c. Knight and
 Lady Riding to the Hunt,
 mirror case
--Vice of Cowardice
 German--12th c. Apse Demon
 Heads; Hares Ensnaring
 Hunter

1669/83 stucco; over LS
BUS 81; MOLE 187; WIT
pl 116B IRGe
Death of St. Cecilia, left
altar c 1670/80
BUSB 82; WIT pl 116A
IRAg
St. Charles Borromeo
WIT pl 76B IRCar
RAGGI, Niccolo Bernardo (Italian fl
1791-1855)
Bayard bronze
HUBE pl 65 FGA
Metabus 1855 marble
HUBE pl 67 FPL
Surrender of Pamplona
(La Reddition de Pampelune),
relief 1824 marble
HUBE pl 69 FPL
RAHR, Erik
C. L. Hansen, head black
granite
CASS 52
Railings See Grilles and Railings
RAIMONDI, Mario (Italian 1899-)
Marcella plaster
VEN-42: pl 30
RAINER OF HUY See REINER VON
HUY
Rainer's Chair. Kramer
Rakoczy, Francis II (Hungarian
Patriot 1676-1735)
Kisfaludi-Strobl. Franz
Rakoczi II
Rakoczy, Gyorgy II (King of
Hungary)
Hungarian--17th c. Gyorgy
Rakoczi II
RAKOV, M.
Map of Wrangel Island, box
lid bone figures
CASS 143
Raleigh, Walter
Causici and Capellano. Sir
Walter Raleigh, relief bust
RAM, Marcel
La Roseraie 1935
CASS 94
Ramasse Mousse
Dubuffet. Moss Gatherer
RAMBELLI, Domenico (Italian)
Monument to Francesco
Baracca
CASS 135
Rambona Diptych. Early Christian
RAMO DI PAGANELLO (Italian fl
1288-1314)

Monument to Philippe de
Courtenay
POPG fig 60 IAsF
RAMOUS, Carlo (Italian 1926-)
Apertura nel Vuoto 1961
bronze
VEN-62: pl 69
Colloquy bronze
VEN-58: pl 77
Dance in the Full Moon 1960
bronze
SAL 51
In the Morning Wind 1959
bronze; 37-1/4
TRI 97
Rams See Sheep
RAMSAY, David (Scottish)
Clock, with silver plaques
c 1610 4-1/4x4-1/4
VICK 11 ELV (M. 7-1931)
Ramsbury Cross. Anglo-Saxon
RAMSEYER, Andre (Swiss 1914-)
Asteroide# 1957
JOR-2: pl 140; pl 265
Atlantic 1956 bronze; 48
BERCK 170; JOR-2: pl 139
Consolation 1954 plaster; 150
cm
JOR-1: pl 65
Le Couple 1955 bronze; 115 cm
JOR-1: pl 67
Eurythmy 1955 bronze
JOR-2: pl 261; LARM 386;
MAI 248 UDCS
Evasion
JOR-2: pl 259
Naissance 1957
JOR-2: pl 262
La Seve 1955 plaster; 120 cm
JOR-1: pl 66
La Vague 1957
JOR-2: pl 260
Rangone, Tommaso
Sansovino, J. Tommaso Ran-
gone Monument
Vittoria, A. Tommaso Ran-
gone, bust
Rape of Persephone. Bernini, G. L.
Rape of Proserpine. German--17th c.
Rape of Proserpine, Meissen
Porcelain. Kandler
Rape of the Nymph. Zamboni
Rape of the Sabine Women. Bologna
Rape of the Sabine Women. Martini,
A.
Raphael, Archangel
German--11th c. Basle
Antependium

Gunther, F. I. Guardian Angel
Group
Gunther, F. I. Raphael
RAPHAEL (Antonietta Raphael Mafai)
(Lithuanian-Italian 1900-)
Niobe 1948 bronze; 1 m
SCUL pl 29
La Sognatrice 1946 bronze;
1.40 m
SCUL pl 28
RAPHAEL (Raffaelo Sanzio d'Urbino)
(Italian 1483-1520)
Disputa (relief copy)
WOLFFP 130
Jonah (after design of Raphael)
BEREP 28 IRPo
--seated nude terracotta
MACL 227 ELV
RAPOPORT, Nathan (Polish-Israeli
1911-)
Death Walk, Memorial to
Warsaw Ghetto Victims
1952
SCHW pl 93 PW
Negba Monument
GAM pl 126
Yad-Mordekhay Monument
detail bronze
GAM pl 128
Young Warrior, detail
bronze
GAM pl 127
Rapport des Volumes. Vantongerloo
Rapport en Trois Volumes.
Vantongerloo
Le Rapt. Muller, R.
A Rascal. Messerschmidt
Rasini, Fiorella
Messina. Fiorella Rasini,
head
Rasmussen, Mads
Nielsen, K. Mads Rasmussen
RASMUSSEN, Wilhelm Robert
(Norwegian)
Eidsvoll Commemorative
Column granite
HOF 209
Facade Figures, Training
School for Sailors
AUM 115
Grotesques, studies; Angel;
Head
AUM 114-5 NoTC
Rastourmji, Ferosa
Epstein. Ferosa Rastourmji,
head
RASTRELLI, Bartolommeo Francesco

(Italian-Russian 1700-71)
Great Palace, State Apart-
ments, and Chapel,
interiors
HAMR pl 120, 121 RuTs
RASTRELLI, Carlo Bartolommeo
(Florentine 1675-1744)
Peter the Great, bust
1723/24 bronze
HERM il 4; RTCR 193
RuLH
Ratapoil. Daumier
RATCLIFF, H. G. (English)
Cathedral Seat Ends
AUM 123 ELivC
Choir Stalls
AUM 122 ELivC
Il Ratto. Muller, R.
RAU, Marcel (Belgian 1890-)
Monument to the Pioneers of
Congo
GOR 73 BI
RAUCH, Christian Daniel (German
1777-1857)
Alexander I of Russia 1814/21
plaster; 5-3/4
NOV pl 181b GBRau
Frederick the Great, equest,
east end of Unter den
Linden 1851 bronze
CHASEH 456; MARQ 252;
MARY pl 142; POST-2:161;
RAD 441 GB
--bust detail
PRAEG 427
Queen Louise Tomb c 1815
marble; 87x233x90 cm;
base: 80x269x124 cm
KO pl 99; LIC pl 36 GBCh
RAUCH, Ernst Andreas (German)
Birth of Christ, panel stone
AUM 19
The Shepherd, panel stone
AUM 6
RAUCHMILLER, Matthias (Austrian
1645-86) See also Benkert,
J. P.
Bishop Karl von Metternich
Tomb c 1675
BUSB 101; HEMP pl 39
GTL
St. John of Nepomuk, Bozetto
1681
STECH 36 CzPN
RAUCHMILLER, Matthias, and
FISCHER VON ERLACH, J. B.
Pestsaule (Dreifaltigkeitssaule)
1679/92

BAZINW 399 (col); HEMP
pl 58 AV
RAUCHMILLER, Matthias, and BRO-
KOFF, Johann
St. John of Nepomuk 1683
bronze
STECH pl 31b CzPCh
Raum und Raum Korper. Rehmann
Raumknoten
Hajek. Space Cluster#
Raumplastik Mannesmann
Kricke. Space Sculpture
RAVEEL, Roger (Belgian 1921-)
La Fenetre 1963 wood and
glass; 63x38-3/8
NEW pl 189
RAVERTI, Matteo (Italian fl 1404-34)
Gargoyle and Gigante (cast)
1404
SEY pl 3 IMC
Raving Madness. Cibber
RAVY, Jean (French), and Jean de
Bouteiller (French)
Adoration of the Kings,
north choir screen 1325/51
ptd sandstone
AUBA 83 (col) FPN
RAY, Man (American-French 1890-)
Boardwalk 1917 oil and
assemblage
RICHT pl 42
Enigma of Isidore Ducasse
1920 (destroyed)
LIP 180
Fascinated, object 1922
RICHT pl 44
The Gift (Le Cadeau) 1921
flat iron with metal
tacks; 6-1/2
READS pl 85
--
HAMP pl 149B; SEITA
49 UICNeu
--
SELZS 85 UNNCor
--(replica authorized by
artist 1966) iron with 14
metal tacks; 8
JLAT 39 UNmAUA
Indestructible Object:
Metronome with Cutout
Photograph of Eye on
Pendulum (replica of the
earlier Object to be
Destroyed) 1958 H: 9
SEITA 49 UICNeu
Marteau, assemblage, Paris
1963 RICHT pl 110

Mathematical Object: Kummer's
Plane Surface with 16
Points of which 8 are True
READCON 130; READS
pl 94
Mr. Knife and Miss Fork 1944
knife, fork, wooden heads,
net-covered embroidery
frame, on cloth; 13-3/8x
9-3/8
MOHV 337; SEITA 86
FPRi
Object 1933
READS pl 86
Raymond, Lord Justice d 1732
Cheere, H. Lord Justice
Raymond Monument
RAYNAUD, Jean Pierre (French
1939-)
Psycho-Object 1964 assemblage;
43-1/4x73-1/4
NEW pl 58 FPLar
Psycho-Objet Oiseau 1965
KULN 108
RAYSSE, Martial (French 1936-)
America, America 1964
KULN 49
Picture in the French Style
1965
PEL 257 UNNI
Promenade au Clair de Lune
avec une Fille de Bonne
Famille 1966
KULN 200
Proposition to Escape: Heart
Garden 1966 neon
assemblage
BURN 306; KULN 201 UNNI
Tricolore Modern Painting
1964
KULN 76
Rea Silvia
Quercia. Fonte Gaia, detail
READ, Nicholas (English c 1733-85)
Admiral Richard Tyrrell
Monument 1766
CARP pl 77; GUN pl 19
ELWe
Nicholas Magens Monument
1779
WHINN pl 116A EBright
Readers
Agostini dei Fonduti.
Children Playing and
Reading, frieze
Antokolski. The Jewish
Scholar
Barlach. Lesender Mann im
Wind

Red Army Monument. Augustincic
Red Cat. Skinner
"Red Door", Paris Cathedral
 French--13th c. Coronation of
 the Virgin, tympanum
Red Riding Hood. Abrahams
Red Sea
 Early Christian. Doors of
 West Portal
The Red Shawl. Garbe, R. L.
The Red Stone Dancer. Gaudier-
 Brzeska
Red Woman. Minne, J.
Redemption
 French--13th c. The
 Redemption, tympanum
 German--9th c. Codex
 Monacensis Cover: Doctrine
 of Salvation
 German--13th c. Prince's
 Portal: Doctrine of
 Redemption
 Sansovino, J. Allegory of the
 Redemption, relief
Redman, Sir Richard and Lady
 English--15th c. Sir Richard
 and Lady Redman, effigies
Der Redner. Fischer, F.
Reese-Brunne. Poelzig
Reflecting Forms 5. Bakic
Reflection #48. Tomasello
Reformation
 Landowski and Bouchard.
 Reformation Monument
Refugees. Hartwell
Regelindis
 German--13th c. Hermann and
· Regelindis
REGENSBERG MASTER
 Self Portrait, kneeling
 spandrel figure c 1400/1410
 MULS pl 50 GRegC
The Regent, bust. Lemoyne, J. B.
REGER, Walter (German)
 Eagle, decorative facade
 figure
 AUM 10 GBPO
 Overdoor Decoration, private
 dwelling colored stucco
 AUM 9 GB
REGNAUDIN, Thomas (French 1622-
 1706) See BIRARDON,
 Francois. Apollo Served by
 Nymphs
REGNAULT, Guillaume (French
 1460-1523)
 Children of Charles VIII and
 Anne de Bretagne Tomb
 1506 JAL-4: pl 2 FTourC

Virgin and Child 1510 marble
 LOUM 51 FPL (301)
REGNAULT, Guillaume, and
 CHALEVEAU, Guillaume
 Louis de Poncher and Roberte
 Legendre Tomb
 LOUM 58 FPL (457; 458)
Regnault, Henri
 Chapu. Regnault Tomb
REGNIER DE HUY See REINER VON
 HUY
REHMANN, Erwin (Swiss 1921-)
 Coupe Lumineuse 1952/54
 JOR-2: pl 143
 Gelenkraum 1952 plaster
 JOR-1: pl 85
 Mutterschaft 1950 H: 120 cm
 JOR-1: pl 84
 Quatre Rayons Centraux de
 Lumiere 1956
 JOR-2: pl 264
 Raum und Raum Korper,
 detail 1952 Eisen bemalt
 JOR-1: pl 86
 Sphere de Lumiere 1955
 JOR-2: pl 263
Rehovot War Memorial. Feigin
REICH, Paul (German 1925-)
 Dynamic Square (Dynamisches
 Quadrat)
 KUL pl 29 GGmS
 LX/62 stone, metal, glass;
 72x45x35 cm
 KUL pl 30
 mn/62 1962 stone, metal,
 glass; 70x52x28 cm
 KUL pl 31
 ni/62 1962 stone, metal,
 glass; 55x60x20 cm
 KUL pl 32
REICHENAU WORKSHOP (?)
 Gold Altar Frontal, presented
 by Emperor Henry II to
 Basle Cathedral c 1020
 LARB 255 FPCl
REICHHOLD, Werner (German 1925-)
 Eisenplastik
 KUL pl 38
 Eisenplastik 1959 iron; 70x
 83x40 cm
 OST 94 GHaB
 Eisenplastik 1962 iron;
 100x120 cm
 KUL pl 37
REICHLE, Hans (German 1570-1642)
 Archangel Michael Victorious
 over Satan (St. Michael and
 Lucifer) 1606/07 bronze;
 c 180 BOE pl 168; VEY 59,
 140 GAuAr

--Archangel Michael bronze;
over LS
MUL 85
--Satan
BUSB 29; MUL 86
Crucifix
MUL 86 GAuU
Mourning Virgin (cast by
Wolfgang Neihardt) 1605
bronze; 190 cm
MUL 87 GAuU
REIDEL, K. (German)
Couple
FPDEC--German il 6
REIDL, Josef and Otto HOFNER
(German)
Figures
RICJ pl 7 AVMa
REINER VON HUY (Rainer of Huy;
Regnier de Huy; Renier de
Huy) (Flemish fl 1107-50)
Baptismal Font, commis-
sioned by Abbot Hellinus,
for Church of Notre Dame
des Fonts, Liege 1107/18
brass; 25
GOMB 127; KIDS 82 (col);
LARB 239; MCCL pl 17;
ROOSE 31; SWA pl 110
BLB
--detail(s)
KO pl 48; NEWTEM
pl 57, 58
--Baptism of Christ bronze;
25
BECKM 180, 181; JANSH
223; JANSK 433
--Baptism of the Jews in the
Jordan River
DEVI-2
--John Preaching and Bap-
tising 1107/18 cast bronze;
635 cm; Dm: 103 cm
SWA pl 111-13
--Two Publicans Awaiting
Baptism
BUSRO pl 27
Censer: Angel, and Three
Worthies in Fiery Furnace,
Mosan 2nd Q 12th c.
cast bronze; 160x104 mm
SWA pl 155 FLiP
REINHART, Hans, the Elder
(German)
Medal: Fall and Redemption
of Man 1536 silver; Dm:
2-5/8
KUHN pl 36 UMCB (1961.
124)

The Trinity Medal 1544 silver
CLE 108 UOCIA (56.337)
Reinhart, Oskar
Banninger. Oskar Reinhart,
head
Reinheldis
German--12th c. Angel
Receiving Soul of
Reinheldis, tomb relief
REINHOUD See D'HAESE, Reinhoud
Reiter See Equestrians
RETISCHELL
Goethe-Schiller Monument
REED 106 UCSFG
REITZENSTEIN, Vera (Swiss 1924-)
Sculpture 1950 white marble
JOR-1: pl 101
Relation of Spherical Forms. Moss
Relic Bearer
Minne, G. Little Relics
Carrier
Relic from an Ossuary. Tajiri, S.
Relief (Paros). Nicholson
Relief aus Draht und Blech. Bodmer
Relief-Composition. De Giorgio
Relief Construction# Hill
Relief Construction. Miro
Relief Construction. Pasmore
Relief Construction. Pevsner
Relief Construction. Picasso
Relief Construction. Tatlin
Relief Construction in White, Black
and Indian Red. Pasmore
Relief from an Ossuary. Tajiri, S.
Relief in Black and White. Pasmore
Relief in White, Black and Indian
Red. Pasmore
Relief Metallique. Bodmer
Relief Meter. Richter
Relief Painting in White, Black
and Maroon. Pasmore
Relief Tri-etage en Metal. Bodmer
Relief with Eight Figures. Wotruba
Relief with Five Figures. Wotruba
Religion
Roubiliac. Religion
Reliquaries
Arditti. St. Zenobius,
reliquary bust
Aretino, Pietro, and Aretino,
Paolo. S. Donato, reliquary
bust
Austrian--14th c. Reliquary
bust
Belgian--12th c. Reliquary
Triptych of the Holy Cross
Belgian--16th c. Reliquary:
Bishop, bust
Byzantine. Christ on Cross

Byzantine. Deesis and Saints,
 reliquary
Byzantine. Panel Reliquary
Byzantine. Reliquaries of
 True Cross
Byzantine. Reliquary#
Donadino di Cividale. S.
 Donato, reliquary bust
Early Christian. Reliquary
 Casket
Egbert of Treves--Foll.
 Reliquary: Nail of True
 Cross Case
Eilbertus--Foll. Arm Reliquary
English--10/11th c. Reliquary
 Cross
Flemish--11th c. Reliquary:
 Book
Flemish--13th c. St. Eleuthere
 Reliquary
Flemish--15th c. Reliquary#
Flemish--16th c. Brabant
 Reliquary Bust
French. Hand Reliquary of St.
 Judicael
French--8th c. Reliquary
French--9th c. Pepin Reliquary
French--10th c. St. Foy,
 reliquary
--Reliquary of Sandal of St.
 Andrew
French--11th c. St. Candidus,
 reliquary head
French--12th c. Phylactery
 Reliquary of the Tooth of
 St. Maclou
--Reliquary of St. Samson
French--13th c. Death of St.
 Thomas a Becket, chasse
--Reliquary#
--St. Stephen, reliquary
--St. Yrieix, head
--Virgin of Notre Dame de
 l'Epine
French--14th c. Hand
 Reliquary of St. Louis of
 Toulouse
--Reliquary Casket
French--14/15th c.
 Reliquary Bust of St.
 Martin
--Reliquary of the Holy Thorn
French--15th c. Angel
 Carrying Reliquary
--Gothic Reliquary
--Reliquary of St. Ursula:
 Ship with Figures
--St. Fortunade, head

--St. Yrieix, reliquary head
French--16th c. Reliquary:
 Female Figure, bust
--St. Barbara, reliquary bust
German--10th c. (?) Enger
 Reliquary
--Reliquary: Foot of St.
 Andrew
German--11th c. Arm
 Reliquary of St. Blase
--Reliquary Cross of Bern-
 ward of Hildesheim
--Reliquary Cross of Bertha
 of Borghorst
German--12th c. Arm
 Reliquary
--Domed Reliquary: Church
--Frederick I, reliquary head
--Head Reliquary
--Reliquary#
--German--14th c. Reliquary#
German--15th c. Goldenes
 Rossel
Godefroid de Claire. Pope
 Alexander, head reliquary
Godefroid de Claire--Foll.
 Reliquary
Italian--13th c. Reliquario
 della Testa di S. Galgano
Italian--13/14th c. Reliquary
 of S. Galgano
Italian--15th c. Arm Reliquary
--Reliquary
--Reliquary of St. Blaise
--Reliquary Supported by Two
 Angels
Italian--18th c. Martyrdom of
 John the Baptist, reliquary
Juni. Reliquary: St. Anne,
 bust
Loyet. Charles the Bold
 Reliquary
Memling. Reliquary of
 St. Ursula
Notke. Reliquary of St. George
Ottonian. Reliquary Arm of
 St. Sigismund
Polish. St. Dorothea,
 reliquary head
Polish. St. Sigismund,
 reliquary head
Romanesque--English. The
 Eltenberg Reliquary
Spanish--15th c. Reliquary:
 Gothic Chapel with
 Candelabra Angels
Spanish--16th c. Female
 Saint, reliquary

Syrlin, J., the Elder. Luster-
weibchen Reliquary Bust
Syrlin, J., the Elder.
Reliquary: Woman, bust
Ugolino di Vieri. Reliquary
of the Holy Corporal
Ugolino di Vieri and Viva
di Lando. Reliquary of
S. Savino
Vanni. Reliquary of S.
Reparata
Reliquary Carrier
Minne, G. Little Relics
Carrier
Rembrandt van Rijn (Dutch Painter
and Etcher 1606-69)
Borsos. Rembrandt, medal
Mills. Mask of Van Rijn
REMENYI, Jozsef (Hungarian 1887-)
Bela Procopius Medal 1924
bronze; 6.1 cm
GAD 95 HBA
Girls from Kalotaszeg, relief
bronze; 4.8x7.1 cm
GAD 95 HBA
Remorse. Octobre
Remoulus. Ipousteguy
REMUND, Benedikt (Swiss-French
1904-)
Der Rote Hahn (Le Fleau)
1945 stone
JOR-1: pl 41 SwBF
School Fountain stone
JOR-1: pl 40 SwBN
Remus See Romulus and Remus
RENAISSANCE
Jewel of Minerva 17th c.
INTA-2: 135
Negress, seated figure
examining foot 16th c.
TAYFF 63 (col) UNNMM
RENAUD, Francis (French fl 19th c.)
War Memorial granite
GAF 249; HOF 168 FTreg
RENDIC, Ivan (Yugoslav 1849-1932)
Ivan Gundulic, bust marble
BIH 25 YD
Rene I (King of Sicily 1409-80)
German--16th c. Good King
Rene, medallion
Rene d'Anjou (Duke of Anjou and
King of Naples 1408-80)
Pietro da Milano. Rene
d'Anjou, medal
RENIER DE HUY See REINER VON
HUY
RENIER VAN THIENEN, THE ELDER
(Flemish fl 1465-98) See also

Jacques de Gerines
Paschal Candelabrum; figures:
St. Mary Magdalene; St.
Leonard 1483 cast brass;
24-7/16x12-9/16
DETF 270, 268, 269
BLeL
Figures, Crucifixion
Candelabrum 1482/83
MULS pl 107D NZoL
RENNE, Salomon van der (Danziger)
Camel and Rider 1642 silver
gilt; 24
COOP 173 FPRoths
Renneberg, Eva von
German--16th c. Eva von
Renneberg, effigy detail
RENOIR, Auguste (Pierre August
Renoir) (French 1841-1919)
Coco, bust 1908 bronze
SELZJ 179
Coco, medallion Dm: .217 m;
D: .06 m
TOKC s-64 JTNMW
Head 1918 bronze; 14
DETS 21 UNNH
Maternity c 1916 bronze
FAIN 43 UCtNlA
Mother and Child (Mere et
Enfant) bronze
SEYT UDCP
--c 1915 bronze; 21-1/4
TATEF pl 45A ELT (4435)
--1916 bronze
SELZJ 179
Petit Jugement de Paris,
relief c 1913 bronze;
10x12 cm
SP 197 GHaS
La Petite Laveuse Accroupie
(Water) bronze
INTA-2: 122
Pierre Renoir, head bronze;
10-1/2
NM-15: 37
Standing Venus, with base
1913 bronze; 33-1/2 (with
base)
DETS 20 UNNH
Tambourine Dancer (The
Dance), relief
MALV 465 FPRen
Venus Victorious (Venus
Victorieuse; Venus
Victrix)
BARD-2: pl 380 BrSpA
--1914 bronze; 23-1/2
ALB 145 UNBuA

--1914 bronze; 72
 MYBS 57; READCON 29;
 ROTJG pl 13; ROTJT 23;
 TATEF pl 45d ELT (5934)
--1915 bronze; 24
 SELZS 46 UNNSl
--1915/16 bronze; 71
 MID pl 8 BAM
The Washerwoman (La Laveuse)
 1916 plaster
 SELZJ 180 FPReno
--1917 bronze
 MAI 249
--1917 bronze; 48
 BAZINW 425 (col); LIC
 pl 140; MCCUR 251;
 NNMMM 41 UNNMMA
--1917 bronze; 48
 RIT 63 UNNV
--1917/18 bronze; 48
 ROTJG pl 12; TATEF pl
 45c ELT (5933)
 Portraits
Maillol. Renoir, head
RENOIR, Auguste, and GUINO,
 Richard
 Judgment of Paris, relief
 1914 bronze; 29-1/2x
 35-1/2x6-3/4
 CLE 176; HAMP pl 5; LIC
 pl 141; UPJH pl 239 UOClA
 (41.591)
Renoir, Pierre
 Renoir, A. Pierre Renoir,
 head
Renomee
 Coysevox. Fame
Renown
 Coysevox. Fame
 Goujon. Renown, fireplace,
 Main Reception Room
RENVALL, Ben (Finnish 1903-)
 Morning (Di Mattina) 1958
 bronze
 VEN-58: pl 143
Reparata, Saint
 Arnolfo di Cambio. S.
 Reparata
 Arnolfo di Cambio. Virgin
 and Child Blessing, Sts.
 Reparata and Zenobius
 Pisano, A. S. Reparata
 Vanni. Reliquary of S.
 Reparata
Repentant Son
 Donatello. High Altar:
 Miracle of the Repentant
 Son

Repentant Magdalen
 Donatello. Mary Magdalene
Repos de Jesus. Flemish--15th c.
Le Repos du Guerrier. Strebelle
Repose. Krsinic
Repose. Scheurich
Repose. Vincent
Le Republique, bust. Yencesse
Requiem
 French--13th c. Requiem,
 jamb of former cloister
 door
 Hepworth. Figure (Requiem)
Reredos
 Benney. Reredos with Cross
 and Candlesticks
 Borman, J., the Younger.
 Reredos of the Nativity
 Flemish--16th c. Reredos#
The Rescue of Andromeda. Fehr
Resignation. Saloun
Resting Faun. Sergel
Restive Ram
 Bourdelle. Stubborn Ram
Resumption of Idea, No. 3. Mannucci
Resurrection See also Jesus Christ--
 Resurrection
 Bistolfi. Resurrection
 English--13th c. Christ and
 the Doctors; Resurrection
 of the Dead, frieze
 French--13th c. The
 Resurrected
 --The Resurrection of the
 Dead, lintel
 German--9th c. Resurrection
 of the Dead
 German--12th c. Cross Base:
 Adam Rising from Tomb
 German--14th c. Lion Reviving
 Stillborn Young by his
 Breath, symbol of
 Resurrection
 Gislebertus. Tympanum: Last
 Judgment
 Italian--14th c. Last Judgment:
 Resurrection of the Dead,
 right pier relief
Retables See also Altars
 English--14th c. The Passion,
 scenes, retable panels
 Flemish--16th c. Retable de
 Coligny
 French--12th c. Altar Retable
 French--15th c. Retable
 French--16th c. Retable:
 Resurrection Scenes
 German--12th c. Retable

St. Christopher c 1500 oak; 22
ASHS pl 14 ELV
St. James the Less c 1480
lindenwood; 66-1/2
DEYE 55 UCSFDeY (46.8.2)
Virgin and Child with St.
Anne 16th c.
RAY 36 UNNMM
RHENISH-WESTPHALIAN
Madonna and Child and St.
Anne c 1490 lindenwood;
13-5/8 (excl base)
KUHN pl 24 UMCB (1963.29)
Rhetoric
Italian--15th c. Rhetoric
Pisano, Giovanni. Pisa Pulpit:
Dialectic and Rhetoric
Pollaiuolo, A. and P. Sixtus
IV Monument
Rhine
Probst. Vater Rhein
Rhinoceros
Fremiet. Rhinoceros
Lalanne. Le Rhinoceros
Rhodes, Cecil John (British
Administrator in South Africa
1853-1902)
Watts. Physical Energy
Rhone
Coysevox. River God of the
Rhone
Rhyme Contest. Lardera
Rhythm. Traverse
Rhythm in Space. Bill
Rhythm-Relief. Delaunay
Rhythmes dans L'Espace
Vieira, M. Tension-
Expansion
Rhythmic Plant. Linck, W.
Rhythmical Statuette. Wyatt, C.
Rhythms. Magnelli
Rhythms. Selva
Rhythms II. Jarnuszkiewicz
Rhys, Richard
Roberts-Jones. Richard
Rhys, head
Rhytons
Italian--4th c. Rhyton:
Dog's Head
Riario, Caterina
Spinelli. Caterina Riario,
medal
Riario, Pietro d 1474
Bregno, Andrea, and
Giovanni Dalmata, and
Mino da Fiesole. Cardinal
Pietro Rario Tomb

Ribar, Ivo Lola
Angeli-Radovani. Ivo Lola
Ribar, head
RIBAS, Felipe de (Spanish 1609-48)
See MARTINEZ MONTANES,
Juan
RIBAS, Francesco de (Spanish d 1648)
Infant Christ 1644 ptd wood
GOME pl 79-80 SpSJ
RIBERA, Pedro de (Spanish c 1683-
1742)
Bridge Niche 1721/32
LARR 369 SpT
Entrance
ENC 762 SpMaM
Portal after 1722/29 sandstone
CHRP 269; CIR 184; KUBS
pl 14a SpMaHF
RIBNIKAR, Milica (Yugoslav 1931-)
Female Nude 1954 plaster
BIH 181 YBMG
RICCARDI, Eleuterio (Italian-English
1884-)
Pompeo Aloisi, bust veined
marble
PAR-2:20
RICCIARELLI, Daniele da See
VOLTERRA, Daniele da
RICCIO (Andrea di Ambroglio
Briosco; Andrea Riccio; Il
Riccio) (Italian 1470-1532)
Adoration of the Magi, relief
c 1500 bronze; 9-1/4x12-
9/16
CLE 86; DETD 114 UOClA
(54.601)
Arion c 1510 bronze; 9-3/4
CHAR-2:46; DETD 117 FPL
Base for Satyr and Satyress
Group bronze
CLE 87 UOClA (50.375)
Boy with Grasshopper, inkstand
bronze
BODE 161 GBK
Paschal Candlestick 1507/16
bronze; 10
BURC pl 29; POPR fig
152 IPSA
--Christ in Limbo
ENC 763; POPR pl 125
--Satyr
POPR fig 147
David Dancing Before the Arc
of Covenant, relief 1507
bronze
SEY pl 145A IPSA
--Self Portrait, second head

from left, left, second
row
GOLDF pl 59
Death of della Torre, relief
1516/20 bronze; 14-1/2
MOLE 157; POPR pl 124
FPL
Della Torre Monument
POPR fig 151 IVeFe
The Entombment bronze;
19-13/16x29-11/16x3-1/4
SEY 130-32 UDCN
God of a Spring (Quellgott?)
16th c. bronze; 27.7 cm
BSC pl 88 GBS (312)
Humanism Overcomes Death,
relief, Tomb of
Marcantonio della Torre
c 1510 bronze; .37x.49 m
CHAS 3 FPL
Inkstand: Pan Listening to
Echo bronze; 8-1/2
DETD 119; GAUN pl 49;
POPR fig 150 EOA
Inkstand: Seated Figure
1520 bronze
BURC pl 30 UNNMM
Inkstand: With Two Satyrs
1520 bronze
BURC pl 30 ELWal
Pegasus, relief, Tomb of
Marcantonio della Torre
1516/21 bronze; 14-1/2
x4-1/2
CHAR-2:48 FPL
Pomona bronze
CLE 87 UOClA (48.486)
Relief with Three Horses
bronze; c 18
DETD 115 IVCO
St. Martin and the Beggar,
plaque bronze; 26-1/2x23
DETD 118 IVCA
Satyr
POPR fig 148
IFMN
Satyr and Satyress 1st Q
16th c. bronze; 9-1/2
VICF 58 ELV (A. 8-1949)
Seated Shepherd c 1500
bronze; 7
CHAR-2:44; POPR fig
149 FPL
Satyress 1510/30 bronze
CLE 87 UOClA (47.29)
Self Portrait, bust bronze;
1-3/4 DETD il 240
FPL

--head
GOLDF 26 AVK
--medallion c 1507 bronze
GOLDF pl 57 GBSBeM
Shepherd Milking a Goat
bronze; 26 cm
BARG; POPR pl 123 IFBar
Venus Chastising Cupid,
plaquette c 1520 bronze;
4-3/16x3-3/16
SHAP pl 41 UDCN
Warrior on Horseback 1515/32
bronze; 13-1/2
ASHS pl 21; CHAS 143;
ENC 763; MOLE 133;
POPR pl 126; WCO-3:49
ELV
RICCIO, Andrea or Antonio RIZZO
Young Man, bust from life or
death mask c 1490 bronze
SEY pl 141A IVCo
RICCIO, Andrea--ATTRIB
Old Woman, seated bronze
LIC 20 FPBN
RICCIO, Andrea--FOLL
Livy, head bronze; 26 cm
WPN pl 60 PWN (164751)
Negro Boy Riding on a Long-
Haired Goat c 1500
bronze; 8-1/2
DETD 119 EBB
Samson and the Lion bronze;
7-1/8
BMA 20 UMdBM
Rich, Robert (2nd Earl of Warwick
1587-1658)
Evesham. Robert Rich
Monument
Richard I (King of England
1157-99), Surnamed: Coeur
de Lion, or Lion-Hearted
English--12th c. Great
Seal of Richard I
Marochetti. Richard, Coeur
de Lion, equest
Richard II (King of England 1367-
1400)
Broker, N., and G. Prest.
Richard II and Anne of
Bohemia Tomb
Richard III (King of England 1452-85)
English--15th c. (?). Richard
III, misericord
Richard of Reading (Earl of Warwick)
Massingham, J., and others.
Richard, Earl of Warwick,
effigy; Weepers, tomb detail

RICHARDS, Ceri (Welsh-English
 1903-)
 Cathedrale Engloutie 1962
 wood and metal; 33-1/4x28
 SFMB #73
 Construction, Black and White
 1936
 ptd wood; 21-1/2x21-1/2
 ARTSBR 28
Richelieu, Armand Jean du Plessis
 (French Statesman 1585-1642)
 Girardon. Richelieu Tomb
 Mochi. Cardinal Richelieu,
 bust
 Warin. Richelieu, bust
RICHIER, Germaine (French 1904-59)
 The Bat 1952 plaster; 47
 BERCK 110; GIE 259;
 MYBS 86; READCON 220
 FPMa
 Bat-Man 1946 bronze; 88 cm
 LIC pl 304; SEITC 70
 UCtHWA
 Crucifix
 DAM 165; GAF 421 FAsN
 The Devil 1950 bronze
 VEN-64: pl 48 FPM
 The Diabolos Player
 (Diabolospierlerin)
 1949 bronze
 GERT 232
 Don Quixote (Don Quichotte)
 1951 bronze; 233 cm
 JOR-1: pl 69
 Don Quixote of the Forest
 1950/51 bronze; 93
 SELZN 133 UMnMW
 --1951 bronze; 82
 BOW 79 ELMa
 --1951 bronze; 91
 BERCK 109
 Don Quixote with the Sail of
 a Windmill 1949 gilt
 bronze; 22-7/8
 TRI 98
 Figure 1952 lead and colored
 glass
 READAN #189
 A Floresta bronze; 110 cm
 SAO-1
 Le Grain 1955 bronze; 59
 DETS 87 UNNH

 --
 SELZN 132 FPCr
 Grasshopper (Small Grass-
 hopper) 1946 bronze;
 10-1/2
 BOW 82 ELH

Grasshopper 1946/55 bronze;
 21
 SELZN 129 UNGK
The Great Bat 1946/56 bronze
 WCO-3: 11
Great Diablo (Diablo--Large
 Version) 1949 bronze; 66
 CHICC 46; NMAD 36 UICSt
Le Griffu 1952
 KULN 9
Horse 1957/58 polychrome
 plaster
 MAI 251
Hydra 1954 bronze; 31
 SELZN 130 UIOS
Ogre 1951 bronze; 30
 SELZN 130 UICF
L'Ouragane 1948/49 bronze;
 72
 EXS 106 FPM
Praying Mantis (Mantis) 1949
 bronze; 47
 MID pl 95; STM BAM
Rebellion (Aufruhr) 1954
 bronze
 GERT 233
Sculpture*
 EXS 16
Shepherd of the Landes (Le
 Berger des Landes) 1951/56
 bronze; 60
 LOND-5: #36 ELH
--CHICSG FPCr
--BOW 81 -SnB
Storm 1947/48 bronze; 72-1/2
 BAZINW 441 (col); BERCK
 321; MARC pl 62, 63 (col)
 FPM
Tauromachy (The Bullfight)
 1953 bronze, gilded; 43-1/4
 CALA 201; GUGP 93; JOR-
 1: pl 68; LARM 291; LYN
 162; MCCUR 277; MAI
 250; NMAD 38; SAO-2 IVG
Thistle (Sun) 1956/59
 ptd bronze, slate background
 MAI 251
Three Sculptures Against a
 Background copper and brass;
 14-1/2x7-1/2x7-3/4
 CARNI-58: pl 22
The Top 1953 lead; 50-3/4
 TRI 161 (col) GDuK
The Wasp 1953 bronze
 SELZJ 7 FPCr
The Water (L'Amphore; L'Eau)
 1953/54 bronze
 MARC 49 FPM

--1953/54 bronze; 57-1/8
 BOW 83; LARM 322; NMAD
 37; TATEF pl 16 ELT
 (T. 75)
RICHIER, Jean (French 1551-1624)
 Francois de Bonne, Duc de
 Lesdiguieres, Tomb
 marble
 GAF 425 FGapM
RICHIER, Ligier (French 1500-66)
 Altarpiece, detail 1523 stone
 GAF 178 FH
 Fainting Virgin polychromed
 walnut
 GAF 193 FStMM
 Holy Sepulchre (The Entomb-
 ment; Lamentation at the
 Tomb)
 CHASEH 353; GAF 193;
 JAL-4:pl 19; POST-1: 243
 FStME
 Joseph of Arimathea with Head
 of Christ 1553
 BUSR 131
 The Passion: Way of the Cross;
 Crucifixion; Deposition
 1523 stone, ptd
 ROTHS 191 FH
 Philippe de Gueldres, Duchess
 of Lorraine, Tomb c 1550
 LAC 76 FNanCo
 Rene de Chalons Tomb: Death
 (Skeleton) after 1544 stone;
 64
 BLUA pl 57; BUSR 208;
 GAF 171; LAC 196 FBaP
Richmond, Duchess of
 Roettier. Medal: Duchess of
 Richmond
RICHMOND, Oliffe (Tasmanian-
 English 1919-)
 Sea God 1962 ciment fondu;
 59
 HAMM 140; LOND-6:#33
RICHTER, Vjenceslav (Yugoslav
 1917-)
 Escultura de Sistema 100x
 100 cm
 SAO-8
 Relief Meter 1964/67 plastic,
 steel, wood; 72x43x7
 GUGE 73
RICKENBACKER, Josef (Swiss)
 Last Supper, relief,
 Sanctuary 1953
 DAM 170 SwTCh
Ricostruzione del Dinosauro.
 Pascali

Rider. Caille
Rider. Duchamp-Villon
The Rider. Mastroianni
Rider with Outstretched Arms
 Marini. Horseman with Out-
 stretched Arms
Ridolfi, Virginia Pucci
 Poggini. Virginia Pucci
 Ridolfi, bust
RIEDEL, J. (Austrian)
 Infant, Kindergarten ornament
 AUM 86
 Infant Musician, Tenement
 court figure
 AUM 86 AV
RIEDL, Josef and Otto HOFNER
 Figures
 AGARN il 23 AVMa
RIEGELE, Alvis
 Public Building Entrance
 AUM 82 APA
RIEMENSCHNEIDER, Tilman
 (German 1460?-1531)
 Adam and Eve, Marienkapelle,
 south portal 1491/93
 stone
 KO pl 64; LIL 117; MULS
 pl 176 GWuMai
 --Adam, head
 CHASEH 264; READM pl 20
 --Eve 1491/93 white sand-
 stone; 72-7/8
 BAZINW 326 (col); NEWTEM
 pl 108
 Altar Detail 1501/05
 MULS pl 178 GRoJa
 Altar of Our Lady (Marienaltar)
 c 1500
 ST 253 GCrL
 --Disciple, head
 LOH 174
 --Virgin
 BAZINW 326 (col)
 --The Visitation
 BAZINW 324 (col)
 Altar of the Holy Blood
 POST-1: 110
 --Last Supper 1504
 wood; 96-1/8
 VEY 136
 Apostle c 1505/10 limewood;
 less than LS
 NEWTEM pl 109 GCrL
 --head
 WORR 147 GRoJ
 Assumption of the Virgin,
 Marienaltar c 1505/10
 limewood

BAZINW 325 (col); BUSR
113; ENC 766; LOH 175;
NEWTER 155; PRAEG 244;
STA 50 GCrL
Birth of Christ, fragment
1500/05 lindenwood;
56.5x31.5 cm
BERLE pl 27; BERLEK
pl 21 GBSBe (406)
Christ Appearing to Mary
Magdalen (Noli me Tangere)
relief, Munnerstadt High
Altar 1490/92 lindenwood;
143.5x101.5 cm
BSC pl 59; MULS pl 177A
GBS (2628)
Christ in the House of Simon
c 1490 wood
ROTHS 133 GBD
Christ on the Cross 1510/15
lindenwood; 71.5 cm
BERLE pl 26 GBSBe
(2931)
Death of the Virgin, relief
16th c. stone
CHENSW 367; MARQ 234
GWuC
Evangelist Luke, seated figure
VEY 61 GBS
God the Father with Body of
Christ (Gottvater mid tem
Leichnam Christi) 1516
lindenwood; 185 cm
BSC pl 60 GBS (2549)
Henry II and Kunigunde,
effigies 1513 marble
LOH 178 GBaC
--Kunigunde, tomb relief
KO pl 64 (col)
The Lamentation 1525
BUSR 115 GMaidC
Life of Virgin Mary, High
Altar c 1495/99 wood
ROTHS 129 GC
Madonna and Child lindenwood;
37-3/8
SFGM #13 UDCD
Madonna and Child on Crescent
Moon wood
NYWC pl 11b UNNWarbu
Mourning Mary, Vesper Group
fragment c 1505
BUSR 111 CStWL
Prince-Bishop Rudolf von
Scherenberg, effigy head
1496/99
BUSR 116 GWuC

Retable, detail: Christ 1501/04
wood; 8x4.16 m
CHAS 312 GRoJ
St. Andrew
CARTW 174 UGAA
St. Barbara c 1485
MULS pl 173B GBremR
St. Bernard of Wurzburg
16th c. wood
CHENSW 397 UDCN
St. Boniface, head detail
H: 70-3/4
DEY 110, 112 UCSFDeY
St. Burchard of Wurzburg,
half figure, head detail
c 1510 lindenwood; 32x18
CHRC fig 115; RUS 84;
SHAP pl 83; USNK 175;
USNKP 427; USNKS 11, 12
UDCN (A-152)
St. James Minor; head detail
1st Q 16th c. lindenwood;
66-1/2
DEY 110, 111 UCSFDeY
St. Jerome and the Lion c
1510 alabaster
CLE 77 UOCIA (47.82)
St. John, detail early 16th c.
wood
CHENSW 397 GKalN
St. John the Evangelist, seated
figure, Munnerstadt High
Altar 1390/92 wood
MULS pl 177B GBS
St. Lawrence and St. Stephen
1502/10 lindenwood
CLE 76 UOCIA (59.42;
59.43)
St. Luke, Kneeling figure
early 16th c.
VEY 61 ELV
St. Mark, with Book, detail
1490/92 lindenwood; 72x78
cm
BSC pl 58 GBS (402-405)
St. Philip the Apostle, head
c 1500 wood
BUSR 112; ROTHS 131
GCrL
St. Sebastian c 1505/10
lindenwood; 23-3/8x9-1/2
CAMI t
St. Sebastian, detail 1500/05
wood; 1.15 m
CHAS 312 GWuM
Self Portrait c 1520
GOLDF pl 46 GMaidP

River Gods
 Bologna. River God
 Clodion. A River God
 Gerhard. Augustus Fountain:
 River God and River
 Goddess
 Michelangelo. River God,
 fragment
 Pierino da Vinci. River God
 Robba. Fountain of Four
 Rivers of Carniola
The River March
 Donner. Providentia Fountain
River Marne. Bouchardon, E.
The River Traun
 Donner. Providentia Fountain
RIVERA, Manuel (Spanish 1927-)
 Metamorphosis 1959 iron-
 wire and metal-netting;
 35-3/8x25-5/8
 TRI 42 FPDro
Rivers of France
 Goujon. Fountain of the
 Innocents
Rivers of Paradise
 French--12th c. Rivers of
 Paradise
 German--13th c. Font, details:
 Serpent; Rivers of
 Paradise
 Italian--13th c. Tivulzio
 Candlestick, details: Rivers
 of Paradise
Riviere, Jean Bureau de la
 French--14th c. Jean Bureau
 de la Riviere, north
 tower
RIVIERE, Louis (French)
 Les Deux Douleurs
 TAFTM 41
RIVIERE, Theodore A.
 Salammbo at the House of
 Matho gold and ivory
 MARY pl 55
RIZK, Abdel Kader (Egyptian
 1912-)
 Child's Head marble; 23 cm
 SAID pl 99 EgCMA
RIZO See RIZZO, Antonio
RIZZI See RIZZO, Antonio
RIZZO, Antonio (Antonio Rizo;
 Antonio Rizzi) (Italian 1430-
 98?)
 Adam, Arco Foscari c 1485
 marble; 206 cm
 POPR pl 131; SEY pl
 141B IVP

Doge Niccolo Trono Monument,
 choir c 1476 marble
 MURA 132; POPR fig 154
 IVMF
--Virtue marble; 167 cm
 POPR pl 129
Eve, Arco Foscari c 1485
 marble; 80
 BUSR 214; CHASEH 326;
 KO pl 83; LARR 139;
 MACL 181; MOLE 136;
 MURA 102 (col); POPR pl
 130; POST-1:96; SEY pl
 143A IVP
General Vittore Cappello
 Monument, detail c 1476
 marble
 MURA 129 IVE
Philosopher, medallion,
 Giants' Staircase marble;
 Dm: 5-1/4
 MURA 100 IVP
Venetian Youth, bust c 1490
 bronze
 BURC pl 46 IVCo
ROBBA, Francesco
 Fountain of Four Rivers of
 Carniola, detail: River
 God 1751
 BUSB 190 YL
Robber. Hrdlicka
ROBBIA, Andrea della (Italian
 1435-1525) See also Robbia,
 Luca della
 Adoration of the Child, relief
 terracotta; 50-3/8x
 30-1/2
 USNKP 409 UDCN (A-159)
The Agony in the Garden,
 altarpiece ceramic; under
 LS
 MOLE 117 (col) FPL
Altarpiece
 CHASEH 310 IAsM
--
 ROOS 111C IFMA
Annunciation glazed terracotta
 MYBA 378 ICC
--glazed terracotta; Virgin:
 65; Angel: 62
 NCM 275; NMI 30, 31;
 SFGM #64 UCLCM
 (5832.46.27)
--detail terracotta
 KUH 16
--lunette glazed terracotta;
 66x112 MCCA 82; UPJ 260
 IFI

Assumption of the Virgin,
altarpiece relief
NM-11:22 UNNMM
Boy, bust c 1500 glazed
ceramic
BUSR 139 IFMN
Boy Playing the Bagpipes
begin 16th c. enamelled
terracotta; 17
VICF 50 ELV (4677-1858)
Boy with Puppies tinted plaster
BODE 158 GBK
Bust of a Child
BARG IFBar
Christ Child, bust
USNI 233 UDCN (A-35)
Christ in Swaddling Cloths
("Bambino"), facade
medallion c 1463 glazed
ceramic
BARSTOW 133; BUSR 138;
MCCA 100; RAY 39 IFI
Coronation of the Virgin,
relief faience
CHENSW 383; FREEMR
96 ISO
Head of a Girl
BARG IFBar
Infant Christ 1463/66
ROOS 111B IFI
Madonna, garland of fruit
relief glazed ceramic
BUSR 137 ELV
Madonna and Child glazed
terracotta; 47-1/4x29-3/8
DETT 69 UMiD (45.514)
--relief glazed terracotta
BODE 49
ELV
--tondo
ROOS 110G IFBar
--tondo glazed terracotta
BR pl 7 (col) UNNMM
Madonna of the Architects
BARG; POST-1:183 IFBar
Madonna of the Pillow
(Vierge au Coussin; Madon-
na del Cuscino)
BARG IFBar
Male Head, medallion in
fruit and foliage frame
CHASE 208 UNNMM
Meeting of St. Francis and
St. Dominic, lunette 1490/
95 enamelled terracotta
BR pl 6 IFPao
Putto, fountain figure c 1470

gilded and glazed terracotta
BURC pl 27 GBM
St. John the Baptist, bust
USNI 233 UDCN (A-36)
St. Michael and the Archangel,
lunette c 1475 glazed
terracotta; 61-7/8
BR pl 5 (col); INTA-1:98;
NM-8:1 UNNMM (60.127.2)
St. Peter, half figure
USNI 234 UDCN (A-33)
La Verna Annunciation glazed
terracotta
MACL 155; MYBU 141
ILaVM
Virgin Adoring the Child,
fruit and flower arch
terracotta
CRAVR 68
--medallion c 1470/75 enamelled
terracotta
LOUM 115 FPL (757)
The Virgin in Adoration
terracotta; 30-1/4x16-1/4
CHRP 200; USNI 233;
USNP 162 UDCN (A-13)
The Visitation after 1491
BAZINW 337 (col); BUSR
141 IPiF
Young Florentine Lady 1470/80
glazed terracotta
MU 137 IFBar
ROBBIA, Andrea della--FOLL
Adoration of the Child, relief
c 1480 glazed terracotta
SEY pl 105 ILaVM
Adoration of the Child by
Virgin and St. John, tondo
glazed terracotta; Dm:
41-1/2
TOR 120 CTRO (915-5-121)
Madonna and Child with
Cherubim glazed terracotta;
Dm: 21-1/2
USNI 234; USNP 164 UDCN
(A-11)
Madonna and Child with God
the Father and Cherubim
glazed terracotta; 35-1/2
x19
USNI 233; USNP 163 UDCN
(A-12)
Christ, Majolica tondo early
16th c. Dm: 70 cm
WPN pl 156 PWN (SZC
2106)

ROBBIA, Giovanni della (Italian
 1469-1529)
 Adoration of the Kings, re-
 lief bordered with grotesques
 glazed ceramic
 BUSR 136 ELV
 Christ, bust
 ENC 769
 Pieta
 USNI 235 UDCN (A-45)
 --crypt of the Gesu c 1500
 terracotta
 SEY pl 160 ICorC
 --lunette colored and glazed
 terracotta
 BODE 197 IFMN
 --with St. John and the Mag-
 dalen colored terracotta
 BODE 196 GBK
 Plenty 1520/30 glazed terra-
 cotta
 CLE 91 UOClA (40.343)
 St. John, bust 16th c. glazed
 terracotta
 DOWN 109 UNNMM
 Young Christ, bust terracotta;
 14-1/2x14-1/2
 USNI 234; USNK 189 UDCN
 (A-48)
ROBBIA, Giovanni della--FOLL
 Pieta ptd terracotta
 NCM 273 UNNMM
 (14.23-A, B, C, D)
ROBBIA, Girolamo della (Italian
 1487-1566)
 Catherine de Medici, effigy
 SHAP 35 FPL
ROBBIA, Luca della (Italian 1400-
 1482)
 Adoration of the Child, tondo
 wreathed in fruit and
 flowers glazed clay
 BODE 102 FPF
 Adoration of the Magi, tondo
 15th c. enamelled terra-
 cotta
 GLA pl 35
 Adoration of the Shepherd
 glazed clay
 BODE 110 ELV
 Angels, relief detail faience
 CHENSW 383 IFMo
 Annunciation, relief
 BARSTOW 134
 Apostles, medallions glazed
 terracotta
 MCCA IFPC

Arms of the Guilds of Silk-
 weavers and of Merchants,
 reliefs glazed terracotta
 BODE 88 IFO
The Ascension, relief lunette
 enamelled terracotta; 200x
 260 cm
 POPR pl 45 IFCO
Benozzo Federighi Monument
 marble, enamelled terra-
 cotta surround; 270x257 cm
 BODE 77; POPR pl 47 IFT
Boy, bust glazed clay
 BODE 111 GBK
Boy-Christ, bust glazed
 terracotta
 BODE 147 IFMN
Cantoria (Singing Gallery),
 detail
 GLA front IFF
--marble
 BARSTOW 130; BODE 74-
 75 IFMO
--relief 1431/38 marble;
 c 12-1/2x18-1/2'
 BR pl 4; GARDH 311;
 MONT 141; STI 584; UPJH
 pl 111 IFCO
--detail(s)
 BEREP 183; HALE 10
 (col); LARR 112; POST-1:
 173; RAY 39
--Angels and Musicians
 BUSR 75 IFCO
--Boys Singing and Playing
 GAUN pl 47
--Dancing Children; Inscrip-
 tion
 SEY pl 39
--Drummers; Trumpeters;
 Singing Boys
 POPR pl 41-3; fig 19, 43
--Singers with Book
 MACL 85
--Singing Angels marble; c
 38x24
 BAZINW 337 (col); JANSH
 333; JANSK 631
--Singing Boys (Choristers;
 Singing Children)
 KO pl 73; MURRA 205;
 SEY pl 38A; SIN 248;
 STA 72; WB-17:201
--Tambourine Playing Children
 SEY pl 38B
--Trumpeters
 ENC 769

Nativity, relief terracotta;
22-1/4x18-7/8
USNKP 408 UDCN (A-162)
Orpheus Playing to the
Animals, Campanile relief
1437/39
BUSR 40 IFC
Peasant Reaping Corn, roundel
c 1440 terracotta,
enamelled blue and white
BURC pl 83 ELV
The Philosophers, panel
BROWF-3:14 IFC
Prudence, tondo with fruit and
foliage frame ceramic
FAUL 213 UNNMM
The Resurrection, lunette
1442/45 enamelled terra-
cotta; 200x260 cm
BODE 79; POPR pl 44;
SEY pl 57 IFCO
St. Luke with the Bull, tondo
pendentive glazed terra-
cotta
MCCA 69 IFPC
St. Mathias, tondo c 1440/50
MONT 142 IFPC
Singing Boy, head, plaque
marble
CLE 79 UOClA (31.454)
Stemma of the Arte de' Medici
e Speziali 1455/65
enamelled terracotta; Dm:
180 cm
POPR pl 48 IFO
Tabernacle 1442 marble and
colored glazed terracotta
BODE 76; POPR fig 39;
SEY pl 58 IPerCh
Trumpeters, relief, sketch
for Cantoria
MACL 86 ELV
Virgin Amidst Adoring Angels,
lunette glazed terracotta;
32-5/8x60-5/8
BERL pl 198-99 GBSc
(2967)
Virgin and Child
RAY 38 UNNMM
--faience
PRAEG 310
--terracotta, enamelled
BAZINH 209; BAZINW 337
(col) IFBar
--medallion c 1455/60 terra-
cotta, polychrome glaze;
Dm: 1.8 m
CHAS 65 (col) IFO

--tondo 15th c. glazed terra-
cotta
CHENSN 347; CHENSW
382 UPPPM
Virgin with the Apple (Madonna
mit dem Apfel), half
figure 1450 ceramic, with
color and gilt; 58x44 cm
BSC pl 80 GBS (M 6)
The Visitation c 1455 white
glazed terracotta
BODE 112; MACL 91;
SEY pl 75B IPiF
Young Florentine Lady, tondo
bust c 1470 glazed terra-
cotta
BURC pl 47 IFMN
ROBBIA, Luca della and Andrea
della ROBBIA
Three Guild Emblems:
Physicians and Apothe-
caries; Masons and
Carpenters; Silk Manu-
facturers 1455/65 glazed
terracotta
HALE 76 IFO
ROBBIA, Luca della, and
MICHELOZZO
Altar of the Holy Cross, with
St. John the Baptist and
St. Ambrose glazed clay
BODE 89 IFMo
ROBBIA FAMILY--FOLL
Prudence, tondo with garland
frame
RAY 38 UNNMM
Savonarola, profile bust
c 1496
MU 143
St. Matthew, tondo c 1490
glazed terracotta
SEY pl 150A IPrMC
Robert, Lord Hungerford
English--15th c. Robert,
Lord Hungerford, effigy
Robert of Anjou (Duke of Anjou and
King of Naples 1275-1343)
Giovarni da Firenze, and
Pacio da Firenze. King
Robert of Anjou Monument
Robert II of Artois d 1317
Huy, J. P. Robert of Artois,
effigy
ROBERTO, and NICODEMO OF
GUARDIAGRELE
Pulpit, details: Salome Dancing;
Samson and Lion c 1150
DECR pl 208 IMagM

ROBERTS-JONES, Ivor (Welsh 1916-)
 Blind Man 1960 plaster; 60
 ARTS #53
 Dorothy 1957 bronze; 14
 ARTS #50 -EB1
 Free Standing Relief 1960
 plaster; L: 24
 ARTS #55
 Head of Young Girl 1960
 plaster; 14
 ARTS #54
 Kite Rider 1960 plaster; 27
 ARTS #52
 Kyfflin Williams, head 1959
 bronze; 16
 ARTS #51 WCaN
 Paul Claudel, head 1956/59
 bronze; 10-1/4
 MILLS pl 21; ROTJB pl
 128 ELT
 Richard Rhys 1961 plaster;
 18
 ARTS #58 -ERh
 Scapegoat 1961 plaster; 68
 ARTS #56
 Sleeping Girl 1961 plaster;
 L: 36
 ARTS #57
 Smiling Woman 1956 plaster;
 52 ARTS #49
 Winged Figure with Bird 1946
 terracotta; 12
 NEWTEB pl 49
Robeson, Paul
 Epstein. Paul Robeson, head
Robinson, W.
 Chantrey. Children of Rev.
 W. Robinson Monuments
ROCCAMONTE, Amelio (Italian
 1927-)
 L'Incontro
 DIV 84
ROCCATAGLIATA, Niccolo (Italian
 fl 1593-1636)
 Altar Frontal
 POPRB fig 136 IVMoi
 Bacchus early 17th c. bronze;
 17
 MOLE 169 ELV
 St. Stephen bronze; 60.1 cm
 POPRB pl 133 IVGM
Roch, Saint
 English--16th c. Croft Monu-
 ment: St. Roch
 German--18th c. St. Roch
 Giuliani. St. Roch
 Vittoria, A. Altar of the
 Luganeghieri: St. Roch;
 St. Sebastian

ROCHE, Pierre (French 1855-1922)
 Loie Fuller c 1900 bronze;
 21-5/8
 SCHMU pl 169; SELZPN 64
 FPDec
 Monument to Dalou
 TAFTM 35
Rochefort, Henri (French Journalist
 and Playwright 1830-1913)
 Rodin. Henri Rochefort,
 bust
Rochejacquelin, Henri de la
 Falguiere. Henri de la
 Rochejacquelin
ROCHET, L., and C. ROCHET
 King William I, equest
 bronze
 MARY pl 131 FFa
Rock. Alley
Rock Drawings
 Norwegian--1st c. Rock
 Drawing
Rock Drill. Epstein
Rock Form (Porthcurno). Hepworth
Rock Formed by a Human Hand. Arp
Rocker, No. 10
 Tinguely. Bascule, No. 10
Rockingham, Lewis, Earl of
 Scheemakers, P., and L.
 Delvaux. Monument to
 Lewis, Earl of Rockingham
Rockingham, 2nd Marquess of
 Nollekens. 2nd Marquess of
 Rockingham, bust
Rockingham Ware
 English--19th c. Rockingham
 Ornaments
 --Rockingham Toby Jug
Rocks and Clouds. Cimiotti
RODAVI, Tomaso
 Cathedral Facade, detail
 1463/86 marble decorations;
 central H: 38.7 m
 CHAS 207 IComC
RODCHENKO, Alexander (Russian
 1891-1956)
 Construction 1917 (destroyed)
 READCON 89
 --1921 metal
 GIE 170; MCCUR 264;
 NMAC pl 131 RuM
 Construction of Distance 1920
 wood
 GRAYR pl 175; READCON
 92
 Hanging Construction 1920 wood
 GRAYR pl 176; NMAC pl
 130; READCON
 93

RODERIGO THE GERMAN See PETIT
 JUAN
RODIN, Auguste (French 1840-1917)
 Adam (The Creation of Man)
 TAFTM 5
 --
 DIV 7; NM-11:67 UNNMM
 --bronze; 78
 CHICS; WB-17;202 UICA
 --1880 bronze; 1.98x. 76x. 84 m
 TOKC S-1 JTNMW
 Aesclapius (Esculape) bronze;
 .40x.40x.22 m
 TOKC S-17 JTNMW
 Age of Bronze (L'Age d'Airain;
 Bronze Age; The Con-
 quered; Man Awakening to
 Nature)--male nude
 TAFTM 4
 --
 RAY 57 UNNMM
 --bronze
 CLE 175 UOClA (18.328)
 --bronze; 71-1/2
 CPL 77; SUNA 175
 UCSFCP (1940.141)
 --1875/77 bronze; 71-1/4
 AUES pl 32; BOW 13;
 ENC 771; MYBS 56;
 READCON 13; ROTJG pl
 5; TATEF pl 46f ELT
 (6046)
 --plaster modelled 1875/77
 (cast 1911) bronze; 72
 ALB 147; FAIY 6 UNBuA
 --1876 bronze
 SELZJ 102 FPR
 --1876 bronze; 22
 PUL-2:pl 125
 --1876 bronze; 72
 READAS pl 187 UDCN
 --1876 bronze; 180 cm
 LIC pl 116 UMnMI
 --1876 bronze; 181x70x66 cm
 TOKC S-2 JTMNW
 --1876 (cast 1880) bronze;
 70-1/2
 CAN-2:191 CON
 --1876/77 bronze; 68-1/2
 NEWTEM pl 153
 --1876/80 bronze; 74
 MID pl 1 BAM
 --1877/80 bronze; 71
 CHAR-2:322-24 FPL
 --c 1900 bronze; 41x14x8-
 5/8
 CHRP 375; SEYM 168;
 SEYT 26 UDCN

Apollo and Python, relief
 AGARC 16 ArB
 Arthur Jerome Eddy, bust
 1898 bronze; 18-3/4
 HAMP pl 16A FPR
 Balzac (Monument to Balzac)
 CHENSP 263; TAFTM 14
 --detail
 WILM 20
 --
 GAF 136 FP
 --
 SEITC 173 IsJR
 --plaster
 MARY pl 74 FPR
 --1891/98
 BERCK 17
 --c 1893 bronze; 50-1/4
 SOTH-4:75
 --1897 bronze; 114
 EXS 107 FPR
 --1897 bronze; 275x92 cm
 LIC pl 130; MCCUR 149;
 UPJH pl 202 UNNMMA
 --1897 plaster
 CHENSW 472 FMeR
 --1897 plaster; 113-3/4
 NEWTEM pl 155; READCON
 17 FPR
 --1897 plaster; 118
 CHENSN 644; JANSH 502;
 JANSK 970; MYBA 598;
 UPJ 517 FPR
 --1897/98 bronze; 280x124x
 124 cm
 CAS pl 117 FMeR
 --1897/98 bronze; 107
 MID pl 2 BAM
 --1898
 GAUN pl 55 FPR
 --1898 bronze
 MAI 257
 --1898 bronze
 WATT 175 FPMont
 --1898 bronze; 118
 BOW 17 FPR
 --1898 plaster
 GERT 47
 --1898 bronze; 107/111
 GIE 8; HAMP pl 19;
 MARC pl 2 (col) FPRasp
 --next to last version 1896
 CANK 71 FPR
 --final version 1898 bronze
 CANK 164
 --studies 1892/96
 CANK 165
 --study c 1893 bronze; 49-1/2
 RIT 54, 55 UNNS

--study 1893 bronze
SELZJ 91 FPR
--study 1897 bronze; 30
CANM 402 UPPeI
Balzac, bust
BROWF-3:82 ELV
Balzac, figure looking to
his left 1898 bronze
SELZJ 35 (col) FPR
Balzac, figure looking up
bronze
SELZJ dust jacket
Balzac, head c 1891 bronze;
16-3/8 (excl base)
TATEF pl 47g ELT (6055)
--c 1892 bronze; 12-1/4
(excl base)
TATEF pl 46b ELT (4589)
--1893 bronze; 6-7/16x
7-1/2
READAS pl 190 UDCN
--c 1895 terracotta; 9-1/4
NM-8:47 UNNMM (12.11.1)
--1897 bronze; 7
YAP 226 -UHam
--20th c. clay; over LS
ELIS 37 UNNMM
--3 versions terracotta study;
bronze
HOF 140 FPR; UNNMM
Bastien-Lepage
TAFTM 10 FDa
The Bather marble
PUT 309
Baudelaire, head 1898 plaster;
7-7/8
MCCUR 248 FPR
La Belle Heaulmiere (Celle
qui Fut La Belle Heaul-
miere; The Old Courtesan;
La Vieille Heaulmiere)
WILM 28
--c 1885 cast bronze; 50x25x
30 cm
ELIS 102; LIC pl 118;
119 UNNMM
--back view
ELIS 103
--1888 bronze; 20
CLAK 344; MARY pl 75;
RAMS pl 28 FPR
--1888 bronze; 50x31x24 cm
TOKC S-5 JTNMW
Bellona (Bellone) 1881 bronze;
83x52x41 m
TOKC S-6 JTNMW
Benedict XV, head (Buste de
Benoit XV) 1951 bronze; 9-
1/2x9-3/4 SELZS 79 UPPR

--1951 bronze; 23x19x26 cm
TOKC S-7 JTNMW
Bernard Shaw, head
INTA-2:121
Beside the Sea marble; 59 cm
BR pl 13; CRAVR 194;
LIC pl 132 UNNMM
Brother and Sister
TAFTM 21
--(Frere et Soeur) 1887
bronze; 40x22x20 cm
TOKC S-21 JTNMW
Burghers of Calais (Bogerne
fra Calais; Les Bourgeois
de Calais; Citizens of
Calais), monument com-
memorating heroism of
Eustace de Pierre
BURN 24; JAG 71; SCHN
5
--
HOW UCSFCP
--1884/86 bronze
LARM 190
--1884/86 bronze
MU 226; SELZJ 104 FPR
--1884/86 bronze
MARY pl 25; WHITT 144;
WCO-1:59 (col), 58-9 ELVT
--1884/86 bronze; 82x94x75
ENC 771; GAF 19; GARDH
753; NATSE; NEWTEM pl
154; RICH 118; STI 707 FCa
--1884/88
PRAEG 398
--1884/88 bronze; 2.3x2.2 m
TOKC S-8 JTNMW
--c 1884/88 bronze; 84
EXM 242; SLOB 240 UPPR
--1885/95 bronze; 300x750x
150 cm
LIC pl 127, 129; MCCUR
249 SwBKM
--1886 bronze; 82
RAMS pl 30-31
--detail
FRY 9; TAFTM 11, 14
--detail 1884/95 bronze;
214x233x178 cm
COPGM 135 DCN (I.N.608)
--detail 1885
GERT 46
--figure cast
RAD 467 UICA
--hands
MILLS pl 13, 14
--plinth detail
BURN 26 UPPR

--replica 1915 bronze; granite
pedestal
GLE 96 ELWeP
--study 1884/86 plaster
COL-20:536
--study for monument at
Calais, 1895 1884/86
plaster
LIC pl 128; ROTHS 227;
WATT 129 FPR
--detail
BAZINH 375
--study: Head terracotta
PANA-1:74 UMdHW
Call to Arms
FAIN 116 UMCF
Camille Claudet, bust 1884
bronze; .20x.15x.13 m
TOKC S-9 JTNMW
--head plaster
HOF 141
Caryatid
TAFTM 9
--terracotta
HOF 288 UNNMM
--(Cariatide Tombee a la
Pierre) bronze; .44x.32x
.30 m
TOKC S-10 JTNMW
The Cathedral (Hands) 1908
stone
SELZJ 114 FPR
The Centauress
TAFTM 21
A Child of the Century
TAFTM 21
Children Embracing (Enfants
S'Embrassant) 1883
marble; .44x.26x.26 m
TOKCS-15 JTNMW
Child's Dream
TAFTM 9
Christ et Madeleine white
marble; 44-1/2
SOTH-2:73
Claude Lorrain Monument
bronze and stone
MARY pl 63 FNan
Clemenceau, bust 1911
bronze; 46x28x28 cm
LIC pl 131; SELZJ 115
FPR
Clementel, bust 1916 bronze;
57x58x28 cm
TOKC S-11 JTNMW
Constellation 1902 bronze;
73x45x28 cm
TOKC S-12 JTNMW

Crouching Woman (Femme
Accroupie; La Luxure)
1882 bronze; 9-1/4
DETS 23 UNNH
--1882 bronze; 33-1/2
MARC 7; MCCUR 248;
NEWTEA 220 FPR
--1882 bronze; 95 cm
JOO 179 (col) NOK
--1882 bronze; 96x68x55 cm
TOKC S-20 JTNMW
--c 1891 bronze; 20-7/8
BOW 19; TATEF pl 47e
ELT (6053)
The Crying Girl bronze;
11-3/4
YAP 226 -UC
Cupid and Psyche (L'Amour et
Psyche) c 1893 marble
MU 226 FPL
--c 1908 marble; 26
TATEF pl 48e ELT (6061)
Cybele (Torde de Femme)
c 1904/05 bronze; 64
ROTJG pl 7; TATEF pl
46h ELT (6048)
Danaid 1885 marble
SELZJ 36 (col) FPR
--1885 marble; 13-5/8x18-
3/4
NEWTEM pl 156 FPR
--1885 marble; 13-3/4x
28-1/2
RAMS pl 19b FPLu
Danaide
TAFTM 15
--marble
MILLER il 177
--1885 marble; 12-3/4x
28-3/4
SCHMU pl 127 FPR
--1885 marble; 35x63x80 cm
COPGM 137 DCN (I.N.1811)
Danaides
GLA pl 45
Dante, mask 1908 terracotta;
7-1/2
TATEF pl 48f ELT (6062)
Death of Adonis (La Mord
d'Adonis; Adonis Død)
c 1893 plaster; 13x24 cm
COPGM 139 DCN
(I.N. 2608)
La Defense 1878 bronze; 109
cm
LIC col pl 3 (col); STA 85
FPR

--1912/19 bronze; 216x124x
 85 cm
 TOKC S-13 JTNMW
--study 1878 bronze; 45
 RIT 51 UNNR
Despair stone
 CHENSS 704; CHENSW
 471 UMoSL
--(La Desespoir) 1890
 plaster; 11
 TATEF pl 49a ELT (T.78)
The Dream
 TAFTM 19
Duse, a study
 TAFTM 20
La Duchesse de Choiseul,
 bust 1908 bronze; 14-3/8
 (excl base)
 TATEF pl 48a ELT (6057)
--1908 bronze; 13-3/8
 TATEF pl 48b ELT (6058)
Earth and the Moon
 TAFTM 22
The Embrace
 TAFTM 20
L'Emprise
 TAFTM 23
Erect Faun (Faunesse Debout)
 1884 bronze; 60x26x23 cm
 TOKC S-19 JTNMW
The Eternal Idol
 TAFTM 23
--plaster sketch; marble;
 bronze
 HOF 123 FPR
--1897 plaster
 MARC 5 FPR
Eternal Spring (Eternal
 Springtime; L'Eternal
 Printemps) 1884
 marble
 ROTHS 225 UNNMM
--1898 bronze; 65x71x38 cm
 TOKC S-16 JTNMW
--c 1900 marble; 30
 BOW 112 RuLH
Eve (Eva)
 TAFTM 5
--bronze; 68-1/2
 DETT 213 UMiD (53.145)
--bronze; 174x67x77 cm
 TOKC S-18 JTNMW
--1881
 ROOS 201H FPR
--1881 kalksten
 COPGM 141 DCN (I.N.
 1380)

--1913 bronze; 68
 ALBA; TOW 38 UNBuA
The Fallen Angel (L'Ange
 Dechu) 1895 bronze;
 19-7/8
 RAMS pl 29; TATEF pl 47b
 ELT (6050)
The Fallen Caryatid, figure
 for Gates of Hell
 FAIY 194 UNEE
The Fallen Caryatid Carrying
 her Stone (La Cariatide
 Tombee Portant sa Pierre)
 c 1880/81 bronze; 16-3/4
 TATEF pl 46d ELT (5955)
Falquiere, head 1895 bronze
 HUX 72; SELZJ 95
Female Torso 1889 bronze;
 19-3/4
 YAP 227 -UBa
Figure of a Woman bronze
 MILLS pl 11 ELT
--maquette plaster
 MILLS pl 9 ELT
France c 1907/08 bronze;
 25-1/4
 TATEF pl 47d ELT (6052)
Fugit Amor 1882 bronze
 SELZJ 149 FPR
--1887 bronze; 36x45x20 cm
 TOKC S-22 JTNMW
Funeral Genius (Genie
 Funeraire), head 1900
 bronze; 22x13x13 cm
 TOKC S-23 JTNMW
Gate of Hell (La Porte de
 l'Enfer), detail
 ENC 771
--detail: Three Figures
 TAFTM 18
--detail begun 1880
 ST 411 SwZK
--1880 bronze; 18x12
 CANM 209; LIC pl 120-22
--petite maquette 1880
 terracotta; 115x62x19 cm
 TOKC S-46 JTNMW
--1880-1917 bronze; 20'10'x
 13'1-1/4'x33-1/2''
 CAS pl 56; HAMP pl 18;
 HOF 310; MCCUR 249;
 MARY pl 85; RIT 49;
 SELZJ 112, FPR
--1880-1917 bronze; 540x390
 x100 cm
 TOKC S-45 JTNMW
Geffroy, bust 1905 bronze; 45x

45x26 cm
TOKC S-24 JTNMW
General Lynch Monument,
equest 1886 bronze; 41x
25x17 cm
TOKC S-32 JTNMW
Genius of War
TAFTM 5
George Wyndham, bust 1904
bronze; 16-1/2 (excl base)
TATEF pl 48c ELT (6059)
Grand Main Crispee c 1884/
86 bronze; 18-1/4
SOTH-4: 77
Group
TAFTM 23
Hanako 1908 bronze; 6-1/4
COOPC pl 85 ELCo (#228)
--head bronze
CHENSW 470 UCSFCP
--head bronze; 17x13x14 cm
TOKC S-26 JTNMW
--mask bronze oxide
HAM NOK
--mask 1906 bronze; 28x12x
13 cm
TOKC S-25 JTNMW
The Hand of God
EA 469; TAFTM 22
--marble
PUT 337
--plaster
SEYT 18 UDCN
--1898 marble
RAMT pl 25; SEYT 18 FPR
--1902 bronze; 26-3/4
CANM 208 UPPR
--1902 marble; 29
BALD 145; FLEM 687;
RAY 57 UNNMM
Head (Tete) bronze
MARY pl 17 ELV
--c 1908 bronze; 23-1/4
TATEF pl 47f ELT (6054)
Head of Grief (La Douleur;
Head of Pain; Head of
Sorrow; Suffering; Tete
de Douleur) bronze;
18x9x9 cm
TOKC S-14 JTNMW
--1882 bronze
CHENSW 471 UCtY
--1882 bronze; 9-1/4
LARM ht (col); LYN 30;
MAI 255; MARC pl 1;
SELZJ 98 FPR
Henri Rochefort, bust
CHASEH 451; POST-2:153
FPLu

--1891 bronze; 75x43x45 cm
TOKC S-48 JTNMW
I Am Beautiful (Je Suis Belle)
HOF 176
--1882 bronze; 70x32x35 cm
TOKC S-28 JTNMW
Interlacing Bacchantes
(Bacchantes S'Enlacant)
1910 bronze; 18x16x12 cm
TOKC S-3 JTNMW
Iris, Messenger of the Gods
1890/91 bronze; 33x34
DETS 22; LIC pl 124;
READCON 31 UNNH
--large head 1891 bronze;
24x14
GIE 11; SELZJ 108 FPR
Jacques de Wiessant, head
1884/86 bronze
SELZJ 99 FPR
Jean D'Aire, head--one of
Burghers of Calais terra-
cotta on marble; 15-1/2
TORA 35 CTA (900)
Jean Paul Laurens, bust
TAFTM 8
--bronze
MILLER il 180 FPLu
--1882 bronze; 58 cm
COPGM 133 DCN (I.N.1342)
--1881 bronze; 60x40x33 cm
TOKC S-30 JTNMW
Joseph Pulitzer, bust 1907
bronze; 19-1/2
PUL-1: pl 57
--1907 marble; 19-1/2
PUL-2: pl 128
The Juggler (Le Jongleur)
1909 glazed clay; 16
GIE 9; MCCUR 248; RIT
50 FPR
Jules Dalou, bust
TAFTM 8
--bronze
MARY pl 77 FP
--1883 bronze
GOMB 400; SELZJ 95 FPR
--1883 bronze; LS
JANSK 967 FPL
--1883 bronze; 51 cm
COPG 100 DCN
(721; I.N. 1545)
The Kiss (Le Baiser)
CHENSP 257; INTA-2:
120; TAFTM 18
--
SUNA 174 UCSFCP
--
BR pl 13 UNNMM

--marble
 MILLER il 184
--marble
 MARY pl 34 FPL
--1886
 ENC 56
--1886 marble; 72
 CANM 208 UPPR
--1886 bronze; 87x51x55 cm
 TOKC S-4 JTNMW
--1886/98 marble; over LS
 AUES pl 33; CHENSW 7;
 FLEM 688; JANSH 502;
 JANSK 969; MAI 258;
 POST-2:153; ROBB 399;
 ROOS 201i; SELZJ 114;
 WATT 130 FPR
--1898 H: 72
 CHASEH 450; CHENSN
 643; UPJ 516 FPLu
--(Third Version) 1904
 Pentelic marble; 71-3/4
 x48x60-1/2
 BOW 18; ROTJT 21; MYBS
 58; TATEF pl 14; WHITT
 55 ELT (6228)
Labor Monument, project
 1897 plaster
 GIE 166 FMeR
Lord Howard de Walden, bust
 1906/06 bronze; 21-1/2
 TATEF pl 46c ELT (5034)
Love Flies
 TAFTM 19
Madame Goloubeff
 HUX 73 FPR
Mme Rodin, bust bronze
 CLE 175 UOC1A (46.351)
Mme Vicunha, bust
 TAFTM 9
Mahler, head bronze
 CHENSW 470 UPPR
Man and His Thought c 1900
 marble; 29-7/8
 BERL pl 246; BERLES
 246 GBSBe (B 158)
Man with the Broken Nose
 (L'Homme au Nez Casse)
 TAFTM 4
--1864 bronze
 KUHB 22
--1864 bronze; 9-1/2
 NOV pl 192 FPL
--1864 bronze; 9-1/2
 JANSH 500 UPPPM
--1864 bronze; 24x22x27 cm
 LIC pl 114; SELZJ 94
 FPR

--1864 bronze; 27x20x22 cm
 TOKC S-27 JTNMW
The Martyr 1885 bronze
 SELZJ 99 FPR
Meditation 1885 bronze; 155x
 72x65 cm
 TOKC S-33 JTNMW
-- (Half-figure of a Woman)
 1910 bronze; 29-1/4
 JLAT 43 UCSFCP
Metamorphosis of Ovid
 (Les Metamorphoses D'Ovide;
 Two Female Figures)
 TAFTM 18
--c 1886 plaster; 13-1/4
 TATEF pl 49b ELT (T.79)
--
 ASHS pl 37 ELV
Miss Eve Fairfax, 1902/03
 bronze; 17-1/4
 TAFTM 20; TATEF pl 47h
 ELT (6056)
Mrs. Charles Hunter, bust
 1906 marble; 34-3/4
 TATEF pl 46a ELT (4116)
Mrs. Russell, bust 1889 bronze;
 43x20x24 cm
 TOKC S-50 JTNMW
Mourning
 CHRC fig 242 UDCN
Mouvement de Danse (Dance
 Movement) plaster
 SEYT 29 FPR
--c 1911 H: 14
 SEITC 64 -UDel
Mouvement de Danse A bronze;
 12-1/2
 SOTH-3: 75
Movement--study 1911 terra-
 cotta
 MAI 258 FPR
The Muse bronze
 MARY pl 34 FP
--c 1896 bronze; 57
 MOLE 267; ROTJG pl 4;
 TATEF pl 47a ELT (6049)
Nereides 1888 bronze; 43x47x
 35 cm
 TOKC S-35 JTNMW
A Night in May
 TAFTM 21
Nijinski, study c 1911 bronze;
 18x6x9 cm
 CAS pl 176 FPR
Oceanides c 1900 bronze;
 53x84x55 cm
 TOKC S-36
 JTNMW

--1905 marble; 22
 BAZINW 424 (col) FPR
Octave Mirbeau 1889 bronze;
 28x19x23 cm
 TOKC S-34 JTNMW
L'Ombre (Skyggen) 1881/82
 bronze; 192 cm
 COPGM 2 DCN (I. N.
 2749)
Orpheus 1892 bronze; 146x80x
 126 cm
 TOKC S-37 JTNMW
Orpheus and Eurydice
 EA 468
--
 AGARC 128; RAY 57
 UNNMM
Orpheus and Maenads before
 1889 bronze; 81x50x40 cm
 TOKC S-38 JTNMW
Paolo Malatesta and
 Francesca da Rimini in the
 Clouds 1905 marble
 SELZJ 105 FPR
Le Pas de Deux c 1910/13
 bronze; 33x19x13 cm
 LIC pl 126 FPR
La Pensee (Thought)
 marble
 MILLER il 178; TAFTM 9
--marble
 MARY pl 159 FP
--marble
 HOF 141 FPLu
--marble
 CASSM 48 FPR
Pere Pierre Julien Eymard,
 bust 1863 bronze; 60x28
 x 29 cm
 TOKC S-41 JTNMW
Pierre de Wiesant--Burghers
 of Calais study 1884/86
 bronze; 79
 KO pl 100 GHK
La Poete et la Muse marble
 STI 708 FPR
Polyphemus 1888 bronze;
 9-3/4x5-1/2x6-1/4
 LYN 67 FPR
Les Premieres Funerailles
 (La Purgatoire; La Tombee
 d'une Ame dans les
 Limbes) c 1900 bronze; 24
 BOSMI 163 UMB (60.958)
President Sarmiento
 TAFTM 10
Prodigal Son c 1885 bronze;
 137 cm LIP pl 125 UOOC

--c 1885/87 bronze; 54-3/8
 RAMT pl 26; TATEF pl 46g
 ELT (6047)
--before 1889 bronze; 54-3/4
 MARY pl 140; READAS pl
 189; TAYJ 10 FPR
Prometheus and Sea Nymph
 TAFTM 22
Purgatory 1900
 MOHN 44
Puvis de Chavannes 1895
 bronze
 LARM 190 FPR
--bust
 TAFTM 8
--bust bronze
 DIV 33 UNNMM
--bust 1891 bronze; 51x50x
 32 cm
 TOKC S-47 JTNMW
--head 1910 marble; 29-5/8
 MCCUR 248 FPR
Rodin's Father (Sculptor's
 Father), bust 1860 bronze
 SLOB 240
--1860 bronze; 41x30x20 cm
 TOKC S-49 JTNMW
Romeo and Juliet 1902 bronze
 LARM 152; TAFTM 20 FPR
Rose Bueret, head 1876
 plaster; 40 cm
 LIC pl 115 FPR
St. John the Baptist
 TAFTM 4
--
 MARQ 265 FPLu
--
 RAY 57 ELV
--bronze; 79
 CPL 77; SPA 200; SUNA
 175 UCSFCP (1940.140)
--1878
 ROOS 201g
--1878 bronze; 19-3/4
 CAMI pl 99 CMB
St. John the Baptist, head
 marble; 25x42x45 cm
 TOKC S-51 JTNMW
St. John the Baptist Preach-
 ing (St. Jean-Baptiste
 Prechante) 1876 bronze;
 200 cm
 LIC pl 117; RUS 141;
 VALE 37 UNNMMA
--1878 bronze; 79x21-3/4x38-
 3/4 CHENSW 468; LYN 67;
 MCCL pl 48; READAS pl
 188 FPR

--1878-80 bronze; 80-1/2
 RIT 53 UMoSL
--1878 bronze; 201x58x
 127 cm
 TOKC S-52 JTNMW
--1879/80 bronze; 78-3/4
 BOW 14; ENC 771;
 ROTJG pl 3; ROTJT 22;
 TATEF pl 46e ELT
 (6045)
Sappho
 TAFTM 22
Sarmiento Monument:
 Apollo
 TAFTM 10
The Shades, Weill Memorial
 REED 134 UCSFLi
The Shadow
 GAF 158 FPR
Siron on a Pillar, detail
 c 1900 bronze; 35-3/4
 TATEF pl 48g ELT
 (6070)
The Sirens 1889 bronze; 17
 SELZPN 72 UOClA
Small Torso (Petit Torse
 d'Homme) bronze; 28x
 20x12 cm
 TOKC S-43 JTNMW
La Source
 TAFTM 23
Springtime
 TAFTM 15
The Thinker (Le Penseur)
 CHENSA 96; CRAVR
 196; EA 462; PERR 171;
 TAFTM 14; VEN-7:pl 31
--
 DAN 161 UPPPM
--bronze
 CPL 73; REED 157
 UCSFCP
--bronze; 28-1/2
 YAP 224 UNNCl
--bronze; 78
 BMA 57 UMdBM
--1880 bronze
 CHENSW 469 FMeR
--1880 bronze; half LS:
 71x45x68 cm
 TOKC S-39 JTNMW
--1879-89 bronze; 27-1/2
 GARDH 7; JANSH 501;
 JANSK 968; RAY 56
 UNNMM
--1880-89 bronze
 BAZINW 423 (col); ENC
 878; LARM 190; ROOS
 201j; SELZJ 101 FPR

--1894
 ENC 878 FPL
--1904 bronze; 186x102x
 144 cm
 TOKC S-40 JTNMW
Thomas F. Ryan, bust 1909
 bronze; 24-1/8
 TATEF pl 48d ELT (6060)
Three Dancers (Les Trois
 Danseuse) 1882 bronze;
 14x30x15 cm
 TOKC S-42 JTNMW
Three Shades
 CLAK 272 FPR
Three Sirens 1889 marble
 LARM 178 DCN
Toilet of Venus (La Toilette
 de Venus) bronze; 47x27
 x21 cm
 TOKC S-53 JTNMW
Torso 1914 bronze; 21-1/4
 x24-1/2
 GIE 10; TATEF pl 47C
 ELT (6051)
Torso of a Woman 1909
 bronze; 39-1/4
 SELZS 61 UNNSl
Torso of a Young Woman
 1909 bronze
 SCHAEF pl 2
Torso of Adele c 1882
 bronze; L: 16-3/4
 HAMP pl 17 UMnMD
--1882 plaster; 15x47x
 25 cm
 LIC pl 123; MAI 255;
 SELZJ 109 FPR
Victor Hugo, detail
 PRAEG 14
--bust
 TAFTM 8
--bust marble
 MILLER il 179 FPR
--1883 marble; 21-3/4
 UMCF UMCF (1943.1033)
Victor Hugo at Guernsey
 1897 marble
 ROTHS 223 FPRoyG
Victor Hugo Monument,
 study
 TAFTM 11
Ugolino
 TAFTM 5
Walking Man (L'Homme qui
 Marche; Man Walking)
 GAF 431 FLM
--bronze
 MILLS pl 12 FPR

--bronze
 SEYT 46 UDCN
--bronze
 ZOR UNNMM
--1877 plaster; 76-5/8
 RIT 52 FPR
--1877/1900 bronze; 33-1/4
 BOW 15 -EM
--1888 bronze
 SELZJ 111 FPR
--1897 bronze; 35
 YAP 225 -UG
--1905 bronze; 83-3/4
 SELZS 24 UNNMat
--study for St. John the
 Baptist 1877 bronze
 LARM 255 FPR
Weeping Lion (Le Lion qui
 Pleure) 1881 plaster;
 29x34x16 cm
 TOKC S-31 JTNMW
Weeping Woman (La
 Pleureuse) marble; 50x
 42x17 cm
 TOKC S-44 JTNMW
William E. Henley, head
 1883 bronze
 CLE 175 UOC1A (50.581)
Young Girl
 TAFTM 4
Young Girl with Flowers in
 her Hair (Jeune Fille
 avec Fleurs dans les
 Cheveux), bust bronze;
 50x35x26 cm
 TOKC S-29 JTNMW
The Young Mother (La Jeune
 Mere) bronze; 15-1/4
 MIUH pl 38 UMiAUA
--1885 plaster; 14-1/4
 TATEF pl 48h ELT (T.77)
 Portraits
Bourdelle. Rodin, bust
Bourdelle. Rodin at Work
Bourdelle. Rodin Working on
 "The Gate of Hell"
Puvis de Chavannes. Auguste
 Rodin, version of head
Rodney, Anne d 1651
 English--17th c. Anne
 Rodney Monument
Rodney, Lord d 1792
 Rossi, J. C. F. Lord
 Rodney Monument
RODO See NIEDERHAUSERN, A.
RODOLFO and BINELLO
 Emperor Frederick I; Fight-
 ing Dragons, relief
 1201 DECR pl 91 IFoF

RODRIGUEZ, Lorenzo (Spanish
 c 1704-74)
 Facade 1749
 KUBS pl 36 MeMS
Rods on Round Background. Bury
RODT, Dietrich von (German)
 Glass (Humpen) Holder c 1620
 SOTH-4:222
ROEDER, Emy (German 1890-)
 The Friends (Freundinnen)
 1930 bronze
 GERT 96
 Hans Purrmann, head 1950
 bronze; 26 cm
 GERT 94; MAI 258; OST
 52; SCHAEF pl 51 GMaM
 Kinderhopfe 1928
 Kunststein; 32 cm
 HENT 111 GBN
 "Lysistrata", relief--design
 for Peace Memorial
 1951/52 bronze
 GERT 95
 Madchen Kopf 1932 Kunstein
 HENT 110
 Schwangere 1919 wood; 78 cm
 OST 53
 Self Portrait, head 1958
 bronze; LS
 TRI 125
 Two Goats Resting 1948
 bronze; W: 10-1/2
 RAMS pl 58b; SCHAEF
 pl 50
 Young Woman Carrying a
 Basket (Junge Korbtragerin)
 1940 bronze; 17
 GERT 96; SCHAEF pl 49
Roentgen, Wilhelm (German 1845-
 1923)
 Breker. Rontgendenkmal
ROESNER-DRENHAUS, Christa
 (German 1926-)
 Im Viereck 1957 aluminum;
 30x30 cm
 KUL pl 17
ROETTIER, John
 Medal: Duchess of Richmond
 c 1667 silver: Dm: 2-3/4
 NATP pl 31J ELNP
ROETTIERS, Charles Norbert
 (French)
 Louis XV, obverse of Com-
 memorative Medal of
 Union of Corsica with
 France
 LARR 391
 FPMe

ROETTIERS, Jacques Nicolas(French
1707-84)
Soup Tureen 1770/71 silver;
14; Dm: 19
CHAR-2:241 FPL
ROGER-BLOCHE, Paul (French)
L'Accident
TAFTM 42
L'Enfant
TAFTM 42
Le Froid stone
MARY pl 70; TAFTM 42
FPLu
ROGER OF MELFI
Lion's Head, with ornamental
Kufic script, door detail
c 1100
DECR pl 201 ICanP
ROGER VON HELMARSHAUSEN
(Rogker von Helmwardeshusen)
Abdinghof Altar; side detail:
Scene from Life of St.
Paul
LOH 64 GPF
Portable Altar of St. Kilian
and St. Liborius, com-
missioned by Bishop
Heinrich von Werl c 1100
jeweled silver nielloed;
6-3/4x13-3/4x8-1/4
BECKM 177; KIDS 79;
LOH 64; SWA pl 102 GPC
Smiling Angel, portable
altar detail wood; 2
BUSRO pl 14 GPA
ROGER VON HELMARSHAUSEN--
FOLL
Christ on Cross, Hilde-
sheim(?) c 1130 bronze;
177 mm
SWA pl 105 UMoSL
ROGGE, Helmut (German 1924-)
Coolie (Kuli) 1955 bronze
GERT 252
Ubereinander 1952 bronze;
38
OST 79 GCoW
ROGKER VON HELMWARDESHUSEN
See ROGER VON
HELMARSHAUSEN
Roholfs, Christian
Zschokke. Christian Rohlfs,
head
ROHRBACHER, J. See BULLA,
Giovanni B.
ROIG, Juan (Spanish), and Juan
MATONS

Monumental Candelabrum 1703
H: 99
CIR 192 (col) SpPalmC
Rojas y Sandoval, Cristobal de
(1552-1623)
Arfe y Villafrane, J. de, and
L. del Moral. Cristobal de
Rojas y Sandoval, kneeling
effigy
ROKSANDIC, Simeon (Yugoslav
c 1850-1910)
Boy with an Injured Foot
1911 bronze
BIH 30 YBN
Rolande. Wlerick
ROLDAN, Luis (Spanish 1656-1704)
Virgin of the Macerena late
17th c. ptd wood,
precious stones and
fabrics
MOLE 230 SpS
ROLDAN, Pedro (Spanish 1624-99)
See also Pineda, B. S. de
High Altar of La Caridad,
with Descent from the
Cross 1617 ptd wood
BAZINB 54 SpSCar
--Burial of Christ 1670/73
ptd wood; 122
CIR 113 (col); GOME 27
(col); pl 81-88
--Descent from the Cross
LARR 370
Mater Dolorosa (Maria die
Schmerzenreiche), bust
1670/75 poplar/37 cm
BSC pl 123 GBS (353
Roll-Molding
Baroque--German. Roll
Moulding, architectural
decoration
Roly-poly. Armitage
ROMAGNOLI, Giuseppe (Italian)
Countess Bianconini
Nunziante di Mignano
plaster
VEN-5:pl 21
The Mother plaster
Ven-26:pl 122
Weeper (Il Pianto) plaster
VEN-7:pl 106
Roman Manners. Virgili
A Roman Marriage. Bartoli, P. S.
A Roman Marriage. Rysbrack
ROMANELLI, Romano (Italian 1882-)
Ardengo Soffici, bust
bronze VEN-30:pl 91

The Deposition
 AUM 41
Elisabeta de Piccolellis
 marble
 PAR-2:25
George Washington, equest;
 model bronze
 VEN-34:pl 23
Giovanni Papini, bust 1928
 bronze
 VEN-28:pl 73
Justice of Trajan, relief
 HOF 196 IMJ
Little Girl, bust wax
 VEN-42:pl 12
Maffio Maffu, bust
 HOF 145
Pugilist (Prize Fighter)
 bronze
 CASS 114; VEN-32:pl 26
Seated Woman
 PAR-2:24
ROMANESQUE
Animal Forms, carved pillar,
 Ste. Marie, 12th c.
 BAZINH 134
Apostle: Bartholomew, James,
 Simon, and Judas, choir
 screen c 1070
 BUSRO pl 16, 17 SwBMi
Arch Detail marble; 6-7/8
 BARD-2:pl 190
Charles V, medallion 16th c.
 TAYFF 63 (col) UNNMM
Crucifix Corpus 12th c.
 bronze; 5
 TOW 62 UNBuA
Dead Christ 12th c. gilt
 bronze; 10-3/4
 SOTH-3:256
Galaktotrophusa, so-called
 "Dom Rupert's Madonna"
 c 1180
 BUSRO pl 122 BLCu
Interlaced Animals, capital
 Toulouse limestone
 FAIN 66 UMAmA
Legend of St. Vincent,
 Choir screen c 1070
 BUSRO pl 18 SwBMi
Shrine of St. Maurice
 11th c.
 LARB 310 SwAM
Three Chessmen end 12th c.
 morse ivory; 3
 SOTH-3:260
Virgin, seated figure
 TAYFF 35 (col) UNNMM

Wall Carving
 GLA pl 31
--Danish
Virgin, metal figure, Randers
 Fjord 12th c.
 LARB 233 DCNM
--English
Animal Head, fragment
 BATT 38 ETof
Book Cover: Scenes of Life
 and Miracles of Christ
 8th c. ivory
 MOREYC 91 EOB
Capital: Abstract Animal Face
 BATT 21 EPeC
Capital: Animals in Foliage
 BATT 32 ENorP
Capital: Animals in Foliage
 Scrolls
 BATT 33 EWak
Capital: Curling Foliate
 BATT 31 ET
Capital: Foliate
 BATT 30 ECaC
Capitals, south aisle door
 BATT 34 EDurC
The Eltenberg Reliquary 1180
 copper and bronze gilt,
 champleve enamel and
 walrus ivory carvings
 LARB 311 ELV
Font
 BATT 23 ESh
Font: Bird and Foliage
 BATT 37
Frome Font
 BATT 39 EHerF
Moses
 BATT 82 EYoC
Multiple Cushion Capital
 12th c.
 PRAEG 43 ELinC
Tympanum c 1140
 LARB 299 EK
Tympanum: Beasts Feeding on
 Tree of Life; St. Michael
 Fighting the Dragon, relief
 POST-1:45 EDi
Winged Beast, fragment stone
 BATT 38 EWinC
--French
Animal Tamer, with double
 body, capital, Poitou
 LARB 227
Apocalyptic Christ with Signs
 of Evangelists, and Angels,
 tympanum, Languedoc
 POST-1:36 FMP

Apostles, portal reliefs,
 Church of St. Etienne
 POST-1:21 FTM
Atlas Figure, column support
 LARB 281 FOlM
Book Cover gold, jewelled
 MYBA 251 UNNM
Cain and Abel: God Accept-
 ing Abel's Offering, facade
 Provence
 LARB 308 FStGi
Capital
 BATT 35 FCh
Capital: Animals stone
 CHENSW 321
Capital: Annunciation
 GUIT 33 FChau
Christ, seated figure, Loire
 Valley
 LARB 233 FPla
Christ in Majesty, mandorla-
 shaped plaque 11th c. ivory
 LARB 235 ELV
Christ in Majesty, supported
 by two out-facing angels,
 tympanum, Anzy le Duc,
 Burgundy
 LARB 235 FPaM
Christ on the Cross, panel
 CHENSN 284 UNNMM
Christ with Symbols of
 Evangelists, cartouche
 marble
 PRAEG 196 FTS
Death of the Miser, capital,
 Auvergne
 LARB 309 FBeC
Death of the Miser, door
 jamb, Languedoc
 LARB 308 FMP
Emperor, head fragment
 (Frwderick II?)
 DECR pl 192 IBarCo
Equestrian, facade, Poitrou
 LARB 308 FPar
Facade, figure detail,
 Provence
 LARB 283 FStGi
Facade: Frieze and Columns
 LARB 294 FArlT
Figure
 ENC 774 FOlM
Figure, detail
 BATT 82 FCh
Figures, fragment
 GAF 434 FViL
Flight into Egypt, relief
 GUIT 66-67 FMP

Gallery Capital: Geometric
 Decoration
 LARB 237 FMo
Holy Women at the Sepulchre,
 capital, Auvergne
 LARB 309 FM
House Frieze: Bird and Floral
 Motif
 EVJF pl 222A FViL
Madonna and Child
 ROOS 67h UNNMM
Massacre of the Innocents,
 capital
 LARB 309 FArlT
Neo-Persian Foliate Design,
 western portal
 STI 395 FBlaz
Porch, with decorative figures
 CHENSN 287 FAulCh
Portal, detail
 CHENSN 269 FArlT
Stylized Floral Pattern,
 capital
 LARB 319 FM
Temptation of Christ, capital
 SEW 342 FVeMu
Winged Monster, capital,
 Poitou
 LARB 279 FChau
--French, or Spanish
Christ, head 12th c. ptd wood
 FAUL 471 -Pi
--German
Archbishop Frederick I,
 effigy relief bronze
 POST-1:44 GMagC
Door Panel: Moses Fleeing
 from the Serpent
 BUSRO pl 3 GAuC
Double-Basined Fountain,
 market
 PRAEG 55 GGo
Gallus Gate: Apostles, head
 detail
 BUSRO pl 134, 135 SwBM
Lovers, mirror handle bronze;
 c 2
 BUSRO pl 96 GFKu
Schotten Portal: Sirens;
 Lovers
 BUSRO pl 141, 142 GRaJ
--Italian
Choir Screen: Gryphon;
 Dragon stucco
 DECR pl 211 IBomM
Christ in Mandorla, with
 angels; Beggar with Pack,
 reliefs green marble
 DECR pl 77, 78 IMasC

Christ on the Cross, relief
 ROOS 65d IArP
Crucifix, details: Head of
 Christ; Christ in
 Purgatory gilt metal
 DECR pl 31, 33 IVerE
Deposition from the Cross
 MALV 52 ITiC
Devil-Headed Bull (Sin)
 Felling Woman
 DECR pl 79 IVoC
Frederick II, seated figure,
 headless fragment
 POST-1:53 ICaM
Ladies in Court Dress
 Greeting, relief
 DECR pl 102 ILugM
Life of Christ, scenes, doors
 bronze
 POST-1:52 IBeC
Pulpit: Figure and Eagle
 DECR pl 67 IFMi
South Portal: Plaited Orna-
 ment; carved lintel
 DECR pl 177 IBriB
--Spanish
Capital: Fable of Cat and
 Mice
 CHASEH 196: POST-1:42
 SpTaC
Capital: Street Acrobats
 CHASEH 196; POST-1:42
 SpC
Capitals: Monsters; Via
 Dolorosa
 POST-1:42 SpD; SpHP
Facade, St. Maria la Real
 POST-1:39 SpSangM
King David, Puerta de las
 Platerias
 LARB 282 SpSanC
--Swedish
Font: Animal and Human
 Figures wood BUSRO pl
 130 SnM
Herod's Feast, font
 BUSRO pl 131 SnVa
ROMANO, Gian Christoforo
 (Milanese)
Beatrice d'Este, bust c 1490
 marble; 62 cm
 CHAR-1:339 FPL
Duke Gianfrancesco Gonzago
 II of Mantua, bust c 1500
 terracotta
 HALE 176 IFBard
Galeazzo Visconti Monument;
 detail: Scene from Life
 POPR fig 93, 124 IPavCe

ROMANO, Giulio (Italian 1492/99-
 1546)
Sala degli Stucchi: Horse-
 men, double frieze c
 1530/35 stucco
 BAZINW 368 (col) IManD
Romano, San
 Civitali. San Romano Tomb
Romanus IV Diogenes (Eastern Roman
 Emperor d 1071)
Byzantine. Christ Crowning
 Romanus and Eudocia
ROMAY, Miguel (Spanish) See
 CASAS Y NOVOA, F. de
ROMBAUX, Egride (Belgian 1865-
 1942)
The First Morning (Le
 Primier Matin) 1913
 marble; 63
 TATEF pl 49c ELT (3031)
Rome
German--14th c. Romse,
 Seal of Emperor Ludwig
 of Bavaria
Rome, King of
Bosio. King of Rome as a Child
Rome 1963 (1). Sanderson
Romeo and Juliet
Rodin. Romeo and Juliet
Romilly. Epstein
Romsey Christ. Saxon
ROMAULD See MASTER ROMAULD
Romulus and Remus
Giovanni di Turino. Wolf Suck-
 ling Romulus and Remus
Hering, L. Casting Out of
 Romulus and Remus
Italian--8th c. Diptych: Cruci-
 fixion and Biblical Scenes;
 Suckling Romulus and Remus
Italian--13th c. Romulus and
 Remus Suckled by Wolf,
 pillar base
Quercia. Fonte Gaia
Sienese. She-Wolf Nourishing
 Romulus and Remus
RONA, Jozsef (Hungarian 1861-1937)
Prince Eugen von Savoyen
 Memorial 1900 bronze;
 470 cm
 GAD 59 HBB
Ronan, Saint
French--15th c. St. Ronan
 Tomb
Roncalli (Rondanini) Pieta.
 Michelangelo
Ronchamp Chapel. Le Corbusier
Rondanini Pieta
 Michelangelo. Pieta Rondanini

RONDE, Claude Dominique (French)
 See DUPLOS, A.
RONDE, Laurent (French) See
 DUPLOS, A.
Rondo. Uhlmann
RONNEBECK, Arnold
 Sadness (Tristesse)
 MARTE pl 26
Ronsard, Pierre (French Poet 1524-85)
 French--16th c. Ronsard, bust
Rood See also Jesus Christ--
 Crucifixion
 Swedish--13th c. Rood
Rood Screens See also Screens
 Durst. Rood Screen
 Dutch--16th c. Rood Screen
 Flemish--16th c. Rood Screen
 French--15th c. Rood Screen
 German--12th c. Calvary
 German 12, and 16th c.
 Cross, above Rood Screen
 Orlandi. Nave Screen
Roof Beams
 English--15th c. Double
 Hammer Roof Beam
Roof Bosses
 English--13th c. Angel Choir:
 Boss #
Roofs
 English--15th c. Roof, detail
Roosevelt, Franklin Delano (32nd
 President of United States
 1882-1945)
 Dick. President Roosevelt
Rooster See Chickens
Root Bodied Forth. Solomon-
 Cunliffe
Root, Number 2. Chirino
Root, Number 3. Chirino
The Root of the World. Pinto
ROSA, Ercole (Italian 1846-93)
 Cairoli Brothers Monument
 1883
 MINB IRB
Rosa in Bed. Seitz
Rosa of Lima, Saint
 Quellinus II. St. Rosa of
 Lima
ROSALIS, E. O. de
 Nijinsky
 HOF 59 UMoSD
 The Slipper glazed terra-
 cotta
 HOF 287
ROSANDIC, Toma (Yugoslav 1880-)
 Angel, tombstone detail
 1933 plaster
 BIH 62 YB

Dalmation Monument
 AUM 34, 35 YBra
Ecce Homo wood
 MARY pl 117
Girl, details 1928 wood
 BIH 60, 61 YBN
The Harp Player 1920 bronze
 BIH 57 YBN
Head of a Girl marble
 MARY pl 163
Mother and Child marble
 PAR-2:125
Mother and Son walnut
 PAR-2:124
Petrinovic Mausoleum: Door
 CASSM 87 YBrP
Pieta, relief 1924 bronze
 BIH 58-59 YBrS
La Pucelle (Vestal Virgin)
 Walnut; LS
 CASSN 85; RICJ pl 54
The Sculptor bronze
 MARY pl 147
Self Portrait, bust 1928
 bronze
 BIH 56; MARY pl 79 YBN
The Struggle marble
 VEN-38:pl 68
Torso walnut; less than LS
 CASSM 86
--walnut; c LS
 DURS 73 -EWi
Warrior 1935 stone
 BIH 63 YBN
Woman Drinking, detail
 walnut
 MARY pl 147
Roscoe, Henry
 Drury. Sir Henry Roscoe,
 bust
ROSE, Joseph, the Elder (English
 fl 1721-35)
 Richard Ladbroke Monument
 1730
 GUN pl 22 ERei
Rose Garland Altar. Zurn, Martin,
 and Michael Zurn
Rosebud. Evans, G.
Rosebud. King, Phillip
Roselli, Antonio
 Lombardo, Pietro. Roselli
 Monument
La Roseraie. Ram
Roses
 Stockton. Heraldic Details:
 Dragon; Crown and
 Rose
Roseveor. Nicholson

Rospigliosi Cup. Cellini
Ross, Oriel
 Epstein. Oriel Ross, bust
La Rossa. Pepe
ROSSELLI, Domenico di Giovanni
 (Italian c 1439-1497/98)
 Madonna and Saints, altar
 1480 ptd and gilded
 stone
 SEY pl 103 IFosC
ROSELLI, Domenico di Giovanni--
 ATTRIB
 Vase with Carnations,
 chimney piece relief,
 Angel's Hall c 1470
 BUSR 79 IUNM
ROSSELLINO, Antonio (Real Name:
 Antonio di Domenico
 Gambarelli) (Italian 1427-79)
 Adoration of the Child, tondo
 clay, for marble; Dm: 37
 BERL pl 200; BERLES
 200 GBSBe (81)
 Adoration of the Shepherds
 POPR fig 46 INAn
 A Boy, bust sandstone
 BODE 140 GBK
 Boy-Christ, bust marble,
 gilded bronze nimbus
 BODE 142 ELM
 Bust of a Lady marble; 53 cm
 POPR pl 58 GBK
 Cardinal Jacopo of Portugal
 Tomb 1461/66 marble;
 L: c 92-1/2
 BAZINW 338 (col); BUSR
 132; CHAS 80 (col);
 FREEMR 106; MAR 51
 (col); MILLER il 116;
 MURRA 207; RAD 331;
 SEY pl 73; UPJH pl 109;
 WOLFFA 73; WOLFFC 68
 IFMi
 --Effigy, from death mask
 SEY pl 77
 --Madonna and Child, tondo
 SEY pl 74B
 Giovanni Chellini da San
 Minato, bust 1456 marble;
 20
 JANSH 334; JANSK 635;
 KO pl 77; MACL 143;
 MOLE 116; POPR pl 59;
 SEY pl 70A ELV
 Head of Cherub marble
 NCM 271 UNNMM (09.
 155. 2)

Madonna, tondo
 WOLFFA 14; WOLFFC 10
 IFBar
Madonna and Child
 USNI 235 UDCN (A-14)
--c 1478 terracotta
 CLE 80 UOC1A (52. 109)
--marble; 33x22
 USNC pl 26; USNI 235;
 USNK 181; USNKP 399
 UDCN (A-31)
--1460/65 marble; 28-3/4
 NM-8:3; POPR pl 60;
 ROOS 112A UNNMM
 (14. 40. 675)
--relief 1468 marble; 20x
 27-1/2
 KO pl 80 AVK
Man, bust c 1470 Carrara
 marble; 19-5/8
 BERL pl 201; BERLES
 201 GBSBe (84)
Matteo Palmieri, bust c 1468
 marble; 24
 BARG; CHASEH 319;
 ENC 778; KO pl 76;
 READAS pl 162; ROBB
 370 IFBar
Nativity Altarpiece,
 Piccolomini Chapel
 MACL 145 INMO
Pulpit
 POPR fig 49 IPrC
St. Sebastian
 POPR fig 53 IEC
Virgin with Child, relief ptd
 plaster; 80x50 cm
 WPN pl 59 PWN (126176)
The Virgin with the Laughing
 Child c 1465 terracotta;
 19
 READAS pl 88-9; VICF
 38; WHITT 83 ELV
 (4495-1858)
Young St. John the Baptist
 (Boy-Baptist), bust marble
 BODE 146 IFMN
--1470/75 marble; 13-5/8x
 11-3/4x6-11/32
 KRA 39; SEYM 80, 81;
 SHAP 67; USNK 179;
 USNKP 400 UDCN (A-54)
ROSSELLINO, Antonio--FOLL
 Madonna and Child terracotta;
 81x61 cm
 BERLEI 5 GBSBe (82)
 The Nativity, 5 figures of

Presepio ptd terracotta
BR pl 5 (col); NM-11:23;
NCM 274 UNNMM (11.136.
1 to 5)
Prudence: Three-Faced
Head
PANM il 29 ELV
ROSSELLINO, Bernardo (Italian
1409-64)
Beata Villan Monument
ENC 778 IFMar
--Angel Drawing back Curtain
POPR fig 43, pl 53
Facade of Misericordia
POPR fig 50 IAr
Leonardo Bruni Monument
c 1445/46 - c 1449/50
marble; 20' (to top of
arch)
CHASEH 307; JANSH 334;
JANSK 634; KO pl 79;
MACL 137; MURRA 207;
POPR fig 60, pl 52;
POST-1:172; ROOS 111D-E;
SEY pl 59; UPJ 262 IFCr
--Madonna and Child, tondo
MOLE 114; POPR pl 54
Lunette
LARR 119 IFFr
Neri Capponi Tomb
POPR fig 68
IFSp
St. John the Baptist
ROOS 112B IFBar
Tabernacle: Adoring Angels
marble; 140 (excl con-
sole)x92 cm
POPR fig 44, pl 50-51
IFEg
Virgin Annunciate; Angel of
the Annunciation 1444
marble
SEY pl 60 IEC
ROSSI, Angele de' (Italian 1671-
1715)
Pope Alexander VIII, bust
terracotta; 19
DEYE 161 UCSFDeY
ROSSI, Giovanni Antonio de
(Italian 1517-75)
Cosimo I de'Medici and
Eleonora of Toledo and
their Children, relief
ROSSI IFP
ROSSI, Henri (English 1791?-1844)
The Batsman 1819
BOASE pl 5A EBed

The Bowler 1825
GUN pl 21 EWob
ROSSI, John Charles Fox (English
1762-1839)
Captains Mosse and Riou
Monument, detail 1802
WHINN pl 159 ELPa
Lord Heathfield Monument
1825
GUN pl 20 ELPa
Lord Rodney Monument
1810/15
WHINN pl 161B ELPa
ROSSI, Properzia de' (Italian
c 1490-1530)
Joseph and Potiphar's Wife
(includes Self Portrait),
relief c 1528
GOLDF pl 94 IBoP
ROSSI, Remo (Swiss 1909-)
Acrobat II 1957/58 bronze;
79
BERCK 168; JOR-2:pl 113
Acrobate Tombe 1957/58
JOR-2:pl 268
Bull 1952 bronze; 18x39
MID pl 126 BAM
Chat 1956/57
JOR-2:pl 114
Chevaux 1955/57
JOR-2:pl 267
Donna Incinta 1954 bronze;
107 cm
JOR-1:pl 43
Gatto Predone 1955 bronze;
200 cm JOR-1:pl 45
Toro 1953 bronze; 140 cm
JOR-1:pl 44
ROSSI, Vincenzo de'
Hercules and the Centaur
1568
POPRB fig 59 IFV
St. Paul
POPRB fig 68 IRMPa
ROSSO, Giovanni Battista (Giovanni
Battista di Jacopo di
Guasparre; Il Rosso
Fiorentino) (Italian 1494-1540)
Albert Pie of Savoie, Count
of Carpi 16th c. bronze
LOUM 85 FPL (642)
Classical Figure, detail,
Galerie Francoise I 1533/
40
BAZINW 381 (col); BLUA
pl 23; UPJH pl 125, 178
FFP

ROSSO, Il See ROSSO, Giovanni
Battista
ROSSO, Il See NANNI DI BARTOLO
ROSSO, Medardo (Italian 1858-1928)
Bambino al Sole 1892 terra-
cotta
CARR 6 GEF
Bambino all'Asilo dei Poveri
1892 terracotta
CARR 5 IRMo
Bambino Ebreo 1893 terra-
cotta
CARR 7 FTrA
The Bookmaker (Portrait of
Monsieur M. M.)
BERCK 22
--1894 bronze; 43 cm
CAS pl 58 IMAM
--1894 wax over plaster;
44 cm
LIC pl 149 UNNMMA
--1894 wax over plaster;
17-1/2
CARR 12; LYN 69 IMM
Boulevard Impressions: Paris
at Night (cast of original
in Noblet Collection, Gesain
sur Aube) 1895 (destroyed
in World War I) wax;
27x22-1/4
GIE 16
Child in the Sun 1892 wax;
34.5 cm
JOO 181 (col); SELZJ
90 NOK
Concierge 1883 wax; 15-1/2
GIE 85 IVMo
Conversation in a Garden
(Conversazione in Giardino)
ENC 779
--1893
LARM 214 IRMo
--1893 bronze; 33x68x40 cm
LIC pl 148 IRMo
--1893 bronze; 13x26-3/4x
15-7/8
READCON 16; SELZJ 127
IRN
--1893 plaster
CARR 11 IRMo
--1893 plaster original;
12-5/8x25-1/4
GIE 16 IBarzR
--1893 plaster; 12-5/8x
25-1/4
HAMP pl 21 IRArtC
--1893 wax
RIT 67 IB

La Dama dalla Veletta 1893
wax
CARR 9 IVMo
Donna che Ride 1890
CARR 3 FPR
--1891 terracotta
CARR 4 IMAM
Ecce Puer 1906/07 wax over
plaster; 17
CHENSW 467; READCON
20 UMiDW
--1910 bronze
MAI 260 FPM
L'Eta d'Oro 1885 wax
RAMS pl 27 IRMo
The Golden Age 1886 wax
SELZJ 129 (col) UNNH
Head of a Young Woman 1901
wax overplaster; 15-3/4
BAZINW 424 (col); KUHB
23; SELZS 25 UNNPe
Henri Rouart 1890 bronze
SELZJ 122 IRN
Impressioni d'Omnibus 1882
(work destroyed) gesso
CARR 2
The Kiss on the Tomb 1886
BURN 24
Lady with a Veil (Woman with
Veil; Woman with Scarf)
SELZJ 119 IRN
--1893 wax over plaster; 27
BOW 129 IRArt
--1896 gypsum; 30
MID pl 6 BAM
--1896 wax; 29-1/2
TRI 121 BAM
Laughing Woman 1890
SELZJ 119 IRN
Little Jewish Boy (Jewish
Youth) 1893 wax; 9
MID pl 5 BAM
Madame Noblet 1896 plaster
SELZJ 123 IRN
Madame X 1896/1913 wax;
11-3/4
GIE 17; HAMP pl 20B; VEN-
50: pl 22 IVMo
--1901 wax
CARR 15 IVPes
Man Reading 1892 bronze; 10
BOW 127 UNNMMA
La Mezzana 1882 wax; 13-1/2
RAMS pl 26 IRMo
Motherhood bronze
SAL 8
Sick Boy 1893 bronze; 24 cm
LIC pl 147 UNNJos

Sick Child 1892 bronze
SELZJ 126 IRN
--1895 bronze; 10-1/4x7
GIE 15 IMM
Sick Man at Hospital (Malata
all' Ospedale) 1889 terra-
cotta
CARR 4; MCCUR 250; RIT
66 IBR
Signor Rouart 1890 gypsum;
47
MID pl 7 BAM
--half figure 1890 bronze;
c 13-1/2
RAMS pl 25 IRMo
Small Laughing Woman 1890
wax over plaster; 8-3/4
BOW 128 IRArt
Street Singer 1882 bronze
MCCUR 250
L'Uomo che Legge 1893 wax
CARR 10 IFP
Yvette Guilbert, head 1894
terracotta; 16
CARR 13; GIE 13; ST
412 IRMo
--1894/95 wax
MAI 260; SELZJ 118 IRN
ROSSO, Mino (Italian 1904-)
Architectura Femminile
VEN-30:pl 128
Dynamic Form
VEN-36:pl 89
Giovanni Arpino, bust 1960
bronze
SAL 47
Rotary Demi-Sphere. Duchamp
Der Rote Hahn. Remund
Rote Schwebplastik. Bodmer
ROTH, Paul (Swiss 1905-)
Torso bronze; 90 cm
JOR-1:pl 23
Rothschild Cameo. Byzantine
Rotor IV: Silbersonne. Mack
Rotozaza, No. 1. Tinguely
Rotrou, Jean de (French Playwright
1600-50)
Caffieri. Retrou, bust
Rottgen Pieta. German--14th c.
ROTTLER, Maria Pauli (Austrian
1900-)
Chancellor Dr. E. Dollfuss,
head bronze
VEN-36:pl 44
ROTTWEILER PROPHETEN-
MEISTER
A Prophet c 1350
BUSGS 156 GNM

Rotund Plastic
Schlemmer. Abstract Figure
Rouart, Henri
Rosso, Medardo. Henri Rouart
Rosso, Medardo. Signor
Rouart#
ROUBICEK, Rene (Czech 1922-)
Untitled 1966 Huttenglas
handgefoamt; 270 cm
BER 41
ROUBILIAC, Louis Francois (French
1702?-62)
Alexander Pope, bust
ENC 724
--
LARR 408 ELV
--c 1738 terracotta
WHINN pl 77B -EC
--1738
CON-3:pl 34 ELeC
--1741 marble
WHINN pl 77A -ER
Bishop Hough Monument 1746
WHINN pl 80A EWC
Colley Cibber, bust colored
terracotta
MILLER il 143 ELNP
David Garrick, bust c 1758
WHINN pl 87A ELNP
Dr. John Belchier, bust
WHINN pl 89 ELRCS
Dr. Martin Folkes, bust
1749
WHINN pl 87B EWil
Francis Willoughby, bust
1751
WHINN pl 91B ECamT
General William Hargrave
Monument 1757
WHINN pl 82, 83 ELWe
John Campbell, 2nd Duke of
Argyll, Monument
1748/49 marble
GERN pl 56; GUN pl 20;
MOLE 255; MOLS-2:pl
34-5; WHINN pl 78, 79
ELWe
--drawing
MOLS-2:pl 32 ELV
--model terracotta; 34
MOLS-2:pl 33; VICF 89
ELV (21-1888)
George Friedrich Handel
ENC 781 ELVa
--1738
WHINN pl 74 ELN
--bust 1739
CON-3:pl 34 EEQ

George Friedrich Handel
Monument 1761
CARP 400; GERN pl 58;
WHINN pl 85 ELWe
Jonathan Tyers, bust c 1738
WHINN pl 76A EB
Joseph Wilton, bust c 1761
WHINN pl 90B ELRA
Lady Elizabeth Nightingale
Monument
1761 marble
BUSB 211; CARP pl 78;
GARL 201; GAUN pl 51;
LARR 352; POST-2:54;
WHINN pl 84 ELWe
--Death
GERN pl 62; MILLER
il 136
The 9th Earl of Pembroke,
bust 1750
WHINN pl 88 EB
Religion 1761
CON-3: pl 36 ELeicM
2nd Duchess of Montagu
Monument 1753
ESD pl 24; WHINN pl
80B ENorthWa
Self Portrait, bust marble
WHINN pl 93 ELNP
--(pencil drwg by Hannah
Brown)
BROWF-3:56
Sir Andrew Fountaine 1747
WHINN pl 86A EWil
Sir Isaac Newton 1755
WHINN pl 92 ECamT
Sir Robert Catton, bust 1757
marble
WHINN pl 91A
--1757 terracotta
WHINN pl 90A ELBr
William and Elizabeth Harvey,
medallion portraits, monu-
ment 1753
WHINN pl 81 EHem
William Hogarth, bust
UND 82 ELV
--c 1740 terracotta; 29
WHINN pl 76B; WHITT
105 ELNP
William Shakespeare
(Original Model) marble
BROWF-3:59 ELV
--bust
SALT 150 UNNVaS
Rouge Madras. Caro
Round Head. Ernst
Round Kinetic Object. Graevenitz

Roundels
French--12th c. Romanesque
Roundels: Dog; Acrobat;
Siren
Rousseau, Jean Jacques (French
Philosopher 1712-78)
Houdon. Rousseau, bust
Masson, F. Jean Jacques
Rousseau Monument
ROUSSEAU, Phillippe (French)
Door of Boudoir of Marie
Antoinette c 1785
LARR 392 FFP
ROUSSEAU, Victor (Belgian 1865-
1954)
Adolescents
TAFTM 79
Alice, bust plaster
VEN-14:29
Constantin Meunier, bust
GOR 50 BBR
Demeter plaster
GOR 51; VEN-3:pl 5 BBR
Francoise W., bust plaster
VEN-22:21
Leopold III, bust plaster
VEN-34:pl 117
Oriental Dancer, detail
GOR 53
Pomona stone
VEN-38:pl 39
Princess Marie Jose of
Belgium, bust plaster
VEN-12:pl 17
Sisters of Illusion
CHASEH 473; GOR 52 BBR
Le Stagioni Virili bronze
VEN-32:pl 129
Star bronze
VEN-28:pl 156
Violinist Ysaye, bust bronze
VEN-20:51
ROUW, P.
Arthur Wellesley, 1st Duke
of Wellington, medallion
1818 wax; Dm: 7-3/4
HUX 71; MOLS-2:pl 53
ELV
ROUX, Constant (French)
Poussin
TAFTM 46
ROUX, Roulland le
Cardinals George I and
George II of Amboise
Tomb c 1518/25
BUSR 179 FRC
Rovere, Cristoforo della
Bregno, Andrea. Cristoforo
della Rovere Tomb

ROVEZZANO, Benedetto (Italian)
　Mantelpiece c 1520 marble
　　and sandstone
　　BURC pl 23 IFMN
ROVIRA BROCANDEL, Hipolio
　(Spanish 1693-1765)
　Palace Entrance, remodelled
　　1740/44
　　KUBS pl 22B SpVaA
ROWE, J.
　Animal Form birch; 7
　　NORM 55
ROXAS, Pedro Joseph de(?)
　(Spanish)
　Altar of St. Joseph c 1768/
　　70
　　KUBS pl 88B MeSalA
A Royal Game. Reynolds-Stephens
Royal Portal. French--12th c.
The Royal Salt
　Cellini. Salt of Francis I
Royal Society Medal. English--
　18th c.
ROYLEY, Richard, and Gabriel
　ROYLEY (English)
　Thomas Fermor Tomb
　　MERC pl 89A EOxfS
RUAO, Joao de (Spanish)
　Pulpit marble
　　WES pl 9 SpCoiC
Ruban sans Fin
　Bill. Endless Ribbon
Rubbish Picture
　Schwitters. Merzbild
Ruben. Muller, E.
Rubens, Peter Paul (Flemish
　Painter 1577-1640)
　Petel, G. Peter Paul
　　Rubens, bust
　Rysbrack. Sir Peter Paul
　　Rubens
Rubezahl. Muller, R.
Rubin, bust. Orloff, C.
RUBINO, Edoardo (Italian)
　Awakening (Risveglio)
　　marble
　　VEN-34:pl 65
　Mrs. M. R., half figure
　　bronze
　　VEN-22:4
　The Mother
　　VEN-42:pl 11
　Victory bronze
　　VEN-28:pl 2
RUBINO, Nicola (Italian 1909-)
　Composizione, medal 1954
　　bronze
　　VEN-54:pl 28

Deposition, tondo 1956 bronze
　VEN-56:pl 42
Rubinstein, Helena
　Alvermann. Hommage a
　　Helena Rubinstein
RUBIO CAMIN, Joaquin (Spanish)
　Concerto para Flauta e
　　Percussao wood, iron,
　　copper; 91x66x18 cm
　　SAO-8
RUCKI, Lambert
　Facade Figures; details:
　　St. Francis of Assisi
　　DAM 66 FHyO
　Stations of Cross; Life of
　　Christ Scenes, relief,
　　detail: 7th Station;
　　Temptation of Christ 1951
　　concrete
　　DAM 157, 158 FB1B
RUDAVSKY
　Assemblage*
　　EXS 53
　Sculpture*
　　EXS 41
Rudbeckius, Johannes
　Milles. Johannes Rudbeckius
　　Memorial
　Milles. Rudbeckius
RUDE, Francois (French 1784-1855)
　Christ, Crowned with
　　Thorns, half figure
　　MCCL pl 48 FPL
　David, bust 1826 marble;
　　22-1/2
　　CHAR-2:259 FPL
　Departure of the Volunteers
　　of 1792 (La Chant du
　　Depart; Le Depart pour
　　le Guerre; The
　　Marseillaise), relief
　　1833/36 marble; c
　　42x26'
　　AUES pl 29; BARSTOW
　　187; BAZINH 374; BOE
　　pl 190; CHENSW 464;
　　ENC 784; FLEM 641,
　　642; GAF 132; GARDH
　　752; HOF 198; JANSH 487;
　　JANSK 916; LARM 44;
　　LIC pl 60; LYN 38;
　　MARQ 257; MCCUR 245;
　　MILLER il 161; MU 219;
　　MYBA 571; NOV pl 185;
　　PRAEG 428; RAY 55;
　　RICH 53; ROMB 341;
　　SELZJ 47; ST 410; STI 706;
　　UPJ 489; UPJH pl 200;
　　WATT 166 FPA

--detail
 LAC 79
--head detail
 JAL-5:pl 18
--La Marseillaise
 BAZINW 421 (col)
Fountain of Barenzae
 GAF 322 FD
Godefroi de Cavaignac
 Monument 1845/47 bronze;
 15-3/4x74-1/2x25-1/2
 LAC 209; LIC pl 61;
 MILLER il 172 FPMo
Imperial Eagle Watching over
 Napoleon 1845 bronze;
 11-3/8x21-1/4x11-3/8
 BRIO 41; BRIONR pl 39;
 MOLE 264 FDM
Joan of Arc Listening to
 the Voices 1845 marble;
 LS
 BR pl 12; FLEM 643;
 LAC 79 FPL
Marshal Ney Monument
 1853 bronze; 105
 BR pl 14; CHASEH 437;
 GAF 136; HOF 38;
 JANSH 487; JANSK 917;
 LARM 44; LIC pl 59;
 POST-2:124; UPJ 490
 FPO
Mercury 1834 bronze; 250
 cm
 LIC pl 57; SELZJ 45 FPL
Napoleon Awakening to Im-
 mortality original plaster
 cast (bronze monument at
 Fixin, near Dijon, 1847);
 215x195 cm
 LARM 44; LIC pl 62 FPL
Neopolitan Fisherboy Playing
 with Tortoise 1833 marble;
 32
 CHAR-2:295; JAL-5:pl
 17; LIC pl 58 FPL
The Prophet Jeremiah c
 1850/55 terracotta
 sketch
 SELZJ 46 FDM
 Portraits
Sicard. The Sculptor Rude,
 seated figure
Ruderi Sul. Pascali
Rudhall, William
 English--16th c. William
 Rudhall Tomb
Rudolf (Duke of Swabia 1057-80)
 German--11th c. Rudolf,
 King of Swabia

Rudolf I, of Hapsburg (Holy Roman
 Emperor 1218-91)
 German--13th c. Rudolf von
 Hapsburg
Rudolf II (Holy Roman Emperor
 1552-1612)
 Vries. Rudolf II
Rudolf IV, Duke
 German--14th c. Duke
 Rudolf IV Choristers'
 Gate
Rudzka-Cibis
 Dunikowski. Rudzka-Cibis
Rufus Probianus
 Byzantine. Rufus Probianus,
 diptych detail
RUGG, Matt (English 1935-)
 Boomerang 1963 wood con-
 struction; 39-2/3x36-3/4
 READCON 272
RUGGERI, Quirino (Italian 1883-
 1955)
 Bruno Barilli, head c 1927
 concrete
 VEN-56:pl 4 IRChia
 Giuliano Briganti, relief
 plaster
 VEN-28:pl 66
 Paolo Balbo, head marble
 VEN-40:pl 26
 Signora Bottai
 CASS 54
 The Walk
 CASS 81
Ruilya. Folk Art--Russian
RUMANIAN
 Transylvanian Coin
 MALV 139 FPMon
 --14th c.
 Transylvanian Censer:
 Church, Tismana Monastery
 silver gilt; 26 cm
 ARTSR pl 31 RBMN
 (M. 369)
 --15th c.
 Moldavian Book Cover silver
 gilt repousse, rock
 crystal cabochons; 35x24
 cm
 ARTSR pl 35-36 RBMN
 (tp 75)
 Moldavian Circular Tile:
 Arms of Moldavia reddish
 glazed earthenware; Dm:
 20 cm
 ARTSR pl 47 RBMN
 (C. 281)
 Panaghiarion: Deesis,
 Wallachian(?) 1490/91

silver gilt, filigreed
and engraved; Dm: 14 cm
ARTSR pl 33, 34 RBMN
(1525)
Wallachian Doors; detail: St.
George, Snagov Monastery
1453 oak; 90x100 cm
ARTSR pl 43, 44 RBMN
(100)
--15/16th c.
Transylvanian Kivotion silver
gilt repousse, chased and
enamelled; 25 cm
ARTSR pl 32 RBMN
(1446)
--16th c.
Moldavian Book Cover, back
cover: St. Daniel 1557
silver gilt repousse;
33x32 cm
ARTSR pl 37 RD
Moldavian Processional
Cross, Slatina Monastery
1558 cypress mounted in
silver gilt; 70x27x4.5 cm
ARTSR pl 45 RBMN (736)
--17th c.
Kivotion: Church, Wallachian
(?), Cotoceni Monastery
1685 enamelled silver
gilt; 29 cm
ARTSR pl 38 RBMN
(1449)
Rumor de Limites
Chillada. Whispering of the
Limits
RUNEFELT, Allan (Swedish)
Foyer Figures, club rooms
DAM 124 SnSM
Runes
Danish--10th c. Runic
Inscription Memorial
Slabs
Danish--11th c. Aarhus Runic
Stone: Magic Mask with
Inscriptions
Frankish. Casket Panel,
with Anglo-Saxon Runes
Swedish--11/12th c. Rune
Stone
Viking. Jellinge Rune Stone
The Runners. Marcks
Running See Games and Sports
Running Bird Totem. Meadows
Running Woman. Olivieri
Rupert (Duke of Bavaria 1619-82)
Dwight. Prince Rupert,
bust

Rupertus
Lackner. Rupertus; Blasius
Ruprecht, Princess
Jerace, F. Princess
Ruprecht
RUSCONI, Camillo (Carlo Rusconi)
(Italian 1658-1728)
Gregory XIII Monument
1719/25
LARR 395; WITT pl
166B IRP
St. Matthew
LOUM 189 FPL (1884)
--seated figure reading,
Nave 1713/15 marble;
over LS
BUSB 135; MOLE 189;
WIT pl 162 IRGio
Two Apostles, niche figures
1718
MATTB pl 42, 43 IRGio
RUSCONI, Gian Antonio
Altar of the Sacrament
POPRB fig 111 IVGi
Ruspoli, Esmeralda
Lucarda. Princess
Esmeralda Ruspoli, bust
Ruspoli, Marina
Berti. Princess Marina
Ruspoli, half figure
Russell, Francis
Stanton, E. Sir Francis
Russell Monument
Russell, Mary
Scheemakers, T. Mary
Russell Monument
Russell, Mrs.
Rodin. Mrs. Russell, bust
RUSSIAN See also Georgian
Silver Dipper, Central
Russia
GABO pl 46 RuMKA
Wooden Cabinet inlaid
THU 64
--2nd mil B. C.
Scoop: Duck, Gorbunovo wood
RTCR 81 RuMH
--8/9th c. B. C.
Act of Worship, relief
HAMR pl 19 RuB
--5th c. B. C.
Comb: Warriors in Combat,
Solokha Barrow, Lower
Dnieper gold
HERM il 21 RuLH
--1st c.
Human Figure, detail fragment
Termez, Uzbek limestone
HERM il 29 RuLH

--2nd c.
Dish: Nereid Riding Hip-
pocampus, Baku silver
HERM il 25 RuLH
--6th c.
Amulet: Horse, Martynovka
silver
RTCR 13 RuMH
--7th c.
Clasp: Birds and Female
Figures, Zenkova,
Poltava District 7th c.
bronze
RTCR 12
--11th c.
Sigtunski Gates
BLUC 42 RuNS
--11/12th c.
Pendants: Horseman with
Bow; Bird bronze
HERM il 2 RuLH
--12th c.
Angel, relief
STA 141 RuYG
King David, enthroned with
birds and animals, facade
relief, center panel, south
HAMR 20 RuNI
Pendant Decorated with
Cloisonne Enamel, and
two Earrings
HERM il 1 RuLH
West Facade Panel, relief
c 1195/1200
HAMR pl 13B RuVD
--13th c.
Aquamanile: Cheetah bronze;
7-5/8x8-1/2
RTCR 94 UMdBW
Church South Porch 1229/34
HAMR pl 15A RuYG
Facade Details: Human and
Animal Figures 1230/34
RTCR 32, 33 RuYG
Helmet of Yaroslav,
Russian Prince, with
Medallion of St. Michael
iron over wooden core
DUNC 43 (col) RuMKA
Relief Figures 1230/34
HAMR pl 21 RuYG
The Virgin, Deesis relief
1230/34
HAMR pl 22 RuYG
--13/14th c.
Cap of Monomakh filigree
gold, jewels, sable
DUNC 44 (col) RuMKA

--14th c.
Ludogoshchinsk Cross,
roundel detail: Samson
and the Lion 1356 wood
RTCR 108
Zion silver gilt
HAR pl 29
--15th c.
Doorway, detail
BLUC 59 RuMCA
Ivan the Great's Book of
Gospels 1499 gold
filigree and enamel
cover
DUNC 63 (col) RuMK
"Jerusalem", or Tabernacle
of Jesus 1486 patinated
silver
DUNC 62 (col) RuMK
Vessel, supporting figures
silver
BLUC 144 RuNS
--15/16th c.
Ivory Throne and Sceptre
ivory plates on wood
DUNC 60 (col) RuMK
--16th c.
Annunciation Cathedral Book
of Holy Gospels Cover
jeweled and enamelled
silver; c 24
DUNC 75 (col) RuMK
Atericos, enamelled gold
1585
BLUC 158
Cap of Kazan gold filigree
with turquoise, pearls,
rubies, topaz
DUNC 69 (col) RuMKA
Chaldean Stove (Khaldeiskaya
Peshch) gilded lime
GLUC 40 RuNS
Gospel Cover: Relief Sacred
Figures in filigree
ground c 1534
silver gilt
HAR pl 28
Helmet of Khan Mohammed
steel and gold
DUNC 64 (col) RuMKA
Nimbus (Halo) of Vladimir
Virgin cloisonne enamel
BLUC 158
Thrones of Tsar and Metro-
politan wood
BLUC 40 RuNS
--16/17th c.
Canopy, palmate and onionate

motif wood
LARB 157 RuYaE
War Shields, Central Russia
steel and reed
GABO pl 45 RuMH
--17th c.
Cap of Mikhail 1627
jeweled gold, with sable
DUNC 87 (col) RuMK
Cap of Peter the Great
1682/89 jeweled gold,
with sable
DUNC 102 (col) RuMK
Cap of the Ruby Cross
1684 jeweled gold and
silver thread
DUNC 101 (col) RuMKA
Comb: Griffin, Lion, Human
Heads walrus bone; 2-3/4
x5-1/4
RTCR 93 RuLR
Cross, Mount Athos type
boxwood, in silver
BLUC 157
Diamond Throne jewel
encrusted gold
DUNC 93 (col)
Gospel Cover, with Christ
in Glory jeweled and
enameled gold
DUNC 144 (col) RuMK
Hat of Yerikhon, helmet
1621 jeweled steel, gold
inlay
DUNC 89 (col) RuMKA
Imperial Orb of Tsar
Michael jeweled and
enameled gold
BLUC 155 (col); HAR 69
(col)
Kvosh 1635 silver
RTCR 81 ELV
Pastoral Staff (Posokh) 1652
champleve enamel
BLUC 157
Pectoral Cross of Peter the
Great ptd enamel
BLUC 159
Prince Dmitri, sarcophagus
lid 1630 silver
HAR pl 34 RuMK
Regal Bridle gold with
rubies and turquoise
DUNC 97 (col) RuMKA
--18th c.
Altar Gates (Royal Doors of
the Priesthood) silver gilt
HAR pl 43 ELSton

Altar Gospel Cover, Moscow
work 1499 enamel and
silver; 13x8-5/8
EXM 378 RuMK
Candelabra green and white
porcelain, gilt bronze
mounts
HAR pl 84 UDCMa
Crown of Catherine I chased
silver with gold and
jewels
DUNC 104 (col) RuMKA
Diamond Crown of Empress
Anna c 1730 jeweled gold
DUNC 105 (col); HAR 71
(col) RuMKA
Goblet: Profile Busts of
Russian Empresses ivory
HAR pl 151 RuLH
Holy Nil Stolbenski wood
BLUC 173
Indian and Blackamoore
Figures Imperial
Porcelain
BLUC 136 RuLW
King of the Bells (Tzar
Kolokol) 1733/35
BLUC 163 RuLW
Panagia, Metropolitan of St.
Petersburg jeweled gold
BLUC 147 -Han
Writing Desk, casket-form,
Archangel pierced ivory
(walrus tusk), stained;
11-3/4x9x4-1/2
RTCR 80 UMdBW
--18/19th c.
Mordovinian and Cheremetian
Woman Gardner Porcelain
HAR pl 82B LBB
--19th c.
Alexander II, in uniform of
General of Cossack
Bodyguard Regiment,
equest bronze
HAR pl 149
Boy Carrying Potted Plant,
Gardner Porcelain;
Russian Dandy, Kornilov
Porcelain c 1840
HAR pl 87
Casket: Recumbent Lion on
Cover, Moscow
HAR pl 51B
Christ, icon hammered
metal
STA 141
GDaR

Chudov Reliquary Pendant
 jeweled rock crystal, gold,
 chalcedony
 BLUC 150
Covered Cup, with relief
 Troika and Prancing
 Horse, Petersburg
 HAR pl 60
Dancing Peasant Couple gilded
 bronze
 HAR pl 147
Dormition of the Virgin,
 icon brass and colored
 enamel
 HAR pl 27A
Gardner Porcelain Figures:
 Woman Carrying Two
 Baskets; Cobbler; Pilgrim
 c 1825/30
 HAR pl 86
Gardner Porcelain Girl
 Leaning on Beer Barrel
 HAR 151 (col)
Iconostasis, Abramtsevo
 Church c 1882
 GRAYR pl 4
Kirghiz Man and Woman,
 Gardner Porcelain
 HAR pl 82A LBB
Kornilov Porcelain Girl with
 Dog HAR 151 (col)
Kvass-Jug: Parrot green glaze
 pottery HAR pl 146 RuMH
Kvosch, with stylized Horses'
 Heads wood HAR pl 138 RuMH
Last Supper, relief
 boxwood
 HAR pl 139A
Maria Fyodorovna, bust
 1882 ivory
 HAR pl 150 UDCMa
Peasant Breaking Ice;
 Peasant Dancers,
 Gardner and Popov
 Porcelain
 BLUC 137
Popov Porcelain Couple
 HAR 151 (col)
Russian National Type
 Figures Safronov
 Porcelain
 BLUC 137
Tazza c 1815 malachite
 and ormolu; Dm: 27
 RTCR 191 (col)
Two Dancing Peasants
 gilded bronze
 HAR pl 148A

Wrought Iron Inner Doors:
 Tsarist Eagle, armorer's
 chamber
 DUNC 39 (col) RuMKA
--20th c.
Lenin: Emblem of USSR,
 Supreme Soviet, Great
 Hall
 DUNC 137 (col) RuMKP
Russian Beggar. Barlach
Russians
 Russian--19th c. Russian
 National Type Figures
 Faberge. Man and Woman
 Peasant Figures
RUSSO, Carlo (Italian)
 Dancing Figure 1960
 terracotta
 SAL 39
RUSSO, Gaetano
 Christopher Columbus
 Monument 1892 granite
 column, with figures
 SALT 58 UNNCi
Rustat, Tobias d 1693
 Gibbons--Foll. Tobias Rustat
 Monument
 Quellinus, Arnold. Tobias
 Rustat Monument,
 medallion portrait
Rustic Harmony. d'Amore
The Rustic Lovers. Signori
RUSTICI, Gianfrancesco (Italian
 1474-1554)
 Mercury bronze; 49.5 cm
 POPRB pl 40
 Preaching of the Baptist;
 details: A Levite; John
 the Baptist, head bronze;
 265 cm (with base)
 POPRB fig 39 IFBap
 Virgin and Child with Young
 Baptist, tondo
 POPRB fig 8 IFMN
RUSTICI, Gianfrancesco--ATTRIB
 Horse and Rider bronze;
 10-1/2x10
 DETD 116 NAR
Ruth
 Spanish--18th c. Ruth
Ruthwell Cross. Anglo-Saxon
Rutland, 1st Earl of
 Parker, R. 1st Earl of
 Rutland Tomb
Rutland, 4th Earl of
 Johnson, G. 4th Earl of
 Rutland Monument

RUWOLDT, Hans (German 1891-)
 Affe 1931 bronze; 90 cm
 HENT 105
 Cheetah (Gepard) 1952
 bronze
 GERT 106
 Flamingoes (Flamingo-
 Gruppe) 1952 bronze
 GERT 106
 Horse at the Start
 (Pferd am Start) 1952
 bronze
 GERT 107
 Leopard 1950 bronze;
 75 cm
 OST 74 GH
 Sea Lions (Seelowen) 1952
 shell-lime
 GERT 105
 Walross 1927 bronze;
 80 cm
 HENT 104 GHVo
Ruyter, Michel A. de (Dutch
 Admiral 1607-76)
 Verhulst, R. Admiral de
 Ruyter#
RUZIC, Branko (Yugoslav 1919-)
 Encounter 1962
 VEN-64:pl 168
Ryan, Thomas F.
 Rodin. Thomas F. Ryan,
 bust
Ryder, Bishop
 Chantrey. Bishop Ryder,
 kneeling effigy
RYGH, Aase Texmon (Norwegian
 1925-)
 Planetario 1963 polyester;
 50 cm
 SAO-7
RYLAND, A. M. (English)
 Abraham and Isaac, relief
 York stone; 22x21
 CASS 99 ELBl
RYSBRACK, John Michael (Michael
 Rysbrack) (Flemish
 1693-1770) See also Gibbs,
 James
 Admiral Wager Monument,
 detail: Taking the
 Spanish Galleons 1742
 ESD pl 137 ELWe
 Alexander Pope, bust 1730
 marble; 27
 GARL 202; WHINN pl 60
 ELAth
 Chimney Piece c 1730
 CON-3:pl 35; WHINN pl 63
 ECl

Daniel Finch, Earl of
 Nottingham, bust 1723
 WHINN pl 59A EAy
Dr. Harbin, bust before
 1732
 WHINN pl 62A ELo
Earl Stanhope Monument
 BROWF-3:60 ELWe
1st Duke of Marlborough
 Tomb 1732
 WHINN pl 70B EBle
1st Lord Harborough Monu-
 ment d 1732
 WHINN pl 66 EStap
George I, bust c 1727
 CON-2:pl 34 EOCh
George II, bust c 1750
 English porcelain after
 Rysbrack(?) model;
 13-1/2
 LAH 144 UCLCM
George II, bust 1760 marble;
 35
 VICK 29 ELV (A. 10-1932)
George II as a Roman Em-
 peror 1735 marble; 96
 GLE 207 ELRN
"Go, and Do Thou Likewise"
 1763
 WHINN pl 95B BBR
Hercules, model c 1743
 CON-3:pl 36; WHINN pl
 94A EStou
"Il Fiammingo" (Frencois
 Duquesnoy), bust 1743
 terracotta; 24
 TOR 145 CTRO (958.204)
James Gibbs, bust 1726
 WHINN pl 59B ELMar
John Gay Monument 1736
 WHINN pl 65B ELWe
John Locke
 UND 81 EOCh
 --1755
 WHINN pl 107C ELV
Matthew Prior Monument,
 bust detail by Antoine
 Coysevox 1723; c 1700
 WHINN pl 56, 57 ELWe
Mr. and Mrs. Knight,
 seated effigies 1733
 GUN pl 18 EGosf
Queen Caroline, bust c 1739
 marble
 MOLS-2:pl 27 ELWal
A Roman Marriage 1723
 WHINN pl 58A ELKeP
Sir Hans Sloane 1737 white
 marble GLE 89; WHINN pl
 62B ELBr

Sir John Dutton Monument
 1749 marble
 MOLE 256; WHINN pl
 95A EShe
Sir Peter Paul Rubens 1743
 WHINN pl 94B ESan
Sir Robert Walpole, bust
 ENC 787
 --
 WHINN pl 86B ELNP
--c 1730 H: 25
 COOPF 225 ENorfH
William III, equest 1735
 WHINN pl 68B EBriQ
RYSBRACK, John Michael, and
 William KENT
Sir Isaac Newton Monument
 1731 marble
 BROWF-3:60; GERN pl
 52; MOLS-2:pl 26;
 WHINN pl 64 ELWe
--Cherub; Sarcophagus Foot;
 Celestial Globe
 GERN pl 54-55
--head detail
 GERN pl 53; WHINN pl 65
--model terracotta; 13-3/4x
 20-1/2x6
 VICF 86 ELV (A.1-1938)
--study c 1731 terracotta;
 8
 KITS 157 ELV

S., Clothilde. Haller
S., Frau
 Hoetger. Frau S., bust
S., Miss
 Orloff. Miss S., head
S. B. B. Monteure. Leinhard
S. 55 Architectonic. Thayaht
SSSSSS, No. 1. Tajiri
SABBATANI, Angelo (Italian)
 Bruno Mussolini, medal
 VEN-42:pl 18
Sabina, Saint
 Vivarini, A., and D'Alemagna.
 Altarpiece
Sabine. Muller, E.
Sabines
 Bologna. Rape of the Sabine
 Women
 Martini, A. Rape of the
 Sabine Women
SABOLIC, Ivan (Yugoslav 1921-)
 Head of an Old Man 1947
 bronze
 BIH 161 YDG

The Pioneer Girl 1948 bronze
 BIH 160 YZMG
Sabran, Countess
 Houdon. Countess de Sabran,
 bust
Sabry, Abdel Fattah
 Hassan. Abdel Fattah Sabry
SACCHI, Bortolo
 Boy's Head bronze
 CASS 44
SACCONI, Giuseppe (Italian 1854-
 1905)
 Monument to Victor Emmanuel
 II 1885 marble, bronze,
 gilt bronze
 LIC pl 159 IRVen
Sachsenhausen Concentration Camp
 Monument. Grzimek
Sackville Tomb. Cibber
The Sacraments
 French--9/10th c. Book
 Cover
Sacred College, plaque. Byzantine
Sacrifice of Isaac See Isaac
Sacrifice of the Ancient Law
 French--12th c. Marriage
 at Cana; Sacrifice of the
 Ancient Law, tympanum
Sacrifices, Offerings, and
 Libations See also Isaac
 Byzantine. Altar Sacrifice
 Early Christian. Marriage
 Diptych: Symmachorum:
 Young Woman
 Early Christian. Vine and
 Figure Column Drums,
 details: Pair with
 Sacrificial Animals
 French--11th c. Capital:
 Offering a Church
 French--12th c. Sacrifice of
 the Bull
 Ghiberti. Baptistry Doors--
 East: Abraham Story
 Italian--12th c. Monreale
 Capitals
 --William I Offering Church
 to Virgin
Sacristy
 Arevalo. Sacristy
Saddled Horse. Wimmer
Saddles
 German--15th c. Saddle:
 Battles and Ideal Love
Sadness. Patzay
Sadness. Ronnebeck
Sadness. Saghini

SAGAR, John
 Chest oak
 CASS 144
 Chest ptd and gilded oak
 CASS 144
SAGHINI, Gamal (Egyptian 1917-)
 Sadness (Tristezza) 1958
 wood
 VEN-58:pl 169
SAGRERA, Guillermo (Spanish
 fl 1422-46)
 Angel c 1440/50
 MULS pl 146B; VEY 206
 SpPalmL
 Archangel, Main Door 15th
 c. stone
 GUID 138 SpPalmL
 St. Peter c 1422 stone;
 68-7/8x15-3/4
 VEY 275 SpPalmC
Sahm, Oberburgomeister
 Gruson. Oberburgermeister,
 Sahm, head
Sailors
 Horno-Poplawski. Sailor,
 head
 Jespers, O. American Sailor
St. Aldegonde, Marnix van
 Vigne. St. Aldegonde, head
St. Anne Portal
 French--13th c. Porte Mere-
 Dieu
St. Bernward's Door
 German--11th c. Hildesheim
 Cathedral Doors
St. Charles Bridge. Czech--18th c.
St. Edward's Chair
 Walter of Durham. Corona-
 tion Chair
St. George's Choir Screen.
 German--13th c.
SAINT-GERMAIN, Jean Joseph de
 (French 1720-91)--ATTRIB
 Caldelabrum gilt bronze
 CLE 137 UOClA (46.81)
St. John, John
 English--16/17th c. Sir John
 St. John, his First and
 Second Wives, and
 Children, Monument
St. Lawrence Gate
 Jakob von Landhut and
 Hans von Aachen. St.
 Lawrence Gate
St. Leger, Ralph and Anne
 English--15th c. Ralph and
 Anne St. Leger

SAINT-MARCEAUX, Charles Rene
 de (French 1845-1915)
 Daudet Monument
 TAFTM 35
 Dumas Monument
 TAFTM 35
 Marie Bashkirtsheff, bust
 marble; 94x50x33 cm
 TOKC S-63 JTNMW
 Secret of the Tomb (Genius
 Guarding the Secret of
 the Tomb)
 GLA pl 41; MARQ 263
 FPLu
SAINT-MAUR (French 1906-)
 Listening Form blue
 polyester
 MAI 264
St. Michael's Door
 German--11th c. Hildesheim
 Cathedral Doors
SAINT-PAULIEN (French 1731-1804)
 Amalthea 1791
 LIC 23 FRamL
St. Peter Fish. Artemoff
St. Peter's, Rome
 Caradosso. Medal:
 Bramonte's Design for St.
 Peter's
SAINT-PHALLE, Niki de (French
 1930-)
 Benedicte 1965
 KULN 41
 Hon 1966
 KULN 38, 39
 Les Nanas 1965 collage, with
 plaster and cloth
 NEW pl 66 FPIo
SAINT-PRIEST See LECLERC, N.
Saints See also Names of Saints
 Anglo-Saxon. Saint
 Byzantine. Deesis and
 Saints#
 Byzantine. Harbaville
 Triptych
 Byzantine. Saints#
 Chiaverri. Saints, roof-top
 figures
 Danish--14th c. Travelling
 Altar of Christian I,
 detail: Saint
 English--11th c. Saint,
 relief
 English--13th c. Saints
 Flemish--15th c. Saint,
 detail
 French. Healing Saints

French--13th c. Bearded
Saint, head
French--14th c. Female Saint
--Saints, facade
French--15th c. Female
Saint, detente style
--Saint(s)#
French--16th c. Saint#
Georgian. Two Saints,
plaque
German--11th c. Female
Saint, relief
--Saint, East Tower, relief
German--14th c. Reliquary:
Saint, bust
German--15th c. Female
Saint
--Little Saint of Dangolsheim
Gothic. Female Saint
Gunther, F. I. Female
Saint
Gunther, F. I. Male Saint
Jordan. Two Saints
Master of Donaueschinger
Madonna. Female Saint
Mena. Boy Saint
Mercadente. Saint
Nanni di Banco. Quattro
Santi Coronati
Ortiz. Saint in Niche
Rhenish. Saint
Spanish--14th c. Saint
Spanish--16th c. Saint,
half figure
Straub. Kneeling Saint
Syrlin, J., the Younger. Two
Saints, busts
Tino di Camaino. Saint
with Worshipper
Wain-Hobson. Saint, head
Saiz de Carillo, Sancho
Spanish--13th c. Don Sancho
Saiz de Carillo
SAKKI, Terho (Finnish 1930-)
Versao 1962 bronze; 55x102
x 27 cm
SAO-7
Sala per Concerti di Musica
Electronica
Constant. "Spatiovore" con
Piedes-tallo
Salamanders
English--12th c. Capital:
Salamander
French. St. Louis Green
Overlay Moulded
Salamander Weight

Salazar, Antonio de Oliveira
(Portuguese Statesman
1889-)
Franco. Dr. Salazar
SALIMBENI, Raffaello (Italian
1916-)
Anna with a Fan 1961
bronze
SAL pl 66 (col)
Gallo Vittorioso 1958
colored plaster
VEN-58:pl 51
Space Man 1960 bronze
SAL pl 65
Salisbury, 1st Earl of
Colt. 1st Earl of
Salisbury Tomb
Salisbury, Hester d 1614
Evesham. Hester
Salisbury Tomb, detail:
Escutcheon with
Emblems of the Passion
Sallets See Armor--Helmets
Salmacis
Bosio. Salmacis
Salome
Audeley. Dance of Salome,
relief
Damman. Salome
Danti. Decollation of St.
John the Baptist;
detail: Salome
Donatello. Dance of Salome
English--14th c. Dance of
Salome, roof boss
German--11th c. Easter
Column: Salome's Dance
German--17th c. Salome
Klinger. Salome
Kowarik. Salome
Riviere, T. A. Salammbo
at the House of Matho
Roberto and Nicodemo of
Guardiagrele.
Pulpit
Salomon, Peter (German Councillor)
Vischer, P., the Elder.
Peter Salomon, relief
SALOUN, Ladislav (Czech 1870-)
Jan Hus Memorial bronze
and limestone
MARY pl 49 CzP
The Liberation Monument
MARY pl 140 CzN
Resignation marble
PAR-2:114
The Union Movement, equest

figures plaster, for
bronze
MARY pl 133 CzBr
Saltarello, Simone
Pisano, Nino. Bishop
Saltarello Monument
Salting Diptych. English--14th c.
Salts
Cellini. Salt of Francis I
English--16th c. Salt
English--17th c. "The Great
Salt"
Lutma. Two Salt Dishes
Salusbury, John d 1578
English--16th c. Sir John
Salusbury Tomb
Salusbury, Thomas and Lady
Nollekens. Sir Thomas and
Lady Salusbury Monument
Salutati, Leonardo
Mino da Fiesole. Bishop
Leonardo Salutati, bust
Salutation. Baum
Salvati Chapel. Bologna
Salvation See also Redemption
Italian--13th c. Allegory of
Salvation
Salvator Mundi. Petel, G.
SALVATORE (Messina Salvatore)
(Italian 1916-)
Corrida bronze; 94-1/2x
70-7/8
READCON 182
Escodo 1954 marble
VEN-54:pl 27
Fecondazione N. 1 1963
bronze
VEN-64:pl 12
Fecondazione N. 2 1964
bronze
VEN-64:pl 13
Figura Marino 1954 bronze;
.70x.45 m
SCUL pl 64 IVS
Flight No. 3 1959 bronze
MAI 265
Girotondo 1955
VEN-56:pl 52
Il Vento 1955 bronze; .55 m
SCUL pl 65 IVS
Salve Regina. Stoss
SALVI, Nicola (Italian Architect
1697-1751), and Pietro
BRACCI
Trevi Fountain 1732/62
travertine; W: 151'
AGARC 91; CHASEH 380;
CHENSW 456; ENC 795;

LARR 394; MATTB pl 46,
47; MU 181; MYBA 471;
NEWTEM pl 142; PRAEG
56; SIN 320; UPJH pl 149;
WIT pl 164; WOLFFP 113
IRPol
--Center Group 1762
BUSB 169
--Neptune 1759/62 marble
MOLE 190
--Neptune and his Train
KO pl 90
--Triton Blowing Conch
1762
MATTB pl 48
SALY, Jacques F. J. (Joseph Saly)
(French 1717-76)
Alexandrine d'Etoilles, bust
c 1750 marble; 19-1/2
VICF 93 ELV (8510-1863)
Frederick V, bust 1754 bronze;
97 cm
BOES 78 DCKA
Frederick V, King of Den-
mark, equest 1768 H: 17
BAZINB 254; BOES 221
DCA
Salzburg Madonna. Austrian--15th c.
SALZILLO, Francesco See
ZARCILLO Y ALCAREZ, F.
Un Samaritain Le Vit et Fut Touche
de Compassion. Diesnis
SAMBIN, Hugues (French c 1520-
1600/02)
Cupboard with Caryatids
c 1580 wood; 81x59
CHAR-2:61 (col); LARR
305 FPL
Door c 1570
BAZINW 384 (col) FDJ
Facade, Maison Milsand
c 1561
BLUA pl 62 FDMil
SAMBIN, Hugues--FOLL
Armoire mid 16th c. ptd
and gilded walnut; 97
NMA pl 187 (col)
UNNMM (25.18)
La Sammarcota. Franchina
SAMMARTINO, Giuseppe (Italian
1720-93)
Dead Christ in Shroud 1752
BUSB 212 INS
The Shepherd
LIC 28 INN
Sicilian Crib 18th c. terra-
cotta and natural
materials BUSB 183 GMBN

Virgin and Child with St.
Anne marble; 320 cm (incl
195 cm plinth)
BODE pl 53; POPRB pl
48 IRA
SANSOVINO, Andrea--FOLL
Virgin and Child with St.
Anne bronze copy of 1512
SOTH-3:262
SANSOVINO, Antonio
Holy House
POPRB fig 78 ILorC
SANSOVINO, Jacopo (Real Name:
Jacopo Tatti) (Italian
1846-1570)
Allegory of Autumn terra-
cotta; 13x13-1/4
DETT 89 UMiD (45.25)
Allegory of the Redemption,
relief gilt bronze; 43x37 cm
POPRB pl 115 IVM
Allegory of Venice
POPRB fig 103 IVMa
Apollo, Loggetta 1537/40
bronze; 54
AGARC 10; BR pl 6;
CHENSW 392; CLAK 22;
MOLE 154; MURA 160
(col); POPRB pl 109;
POST-1:228; RAY 44
IVMa
Bacchus (Bacchus and Faun)
1510/20 marble; 146 cm
AGARC 76; BARG; BAZINW
350 (col); CHASEH 343;
FREEMR 142; KO pl 83;
MACL 225; MOREYC 114;
POPRB pl 50; RAY 44;
ROOS 114C; UPJ 326
IFBar
Bacchus and Young Faun
bronze; 71-1/2
USNI 236; USNP 169
UDCN (A-22)
Cardinal of Sant'Angelo
Monument
POPRB fig 62 IRMarc
Deposition from the Cross,
model wax
MACL 226 ELV
Hermes c 1537/40 bronze;
58-1/2
MAR 147 (col) IVM
Juno, bust marble; 18-1/4x
6-3/8x7
SDF 113 UCSDF
Jupiter bronze; 43 cm
POPRB pl 118 AVK

Loggetta
POPRB fig 101 IVMa
Madonna, plaque 1540
cartapesta on wood;
113x89 cm
BSC pl 87 GBS (285)
Madonna and Child bronze
CLE 94 UOC1A (51.316)
--bronze; 26
NCM 276 UNNMM (10.185)
--terracotta; 36
FAIN 163 UMWelC
--relief ptd and gilded
cartapesta and stucco;
47x37-5/8
USNKP 428 UDCN (K 332)
Madonna and the Young St.
John, relief clay
BODE 54 GBK
Mars
POPRB fig 107 IVP
Mars (or Meleager) bronze;
43
DETD 127; DETT 86 UMiD
(49.418)
Mercury
RAY 44; SEZ 210 IVMa
Miracle of the Maiden,
Carilla, relief
POPRB fig 114, pl 112
IPadAn
Negress with a Looking Glass
NM-11:20 UNNMM
Neptune bronze; 37
DETD 127; DETT 86
UMiD (49.417)
--1567 marble; twice LS
MAR 163; MOLE 154 (col);
POPRB pl 113 IVP
Peace bronze; 149cm
POPRB pl 108 IVMa
Sacristy Doors; detail: The
Resurrection
POPRB fig 113, pl 110
IVM
St. James marble
POPRB pl 51; WOLFFP
59 IFCO
St. John the Baptist bronze
CLE 94 UOC1A (52.276)
--marble; c 120 cm
POPRB pl 114; WOLFFA
267; WOLFFC 271 IVMF
St. John the Evangelist,
seated figure 1550/52
terracotta; 49 cm
BSC pl 86 GBS
(2611)

St. Mark the Evangelist,
seated figure: Healing
the Woman Possessed
by a Devil 1547/56
bronze; 20-1/2
MONT 391; POPRB pl
111 IVM
The Savior, fragment
marble; 27-1/2
BARD-2:pl 162 BrSpA
Tommaso Rangone Monument
POPRB fig 116, pl 116
IVGi
Two Giants, Giants' Stair-
case 1566
MURA 98 IVP
Venier Monument
POPRB fig 105 IVSa
Venus Anodyomene bronze;
65-7/8x18-1/2x13-1/4
READAS pl 125-27; SEYM
127-29; USNI 236; USNP
168 UDCN (A-21)
Portraits
Vittoria. Jacopo Sansovino,
bust
SANSOVINO, Jacopo--FOLL
Cupboard walnut; 8
COOP 88 IFCi
SANT, J. (English)
Dish Handle, model box-
wood, for cast silver
AUM 142
SANTA
Sculpture*
EXS 47
SANTACROCE, Girolamo (Italian
c 1502-37)
Virgin and Child
POPRB pl 53 INMCap
SANTAGATA, Antonio Giuseppe
(Italian)
Carlo Delcroix, bust
bronze
VEN-28:pl 43
SANT'AGATA, Francesco da
(Italian fl 1520)
Niobid bronze; 13-1/2
DETT 87 UMiD (37.148)
Schutzflehende 1520 bronze;
25.5 cm
BSC pl 89 GBS (1996)
Sant'Angelo, Cardinal of
Sansovino, J. Cardinal of
Sant'Angelo Monument
SANT'ELIA, Antonio (Italian 1888-
1916) See TERRAGNI,
Giuseppe and Attilio

SANTI, Paolo
Basin and Amphora red
porphory; 40; Dm: 90 cm
Pavonazzetto on marble
column; 40; Dm: 26 cm
FAL pl 57, 58 IRB
(CLXIV; and CIX)
Santina. Zadikow
El Santo See Ferdinand III (King of
Castile)
Il Santo. De Lednicka Lzczytt
Il Santo. Nicolini
Santorio, Giulio Antonio
Finelli. Cardinal Giulio
Antonio Santorio Tomb
SANTORO, Pasquale (Italian 1933-)
"...Il Temp non Conta..."
1966
VEN-66:#121
Lafcadio 1965 wood laths;
43-1/4x15-3/4x11-3/4
NEW pl 123
Santucci, Girolamo (Bishop of
Fossombrone d 1494)
Fiorentino, N. S. Girolamo
Santucci, medal
Saona. Hajdu
The Saone. Tuby
Sapientia
Quercia. Fonte Gaia: Wisdom
Sapphira
Early Christian. Santa Giulia
Casket
Sappho
Bourdelle. Sappho, seated
figure
Dupre. Sappho, seated figure
Mascherini. Sappho
Pradier. Sappho
Rodin. Sappho
Sara
Gill, E. Tobias and Sara
SARACCHI--FOLL
Vase: Dragon, Milan rock
crystal
CHRC fig 183 UDCN
The Saracen. D'Haese, Roel
Sarah
Ghiberti. Baptistry Doors--
East: Abraham Story
Sarcophagi
Byzantine. Sariguzel
Sarcophagus
Early Christian. Child's
Sarcophagus
Early Christian. Christ
between SS. Peter and
Paul, sarcophagus

Early Christian. Columnar
 Sarcophagus
Early Christian. Empress
 Helena Sarcophagus
Early Christian. The Good
 Shepherd, sarcophagus
Early Christian. Jonah
 Sarcophagus
Early Christian. Ravenna
 Sarcophagus: Apostles
Early Christian. Sarcophagus#
French--7th c. St. Agilbert
 Sarcophagus
--Sarcophagus: Classical
 Funeral Symbol
Italian--17th c. Sarcophagus
Moll. Sarcophagus of Franz I
 and Maria Theresa
Sarfatti, Amedeo
 Prini. Amedeo Sarfatti, head
SARGANT, Francis W. (English)
 Lamia, relief marble
 PAR-2:12
Sariguzel Sarcophagus. Byzantine
Sarmiento, Domingo Faustino
 (Argentine Political Leader
 1811-88)
 Rodin. President Sarmiento
 Rodin. Sarmiento Monument:
 Apollo
SARPENEVA, Timo (Finnish)
 Vases, free-form glass
 FAUL 220
SARRAZIN, Jacques (French 1588-
 1660)
 Cardinal de Berulle Monu-
 ment 1657 marble
 LOUM 147 FPL (1506)
 --effigy
 POST-2:20
 Henri de Bourbon Monument
 1648/63 marble and
 bronze
 BLUA pl 151A; COOPF
 246; LAC 199; LARR 271;
 ST 361 FChanC
 --Caryatids
 GAF 340
 Louis XIV as a Child, bust
 bronze; 23-1/2
 CHAR-2:107; LOUM 143
 FPL
 Temperance, medallion,
 Heart of Louis XIII Monu-
 ment c 1645
 BAZINW 393 (col) FPL
 Two Children with Goat
 LAC 80 FPL

SARRAZIN, Jacques, and Gillas
 GUERIN
 Caryatids 1636
 BLUA pl 150A FPL
SARTELLI, Germono (Italian 1925-)
 Sculpture 1964 iron
 VEN-64:pl 5
Sassetti, Francesco
 Sangallo, G. Francesco
 Sassetti Monument
SASSU, Aligi (Italian 1912-)
 Rearing Horse 1958 bronze
 SAL 36
Satan See Devil
Satellite Man. Jacobsen, R.
Saturn See Cronos
The Saturnalia. Biondi
Satyresses
 Clodion. Satyress and Child,
 tondo
 Riccio. Satyress
Satyrs See also Pan; Silenus
 Angemair. Satyr Mask
 Bernini, G. L. Satyr, bust
 Canova--Foll. Nymph and
 Satyr
 Clodion. Bacchante and Satyr
 Clodion. Satyr Crowning
 Bacchante
 Clodion. Satyr with Tambourine
 French--13th c. Satyr
 French--18th c. Mennecy Satyr
 Gericault. Nymph and Satyr
 Gericault. Satyr and Nymph
 Italian. Satyr and Hermaphro-
 dite
 Leoni, L. Satyr Attacked by
 Lion
 Lequesne, Satyr
 Niccolini. Satyr Family
 Fountain
 Riccio. Inkstand: With Two
 Satyrs
 Riccio. Paschal Candlestick;
 detail: Satyr
 Riccio. Satyr
 Riccio. Satyr and Satyress
 Zajec. The Frightened Satyr
 Zamboni. Rape of the Nymph
Sauceboats
 Kidney. Sauceboats, animal-
 form
Die Saule. Muller, E.
Sauli, Alessandro
 Puget. Blessed Alessandro
 Sauli
SAUPIQUE, Georges Laurent

Church of the Sacred Heart
detail: Angel
HOF 201 FP
Sausmarez, Philip de d 1747
Cheere, H. Philip de
Sausmarez Monument
Savage Tomb. English--17th c.
Saved. Brutt
Savile, George
Nollekens. Sir George Savile,
bust
Savile, Henry (English Classical
Scholar 1549-1622)
English--17th c. Sir Henry
Savile Monument
Savino, Saint
Ugolino di Vieri, and Viva
di Lando. Reliquary of
S. Savino
SAVINSEK, Jakob (Yugoslav 1922-)
The Camp 1952 bronze
BIH 168
Clown Dancing brass
BIH 169
Savoie, Marie Adelaide de
Coysevox. Marie Adelaide
de Savoie as Diana
Savoia Bonaparte, Clotilde, Princess de
Canonica.
Princess Clotilde di
Savoia Bonaparte /
Savonarola, Girolamo (Italian
Reformer 1452-98)
Italian--15th c. Savonarola,
medal
Robbia, L. della. Medal:
Savonarola
Robbia Family--Foll.
Savonarola, profile bust
Spinelli. Savonarola, medal
SAX, Ursula (German 1935-)
City on the Sea (Die Stadt
am Mer) 1960 iron;
90 cm
KUL pl 26
Saxe, Hermann Maurice de Comte
(French Marshal 1696-1750),
Known as Marshal Saxe, or
Marshal de Saxe
Pigalle, Marechal de Saxe
Tomb
SAXON, See also ANGLO-SAXON
Christ, head detail of
Crucifix 11th c.
bronze
MOREYM pl 74 GWeA
Raising of the Widow of
Nain's Son, pierced tablet

late 10th c. ivory; 5
GRIG pl 113 ELBr
Romsey Christ 11th c.
BAZINW 222 (col) ERomA
Seated Apostle, relief,
gallery c 1170/80 stucco;
50
BERL pl 191 GBSc (2739)
SCALA, Can Francesco della (Ruler
of Verona 1291-1329), called:
Can Grande della Scala
Campione. Can Grande della
Scala
Italian--14th c. Tomb of Can
Signorio
Scala, Cansignorio della d 1375
Bonino da Campione.
Consignorio della Scala
Monument
Scala, Mastino II della d 1351
Italian--14th c. Mastino II
della Scala, equest
Scala Regia. Bernini, G. L.
Scales See also Justice
Dutch--12th c. Shrine of
St. Servatius: Truth
(Veritas) Holding Scales
French--12th c. Last
Judgment
French--13th c. St. Firmin
Portal
--Last Judgment: St. Michael
Weighing Souls
Gislebertus. Tympanum: Last
Judgment: Weighing of
Souls
Italian--12th c. Kairos, re-
lief
Jamnitzer Workshop. Scales
Master H. L. Altarpiece:
Left Wing: Michael
Weighing Souls
Scaliger Family
Campionesi. Scaliger
Family Tomb
Scallop Capitals
English--12th c. Scallop
Capitals
SCALVINI, Giuseppe (Italian 1908-)
Offering 1957 bronze
SAL 35
SCAMOZZI, Vincenzo
Library of St. Mark,
Addition: Procuratic
Nuove, facade detail 1584
FLEM 419 IV
SCANDINAVIAN See also Viking; art
of countries, as Swedish

Engraved Tombstone: Whorl
and Beasts c 500
LARB 315
Plaque, with stylized Horses'
Heads, Lilleberre, Nam-
dalen, Norway 9th c.
whale bone
GRIF pl 114 ELBr
Plaques, for casket decora-
tion: Human and Animal
Figures, Vendel 7th c.
style bronze
LARB 109 SnSN
Stave Church Door, interlace
motif plaster cast c 1050
KIDS 16; LARB 85 NoU
Virgin Mary, seated figure
11/12th c. metal
BAZINW 282 (col) DCNM
Scapegoat. Roberts-Jones
Scaramouche See Commedia dell'
Arte
Scarf Dancer. Sicard
SCARPA BOLIA, Francesco (Italian)
Davide Giordano, bust
bronze
VEN-28:pl 103
"Scendea dalle Soglia..." Lotti
Scent Bottles See Perfume
Containers
Scepters See also Staffs
French--14th c. Gold Scepter
with Ivory Handle: Main
de Justice
--Sceptre of Charles V
Russian--15/16th c. Ivory
Throne and Sceptre
SCHACHERL-HILLMANN, Jeane
(Austrian-Israeli 1913-)
Kneeling Boy cast stone
SCHW pl 96
SCHACHT, Eilhard
German--17th c. Eilhard
Schacht Tomb
SCHADE, W. E. (German)
Figures, Commercial
Building facade terracotta
AUM 5 GB
SCHADOW, Johann Gottfried (German
1764-1850)
Count Alexander von der
Marck Tomb 1788/89
marble; 6 m
BAZINW 418 (col); KO pl
99; LARM 74; LIC pl 35;
RAY 53 GBDo

General Joachim Ziethen 1794
marble; 114
NOV pl 180b GBNea
Man, bust c 1797 ptd terra-
cotta on marble base; 16
(with 5-1/4 base)
KUHN pl 84 UMCF (1943.
1083)
Princesses Luise and
Friederike of Mecklenberg-
Schwerin (Two Princesses)
c 1797 marble; 67-3/4
BERL pl 247; BERLES
247; BRIO 38; CHASEH
426; ENC 803; KO pl 99;
LIC pl 34; LOH 253;
MARQ 251; MOLE 261;
NEWTEM pl 150; NOV pl
180a; POST-2:102; PRAEG
397; RICH 32; ST 409;
STA 47; VEY 144 GBSBe
(B II 34)
Quadriga of Victory, Branden-
burg Gate 1788/91
copper
BOE pl 188; CHRP 386 GB
Self Portrait, head c 1790
GOLDF pl 366 GBN
Woman, bust c 1797 ptd
terracotta on marble base;
16-1/8 (with 5-1/4 base)
KUHN pl 85 UMCF
(1943.1084)
Schaepkens, Theodore (Belgian
Engraver)
Geefs. Theodore Schaepkens,
bust
SCHARDT, Gregor van der (German
1530-81)
Frederick II, bust 1578
terracotta; 35 cm
BOES 122 KHiNF
Willibald Imhoff the Elder,
half figure, Nuremberg
1570 ptd terracotta;
81.5 cm
BSC pl 98; MUL 72 GBS
(538)
SCHARFF, Edwin (German 1877-
1955)
Badende 1930 marble;
80 cm
HENT 60
Curled-up Woman
VEN-30:pl 185
Fountain Nymph (Quellnymphe)
1949 bronze GERT 62

Heinrich Wofflin, bust 1923
bronze; 56 cm
OST 27 GCoW
--1923/24 granite; LS
HENT 58
Pandora 1953/53 bronze;
250 cm
ENC 803; GERT 62;
STM BAM
Portal, Marienthal Cathedral
1945/49 bronze
GERT 60
Shepherds of Bethlemen (Die
Hirten von Bethlehem),
relief 1946 bronze
GERT 61
Torso of a Woman (Weib-
licher Torso) 1929 bronze;
110 cm
MAI 265; NNMMAG 164;
OST 26 GHK
War Monument
(Kriegerdenkmal) 1925/32
stone; 10 m
HENT 59; VALE 82 GU
SCHATZ, Boris (Polish-Israeli
1866-1932)
Matthitjahu, the Father of
the Maccabees 1896
bronze
SCHW pl 6 BulS
The Sopher, relief bronze
SCHW pl 5 IsJB
SCHATZ, Zahara (Israeli 1916-)
Composition 1938
VEN-58:pl 159
Schaumberg, Ernst von d 1615
Vries. Mausoleum of
Count Ernst von
Schaumberg
SCHEEMAKERS, Henry (English
d 1748)
Sir Francis and Lady Page,
reclining effigies 1730
GUN pl 25; WHINN pl
73A ESteep
SCHEEMAKERS, Peter (Flemish-
English 1691-1781)
See also Plumier, Denis
Captain Robert Sanders
1746
WHINN pl 99 ELTH
Dr. Hugh Chamberlen, effigy
model c 1730 terracotta
BUSB 154 ELV
Dorothy Snell Monument
d 1746
WHINN pl 96A EGM

Edward VI, boy-king 1737
bronze; LS
GLE 100 ELStT
1st Earl of Shelburne Monu-
ment 1754
WHINN pl 96B, 98 EHi
General the Hon. Percy Kirk
Monument after 1743
WHINN pl 97B ELWe
John Dryden Monument
BROWF-3:61 ELWe
Sir Justinian Isham, bust
c 1737
marble; 24
CON-3:pl 34; GARL 203
ENorI
Sir Richard Brodrepp Monu-
ment 1739
WHINN pl 65A EMap
Viscount Cobham c 1733
WHINN pl 61 ELV
William III, equest 1735
WHINN pl 68A EHuM
SCHEEMAKERS, Peter, and Laurent
DELVAUX
Dr. Hugo Chamberlen Monu-
ment 1731 marble
MOLS-2:pl 28; WHINN pl
71B ELWe
Lewis, Earl of Rockingham,
Monument 1732
WHINN pl 71A ERock
Sir Samuel Ongley, monument
1726
GUN pl 26 EOldW
SCHEEMAKERS, Peter, and William
KENT
William Shakespeare Monu-
ment 1740
ENC 804; GERN pl 60;
GLA pl 44; HORS cont;
MOLS-2:pl 29;
WHINN pl 75 ELWe
SCHEEMAKERS, Thomas (English
1740-1808)
Admiral Balchen Monument,
detail: Foundering of the
"Victory" 1744
ESD pl 134 ELWe
Mary Russell Monument
1787
ESD pl 141, 142; WHINN
pl 133B EPo
Ralph Freman and Elizabeth,
his Wife, roundel, monu-
ment c 1773
GUN pl 24
EBraug

SCHEGGI, Paolo (Italian 1940-)
 Intercamera Plastica 1967
 KULN 205
SCHEIBE, Richard (German
 1879-)
 Ehrenmal auf dem Friedhof
 1932 stone; 232 cm
 HENT 44 GFS
 Little Girl bronze
 VEN-34:pl 157
 Male Head 1913 bronze;
 35.5 cm
 OST 25 GHaL
 Self Portrait (Selbstbildnis),
 head 1931 bronze; LS
 HENT 45; RICH 189 GBN
 Stehender Jungling 1933
 plaster, for bronze;
 204 cm
 HENT 46
 The Suppliant (Flehende) 1941
 bronze
 GERT 57
 Vision 1924 wood; 59 cm
 HENT 47 GDA
SCHELDEN, Peter van (Flemish)
 Panels (line drwg) 1531 oak
 CHRP 249 NOuH
SCHEPS, Marc (Israeli 1933-)
 Espace de Reve II 1963 wood
 NEW pl 229
Scherenberg, Rudolf von
 Riemenschneider. Prince-
 Bishop Rudolf von
 Scherenberg, head detail,
 effigy
SCHEUERNSTUHL, Hermann
 Aurelia, meadow ore
 GERT 88
SCHEURICH, Paul (German)
 Repose Berlin Porcelain
 VEN-26:pl 77
La Schiapa. Orsolini
Schickedanz, Albert (Architect)
 Strobl. Albert Schickedanz,
 bust
SCHIFFERS, Paul Egon
 Fugue (Fuge) 1953
 plaster
 GERT 126
 Seated Woman (Sitzende) 1948
 Solnhof slate
 GERT 126
Schiller, Friedrich von (German
 Dramatist 1759-1805)
 Dannecker. Schiller, bust
 Reitschell. Goethe-
 Schiller Monument

SCHILLING, Albert (Swiss 1904-)
 Church Door 1955
 JOR-1:pl 38
 Forme II 1957
 JOR-2:pl 270
 Turris Davidica 1959 polished
 bronze
 VEN-62:pl 192 SwBSt
 Zweiklang 1957
 JOR-2:pl 269
SCHILLING, Johannes (German)
 Germania-Niederwald
 Monument of German
 Unity (cast)
 RAD 443 GDSc
SCHILSKY, Eric
 Edouard Shilsky, bust
 HUX 86
SCHIMKOVITZ
 Apartment House Corner
 Windows
 AUM 82
SCHINKEL, Karl Friedrich (German)
 School of Architecture Porch
 1831
 BOE pl 189 GB
SCHIPPERS, Wim T. (Dutch 1924-)
 Lilac Chair 1965 cast
 concrete; 16'4-7/8"
 NEW pl 156 NAS
SCHLANSOVSKY, J. J. See
 SLANZOVSKY, J. J.
SCHLEEH, Hans (German 1928-)
 Abstract Form in
 Serpentine 17-1/2x15x
 7-1/2
 READCON 188 CMD
SCHLEMMER, Oskar (German
 1888-1943)
 Abstract Figure 1921
 BURN 214
 --1921 bronzed and matted
 nickel; 41-1/2
 HAMP pl 128B UMdPW
 --(Abstrakte Figure; Rotund
 Plastic; Rundplastik)
 1921 nickel plated bronze;
 107x67 cm
 LIC 251; OST 87; ROOS
 281G GStS
 --sculpture in the round 1921
 nickelled bronze; 48-1/8
 LYN 134 ELMa
 Abstrakte Rindplastik 1921
 gilded bronze; 41
 ENC 806; LARM 375;
 READCON 122
 GMB

Dance in Metal 1926
GIE 54
Homo 1931 iron wire
MAI 266 GZR
Relief 1921
BERCK 326
Sculpture 1921 plaster; 43x27
GIE 53 GStS
SCHLETTER, Jakob Christian
Staircase Figures 1726/27
GIE 53 GStS
SCHLOR, Simon (German d 1597/98)
Armed Figures, choir
monuments to the Counts
of Wurtemberg 1574
BUSB 31 GStCh
Schlozer, Dorothea von Rodde (1st
Woman Ph D in German
University 1770-1825)
Houdon. Dorothea Schlozer,
bust
SCHLUTER, Andreas (German 1644-
1714?)
Apollo, and Daphne 1712
sandstone; ea: 200 cm
BERLE pl 84, 85 GBSBe
(8658, 8659)
Courtyard 1698/1707
(destroyed)
HEMP pl 130 GBSS
Courtyard Keystone: Dying
Warriors Masks c 1696
BUSB 128-29; HEMP pl
128; MARQ 236; ST 364
GBAr
Courtyard Keystone: Medusa
Head c 1696
BOE pl 172; HEMP pl
128 GBAr
David Mannlich Monument,
detail 1700
HEMP pl 129 GBNi
Death, Sarcophagus of
Queen Sophie Charlotte
1705
BUSB 126 GBCa
Europa, relief, Rittersaal
c 1700 (demolished 1950)
BUSB 127 GB
Friedrich II, "Prinz von
Homburg", bust
BUSB 124 GHomS
Friedrich Wilhelm, Great
Elector of Brandenberg,
equest, Long Bridge
1698/1703 bronze; 114
BAZINW 409 (col); CHASEH
407; CHENSW 457; ENC
806; HEMP pl 131; JANSK

870; KO pl 94; LARR 322;
NEWTEM pl 144; POST-2:64;
PRAEG 333; VEY 141
GBCh
Friedrich Wilhelm I, bust
1698/1709
BUSB 125 GBCh
Great Staircase, detail:
Atlas 1699/1706
BOE pl 176 ASM
Kamecke House, ext with roof
figures (destroyed); figure
details: Poseidon;
Amphitrite 1711/12
HEMP pl 132 GBM
Neptune c 1711/12 sandstone;
82
BERL pl 197; BERLE pl
87; BERLEK pl 41;
BERLES 197 GBSBe (8656)
Warrior's Mask c 1697
VEY 65 GBMK
Youth, head 1712 sandstone;
49 cm
BERLE pl 88 GBSBe (8661)
Schmeling, Max (Pugilist 1905-)
Belling. Max Schmeling
Fiori. Il Pugile Max
Schmeling
Schmelka, Eleazer ben Samuel
(Rabbi of Amsterdam)
Levi. Eleazer ben Samuel
Schmelka, medal
SCHMID, Joseph, of Urach d 1555
Duke Ulrich Tomb, detail:
God the Father and
Christ, medallion c 1550
BUSB 10 GTuS
SCHMIDT, Joost
Hyperboloid Sculpture 1928
MOHN 48
SCHMIDT, Rudolf
Figure
AGARN il 4 AV
SCHMIDT-ROTTLUF, Karl (German
1884-)
Head 1917 wood; 13-1/2
LYN 106; OST 48;
TATEF pl 50e ELT (6250)
--Head 1928 pebble; 2-1/4
RAMS pl 63b -Scha
Head of Woman
VALE 158
Relief: Two Nudes 1911
wood; 7-3/4x11
ARTSP 81 -GS
Standing Figure c 1917 wood;
12 RAMS pl 63a -Scha
Schmiedel, "Baron"

German--18th c. Postmaster
"Baron" Schmiedel
SCHMIEDT, Frederic (Swiss)
Dawn (L'Alba) bronze
VEN-26:pl 158
SCHMITZ, Bruno, Emil
HUNDREISER, and Nicolaus
GEIGER.
Kyffhauser Plateau Monu-
ment: With Statues of
Kaiser Wilhelm I and
Frederick Barbarosa H:
213'
POST-2:172; TAFTM 58
SCHMUZER, Josef and Franz
Xavier SCHMUZER (German)
Parish Church Interior
Decoration 1738/57
LARR 316 (col) GRotte
SCHNEGG, Lucien Jane (French
1864-1909)
Poupelet, head 1897 bronze
SELZJ 142 FPMP
SCHNEIDER, Christopher (Danish)
Medal: Danish Koge Bay
Naval Victory over
Swedes c 1686 gold;
Dm: 12. 7 cm
BOES 46 DCNM
SCHNEIDER, Georges (Swiss-
French 1919-)
Christ
JOR-2:pl 124
L'Ouvrier 1953 bronze;
75 cm
JOR-1:pl 42
SCHNELLENBUHEL, Gertraud
von (German 1878-)
Candelabrum for 24 Candles
after 1911 silver plated
brass; c 19
SELZPN 119 GMStm
SCHNIER, Jacques (Rumanian
1898-)
Cubical Variations Within
Rectangular Column
1961 copper; 83x14x12
READCON 207
Jacqueline Ehrman, relief
wood
NEUW 93
Schnitterin. Garbe, H.
Schoendorff, Hermann
Elkan. Hermann Schoendorff,
head
SCHOFFER, Nicolas (Hungarian-
French 1912-)
Chronos I, mobile with

electric motor 185x120x
125 cm
SAO-6
Chronos 5 1962 aluminum,
cast steel, plastic; 72
ALBK; LARM 329; EXS
109 FPSc
Cysp I 1956
BERCK 132; BURN 341
FMa
Cysp II 1956
BERCK 133
Lux I 1957
BURN 297
--1958
KULN 194
Lux 4 (Lumino Dynamic
Complex) 1957
MAI 268; MARC pl 71
Lux 8, Sculpture
Spatiodynamique 1959
Copper plated steel; 101
TRI 29
Lux 9 1959
PEL 161 FPRe
Microtemps 10 1964
BURN 279
Projections Lumino-Dynamisme
1958
KULN 194
Sculpture Spatiodynamique et
Peinture Mobile
FPDEC il 19
Spatiodynamique Relief 1952
Dellite, Plexiglas, and
Duralumin; 36x24
SCHAEF pl 128
Spatiodynamic Sculpture 1954
iron
MARC pl 70
Spatiodynamique No. 19 1953
brass and iron; 39-3/4x28x
32-5/8
READCON 206 FPRe
Spatiodynamique No. 22 1954
cast steel and aluminum;
49-1/2x22-3/4x29-1/4
ALBC-4:73 UNBuA
SCHOFIELD, John
George III Candelabra 1798
silver gilt
SOTH-3:213
George III Three-Light
Candelabra 1793
SOTH-3:212
Scholar, bust. Francia
Schone Madonna See Beautiful
Madonna

SCHONHERR, Matthias
 Allegory of Faith, altar
 1738/39
 STECH col pl 7 (col)
 CzPJ
SCHOOL OF CHAMPAGNE
 Virgin early 14th c.
 EVJF pl 249
 FPL
SCHOOL OF METZ
 Baptism of Christ, casket
 panel 10th c. ivory
 MOREYM pl 66 GBrSM
SCHOONHOVEN, J. J. (Dutch
 1914-)
 Relief with Squares 1964
 mixed media; 40-1/2x50
 NEW pl 159 NEA
SCHOOP, Uli (Swiss)
 Fountain 1946
 DAM 210 SwZ
Schopflin, Aladar
 Beck, A. Aladar Schofflin,
 medal
SCHORDERET, Bernard (Swiss
 1918-)
 Panneau de Marbre 1957)
 JOR-2:pl 271
Schotten Portal. Romanesque--
 German
SCHOTZ, Benno (Estonian-
 Scottish 1891-)
 Girl Crouching sandstone
 NEWTEB pl 54
 H. McAlevey, bust bronze
 NEWTEB pl 55
 Helen Biggar, head
 CASS 50 ScDuP
 Major Malcolm V. Hay,
 head 1952 bronze
 SCHW pl 45
 Miss Maud Risdon, bust
 CASS 42
 Moses Hammering out the
 Ten Commandments
 (Moses the Sculptor)
 limestone
 ROTH 884; SCHW pl 46
 Mother and Child
 CASS 76
 Nude 1956 terracotta;
 36x23x31
 LONDC pl 24
SCHRAMM, Friedrich(?) (German
 c 1480-1515)
 Madonna with Cloak,
 Ravensburg 1480 ptd wood
 KO pl 66 (col) GBS

SCHREIB, Werner (German 1925-)
 Petrification Semantique
 1963 seal ring on wood
 board
 NEW pl 315 IRBie
SCHREINER, Carl Moritz (German
 1889-1948)
 Standing Cat 1930 bronze; 96
 SCHAEF pl 10
 Woman Sitting 1928 cement;
 28
 SCHAEF pl 11
Schreitende Junger. Karsch, Joachim
Schreitender
 Giacometti. Man Walking
SCHREITER, Gerhard
 Eventide (Feierabend) 1951
 clay
 GERT 229
 Man in Arm Chair (Mann im
 Liegestuhl) 1952 clay
 GERT 229
Schreyer, Sebald
 Kraft. Sebald Schreyer
 Tomb
SCHRO, Dietrich (?) (German)
 Kurfurst Ottheinrich von der
 Pfalz, bust, Mainz
 1556/58
 alabaster; 16 cm
 MUL 47 FPL
Schroder, Ernst
 Heiliger. Ernst Schroder,
 head
Schuffenecker, Emile
 Gauguin. Mme. Emile
 Schuffenecker
Schulte, Antoinette
 Despiau. Antoinette Schulte,
 bust
SCHULTZE, Bernard (German 1915-)
 Baal-Migof 1965 polyester on
 canvas, wire, textiles,
 oil; 73-1/4x41
 NEW col pl 121 (col)
 UNNWise
SCHUMACKER, Emil (German 1912-)
 Tactile Object 1957
 BERCK 329
SCHUMANN, H. P. (German
 Pierre
 FPDEC-German il 7
SCHUMANN, Hans Adolf
 Reclining Female Figure
 (Liegende Weibliche Figur)
 polished Blaubank
 GERT 224
 Shepherd (Schafer)
 GERT 225

Schuster, Ildefonso
 Messina. Cardinal Ildefonso
 Schuster
Schutzflehende
 Sant'Agata. Shutzflehende
Schutzmantel Madonna
 Erhart, Gregor. Madonna
 with the Protecting Mantle
Schutzmantel Virgin. German--
 15th c.
SCHWAB, Alex C.
 Janet Thompson 1963 bronze
 PER 51
Schwangere. Roeder
SCHWANTHALER, Franz(?)
 (Austrian 1683-1762)
 Kneeling Magdalen c 1730
 pearwood; 6-1/2
 KUHN pl 74 UMCB
 (1964. 36)
SCHWANTHALER, Johann Peter,
 the Elder (Austrian 1720-95)
 God the Father ptd and
 gilded wood
 CLE 149 UOClA (61. 30)
SCHWANTHALER, Thomas
 (Austrian 1634-1707)
 Coronation of the Virgin,
 winged altar 1675/76
 BUSB 112 AStW
SCHWARTZ, Buky (Israeli 1932-)
 Composizione 3 1966 aluminum
 VEN-66:#190
Schwartzenburg, Friedrich (Austrian
 Ecclesiastic 1808-85)
 Myslbec. Cardinal
 Schwartzenburg
SCHWARZ, Hans (German 1492-1519/
 20)
 Allegorische Darstellung(?),
 tondo maple; Dm: 10.8 cm
 BSC pl 99 GBS (M 187)
 Count Palatine Georg, Bishop
 of Speyer, medal 1520
 bronze; Dm: 2-5/8
 VEY 151 GMSM
 Death and the Maiden (Der
 Tod und das Madchen),
 tondo 1520 maple; Dm:
 10.5 cm
 BSC pl 99; MUL 12 GBS
 (M 186)
 Judgment of Paris, tondo
 1520 maple; 10.5 cm
 MUL 12 GBS
 Unrighteous Judge (Der
 Ungerechte Richter),
 Nuremberg Rathaus 1519/20
 lindenwood; 50 cm MUL 30
 GNG

SCHWARZ, Heinz (Swiss 1920-)
 Chat 1955
 JOR-2:pl 272
 Le Depart 1957
 JOR-2:pl 275
 Femme Debout 1955 plaster;
 85 cm
 JOR-1:pl 57
 Fille Assise 1959
 JOR-2:pl 274
 Fille au Chien 1955 plaster;
 75 cm
 JOR-1:pl 58
 Fille aux Nattes 1957
 JOR-2:pl 273
 Fille Debout 1959
 JOR-2:pl 118
 Torse 1947/50 plaster;
 200 cm
 JOR-2:pl 56
Schwarzburg, Gerhard von
 German--14th c. Gerhard
 von Schwarzburg Tomb
Schwarzer Bovist. Hiltmann
Schwebender Engel
 Barlach. Hovering Angel
Schwebende Landschaft. Cimiotti
Schwebeplastik. Bodmer
Schweidnitz, Anna von
 Parler. Anna von Schweidnitz,
 Triforium bust
SCHWEIGGER, Georg (German)
 Neptune, detail, Nuremberg
 Neptune Fountain 1667
 bronze; LS
 MUL 98, 99 RuPet
SCHWEINBERGER, Anton (German
 fl 1587-1603)
 Palm Nut Jug c 1602 silver
 gilt mount; 15-1/8
 ARTV pl 43 AVK
SCHWERTDFEGER, Kurt
 Deshabille terracotta
 MARTE pl 16
 Llame (Lama) terracotta
 MARTE pl 16
 Poodle (Caniche) terracotta
 MARTE pl 41
 Ram (Belier) terracotta
 MARTE pl 16
 Woman with Bread (Femme a
 la Tresse) stone
 MARTE pl 16
 Zebra terracotta
 HOP 225; MARTE pl 41
SCHWILGUE
 Astronomical Clock, restored
 1838 by Schwilgue
 GAF 195
 FStrCN

SCHWIPPERT, Kurt
 Portrait 1945 bronze
 GERT 113
 Standing Female Figure
 (Stehende) 1954 plaster
 GERT 112
 Young Woman with Shawl
 (Madchen mit Tuch)
 GERT 112
SCHWITTERS, Kurt (German
 1887-1948)
 Autumn Crocus 1926/28 (cast)
 composition stone; 31-1/2
 READCON 128 ELL
 Christmas Tree, Hanover
 1920
 RICHT pl 69
 Grey-Rose Picture 1932
 READAN #55 GHaKL
 Matthias Merzbild 1919 oil
 and assemblage
 RICHT pl 68
 Mermaid Purse 1942/45
 eggshell on a skate;
 16x23 cm
 LIC pl 261 ELL
 Merzbau c 1924 (begun 1920,
 destroyed 1943)
 BAZINW 343; KULN 203;
 READCON 127; SEITA
 50, 51 GHa
 Merzbau I 1918/36 wood,
 plaster, paint collage;
 c 75 m
 OST 83 GHaWa
 Merzbild (Rubbish Picture)
 MYBM UPPPM
 --1919 oil and assemblage
 RICHT pl 72
 Merz Construction 1921 ptd
 wood, wire, mesh, paper,
 cardboard; 14-1/2x8-1/2
 SEITA 55 (col); SEW
 914 UPPPM
 Merz Construction (Gallows
 of Lust) (destroyed) 1919
 wood, iron, papier mache
 GIE 91
 Merz Relief (destroyed)
 1928/30 ptd wood; c 45
 to 60 cm
 OST 86
 Relief 1923
 BERCK 330
 Schwitters' Column (Schwit-
 ters-Saule) 1918/58
 RICHT pl 73

 Schwitters' Column
 (Schwitters-Saule), with
 Guinea Pig 1918/58
 RICHT pl 74
 Spherical Form (destroyed)
 1932 plaster and ptd
 stone; c 20
 GIE 228
 Ugly Girl c 1943/45 ptd
 wood and plaster; 10-1/4x
 12-1/4x9-1/4
 READCON 129 (col) ELL
 Wall Decoration begun 1920
 (destroyed 1943)
 TRT 256 GHaM
Schwitters' Column# Schwitters
Science and Scientists
 Vantongerloo. Sculpture in
 Space: $y = ax^3 - bx^3$
Science Fiction. Mastroianni
Scilenos See Silenus
Scipio
 Mantegna. Triumph of Scipio,
 relief
Scipio Africanus (Roman General
 237-183 B. C.)
 Italian--17th c. Scipio
 Africanus, bust #
Scoops
 Russian--2nd mil B. C.
 Scoop: Duck
Scooter and Feather. Picasso
SCOTT, George Gilbert (English
 1811-78)
 Albert Memorial (Frieze by
 Foley; Weekes; H. H.
 Armstead) marble, bronze,
 mosaic; 175'
 BROWF-1:94; MILLER il
 167; WHITT 147 ELKe
 Capitals c 1858
 BOASE pl 77A EHalA
 Portraits
 Philip. Albert Memorial,
 Frieze detail: Pugin,
 Scott, Cockerell, and
 Barry
Scott, Robert Falcon (English
 Antarctic Explorer 1868-1912)
 Kennet. Captain Scott
Scott, Tim (English 1937-)
 ... for Cello 1965 plastic
 and steel tube; 54x108x152
 LOND-7:#35 ELW
Scott, Walter (Scottish Writer
 1771-1832)
 Chantrey. Sir Walter Scott,
 bust

Steell. Walter Scott,
seated figure
Scott, William
McWilliam. Wiliiam Scott,
bust
SCOTTISH
Cat Clothed in Roses 19th c.
Wemyss China
NMFA 233 UNNRay
Scouting Woman. Volwahsen
Scramasax. Sweddish--7/8th c.
Screen Form. # Adams, R.
Screen with Slats. Adams, R.
Screens and Lattices See also Choir
Screens; Reredos; Rood
Screens
Adams, R. Architectural
Screen
Arp. Two Screens
de l'Orme. Screen
Down, R., and J. Hyll.
Wooden Screen, cornice
detail
Endell. Radiator Screen
English--15th c. Decorated
Style Screen
--Edward II, and Edward III,
choir screen
English--16th c. Screen,
detail
English--17th c. Chapel
Screen
--Hall Screen
Evans, M. Screen
French--16th c. Cathedral
Ambulatory Screen
Galle. Screen
Georgian. Altar Screen, detail
German--16th c. Window
Lattice
Gothic-English. Screen, detail
Goujon. Apostles John and
Matthew, relief from
screen
Goujon. The Deposition,
relief
Hutton. Engraved Screen
Moore, H. Time-Life Facade
Screen
Netherlandish. Rood Screen
Scriabin. Zalkalns
Screw Mobile. Martin, K.
Scribes See Writers
Scroll Cases
German--17th c. Scroll of
Esther Case
Scrolls
Giovanni da Udine. Foliated
Scroll

Scrope, Lord d 1609
English--17th c. Lord and
Lady Scrope Monument
Scrovegni, Enrico
Italian--14th c. Enrico
Scrovegni Monument
Scrovegni Madonna
Pisano, Giovanni. The Arena
Madonna
Sculptors and Sculpting See also
Self Portraits
Apolloni. La Sculptura
Bourdelle. Little Sculptress
Resting
Bourdelle. Theatre de
Champs-Elysees
Fischer, A. Sculptor, bust
Krsinic. Sculptor, hand
detail
Milles. Aganippe Fountain:
The Sculptor
Multscher. German Yeoman
Nanni di Banco. Stone-Work-
ers and Sculptor, relief
Pisano, A. Sculptor at Work
Rosandic. The Sculptor
Schotz. Moses Hammering Out
the Ten Commandments
Tassaert. Painting and
Sculpture
Zocchi, E. Michelangelo at
Work on First Sculpture
Scultura con un Piccolo Nucleo.
Tihec
Scultura Forte. Guerrini
Sculptural Object. Moore, H.
Sculpture: Wood with Colour.
Hepworth
Sculpture 53: Equilibrium. Pan
Sculpture Auto-Mobile-Meta
Mecanique. Tinguely
Sculpture Conjugale. Arp, J., and
Taeuber-Arp, S.
Sculpture en Deux Parties II. Monney
Sculpture for a Garden. Willequist
Sculpture for the Blind. Brancusi
Sculpture in Black Carrara
Marble. Signori
Sculpture in Iron. Crippa
Sculpture in Iron. Gerdur
Sculpture in Space: $y = ax^3 - bx^3$.
Vantongerloo
Sculpture in Wood. Stahly
Sculpture Mediterranneene. Arp
Sculpture Spatiodynamique et
Peinture Mobile. Schoffer
Sculpture Verticale. Gigon
Sculpture with Colour and Strings.
Hepworth

and Child; Professions
Teaching
French--14th c. Seal of
Louis I, King of Naples
and Duke of Anjou
German--10th c. Lothar
Crucifix, with Seal of
Lothair
German--12th c. Seal of
Bishop Adalbert I
German--14th c. Rome, Seal
of Emperor Ludwig of
Bavaria
German--15th c. Council of
Basle Seal
Inghelbrecht. Seal of City of
Bruges
Seasons See also names of Seasons,
as Autumn; Spring; Summer;
Winter
Armitage. The Seasons
Boulle. Bureau of Elector
of Bavaria; detail: Seasons
Chadwick. The Seasons
English--18th c. Chelsea
Four Seasons
English--19th c. Pearlware
Figures: Mars; Spring
and Autumn
Fouquay, N.--Attrib. Seasons:
Two Busts
French--16th c. Portal and
Retable: Seasons; Last
Judgment
Gunther, J. J. The Four
Seasons
Labroureur, and L. Cardelli.
Season Vases
Oakley. "Spring"; "Winter"
Raemisch. Summer; Winter--
Table Decorative Figures
Yencesse. The Four Seasons
(Les Quatre Saisons)
The Seasons--Cock. Meadows
"Seat of St. Mark". Byzantine
Seated Armed Figure. Meadows
Seated Figure Against a Curved
Wall. Moore, H.
Seated Figure with Raised Arms.
Armitage
Seated Greek. Couzijn
Seated Group Listening to Music.
Armitage
Seated Pugilist. Marini
Seated Queen. Brown, R.
Seated Woman with Arms Extended.
Armitage
Seated Woman with Child. Butler

Seats
Ratcliff. Cathedral Seat Ends
Sebald, Saint
German--14th c. Bride's Door
Vischer, P., the Elder; P.
Vischer, the Younger;
Hermann Vischer, the
Younger. St. Sebaldus Tomb
Sebastia (Sebaste)
Byzantine. Forty Martyrs of
Sebastia
Sebastian, Saint
Albiker. Der Heilige
Sebastian
Benedetto da Maiano. St.
Sebastian
Berruguete. Altar of San
Benito
Bourdelle. St. Sebastian
Braun, M. B. Holy Trinity
Column: St. Sebastian
Bulla, J. B., and Cechpauer.
St. Sebastian, fountain
Civitale. St. Sebastian
English--14th c. Henry VII
Chapel: St. Sebastian and
Two Executioners
Francesco di Giorgio Martini.
St. Sebastian
Gemelich. St. Sebastian
German--15th c. St.
Sebastian #
German--17th c. St.
Sebastian
German--18th c. St. Sebastian
Gill, E. St. Sebastian
Giorgetti. Martyrdom of
St. Sebastian
Giuliani. St. Sebastian
Hungarian--18th c. St.
Sebastian
Italian. St. Sebastian
Italian--15th c. St. Sebastian
Kern, E. St. Sebastian
Leoncillo. San Sebastiano#
Leygur. Sao Sebastiao ou o
Fuzilado
Paolozzi. St. Sebastian#
Petel, G. St. Sebastian#
Puget. Martyrdom of St.
Sebastian
Puget. St. Sebastian
Riemenschneider. St.
Sebastian
Rossellino, A. St. Sebastian
Silvestro dell'Aquila. St.
Sebastian
Vittoria. Altar; detail: St.
Sebastian

Vittoria. Altar of the
Luganegheri; details:
St. Roch; St. Sebastian
Vittoria. St. Sebastian
Zurn, Martin. St. Sebastian
Zurn, Martin, and Michael
Zurn. Death of St.
Sebastian
SEBASTIAN DE ALMONACID
(Spanish fl 1486-1527)
Monuments of Condestable
Alvaro de Luna and his
Wife, Capilla de Santiago
1489
MULS pl 151 SpTC
SEBASTIAN DE ALMONACID--
ATTRIB
Martin Vazquez de Arca
Tomb c 1486 marble
BAZINW 328 (col);
BUSR 100; CHASEH 280;
GUID 139; MULS pl 148;
WES pl 5 SpGuS
The Second War Dream. Fullard
The Secret. Eberlein, G.
Secret of the Tomb. St. Marceaux
Sedan Chairs
Perchin. Miniature Sedan
Chair
Spanish--18th c. Sedan Chair
of Philip V
Seed No. 3, 1959. Tajiri, S.
SEGER, Ernst (German)
Leaping Figure
CASS 88 GBWan
Seventeen-Year-Old Girl
TAFTM 71
Segers, Herkules
Borsos. Herkules Segers
SEGESDI, Gyorgy (Hungarian 1931-)
Immaculate Virgin 1964
sheet lead
VEN-64:pl 196 HJa
Partisan, bust 1953 plaster;
35 cm
GAD 118
SEGOFFIN, Victor
Man, bust marble
MARY pl 80
FPLu
SEGUINI, Gamal el (Egyptian 1917-)
This is our Lord bronze;
33.5 cm
SAID pl 98 EgCMA
La Seine. Coysevox
SEITZ, Gustav (German 1906-)
Bertolt Brecht 1958 bronze;
19-5/8 BERL pl 251;
BERLES 251 GBSBe (B II 31)

Francois Villon 1950/51
terracotta
GERT 93
Francois Villon IV, bust
1952/53 bronze; 26
MID pl 91 BAM
Girl with Garment (Madchen
mit Gewand) 1951 terracotta
GERT 92
Happy Wet-Nurse bronze; 11
MID pl 92 BAM
Rosa in Bed 1956 bronze;
7-5/8x15
TRI 65 GBN
Spanish Woman, head 1956/59
terracotta
MAI 269
The Student (Der Lehrer)
1950/51 bronze; 1.90 m
OST 54 GMaM
Union, relief sketch 1947
plaster of Paris
SCHAEF pl 32
SEKAL, Zbynek (Czech 1923-)
End of the Woods 1963
wood; 23-1/2x32-1/4
NEW pl 252
Sculpture*
EXS 41
Selene See also Endymion
Bourdelle. Selene
Bourdelle. Selene with Bow
Self Destroying Sculpture
Tinguely. Homage to New
York
Tinguely. Metametric No. 17
Self-Portraits
Alberti. Self Portrait#
Avraam. Korsun Gate, details:
Avraam, self portrait
Bakic. Self Portrait, head
Bandinelli, B. Self Portrait,
profile relief
Bernini, G. L. David
Bokros-Birman. Self Portrait,
head
Boldu. Self Portrait,
medallion
Bourdelle. Self Portrait#
Breyer. Self Portrait, head
Brokoff, F. M. Self
Portrait, head detail,
St. Francis Xaverius Group
Brunelleschi. Self Portrait,
tondo
Buvina. Self Portrait, choir
stall
Canova. Self Portrait,
head

Conrad von Einbeck, Self
 Portrait, bust
Cornet. Mon Portrait, head
Coysevox. Self Portrait,
 bust#
Dannecker. Self Portrait,
 bust
Daumier. Self Portrait,
 head
Debonnaires. Self Portrait,
 head
Dubroeuca. "Three Women in
 the Sculptor's Studio"--
 artist at work at left,
 chancel screen
Einbeck. Self Portrait
Filarete. Basilica Doors:
 Master Sculptor with
 Assistants
Flaxman. Self Portrait,
 medallion
Gargallo. Self Portrait
Gauguin. Be in Love and
 You Will be Happy, relief,
 with self portrait
Gauguin. Self Portrait,
 profile relief
Gerhaerts. Self Portrait(?)
 bust
Gettinger. Self Portrait
Ghiberti. Baptistry Doors-East:
 Self Portrait, tondo, bust
Glicenstein. Auto Portrait,
 head
Heerup. Self Portrait
Keller. Selbstbildnis, seated
 figure
Kern, H. Sculptor at Work,
 relief
Kokoshka. Self Portrait as
 a Warrior, bust
Kolbe. Self Portrait, head
Kollwitz. Self Portrait, head
Konnenkov. Self Portrait,
 bust
Kraft. Sacrament Tabernacle:
 Self Portrait, kneeling
 figure
Kraft. Sebald Schreyer Tomb:
 Self Portrait, kneeling
 support figure
Kraus. Selbstbildnis, head
Larchevesque. Self Portrait
Madrassy. Self Portrait,
 profile medal
Mantegna. Self Portrait,
 head
Martini, A. Self Portrait
 (Autoritratto)

Master Matteo. Portico de la
 Gloria: Self Portrait,
 kneeling figure
Master of Abbey of Saint-
 Lucien Choir Stalls. Master
 at Work
Master of the Berne Choir
 Stalls. Master at Work
Master of the Mercy Gate.
 Mercy Gate, tympanum
Master of the Poehlde Choir
 Stalls. Self Portrait--at
 work
Messerschmidt. Self Portrait:
 "Dismal Gloomy Man"
Messerschmidt. Self Portrait:
 "Man in Distress
Messerschmidt. Self Portrait,
 head
Meszaros. Self Portrait, head
Michelangelo. Pieta: Self
 Portrait
Nanni di Banco. Self
 Portrait: Chiselling Putto,
 relief
Niclaus von Hegenau. Self
 Portrait
Orcagna, A. Tabernacle:
 Self Portrait, back relief
Parler. Self Portrait, bust
Parmeke. Self Portrait, head
Permoser. Apotheosis of
 Prince Eugen: Self
 Portrait: Crouching Figure
 of Conquered Turk
Pilgram, A. Self Portrait#
Pisanello. Medallion: Self
 Portrait
Puget. Self Portrait, head
Raeburn. Self Portrait,
 medallion
Ragensburg Master. Self
 Portrait, kneeling spandel
 figure
Riccio. "David Dancing
 Before the Ark of Covenant":
 Self Portrait, left, second
 row, second figure from
 left
Riccio. Self Portrait#
Riemenschneider. Self
 Portrait#
Roeder. Self Portrait, head
Rosandic. Self Portrait,
 bust
Rossi, P. de'. Joseph and
 Potiphar's Wife, includes
 self portrait, relief
Roubiliac. Self Portrait, bust

SEVERINI, Gino (Italian 1883-)
 Marinetti 1913 mixed media;
 65x54 cm
 CARR 69 IRMari
Severus, Lucius Septimius (Roman
 Emperor 146-211)
 Italian--17th c. Settimius
 Severus, head
Sevres Porcelain
 Boizot. The Toilette of
 Madame
 Duplessis. Inkstand
SEXTON, Joan M. (English)
 St. Francis of Assissi 1942
 teak; 30
 BRO pl 32
SEYFER, Hans, the Elder
 c 1460-1509)
 Gregory, Predella, High
 Altar 1498 lindenwood
 KO pl 62 GHeilK
 Nicodemus, Entombment
 1488 stone
 KO pl 62 GWoC
Sforza, Ascanio
 Sansovino. Ascanio Sforza
 Monument
Sforza, Battista (Wife of Federigo
 da Montefeltro, Duke of
 Urbino)
 Italian--15th c. Battista
 Sforza, death mask
 Laurana. Battista Sforza,
 bust
Sforza, Bianca
 Austrian--16th c. Maximilian
 Tomb
Sforza, Giangaleazzo 1469-94
 Amadeo, G. A. Gian
 Galeazzo Sforza, tondo
 Filarete. Gian Galeazzo
 Sforza Monument
Sforza, Lodovico (Duke of Milan
 1451-1508), called Il Moro
 Amadeo and Briosco. Lodo-
 vico Sforza, tondo
 Caradosso--Attrib. Medal:
 Lodovico Sforza
 Solari. Lodovico Sforza
 (Il Moro) and Beatrice
 d'Este
SGARLATA, F.
 Pugilists, medal
 CASS 140
Shabazia. Danziger
Shackleton, Ernest Henry (British
 Explorer 1874-1922)
 Jagger. Shackleton

A Shade. Jacobsen, N. H.
The Shades. Rodin
Shadow. Kneale
The Shadow. Rodin
Shadow-Scene. Arp
Shadow in the Wood. Minguzzi
The Shadows. Minguzzi
Shadowslab. Brazdys
Shadwell, Thomas
 Bird. Thomas Shadwell,
 bust, monument detail
Shaflesbury Memorial Fountain.
 Gilbert, A.
Shakespeare, William (English
 Dramatist and Poet 1564-
 1616)
 Bullock. G. and G. Jensen.
 Shakespeare, bust
 English--17th c. Shakespeare,
 bust
 Gower. William Shakespeare
 Memorial
 Roubiliac. William Shakes-
 peare#
 Scheemakers, P. William
 Shakespeare Monument
 Theed, the Younger. The
 Bard
SHANNON, McFarlane
 Henry Alfred Long, bust
 MILIER il 158 ScGG
Shape in Repose. Arp
SHAPSHAK, Rene (French)
 The Mother wood
 ROTH 887 SoJB
Sharks
 French--17th c. Neptune Cup
Sharp, O. H.
 Petrie. C. H. Sharp of
 Abbotsholme, bust
Shaw, George Bernard (English
 Playwright and Critic
 1856-1950)
 Epstein. George Bernard
 Shaw, bust
 Kisfaludi-Strobl. G. B.
 Shaw, head
 Rodin. Bernard Shaw, head
 Troubetzkoy. George Bernard
 Shaw, bust
SHCHEDRIN, Fedos Feodorovitch
 (Russian 1751-1825)
 Caryatids, principal
 entranceway, New
 Admiralty 1812
 HAMR pl 150B RuLAd
 Marsias
 BLUC 218 RuLAc

The She-Goat. Picasso
She-Wolf. Martini, A.
Sheba (Biblical Queen) See also
 Solomon
 French--13th c. Queen of
 Sheba#
 Mokhtar. Queen of Sheba
 Muller, R. Sheba
 Spanish--13th c. Queen of
 Sheba
Sheep See also Good Shepherd;
 Shepherds
 Andrea da Pontedera. Arts,
 reliefs
 Byzantine. Lambs
 Cano, A. St. John the
 Baptist, seated with Lamb
 Ceroli. Les Moutons
 Danziger. Sheep
 Dierkes. Sheep's Head
 French--12th c. Allegorical
 Figure with Ram
 --Capital: Sheep Playing Harp
 German--12th c. Lion Strik-
 ing Lamb, symbolizing
 persecution of goodness
 Gies. Decorative Fireplace
 Panel: Sheep
 Gumpel. Ram's Head
 Parker, H. W. Lamb
 Picasso. Man with Lamb
Sheffield, John (Duke of Buckingham
 and Normandy d 1721)
 Plumier, D.; L. Delvaux;
 and P. Scheemakers.
 Monument to John Shef-
 field
Sheffield Cross. Anglo-Saxon
Shelburne, 1st Earl of
 Scheemakers, P. 1st Earl
 of Shelburne Monument
SHELDEN, Francis (English)
 Elphanten, Royal
 Pleasure Frigate of King
 Christian V, model 1687
 H: 27 cm
 BOES 117 DCO
Shell. Arp
Shell. Fazzini
Shell. Gower
Shell and Head. Arp
Shell-Crystal. Arp
Shell Fountain. Belsky
SHELLEY, Gar (English)
 Mother and Child Portland
 stone; 38
 NEWTEB pl 39

Shelley, Percy Bysshe (English
 Poet 1792-1822)
 Ford, E. O. Shelley
 Monument, Oxford
Shells
 French--7th c. Theodochilde
 Tomb: Scallop Shell Motif
Shells and Flowers, painted relief,
 Taeuber-Arp
SHEMI, Yehiel (Israeli 1922-)
 Elements I 1959 58x26
 CARNI-61:#354 UNNPa
 Father and Son, detail
 basalt
 GAM pl 129
 Head stone
 GAM pl 130
 Sculpture 1955 welded iron
 ROTH 943 IsTT
 --(Escultura) 1961 iron
 SAO-6
 --1963 welded iron; 35x
 15-1/2x12-5/8
 SEIT 63
 --1963 welded iron; 44-7/8
 x30-3/4x25-3/4
 SEIT 63
 --1964 iron
 NEW pl 228
 Standing I 1963 welded iron;
 83x39-1/2x35
 SEIT 62
Shenandoah. Marcks
Shepherd Boy. Langer
Shepherd King. Danziger
Shepherd of the Clouds. Arp
Shepherd with a Horn. Achiam
Shepherds See also Adoration--
 Magi and Shepherds
 Blumenthal. Campagna
 Shepherd
 Borsos. Tihany Shepherd
 Byzantine. Dish: Shepherd
 Early Christian. Vine and
 Figure Column Drums
 Efthimiadi. Greek Shepherds
 English. Angel Appearing to
 Shepherds
 English--14th c. Shepherd,
 misericord
 English--18th c. Chelsea
 Shepherd and Two Dogs
 English--18th c. Longton
 Hall Shepherd
 Frerenczy, I. Shepherdess
 French--12th c. Annunciation
 to Shepherds

--Royal Portal: Annunciation
to The Shepherds
French--13th c. Shepherd,
head, rood screen
--Shepherds Led by Angel,
detail
French--17th c. Shepherdess
German--9th c. Bookcover:
Virgin and Child
Enthroned...below, The
Nativity, and The An-
nunciation to the
Shepherds
German--11th c. Cologne
Doors: Annunciation to
the Shepherds
German--12th c. Annunciation
to the Shepherds
Gofridus. Choir of S.
Pierre: Grotesque Capitals
Landowski. The Shepherd
Martini, A. The Shepherd
Mazzoni. Nativity: Donor as
Shepherd
Morescalchi. Shepherd
Picasso. Man with Lamb
Rauch, E. A. The Shepherd,
panel
Riccio. Seated Shepherd
Riccio. Shepherd Milking a
Goat
Richier, G. Shepherd of
the Landes
Sammartino. The Shepherd
Scharff. Shepherds of
Bethlehem
Schumann, H. A. Shepherd
Schwerdtfeger. Ram
Thorvaldsen. Shepherd Boy
Walther. Annunciation to
Shepherds, relief
Willems. Shepherdess,
Chelsea Porcelain
SHERIDAN, Clare (English)
Crucifix 1946 cherry wood;
72
NEWTEB pl 36A
Shield Bearer. Flemish--14th c.
Shield Bearer of Emperor Charles.
Multscher
Shield of Theodosius, relief,
silver dish. Early Christian
Shields See Armor--Shields
Ships See also Jonah
Bellano. Jonah Thrown into
the Sea
Bellotto, U. Coppa da
Mattere in Pallio per
Regate a Remi

Capello. Boat
Copnall. History of Shipping
Copnall. Ships, Queen Mary
Panel
Deighton. Battle of Trafalger
Early Christian. Oil Lamp:
Christ and St. Peter in
Boat
Early Christian. Sarcophagus:
Biblical Scenes
Early Christian. Ulysses and
the Sirens, sarcophagus
detail
English--12th c. Tournai
Font Boat
English--15th c. St. James
Preaching
English--16th c. Facade of
Greneway Aisle
English--17th c. Capt. Smith
Monument: Merchant Ship
English--19th c. Bone Ship
Model
French--12th c. Capital:
Noah's Ark on Mt. Ararat
French--13th c. Dagobert I
Tomb: Death Barque
French--15th c. Galley of
Jacques Coeur, tympanum
--Reliquary of St. Ursula:
Ship with Figures
French--16th c. Ship, relief
German--17th c. Pendant: Ship
German--20th c. Wheeled Toy
Ship
Ghiberti. Baptistry Doors--
North: Christ and Peter
on the Water
Gibbons. Admiral Sir Clouds-
ley Shovell Monument:
Wreck of Sir Cloudesley
Shovell's Flagship on the
Scillies
Italian. Gallery Fountain
Janousek. Boats
Keyser--Attrib. Fortune
Moesman. Vlissingen Ship
Builders Man-of-War
Model
Pierre de Montreuil.
Legend of St. Dagobert
Rysbrack. Admiral Wager
Monument: Taking the
Spanish Galleons
Scheemakers, T. Admiral
Balchen Monument:
Foundering of the
"Victory"

Schneider, C. Medal: Danish
Koge Bay Naval Victory
over Swedes
Shelden. Elphanten, Royal
Pleasure Frigate of King
Charles V, model
Spanish. Pendant: Galleon
Swedish--8th c. Figurative
Stele
--Gotland Stone: Eight-
Legged Horse; Long Ship
Torgau. German Nef: Ship
Viking. Funeral Ship Carving,
detail
The Shipwrecked. Nielsen, K.
Shireburn, Robert and Isabella
Stanton, W. Richard and
Isabella Shireburn Tomb
Shirt-Front and Fork. Arp
Shivering Woman. Barlach
Shoe-Bill Stork. Durst
Shoemaking See Cobblers
Shoes See also Armor--Sabatons
Donatello. Athys, or Amore,
detail: Feet in Sandals of
Mercury
English--18th c. Bristol
Delft Shoes
Orchard, John. Edward III:
Shoes
Shopping Girl. Taher
Shot Bird. Meadows
Shot Putter. Grandtner
Shovell, Cloudesley d 1707
Gibbons. Admiral Sir
Cloudesley Shovell
Monument
The Shower, detrompe-l'oeil. Spoerri
Shrewsbury, 7th Earl of
Colt. 7th Earl of Shrewsbury
Tomb
Shrine of Our Lady
German--13th c. Shrine of
Charlemagne
Shrine of the Magi
Nicholas of Verdun. Shrine
of the Three Kings
Shrines
Byzantine. "Seat of St.
Mark"
Clodion. Egyptian Woman
with Shrine
Flemish--13th c. Shrine of
St. Gertrude
Franciscus of Milan. Silver
Shrine of St. Simeon
French--13th c. Gothic
Shrine

--Shrine of St. Etienne
French--14th c. Folding
Shrine
German--12th c. Shrine of
St. Heribert
German--13th c. Shrine of
Charlemagne
--Shrine of St. Elizabeth
Italian--15th c. Virgin and
Child, household shrine
Maitre Jacques. Shrine of
St. Gertrude
Niccolo dell'Arca and
Michelangelo. Shrine of
St. Dominic
Nicholas of Verdun. Shrine
of the Three Kings
Nicholas of Verdun. Shrine
of Virgin
Romanesque. Shrine of St.
Maurice
Spanish--12th c. Shrine,
Santo Domingo de Silos
Spanish--17th c. Sargossa
Shrine
Vischer, P., the Elder;
P. Vischer, the Younger;
Hermann Vischer, the
Younger. St. Sebaldus
Tomb
SHUBIN, Fedot
Count A. G. Orlovski, bust
1771 marble
RTCR 195 RuLR
Shuckburgh, Julia
Flaxman. Julia, Lady
Shuckburgh, monument
Shulamit. Kosso
Shuttles
Folk Art--Russian. Shuttle
"Si em Mort, Que el Cant Siga
Realitat". Alfaro
Siamois. Arp
Sibelius, Jean (Finnish Composer
1865-1957)
Aaltonen. Jean Sibelius
SIBILIA, Gaspare
Monument of Pius VI
NOG 51 IRP
Sibilla See Sibyls
Sibthorp, John
Flaxman. Dr. John Sibthorp
Monument
Sibyls See also Cumaean Sibyl;
Phrygian Sibyl
Agostino di Duccio.
Temperance; Sibyl
Fazzini. The Sibyl

Sigusmund, Johann (Elector of
 Brandenburg)
 German--17th c. Elector
 Johann Sigusmund of
 Brandenburg, badge
Signal# Bloc
Signal(s)# Takis
Signe. Linck, W.
SIGNORI, Carlo Sergio (Italian-
 French 1906-)
 Gli Amanti Complicati
 1956 stone
 VEN-58:pl 41
 Black Portrait 1958 marble;
 17-3/4x11-1/2
 GIE 280; MAI 270
 Juliana 1958
 BERCK 155
 Madame X 1958 Pakistan
 onyx; 15-3/4x11-3/4
 TRI 131 FPCr
 Reclining Venus 1959
 marble
 SAL 46
 The Rustic Lovers
 BERCK 332
 Venere 1950 marble; .90 m
 SCUL 62
 --1955 marble; 1.20 m
 SCUL 63
 Venus 1957 marble; 32
 ALBC-3:#71 UNBuA
 --1958
 BERCK 155
Signs and Signboards See Guild
 Signs; Trade Signs
Signs-Lines. Kemeny
Sigtunski Gates. Russian--11th c.
Sigurd I (King of Norway 1089?-
 1130)
 Bayes. Sigurd, equest
Sigurd the Dragon Killer
 Norwegian--13th c. Tales
 of Sigurd the Dragon
 Killer
SIGVALD, Patriarch (German fl
 762-76)
 Ornamental Balustrade:
 Symbols of 4 Evangelists,
 font c 725/50 marble;
 36x60
 JANSH 198 IClB
Sigwald Relief. Teutonic
Silence. Arp
Silence. Dick
Silence of the Tomb. Dillens
Silent. Arp
Silent Music
 Chillada. Mute Music

Silenus
 Byzantine. Dish: Silenus
 Byzantine. Silenus, dish
 fragment
 Byzantine. Silenus and Danc-
 ing Maenad
 Dalou. Silenus and Attendants
Silesian Rebellion Memorial.
 Augustincic
Siliceo, Cardinal
 Bellver. Cardinal Siliceo
 Tomb
Silk Manufacturers
 Robbia, L. della, and A.
 della Robbia. Three Guild
 Emblems
Silk Weavers
 Robbia, L. della. Arms of
 the Guild of Silk Weavers
 and Merchants
SILOE, Diego (Spanish 1495-1563)
 See also Vigarny de Borgona,
 F.
 Dead Christ ptd wood
 GOME pl 12-13 SpBC
 Madonna, relief detail, choir
 pier 1528/30
 BUSR 170 SpGC
 Main Altar: Annunciation
 BAZINW 357 (col) SpBC
 St. Jerome, seated figure
 GOME pl 14 SpBC
 St. John the Baptist, choir
 stall 1528? walnut
 GOME pl 16; KUBS pl 68
 SpVM
 Scourging of Christ, head
 detail LS
 GOME pl 15 SpBC
 Throne of Benedictine Abbot of
 Burgos, detail: St. John
 The Baptist 1522/28
 CIR 42 SpVM
 Virgin and Child, choir stall
 1528/30
 KUBS pl 69 SpGJe
 Virgin and Child, Diego de
 Santander Tomb c 1524
 BAZINW 357 (col) SpBC
SILOE, Gil de (Spanish fl 1486-99)
 Don Rodrigo de Cerdanas
 Tomb: S. Pedro, figure
 detail
 TAT-sc pl 10 ELV
 Infante Don Alonso of Castile
 Monument designed 1486
 marble MULS pl 157A;
 STA 167; WES pl 6 SpBMir

Juan de Padilla Monument
c 1500/05 alabaster;
25-1/4x13-1/4
LARR 75; MULS pl 157B;
POST-1:136; VEY 276
SpBM
Juan II of Castile and Isa-
bella of Portugal Tomb
designed 1686 alabaster
MULS pl 156B; WES pl 4
SpBMir
Retable, detail
VEY 291 SpBCar
St. Catherine, Main Altar
1466/99
BAZINW 328 (col) SpBCart
SILOE, Gil de, and DIEGO DE LA
CRUZ
High Altar, detail 1496/99
MULS pl 156A SpBCart
SILOE, Gil de--FOLL
Don Garcia Orsorio Monu-
ment, Church of San
Pedro de Ocana, near
Aranjuez, Spain 16th c.
marble
MOLE 225 ELV
SILVA, Joao da
Commemorative Medal,
Lisbon Academy of
Fine Arts Centenary
CASS 141
SILVANO, Gherardo (Gherardo
Silvani) (Italian 1579-1673)
Facade 1645
WIT pl 112A IFGa
Grotesque Ornament, and
Bat Wing, Via Cavour
MCCA 104 IFVaC
Silver Dynamo. Mack
Silverware
Gentili, A. da F. Knife,
Fork, and Spoon
Silvester, Saint
Italian--10th c. Diptych:
Crucifixion; Roman Wolf;
Madonna; St. Gregory,
Silvester, and Flavian
SILVESTRI, Lidia (Italian)
Torso di R. R. R. 1966
Portogallo marble
VEN-66:#33 IMRo
SILVESTRO DELL'AQUILA (Silvestro
di Giacomoda Sulmona, called
Ariscola) (Italian fl 1471-
1504)
Maria Pereira Camponeschi
Monument c 1490/1500
marble SEY pl 99 IAqB

St. Sebastian 1478 ptd wood
SEY pl 100A IAqB
Silvia. Licudis
SIMARD, Marie Louise
Don Quixote, equest bronze
HOF 56 FPLu
SIMAY, Imre (Hungarian 1874-1940)
Apes 1905 bronze; 38 cm
GAD 88 HBA
Simeon, Saint
Franziscus of Milan. Silver
Shrine of St. Simeon
French--12th c. Royal
Portal
French--13th c. Presentation
in the Temple; Simeon and
Prophet Anna
--Simeon with Christ Child,
and John the Baptist
Marco Romano. St. Simeon
effigy
Simeon Stylites, Saint
Byzantine. Reliquary of St.
Simeon Stylites: St. on
Column
Similia Similibus. Maccagnani
SIMMONDS, William G. (English)
Autumn Calf ptd oak; L: 14
DURS 67 EChA
Calf marble
CASS 117
The Farm Team elm
MILLER il 183 ELT
--wood
MARY pl 178 ELN
Young Hare oak; L: 9
DURS 67
Simon, Saint
French--13th c. St. Simon
Pisano, G. Simon
Simon, Berthe
Despiau. Berthe, head
SIMON, Thomas
Medal: Lady Lane 1662
silver; Dm: 1-5/16
MOLS-2:pl 10 ELV
Medal: Sir James Harrington
1653 silver; Dm: 1-5/16
MOLS-2:pl 11 ELV
SIMON DE COLONIA (Simon of
Cologne)
German-Spanish fl 1481-1505)
Chapel of the Constable
1483/94
LARR 17 SpBC
Portal, detail 1482/98
MULS pl 154B SpBCo
SIMON MAGUS
French--11/12th c. Capital:
Fall of Simon Magus

German--13th c. Capital:
 Siren
German--14th c. Island of
 Sirens
Italian--16th c. Pendant: Siren
Laurens. Little Siren
Laurens. Siren
Laurens. Winged Siren
Martinez, G. Young Siren
Milles. Siren
Puech. Siren
Puvrez. Siren
Rodin. Siren on a Pillar
Rodin. The Sirens
Rodin. Three Sirens
Romanesque--German. Schot-
 ten Portal: Sirens
Subirachs. Siren
SIRLIN, Jorg See SYRLIN, Jorge
SIRONI, Mario (Italian)
 Soldiers Raising Standard
 AGARN il 5 IRFa
Sisters. Laurens
Sisters of Illusion. Rousseau, V.
Sisyphus
 Austrian--13th c. Sisyphus,
 Tantalus, Ixion
 Hoflehner. Sisyphus
 (Homàge to Albert Camus)
 Leleu. Sisyphe
Situation. Hartung
Situla
 German--10th c. Situla
 Italian--10th c. The
 Basilewsky Situla
 --St. Matthew, ivory situla
Sitwell, Osbert
 Dobson. Sir Osbert Sitwell,
 head
Sividius (Roman Consul)
 Early Christian. Consul
 Sividius
Siviley. Woodham
Six Circles. Wall, Brian
Six Figures. Giacometti
Sixtus IV (Pope 1414-84)
 Guazzalotti. Medal: Sixtus IV
 Pollaiuolo, A. and P.
 Sixtus IV Monument
Sixtus V (Pope)
 Fontana, D. Sixtus V Tomb
 Torrigiani, B. Pope Sixtus
 V, bust
65/1. Meier-Denninghoff
Sizzo.
 Naumberg Master. Founders'
 Choir Screen: Sizzo, head
 details

SJOHOLM, Adam (Hungarian-French
 1923-)
 Movement in Space cutout
 metal
 MAI 272
Skating See Games and Sports
SKEAPING, Barbara Hepworth See
 HEPWORTH, Barbara
SKEAPING, John Rattenbury (English
 1901-)
 Akua-ba
 WILM 141
 Blood Horse, head white
 pine; c LS
 CASS 119; DURS 71 ELSad
 Cow 1949 beechwood; 30
 RAMS pl 59a
 Memorial 1956 granite;
 78x30
 LONDC pl 25
 Pouter Pigeon c 1933
 alabaster
 RAMT pl 3 ELTo
 Rita Ling terracotta
 HUX 90
 Seated Woman
 JOHT pl 204
 Sitting Female Torso veined
 marble
 PAR-1:128
 Torso 1958 ebony; 32
 LOND-5:#37
 Torso in White Sicilian
 marble
 CASSTW pl 32
 Tortoise 1938 granite;
 30x54
 RAMS pl 61a EAshd
Skeletons See also Death
 French--15th c. Guillaume le
 Francois Tomb
 Richier, L. Rene de Chalons
 Tomb
SKINNER, Freda (English)
 Phoenix 1946 terracotta; 19
 NEWTEB pl 56
 Red Cat 1942 terracotta;
 L: 16
 BRO pl 33
 Seated Figure 1942 terracotta;
 11
 BRO pl 34
SKLAVOS, Yerassimos (Czech-French
 1927-)
 Diaplanetic Light 1964 28-1/2x
 26-1/4x19-3/4
 CARNI-64:#119
Skokloster Shield. Flemish--16th c.

Skolepigen
 Degas. L'Escolier
Skulls
 French--19th c. Mortuary
 Image of Le Fas
 German--16th c. Skull,
 Memento Mori
 Italian--15th c. Child with
 a Skull and Hourglass
 Picasso. Skull
Sky, No. 2. Toyofuku
Skyggen
 Rodin. L'Ombre
Skynner Family Monument.
 English--17th c.
Slab Figure. Armitage
Slancio Trattenuto. Cassani
Slant. King, Phillip
SLANZOVSKY, Jan Jiri (Jan Jiri
 Schlansovsky) (Czech fl
 1682-1740)
 Christ at the Pillar, Calvary
 steps 1720-40 ptd wood
 BUSB 116 CzPChC
 Flagellation of Christ, "Holy
 Staircase" Figure; detail
 ptd wood
 STECH pl 49, 50 CzPOuN
 Organ Figures, detail: St.
 Ludmilla and King David
 ptd wood
 STECH pl 51 CzPOuN
 Virgin Mary with Infant
 Jesus ptd wood
 STECH pl 52 CzPOuN
Slate Relief. Ubac
Slaughter
 Preault. Massacre
Slaughtered Woman
 Giacometti. Woman with her
 Throat Cut
Slaves and Slavery
 Bandini, and P. Tacca.
 Ferdinand I; details by
 Tacca: Slave
 Bertoldo di Giovanni. The
 Suppliant
 Francheville. Henry IV,
 pedestal: Slaves
 French--12th c. Barbarian
 Slaves in Chains
 Italian--17/18th c. Negro
 Slave
 Matisse. The Slave
 Michelangelo. Atlas Slave
 Michelangelo. Awakening Slave
 Michelangelo. Bearded Slave
 Michelangelo. The Rebellious
 Slave

 Michelangelo. A Slave
 Michelangelo. Slaves--unfinished
 and finished
 Michelangelo. Young Slave
 Monti, R. The Veiled Slave
 Oppler. The Slave
 Wedgwood. Slave Medallion
 Westmacott. Charles James
 Fox Memorial: Kneeling
 Slave
SLAVIC
 Pagan Female Figure, seated
 stone; LS
 BAZINW 233 (col) FPRat
Sledges See Sleighs
Sleep. Aīchele
Sleep. Garbe, H.
The Sleeper. Gilioli
Sleeping Apostles. French--13th c.
Sleeping Baby, head. Dalou
Sleeping Calf. Ehrlich
Sleeping Captive
 Michelangelo. Bound Slave
Sleeping Child. Jespers, O.
Sleeping Child and Dog. Weekes
The Sleeping Children
 Chantrey. Children of Rev. W.
 Robinson Monument
Sleeping Faun. Bouchardon, E.
Sleeping Faun. Gaudier-Brzeska
Sleeping Girl. Roberts-Jones
Sleeping Hebe. Carrier-Belleuse
Sleeping Muse# Brancusi
Sleeping Nude. Volti
Sleeping Nymph. Canova
Sleeping Tramps. Barlach
Sleeping Woman. Adam, H. G.
Sleeping Woman. Gerardi
Sleeping Woman. Grard
Sleeping Woman. Marini
Sleeping Woman. Orloff
Sleeping Youth. Verrocchio
Sleighs
 Folk Art--Russian. Bear
 Driving Troika Sleigh
 Folk Art--Russian. Peasant
 Sledge
 Folk Art--Russian. Sleigh
SLESINSKA, Alina (Polish 1926-)
 Family 1958 patinated plaster
 JAR pl 32
 Woman Seated 1952 L: 24
 BERCK 332
Slevogt, Max
 Kolbe. Painter Max Slevogt,
 head
Slim Bust. Giacometti
The Slipper. Rosales
Slit. King, P.

Sloane, Hans (British Physician
and Naturalist 1660-1753)
Rysbrack. Sir Hans Sloane
Slocombe, George
Kisfaludi-Strobl. George
Slocombe, head
SLODTZ, Rene Michel (called:
Michelange) (Flemish
1705-64)
St. Bruno 1744
BUSB 159; WIT pl 159B
IRP
Languet de Gergy Tomb 1753
marble and bronze
LAC 206 FPStS
St. Louis Giving Alms to
Poor, relief
LAC 80 FV
Slovak Girl Weeping. Uprka
Slow Forms Before Closing Space.
Oteiza
SLUTER, Claus (Dutch-Burgundian
c 1340-1406)
Christ, head, Chartreuse de
Champol c 1398
EVJF pl 137 FDM
Crucifix Base: Zachariah;
Daniel, and Isaiah 1397/
1405
EVJF pl 140 FCC
John the Fearless Tomb;
detail: Mourner 15th c.
GAF 325, 324 FDM
Madonna and Child
ENC 258
--(Virgin and Child 1390/91
marble
BAZINH 504; BAZINW
314 (col); LARR 55; MAR
37 FDC
Philip the Bold Tomb: Mourn-
er c 1404/10
BAZINW 314 (col) FDM
Portal, Chartreuse de
Champol 1385/93
JANSH 260 FDC
--Madonnas, right and left
portal figures
UPJH pl 91
--Philip the Bold Commended
to the Virgin by St. John
BOE pl 128; BUSR 24;
MULS pl 2A; MURRA 28
--Philip the Bold
GAF 325
--Prophet, portal corbel
(cast)
MULS pl 3A

--Virgin and Child
MULS pl 2B; MURRA 20
St. John the Baptist
NYWC pl 10 UNNWarbu
Portraits
Bouchard. Claus Sluter
SLUTER, Claus, and Jean de
MARVILLE
Portal 1385/93
JANSK 496 FDC
Well of Moses (Fountain of
the Prophets; Moses
Fountain; Les Puits de
Moise; Well of the
Prophets) 1395/1403
stone; figure H: 72
BR pl 2; CHRC fig 110;
GARDH 282; GOMB 169;
JAL-3:pl 8; JANSH 260;
JANSK 497; MAL pl 24:
MOREYM pl 160; MU 294;
ROOS 83G; ST 252; UPJ
217 FDM
--detail
ENC 833; LARR 56
--Angel
MOLE 77 (col)
--Calvary, pedestal detail
CHASEH 235; MAR 38
--Calvary: Head of Christ
HAMF 258; KIDS 142;
MULS pl 6
--Calvary: Prophets from
Mystery Play, "Judgment
of Jesus"
POST-1:73
--Daniel and Isaiah H: 68
UPJH pl 91
--David
BIB pl 171
--David and Jeremiah; Daniel
FOC-2:pl 144, 145
--Isaiah marble; 126
EVJL pl 87; MULS pl 5;
SEW 444,445
--Jeremiah
GAF 323; HAMF 107; KO
pl 45; MULS pl 3B;
NEWTEM pl 98
--Moses
BAZINH 224; BAZINW
312-3 (col); BUSR 23;
CHENSW 361; HAMF 259;
MYBA 346; NEWTEM pl
97; PRAEG 246; RAY 37;
REAU pl 114-15; ROBB 355;
ROTHS 117; ROTHST pl
36; STI 450

--Moses, David and
 Jeremiah
 MULS pl 4; UPJH pl 91
--Zacharias
 BIB pl 195; HAMF 259;
 MULS pl 1
SLUTER, Claus, and Claus de
 WERVE, and Jean de
 MARVILLE
 Philip the Bold Tomb
 1397/1405
 CHASEH 236; FOC-2:pl
 143; HAMF 107; POST-1:
 76 FDM
--Mourners (Mourning Monk;
 Pleurant; Weeping Monk)
 c 1404 stone; c 16
 BUSR 25; HAMF 291; JAL-
 3:pl 9; JANSK 498; KO pl
 45; LAC 216; LARR 93;
 MULS pl 8; PUT 266;
 ROOS 83H; ROTHS 119;
 STA 114
 Philip the Bold Tomb: Three
 Mourners 15th c. Vizelle
 alabaster
 CLE 64 UOC1A (40.128;
 56.66; 58.67)
SLUTER, Claus--FOLL
 Virgin and Child early 15th c.
 stone; 42-1/4
 DETT 184 UMiD (36.27)
SMAJIC, Petar (Yugoslav)
 Poor Woman 20th c. wood
 BIH 21
Small Amphion. Laurens
Small Gathering. Consagra
Small Grasshopper
 Richier, G. Grasshopper
Small Horseman. Marini, M.
Small Kneeling God. Kolbe
Small Laughing Woman. Rosso, M.
Small Model with 5 Flanges.
 Armitage
Small Model with 6 Flanges.
 Armitage
Small Monument. Haber
Small Saint of Dangolsheim
 German--15th c. Little
 Saint of Dangolsheim
Small Screw Mobile. Martin, K.
Small Sculptured Steel Shell.
 Descombin
Smelters
 Farkas. Smelter
 Somogyi. Steel Smelter
SMERDU, Francisek (Yugoslav
 1908-)

Recumbent Nude 1944 marble
 BIH 137
Recumbent Woman 1943 ter-
 racotta
 BIH 136
Smiling Angel, Rheims. French--
 13th c.
Smiling Angel, Freiburg. Gothic--
 German
Smiling Woman. Roberts-Jones
SMITH, Charles R. (English 1799-)
 Rev. Thomas Whitaker,
 reclining effigy 1822
 GUN pl 27 EWhal
Smith, David (American Sculptor
 1906-65)
 Caro. Homage to David
 Smith
SMITH, H. Tyson (English 1883-)
 Frieze Detail, Birkenhead
 War Memorial
 AUM 120
 Garden Bench cast Portland
 stone
 AUM 150
 Garden Figure Bath stone
 PAR-1:73
 Memorial Panel greenstone
 AUM 130
 Panel, Southport War
 Memorial
 AUM 120
 Panel, detail, St. Lawrence
 War Memorial, Kirkdale
 AUM 120
 Sphinx, garden ornament
 AUM 134
Smith, John (English Colonist in
 America 1580-1630)
 Capellano. Preservation of
 Capt. John Smith by
 Pocahontas
Smith, John Raphael (English
 Portrait Painter and Engraver
 1752-1812)
 Chantrey. John Raphael
 Smith, bust
SMITH, Richard (English 1931-)
 Gift Wrap 1963 208x80x33
 PRIV 200
 Piano 1963 108x70x44
 PRIV 201
 Quartet, "shaped canvas"
 1964 acrylic on canvas;
 56x72x20-1/2
 AMA 134 UMnMW
 Various Activities 1963 sq: 54
 NEW pl 84 ELStu

Sofarts Monumentet
 Nielsen, K. The Shipwrecked
Soffici, Ardengo
 Graziosi. Ardengo Soffici,
 head
 Romanelli. Ardengo Soffici,
 bust
La Sognatrice. Raphael (Mafai)
The Soil. Meunier
Le Soir. Jacquot
Soissons Diptych. French--13th c.
Sokic, Ljubica
 Bodnarov. Painter Ljubica
 Sokic, head
Sol Vitoria. Stahly
Sola
 German--9th c. Sola, Anglo-
 Saxon Monk, tondo
Solar Workshop. Colla
SOLARI, Cristoforo (Il Gobbo, "The
 Hunchback") (Italian c
 1470-1527)
 Eve after 1500 marble
 KO pl 83 IMC
 Ludovico Sforza and Beatrice
 d'Este, effigy figures 1498
 marble
 BUSR 166; KO pl 79;
 POPR pl 118; SEY pl 135B
 IPavCe
 Madonna and Child; head
 detail, relief c 1489
 marble; 20x22-1/2
 SEYM 122-23; USNK 197;
 USNKP 421; USNKS 42, 43
 UDCN (A-158)
 Man of Sorrows, relief
 marble; 11-1/4x9-3/4
 USNKP 420 UDCN (A-66)
SOLARI, Guniforte See FILARETE
SOLARI, Pietro Antonio See
 LOMBARDO, Pietro; PERSICO,
 P.
SOLARI, Tullio See LOMBARDO,
 Tullio
SOLDANI, Massimiliano (Benzi)
 (Italian 1656-1740)
 Venus and Adonis bronze;
 27-3/4
 DETI 122 UMdBW
SOLDATOVIC, Jovan (Yugoslav
 1920-)
 Nude 1954 plaster
 BIH 171
Soldiers
 Astbury. Soldier
 Augustincic. Partisan Girl
 Baroni, E. Monument to the
 Infantry

Boehm. Duke of Wellington
 Monument: Grenadier of
 the First Guards
Bologna. Cosimi I, equest:
 Marching Soldiers, relief
Byzantine. Warrior Equestri-
 ans, casket panel
Celtic. Eglwysilan Warrior
--Warrior
Cornet. Guerrier
Dazzi, A. Soldiers, arch
Desjardins. Crossing the Rhine,
 relief
English--14th c. Warrior and King,
 facade
Fiori. The Soldier
Flemish--14th c. Militiamen of
 Ghent
German--5th c. Warrior, plaque
German--12th c. Sentinel,
 chandelier
German--17th c. Stoveplate
Giorgi, B. Two Warriors
Glicenstein. Soldiers
Guttfreund. Return of the
 Legionaries
Hajdu. Soldiers in Armor
Jan van Mansdale. Soldier in
 Armor, relief
Kennington. 24th (East Surrey)
 Division Memorial
Ligeti. Soldiers
Marini. Warrior
Mascherini. Warrior
Moore, H. The Warrior
Moore, H. Warrior with
 Shield#
Netherlandish. Standing
 Warrior
Pollaiuolo, A. Warrior, bust
Pollaiuolo, A. Young Warrior,
 bust
Riccio. Warrior on Horse-
 back
Rosandic. Warrior
Russian--5th c. B. C.
 Comb: Warriors in Combat
Schadow. Genl. Joachim
 Ziethen
Sidlo. Hungarian Warrior,
 equest, roundel
Sironi. Soldiers Raising
 Standard
Spanish--3rd c. B. C. Roman
 Soldiers, relief
Swedish--7/8th c. Toslunda
 Matrices: Armed Warrior
Tarantino. Two Warriors
Wedgwood. Death of a Warrior

Wigstrom, H. Faberge Figure
of Capt. of 4th Harkovski
Lancers Regiment
Soglitter. Milles
SOLI, Ivo (Italian 1898-)
Giorgio Nicodemi, head
VEN-36:pl 19
Solidarity. Minne, G.
The Solitary One. Barlach
Solomon (King of Israel)
English--12th c. Capital:
Judgment of Solomon
French--12th c. Solomon
and Queen of Sheba
French--13th c. Buckle:
Solomon and Queen of
Sheba
--Chartre Cathedral, north
transept: Balaam;
Queen of Sheba
--Porte Mere Dieu
--Solomon
Ghiberti. Baptistry Doors--
East: Solomon and the
Queen of Sheba
Gozbert. Temple of Solomon
Italian. Judgment of
Solomon, relief
Italian--14th c. Judgment of
Solomon
Lamberti, Niccolo di Pietro.
Judgment of Solomon,
relief
Martini, A. Judgment of
Solomon
Mastroianni. Solomon
Nanni di Bartolo. Judgment
of Solomon
Nicholas of Verdun. Shrine
of the Three Kings: King
Solomon
Quellen, A. , the Elder.
Judgment of Solomon,
relief
SOLOMON-CUNLIFFE, Mitzi
(American-English 1918-)
Root Bodied Forth, Waterloo
Station Entrance, Festival
of Britain 1951 cast stone;
260 cm
SCHW pl 108
"Solomon" Type Column. Baroque--
Portugal
SOLON, I.
Vase, Monton Pate-sur-Pate
1875
SOTH-1:161
Solski
Dunikowski. Actor Solski, bust

SOMAINI, Francesco (Italian 1926-)
Conquista Impenetrabilita
1957 conglomerato
ferrico; 118x98 cm
SCUL pl 72
Felicita di Essere 1957
conglomerato ferrico; 125x
107 cm
SCUL pl 73
Grand Blesse, No. 1 1960
lead; 34x60x45 (with 72
base)
READCON 257
Great Martyrdom (Grande
Martirio; Great Martyr)
1960 iron; 53x26.75 cm
CARNI-61:#364; VEN-60:
pl 120 IRO
Greviously Wounded--The
Farewell
cast lead, plastic filling,
iron support; 40x42
ARTSI #19
Iron 5925 1959 iron; 38-5/8
MAI 273; TRI 154 IRMe
Large Bleeding Martyrdom 1960
bronze
SAL pl 73
Open Song 1956 iron con-
glomerate; 63
BERCK 156
Sculpture, Villa Garden
DAM 200 ICom
Study for Monument N. 5829
1958 iron
VEN-58:pl 72
Vertical (Absalom) 1960 iron
SAL pl 74; VEN-60:pl 121
Wounded (Ferito) 1960 bronze
KUHB 129 UNNOd
Somerset, Duke of
Gibbons. Duke of Somerset
Sommeren
Maillol. Summer
Somnambulist. Lerche
SOMOGYI, Arpad (Hungarian)
Young Farm Girl 1953 plaster;
163 cm
GAD 124 HBA
SOMOGYI, Jozsef (Hungarian 1926-)
Hunyadis Memorial, equest
model 1951 bronze; 60 cm
GAD 121 HBA
Korean Youth, head 1953
terracotta; 30 cm
GAD 122 HBA
Steel Smelter 1953 plaster;
163 cm
GAD 125 HBA

Sonate Pathetique--Beethoven.
 Garbe, R. L.
The Song. Cordonnier
Song of Battle. Danziger
Song of Evil. D'Haese, Roel
Song of Songs. Landowski
Song of the Hours. Jonas
Song of the Sea. Garbe, R. L.
SONNENSCHEIN, Valentin (German-
 Swiss 1749-1828)
 Berne Alderman, seated
 figure c 1780/90 terracotta;
 29 cm
 LIC pl 43 SwBeKM
Il Sonno. Algardi
The Sons of Cain. Landowski
The Sopher, relief. Schatz, B.
Sophia, Princess d 1607
 Colt. Princess Sophia Tomb
The Sorcerer. Dubuffet
Sorceress. Brancusi
SORENSEN, Jorgen Haugen (Danish
 1934-)
 Scene of Slaughter (Scena di
 Macello) 1958
 terracotta
 VEN-58:pl 140
 Woman 1960 44x39.4
 CARNI-61:#366 DCB
SORENSEN-POPITZ, Irmgard
 Equipoised Sculpture 1924
 MOHN 47
Sorgende Frau
 Barlach. Sorrowing Woman
SORIANO MONTAGUT, Inocencio
 Autumn
 CASS 89
Sorolla y Bastida, Joaquin
 (Spanish Painter 1863-1923)
 Benlliure. Joaquin Sorolla
 y Bastida, bust
 Troubetzkoy. Joaquin Sorolla
 y Bastida, seated figure
Sorrow Burdened. Metzner
Sorrowing Woman. Barlach
SORTINI, Saverio (Italian)
 La Fonte bronze and marble
 VEN-14:59
 Miners plaster
 VEN-7:pl 38
 Surprise (Sorpresa) bronze
 VEN-20:102
SOTO, Jesus Raphael (Venezuelan-
 French 1923-)
 Gabon 1965 wood and metal;
 12-1/2x15
 SELZS 168 UNNAld
 Vibration Structure 1964
 ARTSM

Vibrations with Black Form
 1959 wood and metal
 VEN-64:pl LI SnSNM
Soubrette Picarde
 French--13th c. La Vierge
 Doree
Souche, Raduit de
 Czech--17th c. Raduit de
 Souche Tomb
SOUDBININE, Saraphin (Russian
 1867-)
 Apocalypse wood, lacquered
 PAR-2:140
Le Souffle. Chavignier
SOUKOP, W. (English)
 Standing Woman yew; 84
 DURS 63
Soul Struggle. Baker, R. P.
Source. Dobson
The Source. Graziosi
La Source. Jacquet, A.
La Source. Rodin
Source of Life and Thought.
 Martin, E.
Sourel, M.
 Belmondo. M. Sourel, head
Sourire de Reims
 The Visitation Master.
 Angel of the Annunciation
 (showing "Sourire de
 Reims")
South Sea Maiden
 Kolbe. Standing Figure (South
 Sea Maiden)
Southampton, 2nd Earl of
 Johnson, G. 2nd Earl of
 Southampton Tomb
Southey, Robert (English Poet
 1774-1843)
 Chantrey. Robert Southey
 Weekes. Robert Southey, bust
SOUTHWICK, Alfred (English)
 Bracket 1940 oak; 24
 BRO pl 35 IKilA
Southwood Memorial
 Hardiman. Fountain Figure:
 Boy on a Shell
Souvenir. Penic
Souvre, Jacques de
 Anguier, F. Jacques de
 Souvre Tomb
Sowers
 Ben-Zvi. The Sower
 Gill, E. The Sower
 Meunier. The Sower
 Orsolini. The Sower
Soyez Amoureuses, vous Serez
 Heureuses.
 Gauguin. Be in Love and You
 Will Be Happy

Sozzino, Mariano, the Elder
 Vecchietta. Mariano
 Sozzino, the Elder, head
 detail, effigy
Space. Hajek
Space. Serrano
Space Clasp
 Luginbuhl. USRH
Space Cluster# Hajek
Space Construction. Haber
Space Light la. Carlucci
Space Man. Salimbeni
Space Planes 130. Hajek
Space Sculpture. Kricke
Space Sculpture
 Vantongerloo. Sculpture in
 Space
Space-Time. Kricke
Spaceboys. Hoeydonck
Spackman, Thomas
 Deval, J., the Younger.
 Thomas Spackman
 Monument
The Spaghetti-Eaters. Italian--18th c.
Spagna L. Pepe
SPALLA, Giacomo (Italian 1775-1831)
 General de Boigne, bust
 marble
 HUBE pl 73 FChambM
Span. Caro
SPANG, Michael
 James Thompson Monument,
 detail 1762
 GERN pl 57 ELWe
SPANIEL, Otokar (Czech)
 Dr. J. E. Purkyne, bust
 stone
 PAR-2:119
 Ivo Vojnovic, bust bronze
 CASS 58; MARY pl 78
SPANISH
 Cathedral Interior Figures
 DUR 879 SpSanM
 Christ Imperator
 MALV 426 SpTC
 Condestable of Castile Tomb
 WES pl 13 SpBC
 Fountain of the Lions, Court
 of Lions
 DUR 303 SpGA
 Gothic Altarpiece parcel
 gilt alabaster
 INTA-1:96 SpPob
 Gothic Figures
 ENC 354 SpLeA
 Pendant: Galleon 16th c.
 Gold and enamel
 SPA 53 UMdBW

Retable alabaster
 ENC 760 SpHuC
St. Isidoro
 FOC-1:pl 143 SpLeI
St. Pelayo
 FOC-1:pl 142 SpLeI
Virgin of the Tower of Belem,
 Manueline Art
 GUIT 79 PoLB
--6th c. C.
Centaur bronze
 SMIBS 40 (col) SpMaA
--3rd c. B. C.
Iberian Woman in Manto
 bronze
 SMIBS 41 (col) SpMaA
Roman Soldiers, relief
 206 B. C.; 200 B. C. stone
 SMIBS 50 (col) SpMaA
--10th c.
Cordoba Capital 964
 ENC 424
--11th c.
Alfonso, son of Count Pedro
 Ansurez, Tombstone
 LARB 282 SpMaA
Apostle, relief, casket panel
 1059 ivory
 ROBB 673 SpLeI
Book Cover: Crucifixion ivory,
 metal, jewels
 CHENSW 324 UNNMM
Christ and Two Disciples on
 Road to Emmaus
 MOREYM pl 84 SpD
Christ on the Cross, carved
 for King Ferdinand I of
 Leon and Castile c1063 ivory
 BAZINW 276 (col); BECKM
 208 SpMaA
Crucifix
 LARB 301 SpMA
Crypt Capital c 1170
 FOC-1:pl 135 SpLeI
Crypt Capitals: Raising of
 Lazarus c 1070
 FOC-1:pl 133-34 SpLeI
Deposition and Ascension,
 Tympanum 1090/95
 BAZINW 276 (col) SpLeI
Descent from the Cross,
 panel ivory
 READM pl 9; WORR 48 ELV
Entombment, relief, Cloisters
 TAT-sc pl 1 SpSilD
Gift of the Holy Ghost at
 Pentecost, relief, Cloisters
 TAT-sc pl 1 SpSilD

Lintel: Christ in Mandorla
GUID 62 SpRoG
St. Vincent, south transept
portal
BAZINW 276 (col) SpLeI
Thomas before Christ and
the Apostles c 1096
BUSRO pl 19 SpSanta
--11/12th c.
Biblical Scene, diptych leaf
ivory
CHENSW 324 UNNMM
King David, South Porch
1075/1122
FOC-1:pl 146; NEWTEM
pl 61; STA 100 SpSanC
Romanesque Capital limestone;
16-1/4
NM-7:27 UNNMM (21.21.3)
St. Jerome, relief stone
CHENSW 325 SpSanC
--12th c.
Adoration of the Magi, Cerezo
de Riotiron; detail: Joseph
c 1188
NM-12:25, 24 UNNMMC
The Annunciation, Southern
Portal figure
STA 100 SpAvV
Apostles, column figures,
Camara Stana stone
GUID 78; TAT-sc pl 2
SpOC
Apostles, West Porch right
jamb
BOE pl 88 SpAvV
Capital: Demons Hanging
Victim
FLEM 200 SpSanC
Christ ptd wood
GUID 108 (col) SpBaA
Christ, head ptd wood
CHENSW 336 UNNMM
Christ of Mitgaran, Deposi-
tion fragment ptd wood
GUID 102 SpLer
Cloister Capital: Birds
Eating Fruit
FOC-1:pl 145 SpGerC
Crucifix ptd wood; 94x62
DETT 175 UmiD (28.3)
Crucifix walnut figure on
red pine cross
NM-12:40 UNNMMC
Crucifix, detail 1150/1200
SLOB 230 UNNMM
Diptych Leaf: Christ on Road
to Emmaus; Nole me
Tangere ivory; 10-5/8
CHENSN 277; NM-7:21

UNNMM (17.190.47)
Double Capitals: Glass Blow-
ing; Animals
ROTHS 101 SpD
The Entombment
FOC-1:pl 136 SpSilD
God the Father with the
Christ Child, door detail
c 1150
BUSRO pl 80 SpSoD
Journey to Emmaus stone
SLOB 228 SpSanta
King David, facade c 1130
granite BAZINW 277 (col);
BUSRO pl 87 SpSanC
Madonna, late Romanesque
c 1180
BUSRO pl 144 SpSolC
Majestad de Battlo (Crucifix,
Syrian Style) 3rd Q 12th
c.
BAZINW 277 (col); BUSRO
pl 110 SpBaMAC
Majesty Capital, Sta. Maria de
Alabanza 1165 H: 31-1/8
TAT-sc pl 4 UMCF
Marys at the Sepulchre, capital
Sta Maria de Alabanza 1185
H: 30-3/8 TAT-sc pl 4 UMCF
The Miraculous Fishing, relief,
San Pedro de Roda, Gerona
GUID 71 SpBaMa
Musicians: Viol; Zither; Vielle,
or Hurdy-Gurdy; Irish Harp;
Lute, central portal
STI 402 SpSanC
Portal: Christian Scene
Panels
BAZINW 277 (col); LARB
282 SpRipM
Portico de la Gloria:
Narthex Detail 1168/88
BAZINW 279 (col) SpSanC
Processional Cross, San
Salvador de Fuentes
silver
NM-7:20; NM-11:10 UNNMM
Puerta de Platerias, south
portal 1075/1122
CHASEH 204; FOC-1:pl
91 SpSanC
Romanesque Capitals,
Fuentiduena
NM-12:31 UNNMMC
St. Martin; Acrobats--Pier
Figures, Fuentiduena
NM-12:35 UNNMMC
St. Peter, portico figure
TAT-sc pl 1 SpRipM

Shrine, Santo Domingo de
Silos champleve enamel
on copper
GUID 106 SpBM
Thomas the Unbeliever,
relief
KO pl 40 SpSilD
Trumpet Angel of Last
Judgment, porch
archivolt
BOE pl 59 SpGerCh
Virgin and Child ivory
LARB 233 SpMal
West Porch, detail
BOE pl 58 SpGerCh
Woman with a Skull,
Puerta de las Platerias
BAZINW 276 (col) SpSanC
--12/13th c.
Isabella Monument 1158/1223
BUSG pl 86 PoAC
Mythical Beasts, capital,
Cloister of Aguilar de
Campo
LARB 231 SpMaA
--13th c.
Adoration of the Magi,
cloister pillar figures
c 1255
MOREYM pl 133; STA
154 SpBC
Alfonso X and Dona Violante,
cloister figures stone
GUID 129; FOC-2:pl 96
SpBC
Annunciation, south porch
c 1200
TAT-sc pl 3 SpAvV
Annunciation of the Virgin,
cloisters relief c 1230
BUSGS 25 SpSilD
Bishop Martin Tomb
POST-1:128 FLC
Christ in Majesty and
Apostles, Altar Frontal,
S. Maria de Tahull ptd
wood
BAZINW 278 (col) SpBaMAC
Christ in Majesty and Apostles,
Altar frontal 1251 ptd
stucco
BAZINW 278 (col) SpBaM
Death of the Virgin, cloisters
c 1250
BUSGS 116 SpPamC
Deposition; Crucifixion wood
TAT-sc pl 7
Descent from the Cross c 1250
BUSGS 26 SpVi

Don Sancho Saiz de Carillo
SPA 120 UOCiM
Infante, head, donors' group,
cloister pier c 1255
BUSGS 94 SpBC
Infante Don Felipe Tomb 1274
marble
GUID 134 SpPalV
The King; The Queen c 1260
VEY 208, 273 SpBC
Last Judgment, north
transept
MOREYM pl 132 SpBC
Madonna and Child ptd wood;
49-1/2
DEY; DEYE 17 (col)
UCSFDeY (45.32)
--Hand
DEY 88
Madonna and Child Enthroned
c 1200 gilded wood; 38
TOR 109 CTRO (938.15.2)
Madonna Portal, with Apostle
Jamb Figures
BUSGS 38 SpRod
Mary; and John, Crucifixion
Group wood; 153; and
163 cm
BSC pl 25 GBS (8001/02)
Mourning Virgin, Castile,
c 1275 ptd wood
CLE 51 UOClA (30.622)
Mourning St. John Castile
c 1275 ptd wood
CLE 51 UOClA (30.621)
Portal, detail Burgode Osma
c1250/75 BAZINW 305 (col)
SpSoD
Princes, cloister figures
CHASEH 275 SpBC
Puerta de Sarmental, Burgos
Cathedral; archivolts FOC-2:
pl 97, 98; LARB 345 SpBC
--Christ, Sarmental
Door c 1230
BAZINW 305 (col); GUID
128
Queen of Sheba, South Porch
c 1200
TAT-sc pl 3
Queen of Swabia, cloister
BAZINW 305 (col) SpBC
Romanesque Crucifix wood
CHICB 13 UICA
St. James (?), head c 1240
ptd walnut; 32
SPA 36 URPD
St. Joseph, seated figure
PANA-1:99 UNNMMC

Tomb-Effigy; detail: Saul Caught
up to Paradise
TAT-sc pl 5 SpZM
Virgin and St. John Mourning,
Crucifixion Figures
TAT-sc pl 6 SpCuA
West Portal c 1250
BUSGS 117 SpToM
The White Virgin (Nuestra
Senora la Blanca), west
transept, main portal
stone
BAZINW 304 (col); BR pl
1; GUID 130 SpLeA
--13/14th c.
Armengol VII Tomb 1299/1314
NM-12:98 UNNMMC
Armengol X and Dona Dulcia
Tomb
1299/1314
NM-12:101 UNNMMC
Don Alvaro de Cabrera the
Younger Tomb 1299/1314
NM-12:102 UNNMMC
--13/15th c.
St. Peter, seated figure
wood; 19-1/4
NORM 73 ELV
--14th c.
Calvary: Pieta, King Pedro
Tomb
GUIT 100 PoA
Cloister, decorative detail
1387/1415
FOC-2:pl 100 PoBD
Gothic Madonna, head
FEIN pl 19 UMWA
Gothic Madonna, head
limestone
FEIN pl 21 UNNMM
Mourner, Entombment figure
gessoed wood; 61
WORC 37 UMWA
Portado de la Chapineria,
Toledo
FOC-2:pl 99 SpTC
"La Preciosa", Chapter
House door
GUID 134 SpPamC
Saint c 1330
NM-12:105 UNNMMC
St. John the Evangelist,
bust walnut; 14
NORM 72 ELV
Tombs of Two Knights,
Gothic and Moorish
Motifs
POST-1:132 SpCuE

Wall Decoration
tomb detail
CHASEH 277 SpCuE
--14/15th c.
Fountain Chapel
BUSG 199 PoBM
--15th c.
Adoration of the Kings, re-
table c 1447 alabaster;
LS
TAT-sc pl 9 SpZarS
Bishop Alonso de Cartagena
Monument c 1480
MULS pl 155 SpBC
Bishop Alonso Carrillo de
Albornoz, effigy d 1439
MULS pl 64A SpSiC
Capella del Conestabile; Coat
of Arms, detail begun
1482
FOC-2:pl 164, 165 SpBC
Christ Appearing to St.
Martin, retable; detail
alabaster
NM-12: 159, 160 UNNMMC
Crucifix, Hospital de la Vera
Cruz de Pomar silver gilt;
17-1/4
GRIG pl 121 ELBr
Dona Aldonza de Mendoza,
effigy detail d 1435
MULS pl 63 SpMaA
Facade: Royal Arms, detail
1488/96
BAZINW 328 (col); JANSK
477 SpVG
Facade, Santa Maria, Aranda
de Duero
FOC-2:pl 163 SpAM
Fair Virgin c 1420
MULS pl 61A SpMaP
Gomez Manrique, effigy
detail, Fresdeval c 1430
alabaster
MULS pl 55 SpBM
Juan Fernandez de Morales,
effigy detail c 1490
MULS pl 149 SpTCl
Main Doorway, S. Pablo,
FOC-2:pl 162 SpVP
Mourners, Crucifixion Group
c 1460/70
MULS pl 147B SpGua
Pax, Segovia 1480 parcel
gilt; 9-1/2
SOTH-2:215
Pieta wood
TAT-sc pl 9 SpSeM

Portal Facade: Royal Coat
of Arms
GUID 126 SpVG
Prophet, head wood
CHENSN 423; CHENSW
336 FPRid
Reliquary: Gothic Chapel,
with Candelabra Angels
silver gilt
HUYA pl 39 FPL
St. James (San Juan de los
Reyes) after 1477 stone
BUSR 124; MULS pl 147A
SpTJ
Two Wild Men 1480/96
BAZINW 329 (col) SpVG
--15/16th c.
Door Knocker iron; c 16
DOWN 103 UNNHis
High Altar c 1498/1504
BAZINW 327 (col) SpTC
--16th c.
Altar, detail c 1500 ptd wood
MULS pl 152B SpCovCh
Apostle, High Altar wood
KO pl 84 SpGen
Arcade detail
BAZINW 368 (col) SpSalF
Barcelona Bridal Chest c
1500 wood; 69x126 cm
BOES 98 DCK
Breastplate of Archduke
Albert
CIR 28 (col) SpMaRA
Carlos I in Full Armor in
Cavalry Battle, relief
marble
SMIBS 171 (col) SpGCa
Cybele
MARQ 241
Dancers, banister relief
stone
STA 100 SpSalU
Dona Mencia de Mendoza,
effigy Chapel of
Constable; detail: Dog
marble
GOME pl 25-26 SpBC
Duke of Alba, with Heads of
Spain's Enemies: Pope;
Elizabeth I, Elector of
Saxony; Escuela Flamenca
Caricature ptd wood
SMIBS 182 (col) SpMaAl
Entrance, Conceicao Velha
1520
BUSR 180 PoLC

Female Saint, reliquary
SDP #154 UCSs
Helmet of Charles V
CIR 29 (col) SpMaRA
John the Baptist bronze
CHICC 55 UICEp
Plateresque Portal 1519/25
BAZINW 358 (col);
BUSG 191; CIR 13 (col);
ROOS 170E SpSalU
--Ferdinand and Isabella
BAZINW 358 (col)
Portable Altar of Charles V
bronzed silver with enamel
ESC 97 SpE
Prophet Elias ptd wood
WES pl 20 SpTTo
Saint, half figure 1530
pine; 111.5 cm (with
26 cm base)
BSC pl 96 GBS (M 243)
St. Apollonia, half figure
1530 pine; 113 (with 27 cm
base)
BSC pl 97 GBS (N 243)
St. Jerome; detail terracotta;
13-1/2
DEY 90, 91 UCSFDeY
San Salvador Church: Facade;
Vestry Door 1540/59
BAZINW 359 (col) SpU
Staircase Handrail 1500/25
BAZINW 359 (col) SpSalU
Torrecilla Monstrance silver
WHY 19 PrSC
Treasure Chest iron
DOWN 102 UNNHis
--16/18th c.
Monstrance
CIR 189 (col) SpSalC
--17th c.
Angels silver
WHY 20 PrSC
Christ at the Column box-
wood; 15-3/8
ASHS pl 28 ELV
Cup-Hilt Rapier, detail c 1650
W: 11-5/8
NM-3:16 UNNMM (51.170.2)
Door of Staircase, King's
Pantheon 1654 bronze
ESC 63 SpE
Gate, detail wrought iron
DOWN 104 UNNMM
Grand Duke of Alba Trampling
Hydra, with Features of
Queen Elizabeth I of England,
and Pope Paul IV, and

Elector of Saxony 1680
ptd wood; 11-1/2
COOPF 269 -SpA
Inscription Detail
NATSE MeDC
Left-Hand Dagger c 1650
W: 11-1/4
NM-3:16 UNNMM (15.170.1)
Our Lady of La Purisima 1666
WHY 212 PeL
St. Francis Xavier
TAT-sc pl 14 ELV
El Santo: Ferdinand III of
Castile ptd wood; 76
DENV 58 UCoDA (E-201)
Sargossa Shrine c 1600
INTA-2:134
Wrought Iron Choir Screen,
Cathedral of Valladolid
begun 1668 H: 52'
NM-8:15 UNNMM (56.234.1)
--18th c.
Abigail 1783
CIR 194 (col) SpCamG
Baptistry Window 1720/31
LARR 425 UTxSAJ
Buen Retiro Plaque Porcelain
ENC 136
Porcelain Figures 1760
VEY 296 SpMaB
Ruth 1783
CIR 194 (col) SpCaMG
Sacramental Chapel (Sagrario)
1740/72
CIR 180 (col) SpLuM
Sedan Chair of Philip V
CIR 196 (col) SpMaPal
--18/19th c.
Milled Eight Real Pieces--
obverse and reverse 1766,
1804
PAG-4:287 UNNAmN
Spanish Bull. Marcks
Spanish Dance(r). Degas
Spanish Woman, head. Seitz
The Spark. Penalba
Spatial Being. Fabbri
Spatial Concept# Fontana, L.
Spatial Construction. Gorin
Spatial Decoration for a Cinema
Ceiling. Fontana
Spatial Event. Toffoli
Spatial Figure. Fabbri
Spatial Form. Alley
Spatial Idea. Fontana, L.
Spatial Rhythm
Bill. Rhythm in Space
Spatial Sculpture in Space.
Jacobsen, R.

Spatiodynamique# Schoffer
Spazio Luce. Lo Savio
Speakers
Fischer, F. Der Redner
Spears
Byzantine. Spear Mount
Swedish--7/8th c. Vendel
Ship Burials
Specchio Alienato. Consagra
SPECK, Paul (Swiss 1896-)
Bread and Wine (Pane e Vino),
architectural composition
1957 granite; 49-1/4
GIE 236; JOR-2:pl 131;
VEN-62:pl 193
Brunnenfigur granite
JOR-1:pl 37
Garden Court Sculpture
DAM 204, 205 SwZCon
Losange 1957
JOR-2:pl 277
Petite Masse 1957
JOR-2:pl 276
Woman and Angel 1944 bronze
VEN-54:pl 116
The Spectator. Chadwick
Spectral Vision. Pevsner
Spectre of the Gardenia. Jean, M.
Speed. Seale
Speed. Stevenson
Spencer, Countess
Flaxman. Charity, model for
Monument to Countess
Spencer
Spencer, John
Hollemans. Sir John Spencer
and Wife Katherine
Monument
Spencer, Lady
English--16th c. Lady
Spencer Tomb
Spencer, Lord and Lady
Stone. Monument to Lord and
Lady Spencer
SPERANDIO (Italian)
Giovanni Francesco de
Gonzaga, Marquis of Mantua,
equest late 15th c. bronze;
13
HUYA pl 43; HUYAR 153
FPL
Medal: Giovanni II Bentivoglio
c 1485 bronze; Dm; 9.8 cm
CHAS 301; CHRC fig 184
UDCN
Pope Alexander V Monument:
Virgin and Child 1482 terra-
cotta
POPR fig 132 IBoF

--1960 wooden chair with
utensils and remains of
two breakfasts; 14-3/8x
27-1/4x25-1/4
SEITA 132 IMSc
The Lovers 1962 assemblage;
c 41x18
LIP 183 IMSc
The Pail is not Arman's 1961
household articles glued to
wooden board; 17-1/4x47
SEITA 9 IMSc
Sculpture*
EXS 51 UNNMMA
The Shower, detrompe-l'oeil
1961 object on canvas
NEW pl 54 IMSc
Trick-Picture
PEL 256
Spoons
Celtic. Spoons
Flemish, or Burgundian. Spoon:
Fox in Monk's Dress Preach-
ing to Geese
German--17th c. Carved Spoon
Sporck, Count
Braun, Anton--Foll. Count
Fr. Sporck Memorial
Braun, M. B.--Foll. Apothe-
osis of Count Sporck
SPORRI, Eduard (Swiss 1901-)
Kauerende 1947 bronze
JOR-1:pl 14 SwB
Spring
Antelami. Labors of the
Months: Spring
Barovier. Primavera
Bayes. Unfolding of Spring
Canonica. Spring
Carter, A. C. Primavera
Chelsea Porcelain. Spring
d'Antino. Spring
English--18th c. Bow "Spring"
Fiala. Spring
French--18th c. The Spring
Garbe, R. L. Primavera
German. Hochst Arbour
Group of Spring
Jamnitzer, W. Spring
Maillol. Spring
Mascherini. Awakening
Spring
Nicoloff. Spring
Palavicini. Spring
Pellini. Primavera
Pullinen. Primavera II
Tietz. Spring
Turner Spring

Vela. Spring
Wagner, J. P. A. Spring
Wagner, Josef. Spring
Springtime. Rodin
Springtime of Life. French--14th c.
The Sprite. Po
Sprouveduta. Di Martino
SPURR, Elizabeth (English)
Girl with Long Hair Gervaise
stone
NEWTEB pl 57 -EY
--1943 American whitewood;
24
BRO pl 37A
Pine Marten 1940 Peruvian
boxwood; 8-1/2x18
BRO pl 36
Spurs
French--12/19th c. Coronation
Spurs of the Kings of France
French--15th c. Rowel Spur
The Square. Giacometti
Square Figure, relief. Armitage
Square Flat. Hoskin
Square Form. Moore, H.
Square Seated Figure. Armitage
Squares with Two Circles. Hepworth
Squirrels
English--18th c. Chelsea
Scent Bottles
--Chelsea White Squirrel
Kandler. Squirrel, Meissen
Oppenheim. Squirrel
Stack of Cups. Arp
STADERINI, Giovanni, and Gaspare
MOLA
Plate Commemorating Reform
of Gregorian Calendar silver;
Dm: 21
COOP 88 IVCi
STADLER, Toni (German 1888-)
Arethusa, detail 1951/53
bronze
GERT 84
Diver (Taucher) 1953 bronze;
45-1/4
NNMMAG 170
Dog (Der Hund) 1950 bronze;
40-1/2
NNMMAG 171 GMB
--1950/51 bronze; 39x49
MID pl 48 BAM
--1950/51 bronze; 125 cm
OST 56 GMB
--1951 bronze; 43-3/8
SCHAEF pl 61
Knabenbuste 1928 bronze; 24 cm
HENT 84 GMSGal

Kneeling Figure Eos 1958
 bronze; 59
 TRI 64 GDuK
Madchen 1931 Kunststein;
 42 cm
 HENT 85 GMSG
Madchen Mit Taube 1960
 bronze; 33 cm
 SP 215 GHaS
Mask (Maske) bronze
 GERT 83
Portrait of a Young French
 Woman, head 1956
 MAI 275 GBrimK
Portrait of Margaret Knittel
 bronze
 GERT 82
Stehende 1946 bronze; 106
 cm
 SP 215 GHaS
Stehende Frau 1940/41
 bronze; 156 cm
 OST 57 GFSt
Standing Dog (Stehende
 Hund) 1950/51 bronze
 GERT 81
Standing Girl 1935/38
 cast stone; 66-1/8
 NNMMAG 170 GH
STAFFORDSHIRE
 Baker's Boy, and Pair of
 Deer with Trees c 1825
 earthenware
 CON-5:pl 61 ELutW
 Teapot in form of Camel
 c 1745 salt-glazed
 stoneware; 4-1/2
 CON-3:pl 50 ELV
 Woman Equestrian c 1740
 lead-glazed earthenware;
 7-9/16
 CON-3:pl 47 ELV
Staffs See also Croziers
 French--13th c. Decorated
 Staff
 French--14th c. Pastoral
 Staff Handle: Virgin and
 Child with Angels
 --Virgin and Angel, pastoral
 staff head
 Russian--17th c. Pastoral
 Staff (Posokh)
Le Stagioni Virili. Rousseau, V.
Stags See Deer
Stahl# Hauser
STAHLY, Francois (Henry Francois
 Stahly) (German-French
 1911-)

The Angel 1949 wood; 100
 SCHAEF pl 113
Big Wood 1959/60 wood; 80x
 43x102
 SEAA 152 FPSC
Birth 1955 wood
 MARC pl 73 (col)
The Castle of Tears (Chateau
 des Larmes) 1952 walnut;
 51
 BERCK 334; GIE 289 FPSp
Combat of Birds 1960 wood
 SELZJ 10 FLouP
L'Ete de la Foret 1964/66
 oak; 157x393x235
 CHICSG
Flammes
 FPDEC il 20
Fountain 1956
 BERCK 135
--1963 bronze; 594 cm
 LIC pl 336 SwSGH
Le Grand Portique 1964 wood
 LARM 326
The Guardian 1961 wood
 MARC pl 72 FPSp
Homage to Rimbaud 1953 oak
 MAI 276
Medusa 1959 olive wood;
 23-5/8
 TRI 171
Model for a Fountain, for the
 University of St. Gall,
 Switzerland bronze; 236-1/4
 READCON 202
Mother Tree (L'Arbre Mere)
 1963 60-1/2x37-1/2
 CARNI-64:#81 FPBu
Mountain Mothers (An-Di-Andi
 or Les Meres Montagnes)
 1956/57 cherry; 51-1/4x
 23-1/2x17-3/4
 GIE 290
Sculpture in Wood 1949
 MAI 276
Serpent of Fire (Serpent de
 Feu) 1956 bronze; 32x55x13
 LOND-5:#9; SELZJ 149 FPBu
Sol Vitoria 1961 cedar; 250x
 300x100 cm
 SAO-7
Star I 1959/60 wood
 VEN-64:pl LIII FPM
STAHR-NIELSEN, O. (Danish)
 Justice, corridor wall panel
 AUM 97 DCF
Shop Wall Figures
 AUM 96, 97 DC

STAINER, Thomas See STAYNER,
 Thomas
Stairs and Stairways
 Bernini, G. L. Scala Regia
 Boullier. Staircase
 Bucke. Staircase Figure
 Endell. Atelier Elviar:
 Staircase
 English--17th c. Staircase#
 Fischer von Erlach. Stair-
 case: Columnar Figures
 Garnier. Grand Staircase
 German--18th c. Baroque
 Staircase, with Figures
 Gibbons. Staircase
 Hermann, G. Outside Stair-
 case Sculpture
 Horta. Staircase
 Le Pautre, A. Staircase
 Mansart. Staircase Balustrade
 Neumann. Baroque Staircase
 Schluter. Great Staircase
 Sutkowski Carved Stair-Rail
 Tomasini. Apartment House
 Stair Rail
Stalin, Joseph (Russian Leader
 1879-1953)
 Kepinov, A. J. V. Stalin,
 bust
 Mikus, S. Stalin Memorial
Stalls
 English--15th c. Martyrdom
 of St. Edmund
 French--13th c. Amiens
 Cathedral Stall
 French--16th c. Abbot's
 Stall
 German--15th c. Stalls,
 details
STAMMEL, Josef Thaddaus
 (Austrian 1695-1765)
 Death c 1760
 BUSB 189 AAdB
 Descent into Hell gilt
 bronzed wood; over LS
 BAZINW 414 (col) AAdB
 Fear c 1760/65 boxwood;
 14-1/4
 READAS pl 110 ELV
 St. Martin and the Beggar,
 equest, High Altar
 HEMP pl 65 AGM
STAMP, Percy (English)
 Hatpin, detail 1908 silver
 SELZPN 103
Stamps See Seals (Numismatics)
Standard. Delahaye
Standard Bearer. Lancere

Standarte. Vozniak
Standing I. Shemi
Standing Armed Figure. Meadows
Standing Figure (South Sea Maiden).
 Kolbe
Standing Venus
 Renoir. Venus Victorious
Stanhope, Earl
 Rysbrack. Earl Stanhope
 Monument
Stanhope, Lady Frederica
 Chantrey. Lady Frederica
 Stanhope, recumbent effigy
Stanislas, Saint (Patron Saint of Poland
 1030-79)
 Polish. Cross of the Order of
 St. Stanislas
 Polish. Dismemberment of St.
 Stanislas
Stanislas Kotska, Saint
 Legros, P., the Younger. St.
 Stanislas Kotska on His
 Death Bed
STANKOVIC, Radeta (Yugoslav 1905-)
 The Liberation of Belgrade,
 relief 1954
 BIH 122-23 YBNC
STANLEY, Charles
 Colen Campbell, medallion,
 ceiling detail c 1728
 WHINN pl 105A ECom
 Lord Maynard Monument 1746
 ESD pl 21; ESP pl 102 EEsL
Stanley, Thomas
 English--17th c. Sir Thomas
 Stanley Monument
STANTON, Edward (English 1681-1734)
 Dr. Edward Tyson Monument
 d 1708
 WHINN pl 51A ETw
 Sir Francis Russell Monument
 1705
 GUN pl 27 EStren
STANTON, Thomas (English 1610-74)
 Lady June Bacon Monument
 1657 c LS
 ESD pl 86; WHIN pl 29b
 ESufC
STANTON, William (English 1639-1705)
 1st Lord of Coventry Tomb
 d 1699
 WHINN pl 49B EElm
 The Orphans, Monument to
 Mrs. Olive Talbot
 ESD pl 105 EWorS
 Richard and Isabella Shirburn
 Tomb c 1699
 WHINN pl 48 EMi

Sir John and Lady Brownlow,
busts, monument c 1679
GUN pl 24 EBelt
Sir Richard and Lady Atkins
Tomb, detail marble
MOLS-2:pl 17 ELPaul
--Recumbent Effigy, sketch
model terracotta; L: 14
MOLS-2:pl 16 ELV
STANZANI, Emilio (Swiss 1906-)
Arlecchino in Attesa 1949/50
stuck bemalt; 155 cm
JOR-1:pl 47
Arlecchino in Movimento
bronze; 120 cm
JOR-1:pl 46
Composition au Chasseur 1956
JOR-2:pl 119
Emigrante 1956/57
JOR-2:pl 280
Filippo 1953 stuck bemalt
JOR-1:pl 48
Mort de l'Arlequin 1956
JOR-2:pl 278
Transport de Statues 1957
JOR-2:pl 120
Velo-Taureau 1956
JOR-2:pl 279
Le Vendeur de Reves 1956
JOR-2:pl 281
Stapleford Cross Shaft. Anglo-Saxon
STAPPEN, Karel van der (Belgian
1843-1910)
Le Devouement
MARY 81
Man with the Sword
ROOSE 293 BBMu
The Sphinx 1898 marble; 28
HAMF 280 BBR
Town Planners 1893 bronze
HAMF 109 BBCi
Star. Arp
Star. Rousseau, V.
Star I. Stahly
Star in the Road. Szapocznikow
Starhemberg. Hellmer
STARCKE, Henrik (Danish 1889-)
Dronning Dagmar, relief
1948/49 braendtler;
95x31 cm
COPGM 59 DCN (I. N. 2709)
The Fourth of May, relief
VEN-48:pl 66
Hoved 1940 sortbasalt; 27 cm
COPGM 55 DCN (I. N. 2814)
Tyrehoved 1962 bronze;
90x92 cm
COPGM 63 DCN (I. N. 2841)

Starter. Perincioli
Starter II. Chadwick
Startled Bird. Meadows
STARTUP, Peter (English 1921-)
Falling Figure 1960 lime,
sycamore, pine; 90
READCON 203
Locked Figure 1962 wood;
32x9x6
ARTSS #44 ELBrC
Separation 1964 wood; 88x
44x24
ARTSB-66:pl 4
Up-Ended Figure 1961 pine,
mahogany, teak; 103-1/2x
29x18
TATES pl 17 ELT (T. 612)
Starzynski, Professor
Dunikowski. Professor
Starzynski, head
STASINSKI, Jozef (Polish 1902-)
Medal: Janina 1955
JAR pl 35
Statement. Kosso
STATI, Cristoforo (1556-1618)
Mary Magdalen 1606
BUSB 48 IRAndrV
STATIO, Abondio See MAZZETTI,
Carpoforo
Stations of the Cross. See Jesus
Christ--Passion
"Statiovore" con Piedestallo.
Constant
Statique II. Jacobsen, R.
Statue of Liberty. Bartholdi
Staubling. Janouskova
STAURIS, Rinaldo de' See AMADEO,
Giovanni Antonio
Stavelot Triptych. Godefroid de
Claire
STAYNER, Thomas (Thomas
Stainer) (English c 1668-
1731)
Dr. Turner Monument 1714
GUN pl 27; WHINN pl 50B
EStowe
STAZEVSKY, Henryk (Henryk Sta-
zewski) (Polish 1894-)
Rilievo 7 1966
KULN 164
Rilievo 9 1965 rame
VEN-66:#201
Steam. Chapu
Steel Devil. Depero
Steel Painted Silver. Turnbull
Steel Sculpture. Gorin
Steel Working.
Meunier. Monument to Labor:
Industry

STEELL, John (English)
Robert Burns, seated figure
bronze
SALT 68 UNNCentM
Walter Scott, seated figure
1871 bronze
SALT 70 UNNCentM
Steeple Cup. English--17th c.
STEFAN, Pierre
The Elements, 4 Bristol figures
SOTH-3:189
STEGER, Milly (German 1881-)
"Mein Ball" 1932 bronze;
132 cm
HENT 48
STEINBRENNER, Hans (German
1928-)
Cherubin
FPDEC-German il 8
Composition 1956 elm wood;
69
MID pl 122; TRI 95 BAM
Grosse Pappel 1961 wood;
510 cm
KUL pl 15
STEINER, Rudolf (German 1861-
1925)
Goetheanum 1925/28 reinforced concrete; 121x295x
276'
TRI 238 SwD
STEINL, Matthias (Austrian 1644-1727)
Joseph I, equest c 1710 ivory
BAZINW 399 (col); HEMP
pl 59 AVK
Stela for a Saint. Kalinowski
Stele
Basque. Fumerary Stele
Berrocal. Stele: Soul of a Tree
Celtic. Stele of Fahan Mura
Celtic-Pictish.
Stele of Hilton
Chillada. Ilarik, sepulchral
stele
Csaky. Stele
Frankish. Memorial Stele
French--7th c. Hypogeum of
the Martyrs
Gill, E. Stele
Kock. Granite Stele
Swedish--8th c. Figurative
Stele
Swedish--7/8th c. Stele:
Figures in Registers
Stelzhamer Monument. Metzner
Stem of Jesse See Tree of Jesse

STEMOLAK, Karl (Austrian)
Mother and Son marble
VEN-7:pl 14
Tombstone Figure
TAFTM 65
STENVERT, Curt (Austrian 1920-)
La Forma si Sfascia, la
Materia Rimane 1966
VEN-66:#144
The 38th Human Situation:
The Dead Manager has Bequeathed his Own Gilded
Skeleton to his Enchanting
Widow 1964 61-3/8x74x
21-5/8
NEW pl 322
The Step Mother. Trsar
STEPANOV, Victor Vladimirovich
(Russian 1932-)
Mobile 1966
KULN 195
STEPHAN See STEPHANUS
Stephanos I (Patriarch of Kartli)
Georgian. Stephanos I,
Patriarch of Kartli, relief
STEPHANUS (Stephan)
Figure*
MARTE pl 49
Male Figure 1st c. B. C.
CHASEH 148 IRAl
Stephaton
German--10th c. Codex
Aureus Epternacensis:
Christ on the Cross between
Longinus and Stephaton
Stephen, Saint
Belgian--16th c. St. Stephen
Byzantine. St. John the Baptist with Apostles
Donatello. SS Stephen and
Lawrence
English--14th c. Travelling
Altar, including figures
of Saints
French--12th c. Martyrdom
of St. Etienne, tympanum
--St. Steven, trumeau
figure
French--13th c. St. Etienne
--St. Stephen, reliquary
--St. Steven Legend, tympanum
--Shrine of St. Etienne
French--14th c. St. Stephen,
head detail
French--15th c. St. Stephen
French--16th c. St. Stephen,
west door figure

German--12th c. Stoning of
 St. Stephen
German--13th c. Adam Portal
Ghiberti. St. Stephen
Gibbons. Stoning of St.
 Stephen, relief
Guggenbichler. Dying St.
 Stephen, head
Riemenschneider. St.
 Lawrence, and St.
 Stephen
Roccatagliata. St. Stephen
Stephen, King
 German--13th c. Bamberg
 Rider
Stephen (King of England 1097?-
 1154)
 English--15th c. Niche
 Figures: King Henry I;
 King Stephen; King
 Henry II
 English--15th c. Screen
 Statues: King Stephen;
 Henry II
Stephen I (king of Hungary 975?-
 1038), called St. Stephen
 Hungarian--16th c. King
 Stephan
Stephen of Muret, Saint (1046?-1124)
 French--13th c. Reliquary:
 St. Etienne de Muret
STERN, Catharny (English 1925-)
 Race Horse 1952 plaster; 12
 BED 113
Sternberg, Josef von
 Belling. Joseph von Stern-
 berg, head
Sterne, Laurence (English Novelist
 1713-68)
 Nollekens. Laurence Sterne,
 bust
Sternness
 French--13th c. St. Firmin
 Portal: Sternness
STERNSCHUSS, Moshe (Israeli
 1903-)
 Biblical Figure concrete
 GAM pl 133
 Figure clay
 SCHW pl 69
 Reclining Figure concrete
 GAM pl 132
 Wounded Bird concrete
 GAM pl 134
STERNSCHUSS-ZARFATI, Ruth
 (Israeli 1928-)
 Nude
 GAM pl 131

STETHAIMER, Hans (German d 1432)
 Self Portrait, from epitaph
 BUSR 65 GLaM
The Stevedore
 Meunier. The Docker
STEVENS, Alfred (English 1817-75)
 Caryatid c 1860 plaster; 74
 VICF 102 ELV (129-1879)
 Caryatids
 CHASEH 481
 --Dorchester House Fire-
 place marble
 MILLER il 173 ELT
 --Supporting Figure, model
 plaster
 AUES pl 34 ELT
 Firedog, study mid 19th c.
 plaster (cast from sketch
 model); 15-1/2
 ASHS pl 35 ELV
 Fountain Figure plaster
 UND 133 ELV
 Great Exhibition Memorial,
 model (not carried out)
 VICG 139 ELV
 Infant Son of L. W. Collmann,
 bust
 UND 135 ELV
 Wellington Memorial 1875
 marble and bronze
 BOASE pl 91; GIA pl 44;
 LIC pl 99; MARY pl 54;
 POST-2:205; RICH 116
 ELPa
 --original model
 BROWF-3:71; MILLER il
 171; UND 138 ELV
 --Model: Truth Plucking Out
 the Tongue of Falsehood
 BROWF-3:78; MARY pl 32
 ELV
 --Model: Valour Spurning
 Cowardice c 1860 plaster;
 103-1/2
 MARY pl 31; ROTJG pl 1
 ELV
 --Model: Virtue Overcoming
 Vice
 MOLE 266 ELT
STEVENSON, James Alexander
 (English 1881-1937)
 Memorial at Mombasa, de-
 tail: Two Figures
 BROWF-3:88
 Speed
 BROWF-3:89
Stevens, N. Larsen (Danish
 Painter 1864-1941)

Nielsen, K. N. Larsen
Stevns, head
Stewart, Robert (2nd Marquis of
 Londonderry, known as
 Viscount Castlereagh
 1769-1822)
 Chantrey. Viscount
 Castlereagh, bust
Stick Statuettes. Picasso
Stier. See Cattle
Stigmata
 Masegne, J. dalle--Attrib.
 Miracle of the Stigmata
STIJOVIC, Risto (Yugoslav 1893-)
 Caryatid 1933 wood
 BIH 110
 Indian Dancer 1930 wood
 BIH 111 YBN
 Seated Nude 1936 bronze
 BIH 109 YBYT
Stilicho (Roman General and
 Statesman 359?-408)
 Early Christian. Diptych:
 Stilicho
 Early Christian. Sarcophagus
 of Stilicho
Still Alein. Marcks
Still Life. Gonzalez
Still Life. Laurens
Still Life. Magnelli
Still Life. Picasso
Stille Iridescenti. Mayer, G.
STILP, Karl (German 1688-)
 The Librarian 1724/25
 BUSB 188 GWa
Stirachiamento. Gador
STIRLING, William
 Prince Ardjuna, plaque bronze
 CASS 141
STOCKER, H. (Swiss)
 Sculptured Altar 1954
 DAM 172 SwSoM
STOCKTON, Thomas (English)
 Heraldic Details: Dragon: Crown
 and Rose, Chapel 1512/13
 stone STON pl 187 ECamK
Stoic Figure. Hoflehner
STOJADINOVIC, Ratimir (Yugoslav
 1913-)
 Figure for a Fountain 1954
 bronze; 67
 MID pl 130 BAM
 Nude plaster
 BIH 180
Stojanovic, Marko
 Jovanovic. Marko Stojanovic
STOJANOVIC, Sreten (Yugoslav
 1898-)

Arch V. S., head 1930 bronze
 BIH 112
Dancer Natasa, head 1930
 bronze
 VEN-54:pl 102
Liberation, relief detail, for
 monument near Bosanko
 Grahovo
 BIH 117
Mother and Child 1939 bronze
 BIH 115
The Necklace 1938 plaster
 BIH 114 YBN
Nikola Vulic, head 1944
 bronze
 BIH 113 YBN
The Uprising, relief detail,
 for monument near Bosanko
 Grahovo 1951
 BIH 116
Stolbenski, Nil
 Russian--18th c. Holy Nil
 Stolbenski
Stone, Mme.
 Despiau. Mme Stone, head
STONE, Nicholas (English 1586-
 1647)
 Edward Pinchon Monument
 d 1625
 WHINN pl 20 EWr
 Francis Holles Monument
 d 1622
 WHINN pl 20 ELWe
 John and Thomas Lyttleton
 Monument 1634 LS
 WHIN pl 28b; WHINN pl 21
 EOM
 John Donne Monument c 1691
 marble
 ENC 853; GARL 198;
 LARR 254; MOLE 223;
 MOLS-2:pl 8; WHINN pl
 22A ELPa
 John Law Monument 1615
 WHINN pl 24A ELCh
 Lady Elizabeth Carey, effigy
 1617
 BUSB 32; WHINN pl 16
 EStowe
 Monument to Lord (by John
 Hargrave and Richard
 White) and Lady Spencer;
 detail Crest
 ESD pl 92, 93, 77 ENorG
 Sir Charles Morison Tomb
 1619; 1630
 WHINN pl 19, 21 EWat
 --A Son
 ESD pl 68

Sir George Holles Monument
c 1626
MERC pl 91a ELWe
Sir Thomas Bodley Monument
1615 15-1/2x9-1/2'
GARL 73; WHIN pl 28a
EOMC
Sir William Curle Tomb 1619
BUSB 52; MERC pl 90B;
WHINN pl 17 EHatCh
Thomas, Lord Knyvett, Tomb
1623
CON-2:pl 41 EMiddS
Virgin and Child, south
porch
UND 69 EOM
STONE, Nicholas, and Nicholas
JOHNSON
Thomas Sutton Tomb 1615
WHINN pl 18 ELCh
Stone. Hartung
Stone of Scone
Walter of Durham. Coronation
Chair
Stones are the Arms of the
Proletariat. Chadre
Stonings See Lapidation
Stools
English--17th c. Stool, with
four braced legs
Italian--16/17th c. Stool:
Carved Face Decoration
STORCK, Frexeric (Rumanian)
The Offering
CASS 74 RBP
STOREY, Abraham (English d c
1696)
Lord and Lady Crofts,
reclining effigies c 1678
GUN pl 23 ELitS
"Storied Urn"
Hayward. Ladies Newdigate
Monument
Storks
Durst. Shoe-Bill Stork
Harth. Stork Group
Storm. Richier, G.
Storm Driven Away by Fair
Weather. Fenosa
STORR, Paul (English)
Centerpiece 1808/09
silver
CLE 161 UOClA (43.189)
STORSS, John
Figure* stone
MARTE pl 31
Story-Teller. Griselli

Stosch, Philipp von (Baron 1691-
1757)
Bouchardon, E. Baron
Philipp von Stosch, bust
Italian--18th c. Philip von
Stosch, bust
STOSS, Viet (Wit Stosz) (German
1447?-1533)
Altar of Our Lady (High
Altar) 1477/89 wood;
shrine: 215x140; altar: 39'
KO pl 63; MULS pl 134-35;
ST 253; UPJH pl 100 PCL
--Apostle, head wood
BAZINH 230; GOMB
202, 205; LARR 74
--Dormition of the Virgin
(Death and Assumption
of the Virgin)
BAZINW 322 (col); BUSR
104, 105; CHASEH 261;
JANSK 603; NEWTET 155;
POST-1:106
--St. John the Evangelist,
head
BAZINW 323 (col)
Angelus 1517/18 wood
LOH 186 GNL
The Annunciation, with God
the Father Above, and
Medallions of the Seven
Joys of the Virgin 1517/18
wood; c 156'
BUSR 107; PRAEG 247;
VEY 138 GNL
--Flying Angel
JANSH 301
--Salutation of the Angels
1517/18 limewood;
146-1/2x126
NEWTEM pl 107
Baptism of Christ, relief
ptd and gilded wood
NCM 287 UNNMM (12.130.1)
Betrayal of Christ
RAY 36
Casimir Jagiello, effigy detail
1492 red Hungarian
marble
MULS pl 136 PCW
Crucifix, St. Sebald c 1500
wood
MULS pl 179 GNL
Englishe Gruss
LIL 120 GNL
Kiss of Judas, relief 1499
MULS pl 181A GNS

Marienaltar, center panel:
 Angel Musicians c 1523
 BUSR 114 GBaC
St. Andrew c 1505 limewood;
 78-3/4
 MAR 111 GNS
Salve Regina 1517/18 ptd
 wood
 MULS pl 180A GNL
Tobias and the Angel 1516
 wood
 BAZINW 322 (col) GNG
Virgin and Child c 1500
 wood
 MULS pl 180B GNG
--c 1505 boxwood; 8-9/16
 ASHS pl 13; FREED pl
 31; MILLER il 109; MOLE
 84; MUL 33; NEWTEA
 139; READAS pl 178;
 VEY 68; VICF 30 ELV
 (646-1893)
Virgin Weeping wood; 12-3/16
 CLE 67; CLEA 8 UOC1A
STOSS, Viet (Wit Stosz)--FOLL
 Dormition of the Virgin,
 altarpiece, Wroclaw
 1492 ptd wood; 96
 WPN pl 78 PWN (SR 12)
St. Catherine c 1500 ptd linden-
 wood; 13-3/8
 KUHN pl 18 UMCB (1956.12
Triumphal Cross 1360
 BUSB 120 PCL
Stovepipe. Kramer
Stove Plates
 German--16th c. Stoveplate
 German--17th c. Stoveplate
Stoves
 French--18th c. Stove:
 Bastille
 Russian--16th c. Chaldean
 Stove
 Swiss--17th c. Dutch Tile
 Stove
 Vrubel. Ceramic Stove
Stow, John (English Historian and
 Antiquary 1525?-1605)
 English--17th c. John Stow
 Monument
Strachey, Lytton (English Writer
 1880-1932)
 Tomlin. Lytton Strachey,
 head
The Stranger# Chadwick
STRASSBURGER MEISTER
 Bearded Man, bust sandstone;
 66 cm (with base) BERLEK
 pl 16 GBSBe (5598)

Strata, No. 10. Lenk, K. T.
Stratification 21a. Lenk, K. T.
STRAUB, Johann Baptist (German
 1704-84)
 Kneeling Saint ptd and
 gilded wood
 CLE 150 UOC1A (61.414)
 Putto with Dolphin
 ENC 855
St. Catherine of Siena c 1760
 HEMP pl 144 GMBN
STRAUB, Johann Baptist, and
 Joachim DIETRICH
 Opera House, detail: Left
 Proscenium Box 1751/53
 BOE pl 185 GMOp
STRAUSS, Anne (English 1902-)
 Group in Tulip Wood
 UND 164
 The Tree cedar; 30
 DURS 64
STRAUSS, Bernard (German fl
 2nd H 17th c.)
 Tankard: Battle with Centaur
 1651 ivory, silver gilt
 mounts; 19
 MOLE 216; VICF 70 ELV
 (4529-1858)
Strauss, Richard
 Lederer, H. Richard Strauss,
 bust
Stravinsky, Igor
 Marini. Igor Stravinsky, head
STRAYFF, Thomas (Austrian fl
 1466-83)
 Man of Sorrows 1478
 MULS pl 118A AWG
STREBELLE, Olivier (Belgian
 1927-)
 Bird Man 1958 cast bronze
 VEN-62:pl 120
 Chevel Bayard
 DIV 105 BNaP
 Fountain 1951 ceramic; 120x
 185 cm
 MID pl 125 BAM
 Le Repos du Guerrier
 DIV 91 GStM
 L'Un L'Autre bronze
 DIV 91 BAM
Street Singers. Marques
Streitbare, Philipp der
 Gebel. Duke Philip der
 Streitbare
Strength
 Dubroeucq. Strength, Rood
 Screen
 French--12th c. House Tym-
 panum: Learning; Strength
 of Love

Pisano, Niccolo. Pisa Baptistry Pulpit: Strength
Striding. Hartung
Striding Girl. Marcks
Striding Woman. Barlach
Striding Youth.
 Vischer, P. , the Elder--Foll.
Strife. Leonardo da Vinci
Stringed Figure# Hepworth
String(ed) Figure. Moore, H.
STROBL, Alajos (Hungarian 1856-1926)
 Albert Schickedanz, bust
 c 1886 bronze; 30 cm
 GAD 54 HBA
 Ferenc Liszt, head c 1886
 bronze; 30 cm
 GAD 51 HBA
 Girls Reading c 1916 bronze;
 136 cm
 GAD 60 HBBP
 Mother 1894 marble; 161 cm
 GAD 53 HBA
 Poet Arany Memorial 1893
 bronze; 365 cm
 GAD 49 HBNM
 Self Portrait, head 1878
 terracotta; 30 cm
 GAD 50 HBA
 Woman, bust c 1920 marble
 GAD 52
Stroganoff Ivory. Byzantine
Strossmayer, Juraj
 Valdec. Bishop Juraj Strossmayer, bust
Strozzi, Filippo (Florentine
 Banker 1426-91)
 Benedetto da Maiano. Filippo
 Strozzi, bust
Strozzi, Marietta
 Desiderio da Settignano.
 Marietta Strozzi, bust
Strozzi, Niccolo
 Mino da Fiesole. Niccolo
 Strozzi, bust
Strozzi Madonna
 Benedetto da Maiano--Foll.
 Strozzi Madonna version
Structure# Gilbert, S.
Structure in Plexiglas. Sobrino
Structure Optique. Boto
STRUDEL, Paul See BENKERT, J. P.
STRUDEL, Peter von (1660-1714)
 The Virgin, Sepulchral Altar,
 right chapel 1713/17
 BUSB 117 AVKa
The Struggle. Rosandic
Struggling Children. Donatello--Foll.

Struktur Remanit. Werthmann
Struttura# Cannilla
Struttura. Carrino
Struttura d. 724. Mari
Struttura Sonora. Pierelli
Strutturale Variante I. Frasca
Strutturaspazio 14. Uncini
STRYNKIEWICZ, Franciszek (Polish
 1893-)
 Athlete, head 1954 plaster
 JAR pl 6
 Heroes of the Warsaw
 Monument, design 3rd prize
 1958
 JAR pl 7
Stuart, Sarah
 Byng. Lady Sarah Stuart,
 head
Stuart Monument. Canova
Stubborn Ram. Bourdelle
STUCK, Franz von (German 1863-1928)
 Amazon, equest bronze
 AGARC 130; CHENSW 482;
 TAFTM 53 UICA
Students
 Caragea. Woman Student
 French--13th c. Student Life,
 scenes
 Seitz. The Student
STUDIN, Marin (Yugoslav 1895-)
 The Bread Winner, relief
 1943 wood
 BIH 99
 Dark Days, relief 1944 wood
 BIH 98 ELT
 War, low relief 1944 walnut;
 31-3/8x46-1/8
 TATEF pl 52g ELT (6170)
Studio per il Costume Moderno#
 Martini, A.
Study for Clothed Dancer. Degas
Stuhl mit Fett. Benys
Stuma Paten. Byzantine
Der Stumische Salan. Bustelli
Le Stupide. Daumier
Sture, Sten, the Elder (Swedish
 Patriot 1440?-1503)
 Milles. Sten Sture, monument
 Notke. St. George and the
 Dragon
STURM, Johann Anton (German
 c 1690-1757)
 Putti, pulpit after 1717
 BUSB 173 GFusM
 St. Ambrose 1739/57
 BUSB 174 GSteinCh
 St. Jerome 1753/54 ptd wood
 KO pl 93 GWiesCh

STURM, Robert (German 1935-)
 Sandstone 1959 H: 57 cm
 KUL pl 16
Sturmender. Lehmbruck
Sturmender, Getroffener Jungling
 Lehmbruck. Sturmender
STURSA, Jan (Czech 1880-1925)
 Burial in the Carpathians
 1917 pearwood; c 17
 RAMS pl 11a CzPM
 Donna che si Lapa i Capelli
 marble
 VEN-26:pl 71
 Eduard Vojan, bust bronze
 MARY pl 77
 Eve bronze
 MARY pl 102 GM
 Falling Warrior 1921 bronze
 RAMT pl 18
 Garden Entrance
 AUM 26 CzPHC
 Girl Combing her Hair
 TAFTM 93
 Kneeling Girl
 TAFTM 93
 Melancholy (Melancholy Girl)
 stone
 PAR-2:front; TAFTM 93
 Memorial
 TAFTM 93
 Morning Hour
 TAFTM 92
 Playmates
 TAFTM 92
 Sculptor's Mother, bust 1921
 bronze
 RAMT pl 17 CzPN
 T. G. Masaryk
 CASS 60
 Ukranian Fiddler stone
 PAR-2:113
 Wounded bronze
 MARY pl 104 CzPM
Stymphalian Birds
 Bourdelle. Hercules Shoot-
 ing the Stymphalian
 Birds
SUBIRACHS, Josep Maria (Spanish
 1927-)
 Esquerda 1964 bronzed
 cement; 16-7/8x8-1/4x
 7-1/8
 NEW pl 143 SwZHu
 Sculpture terracotta
 MAI 278
 Siren 1957 terracotta
 BERCK 183
 Tribute to Gaudi 1957
 BERCK 335

Successive Illuminations. Morellet
SUCHARDA, Stanislav
 Bedtime Song, lunette bronze
 CASS 106
 Palacky Monument grey
 granite and bronze
 MARY pl 44 CzP
 Prague and Moldau, relief
 bronze, onyx, marble
 MARY pl 105 CzP
Sudary
 Fancelli, C. Angel with
 Sudary
SUE ET MARE, Architects
 Facade, D'Orsay's Scent
 Shop, Rue de la Paix
 AUM 51
Suez Canal
 Magni. Commemorative
 Monument to Cutting of
 Suez Canal
Suffering
 Rodin. Head of Grief
Sugar Bowls and Caster
 Kandler. Meissen Sugar
 Caster: Chinese Lovers
Suger (French Churchman and
 Statesman 1081?-1151)
 French--12th c. Abbot Suger's
 Chalice
Sui III. Toyofuku
Suintilla (King of Visigoths)
 Visigoth. Crown of King
 Suintila
Suks, Kenya
 Baberton. Tinder Ketch, Suk
 Man, Kenya, head
Sully, Duc de Maximilien de
 Bethune (French Statesman
 1560-1642)
 Bourdin. Sully Tomb
Sulpitius, Saint
 Voort. High Altar, detail:
 Seraphim Heads; St.
 Sulpitius
Summer
 Bouchardon, E. Fountain of
 the Four Seasons: Summer
 Egell, P. --Foll. Summer
 Jaeckel, J. Summer
 Maillol. Summer
 Obrovsky. Summer
Summer Solstice. Cascella, A.
Sun
 Basque. Funerary Stele: Cross
 and Solar Symbols
 German--15th c. St. Servatius
 Protected by an Eagle
 against King of the Huns
 Richier, G. Thistle (Sun)

Sun and Moon
 German--17th c. Virgin in
 Glory, with Sickle Moon
 and Sun
Sun Bathing. Eikhoff
Suncat. Hoskins
Sun Horses
 Le Lorrain. Sun Horses
The Sun Singer. Milles
Sun Suite. Kemeny
Sunday Pleasures. Wijnants
Der Sundenfall See Adam and Eve
Sundials
 Anglo-Saxon. Sundial
 Asam, E. Q. Facade, detail,
 with Athena and Sun Dial
 French--12th c. Angel with
 Sun Dial
The Sunflower. Ledward
Sungazer# Turnbull
SUNOL, J.
 Christopher Columbus,
 bronze
 SALT 64 UNNCentM
Sunset
 Michelangelo. Lorenzo de'
 Medici Tomb: Evening
Sunset and Deposition. Piche
"Suor Papina"
 Mazzoni. Nativity, with
 "Suor Papina"
Superficie-Espaco. Cappello
The Suppliant. Bertoldo di Giovanni
The Suppliant. Scheibe
Supplication. Kafka
Supplice
 Brancusi, Torment
Suprematist Architecture. Malevich
Suprematist Composition. Puni
Sur le Pave. Cordonnier
Surdis, Stefano de
 Giovanni di Cosma. Stefano
 de Surdis Monument
Surface-Espace. Vieira, M.
Surface Way in Two Plays. Kricke
SURLIN, Jorg See SYRLIN, Jorg
Surprise. Sortini
The Surprise Fountain. Origo
Surrealer Gegenstand. Fischer, L.
Surrender of Pamplona. Raggi, N. B.
Surrey, Lord d 1559
 Cure, William II. Lord Surrey
 Tomb
Susan, Head. Gill, E.
Susanna
 Baglioni. Susanna
 Beauvallet. Susanna Bathing
 Belgian--9th c. The Chaste
 Susanna

 Byzantine. Daniel in the
 Lion's Den; Susanna and
 the Elders; Susanna Before
 Daniel, reliefs
 Dobson. Susannah
 Duquesnoy, F. St. Susanna
 Germany--9th c. Story of
 Susanna, rock crystal
 Italian--15th c. Ivory Comb:
 Story of Susannah, scenes
 Kayser. Susanna at her
 Bath, relief
 Manzu. Susanna
 Milles. Susanna, fountain
 Milles. Susanna on a Shell,
 fountain
 Quesnoy. St. Susanna
 Suter. Susanna
SUSINI, Antonio (Florentine d 1624)
 Farnese Bull bronze; 47 cm
 FAL pl 59 IRB (CCXLIX)
SUSINI, Antonio--FOLL
 Prancing Horses 17th c.
 bronze
 INTA-2:120
Suspended Ball. Giacometti
Suspension Parallele. Witschi
SUSSNER, Max Conrad (Konrad Max
 Sussner) (German c 1650-90)
 St. John Nepomuk 1889/90
 BUSB 110 CzPKr
 St. Martin 1889/90 stucco
 BUSB 111; STECH pl 24,
 25 CzPKr
SUTER, Ernesto (Swiss 1904-)
 Susanna 1948/50 bronze
 VEN-50:pl 104
Sutherland, 1st Duke of
 Chantrey. 1st Duke of
 Sutherland Monument
SUTKOWSKI, W. (German
 Carved Stair-Rail
 AUM 4
 Electric Light Fitting
 AUM 18
SUTTON, Thomas See STONE,
 Nicholas
 Portraits and Memorabilia
 Stone, N., and N. Johnson,
 Thomas Sutton Tomb
Suzuki. Tinguely
SVED, Wiig Hansen (Danish 1922-)
 Seated Woman 1964 bronze
 VEN-64:pl 142
SVEINSSON, Asmundur (Icelandic
 1893-)
 Construction in Iron 1960
 VEN-60:pl 139
 David and Goliath 1952 wood;
 51 BERCK 181

Svennevad Brooches
 Swedish--5/7th c. Haste and
 Svennevad Brooches
Sviluppo di Una Bottiglia nello
 Spazio
 Boccioni. Evolution of a
 Bottle in Space
Sviluppo Tridimensionale. Bogoni
SVOR, Anders
 Fountain bronze
 MARY pl 178 SnO
SWABIAN
 Christ Child c 1530/40 ptd
 lindenwood; 15-3/8
 KUHN pl 35 UMCB
 (1959. 96)
 Christ on Cross c 1200
 CHENSN 293 GNG
 Madonna c 1430 ptd linden-
 wood; 24-1/2
 KUHN pl 8-9 UMCB
 (1936. 35)
 Madonna and Child and St.
 Anne c 1510/20 ptd
 lindenwood; 18-3/4 (with
 modern base)
 KUHN pl 24 UMCB
 (1958. 240)
 St. John the Evangelist
 c 1490/1500 lindenwood;
 49-7/8 (excl base boards)
 KUHN pl 14-15 UMCB
 (1964. 5)
 Three Mourning Women 15th
 c. limewood; 45-5/8x22
 BERL pl 192 GBSc (5556)
Swahili
 Baberton. Yussif Ben Abdulla,
 Swahili Man of Mombasa,
 head
Swallow. Cole, W. V.
A Swallow. Hermes
SWAN, James Macallan (English
 1847-1910)
 Walking Leopard bronze; 7
 CAN-2:197 CON
Swan Service. German--18th c.
Swan Service. Kandler
Swans See also Leda
 Anastasijevic. The Swan
 Austrian. Leda and the Swan
 Dali. The Swan of Leda
 English--18th c. Chelsea
 "Fable" Scent Bottles
 --Chelsea Scent Bottles
 German--18th c. Swan,
 Meissen
 Kandler. Louis XV Meissen
 Swan Candlestick

Tuby. Cherubs Playing with
 a Swan
Wederkinch Swans
SWEDISH
 --2nd/1st mil B. C.
 Elk's Head, Uppland 2000/
 1500 B. C. polished
 greenstone; 8-1/4
 GRAT 27 SnSHM (14168)
 --5/7th c.
 Bracteates gold; Dm: 1-1/8
 to 3-5/8
 GRAT 38-41 SnSHM
 (21468; 18375; 1164;
 5802e; 2681)
 Haste and Svennevad
 Brooches silver gilt;
 6-3/4, and 8
 GRAT 36, 37 (col)
 SnSHM (3445; 19572)
 Tureholm Treasure: Neck-
 laces; Sword Scabbards
 gold
 GRAT 42, 43 SnSHM (21)
 --6th c.
 Necklace, animal decoration
 beads; detail: Beads gold;
 1-1/4; Dm: 7-7/8
 GRAT 33, 35 (col) SnSHM
 (492)
 --7th c.
 Animal Style Bridle Fitting,
 Uppland c 650 bronze
 gilt
 ST 126 SnSNH
 Helmet c 650 bronze covered
 iron
 ST 122 SnUU
 --7/8th c.
 Scramasax, Gotland bronze
 GRAT 49 SnSHM (8767)
 Stele: Figures in Registers,
 Larbro
 BAZINW 209 (col) SnSHM
 Torslunda Matrices: Armed
 Warriors; Animals bronze;
 2-1/4; Dm: 1/8
 GRAT 50, 51 SnSHM
 Vendel Ship Burial: Harness,
 Weapons (Spear), and
 Armor (Helmet, Shield)
 GRAT 44, 45 (col), 47
 SnSHM (7250)
 --8th c.
 Animal-Style Scabbard, detail
 ST 127 SnSNH
 Figurative Stele
 GRAT front (col)
 SnGoBu

Gotland Stone: Eight-Legged
Horse; Long-Ship lime-
stone; 68-1/2
GRAT 53 SnSHM (4171)
Scabbard, detail c 700 bronze
gilt
ST 127 SnUU
--9th c.
Broa Bridle Fittings c 800
gilded bronze
GRAT 54, 55 SnSHM
(11106)
--11th c.
Soderala Weathercock gilded
bronze; 9-7/8x14-3/4
GRAT 61 SnSHM (16023)
--11/12th c.
Rune Stone limestone; 50
GRAT 58 SnKS
--12th c.
Madonna from Hall c 1150
wood
BUSRO pl 92 SnViG
Madonna of Mosjo; detail
limewood; 28
BAZINW 282 (col); GRAT
65 (col), 67 SnSHM
(7306:4)
--13th c.
Baptismal Font c 1200 pine;
39-1/2
GRAT 69 SnMA
Capital: Adam's Legend,
detail
BUSGS 118 SnGoG
Flight into Egypt, choir
portal detail
BUSGS 118 SnGoM
Madonna, plaitwork headdress
c 1200
BUSGS 29 SnNM
Rood
ENC 777 SnRo
The Virgin in Grief
BUSGS 42 SnSH
The Visitation, choir stall
c 1270 stone
BUSGS 119 SnGoB
--14th c.
Drinking Horn, with Armed
Knight wood; 9-1/2x15
GRAT 71 SnSHM (25926)
Gothic Fibula; detail gold
jeweled; Dm: 7-1/2
GRAT 73 (col), 75
SnSHM (423)
--15th c.
St. Bridge, seated figure,
limewood; 48-1/2 GRAT 83
SnVB

--17th c.
Tankard 1683 silver; 8
COOPF 88 SnSkW
Wasa Warship Ornaments;
Lion; Sea God; Drowned
Sailor wood; 23; 29-1/2;
and 31-1/2
GRAT 99, 101 SnSW
--18th c.
Coronation Crown of Queen
Louisa Ulrica 1751 silver,
diamond, enamel; 5;
Dm: 5-1/4
GRAT 109 SnSB
--19th c.
Charles XIV as Mars marble
COOPF 84 SnSkW
Sweet Tooth
Feuchtmayer. Honey Thief
SWIECINSKI, George Clement de
(Polish)
Young Basque Woman
AUM 23
Swieten, Gerard van
Messerschmidt. Gerard van
Swieten, bust
Swimming See Games and Sports
Swimming Movement. Brown, R.
Swimming Pool Sculpture
Tomasini. Swimming Pool
Abstract Sculpture
Swine
Antico. Hercules and the
Erymanthean Boar, plaque
Carew. Adonis and the Boar
Faberge. Boar's Head Box
French--12th c. Slaughter of
Sow, misericord
Italian--17th c. Crouching
Boar
Kneale. Iron Pig
Machin. Pig
Mattielli. Old Woman with
Pig
Mattielli. Winter
Pompon. Two Pigs*
Swineherd. Kenar
Swinfield, John (Chancelor)
English--13th c. John Swin-
field, effigy
SWISS
Figures, capital, Payerne
MALV 236
--8th c.
Charlemagne
BAZINW 219 (col) GMus
--11th c.
Two Apostles, arched relief
c 1000 STA 65
SwBMi

--12th c.
St. Gallus, porch
BOE pl 49 SwBMi
--13th c.
Bishop with Angel, choir
stall c 1260
BUSGS 110 SwLaC
--14th c.
Christ and St. John,
Zwiefalten c 1300
BUSGS 166 UOClA
The Visitation, Katharinental
c 1310 ptd and gilded wood;
23-1/4
NM-7:32 UNNMM (17.190.
724)
--15th c.
Bishop, head c 1460
MULS pl 83A SwBKl
Halberg W: 8-1/4
NM-3:1 UNNMM
(48.149.34)
Mary Magdalen, from a Holy
Sepulchre 1433
BUSR 57 SwFC
Wise and Foolish Virgins,
portal begun 1481
BUSR 60 SwBeC
--17th c.
Dutch Tile Stove
ENC 883
--17/18th c.
Swiss Peasant Table
(Maldentisch) wood
GIE 98 SwZS
Swords
Celtic. Sword of Charlemagne
da Sesso. Ceremonial Sword
of Gonzaga Family
Frankish. Sword Fitting of
King Dhilderic
French--9/14th c.
Coronation Sword of the
Kings of France
French--18th c. Court Sword
Hilt
French--18th c. Sword of
Louis XV
German--17th c. Two-Handed
Sword
Harnischter. Ceremonial
Sword
Italian--15th c. Knight's
Sword
Spanish--17th c. Cup-Hilt
Rapier
Viking. Sword

Swynborne, Robert and Thomas
(d 1381, and d 1412)
English--15th c. Sir Robert
and Sir Thomas Swynborne
Sybil, bust. Khnopff
Sybil III. Armitage
Sybils See Sibyls
SYFER, Hans (German fl 1487-1512)
Entombment, detail 1487/88
MULS pl 169A GWoC
Prophet, bust c 1485
MULS pl 167A GBSBe
Self Portrait, bust, High
Altar 1498
MULS pl 169B FHeilK
SYKORA, Zdenek (Czech)
White Structure 1965
KULN 167
Symbols See also Heraldry; Jesus
Christ--Monogram; Seals
(Numismatics)
Basque. Funerary Stele:
Cross and Solar Symbols
German--12th c. Virgin,
framed in relief of Symbolic
Beasts
Mackintosh. Staircase Emblem
--Christian
Early Christian. Book Cover:
Christian Symbols and
Biblical Scenes
Early Christian. Funeral
Stele: Fish of Christ,
Anchor of Faith
--Evangelists
Buon, B. and G. Porta della
Carta, detail: Doge Kneel-
ing before Lion of St. Mark
Byzantine. Christ Enthroned,
by Symbols of Evangelists
Carolingian. Symbols of 4
Evangelists, font canopy
Dutch, or French--10th c.
Beasts of Evangelists
English--11th c. Crucifixion,
with Symbols of Evangelists,
panel
Flemish--15th c. Ressina Lec-
tern: Reading Desks detail:
Symbols of 4 Evangelists
French--10th c. Beasts of
Evangelists
French--11th c. Christ in
Majesty, with Symbols of
the Evangelists, relief
German--10th c. Beasts of
the Evangelists

German--11th c. Book Cover:
Codex of Abbess Vota...
Showing Christ in Majesty
between Symbols of Four
Evangelists
--Cross of Holy Roman
Empire
German--12th c. Lectern,
Alpirsbach: Four
Evangelists and Symbols
German--13th c. Keystone,
Bishop's Gallery: Angel,
Symbol of Matthew the
Evangelist
Italian--8th c. Sigvald Relief:
Apostle Symbols
Italian--11th c. Pulpit:
Hermit among Symbols of
the Evangelists
--Pulpit: San Giulio and
Symbols of Evangelists
Italian--12th c. Pulpit:
Evangelists' Symbols
Italian--18th c. Lion of St.
Mark, Venetian canon
ornament
Romanesque--French. Christ,
with Symbols of Evangelists
Sigvald. Ornamental
Balustrade: Symbols of 4
Evangelists
--Good and Evil
French--12th c. Capital:
Angel Enchaining a Devil
--Lion (The Devil) Devouring
Sinner
German--12th c. Door Knocker:
Lion's Head
--Head Representing Demoniacal
Power, font
--Lion Striking Lamb, symbol-
izing Persecution of
Goodness
--Lion's Head, Symbol of
Devil, font
--Heresy
German--11th c. Centaur,
symbol of Heresy, relief
--Lust
German--13th c. Capital:
Siren
--Pagans
Italian--11th c. Portal:
Cattle as symbols of the
Ungodly
Symmachi Panel
Early Christian. Marriage
Diptych

Symmachorum
Early Christian. Marriage
Diptych, Symmachorum
Synagogue
Durst. Church, and
Synagogue
French--13th c. Synagogue
German--13th c. Prince's
Portal
Master of the Synagogue.
Synagogue
Naumberg Master. The
Synagogue
Synagogue Stand. Palestinian
Synagogues
Jewish--6th c. Synagogue of
Askalon Screen, detail:
Menorah, Shofar, Lulav
Synthetic Spirit. Kemeny
Syntia. Hajdu
Syon House
Adam, R. Syon House,
interior
SYRLIN, Jorg, the Elder (Jorg
Sirlin; Jorg Surlin) (German
1425?-1491)
Choir Stall Busts 1469/74
MULS pl 122, 123 GUM
Cicero, choir stall wood
ROTHS 125 GUC
Cumaean Sibyl, choir stall
1469/74
oak
KO pl 65 GUM
Gothic Pinnacle Fountain:
"Fish-Box"
PRAEG 55 GU
Lusterweibchen Reliquary
Bust (Woman of Pleasure)
c 1470/80 ptd limewood
KO pl 65 (col) GUU
The Phrygian Sibyl, choir
stall 1469/74 oak
CHASEH 263; NEWTEM
pl 104
ROTHS 125 GUC
Ptolemy as an Ulm Patrician,
choir stall 1469/74 oak
BUSR 90; KO pl 65;
NEWTEM pl 103 GUC
Reliquary: Woman, bust
c1480
LOH 173 GUU
Virgil, bust (Self Portrait?),
choir stall c 1474
GOLDF pl 44; LOH 182 GUC
SYRLIN, Jorg, the Younger (German fl
1480-1520)

Two Saints, busts c 1500 wood;
 20x20x7
 MIUH pl 7 UMiAUA
Virgin and Christ ptd wood;
 39-1/2
 DETT 157 UMiD (22.205)
De Syv Frie Kunster, relief. Eickhoff
SZABO
 Sang des Montagnes
 FPDEC il 21
SZABO, Ivan (Hungarian 1913-)
 Girl Riding Horse 1953
 bronze; 300 cm
 GAD 113
SZABO, Laszlo (Hungarian-French
 1917-)
 Dawn and Germination
 MAI 278
SZAPOCZNIKOW, Alina (Polish 1926-)
 Exhumated 1957 patinated
 plaster
 JAR pl 28
 Mary Magdalen bronze; 154 cm
 (with 18 granite stand)
 WPN pl 210 PWN (2128836)
 Mary Magdalene 1958 plaster
 JAR pl 29
 Star in the Road (La Stella
 in Cammino) 1961 iron and
 polyester
 VEN-62:pl 171 PWC
SZCZEPKOWSKI, Jan (Polish 1878-)
 Angel of the Adoration wood
 VEN-38:pl 73
 Best Man, relief 1955
 JAR pl 9
 Musical Angel, Chapel figure
 pine
 MARY pl 58
 Panel, Chapel pine
 MARY pl 59
SZEKELY, Pierre (Hungarian-French
 1923-)
 Clown 1960 stone
 MAI 279
SZENTGYORGYI, Istvan (Stefani
 Szentgyorgyi) (Hungarian
 1881-1939)
 Artist bronze
 VEN-38:pl 93
 Fountain bronze
 VEN-30:pl 169
 Miklos Horthy, bust plaster
 VEN-34:pl 180
 Nude bronze
 VEN-24:pl 153
 Playing Boy 1920 bronze;
 76.5 cm
 GAD 64 HBA

SWARC, Marek (Polish-French
 1892-1958)
 David 1954 bronze
 MAI 280
SZYMANSKI, Rolf (German 1928-)
 Fraulein in Algier 1960 bronze;
 30 cm
 SP 220 GHaS

T. R. 2 Garelli
Tabernacles
 Desiderio da Settignano.
 Tabernacle#
 Donatello. Cavalcanti
 Annunciation
 Donatello. St. George
 Tabernacle
 Donatello and Michelozzo.
 Tabernacle of the Sacrament
 French--14th c. Tabernacle
 German--15th c. Altar
 Tabernacle
 Italian--16th c. Kiss of Peace
 Kraft. Sacrament Tabernacle
 Orcagna. Tabernacle
 Robbia, L. della. Tabernacle
 Rossellino, G. Tabernacle
 Russian--15th c. "Jerusalem",
 or Tabernacle of Jesus
 Vriendt. Tabernacle#
TABERNACLES OF THE VIRGIN
 ATELIER
 Virgin and Child and Two
 Angels, central plaque of
 triptych 14th c. ivory
 CLE 53 UOClA (23.719)
Table Fountain
 SOTH-2:178
The Table is Set. Ernst
Tableau-Feu# Aubertin
Tablepieces
 Christofle. Table Centre
 Made for Naopleon III
 French--18th c. Louis
 Quinze Centerpiece
Tables
 English--17th c. Table-Settle
 Fletcher. Gladitorial Table
 French--16th c. Inlaid Table
 French--18th c. Rococo Con-
 sole Table
 Italian--16th c. Side Table
 Italian--18th c. Console Table
 Supported by Fish
 --Octagonal Table
 --Table#
 Kolibal. The Table
 Swiss--17/18th c. Swiss
 Peasant Table

Tietz. Console Table
Vignola. Roman Table
Weisweiler. Writing Table
Wolff, Eckbert, the Younger.
 Altar Table
Tablets
 Turner, H. T. Phillips
 Memorial Tablet
TACCA, Ferdinando (Italian fl
 1600)
 Infant Bacchus
 AGARC 80 IPrM
TACCA, Pietro (Italian 1577-1640)
 See also Bandinelli,
 ‾Giovanni; Bologna, G.
 Capella dei Principi
 POPRB fig 77 IFLo
 Crucifix, Sacristy
 ESC 68 SpE
 Four Moors in Chains,
 Ferdinand I of Tuscany
 Memorial 1615/27 bronze
 KO pl 90 ILeghD
 --Moorish Slave
 BAZINW 366 (col)
 Horse and Rider (Philip IV)
 1st Q 17th c. bronze; 16
 YAP 221 -UFo
 Lamp: Vulcan Seated at a
 Forge bronze; 16-1/2
 DETD 125 UNNUn
 Merman, Fountain 1627 bronze
 BAZINL pl 285; BAZINW
 366 (col) IFAnn
 Philip IV, equest bronze;
 15-3/4
 DETI 93; DETT 89;
 VALE 116 UMiD (29.348)
 --Philip IV, equest 1634/40
 bronze
 POPRB fig 138; VALE
 116; WIT pl 43 SpMaOr
 Rearing Horse c 1750 bronze;
 8-3/4
 DETI 94 UWaSA
TACCONE, Paolo di Mariano di
 Tuccio See PAOLO ROMANO
Tactile Object.‾Schumacher
Taddei Tondo
 Michelangelo. Virgin and
 Child with Infant St. John
 the Baptist
TADDEO See PELLEGRINO
TADOLINI‾
 Ganymede
 COOPF 168 ECha
TAEUBER-ARP, Sophie Henriette
 (Swiss 1889-1943) See also
 Arp, Hans

Dada Head (Dada Kopf) 1920
 ptd wood
 RICHT pl 20
--1920 ptd wood; 11-1/2
 NMFA 200
--1920 wood; 13
 GIE 91 FMeA
Guarda-Sol, relief 1938 88.2x
 63.2 cm
 SAO-3
Last Construction, No. 8
 1942 bronze; relief; 14x4
 READCON 131 FPRe
Parasols 1938 wood and white
 oil paint; 34-5/8x24-7/8
 BERCK 215; TRI 44 NOK
Rectangular Relief... 1936
 wood
 VEN-56:pl 142
Shells and Flowers, ptd
 relief 1938
 BERCK 337
Taglio Bianco
 Leoncillo. White Cat
TAGLIONI, Filippo
 Jove Deposing the Titans
 1787 porcelain; 17-5/8
 MONT 416 INGal
Tagore, Rabindranath
 Epstein. Rapindranath
 Tagore
TAHOR, Mohye El-Din (Egyptian
 1928-)
 A Find plaster; 110 cm
 SAID pl 17
 Hopscotch plaster; 32.5 cm
 SAID pl 19
 Maternity plaster; 93 cm
 SAID pl 16
 Shopping Girl plaster; 41.5 cm
 SAID pl 18
TAJIRI, Shinkichi G. (American-
 Dutch 1923-)
 Flight 1957 bronze; 9-1/2x
 18-1/2x4-1/2
 CARNI-58:pl 51
 Made in U. S. A. No. 12
 1965 bronze; 34-5/8
 NEW pl 161 NBaS
 Orbit No. 1 1962 bronze
 VEN-62:pl 167
 Plant 1959 bronze; 27-5/8
 TRI 158
 Relic from an Ossuary 1957
 bronze; 16
 BERCK 337; READCON 256
 SSSSSS, No. 1 1966 H: 223
 CARNI-67:#309

Samurai 1960 welded cast
 iron and forged iron
 machine parts; ax, nuts,
 and bolts; 33-1/2
 SEITA 146
Seed No. 3, 1959 H: 60
 CARNI-61:#386
Warrior 1959 bronze
 MAI 281 BAJ
TAKIS (Takis Vassilakis) (Greek-
 French 1925-)
 Double Signal, Purple and
 Amber 1966 H: 162
 CARNI-67:#67 UNNWise
 Electro Signal III 1964
 H: 27-1/8
 WATT 180 FPIo
 Electromagnetic Musical
 Pendulum II 1965 cork,
 permanent magnet, electro-
 magnetic spool and wood--
 in two parts; relief:
 78-3/4x39-3/8x8; timing
 box; 33-1/2x4-3/4x5-1/2
 SELZP 63 UNNI
 Electromagnetic Sculpture II
 1965 cork, plexiglas,
 permanent magnet, and
 electromagnetic spool--
 in three parts; cork ball:
 Dm: 11-7/8; timing box:
 33-1/2x4-3/4x5-1/2;
 table: 15-3/4x24-7/8
 SELZP 61 UNNI
 Electromagnetic Vibrator
 1965 wood, permanent
 magnet, electromagnetic
 spool, and steel; 78-3/4x
 39-3/8x8
 SELZP 61 UNNI
 First Vibrating Electro-Signal
 1964
 LARM 397
 Musical Wire Sculpture IV
 1965 wood, permanent
 magnet, electromagnetic
 spool, and steel; 59x39-3/8
 x8
 SELZP 60 UNNI
 Sculpture*
 EXS 27 UNNMMA
 Sculpture* (Exhibition at
 Howard Wise Gallery, New
 York, 1967)
 BURN 271
 Signal 1955 steel; 48-1/2
 SELZS 169 UNNI

--1958 iron; 125
 CALA 216 IVG
Signals 1958 steel and iron
 MAI 282
Telemagnetic Sculpture 1959
 magnet and iron; 19-5/8x
 13-3/4
 TRI 39 FPCle
Telemagnetique 1965
 ARTSM
Telephota VIII wood, mercury
 vapor lamps, electrical
 parts; 53-1/8x14-1/4x
 7-1/2
 SELZP 62 UNNI
Tele-Sculpture 1959 ball and
 electromagnet; 39x37x31 cm
 LIC pl 307
"Tete"--Peinture, Electro-
 matique III 1964; Dm:
 35-3/8
 NEW pl 53 FPIo
Talbot, Gilbert, of Grafton Manor,
 Worcestershire
 English--16th c. Sir Gilbert
 Talbot, bust
Talbot, Olive d 1684
 Stanton, William. The
 Orphans Monument to
 Mrs. Olive Talbot
Tall Figure# Giacometti
The Tall Kneeling Woman. Lehmbruck
Tall Spike Form. Adams, R.
Talleyrand-Perigord, Charles
 Maurice de (French Statesman
 1754-1838)
 Bosio. Talleyrand, bust
TALLONE, Filippo (Italian 1902-)
 Figure 1940 cement
 VEN-40:pl 75
TAMAGNINO See PORTA, Antonio
 della
Tambourine See Musicians and
 Musical Instruments
Tambourine Dancer (The Dance),
 relief. Renoir
Tanagra. Gerome
TANAVOLI, Parviz (Iranian 1937-)
 Poeta com Simbolo della
 Liberta 1964 bronze
 VEN-66:#124
TANDBERG, Odd (Norwegian 1924-)
 Free-Standing Garden Wall
 1962 terrazzo; 78-3/4x39
 NEW pl 172 NoON
Tangelgarda Stone
 Viking. Memorial Picture
 Stone

Tankards
 Celtic. Tankard
 German--15th c. Griffin Tankard
 German--17th c. Tankard(s)#
 Kern, L. Tankard
 Strauss, B. Tankard: Battle
 with Centaur
 Swedish--17th c. Tankard
 Vianen, P. Tankard
Tantalus
 Austrian--13th c. Sisyphus,
 Tantalus, Ixion
Tanzendes Paar. Minkenberg
Tap Handle: Basilisk. Danish--14th c.
TAPPER, Kain (Finnish 1930-)
 Golgotha 1951 wood; 126x
 161-3/8
 NEW pl 181 FiOP
 Night 1961 wood
 VEN-62:pl 134 FiHV
Tappeto Natura. Gilardi
Tapster, misericord. English--
 15th c.
TAR, Istvan (Hungarian 1910-)
 Siege of the Eger Fortress, re-
 lief 1952 bronze; 250x300 cm
 GAD 112 HEg
Tara Brooch. Celtic
TARANTINO, Giuseppe (Italian 1916-)
 Two Warriors (Due Guerrieri)
 1958 bronze
 VEN-58:pl 103
Tarlati, Guido (Bishop of Arezzo)
 Agostino di Giovanni, and
 Agnolo di Venturi. Tarlati
 Monument
Tarquinius, Sextus (Legendary
 Roman d 496(?) B. C.
 Gerhard. Sextus Tarquinius
 Threatening Lucrece
TARSIA, Antonio (Italian c 1663-
 1739)
 Thetis c 1700 terracotta;
 11-1/2x16
 DEYE 157 UCSFDeY
 (53.17)
Tartini, Giuseppe (Italian
 Violinist and Composer
 1692-1770)
 Dal Zotto. G. Tartini
TASSAERT, Jean Pierre Antoine
 (French 1727-88)
 Painting and Sculpture
 marble; 38-5/8x34-1/4
 USNKP 453 UDCN (A-1636)
Tassel House
 Horta. Staircase

TATLIN, Vladimir Evgrafovich
 (Russian 1885-1956)
 Complex Corner Relief
 (presumed destroyed)
 1915 iron, aluminum,
 zinc
 GRAYR pl 127
 Construction
 SELZJ 236
 --1919 iron
 GIE 168 RuM
 Corner Counter-Relief Con-
 struction 1914/15 various
 materials
 NMAC pl 127
 Corner Relief, detail
 (presumed destroyed)
 1914/15 iron, cord,
 etc.
 GRAYR pl 126
 --1915 (presumed destroyed)
 iron
 GRAYR pl 128; READCON
 87
 Counter-Relief 1915 wood and
 iron
 MAI 283
 Monument to the Third Inter-
 national, project (remnants
 only survive) 1919/20 wood,
 iron, glass
 BERCK 52; BURN 156;
 ENC 204; GIE 167; GRAYR
 pl 168; LARM 394;
 MAI 283; MCCUR 264;
 NMAC pl 128-29;
 READCON 95 RuLR
 Nude
 ENC 870
 Painting Relief: Selection of
 Materials (presumed
 destroyed) 1914 iron,
 plaster, glass
 GRAYR pl 125
 Relief (presumed destroyed)
 1914 wood, glass, tin can
 GRAYR pl 124; HAMP pl
 120A; READCON 89
 --1917 wood, zinc sprayed on
 iron; 19-3/8x25-1/4
 GRAYR pl 130; LYN 103
 RuMT
 Relief Construction 1914
 NMAC pl 126
TATTI, Jacopo See SANSOVINO,
 Jacopo
Tatzel. Hafelfinger

Tau Crosses
 English--11th c. Alcester
 Tau
 English--12th c. Tau Cross#
Tauberbischofsheim Madonna.
 Riemenschneider
Taureau See Cattle
Taurin, Saint
 French--13th c. Reliquary
 of St. Taurin in form of
 Church
Taurobolium. Serrano
Tauromachy. Richier, G.
Tavera, Juan de
 Berruguete. Don Juan de
 Tavera Tomb
TAVERNARI, Vittorio (Italian 1919-)
 Abstract Sculpture, second
 floor hall
 DAM 140 IMT
 Calvary 1963 wood
 VEN-64:pl 51
 Grand Torso 1961 78.2x34.4
 CARNI-61:#393 FPFa
 Three Figures 1958 concrete
 SAL 37
 Two Women 1964 bronze
 VEN-64:pl 52
 Woman without Arms (Figure
 Femminile senza Braccia)
 1958 patinated cement
 VEN-58:pl 57
TAYLOR, Robert (English)
 Lieutenant-General Joshua
 Guest Monument, bust
 detail marble
 MOLS-2:pl 31 ELWe
 Sir Henry Penrice Monument
 WHINN pl 101A EOf
 William Ashby ("The
 Animated Bust")
 ESD pl 139 EMiddH
 William Phipps Monument
 d 1748
 WHINN pl 103A EWes
Tazza, footed vessel
 German--16th c. Tazza
 Italian--15th c. Tazza
 Russian--16th c. Tazza
Tcheekle. Butler
"Te Fare Amu". Gauguin
Tea Caddy. Lamerie
Teachers and Teaching
 Flaxman. Dr. Joseph Warton
 Monument
 Robbia, L. della. The
 Grammar Lesson, panel

French--13th c. Seal of
 University of Paris:
 Madonna and Child; Pro-
 fessors Teaching
 --Student Life
The Teak. Pan
TEANA (Marino Teana, called:
 Marino di Teana)
 (Argentine-French 1920-)
 Architectonic Conception
 No. 1 1959 steel; 27-3/8
 TRI 33 FPRe
 Disintegration 1958 27-1/2x24
 BERCK 203 FPRe
 Centre Universitaire 1962
 KULN 171
 Espace et Masse Liberes--
 Hommage a l'Architecture
 1957 steel; 41-3/8x45-3/4
 x15-3/4
 READCON 210 FPRe
 Metal Sculpture
 MAI 284
 Sculpture 1957
 BERCK 338
 Universities 1963 stainless
 steel; 41-3/4x31-7/8x24-3/8
 WALKA 34
Teapots
 Staffordshire. Teapot in
 form of Camel
"Tears of Enak"
 Arp. Earth Forms
Tectosage Volcae, coin (Gaul).
 Celtic
Tecumseh (Shawnee Indian Chief
 1768-1813)
 Pettrich. Dying Tecumseh
Teddy Boy and Girl. Chadwick
TEDESCO, Piero di Giovanni See
 LAMBERTI, Niccolo di
 Pietro
Tegner, Esaias (Poet)
 Milles. The Sunsinger,
 Monument to Esaias Teg-
 ner
TEGNER, Rudolph
 The Finsen Monument
 MARY pl 47 DC
 Heracles and the Erymanthian
 Boar bronze
 MARY pl 114
 Heracles and the Hydra bronze
 HOF 64; MARY pl 68 DC
Tehura, head. Gauguin
Teichmann Fountain. Maison
Tele-Sculpture. Takis

Telemagnetic Sculpture. Takis
Telemagnetique. Takis
Telephones
 Bat-Yosef. Le Telephone des
 Sourds
 Guttfreund. Commerce
Telephota VIII. Takis
Tellus Herbas Virgultaque Sustulit.
 Cavaliere
TELO GARCIA (Portuguese) See PERO
 OF COIMBRA
Tellstar
 Hepworth. Pierced Form
Temperance
 Agostini di Duccio. Temperance
 Balducci. Arca of St. Peter
 Martyr: Temperance
 Bregno, Antonio. Foscari
 Monument; detail: Fortitude;
 Temperance
 Carpeaux. Temperance
 Ceracchi, G. Temperance
 Giovanni da Nola. Don Pedro
 da Toledo Monument
 Isaia da Pisa. Cardinal Martinez
 de Chavez Monument:
 Temperance
 Sansovino, A. Girolamo Basso
 dalle Rovere Monument:
 Temperance
 Soest. Temperantia
 Valle. Temperance
Tempest. Sangregorio
Templar
 English--13th c. Knights
 Templar, effigies
Temple Newsam Mazer. English--17th
 c.
Temple of Bacchus
 German--18th c. Temple of
 Bacchus, Berlin Porcelain,
 centerpiece
Temple-West, Admiral d 1757
 Wilton. Admiral Temple-West,
 bust
Temples
 English--10/11th c. Pershore
 Censer
Tempo di Ballo. Mirko
"... Il Tempo non Conta..." Santoro
Temptation. Enderlie
Temptation. Pasztor
Temptation. Quercia, Jacopo della
Ten Commandments See also Moses
 Jewish--18th c. Torah Scroll
 Breastplate: Tablets of Ten
 Commandments
Ten-Year Old Girl. Putrih

TENNANT, Trevor (English)
 Madonna and Child 1940 elm; 42
 BRO pl 38
 Mother and Child 1946 terra-
 cotta NEWTEB pl 58
 Turning Movement 1942 terra-
 cotta; 9 BRO pl 39
Tenneyson, Alfred (English Poet 1809-
 92)
 Woolner. Lord Tennyson, bust
Tension-Expansion. Vieira, M.
Tents
 Andrea da Pontedera. Arts,
 relief
 German--13th c. Shrine of
 Charlemagne; Charlemagne in
 his Tent
Terenzio, Saint
 Emilian Sculptor. Legend of
 S. Terenzio
Teresa, Saint
 Bernini, G. L. Ecstacy of St.
 Teresa
 Fernandez. St. Teresa
Terpsichore
 Canova. Terpsychore
La Terra. Mascherini
TERRAGNI, Giuseppe, and Attilio
 TERRAGNI (Italian)
 Monument to the Fallen, adapted
 from Lighthouse design by
 Antonio Sant'Elia (1914) 1933
 LIC pl 160 ICom
Terras Frugiferentis Concelebras.
 Cavaliere
La Terre. Ipousteguy
Terrestrial Forms
 Arp. Earth Forms
Terrosa. Chillada
Terrus, Etienne
 Maillol. Etienne Terrus, head
TERRY, Emilio (French 1890-)
 The Snail, model NMFA 243
TERWEN, J. (Dutch)
 Choir Stalls 1538/40
 GEL pl 113 NDoO
Testa. Perez
Testa+Casa+Luce. Boccioni
Tester Bed. French--16th c.
Testimony of the Innocent Baby.
 Lombardi, A.
Tete aux Grappes
 Garde. Head with Grapes
Tete Bronze Poli. Hajdu
Tete d'Apollon
 Bourdelle. Apollo, head
Tete de Douleur. Rodin
Tete Double: Oedipus. Ernst

Tete Floral. Arp
Tete Onyx Vert. Hajdu
"Tete"--Pienture, Electromatique III.
 Takis
Tetramorph
 Celtic. Tetramorph, altar frontal
 of the Patriarch Sicuald
 German--14th c. Ecclesia on
 Tetramorph, ornamental
 gable
Tetrarchs
 Byzantine. Pillar of Acre
Teucer
 Thornycroft, H. Teucer
TEUTONIC
 Crucifixion, manuscript cover
 c 870 ivory ROBB 672 GMS
 Sigwald Relief 762/76
 ROBB 339 ICiB
Textile Workers
 French--13th c. Chartres Ca-
 thedral: North Transept:
 Woman Carding Wool; Woman
 Washing Wool
Teynham, Lord
 Evesham. Lord Teynham Tomb
Thaleia
 Janniot. Thalie
Tham
 Hladik. Actor Tham
Thame, William, Lord of d 1559
 Johnson, G. Lord William of
 Thame and his Wife: Effigies
THAYAHT, Ernesto (Italian 1893-)
 S. 55 Architectonic marble
 VEN-36:pl 92
Theatre Facade, relief. Kricke
Thebes. Tucker
Thecla, Saint
 Johan de Vallfogona. Martyrdom
 of St. Thecla, retable panel
THEED, William, the Elder (English
 1764-1817)
 Hercules Taming the Thracian
 Horses c 1816 WHINN pl
 166A ELBP
 Rebecca
 LONDC ELCiM
 Thetis with the Armour of
 Achilles 1829 bronze; 51
 LONDC EWind
THEED, William, the Elder, and E. H.
 BAILY
 William Ponsonby Monument
 1820 BOASE pl 49A ELPa
THEED, William, the Younger (English
 1804-91)
 Albert Memorial: Africa--figures
 with Camel and Sphinx
 BOASE pl 90B ELAl

The Bard 1858
 BOASE pl 81C EMan
Musidora 1857 Copeland Parian
 Porcelain; 16-1/4 CON-6:
 pl 59 ELCop
Narcissus c 1847 marble; 50
 CON-6:pl 48; LONDC ELBP
Thelusson, Countess of
 Houdon. The Countess of Thelus-
 son as a Vestal, bust
Themis. Dalchev
THENY, Gregor (Austrian)
 Allegory of Faith
 STECH pl 175 CzMo
 Allegory of Hope
 STECH pl 176 CzMo
 Calvary; detail: St. John the
 Evangelist STECH pl 177,
 179 CzMoC
 Christ in the Garden of Geth-
 semane 1730 STECH pl 178
 CzMo
 Church Interior; detail; Glorifi-
 cation of St. John of Nepomuk
 1719/23 STECH pl 173, 172
 CzZe
 High Altar 1730/40
 STECH pl 174
Theocritus Cup. Flaxman
Theodelinda's Crown. Italian--7th c.
Theodochilde d 662
 French--7th c. Theodochilde
 Tomb
THEODON, G.
 Barbarity, detail: Faith Adored
 by Barbarians MATTB pl 36,
 37 IRGe
Theodora (Eastern Roman Empress 980-
 1056)
 Byzantine. Constantinople Coin:
 Empress Zoe and Theodora
 Byzantine. Theodora, head
Theodore, Saint
 French--13th c. Portal des
 Martyrs: St. Theodore
 --St. Theodore#
 Venetian. Cross of St. Theodore
Theodoric (King of Ostrogoths 454?-
 526), called: Theodoric the Great
 Nicolaus. Porch Relief Panels:
 Genesis; Fate of Theodoric
 Vischer, P., the Elder. King
 Theodoric
THEODOROS
 Sculpture* EXS 41
Theodorus, Saint
 Early Christian. Sarcophagus of
 St. Theodorus: Symbolic Pea-
 cocks Facing Sacred Emblem

"Theodosian" Capital. Byzantine
Theodosius I (Roman Emperor 346-95)
 Byzantine. Dish: Theodosius I
 Early Christian. Missorium of
 Emperor Theodosius I
 Early Christian. Obelisk of
 Theodosius
 Early Christian. Shield of
 Theodosius
Theodosius II (Eastern Roman Emperor
 401-50)
 Byzantine. Consular Solidus:
 Theodosius II
Theological Virtues. Delvaux
Theology
 Pollaiuolo, A. , and P. Pollai-
 uolo. Sixtus IV Monument:
 Theology
Theophano (Empress of Otto II, Holy
 Roman Emperor 955?-91)
 Italian--10th c. Ivory Panel:
 Christ in Majesty. . adored by
 Emperor Otto II and Empress
 Theophano
Theophile, Saint
 French--12th c. Legend of St.
 Theophile, scene
There Were Many of Them.
 Pomodoro, A.
Therese Assise. Wlerick
Therese of Lisieux, Saint
 Crook. St. Therese of Lisieux
Theseus
 Barye. Theseus Fighting the
 Centaur Bianor
 Barye. Theseus Slaying the
 Minotaur
 Canova. Theseus and the
 Minotaur
Thesiger, E.
 Botzaris. Mr. E. Thesiger, head
Thetis
 Banks. Thetis and her Nymphs
 Consoling Achilles
 Bernini, G. L.--Foll. Thetis
 Grupello. Fishmonger's Guild
 Fountain: Neptune and Thetis
 Linck, K. Oceanus and Thetis
 Tarsia. Thetis
 Theed, W. , the Elder. Thetis
 with the Armour of Achilles
Thibault de Champagne d 1270
 French--13th c. Heart of Thi-
 bault de Champagne Tomb
THIEDE, Oscar (Austrian)
 Tenement Block Figures
 AUM 85 AV
Thief on the Cross. Petel, G.

THIERRY, Jean (French 1669-1739)
 Leda and the Swan
 LOUM 185 FPL (1516)
Thietze, H.
 Erlich. Prof. H. Thietze, bust
Thieves
 Flemish--16th c. Bad(?) Thief
The Thinker. Konenkov
The Thinker
 Maillol. Mediterranean
The Thinker. Rodin
The Third Class. Founev
Third International
 Tatlin. Monument to the Third
 International
Thirst. Crippa
Thirsting Woman. Arnolfo di Cambio
36 Puppen. Hoke
The 38th Human Situation. Stenvert
This Announces. Penalba
This is our Land. Seguini
Thistle (Sun). Richier, G.
Thokely, Imre (Hungarian Patriot 1657-
 1705)
 Grandtner. Imre Thokoly
Thomas. Michieli
Thomas, Saint, Apostle
 Byzantine. St. John the Baptist,
 with Apostles
 French. Legend of St. Thomas
 French--12th c. Capital: Christ
 and Doubting Thomas
 German--10th c. Incredulity of
 St. Thomas#
 German--11th c. Thomas, and
 Moses
 Gislebertus. St. Thomas, relief
 Italian--14th c. Porta della Man-
 dorla: Gift of the Girdle
 Kohl, H. St. Thomas the Apostle
 Spanish--11th c. Thomas before
 Christ and the Apostles
 Spanish--12th c. Thomas the
 Unbeliever, relief
 Verrocchio. Christ and St.
 Thomas
THOMAS, Cecil (English)
 Deer, garden figure AUM 151
 Lioness, garden figure AUM 151
 Memorial Font, Llandollas
 Church AUM 151
Thomas a Becket, Saint (Archbishop of
 Canterbury 1118-70)
 English--14th c. Murder of
 Thomas a Becket
 --Travelling Altar, including
 Figures of Saints
 English--14/15th c. Pilgrim's
 Badge: Thomas a Becket

Riding in Triumph
English -16th c. Chalice of
Thomas a Becket
French--13th c. Death of St.
Thomas a Becket, chasse
Thomas Aquinas, Saint
Gimond. St. Thomas Aquinas
Thomas de Cantiloupe, Saint
English--13th c. Thomas de
Cantiloupe Tomb: Knight
Weepers
Thomas of Villanova, Saint
Caffa. St. Thomas of Villanova
Distributing Alms
Weiss, F. I. St. Thomas of
Villanova
THOMIRE, Pierre (French 1751-1843)
Candelabrum of American In-
dependence 18th c. Sevres
Porcelain and bronze; 28
CHAR-2:247 FPL
Urn Vase 1787 Sevres China
mounted in bronze; 26; Dm:
17-1/2 CHAR-2:251 FPL
THOMMESEN, Erik (Danish 1916-)
Girl with Braid (Bambina con
la Treccia) 1949 wood
VEN-46:pl 108 DCJu
Head of a Child 1951 wood; 12
GIE 284
Woman 1961 black oak; 60-5/8
READCON 192 ULaNM
Thompson, James d 1748
Sprang, M. James Thompson
Monument
Thompson, Janet
Schwab, A. C. Janet Thompson
Thompson, Mrs.
Hollins. Mrs. Thompson, re-
cumbent effigy
THOMSEN, Arnoff (Danish 1891-)
Angel with Scales
VEN-36:pl 56
Thomson, Arthur
Belsky. Sir Arthur Thomson, bust
Thor
Fogelberg. The God Thor
THORAK, Josef (Austrian- German
1889-)
Entwurf fur ein Grabmal wax
HENT 72
Il Fuhrer, head stone
VEN-38:pl 54
Thorfinn Karlsefni (Icelandic Explorer
fl 11th c.)
Jonsson. Thorfinnur Karlsefni
THORMAEHLEN, Ludwig (German 1889-)

Gefallenenmal in Kreuzgang
bei unser Lieben Frauen
1920 Kalkstein; LS HENT 89
GMag
Thorn in Foot
English -13th C. Capital;
Thorn in Foot
THORNTON, Leslie Tillotson (English
1925-)
Children Playing on Stilts 1957
welded bronze; 50x34 LONDC
pl 26
Figure Falling from Chair 1959
welded bronze; 13x12-1/2x
16-1/2 READCO pl 11 ELG
Figure in a Doorway 1956
bronze MAI 285
Large Seated Figure with Chair
(Version II) 1960 welded
bronze; 46-1/2 ALBC-3:
#65 UNBuA
The Martyr 1961 steel, bronze;
69-1/2 READCON 255 (col)
ELG
Roundabout 1955 bronze; 27-
5/8 CALA 215 IVG
THORNYCROFT, Hamo (William Hamo
Thornycroft) (English 1850-1925)
Artemis BROWF-3:78
Dean John Colet 1902 bronze
GLE 79 ELStP
Dean John Colet Memorial
TAFTM 75
King Edward I, equest bronze
MARY front ELGH
King George V, bust 1907 bronze;
24-1/2 CAN-2:198 CON
The Kiss POST-2:210 ELT
Lot's Wife, head detail
BROWF-3:78
The Mirror RAY 58 ELBur
The Mower 1884
BROWF-3:79; RAD 478
Oliver Cromwell 1899
GLE 36 ELOldPy
Teucer 1881 bronze AGARC 134;
CHASEH 482; UND 115 ELT
Thornycroft, John
Carpentiere. Sir John
Thornycroft, recumbent
effigy
THORNYCROFT, Mary Francis
(English 1814-95)
Alfred, Duke of Edinburgh
1848 bronze; 36 LONDC
ELBP

THORNYCROFT, Thomas (English
 1815-85)
 Boadicea cast c 1902 bronze
 GLE 97 ELWeBr
THORNYCROFT, Thomas, and
 Mary Francis THORNYCROFT
 H. R. H. Prince of Wales
 as a Young Shepherd
 VICG 131 ELV
 Queen Victoria on her
 Favorite Charger, Hammon
 marble
 VICG 131 ELV
Thoroughbred. Andreotti
THORVALDSEN, Bertel (Barthel
 Thorwaldsen) (Danish 1770-
 1844)
 Adonis 1832 marble; c 72
 RAMS pl 9d GMG
 Angel Holding a Font 1839
 marble; 141 cm
 LIC pl 14 DCOL
 Annunciation, relief 1842
 plaster; 67x125 cm
 LIC pl 17 DCT
 Christ (reproduction)
 REED 72 UCGF
 Classical Figures, relief
 COOPF 168 ECha
 Cupid and the Three Graces
 1817/19 marble
 SELZJ 36 DCT
 Ganymede with Jupiter as the
 Eagle 1817 marble; 86x
 107 cm
 AGARC 111; BOES 83;
 LIC pl 13; PRAEG 392;
 STA 186 DCT
 The Graces (line drwg)
 CHRP 371
 Hebe 1806 marble; 59
 BAZINW 420 (col); NOV
 pl 177 DCT
 Jason with Golden Fleece
 1802/03 marble; 244 cm
 LIC pl 15 DCT
 Lion of Lucerne 1819/21 rock;
 9 m
 BARSTOW 179; LIC pl 16;
 SIN 336 SwLG
 Mars and Cupid c 1810
 LARM 33 DCT
 Mercury Putting Mars to
 Sleep with his Pipes
 RAY 53 SpMaM
 Morning, relief (replica)
 POST-2:94 IRAl

Night, tondo
 CHASEH 422 IRAl
 --1815 marble; Dm: 78.5 cm
 BOES 83 DCT
Priam Entreating Achilles to
 Deliver the Body of Hector,
 relief 1815 marble; 37x76
 NOV pl 178b DCT
Prince Clemens Metternich,
 bust 1819 marble; 61 cm
 BOES 82 DCT
Professor Vacca Berlinghieri
 Monument
 MARQ 247 IPisaCam
St. Paul
 ENC 881
Self Portrait 1839 LS
 SALT 88 UNNCont
 --1840
 GOLDF pl 368 DCT
Shepherd Boy early 19th c.
 marble
 ENC 660; MOLE 261 DCT
Triumph of Alexander, frieze
 BARSTOW 182 ILaC
Vestal marble
 MILLER il 154 UNNMM
Villa Carlotta, Salon:
 Fireplace, and Wall
 Relief c 1829/31
 FLEM 631 ILaC
Thous, Jacques Auguste de
 Anguier, F. Jacques
 Auguste de Thou Monument
Thought
 Boucher, A. Thought
 Maillol. Mediterranean
 Rodin. La Pensee (Thought)
Thousand Souls. Kemeny
Three Buds. Arp
The Three Continents. German--
 12th c.
Three Dancers. Rodin
Three Female Figures. Picasso
Three Fighting Lynxes. Wederkinch
Three Figures. Giacometti
Three Figures. Heiliger
Three Figures. Tavernari
Three Figures. Wotruba
3/4/5. Turnbull
Three Graces
 Arp. Three Graces
 Barye. Three Graces
 Canova. Three Graces#
 Carpeaux. Three Graces
 Falconet. Clock of the Three
 Graces

Fiorentino, N. S. Medal:
 Giovanna Albiza Tornabuoni;
 Three Graces
French--18th c. Clock with
 Three Graces
Italian--15th c. Nature and
 Grace with Fountain of
 Life, Medal of Constantine
Maillol. Graces, first study
Maillol. The Three Graces
Pilon. The Three Graces
Poisson. Grace
Spinelli, N. di F. The
 Three Graces
Thorvaldsen. Cupid and the
 Three Graces
Thorvaldsen. The Graces
Three Men. Giacometti
Three Men Walking. Giacometti
Three Motives Against a Wall.
 Moore, H.
Three Mourning Women. German--
 15th c.
Three Nudes, relief. Marini
The Three Nymphs. Maillol
Three Oscillations. Martin, K.
Three-Part Reclining Figure.
 Moore, H.
Three Penguins
 Brancusi. Penguins
Three-Piece Reclining Figure.
 Moore, H.
Three Profiles. Beaudin
Three Sculptures Against a Back-
 ground. Richier, G.
Three Shades. Rodin
Three Sirens. Rodin
Three Standing Figures. Moore, H.
3 Stappages etalon. Duchamp
Three Theological Virtues
 Pilon. The Three Graces
3x1, second version. Turnbull
Three to Go. Wall, Brian
Three Towers Reliquary. German--
 14th c.
Three Transparent Constructions.
 Pevsner
Three Variations. Beothy
Three Way Piece: Archer. Moore, H.
Three Way Piece: Points, Moore, H.
Threefold Harmony. Belling
Throne of Dagobert. French--9th c.
Throne of Maximian. Byzantine
Throne of St. Peter. Bernini, G. L.
Thrones See also Chairs
 Danish--17th c. Coronation
 Chair and Three Silver
 Lions

English--11th c. Coronation
 Chair
English--14th c. Bishop's
 Throne
French--14th c. Double d'Or:
 Philipp VI on Gothic Throne
French--16th c. Bishop's
 Throne
German--9th c. Charlemagne's
 Throne
German--11th c. Imperial
 Throne of Goslar
Italian--11th c. Throne of
 Archbishop Elias
Italian--13th c. Episcopal
 Throne of San Lorenzo
Master Romuald. Throne of
 Archbishop Urso
Merovingian. Throne of
 Dagobert
Russian--15/16th c. Ivory
 Throne and Sceptre
Russian--16th c. Thrones of
 Tsar and Metropolitan
Russian--17th c. Diamond
 Throne
Walter of Durham. Coronation
 Chair
Thronoi. Hartung
Through. King, P.
Throw Away. Hall, D.
THRUPP, Frederick (English 1812-95)
 Flora 1854
 LONDC ELCiM
Thurible of Godric
 English--10/11th c.
 Pershore Censer
THURINGIAN
 Triptych of St. Anne 1516
 ptd lindenwood; 47-1/2;
 central section W: 90-1/4;
 wings W: 20
 KUHN pl 25 UMCB
 (1932.65)
"Thus He Leads Them to the
 Desired Gate".
 Frampton
Thynne, Tom d 1682
 Quellinus, Arnold. Assassina-
 tion of Tom Thynne of Long-
 leat
 Quellinus, T. Thomas Thynne
 Tomb
Thyrsis. Harvard-Thomas
Thys, Jean
 Despiau. M. Jean Thys, head
Tia Lola. Gonzalez
Tiare with Necklace. Matisse

TIBALDI, Pellegrino (Italian 1527-96)
 Facade
 POPRB fig 144 IMMar
Tiberius
 Italian--17th c. Tiberius,
 bust
 Porta, G. B. della. Tiberius,
 bust
TIETZ, Ferdinand (Adam Ferdinand
 Tietz; F. Dietz; Johann
 Ferdinand Dietz) (German
 (1708-77)
 Console Table, Schloss
 Seehof gilded wood
 CLE 151 UOClA (62.63)
 A Dancer 1765/68
 HELM pl 164 GWuV
 Female Figure ptd linden-
 wood; 44-7/8
 KUHN pl 77 UMCB
 (1962.33)
 Mercury, Schloss Veitschoch-
 heim Park after 1763
 BUSB 107 GWuMai
 Neptune and Amphitrite,
 fountain model c 1748
 BUSB 205 GHKG
 Pegasus 1765/68
 BAZINW 414 (col); HELM
 pl 163 GWuV
 Spring ptd and gilded wood
 CLE 150 UOClA (62.209)
 Triumph of Flora, tympanum,
 Formal Electral Castle
 1758
 BOE pl 186 GT
Tiger-Tiger. Armitage
Tigers
 Barye. Indian Mounted on
 an Elephant Killing a
 Tiger
 Barye. Tiger#
 Barye. Walking Tiger
 Danish--20th c. Tiger
 English--18th c. Longton
 Hall Tiger
 Hardt. Attacking Tiger
 Harth. Tiger
 Kiss, A. Amazon Attacked
 by Tiger
 Pilz. Standing Tiger
 Weiss, M. Tigre
TIHEC, Slavko (Yugoslav 1928-)
 Scultura con un Piccolo
 Nucleo 1965/66 iron
 VEN-66:#194
 Vegetative Form III 1962 iron
 and concrete; 38-5/8x21-
 5/8 NEW pl 268 YLMo

Tiles
 Rumanian--15th c. Moldavian
 Circular Tile: Arms of
 Moldavia
TILGNER, Viktor (Austrian 1844-96)
 Mozart Monument
 CHASEH 461; POST-2:173
 AVA
Tillotson, Archbishop
 Wilton. Archbishop
 Tillotson, figure detail
TILSON, Joe (English 1928-)
 Joy-Box 1962 oil on wood;
 14x9x11-5/8
 PRIV 246 (col)
 Key-Box 1964 acrylic and
 metallic paint on wood;
 72x57x9
 PRIV 246 (col)
 Nine Elements 1963 acrylic
 on wood relief; 102x71-1/4
 NEW pl 85 ELMa
 Vox-Box, relief 1963 ptd
 wood
 VEN-64:pl 157
 Wood Relief No. 17 1961
 wood; 36x48x2
 TATES pl 26 ELT (T.480)
 Wristwatch, articulated
 sculpture 1964/65, acrylic
 metalflake on wood; 24x144
 MAE 85
 Xanadu, construction 1962
 ptd wood; 78x63
 SFMB #88 ELMa
Tilting See Games and Sports--
 Tournaments
Timber Buildings
 German--16th c. Willmann
 House, Carved Half-
 Timbering
Timbrels See Musicians and Musical
 Instruments
Time
 Braun, M. B. Allegory of Time
 Braun, M. B. Chronos, head
 detail
 Brokoff, F. M. Vratislav of
 Mitrovice Tomb: Chronos
 Faydherbe. Bishop Andreas
 Cruesen Tomb, with Figure
 of Father Time
 German--18th c. Time
 Italian--15th c. Atys-Amorino:
 Time as a Playful Child
 Throwing Dice
 Italian--18th c. Time Exalting
 Virtue and the Arts
 Schoffer. Chronos#

Time and Opportunity. Marchand,
 D. L.
Time-LIFE Facade Screen. Moore,
 H.
Timoteo. Ghermandi
Tinder Ketch
 Baberton. Tinder Ketch,
 Suk Man, Kenya, head
TINGUELY, Jean (Swiss-French
 1925-)
 Atlas 1963 mixed media;
 70x44
 UCLD 14 UCLD
 Bascule, No. 101 Rocker,
 No. 10 1966 28-1/2x38-
 1/2x11
 CARNI-67:#91 UNNI
 Electromechanical Sculpture
 1956
 BERCK 339; JOR-2:pl 154
 Eos 1964 H: 125 cm
 MYBS 92 FPIo
 Homage to New York: A Self-
 Constructing, Self-
 Destroying Work of Art,
 assemblage in motion
 activated March 17, 1961
 ARTSM; KAP pl 81, 82;
 SEITA 90; SELZP 11
 M. K. III 1964 iron,
 machine belts, motors;
 36-1/4x82-1/2
 NEW pl 55; SELZP 67
 UTxHA
 Makroko 1961 metal con-
 struction; 19
 SELZS 169 UNNSt
 Meta-Mechanic Relief 1954
 PEL 253 UNNI
 Metamechanical Sculpture
 1953 steel wire
 SELZJ 15-K
 Metametic No. 17, self-
 destroying machine 1959
 MAI 286
 Monstranz 1960 junk-mobile;
 36
 LARM 329; READCON 256
 UNNSt
 Narwa 1961 steel, rubber,
 aluminum; 118x98x98
 SEAA 153 SnSNM
 Nicator 1966
 KULN 94, 95
 Olympia 1960 construction
 VEN-64:pl 58 GKrefW
 Peut-etre No. 11, motorized
 relief c 1959 metal; 28x
 28-3/4 ALBD-4:70 UNBuA

Radio Sculpture Number 5
 1962 iron, radios, motors;
 21x14x13
 SELZP 67 UNNDw
Radio Sculpture with Feather
 (Radio Drawing) 1962 iron,
 radios, motor and feather;
 37-1/2
 BURN 246; SELZP 66 UNNI
Rotozaza No. 1 1967 iron,
 wood, motorized elements,
 87x162x91
 GUGE 100 FPIo
Samurai 1963
 KULN 94
Sculpture*
 EXS 27
Sculpture Auto-Mobile-Meta-
 Mecanique 1954
 JOR-2:pl 284
Self-Destroying Machine 1960
 LIC pl 349 UNNMMA
Suzuki 1936 iron, machine
 belts, motors; 28-3/8
 SELZP 66 UTxHA
Volume Virtuel 1955
 JOR-2:pl 282
Wall
 KULN 163 GGelT
Yokahoma, in Metamorphosis
 1956 oil paint on mechan-
 isms; 56-1/2x49-1/4
 TRI 38 FPRe
TINO DI CAMAINO (Sienese c
 1285-1337)
 Angel, kneeling in prayer
 BEREP 172 IFV
 Bishop Antonio degli Orsi,
 monument detail 1321
 WHITJ pl 130A IFCO
 --effigy marble; 132 cm
 POPG pl 29
 --Madonna and Child marble;
 78 cm
 ENC 883; POPG pl 28
 Cardinal Petroni Monument
 c 1318
 WHITJ pl 129B ISC
 --effigy head marble
 POPG fig 57, pl 27
 --Noli Me Tangere marble;
 caryatid; 95 cm; relief:
 72x71 cm
 POPG pl 26
 Catherine of Austria Monu-
 ment: Charity 1323 marble;
 39
 MOLE 102; POPG pl 30
 INL

Charity c 1321/24 marble;
 49-1/4
 READAS pl 79 IFBard
Henry VII and Councillors,
 tomb detail 1315
 WHITJ pl 129A IPisaCam
Madonna and Child
 BARG IFBar
--marble; 19-1/4
 DETT 58; NCM 36 UMiD
 (25.147)
Madonna and Child, relief
 marble
 FAIY 110 UNGIM
--18x15-1/2
 NCM 36 UNcRA
Madonna and Child, tondo
 USNI 236 UDCN (A-39)
Madonna and Child, with Queen
 Sancia, with Sts. Clara and
 Francis, votive relief c1335
 marble; 20-1/4x15x3-3/8
 READAS pl 75; SEYM pl
 49-52; USNK 173; USNKS
 19; USNKP 386 UDCN
 (A-156)
Saint with Worshipper
 BARG IFBar
Virgin of the Annunciation
 c 1319 marble; 28-3/4
 READAS pl 78 IFCr
TINO DI CAMAINO, and Gagliardo
PRIMARIO
 Mary of Hungary Tomb (Mary
 of Valois Monument)
 c 1325 damaged(1940-45)
 marble
 CHASEH 288; MOLE 101;
 POPG fig 58; POST-1:
 147; VALE 21, 60 INC
--effigy head
 WHITJ pl 131B
--Faith marble; 100 cm
 POPG pl 31
--Hope
 POPG pl 31; WHITJ pl
 131A
--Two Figures
 VALE 21
--Tomb under Construction
 1325
 WHITJ pl 130B
"Tinted Venus". Gibson, J.
TINWORTH, George (English fl
1880)
 Henry Fawcett, seated figure
 1893 terracotta
 GLE 170 ELVa

Tireur a l'Arc. Drivier
TIROLEAN
 Madonna and Child c 1430
 ptd poplar(?); 61 (with
 pedestal)
 KUHN front (col), pl 10
 UMCB (1963.2)
 St. Diakon (Laurentius?),
 seated figure 15th c. lin-
 denwood; 130 cm
 BERLEK pl 29 GBSBe
 (8187)
 St. George 1490 lindenwood;
 75 cm
 BERLEK pl 22 GBSBe
 (8179)
TISNE, Jean Lucien (French)
 Tout en Fleurs
 TAFTM 41
Titan. Caro
Titio Livio
 Martini, A. Livy
Tito, Marshal See Broz, Josip
Titus
 Italian--17th c. Titus, bust
 Porta, G. B. della. Titus,
 bust
TIZZANO, Giovanni (Italian 1889-)
 Maria bronze
 VEN-40:pl 51
TJOMSLAND, Arne (Norwegian)
 Birds of the Northland:
 Ptarmigan, Tern, Penguin
 20th c. whale bone
 DOWN 183
To Be Looked at with One Eye,
 Close To, for Almost an
 Hour. Duchamp
Tobacco
 Raemisch. Fireplace Relief:
 Cigarette Manufacture
Tobacco Capitals. Iardella
Tobias
 French--13th c. Tobias,
 archivolt figure, north
 porch
 Gill, E. Tobias and Sara
 Gunther, F. I. Guardian
 Angel Group
Toby Jugs
 English--19th c. Rockingham
 Toby Jug
 Wood. "Prince Hal", Toby
 Jug
Toccata et Fugue. Arman
Toda Tribe, India
 Milward. Toda Man, head
TOFANARI, Sirio (Italian)

Gazelle in Watchful Repose
 bronze
 VEN-28:pl 81
Geese (I Paperi) bronze
 VEN-26:pl 49
TOFFOLI, Bruno de (Italian 1913-)
 Spatial Event (Evento Spaziale)
 1958 plaster
 VEN-58:pl 109
TOFT, Albert (English)
 The Bather marble
 MARY pl 43; TAFTM 76
 ELN
 Man, head clay
 MARY pl 80
 The Metal-Pourer bronze
 MARY pl 38
Toilet. Emanouilova
Toilet of Venus. Rodin
Toki.
 Viking. Tombstone of Toki
Tokio. Paolozzi
Tokyo II. Chadwick
Tolentino, Niccolo da
 Castagno. Niccolo da
 Tolentino, fresco imitating
 sculpture
TOLSA, Manuel (Spanish 1757-1816)
 Charles IV, equest 1803 H:
 83
 NMAT 103 MeM
 High Altar
 GARDH 446 MePu
Tolstoi, Leo N. (Russian Novelist
 1828-1910)
 Bourdelle. Tolstoi
 Martsa. L. N. Tolstoi, medal
 Troubetzkoy. Leo Tolstoy#
TOMASELLO, Luis (Argentine-French
 1915-)
 Atmosphere Chromoplastique
 Number 109 1963 ptd wood
 relief; 39-3/8x39-3/8
 SEITR 50 FPRe
 Reflection #48 1960 wood;
 48x13-1/2
 WALKA 3 ArBNB
TOMASINI, Antonia (Italian)
 Apartment House Stair Rail
 DAM 188 IM
 Swimming Pool Abstract
 Sculpture ceramic mosaic
 on concrete
 DAM 203, 204 IMon
Tomb Figure. Dillens
TOMBA, Cleto (Italian)
 La Marcia su Roma plaster
 VEN-28:pl 3

La Tombee d'une Ame dans Les
 Limbes
 Rodin, A. Les Premieres
 Funerailles
TOMBROS, Michel (Greek 1889-)
 Exotic Composition 1955
 bronze
 VEN-56:pl 125
 Two Friends marble
 CASS 94; VEN-34:pl 169
 Women Athlete, torso 1928
 marble
 VEN-38:pl 64 GrAPa
 Young Athlete
 CASS 112
Tombs See also Monuments and
 Memorials; and names of
 sculptors, as: Bacon, J.;
 Evesham; Flaxman;
 Scheemakers
 Adams, N. S. Catherine
 Opalinska Mausoleum
 Adye. Charles Sergison
 Monument
 Alexander of Abingdon. Prince
 John of Eltham Tomb
 Algardi. Leo XI Monument
 Amadeo. Bartolommeo Colleoni
 Tomb
 Amadeo. Medea Colleoni Tomb
 Ammanati. Antonio del Monte
 Tomb
 Ammanati. Benavides Monu-
 ment
 Ammanati. Buon Compagni
 Monument
 Andriolo de'Santi. Jacopo
 della Carrara Tomb
 Andriolo de'Santi. Raniero
 degli Arsendi Monument
 Anguier, F. Dukes of Longue-
 ville Monument
 Anguier, F. Henri II of
 Montmorency Tomb
 Anguier, F. Jacques Auguste
 de Thou Monument
 Anguier, F. Jacques de
 Souvre Tomb
 Aprile. Pietro and Francesco
 Bolognetti Tombs, model
 Arfe y Villafane, and
 Fernandez del Moral.
 Cristobal de Rojas, kneel-
 ing effigy
 Arnolfo di Cambio. Baldac-
 chino
 Arnolfo di Cambio. Boniface
 VIII Monument

Colt, Alice, Countess of
Derby, Hearse Monument
Colt. John Eldred, medallion
Colt. Margaret Lady Legh
Monument
Colt. Princess Sophia Tomb
Colt. 7th Earl of Shrewsbury
Tomb
Cure, William II. Alderman
Humble, and Family,
Monument
Cure, William II. Lord
Surrey Tomb
Chapu. Regnault Tomb
Cheere, H. Monument Com-
memorating Centenary of
the Death of Hampden
Colin. Maximilian I Tomb
Coysevox. Cardinal Mazarin
Tomb
Coysevox. Marechal de
Vauban Tomb
Crutcher. Robert Clayton
Tomb
Cure, W. II. Prince
Charles
David, C. Philip Cataret,
bust
Delcour. Bishop d'Allamont
Monument
de l'Orme, P., and P.
Bontemps. Francis I and
Claude of France Tomb
Desiderio da Settignano.
Carlo Marsuppini Monu-
ment
Deval, J., the Younger.
Thomas Spackman
Monument
Dieussart. Charles Morgan
Tomb
Donatello and Filarete--
Foll. Martin V Monument
Donatello and Michelozzo.
Cardinal Rinaldo
Brancacci Tomb
Dubois, P. General
Lamoriciere Tomb
Dunn. Edward Colman
Monument
Duquesnoy, F., and Jerome
Duquesnoy, the Younger.
Anton Triest Monument
Dutch--16th c. Engelbert II
of Nassau and Wife Tomb
English. Dean Aquablanca,
relief tomb figure
English--11th c. Shrine of
Edward the Confessor

English--13th c. Bishop Giles
of Bridport Tomb
--Edmund Crouchback
Monument
--Knight's Tomb
--Peter of Aigueblanche Tomb
--William de Valence, effigy
English--14th c. Aymer de
Valence Tomb
--Black Prince Tomb
--Edward II Tomb
--Geoffrey Luttrell Tomb
--Henry Fitzroy Tomb
--Knight, effigy#
--Percy Tomb
--St. John Crosby Tomb
--Sir Roger de Kerdeston
Tomb
--Tomb of a Lady
--William, Lord Graunson,
Tomb
English--15th c. Bishop
Beckington Tomb
--Bishop Chichele's Tomb
--Dean Hussey Tomb
--Henry IV and Joan of
Navarre Tomb
--Shrine of Henry V
--Sir John Golafre
--Sir Nicholas Fitzherbert
Tomb
--Thomas, Lord Berkeley,
Tomb
English--16th c. Babington
Tomb
--Croft Monument
--De la Warr Tomb
--1st Lord Marney Tomb
--George Brooke Tomb
--John Lewiston Monument
--Lady Spencer Tomb
--Margaret, Countess of
Lennox, Monument
--Matthew Godwin Monument
--Natural Son of 1st Earl of
Pembroke, effigy
--Richard Harford Tomb
--Sir Anthony Cooke
Monument
--Sir Hugh Poulett Tomb
--Sir John Salusbury Tomb
--Sir Philip and Sir Thomas
Hoby Tomb
--Sir Thomas Bromley Tomb
--Sir Thomas Gresham Tomb
--3rd Duke of Norfolk Tomb
--Thomas, Lord Marney
Tomb
--Thomas, 2nd Duke of
Norfolk, Tomb

--Duke of Villeroy Tomb
Gagini, G. --Foll. Giovanni
 Montaperto Monument
Gahagan, S. General Sir
 Thomas Picton Monument
Gentils. Anonymous Tomb
Gerhaerts. Canon Conrad von
 Busnang Monument
Gerhaerts. Frederick III
 Tomb
German--11th c. Rudolf, King
 of Swabia, tomb cover
German--12th c. Priest Bruno
 Tomb Slab
German--14th c. Albert von
 Hohenlohe Tomb
--Frederick of Hohenlowe
 Tomb
--Gerhard von Schwarzburg
 Tomb
--Konrad von Weinsberg
 Tomb
German--15th c. Prince Bishop
 Dieter von Isenberg
 Monument
German--16th c. Philibert le
 Beau Tomb
German--17th c. Eilhard
 Schacht Tomb
--Prince Bishop Franz von
 Ingelheim Monument
Gerthner. Archbishop Konrad
 III Tomb
Gibbs, and M. Rysbrack.
 Katherine Bovey Monument
Gibbons. John, Lord
 Coventry, Monument
Gibbons. Viscount Campden
 Monument
Gilbert, A. Duke of Clarence
 Tomb
Giovanni Dalmata, and Mino
 da Fiesole. Pope Paul
 II Monument
Giovanni da Nola. Don Pedro
 da Toledo Monument
Giovanni di Cosma. Stefano
 de Surdis Monument
Girardon. Richelieu Tomb
Girolamo da Fiesole, and
 M. Colombe. Francis II
 of Brittany Tomb
Giusti, A. and G.
 Maximilian I Tomb
Goujon. Louis de Breze
 Monument
Goulden. Margaret Mac-
 donald Memorial

Grapiglia. Loredano Monument
Green. Lord Justice Holt
 Monument
Groninger, J. M. Dean
 Heinrich Ferdinand von
 der Leyden Tomb
Gudeworth. Memorial to
 Heinrich Ripenau
Guillain. Pont-au-Change
 Monument
Hancock. Joseph Mellish,
 recumbent effigy
Hargrave. Sir Cope d'Oyley
 Monument
Harris. 3rd and 4th Duke
 of Lancaster Monument
Hartshorne. Sir Thomas Powys,
 recumbent effigy
Hayward. Barton Booth
 Monument
Hayward. Ladies Newdigate
 Monument ("Storied Urn")
Hayward. Rev. Stephen
 Slaughter Clarke and Wife
 Monument
Hickey, J. Elizabeth
 Hawkins Monument
Hogadt. Frisian Chieftan
 Edo Wiemken Tomb
Hollemans. Sir George and
 Lady Fermor Monument
Hollemans. Sir John Spencer
 and Wife Katherine
 Monuments
Hollins. Mrs. Thompson,
 recumbent effigy
Horsnaile, C., the Elder.
 Sir Jacob Garrard,
 recumbent effigy
Hunt. Sir William Boughton
 Monument
Huszar. Poet Petofi Memorial
Huy, J. P. Robert II of
 Artois, effigy
Italian. Filippo Sanigneto
 Tomb
--Isabella of Aragon Tomb
--Princess of Odescalchi
 Chigi Family Tomb
Italian--13th c. Cardinal
 Guglielmo Fieschi
 Monument
Italian--14th c. Bernalbo
 Visconti Monument
--Can Grande della
 Scala, equest
--Cardinal Guglielmo Longhi
 Monument

Tino di Camaino, and Primario.
 Mary of Hungary Tomb
Tommaso Vincidor da
 Bologna. Engelbrecht II
 of Nassau Tomb
Torel. Eleanor of Castile,
 recumbent effigy
Torel. Henry III, effigy
Torrigiani, P. Henry VII
 and Elizabeth of York
 Tomb
Tyler. 3rd Earl of Lichfield
 Monument
Urbano. Monument of
 Cristoforo Felici
Valle. Tomb of Innocent XII
Van Gelder. Tomb of 3rd
 Duchess of Montagu
Vela. Tomb Contessa d'Adda
Verhulst, R. Admiral de
 Ruyter Monument
Verhulst, R. Johannes
 Polyander van Kerckhoven
Verhulst. Willem von Lyere
 and Maria van Reygens-
 berg Monument
Verrocchio. Forteguerri
 Monument
Vervoort. Monument of
 Bishop de Precipiano
Viscardi. Duke of Orleans
 Tomb
Vries. Mausoleum of Count
 Ernst von Schaumberg
Wilton. Dr. Stephen Hales
 Monument
Wilton. Duke of Bedford,
 2nd, Monument
Wolff, Albert. Monument
 to Friedrich Wilhelm III
Woodman. Monument of
 Viscount Newhaven
Wrba. The Wittlesbach
 Monument
Wyatt, M. C. Monument
 to Princess Charlotte
Wyatt, R. J. Ellen Legh
 Monument
Wyss. Monument to H.
 Dunant
Zarza. Tomb of Cardinal
 Alonso de Madrigal
Tombstones See Gravemarkers
TOME, Narciso (Spanish fl 1715-42)
 Transparente Altar 1721/32
 bronze and multi-color
 marble

BAZINW 406 (col); CIR
 182 (col); ENC 888; GUID
 254; KITS 18 (col); KUBS
 pl 14B; LARR 369; MU
 183; ST 361; WES pl 29
 SpTC
--"La Gloria"
 CIR 158 (col)
--Madonna and Child
 VEY 208, 286
TOMIC, Mijajlo (Yugoslav 1902-)
 The Musician 1934 bronze
 BIH 120 YBN
TOMLIN, Stephen (English 1091-37
 Lytton Strachey, head 1928/30
 bronze; 18x10x10-7/8
 TATEB-2:46 ELT (4616)
TOMMASO VINCIDOR DA BOLOGNA
 Engelbrecht II of Nassau
 Tomb c 1535
 BAZINW 385 (col);
 GEL pl 96 NGB
Tompson, Bishop
 English--17th c. Bishop
 Tompson of Exeter, Dean
 of Bray, Monument
TOMSKI, Nicola (1900-)
 S. Gherassimov, bust
 1957/58 marble
 VEN-58:pl 187 RuME
Tonisation. Beothy
TOOTH, Henry (English)
 Tobacco Jar and Cover
 c 1900 Bretby Art
 Pottery; 6; Dm: 5-1/4
 ARTSN -Me
Toothache
 English--13th c. Capital:
 Toothache
Toothless Laughter. Daumier
The Top. Richier, G.
Torah Crowns
 Jewish--18th c. Torah
 Crowns
Torah Headpieces
 Jewish--17th c. Torah
 Headpieces
 Polish. Torah Headpieces
Torah Pointer
 Jewish--18th c. Torah Scroll
 Pointer(s)#
Torah Scrolls
 Dutch--18th c. Torah Scroll
 Finials
 Italian--18th c. Torah
 Scroll Finials
 Jewish--18th c. Torah
 Scroll Breastplate

--Torah Scroll Case
Polish. Torah Scroll Crown
Wolff. Torah Scroll Breast-
plate
Torah Shrines
Jewish--13th c. Fustat Torah
Shrine
Torah Holders
Baroque. Torch Holder: Two
Putti
Italian--15th c. Woman-
Headed Winged Monster,
torch holder
Torch of Hope. Matisse
Torcheres
French--19th c. America,
torchere
Torcs
Celtic. La Tene Torc
TORDESILAS, Gasper de (Spanish
fl 1562)
St. Bernard
TAT--sc pl 13 SpVM
Toreador. Gris
TOREL, William (English 1272-91)
Eleanor of Castile, recumbent
effigy 1291/93 bronze;
c LS
AUBA 121 (col); BAZINH
167; BAZINW 304 (col);
BRIE pl 76a; GAUN pl
36; KIDS 154 (col); STON
pl 108-09; UND 36 ELWe
Henry III, effigy 1291/92
bronze; LS
BAZINH; MOLE 66 ELWe
--head detail
BRIE front; BUSGS 197;
HUX 66; MOLS-1:pl 33
Torero
Gris. Harlequin
TORGAU, S. L.
German Nef: Ship c 1610
SOTH-3:202
Torment. Brancusi
Tornabuoni, Francesco
Mino da Fiesole. Francesco
Tornabuoni Tomb
Tornabuoni, Giovanni Albizi
Fiorentino, N. S. Medal:
Giovanni Albizi Tornabuoni;
Three Graces
TORNI "L'INDACO" See JACOPO
FLORENTINO
Toro Ferito. Mirko
Torque See Drinking Horns
Torre, della
Riccio. Death of della
Torre, relief

TORRE, Francesco de, and H. KOHL
Courtyard Fountain 1686
STECH 32 CzPHC
Torrecilla Monstrance. Spanish--
16th c.
TORRESANY, Peter See TORRIGIANO,
Pietro
TORRESINI, Attilio (Italian 1884-)
Antonello terracotta
VEN-32:pl 57
TORRIGIANI, Bastiano (Italian
d 1596)
Pope Sixtus V, bust bronze;
70 cm
POPRB pl 134 IBSBe
TORRIGIANO, Pietro (Peter
Torresany) (Italian 1472-1522)
Chapel of Henry II 1519
RAD 426 ELWe
Henry VII, bust c 1512 ptd
and gilded terracotta; 24
x21-1/2
BUSG 169; MOLS-1:
pl 55; VICK front ELV
(A. 49-1935)
Henry VII and Elizabeth of
York Tomb 1509/18 bronze
ESD pl 41; GARL 193;
GERN pl 39; GLA pl 42;
POPR fig 74 ELWe
--Elizabeth of York, effigy
head
CARP 256; ESD pl 43
--Henry VII, effigy
GAUN pl 37
--Henry VII, effigy head
CARP 105; POPR pl 94
--Henry VII and Elizabeth
of York, effigies
BROWF-3:42; WHINN pl
1, 2
--Hands
GERN pl 38
--Male Head
MOLE 199
--Putto (Cherub Head)
ESD pl 42; GERN pl 40;
MOLE 199
Henry VII, electrotype from
bronze effigy in West-
minster Abbey
MILLER il 107 ELNP
Henry VII Monument: Putto
c 1519
BUSR 171 ELV
John Fisher, Bishop of
Rochester, bust c 1511/15
ptd terracotta; 24-1/4
HUX 68; MILLER il 105;

NM-8:4; NMA 192
UNNMM (36.69)
St. Jerome, kneeling figure
1525 ptd terracotta
BUSR 172; GOME pl 7;
KUBS pl 63A; WES pl 10
SpSM
Torse d'Homme. Martin, R.
Torse Poupee. Arp
Torso: The June of Youth.
Underwood
Torso (Ulysses). Hepworth
Torso 1. Beslic
Torso 2--Torcello. Hepworth
Torso III (Galatea). Hepworth
Torso de l'Ete
Maillol. Sommeren
Torso d'Uomo. Martini, A.
Torso in White Sicilian Marble.
Skeaping
Torso of a Young Man. Duchamp-
Villon, R.
Torso of Adele. Rodin
Torso of Monument to Blanqui
Maillol. Chained Action
Torso Ronda II. Berrocal
TORTI, Lavoslav (Yugoslav)
Self Portrait, head 20th c.
stone
BIH 23
Tortoise Fountain. Porta, Giacomo,
and T. Landini
Il Tortuarato. Mucchi
Toscanini, Arturo (Italian-American
Conductor 1867-1957)
Elkan. Arturo Toscanini,
head
TOSI, Arturo
Marini. Arturo Tosi, head
"El Tostado"
Zarza. Tomb of Cardinal
Alonso de Madrigal
TOT, Amerigo (Italian 1909-)
Frieze Detail, front
elevation
DAM 94 IRRr
Protest II 1962 cast cement
VEN-62:pl 2
Relief Band, Commercial
Building 1950
BOE pl 201 IRSt
Totem. Gisiger
Totem. Hepworth
Totem. Le Corbusier
Totem# Turnbull
Totem Head. Lewers
Totenschild
German--16th c. Heraldic
Epitaph

TOTH, Paolo (Czech)
Torso EXS 29
Touch
Eberlein, J. F. Sense of Touch
Kandler. Sense of Sight;
Sense of Touch
Touchka. Gisiger
Tounette. Osouf
TOURET, Jean Marie (French 1916-)
Parable of the Blood, relief
wood
MAI 287
Tournai Font. English--12th c.
Tournaments See Games and Sports--
Jousting
Tournay Group. French--18th c.
Tournon, Camille
Maggesi. Count de Tournon,
bust
Tout en Fleurs. Tisne
TOVAR, Jeshurun (Italian)
Housewive's Casket
c 1460/80
ROTH 505 IsJB
Towards the River. Mokhtar
Towards the Sweetheart. Mokhtar
Towers
English--13th c. Tower,
north, west front
English--15/16th c. Bell
Harry Tower
Flemish--15th c. Tower
Monstrance
Mendelsohn. Einstein Tower
Town Planners. Stappen
Town Tower. Paolozzi
Townley, Charles
Nollekens. Charles Townley,
bust
Townley Brooch. English--10/11th c.
Townshend, Colonel d 1758
Carter, T. I., and Eckstein.
Death of Col. Townshend at
Ticonderoga in 1758
The Toy. Jespers, O.
TOYOFUKU Tomonori (Japanese-
Italian 1925-)
Adrift III 1960 wood; 83-7/8
x12x33
NMAJ 67; VEN-3:pl 171
UNNMMA
Caelum II, relief 1963 wood
VEN-64:pl 155
Drifting 1958 wood; figure:
170 cm
WW 220
Sky, No. 2 1965 79 (excl base)
x122 CARNI-67:#171
IMNav

Sui, III 1964 bronze; 80-1/8
x19x19-7/8
NMAJ 66 UNNH
Venus 1964 wood; 55-3/8x
45-1/4
NMAJ 67 UNNSar
Toys See also types of toys, as
Dolls; Ships
Folk Art--Russian. Bird
with Fanned Wing and
Tail Feather
--Wheeled Animal
Penkina. Kid and Grey
Wolves
Ustratov. Peasant Toy:
Figures at Table
Tra-la-la. King Phillip
Trade Signs See also Figureheads
French. Sign of Locksmith
"Filliol"
Italian--13th c. Main Portal:
Trades--Smithy; Fisher-
man
TRAFELI, Nino (Italian 1922-)
Figura e Ambiente 1963
bronze
VEN-64:pl 91
Tragedy See Comedy and Tragedy
Tragic Group. Brown, R.
Tragic Group
Jarnuszkiewicz. Marcinelle
Trajan
Romanelli. Justice of
Trajan, relief
Transenna with pierced decoration.
Byzantine
Transformation. Heiliger
Transgression. Uecker
Transition. Bill
Transparent
Polychromatic Construction
in White, Black and
Indian Red. Pasmore
Transparente Altar. Tome
Transport de Statues. Stanzani
Transportation
Bottiau. Decorative Panels:
Agriculture; Transporta-
tion
TRANSYLVANIAN
Brooch, Rumania silver
with gold foil
ST 121 HBNM
TRAPMAN, Jan (Dutch)
Kangaroo with Young, panel
sandstone
AUM 111 NA

Trasalter (Rear Wall High Altar).
Vigarny de Borgona
Traun (River)
Donner. Providentia Fountain
Travalgan
Hepworth. Curved Form
Travellers, choir screen. French--
16th c.
Traveller's Folding Iron. Duchamp
TRAVERSE, Pierre (French 1892-)
Bacchus Enfant
BAS 174
Baigneuse
BAS 176
--
BAS 178
Education of Achilles,
maquette
BAS 181
Eve onyx
BAS 179
La Famille
BAS 173
L'Homme
BAS 177
Maternite onyx
BAS 175
Mere et Enfant onyx
BAS 175
Nessus and Deianira
BAS 180
Nu
BAS 183
Rhythm (Ritmo) bronze
VEN-30:pl 177
Seated Woman
BAS 182
Venus and Adonis
BAS 181
Trays
German--17th c. Tray
(Lokhan)#
Treachery, War, Love, relief.
Kennington
Treasure Chests
Spanish--16th c. Treasure
Chest
Tree of Jesse
Douvermann. Altar of the
Virgin of the Seven
Sorrows: King David at
the Root of the Tree of
Jesse
Douvermann--Foll. Jesse Tree
English--15th c. Tree of
Jesse Springing form from
Sleeping Isaiah

French--16th c. Tree of
 Jesse, tympanum
Tree of Judgment, facade. Maitani
Tree of Knowledge
 German--11th c. Cathedral
 Door: Tree of
 Knowledge
Tree of Life
 Bacon, J. , the Younger.
 Tree of Life
 Barisanus of Trani. Door
 Panels
 Byzantine. Opposing
 Gryphons by Tree of Life,
 screen
 English--12th c. Tympanum:
 St. Michael and the
 Dragon; Tree of Life
 French--13th c. Adelais of
 Champagne Tomb: Youth
 Standing in a Tree,
 relief panel
 Italian--8th c. Abbot Attala
 Grave Slab: Tree of Life
 Romanesque--English. Tym-
 panum: Beasts Feeding on
 Tree of Life
Trees
 Boisecq. The Tree
 Strauss, A. The Tree
 Vigeland. Fountain for
 Christiania: Tree
 Vigeland. Frogner Park
 Fountain
TREMBLAY, Barthelemy (French
 1578-1629)
 Henry IV in Armor marble
 LOUM 139 FPL (466)
"Tremblement de Fer #3." Chillada
TREMONT, Auguste (French 1893-)
 Antelope
 CASS 123
Trenker, Luis
 Hahn. Luis Trenker, head
Trenta Altar. Quercia
TRENTACOSTE, Domenico (Italian
 1860-)
 Boy's Head marble
 VEN-1:pl 58
 Il Ciccaiuolo bronze
 VEN-1:pl 59
 Dead Christ marble
 VEN-12:pl 120
 Nude Woman marble
 VEN-10:pl 129
Trevi Fountain. Salvi, N. , and
 P. Bracci
Triad. Belling

Triad. McWilliam
Triangle-Quadrato. de Vecchi
Triangulated Column. Adams, R.
Triangulated Structure. Adams, R.
Triangular Surface in Space. Bill
Triarchy 1. Armitage
TRIBOLO, IL (Niccolo dei
 Pericole; Niccolo Pericoli)
 (Italian 1485-1550)
 Assumption of the Virgin,
 relief marble; W: c
 250 cm
 POPRB fig 83, pl 60 IBoP
 Fountain Figure, Medici
 Villa at Castello
 ROSSI IFP
 Fountain of Hercules and
 Antaeus, design 1536
 bronze and marble
 MOLE 161; POPRB fig 92
 IFCas
 --Putti with Geese
 POPRB pl 59
 Fountain of the Labyrinth
 POPRB fig 93 IFPe
 Pan bronze; 26 cm
 POPRB pl 58 IFMN
TRIBOLI, IL--ATTRIB
 Fountain Model terracotta; 17
 YAP 219 -UFo
Tribute Money See Jesus Christ--
 Betrayal
Tribute to Gaudi. Subirachs
Trick-Picture. Spoerri
Tricolor Modern Painting. Raysse
Tricurvular II. Phillips, P.
Triest, Anton d 1657
 Duquesnoy, F. , and Jerome
 Duquesnoy, the Younger
 Bishop Anton Triest
 Monument
Trigon. Chadwick
Trinacria, Sicily. Franchina
The Trinity
 Altri. Trinity
 Asam, E. Q. The Trinity
 Burgundian(?)--15th c.
 Morse: The Trinity
 English--14th c. Holy
 Trinity
 German--14th c. The
 Trinity, as a Mercy Seat
 Gunther, F. I. The Trinity
 Reinhart, H. , the Elder,
 the Trinity, medal
 Rhenish. The Dead Christ
 Supported by an Angel
Trinity Column. Fischer von Erlach

The Trinity Morse (Ecclesiastical
 Brooch). Franco-
 Burgundian
Trio. Wright, A.
Tripartite Unity. Bill
Tripatte# Poncet, A.
Triple Clang
 Belling. Triad
Tripodal Form. McWilliam
Tripods
 Italian--13th c. Griffins
 Flanking Tripod, pillar
 base
Triptiek van de Ruimte. Hoeydonck
Triptychs
 Byzantine. Pictorial Triptych
 Byzantine. Triptych#
 Embriachi. Triptych
 English--14th c. Triptych of
 John Grandissen
 French--14th c. Triptych#
 Godefroid de Claire. Stavelot
 Triptych
Triskele Plaque. Celtic
Tristan and Iseult
 German--13th c. Mirror Case
 with Handle: Tristan and Iseult
 Jean de Valenciennnes.
 Zachariah and the Arch-
 Angel Gabriel; Tristan and
 Iseult
Triton Fountain. Bernini, G. L.
Triton Fountain. Milles
Tritons
 Almquist Musician Triton
 and Nymph, balustrade
 figures
 Bernini, G. L. Neptune and
 Triton
 Bernini, G. L. Triton with
 Sea Serpent
 Bernini, G. L. Triton with
 Shell
 Bizaccheri, C., and Maratti.
 Triton Fountain
 Braun, M. B. Triton,
 fountain
 Carrier-Belleuse. Triton
 Carrying a Nymph
 Czech--18th c. Tritons Fountain
 Italian--18th c. Harpsichord:
 Triton Legs
 Leoni, L. Triton on a Tortoise
 Salvi, N., and P. Bracci.
 Trevi Fountain: Triton
 Blowing Conch
 Vries. Triton
Triumph of Alexander. Thorvaldsen

Triumph of Flora. Carpeaux
Triumph of Napoleon
 Cortot. Apotheosis of
 Napoleon
Triumph of the Republic. Dalou
Triumph of the Sea Goddess, roundel.
 Flotner
Triumphal Cross--See Jesus Christ--
 Crucifixion
Triumphal Procession. Weyr
Trivulzio, Giangiacomo
 Caradosso. Giangiacomo
 Trivulzio, square medal
Trivulzio Candlestick. Italian--13th c.
Trivulzio Monument. Leonardo da
 Vinci
Trofei di Caccia. Pascali
Troika
 Folk Art--Russian. Bear Driv-
 ing Troika Sleigh
 Lansere. Troika
Les Trois Danceuses
 Rodin. The Three Dancers
Trois Jeunes Filles. Janniot
Les Trois Nymphes
 Maillol. The Three Nymphs
Trois Pointes. Adam, H. G.
Trois Vents. Kemeny
Trojan Horse
 Lardera. Il Cavallo di Troia
Trolls
 Jacobsen. Troll Scenting
 Christian Flesh
 Jonsson. In the Hands of the
 Trolls
TROMAN, Morley
 Nude wood
 NORM 87 FPDrou
Trono, Niccolo (Doge of Venice
 1471-73)
 Rizzo, A. Doge Niccolo Trono
 Monument
Trophime, Saint
 French--12th c. Capital: St.
 Trophimus, head
 --Facade of St. Trophime
 --Portal Figures: St. Peter;
 St. John the Evangelist;
 St. Trophime
Trotting Horse. Degas
Trotting Horse. Leonardo da Vinci
TROUBETZKOY, Paul Petrovich (Paul
 Trubetskoi) (Russian 1866-1938)
 Dancer
 VEN-22:10
 Dancing Girl cast bronze
 ELIS 108; RAY 58 UNNMM
 Elephant 1889 bronze; 7-3/4
 BROO 79 UScGB

General Harrison Gray Otis
REED 57 UCLMP
George Bernard Shaw 1926
bronze; 23-1/4
TATEF pl 53g; VEN-28:
pl 114 ELT (4274)
Girl bronze
VEN-1:pl 50
Horseman
VEN-97
Joaquin Scrolla y Bastida,
seated figure, sketch clay
MARY 52; TAFTM 82
Leo Tolstoy, bust bronze
VEN-99
Leo Tolstoy, equest
CHASEH 491 UMiD
--bronze
VEN-1:pl 51
--bronze
CHENSW 466 formerly
FPLu
Little Girl and Dog
TAFTM 82
Marquesa Luisa Casati wax
VEN-14:96
Mussolini, head bronze
VEN-26:pl 152
Prince Golitsin, bust 1899
bronze
BLUC 217
Princess Baratinsky
POST-2:223
S. Iu Vitte 1901 bronze
HAMR pl 180 RuLR
La Trousse du Voyageur. Arp
Troy in Ruins. Lorcher
TRSAR, Drago (Yugoslav 1927-)
The Channel (Kanal) 1966
bronze; 23-1/4x24x15
GUGE 108 UNNAdr
Consolation, relief 1953
plaster
BIH 166
Demonstrators (Manifestants)
1957 bronze; 65x120
MID pl 123 BAM
Demonstrators II 1957
bronze; 53-7/8x66-7/8
TRI 108
Life of Man III 1965 plaster
NEW pl 267 YLMo
Manifastations 1960 bronze;
57x75-1/4
ARTSY #110
The Step-Mother 1953 plaster
BIH 167

TRUBBIANI, Valeriano (Italian 1937-)
Ludi Armilastrium 1966 steel
VEN-66:#110
TRUBETSKOI, Paul See
TROUBETZKOY, Paul
Truhendingen, Bishop von d 1366
German--14th c. Bishop von
Truhendingen Tomb
Trumpeldor, Joseph
Melnikoff, A. Joseph Trumpledor
Monument
Trumpets See Musicians and Musical
Instruments
Trust in God. Bartolini
Truth
Bernini, G. L. Truth
Brock. Queen Victoria
Memorial: Truth
Dutch--12th c. Shrine of St.
Servatius: Truth (Veritas)
Holding Scales
Stevens. Wellington Memorial:
Truth Plucking Out the
Tongue of Falsehood
TSIFFER, Moshe (Polish-Israeli
1902-)
Motherhood stone
ROTH 950
TUAILLON, Louis (German)
Amazon
TAFTM 53
Frederick III
TAFTM 53 GBrem
The Tub. Degas
TUBI, Jean Baptiste See TUBY, J. B.
TUBY, Jean Baptiste (Jean Baptiste
Tubi) (Italo-French 1630/36-
1700) See also Coysevox, A.
Cherubs Playing with a Swan
lead; 47
USNI 219; USNP 170 UDCN
(A-41)
Eros 1672/74 lead; 59-7/8
CHICT #142 FV (M. V.
7931)
Fountain of Apollo, after a
design by Lebrun 1668/70
lead
KITS 36 FV
The Saone, detail, Parterre
D'Eau 1683
LARR 271 FV
TUBY, Jean Baptiste, and Antoine
COYSEVOX
Lyric Poetry
BR pl 10 FV
TUCKER, William (English 1935-)

Anabasis I 1964 plastic;
59x41
NEW col pl 41 (col) ERicP
Four Part Sculpture No. 1 1966
fiberglass; 18x72x90
GUGE 121
Memphis 1965/66 plywood, for
plastic; 30x56x65
ARTSCH #17 EA
Meru II 1964/65
KULN 142
No. 37 1961
PRIV 254
Persephone 1963/64 fiberglass
PRIV 254
Thebes 1966 fiberglass, ptd;
48x78x50
LOND-7:#37 ELRo
2-5-A 1960 iron; 42x20x5
ARTSS #46 ELBrC
Tugendbrunnen
Wurzelbauer. Justice Fountain
TUGWELL, Lewen
Angela 1962 bronze
PER 49
Louise--Ballet Dancer 1962
bronze
PER 57
TUMARKIN, Yigael (Israeli 1933-)
Crematorium 1964 welded
iron; 62.3/4x44x30-3/4
SEIT 77 IsTI
Fetish 1963 bronze; VEN-64:
pl 166
Sculpture 1963 bronze; 47-1/8x
20x16-3/4 SEIT 76 IsTI
Window to the Sea Beach Monu-
ment 1963/64 concrete and
iron; 98-3/4x23 NEW col pl
102 (col) -IsAp
TUNNARD, John (English 1900-)
PSI 1938 oil on hardboard;
30-3/4x46-1/2
CALA 212 IVG
TUOTILO (Tutilo) (Swiss c 900)
Book Cover
MARQ 105 SwSGB
Book Cover for Evangelium
Longum: Christ in Majesty
with Four Evangelists;
Assumption of the Virgin;
Legend of St. Gall,
St. Gall c 900 ivory;
13x6-1/8
BECKM 77 SwSGB
Book Cover: Foliate Scrolls
with Wild Beasts Pouncing

on Cattle, St. Gall c 900
ivory; 10-1/2x4
BECKM 79 SwSGB
Turati, Augusto (Italian
Fascist Politician 1888-)
Borelli. Augusto Turati, bust
Tureens
Chelsea Porcelain. Rabbit
Tureen
English. Worcester "Billing
Doves" Tureen
English--18th c. Chelsea
Rabbit Tureen
English--19th c. Worcester
Cauliflower Tureen and
Cover
German--18th c. Swan
Service Covered Tureen
Kandler. Meissen Quail
Tureens
Lanz. Strasbourg Duck Tureen
Roettiers, J. N. Soup Tureen
Tureholm Treasure. Swedish--5/7th c.
Turgot, Anne Robert Jacques (Baron
d'Aulne 1727-81)
Houdon. Anne Robert Jacques
Turgot, Baron d'Aule, bust
TURING, Nickolaus
House with Golden Roof (Haus
zum Goldenen Dahl), detail:
Dancers 1500
BUSR 95 AI
TURINI, G. (Italian)
Giuseppe Garibaldi 1888
SALT 22 UNNWashS
Giuseppi Mazzini, Bust
SALT 78 UNNCent
TURKISH
Regal Harness 18th c. jeweled
gold
DUNC 118-19 (col) RuMKA
Turkeys
Bologna. Strutting Turkey Cock
Turks
Brokoff, J. Turk, bust
German--18th c. Meissen
Figure: Turk with Guitar
Kandler--Foll. Turkish Man
and Woman
Turmengel. Knappe
TURNBULL, William (Scottish 1922-)
Aphrodite 1958 bronze; 75
LOND-6:#41 ELMa
--1958 bronze, wood, and
stone; 75
PRIV 81
Chief 1962 rosewood; 57-1/2
SFMB #126 ELMa

Cortez 1960 bronze and
 rosewood; 57
 ALBS-3:#66; CARNI-61:#
 407; TOW 110 UNBuA
Drum-Head 1955 bronze
 MAI 288
Head 1955 wood and bronze;
 18; Dm: 22
 ARTSS #47 ELBrC
--1960 bronze; 12-1/4x12-1/4
 x10-1/2 on stone cylinder
 block: 10; Dm: 14-1/2;
 and rosewood stand: 23-1/2;
 Dm: 12
 HAMM 129 (col); TATES
 pl 25 ELT (T.424)
Head-Object 1955 bronze; 9
 GIE 278 UNNBli
Idol 1956 bronze; 63
 LOND-5:#38
Idol I 1957 bronze; 70
 MINE 44 UNNBli
Llama 1961 bronze and rosewood;
 61 READCON 193
Mobile-Stabile 1949 bronze base;
 26x18 GIE 218; RIT 218
Night 1962/63 rosewood,
 ebony, and bronze; 64
 HAMM 128 ELMa
No. 3 1964 steel, ptd silver
 LARM 370
No. 7 1965 steel, sprayed
 with copper; 93x16
 LOND-7:#38
Oepidus 1962 bronze, rose-
 wood, and stone; 65-1/2
 READCON 193 UW
Prometheus 1962 H: 37
 SEITC 47 UNNMa
Ripple 1966 steel, shot-
 blasted, ptd; 89-1/2
 LOND-7:#39
Ripple 2 1966 ptd steel;
 36x26x9
 ARTSCH #14
Standing Female Figure 1955
 bronze; 63
 BERCK 150
Steel Painted Silver 1964
 H: 102
 HAMM 126
Sungazer II 1959 bronze; 16
 READCO pl 13b ELPo
3x1, second version 1966 ptd
 steel; 84-1/2x93x31
 GUGE 89
3/4/5 1966 ptd steel; 100
 LOND-7:#40

Totem 1956 H: 87
 BERCK 150
Totem (Sun Gazer) 1956 bronze;
 63
 MINE 10 UNNC
Ulysses 1957/61 bronze; 50
 NEW pl 88
Untitled 1964
 KULN 128
Turned Head. Antes
TURNELLI, Peter (English 1774-1839)
 George III, bust c 1810 marble;
 30
 VICK 36 ELV (A.11-1937)
TURNER, Alfred (English)
 Psyche marble
 PAR-1:24 ELT
Turner, Dr.
 Stayner. Dr. Turner Monument
TURNER, H. Thackary (English
 Architect)
 Phillips Memorial Tablet
 NATSE EGoP
Turner, Henry James
 Carpeaux. Henry James
 Turner, bust
Turner, Mrs. Henry James
 Carpeaux. Mrs. Henry James
 Turner, bust
TURNER, Winifred (English)
 Female Figure (Figurine) 1943
 plaster; 30
 BRO pl 37B
 Spring
 CASS 88
Turning Forms. Hepworth
Turning Movement. Tennant
Turning Woman. Brown, R.
Turpin, Archbishop of Rheims
 German--13th c. Shrine of
 Charlemagne
Turpin, Dick (English Robber 1706-
 39)
 English--19th c. Dick Turpin,
 flat-back equest
Turquoise Iron. Consagra
Turrets
 Pauwels, J., the Younger.
 Chrismatory: Turret
Turris Davidica. Schilling, A.
Turtle Fountain
 Porta, Giacomo della, and
 Landini. Tortoise Fountain
Turtles
 Barye. Hound and Turtle
 Cellini. Rospigliosi Cup
 Leoni, L. Triton on a
 Tortoise

Porta, Giacomo della, and
Landini. Tortoise Fountain
Rude. Neapolitan Fisherboy
with Tortoise
Skeaping. Tortoise
TUSCAN
Bust of a Lady c 1500
majolica; 21
BOSMI 131 UMB (54.146)
Samson and the Lion, tondo
12th c.
CLAK 192 ILuCiv
TUTILO See TUOTILO
22. Bill
23 Boules sur 5 Plans Inclines. Bury
24th (East Surrey) Division.
Kennington
Twilight. Clara
Twilight
Michelangelo. Lorenzo
de'Medici Tomb: Evening
Twilight. Wostan
Twin Tower of the Sfinx-State.
Paolozzi
Twinned Column. Pevsner
Twins. Visser
Twister II. Chadwick
Two. Martin, E.
Two Agressions. Luginbuhl
Two Birds. Bates, T.
Two Children. Masson, A.
Two Children are Menaced by a
Nightingale. Ernst
Two Children with a Goat. Sarrazin
Two Circular Forms# Adams, R.
Two Dancing Figures. Chadwick
Two Dogs. Damer
Two Figures. Giacometti
Two Figures# Hepworth
Two Figures. Jancic
Two Figures. Leirner
Two Figures. Wotruba
Two Figures in Relation. Heiliger
2-5-A. Tucker
Two Forms, Hepworth
Two Forms. Minguzzi
Two Forms. Moore, H.
Two Forms on a Rod. Paolozzi
Two Forms with Sphere. Hepworth
Two Freemasons Contemplating a
Globe. Kandler
Two Friends. Kirchner, E. L.
Two Friends. Raftopoulou
Two Friends. Tombros
Two-Front Sculpture No. 2. Milani
Two Goats Resting. Roeder
Two Heads. Arp
Two Linked Figures. Armitage

Two Peasant Girls. Eickhoff
Two People. Cantre
Two-Piece Reclining Figure. Moore, H.
Two Pregnant Women. Leplae
Two Princesses
Schadow. Princesses Luise
and Frederike of Prussia
Two Royal Sisters
Schadow. Princesses Luise
and Frederike of Prussia
Two Seated Figures. Armitage
Two Seated Figures. Moore, H.
Two Shadows. Minguzzi
Two Sisters. Ehrlich
Two Sitting Women. Leinfellner
Two Slabs and Their Bars. Clarke
Two Standing Figures. Armitage
Two Swimmers. Malfray
Two Torsos. Appel
Two Victims of the Fiesta. Benlliure
Two Village Women. Kompanek
Two Warriors. Giorgi, B.
Two Watchers. Chadwick
Two Winged Figures. Chadwick
Two Women. Meyer-Fassold
Two Women. Tavernari
Two Women. Volwahsen
Two Women and a Child. Adams, R.
The "Tycho Brahe" Vase. Bang
Tycoon (Opus 54). Meadows
Tyers, Jonathan
Roubiliac. Jonathan Tyers,
bust
TYLER, William (English d 1801)
Samuel Vassall, bust 1766
GUN pl 28; WHINN pl 115B
UMBK
3rd Earl of Lichfield Monu-
ment, after Henry Keene
1776
ESD pl 127 EOkD
TYLER, William, and Robert
ASHTON
Dr. Martin Folkes Monument:
Effigy 1788
WHINN pl 115A ELWe
Tympani
Belgian--14th c. Childhood of
Christ
Burgundian. Christ with
Apostles
Burgundian--12th c. Pentecost
Dutch--12/13th c. Cloister
Tympanum
English--11th c. Tympanum:
Archangel Michael
English--12th c. Christ as
Lord of the Universe

--Christ Supported by
Angels
--Doorway, south
--Prior's Door
--Tympanum: Virgin and
Child
French--12th c. The Ascension
--Christ at Last Judgment
--Christ in Majesty
--Christ in Miracle of the
Pentecost
--Church Portal
--Church Tympanum
--Descent from the Cross
--Figures
--House Tympanum: Learning
--Last Judgment#
--Marriage at Cana
--Portal Tympanum#
--Porte Miegeville: Ascension
of Christ
--Tympanum#
French--13th c. Tympanum#
French--16th c. Tree of Jesse
Gerthner. South Porch
Tympanum
Gislebertus. Tympanum
Gothic-French. Tympanum
Statues, relief
Italian--12th c. Abbot
Leonatus Offering Church to
Pope Clement III
Panzer. Tympanum
Romanesque-English. Tympanum#
Romanesque-French. Christ
in Majesty
Romanesque-French. Christ in
Majesty, tympanum
Spanish--13th c. Puerta de
Sarmental
Tyrehoved. Starcke
TYROLESE See TIROLEAN
Tyrrell, Richard
Read. Admiral Richard
Tyrrell Monument
Tyson, Edward d 1708
Stanton, E. Dr. Edward
Tyson Monument
Tytgat. Edgard
Jespers, O. Edgard Tytgat,
head
Tzar Kolokol
Russian--18th c. King of
the Bells
USRH (Space Clasp). Luginbuhl
UBAC, Raoul (Belgian-French
1910-)

The Calvary 1958 58x41
BERCK 221 FPMa
Cut Slate 1958 slate; 26x27-1/4
CARNI-58:pl 43 FPMa
Relief slate; 29-1/2
READCON 227 GDuK
Slate, relief 1954
TRI 215
Torso 1960 slate
MARC pl 15 (col) FPMa
UBAVKIC, Petar (Yugoslav c 1850-
1910)
Vuk Karadzic, bust 1889
marble
BIH 29 YBN
UBELHERR, Joseph G. (1700-63)
See FEUCHTMAYER, J. M.
Ubereinander. Rogge
Uccelatore
Bologna. Bird Catcher
L'Uccello di Fuoco. Franchina
Udienza. Bandinelli, B.
UECKER, Gunther (German 1930-)
Lichtmedien im Raum 1961
700x300 cm
KUL pl 66 GDusR
Lichtregen 1966
KULN 197
Moving Light 1960
BURN 259 UNNWise
Nail Construction 1962 nails,
canvas, and wood; 24x21
CALA 221 IVG
Overgrowth, wall relief 1962
paint and nails on canvas
mounted on wood; 43-1/2x
43-1/2x4
ALBC-4:61 UNBuA
Sculpture 1965
KULN 159 GGelS
Transgression 1962
KULN 83
White Field (Weisse Muhle)
1964
LARM 376 ELT
--1964 nails on canvas over
wood; 6-1/2
NEW pl 287 UNNWise
Les Uelees. Lachat
Ugly Girl. Schwitters
UGO, Antonio (Italian 1870-)
Adolescent Boy (Pubescit)
marble
VEN-1:pl 78
Princess Cuto, bust marble
VEN-14:9
Ugolino

Carpeaux. Ugolino and his
children
Rodin, A. Ugolino
UGOLINO DA PISA See GHERARDESCA
UGOLINO DELLA GHERADESCA See
GHERADESCA
UGOLINO DI VIERI (Italian fl 1329-85)
Reliquary of the Holy Corporal
1338 gold and silver, enamels;
55 WHITJ pl 141A IOrC
UGOLINO DI VIERI, and VIVA DI
LANDO
Reliquary of S. Savino 2nd Q
14th c.
WHITJ pl 142 IOrC
UHER, Rudolf (Czech 1913-)
Combattimento 1965 wood
VEN-66:#158
Parallelen I 1966 iron; 76 cm
BER 17
Sculpture*
EXS 45
UHLMANN, Hans (German 1900-)
Amsterdamer Plastik 1965
chromium nickel steel;
98-3/4x128x98-3/8
NEW pl 291 GHaU
Berlin Opera House Sculpture
1961 steel chrome and
nickel, colored black;
65'7-3/8"
READCON 251 GB
Constellation 1956 ptd steel
MAI 288
Construction 1954 steel; 63
NNMMAG 177
Dancing Configuration
(Tanzerische Figuration)
1948 bronze
GERT 175
The Dialogue (Zweigesprach)
1947 bronze
GERT 174
Fetisch 1955 galvanized
steel; 38
CARNI-58:pl 69
Figuration 1951 iron; 78-3/4
RIT 208
Growth 1952 bronze; 67
ALBC-3:#69; CLEA 76;
TOW 71 UNBuA
Insectbird (Insektenvogel) 1948
aluminum
GERT 177; STA 214
Memorial (Widerstandsdenkmal)
1959
KUL 11 GLeA

Messingplastik 1956 brass,
partially painted; 146 cm
OST 107 GHaL
Metal Sculpture 1956 copper;
59
BERCK 161
--concert hall foyer 1954
DAM 135-36 GBCo
Plantlike Form (Pflanzliche
Form; Vegetal Form)
1952/53 bronze; 68
GERT 176; SCHAEF pl 119
Rondo 1958/59 brass; 59x
35-3/8x31-1/2
LARM 376; READCON 250;
TRI 207
Sculpture 1951
VEN-54:pl 92
--1951 steel; 17x32
MID pl 93
--1954 steel; 31-1/2x47x39
GIE 219
--Berlin Pavilion 1953
DAM 148 GMT
Steel Relief 1959 black, red
and white colored steel;
126x196-7/8
LARM 376; READCON 251
(col) GFreiUP
Steel Sculpture 1951 polychrome;
80
SCHAEF pl 118
--1951 steel; 78-3/4
MCCUR 277; NMAD 45
--1954 H: 34-5/8
NMAD 45
--1954 H: 78-3/4
NMAD 47
Suspended Sculpture, University
Library Staircase 1957 brass
and chrome steel: c 63x118x
59
TRI 248 GFreiUL
Wandplastik 1958
KUL 13 GMLa
Winged Insect 1954 steel;
23-5/8
NMAD 46
Ukranian Fiddler. Sturza
ULDERICO, Rusconi (Italian)
Adolescence plaster
VEN-10:pl 136
Ulenspiegl See Eulenspiegel
Ulrich, Duke d 1550
Schmid. Duke Ulrich Tomb
ULRICH VON ENSINGEN (German
fl 1392-1417)

St. Catherine, kneeling figure,
rear view c 1390
MULS pl 36 GS
Ultrameuble. Seligmann
ULTVEDT, Per Olof (Finnish 1927-)
Hommage a Christopher Pol-
hem 1965 wood construction;
17'6-1/4"x44'x10-5/8"
NEW pl 180
Mobile Sculpture LARM 392
Ulysses (Odysseus)
Early Christian. Ulysses and
the Sirens, sarcophagus
Gill, E. Odysseus Welcomed by
Nasicaa
Gisiger. Tombeau d'Ulysse
Hepworth. Torso (Ulysses)
Lienhard. Ulysse
Turnbull. Ulysses
Umberto See Humbert
L'Un l'Autre. Strebelle
Una Grand Liberta. Dalwood
UNCINI, Giuseppe (Italian 1929-)
Strutturaspazio 14 1966 alumi-
num and formica VEN-66:#117
Underwood, Jacynthe
Dobson. Jacynthe Underwood,
head
Underwood, John
Dobson. John Underwood,
head
UNDERWOOD, Leon (English 1890-)
African Madonna lignum
vitae with silver gilt; 48
DURS 72 SoJR
Family 1944 rosewood; 30
NEWTEB pl 59 -EEv
Music in Line 1944 Roman
stone; 24
NEWTEB pl 60
Negro Rhythm 1944 cut brass;
18
NEWTEB pl 61
The New Spirit 1933
UND 161
Runner
WILM 133
Torso
PAR-1:119
--1924 slate; 16
RAMS pl 56
Torso: The June of Youth
1937 bronze; 24x15x8-1/2
HAMM 55; ROTJB pl 36
TATEB-2:47 ELT (4975)
The Undrained Glass. Karsch, Joseph
Undressing. Priver
Undulating Threshhold. Arp

Unendliche Schiefe
Bill. Endless Ribbon
Unflattering Portrait
Boccioni. Antigrazioso
Unfolding of Spring. Bayes
Ungaretti, Giuseppi (Italian Poet
1888-)
Fazzini. Ungaretti, bust
UNGVARI, Lajos (Hungarian 1902-)
See KISFALUDI-STROBL
Unhuman Form. Bloc
Unicorns
French--16th c. Unicorns,
coat of arms
German--15th c. Unicorn Hunt
Muller, E. Einhorn
Netherlandish. Five Triumphs
Pisanello. Medal: Cecilia
Gonzaga
Union, relief sketch. Seitz
The Union Monument. Saloun
Unique Forms of Continuity in
Space. Boccioni
Unit of Three Equal Volumes. Bill
Unite d'Habitation. Le Corbusier
United States of America
Persico, E. L. Genius of
America
Unity of Habitation. Vigo
Universities. Teana
University of Paris
French--13th c. Seal of
University of Paris:
Madonna and Child;
Professors Teaching
The Unknown Political Prisoner, Inter-
national Sculpture Competition
(1953), sponsored by
Institute of Contemporary
Art, London. Grand Prize
Winner ($2500): Butler
Butler. Unknown Political
Prisoner
Consagra. Unknown Political
Prisoner
Dzamonja. Head of Unknown
Political Prisoner
Gilioli. Prayer and Force
(Priere et Force), Unknown
Political Prisoner Monu-
ment
Leygue. Monument to the Un-
known Political Prisoner
Minguzzi. The Unknown
Political Prisoner: Figure
Enmeshed
Pevsner. Monument for an
Unknown Political Prisoner

Rosselli, D. --Attrib. Vase
 with Carnations
Saracchi--Foll. Vase:
 Dragon, Milan
Sarpeneva. Vases, free-form
Solon. Vase, Minton Pate-sur-
 Pate
Thomiere. Urn Vase
Westmacott. The Waterloo
 Vase
Willumsen. Vase
Vaso Uccello. Meli
Vassall, Samuel
 Tyler. Samuel Vassall, bust
VASSALLETTI--FOLL
 Pulpit: Frieze of Sphinxes and
 Gryphons c 1230
 DECR pl 116 IRCe
VASSELLETUS, Petrus See also
 Angelo, Nicolo d'
 Crouching Boy Holding Basin,
 Easter Candlestick detail
 1263 marble
 DECR pl 117 IAnM
VASSE, Louis Claude (French 1716-72)
 See also Bouchardon, Edme
 Francois Quesnay, bust
 DEVI-2 BBR
VASSILAKIS, Takis See TAKIS
VATAGIN, V.
 Chimpanzee with its Young
 wood
 BLUC 256
Vater Rhein. Probst
Vauban, Marquise de (French
 Military Leader 1633-1707)
 Coysevox. Marechal de Vauban,
 bust
 Coysevox. Marechal de Vauban
 Tomb
 Ipousteguy. Vauban
Vaudemont, Count
 French--12th c. Count of
 Vaudemont and Wife, Anne
 of Lorraine
Vaulting
 French--16th c. Vaulting,
 jube
Vayu II. Knoop
VAZQUEZ, Juan Battista (Spanish)
 Seminary Madonna (Madonna
 del Seminario; Virgen de
 la Magdalena; Our Lady
 of the Remedies) 1565
 WHY 16 PrSC
Vazques de Arca, Martin d 1486
 Sebastian de Almonacid--Attrib.
 Martin Vazquez de Arco
 Tomb, figure detail

Veale, Douglas
 Batten. Sir Douglas Veale,
 head
VECCHI, Ferruccio (Italian 1894-)
 Precipice of Empire in the
 Mind of Il Duce (L'Impero
 Balza dalla Mente del
 Duce) bronze
 VEN-40:pl 17
VECCHIETTA (Lorenzo di Pietro)
 (Italian 1412-80)
 Mariano Sozzino the Elder,
 effigy head c 1460
 BUSR 84 IFMN
 Resurrection, relief 1472
 bronze
 MACL 177; POPR fig 97;
 SEY pl 83 UNNF
 Risen Christ bronze; 183 cm
 CHENSW 381; ENC 911;
 POPR pl 95 ISM
 St. Paul
 POPR fig 96 ISPa
 St. Peter 1458 marble
 SEY pl 85B ISPa
Vecchietti, Alessandro
 Spinelli. Alessandro
 Vecchietti, medal
VEDOVA, Emilio (Italian 1919-)
 Plurimi di Berlino 1964
 mixed media, arranged at
 will
 NEW col pl 50 (col) ELMa
 Plurimo N. 8. Feet on Top
 1962/63
 PEL 85 ELMa
VEDRES, Mark (Hungarian 1871-)
 Girl Fastening Sandal c 1904
 bronze;
 41 cm
 GAD 68 HBA
Vegetal Form
 Uhlmann. Plantlike Form
Vegetatif. Linck, W.
Vegetative Form III. Tihec
Vegetative Sculpture. Heiliger
Vegh, Sandor
 Hutchinson. Sandor Vegh
The Veil. Giordani
Veil Dancer
 Larche. Loie Fuller Dancing
Veiled Beggar Woman. Barlach
The Veiled Slave. Monti, R.
Veiled Woman. Monti, R.
VELA, Vincenzo (Italian 1820-91)
 Napoleon, seated figure
 CHASEH 475; POST-2:200
 FV

Spring 1857 marble
SELZJ 39 IPC
Tomb of Contessa d'Adda
1849 plaster; 371 cm;
base: 225x130 cm
LIC pl 113 SwLigV
Victims of Labour: Com-
memorative Monument to
Workers Killed During
Building of St. Gotthard
Tunnel c 1882 224x327 cm
LIC pl 112 SwLigV
VELASQUEZ, Christobal (Spanish)
The Annunciation, relief ptd
wood
WES pl 25 SpVN
VELDE, Henry van de (Belgian 1863-
1957)
Belt Buckel c 1898 silver,
amethyst
SELZPN 103 NoTNK
Candelabrum c 1902 silver
plates bronze; 21-3/4
LOWR 244; SELZPN 96
NoTNK
Portraits
Kolbe. Henry van de Velde,
head
VELLETRI, Silvio Calci da See
ALGARDI, Alessandro
Velo-Taureau. Stanzani
VENARD, Salome (French 1904-)
Fear 1953 dtone
MAI 291 FPM
La Vendange, fragment. Reymond, C.
Le Vendeur de Reves. Stanzani
VENDITTI, Antonio (Italian 1914-)
We Build the City (Si
Costruiscono le Citta),
relief
VEN-40:pl 41
Vendome Column. Percier and Fon-
taine
Vendramin, Andrea (Doge of Venice
d 1428)
Lombardo, Tullio. Vendramin
Monument
Venere# Signori
Venere Madrilena. Cristobal, J.
VENETIAN
Blackamoor 18th c. colored
marble
MU 208 (col) UMSpA
Cross of St. Theodore 15th c.
VAL IVAc
Decorative Panel: Animal
Motif 10/11th c. parian
marble; 56-1/4x21-1/4
BERL pl 186 GBFB (8)

Decorative Panel: Animal
Motif 11/12th c. Greek
marble; 35-3/8x17-3/4
BERL pl 185 GBFB (20)
Tunny Fish 17th c. glass
READM pl 41 ELV
Venice
Giacometti. Woman#
Sansovino, J. Allegory of
Venice
Venier, Antonio (Doge of Venice
1382-1400)
Dalle Masegne, J. Doge
Antonio Venier, kneeling
figure
Venier Monument. Sansovino, J.
Venite Adoramus. Bidder
Le Vent de la Vie. Chauvin, J.
Il Vento. Salvatore
Venus See Aphrodite
"Venus". Deare
Venus au Collier
Maillol. Venus with Necklace
Venus of Meudon. Arp
Venus of Victory.
Canova, A. Pauline Bonaparte
Borghese as Venus Victrix
Venus Victorious. Renoir
Venus with Necklace. Maillol
VERBANCK, Georges(Belgian 1881-)
Orpheus
GOR 72
VERBERCKT, Jacques (1704-71)
St. Anne Teaching the Virgin,
relief, Chapelle Royale
wood
GUIT 20 FV
Urn, detail 1742 marble; 70
CHAR-2:220 FPL
VERBRUGGEN, Hendrik Frans
(Flemish)
Pulpit 1699/1702
BAZINB 80 BMP
Pulpit; details 1699
GER pl 22B, pl 23 BBC
--Adam and Eve Banished
from Eden
MOLE 245; POST-2:46;
ROOSE 202
Verdi, Giuseppe (Italian Operatic
Composer 1813-1901)
Civiletti. Giuseppe Verdi
Monument
Grossoni. Verdi Memorial
Vere, Francis (English Soldier 1560-
1609)
English--17th c. Sir Francis
Vere Monument

VERGARA, Ignacio (Spanish 1715-76)
 Ornamental Gateway 1740/44
 white alabaster
 BAZINH 312; BAZINW
 404 (col); CIR 172; GUID
 242; JANSK 866; LARR
 331 SpVaA
VERHAEGEN, Theodore (Flemish)
 Good Shepherd Pulpit 1741
 GER pl 25; ROOSE 202
 BMJ
VERHELST, Agidius (German fl 1749)
 Choir Figures 1739/57
 BUSB 172 GSteinCh
VERHULST, Hans (Dutch 1921-)
 See also Esser
 Frieze
 BERCK 214 NArP
 Natural Disaster 1959 bronze;
 9-7/8x23-5/8
 TRI 214
VERHULST, Rombout (Dutch 1624-
 96)
 Admiral de Ruyter, head,
 effigy model 1676
 HAMF 118 NAR
 Admiral de Ruyter Monument
 1681
 GER pl 19A NAN
 Admiral van Ghert, head
 terracotta
 LARR 253 NH
 Johannes Polyander van
 Kerckhoven, effigy
 detail 1663
 GEL pl 99; ROS pl 207
 NLP
 Maria van Reygersberg(?),
 bust terracotta; 17-3/4
 BAZINB 85; BAZINW 398
 (col); RIJA pl 120 NAR
 Purchase of Butter
 CHASEH 400 NLW
 Relief Figure, Amsterdam
 Town Hall
 GEL pl 101 NATJ
 Venus c 1650 marble; 73-3/4
 x50
 HAMF 273; ROS pl 206A
 NATJ
 Willem van Lyere and Maria
 van Reygersberg Monument
 1663 marble; 137-3/4x63
 GER pl 19B; HAMF 274
 NKR
La Verite Meconnue. Dalou
Verkundigung an Maria See Mary,
 Virgin--Annunciation

VERLET, Charles Raoul (French)
 Guy de Maupassant, bust
 MARY pl 52 FPPM
 Maupassant Monument
 TAFTM 33
VERMARE, Andre (French)
 Pierrot
 TAFTM 41
Vermeylen, August
 Ianchelevici. August Vermeylen
La Verna Annunciation. Robbia, A.
 della
Vernal Figure. Brown, R.
VERNON, Hilary
 Heron*
 EXS 25
Vernon, Richard
 English--16th c. Sir Richard
 Vernon, effigy
Veronica, Saint
 Fernandez, G. St. Veronica
 Flemish--15th c. Geel
 Altarpiece
 French--14th c. St. Veronica
 Marton. Veronica
 Mochi. St. Veronica
Verrazano, Chiaro da
 Italian--17th c. Chiaro da
 Verrazano, bust
Verrazano, Giovanni da (Florentine
 Navigator 1485?-1528?)
 Italian--16th c. Giovanni da
 Verrazano
 Italian--17th c. Giovanni da
 Verrazano, bust
 Ximenes. Giovanni da
 Verrazano, bust
Verriest, Hugo (Poet)
 Lagae. Hugo Verriest, head
VERROCCHIO (Real Name: Andrea di
 Michele Cione)(Italian 1435-85)
 Adoration of the Shepherds,
 relief
 USNI 238 UDCN (A-37)
 Alexander the Great, relief
 marble
 NYWC pl 22 UNNStra
 Baptistry Altar, relief detail:
 Beheading of St. John the
 Baptist 1477/80 silver
 SEY pl 113 IFOp
 Boy with Dolphin (Child with
 Dolphin; Putto with Dolphin),
 fountain figure c 1470 bronze;
 27 (excl base)
 BODE 155; BR pl 6; BURC
 pl 27; GARDH 319; JAG 69;
 JANSH 341; JANSK 633;

MONT 162; POPR pl 78;
RAMS pl 14a; SEW 578-9;
SEY pl 114B; UPJH pl 111
IFV
Candlestick 1468 bronze; 157x
46 cm
DETD 20 NAR
Christ and St. Thomas (Christ
and Doubting Thomas;
Incredulity of St. Thomas),
east facade c 1465/83
bronze (in marble tabernacle
of c 1423 by Donatello);
niche: 9'9"
BODE 43; BOE pl 151;
JANSK 637; MACL 169;
MAR 52 (col); MOLE 144;
POPR fig 57; ROOS 113D
IFO
--Christ
MCCL pl 31; POPR pl 81;
SEY pl 116B
--St. Thomas
POPR pl 80; SEY pl 116A
--Tabernacolo di Mercanzia
HALE 52 (col)
Condottiere Bartolommeo
Colleoni, equest (monument
completed by Alessandro
Leopardi) 1481/88 bronze;
c 13'
AUES pl 17; BARSTOW
137; BROWF-3:17; BURC
pl 1; BUSR 146-7; CANK
81; CHASEH 317; CHENSN
331; CHENSW 379; CHRC
233; CRAVR 67; ENC 917;
FLEM 345; GARDH 320;
GAUM pl 39; GOMB 213;
JANSH 343; JANSK 637;
KO pl 79; LARR 116; MAR
9; MARQ 195; MONT 163;
MYBU 349; MYBS 46;
NEWTEM pl 122; POPR fig
89; ROOS 113H; SEY pl
117; ST 304; UPJ 264;
UPJH pl 110; WB-17:201;
WCO-3:48-9 IVGP
--Figure Detail
POPR pl 84; ROOS 113I
--Horse's Head
POPR pl 85
David 1465 bronze; c 48
BARG; BAZINH 208;
BAZINW 340 (col); BR pl
6; BUSR 71; CANK 19-21;
CHENSW 379; ENC 917;
FREEMR 112; KUH 78; MACL

166; MONT 384; MURRA
212; NMI 22-3; POPR pl
79; PUT 26; RAY 40; ROBB
373; ROOS 113F-G; SEY pl
118A; SFGM #65; STI 585;
UPJH pl 110; WOLFFA 13;
WOLFFC 9 IFBar
The Entombment, relief
terracotta
BODE 211 GBK
Florentine Lady (Bust of a
Lady; Lady with Bunch of
Flowers; Lady with Bunch
of Primroses) c 1478
marble; 24
BARG; MACL 167; MCCA
79; MONT 385; NEWTEM
pl 123; POPR pl 77;
READAS pl 161; ROOS
113E IFBar
Forteguerri Monument, sketch
MACL 168; POPR fig 66
ELV
--Christ
POPR pl 82-3 IPiC
--Faith
SEY pl 115A IPiC
--Virtue
POPR fig 67 IPiC
Giuliano de'Medici, bust c
1475 ptd terracotta;
24x26x11-1/8
POPR fig 82; SEY pl 115B;
SEYM 113-6; USNI 238;
USNP 158 UDCN (A-16)
Judith bronze; 16-7/8
DETT 71 UMiD (37.147)
Lorenzo de'Medici, bust
BARG IFBar
--c1470/88 terracotta;
25-7/8x23-1/4x12-7/8
CARTW 61; CHRC fig 163;
FLEM 357; KRA 45 (col);
PACHA 71; PANA-1:49;
READAS pl 163; RUS 61;
SEYM 117-9; USNK 186;
USNKP 404 UDCN (A-146)
Madonna and Child, relief in
architectural frame terra-
cotta
BARG; BODE 52; CHASEH
318; POPR pl 76; POST-1:
187; ROOS 114A IFBar
Medici Monument
POPR fig 69 IFLo
Piero de'Medici, bust
MCCA 96
IFBar

Putto on Globe (Putto Poised
on a Globe) c 1485 ptd
terracotta; 29-1/2x15
READAS pl 91; SEYM
111-12; SHAP pl 103;
USNI 237; USNP 159 UDCN
(A-17)
Reclining Putto c 1487/88
marble; 19-1/2
DEY 92-4; DEYE 58
UCSFDeY (49.5)
Resurrection, detail: Christ
LARR 108 IFBar
Sleeping Youth (Schlafender
Nackter Jungling) 1480
terracotta; 36x58 cm
BSC pl 82 GBS (112)
Virgin and Child, relief
c 1470 ptd and gilded
terracotta; 48x36
BR pl 5 (col); FAUL 474;
NCM 270; NMA pl 183 (col)
UNNMM (09.215)

VERROCCHIO--ATTRIB
Altar of the Sacrament,
detail: Candle Bearer
c 1461/62 marble
SEY pl 88 IFLo

VERROCCHOI--FOLL
Cosimo de'Medici, profile
bust 1460 marble; 36x32
cm
BSC pl 81 GBS (124)
Reclining Child bronze
NCM 270 UNNMM (09.155)

Versailles. Lazzaro

Versao. Sakki

VERSCHAFFELT, Pierre Anton von
(Pietro Flammingo) (Flemish
1710-98)
Group of Deer, Schlosspark,
Schwetzingen 18th c.
KULN 53
Pope Clement XII, bust
DEVI-2 BGMS
Self Portrait, detail marble
GOLDF pl 323 GSpP

Vertical (Absalom). Somaini

Vertical Breakthrough. Calo

Vertical Configuration. Partridge

Vertical Form(s)# Adams, R.

Vertical Forms. Hepworth

Vertical Pressure. Jacobsen, R.

Vertumnus
Delvaux. Vertumnus and
Pomona

VERVOORT, Michel See VOORT,
Michiel van der

Verwandlung II. Heiliger

Very Large Head. Paolozzi

VESELY, Ales (Czech 1935-)
Enigma IV--Bird's Nest
1965/66 metal assemblage;
233 cm
BER 73

Vespasian (First Flavian Roman
Emperor 9-79)
Italian--17th c. Vespasian,
bust#
Porta, G. B. della.
Vespasian, bust

Vesper Group See Jesus Christ--
Pieta

Vesperbild See Jesus Christ--
Pieta

Vessels
Belgian--17th c. Wine
Cistern with Dragon Handles
Fontana, O. Wine Cistern
French--13th c. Tithe Vessel
for Grain
Koch, B. Owl, vessel
Russian--15th c. Vessel,
supporting figures

A Vestal. Clodion

Vestal. Thorvaldsen

Vestal Virgin
Rosandic. La Pucelle

VEVER (French 20th c.)
Pendant 1900 enameled and
jeweled gold 4-1/2
GAF 161 FPDec

VEYSSET, Raymond (French 1913-)
Comborn FPDEC il 22
Prophetic Wind stone
MAI 292

VEZELAY, Paule (English 1893-)
Lines in Space No. 5 1936
BERCK 146

VEZIEN, M. (French)
The Passion, detail: One
Station of the Cross,
relief
AUM 59 EgAlC

Viana, Prince of
Lomme de Tournai. Prince of
Viana as a Mourner at Tomb
of Kings of Navarre

VIANEN, Adam van (Dutch 1569-1627)
Ewer c 1620 silver
LARR 319 NAR
Pedimented Drinking Bowl 1621
silver; 6-1/8
RIJA pl 125 NAR

VIANEN, Paulus van (Dutch fl 1555-
1614)

Diana and Actaeon, oval
 dish 1613 silver; 16-1/8
 x20-1/4
 BAZINB 103; GEL pl 131;
 RIJ 142-3; RIJA pl 124-24a
 NAR
Tankard 1608 jasper, gold
 mounts; 15-1/2
 ARTV pl 42 AVK
VIANI, Alberto (Italian 1906-)
Abstract Nude (Abstract Naakt)
 1949/53 marble; 52
 MID pl 100; STM BAM
Caryatid 1952 bronze
 MAI 293
--1952 bronze; 125x85x54 cm
 SCUL pl 46 IBuF
--1952 stucco; 68
 SCHAEF pl 103
Female Nude (Nudo Femminile)
 1952/65 bronze
 VEN-66:# 55
Female Torso (Woman's Torso)
 1945 marble
 SAL pl 88 (col)
--1945 marble; 39-3/4
 FEIN pl 120; MCCUR 275;
 RAMT pl 46; RIT 198
 UNNMMA
--1954 marble
 SAL pl 90 (col)
--1955 marble; 81
 MID pl 99 BAM
La Grande Madre 1966 bronze
 VEN-66:# 56
Homage to Michelangelo 1964
 bronze; 72
 ARTSI # 20 IRO
Male Torso (Torso Virile)
 1954 marble; 136 cm
 SCUL pl 47 IIO
Nude
 VEN-48:pl 59
--1945 marble; 39-3/4
 SOBYT pl 133 IFTr
--1947 plaster
 CARR 271 IVMe
--1952
 VEN-52:pl 27
--1956
 VEN-58:pl 14
--1958
 VEN-58:pl 15
Nudo al Sole 1956 plaster
 VEN-56:pl 23
Sculpture 1958 plaster
 SAL pl 87
--1960 plaster
 SAL pl 89

Seated Nude 1957
 BERCK 155
Sitting Nude (Nudo Seduto)
 1954 marble; 67x63
 GIE 266 UICGi
Torso
 ENC 919
--1945 marble
 GERT 243
--1953 stucco
 GERT 251
--1956/62 marble; 57-1/2
 READCON 188 IRO
Viani, Lorenzo
 Martini, A. Lorenzo Viani,
 Head
Vibrations No. 1. Chillada
Vibration Structure. Soto
Vibrations with Black Form. Soto
Vibrazione Spaziale. Jacobsen, R.
Vicenti, Colomba
 Cametti. Colomba Vicenti,
 bust
The Victim. Benlliure
Victoire, Mme.
 Houdon. Mme. Victoire, bust
The Victor. Arpesani
Victor. Batten
Victor, Saint
 German--10th c. Christ in
 Majesty Blessing St.
 Victor and St. Geron
Victor Emmanuel II (King of Italy
 1666-1732)
 Sacconi. Monument to
 Emmanuel II
Victor Emmanuel III (king of Italy
 1869-1947)
 Berti. Victor Emmanuel III,
 half figure
 Boldrin. King of Italy
 Drei. The King, head
Victoria (Queen of England 1819-1901)
 Behnes. Princess Victoria,
 bust
 Brock. Queen Victoria
 Memorial
 Cheverton. Queen Victoria,
 bust, after marble bust by
 Sir Francis Chantrey
 Fraikin. Queen Victoria, bust
 Gibson, J. Queen Victoria,
 head
 Gibson, J. Queen Victoria,
 between Justice and Mercy
 Gilbert, A. Queen Victoria
 Monument
 Thornycroft, T. and M. Queen
 Victoria on her Favorite
 Charger, Hamon

Wyon, W. Council Medal of
 Great Exhibition, obverse:
 Victoria and Albert, profile
 heads
Victory
 Ammanati. Victory
 Andreou. Victory
 Baroni. Monument to the
 Infantry: Victory
 Broggini. Victory with
 Clipped Wings
 Byzantine. Consular Solidus:
 Theodosius II; reverse:
 Victory Holding Cross
 Byzantine. A Victory, relief
 Crippa. Victory
 Early Christian. Constantius
 II, in Chariot Crowned by
 Victories, medal
 Early Christian. Winged
 Victory relief
 Fontana, L. Victory
 Franchina. Nike
 Italian--12th c. "Victory"
 Slaying a Bull, capital
 Lepage. Victory, pillar
 figure
 Meier-Denninghoff. Victory
 Michelangelo. Julius II Tomb:
 Victory
 Michelangelo. Victory
 Orlovski. Winged Victories,
 Moscow Gate
 Pilon. Allegory of Victory
 Poisson, P. Monument to
 the Dead: Victory
 Rubino, E. Victory
 Spiteris-Veropolou. Nike II
 Wittig. Nike
The Victory of Villetaneuse. Cesar
Vicunha, Mme.
 Rodin. Mme. Vicunha, bust
Vide, Maintenant le Vide
 Giacometti. Invisible Object
La Vieille Heaulmiere
 Rodin. La Belle Heaulmiere
VIEIRA, Jacinto (Portuguese)
 St. Gertrude c 1720/25 white
 ptd wood
 BAZINW 406 (col); LARR
 401; SANT pl 92 PoAr
VIEIRA, Mary (Brazilian-Swiss
 1927-)
 Equilibrium 1952/53 silver
 MAI 293
 Sculpture 1953
 BERCK 342

Sphere-Tension 1956/58
 aluminum; 12-5/8x25-1/4
 TRI 209 UICFl
--1958
 JOR-2:pl 289
--1958 12-1/2x25-1/2
 CARNI-61:#416 SwBMo
Surface-Espace 1956/58
 JOR-2:pl 288
Tension-Expansion 1953/53
 JOR-2:pl 304
--Rhythmes dans L'Espace
 1959 aluminum; 66-1/4x99-
 1/4
 GIE 220; READCON 244
 BAM
La Vienne. Cornet
VIENNESE
 Neptune, Hofburg Palace
 SUNA 24 UCSmH
Vierge au Poupon
 French--15th c. Vierge
 Bulliot
Vierge Bulliot. French--15th c.
Vierge de Paris
 French--14th c. Virgin of
 Paris
Vierge d'Olivet. French--16th c.
La Vierge Doree. French--13th c.
Vierge Noir
 French--12th c. Black Virgin
Vieuville, Charles de la d 1653
 Guerin. Duke Charles de la
 Vieuville
VIGARNY DE BORGONA, Felipe
 (Felipe Bigarny; Felipe de
 Bigarny; Philippe
 Biguerny) (French-Spanish
 c 1470-1543)
 Agony in the Garden, choir
 screen 1507/12
 BUSR 182 SpBC
 The Crucifixion
 WES pl 14 SpBC
 Fernando, kneeling effigy
 c 1516 wood
 SMIBS 126 (col) SpGC
 Isabella, kneeling effigy c 1516
 wood
 SMIBS 127 (col) SpGC
 Retablo
 WES pl 15 SpGR
 Royal Chapel Altar (High Altar)
 1521
 KUBS pl 67B SpGR
--Baptism of the Moors
 BUSR 200; SMIBS 121 (col)

--St. Matthew
 GOME 8 (col)
--Surrender of Granada: abu
 Abdula Leaving the Alham-
 bra
 SMIBS 122-3 (col)
--Surrender of Granada:
 Ferdinand and Isabella
 Riding to Receive Keys to
 Conquered Granada
 GOME pl 1; SMIBS 120
 (col); WES pl 16
 Trasaltar (Rear Wall High
 Altar): Christ Bearing
 the Cross 1498/1513
 BAZINW 356 (col) SpBC
VIGARNY DE BORGONA, Felipe, and
Diego de SILOE
 Main Altar, Du Guesclin
 Chapel 1523/26
 BAZINW 357 (col) SpBC
--Presentation in the Temple
 CIR 41 (col)
VIGELAND, Gustav (Norwegian
1869-1943)
 Abel
 HOF 64 NoO
 Bjornstjerne Bjornson, bust
 marble
 MARY pl 95
 Camilla Collett bronze
 MARY pl 96 NoO
 Female Torso
 LARM 233 NoONas
 Fountain for Christiania:
 Tree
 CHASEH 490
 Monolith (Central Obelisk;
 Frogner Park Column),
 and Figures c 1906 granite;
 16.76 m
 EXS 23; LIC pl 162; MAI
 294; SELZJ 162 NoOF
--sketches plaster, for
 granite
 MARY pl 91-95 NoOF
 Frogner Park Fountain, model;
 details
 AUM 116-17 NoOF
--Fountain Panels: Boys
 Wrestling; Boy with Eagle
 clay, for bronze
 MARY pl 87
--Death in a Tree c 1908
 bronze
 HAMP pl 46B
--Tree, with Figures bronze
 MARY 108

--Trees for Fountain bronze
 MARY pl 88-90
 Group
 ENC 921 NoOF
 Henrik Wergeland 1907 clay,
 for bronze
 RAMT pl 50 NoK
 Lovers
 EXS 31
VIGH, Tamas (Hungarian 1926-)
 Avicenna, medal 1953
 bronze; Dm: 11 cm
 GAD 132 HBA
 Beni Ferenczy, bust 1953
 terracotta; 30 cm
 GAD 123 HBA
Vigia IV. Chadwick
The Vigil. Martini, A.
VIGNE, Paul de (Belgian 1843-1901)
 Glorification of Art
 GOR 26 BBR
 Immortality 1884
 GOR 25; HAMF 123;
 ROOSE 292 BBR
 Jan Breydel, bust
 DEVI-2 BA
 Marnix van St. Aldegonde,
 head bronze; 18-1/2
 HAMF 280 BA
 Mercury Fountain, detail 1596/
 1602
 HAMF 124 GAu
Vigne, Pier delle (Minister to
 Frederick II)
 Italian--13th c. Pier delle
 Vigne, bust
VIGNEAU, Andre
 Mannequin
 MARTE pl 36
 Mannequin
 MARTE pl 39
VIGNOLA, Jacopo Barozzi da
 (Italian)
 Roman Table, with piers of
 fauns, satyrs and sirens
 marble and alabaster;
 37-3/4
 NM-8:8 UNNMM (58.57a-d)
VIGNOLI, Farpi (Italian 1907-)
 La Cordata, relief
 VEN-40:pl 40
VIGO, Nanda (Italian 1936-)
 Unity of Habitation, with
 painting by Enrico Castellani
 1966
 KULN 169
VIK, Ingelbrigt (Norwegian)
 Nude Girl bronze
 VEN-14:8

VILLAREALE, Valerio (Italian 1773-
 1854)
 Bacchante; detail marble; LS
 BARD pl 162, 165 BrSpA
Villars, Claude Louis Hector de
 (Marshal of France 1653-1734)
 Coustou, N. Duke de Villars
 Coysevox. Duc de Villars,
 bust
Villelia, Moises (Spanish 1928-)
 Sculpture 1965 reed and
 wire
 NEW pl 144
VILLENEUVE, Jacques (French)
 Rabelais Monument
 TAFTM 34
Villeroy, Duke of
 French--17th c. Duke of
 Villeroy Tomb
Villetaneuse Venus. Cesar
Villon, Francois (French Poet 1431-
 after 1462)
 Radaus. Villon, seated figure
 Seitz. Francois Villon#
VILT, Tibor (Hungarian 1905-)
 Head wood
 CASS 46
 Self Portrait, head 1940
 blei; 39 cm
 GAD 81 HBA
Vincent, Saint
 French--12th c. St. Vincent
 Protected by Two Eagles,
 capital
 Romanesque. Legend of St.
 Vincent, choir screen
 Spanish--11th c. St. Vincent
VINCENT, Julio
 Repose bronze
 CASS 89
Vincent Ferrera, Saint
 Brokoff, F. M. St. Vincent
 of Ferrera and St.
 Procopius
VINCI, Leonardo da See LEONARDO
 DA VINCI
VINCI, Pierino da See PIERINO DA
 VINCI
VINCKENBRINCK, A. (Dutch)
 Pulpit 1649
 GEL pl 109 NAN
VINCOTTE, Thomas (Belgian 1850-
 1925)
 Leopold II, bust
 GOR 54; ROOSE 297
 BBR
 Pediment 1850
 ROOSE 297 BBRP
Vinea Bust. Italian--13th c.

VINGERHUT, Heinrich (?)
 Chancel Corbel: Bearded Figure
 c 1230
 BOE pl 92 GGeL
VINGLER
 Owl
 EXS 25
Vintage See Wine Harvest and Wine-
 Making
Vintner's Column
 Bendle, J. G. St. Wenceslas,
 Vintner's Column /
Vintner's Madonna. German--15th c.
Violas
 German--16th c. Angel with
 Viola
Violante, Dona (Wife of Alfonso X of
 Spain)
 Spanish--13th c. Alphonso X
 and Dona Violante
Violets. Larche
Violins See Musicians and Musical
 Instruments
Virgen de las Cuevas
 Mesa. Virgin of the Grotto
Virgen de los Chuchillos. June,
 J. de
La Virgen do los Dolores See Mary,
 Virgin--Dolorosa
Virgil (Roman Poet 70-19 B. C.)
 Antelami. Virgil, seated
 figure
 Italian--13th c. Virgil, seated
 figure
 Syrlin, J., the Elder. Virgil,
 bust (Self portrait?)
VIRGILI, Giuseppe (Italian 1894-)
 Roman Manners (Civilta di
 Roma), relief
 VEN-38:pl 35
Virgin and Child c 1465/70
 MULS pl 94A
Virgin Hodighitria: "Guide"
 Byzantine. Virgin and Child
 (Virgin Hodighitria)
Virgin of Autun
 French--15th c. Vierge
 Bulliot
Virgin of Sorrows. Mena
Virgin of the Grotto. Mesa
Virgin of the Macerena. Roldan, L.
"Virginian" See "Black Boy"
Virginity. Corradini
Virtue Overcoming Vice
 Stevens. Wellington Memorial
Virtue Vanquishing Vice. Bologna
Virtues and Vices See also names, as
 Charity; Cowardice; Faith;
 Hope; Lust; Prudence; Strength

Agostino di Duccio. Facade;
 Virtue
Amadeo. Colleoni Chapel
 Facade; Virtue
Andrea da Fiesole. Monument
 of King Ladislas: Virtues
Bacon, J. Ashby Monument,
 relief, with Justice and
 Charity
Banks. Mrs. Petrie Monument,
 attended by Faith, Hope,
 and Charity
Braun, M. B. Virtues and
 Vices: Despair, Light-
 heartedness, Charity
Cellini. Virtue Overcoming
 Vice
Delvaux. Theological Virtues
Donatello, and Michelozzo.
 Brancacci Monument;
 detail: Virtue
English--13th c. Judgment
 Porch: Virtues
English--14th c. Virtue,
 fragment
French--12th c. Acanthus,
 Virtues Trampling on
 Vices, west door
--Archivolts; detail: Virtues
 and Vices
--Choir Capital: Virtues
 and Vices
French--13th c. Porte Mere
 Dieu
--The Virtues, tympanum
--Virtues Trampling Vices
French--16th c. Virtue, relief
German--11th c. Clement II
 Tomb: Virtues: Moderation;
 Strength
Guardi. Faith and Hope
Netherlandish. Five Triumphs
Pellegrino. Virtues, Easter
 Candlestick
Pisano, G. Pisa Pulpit:
 Charity and Four Cardinal
 Virtues
Pisano, Niccolo. Siena Pulpit:
 A Virtue
Pollaiuolo, A. and P. Sixtus
 IV Monument: 2 Virtues
Porta, Guglielmo. Paul III
 Tomb, with Prudence and
 Wisdom
Quercia. Fonte Gaia: Virtue
Rizzo. Doge Niccolo Trono
 Monument
Verrocchio. Forteguerri Monu-
 ment: Virtue
Vries. Virtue and Vice

Virtues Trampling Vices
 Master Requinus. Door
Vis. Witschi
VISCARDI, Girolamo (Florentine
 fl 1500) and ASSISTANTS
 Duke of Orleans Tomb 1502
 BLUA pl 12A FPDe
VISCHER, Georg (German 1528-92)
 Inkstand, with Vanitas (Tinten-
 fass mit "Vanitas") 1547
 bronze; 17.6 cm
 BSC pl 106 GBS (810)
VISCHER, Hans, the Elder (German
 1489-1550)
 Apollo Fountain 1532
 BUSR 193 GNR
 Escutcheon with Centaur Battle
 (Wappen mit Kentaurenkampf),
 Nuremberg Rathaus Door
 1540 bronze
 MUL 8 FMontroM
VISCHER, Hans, the Younger
 Combat Scene, relief c 1516
 bronze
 MUL 9 FMontroM
VISCHER, Hermann, the Younger
 (German 1486-1517)
 Cardinal Friedrich Kasimir
 Jagello Tomb 1510 bronze
 MUL 3 PCC
VISCHER, Peter, the Elder (German
 1460-1529)
 Archbishop Ernst von Sachsen,
 effigy 1495 bronze
 MULS pl 184 GMagC
 Branch-Breaker 1490 bronze
 MULS pl 185 GMBN
 King Arthur, Emperor
 Maximilian Tomb 1513 bronze;
 192.8 cm
 BARSTOW 172; BAZINW
 355 (col); BUSR 192; ENC
 924; JANSK 738; LARR 151;
 MARQ 232; MUL 36; RAY
 46; ROOS 166B; SIN 270;
 ST 328; VEY 139 AIH
 King Theodorich, Emperor
 Maximilian Tomb 1513
 bronze; 191.4 cm
 BAZINW 355 (col); MUL 37
 AIH
 Neptune, seated figure 1st Q
 16th c. bronze
 INTA-1:99
 Nuremberg Madonna 16th c.
 ptd wood; 60
 STI 451 GNG
 Peter Salomon, relief bronze
 STA 166 PoCr

St. Paul, St. Sebald Shrine
1507/12
BAZINH 272; BAZINW 354
(col) GNS
Self Portrait, relief profile,
medallion c 1510 lead
GOLDF pl 56 FPMe
VISCHER, Peter, and Gilg
SESSELSCHREIBER
Maximilian Cenotaph: King
Arthur; Ferdinand IV of
Portugal; Ernst der
Eiserne; Theodoric the
Great
BAZINW 354 (col) AIH
VISCHER, Peter, the Elder; Peter
VISCHER, the Younger;
Hermann VISCHER, the
Younger
St. Sebaldus Tomb (Reliquary
of St. Sebaldus; Shrine
of St. Sebaldus) 1508/19
bronze; L: 257; W: 137 cm
CHASEH 358; LOH 187;
MAR 112; MUL 39; POST-1:
250; PRAEG 317; SIN 264
GNS
--Canopy bronze; figures: 110
BUSR 191
--Hercules (ascribed to
Hermann Vischer, the
Younger) bronze; 10-1/4
BUSR 190; MOLE 92
--Self Portrait of Peter
Vischer, the Elder
GOLDF pl 55
Shrine of St. Sebald, Nurem-
berg (cast)
RAD 404 UMoSL
VISCHER, Peter, the Elder--FOLL
Striding Youth (Schreitender
Jungling)
LIL 156 GMB
VISCHER, Peter, the Younger (Ger-
man 1487-1528)
Child on a Dolphin c 1515
bronze; 5-3/4
SHAP 104 UDCN
Eve c 1500 bronze
CHENSW 397 URPD
Orpheus and Eurydice, plaque
1514 bronze; 16.2 cm
BSC pl 107 GBS (1464)
--1515/20 bronze; 16.3x11.3
cm
MUL 35; ST 328 GHKG
--1519 bronze; 8x5-21/32
CARTW 94; KRA 88 (col);
SHAP pl 42 UDCN (A-709.
431B)

St. Sebaldus Tomb:
Candelabra: Female Figure
(Leuchter Weibchen)
bronze; 25 cm
MUL 42 GNS
--Miracle of the Icicles
(Eiszapfenwunder), relief
bronze; 35 cm
MUL 41
--Music bronze; B: 23 cm
MUL 40
Two Prophets 1508/19 bronze;
ea: 28 cm
KO pl 70; MUL 38 GNS
VISCHER, Peter, the Younger--FOLL
Adam and Eve, Nuremberg
c 1520 bronze
CLE 106 UOC1A (61.29)
VISCHER FAMILY--FOLL
St. Martin, equest 1525 bronze;
65 cm
MUL 44 GMBN
Visconti, Bernalbo (Duke of Milan 1323-
85)
Bonino da Campione. Bernalbo
Visconti Monument, equest
Visconti, Filippo Maria (Duke of
Milan)
Amadeo. Filippo Maria Vis-
conti, bust
Pisanello. Medal: Filippo
Maria Visconti
Visconti, Gian Galeazzo (1351-1402)
Romano, G. C. Gian Galeazzo
Visconti Monument
VISEUX, Claude (French 1927-)
Petrified Crowd 1959 bronze;
27-5/8x29-1/2
SELZJ 8; TRI 120 FPDB
Sculpture*
EXS 47
VISIGOTH
Capital: Human and Animal
Figures, with Floral Scrolls
7th c.
GUID 29 SpZP
Crown of Guarrazar 7th c.
jeweled gold
KIDS 18; WATT 147 FPC1
Crown of King Suintila, retable
detail 7th c. jeweled gold
SMIBS 56 (col) SpMaA
Eagle Brooches, Estamadura
6th c. gilt bronze and gems
CHRC fig 65; ENC col pl 23
(col) UMdBW
Pilaster
SANT pl 57 PoLM
The Vision. Maltwood
Vision. Scheibe

Vision of St. Theresa
 Bernini, G. L. Ecstacy of
 St. Theresa
THE VISITATION MASTER (Rheims)
 Angel of the Annunciation
 (showing "Sourire de Reims"),
 central west portal, right
 1250/60
 AUBA 77 (col) FRhC
 Visitation of Mary and
 Elizabeth, central west
 portal, right; Mary, head
 detail before 1250
 AUBS 73 (col), 75 (col)
Visiting the Sick. Buglione, S. di M.
VISSER, Carel Nicolaas (Dutch
 1928-)
 Bird Lovers 1954 iron; 19-3/4
 GIE 263 NAS
 8 Beams 1965 iron; L: 118-1/8
 NEW pl 165 NOK
 Fugue 1957 iron; 11-3/4
 READCON 210 UNNP
 Hugo Ball 1960 50.4x20
 CARNI-61:#417
 Joy 1958 galvanized iron
 MAI 295
 Twins 1958 iron; 67x49-1/4x
 49-1/4
 SEAA 154
Visual Dynamics Costa, T.
Visualization of the Invisible.
 Kemeny
Vitellius (Roman Emperor 15-69)
 Italian--17th c. Vitellius, bust
 Porta, G. B. della.
 Vitellius, bust
Vitesses Involuntaires. Kemeny
VITRY, Jean de (Swiss)
 Choir Stall Back 15th c.
 GAF 335 FStCl
Vitte, S. Iu.
 Troubetzkoy. S. Iu Vitte
VITTORIA, Alessandro (Italian
 1525-1608)
 Altar; detail: St. Sebastian
 marble; Sebastian: 171 cm
 POPRB fig 109 IVFr
 Altar of the Luganegheri;
 details: St. Roch; St.
 Sebastian
 POPRB fig 110, pl 125,
 pl 127 IVSa
 Andiron, surmounted by
 Mercury, Venetian bronze;
 36-1/8
 NMA 174 UNNMM
 (41.100.91a, b)

Annunciation, relief
 KUH 79 UICA
Apollo 1560 bronze; 28.9 cm
 BSC pl 90 GBS (1817)
Doge Niccolo da Ponte, bust
 c 1585 terracotta; 39
 MURA 167 (col); POPRB
 fig 117 IVSe
Feast of the Gods, plaque
 bronze
 CLE 99 UOC1A (52.464)
Jacopo Contarini, bust
 terracotta; 28x20-7/8
 USNK 198; USNKP 434 UDCN
 (A-60)
Jacopo Sansovino, bust
 LARR 144 IVSe
Neptune Taming Sea Horse
 16th c. bronze; 19-1/2
 ASHS pl 26; MOLE 169;
 POPRB pl 131; VICF 62
 ELV (A.99-1910)
Ottavio Grimani, bust 1571/76
 marble; 81 cm
 BSC pl 91 GBS (303)
Pietro Aretino, medal bronze;
 Dm: 58 mm
 DETD 136 UCStbMo
St. Jerome marble; 169 cm
 POPRB pl 129 IVGP
--16th c. marble
 KO pl 89 IVSa
--before 1568 marble; 75-1/2
 HAUS pl 282; MAR 164;
 POPRB pl 128 IVMF
St. John the Baptist bronze;
 71 cm
 POPRB pl 130 IVFr
St. Sebastian bronze
 VALE 89 UNNMM
--c 1575 bronze; 21-1/2
 DETD 129 UCLCM
Tommaso Rangone, bust bronze;
 81 cm
 POPRB pl 124 IVAt
Venetian Lady, bust terra-
 cotta; 31-7/8x23-1/4
 USNKP 432 UDCN (K-326)
Venetian Nobleman, bust c
 1590 terracotta; 28
 TOR 131 CTRO (957.202)
Young Knight, bust 1590/1600
 terracotta; 35-7/8x24x
 12-3/4
 KRA 131; USNKP 433 UDCN
 (A-1666; K-282)
Vittoria del Piape. Minerbi
Vittoria fra I Venti. Bortolotti

Vittorio, Saint
 Federighi. S. Vittorio
VITULLO, Sesostris (Argentine-
 French 1899-1953)
 Dead Christ, head 1949
 wood; 16-1/2x47x16-1/2
 SEAA 155 FMontrV
 Sculpture 1951 stone
 BERCK 124; MAI 295
Vitus, Saint
 Brokoff, M. J. J. St. Vitus#
 Parler. St. Vitus between
 Charles IV and Wenzel IV
 Quitainer. St. Vitus
VIVA DI LANDO (Italian) See
 UGOLINO DI VIERI
Viva Maria. Davidson
Vivaldi, Antonio (Italian Violinist
 1680?-1743)
 Borsos. Vivaldi, medal
VIVARELLI, Carlo (Swiss)
 Metal relief, Auditorium
 DAM 144 SwZA
VIVARINI, Antonio (Italian c 1415-76);
 and GIOVANNI D'ALEMAGNA
 Altarpiece: St. Sebina between
 St. Jerome and St. Egerius
 1443 11'5"x6'1"
 MURA 121 (col) IVZ
VIVES, Mario
 Three Figures* terracotta
 MARTE pl 34
 Woman and Child* terracotta
 MARTE pl 34
VLAD, Jon (Ion Vlad) (Rumanian
 1920-)
 Composer Glinka, bust 1953
 plaster
 VEN-54:pl 108 RBC
 The Winds (I Venti) 1962
 cement
 VEN-62:pl 178
VLAVIANOS, Nikos (Greek)
 Escultura*
 SAO-6
VLEESHOUERS, Lode (Belgian 1899-)
 Male Head*
 GOR 82
VLUTEN, Guillaume (French fl 1450)
 Anne de Bourgogne, Duchesse
 de Bedford, effigy c 1442
 marble
 LOUM 46 FPL (535)
Vochieri Tomb
 Bistolfi. Brides of Death,
 relief
VOEGELI, Walter (Swiss 1929-)
 Colonne 1958
 JOR-2:pl 287

Relief 1956
 JOR-2:pl 285
--1957
 JOR-2:pl 286
VOGEL, Karel (Czech-English
 1897-)
 Boy 1954 bronze; 65
 LOND-5:#40 ELHa
Voghera Monstrance. Italian--15th c.
Voice. Kneale
Voices. Mirko
VOIMER (French)
 Peace Fountain 1806
 GAF 135 FP
Voisins, Comtess Gilbert de
 Despiau. Comtesse Gilbert de
 Voisins, head
Vojan, Eduard
 Stursa. Eduard Vojan, bust
Vojnovic, Ivo (Yugoslav Dramatist)
 Spaniel. Ivo Vognovic, bust
Volante. Couzijn
Volder Monument. Minne, G.
VOLKERLING, Frederick
 The Valkyrie bronze
 MARY pl 135 GL
Volkerschlacht Monument. Metzner
VOLL, Christoph (German 1897-)
 Frauenkopf 1930 granite; LS
 HENT 82 GMaM
 Junger Arbeiter 1928 bronze;
 90 cm
 HENT 80
 Madchen 1923 Eichenholz;
 80 cm
 HENT 82
Volpato, Giovanni (Italian Engraver
 and Antiquarian)
 Canova. Giovanni Volpato
 Monument
Volpi di Misurata (Italian Statesman
 and Financier 1877-1947)
 Berti. Count Volpi di
 Misurata, half figure
 Jerace, V. Count Giuseppe
 Volpi di Misurata, bust
Volsung Saga
 Norwegian--13th c. Tales of
 Sigurd the Dragonkiller
 Viking. Memorial Picture
 Stone: Saga Details
Voltaire (French Writer 1694-1778)
 English--18th c. Voltaire
 Houdon. Voltaire#
 Lejeune. Voltaire with Laurel
 Crown, bust
 Lemoyne. Voltaire, bust
Volte per gli Uomini. Serrano

VOLTEN, Andre (Dutch 1925-)
 Advertisement Sign 1964
 iron; 98-1/2
 NEW pl 163 NRiI
 Architectonic Construction
 1958 metal; 25-1/4
 READCON 206 NOK
 Construction 1956 iron; 87x
 24x16-1/2
 CARNI-58:pl 83
 --1958 galvanized steel
 LARM 361; MAI 296 NAS
 Construction with Crystal 1956
 steel; 63
 TRI 203
 Sculpture with Sphere (Plastico
 con Sfera) 1954 iron with
 plastic
 VEN-56:pl 130
VOLTERRA, Daniele da (real Name:
 Daniele da Ricciarelli)
 (Italian 1519-66)
 Michelangelo, bust
 BEREP 176; MACL 219
 IFMN
VOLTI (Volti Antoniucci) (Italian
 1915-)
 Harmony 1952 bronze
 MAI 297
 Nu
 FPDEC il 23
 Sleeping Nude 1960 bronze
 SELZJ 5 FPCha
Volume Construction. Vantongerloo
Volume Virtuel. Tinguely
Voluptas
 German--14th c. Prince of the
 World as Seducer, and
 Voluptas
Volupte. Bouraine
Voluptuousness. Charpentier, F.
Volvic Stone. Lipsi
VOLVINUS (Italian)
 Self Portrait, back of Altar
 Frontal c 835 beaten gold
 GOLDF 14 IMA
VOLWAHSEN, Herbert
 Scouting Woman (Spahende)
 1949 bronze
 GERT 207
 Seated Youth (Sitzender
 Jungling) 1949 bronze
 GERT 206
 Two Women (Zwei Frauen)
 1952 stucco
 GERT 208
VON GRAEVENITZ, Gerhard (German
 1934-)

Moving Disks 1965 iron and
 wood; Dm: 47-1/4
 SELZP 35
VOORT, Michel van der (Michel
 van der Voord; Michal Vervoort)
 (Flemish 1667-1737)
 High Altar Details: Seraphim
 Heads; St. Sulpitius
 DEVI-2 BDieS
 Madonna c 1720 oak; 37-1/2
 KUHN pl 58-59 UMCB
 (1950.460)
 Monument of Bishop de
 Precipiano 1709
 GER pl 26-27 BMC
 Pulpit 1713
 CHRC fig 200 BAC
 --1721/23 wood
 GER pl 24; HAMF 276;
 LARR 247 BMC
 Samson and the Lion 1706
 terracotta
 BUSB 136 ELV
VOORT, Michiel van der, and
 J. F. VAN GEEL
 Pulpit: Conversion of St.
 Norbert (work completed
 by J. F. Van Geel) 1723
 BAZINW 415 (col) BMC
VOROS, Bell
 Figure*
 MARTE pl 49
VOROVEC, Stephan (Czech)
 Holy Trinity 1719
 STECH pl 189 CzM
VOS, T. A. (Dutch)
 Protection, cottage corner
 figure
 AUM 112
Voussoirs
 English--12th c. Voussoirs#
 French--12th c. Voussoirs
VOUTCHETICH (Russian)
 Warrior Defending Orphan*
 EXS 31
Vox-Box. Tilson
VOYEZ, John
 "Fair Hebe" Jug 1788 pottery
 CON-4:pl 42 ELV
VOYS, Jacques (Flemish)
 Jousting Helmet 15th c. iron;
 17-5/16
 DETF 313 BBRA (57)
VOZNIAK, Jaroslav (Czech 1933-)
 Standarte 1965 textile, doll,
 gloves, jewels; 168x85 cm
 BER 69

Vratislav of Mitrovice
 Brokoff, F. M. Vratislav of
 Mitrovice Tomb
VRIENDT, Cornelis (Cornelis de
 Floris) (Belgian 1514-75)
 Choir Screen, detail
 CHASEH 355 BTouC
 Tabernacle
 ROOSE 153 BZ
 Tabernacle: Tower stone;
 100'
 ROOSE 152 BLeL
VRIES, Adriaen de (Dutch 1560-1627)
 Allegorical Figures (copy)
 1624/26 bronze
 STECH pl 2 CzPW
 Battle with Centaur, garden
 1624/26
 BUSB 51 CzPW
 Font-Supporting Figure 1613/15
 BUSB 50 GBu
 Garden Figures 1626/27 bronze
 STECH col pl 1 (col) CzPW
 Hebe bronze; 30
 DETT 130 UMiD (59.123)
 Hercules, head detail 1624/26
 bronze
 STECH pl 3, 21 CzPP
 Hercules Fountain (executed by
 Wolfgang Niedhardt) 1602
 bronze
 MAR 124 (col); MUL 82, 83;
 POST-1:258 GAuMax
 --Naiad bronze; LS
 KO pl 86; NEWTEM pl 136
 --Woman Washing Foot
 BAZINW 370 (col)
 Horse 1610 bronze
 STECH pl 1 CzPA
 Mausoleum of Count Ernst von
 Schaumberg after 1615
 BUSB 49 GStad
 Mercury and Pandora, Prague
 1593 bronze; 98
 CHAR-2:86 FPL
 Mercury and Psyche
 HAUS pl 272; LARR 252;
 MACL 246; PANB 20 FPL
 --bronze; 23-3/8
 HUNT pl 11 UCSmH
 Nude Runner 1600 bronze; 11
 COOP 143 UNNUn
 Nymph 1600/10 bronze; 41 cm
 MUL 81 GBrU
 Rudolf II, bust 1609 bronze;
 28x20-3/4
 VICF 66 ELV (6920-1860)

--half figure 1603 bronze; 44
 ARTV pl 36; MUL 78 AVK
Samson Slaying the Philistine
 1612 bronze; 28
 SCON 128 ScEN (No. 137)
Seated Figure 1600/25 lead;
 16-1/2
 HAMF 267 ELV
Triton
 AGARC 83 UNNMM
Victory of Rudolf II over the
 Turks, relief 1609 bronze;
 28
 BAZINW 371 (col) AVH
Virtue and Vice 1610 bronze;
 30-7/16x13-11/16x12-1/2
 CHRP 204; SEYM 147, 149-
 51; SHAP pl 54 UDCN
VRUBEL, Mikhail (Russain 1856-1910)
 Ceramic Stove, Abramtsevo
 pottery c 1899
 GRAYR pl 9 RuMA
 Two Figures 1896
 GABO 166
VUCHETICH, Evgeniy V. (Russian
 1908-)
 Let us Beat Swords into
 Ploughshares, north Rose
 Garden bronze; 108x29x82
 BAA front, 33, pl 15
 UNNUN
VUILLEUMIER, Willy
 Pelican 1953/54 plaster;
 103 cm
 JOR-1:pl 33
Vulcan See Haphaestus
Vulic, Nikola
 Stojanovic. Nikola Vulic, head
Vultures
 Costa, Joseph Mendes da.
 Vulture
 Kandler. Meissen King Vulture
VUOLVINIO
 Golden Altar, detail of
 equest panel 9th c.
 embossed gold
 BAZINH 131 IMA
Vuoti e Pieni Astratti di Una Testa
 Boccioni. Abstract Voids and
 Solids of a Head

W., Francoise
 Rousseau, V. Francoise W.,
 bust
WACKERLE, Joseph (German 1880-)
 Bogenschutze 1930 bronze
 HENT 83

Decorative Figure, Steamer
"Columbus" wood
AUM 4
Decorative Panel
AUM 17 GMSH
Figures, house decoration
TAFTM 63 GB
Peasant Woman porcelain
TAFTM 63
Pillar Relief
AUM 4 GMSt
Youth and Deer wood
PAR-2:68
Waddar Tribe, India
Milward. Waddar Man, head
The Wader. Aaltonen
Wading Woman. Aaltonen
Wager, Admiral
Rysbrack. Admiral Wager
Monument
Wager. Brekker
WAGNER, Johann Peter Alexander
(German 1730-1809)
Autumn (Der Herbst) red
sandstone; 114 cm
BERLE pl 93 GBSBe (7978)
Flora, staircase figure after
1771
HELM pl 164 GWuV
Freedom
LIL 232 GMB
Putti
POST-2:65 GWuPG
Spring (Der Fruhling) red
sandstone; 110 cm
BERLEK pl 48 GBSBe
(7977)
WAGNER, Josef (Czech)
Poetry
CASS 112
Spring stone
VEN-48:pl 65
WAGNER, Siegfried (German 1874-
1952)
Beggar in Jerusalem ptd
wood; 1/2 LS
SCHW pl 12
WAGNER, Viet (German fl 1492-98)
St. Peter, Mount of Olives
Group 1498
MULS pl 167B FStrMu
Wagons
Austrian--19th c. Austrian
Spirit Wagon
WAIN-HOBSON, Douglas (English)
Angel birch; 42
NORM 48 -EBar
Ave Maria 1946 birch; 30
DURS 68

Saint, head elm; LS
NORM 92
Waiting for his Innings. Durham
Waiting Woman. Jespers, O.
WALDBERG, Isabelle (Swiss-French
1917-)
Flesh of a Tree 1957 plaster
MAI 298
Followed by
BERCK 344
Waldeck-Rousseau, Pierre Marie
Rene (French Statesman
1846-1904)
Marqueste. Waldeck-Rousseau
Monument
Walden, Lord Howard de
Rodin. Lord Howard de
Walden, bust
The Walk. Ruggeri
WALKER, Arthur (English 1861-);
and J. BELL; and J. H.
FOLEY
Crimean Memorial Group
(Guards Memorial) bronze
figures, granite pedestal;
38'
GLE 19 ELWat
The Walkers. Brignoni
Walkers. Osman
"Walking". Hartung
Walking Group. Armitage
Walking Lion. Barye
Walking Man
Giacometti. Man Walking
The Walking Man. Rodin
Walking Man and Child. Brown, R.
Walking Woman. Guerrisi
WALL, Bernard (English)
Sculpture No. 6 1963 ptd
steel; 20
ARTSS #50
WALL, Brian (English 1931-)
Rising Form 1962 welded
steel; 132
PRIV 255
Sculpture IX 1963 steel ptd
black; 82
ARTSB-64:pl 5
Six Circles 1966 ptd steel;
5x15x5'
LOND-7:#41 ELGro
Standing Form 1962 steel ptd
black; 24
SFMB #128
Three To Go 1962 iron ptd
black; 42
READCO pl 12a PoLG
Untitled Grey 1964 mild steel;
80 ARTSB-65:pl 2

Wall. Tinguely
Wall Brackets
 French--18th c. Louis XV Wall
 Bracket
Wall Decoration See also Screens and
 Lattices
 Aumonier, E. Panels
 Bayes. Theatre Frieze
 Bentham. Steamship Office
 Panels
 Binguet. Filling Details,
 Private residence
 Bjerg. Two Decorative Panels
 Bloc. Stained Glass Chapel
 Wall
 Bossi, Antonio. White Salon
 Plaster Work Decoration
 Bouchardon. Ambassador's
 Room Decorative Panel
 Brignoni. Carved Mural
 Brouwer. Cinema Wall Panel
 Bucher. Wandgestaltung
 Byzantine. Foliate Motif
 Cameron. Green Dining Room
 Cappello. Wall Relief
 Carcani. Decorative Figures
 Cortona. Stuccoes, Sala di
 Apollo
 Coysevox and Charles Le Brun.
 Palace of Versailles, Salon
 de la Guerre, Wall
 Decoration
 De Laak. Wall Relief
 Domenico di Paris. Ante-
 camera Decoration
 Dutch--18th c. Decorative
 Woodwork
 Early Christian. Open Work
 Slabs
 Early Christian. Slabs:
 Cross, Geometric, and
 Vine and Peacock Motifs
 Early Christian. Wall Orna-
 mentation and Ornaments
 Edwin. Corridor Panel
 English. Modelled Ornament
 English--14th c. Gatehouse
 Detail: Armorial Panel
 --Lady Chapel Detail
 English--17th c. Frieze,
 bedroom
 Evans, D. Panel
 Fanzago. Cloisters, detail
 Fontana, L. Bar Glass
 Mosaic
 French--16th c. Porch,
 north
 French--18th c. Carved Panel:
 Fruit with Foliage Swirls

 Giacomo da Campione. Relief
 over North Door of Sacristy
 Gibbons. Wall Detail
 Gothic-Italian. Wall Decora-
 tion: Floral Motif
 Goujon. Wall Decoration:
 Figures
 Hajek. Wandgestaltung
 Huet. Panel
 Italian. Intarsia Panel:
 Classical Foliage
 Italian. Renaissance Arabesque
 Italian--10/11th c. Palazzo
 Facade Panel: Animal
 Motif#
 Janniot. Bas Relief
 Jespers, O. Relief
 Jewish--14th c. Mudejar Wall
 Decoration
 Jones, Arne. Primary School,
 wall relief
 Jones, Arne. School Entrance
 Relief
 Jung. Ornamental Church
 Panels
 Kennington. Decorative Panels
 Lamberti, Niccolo di Pietro.
 Hercules-Fortitude,
 decoration
 Lardera, B. Wall Sculpture
 Lohse. Wall Relief
 Martin, R. Wall Decoration
 Mazzoni. Stucco Decoration
 of Salon
 Neumann. Wall Decoration
 Palliser. Chancel Carving
 Pehrson. High School Wall
 Relief
 Pernevi. House Exterior Wall
 Sculpture
 Pledge, C. T. Wood Paneling
 Poisson. La Commerce
 Maritime, dining room wall
 decoration
 Primaticcio. Stucco Decoration
 Primaticcio. Wall Decoration
 Quellin, A., the Elder. East
 Pediment Decoration
 Raemisch. Wall Decoration,
 Clerical House
 Rastrelli, B. F. Great Palace,
 State Apartments, and
 Chapel, interiors
 Schelden. Panels
 Schwitters. Wall Decoration
 Serpotta. Wall Decoration,
 and Statues
 Stahr-Nielsen. Shop Wall
 Figures

Uhlmann. Wandplastik
Zuffi, P. Ceramic Panels
Wall Panel 36x60
 PER 91
Wall Relief. Arp
Wall Relief. Moore, H.
Wallace Fountain. French--19th c.
WALLBAUM, Matthias (German
 1554-1632)
 Altar, detail Palisandro and
 silver; 105x40 cm
 GAL pl 60A, 60B IRB
 (CCLXXIII)
 Diana on the Stag c 1585
 silver, parcel gilt; 10-1/2
 x14
 TOR 137 CTRO (L 960.9.
 153)
WALLENBERG, Axel (Swedish 1898-)
 Girl on a Blossoming Bough
 1951/52 bronze; 71
 MID pl 73 BAM
Walls
 Ehlers. Buttressing Wall
 Ehlers. Wall
 Hajek. Spatial Wall
 Koblick. External Wall
 Mitchell, William. Wall
 Relief
 Tandberg. Free-Standing
 Garden Wall
Walls on Asphalt. Leoncillo
Walpole, Lady (Mother of Horace
 Walpole)
 Valle. Monument to Lady
 Walpole
Walpole, Robert (English States-
 man 1676-1745)
 Rysbrack. Sir Robert
 Walpole, bust
Walruses
 Ruwoldt. Walross
Walsdorf Crucifix. German--12th c.
Walsh, General
 Westmacott. Generals Paken-
 ham and Walsh Monument
WALSH, John (English fl 1757-1778)
 Lady Lechmere, bust,
 monument c 1778
 GUN pl 28 ELWe
Walter Dear. Hussmann
WALTER OF DURHAM (English)
 The Coronation Chair (St.
 Edward's Chair) with Stone
 of Scone c 1300 oak
 BROWF-1:36; CARP 401
 ELWe
WALTHER, Sebastian (German 1576-
 1645)

Annunciation to Shepherds,
 relief 1640
 HEMP pl 21 GDG
WALTON, George
 Andiron, detail 1896 wrought
 iron, copper and colored
 glass medallions; 7-1/8x
 8-5/8
 SCHMU pl 183 ELV
The Waltz. Claudel
Walworth, William
 Pierce. Sir William Walworth
Wanderer. Kirchner, Heinrich
Wandworth's Shield. Celtic
WANSART, Adolphe (Belgian
 1873-1954)
 Fernand Crommelynck, bust
 DEVI-2 BA
 Ulenspiegel GOR 71
War and Battles
 Bertoldo di Giovanni. Battling
 Horsemen
 Bontemps. Francis I Tomb,
 detail: Battle of Morignan
 Capizzoldi. General Wolfe
 Monument: Crossing of St.
 Lawrence
 David D'Angers. Battle of
 Fleuris
 Deighton. Battle of Trafalger
 Early Christian. Ampoule: St.
 Peter
 Early Christian. Battle between
 Footmen and Horsemen
 Early Christian. Oil Vial with
 Biblical Scenes
 English--17th c. State Car-
 riage, panel details
 Flemish--14th c. Flemish
 Infantry Battle French
 Cavalry at Courtai
 French--9th c. Book Cover
 Fragment: Biblical Battle
 French--13th c. Stone of the
 Siege of Carcassone
 French--16th c. Henri II's
 Armour: Battle Scene
 --Shield: Siege of Boniface in
 Corsica
 German--14th c. Battle Scenes,
 frieze
 German--15th c. Saddle: Bat-
 tles and Ideal Love
 Leonardo da Vinci. Battle of
 Anghiari
 Leonardo da Vinci. Strife
 Marchand, F. and P. Bon-
 temps. Monument of Francis I

Michelangelo. Battle of
 Centaurs and Lapithae
Persico, E. L. War, as
 Roman Warrior
Peschi. Aerial Sculpture of
 War
Spanish--16th c. Carlos I
 in Full Armor in Cavalry
 Battle, relief
Stankovic. The Liberation of
 Belgrade, relief
Studin. War
Vischer, Hans, the Younger.
 Combat Scene, relief
Westmacott. The Waterloo
 Vase
Zala. War
War Games. Fullard
War Ghost. Fullard
Ward, Joshua
 Carlini. Joshua Ward
WARIN, Jean (French 1604-72)
 Louis XIII, bust bronze
 LAC 83; LOUM 143 FPL
 (1538)
 Richelieu, bust c 1640 bronze;
 27-1/2
 BLUA pl 149B; LAC 200
 FPMaz
Warren, Mrs.
 Westmacott. The Distressed
 Mother, Monument to Mrs.
 Warren
WARREN DAVIS, John (English 1919-)
 Imago, No. 2 1963 ptd
 plaster; 96x42x36
 READCON 267 (col)
Warrington, Earl of
 Carpentiere. Earl of Warring-
 ton Monument
Warrior. Frink
Warrior. Marini
Warrior. Mirko
The Warrior. Moore, H.
Warrior. Tajiri
Warrior Bird. Frink
Warrior Dance. Mirko
Warrior of Montauban. Bourdelle
Warrior with Shield. Moore, H.
Warriors See Soldiers
Warriors' Monument. Lishansky
Wart, Isaac van (1792-1834)
 Browere. Isaac van Wart,
 life mask
WARTHOE, Christian (Dutch)
 Icelandic Girl plaster
 SGO-4:pl 71
Wartime Cat. Fabbri

Warton, Joseph
 Flaxman. Dr. Joseph Warton
 Monument
Warwick, 2nd Earl of See Rich,
 Robert
Warwick Chantry. English--15th c.
Warwick Ciborium
 English--12th c. Warwick
 Ciborium
WASA, Gustav See VASA, Gustav
Washerwomen
 Maillol. The Laundress
 Maillol. Washerwoman
 Minguzzi. Washerwoman
 Pradier. Laundress
 Renoir. La Petite Laveuse
 Accroupie
 Renoir. The Washerwoman
Washing Fountain, detail. English--
 12th c.
Washington, George (1st President of
 U. S. A. 1732-99)
 Bartholdi. Lafayette and
 Washington
 Canova. George Washington,
 seated figure as Roman
 Emperor
 Capellano. Fame and Peace
 Crowning George Washing-
 ton, bust and relief
 Ceracchi. George Washington,
 bust
 Chantrey. George Washington
 David D'Angers. George
 Washington, bust
 Houdon. George Washington#
 Romanelli. George Washington,
 equest
 Siemering. Washington
 Monument
Wasp, Opus 138. Beothy
The Wasp. Richier, G.
Wassergarten. Goepfert and
 Hoelzinger
Wasserwald
 Kricke. Water Sculpture
Watcher II. Chadwick
The Watchers. Chadwick
Watchers. Meadows
Watches See Clocks and Watches
Water
 Renoir. La Petite Laveuse
 Accroupie
The Water. Laurens
The Water. Richier, G.
Water
 Hildebrand. Wittelsbach
 Fountain: Healing Power of
 Water

Water Carrier. Bernard
Water Carrier. Gemito
Water Hen. Pompon
Water-Lily. Koch, O.
Water Nymphs See Nymphs
Water Sculpture. Kricke
Water Skis. Cappello
The Waterfowl, reverse side of
 architectural model. Martin,
 M.
Waterloo Medal. Pistrucci
The Waterloo Vase. Westmacott
Waterspouts
 Gaudi. Rain Pipe: Snake
Waterton, Robert
 English--15th c. Robert
 Waterton, effigy
WATSON, Mary Spencer (English)
 A Hero: Purbeck Burr
 NEWTEB pl 12B
Watt, James (Scottish Mechanical
 Engineer and Inventor 1736-
 1819)
 Chantrey. James Watt
 Monument
Watteau, Antoine (French Painter
 1684-1721)
 Carpeaux. Antoine Watteau#
 Gauquie. Watteau Monument
Watts, David Pike
 Chantrey. David Pike Watts
 Monument
WATTS, George Frederick (English
 1817-1904)
 Clytie, bust c 1868/80
 bronze; 33
 MILLER il 170; ROTJG pl
 2 ELT
 Dying Clytie, bust bronze
 UND 108 UNNMM
 Physical Energy (Progress),
 equest detail, Cecil
 Rhodes Monument, Matopo,
 Southern Rhodesia 1904
 bronze
 CHASEH 483; GLA pl 45;
 GLE 71; MARY pl 138;
 MILLER il 169 ELKe
 (copy); SoC
WAUER, William
 Rudolf Bluemner, head
 CHENSP 272
The Wave. Adams, H. G.
The Wave. Hepworth
The Wave
 Laurens. Woman Bathing
 (The Wave)
Wave II
 Hepburn. Curved Form

Wawila
 Karny. Wawila, head
We are Builders Of Our Future.
 Kiss, Z. O.
We Build the City. Venditti
Wealth of East and West. English
Weather Vanes
 French--15th c. Wind Vane:
 Angel
 Jehan Barbet de Lyon. Wind
 Vane: Angel
 Norwegian--11th c. Weather-
 vane: David Rescuing Lamb
 from Lion
 Swedish--11th c. Soderala
 Weathercock
 Viking. Animal on Interlinear
 Staff
Weaving
 Pisano, A. The Weaver
WEBB, Philip (English 1831-1915)
 Rustic Fireplace 1860
 CAS pl 215 EKenBe
WEBBER, Henry (English 1754-1826)
 David Garrick Monument 1797
 marble
 MOLS-2:pl 38; WHINN pl
 130A ELWe
WEBER, Max (Swiss 1897-)
 Figure aux Bras Croises, half
 figure H: 120 cm
 JOR-1:pl 17
WECKSTROM, Marjatta
 Sculpture*
 EXS 20
Weddell, William
 Nollekens. William Weddell,
 bust
Wedding at Cana
 Belgian--10th c. Wedding at
 Cana, book cover
 French--9th c. Wedding at
 Cana, book cover
 French--12th c. Wedding of
 Cana
Weddings
 Bartoli, P. S. A Roman
 Marriage
 Early Christian. Marriage
 Diptych
 English--17th c. Portland Vase,
 Wedgwood: Marriage of
 Peleus and Thetis
 Rysbrack. A Roman Marriage
WEDERKINCH, Holger (Danish 1886-)
 Hare, Eagle, and Lynx red
 polished granite AUM 91
 Lynx and Two Owls old oak
 AUM 91

Lynx Awakening yellow marble
 AUM 92
Lynx in Love Euville lime-
 stone
 AUM 92
Three Fighting Lynxes
 Euville limestone
 AUM 90
Swans (Wild Swans) Euville
 limestone
 AUM 90; PAR-2:201
WEDGWOOD
 Classical Portrait Medallions
 black basalt
 SOTH-2:164
 Death of a Warrior c 1776
 black basalt; 11-1/2x
 20-1/8
 DETT 224 UMiD (51.235)
 Rhyton: Head black basalt
 DOWN 137 UNNMM
 Slave Medallion: Am I Not a
 Man and a Brother
 ENC 937
 Francis Bacon, bust
 SOTH-2:164
Wedgwood
 Flaxman. Homeric Vase
WEEKES, Henry (English 1807-77)
 Robert Southey, bust 1843
 GUN pl 28 ELWe
 Sleeping Child and Dog (from
 Illustrated Catalog of the
 Great Exhibition, Vol II)
 CON-6:pl 68
Weepers See Mourners
Weeping Lion. Rodin
Weeping Madonna. Einbeck
Weeping Monk
 Sluter and Werve. Philip the
 Bold Tomb
Weeping Woman. Epstein
Weeping Woman. Milson
Weeping Woman. Rodin
Weeping Women
 Minne, G. Mourning Women
Weibliche Figur. Geiser
WEIDITZ, Christoph (German)
 Adam and Eve, Augsburg
 1540 pearwood; 32x31.2 cm
 MUL 68 AVK
WEIDITZ, Hans See WYDYZ, Johann
Weighing Souls
 French--12th c. The Last
 Judgment, tympanum, west
 portal
 French--13th c. Last Judgment:
 Weighing of Souls

Weights
 English--14th c. Steelyard
 Weight, with Heraldic
 Shield of King Edward II
 French. St. Louis Green
 Overlay Moulded Salamander
 Weight
Weihwasserbecken See Fonts
WEIKS, George
 Male Figure
 DIV 37
Weill, Raphael
 Rodin. The Shades: Weill
 Memorial
WEINGARTNER, L. (English) See
 GILBERT, Walter
WEISS, Frantisek Ignac (Czech 1690-
 1756)
 High Altar 1742
 STECH pl 185 CzPCa
 St. Adalbert 1741/43 ptd wood
 STECH CzPCa
 St. Michael 1742 ptd wood
 STECH col pl 8 (col) CzPCa
 St. Thomas of Villanova
 1741/43 ptd wood
 STECH pl 187 CzPCa
WEISS, Max (Swiss 1921-)
 Cheval 1956
 JOR-2:pl 290
 Figure 1957
 JOR-2:pl 293
 Figure Couchee 1959
 JOR-2:pl 292
 Hirsch (Cerf) 1953/53 bronze;
 275 cm
 JOR-1:pl 34
 Taureau 1957
 JOR-2:pl 291
 Tigre
 JOR-2:pl 295
 Venus Barbare 1955
 JOR-2:pl 115
Weisse Muhle. Uecker, G.
WEISWEILER, Adam
 Writing Table, detail 1784
 gilt bronze; 32
 CHAR-2:243 FPL
Welby, Richard d 1714
 Green. Richard Welby
The Well. Minne, G.
Well Heads
 Italian--10th c. Well Head:
 Floral Motif
Well of Moses. Sluter and Werve
Well of the Prophets
 Sluter and Werve. Well of
 Moses

Wellcurb. Italian--8/9th c.
Wellington, Arthur, 1st Duke of
(British General and States-
man 1769-1852)
Chantrey. Duke of Wellington,
equest
Rouw, P. Arthur Wellesley,
Duke of Wellington,
medallion
Stevens. Wellington Memorial
Wells See also Fountains
French--17th c. Well
WELSH
Christ, rood figure 14th c.
wood; figure: 48
ARTS 63 WCaN
Jug 13/14th c. green pottery;
13-1/2
ARTSW 61 WCaN
Pax Board: Crucifixion 14th c.
gilt copper; 9x4-1/2
ARTSW 64 WAO
Sleeping Jesse 14/15th c. oak;
L: 120
ARTSW 65, 11 WAM
Welsh National War Memorial,
sketch, Dobson
Wenceslas, Saint (Duke of Bohemia
903-c935)
Bendl, J. G. St. Wenceslas#
Braun, M. B. High Altar;
details: Sts. Ludmilla and
Wenceslas
Braun, M. B. St. Ludmilla
with Young St. Wenceslas
Braun, M. B. St. Wenceslas,
head detail
Braun, M. B. --Foll. Death
of St. Wenceslas
Brokoff, M. J. J. St. Vitus;
St. John of Nepomuk; St.
Wenceslas
Mosto. St. Wenceslas
Quitainer. St. Wenceslas
Wenceslaus (Holy Roman Emperor
and Wenceslaus IV, King of
Bohemia 1361-1419)
Parler. St. Vitus between
Charles IV and Wenzel IV
WENDE, Oswald
The Holy Trinity 1716
STECH 128 CzKa
Wendelin, Saint
German--18th c. St. Wendelin
Wenemaer, Willem d 1325
Flemish--14th c. Willem
Wenemaer, and his Wife,
memorial plaques

Wentworth, Thomas
Latham, J. Sir Thomas and
Lady Wentworth Tomb
Wenzel IV See Wenceslaus (Holy
Roman Emperor)
Wenzel von Radecz
Polish. Wenzel von Radecz,
bust
WENZINGER, Christian (Johann
Christian Wenzinger) (German
1710-97)
Font 1768
HELM pl 155 GFrei
St. Joseph 1750 terracotta;
98 cm
BERLEK pl 46 GBSBe (8296)
Self Portrait 1745 ptd terra-
cotta
GOLDF pl 296 GFL
Virgin and Child 1760 terra-
cotta; 30.7 cm
BSC pl 140 GBS (2344)
WERCOLLIER, Lucien (Luxembourg
1908-)
Sculpture 1959 bronze
MAI 299
Werden, Sibyl
Wimmer. Head of a girl-
dancer
Werden Crucifix. German--11th c.
Wergeland, Henrik Arnold
(Norwegian Poet 1808-45)
Vigeland, Henrik Wergeland
Werl, Heinrich von (Bishop 1085-
1127)
Roger of Helmarshausen.
Portable Altar
WERTHEIM, John G. (Dutch 1898-)
Tomb Figure for Van den
Bergh Family
SCHW pl 58 GWes
WERTHMANN, Friedrich (German
1927-)
Entelechie II 1960 welded
stainless steel
MEILD 27
--1960 welded stainless steel;
Dm: 78-3/4
KUL pl 53 GHPl
--
READCON 260 GHamT
Facade Relief 1960 steel;
350x170 cm
KUL pl 54 GRonG
Der Geflugelte welded steel
MEILD 103
Gordian Knot (Gordischer
Knoten) 1963 tungsten steel;

5x1-1/8x1-1/8
NEW pl 334 ELouC
Struktur Remanit 1959 steel;
 98-3/8
TRI 190
WERVE, Claus de (Claes van der
 Werve) (Burgundian fl
 1398-1439) See also
 Marville, Jean de; Sluter,
 Claus
A Mourner
 LEE UOClA
St. Peter
 RAY 36
WESEL, Adriaen van (Dutch c
 1420-1500)
St. Joseph and the Music-
 Making Angels c 1477
 oak; 17-1/2x14-3/4
 HAMF 260; MULS pl 108;
 RIJA pl 117, pl 117a NAR
Singing Angels, altarpiece
 fragment
 GEL pl 93 NHeB
Sterfbed van Maria; detail
 oak; 76 cm
 RIJ pl 128-29 NAR
Wesselenyi, Miklos
Hollo. Miklos Wesselenyi,
 memorial plaque
Westcott, Captain
Banks. Capt. Westcott
 Monument
WESTMACOTT, Richard (English
 1775-1856)
Achilles
 AGARC 113 ELHy
Charles James Fox Monument
 1810/23 marble
 LIC pl 26; WHINN pl 169
 ELWe
--detail
 BOASE pl 53B; MOLS-2:
 pl 48
--Charles James Fox in
 Senator's Robes, seated
 effigy bronze; c 17'
 GLE 175
--Kneeling Slave (Kneeling
 Negro)
 ENC 941; GERN pl 63;
 MOLE 258; WHINN pl 168B
The Distressed Mother,
 Monument to Mrs. Warren
 c 1816/22
 WHINN pl 170B ELWe
A Dream of Horace 1823
 WHINN pl 174 -EPe

Duke of Bedford 1809 bronze;
 9', on 18' granite pedestal
 GEL 175 ELRu
Earl of Bridgewater, 7th,
 Monument d 1823
 WHINN pl 73 ELitG
Earl of Pembroke, 11th,
 Monument d 1827
 WHINN pl 175A EWil
General Sir Ralph Abercromby
 Monument 1802/05
 WHINN pl 158 ELPa
Generals Pakenham and Walsh
 Monument 1823
 WHINN pl 164A ELPa
George Canning 1832
 WHINN pl 165A ELPS
Grace Bagge Monument d 1834
 WHINN pl 175B EStrad
Hon. John Yorke Monument
 1801
 WHINN pl 72 EWiM
James Dutton Monument 1791
 GUN pl 32; WHINN pl 134
 ESh
Joseph Addison Monument,
 base detail 1803/09
 WHINN pl 170A ELWe
Lord Collingwood Monument
 1813
 IRW pl 84; WHINN pl 162A
 ELPa
Nymph and Cupid 1827
 WHINN pl 155B -EPe
Spencer Perceval Monument
 1822 marble
 MOLS-2:pl 49 ELWe
The Waterloo Vase c 1830 H:
 c 15'
 WHINN pl 167 ELBP
William and Olivia Barker
 Monument c 1800
 WHINN pl 171A ESon
William Pitt Monument
 1807/13
 WHINN pl 168A ELWe
Westminster Abbey Dean
English--17th c. Common Seal
 of Dean and Chapter of
 Westminster, die
"Westminster" Attitude of Prayer
English--13/14th c. Sir
 Robert de Bures
WESTON, English fl 1696-1733
Relief and Skulls, detail of
 Monument to Jonathan and
 Elizabeth Ivie 1717
 GUN pl 31 EExP

WESTPHALIAN MASTER
 Burgkirche Figures 1399/1401
 stone
 MULS pl 30B GLuA
WEYDEN, Rogier van der (Flemish
 1400?-1464)
 Epitaph of Robert de
 Quinghien 1429
 CHASEH 246 BTouM
WEYR, Adolphe von (Austrian)
 Triumphal Procession
 TAFTM 63 AV
WEZELAAR, H. (Dutch)
 Torso
 SFGC 29
WHALEN, Thomas (Scottish)
 Eve Orocco wood; 20
 NEWTEB pl 34B
Whales See Jonah
Whalley Cross. English--11th c.
Wheel of Fortune
 French--12th c. Rose Window
 with Wheel of Fortune
Wheel of Universe
 Belgian--12th c. Phylactery
Wheelbarrows
 Flemish--15th c. Misericords
WHEELER, Charles (English 1892-)
 Aphrodite alabaster
 AGARC 22; CASS 68;
 MILLER il 201 ELBur
 The Artist's Wife, head
 bronze
 HUX 81
 --seated figure
 UND 163
 The Lone Singer 1950 bronze;
 60
 LONDC pl 27
 Man and Woman 1927 Portland
 stone; 52x46x13
 LOND-5:#41
 Mother and Child lime tree
 trunk; 72
 DURS 64; PAR-1:112
 Symbolic Facade Figures
 c 1924 Portland stone
 CASS 96; RAMS 6A
 ELBan
 War Memorial in Halfarga,
 North Africa: Lions, group
 detail 1946 stone
 NEWTEB pl 63
 Portraits
 Huxley-Jones. Charles
 Wheeler, bust
WHEELER, Muriel (English)
 Madonna and Child terracotta;
 24 NEWTEB pl 62

Wheels
 Benquet. Oval Wheel
Whetstones
 Anglo-Saxon. Ceremonial
 Whetstone
Whichcot, Jeremy d 1677
 English--17th c. Ledger
 Stone to Jeremy Whichcot
Whispering of the Limits# Chillada
Whitaker, Thomas
 Smith, C. R. Rev. Thomas
 Whitaker, reclining effigy
Whitbread, Samuel
 Bacon, J. Samuel Whitbread
 Monument
 Nollekens. Samuel Whitbread,
 bust
White Bear
 Pompon. Polar Bear
White Cut. Leoncillo
White Field. Uecker
White Form. Arp
White Light Dynamo. Mack
White Lighthouse. Dobes
The White Madonna, half figure.
 Langer
White Memory. Wragg
The White Negress. Brancusi
White Relief. Nicholson
White Seal
 Brancusi. Miracle
White Structure. Sykora
The White Virgin. Spanish--13th c.
Whitsun See Pentecost
Why Not Sneeze, Rose Selavy?
 Duchamp. Ready Made
Whytell, Ann
 Bacon, J. Ann Whytell
 Monument
WIDDEMANN, Christian
 Column 1713/14
 STECH 43 CzPi
Wide. Caro
The Widow. Lopes
A Widow, head. Pollaiuolo, A.
Widukind See Witterkind
WIECEK, Magdalena (Polish 1924-)
 Composition 1957 plaster
 JAR pl 20
Das Wiedersehen
 Barlach. The Reunion
WIELAND, J. G. (fl 1780) See
 DIRR, G.
Wiemken, Edo
 Hogadt. Friesian Chieftain
 Edo Wiemken Tomb
WIENER, Charles (Dutch-Belgian
 1832-88)
 Aristride Astrue, medal
 ROTH 550

WIENER, Leopold (Dutch-Belgian
 1823-91)
 Hans Memling, medal
 ROTH 549
WIERICK, Robert (French 1882-
 1944)
 Bust of a Woman 1923 bronze
 MAI 299 FPM
 Portrait bronze
 SFGC 21
Wiesant, Pierre de
 Rodin, A. Pierre de
 Wiesant
Wieskirche. Zimmermann, D. and J.
Wiessant, Jacques de
 Rodin, A. Jacques de
 Wiessant, head
Wife of Shiekh El Balad. Mokhtar
WIGGLI, Oscar (Swiss 1927-)
 Untitled 1962 iron; 11-3/4
 READCON 248 SwNJ
WIGSTROM, H.
 Faberge Figure of Capt. of
 4th Harkovski Lancers
 Regiment 1914/15 hard-
 stone; 5-1/4
 SOTH-3:218 (col)
WIJNANTS, Ernest (Belgian 1878-)
 Angel, relief stone
 VEN-38:pl 38
 Marieke gilded lindenwood
 GOR 46 -BQE
 Market Vender, monument
 GOR 47 BBo
 Muse 1926/30 bronze; 63
 MID pl 38 BAM
 Standing Nude
 GOR 49
 Sunday Pleasures, relief
 fragment
 GOR 48
WIKSTROM, Emil (Finnish)
 Guardians of Transportation
 AGARN il 3 FiHR
Wilberforce, William (English
 Philanthropist and Antislavery
 Crusader 1759-1833)
 Joseph. William Wilberforce,
 seated figure holding book
Wilcocks, Bishop
 Cheere, H. Bishop Wilcocks
 Monument
Wilcote, Sir William and Lady
 English--15th c. Sir William
 and Lady Wilcote,
 effigies
Wild Dancer. Wouters
Wild Men

German--16th c. Wild Man,
 candle holder
 Spanish--15th c. Two Wildmen
Wild Swans
 Wederkinch. Swans
Wilde, Ida (Daughter of J. M.
 Thiele 1830-63)
 Bissen. Ida Wilde, bust
Wilde, Oscar (Irish Writer 1854-1900)
 Epstein. Oscar Wilde Tomb
WILDT, Adolfo (Italian 1868-1931)
 Benito Mussolini, bust
 bronze
 VEN-24:pl 1
 --marble
 PAR-2:4
 The Crusader 1906 bronze;
 74x53x62 cm
 LIC pl 223 IMW
 The Family marble
 VEN-22:63
 Foolish Virgin marble
 PAR-2:5
 S. S. Pio XI marble
 VEN-26:pl 1
 Self Portrait, head mask
 1908 marble; 38x32x20 cm
 GOLDF pl 470; LIC pl
 224 IFU
WILFERT, Karl (German)
 Sensitivity
 TAFTM 62
Wilgefortis, or Uncumber, Saint
 English--16th c. St.
 Wilgefortis, or Uncumber
Wilgress, Charlotte Heberden
 Miller, A. Charlotte
 Heberden Wilgress, bust
WILIGELMUS (Guglielmo; Guglielmo
 da Maderno; Guglielmo da
 Pisa; Guglielmus; Guillelmus;
 Master Wilhelm; Wiligelmo)
 (Italian fl 1178-1310) See
 also Nicolaus
 Cupid, with Inverted Torch
 (2 figures) Ibis, west
 facade c 1170
 PANR fig 66 IMo
 Daniel and Zacharias 1106/20
 BAZINW 272 (col) IMo
 Funerary Genius early 12th c.
 BAZINL pl 207 IMo
 Genesis Scenes, west facade
 c 1110/20 stone
 JANSK 435; MACL 29; MYBA
 274; ST 194 IMo
 --Adam and Eve
 BUSRO pl 18; CLAK 312

--Adam and Eve Labouring
 BIB pl 16
--The Creation
 MOLE 36 (col)
--Creation and Fall of Man
 CHRC fig 86; MOREYM pl
 75
--Creation of Man; of Woman;
 The Fall
 MOREYC 96
--Fall of Adam
 LARB 282; ROBB 346
Pulpit 1162
 MACL 33; POPG fig 2
 ICagC
Pulpit 1270
 WHITJ pl 21A IPiF
--Christ in Limbo
 POPG fig 6
St. Hilarion, colonnette
 12th c. marble
 NCM UNNMM (08.175.9)
Slaying of Cain, relief
 1099/1106 marble
 BECKM 190 IMo
WILIGELMUS--FOLL
 Antefix c 1125/30
 BAZINW 273 (col) IMo
Will Tension Energy Creation.
 Kemeny
WILLAUME, David (French)
 Huguenot Ewer
 ENC 410
WILLEMS, Joseph(?) (English 1722-
 1803)
 Actor in Turkish Costume
 c 1760/65 Chelsea
 Porcelain; 12-3/4
 KITS 150 (col) ELV
 Shepherdess c 1760/65 Chelsea
 Porcelain; 12-1/2
 KITS 150 (col) ELV
WILLEQUIST, Andre (Belgian 1921-)
 Sculpture for a Garden 1956
 L: 97
 BERCK 345 BCouH
William I (King of England 1027-87),
 called: William the Conquerer
 Rochet. King William I,
 equest
William II (King of England 1087-
 1100)
 Italian--12th c. William II
 Offering the Church to
 the Madonna
William III (King of England
 1650-1702)
 Blommendael. William III,
 bust

Marot. William III Monument
Nost. William III
Rysbrack. William III, equest
Scheemakers, P. William III,
 equest
William I (Prince of Orange, and
 Count of Nassau 1533-84),
 known as: William the Silent
 Keyser. William the Silent
 Tomb
William III (Prince of Orange 1650-
 1702)
 Abeele. William III, Prince
 of Orange, at the Age of
 Four
 Arondeaux. Medal: Coronation
 of William III and Mary II
William I (Wilhelm Friedrich Ludwig)
 (King of Prussia 1861-88)
 Begas. Wilhelm I Memorial,
 equest
 Schmitz, Hundreiser, and
 Geiger. Kyffhauser Plateau
 Monument
William IV of Bavaria (Duke)
 Krumper. Ludwig of Bavaria
 Tomb: Duke Wilhelm IV of
 Bavaria
William (Prince of Sweden 1884-)
 Blomberg. Prince William of
 Sweden, head
William of Aquitaine, Saint
 French--15th c. Christ of
 Pity, Adored by Donors,
 with St. Michael, and St.
 William of Aquitaine
WILLIAM OF IRELAND See also
 John of Battle
 Eleanor of Castile 1291/92 stone
 STON pl 109 ENorthH
William of Orange See William I
 (Prince of Orange)
William the Silent See William I
 (Prince of Orange)
Williams, Elizabeth
 English--16th c. Elizabeth
 Williams, effigy
WILLIAMS, Garth
 Adam and Eve
 CASS 75
Williams, Kyfflin
 Robert-Jones. Kyfflin
 Williams, head
Willibald, Saint (English Missionary
 in Germany 700?-786)
 Hering, L. St. Willibald,
 tomb figure
Willing Sacrifice. Metzner

Willmann House, carved half-
timbering. German--16th c.
Willoughby, Francis
Roubiliac. Frances Willoughby,
bust
WILLUMSEN, Jens Ferdinand
(Danish 1863-1958)
Mother and Son on Seashore,
After the Hurricane
VEN-36:pl 57 DCBl
Vase 1890 ceramic
CAS pl 237 DCK
Wilten Chalice. German--12th c.
WILTON, Joseph (English 1722-
1803)
Admiral Holmes, monument
detail 1761
GUN pl 30 ELWe
Admiral Temple-West, bust,
monument detail d 1757
marble
MOLS-2:pl 37; WHINN PL
110 ELWe
Archbishop Tillotson,
monument detail 1796
WHINN pl 114A ESow
Earl of Chesterfield, head 1757
WHINN pl 108A ELBr
General Wolfe, bust c 1760
WHINN pl 108B -ERo
Death of General Wolfe, monu-
ment detail 1772 marble
CHASEH 404; ESD pl 123;
GARL 205; MOLE 16; MOLS-
2:pl 36; WHINN pl 109 ELWe
Dr. Stephen Hales Monument
1761 FSD pl 126; WHINN pl
111 ELWe
Duke of Bedford, 2nd, Monu-
ment 1769
WHINN pl 112 EChe
George III, as a Roman Emper-
or, equest (destroyed July
9, 1776) 1770 gilded lead,
marble pedestal; 15' SALT
160 UNN
Oliver Cromwell, bust 1762
marble; 29-1/2 BUSB 156;
MOLE 257; VICK 13 ELV
(A. s2-1930)
William Pitt, the Elder
(mutilated by British
soldiers capturing city dur-
ing Revolutionary War)
ADAM-1:360 UNNHS
--replica of New York City
original 1770 marble CRAVS
77 UScCh
Portraits
Roubiliac. Joseph Wilton, bust

WIMMER, Hans (German 1907-)
Crucifix 1950 bronze;
figure: 7-3/4'
GERT 71; SCHAEF pl 43
Ernest Buschor 1946/47
bronze
GERT 69
Girl Standing 1943 bronze;
26
SCHAEF pl 42
Head of a Girl-Dancer
(Sibyl Werden) 1951 terra-
cotta; 14
MID pl 106 BAM
Saddled Horse (Gesatteltes
Pferd) 1952 bronze
GERT 72
Wilhelm Furtwangler, bust
1953 bronze; 45 cm
OST 63 GLuB
Youth (Jungling) 1953 bronze
GERT 70
WIND, Gerhard (German 1928-)
Holzrelief 1960 wood; 85x60
cm
KUL pl 19
Wind
Aumonier, E. South Wind
Chirino. The Wind
French--12th c. Capital:
The Four Winds
German--11th c. Essen
Candlestick, base details:
Personification of Winds
Gerrard. North Wind
Gill, E. South Wind; North
Wind; East Wind
Gill, E. The Wind
Moore, H. The North Wind
Moore, H. West Wind
Rabinovitch. West Wind
Vlad. The Winds
Wyon, A. East Wind
Wind of Life. Chauvin, J.
Wind Vanes See Weather Vanes
Window Frames
Folk Art--Russian. Window
Frame, carved and painted
Window Open on the Sky, mobile.
Linck, W.
Window Railing
Pernevi. Window Railing
Window Soffit Relief. English--13th c.
Window to the Sea. Tumarkin
Window Tracery
English--13th c. Plate-
Tracery, Gothic Window
English--14th c. Decorated
Bar-Tracery

English--13th c. Judgment
 Porch: Foolish Virgins
French--12th c. Capital;
 Portal, details: Foolish
 Virgin
French--13th c. Foolish
 Virgin
--Wise Virgin, facade
--Wise and Foolish Virgins,
 facade
German--13th c. Wise and
 Foolish Virgins
German--14th c. Bride's
 Door
--Foolish Virgin, portal
Lupola. Foolish Virgin
Swiss--15th c. Wise and
 Foolish Virgins
Wildt. Foolish Virgin
Wiseman, Elizabeth d 1691
 English--17th c. Ledger
 Stone to Elizabeth Wiseman
WINIEWSKI, Alfred (Polish 1916-)
 Coloured 1954 plaster
 JAR pl 19
 Girl's Torso 1959 bronze
 VEN-60:pl 190 PPN
WIESEL, Hans
 Head chased copper
 MARTE pl 11
Witch of Agnesi. McWilliam
Witching Hour. Giacometti
With Hidden Noise
 Duchamp. Ready Made: Ball
 of Twine
WITKIN, Isaac (South African-
 English 1936-)
 Alter-Ego 1963 wood ptd
 blue; 65
 HAMM 153 (col)
Witkoroski, R. K.
 Kuna. R. K. Witkoroski
WITSCHI, Werner (Swiss 1906-)
 Auseinanderstechen 1956/57
 JOR-2:pl 159
 Berceau I 1956
 JOR-2:pl 158
 Deux Plans S'Interpenetrant
 1959
 JOR-2:pl 299
 Gehaltene Unsicherheit 1954
 iron, brass, nickel
 JOR-1:pl 100
 Innen-Aussen 1953/54 iron,
 nickel
 JOR-1:pl 99
 Jeu de Formes Ovales dans
 L'Espace 1955 JOR-2:pl
 296

Mouettes 1958
 JOR-2:pl 298
Overt-Ferme 1958/59
 JOR-2:pl 161
Suspension Parallele 1958
 JOR-2:pl 297
Vis 1959
 JOR-2:pl 160
Witt, Johan de 1625-72
 Quellinus, A., the Elder.
 Johan de Witt, bust
Wittelsbach Fountain. Hildebrand
Wittelsbach Monument. Wrba
Wittelsboel, Johann Wilhelm van
 Neuberg
 Grupello. Johann Wilhelm
 van Neuberg Wittelsboel,
 Count Palatine, bust
WITTEN, Hans (German fl 1490-1520)
 The Flagellation, tree-form
 pillar (Pillar of Chastise-
 ment) c 1515
 BUSR 155; LOH 185 GChS
 Tulip Pulpit c 1510
 LOH 180 GFreiC
 --Dreaming Daniel
 BUSR 156
 Vesper Group after 1490
 BUSR 154 GGoJ
WITTEN, Hans, and Franz MAIDBURG
 Side Porch
 BOE pl 139 GChS
Witterkind (Widuking) (Westphalian
 Chieftain and Saxon Leader
 d c 807)
 German--12th c. Saxon Duke
 Widukind, tombstone relief
WITTIG, Edouard (Polish)
 Eve stone
 PAR-2:174
 Nike bronze
 VEN-20:40
WIWULSKI, A.
 Jagiello, equest, Grunwald
 Monument bronze and stone
 MARY pl 137 PC
WLERICK, Robert (French 1882-1944)
 Dedette
 BAS 115
 Jacqueline, daughter of the
 artist 1943 gilded bronze;
 56x45x28 cm
 MOD FPM
 Jenny, head
 BAS 113
 La Landaise, bust
 BAS 114
 Lydie
 BAS 112

Marshal Foch, equest
 BAS 118-19 FChai
Painter Petrelle, head
 BAS 117
Pomone
 BAS 116 FChai
Rolande
 BAS 110 FPM
Therese Assise
 BAS 115
Torse de Femme, fragment
 BAS 113 FPM
Youth (Jeunesse), fragment
 BAS 112
WNUK, Marian (Polish 1906-)
 Lenin 1951 plaster
 JAR pl 14
 Polish-Soviet Friendship
 Monument 1952 bronze
 JAR pl 15 PGd
Woestijne, Karel van de (Belgian
 Poet 1879-1929)
 Cantre. Karel van de
 Woestijne, head
WOJCIESZYNSKI, Stanislas See
 WOSTAN
WOLF, Ebert, the Younger See
 WOLFF, Eckbert, the Younger
WOLF, Ekbert, the Younger See
 WOLFF, Eckbert, the Younger
WOLF, Evert See WOLFF, Evert
WOLF, Jonas See WOLFF, Evert
WOLF, Karl Anton (Austrian 1908-)
 Sculpture 1962 ptd iron;
 80 cm
 SOT pl 113
Wolf-Table. Brauner
Wolfe, James (British Army Officer
 1727-59)
 Capizzoldi. General Wolfe
 Monument, detail: Cross-
 ing of St. Lawrence
 Wilton. Death of General
 Wolfe
 Wilton. General Wolfe, bust
WOLFERS, Philippe (Belgian 1858-
 1929)
 The Dance cast bronze
 VEN-12:pl 29
 Medusa, pendant 1898/99
 ivory, enameled gold,
 opal; 4
 SELZPN 100 BBWit
WOLFF, Adolf (Belgian)
 Pro Patria plaster
 SGO-4:pl 75
WOLFF, Albert (German 1814-92)
 Combat with Lion zinc from

chromolithograph
 MOLS-2:pl 54
Monument to Friedrich
 Wilhelm III, equest 1868
 bronze (destroyed)
 SELZJ 41 GBL
WOLFF, Eberhard, the Younger See
 WOLFF, Eckbert, the Younger
WOLFF, Eckbert, the Younger
 (Ebert Wolf; Ekbert Wolf;
 Eberhard Wolff) (German)
 Altar c 1608
 HEMP pl 23 GBuCa
 Altar Table 1601/04 wood
 MUL 97 GBuCa
 --Angel Head, support detail
 BUSB 40
 Interior Decoration
 LOH 215 GBuCa
 Portal of God (Portal of the
 Gods): Venus, Golden Hall
 BUSB 41 GBu
WOLFF, Evert, and Jonas WOLFF
 (WOLFF BROTHERS)
 (Hildeshiem)
 Portal of God (Portal of the
 Gods), Golden Hall 1605
 LOH 211; ST 316 GBuCa
WOLFF, Gustav Heinrich (German
 1886-1934)
 Frau auf Liegendem Pferd
 (Europa zu Pferd) 1924
 bronze; 9x11.5x6 cm
 SP 232 GHaS
 Gottfried Benn, head 1927
 clay; 12-1/4
 HENT 94; NNMAG 166; OST
 59 GHK
 Griechen 1928/29 marble;
 72 cm
 HENT 92
 Orpheus and Eurydice 1928
 bronze; 24-3/4
 BOSME pl 69 GHH
 Standing Woman, mantel figure
 1925 stone; 82-1/4
 NNMMAG 167 GH
 Zwei Kamin figuren 1925
 limestone; 209; and 212 cm
 OST 51 GHK
WOLFF, Helmut (German 1932-)
 Auschwitz Monument, model
 1958 wood; 35-3/8x51-1/8x
 22
 TRI 236
WOLFF, Jonas See WOLFF, Evert
WOLFF, Markus (Matthews Wolff)
 (German)

Torah Scroll Breastplate,
 Augsburg, 18th c. silver,
 parcel gilt ROTH 323 UNNJe
WOLFF, Tobias (German d c 1570)
 Pope Alexander V, medal
 model Kelheim stone
 CLE 111 UOClA (56.28)
WOLFF BROTHERS See WOLFF,
 Evert, and Jonas WOLFF
Wofflin, Heinrich
 Scharff. Heinrich Wolfflin#
Wolfgang, Saint
 Kreichbaum. Winged High
 Altar
 Pacher. St. Wolfgang Altar
Wolfgang Altar
 Pacher. St. Wolfgang Altar
Wolfhart von Rot d 1302
 German--14th c. Bishop
 Wolfhart von Rot, effigy
WOLFRAM
 Erfurt Candelstick, details
 1157(?) cast bronze; 180 cm
 SWA pl 200 GErC
"Wolfram". German--12th c.
WOLFSKEHLMEISTER
 Bishop Friedrich von Hohenlohe,
 effigy; head detail
 BUSGS 154, 155 GBaC
Wolryche, Lady
 English--17th c. Lady Wolryche,
 effigy
Wolves See also Romulus and Remus
 Hajdu. The Wolves
 Martini, A. She-Wolf
WOLVINUS
 Flying Angel, relief, altar
 824/59 chased and enameled
 gold
 DECR pl 33 IMA
 High Altar, plaque detail c 835
 silver gilt, gems and
 enamel
 LARB 249 IMA
Woman Arranging Her Hair
 Gonzalez. Woman Combing
 her Hair
Woman at a Mirror. Laurens
Woman at the Fountain, relief.
 Blumenthal
Woman at the Window. Martini, A.
Woman Bather. Mascherini
Woman Bathing. Laurens
Woman Bathing. Mascherini
Woman Bitten by a Serpent. Clesinger
Woman Carrying Water. Bilger
Woman Combing her Hair. Bertoni
Woman Combing her Hair. Gonzalez

Woman Combing her Hair.
 Italo-Flemish. Woman
 Touching her Foot.
Woman Combing her Hair. Patzay
Woman Cutting Bread. Patzay
Woman Descending. Kolbe
Woman Diving. Picasso
Woman Dressing her Hair. Maillol
Woman Drinking. Rosandic
Woman from the Hills. Palavicini
A Woman Holding a Heart.
 Netherlandish
Woman Holding a Void. Giacometti
Woman Holding her Foot, No. 1.
 Fazzini
Woman in a Black Hat. Melli
Woman in an Armchair. Couturier
Woman in an Armchair. Degas
Woman in Bath. Ipousteguy
Woman in the Sun. Martini, A.
Woman in the Wind. Barlach
Woman Jumping. Mazzulo, G.
Woman Jumping Rope. Minguzzi
Woman Looking Back. Lehmann, K.
Woman Looking Up. Kolbe
Woman of Pleasure
 Syrlin, J., the Elder. Luster-
 weibchen Reliquary Bust
Woman Playing with a Child. Clodion
Woman Reading# Dalou
Woman Reading. Picasso
Woman Resting. Butler
Woman Resting. Day, G. H. J.
Woman Resting, relief. Lehmann, K.
Woman Returning Home from Market.
 Italo-Flemish
Woman Rubbing her Back with a
 Sponge. Degas
Woman Seated. Durasova
Woman Seated. Laurens
Woman Seated. Slesinska
Woman Sewing. Dalou
Woman Sewing. Kantoci
Woman Sitting. Fazzini
Woman Sitting. Matisse
Woman Sitting. Schreiner
Woman-Spoon. Giacometti
Woman Standing. Butler
Woman Standing. Nielsen, K.
Woman Swimmer. Yencesse
Woman Swimming Underwater
 Martini, A. Donna che Nuota
 Sott'Acqua
Woman Taking off her Stockings.
 Dalou
Woman Touching her Foot. Italo-
 Flemish
Woman Twisting her Hair. Conte

Woman Waking Up. Caro
Woman Walking. Butler
Woman Walking. Giacometti
Woman Washing her Left Leg. Degas
Woman with a Basket. Gonzalez
Woman with a Bird. Laurens
Woman with a Dove. Maillol
Woman with a Guitar. Laurens
Woman with a Mirror. Gonzalez
Woman with a Necklace
 Maillol. Venus with Necklace
Woman with a Washcloth. D'Altri
Woman with an Accordion. Laurens
Woman with Bird. Miklos
Woman with Bowl. Dobson
Woman with Braids. Hajdu
Woman with Bucket. Kompanek
Woman with Flowers. Fullard
Woman with Folded Arms. Barlach
Woman with Folded Arms. Edzard
Woman with Folded Arms. McWilliam
Woman with her Throat Cut.
 Giacometti
Woman with Jug. Bernard
Woman with Jug. Couturier
Woman with Mirror. Graef
Woman with Mirror. Henning,
 Gerhard
Woman with Peacock. Falguiere
Woman with Raised Arms, No. 2.
 Broggini
Woman with Scarf
 Rosso, M. Lady with a
 Veil
Woman without Arms. Tavernari
Woman's Body. Caro
Wong, Anna May
 Botzaris. Anna May Wong,
 head
Wonnerberg Monument. Eldh
Wood, F. W.
 Seale. Capt. F. W. Wood,
 head
WOOD, Ralph (English)
 "Prince Hal" Toby Jug,
 Burslem c 1765 H: 14
 CON-4:pl 42
Wood, Azpiazu
Wood. Condoy
Wood. Dedieu
Wood Relief No. 17. Tilson
Woodburn, Samuel
 Behnes. Samuel Woodburn,
 bust
Wooden Lights No. 6. Minguzzi
WOODFORD, James (English)
 Mr. Hunter-Crawford, head
 1940 bronze BRO pl 40

 Nereid, fountain group
 NEWTEB pl 64
WOODFORD, James, and Bainbridge
 COPNALL
 Facade Figures and Panels
 AGARN il 11 ELRIA
WOODHAM, Derrick (English 1940-)
 A fibre-glass and polyester
 resin, ptd; 58x63x24
 ARTSB-66:pl 5
 Assume, Concede 1864/65 ptd
 fibreglass and wood; 29x53
 x23
 MAE 130 ELStu
 Siviley 1965 wood and poly-
 ester resin; 48x51x25-1/2
 MAE 131
 Untitled 1966
 KULN 145
WOODMAN, William
 Monument to Viscount New-
 haven c 1728/32
 WHINN pl 104 EDr
Woodwork
 French--15/16th c. Wood-
 work, Abbeville
Woolf, Vladimir Markovitch
 Seale. Vladimir Markovitch
 Woolf, bust
WOOLNER, Thomas (English 1825-
 92)
 Lord Tennyson, bust 1857
 marble
 CON-6:pl 47; GARL 208
 ECamT
 --replica made in 1876 of
 Trinity College bust
 BOASE pl 61C ELWe
Woolton, Lord
 Kennet. Lord Woolton, bust
Worker. Minne, G.
Working Partners. Bone
World Construction. Pevsner
The World Through the Eyes of an
 Imbecile. Udinotti
WORMS, Wilhelm (German)
 Crossbow 16th c. wood inlaid
 with bone and steel; L:
 23-1/2; W: 22-1/8
 TOR 119 CTRO (924.17.4)
Worship See Prayer and Worship
WOSTAN, Stanislav (Stanislas
 Wojcieszynski) (Polish-
 French 1915-)
 Cain 1949 plaster of Paris;
 10-1/4x14-1/2
 SCHAEF pl 75

Grand Duke 1952 crushed
brick and colored cement
MARC pl 79 (col) FPM
Great Horned Owl 1952 brick
and plaster
BERCK 143 FPM
Sculpture 1958 bronze
MAI 300
Twilight 1959 beaten copper
MARC pl 78 FPM
Vaisovie, relief 1965 ham-
mered copper
MEILD 147 FPVi
WOTRUBA, Fritz (Austrian 1907-)
Caryatid 1963 H: 35-1/2
SEITC 111
Column 1959 marble;118
TRI 260 IVMH
Feminine Rock 1947/48 lime-
stone; 47x63
MID pl 107; STM BAM
Figure 1959 limestone;
39-3/8x26-3/4x19-5/8
TRI 67
--1961/62 H: 70-1/8
SEITC 111
--1965 69-1/2x16x15
CARNI-67:#12 UNNMa
--1966 marble; 88
EX 36; EXS 112
Figure Composition, relief
1949 bronze; c 20
RAMS pl 65
Figure of a Young King
1961/62 marble; 178 cm
SOT pl 93
Figure Relief (Figurenrelief)
1958 bronze; 3.5x5.5 m
OST 90, 91; SEITC 68
AVT
Figure with Raised Arms
1956/57 limestone; 76-5/8
ENC 953; LARM 381;
READCON 202;
SELZN 149; SOT pl 91
UNNH
Grosse Skulptur 1964 bronze;
120-1/8
NEW pl 294 ELMa
Head
SELZJ (dust jacket)
--1954 bronze; 16-3/4
LYN 162; SELZN 148
UNNMMA
--1954/55 bronze; 18-1/2
GIE 279 BBL
--1955 bronze; 20
BERCK 347

--1962 H: 18-1/2
SEITC 113
Large Figure 1963 47-1/2x42-
1/2
CARNI-64:#13 ELMa
Large Reclining Form 1951
stone
MAI 301
Large Recumbent Figure 1951
ST 449
Majestic March 1950 sand-
stone
VEN-52:pl 65
Man and Woman 1948 bronze;
16x12
SCHAEF pl 73
Reclining Figure (Liegende
Figure) cement casting
PRAEG 515
--1953 cement casting
GERT 243
--1960 L: 55-1/8
SEITC 112
--1960 20x80
CARNI-61:#431 UNNGe
--1960 bronze; 59 cm
CHENSW 510; LIC pl 275
UNNMa
--1960 limestone; W: 55-1/2
READCON 202 SwZL
Relief 1960 marble; 210x75 cm
JOO 198 (col) NOK
Relief with Eight Figures 1961
H: 11-3/4
SEITC 114
Relief with Five Figures 1959
L: 16-1/2
SEITC 113
Seated Figure ("Penseur")
1948 bronze; 32-1/2
SELZN 146 UNNFi
Seated Figure (Sitzender)
1952 cast stone
GERT 242
Seated Figure 1959 H: 33-3/8
SEITC 113
Squatting Figure 1951/52 stone
STA 60
Standing Figure (Stehende Figur)
1949/50 bronze; 14-3/8
TATEF pl 56d ELT (6013)
--1950/52 H: 65
BERCK 112
--1953/55 stone; 71
BERCK 112
--1955/56 bronze; 31-1/2x11
x16
CARNI-58:pl 106

--1956 stone; 71
 BERCK 113
--1961 H: 30-3/8
 SEITC 115
--1966 marble; 79
 GUGE 59
Standing Woman 1953/55
 puddingstone; 168 cm
 SOT pl 92 FPM
Three Figures 1950 stone;
 28x20
 SCHAEF pl 74
Torso 1930 marble; 165 cm
 SOT pl 90
--1955 bronze
 MAI 301
--1955 bronze; 31-1/2
 BERCK 347
Two Figures 1945 limestone;
 c 55
 RAMS pl 64
--1949/50 stone; 61
 SEAA 157 UNNGe
Wounded. Somaini
Wounded. Stursa
Wounded Bird. Sternschuss
Wounded Brigand. Pinelli
Wounded Flyer. Kolbe
WOUTERS, Rik (Belgian-Dutch
 1882-1916)
 Attitude
 GOR 41
 Contemplation 1911
 BERCK 348
 Domestic Worry (Domestic
 Cares; Domestic Worries;
 Huiselijke Zorgen) 1913
 bronze; 87
 CAS pl 184; DEVI-2; MID
 pl 34; STM BAM
 James Ensor, bust plaster
 VEN-14:48
 Mad Virgin 1912 bronze; 77
 LARM 357; MAI 302;
 MID pl 33 BAM
 Nel with Chignon 1909 bronze
 SELZJ 144 BOW
 Self Portrait, bust bronze; 18
 MID pl 35; RAMT pl 15
 BAM; BBR
 Wild Dancer (La Folle Dan-
 seuse), rear view
 GOR 44, 45
WOZNA, Zofia (Polish 1900-)
 From "The Sea" Series:
 Encounter 1960/61 bronze
 VEN-64:pl 174 PSP

Head of a Girl 1954 bronze
 JAR pl 37
WRAGG, John (English)
 Funeral Group 1963 three
 aluminum forms;23-1/2x
 21-1/2x15; on slate base
 TATES pl 31 ELT (T.635)
 White Memory 1965
 KULN 137
WRAMPE, Fritz (German 1893-1934)
 Blinder mit Hund 1933 bronze;
 45 cm
 SP 233 GHaS
 Liegende Antilope 1932/33
 bronze; L: 58 cm
 OST 9 GFSt
Wrangel Island
 Rakov. Map of Wrangel Island,
 box lid
Wreath of Breasts. Arp
Wreaths See Robbia, Luca della
WREN, Christopher (English archi-
 tect 1632-1723)
 Fountain Court
 FLEM 556 ELHC
 Portraits
 Pierce. Sir Christopher Wren,
 bust
WRBA, Georg
 The Wittlesbach Monument,
 Sketch
 MARY 177 GM
Wrestling See Games and Sports
WRIGHT, Austin (English 1911-)
 Hammerhead 1956 lead; 11
 ARTSS #52 ELBrC
 The Lovers 1955 lead
 MAI 303
 Trio 1956/57 plaster, for
 bronze; 108
 LONDC pl 28
WRIGHT, F. Arnold (English)
 Britannia
 MARY pl 153
 Galatea, head marble
 MARY pl 161
 War Memorial
 MARY pl 41 IreB
WRIGHT William (English)
 Resurrection Monument to
 Lady Deane
 ESD pl 110 EEsG
Wristwatch. Tilson
Writers
 French--12/13th c. Aristotle
 with Writing Tools, relief
 French--13th c. St. Matthew
 Writing his Gospel, relief

German--9/10th c. St.
Gregory with Three Scribes
Giovanni da Firenze, and Pacio
da Firenze. St. Catherine
of Alexandria Life: Father
of St. Catherine of Alexan-
dria Dictates his Testa-
ment, relief
Gothic--French. St. Matthew
writing at Command of an
Angel
Master H. L. High Altar:
St. John the Evangelist
Writing with Quill in Book
Milles. Aganippe Fountain:
Poet
Vigarny de Borgona. Royal
Chapel Altar, relief detail:
St. Matthew
Writing
Gill, E. Incised Alphabets
--French
French--12th c. Moissac
Inscription
--Greek
Palestinian. Synagogue Stone
--Kufic
Roger of Melfi. Lion's Head,
with Ornamental Kufic
Script, door
--Latin
Italian--13th c. Medieval
Inscription
Robbia, L. della. First
Singing Gallery: Dancing
Children; Inscription
Spanish--17th c. Inscription
Detail
Writing Desk
Russian--18th c. Writing
Desk, casket-form
Wrought Iron See also Grilles and
Lattices
French--12th c. Iron Work
French--17th c. Doors
Gattinger. Choir Screen
Italian--17th c. Wrought Iron
Gates
Oegg. Wrought Iron Gate
Russian--19th c. Wrought
Iron Inner Doors: Tsarist
Eagle
Spanish--17th c. Gate
Wundt, Wilhelm (German Psychologist
1832-1920)
Klinger. Wilhelm Wundt, bust
WURZELBAUER, Benedikt (German
1548-1620)

Justice Fountain (Tugendbrun-
nen) 1589 bronze; ea
figure: 100 cm
MUL 69 GNL
--detail
BUSB 19
WURZELBAUER, Benedikt--FOLL
Neptune Fountain c 1600
bronze; 29
HUNT pl 21-22 UCSmH
Wyandotte Cock. Bachelet
WYATT, Colin
Rhythmical Statuette
CASS 95
WYATT, Matthew Cotes (English
1777-1862)
Monument to Princess
Charlotte 1820/24 marble
BOASE pl 55; LIC pl 24
EWindG
WYATT, Richard James (English
1795-1850)
Ellen Legh Monument, detail
1831
BOASE pl 52B; GUN pl 29
EWinw
Glycera 1848 marble; 58
LONDC EWind
Penelope 1844 marble; 66
LONDC EWind
WYDYZ, Hans (Hans Weiditz)
(German fl 1500)
Adam and Eve (The Fall;
Sundenfall) 1st half 16th c.
beechwood; 8-1/2
KO pl 85; MUL 21; MULS
pl 172B SwBKH
WYLIE, Florence
Torso
CASS 68
Wylmer, Thomas d 1580
English--16th c. Thomas
Wylmer Monument
WYNANTS, Ernest (Belgian 1878-)
The Colporteur
DEVI-2 BA
Wyndham, George
Rodin. George Wyndham, bust
Wyndham, Henry
Carew, J. E. Henry Wyndham
WYON, Allan (English)
East Wind
AUM 128 ELUR
WYON, W.
Council Medal of Great
Exhibition, obverse:

Victoria and Albert,
profile heads
VICG 138 ELV
WYSS, Joseph (Swiss 1922-)
Monument to H. Dunant,
study 1957/58
JOR-2:pl 300

X, Madame
Signori. Madame X
xyz K³(x y z 1)³, Visual Representa-
tion of Algebraic Formula.
Henrici
Xanadu. Tilson
XAVERY, Jan Baptist (Flemish-
Dutch fl 1735-d 1742)
Allegory of Faith 1735
ROS pl 208 NHaGK
Xavier, Saint Francis (Jesuit
Missionary to Orient 1506-52)
Brokoff, F. M. St. Francis
Xaverius
Egell. St. Francis Xavier
Fernandez. St. Francis
Xavier, detail
Pacak, J. St. Francis
Xaverius
Spanish--17th c. St. Francis
Xavier
Xaviere de France, Marie Adelaide
Clotilde (Sister of Louis XVI
of France)
Houdon. Mme. Marie
Adelaide Clotilde Xaviere
de France, bust
XIMENES, Ettore (Italian)
Dante 1921 bronze
SALT 94 UNNBroad
Giovanni da Verrazzano, bust
1909
SALT 4 UNNBat
Giuseppe Zanardelli, seated
figure plaster
VEN-5:pl 23

Yad-Mordekhay Monument. Rapoport
Yanaihars, bust.
Giacometti
YANCO, Marcel (Marcel Janko)
(Rumanian-Swiss 1895-)
Construction 3 1917 wire and
plaster
GIE 92; HAMP pl 142B
Construction 5 1917 plaster
and wire
RICHT pl 19
Petite Architecture Lumiere,
relief 1919 ptd plaster
RICHT pl 14

Yarborough, Countess of
Nollekens. Countess of
Yarborough, effigy
Yaroslav (Russian Prince fl 1216-34)
Russian--13th c. Helmet of
Yaroslav
Yatagan. Gisiger
YEFIMOV, I. S.
Dolphin glass and wrought
copper; 110 cm
CASS 122
Yellow Bird
Brancusi. Maiastra
Yellow Swing. Caro
YENCESSE, Hubert (French 1900-)
Decorative Figures
BAS 164-65 SwGAs
Diane au Rocher
BAS 159
Femme Assise
BAS 167 FPTo
Femme Nue Accoudee
BAS 166
The Four Seasons (Les Quatre
Saisons) Sevres
BAS 161
Nageuse
BAS 163
La Republique, bust 1944
BAS 160
Woman Swimmer 1948 bronze;
72
MID pl 80 BAM
Young Woman Leaning on her
Elbow bronze
MAI 304
Youth (Jeunesse)
BAS 162
Yeoman
Multscher. German Yeoman
Yokahama, in Metamorphosis.
Tinguely
York, James, Duke of See James II
(King of England)
Yorke, John
Westmacott. Hon. John Yorke
Monument
Young Athlete. Tombros
Young Aviator. Emerson
Young Basque Woman. Swiecinski
Young Bather. Gelli
Young Boy. Leplae
Young Communist, head. Epstein
Young Cyclist. Maillol
Young Dancer
Degas. Little Dancer of
Fourteen Years
Young Elk. Milles
Young Fisherman. Gemito

Young Florentine Lady. Robbia, A.
 della
A Young Frenchman, head. Fraenkel
Young Girl. Aronson
A Young Girl. Bernard
Young Girl. Csikasz
Young Girl. Giacometti
Young Girl. Kolbe
Young Girl. Marini
Young Girl. Matisse
Young Girl. Rodin
Young Girl Kneeling. Laplae
Young Girl on a Chair. Manzu
Young Girl Removing her Dress.
 La Fresnaye
Young Girl Removing her Shift.
 Butler
Young Girl Sitting. Maillol
Young Girl Skipping. Couturier
Young Girl Standing. Kolbe
Young Girl with Fish. Moryce-Lipszc
Young Girl with Flowers in her
 Hair, bust. Rodin
Young Girl with Flute. Chaim
The Young Girls. Hajdu
Young Hare. Simmonds
Young Knight. Vittoria
Young Man. Indenbaum
Young Man Seated. Blumenthal
Young Man Seated
 Lehmbruck. Seated Youth
Young Man Standing. Lehmbruck
Young Man Standing. Hildebrand
Young Man Stepping Forward. Kolbe
The Young Mother. Rodin
Young Mother. Vallotton
Young Ox. Sintenis
Young Peasant Girl. Despiau
Young Rider. Marini
Young Runner. Maillol
Young Sculptor, head. Andreotti
Young Siren. Martinez, G.
The Young Warrior, bust.
 Pollaiuolo, A.
Young Woman Carrying a Basket.
 Roeder
Young Woman Leaning on her Elbow.
 Yencesse
Young Woman Meditating. Barlach
Young Woman with Shawl. Schwippert
Younge, Edward d 1607
 English--17th c. Edward
 Younge, and his Family,
 Brass
YOUNGMAN, Harold (English 1886-)
 Ishmael oak
 PAR-1:96
Your Portrait. Kudo

YOURIEVITCH, Serge
 The Dancer Nattova plaster, for
 bronze
 MARY 42 FP
Youth and Deer. Wackerle
Youth Playing the Flute. Lehmann, K.
Youth with Colt. Sintenis
Yrieix, Saint
 French--13th c. St. Yrieix,
 head
 French--15th c. St. Yrieix,
 reliquary head
Ysaye, Eugene (Belgian Violinist
 1858-1931)
 Rousseau, V. Violinist Ysaye,
 bust
YSELIN, Heinrich (German fl 2nd H
 15th c.)
 Self Portrait with tools, choir
 stalls, St. Peter an der
 Fahr 1487
 GOLDF pl 45 GConR
YUGOSLAVIAN
 Portal, detail 12th c.
 BIH 5 YSt
Yussif Bin Abdulla
 Baberton. Yussif Bin Abdulla,
 Swahili Man of Mombasa,
 head
YVARAL, Jean Pierre (Hungarian-
 French 1934-)
 Acceleration Optique, relief
 1963
 LARM 329
Yves. Dacker
Yves, Saint (Yves Helori 1253-1303)
 French--16th c. St. Yves
 French--18th c. St. Yves
 --St. Yves and the Rich and
 the Poor Man

ZABEL, Johannes
 Construction in Equilibrium
 1923
 MOHN 46
ZACCARI, Frederigo
 Window: Face and Figure
 Decoration 1590
 MU 158 IRZ
ZACCHI, Giovanni
 Medal of Doge Andrea
 Gritti: Fortune 1536
 PANM il 37
Zachariah
 Jean de Valenciennes.
 Zachariah and the Archangel
 Gabriel
 Sluter. Crucifix Base:
 Zachariah; Daniel; and Isaiah

Zacharias, Saint
 Early Christian. Doors of
 the West Portal
 French--12th c. Capital:
 Joseph Reassured; An-
 nunciation to Zacharias
 German--9th c. Book Cover:
 Virgin and Child Enthroned
 between Zacharias and St.
 John
 German--16th c. Mary,
 Elizabeth, and Zacharias
 Pacak, J. Altar Figures:
 St. Zacharias and St. Anne
 Quercia. Font#
 Sluter and Werve. Well of
 Moses
Zacchia, Laudivio (Cardinal)
 Algardi. Laudivio Zacchia,
 bust
ZADIKOW, Arnold (German 1884-
 1943)
 Motherhood 1926/27 Unter-
 sperg marble; 3/4 LS
 (destroyed by Nazis)
 SCHW pl 26
 Santina, oval medallion
 ROTH 871
 Wrestler 1927 bronze; 1/2 LS
 (destroyed by Nazis)
 SCHW pl 25
ZAJEC, Ivan (Yugoslav 1869-1952)
 The Frightened Satyr 1894
 bronze
 BIH 28 YLN
ZAKHAROFF, Adrian D. (Russian
 1761-1811)
 Main Gateway of the Admiralty,
 Leningrad 1806/08
 BAZINH 390; LARM 86
 RuL
ZALA, Gyorgy (Hungarian 1858-1936)
 Antal Ligeti, bust marble;
 76.5 cm
 GAD 55 HBA
 Congress of Berlin 1906
 (destroyed) bronze
 GAD 57
 War, Memorial Detail 1906
 bronze
 GAD 56 HBD
ZALIT
 Man's Head
 MARTE pl 42
ZALKALNS, Teidors (Russian)
 Scriabin stone
 CHENSP 44 RuL

ZAMBONI, Dante (Italian 1905-)
 Dancer 1959 bronze
 SAL pl 42 (col)
 Rape of the Nymph 1961 bronze
 SAL pl 41
ZAMOJSKI, Andrzej (Polish Statesman
 and Law Codifier 1716-92)
 Guyski. Andrzej Zamoyski,
 bust
ZAMOJSKI, Jan (Polish General
 1541-1605)
 Le Brun. Jan Zamoyski, bust
ZAMOYSKI, August (Polish 1890-)
 Carmela de Pampulhu 1942
 stone
 JAR pl 5
 Eve, reclining figure granite;
 84x127x66 cm
 WPN pl 189 PWN (121629)
 Leopold Zborowski, head 1919
 wood; 11-3/4
 BARD 127 BrSpA
 St. John the Baptist, detail
 1954 bronze
 JAR pl 4
 Serge Lifar, head diorite
 VEN-36:pl 72
Zanardelli, Giuseppe (Italian Lawyer
 and Statesman 1829-1903)
 Ximenes. Giuseppe Zanardelli,
 seated figure
ZANELLI, Angelo (Italian 1879-)
 Campo Sportivo, facade bronze
 VEN-34:pl 81 ICadu
 Gasparo da Salo, bust marble
 VEN-24:pl 104 ISal
Zanetti, Giovanni (Archbishop of
 Thebes)
 Lombardo, Pietro. Zanetti
 Monument
ZANETTI, Giuseppe (Italian 1891-)
 The Blind Orphans of War
 (Il Cieco e l'Orfano di
 Guerra) plaster
 VEN-24:pl 95
 St. John as a Boy bronze
 VEN-28:pl 86
 St. John the Baptist colored
 plaster
 VEN-32:pl 19
Zanzi, Emilio
 Guerrisi. Emilio Zanzi, head
Zarathustra. Henning, P. R.
ZARCILLO Y ALCAREZ, Francisco
 Antonio (Francisco Antionio
 Salzillo) (Spanish 1707-81)
 The Agony in the Garden 18th c.

ptd wood
 GUID 254; POST-2:78 SpMS
Christ Carrying his Cross,
 detail c 1780
 BUSB 214 SpMuS
Christ on Mount of Olives,
 processional figure 1707/81
 ptd wood, cloth garment
 STA 101; WES pl 32 SpMuJ
Dolorosa
 BAZINW 406 (col) SpME
Fall on the Road to Calvary
 1752
 VEY 207 SpMuS
Kiss of Judas, paso detail
 LARR 372 SpMuJ
Last Supper c 1780
 BUSB 215 SpMuJ
Peter Striking Malchus,
 processional figure
 STA 178 SpMuJ
St. Jerome 1755 ptd wood;
 63-3/4x51-1/8
 VEY 287 SpMuS
ZARZA, Vasco de la (Spanish fl
 1499-1524)
 Tomb of Cardinal Alonso de
 Madrigal ("El Tostado")
 1518 marble
 BUSR 175; CIR 39 (col);
 GUID SpAvC
ZAUNER, Franz Anton von
 Emperor Joseph II, equest
 1795/1806 bronze; 35' (with
 pedestal)
 NOV pl 184a AVJ
Zborowski, Leopold
 Zamoyski. Leopold Zborowski,
 head
Zebedee
 Riemenschneider. Zebedee and
 Mary Salome
Zebras
 Schwerdtfeger. Zebra
Zehnkampfmann. Kolbe
Zeitspiele. Blecher
ZELEZNY, Franz (Austrian)
 Lincoln c 1908
 BUL 159 UNbOL
Zen Altar. Lombardo, Antonio
Zeno, Saint
 Italian--12th c. St. Zeno,
 seated in Episcopal Chair
Zenobius, Saint
 Arnolfo di Cambio. Virgin and
 Child Blessing, and Sts.
 Reparata and Zenobius
 Arditti. St. Zenobius,
 reliquary bust

Zephir. Haese, G.
Zephyr. Kemeny
Zeus (Jupiter)
 Agostino di Duccio. Jupiter,
 relief
 Braun, M. B.--Foll. Jupiter,
 head
 Cellini. Jupiter
 Couturier. Joven
 Pisano, A. Jupiter as a
 Monk, relief
 Sansovino, J. Jupiter
 Taglioni. Jove Deposing the
 Titans
 Thorvaldsen. Ganymede with
 Jupiter as the Eagle
Ziethen, Joachim
 Schadow. General Joachim
 Ziethen
ZIFFER, Moshe (Polish-Israeli 1902-)
 Kneeling Figure limestone
 SCHW pl 65
 Nude wood
 GAM pl 122
 --Nude; rear view
 GAM pl 119, 120
 --relief wood
 GAM pl 121
 Squatting Figure limestone
 SCHW pl 66
ZIJL, Lambertus (Dutch 1866-1947)
 Binding Corn, detail 1917
 bronze; 16-3/4
 HAMF 284 NOK
 Dr. C. A. Lion Cachet, head
 1931
 HAMF 126 NOK
 Exchange Entrance relief 1897
 BOE pl 92 NA
 Fishermen*, facade figures
 1912
 GEL pl 106 NAH
 Gysbrecht von Amstel, corner
 figure 1903 sandstone;
 197-1/2x28-3/4
 HAMF 285 NAE
 The Sea, relief 1915 bronze
 HAMF 126 NOK
 Youth
 HAMF 126 NOK
Zimburgis of Masovia
 Austrian--16th c. Maximilian
 Tomb
ZIMMERMANN, Dominikus (German
 1685-1766); and Johann Baptist
 ZIMMERMANN
 Wieskirche, interior 1746/54
 ENC col pl 64 (col); 963;
 FARR 341; STA 181 (col)
 GWP

--Choir and High Altar
 MYBA 561
--Pulpit stucco
 BAZINW 413 (col); LARR
 355
Church Ceiling, detail after
 1727
 LARR 355 GStei
ZIMMERMANN, Eduard (Swiss)
 Giovanetta Che S'Incammina
 bronze
 VEN-20:59
ZIMMERMANN, Johann Baptist; and
 J. DIETRICH
 Spiegelsaal (Hall of Mirrors):
 Hunting and Fishing Wall
 Decoration, Amalienburg
 1734/39 white, silver, and
 blue stucco
 BAZINW 411 (col) GMN
ZIMMERMANN, Kurt (German 1910-)
 Liegende 1933 plaster, for
 bronze; L: 35 cm
 HENT 67
La Zingara
 Martini, A. La Gitana
"Zingarella". Cordieri
Zion. Mayer-Michael
Zion (Casket for Holding Gifts or
 Holy Relics)
 Russian--14th c. Zion
ZIVR, Ladislav (Czech 1909-)
 Donna con Strappo 1960
 ptd plaster
 VEN-62:pl 129
ZMAJ See JOVANOVIC, Jovan
ZOCCHI, Arnoldo (Italian)
 Columbus, detail: Planting
 the Cross in the New World,
 base group 20th c.
 PAG-10:13 ArB
ZOCCHI, Emilio
 Michelangelo at work on
 First Sculpture
 BARSTOW 145 IFP
Zodiac
 Agostino di Duccio. Mars,
 zodiac sign, relief
 French--12th c. Christ in
 Miracle of the Pentecost:
 Signs of Zodiac
 --Signs of Zodiac
 --Woman with Signs of
 Zodiac: Lion, Ram
 French--13th c. St. Firmin
 Portal
 Hald. Zodiac, celestial globe
 Italian--13th c. Signs of
 Zodiac, marble intarsia
 pavement

Zoe (Eastern Roman Empress 980-
 1050)
 Byzantine. Constantinople
 Coin: Empresses Zoe and
 Theodora
 Byzantine. Crown of
 Constantine IX Monomachus;
 detail: Zoe
 Byzantine. Empress Zoe,
 Medallion
Zoe: Charge Objet. Sanejouand
ZOLLNER, Waki (German 1935-)
 Mobiles Objekt 1966
 KULN 193
ZONGOLOPOULOS, Giorgio (Greek
 1903-)
 Olive 1963 bronze
 VEN-64:pl 162
 The Poet, equest 1957 iron;
 110 cm
 SAO-4
Zouave. French--19th c.
ZSCHOKKE, Alexander (Swiss-
 German 1894-)
 Brunnen, Inselschulhof 1924
 bronze; 1 m
 HENT 90 SwB
 Christian Rohlfs, head 1932
 bronze; LS
 HENT 91 GBN
 Erich Heckel, head 1927
 bronze; 31. 5 cm
 OST 58 GHaL
 Oscar Kokoschka, half figure
 bronze; 100 cm
 JOR-1:pl 32
 Rene Auberjenois, half figure
 1948 bronze; 100 cm
 GERT 97; JOR-1:pl 31
ZUCCARI, F.
 Window
 GOMB 267 IRZ
"Lo Zuccone"
 Donatello. Prophet Habakkuk
ZUFFI, Pierre (Italian)
 Ceramic Panels, Winter
 Garden, SS Andrea Doria
 DAM 215
ZUMBO, Giulio Gaetano (Italian
 1655-1701)
 Adoration of the Shepherds
 end of 17th c. ptd wax;
 24x33x28
 VICF 82 ELV (A. 3-1935)
ZUR STRASSEN, H. (German)
 Figure de Proue
 FPDEC--German il 9
ZURCHER, Arnold (West African-
 Swiss 1904-)

Figure IV-56 1956
JOR-2:pl 301
Figure VI-57 1957
JOR-2:pl 302
Figure VIII-57 1957
JOR-2:pl 303
I-58 Ailes 1958
JOR-2:pl 144
ZURN, Jorg See ZURN, Michael
ZURN, Martin (German 1590/95-
1665)
St. Sebastian; detail 1638/39
lindenwood; figure: 286 cm
BSC pl 110, pl 111 GBS
(3/58)
ZURN, Martin; and Michael ZURN
Death of St. Sebastian
c 1650/53
BUSB 84 AStGF
Rose Garland Altar 1634 ptd
limewood
BAZINW 373 (col); BUSB
56; HEMP 21; KO pl 86
(col); MUL 89; VEY 149
GUbN
--Adoration of the Shepherds
BAZINW 372 (col); MUL
88
--Annunciation; Virgin, head
MOLE 219
--St. Michael
BUSB 59
--Virgin
BUSB 58; HEMP pl 20
ZURN, Martin; and Michael ZURN
Virgin on the Crescent Moon
(Maria auf der Mondsichel)
1630 boxwood; 20 cm
BERLE pl 82 GBSBe (8683)
ZURN, Michael (Jorg Michael Zurn)
(German 1590/95-1651)
Kneeling Angel, Salzburg
1683 marble; 80
KO pl 92 AKrS
Mater Dolorosa 1683 giltwood;
46
KO pl 92 AVO
St. John the Evangelist 1640
ptd lindenwood; 100 cm
BSC pl 109; KO pl 86
GBS (8433)
ZURN, Michael, the Younger (D. J.
Michael Zurn, the Younger)
(German-Austrian 1626-91)
Angel, Candida Altar 1682
marble
BAZINW 398 (col); BUSB
107 AKrS

ZWEDEN, Johan van (Dutch)
Baby, head
CASS 44
Zweiklang. Schilling, A.
Zwei Madchen. Marcks
Zwei Madchen. Otto
Zwei Redende mit Krugen. Lorcher
Zwei Reiter, relief. Blumenthal
Zwei Stehende Frauen. Hartung
Zwinger Pavilion Atlantes. Permoser
ZWOBADA, Jacques (French 1900-)
Chevauchee Nocturne 1963
bronze; 4x13'
CHICSG
The Couple, 1956 bronze
MAI 310
Dance 1952
BERCK 350
Night Ride 1957 bronze
MAI 311